"In his new, staggeringly well-researched biography of Breton, Mark Polizzotti does not shy from his subject's behavioral unsavoriness, and some of it makes for reading so hilarious one is tempted at moments to believe that his intention was to debunk the man. But the hilarity merely reflects the central paradox of Breton's existence . . . [Breton] conjured a whole new way of thinking about the world. And, in Mark Polizzotti, he has found a flawless biographer."—Gilbert Adair, [London] *Sunday Times*

"Mr. Polizzotti has produced a substantial work. While mapping a wide area of French literary and artistic life between the wars, he offers much the most complete portrait available in English or French of Surrealism's *magister ludi.*"—Frederick Brown, *New York Times Book Review*

"Wonderfully thorough . . . Polizzotti takes us expertly through the years of Breton's dealings with Dada, the rupture of 1921, and the creation of Surrealism [and he] handles the awkward half-embraces between the Surrealists and the Parti Communiste Français well and in detail." —front page, *Times Literary Supplement*

"Enriched with new information, Mark Polizzotti's meticulous biography is likely to become the standard reference."—*Le Monde*

"Monumental . . . Not only a very extensive portrait, but also the portrait of a vast, conflict-laden field of interpersonal disharmony and deep abysses in the realm of creative self-expression . . . A lively, eminently readable piece of literary history."—*Neue Zürcher Zeitung*

"Mark Polizzotti has written the portrait of an intransigent, uncompromising genius who founded the most characteristic artistic movement of our century. In painting his canvas Polizzotti has demonstrated his mastery of intellectual history, the intricacies of Parisian literary politics, Breton's own complex psychology, and the subtleties of artistic influence. How astonishing that this summum should be a first book!" —Edmund White

"*Revolution of the Mind* is a rare feat, a scholarly book that debunks and glories in its subject with serene pertinacity and a distinct genius for the back story. It is the best history of Surrealism we are likely to get for many years . . . Polizzotti had a daunting quantity of skillful mystification to plow through . . . To his immense credit, [he] sorts out as much as he can without boiling off the truly mysterious."—Gary Indiana, *VLS*

"Better than a history of Surrealism, this evenhanded biography of Breton lets us live a movement from the inside looking out. It's all here—pranks, loves, politics. With cool authority, Polizzotti reveals the most influential artistic movement of the twentieth century as essentially opposed to art."—Roger Shattuck

"For all its devotion to the smallest detail, its patient tracing of Breton's life almost day by day, the book remains consistently absorbing . . . [Polizzotti] writes convincingly and with insight. And he has done his homework: He has had access to unpublished materials and knows his way around the published materials . . . Polizzotti's full guide to Breton's life will not need to be redone for a long time."—Peter Gay, *Los Angeles Times Book Review*

"Polizzotti blows off the dust, out of which not only an intellectual movement but an entire epoch begins to shine . . . One cannot imagine a more intensive biography."—*Die Weltwoche*

"Admirably dispels much of the mist surrounding the figure of Breton and gives us a splendidly clear picture of the man himself. In a richly documented, seamlessly composed narrative that is as engrossing as it is informative, Polizzotti has brilliantly succeeded in filling in many of the lingering gaps in our knowledge of the life of one of the seminal cultural figures of our troubled century . . . If the best biographies go beyond mere advocacy or enmity to present, as much as possible, the full human complexity of their subjects, with all their foibles and virtues, then Polizzotti, with this, his first book, has given us an exemplary model of the art."—Stephen Sartarelli, *New Criterion*

"A marvel of style and substance. It is written so engagingly that it reads almost like a novel, but it is clearly carefully researched and thorough . . . Polizzotti's treatment of [Breton] is even-handed and fair, showing the warts as often as the splendid head."—*Art Book*

"Polizzotti relates his story fluidly and straightforwardly . . . With cool passion he gathers his material together without selling out the facts to gossip and speculation."—*Frankfurter Rundschau*

"The first great biography of Breton . . . Heavily researched but not punctilious, sufficiently erudite but written with ease and elegance, this biography brings its subject to life . . . Breton can be found here—finally—as he was, with his grandeur, his failings, and his humor."—*Livres Hebdo*

"Masterly; this is a story superbly told. Polizzotti has an impressive knowledge of the social and intellectual history of the lengthy period the biography covers, as well as a solid feel for the numerous artistic spheres with which Surrealism inevitably comes into (generally confrontational) contact."—*Boston Book Review*

"At the end of Polizzotti's book one has the feeling of knowing a man and an era as never before. Breton's influence has been enormous, and this long biography is one of the few that fully justifies its length." —*Literary Review*

"Beautifully written, this book is a memorable addition to the cultural history of our century and a work of literary art."—James Lord

"A remarkable biography, filled with sublime women, hilarious anecdotes (especially about Dalí), scandals, and flashes of poetry."—*Lire*

"Both an expertly researched life and an informed history of one of the defining cultural movements of this century . . . Very well written [and] highly recommended."—*Library Journal* (starred review)

"A discriminating, highly detailed book that portrays the Pope of Surrealism as an ambivalent, contradictory personality . . . Polizzotti sides with neither Breton's enemies nor his disciples, and his opulent portrait reveals, for the first time, the poet's private life."—*Neue Luzerner Zeitung*

"Easily read and eminently worth reading."—*Süddeutsche Zeitung*

"A well-researched, lucid biography . . . What Polizzotti does best—and he does it very well—is to show the influence of Breton's personality and his enthusiasms not only on colleagues like Buñuel, Duchamp, Dali, Robert Desnos, and Miró but also on the course of culture in the 20th century." —*Publishers Weekly* (starred, boxed review)

"Polizzotti skillfully covers all of Breton's influential critical, polemical, and creative activities, providing brisk but telling profiles of his friends, colleagues, and loved ones. He also conveys the full extent of the turbulence that dominated Breton's complex personality . . . [A] vividly detailed and invaluable tome."—*ALA Booklist*

"Not merely the biography of André Breton, but the life stories of his friends, acquaintances, and relatives as well . . . One has to bow mentally before this almost superhuman performance." —*Frankfurter Allgemeine Zeitung*

"[Breton is] not easy to write about, but Mark Polizzotti, who has read everything and talked to everyone, succeeds. Here is the Surrealist world in fascinating detail."—*New Statesman*

"Mark Polizzotti restores Breton as he was, day by day . . . His access to unpublished documents gives the book some of its strength and newness."—Gérard de Cortanze, *Le Magazine littéraire*

"Polizzotti has succeeded in lifting the cloak of silence. He has discovered that Breton hesitated to reveal his past for good reasons . . . Thanks to sufficient critical detachment, he leans neither toward transfiguration nor iconization. Breton comes through as a genius with more than one human weakness . . . Polizzotti's accomplishment is to have uncovered his psychologically rooted mechanisms."—*Märkische Allgemeine*

"A carefully researched, intricate, and well-written daybook of André Breton's life and work."
—*Boston Phoenix*

"What one admires about this biography is that it's also a deeply informed evocation of the era in which modernism emerged. Mark Polizzotti explores the politics of culture in early twentieth-century France through André Breton with verve and sympathy, while keeping himself at just the right critical distance, it seems, from its intellectual zaniness, political turbulence, and roiling artistic genius."—David Levering Lewis

"Even at more than 600 pages, [Polizzotti] never repeats himself and keeps the narrative of artists in bitter conflict and aesthetic theories in disarray flowing with unstoppable, captivating force."
—*Library Journal* ("Best Books" round-up)

"Invaluable . . . It is one of Polizzotti's many virtues that, while there is no attempt to conceal his subject's failings, Breton still emerges as a man whom the playwright Ionesco correctly described as 'one of the four or five great reformers of modern thought' . . . Essential reading for both tyro and veteran alike."—George Melly, *Sunday Telegraph*

"An eminently readable book, rich in anecdotes, with a lively portrayal of conflicts and psychological insights."—*Falte*

"An interesting read . . . We learn much about Breton's youth, the women he loved, and his time in the United States."—*Le Figaro littéraire*

"Breton has been fortunate in having [a biographer] as subtle and knowledgeable as Mark Polizzotti . . . [He] has been able to create Breton and his world anew."—Thomas McGonigle, *Chicago Tribune*

"Essential for anyone interested in Surrealism . . . Polizzotti draws on letters, journals, and interviews with actual participants, recounting Breton's story as if he had been an eyewitness, and giving the reader the feeling of having attended historic events."—Zack Rogow, *Harvard Review*

"In addition to having provided a painstakingly detailed inventory of an incredibly eventful life, Mark Polizzotti also deserves credit for his efforts at demythologizing some of the most notorious moments."—*Der Standard*

"Mark Polizzotti has two obvious qualities: he knows how to relate facts and analyze ideas in a clear, lively style . . . and he bases his narrative and analyses on hundreds of source notes . . . Certain key moments, such as Breton's meeting with Vaché, his meeting with Trotsky, or his exile in New York, are rendered flawlessly. Armed with a wide range of information and a solid critical sense, he manages to reconstruct events, to express their significance, and especially to situate Breton's place in the Surrealist group."—*BCLF*

"Thanks to this comprehensive study, it is now possible to hold a nonpartisan discussion about Breton and Surrealism . . . Polizzotti avoids the twin dangers to which a biographer is exposed more than any other researcher: identification with his subject and a desire for revenge. *Revolution of the Mind* is the work of a passionate researcher who has sifted through countless works and archives, then proceeded to detail that material in a way that is well organized and easily accessible . . . Polizzotti puts himself in the service of the material and undogmatically negates historical errors with the aid of his superior knowledge."—*Wespennest*

"[A] scrupulously researched and highly readable work of biography and scholarship . . . Polizzotti's book goes a long way toward humanizing the formidable Breton."—*Sulfur*

"Excellent."—Philippe Sollers, *Le Journal du Dimanche*

"An astonishing biography . . . It heralds a brilliant career."—*Review of Contemporary Fiction*

"If one of the delights of this biography is to be found in the multiplication of detail, its principal virtue is its level-headedness . . . This highly engaging biography is worthy of a subject whose paradoxes and contradictions are very much our own."—Terry Hale, *In Other Words*

"Monumental . . . Supported by vast documentation, the author evokes with remarkable precision the events, anecdotes, friendships, and loves that conditioned the life and influenced the work of Breton, and brushes a living portrait of the literary and intellectual life of the period." —*The Lion*

"Polizzotti succeeds in eavesdropping on that uniquely Parisian carrying-on that lasted from the end of the first World War until the beginning of the second . . . relating in lively fashion and with the proper emphasis the backstage fights, expulsions, acts of revenge, and tumultuous, at times infantile, activism."—*Rhein-Neckar Zeitung*

"Highly intelligent, readable, and informative . . . Like Roger Shattuck's earlier cultural chronicles, *The Banquet Years*, Polizzotti's book engagingly adds to the picture of the French literary and artistic avant-garde."—*Art Journal*

✳

REVOLUTION OF THE MIND was a finalist for the PEN/Martha Albrand Award for Best First Book of Nonfiction, and was named a Best Book of the Year by the *New York Times Book Review*, the *Village Voice Literary Supplement*, *Library Journal*, and *Critics' Choice*.

REVOLUTION OF THE MIND

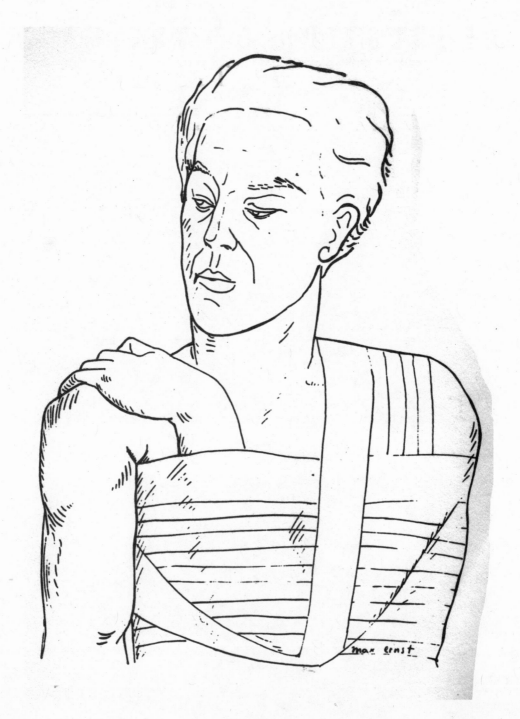

MARK POLIZZOTTI

REVOLUTION

OF THE

MIND

The Life of André Breton

revised & updated edition

BLACK
WIDOW
PRESS

BOSTON, MASS.
www.blackwidowpress.com

Note on the titles of works cited:
Titles of works that exist in English are given in translation. All others are given in the original, with, when needed, a translation in square brackets.

FIRST BLACK WIDOW PRESS EDITION, 2009

Frontispiece: Portrait of André Breton by Max Ernst (1923), courtesy Dorothea Tanning.
Additional photo credits appear on page 666.

Black Widow Press is an imprint of Commonwealth Books, Inc., Boston. Distributed to the trade by NBN (National Book Network). All Black Widow Press books are printed on acid-free paper. Black Widow Press and its logo are registered trademarks of Commonwealth Books, Inc.

Joseph S. Phillips, Publisher.
www.blackwidowpress.com

ISBN: 978-0-9795137-8-7

Library of Congress Cataloging-in-Publication Data on file

Printed in Canada by Friesens
10 9 8 7 6 5 4 3 2 1

CONTENTS

Photographs follow pages 150 and 366.

ACKNOWLEDGMENTS

IN PREPARING THIS BOOK, I have benefited first and foremost from special access to Breton's unpublished papers and correspondence. This access was granted by Breton's heirs, who waived a specific testamentary provision that the papers not be made public until 2016. Although this provision has now been superseded by the terms of the April 2003 auction of Breton's papers, I remain indebted to Breton's daughter, Aube Elléouët, as well as to two key figures who have passed away since this book was first published—Breton's widow, Elisa Breton, and his literary executor, Jean Schuster—for having allowed me to consult these documents at a time when very few people could have access to them.

I am also grateful to François Chapon and his assistants at the Bibliothèque Littéraire Jacques Doucet in Paris; to Claire Blanchon and Brigitte Vincens of the Centre Georges Pompidou; to the staffs of the Harry Ransom Humanities Research Center at the University of Texas, Austin, the Bibliothèque Nationale in Paris, the Museum of Modern Art Library and the Archives of American Art in New York, and the Houghton Library at Harvard University; and to Jean-Pierre Dauphin of Editions Gallimard and his able assistant, Liliane Phan, for facilitating my archival research and for putting many documents at my disposal.

Harvard University, New York University, and the French Library in Boston gave me opportunities to test out early versions of some of my material on live audiences. The Cultural Services of the French Ministry of Foreign Affairs financed several indispensable research trips to Paris. More generally, the National Endowment for the Humanities and the Atlantic Center for the Arts provided money and workspace during different segments of the writing process. My thanks to them all.

A number of individuals, some of them now gone, gave generously of their time, memories, insights, collections, and copyright permissions. For want of being able to detail specific contributions, I express my sincere gratitude to Lionel Abel, Hester Albach, Noël Arnaud, Timothy Baum, Jean-Louis Bédouin, Georges Bernier, Jean-Claude Blachère, Michel Carassou, Leonora Carrington, Claude Courtot. Alexina Duchamp, Alain Dugrand, Cécile Eluard, Serge Fauchereau, Monique Fong, Charles

Henri Ford, Jacques Fraenkel, Michel Fraenkel, Catherine Gide-Desvignes, Madeleine Goisot, Mary Jayne Gold, Jean-Michel Goutier, Myrtille Hugnet, Edouard and Simone Jaguer, Marcel Jean, Ted Joans, Alain Jouffroy, Nelly Kaplan, Jacqueline Lamba, Michel Leiris, Claude Lévi-Strauss, Helena Lewis, James Lord, Thomas Maeder, Judith Young Mallin, Samir Mansour, Anne de Margerie, Marcel Mariën, Julie Martin, Jean-Claude Masson, Pierre Matisse, Yvonne Mayoux, Bernard Minoret, Bernard Morlino, Pierre Naville, Gérard Paresys, André Parinaud, Henri Pastoureau, Jacqueline Paulhan, José Pierre, Jean-Marie Queneau, Dominique Rabourdin, Mme. Georges Ribemont-Dessaignes, Edouard Roditi, Michel Sanouillet, Sylvie, Marc, and Vincent Sator, Meyer Schapiro, Georges Schehadé, Georges Sebbag, Georges Seligmann, Philippe Soupault, Matthew Spender, Dorothea Tanning, Paule Thévenin, André Thirion, Virgil Thomson, Olivier Todd, Lucien Treillard, Christophe Tzara, and Klaus Wust.

Many others furnished me with books, encouragement, suggestions, criticism, and homes away from home during my years of research and writing. For this and more, my heartfelt thanks go to Pierre Assouline, Neil Baldwin, Susan Bell, Gabriel Bernal Granados, Frédéric Berthet, Hector Bianciotti, Marguerite Bonnet, Dominique Bourgois, Jean-Jacques Brochier, Andreas Brown, Marie-Claude de Bruhnoff, Phyllida Burlingame, Marie Chaix, Isabelle Châtelet, Jacqueline Chénieux-Gendron, Olivier Cohen, the Daynard family, Paul De Angelis for setting the idea in motion, Florence Delay, Jean Echenoz, Didier Eribon, Mercedès Fort, Françoise Fritschy, Jean Gaudon for the initial impetus, Elisabeth Gille, André Heinrich, Robert Hemenway, Frederick Karl, Aline Luque, Mathieu Marcenac, Robert Massie, Harry Mathews, Roberto Matta, Claude and Ivan Nabokov, Monique Nemers, Pascal Quignard, Zack Rogow, François and Annie Samuelson, Enrico Santí, Christopher Sawyer-Lauçanno, Rick Scarola, Bob and Françoise Schneider, Jean-François Séné, Roger Shattuck, Jacques Simonelli, Sally Singer, Rachel Stella, Dorothy Straight, Susan Suleiman, Denise Tual, Juan José Utrilla, Mike Vahala, Trevor Winkfield, Bill Zavatsky, and my parents, Grace and Mario Polizzotti.

Finally, I gratefully acknowledge the help of Deborah Karl and of the publishers and editors in several countries whose advice and guidance have helped make this a much better work than it would otherwise have been: at Farrar, Straus and Giroux, Jonathan Galassi and Paul Elie; at Bloomsbury, Liz Calder; at Carl Hanser Verlag, Michael Kruger; at Editions Gallimard, Eric Vigne, Isabelle Gallimard, and Georges Liébert; at Fondo de Cultura Economica, Juan Carlos Rodríguez Aguilar, Joaquin Díez-Canedo Flores, Adolfo Castañón, and Laura González Durán. And particular thanks to Joe Phillips of Black Widow Press for giving it a new life.

This book is for my wife, Sadi Ranson-Polizzotti, and for my son, Alex Polizzotti.

FOREWORD TO THE REVISED EDITION

MANY NEW FACTS ABOUT ANDRÉ BRETON'S LIFE have emerged in the nearly fifteen years since this book was first published, and the present edition incorporates a fair number of them. Most notably, the auction of Breton's private collection of artworks and manuscripts in April 2003—whatever reservations one might have about it in principle —made available to researchers for the first time previously unknown information about his dealings with some of those closest to him, providing a better understanding of how these dealings helped shape the course of Breton's life and of the Surrealist movement. New documents and research resulting from this auction, for example, have allowed me to shed more light on the life and death of Nadja, Breton's legendary heroine, illuminating not only their complex interactions but the process by which Breton composed his celebrated account. Several recent publications have also afforded me new insights into Breton's marriage to his first wife, Simone Kahn, and his relationship with Suzanne Muzard, the woman for whom that marriage ended. More generally, these and other previously unknown documents have allowed me to present a more balanced picture of various episodes than was originally possible, and to supplement or reassess my interpretations of key events.

I have also taken the opportunity to address some stylistic infelicities that had crept in the first time around and to correct the occasional error or misstatement, some of these pointed out to me by correspondents, to whom I extend my thanks. Attentive readers will notice as well the disappearance or condensation of a few minor episodes, judged on second thought to be extraneous, a distraction from the larger point. I like to think that the years render us less indulgent toward our youthful excesses.

Over time, the various editions of this book have given rise to a number of articles and reviews, which, while gratifying, prompted me both to reflect further on the biographical process and, especially, to gauge just how subjective that process is—not only the writing of it but the reading as well. While it was no surprise to see the remaining Surrealist loyalists of the French association Infosurr take potshots at some of my assertions—given Breton's horror of self-revelation in all but its most regulated forms, this was to be expect-

ed, even desired—I was struck on several occasions by the diametrically opposed reactions of some other, ostensibly less biased, critics. It is an odd feeling, at once amusing and bemusing, to see the same work characterized as "hagiography" in one newspaper and "character assassination" in another. Readers, even professional ones, bring their own baggage to the reading experience, of course. But more to the point, if I've given partisans of both sides something to deplore (as well as, presumably, to applaud), to me it means I've avoided falling into either camp. It means I've done my job.

Admittedly, biography is a strange genre, and as it has risen in popularity in recent decades it has also come under increased criticism, not always unfounded. Indeed, there is something suspect about spending years of one's life unearthing the skeletons of great and not-so-great men and women. No matter how even-handed one sets out to be, a certain degree of tendentiousness inevitably creeps in. The fact that many biographies are written for personal gain often adds a patina of venality to the whole enterprise. And even when the motives are more valorous, one is unavoidably caught (if one aims at honesty) in the dilemma of having to confront an admired figure with the less flattering aspects of his existence. Let's face it: a person's great deeds are generally a matter of public record, trumpeted by the actor himself and by his descendants, but most of life happens quietly, behind proverbial closed doors. And if a biographer assumes the unpopular task of looking behind those doors, of uncovering and reporting actions that the subject chose not to make known, it is not in order to embarrass him or diminish his accomplishments, but to set him and them in a more complete, more realistic context. Monuments, and those who erect them, tend to eschew defects. Still, think how silent and immobile such monuments are, how little they tell us beyond the most superficial notion of magnificence.

It is a commonplace to say that our flaws are what make us human. Yet this commonplace does not seem to apply to those whose lives are deemed worthy of serious study. Does it truly undermine a person's landmark achievements to discover that not every one of them was motivated by purely altruistic impulses? Doesn't it, rather, bring us closer to understanding that person not as some sort of cardboard hero but as a shrewd, complex, often tragic, and in any case human figure? And aren't these subtler shadings more liable to deepen our sense of the historical and emotional imperatives surrounding that person and his or her actions? I began writing *Revolution of the Mind* out of a longstanding admiration for and fascination with André Breton's public persona. By the time the book was finished nearly a decade later, I had supplemented that fascination with something of considerably greater value: a kind of virtual acquaintance with an imperfect, but far more engaging, human being.

In the best of cases, a biography is a cameo portrait not only of an individual but of humanity as a whole. The specifics of Breton's life might well be unique to him, but the doubts, hesitations, moments of triumph and weakness he experienced, the grandeur and the pettiness, the loves and irrational hatreds, are familiar to us all. We read Breton's life, as we might any life, not only to learn about his own history or that of Surrealism but also, ideally, to glimpse truths about ourselves. I wrote about this life to discover the portions of a fascinating story that I instinctively knew were missing from the standard accounts, but perhaps even more so to confront my own being with an examination of his. My aim is neither to praise nor to damn, but to excavate. To orchestrate and convey the passions of all those involved in the story, beginning with the subject and ending with myself. And, ultimately, to shed light on one dark corner of the human experience.

As time goes on, new information will continue to emerge about Breton, clearing the path for other, better informed, possibly more penetrating portraits of the man. The documents made available by the 2003 auction have proven especially valuable and, not having had them at my disposal when the book was first written, I am glad that this new edition has allowed me to make use of them after the fact. At the same time, I consider myself fortunate to have undertaken the project when I did, as many of those who contributed their insights to it—Philippe Soupault, Michel Leiris, Meyer Schapiro, André Thirion, Elisa Breton, Jean Schuster, Charles Henri Ford, Edouard Roditi, Jacqueline Lamba, Virgil Thomson, Marcel Jean, to name only a few—have passed away in the intervening years. More than anything, it was their oral testimony, and the personal contact I was privileged to have with them, that helped shape my understanding of Breton, and for this I remain forever grateful.

— MP, *June 2008*

REVOLUTION OF THE MIND

"THE PASSABLY HAGGARD AND VERY HOUNDED CHILD"

(February 1896 – August 1913)

HE HAD TWO BIRTH DATES. The chronological one, the one that appears on his birth certificate and other official documents, is February 19, 1896. The other, which he permanently adopted in 1934 (and which many of his commentators have perpetuated), is February 18 of the same year. The discrepancy is slight, but as with many aspects of Breton's biography, its importance has been magnified beyond normal proportions.

What lies behind so subtle a change? An attempt to cover biographical tracks? To "correct" existing data into something more compatible with a desired persona? Possibly both. Throughout his life Breton was extremely parsimonious with personal reminiscences, notably about his childhood; and if his writings are heavily—one might even say shamelessly—autobiographical, the incidents recounted are like so many case studies, at once open to clinical scrutiny and unyielding of much concrete information. Like good sleight of hand, they give the illusion of disclosure without the attendant intimacy.

In addition to this, Breton often evinced a will to improve upon the mundane aspects of existence, to recast them into something larger and more resonant—even if, at times, it meant adjusting his curriculum vitae. He claimed that he had no use for the "empty moments" of his life, the instances of "depression or weakness" that would nonetheless visit him so regularly, preferring instead to accentuate the unusual or dramatic episodes, to project them beyond simple biography into something approaching universal truth.

Initially, Breton's change of birth date might have been inspired by his first love, a cousin on his mother's side named Manon, whom he later credited with initiating him into the disturbing blend of "seduction and fear" that is sexuality. Manon was born on February 18, 1898, and it was not long after their brief liaison that Breton first officially gave his own birth date as February 18, on a medical school registration. But the definitive modification of the 1930s seems to have been governed by a more enduring passion: astrology. Breton had developed a strong interest in astrology in the mid-1920s, seeing the discipline as another way to mine the hidden side of life for the thrilling coincidences it might reveal. In his own case, an astrological reading of February 18 (as opposed to the 19th) establishes various "links" between himself and several of his most

admired predecessors, notably the poets Arthur Rimbaud and Gérard de Nerval and the utopian philosopher Charles Fourier. In opting for the 18th, Breton was placing himself from the outset in privileged company, the kind that he would seek throughout his life.

This dual birth date is only one facet of the larger mystery with which Breton covered his origins: one rarely finds an author so reluctant to discuss his early years. In part, this might have stemmed from the unhappy nature of his childhood, a way simply of avoiding unpleasant memories by erasing their existence. In part, too, it responded to Breton's modesty regarding "empty moments," which by his own definition included everything before his early adulthood.

Few have made such literal use of Lautréamont's phrase "the unmentionable day of my birth." The irony is that the man who professed such an intolerance of the fictional genre should from early on place his own life in the realm of invention.

<p style="text-align:center">✳</p>

On the evening of Ash Wednesday, February 19, at ten o'clock, in the town of Tinchebray in Normandy, the former seamstress Marguerite-Marie-Eugénie Le Gouguès, aged twenty-four and wife of Louis-Justin Breton, a twenty-nine-year-old policeman, gave birth to her only child. The following morning the boy was registered at the town hall and christened André Robert, after a maternal great-uncle who had mysteriously vanished on his wedding day.

Perhaps even more mysterious than the namesake's disappearance was the union of Marguerite and Louis, for the two were incompatible in nearly every respect. Louis Breton was a good-natured, apparently unambitious man whose one strong conviction was atheism. He was thin and relatively tall for his day, with the conventional demeanor of the petty bourgeois, his sober dress and well-trimmed goatee only slightly offset by a rather piercing gaze. Inclined to be self-effacing, he was sometimes forced by the stricter Marguerite to adopt a severe disciplinary position toward his son. This severity, however, was most often overcome by Louis's fundamental tolerance and his interest in André's activities, both in childhood and in later, more public times. Although Louis, a man of average intelligence, was mystified by Dada and Surrealism, he took a certain pride in his boy's fame and literary successes. For Breton's part, and despite his professed hatred of the family, he maintained generally affectionate relations with Louis throughout his life. The only true note of annoyance had to do with what he considered his father's obtuseness—as well as his willingness to defer to his wife in matters of discipline.

In contrast to her husband, Marguerite Breton tended to be cold and domineering, with a thickset body and a willful, unforgiving look—the same look that many would later ascribe to Breton in his moments of fury. She had outsized social aspirations for her modest household, and, also in contrast to Louis, she was deeply pious, if only out of convention. For Marguerite, the path to the Church and the path to social respectability were one, and she fought her husband's anticlericalism by trying to infuse Breton with her own brand of religious respect. Breton, like most French children of his day, received First Communion at age eleven. And like most, he suffered the obligatory commemorative photograph (kneeling, devoutly clutching his missal), in which only his slightly annoyed expresion betrays his displeasure.

From the outset, there seems to have been little affection between the mother and her only son, who—no doubt in reaction to the absence of maternal warmth—quickly developed attitudes that sharply diverged from her own. Breton later flatly described his mother as "authoritarian, petty, spiteful, preoccupied with social integration and success," and to his own eight-month-old daughter he wrote: "For a long time I thought it was the gravest insanity to give life. In any case I held it against those who had given it to me." He also confided that, as a child, he found the daily sight of his flowered lace bedspread—Marguerite's handiwork during her pregnancy—unbearable. Although Breton maintained regular contact with both his parents, keeping up correspondence and returning virtually every summer throughout his adulthood to visit them, his relations with Marguerite were primarily marked by deep resentment.

The conflict with Marguerite was never resolved; on the contrary, it permeated Breton's life, coloring his character and convictions. And perhaps more than anything, it left him with a legacy of mistrust and anger that carried through to his adult relations with women. For if, as Freud posited, the primary love object is the mother, it is also the case that a loveless mother can become the primary object of hatred. Breton's life and writings attest, on the one hand, to a deep reverence, even idolization, of Woman as an ideal; and, on the other, to a bitter resentment that surfaced in moments of perceived sexual or emotional betrayal: the same betrayal that Marguerite, with her absence of warmth, had practiced against him from the "unmentionable" moment of his birth.

It is not certain what lay behind Marguerite's rejection of her son, but one clue might be provided by the unusually long interval between her marriage to Louis on September 2, 1893, and André's birth two and a half years later. It is possible that Marguerite, against the expectations of her time and milieu, simply wanted no part of motherhood, and had either grudgingly consented to her older husband's wishes or been the victim of a not-uncommon accident; the couple, in any case, had no further offspring. But there is

another, albeit less likely, possibility: that for her, Breton was the unsatisfactory surrogate for a firstborn who had died in infancy. Poet Charles Duits once recalled an evening in the 1950s when Breton spoke of "the phantom that hounded him. 'Robert, his name is Robert. I see this person every night. He's my brother, you know. My brother Robert. No, I never had a brother. But that's precisely why these dreams are so abominable . . .'" A buried family memory? More invention on Breton's part? It is impossible to tell, and we can only note that it was customary to name "replacement" children after their deceased siblings; and that Robert—a name that figures nowhere in Breton's ancestry—was given the boy as a middle name.

✳

Although Tinchebray is located in Orne region of Normandy, Breton's family roots actually stretch eastward to the Vosges, near the German border, and westward to Brittany. Louis Breton, who represented the eastern side, was born on March 26, 1867, in Vincey, a small town in an area of the Vosges famous for its mineral waters, and spent most of his childhood and youth in the nearby village of Ubexy. The son of a winemaker and an embroideress, he was one of four children, but only he and his sister, Lucie, reached adulthood. Despite Louis's lack of professional and social ambition, it was nonetheless he who raised the Bretons from working class to petty bourgeoisie, for his background was populated by peasants and manual craftsmen, mainly cabinetmakers and thatchers. The young man moved west to Brittany shortly before his marriage, leaving the rest of the family behind.

The family of Marguerite Le Gouguès, on the other hand, had long resided in Brittany, particularly the town of Lorient, where Marguerite herself was born on July 1, 1871; although André's surname came from his father, it was due to his mother that the boy was Breton in ancestry as well. Much later, he would observe: "My maternal ancestry is purely Breton and, as it were, my family name would lead one to suspect that the filiation does not end there"—adding that "the atmosphere of Brittany, both inland and on the coast, strongly permeated Surrealism."

Like Louis's people, the Gouguès clan was predominantly working class—weavers, tanners, more thatchers, and a few small businessmen. Apart from some schoolmarms, a Trappist monk, and two nuns (both on Louis's side, both defrocked and one apparently deranged), this is the combined families' professional profile. Unlike the Bretons, however, the Gouguèses also boasted several sailors and naval employees. Breton later brought up this aspect of his mother's lineage to remark that, as a child, the one thing he

knew he *didn't* want to do was join the navy: "I felt that I could never find an occupation that was *sufficiently* its opposite."

At the time of Breton's birth, Louis was employed as a ledger clerk in the local police force; although the post was strictly administrative, his profession figures on the birth certificate—and in many people's memories—as "gendarme." In reality, the law was more a matter of opportunity than of vocation for Louis, a way of supporting his young family. He had held several minor business positions since the age of fourteen, when his father's death had left him head of the household. While this situation also exempted him from military service, he had volunteered for the army in March 1888, several days shy of his legal majority. Five years later, honorably discharged from the infantry and over-qualified for his earlier civilian occupations, Sergent-Major Breton chose to put the accounting skills he'd learned in the army at the service of the local constabulary—at least for the time being. Then, in 1898, apparently without regret, he resigned from the gendarmerie. (Later, a standard joke about Breton had it that his famous authoritarianism was understandable: after all, he was the son of a cop. But the real kepi in the family was worn by Marguerite, not Louis. It was she, with her rigid moral attitudes and personal austerity, who imbued her son—even as he rejected her example—with the intransigence for which he became notorious.)

Breton recalled his childhood (when he recalled it at all) as sad, lonely, and bleak. Shortly before his death, he told a correspondent that he could still recognize in himself "the passably haggard and very hounded child" he had once been—hounded, he added, "by the coercive apparatus jointly fostered by my parents and teachers." But while his formative years left in him an indelible rancor against his parents, and (at least on paper) against the notion of family in general, they were not entirely desolate. With the peculiar resilience of children, Breton carved out for himself moments of relative contentment, even wonder.

Many of these moments were due to his maternal grandparents, with whom André lived for the third and fourth years of his life, Louis Breton having gone to Paris to clerk in a bookstore. His grandfather, Pierre Le Gouguès, was an "old Breton, taciturn but a good storyteller, of whom [Breton] kept a loving memory." It was primarily his grandfather, retired since 1893 (he died in 1917, shortly before his eighty-first birthday), who raised the boy during these years, just as it was primarily his grandfather who gave him several lasting aspects of his character: his love of language and mystery; his interest in plants and insects; his fascination with forests. It was perhaps also Pierre Le Gouguès who opened the door to a rare note of nostalgia in this reflection from 1924: "If [man] still retains a certain lucidity, all he can do is turn back toward his childhood which,

however his guides and mentors may have massacred it, still strikes him as somehow charming."

This nostalgia for childhood—or, rather, this quest for a childhood denied—would be a primary motivation behind Surrealism. Often in his writings Breton celebrated those aspects of adult life that harked back to the marvels of the formative years, from Max Ernst's collages, reminiscent of a "child's first picture-book," to Rimbaud's juvenile insolence. A number of Surrealism's activities—whether games, automatic writing, or political revolution—were on one level a way of trying to recapture (as Breton later put it) childhood's "absence of any known restrictions," to satisfy his and his friends' "hunger for the marvelous." In 1924, when first stating the principles of the newly formed Surrealist movement, he would specify:

> The mind which plunges into Surrealism relives with glowing excitement the best part of its childhood . . . It is perhaps childhood that comes closest to one's "real life" . . . Thanks to Surrealism, it seems that opportunity knocks a second time.

Many of Breton's own early memories revolved around Pierre Le Gouguès and the time spent in Brittany, either in Lorient itself or in the coastal town of Saint-Brieuc, where his grandfather sometimes took him. (Breton, in fact, spent very little time in his native Tinchebray—all to the good, as it was a small, drab town whose main industry was the production of gardening tools and hardware.) When he was twenty-three, he fleetingly evoked some of these memories in hazy strokes, in his book *The Magnetic Fields* (*Les Champs magnétiques*). Significantly, they are among the only childhood recollections Breton ever committed to paper; perhaps even more significantly, they occur in a work of automatic writing, deliberately composed without conscious control: "I leave the halls of Dolo with Grandfather very early in the morning. The kid would like a surprise. Those halfpenny cornets have not failed to have a great influence on my life." He also revived a number of pleasurable terrors, especially brought by the Celtic legends and horror stories that his grandfather told him, filled with witches, death chariots, and Breton goblins.

But despite such moments, and the lighthearted tone of their evocation, Breton's general attitude toward his childhood was most accurately summed up in this further reflection from *The Magnetic Fields*: "I believe I was very well brought up," which he later annotated: "may it be said with rancor and hatred."

※

In 1900, at the age of four, Breton left the forests of Brittany for Paris's industrial northern suburbs. Louis Breton settled with his family in the town of Pantin, where he had found employment as an accountant, a position he soon traded for that of assistant manager in a small glassworks. The family lived on Rue de Paris, in a sooty, unprepossessing neighborhood distinguished by its large perfume factory and extensive population of streetwalkers.

As there was no state nursery school in Pantin, the boy was enrolled in a religious institution, the Maison Sainte-Elisabeth, run by an order of nuns. Breton had been baptized at birth, in deference to convention and despite Louis's atheism; now, at Sainte-Elisabeth, he received the standard dose of Catholic indoctrination and, despite his later hatred of religion, earned first prizes in spelling and attention at the end of his first year. But although Marguerite's pietism was no doubt flattered by this state of affairs, Breton's contact with religion would never again be so harmonious.

In any case, Sainte-Elisabeth was no more than a way station. Perhaps as a symptom of the family's religious schism, Breton was transferred to the secular Pantin public school in 1902, as soon as he was old enough to attend, and would spend the next five years there. As in Brittany, the daily routine was tempered by small fragments of marvel: schoolboy composition books, whose illustrated covers depicted scenes from history, legend, and world travel (Breton loved—and used—such composition books for the rest of his life); or the horror stories that both terrified and thrilled him and his "little six-year-old comrades," with which "a singular Auvergnat schoolmaster" with the colorful name of Tourtoulou sometimes regaled the class.

In public school, as at Sainte-Elisabeth, Breton won a goodly portion of the scholastic kudos. His August 1905 report lists him as having received the grand prize, seven first prizes (including those for civics, reading, history, science, and geography), second prizes in calculus and handicrafts, and third in drawing. More attractive from his point of view than the honors themselves were the books that were given in reward: primarily adventure stories for boys, whose illustrations provided a continual source of fascination.

In fact, studies and books were nearly all of Breton's life at this time. The tales of exotic adventure he avidly read were both a "magic lantern," projecting enticing mental landscapes of far-off Mexico and the American West, and an escape from the loveless home atmosphere created by his mother. In adolescence, this taste for adventure novels having been replaced by a more precious aestheticism, Breton still attributed his love of poetry and literature to its ability (as he said in one of his earliest poems) to "topple the walls of reality that imprison us."

But the magic lantern was also a dark lantern: forbidden by Marguerite to waste his

time with frivolous reading (she would enforce this interdiction well into her son's college years), Breton often had to wait for nighttime before indulging in his escapist pleasures. Nor was such reading the only thing his mother frowned upon. Concerned with maintaining an imagined social standing, she forbade young André from joining the neighborhood children as they played in the street. It might be pure speculation to imagine him staring out the window at his less fettered comrades, or burrowing further into his studies so as not to hear their shouts. But it is clear that, when in 1923 he designated the urban byways as his "true element," where he "could test like nowhere else the winds of possibility," on one level he was finally granting himself permission to play in that street—a street that, simply by virtue of its having been denied, became endowed in his mind with almost limitless opportunities. It is also clear that the loneliness of childhood helped determine Breton's adult need to surround himself with a group. As Philippe Soupault once noted, "André Breton was a solitary man who could not live alone."

In October 1907, at the beginning of the fall term, Breton entered the Collège (today Lycée) Chaptal in Paris's 8th arrondissement. He studied neither Latin nor Greek, benefiting from a recent law that had stripped the classical languages of their mandatory status, but rather opted for German. Despite his legendary inaptitude for foreign languages (Breton willingly admitted having little taste for them), he achieved respectable, if not excellent, results. In other disciplines he continued to win praises and prizes, particularly in French and history, only slightly less so in math and physics. His one demerit: a mention under the "conduct" column of a "tendency to talk too much."

But despite his satisfactory grades, Breton was beginning to chafe against the discipline of school. While the resentment remained internal for the moment—just as his hostility toward his mother's authoritarianism was most often translated into a silent rancor—he saw his *lycée* years primarily as a mixture of boredom and anger against "the distant incomprehension of the teachers." Still, as a dutiful half-boarder he caught the train every morning from his parents' new Pantin address at 33 Rue Etienne-Marcel to the dark and massive school building on Boulevard des Batignolles.

It wasn't until 1910 that events began to trace new designs in Breton's life. In the summer, instead of the customary trip to Lorient, his parents sent him to spend a month in the Black Forest region of Germany. From the moment of his arrival, his love of forests was deepened by walks in the German woods. Also deepened that summer was his knowledge of German, thanks to daily two-hour sessions with a Professor Kleinfeld.

When Breton returned to school in the fall, his German grades showed a marked improvement. More important, the trip solidified in him an appreciation for German literature and philosophy in general, and the Romantics in particular, that would later form one of the cornerstones of Surrealism.

Along with German, Breton began to study English in the fall of 1910, with more success than his later American sojourn would indicate—at least initially. As he was less taken with the language of Shakespeare than with that of Novalis, his enthusiasm, along with his grades, soon deteriorated, and Breton's manipulation of English never progressed beyond the rudimentary. Also deteriorating was his performance in math and physics, equally due to slackening interest, accompanied by increasingly frequent reprimands for poor conduct. If Marguerite had been concerned before about frivolous studies, she now had all the more reason to worry: she and Louis had been hoping to see their son in one of the prestigious applied science colleges, if not the Naval Academy! Breton had already refused the latter; now his declining scholastic results were putting the former in jeopardy.

Breton was now nearly fifteen years old, an age when personality—and incipient rebelliousness—begin to assert themselves. Still, he might have continued to suffer his boredom patiently were it not for the incitement of a like-minded fellow student named Théodore Fraenkel. Born the same year as Breton, Fraenkel had until then been in another section of Chaptal, but had transferred at the beginning of the new term. He was the son of Russian Jewish émigrés with Socialist tendencies, and he possessed a keen intelligence that fed a caustic wit. His talent for languages earned him high marks, even as he received poor results in the sciences and frequent warnings about misconduct, including a demerit for telling "vulgar jokes." Fraenkel, recalled his brother, "was fiercely sarcastic and mocking. One of his quips might hurt someone, but if it was clever he couldn't resist saying it. He was always quick with a well-placed jab." Dark-complexioned, with high cheekbones and eyes that betrayed his Slavic origins, Fraenkel was precisely the kind of catalyst that Breton's long-buried resentment needed—even if it emerged a bit hesitantly at first.

But the stronger and more lasting bond between Breton and Fraenkel was their mutual love of poetry. "From the way he recites *La Jeune Captive* [by André Chénier], I choose my first friend," Breton wrote in *The Magnetic Fields*. Increasingly, he had been developing a taste for verse; now, in Fraenkel, he found at once an audience, a foil, and an encouragement. The two adolescents spent hours composing sonnets, which they then critiqued mutually and mercilessly.

Breton's interest in poetry was given a further boost at this time by Albert Keim, a

teacher at Chaptal. Keim had been hired only as a temporary replacement—his opinions were considered too radical by the permanent faculty—but he ended up marking Breton more than any other teacher at the school. A novelist in his own right, he had been impressed by a composition of Breton's and invited the young pupil home, where he introduced him to the works of Joris-Karl Huysmans (which Breton liked immediately), Charles Baudelaire, and Stéphane Mallarmé. Although the obscure phrasings and rarefied sentiments of Mallarmé were still beyond Breton, the "manner" of these poems, a certain nobility of expression that he could feel in each line, enchanted him. For the first time, he later said, he saw "what can be done with words."

Several other new acquaintances at Chaptal took this interest in a more active direction. One in particular, a student named René Hilsum, co-edited a mimeographed literary magazine with the suitably dreamy title *Vers l'Idéal* [Toward the Ideal]. It was here that Breton first saw publication, when in May 1912, in its only issue, *Vers l'Idéal* printed two of his early efforts: a sonnet called "Le Rêve" [The Dream] from the previous September and "Eden," dated April 1912 and dedicated to Albert Keim. Perhaps to hide his "frivolous" literary pursuits from his mother, the poems appeared over the anagrammatic pseudonym "René Dobrant."

As with Fraenkel, it was on the common ground of literature that Breton's friendship with Hilsum developed, and more specifically on the ground of Paul Fort's magazine *Vers et prose*, to which Hilsum's mother subscribed. In it the young men discovered the Symbolist poetry of Francis Vielé-Griffin, René Ghil, and Stuart Merrill, as well as the Poe-like horrors of Villiers de l'Ile Adam and the off-color frenzies of Jean Lorrain. Their work evoked a dark and dusty mystery that harked back to the horror tales told by Grandfather Le Gouguès and schoolmaster Tourtoulou, which had so excited Breton as a child.

Literary Symbolism was not the whole of Breton's reading, of course. In October 1912 he and Fraenkel entered their final year at Chaptal, called *classe de philosophie* after the year's primary course of study. He continued to win good grades, despite the demerits for conduct and his dislike of his teacher, a conservative Kantian named André Cresson. It was Cresson, by virtue of his sarcastic interjections, who inadvertently awakened in his student an enthusiasm for the social reformists Saint-Simon and Charles Fourier (in Fourier's case, this would evolve into a full-fledged passion after World War II), as well as for the German philosophers, notably Hegel—philosophical reference points that would act as signposts in many of Breton's future writings.

Not all of Cresson's influence was so indirect, however, nor so positive, for Breton's resistance to his teacher's opinions caused his marks to slip in the year's main subject.

This, combined with mediocre grades in math, physics, chemistry, and natural science, pulled his overall ranking down below the fiftieth percentile of his class. The headmaster's assessments reflect the same trend: called a "solid mind" at the start of the year, by the spring Breton needed "to acquire a little more mental maturity."

Regardless, both Breton and Fraenkel passed the difficult *baccalauréat* exam the following July. Now, with his secondary studies officially behind him, Breton had to decide upon a career. Unlike many of his future comrades, he had received an education that was less classical (the normal training for those with a "literary" bent) than scientific, reflecting his parents' professional aspirations on his behalf. "My parents—like many others at the time—dreamed of the Polytechnique or engineering school for me," he later said. Forced to choose a career, but with "no desire whatsoever for the kind of life" his parents envisioned for him, Breton, "by process of elimination," opted for medical school. "It seemed to me that it was what I could best tolerate. I also thought that the medical profession would be the most likely to accommodate the exercise of other intellectual activities on the side." So it was decided: in October he would begin PCN, or "Physics-Chemistry-Natural Sciences," the standard, yearlong premedical program. Marguerite and Louis resigned themselves—a doctor might not have had the cachet of an engineer, but things could have been worse.

In the meantime, Breton continued to "exercise other intellectual activities," particularly the reading and composition of verse. It was this love of poetry, and the friendships it nourished with Fraenkel, Hilsum, and a few others, that provided some glimmer of excitement in the dullness of his later adolescence. Pantin would forever be a dreary little suburb, and home life would continue to abound in tensions and strictures. But in a fundamental way, the solitary boy was no longer quite so alone.

MEETINGS WITH REMARKABLE MEN

(Spring 1913 – February 1916)

IN 1912, AS BRETON AND FRAENKEL WERE PRACTICING home-grown anarchism (under the guise of disciplinary infractions) at the Collège Chaptal, a certain Jules Bonnot and his "tragic bandits" were taking the schoolboy pranks one step further. *Their* ammunition was live, and it ricocheted off the streets and banks of the Paris area for a full six months, seemingly immune to police capture. Few at the time failed to draw the parallel between Bonnot and his predecessors in terror, the anarchists Ravachol (François Koenigstein) and Emile Henry, both of whom were still fresh in the collective memory. Largely because of this, and despite the fact that Bonnot's political convictions stopped at his own pocket, "Bonnot's band" became instant celebrities, to some even folk heroes. Like Jesse James before them, like Bonnie and Clyde in their wake, they were the stuff of legend for adolescent imaginations hungry to replace childish adventure stories with more adult drama.

For Breton, the band's actions, its social rebelliousness and outlaw overtones, even the bravado of its signature yellow getaway car, took on an irresistible cast. Many years later the excitement of it was still fresh enough in his mind for him to assert that political anarchy was "one of the seeds of Surrealism." Still, what Breton was responding to was more a matter of surface than of substance, and he admitted that his feelings about anarchism were mainly "confused admiration." He was, in fact, unfamiliar with the theoretical texts of anarchism and Socialism and, to a large extent, their practical applications. Rather, what he found so seductive about them (just as he had found in the horror tales of his childhood, and was still finding in the Symbolist poets) was their patina of "infernal grandeur"—in other words, their *tone*.

It was with the same mix of naive sincerity and aesthetic preoccupation that Breton, around the spring of 1913, began taking an interest in the anarchist press. It is true that periodicals such as *Le Libertaire*, *L'Anarchie* (edited by Victor Serge), and the newly founded *L'Action de l'art*, with their stirring revolutionary rhetoric, would have found an echo in a young man eager to lose the chains of his oppressive family. At the same time, one of the ideas that most intrigued Breton in *L'Action de l'art* was that of the "artistoc-

racy," which proclaimed that art itself was action. The artist's "life *is* his work," the magazine's editors declared. "Art is revolt in the widest sense." On the one hand, this stood in opposition to the dreamy artist-for-art's-sake so prized by the decadent fin-de-siècle. More to the point, it provided Breton with one of his earliest outside intimations that art and life did not have to remain separate.

What this shows, even then, is a desire on Breton's part to extend the role of literature beyond its traditional boundaries. He was not the first: several nineteenth-century figures, notably Victor Hugo, had explored how poetry could go hand in hand with social activism. In 1913, however, it was not yet a common attitude among artists that one should become politically involved, and some, such as the Symbolists, had made a virtue of retreating as far from the world as possible. Whatever Breton's political naïveté at the time, however unformed his convictions, he was already beginning to intuit that art could be as revolutionary as an anarchist's bomb.

The world into which André Breton was born was on the edge of an unprecedented transition. Not yet having reached the war that would usher in the modern age, Europe, for centuries the undisputed hub of civilization, was nonetheless showing signs of upheavals to come. No sooner had Nietzsche pronounced the Christian God dead than they started burying the corpse of reason as well. In 1889, the psychiatrist Pierre Janet, in his influential *L'Automatisme psychologique*, had given scientific currency to the word "subconscious," while Janet's friend Henri Bergson was elsewhere assigning a primary role to intuition. In the year of Breton's birth, Sigmund Freud introduced psychoanalysis, which he had begun elaborating the previous year in his *Studies on Hysteria*. Thanks to science and philosophy, the subconscious was now being hailed as the seat of everything from artistic genius to mental well-being.

Visual artists, meanwhile, having recently upset the cart with Impressionism, were now serving up the outrage of Cubism. And the twenty-three-year-old playwright Alfred Jarry was lifting the curtain on his satiric play *Ubu Roi*, a brilliant, extended college farce that caused a scandal at its 1896 premiere as of its first word: "Shite!" Taking his cue from the bloody bombings by Ravachol and Henry, Père Ubu vowed to "destroy even the ruins." Among the ruins he helped sweep aside were the otherworldly aesthetics of Symbolism and its subcultural counterpart, bohemia. Although bohemia was in its own way a reaction against the bourgeois revolution, the illegitimate offspring of frustrated art after it had been forced into the stiff collar and tight waistcoat of the middle-

aged, middlebrow middle class, its veneer of good humor was now seriously grating against the more strident ambient nihilism.

With the century's end, bohemia found itself buried under a proliferation of schools and movements offering uneven degrees of originality, interest, and duration. The decades that had witnessed the rise (and generally rapid fall) of Populism, Symbolism, Naturalism, Parnassiansim, Scientism, Free-Versism (*vers-librisme*), Decadentism, Magnificism (founded by the poet Saint-Pol-Roux, nicknamed "the Magnificent One"), Magicism, the Roman School, Synthetism, Regionalism, Impressionism, Humanism (one of many), and Fauvism, not to mention literary varieties of Socialism and anarchism, gave way to an age that would bring Primitivism, Sincereism, Subjectivism, Synchronism, Impulsionism, Integralism, Intenseism, Unanimism, Neo-Mallarméism, Paroxysm, Druidism, Pluralism, Dynamism, Dramatism, Totalism, Patriartism, Vivantism, and Machinism (the list is not exhaustive), before finally arriving at Futurism, Cubism, Dadaism, Surrealism, and beyond. This is less a list of disparate manifestations than a chart of symptomatic outbreaks over the same anxious face of French intellectual life. With everything being permitted, it was becoming more and more difficult to know which way to head.

The new sense of permissiveness slowly ate away at the centuries-old European order, giving rise to a new level of democracy, and with it a new level of instability. A wave of terrorist attacks had hit Paris in the 1890s, wearing down the public's confidence in law and order. The Paris metro was inaugurated with the new century, giving the urban working classes unprecedented freedom of movement. And France broke off diplomatic relations with the Vatican in 1904, signaling a new separation of Church and State.

By 1913, some twenty years of European colonial rivalry, overlaid with more recent industrial competition, had steered the continent into extreme volatility—a volatility intensified by strikes and assassinations, which increased in number as the disenfranchised demanded recognition and the continental mood turned uglier. As the historian J. A. Spender explained: "The stage which Europe had reached was that of a semi-internationalism which organized the nations into two groups but provided no bridge between them . . . The equilibrium was so delicate that a puff of wind might destroy it." That puff of wind would come the following year, on June 28, 1914, when Serbian nationalist Gavrilo Princip assassinated Archduke Francis Ferdinand, giving the First World War its catalyst.

Meanwhile, the arts and sciences began waging their own war against an equally precarious cultural order. The year 1913 alone saw the publication of Blaise Cendrars's *The Prose of the Transsiberian*, a long poem that wedded the new, technologically induced love

of speed with the visual innovation of collage; Diaghilev's Ballets Russes and Stravinsky's *The Rite of Spring*; and Giorgio de Chirico's first "metaphysical paintings." Pablo Picasso and Georges Braque developed analytical Cubism, and Wassily Kandinsky painted his first major abstractions. Husserl unveiled the concept of phenomenology and Niels Bohr laid bare the structure of the atom. Proust published *Swann's Way*, Lawrence *Sons and Lovers*, and Freud *Totem and Taboo*, while Kafka offered his first significant work, *The Judgment*. "In the end you are weary of this ancient world," Guillaume Apollinaire, one of the great poetic innovators of the age, intoned in the opening line of his groundbreaking collection *Alcools*, also published that year. If Breton could later point to 1913 as the moment when a number of his own "likes and dislikes" first emerged, the same could be said of the modernist aesthetic in general.

Across the Atlantic, the International Exhibit of Modern Art (committed to history as the New York Armory Show) was mounting its own offensive. The show featured— and was roundly attacked for—work by Matisse, Derain, Vlaminck, Dufy, Picasso, Braque, Léger, and Delaunay, among others. But the largest share of its scandalous provocativeness, and its lasting impact, were due to the participation of two of the century's most innovative minds, Francis Picabia and Marcel Duchamp. Painters both (although Duchamp would more or less renounce painting out of "boredom," preferring to spend his time playing chess), they understood perhaps better than anyone else at the time the profound aesthetic and philosophical upheavals about to break through the surface. Their canvases—in this case, *Nude Descending a Staircase* for Duchamp, *Dances at Spring* and *Procession, Seville* for Picabia—were no more outrageous than their nonchalant attitudes toward art and life in general. They were, however, more visible, and *Nude* in particular (which one critic famously mocked as "an explosion in a shingle factory") became the butt of most of the jokes—even as it drew in most of the crowd. Unwittingly, Duchamp and Picabia had just set the fuse for a Dadaist explosion that would not actually occur for another three years. The fact that they were still lacking a match hardly mattered: European politics would soon provide that.

Breton, too, was quickly revising his ideas about art. In his early teens he had suffered regular Sunday outings in Paris with his family, a stroll from the Gare de l'Est (a short train ride from Pantin) to the Madeleine church. His one pleasure during these walks— lugubrious occasions, exacerbated by Marguerite's posturing and Louis's resignation— had been the sight of the Matisse canvases in the window of the Bernheim-Jeune gallery

on Rue Richepanse, where he sometimes stopped to exchange a few words with the gallery's manager, art critic Felix Fénéon. Breton's enjoyment of the Matisses had been sharpened by the fact that his father found them scandalous. As an adolescent, he had further incurred parental outrage during a stay in Lorient by using his school prize money to buy a native fertility doll that a sailor had brought back from Easter Island— the first of what would become an extensive collection. But it wasn't until late 1912 that Breton had truly begun exploring the visual domain—displaying from early on the shrewd and original artistic acumen that would later serve him well, as witnessed by his fascination with "savage" or "primitive" arts at a time when few considered them worthy of attention. During his Easter 1913 vacation, while his parents were busy moving into a new home at 44 Rue Hoche (still in Pantin), he spent his time visiting the museums and galleries of Paris.

Curiously, the artistic tendencies that least enjoyed his favor at this time were often the newest. Futurism and Cubism, which he had briefly admired, now seemed disappointing. There were, however, some new currents that did touch him, such as his discovery at the end of 1913 of Picasso's *Guitar on a Table* in the magazine *Les Soirées de Paris*, edited by Guillaume Apollinaire. Breton remembered experiencing the "shock provoked by an entirely new visual experience."

But the artistic discovery that had by far the greatest impact was the Gustave Moreau museum. Breton had first come across references to Moreau in the writings of Huysmans, whose neurasthenic hero Des Esseintes (in *Against the Grain*) had been created under the influence of the neglected painter's work. After Moreau's death in 1894, the bulk of his 800 paintings and 7,000 drawings had gone to fill the small museum on Rue de La Rochefoucauld, near Montmartre. The fact that the museum was seldom frequented made it all the more mysterious and appealing in Breton's eyes, "the ideal image of what a temple should be." The real fascination of the place, however, lay in the paintings themselves. Moreau had been captivated by the "evil women" of history and mythology—Helen of Troy, Salome, Delilah—whose voluptuous figures reclined on divans of cruel sensuality and debauched opulence. It was the paintings' unabashed sexuality that gave Breton's admiration its full charge, and his response to them was on grounds as much erotic as aesthetic: "My discovery, at the age of sixteen, of the Gustave Moreau museum influenced forever my idea of love," he wrote in 1961.

The question of Breton's "idea of love" was in fact becoming an increasing preoccupation, although at seventeen he could still only fantasize about someone with whom he might explore the delights of the senses. During his childhood, his sexual development, if not quite atypical of boys in his generation, had been made rather more uncomfortable

than normal by his mother's watchful prudishness. Breton long recalled the "modesty and revulsion" he had felt at age six over his involuntary nocturnal erections—a common occurrence in young males, but one for which the alarmed Marguerite saw fit to summon the family doctor. Several years later, at around age twelve, he reacted to his first masturbatory probings with a mix of "intense pleasure" and worry over his ejaculations. By now, however, he was filled with adolescent sexual urgings, and his head had been turned in recent years by more than one passerby, including a violet-eyed Paris streetwalker and a young Russian named Olga, next to whom Breton "managed to sit in the top deck of a bus taking [him] to school" and whom he later called "perhaps the first woman I ever truly desired." Still, these women, fleetingly evoked in reminiscence, seem to have had less reality for Breton than Moreau's femmes fatales. Conditioned by such models in the art and literature he admired, he was looking for a Delilah or Salome of his own.

Was it for this reason that he began to feel an attraction for his cousin Manon? Two years younger than Breton, Madeleine-Marie-Louise Le Gouguès (the same Manon who most likely inspired Breton's later change of birth date) was the daughter of Breton's maternal uncle; the nickname Manon, by which she had been known since childhood, had reportedly been given her by Breton himself. Now on the verge of womanhood, the fifteen-year-old girl compensated for the two-year difference in their ages by her precociousness and her provocative, independent spirit: by his own admission, Breton's attraction to Manon contained a large measure of intimidation at her daring. But although Manon appears to have had a similar interest in her older cousin, their relationship at the time did not go beyond vague flirtation.

Instead, Breton's passion focused mainly on aesthetics, and his desire for companionship on Théodore Fraenkel and a few others, such as Etienne Boltanski, future father of the artist Christian Boltanski. With them, Breton founded the first of his intellectual roundtables, a "philosophical society" called the Sophists' Club. Meetings generally took place at Fraenkel's house at 11 Rue Taylor after school, no nonmembers allowed. "It was out of the question for anyone else to enter, to participate in any way whatsoever," said Fraenkel's younger brother, Michel. "Breton was very cold and distant. He showed no courtesy at all toward my parents, or toward me." Although the "meetings" were generally excuses to read aloud the works of the *poètes maudits*, and the sounds coming through the door just as often wild laughter as impassioned outbursts, the element of arrogance and exclusivity foreshadowed the tenor of Surrealist café gatherings.

Not yet out of high school, Breton was already adopting the reserved, self-assured mannerisms that later became so much a part of his authority. He was helped in this by his physical appearance. While he was not excessively tall—he stood about five feet nine

inches at this time—his stiff bearing and slightly stocky build, aided by the high starched collars and sober tweed suits he often wore, gave others the impression of commanding height. But the most dramatic component was his head: it appeared slightly outsized, due in part to the mane of wavy light brown hair worn unfashionably long and pomaded into tumults over the ears. (Man Ray later quipped that Breton carried "his imposing head like a chip on the shoulder.") And in that head, the face was easily given to a resolute, almost haughty expression, visible even in portraits from infancy. Breton's face was made all the more striking by an overly fleshy lower lip, itself accentuated by a minor deformity of the jaw that pulled it slightly leftward and shaped his countenance into a willful whole. Like his bearing, Breton's head communicated solidity, substance, and authority.

The authority of Breton's physical presence was matched by the force of his opinions and enthusiasms, and nowhere more so than in literary matters. Throughout the summer of 1913, he exchanged letters with Fraenkel that were virtual correspondence courses, featuring lengthy critiques of the day's major authors and, increasingly, praise for the work of the Symbolist poet Stéphane Mallarmé.

Mallarmé, who had died two years after Breton's birth (leaving behind a group of disciples that included Paul Valéry, Paul Claudel, and André Gide), was only then beginning to gain a readership outside of very limited circles. Within these circles, however, he had the stature of absolute, unchallenged master. Valéry, one of his most brilliant followers, once asked him, "Do you realize that in every city of France there is a secretive young man who would gladly let himself be slashed to pieces for you and your verses?"

Mallarmé had deliberately expunged from his work "everything that pleases most people," as Valéry explained. (His best-known poem, "The Afternoon of a Faun," owes its popular recognition far more to Debussy's and Nijinsky's adaptations than to the text itself.) For him, there was no world outside of the word, no poetry save that which sought to "give a purer meaning to the language of the tribe." In 1897, the year before his death, this had led him to the abstract patternings of *Un Coup de dés jamais n'abolira le hasard* [A Cast of the Dice Will Never Abolish Chance], a twenty-one-page poem that innovatively used typography, layout, and a striking economy of language to scrupulously reproduce a haphazard constellation of thought across the page.

While Fraenkel snickered at what he considered Mallarmé's willful abstruseness, Breton pledged his allegiance. "Mallarmé reigns," he told his correspondent the following summer. "This is not idolatry on my part, but simply devotion to God made manifest." Under the poet's influence, Breton's letters, which exhibited a marked formality as it was, soon began to take on "the courteous and precious tone of the Master—very much old France."

✳

In October, the two friends began their PCN studies at the Faculté des Sciences. Having chosen medicine as a kind of lesser evil, Breton now attended his courses with scant enthusiasm: "My physical presence on the lecture-hall benches or at the laboratory tables should not imply the same presence of mind," he later recounted. (Fraenkel, who eventually pursued a long medical career, was presumably more attentive.)

At the same time, Breton was not dreaming of the literary cafés of Montparnasse; and if he was "drawn to other things," those "other things" did not include a writing career any more than a medical one. Rather, what attracted him was poetry, of a sort that he could not yet define. It was not quite the poetry gathered in collections of verse, still less the kind studied in stuffy literary courses at the Sorbonne, but a form of energy, just as liable to be found in the writings he loved as in a political rally, a woman's eyes, or a chance occurrence in the street. "I continue to find no common ground between literature and poetry," he later explained. "The former, whether it looks out on the external world or prides itself on introspection, is to my mind all the same nonsense. The other is pure adventure, and this adventure is the only kind that interests me."

For the moment, Breton had to make do with poetry of a more traditional sort. Accompanied by Fraenkel and René Hilsum, who was also in the PCN program, he attended plays and poetry readings on Thursday afternoons at the Théâtre du Vieux-Colombier or the Théâtre Antoine. These visits, as well as his occasional book purchases, were kept strictly secret from Mother Breton, who considered such activities a waste of time and money, not to mention a distraction from the schooling at hand. To be sure her son wasn't indulging in useless literature (or perhaps sensing that he was, despite her best efforts), Marguerite insisted he study his medical textbooks aloud, within earshot.

Breton's literary pursuits took a more public turn in early 1914, however, when the magazine *La Phalange*, edited by the neo-Symbolist poet Jean Royère (whom Breton had met shortly before), agreed to publish three of his recent poems—"Rieuse," "Le Saxe fin," and "Hommage"—in its March 20 issue. Royère, some twenty-five years Breton's senior, had founded *La Phalange* in 1906 and would keep it going until the war. Himself a devotee of Mallarmé, he described his own poetry as "obscure as a lily," and it was no doubt this same obscurity that he appreciated in Breton's verse.

Indeed, Breton's sonnets at this time were so imbued with Mallarmé's opus that they faithfully reproduced the elder poet's preoccupations, convoluted syntax, and willful incomprehensibility. In later years, he would criticize these early poems for their quali-

ty of "*mystery* as an end in itself, intentionally injected." But for the moment, he was content to follow the path traced by the Symbolist doyen.

What this also means is that, while the great modernist inroads of 1913 were being made, Breton was in large part looking the other way, specifically back toward a remaining Symbolist "fringe" constituted by such now forgotten poets as Royère, Vielé-Griffin, and Saint-Pol-Roux: minor champions of a waning aesthetic who, by their very refusal to "update" their output, earned Breton's lasting admiration. He was aware of the newer literary currents—he confessed to being "wild about" the poems of Apollinaire, for example—but the pull was in another direction. "You cannot know how I longed to approach the men who were carrying on [the Symbolist] tradition," he later recalled.

Accordingly, publication in *La Phalange* mattered to Breton less as a recognition of his own talent than as a way of putting out a call to like-minded poets, of making "contact with the few men whose minds I held in the highest esteem." But in publishing Breton's verse, Royère did more than help the young poet sound the call; he also encouraged him to see the man Breton later called "unique . . . the great enigma": Paul Valéry.

In 1914, the forty-three-year-old Valéry was not yet the French Academician and unofficial poet laureate that literary history would later enshrine. What little reputation he enjoyed—mainly in the same rarefied circles that struggled to keep the Symbolist flame alive—was based on a handful of hermetic poems published in literary quarterlies and on a few brilliant, mysterious prose works. Breton admired Valéry's verse, but the book that truly captivated him was the enigmatic narrative *An Evening with Monsieur Teste*, which he knew practically by heart. Struck by its cold, mathematical intelligence—Teste's name translates as "Mr. Head"—Breton never stopped considering it Valéry's masterpiece. "I could not stop praising that work to the skies," he later admitted. "At certain moments, the character of Mr. Teste seemed to emerge from his frame—Valéry's story—to come mutter his harsh complaints in my ear . . . For me, Valéry had reached the supreme point of expression with Mr. Teste."

This was not merely a question of literary craft. For Breton, Valéry *was* Mr. Teste; the character's brilliance and irony melded completely with the author's own. Moreover, adding to their prestige in the young man's eyes was the fact that *Monsieur Teste* was virtually the last work Valéry had published before renouncing literature altogether in 1896. It was yet one more proof of their ultimate identification, of Valéry countersigning Teste's declaration of principle: "I gave up books twenty years ago. I have burned my papers also." As Breton later put it, Valéry "benefited from the prestige inherent in a myth . . . that of a man turning his back on his life's work one fine day, as if, once he had

reached certain heights, the work somehow 'rejected' its creator. Such behavior on his part lent these heights an unsurpassable, somewhat vertiginous character."

Still, if Breton wrote to Valéry on March 7, 1914, he was addressing not only the author of *Monsieur Teste* but also Mallarmé's gifted disciple—indeed, the pretext given for wishing to meet Valéry was to hear him relate his "precious memories of Stéphane Mallarmé"; just as it was to an elder poet and potential mentor that Breton enclosed his poem "Rieuse," replete with the flattering dedication to Valéry it would bear on its publication in *La Phalange* two weeks later. Valéry appears to have been touched by the dedication, even more so by the sonnet. "A single glance, fortunately, allowed me to grasp the fine euphony, the precious system of your verses," he answered on March 11. To Breton's delight, he extended an invitation. The call had been answered.

"I can still see myself entering his home for the first time," Breton later described their meeting. "Beautiful Impressionist canvases crowded onto the walls as best they could, covering over the mirrors. [Valéry's] eyes, which were the pretty transparent blue of the sea at low tide, stared at me from beneath sharp-edged lids." Asked about his reasons for writing, Breton told his host that he wanted to generate in himself "states of mind" similar to the ones that others' poems sometimes provoked in him; and which he later likened to "the feeling of a feathery wind brushing across my temples . . . I could never avoid establishing some relation between this sensation and that of erotic pleasure, finding only a difference of degree." Not all the conversation flew in such lofty spheres, however: Breton long remembered Valéry's glee at the fact of his living in Pantin, "which for him meant the perfume factories on Rue de Paris. He envied me having grown up, as he said, 'among the skirts of tarts.'"

This first meeting with Valéry provided Breton with an invaluable spur in his poetic development. Valéry was an attentive reader, an insightful critic, and a faithful correspondent. He treated Breton's early efforts with seriousness and tact, and invited him to submit his new work for comment. The invitation was not long left fallow.

Breton's parents were probably unaware that their son was now a published poet, or that he had begun keeping such distinguished company. Had they known, their reaction would have been less admiration than concern—and with good reason: like a system of communicating vessels, Breton's devotion to poetry drained what little remaining interest he had in his PCN courses. As spring approached summer and the end-of-year examinations loomed, Breton, shut away in Lorient, made a valiant effort to catch up on months of neglected dissections and bone nomenclatures, but to little avail. "The fine courage of the first days is dead," he wrote Fraenkel on June 22, "and I'm spending my time on some poem." Fraenkel, who had always shown more aptitude for the medical

métier, passed his exam in July; not surprisingly, Breton did not. His second attempt, in September, was more successful—but by then the situation had changed considerably.

<div align="center">✳</div>

"Germany has declared war on France," the front page of *Le Temps* announced on August 4. It was the end of nearly fifty years of peace in Europe: since July, the newspapers had been reporting on war in the Balkans; and France itself, anxious to preserve its defensive alliances, had begun mobilizing several days earlier in response to Germany's declaration against Russia. Eligible young Frenchmen were called to arms, the exhortations fueled by lasting resentments from the Franco-Prussian War of 1870 and long-standing territorial disputes over Alsace-Lorraine. The French government confidently promised a rapid victory, but within a month German troops would advance, seemingly without effort, to within thirty miles of Paris. Caught unprepared, in those early weeks the French were losing 15,000 men each day.

Breton, imbued with the reserve that distinguished his literary tastes and repelled by his compatriots' readiness to do battle, remained impervious to the adrenaline of mobilization. Moreover, for him the European turmoil was overshadowed by political events at home. On July 31, the Socialist leader Jean Jaurès had been assassinated in a Paris café by the aptly named Raoul Villain. For a number of Europeans, Breton among them, Jaurès's death was also the death of any last hope for peace on the continent. "The news of Jaurès's assassination deeply affected me," Breton confessed to Fraenkel, "perhaps more than the possible declaration of war will be able to." (The non-working-class majority, however, viewed events differently, and one young widow no doubt spoke for many when she hoped that they would "pin a medal on the guy who killed Jaurès.")

In Lorient, to which Breton's parents had repaired in late July, Breton reflected sarcastically on the battlemania that had gained even the far reaches of Brittany. "Here I sit, an a-potent witness to the most ridiculous bellicose enthusiasm I've ever seen (puerile chauvinistic declarations, exorbitant self-confidence, drunken 'Marseillaises,' etc.). The arrival of the reserves and Territorials after the mobilization is quite comical. About half the men are besotted with desire to enter the barracks," he told Fraenkel on August 3, the day Germany declared war. The only thing that stirred his blood was poetry, and particularly a newfound enthusiasm for the work of Arthur Rimbaud. An edition of Rimbaud's works was the one book Breton had brought with him in the family's haste to leave for Lorient; thanks in part to the context, it became an encounter of singular importance.

Until this point, Breton had known only a few of Rimbaud's poems, mostly pieces in anthologies, for at the time the young "visionary" was all but ignored by even a cultured readership, who considered him less a poet than a punk. Many of those who did know of Rimbaud were familiar mainly with the picturesque aspects of his career: his tumultuous affair and violent rift with Paul Verlaine, his mysterious disappearance to Harrar in Ethiopia, his activities as an arms smuggler, his casual denigration of the poetic "trade"—"A writer's hand is no better than a ploughman's," he had written—and his prescription of becoming a "seer" through "a huge, sustained, and rational *derangement of all the senses.*" Moreover, Rimbaud's recently discovered letters from 1870 were not what many wanted to hear at the moment, for in remarkably current terms he had ridiculed the "terrible spectacle" of France preparing for its previous war against Germany: "My country is rising up! . . . I prefer to see it seated: don't bestir yourself! that's my motto." So it was either by brilliant intuition or by singular coincidence that Breton began reading Rimbaud now: the poet excited his aesthetic longings, while the defeatist pacifist provided a spiritual companion in martial times. Rimbaud's mocking observations on the Franco-Prussian War closely mirrored (and probably inspired) Breton's own about the new century's first major conflict.

As Mallarmé had the previous summer, Rimbaud now filled Breton's horizon. His letters to Fraenkel were littered with quotes by the bard of Charleville, his reflections and attitudes conditioned by Rimbaud's sarcastic indifference. "For me, my mental, or rather moral, long-sightedness is incurable," he told Fraenkel on the 16th. "Rimbaud, as I've said before, only exacerbates it."

Fraenkel, however, did not approve of Breton's attitudes. In his own letters, he urged his friend to get passionate over "the outcome of this adventure," arguing that "the rule of civilization or barbarity is now being decided . . . [If the Germans won] the world would be transformed into an armed camp; for a long time to come there would be no more culture, science, or intellectual life." In answer, Breton mocked Fraenkel's "bellicose arguments," even as he chided his friend for not sharing his passion over Rimbaud. "It's regrettable that you bestow approval only on those works whose value is absolutely indisputable, and that you follow—involuntarily, I know—on a number of points the absurd tide of public opinion," he wrote on August 30.

Breton's own work also showed a desire to distance himself from the "absurd wave of public opinion." One such poem, sarcastically titled "Hymn," bears markedly little relation to the more jingoistic hymns being chanted at that moment throughout France. It was this resolve that gave Breton's rebuttals to Fraenkel their particular vehemence. For Breton, more than just literature was at stake: Rimbaud had become the voice of his

political and philosophical, as well as aesthetic, conscience; the literary message contained a greater measure of reality for him than did any reports from the front. In criticizing Fraenkel for dismissing Rimbaud's work, Breton was also attacking his friend's evident willingness to accept the widespread embrace of war—for to his mind, the two attitudes were practically synonymous.

Fraenkel's susceptibility to so-called common wisdom was all the more distressing, in Breton's eyes, in that fewer and fewer were resisting it. In the domain of letters, the intellectual guides of a generation had begun leading their charges into the belligerent fever of nationalism. As more and more succumbed to the warlike mood, writers began outdoing each other in their paeans to honor and glory, often marked by thick xenophobic accents. Over the following months, the press was crowded with exhortations. "War is sublime and all those who enter it become transfigured," French Academician René Doumic proclaimed in the prestigious *Revue des Deux Mondes.* "Approaching the battlefield, a sacred giddiness, a holy elation seizes those for whom the supreme joy of braving death for the fatherland has been reserved." Another sang the praises of the bayonet that "plunges to the hilt into the drumskin of human torsos." Even Maurice Barrès, once a fervent champion of anarchism, had switched to boisterous nationalism.

There were some exceptions, of course, notably the novelist Romain Rolland, who in early 1915 published the anti-war pamphlet *Above the Battle*; but such men were denounced as traitors, and their writings suddenly disappeared from circulation. Others left the country, kept silent, or, like Breton's Symbolist acquaintances, simply tried to ignore the war. All in all, the dissenters were easily dismissed.

It was in such an atmosphere that Breton returned to Paris in October to begin medical school. Still not entirely convinced of his calling, but with his PCN diploma finally in hand, he duly registered on the 29th at the Faculté de Médecine. In large part, and despite the war, Breton's life took on the same colorations as in previous years. He attended classes, showing the same lack of interest as ever; in the evening he returned to his parents' home in Pantin, located as of the beginning of the year at 70 Route d'Aubervilliers.

But no matter how similar life may have appeared, it could not be as before; no matter how resolutely the nineteen-year-old wished to ignore world events, they nonetheless existed. It was not long before he, too, was sent off to the Great War—or, as he put it nearly forty years later, "flung into a cesspool of blood, mud, and idiocy."

✳

The summons came in February 1915: the army physical was one examination Breton did not fail. He was declared fit for service on the 17th, called up on the 25th, and assigned the next day to the 17th Artillery Regiment. Toward the end of March he was sent back to Brittany, to the town of Pontivy, for basic training.

In the sky-blue uniform of the artillery, Breton tried vainly to maintain a "false good humor" before all the "contingencies of the phenomenal world" with which army life abounded: marches, senseless orders, maneuvers, lessons on horsemanship, kitchen duty, the undesired proximity of so many comrades-in-arms. He quickly sank into a state of lethargic indifference. "Thought lamentably crumbles to the ground of the training field. It is keenly aware how vain its efforts are," he told Fraenkel. His only distraction from the "atrociously slow life" of the barracks, he said, came from their correspondence.

Even poetry provided scant remedy, for he no longer dared read Mallarmé or Rimbaud, finding them painful under the circumstances. In desperation, he wrote to Valéry in June, asking him to intervene on his behalf to shorten the training period. But Valéry counseled "resignation, the most difficult and the flattest of virtues . . . Even the voluptuous, the tender, the subtle, the rare, and the pure grow imperceptibly, marvelously, under a heap of potato peelings." There was no recourse but to stick it out.

Breton's state of depressed stupor was not to last long, however. In July, he was dispatched to the city of Nantes in the southern part of Brittany, some 250 miles southwest of Paris. He was made a male nurse on the basis of his scant medical training and sent to the voluntary hospital of Municipal Ambulance no. 103-bis at 2 Rue du Boccage (formerly the dormitory of a local girls' school).

The improvement over the training fields of Pontivy was considerable. Freed from barracks life, Breton found a small room in town, taking pleasure in its austerity. He also formed a new friendship with a young pharmacology student named André Paris, whose true interests, like Breton's, lay in literature. Perhaps best of all, through the offices of Paul Valéry, Breton met Dr. Edmond Bonniot and his wife, Geneviève Mallarmé, the poet's daughter, with whom he spent several "delightful evenings" discovering unpublished works by Bonniot's father-in-law. Then there were the surroundings themselves, for as Breton later wrote, Nantes was, "with Paris, the only city in France where I feel that something worth while can happen to me . . . where for me the rhythm of life is not the same as elsewhere, where certain beings still nourish a spirit of supreme adventure." The city seemed to breathe mystery, from the enchanting optical illusions of Passage Pommeraye, to the fog that rolled in from its ports at the mouth of the Loire, to the maze of dark alleyways that criss-crossed it.

It was around this time that Breton began a short-lived love affair with his cousin

Manon Le Gouguès—a "terrible sentimental adventure," he reported to Fraenkel on September 3. Manon's father (named Louis like Breton's own father, he was Marguerite Breton's only living brother) was a career army doctor who had served in Algeria, Tunisia, and Belgium. Owing to her father's various posts, Manon at seventeen was far better traveled and more sophisticated than most women her age. She had also matured into a very enticing brunette, with the languorous eyes and pleasantly zaftig features that found favor at the time. The simultaneous attraction and intimidation that had long characterized Breton's feelings toward her now became overlaid with an element of keen sensual attraction—a feeling that Manon returned in kind.

On Sunday, October 10, Manon visited Breton in Rennes. "Since she couldn't invite me to her room," he wrote to André Paris shortly afterward, "she had hit upon a romantic and charming stratagem. I slept in a beautiful room in the Hôtel Continental almost adjoining hers; our balconies were barely separated." Partly out of shyness, partly out of "the silence to which a rather awkward proximity confined us," the couple spent the night on the balcony, contemplating the stars—"a somewhat inane Platonism," Breton commented—but doing little more: after four hours, the young man still had not "infringed upon the puerile defense" of Manon's veil. The next morning, the disappointed maid wrote her suitor a letter gently scolding him for his timidity. In his own account, however, Breton turned this timidity into superior will, boasting to Paris: "I profoundly surprised her by denying the omnipotence of her charm and I exposed her weakness in the bright light of day."

The promised denouement was not long in coming, but the event proved less pleasurable than the anticipation. "Bah! I slept with Manon on Sunday," Breton confided to Paris two weeks later. "A whole night. I don't love her anymore . . . I observe myself with curiosity. I'm not suffering . . . I'm leaning toward some *absolute* Platonism. A purely plastic beauty is Woman! it requires very chaste contemplation. Eunuch's ideal . . . I only gathered a malodorous bouquet of spurges on the poisonous terrain of those summits, where I brushed against irresistible Peril. Miraculously safe!"

Sheer bravado, or an avowal that the sexual experience had not lived up to his expectations? Nourished on literary conceptions of love, in which Woman was a nymphlike presence or distant ideal (for the Symbolists), or something to be callously disdained (for Rimbaud), Breton was in all likelihood unprepared for the physical reality of Manon.

It is also possible that Breton had been impotent that night. Years later, in discussing this period of his life, he admitted having been unable to make love to a woman "who hadn't yet become my mistress," noting his youthful anxiety at the thought "of making love to a woman I desired." What seems clear is that so long as Manon remained an unat-

tainable temptress, like one of Moreau's subjects, then passion could flower. But a living, breathing young woman, with sexual attitudes and expectations of her own, was more than the young poet could handle. In an almost perverse movement of abnegation, he demonstrated greater satisfaction at having "denied the omnipotence of her charm" than in finally "possessing" her.

Much more comforting was the surer ground of male companionship, and the real accents of passion in Breton's letters to Paris emerged in his statements about their own friendship. "At a time when none of what used to monopolize me still remains, the memory of you is, I swear, among the most dear. I've never (can you tell?) written that to anyone," he had said in September. Now he added simply, "Only friendship is divine. And beautiful." There was also poetry. But poetry was at once Breton's comfort and his cross. While the reading of certain authors could still, intermittently, fill him with the sense of wonder he cherished, the sheer drudgery of the war experience and his enforced separation from the capital—"If they would just give me back Paris, the Seine, its art galleries, the dissection rooms, Avenue de l'Observatoire!" he told his friend—left Breton too melancholic to write any verse of his own.

While the European conflict persisted without, an aesthetic conflict was raging in Breton's mind. Since the previous summer, the studied density of Mallarmé had been challenged by the visionary energy of Rimbaud's "derangement of all the senses." While unwilling to run the psychological risks inherent in Rimbaud's project—to turn his "I," as Rimbaud had said, into "another"—Breton was nonetheless forced to realize that his previous efforts were unable to procure him the "states of mind" he had earlier described to Valéry. At an impasse, he sought the guidance of a new model: Guillaume Apollinaire.

By 1915, Apollinaire was one of the most influential figures in the French avant-garde. He had been among the first to speak seriously of Cubism, had introduced the Italian Futurist movement to France, and was creating a new poetic vocabulary from the sounds of the city, the cacophony of technological warfare, and the conversations of café-goers. A poet and critic, he was the intimate of Picasso, Braque, Derain, Laurencin, Vlaminck, Rousseau, Max Jacob, and many other leading artistic figures of the day, as well as author of the seminal 1913 collection *Alcools*. As an editor and impresario, he turned *Les Soirées de Paris* into the model for arts periodicals over the next several decades. He was a cultural omnivore, the reigning deity of modernism, and his tentacles were everywhere.

But despite Apollinaire's stature, and his almost continuous residency in Paris since 1899, he could never forget that he was not a French citizen. He had in fact been born in Rome in 1880, of mixed Polish-Russian and Italian heritage, and baptized Wilhelm de

Kostrowitzky; his famous pseudonym was derived from one of his four middle names. The precariousness of Apollinaire's legal status had been made frighteningly plain to him in 1911, when he had been accused of complicity in the theft of the *Mona Lisa* from the Louvre—a charge that, if upheld, could have entailed his deportation. As soon as the war came, Apollinaire had enlisted in the French army, joining (as had Breton) an artillery regiment. His reasons, of course, went beyond mere opportunism, and no doubt involved a sincere love of his adopted country; but it was also true that military service by a foreigner with no such obligation bought a fair amount of official goodwill. Within a month Apollinaire had been admitted to an officers' training program and had filed for naturalization.

Moreover, Apollinaire actually seemed to thrive in the army, and why shouldn't he? He was well liked by both officers and men; found time to compose many poems celebrating the spectacles of the battlefield; contributed to a host of periodicals, from the well-established *Mercure de France*, where he had a regular column, to various fledgling publications; simultaneously courted two women with a barrage of letters and verses; continued to manage the artistic avant-garde from his outposts on the field of honor; and kept in touch with numerous correspondents.

In mid-December 1915, Breton became one of those correspondents. "I hesitate to pen a banal word and I vainly seek the rude shout that would befit you. I dread your smiles, above all," he began his first letter. Many years later, he said that in first writing to Apollinaire, he felt that he was addressing "not a man but a mediating force, one capable of reconciling the human world with the world of natural necessity." As of this moment, the thin, dapper Valéry and the rotund Apollinaire became the trylon and perisphere of Breton's mental world's fair.

Breton's excuse for the contact was provided by a poem he had written only days before, the first since his conscription in February. Titled "Décembre," it contained ironic references to the war and the approaching Christmas holidays, and—hidden in the final lines—a bitter reminiscence of his night with Manon. "The fault of these few lines, in which despair and irresolution become more pronounced, knew extenuating circumstances, Monsieur: the times and my situation," he concluded after several flattering glosses on Apollinaire's own work. Apollinaire did not make his young colleague wait long for a reply. "Your verses show a striking talent," he succinctly wrote Breton on the 21st. A more detailed, but equally positive, critique came from Valéry, to whom Breton had also sent his poem.

Encouraged by these responses, Breton composed an "all too irregular sonnet" called "A vous seule" [To You Alone], inspired by a disappointing love tryst at the end of the

year. In a curious letter of January 3, 1916, its even lines of ink washing over a pencil self-portrait like waves over a drowning man, Breton declared himself "very satisfied" with the sonnet, but nonetheless expressed astonishment "that an ordinary disappointment such as the one in 'A vous seule' could be the object of a literary magnification." The phrase "a literary magnification" was particularly interesting, for it prefigured one of Breton's key motivations: the desire to swell individual experience into something that joined with the flow of marvels running, like a magical subway, under the monotonous pavement of daily existence.

Both "Décembre" and "A vous seule" suggested the beginnings of a shift in Breton's poetic composition. For while each still showed the influence of Mallarmé and his precious syntax, it was also the case that a slightly more ironic, more modern tone was starting to creep into the work—precisely the tone that Breton had appreciated in Rimbaud.

Apollinaire, to whom "A vous seule" was sent, again contented himself with a brief reply, calling it simply "very pretty, very delicate." But the more attentive Valéry spotted the progress of Breton's internal conflicts:

> We have read these latest verses you sent. They make me think you are in a state that doctors would call critical. Their enjambments, the art that fits between defined types, the chance that is introduced, willed, retracted at every instant, indicate that you've reached a certain intellectual fusion- or boiling-point, one I know well, at which Rimbaud and Mallarmé, though irreconcilable, rub against each other in a poet.

What Valéry sensed was a general feeling of malaise, not only on Breton's part but on the part of many poets of his generation. The old ways were incontestably dying, and with them a belief in the forms that had sustained art and civilization for centuries. In the face of a grueling war now entering its third year—the government's early promises of speedy victory having long ago proven hollow—the visual innovations of Cubism, Rimbaud's unseasonal attitudes, even the fragmentary typography of Mallarmé's *Un Coup de dés* seemed to be not so much aberrations as the only sane response to a self-destructing worldview. Who could still write like the Symbolists, with their gauzy, outmoded tranquility? Much more vital, much more relevant were the rhythmic disjunctions found in Apollinaire.

Signs of general upheaval were being reflected in every artistic sphere. In February 1916, the recently founded magazine *SIC* (an acronym for "Sounds, Ideas, Colors"—although critics called it "Société Incohérente de Charlatanisme") ran an editorial defending the "new spirit" in art against its conservative detractors:

You who have laughed or spit at Mallarmé, Manet, Sisley, Puvis, Rodin, Claudel, Marinetti, Picasso, Debussy, Dukas, Moussorgsky, Rimsky-Korsakov,

You who have cursed the railways, the telegraph, the telephone, automobiles, electric trolleys, machines, factories,

You who have denied the bearers of the new, the bearers of something different, the divine habit-killers,

It's *you* who have nearly sunk France . . .

Such declarations, as well as the patronage of Apollinaire (to whom the magazine's editor, Pierre Albert-Birot, had pledged his fealty), made *SIC* one of the best-known and most successful avant-garde periodicals of the war years.

One who particularly embodied this new spirit was the "poet-boxer" Arthur Cravan. Born Fabian Avenarius Lloyd in 1887, the handsome, athletic Cravan, who introduced himself as Oscar Wilde's nephew (he was in fact a relation by marriage) and "the shortest-haired poet in the world," was gaining notoriety for his irreverent public lectures. At one, ostensibly on literature, Cravan had fired several pistol shots over the audience's heads and talked about sports; at another, he arrived onstage drunk and began performing a frenetic striptease.

Cravan had also become infamous for his sniper attacks on modern poets in the magazine *Maintenant*, "the tone of which," said Breton, "was unprecedentedly direct," and for which Cravan was editor, publisher, and sole contributor. Unlike the more respectful Albert-Birot, Cravan meant to spare none of modernity's sacred cows: not Gide ("I will pay Gide this one compliment, moreover unpleasant, that his little plurality derives from the fact that he could very easily be mistaken for a show-off"); not Robert Delaunay ("who has the face of a flaming pig"); not Apollinaire, who was so incensed by Cravan that he challenged him to a duel; and not Apollinaire's mistress, Marie Laurencin: "Now *there's* someone who needs somebody to lift her skirts and stick a fat . . . somewhere to teach her that art isn't just little poses in front of a mirror [but rather] walking, running, drinking, eating, sleeping, and relieving oneself." Cravan would disappear in 1920 somewhere in the Gulf of Mexico; but the example of his flagrant insolence was one that stayed with Breton (who considered Cravan a "veritable precursor") and those of his generation for many years afterward.

That same month of February 1916, in Zurich, a group of exiles named Tristan Tzara, Hugo Ball, Emmy Hennings, Hans Arp, Richard Huelsenbeck, and Marcel Janco met at the newly opened Cabaret Voltaire in the Meierei Bar at No. 1 Spiegelgasse, randomly stuck a letter opener in a Larousse dictionary—exactly who did the sticking has

never been settled; nor the story's veracity, for that matter—and called their anti-labors Dada. Come from France, Germany, and Romania, these Dada exiles had emigrated to Zurich in specific defiance of a world that expected them to make war. As Tzara explained in 1922: "The beginnings of Dada were not the beginnings of an art, but those of a disgust. Disgust with the magnificence of philosophers who for 3,000 years have been explaining everything to us." And Arp added: "Dada wanted to replace the logical nonsense of the men of today by the illogically senseless . . . Dada gave the *Venus de Milo* an enema and permitted Laocoön and his sons to relieve themselves after thousands of years of struggle with the good sausage Python." In their own ways, Dada, *SIC*, and Cravan—like many others over the coming half-century—were showing that art was no longer content to stand idly by while the world sank into hell.

And one more event that month: "On February 19, 1916, the poet tried, without great success, to understand that he was exactly twenty years old," Breton wrote about his next poem. Simply titled "Poème," it had in fact been composed on February 10 and sent to Valéry the day after; only in 1918, on its publication, was the date changed to the 19th and the poem's title to "Age." The specification of the date was significant, for this was above all a celebration of maturity: "Dawn, farewell! I emerge from the haunted forest; I'm braving the roads," it began.

Equally significant was the personal tension underlying "Age." On the one hand, the text's prose form (a novelty for Breton), tone, and diction marked its indebtedness to Rimbaud's prose poems in *Illuminations*. On the other, the sentiments expressed seemed to reject any such patronage. Breton had looked to a number of guides over the past several years—the Symbolists, Mallarmé and Rimbaud, Valéry and Apollinaire—but he was coming to understand that mentors cannot think for their protégés, and that one is finally beholden only to oneself. In this sense, "Age," even while honoring Rimbaud to a greater extent then ever before, was Breton's spiritual farewell to the forces that had shaped him and his work. By turning his gaze from rearward to forward, he was at last, as the poem seemed to acknowledge, coming of age.

Valéry, preoccupied with the poem's literary pedigree, missed the point entirely, and at all events was rapidly losing favor in Breton's eyes. Apollinaire provided a less enclosed and less classical, and therefore more attractive, model. But even Apollinaire was not without his disappointments. As Breton was coming to realize, the time was right for a mentor of an altogether different sort.

JOYFUL TERRORISTS

(February 1916 – August 1917)

IT WAS TOWARD THE END OF FEBRUARY 1916, during his rounds in the hospital on Rue du Boccage, that Breton first noticed an elegant young soldier with flaming red hair, the picture of studied arrogance and otherworldly detachment. Although scarcely twenty years old, Jacques Vaché bore the look of someone for whom the mysteries and cataclysms of this world were old hat, providing at best amusement, at worst a minor inconvenience. He was in the hospital for treatment of a leg wound sustained the previous September. While recuperating, he spent his time dazzling the nurses with his good looks and conversation, and drawing a series of curious postcards depicting a series of arrogantly aloof men (usually himself) standing amidst the war's carnage as if against the zinc of a fashionable Parisian bar.

Jacques-Pierre Vaché was born into a prominent Breton family on September 7, 1895, the son of a career officer with a firm belief in duty and discipline. He had British ancestry on his paternal grandmother's side, which might partially account for his cultivated Anglophilia. According to one legend, Vaché had first seen daylight in Indochina, but in reality he was, like Marguerite Breton, a native of Lorient. His childhood and youth, spent primarily in Nantes, revealed in him both a talent for drawing and a pronounced iconoclastic bent: while still in grade school, he had been expelled for producing an obscene sketch of one of the nuns. During his *lycée* years he and several friends banded together in a loose association that literary historians have dubbed the "Nantes group." They collaborated on homemade literary magazines that echoed both the anarchistic aesthetics of Alfred Jarry and the politics of Bonnot's band—inspiring predictable outrage among the Nantes bourgeoisie. On the eve of the war, Vaché had been a promising student at the Ecole des Beaux-Arts. He now treated his stay in his hometown army hospital as if it were an extension course: his morning ritual consisted in arranging a few photographs, paint pots, and several violets on a small table, which he had covered with lace, before getting on with his sketches.

Immediately recognizing—or believing he recognized—a kindred spirit, Breton spent much of his time at Vaché's bedside, expecting to find in him a sympathetic ear for

his own preoccupations. But unlike the enthusiastic young intern, Vaché wanted no part of modernism's heroes, and he ridiculed virtually everything Breton held up for his inspection—including Breton himself, whom Vaché, with mock-Romantic inflection, called the "po-wet." Breton persisted: "We spoke of Rimbaud (whom he had always hated), Apollinaire (with whom he was barely familiar), Jarry (whom he admired), Cubism (which he distrusted) . . . I believe that he reproached in me my will toward art and modernism." Vaché claimed to have no use for literature whatsoever, although he conceded a little affection for André Gide's anti-hero Lafcadio (from the eponymous novel) because, as he said, "he doesn't read and his only products are amusing experiments—such as Murder." Two years before news of Dada reached France, Jacques Vaché's attitude had anticipated it: accept nothing, trust no one, ridicule everything.

Much of what we know about Vaché comes to us through the writings of Breton, who intermittently for the rest of his life acted as Vaché's chronicler. According to Breton, Vaché took a job unloading coal on the docks of Nantes immediately upon his release from the hospital. He spent his days on the waterfront, his evenings around the city in various military costumes borrowed from relatives stationed in the area, dreaming of creating a composite uniform that could be mistaken simultaneously for that of the Allies and of the enemy. He spent beyond his means, weaving around himself a dramatic atmosphere from a thread of elaborate lies that he did not bother to maintain from one day to the next. He introduced Breton to others as "André Salmon," a minor poet of the older generation and friend of Apollinaire's.

With Breton, Vaché flitted from café to café, from cinema to cinema—his usual practice was to enter one movie theater, then leave for another after five minutes, pasting together a collage of unrelated sequences that delighted the pair far more than any complete film. At times the two friends would settle into their seats and begin opening cans, slicing bread, uncorking wine, and talking aloud, as if around a table. The spectators, thinking they had come to see a more conventional show, obliged them by expressing their astonishment and outrage. "I have never experienced anything quite as *magnetizing*," Breton later wrote. "The important thing is that we came out of it 'charged' for a few days." And he summed up their experiences: "We were those joyful terrorists, hardly more sentimental than was fashionable."

Like Baudelaire's dandy, Vaché worshipped the "cult of himself." And like the dandy, he affected an oh-so-British reserve. He claimed to be of Irish origin—to which his freckled face and bright red hair lent credence—and punctuated his correspondence with anglicisms that reflected his genuine fluency in the language. "The pains he took to attract attention sometimes became comical," one of his high school friends recalled. "He

liked to grimace so as not to give himself over to the pleasures of smiling." He never shook hands, and parted company without a word of goodbye. In their exchanges, he and Breton maintained the formal *vous*. Often he ignored Breton's very existence, pretending not to recognize him in the street and continuing on his way.

Vaché seems to have observed equal restraint in his sexual dealings. When Breton later visited the Paris studio where Vaché lived with a woman named Louise, he noticed that his host obliged her to sit still and silent in a corner for hours on end. At five o'clock she served tea, which Vaché acknowledged by kissing her hand—before ignoring her for the rest of the evening. Although Vaché referred to Louise as his "mistress," he claimed to have no carnal relations with her, but instead to sleep platonically beside her, fully clothed, in their single bed. This was, he assured Breton, his standard procedure.

"None of these young ladies, excuse me, gentlemen!" declared Vaché, as fictionalized by his friend Jean Sarment. "I turn away—honni soit qui mal y pense—from this abusive sex, hardened in despotism. I make an exception for several mysterious, inscrutable little girls; but, for the glory of their duration in my esteem, one would have to kill them off for me at age thirteen." This was a stance typical of the dandy, its most direct roots traceable to one of Baudelaire's darker confessions that "Woman is *natural*, in other words abominable." It rejected the loss of control, and of elegance, that went with sexual passion. For the inexperienced Breton, Vaché's attitude might also have sanctioned his own insecurities—after all, hadn't he echoed the same feelings by crowing to André Paris that he had "surprised [Manon] by denying the omnipotence of her charm"?

What is certain is that Breton very quickly developed an attraction of his own for the redheaded dandy, an attraction made up of close camaraderie, profound intellectual admiration, even a kind of love. And with that attraction went jealousy: Vaché was *his* friend, almost his property. Although he might well have known of Vaché's *lycée* activities, and although Vaché's subsequent letters to him are full of in jokes concerning these activities (not to mention the fact that Vaché continued to see and correspond with these friends throughout the war), Breton never made reference to the Nantes group in his writings. Nor did he mention that Théodore Fraenkel—"the Polish people," as Vaché nicknamed him after Jarry's *Ubu*—had also made Vaché's acquaintance in Nantes. Instead, Breton's written reminiscences bespeak an extraordinary will to exclusivity, from the elimination of potential rivals for Vaché's affection to the strangely isolated, disembodied nature of their adventures together.

The attachment is all the more remarkable given the brevity of the two men's contact, for in May 1916, little more than two months after having met Breton, Vaché was sent back to the front; true to form, he seems to have left without warning. Although

the two men saw each other infrequently from this point on—apparently only five or six more times—the absence occasioned a series of letters by Vaché that were later published by Breton and that constitute one of Surrrealism's earliest and most important documents.

The *Letters from the Front* are Jacques Vaché's only extant writings ("Vaché's good fortune is never to have produced anything," Breton later said). They date from summer 1916 to December 1918; appended to them are a short story signed "Jean-Michel Strogoff"—a send-up of Fraenkel's (a.k.a. "Theodore Letzinski's") belief in the good war—and "Blanche acétylène," an apocalyptic delirium full of whiskey and fire that reads like automatic writing before the fact, and that might have been composed under the influence of opium. With their willful derailing of syntax, their staccato, sarcastic bursts full of dashes, exclamations, and wild fabulations, the *Letters from the Front* spat in the face of accepted values, from nationalism to art ("my dear old, rotten Baudelaire!!!"). Nor was pacifism spared, for Vaché considered conscientious objection "vulgar," preferring to practice what Breton later termed "desertion within oneself." But he reserved his strongest attack for sentimentality, in all its forms. "The enthusiasms— (in the first place they're noisy)—*of others* are hateful," he wrote. "We needed our air dry, a little." Sardonic affection gave way to an equally derisive roguishness; hysterical humor and outrageous projects for the future were clothed in implacable formality. The letters were invariably signed "J.T.H." (for Jacques Tristan Hylar, one of Vaché's pseudonyms from the Nantes days) or "Harry James." Breton, and later his friends, pored over them with the zeal of Talmudic scholars.

Nearly a century later, these letters seem eccentric but relatively tame. In the wartime atmosphere of 1916, they were explosive, even unthinkable. They kept Breton enthralled not only for their highly unusual intelligence but precisely because they, and their author, appealed so strongly to his own, less forthright cynicism.

Of all Vaché's epistolary arsenal, Breton was particularly fascinated by the concept his friend called "umor" (no *h*), which Breton later baptized "black humor," and which could be likened to what would become, with Beckett and Ionesco, the humor of the absurd. Umor was the quintessence of Vaché's stylish and cultivated stance of total indifference, and Breton considered it to be the first complete manifestation of the "new spirit" he had previously divined in Rimbaud's will to vision and Apollinaire's modernism. He repeatedly asked for clarification, rationally trying to understand the irrational. Vaché archly responded in April 1917 with what has now become a celebrated formula:

And then you ask me for a definition of umor—just like that!—

"IT IS IN THE ESSENCE OF SYMBOLS TO BE SYMBOLIC" has long seemed to me worthy of being deemed such in that it is liable to contain a host of living things: EXAMPLE: You know the horrible life of the alarm clock—it's a monster that has always appalled me because of the number of things its eyes project, and the way that good fellow stares at me when I enter a room—why, then, does it have so much umor, why then? But there you have it: it is so and not otherwise . . . —*I believe it is a sensation—I almost said a sense—that too—of the theatrical (and joyless) pointlessness of everything.*

It is not certain whether the serious young Breton fully appreciated umor's purely nihilistic thrust; in any case, he never stopped grappling with it. Like slow poison, however, the "joyless pointlessness of everything" began infiltrating his deepest insecurities, attacking precisely those areas in which he was most sensitive. "One of the freest men, one of the most audacious and disdainful minds I've ever known," Breton said of Vaché several years afterward. "I owe to him, in large part, my ability to take my distance from literature and its tainted charms." Even though these "tainted charms" would ultimately prove rather difficult to leave behind, Jacques Vaché's example was nonetheless acting as a powerful irritant. His person, said Breton, enfolded "a principle of total insubordination . . . desecrating everything in its path."

But Vaché was more than a catalyst, and his relationship with Breton remains one of the central mysteries of Breton's life. There is no doubt that the latter was captivated by what he saw as his friend's dry-eyed brilliance. At the same time, it is curious that *his* Vaché—a man with no past, no family, no friends, no attachments—precisely mirrors the qualities Breton might well have wanted for himself. Just as he tended to equate Valéry with the cerebral Mr. Teste, Breton saw in Vaché largely what he wished to see— to the point where some have wondered whether Vaché's persona wasn't invented by Breton from whole cloth. Breton at this juncture was subject to myriad conflicts—fidelity to his literary ideals, indecision about his medical career, recalcitrant but persistent feelings of duty toward his parents—and to a vague desire for some unspecified form of liberation. In order to find this liberation, he needed a nihilistic Vaché: more than any of Breton's previous guides, the sarcastic redhead seemed most likely to utter the great "No" that would start everything at zero.

In reality, however, Jacques Vaché was not entirely the ur-dandy that Breton made him out to be. Although he flattered Breton's ambivalence toward his parents by claiming to have no family ties of his own, Vaché (as his unearthed correspondence shows)

actually maintained reasonably good relations with his mother, and wrote to her frequently, at times almost daily. (Breton in his portrait maintained that Vaché never wrote to his parents "except, out of self-interest . . . every two or three months.") Moreover, according to Vaché's cousin Robert Guibal, he deeply admired his strict father, although he feigned hatred of him among his comrades. He peppered his letters and conversations with bits of Nantes group arcana, but he had been only a secondary contributor to the group's activities; and the sardonic cast of his *Letters from the Front*—which Breton considered so original—had in fact been taken from other members' writings.

At the same time, what Breton wanted to see also reflected what his subject wanted to show. Vaché was no doubt amused to have an earnest young disciple and future Boswell to impress, and probably never made clear to Breton the extent of the Nantes group's influence on his own attitudes and "sense of umor." He had a fine talent for chameleonism, as witnessed by the tone of his letters, which changed with the correspondent. Vaché was an actor keenly aware of his audience, Breton an audience who knew what he had come for. The more he applauded his friend's umoristic performance, the more he pushed Vaché into assuming the role he had created. As Vaché wrote to his mother in 1917: "It's quite false, I assure you, to judge me by appearances—although now they jibe significantly more with my real character than they used to."

Breton's portrait of Vaché was painted with broad strokes of invention, dissimulation, and projection, on a canvas provided by the sitter himself. It is impossible to tell how much of this projection was due to Breton's own anxieties, how much of the dissimulation resulted from Vaché's need to construct a persona. What *is* certain is that from the moment they met, perhaps without realizing it, the two young men began collaborating on the myth of Jacques Vaché, and through him on one of the founding myths of a Surrealist movement yet unborn.

It was in the immediate aftermath of his meeting with Vaché that Breton told Valéry he was "freed from his obsession with poetry" and that he was now seeking in "the cinema [and] the pages of the newspapers" the aesthetic pleasure he claimed no longer to find in printed verse. Valéry, sharp-eyed as usual, recognized that his protégé's "deliverance" was perhaps not so complete as he pretended and that the only "remedy" for his despair over words "was not to be a poet." Was Breton willing to take such a step? In any case, for the next several months no new verse arrived at Valéry's canvas-laden apartment. Breton did, however, visit his erstwhile mentor during his leave in late April, and again in mid-May.

The city Breton rediscovered had been transformed. The brass and bluster of the war's early days had given way to the grim rigors of rationing, blackouts, and deprivation. A tense, expectant stillness seemed to permeate the air. German zeppelins periodically flew overhead in an attempt to demoralize the civilians, who at night heard the sounds of cannon fire from the not so distant battlefields. Transportation and manpower shortages were such that the municipal taxis had been requisitioned to bring soldiers to the front.

In addition, the artistic flourishing that made Paris the cultural capital of Europe had temporarily ended: theaters had folded, bookstores and art galleries no longer served as the meeting places they had earlier been, and the salons, which helped introduce young artists to wealthy patrons, had mainly been suspended—for many of these wealthy patrons were now in uniform. And yet, in the final account, this very atmosphere and these cutbacks ended up favoring the artistic avant-garde, as artists and writers, forced to rely on their own meager devices, banded together to form an active and energetic subculture. Newer, more informal salons were born, more attuned to the reality of the times.

The most notable of these was Adrienne Monnier's bookstore, La Maison des Amis des Livres. Located at 7 Rue de l'Odéon, across from the future site of Sylvia Beach's Shakespeare and Company, it had first opened its doors in November 1915. And just as Shakespeare and Company would do for a legendary host of expatriates, the Amis des Livres provided a welcoming forum for writers in various stages of their careers. Monnier combined a zealot's energy, a mother's concern, and a librarian's meticulousness to produce what soon became one of the premier meeting places for Parisian intelligentsia, unconscripted or on leave. The store's habitués soon included some of the most prominent names in Paris: novelists and poets such as André Gide, Jean Cocteau, Blaise Cendrars, Léon-Paul Fargue, and Valéry Larbaud, and even nonwriters like Erik Satie made it a second home, as eager to be flattered as Monnier was to flatter them.

That spring the bookstore also caught the eye of Breton. Immediately taken with what he found there, he spread the word to Valéry and Apollinaire, both of whom became regulars of the establishment as well. "Adrienne Monnier had made her store the most attractive intellectual meeting place of the time," he recounted. "The nice touches she could introduce into the conversation, the opportunities she gave young people, and even the provocative bias of her tastes: there was no lack of trump cards in her hand."

Monnier seems to have been equally affected by her young visitor, of whom she left a subjective but evocative portrait:

His physiognomy . . . was beautiful, of a beauty that was not angelic but archangelic. Let me say parenthetically that angels are gracious and archangels are serious . . . Breton did not smile, but he sometimes laughed with a short and sardonic laugh that welled up when he spoke without disturbing the features of his face, as with women who are careful of their beauty . . . Perhaps the most remarkable thing about Breton's face was the heavy and excessively fleshy mouth. Its lower lip, whose development was almost abnormal, revealed, according to the data of classic physiognomy, a strong sensuality governed by the sexual element; but the firmness of that mouth and its delineation, which was rigorous even in excess, indicated a very self-possessed person who would combine duty and pleasure in a singular fashion.

Although Monnier was herself conversant with the most modern literary trends, she felt that the twenty-year-old Breton "was much more 'advanced' than I. I certainly seemed reactionary to him, while in the eyes of my ordinary customers I was a revolutionary figure."

One more event highlighted Breton's leave in May. On the 8th, an unevenly scrawled note from Apollinaire arrived at his parents' home in Pantin, asking Breton to visit him in the hospital. Apollinaire had been in the trenches two months earlier, quietly reading his latest column in *Le Mercure de France*, when a shell exploded nearby. After the dust settled he had calmly returned to his magazine, when suddenly blood began to drip on the page: shrapnel had torn through his helmet, boring into his right temple and lodging beneath his skull without Apollinaire even feeling it. The shrapnel had quickly been removed; but although the poet told friends that the wound was not serious, recurring spells of dizziness, fatigue, depression, and paralysis over the following weeks caused the doctors to feel otherwise, and Apollinaire had been sent to Paris for further treatment. Now, waiting to be trepanned at the Villa Molière branch of the Val-de-Grâce military hospital, he sent word to Breton.

On May 10, the day after Apollinaire's operation, and the one on which Breton was scheduled to return to duty, the young man arrived at the Villa Molière. His first view of the magus was not promising: weak and depressed after his operation, Apollinaire appeared "sad and feeble" to his young guest. His attempts to impress his new audience with his reflections on poetry aroused Breton's pity more than his admiration. "It was very moving," Breton reported to Paris. "He still can't write."

Perhaps more than Apollinaire himself yet realized, his wound had made him into the eponymous "poet assassinated" of his next book: as 1916 wore on, his physical recovery was paralleled by disturbing changes in character. He abruptly broke off his engage-

ment to his fiancée, Madeleine Pagès, and developed a pronounced irascible streak. He was also no longer the flouter of tradition Breton had come to expect, for he grew anxious about his place in the literary constellation and hungry for official recognition. Indeed, hearing that he might be eligible for the Legion of Honor, Apollinaire began toning down his statements in articles and interviews to favor his candidacy.

Because of this hunger, as well as the poet's conscientiousness about his status as a French officer, one of the manifestations that should most naturally have enjoyed his sponsorship was instead greeted with distance and mistrust. Having first seen the light of day in February, the Dada movement began making its activities public as of that summer (beginning, appropriately, on Bastille Day, July 14)—for like Arthur Cravan, the Dadaists knew the value of spectacle. "We want to shit in different colors so as to adorn the zoo of art," the movement's self-appointed spokesman, Tristan Tzara, declaimed to one of Dada's first audiences. One historian described Dada founder Hugo Ball, "pale as a plaster dummy, [playing] the piano accompaniment to [Richard] Huelsenbeck's slamming of a drum, while Tzara managed to make his bottom jump like the belly of an Oriental dancer." Other performances featured raucous noises, simultaneous readings of poems in several languages (or no known language), African chants, jazz songs, dances, shouts, and anything else that would outrage public opinion. Dada painter and historian Hans Richter put it this way: "The devising and raising of public hell was an essential function of any Dada movement, whether its goal was pro-art, non-art, or anti-art. And when the public, like insects or bacteria, had developed immunity to one kind of poison, we had to think of another." The effect on staid, pacifist Zurich was immediate. As Richter said, "Radek, Lenin, and Zinoviev were allowed complete liberty [in Zurich] . . . It seemed to me that the Swiss authorities were much more suspicious of Dadaists, who were after all capable of perpetrating some new enormity at any moment, than of these quiet, studious Russians."

The Swiss were not alone. Tzara, a peerless promoter of Dada's (and Tzara's) interests, had sent Apollinaire a very flattering letter on April 22, which the poet had not seen fit to answer. In June, the Dadaists published the first and only issue of the magazine *Cabaret Voltaire*, named after the movement's birthplace; included in its pages was a pirated text by Apollinaire. This was not the first time that a struggling periodical had published Apollinaire's work without his consent—his name was like a certificate of avant-garde pedigree—but he nonetheless found this instance troubling: the Dadaists were already beginning to acquire a bad reputation, either as Communists (for the Germans) or as Germans (for everyone else). Added to this, some of the names that jostled Apollinaire's in the table of contents sounded suspiciously un-Allied; and many of

the Dadaists were, in fact, of Germanic origin. Indeed, it was not Dada's avant-garde credentials that worried Apollinaire, but their resolutely ambiguous sympathies vis-à-vis Germany and the war.

Given Apollinaire's attitude, it is little wonder that Breton was coming to feel deep ambivalence toward his former mentor. While the poet and aesthetic impresario still exerted a powerful fascination, the man himself was beginning to lose ground in the arch-critical eyes of his young admirer. Breton, his ideas on art and life having been turned inside out by the writings of Rimbaud and the attitudes of Vaché, was grappling with their subversive implications. Declarations such as Apollinaire's "Oh God! how lovely the war is," even when clothed in thrilling new poetics, could hardly have enticed him very far. Still, the "rotting enchanter" (another of Apollinaire's self-mocking titles) had a few remaining tricks in his hat and, whatever his misgivings about Apollinaire's public stances, Breton could not help being attracted by the poet's seemingly boundless energy and curiosity. The pilgrimage to Villa Molière marked the beginning, not the end, of his visits.

Finally, Breton's times in Paris that spring were the occasion to renew his friendship with a young woman named Annie Padiou, whom he had met several months before in Nantes. The "you" of "A vous seule," Annie had accosted him "one day . . . when I was out walking alone in a downpour," and without further ado offered to recite one of her favorite poems, Rimbaud's "The Sleeper in the Valley." Charmed as much by her careful delivery as by her choice of poet, Breton later kissed her under cover of nightfall in the Parc de Procé. The next morning his scruples started getting the better of him—was it wrong to seduce someone he didn't love? Georges Gabory, who later met Annie in Paris, humorously related the incident:

> That night, the poet [Breton] had bad dreams. An angel appeared before him and chided him for his conduct. The angel spoke in slang; he had a wooden leg and goose feathers. Upon awakening, the poet was in despair; he had strict principles . . . Ah! what would Rimbaud have done, Arthur!, if he had found himself in this situation? He would have gone to Harrar, no doubt, but that was awfully far away.

Annie had begun to split her time between Nantes and Paris, where she found her way to the literary café tables of La Rotonde and the Closerie des Lilas. Breton, whom the woman's earnest advances put ill at ease, introduced her to Fraenkel, who then fell in love with her—and who soon found himself the pining recipient of Annie's confidences about Breton. Fraenkel came to Annie's defense against Breton's sarcasm, all

the while hoping to win her affections for himself. But it was wasted effort: Annie, smitten with Breton despite his rejections, did not return Théodore's sentiments.

As Fraenkel soon understood, Breton had quite simply forsaken Annie for another woman. "I kind of love a delightful young girl named Alice, worrisome and fine," the latter told André Paris on June 18. "She knows nothing about me, nor I about her, other than the forms that we have adopted for our pleasure and the taste of our kisses, of the dizziness of being together . . . I've loved her for several days, for, no doubt, several days more." He spent all his free moments with Alice, gathering poppies with which to make her bouquets, stealing hours in peculiar little inns whose rooms were "oppressive with bunches of privet and mean little pendulum clocks."

Little is known of Alice, not even her last name. Was she of Spanish origin, as Breton surmised? Was she an actress, as suggested by these lines from *The Magnetic Fields*: "She's going to shoot in the month of July or August. She is sitting opposite me, in trains that no longer start"? What is certain is that, despite his caveat ("I kind of love"), Breton showed unprecedented signs of physical and emotional attraction to her. "Beautiful, beautiful life! (That we're alive, oh what a delicate marvel!)," he rhapsodized to Fraenkel, who for his part considered Alice "flirtatious and perverse and stupid."

Alongside his infatuation with Alice, Breton developed a sharp interest—one of the brief "jolts of passion" to which by his own admission he was subject—in fashion and fashion magazines. Although this has often been ascribed to Alice's influence, we might just as well see behind it the shadow of Jacques Vaché, who had first caught Breton's eye with his renderings of male fashions and who himself took such sartorial care. Might the interest, in fact, have been a psychological compensation for the absence of Vaché, who had recently departed for the English front?

In any event, the threefold preoccupation with fashion, Alice, and Vaché combined in a poem, "Way," early that month: fashion informs the imagery ("Fondness strews you with brocaded / taffeta plans"; references to the dressmaker Chéruit and the Cour Batave lingerie shop), Alice the overtones of sensuality. As for Vaché, his was perhaps the most significant contribution of all, for "Way" was the first of Breton's poems to show the influence of the great doubts that had infiltrated his literary consciousness. Although a perfect sonnet when reassembled, the lines of the poem as set on paper have been ripped apart, lacerated; it looks like free verse, but the strict internal rhyme creates a feeling of tension and disquiet.

Ever eager for feedback, Breton sent Valéry the new work on June 9, adding: "Please be sure, Monsieur, to castigate this poem." Intrigued but confused, Valéry recognized its structural originality, but complained of not being able to distinguish "the rules of the

game. These are, as you know, my little reward. Let us castigate, then . . ."

The tone of Breton's request, the excessive politeness mixed with humorous self-dep-recation, characterized many of his relations, both written and verbal, for the rest of his life. It was as if Breton used this tone as a kind of talisman, staving off criticism by so broadly inviting it, and at the same time daring the other to challenge his underlying belief in his own work's merit. The fact was, Breton considered "Way" one of his most important early poems—not only at the time of its composition but in later years as well. It opened his 1919 collection *Pawnshop*, and has been included in virtually every volume of his selected poetry since (while many others from this period have been dropped). It was also one of the first texts that Breton showed Louis Aragon on their meeting in late 1917; at the time, it was clear to Aragon that Breton thought very highly of it.

✳

In early July came word—apparently the first—from Vaché, who excused himself for abruptly disappearing "from Nantes circles" and reported that he was now an inter-preter for the British forces. Before signing off, he asked Breton to remember "that I have (and I ask you to accept it) really firm feelings of friendship for you—which I shall kill off, as it happens—(without any scruples perhaps)—after having taken the liberty of robbing you of your dubious probabilities."

It was perhaps in response to this absence that Breton decided to end his own stay in Nantes. Despite his feelings for both the city and Alice, he suddenly requested a transfer to the neuropsychiatric center at Saint-Dizier, in northeastern France. The motivations were complex and contradictory: to Apollinaire he confessed a desire to "steer his life away from its course," to Valéry and Fraenkel a will to free himself from his poetic obsessions. And overriding all of this might have been a fear, confessed to no one, that his attachment to Alice would soon grow beyond his control. A pattern was forming in Breton's relationships with women: just as he had "exposed Manon's weakness" and rejected the lovesick Annie, so now he was terminating his affair with Alice for no per-ceptible reason—unless the reason itself was to cause pain, or to forestall feeling such pain himself.

Breton arrived in Saint-Dizier on July 26. For the next several months, his home was the psychiatric center, his main interlocutor its director, Dr. Raoul Leroy. It was here that Breton made one of the discoveries most crucial to his mental development: the writings of the pioneer psychiatrists, notably Jean-Martin Charcot, the "Napoleon of neuroses"; Emil Kraepelin, one of the most influential German psychiatrists of his day; Constanza

Pascal, author of an important work on schizophrenia (dementia praecox); and, of entirely different import, the *Précis de psychiatrie* by Emmanuel Régis and *La Psychoanalyse des névroses et des psychoses* by Régis and Angélo Hesnard. These last two works revealed to Breton the theories of Sigmund Freud, who at the time was receiving scant attention in France (his work would not begin to be translated there until 1921). Indeed, given the wartime atmosphere, the odd sexual notions of a renegade neuropathologist, made all the more suspect in that their author was Germanic (and Jewish!), were not likely to garner hardy support in the French psychiatric community. Régis and Hesnard, in fact, had to preface their discussion of Freud by reassuring their professional readership that his discoveries were worthy of attention, despite his Austrian nationality.

For Breton, on the other hand, Freud's national origins no doubt constituted an attraction. Since his trip to the Black Forest six years earlier, he had retained his admiration for Germanic literature and philosophy (a point on which neither the reigning atmosphere nor Apollinaire's hesitations had any influence), particularly Hegel's guiding princple that "the essential feature of the mind is Liberty," and the writings of the German Romantics, which blurred the boundaries between poetry and philosophy. Now, Breton's discovery of Freud's theories heightened his respect for German thought. In the fall he condensed this latest enthrallment in a distich to Fraenkel: "Dementia praecox, paranoia, twilight states. / O German poetry, Freud and Kraepelin!" Guided in his readings by Dr. Leroy, who supplemented them each evening with several hours of conversation, Breton developed a passion for Freudian psychoanalysis, and, at least for the next several months, considered making a career of it.

The psychiatric center "took in men who had been evacuated from the front for reasons of mental distress"—including that new category of war casualty, the shell-shock victim. If Breton's duties were largely routine—"My duties all come down to a constant interrogation: with whom is France at war? and what do you dream about at night?" he told Valéry—his contacts with the patients were anything but that. To Fraenkel, he excitedly described the "astonishing images" that emerged from his daily interviews, "on a higher plane than those that would occur to us." Skeptical as always, Fraenkel noted in his diary that Breton "in his nut-case hospital is moved and horrified to see patients who are better poets than he is."

Breton did not unequivocally decide to abandon literature for psychiatry, but rather hesitated between the two, again hoping for some external resolution to his internal dilemma. On one level, however, his choice had been made, for poetry in the larger sense was never far from his mind. Breton's attraction to the phenomena he witnessed at the

center derived less from their therapeutic value than from their applicability to the roots of artistic creation. "Nothing strikes me so much as the interpretations of these madmen," he reported to Apollinaire. "My fate, instinctively, is to subject the artist to a similar test." For him, the genius of the insane (or those labeled as such) lay in their instinctive ability to fashion "the most distant relations between ideas, the rarest verbal alliances" —in other words, to create poetry of the most startling, unusual, and fertile kind.

At the same time, he had seen ample evidence of the degradation and decrepitude their condition entailed, and he harbored few illusions about the fate of someone who gave himself over entirely to delirium, fertile though it might be. He resolved to keep his patients and their uncanny insights at a safe distance. For the moment, he studied the discipline, observed Leroy on his rounds, and flirted with the idea of leaving his literary persona behind—all the while keeping poetry firmly in the corner of his eye.

Valéry, to whom Breton wrote of his new interests, answered with mixed enthusiasm. He did not credit the young intern's conviction that the study of dreams and free association could benefit poetry, and his response was shaded with guarded approbation: "Strangeness in itself doesn't interest me, and I choose among possible exceptions only my own case. I therefore looked for normal man . . . Wouldn't poetry or its equivalent in life's values more likely be on *that* side? . . . My best wishes, Breton, and if you want my advice, observe your subjects carefully." (Apollinaire, whom Breton also tried to interest in psychoanalysis, gave it an equally lukewarm reception. Even Vaché merely answered with the query: "Are your illuminati allowed to write? — I'll gladly exchange letters with a paranoiac, or some 'catatonic' or other," before moving on to other matters.)

Breton did take Valéry's advice in one respect: he closely observed his subjects. The result, appropriately titled "Subject," was a prose monologue of several pages, directly based on Breton's study of a particular case at Saint-Dizier. As he later told it:

> He was a young, well-educated man who, in the front lines, had aroused the concern of his superior officers by a recklessness carried to extremes: standing on the parapet in the midst of the bombardments, he conducted the grenades flying by with his finger. His explanation for the doctors was as simple as could be: strange as it may seem, and although this ploy was not new, he had never been wounded. But underneath, some clearly heterodox certainties were being articulated: the supposed war was only a simulacrum, the make-believe shells could do no harm, the apparent injuries were only makeup . . . Naturally, the doctors did everything in their power to make this man admit that the outsized costs of such a spectacle could not simply be for his personal benefit, but it seemed to me he didn't really believe it.

So faithful is "Subject" that it reads like a transcript from within the patient's own brain. "I stepped over some corpses, it's true," he calmly states. "They stock the dissection rooms with them. A good many more might have been made of wax." Here all lyricism was discarded in favor of scientific accuracy, as if Breton were reveling in the sheer thrill of a fascinating case. The discourse itself was the thing; Breton meant to enter so fully into the other's thought processes that he could artificially re-create them. (A similar, more extended attempt would come in 1930 with *The Immaculate Conception*.) Apparently he was ambivalent about the final product, however: Valéry, who usually received his manuscripts within days, did not see this piece until May 1918, after it had been published.

This ambivalence spread to Valéry himself: he remained faithful to things that were now earning Breton's scorn, and was cynical in cases where the young man sought acceptance. His skeptical take on Freud, schizophrenia, and Cubism (which Breton, under Apollinaire's influence, newly admired) made of him precisely the surrogate father, full of benign interest and affectionate reason, for which Breton had little use.

Worse: after two decades of virtual silence, Valéry was preparing to unveil a new work, an epic called *The Young Fate,* which would establish his standing as one of France's most honored poets but which dismayed his young protégé as much by its retrograde nature as by its hermetic noninvolvement with the world. "I read the three hundred new lines," Breton reported to Fraenkel on November 18. "It's straight out of the classics and Mallarmé . . . The truth, between you and me, is that perhaps the 'clarity of life' is no more . . . So there's been an abdication! Mr. Teste was just a puppet!" Some thirty-five years later, Breton was still asking, "Was it really worth having hidden for so long, only to reappear in that garb? With *The Young Fate*, it was as if Mr. Teste had been *duped*, betrayed." Still, when Valéry sent him the published book version the following spring, he somewhat hypocritically answered, "How I love your *Young Fate*! I never tire of rereading it and it's an endless enchantment."

"How much does it cost to make an entire company disappear?" the anonymous skeptic of "Subject" asks at the close of his monologue. It was a question that Breton would soon have an opportunity to explore. On November 20, over Dr. Leroy's protests, he was sent to the front near Verdun as a stretcher-bearer, in preparation for the "Meuse offensive" that sought to reclaim territory lost that summer. As Théodore Fraenkel was coincidentally to leave with him, they were visited on the eve of their departure by their anxious parents, who had made the trip together from the Paris region to see them off.

This was Breton's only experience of actual combat, but for him it was enough. With the shortage of personnel, the doctors at the front were often no more than medical students, with little training to speak of and scant experience in treating the wounded—assuming they were even given the chance, as the constant bombardments forced rescues to be made only under cover of darkness, while dodging enemy shells. Breton spent nearly four weeks at the front, and ten days out of that in a cave performing triage duties by the light of an acetylene lamp. "We had to go through a horrible crossroads in blackest night. At intervals the rockets lit the shattered trunks, the festoon of ruins, then back once again to the treacherous potholes," he reported to Valéry. Earlier, Valéry had tried to comfort him with the observation that Nietzsche, having been a stretcher-bearer at the siege of Metz in 1870, "made the best of a fate analogous to the one circumstances have handed you." It was small consolation.

By mid-December, Breton was five hundred yards behind the front lines, writing his first poems since his arrival at the Saint-Dizier psychiatric center. Taking his cue from Apollinaire's triumphant war verses, he attempted to describe the battlefield landscape ("Demolished buildings, scraps of blue flowerets"). But although he told Valéry that "Apollinaire's muse sustained me for a certain time," the tone of Breton's two war poems was, by his own admission, one of "derision." Still, he was not entirely impervious to the emotional intensities of warfare. Despite his admiration for, and emulation of, Vaché's resolute indifference toward the carnage, he admitted to "having experienced several hours of rather pleasant giddiness" during his weeks at the front. "I compare this to the voluptuousness of swimming, or galloping," he told Valéry.

In this light, even the two "derisory" poems betray a certain awe before the spectacle of war. Like the Saint-Dizier experience, battle could also be grist for the literary mill. This was hardly unusual, as many a soldier-poet was demonstrating; but in Breton's case, the real goal was not to "capture" or "represent" the war, but rather to evoke the emotional shock that certain episodes had aroused in him. As with his reading of Rimbaud two years earlier, the literary experience had greater reality than the heat of battle itself.

❋

The new year brought a new posting, this time to Paris. After a week's leave, Breton reported for duty on January 8, 1917, to the 22nd Section of Military Orderlies, and was promptly sent to the Val-de-Grâce military hospital for additional schooling. Located on a quiet stretch of Rue Saint-Jacques at the edge of the Latin Quarter, the Val-de-Grâce

had originally been built as a convent by Queen Anne of Austria (the wife of Louis XIII) in the mid-seventeenth century. It had served in its present medical function since the French Revolution, and was now being used additionally as a training center. The building stood at the back of a large enclosed courtyard, which was dominated by the handsome dome of the adjoining church.

Breton's courses were part of an emergency program intended to counter the rapid attrition of French military physicians by calling former medical students back from the front and turning them, as quickly as the minimum requisite knowledge could be dispensed, into "auxiliary doctors" with specific knowledge of battlefield medicine. Every afternoon, Breton suffered the stuffy classrooms like a return to a former life.

In certain respects, however, his current situation differed greatly from the days at medical school. The young men attending these emergency courses were considered soldiers, not students, and discipline at the Val-de-Grâce was as harsh as at any front-line camp. The doctors-in-training were expected to salute their officer-instructors; they also lived in the dormitory, and a nine o'clock curfew was strictly enforced. For many of the future auxiliary doctors, who were eager for a long-denied taste of Parisian nightlife, the curfew was perhaps the primary reason for discontent.

A somewhat more enjoyable assignment came at the end of the month when, in addition to his studies at the Val-de-Grâce, Breton was sent to La Pitié hospital to assist the illustrious neurologist Joseph Babinski. Babinski inspired in Breton an intense admiration. He had been the first to distinguish neurology and psychiatry as separate disciplines, and was the discoverer of the cutaneous plantar reflex (also known as the "Babinski reflex"), which detects organic brain lesions and is used in the identification of diabetes. Perhaps most memorable in Breton's eyes was the combination of "sacred fever" and casual aloofness that Babinski displayed while handling his patients. For his part, Babinski was so taken with Breton's enthusiasm that he inscribed a copy of his new book for him, predicting that the young man would have a "great medical future."

It was not only as an extern that Breton stayed at La Pitié, however. In March, a persistent fever put him under the care of another of the hospital's physicians, a certain Dr. Arron, who after several hesitations diagnosed the cause as appendicitis and prescribed forty days' bed rest. Breton's fellow invalid Apollinaire, who had by now recovered from his injury and was once more a regular figure in Paris literary circles, wrote on March 19, inviting Breton to visit as soon as his health allowed. At first Breton, still subject to high fevers, was content to answer by correspondence. Unable to stay bedridden, however, he attempted a first extramural venture on April 4, with disastrous results. As he told André Paris, "Yesterday afternoon run to Apollinaire's in impossible weather and,

for first time out, over an hour on my knees exhuming marvelous engravings, got my fever back." He returned to La Pitié, depressed by his tenacious illness. Several weeks later his condition still had not improved, and on April 26 he underwent an operation for appendicitis, which only caused further complications. Although by June his symptoms were finally alleviated enough to allow him some freedom of movement, Breton would not be completely out of Dr. Arron's care until early August.

Which is not to say that his stay in the hospital left him idle. At the end of March, at Apollinaire's request, he had begun writing an overview of the poet's work for *Le Mercure de France*, to coincide with the forthcoming publication of Apollinaire's new collection of poems, *Calligrammes*. "I don't know of anyone who can speak of what I've done as well as you can," Apollinaire had said. Breton's response was immediate and thrilled. "After the first moment of emotion, I wanted to tell you that I enthusiastically accept your offer." "Enthusiastically" was indeed the word, for despite his illness, Breton completed a first draft by mid-May. In the end, however, the article did not appear in time to accompany *Calligrammes*, which itself was published in April 1918, nor did it appear in *Le Mercure de France*, but rather in the much less prominent *L'Eventail*.

Also in March, Breton sent Apollinaire a poem, his only verse composition that year. Entitled "André Derain," it paid tribute to the painter's work on the thematic level, while prosodically it pursued the game of fractured alexandrines begun with "Way." "If André Derain were to be touched by the quality of this homage (do you think he could, Monsieur?) it would naturally make me happy and proud," he told Apollinaire. (The poem did, in fact, become the occasion for Breton to begin personal relations with Derain, which lasted for several years.) He also asked Apollinaire to help him submit it to the magazine *Nord-Sud*.

Founded that same month by the poet Pierre Reverdy and a few others, *Nord-Sud* was symbolically named after the metro line (today called the No. 12) that connected Paris's two artistic quarters, Montmartre to the north and Montparnasse to the south. Along with *SIC*, it became one of the most important avant-garde periodicals of the war years; and like *SIC*, it immediately placed itself under Apollinaire's aegis. But whereas *SIC*'s dedication to Futurism and all its children made it something of a modernist hodgepodge, *Nord-Sud*'s focus was narrow to a fault. With the same intransigence that he applied to his own poetry, Reverdy singled out the most accomplished practitioners of "literary Cubism" (so called because they attempted to do on paper what painters such as Picasso, Braque, and Gris were doing on canvas) and published them alongside his own aesthetic meditations. The magazine almost exclusively featured work by those in Reverdy's restricted circle—Apollinaire, Max Jacob, the Chilean poet Vicente Huidobro,

and Paul Dermée—as well as a select group of younger poets that soon included Louis Aragon, Philippe Soupault, Jean Paulhan, Tristan Tzara, and, beginning with the third number, Breton.

Breton's interest in *Nord-Sud* was encouraged both by Apollinaire's recommendation and, to a large extent, by the personality of Pierre Reverdy himself. Fiercely independent and unwilling to compromise, Reverdy kept himself firmly out of the mainstream by his recondite poetry and his irascible nature. Breton was struck by the proud austerity of Reverdy's lifestyle and the intransigence of his views. His introduction to Reverdy at around this time marked the beginning of a series of fertile, if trying, exchanges on the nature of aesthetics.

Meanwhile, the "rival" avant-garde periodical, Albert-Birot's *SIC*, featured a contribution of a different nature, a poem entitled "Restaurant de Nuit" and signed Jean Cocteau. What Albert-Birot failed to notice until after the poem appeared was that "Restaurant de Nuit" was actually an acrostic whose left margin read "Pauvres Birots"— poor Birots—and, moreover, that it contained several snide references to Cocteau's personal life. The poem, of course, was a hoax, and had been written not by the sought-after Cocteau but by Théodore Fraenkel, with, most likely, Breton's help. Stung, the real Cocteau made a fuss in the newspapers, terming the entire affair "the basest practical joke" and comparing himself to the similarly wronged Baudelaire.

As pranks go, the "Restaurant de Nuit" affair was of no special significance (or humor), but it does provide a first glimpse of what would be, on Breton's part, a lifetime of loathing for Cocteau. The reasons for this loathing are a tangled mix of personality, circumstance, and sheer territorial rivalry. Cocteau could be unabashedly sentimental while Breton abjured all sentiment, and aimed to please while Breton forged a badge of honor from insolence. He also seemed to delight in intrigues; Breton, who claimed to "live in [a] glass house," held that Cocteau's "native habitat was behind-the-scenes." While Breton erected a pedestal to Woman, fashioned from a curious amalgam of Symbolist idolatry and cavalier dandyism, Cocteau was foppishly homosexual. And whereas Breton had absorbed his class's distrust of high society, and was anything but graceful in public, Cocteau, a son of the haute bourgeoisie, was adroit at hobnobbing with the dukes and countesses who provided funding for his art and an audience for his celebrated gift for mimicry.

In addition, Cocteau often seemed to be covering Breton's waterfront, although in this regard he was less Breton's competitor than his funhouse-mirror image. While Breton took a scholar's approach to innovation, Cocteau was an artistic fashion plate. For him, Cubism and Symbolism were fads, styles he parroted as ably as he reproduced a celebri-

ty's mannerisms. His clever mind easily absorbed the daily trend, often before it had become popularized, but his version of it remained hollow. On the one hand, this made Cocteau anathema to many—Reverdy considered him the "anti-poet" personified—but on the other it had scored him some undeniable artistic successes, sometimes among the very figures Breton wanted to impress (Picasso, for instance, remained a lifelong friend). Barely seven years Breton's senior, Cocteau was one of the most ubiquitous figures of the literary and artistic avant-garde. It was perhaps this early and easily won success that most stoked the ire of Breton and his friends, along with Cocteau's unrestrained penchant for hyperbole—whether in his protests about "Restaurant de Nuit," or in his description of another incident at that time, the squabbles surrounding his ballet *Parade*, as "the greatest battle of the war."

Parade had been composed in collaboration with Picasso, Erik Satie, and choreographer Léonide Massine, and performed by Diaghilev's Ballets Russes. There could have been no better combination to appeal to monied art patrons, and the ballet's snob appeal was yet one more grievance to be held against Cocteau by the literary rebels of Montparnasse and Montmartre. Despite *Parade*'s public success, however, the last word went not to Cocteau but to Apollinaire, who wrote the program notes: for these notes marked the first use of the word "Surrealism." Apollinaire meant the term "*sur-réaliste*" mainly as a counterpoint to Cocteau's description of *Parade* as a "*ballet réaliste*," and his understanding of it was rather vague. Still, the word had now been publicly launched, and very shortly would take on an undeniable life of its own.

It in fact recurred, with far more resounding significance, the following month, on the occasion of Apollinaire's own play *Les Mamelles de Tirésias* [The Teats of Tiresias], which he subtitled "A Surrealist Drama." "I think it better to adopt Surrealism rather than Supernaturalism, which I had initially used. Surrealism does not yet exist in the dictionaries, and it will be easier to manipulate than Supernaturalism, which is already used by the Philosophers," Apollinaire had written to poet Paul Dermée that March. In his preface to *Tirésias*, he provided this explanation: "When man tried to imitate walking he created the wheel, which does not resemble a leg. He thus performed an act of Surrealism without realizing it."

This was far cry from the definition Breton would give of Surrealism seven years later: "psychic automatism in its pure state." Even now, however, Breton was staking a tentative claim on the term, as evidenced by a letter from around that time that appropriates both Apollinaire's word and his imagery: "I can say that I collaborated on the preface to *Mamelles*. Man, trying to reproduce movement, creates the wheel, which has no connection to the apparatus of the paws that he's observed running. The motor mech-

anism of the locomotive harks back to the system of articulations where the inventor's thought originated. Surrealism includes both the invention and its fine-tuning." It was probably the first, but by no means the last, time that Breton would defend his guardianship of the word.

Although less grandiose in scale than *Parade*, *Les Mamelles de Tirésias* was a literary "event" in its own right, and was accordingly surrounded by all the requisite hoopla. The play was staged by Albert-Birot, who took the opportunity to make *SIC* its champion, promoter, and beneficiary. It attracted many of the most prominent figures in the avant-garde (many of them Apollinaire's friends), as well as the major literary critics of the time—and even Jacques Vaché, who, from his exile among the British, wrote to say that he hoped to be in Paris as of June 23, "in time for Guillaume Apollinaire's sur-realist performance."

On the 24th, a beautiful Sunday afternoon, Breton arrived in front of the minuscule Conservatoire Renée-Maubel on Montmartre's Rue de l'Orient, to see the play and, he hoped, Vaché. Returning home at two o'clock the previous morning to his hospital bed at La Pitié, where he was still under treatment, he had found a note from his newly arrived friend, suggesting they meet at the theater that afternoon.

As Breton was soon to learn, Vaché was not alone in Paris. Leaving La Pitié after his failed attempt to see Breton the evening before, he had been "fortunate enough" to come to the aid of a sixteen-year-old girl named Jeanne, whom two toughs had been manhandling near the Gare de Lyon. There he and the girl caught the first train they saw, got off at Fontenay-aux-Roses some ten miles outside the city, and walked until four in the morning, finally seeking shelter at Jeanne's insistence. They spent the night in the home of a streetlamp extinguisher who, by one of those poetic coincidences so dear to Breton and his friends, worked as an undertaker by day. Vaché promised to take Jeanne to Biarritz, but in two days he would leave town without a backward glance. "I have reason to believe," Breton later recounted, "that in exchange she gave him a dose of syphilis."

Now awaiting his friend's arrival at the premiere of *Tirésias*, Breton stood among a crowd that included, as one newspaper put it, "the artistic *tout*-Montparnasse and the literary *tout*-Montmartre." By late afternoon, the crowd had begun to chafe against a nearly three-hour delay and was "howling wildly" outside the theater doors. A few who had managed to elbow their way into the building now pounded the floor rhythmically, calling for the curtain to rise. Finally the play, a burlesque (and, in the final account, fairly silly) call for French repopulation, began—and immediately got off to a rousing start when the lead character, Thérèse, vowing never to bear another child, removed her breasts—actually two orange rubber balls stuffed into her bodice—and flung them

defiantly at the audience (a device that might have been inspired, as André Derain maintained, by a condition of the mammary glands that caused Apollinaire to produce breast milk).

As it turned out, Breton was to see little of the play and to enjoy it even less. By inter-mission, the audience, its ill humor primed by the delay in raising the opening curtain, was rioting in the hall, while the rhombic Apollinaire stood onstage in his sky-blue lieu-tenant's uniform shouting for order. At that moment, Breton noticed an officer in the front seats, waving a pistol and threatening to fire on the crowd. It was, of course, Vaché in his British interpreter's outfit, who had just entered and whom the ruckus had "prodi-giously excited." Breton rushed to his friend's side and restrained him from carrying out his threat, then calmed him as best he could and forced him to sit through the rest of the play. Breton found the production poorly staged and badly designed, the work itself no more than "good-natured," but insisted on staying to the end. Vaché, whose nerves were put on edge by (in his estimation) its poor man's lyricism, willful obscurity, and cut-rate Cubist decors, continued to mutter about shooting the audience.

But what the afternoon lacked in artistic satisfaction it made up for in spiritual reve-lation. "Never before, as I did on that evening," Breton later recalled, "had I measured the depth of the gap that would separate the new generation from the one preceding it . . . Vaché, standing defiantly before an audience that was at once used to and jaded by this kind of performance, cut the figure of an enlightener. A few more years would pass—maybe three or four—before the break between these two conflicting modes of thought would be complete." The "Surrealist drama" was earning its subtitle in ways it could not have foreseen.

Perhaps the oddest part of the enlightener's demonstration, however, is that no one else seems to have noticed. Of the nearly two dozen reviews the play received, includ-ing Albert-Birot's long and detailed write-up, only Louis Aragon's briefly mentioned the incident—and by the time that piece was written, he was a close friend of Breton's. So, as with much of the Vaché legend, we have only Breton's word for it, which he elab-orated over subsquent decades, in several different accounts. Which is not to say that Vaché's commotion never occurred, only that Breton might have had strategic reasons for bringing it into sharper focus than it warranted. The first of his descriptions appeared in his essay "The Disdainful Confession" in late 1923, at a time when he was struggling to formulate an as yet unnamed movement of his own. In the intervening six years, the premiere of *Les Mamelles de Tirésias* had become a part of literary legend. By making it the setting of Vaché's proto-Surrealist action, Breton knew that the episode would have special resonance for his readership (many of whom were no doubt in that

very audience), and by that same token would lend a similarly "legendary" status to the moral stance embodied in Vaché's gesture—whose importance, by implication, only Breton had recognized.

✳

The war was now in its fourth and most arduous year. One of the harshest winters in memory, a typhus epidemic, and several grueling military offensives had combined to drive the number of French dead and wounded to nearly 3 million by early spring, while 6 percent of French territory was now in enemy hands. As of May 1917, widespread strikes and the forced abdication of Czar Nicholas II had distracted Russia from the conflict, thus eliminating a major obstacle to German expansion in the East. The United States moved to replace the lost Russian ally as of June, when the first troops of General Pershing's American Expeditionary Force arrived in France, but the untrained Yankees would not become an effective combat unit until May 1918—by which time Lenin's Treaty of Brest-Litovsk had established an uneasy peace between the emergent Soviet state and the Central Powers.

Given this situation, it is not altogether surprising that an increasing number of France's leading intellectuals had embraced the ambient nationalism, or that much of the avant-garde (with the notable exception of Dada, but that was in Zurich) had rallied to the nationalist cause. And so it shouldn't have been surprising that Apollinaire, since his operation and removal from active duty, had become one of the most boisterous voices of the war effort, and had even begun working for the War Ministry as a literary censor. It shouldn't have been surprising, but for certain of his younger admirers, Breton among them, it was becoming a source of embarrassment and disappointment.

Indeed, although Apollinaire's charisma and dazzling conversation kept Breton coming regularly to his "pigeon coop" at 202 Boulevard Saint-Germain, or to the Café de Flore several doors away, where Apollinaire presided on Tuesday afternoons, strains were beginning to show in their relationship. Just as Valéry had disappointed Breton by not living up to the ideal of Mr. Teste, so Apollinaire was becoming less and less the wondrous magician of *Alcools*: he might have come to resemble Jarry's corpulent Père Ubu, but he lacked his umor. When in November he gave a famous lecture at the Théâtre du Vieux-Colombier, "The New Spirit and the Poets," Breton helped organize the evening and selected the illustrative texts (poems by Apollinaire, Rimbaud, Gide, Jarry, and his own "Décembre"), but was dismayed by the speech's chauvinistic tone:

While [my friends and I] were pleased to have him confirm that in poetry and art "surprise is our greatest new resource," and to see him demand "freedom of unimaginable opulence," we were worried about the importance he placed on reviving the "critical spirit" of the classics, which to us seemed terribly limiting, as well as on their "sense of duty," which we considered debatable, in any case outmoded, and, regardless, out of the question. The will to situate the debate on a national, even nationalistic, level ("France," said Apollinaire, "keeper of the entire secret of civilization") seemed still more unacceptable to us.

Back at the front, Vaché did his part to break the "rotting enchanter's" spell over Breton: "The entire TONE of our gesture remains almost to be decided—I would desire it dry, without literature, and especially not in the sense of 'ART,'" he wrote on August 18. "Thus we like neither ART nor artists (down with Apollinaire) . . . We no longer recognize Apollinaire—BECAUSE—we suspect him of producing art too wittingly, of stitching up romanticism with telephone wire, and of not knowing that the dynamos THE STARS are still disconnected!"

The message was clear: when society is dissolving, the best one can do is help it crumble. Thanks to Vaché, Breton had been given the philosophical tools of the joyful terrorist's trade, the tools that would allow him to see beyond the obvious limitations of the wartime atmosphere, and even beyond the more subtle ones inherent in Apollinaire's "New Spirit." What he still lacked were active co-conspirators. Ironically, these would be provided by none other than Apollinaire and the French army.

THE THREE MUSKETEERS

(August 1917 – October 1918)

THE FIRST OF THESE CO-CONSPIRATORS appeared at one of Apollinaire's Tuesday roundtables in late August. "A young man in a sky-blue uniform came to sit next to me . . . a tall young man as intimidated as I was," Philippe Soupault later recounted. "'This is André Breton,' Apollinaire said to me . . . And he added, in that portentous tone he had adopted at the time: 'You must become friends.'" This was Soupault's first meeting with his fellow poet, and it began on a note of complicity: "Despite our admiration for the author of *Alcools*, we were both indignant at the jingoistic attitude of Second Lieutenant Kostrowitzky. We made excuses for him. But an article he had published in a periodical called *La Baïonnette* (as the title suggested, it was a patriotic publication) deeply shocked us. That was all there was to it, but we decided to see each other again."

The son of a renowned gastroenterologist, Marie-Ernest-Philippe Soupault was born on August 2, 1897, into a comfortably bourgeois family that also included automobile magnate Louis Renault (Soupault's uncle by marriage, whom he later satirized in his novel *Le Grand Homme*). He had been exempted from active service after an experimental typhoid vaccine administered by the army had almost killed him—several of his fellow soldiers had in fact died from it—and had spent most of the war recovering in a Paris hospital. This, and the death of a close friend that was due as much to incompetence as to his wounds, had conspired to turn Soupault violently against the military and its works.

At the time, Soupault was a law student by parental decree, although his real love was botany. He was also—this very much against parental wishes—imbued with literature. His poetic avocation had begun during a trip to London in 1914 and been confirmed three years later when Apollinaire praised a work that the aspiring poet had sent him; the fact that this avocation scandalized his conventional family only strengthened Soupault's resolve. It was also Apollinaire who had earlier shown Soupault an unpublished poem, "D'or vert," by a certain André Breton.

Breton was immediately charmed by the newcomer, whom he found, "like his poetry, extremely refined, a trifle distant, likeable, and *airy*." He was also taken with Soupault's approach to his own work: "He was probably the only one at the time . . . who left his

poems as they came, safeguarded them from any revisions. Anywhere, in a café, for instance, in the time it took to ask the waiter for 'something to write with,' he could satisfy the request for a poem. The poem ended—I almost said, landed on its feet like a cat—at the first external intrusion. The results of such a method, or absence of method, were of rather variable interest, but at least they were always valid from the point of view of freedom, and of freshness."

Among the most important of Soupault's attractions for Breton were his similarities with Jacques Vaché. Like Vaché (and unlike the literary Apollinaire), Soupault expressed his "keen sense of what was modern" less in writing than in the actions of everyday life: while walking with friends, he would borrow the hat of a street beggar and approach passersby on the man's behalf; or flag down a bus and proceed one by one to ask the passengers their birth dates; or offer to swap drinks with strangers in a bar; or enter a building at random and ask the concierge if Philippe Soupault lived there. "He would not have been surprised, I suspect, by an affirmative reply," Breton later wrote. "He would have knocked on his door." Like Vaché as well, Soupault enjoyed a familiarity with British culture that resulted both in a knowledge of English (he later collaborated on the French translation of James Joyce's *Anna Livia Plurabelle*) and in a cultivated aloofness. Like Vaché, finally, he had a disconcertingly deadpan sense of humor and a professed indifference toward everything.

For his part, Soupault was equally intrigued by a certain mystery surrounding the young intern Breton. Why, for instance, was he studying medicine when he seemed so much more interested in poetry? What lay behind that patina of applied courtesy and ceremonious mannerisms? Whereas for Adrienne Monnier, Breton was an "archangel," Soupault mainly saw a young man who was "very ill at ease, very shy":

> He was anxious, felt and knew himself to be very alone . . . He was also extremely sensitive. Knowing that I was ill, each time we met he gave me advice and warned me against the excesses that I might have committed and did commit. With a modesty that his attitudes concealed, he doubted his talents. He was easily moved to enthusiasm, but he also criticized things harshly. The surprising thing was that he was extremely polite, unexpectedly friendly, even though he could sometimes be quite violent. He did not open up easily, and never spoke about his childhood, nor his adolescence, nor his family, nor his education, nor his background.

Over the following months, Breton and Soupault saw each other almost daily. They spent their evenings walking up Boulevard Raspail or down Boulevard Saint-Germain,

discussing the writers of the preceding generation. Often their path led them to Monnier's bookstore, where many of these writers might be found sitting in conversation and where the cultured atmosphere provided a brief respite from the war. "We were trying," said Soupault, "to escape what was, for me, a blood-soaked fog."

The second co-conspirator to appear on the horizon came through the fortunes of military logistics. In September, his health finally restored, Breton left La Pitié hospital and returned to the Val-de-Grâce, this time as an intern. It was there, at around the beginning of October, that the students staged a prank that would have lasting consequences. As in boarding schools and barracks around the world, the older students took it upon themselves to terrorize the newcomers, breaking into their dormitory for several nights in a row, tossing everything—clothes, books, beds, packages from home, the newcomers themselves—into maximum disorder, or soaking the hapless "plebes" and all their possessions with garden hoses. The Class of 1916 was not to be spared the ritual.

One member of this class, having arrived barely two weeks earlier, now contemplated the chaos from the baggage rack above the top bunk. Peering through a small window that looked out onto the corridor, he suddenly noticed a face in the window across the hall, staring back at him from the dormitory that housed the Class of 1915. "The person opposite me," Louis Aragon later recalled, "even though he belonged to the enemy camp, did not hide his disapproval, his disgust at such a spectacle, and by various gestures and grimaces, his nose pressed against the glass, he occasionally expressed this to me. Where the devil had I seen this fellow?" In fact, Breton and Aragon had previously met, as the latter was informed the next afternoon. "My neighbor across the hall had a rather ceremonious way of speaking, a slightly affected politeness, which seemed to clash with the barracks atmosphere: 'It seems to me we've already been introduced, some time ago, on Rue de l'Odéon at Miss Monnier's. You were reading an issue of *Les Soirées de Paris*.'" The two young men agreed to meet at five o'clock after the day's classes, to spend their few hours of freedom together.

They had much to discuss. Both of them were passionate about Rimbaud, Mallarmé, Jarry, although these names were hardly common currency: "Who else could have made such a choice in those days?" observed Aragon. "No one." Both were medical students by parental fiat, although Aragon had agreed to become one on the assumption that he would not survive the war anyway. Both had attended the premiere of *Les Mamelles de Tirésias*, were regular customers of Les Amis des Livres, and read the same literary reviews. And not only literary: in contrast to the reigning political atmosphere, both were also readers of such pacifist Socialist periodicals as *Drapeau rouge*, *Le Journal du peuple*, and *La Vague*.

But all the similarities did not make for equality: from the start, it was Breton who took the lead. For one thing, he had two years' military experience over Aragon. More importantly, while Aragon prided himself on having read the work of Apollinaire, Max Jacob, Valéry, and others, Breton could boast of knowing the poets themselves. He constantly praised Aragon's wide literary culture, all the while referring to obscure books and authors that his new friend knew only by name, or not at all. "That evening," said Aragon, "I was ashamed." Aragon, for all his knowledge and native brilliance, was extremely sensitive to such authority, and although Breton was older than he by only one year, Aragon looked on him as a father.

Louis Aragon was born on October 3, 1897, under the sign of a double lie. The first was his surname: no one else in his family bore it, and in fact the "Aragon family" did not exist. The second was the absence of parents, killed, or so he was told, when he was still too young to remember. In reality, Aragon lived with and was raised by his mother for the first twenty years of his life, without being aware of it; it was just that he believed Marguerite Toucas to be simply "Marguerite," his older sister. He also—but wittingly, this time—claimed to be the adopted son of his grandmother, Marguerite's own mother, who herself had been abandoned by her husband years before. The old woman lived with them in the fashionable suburb of Neuilly; before this Aragon and his putative sister had resided in the affluent Etoile neighborhood, in a boardinghouse that Marguerite ran. Despite the elegance of the settings, however, Aragon's childhood was plagued by constant money worries.

It was only in June 1917, as Aragon was preparing to leave for war—a mere three months before his meeting with Breton—that Marguerite reluctantly revealed to her son the secret of his birth and the identity of his father. The latter, Louis Andrieux, was a married politician forty years her senior who had seduced Marguerite when she was seventeen. Andrieux had made his reputation by brutally suppressing Commune sympathizers in 1871, and the post he now held was prominent enough for him not to want his second family to become public knowledge. When Marguerite had become pregnant, he had refused to marry her or officially recognize Louis, but instead paid occasional visits as the child's "guardian." Only when it looked as if that child might never return did he come forward, "because he didn't want me to be killed without knowing that I was proof of his virility," Aragon later said. The impact on the young man was devastating, so much so that for years afterward he continued to introduce Marguerite as his sister. In later years he underlined the family disconnection by dropping his and his father's common forename and styling himself simply Aragon, fully adopting the fictional identity assigned to him at birth.

Aragon had spent his childhood, as had Breton, creating his own world from the wonders and fantasies provided by literature, sharing many of his future comrade's enthusiasms. Like Breton, he had also begun writing literature of his own. But here the difference was telling: while Breton had composed a scant handful of poems by his midteens, Aragon claimed to have produced sixty novels by the age of nine.

In other respects, too, the play of similarities and differences made for a provocative complement. Aragon had been raised in a house of women; took great care in his appearance; and had developed a seductive charm that was aided by his verbal brilliance, both in conversation and in the amazing facility with which he wrote (often exercising both talents simultaneously). In contrast, Breton's childhood had been notable for its absence of feminine warmth; his appearance was striking because of natural characteristics rather than grooming; and if he possessed an undeniable charisma, he lacked both Aragon's unctuous charm and his facility of expression. But perhaps because of these very differences, the two immediately developed a closeness that Breton had experienced with very few others. The arrested adolescent in Aragon responded to Breton's greater maturity and authority, while the latter saw Aragon as the seductive verbal craftsman of his ideal self. And, although it was probably not discussed at the time, one can hardly fail to notice the striking coincidence in parental forenames, rendered all the more poignant by the two men's respective family dramas. As one diatribe later charged, "Aragon's heart beats in Breton's chest."

Just as Breton's intransigence has become the trait by which he is best remembered, so Aragon's seductiveness has become his. The American writer Malcolm Cowley later told a friend that Aragon "has so much charm, when he wishes to use it, that it takes him years to make an enemy; but by force of repeated insults he succeeds in this aim also." And Soupault remembered "Aragon the stunning, tireless 'talker,' detecting something unusual on every street corner. He always made grand gestures and couldn't help looking at himself in every window and mirror." When that autumn Breton introduced his two new friends to each other, Soupault found Aragon so different from Breton that he was shocked.

For hours on end the two friends walked through a nervous capital during their off hours, giddily reciting Rimbaud's poems to each other from memory or, as Breton had earlier done with Fraenkel, submitting their own work for the other's approval. Within days of their meeting, they obtained permission for Breton to move into Aragon's dormitory, which they decorated (to the officers' mirth) with reproductions of Picasso, Matisse, Chagall, and Braque.

They also spent time at the movies, particularly to see the recently popular "serial

films," such as *Fantômas*, *Judex*, or *The Exploits of Elaine* (known in France as *Les Mystères de New York*); and, later, such horror classics as F. W. Murnau's *Nosferatu*, a lifelong favorite of Breton's. With Vaché, Breton had experienced the charms of these films and of the cinemas in which they were shown, movie houses with such alluring names as Electric Palace and Folies-Dramatiques. Aragon and Soupault, too, like many of their generation, were taken with the seventh art.

They were especially fond of any film starring Musidora. Like her American counterpart, Theda Bara, Musidora (born in 1889 as Jeanne Roques) embodied the mixture of death and sexuality that was not yet known as "eroticism." She had become an overnight sensation in 1914, when Louis Feuillade had cast her as the lead in his serial *Les Vampires*. As the mysterious "Irma Vep," she prowled through the film's episodes clad only in a black silk body stocking, which she immediately made famous. (The title of the film, furthermore, gave the language the word "vamp," coined to describe her femme fatale persona.) To Fraenkel, Breton enthused, "Musidora is indeed the modern woman in some regard . . . The figure she cuts is the opposite of conscience."

And it was the *modernism* of her particular sexuality that attracted these young men, a modernism they also appreciated in such heroines as the Tristouse Ballerinette of Apollinaire's *The Poet Assassinated*. "She is ugliness and beauty; she is like everything we love today," Apollinaire had said of her. Still in its rough form, this heady brew of novelty, danger, transgression, and sex (the same mixture Breton had earlier found in the paintings of Gustave Moreau) would become the basis for the Surrealists' entire concept of love.

Over the ensuing months, Breton, Aragon, and Soupault formed an almost inseparable threesome—which Valéry, not taxing his imagination, soon dubbed "the three musketeers." Physically they were a striking trio: Breton, with his straight, russet-brown mane brushed back off his heavy head; the tall, thin Aragon, with his slight moustache and dandified affectations; Soupault, with his English cigarettes, sharp features, and blond hair that covered his scalp in tight, regular waves. From the outset, Breton was considered the leader. He had an aura of moral authority that somehow made his views more resonant, more substantial. Soupault recalled that, even at the time, "one felt that he was always right." And while the other two had also made their literary "debuts"—Soupault had even published a volume of poems—it was Breton who had the influential connections.

But impressive as these connections were, for the angry and skeptical young musketeers the most influential of all was not one of the prestigious older poets, but Jacques Vaché. Vaché was Breton's trump card, his showpiece, the marker that oriented all their discussions and plans. Breton described the umorist's exploits to his eager audience and

read them the letters he had received. More than anyone, it was Vaché the terrorist who best responded to the trio's subversive mood. "Vaché . . . exerted an unparalleled seduction over us. His behavior and his statements were an object of continual reference. His letters were an oracle, and the nature of that oracle was to be inexhaustible," Breton later said. For Aragon and Soupault, Vaché contributed to Breton's prestige in still another respect: at the time, he was the only one of the three to have laid eyes on him.

In October, Jacques Vaché was back in Paris; Breton did not take the opportunity to introduce him to his new friends. Rather, sitting at a café table in the unseasonable cold, the two spoke of the future and planned a joint lecture on "umor," to be given at the Vieux-Colombier. In the end, however, the joyless pointlessness of everything carried the day, and plans for the lecture came to naught. Instead, Vaché spoke with resignation of the changes that the war's end would bring to his life, and sarcastically considered trying to be "a success in the grocery business"—that is, trying to fit into the platitudes of peacetime society. In a bad mood, he soon left Breton's side to go ponder his fate alone by the banks of a canal, a long coat thrown over his shoulders. Breton, relating the visit to Fraenkel, observed with some irony that Vaché was playing "that victim of modern inevitability: the traveler. One of his great roles. He threatened to be the one who'd become attached to nothing, who'd sell a 'memento' for the hell of it rather than out of necessity. Dryness of heart; nonetheless allow for friendship . . . Keep one's *natural* lucidity. In all this I adore, as with Rimbaud, a supreme strength. And the awareness of that strength." In any case, and whatever his initial sincerity, Vaché soon recognized the vanity of his conformist projects. A letter from the following May related, "I can no longer be a grocer for the moment—the attempt was a flop."

It had in fact been a year of failed plans. In early 1917, Robert Nivelle, newly appointed head of the French army, had convinced his government that he could win the war that spring—specifically by breaking the German lines at a stretch of the Aisne River called the Chemin des Dames. But Nivelle's propensity to detail his strategies to the press, and the French habit of leaving behind copies of their written orders in the trenches, left the Germans well prepared. By mid-May, the French had lost some 120,000 men and many of the troops had begun to mutiny. Several months later, the British general Sir Douglas Haig had made his own bid to win the war by launching an infantry attack on the German-held village of Passchendaele, Belgium—until a downpour that lasted for over a month turned the fields into a filthy mire that threatened to drown the soldiers and swallow their equipment whole. After three months, the British had won not the war but four and a half miles of terrain—paid for by a quarter of a million casualties. The Germans reclaimed the territory the following spring.

✳

Although Breton and his friends heard the reports from the front, their awareness of, and interest in, political events was at best slight. In part this was due to vigilant wartime censorship. But it also stemmed from the fact that, for these young men, political events stood outside their field of concern. Despite their sympathy in principle for the pacifist cause—or what little they knew of it—their general attitude toward politics was that it was best left alone. Even their opposition to the war, though visceral and sincere, took the form of avoidance rather than actual revolt: these young men made no outward protest, but rather, like Jacques Vaché, practiced "desertion within themselves." So it was that perhaps the largest political upheaval of the time, the so-called October Revolution of 1917 (it actually took place in November), passed them by largely unnoticed, and would not become a significant part of their horizons for nearly ten more years.

What they did take an interest in was poetry; but in the spring of 1918, even poetry seemed to have fallen by the wayside. Breton had written no verse since "André Derain" the previous March, and had derived little encouragement from his publications that summer. He did, however, ask Reverdy why his appearances in *Nord-Sud* weren't more frequent. "I believe I told you what I thought of your poems," the editor replied on January 10, 1918. "I find that your craft is flawless and that one could have no complaints about your poems when viewed without prejudice. But my own efforts and inquiries do not follow the same direction as yours."

Nevertheless, and despite their clear divergences, Reverdy was becoming one of Breton's most important reference-points—was filling, in other words, the place that was slowly being vacated by Valéry and Apollinaire. At the latter's suggestion, the three musketeers began calling on Reverdy in his sparsely furnished Montmartre studio, the perfect setting for the poet's austere editorial stances and the spartan welcome he extended his young visitors. One by one he interrogated them: Why had Soupault written for *SIC*? Didn't Breton realize that publishing in several magazines at once (copies of which were spread out on the table in evidence) threatened to undermine his credibility? Still, as the three deflated poets were leaving, Reverdy invited them to come back soon.

It was especially Reverdy's impatience in conversation that struck Soupault: "He wouldn't tolerate anyone interrupting him, even if you agreed with a timid: 'Yes, you're right . . . ' — 'Will you let me get a word in?' he said, with a movement that threatened a slap across the face." Still, while this impatience might have hindered the true exchange of ideas, it also contributed to the inspiration one could draw from Reverdy's precepts. "Reverdy was much more of a theoretician than Apollinaire," Breton recalled: "he would

even have been an ideal master for us if he'd been less passionate in discussion, if he'd cared more genuinely about the objections we raised. But it's true that his passion was a large part of his charm. No one was ever more thoughtful, or made you more thoughtful, about the deep wellsprings of poetry than he." Indeed, so inspired was Breton that he soon adopted Reverdy's abrupt style of testing any newcomer to his circle.

But an even more profound, and in many ways contradictory, inspiration was on the horizon—and with it, the poetic renewal Breton needed. During their walks together, Aragon had been surprised not to hear Breton drop the name of Lautréamont. When Breton admitted ignorance, Aragon produced a copy of the magazine *Vers et prose* from January 1914, which had reprinted the first of Lautréamont's *Cantos of Maldoror*.

At the time, the colorfully pseudonymed Comte de Lautréamont was unknown to all but a few specialists, and *Maldoror* was the "underground" book par excellence. It was written in the late 1860s, but only the first of its six parts was published during the author's brief lifetime: he died in 1870 at the age of twenty-four, leaving behind a notable absence of biographical detail. The first complete edition of *Maldoror* was printed in 1869 but, fearing censorship problems, its Belgian publisher decided not to release it. When the book was finally distributed by two subsequent publishers, the few critiques it received mainly condemned its late author as mad.

Over a century later, *The Cantos of Maldoror* remains one of the strangest and most powerful experiences in all of literature. It is at once a compendium of Romanticism and all its excesses, a treatise on poetics, and a full-blown Gothic horror story—the whole thing subtended by a hallucinatory, almost schizophrenic vision and ferocity of tone. Lautréamont's world is one of perpetual metamorphosis and disorientation, in which the accepted hierarchy of God, man, and beast is subverted at every turn of the page, and in which the battle of the omnipotent Self against universal Law—what Lautréamont calls "the Creator"—is endless and unremitting.

From the outset, Lautréamont wages war on both his reader and his language. On the one hand, his stated goal is to numb the reader's brain—to "cretinize" him, in Maldoror's parlance—by verbal toxin, as the spider paralyzes a potential meal. On the other, he attacks the matter of poetic language itself, and perhaps nowhere more so than in his now celebrated run of similes beginning "beautiful as": "Beautiful as the congenital malformation of man's sexual organs, consisting of the relative brevity of the urethral canal and the division or absence of its lower wall so that this canal opens at a variable distance from the gland and below the penis"; or "Beautiful as the uncertainty of the muscular movements in wounds in the soft parts of the lower cervical region"; or, the best-known of all, "Beautiful as the chance meeting on a dissecting table of a sewing-

machine and an umbrella." "We now know that poetry must lead somewhere," Breton later said of Lautréamont's work, which struck him as "the expression of a total revelation that seems to exceed human possibility."

But what particularly excited Breton about *Maldoror* was the attitude underlying it, the flagrant nonchalance the author displayed toward his own narrative. Introducing his altar ego in the opening pages, Lautréamont writes with superb arrogance: "I shall set down in a few lines how upright Maldoror was during his early years, when he lived happily. There: done." It was the same attitude that had drawn Breton to Rimbaud's dismissive pronouncements ("A writer's hand is no better than a ploughman's"), and to such poems as Apollinaire's "Monday on Rue Christine," composed entirely of overheard café chatter. It was an attitude that—by brushing aside the sacred notions of literary "art" and "craft"—made the posturings of most writers seem all the more pathetic. More importantly, this uniformly dismissive attitude seemed to act as a safeguard against the wholesale embrace of war and nationalism that Breton had witnessed in 1914.

It was in the euphemistically named *quatrième fiévreux*, or "Fourth Fever Ward," the mental facility of the Val-de-Grâce and perhaps the most lugubrious area of the entire hospital, that *Maldoror* first worked its full magic on Breton. Through heavy padlocked doors, guards watched the ill-lit corridors by day, when the inmates would just as soon strangle the orderlies as accept food from them. But after dark, when the patients had been locked in their cells, and when security checks and doctors' rounds were scarce, the ward became the perfect setting for the hallucinatory voice of Lautréamont to ring forth. All through the late hours, having worked out a scheme whereby they were constantly on night watch (which no one else wanted anyway), Breton and Aragon alternately read *Maldoror* aloud to each other, from a rare copy that Soupault had managed to find. "So André and I remained in the hallway, with our stretchers on the floor in case we felt like lying down, our legs wrapped in regulation blankets," Aragon recalled. "What would our estimable officers have said if they'd arrived unexpectedly and caught us reading at the top of our lungs: 'I have made a pact with prostitution so as to sow chaos among families. I remember the night preceding this dangerous liaison. Before me I saw a tomb. I heard a glowworm huge as a house say to me: "I shall enlighten you . . ."'" Most gratifying of all were the howls of the patients that rose in accompaniment. The future composer Georges Auric, hospitalized at the Val-de-Grâce and invited to attend one of these nocturnal recitations, recalled Breton smiling as the patients cried out, "Help! They're crazy!" in response to a discourse that struck even them as insane. And so the two interns read, by turns, interminably, as the inmates wailed and the sirens howled and the German cannons moved perilously near the French capital in that spring of 1918.

But Lautréamont had still another surprise for them. Soon afterward Breton learned of a thirty-page pamphlet called *Poésies* by a certain Isidore Ducasse—a.k.a. the Comte de Lautréamont. He immediately sought out the only existing copy of the work at the Bibliothèque Nationale. ·

The shock of reading the *Poésies*, said Aragon, was like "an earthquake . . . The enumeration of those whom Isidore Ducasse called the 'Great-Soft-Heads of our epoch' inspired a terror in us that, paradoxically, the reading of Lautréamont had never provoked, even in *Maldoror*'s most horrifying passages." These "Great-Soft-Heads," which included "Jean-Jacques Rousseau, the Socialist-Grouser . . . Edgar Poe, the Mameluke-of-Alcohol-Dreams; George Sand, the Circumcised-Hermaphrodite," and other monoliths of Romanticism, are accused of having retarded the growth of poetry through their excess of sentiment. "Emotions are the most incomplete form of reasoning that can be imagined," Ducasse states in the book's first part.

In the second, he "corrects" a Pantheon of well-known aphorisms from moralists like Pascal and La Rochefoucauld by paraphrasing them so as to make them signify the opposite of their original meaning—pushing them, as he says, "in the direction of hope." In the direction of hope but not of feeling, for he imagines Elohim (Ducasse's name for God) "to be cold rather than sentimental."*

The combined effect of these two works was stronger than anything Breton had yet known. While *Maldoror* offered up the maddened and maddening vision of an overheated Romantic imagination, the *Poésies* were a slap of cool reason. By their seeming reversal of Maldororian amorality, they sent the entire body of work spinning in an endless cycle of self-doubt and self-regeneration. The conjunction of the two, like the earlier meeting with Jacques Vaché, forever recast Breton's standards for literature as well as behavior. Certain of Ducasse's aphorisms remained with him for the rest of his life, as a kind of joint, disembodied *ars poetica* and *ars vitae*: "Nothing is incomprehensible." "Must I write in verse to separate myself from other men? Let charity decide!" And especially the oft-quoted dictum: "Poetry should be made by all. Not by one."

* Two examples among many: Pascal's celebrated "Man is but a reed, the weakest in nature; but he is a thinking reed. The entire universe need not arm itself to crush him: a vapor, a drop of water is enough to kill him. But even if the universe were to kill him, he would be more noble than whatever kills him, because he knows he is dying. The universe knows nothing of the advantage it holds over him," becomes: "Man is an oak. Nature contains nothing sturdier. The universe need not arm itself to defend him. A drop of water is not enough to preserve him. Even if the universe were to defend him, he would no more be dishonored than whatever does not protect him. Man knows that his reign has no death, that the universe boasts a beginning. The universe knows nothing: it is at best a thinking reed." And less grandly: "If Cleopatra's nose had been shorter, the face of the world would have changed" (again by Pascal) into Ducasse's "If Cleopatra's morals had been less short, the face of the world would have changed. Her nose would have grown no longer."

For the next several months Lautréamont worked like a narcotic, clouding all of Breton's waking thoughts. "I can think of nothing but Maldoror," he wrote Fraenkel in July. Particularly significant was the fact that the *Poésies* seemed to dovetail perfectly with the icy sarcasm of Jacques Vaché's letters from the front, and acted as an objective confirmation that these were not simple anomalies, but the gathering harbingers of a zeitgeist to come.

The first and most visible sign of Ducasse's impact on Breton was the change in Breton's own poetry. In place of the recent fractured alexandrines, he began piecing together a spare verbal collage, in which the white spaces shared equal significance with the phrases littered around the page. Inspired by his 1913 visit to the Black Forest, as well as by his interest in German philosophy and in Rimbaud, the new poem, "Black Forest," took Breton a giant step away from the kind of literature he had been producing, toward a form of poetic meditation that tried to incorporate the systematic jolts occasioned by Vaché, Rimbaud, and now Lautréamont. Visually, the poem looked like an unsuspecting sonnet after a sneak attack by a mad eraser (not unlike Mallarmé's *Un Coup de dés*). But the density of allusions, both personal and historical, that Breton squeezed into a mere handful of words, and particularly the thematic experimentation the work implied, were remarkable. Rarely had so much been said with so little ink.

Perhaps most telling were Breton's references in the poem to Rimbaud: not only his lifting of one of the poet's lines, *"que salubre est le vent,"* but also the oblique reference to Rimbaud's breakup with Verlaine in 1875, symbolically the moment when Rimbaud turned his back on literature and went off to become the adventurer of his final years. Encoding the incident in his poem, particularly at this moment of literary crisis, was a way of affirming that poetry was inextricably linked to a certain personal myth, that it demanded of the poet a code of conduct worthy of his writing. But it also betrayed an uncertainty on Breton's part: did his own work, his own life, live up to the standards he had set himself?

Still unsure of the answer, Breton looked to the collage as a regenerative force. The collage technique was hardly new: it most directly harked back to the pictorial technique of *papiers collés* practiced by Picasso and Braque in 1912, and Lautréamont had flirted with it prior to that (for as the *Poésies* said, "Plagiarism is necessary. Progress implies it"). More recently, Apollinaire had obtained innovative effects by inserting overheard bits of conversation into his verse. But as Max Ernst later put it: "It's not the *colle* [paste] that makes the collage"; rather, it's the thought behind it. Breton, in mixing external ingredients into his writing, was seeking less a literary effect than a sanction by precedent. If he included a line of Rimbaud in "Black Forest," it was not only because of his fondness for

it but also because, in the new poetics he was trying to develop, a "found" line of Rimbaud's had just as much place in the poem as an "original" line of Breton's.

In April, Breton sent the newly completed "Black Forest" to Valéry, promising that "the next one, if you'll permit me, will be entitled Mister Paul Valéry." Indeed, "Black Forest," with its homage to Rimbaud, was only the first of such poems; two more of them followed during the course of 1918. The first, in July, was "For Lafcadio," which took as its point of departure the "gratuitous" murderer of André Gide's novel *Lafcadio's Adventures*, and again quoted lines by others (this time Rimbaud and Vaché). Like "Black Forest," "For Lafcadio" obliquely expressed Breton's concern with poetic responsibility: for on the one hand he saluted Gide's creation of the nihilistic Lafcadio, but on the other he found the novelist's current stances far less laudable. Preoccupied with his personal religious crises, Gide was now putting his energies into aiding various humanitarian wartime efforts and supporting the ultra-reactionary newspaper *L'Action française*. At the same time, unwilling to relinquish the credit he'd acquired among the younger generation because of Lafcadio (whom even the finicky Vaché admired), he was making every effort to keep abreast of the new trends. "For Lafcadio" implicitly mocked Gide's fence-straddling (and by extension, Breton's own), even as it drew a parallel between Lafcadio's "gratuitous act" and the attitudes of Vaché. It also made winking reference to Breton's own poetic procedure in the final lines:

> Better to have it said
> that André Breton
> collector of Indirect Loans
> is dabbling in collage
> while waiting to retire

Sending the text to Valéry on June 18, Breton mentioned that he planned to gather it and some other recent poems into a book, for which he had chosen the title in anticipation: *Pawnshop* (*Mont de Piété*). Valéry found the title "delightful," but was less taken with "For Lafcadio" itself, and with the whole disjointed aesthetic of Breton's newest writings. On July 25, he warned Breton that "there are serious reproaches between these lines [of this letter]. Let me recap them: I warn you that you will receive not one more word from my hand if I don't receive in the next two weeks, from yours, a perfect sonnet. Rich or rare rhymes, part in the middle, no punctuation and capitals on the left. Forward, march! You can take it or leave it." Breton's laconic answer to Fraenkel on the 29th was: "I'm leaving it." Nonetheless, he acknowledged Valéry's marching orders by

inserting the lines: "MARCH / Peter or Paul" into his third ambiguous homage, called "Mister V," later that year.* Like its predecessor, "Mister V" took up various assertions of Valéry's, exploring the ambivalence Breton felt toward them. And as before, Valéry's response showed a fair amount of ill-concealed disapproval

But despite Valéry's admonishments, Breton continued to pursue his experiments with the collage, extending the practice even into personal correspondence. Letters to close friends became cut-and-paste assemblages of newspaper clippings, labels, scraps of cigarette packages, medical reports, and pieces of others' letters, along with one or two lines in his own hand written haphazardly between the documents, in sporadic commentary. It was another way of extending his literary concerns into the wider spectrum of life.

At the beginning of May 1918, Aragon passed the examination for auxiliary doctor, while in an echo of 1914 Breton did not—although his performance no doubt suffered from another hospitalization immediately prior to the exam. On May 16, he was sent to the instruction center in Noailles as an orderly, then was almost immediately redirected to a heavy artillery regiment in Moret-sur-Loing, some sixty miles south of Paris near the Fontainebleau forest, where he arrived on the 20th.

Breton was in dark spirits by the time he arrived in Moret, owing to a brief spat with Aragon (they had developed rival crushes on Sylvia Beach's younger sister, actress Cyprian Giles) and to another with Théodore Fraenkel over Vaché. "Never mock Jacques Vaché," Breton warned Fraenkel on May 22, defending one irreverent humorist against another. "I won't say he's all that I love (but even so)."

At that point, Vaché might well have been beyond Breton's help. His letters were beginning to take on darker tones, a weariness that affected even his nihilistic stances. "ART IS FOLLY—Almost nothing is folly—art must be funny and a little bit boring—that's all," he wrote on May 9. "Everything is so amusing—very amusing, it's a fact—how amusing everything is!—(and what if one killed oneself as well, instead of just going away?)." Intimations of mortality permeated his latest letters, from thoughts of suicide to a narrow escape from death in combat ("But I object to being killed in wartime"). Breton offered the use of his literary connections to publish his friend's work, if

* "Peter or Paul" (*Pierre ou Paul*) is a common French expression roughly equivalent to the English "six of one, half a dozen of the other." In context, it stands as a sarcastic comment on Valéry's attempt to force Breton into a "choice" between the classic sonnet and the collage, even as it snubs both the Pierre (Reverdy) and the Paul (Valéry) who would impose such choices.

only Vaché would write something other than occasional missives. Vaché politely declined.

In Moret and nearby Saint-Mammès, where Breton spent the summer of 1918, life was suddenly calm—"normal" was how he described it to Valéry—and he surrendered to feelings of lassitude. He spent the evenings in conversation with local riverside artists (the former home of Alfred Sisley, Moret was a known haven for Impressionist painters, and the Loing River one of their inexhaustible subjects), trying "without result" to educate them about Picasso and Derain. He made day trips, so enjoying Moret and its environs that he would return to the area many times in the future. He also read widely; received a few visits from Fraenkel and Aragon; and engaged in correspondence with a number of friends and acquaintances.

One of these acquaintances, of recent vintage, was the young translator and critic Jean Paulhan, who was serving at the time as interpreter for Madagascan troops stationed in the city of Pau. Future years would see Paulhan become a noted novelist and, most importantly for some, one of the leading figures in the publishing house of Gallimard and its prestigious showpiece, *La Nouvelle Revue Française*. Breton had met Paulhan in the spring, possibly through Reverdy, and was sufficiently moved by his linguistic experiments and translations of Madagascan poetry to dedicate "Subject" to him in April. By mid-June, he was timidly writing Paulhan: "You have offered me your friendship with such simplicity that, examining myself here before you, I've lost all my complacency."

In certain ways, Breton's early correspondence with Paulhan reflected the same restless search for a mentor that had been evident in his letters to Valéry and Apollinaire. On June 27, he wrote again to tell Paulhan of his tastes in literature and art and rejoiced at being able to "reveal" to his friend "something of the work of Paul Valéry." Along with his list of admirations, by now a standard feature of Breton's communications with a new "master," went another recurrent theme: a stance of self-deprecation overlaid with flattery. "Writing to you, I discover in myself a will to sacrifice that I've never known before. It pleases me to seem poor to you . . . I'm experiencing a moment of delightful turmoil," he wrote on July 11. Two weeks later, he added: "You are precisely the friend I was expecting at this point in my life."

This last statement might seem surprising, in light of Breton's expressed complicity with Aragon and Soupault. But Paulhan had the benefit of age (he was only four years younger than Apollinaire, and occupied a chronological midpoint between Breton and Valéry)—a fact that Breton had underlined by pointing out that he himself was only twenty-two years old. While Aragon and Soupault were equals—even, to a slight

degree, subordinates—Paulhan, with his greater experience and maturity, could be a role model, perhaps indeed the one Breton needed "at this point in his life."

In the meantime, Breton was beginning to emerge on his own as a figure in the Parisian literary world. He had all the right connections and had published in all the right periodicals. That fall, the young theater manager and future actor Pierre Bertin commissioned an opera libretto from him, which never materialized, and in July he was asked to let several of his poems be reprinted in an anthology of younger poets. For all intents and purposes, he was well on his way to making a fine literary career for himself. In a rare moment of satisfaction, he even told Fraenkel that he was "full of self-indulgence these days." Despite the relative paucity of his writings, Breton knew how to make people talk about him.

Breton returned to the Val-de-Grâce on September 22 to prepare once more for his qualifying exams, though not without trepidation. "I've been moribund in Moret for so long that I'm finding it hard to return," he told Paulhan. By this time, his parents, worried about enemy bombardments on the capital, had definitively left Pantin for Lorient, where Louis Breton had found work as an accountant. No longer required to bunk at the military hospital, Breton took a room in the nearby Place du Panthéon, at the Hôtel des Grands Hommes—the "hotel of great men."

"Perhaps it was a premonition," Philippe Soupault later said, echoing a frequent quip about Breton's choice of accommodations. In any event, all that was grand about the hotel was the name, which it took from the monumental Pantheon (whose southern wall it still faces) and the "great men" entombed therein. The lodgings themselves were so dilapidated that Soupault was afraid the floor would collapse under him when he visited Breton. He found his friend's room, however, to be fastidiously tidy and impeccably scrubbed, an oasis of clean in a flea-ridden desert. From Breton's third-floor window, the pair watched the corteges leaving the funeral parlor next door.

Once back in the capital, Breton also reestablished contact with Pierre Reverdy, who had come to enjoy the three musketeers' visits and was glad to have one of their number again at hand. Soon, however, the curmudgeonly Reverdy's persistent complaints about everything from his former mentor Apollinaire ("How that overly pretentious star has fallen!") to the literary "scene" in general simply made him too wearing to frequent—leading to further complaints about the seldomness of Breton's appearances at his doorstep. Further stoking his ill humor was the fact that he and his former disciple were starting to have fundamental aesthetic disagreements, particularly over the notion of lyricism, which for Reverdy was paramount. As he saw it, poetic lyricism stemmed from the harmonious juxtaposition of "two more or less distant realities"; whereas for Breton,

it surged from dissonance and jarring silence, the derangements that renewed all the senses. The more the hypertense Reverdy tried to pull Breton in one direction, even attempting to dictate the content of an article the latter was supposed to be writing on the subject, the more Breton strained in the other.

On a more general level, Breton was calling his past admirations into question—Reverdy was too restrictive; Apollinaire had become a classical bore; Valéry, though Breton continued to send him new work, had run short of breath—and with this questioning came doubt and depression. Trying to make sense of his feelings, he drew up a chart of "those I still love," which he sent to Aragon in September. Those favored included Jarry, Rimbaud, André Derain, Lautréamont, Reverdy (even so), Georges Braque, Aragon himself ("in no particular order," Breton assured his friend), Picasso, Vaché, Matisse, and Marie Laurencin. Apollinaire and Valéry had not made the cut. Neither had Soupault and Fraenkel. In part this was a function of mood. But it also indicated that Breton was rapidly shedding elements of his past like snakeskin, and that those who could not keep up with his expectations would irrevocably be left behind.

A MAN CUT IN TWO

(November 1918 – September 1919)

THE WAR ENDED AT PRECISELY ELEVEN A.M. on the eleventh day of November 1918. Just as Breton had been indifferent to its beginning, so its conclusion was overshadowed for him by a catastrophe of a different sort: the death of Apollinaire. Published only three weeks before, Breton's article on the poet had contained the eerily prophetic lines: "If the enchanter had revealed all his secrets to me, I would already have enclosed him in a magic circle and put him in the tomb." Now, what remaining tricks he might have possessed forever hidden, Apollinaire went to the grave.

The poet-magus had succumbed to the raging Spanish Flu epidemic on November 9 at 5 P.M., after a five-day struggle. "I want to live! I have so many things to say!" he reportedly cried out in his agony. Had he been sufficiently lucid, he probably would have appreciated the spectacle surrounding his own demise, at least as legend has preserved it: on the streets below his window, the crowds shouted "Down with Guillaume!" to celebrate Kaiser Wilhelm's abdication. Apollinaire, delirious from fever, is said to have expired believing they were calling for his own downfall.

News of his death caught Breton in the middle of a letter to Aragon. That same November 9, he reported that "Apollinaire is in the worst way." But just before sending it he had added "a little square of paper" saying:

> *But Guillaume*
> *APOLLINAIRE*
> *has just*
> *died.*

For many poets of the younger generation, the sadness and disorientation surrounding Apollinaire's death was more representative of the war's immediate aftermath than was the dancing in the streets. But poets weren't the only ones in disarray. Starting at year's end, thousands of demobilized young men were being fed back into France's sickly economic bloodstream. For many of them, the war had interrupted their education at

its outset, and now left them more comfortable with grenades and gas masks than with granaries and gross profits. Endeavoring to keep their reintegration into society under control, and all too aware of the anger these men felt, the government ensured that many, including Breton, were not officially discharged until nearly a year after the final cease-fire.

One clearly disoriented soldier approached Breton on the evening of November 24, at the premiere of Apollinaire's play *La Couleur du temps*, which Breton had been helping Apollinaire stage shortly before. Now, talking with an acquaintance during intermission, Breton saw a young officer coming toward them from the other end of the row, in such haste that he jostled the seated spectators in his path. As he approached he called out an unfamiliar name: he had mistaken Breton for a friend believed lost in battle. Realizing his mistake, he stammered a brief apology and rushed off in confusion. In civilian life, the officer was a poet named Grindel; but by the time Breton formally met him some five months later, he would answer to the pen name, taken from his maternal grandmother, of Paul Eluard.

As this was happening, another soldier, Jacques Vaché, was awaiting discharge, seeming to dread it more than he had the war itself. His communications to Breton were now marked by a foreboding, a brooding fear of peacetime's enforced normalcy—"Your letter found me in such a state of depression!—I'm devoid of ideas, and almost totally muted . . . I'll emerge from the war gently doddering, perhaps indeed like those splendid village idiots (and I hope so)," he wrote on November 14—or by a flamboyant, delirious desperation nurtured on the proto-Surrealism of American Westerns: "I'll also be a trapper, or thief, or prospector, or hunter, or miner, or well driller.—Arizona Bar (whisky—gin and mixed?), and fine, high-yielding forests, and you know those beautiful riding breeches with their machine pistols, the clean-shaven look, and such lovely hands for playing solitaire. It'll all go up in smoke, I tell you, or I'll end up in a saloon, having made my fortune—Well." Breton considered this passage more poignant than Rimbaud's similarly-toned *A Season in Hell*.

On December 19, Vaché sent Breton a letter from his new outpost in Brussels that was markedly more restrained in tone, yet curiously optimistic about "the marvelous things we'll be able to do;—NOW!" Included with the letter was the story "Blanche acétylène," which Vaché had sent for Breton to publish in "gazettes of ill repute," and a promise to be in Paris the following month, where he counted on seeing Breton "at all costs." At the same time, he almost wearily defended himself against Breton's inflated expectations: "Forgive me for not properly understanding your last sibylline letter: what do you ask of me—my dear friend?—UMOR—my dear friend André . . . it's no small matter." Vaché was not

overestimating his own importance in Breton's eyes; as the latter confessed many years later, "Any action [Aragon, Soupault, and I] sought to undertake, since this was becoming increasingly urgent, always seemed to lead us back to [Vaché]. Indeed, we were only awaiting his return to begin these actions."

Breton in particular was awaiting this return. Depressed after Apollinaire's death, anxious about the future, he resolved to stop writing altogether after completing the collage trilogy of "Black Forest," "For Lafcadio," and "Mister V." Earlier, he had mentioned to Aragon that he was thinking of writing a story called "A Man Cut in Two," its title based on a sentence ("something like: 'There is a man cut in two by the window'") that had come to him one evening as he was falling asleep. But in fact, the "man cut in two" was Breton himself, ambivalent about his activities, uncertain of his direction. Perhaps Vaché would provide the requisite shake-up, the fresh and jarring perspective Breton periodically needed.

In anticipation of the visit, Breton wrote to his friend on January 13, 1919. Among the various bits and pieces that composed the two-sided collage-letter were fragments of articles on Apollinaire, part of a chocolate wrapper, a page from a postal directory, a drawing of a masked man called Double Face ("That was you, Jacques!" Breton wrote under it), and an invitation to a reading at Adrienne Monnier's, all over a background of Breton's own handwriting. There were also, in block letters on a conspicuously clear area, the words: "I'M WAITING FOR YOU." Several weeks earlier, in response to another collage-letter of Breton's, Vaché had quipped that the only thing missing was a train schedule. This time Breton did include something that looked like a train schedule, but Vaché never had a chance to appreciate the gesture: by the time Breton's letter arrived, he had been dead for over a week.

On January 7, a local newspaper reported that two young men had been found the previous evening in the Hôtel de France in Nantes's Place Graslin, lying naked on a bed, victims of an opium overdose. The body of one man, a soldier from Nantes named Paul Bonnet, was already cold; the other man, Vaché, had died several minutes later. A third, an American soldier named A. K. Woynow (or Voinov), had tried to get help, but it was too late. Several days later, another paper reported that the opium had been furnished by Vaché, and quoted his father as having "seen [an] earthenware jar wrapped and tied up. He had not paid any attention to it, for he had simply assumed it contained preserves."*

* Now that Captain Vaché knew what *had* been in the jar, he was apparently so concerned for the family's good name that he undertook to erase all traces of his son's existence. Jacques's many letters home were locked away for almost seventy years (only recently unearthed, they were published for the first time in 1989

The newspapers themselves had not told the whole story, however, for there were two additional men in the room: a certain Maillocheau and a former member of the Nantes group named André Caron. On the evening of Sunday, January 5, to honor their imminent release from the military, Vaché, Bonnet, and Woynow had gone to the movies and a show. At around midnight, joined by Caron and Maillocheau, they had rented room 34 of the venerable Hôtel de France, where they ordered cognac from room service and smoked cigarettes. It was then that Vaché had brought out his earthenware jar. Maillocheau, not interested in drugs, left, while the other four rolled the opium into small pellets and swallowed about half a dozen each. Caron, feeling ill, ran home during the night and had his stomach pumped. At daybreak on the morning of January 6, Vaché and Bonnet undressed, neatly folded their clothes, and got comfortable on the bed, taking about ten more pellets each. Woynow, on the couch, also ate some more opium. That evening he had awakened to find his two companions still lying on the bed, motionless and barely breathing, and had rushed out in futile panic to find the hotel doctor.

Breton learned of the death at around mid-month, perhaps within hours of sending his collage-letter of the 13th, and immediately tried to find out the details. Hearing that Vaché's body had been brought to the Broussais military hospital, he cabled the head doctor for information; the latter answered on the 18th, suggesting Breton get in touch with the victim's family. Apparently his further research at the time was fruitless, for by the end of the month he had still not ascertained even the date of Vaché's death; he only knew that, for him, it took on the proportions of a major assassination. A letter to Fraenkel of the 30th included a newspaper clipping that listed, one above the other, the killings of Jean Jaurès on July 31, 1914, and of the German anarchist Karl Liebknecht on January 16, 1919; between them Breton had inserted, "January ?, 1919: Jacques Vaché."

In a sense, Breton never stopped writing Vaché's obituary. Within days of hearing the news, he composed a dirgelike poem, "Clé de sol" [Treble Clef] ("Love goes away . . . / All is lost . . ."), which, he later said, "transposes the emotion I felt at the announcement of Jacques Vaché's death." In February, he answered a questionnaire of Max Jacob's, listing as his greatest happiness: the presence of a friend; his greatest sorrow: the loss of a loved one; his current state of mind: mourning. In March, he told Paulhan that he had just suffered "the most painful event of [his] life," causing him to wear "a suit of armor" against emotion. And that fall, in his preface to a book edition of the *Letters from the Front*, he concluded the first of several essays he would write about Vaché with the words:

by Georges Sebbag), and Jacques himself disappeared from the family register. It seems that even his younger sister, too small to remember him when he died, discovered she had had an older brother only when chancing upon some papers in the attic many years later.

I once knew a man more beautiful than a reed pipe. He wrote letters as serious as the Gauls. We are in the twentieth century (of the Christian era), and caps explode beneath children's heels. There are flowers that bloom in inkwells specifically for obituaries. This man was my friend.

"I cannot express here the pain that the news of his death caused me, or the trouble I had getting over it," Breton added to a correspondent in 1921. "For a long time, Jacques Vaché was everything in the world to me."

But the true effect of Breton's grief was buried much deeper: he became convinced that Vaché had willfully orchestrated his own demise, intentionally dragging a friend or two along for the ride as a final act of umor. "His death was admirable in that it could pass for an accident," he later said, "although, as you might well imagine, he was not an inexperienced smoker. On the other hand, it is quite possible that his unfortunate companions did not know how to use drugs and that he wanted, in disappearing, to play a final *hilarious trick* on them." He cited a letter in which his friend had bragged, "I definitely smoke a little 'weed'; that officer 'in His Majesty's service' will be transformed into a winged androgyne and dance the dance of the vampire—drooling tea with milk." Later, he added Vaché's reported statement, made several hours before his death: "I will die when I want to die . . . But then I'll die with someone . . . Preferably one of my very best friends." To Breton this death was no accident: it was Vaché's final smirk, his grand farewell, and the conviction stayed with him for the rest of his life.

Not everyone shared this certainty. Aragon, for instance, later expressed doubts about the intentional nature of Vaché's death; and Woynow felt that neither Vaché nor Bonnet had shown any inclination to commit suicide. Pierre Lanoë, a former *lycée* companion of Vaché's, claimed that he saw Vaché several hours before the death and that the latter, "relaxed and confident about life," set a meeting for the next day. There is also the matter of the four other men in the room (Breton, basing his knowledge on the newspaper reports, would have known only of two): Had Vaché intended to play his final act before such a large audience? Or, conversely, had he really meant to take *four* "very best friends" with him into death? In addition, Breton's own case for suicide mainly rested on the claim that Vaché, as a veteran smoker, had known precisely what he was doing. But apart from Vaché's "winged androgyne" remark, there is little proof that the latter quite realized the power of the opium he stored in his earthenware jar. Lanoë, for his part, maintained that Vaché had never experimented with drugs before.

In the final account, however, the salient point is not so much whether or not Vaché had planned his death, but that Breton, regardless of any evidence to the contrary, stead-

fastly maintained that he had. It was as if he needed to believe in an extravagant suicide. Accidental, Vaché's death was merely a sad tragedy; staged, it became a flagrant *coup de théâtre*, dwarfing even his appearance at *Les Mamelles de Tirésias*. A death by umor, magnified by its inherent ambiguity, was the only form Breton could accept for his elusive friend. By disappearing under intentionally mysterious circumstances, Vaché bought himself the first sepulcher in what would become the Surrealist pantheon.

It was also in the wake of Vaché's disappearance that Breton began visibly hardening his views toward homosexuality. Breton's hostility toward sexual "deviance" has since become legendary. He later declared that the practice of male homosexuality "completely disgusted" him and, with rare exceptions, did not tolerate the presence of homosexuals around him. This hostility is also one of the most commonly raised examples of Breton's inner contradictions: How could a man who championed liberation from mental and societal constraints so vehemently espouse a taboo upheld by society's most conservative forces?

The answer has in large part to do with Vaché, who died nude on a bed with another man (in what was no doubt an ill-heated room during one of the coldest months of the year), who had been taking opium with at least one known homosexual (André Caron), who cultivated his distance from his "mistress" Louise and from women in general, and, most of all, who had aroused in Breton an admiration that clearly bordered on passion. Breton himself refused to acknowledge any hint of homosexuality, either in his writings about Vaché or in conversation, and instead clung to the legend he had been building for several years: just as Vaché had composed his own swan song, so he would forever remain the consummate dandy, asexual and disdainful, impervious to the temptations of the flesh. But on some level, Breton's doubts about Vaché's familiarity with "winged androgynes," and about the nature of his own attraction to the redheaded umorist, translated into a hatred of homosexuals that would last him throughout his life.

In his last letter to Breton, Vaché had written: "I rely on you to prepare the way for this disappointing, slightly sneering, in any case terrible God—What fun it will be, you see, if the true NEW SPIRIT is unleashed!" When the spirit was unleashed several years later, it bore the stamp of its departed founding father, via the severe dictates of his prize pupil. Breton's outward detachment; the cold, ironic judgment for which he would become notorious; many of his ideas about literature and art; even aspects of his dress and appearance were echoes of Vaché. And perhaps most of all, Vaché's "desertion within oneself," the generalized refusal that made him not so much anti-war as *a*-war, would sustain Breton in the living battles ahead. "I do not make a practice of honoring the dead," he wrote in 1923, "but [Vaché's existence] is, you can be sure, practically the only

thing that still binds me to a dimly foreseeable future and to some minor problems . . . If not for him, I might have become a poet. He overcame in me the conspiracy of dark forces that makes one believe he can have anything as absurd as a vocation." From almost the moment of his disappearance, the young iconoclast became absorbed into Breton's consciousness. This above all was Vaché's contribution to his times.

✳

It was becoming increasingly clear to Breton that the path he must now take was to be found not in literature but in the new attitudes that were laying bare the irrational mind beneath the skin of culture. At the same time, seemingly unavoidably, his entire frame of reference was literary. No matter how often discouragement led him to renounce writing, inexorably he returned to it, each time seeking a new approach that would justify the act of committing words to paper. For Breton and those like him, whose youth had so passionately revolved around the world of letters, literature was a hard mistress to abandon: even Vaché, all the while pooh-poohing art, had written several stories shortly before his death, and had been planning both an article on Apollinaire and a collaborative piece with Breton on the "new spirit."

It was at this point that Breton heard the dissonant clarion call of Dada. He had leafed through the first two issues of the movement's periodical in 1917, while visiting Apollinaire—one of the many curiosities that the poet, like some avant-garde dentist, kept for his guests to read as they waited to see him—but had found them largely derivative of prewar experiments. *Dada* 3, which had been published in December and which Breton saw in early January 1919, was a different matter. Particularly important from his point of view was Tristan Tzara's "Dada Manifesto 1918." "DADA DOES NOT MEAN ANYTHING," it crowed. "How can anyone hope to order the chaos that constitutes that infinite, formless variation: man? The principle: 'Love thy neighbor' is hypocrisy. 'Know thyself' is utopian, but more acceptable because it includes malice . . . Order = disorder; ego = non-ego; affirmation = negation . . . We are not afraid; we aren't sentimental. We are like a raging wind that rips up the clothes of clouds and prayers, we are preparing the great spectacle of disaster, conflagration, and decomposition . . . Every man must shout: there is a great destructive, negative effort to be made. To sweep, to clean."

At the time, Breton and his friends knew little of the Dada movement other than what they had gleaned from the various publications that managed to reach Paris. Largely because of the suspicious Reverdy, they also felt some ambivalence toward Tzara as a person. But the tone of the "Dada Manifesto" was enough to excite their keen interest.

"Prodigious manifesto *Dada* 3," Breton wrote to Aragon. He considered it "violently explosive. It proclaimed the break of art with logic, the necessity of making a 'great negative effort' . . . What impressed me most, even more than what was said, was the quality that emanated from it: exasperated and nervous; provocative and distant; poetic, too." Still more important, it contained undeniable similarities to Vaché's umor, while at the same time it seemed to link up with the subversive poetics of Isidore Ducasse. It was above all this convergence with the messages of Ducasse and Vaché that predisposed Breton and Aragon toward an enthusiastic embrace.

In addition, Dada appealed by its internationalism. Proto-Dadaist activities had been taking place in Germany and the United States even before the movement's codification in Zurich. By now, the scattered, but nonetheless related, exploits of Marcel Duchamp and Man Ray in New York; Francis Picabia in New York, Barcelona, and Paris; Max Ernst and Johannes Theodor Baargeld in Cologne; Richard Huelsenbeck, Raoul Hausmann, George Grosz, Johannes Baader, and the brothers Wieland Herzfelde and John Heartfield in Berlin; and Kurt Schwitters in Hanover complemented those of Tzara, Ball, Arp, and company, giving Dada the aura of a worldwide upheaval. Breton later said that, for himself and his friends, the important thing "was that the same currents were forming in two countries [Germany and France] that only yesterday had been enemies. As far as we were concerned, there couldn't be a better justification."

Still, the attraction Breton felt would not have been nearly so great had Tzara's entrance not coincided exactly with Vaché's exit: Tzara's initial letter to Breton, a request for a poem, had in fact been written on that same fateful January 6. "I was preparing to write you when grief dissuaded me," Breton responded on January 22:

> What I loved most in the world has just disappeared: my friend Jacques Vaché is dead. Lately it had been my joy to think how well you would have liked each other; he would have recognized your mind as akin to his own, and together we could have done great things . . . Today all my attention is turned toward you.

Breton had immediately sensed in Tzara a replacement for Vaché, and he had no hesitation admitting it. "If I have an insane confidence in you, it's because you remind me of a friend, my best friend, Jacques Vaché, who died several months ago," he repeated in April. Still, not yet having met the Dadaist in person, he confessed that he might be putting "too much stock in the resemblance."

Breton's instincts were correct: there was in fact little similarity between the late Anglicized dandy and the histrionic Dada impresario. Physically, Tzara was short and

slight, with pouty lips and a great shock of black hair that constantly fell over his right eye. He was also full of a manic, juvenile energy quite unlike Vaché's phlegm. He was born Sami Rosenstock on April 4, 1896, in the remote town of Moinesti, Romania. The eldest son of a comfortable family, early on he gave signs of a literary vocation that was encouraged by his parents no more than Breton's or Soupault's had been by theirs. He nonetheless founded and contributed to a few ephemeral literary magazines during his secondary school years, and as of 1915 began publishing his poems in local quarterlies under his now famous pseudonym (deformed Romanian for "sad in the country"). He entered the university in 1914 and began working toward a degree in mathematics and philosophy, but left after the first year, seeking more fertile pastures. With his grandfather's help, he raised enough money to attend university in Zurich in the autumn of 1915; his parents, wishing to distract their son from the literary *vie de bohème* into which he'd fallen, had few objections. It was a miscalculation on their part: by the following summer, Tzara had abandoned mathematics altogether, helped give birth to Dada, and published his play *The First Celestial Adventure of Mr. Antipyrene*, which included the movement's notorious inaugural manifesto.

One of Tzara's most notable attributes was his almost unmatched ability as a promoter. He had first used this talent within Dada itself: although the movement was actually founded by the artist Hans Arp and the writer-mystic-vaudeville performer Hugo Ball—and variously developed by Ball, singer Emmy Hennings (Ball's wife), painter Marcel Janco, and a few others—it is Tzara who has made away into posterity with the credit, just as it was Tzara who quickly became Dada's spokesman to the outside world. His attempts to fill the pages of *Dada* led him to correspond with, among others, Apollinaire, Reverdy, Francis Picabia, and Pierre Albert-Birot, who published some of his work in *SIC*. He also, but with less success for the moment, tried to find a French distributor for *Dada*.

Still, again largely due to his promotional prowess, Tzara and his work were not unknown in the more advanced Parisian literary circles. Alongside his contributions to the avant-garde periodicals, his 1918 book *Vingt-cinq poèmes* [Twenty-Five Poems] had reached the French capital and had even been reviewed by Aragon. Inroads were being made. But despite written invitations from Breton to come to France, Tzara seemed unwilling to send more than his writings for the moment.

Tzara's absence from Paris, and his consequent unfamiliarity with the ins and outs of French literary politics, caused him to take a few false steps. Seeking an outlet to peddle his magazine abroad, he had appealed the previous year to Albert-Birot's associate, the Belgian poet Paul Dermée, who in return had himself named *Dada*'s editor-in-chief.

Tzara acquiesced, but Dermée was held in such low esteem by the more radical elements of the French avant-garde (the ones Tzara mainly wished to attract) that they demanded his expulsion. Dada had filled Breton and his friends with too much enthusiasm to be handled irresponsibly, and in their eyes responsibility meant restricting access only to those who warranted their approval.

One of the elements they most wanted to eliminate was Jean Cocteau. As part of his canvassing of the Parisian avant-garde, Tzara had sent Cocteau a copy of his *Vingt-cinq poèmes* and an invitation to contribute to *Dada*—an invitation to which Cocteau, ever on the lookout for a piece of the current action, had responded warmly. But Breton immediately sought to head any such collaboration off at the pass. "My feeling—altogether disinterested, I assure you—is that [Cocteau] is the most hateful creature around today," he cautioned Tzara later in the year. Breton extended his hostility to attending a few of Cocteau's literary readings, where he so unnerved the poet with his "basilisk stare" that Cocteau complained of feeling faint.

For all this, rebuffs were one hint the sensitive Cocteau seemed unable to take. Despite the obvious dislike of Breton and his friends, he continued to offer his personal and literary services. First he wrote to Breton in February, promising him "bells, beautiful princesses, celebrations of a friendship that I offer you *by the handful*"—to no avail. Then, with no more success, he tried to become involved in a new project of Breton's: a magazine the latter wanted to launch with Aragon and Soupault.

Several projects for such a magazine had fleetingly arisen over the past two years, born of the three friends' common dissatisfaction with the literary outlets they saw around them. They were looking not so much to publish their own experiments, or even such raw offerings as Vaché's letters or Ducasse's *Poésies*, as to present in magazine form, as Aragon said, their "need to blend in with real life, the kind of life we saw reflected in Paris at night, where a kind of great nocturnal air reigns, the violent lighting of sidewalk cafés where everyone is let in without a passport." But because of various factors, including the hazy definition of the projects themselves, the war, Breton's indecision, and the common lack of funds, none of these periodicals ever materialized.

Then, in January 1919, plans were spurred on by two developments: the galvanizing discovery of Tzara's manifesto and a fortuitous offer from a young poet and critic named Henry Cliquennois. At the time, Cliquennois, who edited an undistinguished journal called *Les Jeunes Lettres*, was attracted by Dada and felt enormous admiration for Breton, to whom he offered his magazine lock, stock, and barrel—an offer that Breton was only too happy to accept. But Cliquennois might not entirely have realized the extent of his donation: while he intended to remain the magazine's publisher and head, Breton imme-

diately began renovating the existing edifice from cellar to rafters. On January 30, he wrote to Aragon that he was planning to "invade *Les Jeunes Lettres* and rename it." The prospective contributors included Gide, Valéry, Royère, Max Jacob, Reverdy, Tzara, Paulhan, and the three musketeers themselves.

The first order of business was to find a new title. "Would you come up with a magazine title: a 'label' title of course like *Nord-Sud, Dada, 391, Luciline*, be quick," he asked Aragon. By February 3, having declined Max Jacob's suggested *Ciment armé* [Reinforced Cement] and Valéry's *Littérature* (after the dismissive final line of Verlaine's poem "Art poétique": "And all the rest is literature"), they had decided on Breton's *Le Nouveau Monde* [The New World]. They relinquished the title a few days later, finding that another magazine had been using it since 1885. Reverdy proposed *Carte blanche*, which they tentatively adopted on the 10th. At this point the magazine's publisher was still Cliquennois, its editors Breton, Soupault, and Aragon. But a week later, both the title and the publisher were gone, and with him the money, which a generous slice of Soupault's inheritance helped to replace in extremis. The new title, to be splayed over a bright yellow cover, was in fact Valéry's earlier suggestion, *Littérature*. With these initial details settled, Breton wanted to lose no time: the first issue was put—or thrown—together at the end of February, and hit the stands on March 19.

Much has been made of the irony of naming the first "Surrealist" periodical *Littérature*. In part it was a last resort, the editors having exhausted their other options. In part, too, it was intended as a sarcastic comment on the unwary reader expecting to find "mere literature" between its covers. Breton in particular stressed the title's booby-trap aspect: "If we adopted this word as our title, it was as an antiphrasis and in a mocking spirit in which Verlaine played no part."

Still, and despite Breton's early claim to Tzara that "with one or two exceptions . . . all our contributors to some degree embody that new spirit we're fighting for," the first issue demonstrated a hesitation as to the editors' intent, and indeed merited Breton's later characterization of it as "very well-bred." Included in its twenty-four pages were poetry and prose by Valéry, Gide, and Léon-Paul Fargue—"the great survivors of Symbolism"—as well as Jean Paulhan and ex-Apollinaire intimates Jacob, Cendrars, and André Salmon. Breton's "Clé de sol" and a short poem of Aragon's were also included, but in general the triple directorship wanted to mark its difference from such editors as *SIC*'s Albert-Birot by keeping its own presence as discreet as possible. Rounding out the issue were a few pages of book critiques, a "Review of the Reviews" column written by the young poet Raymonde Linossier, and even a note announcing the "forthcoming reappearance" of the prestigious *Nouvelle Revue Française*, "the prewar

magazine that held the greatest claim to the literary world's respect." In all, hardly the stuff of revolutions, literary or otherwise.

Given such a lineup, unthreatening but with just a hint of daring (most of the contributors were considered "nonconformists" by the artistic mainstream), it was not surprising that *Littérature* found favor with the literary community—all the more so in that, with *Nord-Sud* now defunct and the *NRF* still several months away from relaunching, it provided one of the few serious outlets for new work. Marcel Proust wrote Soupault a twelve-page letter, taking out a subscription and congratulating the editors for their "audacity." Adrienne Monnier immediately agreed to be the magazine's distributor (perhaps because Raymonde Linnossier was an intimate). Breton and Soupault were suddenly the hot young men on the literary scene, and, as befitted visible young editors, began showing up at all the right gatherings (Aragon, still in uniform, was on duty in Alsace). But even as the first issue was being published, Breton was feeling dissatisfied with the magazine's eclecticism, and he suddenly decided on another change of direction.

It happened at the end of March during a walk with Aragon, who was back in Paris on leave. Skirting the fence of the Tuilleries, discussing the contents of the second issue, they suddenly became frightened of *Littérature*'s ability to please. "From the outset we were welcomed by our elders as their successors, their heirs . . . A career like any other. It had already been decided. Shit," Aragon related. What was necessary, they quickly agreed, was to recognize others' expectations the better to frustrate them, to "become the kind of people one didn't associate with." Suddenly, said Aragon, everything seemed bathed in a cruel light. The enemy was literature and all its seductions ("Success, bah!"). The war against it was to be waged with "extreme rigor."

The rage these young men felt, their bitterness against official notions of "culture," was fueled in part by their fury at having seen the representatives of this culture embrace and promote a war they considered pointless and baleful. But even more than this, it was the sheer *vanity* of the literary enterprise that revolted them, the self-congratulatory uselessness of writing yet one more novel, publishing yet one more collection of poems, and in the end doing no more than adding to one's own petty renown. If the act of writing was to mean anything, it had to be more than just literature; creation had to yield more than mere art.

Breton was by this time forming the view—which would become more defined over the next several years—that the work did not justify the artist, but the artist the work. What interested him was the author's "human attitude," the measure of integrity or baseness that distinguished the life behind the page. In the final account, no work of art, no matter how beautiful, could excuse infantile, egotistic, or cowardly traits in its creator,

for the simple reason that the creator and the work were inextricably bound. This was why he took such interest in those whose writings mainly stood as reminders of their living persona—men such as Vaché, who had "never produced anything"; or Jarry, honored as much for his relentless eccentricity as for *Ubu*; or Lautréamont, who had so completely merged with his work that his given name seemed less real than his pseudonym; or Rimbaud, who had abandoned poetry for gunrunning; or Tzara, who maintained that "one could be a poet without ever having written a single poem." As Breton later put it: "Poetry, which is all I have ever appreciated in literature, emanates more from the lives of human beings—whether writers or not—than from what they have written or from what we might imagine they could write." The artist's first and most important creation, in other words, was himself.

So what exactly did Breton mean by poetry? Primarily, a living attitude, a "specific solution to the problem of our lives," in which life itself was defined not as "the sum total of actions that can ultimately be ascribed to an individual," but as "the way in which he seems to have accepted the unacceptable human condition." More generally, poetry was a crystallization of Breton's own belief that words and language could change the world, that the *mind* was the seat of any worthwhile revolution. Poetry, in this sense, was not words on a page but a tool for acceding to a richer, more fulfilling world (such as the lost paradise of childhood), and even for creating such a world out of one's own inner resources.

For it to work, however, poetry had to reach the general consciousness. And so, in place of the written poem (or "po-wem," as Vaché would have said), Breton and Aragon favored the "poem-event." As Aragon observed: "We said about a poem: would it stand up if we made it into a poster? would people in the street stop to read it?" Poetry, in other words, had to become as pervasive, and as influential, as advertising. The comparison was doubly apt: not only did good advertising reach a huge audience, but by giving new, eye-catching twists to well-worn phrases, it actually revitalized language better than most verse.*

Taking his cue from Tzara, whose manifesto had proclaimed that "advertising and business are also poetic elements," Breton pursued his ruminations: "For me, poetry, art stop being an end, become a means (of advertising)," he told Aragon in April, after the

* Modern readers, nourished on the legacy of the Beatniks, the Happenings, Concept Art, and other postwar manifestations, more naturally accept the idea of poetry as living experience. But in France at the beginning of the twentieth century, poetry, and particularly that current deriving from hermetic Symbolism, was tightly barricaded in the ivory tower. Breton and Aragon wanted to yank it out, strip it of its artistic prerogatives, and reinsert it into the life of the street.

latter's return to Alsace. "Advertising stops being a means and becomes an end . . . Naturally, we must take the word advertising in the widest sense. This is how I pose a threat to politics, for example. Christianity is an advertisement for Heaven." Breton later claimed that his desire was to write an advertisement for Heaven that would be "striking enough, convincing enough" to make everyone commit suicide.

For Breton, these thoughts took on the deeply personal character of a life-or-death pact, in which he particularly sought to involve Aragon. "B. thus defined the destructive enterprise that we were about to undertake, with whoever wished to join, but between us was a secret engagement: never breathe a word of it to anyone," Aragon recalled. The secrecy and the long-term commitment were part and parcel of the enterprise. This pact was meant to last until one of the two betrayed its terms, thus leaving himself open to the other's most vicious attacks—for betrayal, too, was programmed into the bargain. "One day, A.B. said, we, too, will part ways . . . who will leave whom?" Aragon, who wrote this account thirty-five years after his own violent break with Surrealism, was only too aware of the irony inherent in the statement—an irony he accentuated by casting Breton as the Christ to his Peter. But even in April 1919, Breton was worried that his friend and confidant might not be equal to the task, or that he might betray their secret in his writings. In his first letter after Aragon's return to occupied Alsace, he wrote:

> Remember
> always
> what we said one particular evening.

"André had a fear that was constantly expressed as soon as he had confided in someone," Aragon reflected years later: "that what he said might be found out."

Devastated by the disappearance of Vaché and discouraged about the value of the poetry he had written so far, Breton clung to the idea of subversive action through language, taking the matter just as seriously as if he'd been assembling real bombs. In his mind, this was no whim but a veritable "conspiracy," a terrorist act that would threaten the very existence of commerce, politics, and religion. If poetry was to mean something, if words were to matter, then they had to have deadly force.

In retrospect, and given the significant literary production of Dada and Surrealism, it is perhaps too easy to dismiss Breton's claims of "killing art" as mere posturing, the self-aggrandizing delusions of a young, ambitious poet. But it was precisely Surrealism's opposition to art—the art of the status quo, of traditional attitudes—that would constitute its biggest impact on the later twentieth century. In this sense, Breton's

confidence to Tzara that April, that he was "nurturing a project that should overturn several worlds," was perhaps not quite as hyperbolic as it might seem.

Predictably, what Breton and Aragon "said one particular evening" had ramifications throughout Breton's few publications of the time, as each new text become one more act of "conspiracy." His next "poem" (following "Mister V" from December 1918) was "A Not-Very-Solid House," actually a human-interest story about a watchman who had died in a collapsing building after saving a little boy's life, which Breton lifted almost verbatim from the newspaper. His sole amendments to the article were the substitutions of two names: "Hope" for the little boy and, in ambiguous tribute, "Guillaume Apollinaire" for the unfortunate watchman ("He had been given a medal for his work, and his friends spoke well of him"). "Today it is impossible to understand how much audacity was implied in the leap from ['Mister V'] to ['A Not-Very-Solid House'], how daredevil the whole thing was," Aragon later said. A few months afterward *Littérature* published "The Mystery Corset," a collage-poem made entirely of "bits of ads alternating with stock phrases." The collage aspect was further accentuated by the use of different typefaces for each discrete fragment; even in the manuscript versions he sent his friends, Breton employed different handwritings to simulate the cut-up effect.

Finally, in April 1919, came the publication in *Littérature* of Ducasse's *Poésies*, which Breton had copied by hand in the Bibliothèque Nationale earlier that month. Soupault later explained that "we thought this publication would cause a stir, since we knew that Isidore Ducasse's *Poésies* contradicted, in a certain sense, Lautréamont's *Maldoror*."

One who didn't appreciate this publication was Reverdy. He was offended by the *Poésies*, and annoyed that his young protégés should waste their time (and the magazine's pages) on something that, despite its name, clearly wasn't poetry. But this was only the latest in a long series of discontents. Although Reverdy would sporadically appear in *Littérature* until the next autumn, he and Breton had little left to say to each other.

As had previously happened several times, the exit of one was compensated by the entrance of another. First and foremost there was Tzara, with whom Breton was in increasingly close epistolary contact. "Of all the living poets, you are the one who touches me most deeply. Have confidence in me. Are we friends?" he wrote in March, having previously asked Tzara for a number of biographical and physiognomic particulars.

Alongside Tzara was a newcomer, a kind of "fourth musketeer," who knocked on the door of Breton's hotel room on March 8. Paul Eluard had been recommended by Jean Paulhan, and Breton had even written him four days earlier, requesting material for *Littérature*. One can imagine his surprise at finding these submissions brought by the same man who had approached him the previous fall at Apollinaire's *La Couleur du*

temps, believing him to be a fallen comrade! The coincidence no doubt helping matters, Breton and Eluard got on sufficiently well during their first meeting for the editor to invite the young poet back in ten days' time. "Breton seemed very happy with this meeting," Soupault remarked. "Despite my friendship and Aragon's, Breton was always afraid of feeling isolated."

But it wasn't only an additional friend that Breton found in Eluard, for in certain ways the newcomer perfectly complemented the *Littérature* group's joint profile. As a colleague and friend of Paulhan's, Eluard echoed the latter's interest in the study of language, and was currently trying to put new proverbs into circulation. He also seemed to have an intuitive grasp of Lautréamont's work that the others found dazzling.

In many ways, however, Eluard stood apart from his three new comrades. Born Eugène-Emile-Paul Grindel on December 14, 1895, in the Parisian suburb of Saint-Denis (adjacent to Pantin and of similar socioeconomic profile), Eluard had published three books of poems by 1919, albeit at his own expense, and he enjoyed the relative financial prosperity of his father's real estate business. He also lacked the others' literary and philosophical education, partially due to prolonged stays in sanatoriums before the war for tuberculosis. Whereas the others had been pushed into the war, Eluard had actually dreamed of serving at the front—although acute bronchitis had ended his stay there after three months (he spent most of the war in military hospitals). And whereas the others, in keeping with their common revolt against the family and its institutions, were resolute atheists, Eluard both maintained good relations with his parents and, following a crisis of faith in 1916, had recently taken his First Communion. He was now in a transition phase between Roman Catholic orthodoxy and the sexual libertinism that would characterize most of his adult life, but these were only surface differences: in fact, the same religious fervor marked his actions and views on either side of the ideological fence. (Giorgio de Chirico once described Eluard as having "a face somewhere between that of an onanist and a mystical cretin.") It was this fervor that made him, for a time, one of Surrealism's most valuable members: if Breton was Surrealism's "pope," as the longstanding jape would have it, then Eluard was surely its archbishop.

Eluard differed from his new companions in one other respect: while they were just discovering the responsibilities of adulthood, he was supporting a family. He had met the nineteen-year-old Russian émigrée Helena Dmitrievna Diakonova in 1913 at the Clavadel sanatorium in Switzerland, where they were both patients, and married her four years later. Their first and only daughter, Cécile, was born in May 1918. Still in uniform, Eluard had only recently been able to return to the Paris region, where he now shared a rented room with his daughter and his "Gala," as he had nicknamed his wife.

André Thirion, a member of the Surrealist group in the 1930s, described a slightly older Eluard as "tall, slender, blond, with a poet's noble and faraway gaze and an asymmetrical but handsome face. His manners were distinguished and serious, and slightly condescending. At thirty, his hands trembled like those of an old man; his voice also trembled when he read, but he managed to draw very poignant effects from this . . . Well dressed, in good health, he looked like *someone*." Eluard's noble romanticism went hand in hand with a marked sensuality that distinguished him from Breton's more cerebral reserve. He was a compulsive seducer and eager wife swapper. Thirion recalled that he always kept a photograph of the nude Gala in his billfold, which he enjoyed passing around among his friends. "It revealed a marvelous body that Eluard was very proud to have in his bed."

As for Gala, Thirion saw her as someone who "knew what she wanted: pleasures of the heart and senses, money, and the companionship of genius. She had no interest in political or philosophical discussions, and she judged people according to their effectiveness in the real world, eliminating the mediocre." Another acquaintance later described Gala as "Russian to the tips of her fingers and proud of it, with everything that entailed in the way of pride, will to power, calculated economy, and a healthy belief in fate, enigmas, and dissimulation." In 1919, Gala's character already possessed its nervous willfulness and tendency toward hysterical exaltation, even if the sexual adventuress she later became was still buried within the heart of a devoted young bride.

In June 1919, *Littérature* scored its first coup: an important unpublished work of Rimbaud's entitled "The Hands of Jeanne-Marie." The poem was acquired in March, after several weeks of negotiations, from Paterne Berrichon, widower of Rimbaud's sister. Isabelle Rimbaud, wishing to accentuate the positive (Rimbaud's deathbed embrace of Christianity) and eliminate the negative (his homosexual escapades, his irreverence, his Communard sympathies), had long opposed the publication of her brother's unknown works. In the case of "Jeanne-Marie" in particular, its evident sympathy with the Communards of 1871 ran counter to the image of the Catholic Rimbaud being promoted not only by Isabelle but also, and with great zeal, by poet-ambassador Paul Claudel.*

* Claudel, as talented as he was conservative, at the time served as France's ambassador to Brazil. In Breton's eyes, his crimes against Rimbaud did not stop with the attempted censorship of "Jeanne-Marie": Claudel, in fact, persisted in considering Rimbaud a Catholic poet "in the rough" and tried to eradicate any aspect of his life and work that would not have been smiled upon by the Church—precisely those aspects, in other words,

But with Isabelle gone, the shrewd Berrichon knew he had a keen audience for the man-uscript, and *his* interests tended more to the material than the spiritual. Over drinks at the Closerie des Lilas, he sorrowfully explained to Aragon and Soupault—Breton having chosen not to attend—how he preferred *Littérature* but had promised the poem to a rival magazine. Still, all that could be changed for 500 francs . . .

For the impecunious young editors, the only solution was to borrow the money. Breton's *lycée* friend René Hilsum, by this point a something of a silent collaborator on *Littérature*, happened to know two sisters who would put up part of their inheritance to acquire the Rimbaud. In order to pay them back, Hilsum decided to start a small pub-lishing concern and reprint "The Hands of Jeanne-Marie" as a limited-edition chap-book. Like any firm, it needed a name, which Hilsum and his *Littérature* colleagues felt, in keeping with Breton's ideas on the advertisement, should be as inappropriate as pos-sible for a publishing house. Breton suggested "A l'Incroyable," a common name for shoe stores; but the choice went to Aragon's "Au Sans Pareil" [The Matchless], taken from a novelty shop. Au Sans Pareil published "The Hands of Jeanne-Marie" in June, trailing the magazine publication by a few weeks.

Rimbaud's poem inaugurated not only Au Sans Pareil as a publishing house, but also the *"Littérature* Collection," its title underscoring the relation between the imprint's authors and the magazine that featured them. Taking a shine to publishing, Hilsum and his two backers decided to continue operating Au Sans Pareil, and quickly announced six future titles. In subsequent months, the *"Littérature* Collection" published Vaché's *Letters from the Front* and poetry collections by Blaise Cendrars, Soupault, Aragon, and Eluard. The following year, a newly created "Dada Collection" also published books by some of Tzara's friends. But the house is no doubt best remembered for a work pub-lished in neither collection: *The Magnetic Fields.*

Although Breton first launched Surrealism as a movement in 1924, he never failed to point out that the true kernel of the "Surrealist revolution" lay in the discovery of auto-matic writing—and specifically in the composition of *The Magnetic Fields*—in the spring of 1919. Automatism, in fact, was initially so central to the Surrealist experience that "Surrealist writing" and "automatic writing" were virtually synonymous for those who practiced it. The label "Surrealism," of course, was taken from Apollinaire (although it referred less to the subtitle of *Les Mamelles de Tirésias* than to his 1908 text "Oniro-critique," whose tone was reminiscent of the automatic flux), and this was no accident:

that sparked Breton's admiration. "They tell me that Claudel destroyed, because he judged it too pagan, the photograph of Rimbaud as a Negro, and this is probably what I consider his greatest crime," he wrote Paulhan that same month.

for Breton, Apollinaire was the man who had invented a new poetic language for the modern age. With automatic writing, he felt he was now making a discovery of similar magnitude.

These were retrospective assessments, however, arrived at long after the fact. In May 1919, even as *Littérature* was gaining momentum and plans were being made for Au Sans Pareil, Breton was facing an intellectual and spiritual dead end. His most recent poetic experiments had yielded only discouragement, all too easily deepened by his stifled, extended mourning of Vaché. Not yet officially discharged from the army, he passed the hours pacing the floor of his hotel room and the streets of Paris or spending evenings alone on public benches. "I don't believe I was pursuing an idea or a solution," he later said. "No, I was prey to a kind of daily fatalism." His indifference at war's outset had been one of affected boredom; by war's end, it had become the indifference of low-grade depression.

Breton nonetheless continued to ponder the questions that had been preoccupying him for several years: Toward what ends did one create poetry? What were the boundaries between "poetry" and "life," and must the two be kept separate? Above all, what was the veritable source of poetic imagery? He had sought this source in the startling phrases proffered by his patients at Saint-Dizier; in the chance juxtapositions of the collage; in his meditations on lyricism *à la* Reverdy; and in the advertisement's hijacking of stock phrases. While these attempts in themselves had so far produced inconclusive results, their convergence suggested that the most fertile images derived not from a deliberate, individual process of creation but from a connection with more universal mental substrata—were not, in other words, dictated by the voice of reason but whispered by what Victor Hugo had called the "mouth of shadows."

Even as he rewove these various threads of an elusive poetic art, Breton remained haunted by his earlier aural hallucination of "a man cut in two by the window" and by other sentences and phrases of similar nature, seemingly unprovoked and increasingly uncontrolled. He later described these first hallucinations:

> One evening . . . before I fell asleep, I perceived, so clearly articulated that it was impossible to change a word, but nonetheless removed from the sound of any voice, a rather strange phrase which came to me without any apparent relationship to the events in which, my consciousness agrees, I was then involved, a phrase which seemed to me insistent, a phrase, if I may be so bold, which was *knocking at the window*. I took cursory note of it and prepared to move on when its organic character caught my attention . . . I realized that I was dealing with an image of a fairly rare

sort, and all I could think of was to incorporate it into my material for poetic construction. No sooner had I granted it this capacity than it was in fact succeeded by a whole series of phrases, with only brief pauses between them, which surprised me only slightly less.

At first he received these messages as they occurred, trying simply to capture them; soon, however, he actively began coaxing the "mouth of shadows" itself. "Completely occupied as I still was with Freud at that time, and familiar as I was with his methods of examination which I had had some slight occasion to use on some patients during the war, I resolved to obtain from myself what we were trying to obtain from them, namely, a monologue spoken as rapidly as possible without any intervention on the part of the critical faculties, a monologue consequently unencumbered by the slightest inhibition and which was, as closely as possible, akin to *spoken thought*."

Very quickly, Breton had gone from seeing the automatic discourse as simple "material for poetic construction" to recognizing in it a philosophical tool of much greater import. As his Saint-Dizier experience had shown, the images it yielded rivaled those found in the works of Rimbaud, Apollinaire, and even Lautréamont (who might have used a similar method in writing *Maldoror*). But more than this, automatic writing promised to do away, once and for all, with the stifling individualism that corrupted literature. On the one hand, since the automatic text was not created by a conscious, laboring author, its creator would have as little "claim" to it as he would to an object found in the street. On the other, the deep unconscious seemed to be a vast melting pot of received information—common wisdom, slogans, idiomatic expressions, miscellaneous phrases—that, when unearthed, answered Isidore Ducasse's call for a kind of poetry "made by all, not by one."

Breton later called *The Magnetic Fields* the first attempt to "adapt a moral attitude, and the only one possible, to a writing process." His intuition was that anyone who managed to muffle the discord of external interference could tap into the unconscious flow, and that to do so would have enormous social and moral repercussions. "As soon as Surrealist methods begin to enjoy widespread favor," he wrote several years later, "a new morality will have to be substituted for the prevailing morality, the source of all our trials and tribulations." In 1930, he was still stressing that automatic writing was not a matter of producing art, "but of casting light upon the unrevealed and yet revealable portion of our being wherein all beauty, all love, all virtue that we scarcely recognize in ourselves, shine with great intensity."

André Breton did not invent automatic writing: even apart from previous medical uses of it (notably by Pierre Janet), literary practitioners of the form—particularly the

Englishman Horace Walpole and the Italian Carlo Gozzi—could be found at least as far back as the eighteenth century; and Breton himself named Gérard de Nerval and Thomas Carlyle as predecessors. But he was perhaps the first to see in the practice something other than either a literary technique or pure therapy. For him, it was both an entry into the innermost mechanism of the poetic image and, because of the challenge automatism posed to notions of responsibility, an unprecedented moral and psychological barometer.

Still, Breton might never have pushed his explorations further if forced to conduct them alone: he was too wary of the psychological risks involved, of the madness and consequent degradation that might befall too intrepid a diver into the unconscious stream. Instead, the texts that ultimately composed *The Magnetic Fields* resulted from a process of collaboration. The "man cut in two" metamorphosed into the two halves of a simultaneous writing consciousness, or as Aragon described it, "a single two-headed author." The other head belonged to Soupault.

It was to Soupault alone that Breton confided his preliminary conclusions about the automatic message. At the time, Soupault was serving in the army administration, which had the double advantage of leaving his evenings free and keeping him in Paris—unlike Aragon, who was currently finishing his tour of duty in defeated Germany. Even if Aragon had been available, moreover, it is not certain that Breton would have chosen him for his co-author; as he told Théodore Fraenkel, he sometimes wished that his friend had "a little less literature" in him. As for Fraenkel himself, his relentless sarcasm threatened to make any such enterprise seem pointless from the start.

In this regard, Soupault occupied an ideal middle ground: he was less worried than Aragon about his literary reputation but not as acidic as Fraenkel; his nonchalance with regard to the written word would keep him from ascribing too much importance to the results, while his sense of adventure made him an eager participant. In addition, he shared Breton's interest in Freud and in the discoveries outlined by Pierre Janet in his *L'Automatisme psychologique* (the term "automatic writing," moreover, was most likely suggested to Breton and Soupault by their reading of Janet, although Breton seems to have taken little else from the renowned psychiatrist).

For several weeks the two men debated, bringing to bear everything they had learned from their various readings in psychology and aesthetics. Then, in late May or early June, they decided to put their reflections into practice. First they spent a night jotting down unconnected sentences (many of which they destroyed; others eventually figured in *The Magnetic Fields*), but soon they began taking longer strides. The rules were simple: they would give themselves a total of one week to "blacken some paper" with whatever came

into their heads, with, as Breton said, "a praiseworthy disdain for what might result from a literary point of view. The ease of execution did the rest." There would be no reflection, no correcting of what flowed from their pens. The end of each text, or "chapter," would be determined solely by the cessation of that day's work. The only condition would be to eliminate external interference as completely as possible.

Three chapters (out of an initial eight) were written separately, for the most part in the grade school composition books for which Breton had never lost his fondness. The day's results were read and compared at the end of each evening; sometimes paragraphs from each man's text were intermixed by cut-and-paste. Still other chapters were written with both authors seated across the table from each other. The chapter called "Barriers," which takes the form of a long dialogue, was written alternately, one author writing a statement as quickly as possible, then either rapidly reading or showing it to his partner, who would compose the response "without thinking, at that very instant." (As the original manuscript shows, and despite the agreed interdiction, Breton later rearranged or eliminated parts of the dialogue—which originally recounted a recognizable, if unorthodox, cops-and-robbers story—to make it more mysterious.) Indeed, although about half the chapters remain almost exclusively the work of one or the other, the rest were truly composed by Aragon's "single two-headed author."

Breton and Soupault experimented not only with different forms but also with different writing speeds. These speeds ranged from velocity v', several times faster than "the normal speed with which a man would undertake to recount his childhood memories"; through v ("very great") and v''', to v'' ("the greatest speed possible"). At times the images came so quickly that the two authors had to resort to abbreviations in order to get them all down. This variation of speed touched the very core of the project, for it constituted no less than an attempt to determine the limits of the bond between thought and expression. "It had seemed to me, and still does," Breton pointed out several years later, "that the speed of thought is no greater than the speed of speech, and that thought does not necessarily defy language, nor even the fast-moving pen."

From the outset, and in keeping with the atmosphere he had woven around his "conspiracy" with Aragon, Breton wanted *The Magnetic Fields* to be "a dangerous book." This sense of danger manifested itself in various ways, from the strict secrecy he and Soupault maintained about the project, to a feeling of terror that arose as the experiment continued, and even into the imagery of the text itself. A major motif in *The Magnetic Fields* is the theme of being hunted, put under arrest, or endangered. "'You know that this evening there's a green crime to be committed. How ignorant you are, my poor friend.'" "The most magnificent doors are those behind which someone says: 'Open up

in the name of the law.'" "Look at our hands: they are covered with blood." Even seemingly innocuous sentences took on a threatening cast: Breton later recounted how the phrase "Tires velvet paws" caused him to spend an afternoon feeling stalked "by cats who were perhaps (but please believe me: only perhaps) cars."

Not surprisingly, the text as a whole was strongly marked by the authors' personal reminiscences and preoccupations, acquaintances and anxieties. The chapter "Seasons," composed exclusively by Breton and titled after a line of Rimbaud's, largely encompassed memories of childhood and youth, and provides an otherwise frenetic ensemble with its few peaceful notes.

Reading over what they had written, Breton was at once excited by the patent similarities between the two men's texts (which didn't exist in their "conscious" productions), and even more so by the "extraordinary verve" and "strong comical effect" of the whole. Soupault, too, was dumbstruck by the texts' oddly comic quality: "When we reread what we had written, we were surprised—more than that, stupefied . . . What astounded André was, more than the images, the involuntary and extraordinary humor that sprung out at the turn of a phrase. We burst out laughing." Indeed, perhaps the most striking aspect of *The Magnetic Fields* is the extraordinarily fresh quality of the writing itself, both inexhaustibly mysterious and unsettlingly hilarious: "Prisoners of drops of water, we are but perpetual animals." "Sweating vertebrate superior cathedrals." "Stiff stems of Suzanne uselessness above all village of flavors with a lobster church." "The world that writes 365 in Arabic characters has learned to multiply it by a two-figure number." "God the Father's will to grandeur does not in France exceed 4,810 meters' height above sea level." "Temptation to order a new drink: for instance, a plantain demolition." Certain lines were even singled out by Breton uniquely for their ability "to make us *laugh* . . . with an offensive, wholly new, absolutely wild laughter."

While it lasted, the feverish writing of *The Magnetic Fields* replaced Breton's aimlessness with a state of exhilaration, and the two authors sometimes spent eight or ten consecutive hours furiously taking dictation from their unconscious. According to Breton, they "lived in a state of euphoria, almost in the intoxication of discovery. We felt like miners who had just struck the mother lode." Even Soupault, who took a more acerbic view of the experiment and had less of a personal stake in it, nonetheless felt "marvelously *liberated*."

Still, subtending the excitement was a pervasive sense of despair, one that became more acute as the authors pushed on. For as they dredged deeper for images, all the horror of the war, fury against family and society, and awareness of personal loss were brought up with them. In Breton's case, the loss most keenly felt was that of Jacques

Vaché: "Of all the passersby who have slipped over me, the handsomest as he disappeared left me this tuft of hair, these gillyflowers without which I would be lost for you. Of course he had to turn back before I did. I weep for him."

The undertow of despair even extended into the superbly contemptuous final chapter. Entitled "The End of Everything," its complete text, designed to look like a business card, reads: "André Breton & Philippe Soupault. WOOD & COAL." In 1930, Breton darkly explained that this postscript represented his desire "to disappear without leaving a trace. 'Wood and Coal,' the anonymity of those pathetic little shops, for example." Despite its ostensible simplicity and insolent humor, "The End of Everything" is perhaps the most ambiguous, and revealing, chapter of *The Magnetic Fields*. On the one hand, Breton saw the "anonymity," the subjective annihilation, of the automatic message as a kind of figurative suicide: it was no accident that "The End of Everything" was immediately followed by the book's dedication "to the memory of Jacques Vaché," whose own suicide, as Breton saw it, had been the single most important event of the preceding months. On the other hand, the book's very existence was an affirmation, proof of an attempt to create something that was, after all, literature, but not in the sense he despised. It was a way of honoring Vaché's dismissal of life and art, while not following him into actual death.

In this sense, the composition of the book was like a reprieve from grief. Soupault later told Aragon "how A. B., who, on the eve of undertaking the experiment of *The Magnetic Fields*, saw before him only emptiness and despair, had changed while writing it." But the reprieve was to be short-lived. As Breton had feared, his "dangerous book" was beginning to take its toll, particularly as the speed of writing increased. He later said that automatic writing worked on them "very much as drugs do." At the end of the allotted eight days, fearing for his mental stability, Breton hastily terminated the experiment.

The writing of *The Magnetic Fields* had pulled Breton away from the abyss into which he had stared every day since learning of Vaché's death. Now, with the experience behind him, Vaché was still dead, and the abyss still yawned. Depressed after his week of exhilaration, Breton again hesitated about his future. That same month of June he returned to the Faculté de Médecine in Paris, studying without conviction, but with sufficient diligence to obtain his auxiliary doctor certification on July 1.

Which is not to say that Breton had forgotten his recent experiment, for his renewed depression stemmed in large part from a deep ambivalence toward *The Magnetic Fields*

itself. On the one hand, the results had not entirely lived up to his grand expectations: Breton knew that he had not managed to push beyond the fear that kept him from taking his explorations to the limit; and that as soon as the experience had begun to jump the guardrails of the written page, begun actually to threaten his psychological well-being, he had ended it. In the final account, no matter how new the sound of what he and Soupault had done, it was still literature. At the same time, the two authors could not help feeling a certain hesitant excitement about the text *as* literature. *The Magnetic Fields*, more than anything they had produced to date, seemed to justify their activity as poets. Despite its shortcomings on the scientific plane, as a piece of writing it surpassed practically any other work they knew.

Still, they worried about the consequences of unleashing so radical a text. Should it be made public, or forever kept in the drawer? If they published it, would they be taken for madmen? And what if, in others' eyes, it was simply no good? For a week and more, the two authors pondered the dilemma. Finally, when Aragon returned from Germany in mid-June, they decided to try the book out on him.

Aragon could see by his friends' faces that something had happened during his absence, something big, but about which they seemed unable or unwilling to talk. "I remember it was unbearably hot, June the color of August. From time to time storms squatted on the slate rooftops, without managing to burst. Everything became pearl grey like the inside of the eye. The café [to which Breton and Soupault brought him] was called La Source." It was morning; the place was practically empty. Soupault soon got up "not to buy the daily paper" and didn't come back. Then Breton, all the while protesting that what they'd done was perhaps nonsense, that perhaps they'd destroy the whole thing, hesitantly began to read the opening lines of *The Magnetic Fields*. Gaining assurance, as the drizzle finally started falling and Aragon sat spellbound, he recited the first four chapters without a pause.

After the reading, Breton was particularly eager to know whether Aragon could identify the author of each passage, and seemed almost disappointed when his friend, from whom he'd kept the manuscript scrupulously hidden, managed to guess them correctly. "It's odd," he said. "I wouldn't have thought you'd find me out." But Breton could hardly have been disappointed by Aragon's reaction to the text itself. In a 1921 article, Aragon hailed the "inescapable emotional impact" of automatic writing. And half a century later, long after he had left Surrealism, he was still calling *The Magnetic Fields* "the moment at the dawn of this century on which the entire history of writing pivots."

Aragon's enthusiasm, however, also masked a profound jealousy: his friends had begun something so important and not waited for him! He immediately began his own

experiments with automatic writing, but in such secrecy that the texts themselves did not see the light of day for fifty years. Breton, sensing Aragon's envy, also collaborated with him on a short automatic prose poem, which *Littérature* published in February 1920.

Bolstered by Aragon's response and, soon after, an unexpectedly favorable reaction from Théodore Fraenkel, Breton decided to go public. He offered *The Magnetic Fields* to Hilsum, who immediately accepted it for Au Sans Pareil and set a tentative publication date of September (although it was not actually published until May 1920). In late July he wrote to Tzara, asking his correspondent not to "judge him" until he had seen the book. Given free rein by Soupault, who claimed to have lost interest, Breton made slight revisions to the text over the next several months: mainly corrections of word repetitions, but also some substantial additions, deletions, and amendments, as well as the occasional suppression of an autobiographical reference he deemed overly transparent. He also arranged the chapters into their final order and gave the overall work its title— turned it, in other words, from a raw pile of notebooks into a finished manuscript.

To test the waters, Breton published a short excerpt over his signature in the September *Littérature*. But if he was anticipating a public echo of his friends' acceptance, or even hostility, he was to be disappointed: the text passed completely unnoticed. Nor was there any stir one month later when the magazine ran the opening chapter. After all Breton's concern over the audacity of making such a statement, the silence of neglect was perhaps the worst outcry of all.

Nor could he take solace in his other activities. *Littérature* itself now struck him as predictable and boring. Breton was still unable to detach himself entirely from his earlier admirations, and this led the magazine to feature in the same issue, for example, neo-Symbolist poems alongside the letters of Vaché. In an attempt to keep it distinct from other periodicals, the editors began devoting a portion of each issue to aggressive snubs directed against their literary colleagues. At bottom, this was little more than schoolboy waggishness, but it evinced a desire to thwart the expectations of those who saw them only as promising young men of letters. The advantage of such jabs was that they were easy and, unlike the excerpts from *The Magnetic Fields*, they did not pass unnoticed. They also provoked some gratifying outrage—notably from Adrienne Monnier, who stopped acting as the magazine's distributor: as of the October issue, *Littérature* was sold through René Hilsum's Au Sans Pareil.

Hilsum also took charge of Breton's own literary output by publishing his first poetry collection, *Pawnshop*, on June 10. The book contained fifteen poems, ranging from several of the prewar works, through the 1918 collage-poems, to the recent "A Not-Very-Solid House" and "The Mystery Corset." Not included were most of the early

poems Breton had written under the influence of Mallarmé. To underscore his develop-ment in the six years covered by *Pawnshop*, Breton presented the pieces virtually in chronological order. But the overall tone of the collection was unavoidably disparate, an unsystematic résumé of Breton's multiple poetic interests since adolescence; and this bric-a-brac aspect was reflected even in the book's title.

The fact was, Breton took little pride in the collection, which, particularly after the experience of *The Magnetic Fields*, struck him as superfluous and vain. He sent a copy to Tzara—promising that the Dadaist would "not like the collection, of course"—and years later did allow that *Pawnshop* was "commendable mainly for the poetically reason-able view . . . that it [took] of the war." But in most other respects, Breton felt only indif-ference toward this shrapnel of his past. Publishing the book was like exhuming a small corpse, serving no purpose other than to ascertain that the body was really dead. It was the work of a man who no longer existed.

Valéry, who received a copy soon after publication, was favorably impressed—little wonder, given his hand in most of the contents. "Mister V is remarkably pleased with your book," he wrote Breton. "Who would have guessed? Is he going crazy like those young men of *Littérature*?" On a more public scale, however, things were less laudatory. The only known reviews were a short and somewhat de rigueur note by Aragon in the October *Littérature*, and an article that accused "André Breton" of being "the pseudonym of a poet who died young": "white gloves and white canvas shoes, cycling outfit with baggy breeches, a rhyming dictionary in hand. Overcome by scruples just as he sent the book to press, the author replaced the rhyming dictionary with a catalogue of seasonal novelties." Although *Pawnshop* did manage to exhaust its print run of 125 copies, sales were sluggish, and not helped by the fact that Breton, lackadaisical about the book itself, was even more so when it came to the practice of sending copies to reviewers.

In September, after a vacation in Lorient, Breton was assigned to the Aviation Center at Orly as an auxiliary doctor. He confided to Valéry that he was glad to leave Paris, tak-ing a break from his habits and friends, and offered to visit "one of these evenings" to bring the manuscript of *The Magnetic Fields*. He also confessed that he'd written noth-ing since the collaboration with Soupault.

It is little wonder: with the initial excitement of the automatic experience gone, Breton had few internal resources with which to power another direction of research. The renewal of *The Magnetic Fields* had been a momentary blaze, cauterizing the trauma of Vaché's death, but leaving Breton emotionally spent. The flat terrain of Orly mirrored the numbness within. "I'm not working," he wrote to Paul Eluard. "I happily ponder the vast airfield, deserted and silent."

DADA COMES TO PARIS

(September 1919 – December 1921)

THE ARMY DISMISSED BRETON ON SEPTEMBER 19, 1919. Leaving Orly he again took up residence at the Hôtel des Grands Hommes and began once more, as during the weeks preceding *The Magnetic Fields*, to wander aimlessly about the city. He later described himself as being "in a state of extreme receptiveness, and unwilling to make peace even with life's necessities." At last free from military constraints, Breton at twenty-three was a young man with no plans and nothing to look forward to other than the resumption of his medical studies. He felt disenchanted with his early writings and—in one of the mood swings that would characterize his relations with others throughout his life—with his friends. The one exception, Jacques Vaché, was dead.

This state of irresolution, while not the source of Breton's interest in the Dada movement, now invested it with an urgency it might not otherwise have had. Not only did Dada seem the most intellectually stimulating current to have emerged from the war, but its implicit message—that there were no prospects, no future, no salvation even in the nonconformist attitudes of art—responded perfectly to Breton's current outlook. The next several years of his intellectual life would be devoted almost wholly to Dada. His writings during this period were almost exclusively Dada tracts and manifestoes; his energies were mainly spent inventing and performing Dada "demonstrations" (*manifestations*).

Even before Tristan Tzara set foot in France, Breton and friends began publicly aligning themselves with him. In September, an anonymous column in the newly relaunched *Nouvelle Revue Française* noted disapprovingly that some French writers were boosting Dada; no sooner was the war over than "Paris seem[ed] to be extending a welcome to such drivel, which [came] straight from Berlin." Breton was quick to respond, both chiding the *NRF* for its "unspeakable ploys" against Dada and asking Tzara to draft a rebuttal of his own. Tzara did, in fact, respond to the *NRF*'s attacks, denying any pro-German sympathies during the war and protesting the implication that any poet of Germanic origin was necessarily inimical to French literary interests. "People these days no longer write with their race, but with their blood (what a platitude!)," he said.

What most intrigued Breton about Tzara's letter—in tone and terms extraordinarily like Vaché's—were his clarifications on *why* one wrote in the first place:

> I believe, my dear Breton, that you too are trying to find men . . . I am not a professional writer. I would have become a successful adventurer, making subtle gestures, if I had had the physical force and nervous stamina to achieve this one exploit: not to be bored. One writes, too, because there aren't enough new men, out of habit, one publishes to try to find men, and to have an occupation . . . There could be a solution: to resign oneself; quite simply: to do nothing. But you need enormous energy. And one has an almost hygienic need of complications.

Breton sent Tzara's rebuttal to Jacques Rivière, the *NRF*'s editor-in-chief, but Rivière declined to publish it. The text would finally appear in *Littérature* as an "open letter to Jacques Rivière."

In the meantime, realizing that Tzara's question lay at the heart of Dada's radical anti-aesthetic, Breton used the first page of *Littérature*'s November issue to announce a philosophical inquiry: "We have decided to ask the most highly qualified representatives of the various tendencies in contemporary literature—while requesting that they not enter into a discussion of these tendencies—the following question: WHY DO YOU WRITE?" As Breton had told Tzara on October 7, "I also smile with great emotion every time I see you begin a sentence this way: I write because . . . The reasons are so variable; I feel so strongly that none of them satisfies you . . . I also tell myself sometimes that if Tristan Tzara didn't write, he'd know only too well why he didn't write. Indeed, this is what gave me the idea of launching the inquiry 'Why do you write?' in the next *Littérature*."

The numerous answers to the inquiry began appearing in December, in "the inverse order of our preference"—that is, beginning with the ones the editors considered most objectionable and ending with those that struck a sympathetic chord. Heading the list were the responses Breton had in mind when he later qualified the majority as "pathetic": "to serve God, the Church, and France . . . But I'm not saying I've become indifferent to glory" (Henri Ghéon); "I write in French, being neither Swiss nor Jewish, and because I've earned all my diplomas" (Jean Giraudoux, in a direct reference to Tzara and his truncated university career); "In order to write better!" (Max Jacob); "I believe I am thus fulfilling, in my little corner and in my own way, my duty as a citizen" (Marius André). Of the more than eighty responses, in fact, only a few gained *Littérature*'s approval, among them Francis Picabia's "I really don't know and I hope never to find out"; Valéry's avowal that he wrote "out of weakness"; and—Breton's favorite—Knut

Hamsun's "I write because it shortens the time," taken from his novel *Pan*. "This is the only answer to which I can still subscribe," Breton noted in 1923, "with the caveat that I also believe I write because it lengthens time. In any case, I claim to act on it."

"Why Do You Write?" provided a wittily subversive challenge to the complacency of the Parisian literary scene. By forcing writers of every stripe to drop their ornaments and stand naked before their peers, the inquiry exposed the paucity of intellectual honesty and depth hiding behind the writing trade. It also demonstrated a marked talent for self-promotion on the part of *Littérature*'s editors. "That inquiry created a considerable stir and prompted the critics to become interested in our magazine," said Soupault.

But "Why Do You Write?" was more than a simple prank or publicity stunt, or even a mere "trap," as Breton later put it. Rather, it addressed Breton's own anxiety (which the experiments with automatic writing hadn't allayed) about the contradiction between continuing to write, on the one hand, and on the other succumbing to the same pitfalls as so many of his predecessors. As Breton's choice of responses suggests, writing simply to create a "work of art" seemed insufficient justification: sooner or later, one fell prey to the debilitating charms of literary vanity. Rather, writing could maintain its integrity only by placing itself outside of literature—for example, by acting as a kind of beacon for the like-minded: this was the meaning of Tzara's gloss that one wrote to find others.

❋

The defense and illustration of Dada was Breton's main professional concern during the fall of 1919. Another, more intimate, concern was a young woman named Georgina Dubreuil, whom Breton had first seen conversing with Aragon the previous spring. Learning that she lived on Rue Soufflot, only yards away from his hotel, he would sometimes follow her in the street (a classic French technique for meeting an attractive woman). He finally approached her in early September and, perhaps because she had recently learned of her own husband's infidelities, they became lovers: it was for Georgina that Breton had made several clandestine visits to Paris during his time in Orly. "She . . . was once, not my friend—far from it—but my mistress, as they didn't hesitate to say back then, and that was far more exhilarating," he commented many years later.

In part, Georgina simply answered a need for sexual companionship, which had been more or less lacking since Alice in 1916. But Breton was also enticed by the woman herself: by her physical good looks as well as her intriguing claims of clairvoyance. She predicted that Breton would soon have a "bourgeois" marriage and that he would "make the acquaintance of madness"; although he laughed, both forecasts eventually

proved accurate. Still, this psychic attunement did not imply the same compatibility in temperament: Georgina had an ardent, possessive, and extremely jealous nature, and her relations with Breton were often tempestuous. "In love there was something of the *firecracker* about her," Breton said of Georgina's outbursts, with a mixture of admiration and disapproval.

Despite Breton's affair with Georgina, the autumn was marked by inactivity and "demoralization"—a term that appeared frequently in Breton's correspondence of the time, and that would soon become a Dadaist rallying cry. As far as his parents knew, he was resuming his medical studies; but this promise had been purely an excuse, a way of ensuring that they would continue to send the meager but steady allowance that covered his room and board. The reality was that he had neither registered at the medical school nor embarked on any writing projects. His one hope was that Tzara would finally come to Paris, but even this was anything but certain.

It was in the context of this anticipation that Breton met Francis Picabia. Tzara had previously mentioned Picabia in his letters, after the latter's visit to Zurich in January. Excited by Tzara's reports and by Picabia's own activities, Breton decided to contact the painter. On December 11, he sent Picabia his "Why Do You Write?" questionnaire, adding: "For a long time I've been seeking a way of meeting you . . . I love having people tell me about you. You are one of the three or four men whose attitudes I completely endorse, and I would be happy to consider myself your friend." Their first meeting took place on Christmas Day 1919, at the home of Picabia's mistress, Germaine Everling, where he was living after having separated from his wife, the musician Gabrielle Buffet.

At first blush, Picabia seemed an unlikely candidate for Breton's admiration. While the young editors of *Littérature* were flailing to meet personal and operational expenses, and while France was struggling to recover from the war's economic ruin, Picabia devoted a fluctuating personal fortune to indulging his taste for luxury sports cars (127 of them over the next twenty years), travel, and sexual adventure. He had casually sired a son by the estranged Buffet only months before, and was expecting another by Everling in January. Spanish and Cuban on his diplomat father's side, related through his mother to arch-conservative elements of the Parisian bourgeoisie, Picabia had not left behind his family's society entrées by turning to the avant-garde; he'd merely swapped stodgy politicians and business tycoons for influential newspaper editors, arts patrons, and performers. In a later age, the hedonistic painter would have been a model jet-setter.

Although Picabia had initially earned a reputation, and a handsome income, by painting in accepted post-Impressionist style, by 1910 he was experimenting with geometric and mechanical abstractions whose titles endowed the paintings with an overlay

of unsettling humor. When the war broke out, he had first used his father's diplomatic connections to become a general's chauffeur, then, finding even this job too taxing, had himself sent to New York on a vague military mission. While there, he'd become involved with Alfred Stieglitz's Photo-Secession Gallery and contributed to the magazine *291*, named after the gallery's Fifth Avenue address. In early 1917, with numerous poems and mechanical drawings—as well as large quantities of alcohol and opium— behind him, he had moved on to Barcelona and founded a new magazine called *391*, the title a conscious echo of its predecessor. He'd also met Arthur Cravan, whose exploits certainly influenced the magazine's restless tone. Finally, at the end of 1918, Picabia had gone to Switzerland—first to check into a psychiatric clinic, then to visit Tzara in Zurich —before returning to Paris in February. In all of it, he remained true to his inexhaustible need for pleasure and constant change. Challenged about "what he had done during the war," he replied: "I was bored to hell."

But in fact, and despite the surface differences, Picabia's attitudes, his nonchalance and disdain for almost everything, perfectly matched Breton's own outlook at the time. The painter's enormous personal appeal, which he did nothing to restrain, and his talent for stinging satire made most other creative figures seem dim-witted by comparison (which many of them indeed were). His standing in the art world coincided with Breton's developing interest in the newest aesthetic tendencies: following the dictates of his passions and his budget, Breton had slowly begun collecting art, and by this time owned canvases or drawings by his friend Derain, as well as by Marie Laurencin, Modigliani, Soutine, and Chirico. And with his conversational prowess and intellectual nomadism, Picabia flattered his young visitor by making him feel part of a world in which one's own brilliance transcended any personal or philosophical allegiances. Breton came away from their first meeting feeling wildly enthusiastic. Eager to please his new friend, he readily forgot his earlier solicitations of men such as Valéry. "It would be so painful for me if you saw *Littérature*'s orientation as being at all due to ambition," he told Picabia in January. "We only use Gide, Valéry, and a few others in order to compromise them and sow as much confusion as possible."

The pleasure Breton took in Picabia's company seemed to be mutual, and from this point on he began frequenting the painter as often, and as exclusively, as possible—all the more so in that Picabia, with his easy, garrulous charm and profusion of ideas, seemed to be another Apollinaire. Like many a predecessor in Breton's esteem, he even had the authority of age, having been born in 1879, a year before Apollinaire himself. Not everyone was so taken with Picabia's seductive powers: Soupault in particular wrote him off as a "snob." But Breton's enthusiasm went unabated.

Breton's second meeting with the painter, held like the first in Germaine Everling's comfortable apartment on Rue (now Boulevard) Emile-Augier in the 16th arrondissement, took place on January 4, 1920. That evening, Picabia led Breton into his salon, which doubled as the pregnant Everling's bedroom; within minutes the two men were excitedly discussing Nietzsche (one of the few authors Picabia read) and Lautréamont. Meanwhile, in the next room, Everling's own guests suddenly realized that she had gone into labor. One of them went to call the midwife while another ran to inform Picabia—and to free the bedroom—but met with a distracted, "Fine, fine. Leave us alone." Further interruptions merely raised Picabia's ire. Finally, it was only the imminence of the birth itself that dislodged the painter and his guest from their armchairs. "Breton sprang up as if stung by an asp," Everling recalled; "no doubt fearing that he'd have to intervene professionally, he grabbed his hat and, overcoat on his arm, quickly made for the door." Lorenzo Picabia was born within the hour.

Still, Breton's enchantment with Picabia did not dampen his desire to meet Tzara. On the contrary, as announcements of Tzara's arrival became more and more frequent during the first weeks of January, this desire ballooned into an obsession, and Breton, believing each promise to be the real thing, set off to the Gare de Lyon to welcome him. "Now I can write to you, I have no more hope to keep me from doing so . . . We could have used you so badly at the moment," he finally told Tzara on January 14, having vainly run to the station five times in two days.

Breton was not alone in his anticipation. "There were several of us who awaited [Tzara] in Paris as if he had been that savage adolescent [Rimbaud] who fell upon the devastated capital at the time of the Commune," Aragon recalled, translating the legendary status that Tzara had already acquired for the entire group. For his part, Soupault also looked forward to Tzara's arrival as the catalyst for their "terrible wish to destroy."

But Soupault (at least in retrospect) also recognized that he and his friends had hardly prepared an ideal ground for Dada in Paris. Instead of emulating Tzara's brash provocativeness, they were still subject at the time to "a certain shyness . . . and what people, in amazement, called our 'good breeding.'" The fact was, Breton and his companions were doing little to counter this "well-bred" reputation—indeed, they were acting precisely as was expected of ambitious young poet-editors. They continued to publish a magazine that, in both its look and its reception, suggested a fledgling *Nouvelle Revue Française* or *Mercure de France* much more than it did *Dada* or *391*. They held public readings of works in progress, particularly after René Hilsum opened his own bookstore (also called Au Sans Pareil) in January. They even adopted a café as their regular meeting place, in the time-honored tradition of Parisian literary movements past and future.

The café, a working-class Basque bar called the Certa, stood at number 11 of a now demolished gallery called Passage de l'Opéra, just off Boulevard des Italiens. Aragon had discovered it toward the end of 1919, after having been drawn into the gallery's twin corridors by the bookstores at the entrance. Before long, the Certa would become the seat of Dada's Paris branch. Aragon later recalled the establishment's barrel tables and portable gas radiator, its long bar and straw chairs, its dim lighting, and its fanciful assortment of cocktails, including the "Pick Me Hup" and the "Kiss Me Quick."

Having a café headquarters responded to a tendency that was clearly forming in Breton: even as he sought to replace his vanished or exiled mentors, he was adopting their traits. From Reverdy he took a brusque, intimidating style of interrogation, particularly toward newcomers; from Vaché, his dry sarcasm; and with the Certa he now had a place to hold court, like Apollinaire and other literary gurus before him. He even affected a preference for Apollinaire's favorite cocktail, a sweet-and-sour amalgamation called a Picon *citron*.

The Certa and its location presented several advantages. It boasted an attractive and uncommon gallery setting. It was reputed to serve the best port wine in Paris. And, by not figuring on the Montparnasse-Montmartre axis, it defined the *Littérature* group (at least in their own minds) as standing apart from literary trends, and flattered their professed hatred of both these artistic centers. Still, despite the posturing, the rejection of both bourgeois morals and the toothless nonconformism of bohemia, there was little in the group's activities of the time—from magazine editorship to café confabs—that suggested anything other than the standard itinerary of young *littérateurs*.

Among these activities was a series of poetic "matinees" under *Littérature*'s sponsorship: the first was scheduled for Friday, January 23, and was to be held at the Palais des Fêtes on Rue Saint-Martin, a grand affair housing a café, various attractions, a ballroom, and two large cinemas (whose competing orchestras threatened to drown out the readings). In fact, the Palais des Fêtes was the most original aspect of the planned matinee, for the program itself offered little by way of novelty. But this program was to undergo a drastic last-minute change when, after months of prevarication, Tristan Tzara finally decided to show up.

Despite his many hesitations, Tzara was stifling in Switzerland. Dada's patented outrages, and its audience, had been thinning out; its publications only sporadically got through the international mails to the outside world; and the war's end, as well as infight-

ing among the principals, had severely dissipated the group. With Dada withering on the vine, Tzara, careful tender of his avant-garde, opted for a transplant to richer soil.

It was in the spirit of things to come that Tzara, after having falsely promised his arrival (and raised Breton's hopes) so many times in the previous weeks, appeared unannounced and unexpected at Germaine Everling's door on Saturday, January 17, following directions Picabia had given him a full year before. Picabia himself was out, and it was Everling, home alone with her two-week-old infant and the nanny, who received a tattered calling card with letters of almost undecipherable ornateness. The inopportune visitor resisted the nanny's attempts to send him away, and was finally shown into the bedroom.

Tzara, Everling recalled, was

> small, slightly stooped, swinging two short arms at the ends of which hung chubby, but certainly sensitive, hands. His skin was waxy, like a candle: behind his pince-nez, his myopic eyes seemed to be searching for a fixed point on which to alight. He hesitated at the doorway, and mainly seemed very embarrassed to be there . . . Constantly, automatically brushing a long shock of black hair from his forehead, he said in a thick Slavic accent: "I am very sorry to bother you, Madame, but I don't know where to put my bags." . . . I realized that he intended to settle into my home.

Seeing that the Romanian had no money, Everling took pity and invited him to sleep on the salon couch. "After all, it would only be several days' inconvenience!" Tzara then proceeded to fill the rococo-style salon with a voluminous publicity arsenal and an industrial-strength typewriter, which he parked on the Louis XV console. The maid was barred from entering the room—"These things are too important for you to touch!" the guest screeched at her—and within days an avalanche of mail began arriving from around the world. The Picabia-Everling home had suddenly become Dada Central, and once it began operating there was no stopping it: the "several days' inconvenience" lasted for nearly a year.

That same afternoon, Picabia alerted his young friends about the long-awaited event, and several hours later the three musketeers plus Eluard, excited as adolescents about to meet a teen idol, knocked in their turn at Everling's door. Earlier, Breton had received a photo of Tzara's face, but the other aspects of the Dadaist's physique were left to his imagination. Among the traits with which this imagination had endowed Tzara were physical stature and a voice befitting the Herculean accents that emanated from his manifestoes.

But what Breton found was something else again: Tzara was short, swarthy, and myopic. One witness described him as "a young Japanese" with "the look of a night bird startled by daylight." His approximate French, which endowed his poetry with so many provocative illogicalities, in person rattled from his mouth with such speed, and with so strong an accent, that the four young natives could barely understand him. What they *could* understand sounded comic, including his pronunciation of the word "Da-Da" in two short, sharp syllables. His abrupt laugh, which barked out at the slightest provocation, betrayed his discomfort: after an intense, yearlong correspondence, Tzara was as intimidated about meeting Breton and friends as the latter were about meeting him. The result was a full round of awkwardness. Against a background of Tzara's incongruous laughter, Picabia's snickers, and little Lorenzo's squeals from the nursery, the editors of *Littérature* could only gape at the diminutive messiah. They had expected Tzarathustra, not the waxen-faced homunculus now fidgeting before them.

Admiration won out over first impression, however, and the next day the group, plus Tzara, turned its attention back to the "First Friday of *Littérature*" matinee, less than a week away. Breton had originally planned the event as a mix of lectures, music recitals, painting exhibits, and poetry readings—not unlike the matinees of his youth. But Tzara's arrival changed all that. Included in his Zurich baggage was three years' experience in getting the public's attention, not to say its goat. An expert on what audiences loved to hate, he preferred riling them by emitting piercing shrieks, sobs, or whistles; or staging simultaneous readings of several poems at once; or reciting something along the lines of: "*higo bloiko russula huju / hollaka hollala / anlogo bung / blago bung / blago bung . . .*" For Tzara, performance should be as loud as a gun burst, as irritating as a pebble in the shoe. But this master of the shock tactic was himself shocked by the timorousness of *Littérature*'s program.

With only days to go, Tzara set out to transform an ordinary poetry reading into a first stab at provocation. "He told us how . . . one moves people to the point where they forget both themselves and the consequences of their actions," Aragon said. "In Zurich, Tzara had seen people throw their house keys at the stage for lack of better projectiles, even though it meant being locked out of their homes." Caught between an already printed playbill and their sheepishness in the face of Tzara's adventurous designs, the young Frenchmen decided to salvage their show by throwing a single, disruptive event into the otherwise traditional agenda. And what would be more explosive than a surprise appearance by Tzara himself, toward whom the press had been increasingly hostile (and therefore attentive) in recent months?

Having been alerted by an ad in the previous evening's newspaper, the crowd that

arrived at the Palais des Fêtes on the afternoon of January 23 was larger than expected. It included journalists, neighborhood wags out to heckle, assorted artists and writers, a number of local shopkeepers come out of sheer curiosity, and even several elderly financiers, who, lured by the promise of a lecture by Apollinaire's friend André Salmon on "The Crisis of Change," had come expecting to hear about international monetary problems—instead of a presentation about the evolution of poetic values. Breton sat in the ticket booth, collecting the three-franc entry fee—and, soon afterward, reimbursing a number of disgruntled patrons.

After a long delay, the show got off to an unremarkable start with readings of poems by the Apollinaire generation; then some music; then more readings. Although running a temperature, Breton lectured on works by Léger, Gris, Chirico, and others. The fever and his nervousness at standing before an audience combined to give his voice a harsh, staccato quality that might have been provocative, but the public's reaction was stony silence. They became more vocal, however, when he presented a chalk drawing by Picabia with a caption that decoded as "LAUGH IN YOUR FACE." Just as the audience was beginning to get the joke and protest, Breton erased the drawing with a wet sponge. (Picabia himself had orchestrated this move, but, as with many Dada demonstrations to come, he declined to bestow his physical presence.)

But the high point of the afternoon came during the next round of poetry readings, when Aragon began reciting Tzara's "The White Leprous Giant in the Countryside":

> the salt collects in a constellation of birds on the padded tumor
> in his lungs the starfish and bugs sway
> the microbes crystallize into palms of swaying muscles
> good morning without a cigarette tzantzantza ganga
> boozdooc zdooc nfoonfa mbaah nfoonfa . . .

The poem's sheer, unapologetic gibberish immediately stirred the audience to new vocal heights, increased a moment later when Aragon introduced Tristan Tzara himself. Curious, the spectators craned their necks to see a small man rush onstage and launch into a heavily accented reading of an article by arch-conservative journalist Léon Daudet, while Breton and Aragon covered his voice from the wings with loud electric bells. It didn't matter that he was inaudible: the gesture was eloquent in its insolence, and left little doubt as to the note Dada intended to sound.

Unfortunately, the inexperienced organizers had little show-business sense: instead of ending the matinee on that climax, they followed Tzara's appearance with another series

of poem after poem after poem, to what was soon a nearly empty house. By the time it was over, the young impresarios were heartily discouraged. Breton went home with a high fever and spent the next day in bed.

On Saturday evening he accompanied Tzara, Eluard, and Aragon to see the Ballets Russes at the Opéra—hoping, perhaps, that Diaghilev could offer pointers about showmanship. But the ballet was not to their liking, and to make matters worse, a friend of Eluard's, secretary to highly placed police inspector, frantically informed the poet two days later that a sable collar had disappeared from the very box they had occupied and that the inspector had set his sights on Tzara. A worried Eluard told Breton, "Just think, if word of this gets around, with the kinds of things we write that'll be the end. We're finished." Breton, expressing the chasm between himself and Eluard, snapped back, "I'd rather be seen as a thief than a poet." Finally, it was the secretary's skillful defense to the inspector that saved Tzara from prosecution—but not before the newspapers made it into good copy. Dada had come to Paris after all.

Even after the disappointment of the first—and last—"Friday of *Littérature*," the question was not whether to stage another demonstration, but rather when and how. Over discussions held in Picabia's salon or the back room of the Certa, plans were made for a sequel, and the sooner the better. Unlike the matinee, however, this was to be not a hastily redesigned poetry reading but a full-fledged Dada show, of which Tzara would assume the organization. A quick stocktaking of the Paris intellectual scene had convinced him that Breton and friends came the closest to sharing his own viewpoint. Having become a permanent guest at Picabia's, he now seemed ready to settle into *Littérature* as well.

Breton, for one, seemed perfectly eager to let the Dadaist-in-chief do the talking: Tzara's infectious energy and enthusiasm had given him renewed hope in his activities, in addition to which the Romanian had practical experience that Breton and the others obviously lacked. Not quite weaned from their literary past, they had intuited the importance of public action but did not entirely grasp its workings. Breton's theorizing on the advertisement, his plans for a silent coup d'état, even his unveiling of the automatic texts were so many halting first steps down that path; whereas Tzara clearly knew the most direct route to the public's attention. This public aspect was in fact fundamental to Dada. It was not enough to attack what Breton called "the bourgeois moral plan" by traditional polemical means (tracts, manifestoes), although such means were certainly used. Instead, one had to take the battle to the same public stage on which this moral plan operated.

Moreover, if Paris Dada's public stunts had an essentially aesthetic, rather than political, character, it is simply because the group comprised poets and artists, rather than politicians. One need only consider the membership roster that spring: along with Tzara, Picabia, and the *Littérature* faction (Breton, Aragon, Soupault, Eluard, and Fraenkel), there were Paul Dermée and his wife, Céline Arnauld, both poets; the American poet (and later historian) Matthew Josephson; and occasional participants such as the poet-sculptor Hans Arp and the Belgian novelist Clément Pansaers. Or one could look at the spate of Dada periodicals in those early months: *Littérature*, *Dada* in various incarnations, and *391* (along with another Picabia review called *Cannibale*); plus Eluard's *Proverbe*, which specialized in linguistic explorations; Dermée's *Z*; and Arnauld's *Projecteur*—all of them bringing Dada to public attention, as well as promoting its own editor's side during inevitable internecine squabbles. What is remarkable is just how deeply Dada, given the esoteric nature of many of its means, nonetheless managed to penetrate the social consciousness of its time, by dipping its literary spears in a particularly venomous ink.

A notable figure in this regard was Georges Ribemont-Dessaignes. Dada's eldest member after Picabia, the thirty-five-year-old Ribemont-Dessaignes was distinguished by the unmatched violence of his fulminations and the almost offensive baldness of his large pate. Originally a painter, he had started writing during the war, and by 1920 was composing poems, plays, and even music. Like the others, he was starting a magazine: $D^dO^4H^2$, titled after the chemical formula for vitriol. His contact with Tzara dated (as did Breton's) from the previous January; but even before this, his writings had shown a vehemence that was pure Dada. "It has now been proven that the purest way of showing love for thy neighbor is to eat him," he had written in 1917. "No selfishness. The stronger eats the weaker. You are welcome at my table, O my lamb! T'amo, t'amo!"

Dada was not the only avant-garde movement in Paris at the time, of course. Various related tendencies were also showing their dissatisfaction with the artistic, and even social, status quo. The Cubists and Futurists maintained their venerable presence in the French capital, joined since the Russian Revolution by a wave of emigrés bearing Constructivist and Futurist luggage of their own. Over the next two years, there were also sporadic noises from Tactilism, Bruitism, Nunism, and Simultanism, all of them bearing a vague family resemblance to Dada. But when it came to scope, impact, and sheer presence, Dada was indisputably the head of the household.

✳

Dada's next public excursion began at 4:30 P.M. on February 5 at the Grand Palais, as part of the Salon des Indépendants. This time Tzara got to work straightaway on generating publicity. Capitalizing on outraged write-ups from the *Littérature* matinee and the public curiosity they had aroused, he announced in a press release that Charlie Chaplin, then enormously popular in France, had converted to Dada and would appear for the first time "in the flesh" at the Grand Palais demonstration. "You didn't need any more than that to make people storm the box office," as Breton later said: the crowd on February 5, in the hundreds, dwarfed that of two weeks earlier, and was much more animated to boot.

The show featured numerous recitals of Dada manifestoes—previously composed or improvised—in choruses of five or more; as well as a harangue by a certain Monsieur Buisson, the "King of Fakirs," who normally read palms and sold newspapers near the Madeleine church. The "King of Fakirs" was wildly applauded. Not so the manifestoes themselves: the assembled journalists and spectators punctuated the readings with boos, shouts, and sarcasms, which only increased as they began to realize that Charlie Chaplin was nowhere within miles of the Grand Palais or Dada. A painter in the audience continually shouted for Picabia, who had vanished minutes before the Dadaists went onstage, leaving Breton to cover for him.

André Gide later reported from his front-row perch:

> I had hoped to have a better time, and that the Dadas would have taken better advantage of the public's artless amazement. Several stiff, stilted, tongue-tied young men got up on stage; in chorus, they proclaimed some disingenuous excesses . . . From the back of the hall someone cried out, 'Make gestures!'—and everyone laughed; for it indeed seemed that, for fear of compromising themselves, not one of them dared budge.

Less amused was the journalist for *Fantasio*, who demanded to know how "the Dada movement, whose leader, Mr. Tristan Tzara, is not French, gained access to this national monument [the Grand Palais]." For his part, Tzara, who readily defined Dada as "the biggest swindle of the century," found the response quite to his liking. He didn't much care whether the roar of the crowd was fueled by joy or disapproval, as long as there was a roar.

At least one other person was favorably impressed by Dada's way with the masses. Leaving the hall, the Dadaists were approached by a dapper man who invited them to speak at his debate club in two days' time. An ex-Socialist, Léo Poldès had turned a con-

verted chapel near Place de Clichy into a forum for political argument, which generally attracted a left-leaning, mainly working-class, and in any case sizable attendance. He now invited the Dadaists to "explain themselves" at the next session. Although they were not eager to take the stage again on such short notice, the prospect of bringing their message to "the people" was an opportunity these bourgeois rebels could not resist.

So it was that on February 7, Breton, Tzara, Aragon, and Ribemont-Dessaignes stood on the stage of Poldès's Club du Faubourg, before an audience of workers, labor leaders, leftist intellectuals, and minor politicians that topped one thousand. Their demonstration was sandwiched between various political speeches, literary lectures, and a dissertation on Socratic morality by the American aesthete Raymond Duncan (Isadora's brother), wearing his Indian-braided hair and customary white toga. Curious to see these much-decried Dadaists, the crowd began changing, "Da-da! Da-da!"—which itself gave way to laughter when the Dadaists starchily began reading their manifestoes. "We began by provoking the audience's hilarity, and soon the fury of some of its members," Aragon recalled. "Young girls sniggered in the front row, until our insolent stares made them quiet down." Aragon improvised an eloquent harangue against the audience's armchair Socialism, which won him the support of the anarchists in the hall—at least until Breton's recital of Tzara's "Dada Manifesto 1918" ("Ideal, ideal, ideal. Knowledge, knowledge, knowledge. Boomboom, boomboom, boomboom") alienated all factions equally. For the third time in a row, the session ended in confused debates that spilled out into the street; and once again, the *Littérature* group walked away depressed: they had fared no better with the Socialists than with the socialites.

Breton in particular was beginning to suffer an emotional backlash. After his initial hopes for Tzara and Dada, the quick succession of public demonstrations (there were additional ones that month) was yielding rapidly diminishing returns. Worse still, even at this early juncture Dada was showing signs of acceptance. On February 27, in the same hall of the Grand Palais in which the group had delivered its manifestoes merely weeks earlier, actors from the Vieux-Colombier and the stodgy Comédie-Française sagely read Dada poems as part of a lecture on poetry "From Symbolism to Dadaism"!

Nor did anyone seem to know how to get Dada out of its rut. As Breton later explained:

> At first glance, we had apparently obtained the desired effect: conformism was made to look bad, common sense was beside itself, and the press was seething with rage. It might seem that everything was for the best, and yet from within—at least as far as Aragon, Eluard, and I were concerned—the situation was perceived differently.

Of course we exploited, ad nauseam, methods of stupefaction, of "cretinization" in the Maldororian sense of the word; but these were mainly harmless provocations that had been perfected in Zurich or elsewhere. Each time a Dada demonstration was planned—by Tzara, of course, who never tired of them—Picabia gathered us in his salon and *enjoined* us, one after the other, to come up with ideas for it. In the end, the harvest was not very abundant.

Part of the problem was an ambivalence within the Dada group itself: it didn't seem to know whether it was courting all, part, or none of its audience. While there was no disagreement about the need to "astonish the bourgeois," sessions such as the one at the Club du Faubourg had implicitly raised the thornier issue of where Dada stood vis-à-vis the political left. Were they attempting to bond with the working classes, or did they prefer to distance everyone without exception? So far, their actions gave no clear indication.

This ambivalence extended even into their writings. Breton's manifestoes of the time, as compared with Tzara's or Ribemont-Dessaignes's, show just how intellectualized a view he held of the antics he was helping to promote. Statements such as "We pass for poets because we primarily attack language, the worst convention of all" suggest that, if Breton agreed with Tzara and Ribemont in spirit, he was quite removed from them in tone.

Neither the spirit nor the tone of Dada appealed to Marguerite Breton, scandalized by newspaper write-ups that had reached as far as Lorient. On Sunday, March 21, she and her husband knocked unexpectedly on Breton's door at the Hôtel des Grands Hommes. Brandishing the incriminating headlines as if they were People's Exhibit A, Marguerite declared that she would rather have had her son die on the field of honor than disgrace his family like this. She demanded he break off his dubious associations and resume his medical studies in earnest, or else return with them that very evening to make a living in Lorient; if he refused, they would cut off his support. Breton's father, skeptical about his son's future in the Paris literary world but otherwise sympathetic, tried to convince his wife that the boy was simply going through a phase. Breton himself hesitated between filial duty and the pressures of personal conviction.

Soupault, who happened to witness part of the scene, later remembered being struck "by the resemblance between mother and son, while his father gave the impression of being erased. [Marguerite] impressed me as authoritarian and domineering." Cowed, Breton was even on the point of packing his bags, but at the last minute he resolved to stay in Paris after all, declaring to his parents that he would neither enroll in medical school nor give up Dada. A fuming Marguerite and saddened Louis left the big city for home; Breton's financial support ceased that night.

Another unexpected intrusion at around this time proved even more distressing: Breton returned to his hotel one day to find that his occasional lover, the volatile Georgina, in a jealous rage over an imagined infidelity, had entered his room and destroyed everything she could find, including letters, inscribed books, and valuable paintings. If Breton's relationship with Georgina had been indecisive, not so its ending: the two never saw each other again.

✳

The break with both medicine and his family left Breton—or at least so he claimed—in a state of "great exaltation," like a "crisis I passed through." Louis Breton did not intend to leave things there, however, and wrote to Paul Valéry immediately on his return, asking his son's former mentor to make Breton see reason. Valéry did talk to his young protégé, criticizing his current frequentations and—with good paternal advice of his own—stressing that a diploma was a practical necessity in these uncertain times. But the poet's waning influence and unwelcome advice could not prevail against Tzara's much more attractive reassurances that Breton would get by, and Valéry was forced to tell Louis that his son's "indifference or lifelessness with regard to everything" left him impervious to argument. He recommended parental tolerance, and meanwhile offered to help Breton find a job.

Several days later, through Valéry's intercession, Gaston Gallimard hired Breton as an assistant at his publishing firm. Breton would earn 400 francs per month for various administrative tasks, including handling correspondence and sending copies of *La Nouvelle Revue Française* (the same *NRF* at which *Littérature* was still taking potshots) to subscribers. "It will not be enjoyable work," Gallimard warned the young man on March 29, during his first visit to the editorial offices on Rue Madame. But with monthly expenses averaging 600 francs, Breton was glad to accept.

Breton also received 50 francs per session for helping Marcel Proust correct proofs of *The Guermantes Way*, which Gallimard was about to publish. The job consisted of reading the galleys aloud—galleys that, "owing to constant, handwritten insertions and corrections, had . . . the appearance of a labyrinth"—so that the novelist could then make further alterations. Although Breton had little taste for Proust's convoluted syntax and psychological (not to say social) concerns, he kept a fond memory of working for the writer. For one thing, despite their aesthetic differences, he came to appreciate certain "poetic treasures" in Proust's work. For another, Proust himself was extremely courteous, and affably welcomed his young helpmeet to the heavily carpeted apartment at 44

Rue Hamelin, near Place de l'Etoile. As Proust worked only at night, Breton's hours ran from about eleven o'clock through the early morning. Ever the gracious host, Proust for their first session had a sumptuous *souper* from the Ritz wheeled in at midnight; Breton, who had eaten a full dinner shortly before, was forced to do honor to the feast, while the other contented himself with *café au lait*. The young man quickly learned to dispense with dinner before going to Rue Hamelin. Whatever their personal sympathy, in the end Proust the perfectionist was not well served by the impatient Breton: when *The Guermantes Way* was published later that year, the mortified novelist had to draw up an errata list with over two hundred missed corrections.

For his part, Breton was producing little. In the early months of 1920, his only contributions to *Littérature* were a few short automatic texts. His one new composition of note was a semi-automatic play in four acts called *If You Please*, which he had written with Soupault in mid-January—that is, before Tzara's arrival. The play borrowed its form and many of its motifs from standard drawing-room or boulevard comedy, even if the dialogues themselves were not quite the usual fare. The first act, for example, presents a love triangle between the young Valentine, her husband, François, and her older lover, Paul (whose age and physical description are not unlike a certain "Mister V"); the protagonists mainly indulge in long conversations on the nature of friendship and love—ending when Paul calmly shoots Valentine dead. Act Three, which stages the pickup of a prostitute in a bar, also draws heavily on its theatrical precedessors.

The second act, however, moves along different lines. A parody detective story, it features a certain Létoile, a private detective "who maintained his authority with curious ferocity," said co-author Soupault. The part was written (and eventually acted) by Breton, who visibly attached great importance to him. Indeed, the cruel, sharp-witted, thoroughly unsentimental Létoile is a kind of Bretonian ideal self, as filtered through memories of Jacques Vaché. He has no qualms about using company time and resources for his personal benefit, cows his male clients and reduces the women to tears, and has two charity matrons arrested for theft. Visitors to his office who choke on his cigar smoke are bluntly told, "The smoke doesn't bother you." When finally the police come to arrest him, he answers, "What should that matter to me?" If the first and third acts extend Breton's and Soupault's variations on the automatic dialogue, the second is a clear homage to Dada's (and Vaché's) phlegmatic aggressiveness.

More important, the act foreshadows the specifically Surrealist ethic of "availability," or receptiveness to chance. "It happens from time to time," Létoile muses, "that I pace up and down for hours between two houses or four trees in a square. The passersby smile at my impatience, but I'm not waiting for anyone." Breton later cited this statement to

note: "It's positively true that he's not waiting for anyone, since he hasn't made any appointments. But, by the very fact of adopting this ultra-receptive posture, he intends to help chance—how should I say it—he means to put himself in a state of grace with chance, in such a way that something *will* happen, that someone *will* show up."

Breton was himself quite familiar with this "ultra-receptive posture." He recounted that, during this period, he was in the habit each night of leaving his hotel door ajar "in hopes of finally waking beside a companion I hadn't chosen." There is no record of a phantom companion having obliged the young man during his stay on Place du Panthéon; but the musings of private detective Létoile, perhaps composed after a night spent waiting in vain, show that the preoccupation was especially present in his mind.

The second act of *If You Please* was on the program of the next Dada spectacle, held at 8:30 P.M. on Saturday, March 27, at Aurélien-Marie Lugné-Poe's Théâtre de la Maison de l'Œuvre (where Jarry's *Ubu Roi* had debuted in 1896). To help ensure a good turnout, the Dadaists had both stepped up their publicity campaign and broadened their objectives. "The evening will be UNIQUE," Paul Eluard promised potential subscribers. "We'll reimburse anyone who gets bored." Said Soupault, "We were determined to spare no one this time, not even those we had initially admired and respected."

In many ways, the March 27 performance was much more ambitious than any of its predecessors. For one thing, the group had taken pains to vary the show as much as possible. Along with the usual readings and manifestoes, the evening included a piano piece by Ribemont-Dessaignes, composed of random notes and covered over by various noises, many of them coming from the audience; the "Latest Dada Fashions," modeled by Breton's cinema idol, Musidora; and various plays and sketches. But the performance was not only "better theatre"; it also raised the tone of its provocation. Picabia's "Manifeste cannibale," read effectively by Breton to a darkened house, poked savage fun at patriotic exhortations (a sensitive topic immediately after a war), while Ribemont-Dessaignes's "Manifeste à l'huile" [Manifesto with Oil] concluded with the lines: "What is beautiful? What is ugly? What is tall, strong, weak? . . . Don't know. What am I? Don't know. Don't know, don't know, don't know."

By the end, public and performers were shouting insults at each other, although even this seemed part of the show. "No 'artistic' endeavor, not even the most audacious, could ever have released such a tumult," one critic wrote. "The public booed, whistled, scoffed at the Dadas, who greeted their insults with bright faces. One would have thought he was among madmen . . . The Dadas exasperated their spectators and I think that is all they desired." Indeed, the only ones disappointed appeared to be Breton and his friends, who deplored "the pitiful carnival ruses [they had] needed in order to attract the public."

For this public, perhaps the greatest "carnival ruse" of all was that Dada's very destructiveness could be turned inward, in perpetual flirtation with suicide. "Dada, after having again attracted the attention of the whole world to *death*, to its constant presence among us, works by destroying more and more, not by extension but in itself," Tzara later noted. In some instances this death-wish was made explicit, as in Tzara's call for universal "decomposition" or Breton's arrival onstage at one of the concerts with two revolvers strapped to his temples; at other times, it was symbolized by Dada's willful deconstruction of linguistic or aesthetic convention.

The problem was, Dada promised more than it delivered: Breton's pistols never fired, and the universe remained composed. Dada had invited the public to a kind of ritual suicide; then, once this public was straining in anticipation of the repulsive idea, Dada laughed in its face and skittered away to something else. (Jean Cocteau, an attentive Dada watcher, noted this *teasing* aspect of the concerts when he complained, "No Dada dares to commit suicide, or kill a spectator. We are given *plays* to see, *music* to hear.") Tzara, for his part, was perfectly content to keep these suicides on the symbolic level, so long as audiences kept paying to see them. But Breton had something else in mind.

This "something else" surfaced several weeks after the Maison de l'Œuvre performance, and centered on the as yet unfinished *If You Please*. Although the play had been conceived as having four acts, to date the last one still had not been written. As Aragon later recounted: "Philippe and André meant to take that conclusion beyond anything they had yet imagined . . . The climax of the play had to implicate its authors." The nature of this conclusion, they finally confided to their friend, would be a one-time performance of the "fourth act" in which one of the two authors, picked at random, would blow his brains out onstage.

The project was soon quietly abandoned. When the play was published in the September issue of *Littérature*, it featured the coda: "The authors of IF YOU PLEASE prefer that the text of Act Four not be printed." A brief fourth act *was* included in a later reprinting of the play, in which disgruntled spectators leave the auditorium while grumbling, "Is that it? I don't understand. This is ridiculous," etc.—reportedly the precise utterances that greeted the performance at the Maison de l'Œuvre. Nonetheless, for several weeks, Aragon lived in the fear that, from one day to the next, one of his dearest friendships could end in suicide.

<div align="center">✳</div>

Barely two months after its arrival in Paris, Dada was losing steam. The problems fac-

ing it were manifold: the constant need for new gimmicks was beginning to tax even the most committed participants; the pressures of performance were creating animosities within the group; the public at large, all the while reacting to Dada with shock and outrage, was settling comfortably into that very outrage; and the newspapers devoted their columns to flinging invective or keeping score of Dada's changing roster, rather than trying to understand what the movement was about—if anything. The whole network of misread alliances, crisscrossed references, accusations, and insults conspired to produce a climate of muddled brouhaha that served the Dada publicity machine but obscured any larger purpose, such as the group's attempts through shock value to make bourgeois society take a hard look at itself. Thanks to Dada, society was howling in laughter or in anger, but not indulging in much self-examination.

Meanwhile, tensions were spawning different camps among the participants themselves. One early sign of dissent came that spring, when Tzara received an anonymous letter so viciously personal that it seemed the author could only have been one of the Dadas. Suspicion fell first on Eluard because of a similarity in handwriting; then on Pierre Reverdy, who was treated to insults in *391* and an interrogation by Picabia and Breton; then in turn on Soupault, Fraenkel, Paul Dermée, Breton, Picabia, and even Tzara himself, before the would-be vigilantes finally gave up.

The importance of this incident lies not in the identity of the perpetrator—which was never established—but in the different reactions it provoked. It soon became clear that the Picabia-Tzara faction enjoyed (and possibly even instigated) the atmosphere of suspicion and distrust, while the *Littérature* group was troubled by such discord in the ranks. Even within the context of Dadaist decomposition, Breton expected such values as respect and friendship to survive—at least toward those few deemed worthy of them. What he failed to realize was that Tzara, who had earned his respect largely through flouting these very values, was hardly bound to make an exception for him.

Even as cracks began appearing in the Dadaist alliance, the group received its first attacks in the press that were more reasoned than visceral—and therefore more disturbing. On April 1 appeared an article by André Gide in *La Nouvelle Revue Française*, in which condescension rubbed shoulders with anti-Semitism, and in which Gide demonstrated a worrisome shrewdness about his subject. "The great misfortune for the inventor of Dada is that the movement he set in motion is knocking him aside, and that he himself is being crushed by his machine," he began. "They tell me he's a foreigner.—I can easily believe it. A Jew.—You took the words out of my mouth." What made the piece so insidious was that Gide appeared to be explaining Dada from within Dada itself: he praised the movement as "a demolition enterprise," set it apart from artistic schools,

and granted that the French language indeed warranted a good shaking-up. Only at the end did he slyly undercut his applause by drawing a distinction between Dada as a group and several of its members. "I hope," he concluded, "that in this cask the best wine of youth will soon begin feeling a bit confined." In one stroke, Gide had managed both to praise the talents of "the best wine of youth" (read: the specifically French vintage of *NRF* intimates Breton and Aragon) and to dismiss "the mediocrities" (notably the "foreigners" Tzara and Picabia) as having shot their bolt. Picabia, himself a past master of the underhanded compliment, had no trouble seeing between the lines. "Reading Gide aloud for ten minutes will give you bad breath," he retorted.

Also on April 1, the arts and entertainment daily *Comœdia* published a violent critique of the Maison de l'Œuvre demonstration by novelist Rachilde. The sixty-year-old Rachilde (born Marguerite Eymery) was by this time a widely renowned literary figure—or "man of letters," as her calling card said. She had penned numerous books and copious articles for the well-established *Mercure de France*, to which she had privileged access through her husband, Alfred Valette, the *Mercure*'s publisher. Although once a champion of feminism and devoted sponsor of Alfred Jarry, Rachilde had since aged into a staunch nationalist, portly and masculine-featured, who now went after Dada like a literary Carrie Nation.

Basing her allegations on the letterhead of the "MoUvEmEnT DADA" (as it was printed), which gave Berlin as one of its six addresses and advertised "consultations" for ten francs, Rachilde accused Dada both of mercantilism and of being a German plot to "undermine French art"; she called on her readers to greet Dada's irreverent high jinks with the "silent smile" of neglect. In response, Breton pointed out that every innovative artistic movement had had to suffer the same brand of distrust. "It is certain that we are 'running toward death' like everyone else," he concluded, "but we are lucky enough to be the last ones out of the gate." The letter was signed, "André Breton, Editor of *Littérature*, Dadaist periodical."

Breton's defense of Dada and its participants was the fruit of complex motivations. In part it reflected his intense loyalty toward those who had inspired his enthusiasm; whatever his reservations about Dada's methods, he still sided with Picabia and Tzara. In addition, his nascent doubts about the ultimate value of the Dada spectacles did not diminish his faith in Dada itself. On top of which, Dada was practically everything Breton had at this time. With no lover, no friends outside the group, no family ties, no writing projects, no professional activity save his uninspiring job at Gallimard, and only a squalid hotel room to return to at night, the daily meetings at the Certa and resulting demonstrations were his only form of human or intellectual contact. Not only was he the

most assiduous attendant, but he also began chiding others for not showing the same consistency. Breton "often reproached us for our infidelities," said Soupault. It was indicative of a basic divergence: Tzara had always considered Dada a loose association, without formal membership or leaders. But Breton wanted a tightly knit group, bound by a passionate commitment to a defined set of principles.

Ironically, one effect of Breton's absorption in Dada was to encourage its dispersion. Some simply drifted away, finding it tiring to live in such close contact. Picabia himself showed up less and less often at the planning sessions, put off by Breton's gravity and the Certa's working-class atmosphere. And Tzara, who wished neither to cède control nor to endow Dada with greater "significance," countered Breton's all too constructive critiques with a wall of boredom, perking up only when it was time to plan another demonstration.

The next of these demonstrations was scheduled for May 26. Although two full months had passed since the last one at the Maison de l'Œuvre, the program showed little development over its predecessor. If anything, the improvements had to do with the publicity flyers, which were soon pasted on everything from kiosks to public toilets. In expectation of the larger crowds this publicity was meant to draw, the Dadaists rented the large, plush Salle Gaveau on Rue La Boétie, in a quarter much more accustomed to overpriced jewelers' shops than to the unwashed avant-garde. Normally reserved for large-scale classical music concerts, the hall was almost taken away at the last moment when its owner, Etienne Gaveau, having seen a program that promised (among other things) that "all the Dadas will have their heads shaved onstage," wrote to Picabia that the show was not suitable for "the audiences who frequent our establishment, who are, as you know, socially acceptable." Picabia reassured the nervous theater owner, and five days later the "Dada Festival" began, as announced, at three o'clock.

For two hours, the packed house traded insults and jibes with the handful of young men and women onstage, even as the latter presented its usual array of manifestoes and music recitals, plays and sketches, provocations and prevarications. Breton, in eyeglasses and stiff collar, read a manifesto while sandwiched between two boards bearing a large bull's-eye and the slogan: "Before you can love something, you have to have SEEN and HEARD it for a LONG TIME you bunch of IDIOTS" (signed Francis Picabia). He also played the part of "Umbrella" in a second automatic play he had written with Soupault, *Vous m'oublierez* [You'll Forget Me], opposite Soupault (as "Sewing Machine"—the roles were inspired by *Maldoror*'s famous simile), a bewigged Eluard (as "House Dress"), and Fraenkel ("A Stranger"). Other highlights included the "sex of Dada," an enormous white paper phallus (as if it were ever in doubt), which began to wilt in the heat of the

auditorium; a manifesto that advised the public to "Punch yourselves in the face and drop dead"; and Tzara's "Vaseline symphonique," a "kind of 'symphony' on a rising scale, whose only lyrics were: 'Cra . . . cra . . . cra . . . Cree . . . cree . . . cree . . .' Breton, his nerves on edge, couldn't stand more than five minutes of these repeated onomatopoeias. He retreated to the next room, grinding his teeth!"

He was not alone. The audience chanted "get the hair clippers" throughout most of the performance (although, needless to say, the Dadas finished the show with manes intact) and began pelting the stage with coins, rotten eggs, vegetables, and even, according to some, steaks and cutlets. Picabia, as was his wont, watched from a private box, in the company of the popular opera singer Marthe Chénal.

As usual, the one who walked away most satisfied was Tzara, delighted that Paris audiences were still shouting—and filling the house. In a bare four months, and largely thanks to him, Dada had made good its own slogan: "Ignorance of Dada is no excuse." Cabarets inserted "Dada skits" into their shows, popular songs satirized Dada, and the press spilled as much ink "boycotting" Dada as it had reviling it. Eluard summed up the situation that May: "If one must speak of Dada, then one must speak of Dada. And if one must not speak of Dada, then one must still speak of Dada." In Tzara's view, that was plenty for one season.

Four days after the Salle Gaveau festival, Au Sans Pareil published *The Magnetic Fields* in a first printing of 796 copies, with pen-and-ink portraits of the authors by Picabia. Although the work in book form garnered more notice than had the excerpts in *Littérature*, it hardly caused the sensation Breton originally anticipated, nor was it a commercial success: three years later, it still hadn't sold out.

On the critical level, however, *The Magnetic Fields* generally enjoyed a favorable welcome. While some reviewers evidenced sarcasm or frustrated confusion, a number of others found much to praise. Edmond Jaloux in *L'Eclair* dubbed it "the best book to come out of the current movement" and compared it to Rimbaud's *Illuminations*. And the chronically ambivalent Rachilde penned an inane note in *Le Mercure de France* that extolled the book's very "incomprehensibility." One critique, however, stood out for its perceptiveness. Paul Neuhuys, writing in the Belgian quarterly *Ca Ira*, noted that "André Breton is no longer drawn to anything. Words are rusted and objects have lost all power of attraction over him."

Indeed, the experience of *The Magnetic Fields*—and even more so, the shock of the

Dada demonstrations—seemed for the moment to have weakened Breton's interest in the written word. Apart from the two automatic plays and a few brief manifestoes, practically his only texts that spring were "PSTT," a reproduction of the "Breton" listings in the Paris phone directory; and "Counterfeit Coin," a calligrammatic reworking of one of his own 1914 stanzas:

> From the vase of crystal made in Bohemia
> From the vase of cry
> From the vase of cry
> From the vase of
> Of crystal
> From the vase of crystal made in Bohemia
> Bohemia
> Bohemia
> Of crystal made in Bohemia
> Bohemia
> Bohemia
> Bohemia
> Hemia hemia yes Bohemia . . . [etc.]

Still, in the summer of 1920 Breton was interested less in Dada's effect on his poetry than in its larger subversive potential—a potential that, as Dada became the press's favorite joke, he felt he was the only one to recognize. After the Salle Gaveau festival, he withdrew into sullen disappointment, feeling that Dada was being played for cheap laughs even by its own members. He temporarily stopped seeing his friends, which, along with his dour mood, alienated him from the others. And most alienated of all was Breton's onetime soul mate, Picabia.

Picabia in recent months had come to resent Breton's serious take on Dada's thunderclap of laughter. Used to being a mentor in his own right, he also distrusted what he saw as Breton's tendency toward domination. Finally, he disliked Breton's relations with the Gallimard literary establishment—for although *Littérature* had never spared the *NRF* its poisoned darts, the talent that Breton and Aragon in particular put into lampooning it only heightened their profile with the prestigious review. In June, Breton had gone from being a simple administrative assistant to one of the magazine's contributors, when Jacques Rivière published his article on *Maldoror*. Rivière had also asked Breton for a piece on Dada. To Picabia, it clearly seemed that Breton was playing both sides of the fence.

Breton, however, didn't notice—or claimed not to notice—Picabia's growing annoyance, and when the painter finally vented his anger he responded with shocked self-justification: "My 'closest' friends, who aren't necessarily the best ones, know that on the days when I'm saddest I prefer to keep to myself and they leave me alone," he wrote on June 19. "I sometimes need enormous credit; why are you denying me yours?" But Picabia remained unmoved, and to Tzara, who had returned to Zurich for the summer, he angrily charged that "*Littérature is playing us for fools* . . . Breton is an out-and-out hypocrite and his two little pals think as he does that you can change friends as easily as you change boots."

Unable to resolve the contradiction of his twin allegiances, and in any event hardly committed to his duties, Breton abruptly quit his job at Gallimard on July 23 and returned to Lorient, where his parents welcomed the prodigal son. He was anxious not to break ties with Picabia, both because the painter was an important figure in the art world and because Breton, despite their differences, still liked him. On the 28th he again tried to justify his recent behavior: "You know better than anyone how bored I was at the *Nouvelle Revue Française*. I ended up wearying my friends, yourself included, with the ways I was acting: it couldn't go on."

But Picabia's distrust was not entirely unfounded, for even as Breton wooed the Dada painter, he took care not to burn the bridges that led back to Gallimard's prestigious offices. On the same July 28, he wrote to Jean Paulhan, now general secretary of the *NRF*, excusing himself for his sudden departure, which he blamed on physical and mental ill health. He also wrote to Rivière himself, in an attempt to smooth over any ruffled feelings caused by his desertion. For his part, Rivière suggested several article topics for Breton to consider. The bridges remained intact.

All the more so in that the August issue of the *NRF* contained Breton's essay "For Dada." Although intended as a response to attacks against the movement—from the most obvious to the subtler, Gidean variety—"For Dada" mainly highlighted what separated Breton from his comrades. Breton defended Dada's absurdist stance, but bent it to a positivism that Tzara and Picabia would never have countenanced: "When will arbitrariness be granted the place it deserves *in the creation of works or ideas?*" he asked. He admiringly cited passages by those whom Gide had dismissed as "mediocrities," but advanced Jacques Vaché as the first true Dadaist, someone who was "verifying [Dada's] principle tenets" by the time Tzara drafted his famous manifesto. And if Breton extolled Dada's will "to deny the outside world," it was because this denial might lead to "a revision of moral values"—not the values of the common herd, perhaps, but values nonetheless. It was also in this essay, ostensibly written "For Dada," that Breton first publicly

used the word "Surrealist" to describe spontaneous literary creation. In almost every respect, the piece betrayed an ambivalence about Dada, a will to pull it in a direction Tzara had never intended.

Both Breton's article and (even more so) Rivière's sympathetic, Breton-biased companion piece, "Reconnaissance à Dada" [Thanks Be to Dada], left Tzara and Picabia "hardly satisfied"; but unlike similar pieces in the spring, they elicited no energetic response from the Dadaists at large. Breton himself struck a supercilious pose, at least to others: "Don't hesitate to say how little you think of my *NRF* article and Rivière's," he told Picabia. To Rivière himself, however, he expressed his own thanks, in terms that ensured his future appearances in the *NRF*'s pages.

Meanwhile, the lazy summer ran its course: with Aragon in the Côtes-du-Nord, Tzara en route to the Balkans via Zurich, and Picabia mainly preoccupied with a book he was writing, Dada, like the rest of France, was on vacation. Breton himself took some badly needed rest on the coast of Brittany. "Absurd as this sea, this sun, this harvest, this idleness, this house, this family might be, I'm recovering a little in Brittany," he admitted to Picabia. The less defensive tone of his letters reflected the calming of his nerves.

Breton's leavened mood that summer was due both to the relaxation and to the presence in his life of a young woman named Simone Kahn. He had met her in late June, while strolling in the Luxembourg Gardens with Théodore Fraenkel and Fraenkel's fiancée, Bianca Maclès (both close friends of Simone's). To Breton's amazement, Simone's first words to him had been a bluntly negative appreciation of Dada. As she later described the meeting:

> It was very sunny in the Luxembourg Gardens when I met the three friends. Breton was a slightly thin and pallid young man, who maintained a certain elegance despite his poverty. He already had that leonine look that contributed to his legend . . . "I'm not a Dadaist, you know," I told him straightaway, after introductions were made. "Neither am I," he answered, with that smile he kept his entire life whenever he had reservations about one of his doctrinal stances. After that, the conversation took off on subjects we both held dear.

Simone had in fact seen Breton in performance at the Salle Gaveau, but this did little to raise his standing in her eyes; she told her cousin Denise Kahn that the show demonstrated "a vulgarity and a poverty that render each other inexcusable." Breton in person was another matter, however, and she agreed to meet him several times over the next month.

A charming and lively brunette, pretty in the style of the 1920s, the twenty-three-

year-old Simone Kahn was as spirited a companion as Breton could have desired. She was born on May 3, 1897, in Iquitos, Peru. Her family, upper-middle-class Alsatian Jews, had prospered in rubber exploitation in Latin America before returning to France to invest their fortune. Simone had spent most of her childhood in Paris, attending prestigious schools and developing what the French call *une belle culture* in philosophy and literature, which she now studied at the Sorbonne. Two years before meeting Breton, she had lost a fiancé to the nearly finished war.

After Breton had left for Lorient in July, Simone described him to her cousin as having "the very special personality of a poet, in love with the rare and the impossible, just the right amount of imbalance, contained by an intelligence that is precise even in unconsciousness, penetrating, with an absolute originality that has not been ruined by a fine literary, philosophical, and scientific education. Great simplicity and sincerity, even in contradiction." Breton, for his part, saw Simone as a light illuminating the "black abyss" into which, as he wrote Paul Valéry on August 5, he was once more on the verge of falling. By month's end, he could already speak to her of "the influence that you are beginning to exert over me. Just think that I personified doubt, in the days when I first met you . . . For several weeks, thanks to you, I've been living on hope and the promise of a cure."

Throughout August and September, Breton wrote to Simone almost daily, sometimes several times a day, on matters ranging from literary tastes to observations concerning Dada, the practice of criticism ("I count myself among the disciples of the man who said: 'Criticism will be love, or will not be at all'"), and the doings of his friends. Mainly, however, the letters were an extended and diffuse exploration of himself, an attempt both to introduce the person he was and to take stock of the previous months' upheaval. "Whatever you might continue to think," he told her on August 19, "I'm speaking to you about myself and myself alone: this letter is about my taste for innocence, nothing more." As had Fraenkel seven years before, Simone provided both a mirror and the comforting certainty of an "elsewhere" that sustained Breton even as he prolonged his retreat in the family home. And more than this, she opened Breton to himself, made him drop the guard he seemed to maintain even in his most affectionate missives. Few of Breton's correspondents, even among his closest friends, would ever hear the intimate accents that marked his letters to Simone.

These accents, moreover, were not uniformly love-struck, for the letters also give a portrait of a young man alternately dazzled and frightened by his passion, prone to lengthy introspection, insecure about Simone's own feelings, and more than a little pessimistic about the possibility of love in general. Anxious for external proofs of his beloved's affection, he occasionally chided her for the infrequency of her letters to him.

Simone, more straightforwardly romantic than her suitor, found his missives too cerebral for her taste; she admonished him in return to be a little less tortured, a little more loving.

Breton's attachment to Simone was further enhanced by his visit to her in mid-September, in the town of Sarreguemines on the German border, where Simone was staying with her cousin Denise. For several days he enjoyed an atmosphere of "diffuse tenderness, poetic exuberance, and clarity"; he read Lautréamont to the two young women and discoursed on modern poetry, with such sensitivity and conviction that both of them were captivated. By the time Breton returned to Lorient, he and Simone were engaged to be married. "Simone, days such as the ones I have just lived open such perspectives that it would be a crime to speak of them . . . To say just how much I'm no longer the same person is almost impermissible. Nothing of what I was remains. There are only suns," he wrote her after his return.

But Breton's obstacles were far from conquered. For one thing, Simone herself, more levelheaded than Breton, questioned the firmness of his sudden resolution. "I work by instinct," he immediately wrote back, "I've already told you that many times." Breton's parents, too, expressed doubts about the seriousness of their son's intentions, which were only exacerbated by his refusal to answer any of their queries about the marriage, and which probably masked a certain distaste (at least on arch-Catholic Marguerite's side) at the thought of their boy bringing home a Jewish bride. Moreover, there was a very real class difference between the Breton-Le Gouguès clan and the *haut-bourgeois* Kahns. As to the latter, Félix Kahn did not look favorably upon a future son-in-law who had no prospects to speak of, did not seem interested in obtaining any, and perhaps worst of all was gaining a reputation as an anarchistic young punk. But Breton was determined, and even promised to return to medical school if Simone wished—although in practically the same breath he questioned the value of such "heroism."

To make matters worse, he had just been refused a 12,000-franc Blumenthal Prize. Founded by a Francophilic rich American, the prize was meant to encourage a promising young French writer. But although Breton had been nominated by Valéry and seconded by Proust and Gide, the jury shied away from his Dada associations, fearing that such a choice would offend their American patron. Instead, the prize—by a coincidence that would have made Jacques Vaché snicker—went to Breton's old "alter ego" André Salmon. The jury needn't have worried. Even as they were passing over his candidacy, Breton was writing to Jacques Rivière that he was undergoing "a complete revision of his ideas." At that moment he was anything but the snarling iconoclast that delicate French juries and American patrons imagined.

The shadow of stability was in fact settling over much of Dada: Soupault had mar-

ried Suzanne ("Mick") Verneuil in late 1918; Aragon was diligently pursuing his medical studies; Fraenkel was pursuing *his* medical degree and would soon wed Bianca Maclès. Dada, in the warm air of summer, was looking unseasonably mild.

✳

Back in Paris by October, Breton began looking for an income and, to economize, moved into Soupault's apartment on the Ile Saint-Louis, a quaint seventeenth-century enclave that lent an ironic twist to Tzara's claim: "Dada is not modern." Almost immediately he began envisioning a resurgence of Dada activity (apparently forgetting his distance of the summer), and tried in particular to renew his ties with Tzara, who was also returning from summer holidays. "I've learned with great emotion about your return, which I no longer dared hope for," Breton wrote the Romanian on October 14. "They told me this morning that you're here. Am I to think you won't come see me?" To excuse his recent silence, he pled "a love affair [that] recently caught me unawares in the middle of my most laudable attempts to bring peace into my life," and begged Tzara not to see him as "duplicitous," despite appearances. But Tzara remained inaccessible regardless of Breton's entreaties, and it was several months before the two men saw each other again.

Tzara also declined Breton's invitation to attend a meeting on October 19—not surprisingly, as it had less to do with Dada proper than with another concern of Breton's: the future of *Littérature*. While the magazine had been tending to publish fewer established writers and more of the younger generation (due in part to competition from the *NRF*), it still looked like a standard literary monthly. The October 19 meeting was an attempt to address that problem. In a restaurant near the Opéra, Breton, Aragon, Aragon's friend Pierre Drieu la Rochelle, Eluard, and Hilsum resolved that politics, current affairs, and "sexual issues" would henceforth have a place in the magazine; and, perhaps more notably, that poetry (in the literary sense) would not—all in an attempt to make *Littérature*, as a promotional note put it, "the 'NOVELTY' so eagerly awaited since the war."

But even as Breton was steering *Littérature* in a direction more to his liking, Dada seemed to be actively courting his disapproval. On the evening of December 9, Jacques Povolozky's small art gallery on Rue Bonaparte hosted the opening of an exhibit of Picabia's paintings. Since the summer, Picabia had moved closer to Tzara and, if anything, further away from the *Littérature* group. Now, as if specifically to rile the aesthetic puritanism of Breton and his circle, the painter staged a gallery opening that was one part Dada demonstration and three parts society cocktail party. A crowd that included

minor royalty, prominent politicians, and various habitués of the art-and-whiskey scene crowded into the small gallery. Perhaps worst of all, Picabia had invited Jean Cocteau and members of his musical confederacy, "Les Six," to play jazz in the background: while Georges Auric and Francis Poulenc tickled keyboards, Cocteau, sporting a stovepipe hat, flailed at an outsized drum kit. It was indeed, as Cocteau's biographer Francis Steegmuller called it, "Dada-in-a-dinner-jacket for the carriage trade."

Adding insult to injury was the fact that Cocteau's band was called upon to participate in the only truly "Dadaist" portion of the evening, Tzara's reading of his "Dada Manifesto on Feeble Love and Bitter Love." The manifesto—which included such oft-quoted lines as "Thought is made in the mouth" and "Dada is the dictatorship of the spirit," as well as the celebrated recipe "to make a Dadaist poem"*—was divided into sixteen cantos, each ending with a variation on the line "I consider myself very likeable," at which point the "jazz band" broke into a frenetic musical interlude. Despite the importance of Tzara's sentences (and the fact that Breton would later cite them as some of Dada's highest achievements), the *Littérature* gang was too disgusted at the sight of Tzara collaborating with Cocteau, as well as of Picabia playing host in a tuxedo, to appreciate them. Tzara's manifesto ended on the word "howl," repeated two hundred times; the three musketeers took the cue to howl "Pitiful!" and "Idiotic!" before storming out.

For Breton, the Povolozky exhibit was one more painful reminder of his earlier disgruntlement with Dada. He began to look more and more skeptically upon Tzara's and Picabia's initiatives, frustrated that the movement was being irrevocably compromised by pointless buffoonery. Still, there was little he could do about it. Not only were his views unpopular outside the *Littérature* faction, but he lacked the time and money to devote himself fully to Dada's activities. His courtship of Simone required both his attention and funds he didn't have; whereas his early Dada activities had supported first by his unwitting parents, then by his chores for Gallimard. At a time when he was expected to provide the wherewithal for a marriage, he found it all he could do to survive.

With no steady employment, Breton spent the fall living off a patchwork of small jobs, including reading to the poor-sighted Jeanne Tachard, owner of the prestigious Suzanne Talbot fashion house; and editing an ill-fated "anthology of younger poets" for

* "Take a newspaper. Take some scissors. Choose from this paper an article of the length you want to make your poem. Cut out the article. Next carefully cut out each of the words that makes up this article and put them all in a bag. Shake gently. Next take out each cutting one after the other. Copy conscientiously in the order in which they left the bag. The poem will resemble you. And there you are—an infinitely original author of charming sensibility, even though unappreciated by the vulgar herd."

the Crès publishing firm—at least until the Comtesse Anna de Noailles, rightly fearing that Breton would make little room for her mediocre versifying, had him fired. These minor incomes, such as they were, covered Breton's daily expenses, and even allowed him to leave Soupault's and take a room at the Hôtel des Ecoles on Rue Delambre. But they were hardly sufficient to support a rich man's daughter, dazzled though she might have been by his spiritual qualities.

It was only at the end of the year that Breton's finances took a turn for the better, when Mme. Tachard introduced him to the *haute couturier* and self-styled arts patron Jacques Doucet. The sixty-seven-year-old Doucet was, after Coco Chanel and Paul Poiret, the most successful dress designer in Paris. His wealthy clientele—which included the Comtesse Greffulhe and the Princesse Murat, celebrated actresses Sarah Bernhardt and Réjane, and numerous society women and demimondaines—supported not only a lavish lifestyle but also an extensive art and rare-book collection.

Doucet's taste in art had evolved from works of the *ancien régime* (which he'd sold in 1912 for thirteen million francs) to the most important productions of modernism. "I've been by turns my grandfather, my father, my son, and my grandson," he joked about his collection. Alongside this, he had established two formidable rare-book libraries, one devoted to art and archeology, the other to literature (the latter became part of the Bibliothèque Sainte-Geneviève upon Doucet's death in 1929). What made Doucet's holdings all the more noteworthy was that the man himself had had little formal schooling; he often quipped that he had been "raised with the pigs." To counter this lack, he had hired a succession of informed, and often contradictory, advisers from among the writers and artists who interested him—including Pierre Reverdy (whose *Nord-Sud* he helped underwrite), Max Jacob, and Blaise Cendrars—to suggest purchases and keep him abreast of modern aesthetic trends. The information generally came in long, detailed commissioned letters, which provided the self-made Mæcenas with an invaluable education, and his putative teachers with a modest income.

Begun in 1916, the literary library had initially been guided by the writer André Suarès, who helped Doucet amass a number of first editions, manuscripts, correspondence, and periodicals by "the precursors of modernity" (mainly the Symbolists and their followers); then by bookseller Camille Bloch, who added the literary Cubists. These materials were housed in a sumptuous, wood-paneled room at 2 Rue de Noisiel in the 16th arrondissement. By 1920, the size of the literary collection required that it be organized, and Doucet decided to hire a librarian. It was at this point that he met Breton.

Charmed by their first conversation, Doucet hired Breton on a part-time basis; the young man catalogued Suarès's literary acquisitions (eventually proposing his own), and

scouted among the day's most important painters and dealers for possible art purchases. In addition, and like his predecessors, Breton was asked to write a series of letters about the issues closest to him. Over the next four years, he would inform his benign and often bemused employer about the state of the avant-garde and of his own literary tastes—using Doucet, as he had Fraenkel and Simone, as a sounding board for his self-explorations. Taken together, these letters form a notable personal history of modernism, as well as a chronicle of Breton's intellectual development at the time. They also provided him with first drafts of his early critical prose: long passages of them would reappear, sometimes verbatim, in the essays on literature, art, and autobiographical exegesis that Breton later collected in his book *The Lost Steps*.

Breton was now earning a monthly salary of 500 francs. He put aside as much of it as he could, hoping to convince Simone's parents that he was a worthy prospect. Still, his thoughts on the marriage remained tinged with pessimism. He rejected the painter Jacques-Emile Blanche's advice that the couple simply elope, noting bitterly in his diary: "He, too, believes that youth sees the future spread before it."

Although Dada had for all intents and purposes lain dormant since the previous May, it had begun to attract young men receptive to its sneering message. One of them, a friend of Simone's named Jacques Rigaut, had begun frequenting the Certa earlier that fall. Reminiscent, for some, of Jacques Vaché, the twenty-one-year-old Rigaut spun variations on the dandy theme that Vaché had so exhaustively played out. Georges Ribemont-Dessaignes remembered him as "very handsome, very elegant in his dress, very mysterious in his attitude." Rigaut was reputedly being kept by a famous actress; he wrote little, and destroyed much of it. Like Vaché before him, he was an anti-artist in the truest sense, barely producing anything but his own ephemeral performance. Among his most frequent performances were pranks, of which he was extremely fond. Soupault, himself an inveterate prankster, recalled being invited to dinner with Rigaut and mistakenly knocking at an apartment on the wrong floor. When an unknown woman answered, revealing a large dinner party inside, Rigaut thrust her the bouquet he was carrying and thanked her for the invitation. The two young men spent the evening entertaining their impromptu hosts, never letting on that they were actually expected in another apartment elsewhere in the building.

But for Breton, the deepest chord was struck by Rigaut's preoccupation with suicide, a temptation with which he himself had flirted during moments of depression. Rigaut

did more than flirt, however: he had made one suicide attempt prior to meeting the Dadaists, during which the gun aimed into his mouth failed to go off. "I then set my weapon down on the bedside table," he recounted. "Ten minutes later I was asleep . . . It goes without saying that I didn't think for an instant of firing a second bullet." (That second bullet would finally be fired at decade's end.) As Breton later wrote, "At around age twenty, Jacques Rigaut condemned himself to death and waited impatiently, from hour to hour, for ten years, for the perfect moment to put an end to his life."

Another relative newcomer, one who would remain by Breton's side until his death forty years later, was Benjamin Péret. Péret had made his Dada debut as an audience heckler at the Salle Gaveau festival in May, and in July had published a note in *Littérature* celebrating sex crimes; but for most of 1920, his contributions to the group were slight. This was due in part to his timidity and in part to the savvy Parisians' scorn for the young provincial. As the poet Robert Desnos recalled, Péret's "naïve good humor and shyness made him the butt of the group's jokes for a time." The scorn was certainly encouraged by the young man's appearance: moon-faced, with sleepy eyes, bat-wing ears, and a prematurely receding hairline, the twenty-year-old Péret often wore a bumpkinish bow tie with his ill-fitting suits. Péret's star would rise considerably within several years, but for the moment even Breton, who found his acerbic poems "remarkable," thought the man rather odd. "I don't quite know what to make of him," Breton mused to a friend. "He's always willing to do the most nonsensical things."

Despite the group's initial disdain, Péret's background seemed almost to predestine him for Dada. He was violently anti-clerical, anti-family, and anti-military. He had, in fact, joined the army only after an episode of adolescent vandalism forced him to choose between the military and reform school—like many parents at the time, Mme. Péret believed the army would straighten out her wayward boy—and had emerged from it harboring the same feelings of revolt as did his new friends. The one significant difference between Péret and the *Littérature* group seems to have been his lack of education: Péret had never graduated from *lycée*, let alone attended a university. Like many of the others, however, he had discovered for himself the poets who would exert the greatest influence on him: Rimbaud, Lautréamont, Jarry, and Apollinaire.

Born on July 4, 1899, in the small Breton town of Rézé, Péret had spent most of his childhood in nearby Nantes, where his mother had taken him and his brother following her divorce. In January 1920, shortly after his discharge from the army, he had headed to Paris, where he had soon met his fellow poet and future comrade Desnos. But his first visit appears to have been to André Breton, engendering the latter's subsequent account of it in *Nadja*:

In my hotel, Place du Panthéon, one evening, late. Someone knocks. In comes a woman whose approximate age and features I cannot now recall . . . Her chief reason for coming, it seems, is to "recommend" the person who has sent her and who will soon be living in Paris. (I still remember the expression "would like to launch himself in literature" which subsequently, knowing to whom it referred, seemed so curious, so moving.) But who was I being urged in this more than chimerical way to welcome, to advise? A few days later, Benjamin Péret was there.

Desnos, meanwhile, wrote a variant, and somewhat less romanticized, account of his own: the woman, Péret's mother, had heard of Breton in Nantes and brought her boy to see him. Coming directly from an all-night train ride, she had knocked at Breton's door at 6 A.M. and announced, "Monsieur, I know you by name and they've told me you could do something for my son, who wants to write." Thereupon she had departed, leaving a tongue-tied Péret in Breton's room while the latter tried vainly to engage him in conversation. It was only several months after this fruitless visit that Péret had begun regularly frequenting the Dadaists.

Even as Rigaut and Péret were drawing closer to Dada, Breton and Aragon were becoming attracted by an entirely different current. In December 1920, at the French Socialist Party congress in Tours, opposition came to a head between the moderate minority led by Léon Blum and more radical elements. These latter, whose numbers included the future leftist notables Boris Souvarine, Paul Vaillant-Couturier, and Alfred Rosmer, were inclined to join the Soviet Third International. Dissatisfied with the turn the Party was taking, the Blum minority split off, leaving the 70 percent majority to put the party—renamed the "French Section of the Communist International," or French Communist Party (PCF)—in the service of the Comintern.

Like Aragon, Breton followed the birth of the PCF with avid interest. During the war he had read the pacifist Socialist dailies and had attended several rallies as an adolescent. But while he would maintain strong if difficult ties to the Communist International nearly until the Second World War, his attraction to Communism in December 1920 was more philosophical than political. Breton and Aragon both respected what they saw as the Socialists' commitment to pacifism, but their understanding of and interest in Communism was slight. Nor did they have much connection with the French proletariat: Aragon, while hardly wealthy, had grown up (and still lived) in affluent Neuilly; and if Breton, in Aragon's words, "was geographically much closer to Communism than I was," his actual contact with working-class Pantin had been minimal. Moreover, they both came from backgrounds that encouraged a distrust of politics:

at the time, the word for them evoked images not so much of masses rising in virtuous indignation as of back-room machinations. Still, enthusiasm for the anti-war stance pushed these considerations aside, at least for the moment, and on December 28 the two men appeared at the Party's Paris headquarters (and offices of the leftist newspaper *Le Journal du peuple*) on Rue de Bretagne, intent on joining.

They were quickly dissuaded. Aragon later recounted their greeting by journalist and Party member Georges Pioch: "The statements this character made, his kind of false bonhomie (he told us: 'There comes a time when you have to go down into the crowd, crush in elbow to elbow, and sweat together') put us ill at ease. We looked at this overweight creature and had no desire whatsoever to sweat with him." They then called at the offices of the Communist organ *L'Humanité*, where they were handed a list of bureaucratic requirements. "Repellent procedures at *Le Journal du peuple* and *L'Humanité*," a discouraged Breton noted in his diary the following day. "You need two sponsors, go through the branch office of your district, etc. . . . I cannot believe that many people consider Socialist discipline a necessity. I'd like to know how far its demands go." He would have his answer, but not immediately: it was nearly five years before his next serious contact with the French left.

✳

With the new year, Dada finally emerged from its winter doldrums and returned to planning sessions at the Certa. This time, however, the mood was different: instead of blindly going along with Tzara the impresario, Breton the theoretician sought to bring a new seriousness of purpose to Dada, a revolutionary energy similar to the one that excited him in Communism. But Tzara and Picabia seemed eager simply to get back to business as usual, taking scandal as its own reward, and as the new round of meetings got underway the contrast between Breton and his fellows only grew sharper.

Even outwardly, Breton contrasted with the other Dada leaders. Whereas Tzara practically vibrated with manic energy, Breton appeared sober to excess. And while Picabia affected flamboyant dress, Breton sported a heavy antique cane, a black coat that seemed to have been lifted from an undertaker, and either a monocle or a pair of heavy horn-rimmed spectacles that made him, in Robert Desnos's judgment, "the spit and image" of American silent comedian Harold Lloyd—a slyly apposite comparison, for Breton's formality of deportment and dress were so exaggerated that they often cast him as the unwitting straight man for Tzara's slapstick. A photograph from the period, emblematic, shows most of the Dadaists laughing uproariously, while off to one side

Breton faces the camera with a grimace as sour as curdled milk.

Only a closer inspection revealed his underlying unconventionality: Breton's spectacles were worn not out of ophthalmological necessity (for the lenses were plain glass) but "in memory of a grammar example: 'Noses were made to hold up glasses; therefore I wear glasses.'" And the heavy cane was "embellished with obscene reliefs, men, women, and animals . . . slugs creeping toward vulvas, suggestive postures, and lower down the comical and terrifying sight of a bearded Negro with a huge erection."

Where Breton and Tzara did agree was in the knowledge that, to accomplish anything, Dada must reestablish itself in the public eye as soon as possible—even if the nature of that reestablishment was hardly a given. Painfully aware that, on its current course, "Dada will survive only by ceasing to exist" (as Jacques-Emile Blanche had earlier put it), Breton slowly began to co-opt Dada, both on paper and in practice. He described the movement as "primarily French," indebted more to automatic writing and Vaché's letters than to the stunts of a few Germanic radicals. He also looked for ways to extend Dada's field of action and save it from the rut of demonstrations.

Among other activities that spring, Breton initiated the "grading" of numerous current and historical figures, in order "to illustrate the degree of respect or disrespect we felt toward a wide variety of individuals." As in French schools, the grades ranged from −25, "the depths of abomination," to +20, "unconditional devotion of heart and mind." In a grid that contained nearly two hundred entries (ranging from Beethoven, Dante, Jesus, and the Unknown Soldier to Apollinaire, terrorist Jules Bonnot, Charlie Chaplin, Isidore Ducasse, and the Dadaists themselves), the players noted their appraisals. Not surprisingly, six of the top ten scores went to Dadaists, with the highest average (16.85) going to Breton. Others on the hit parade included Charlie Chaplin (who came in number three, with a score of 16.09), Rimbaud (15.95), Ducasse (14.27), Vaché (surprisingly only in the fourteenth spot, with 11.90; Breton had given him a slightly tarnished 19), and Bonnot (10.36). The "out" list was topped by popular poet Henri de Régnier, novelist Anatole France, and war hero Marshal Foch, followed by the Unknown Soldier, the right-wing journalist Charles Maurras, and many others. Given the Surrealists' well-established anti-clericalism, the Bible scored surprisingly high: 9.18 overall, with a 16 from Breton (higher than for Apollinaire!). Even Jesus got off with a light −1.54, and an indifferent 0 from Breton.

The results were published in *Littérature*'s March issue under the title "Liquidation" [Elimination]. The magazine adopted a typically sardonic stance, claiming that its goal had been "not to grade but to degrade." But Breton took a more constructive view of the exercise. He sent a copy of "Liquidation" to Doucet, explaining: "I realize how shocking

such a procedure must seem, but the resulting chart will say more, I believe, about the spirit of *Littérature* than a whole string of critical articles by its various contributors. It will have the advantage of situating us very clearly, and even of showing how we proceed, what we relate to, both what binds us together and what separates us."* And still more than acting as a referendum on *Littérature*, the procedure of rating and discarding, of determining alliances and affinities, was one that Breton would employ in moments of doubt for the rest of his life.

That same month of March, Breton devised another activity: excursions around Paris. After having made the Parisian public visit Dada, Dada would now visit the public. A series of tours were planned to places that, as the prospectus announced, "don't really have any reason to exist": the church of Saint-Julien-le-Pauvre, the Louvre, the Parc des Buttes-Chaumont (a favorite of the future Surrealists because of its long suspension bridge, the "veritable Mecca of suicide"), the Gare Saint-Lazare, and the Ourcq Canal in Paris's proletarian northeast.

Saint-Julien-le-Pauvre, the site of the first excursion on April 14, 1921, had been chosen less for its obvious religious affiliations than for its atmosphere of medieval desolation: the abandoned church was falling into ruin, while the surrounding yard was "a deserted lot . . . which the residents of the 5th arrondissement habitually used as a garbage dump." At three o'clock that Thursday afternoon, a group consisting of Breton, Rigaut, Eluard, Ribemont-Dessaignes, Péret, Fraenkel, Aragon, Tzara, Soupault, Arp, and Hilsum assembled under the fine April showers. A crowd of about fifty, including a few journalists and photographers, were there to meet them, but the rain quickly melted much of the audience away. A photograph taken of the event showed the Dadaists standing all in a row, with their "floppy felt hats, stiff collars, and little gray gaiters covering their shoes and half boots." Another caught them huddled together beneath umbrellas, soggily declaiming to an unimpressive (and evidently unimpressed) crowd. Breton, perhaps more sincerely than intended, challenged the audience to spell out "what you want from us. Do you really believe we're talented, destined for any kind of success other than the scandalous success you've handed us?" Tzara shouted a series of unconnected words and phrases, while Ribemont-Dessaignes played tour guide, halting at various statues around the churchyard and reciting at random from a fat Larousse dic-

* What mainly "separated them" was the degree of importance *Littérature* on the one hand and the pure Dadaists on the other granted such nods toward constructive research: while Breton and his friends gave every indication of conscientious reflection, Tzara seemed to note his grades haphazardly, often contenting himself with a simple –25. He hadn't brought his movement up from Zurich only to turn it into another school—artistic or academic.

tionary. "It was the most brilliant sketch of the lot," he later recalled, "which isn't saying much." After an hour and a half the steadily thinning crowd, soaked by the rain and bored by the speeches, went home. The Dadaists themselves repaired to a nearby café to take stock. The bottom line: they had bombed.

Disappointment over the Saint-Julien failure quickly brought latent animosities to a head. Tzara responded by becoming more manic, while Breton seemed to absorb the tension into himself; a note in *391* evoked his high-strung personality, joking that "we await the moment when, sufficiently compressed, like dynamite, [Breton] will explode." And Picabia, disgusted with Breton's gravity and suffering from a painful eye inflammation, pulled further away from the group.

Another factor that helped sever Picabia's remaining ties to Dada was an exhibit of paintings, drawings, and collages by Max Ernst. Ernst was one of the leaders of the Cologne Dada group. He had been denied a visa to visit Paris for the exhibit, owing to a tumultuous Dada demonstration he had organized in Cologne in April 1920. Breton had first discovered Ernst's work the previous year, when a series of collages arrived at Picabia's, and had been "filled immediately with unparalleled admiration." Like the poetic image according to Reverdy, Ernst's visual juxtapositions brought two distinct realities together to form a new and explosive universe. And just as Reverdy's poetic image revived the magic inherent in words, so Ernst's heterogeneous landscapes unearthed the poetic mystery buried in the most commonplace objects, mystery that our jaded glances tended to overlook. Breton immediately began planning and organizing a show to introduce Ernst's work to the French public. As the date for the May 2 opening drew nearer, he and Simone, along with Aragon, Péret, and Rigaut, spent entire nights framing canvases in his room at the Hôtel des Ecoles.

The exhibit opened on the evening of May 2, at the Au Sans Pareil bookstore on Avenue Kléber. Jacques Rigaut greeted the society ladies and their tuxedoed escorts at the door, loudly counting the pearls around the women's necks as they passed. Inside, visitors were met by meows, barks, and frenzied words (all provided by Aragon), while a voice from the closet insulted them by name. Tzara laughed feverishly and played hide-and-seek with Soupault. Péret and the painter Serge Charchoune shook hands, parted, flew back together to shake hands again. A trap door occasionally opened in the floor, releasing a diabolical red light and a flood of gibberish. And the prematurely bald Ribemont-Dessaignes paraded around the room screaming, "It's raining on a skull! It's raining on a skull!" Only Breton, in the midst of the commotion, remained generally "solemn and priestly," while sucking on matchsticks. Seeing Doucet enter, he rushed over to make sure the collector had a good look (he would have been one of the few) at the Ernsts on the wall.

Curiously, the Ernst exhibit was almost uniformly ignored by the art critics, while being widely reviled in the popular press—which itself forgot the exhibit's ostensible object, and even the challenge that exhibiting a German in Paris still constituted, for their usual refrain about Dada's pranks. There was, however, at least one large difference between the Max Enrst opening and previous demonstrations: whereas the earlier shows had ended on a note of hollow laughter and self-recrimination, this one left in its wake the visible power of the works themselves. Ironically, Dada was being saved by Art.

Ernst was important to Breton in one other regard as well. As Picabia drew away from the *Littérature* group, Ernst looked more and more like a strategic counterpart. While Breton's enthusiasm for Ernst's work was genuine, it is also true that the Ernst exhibit, coming when it did, both helped fill the gap left by Picabia, as Dada's departing artist-in-residence, and allowed Breton to regain some of the prestige lost after the Saint-Julien-le-Pauvre fiasco. Breton, moreover, was aware of the rivalry between the two artists, and in October crowed to André Derain that Ernst "made Picabia green with envy."

Jealous of Ernst, annoyed with Breton, tired of Tzara, and disenchanted with the entire enterprise, Picabia finally decided to "separate from the Dadas," as *Comœdia* (the usual arena for such disputes) announced on May 11. "The Dada spirit truly existed only from 1913 to 1918, during which time it never stopped evolving, transforming itself," Picabia told the paper. "After that, it became as uninteresting as the products of the Beaux-Arts or the static rantings of the *Nouvelle Revue Française*." Picabia was expressing essentially the same complaint that several other Dadaists, Tzara among them, would make over the coming months: under Breton's influence, Dada was becoming too moral, too censorious, and altogether too pompous. "Now Dada has a courtroom, lawyers, pretty soon policemen no doubt," he remarked on Breton's newest and most overtly juridical initiative to date: the "trial" of Maurice Barrès.

<div align="center">✳</div>

In the early years of the century, Maurice Barrès had been known as the "prince of youth," the spiritual mentor of a generation, whose works—particularly *Un Homme libre* [A Free Man] and *L'Ennemi des lois* [The Enemy of Laws]—emphasized personal liberty over moral convention. But with the war Barrès had undergone a profound change in attitude, and was now the voice of arch-conservatism, a figure whose influence rivaled Voltaire's or Hugo's before him, but whose message appealed to superpatriots and right-wing radicals. In place of anarchy and revolt, Barrès put his stylistic gifts in the service of rabid anti-Dreyfusism, sabre-rattling bellicism, and, with the war over,

vengeance against the Germans. The "prince of youth" had aged into a "town crier of massacres."

Breton and Aragon had once been great admirers of Barrès; and despite their "particular bitterness" over his current attitudes, they continued to respect his earlier self. As late as April 1921, Breton told Doucet that he had "never lost hope" in Barrès, "not even during the war." Even as he wrote these lines, however, he was questioning the consequences of such a radical about-face. While he did not deny "the right to contradict oneself" (an expression of Baudelaire's that he would make his own), Breton wondered whether such contradictions could be indulged without limits, and what those limits were. His concern about the subject had previously been raised by Dada, whose own constant reversals, as he saw it, threatened to undermine any actions the group undertook. After a debate about Barrès toward the end of March, Breton and Aragon had finally decided to make their former mentor account for his change of heart. Barrès was to be brought to trial. The charge: "conspiracy against the security of the Mind."

This trial was not simply metaphorical. It was to be an actual court proceeding, with witnesses, a jury, defense and prosecution counsel, and, of course, a presiding judge: Breton himself. Breton solicited the participation of numerous witnesses, including fervent Barrès supporters and Dada detractors; and he attended actual hearings at the Palais de Justice to study procedural details. For him this was no parody, but the real thing—or as close as his lack of judicial authority would allow.

At the same time, Barrès was less the subject of the trial than the excuse, and what was being evaluated was not so much an individual as a set of attitudes, and a mode of behavior. Even more than he resented Barrès's conservative views, Breton could not forgive the former mentor for having proven unworthy of his enthusiasm. It was this personal aspect that gave the Barrès trial its emotional resonance for Breton, that made it both a philosophical inquiry and a howl against all those who had betrayed him. Breton was trying not only Barrès, but through him every "prince of youth" he had sooner or later found wanting—up to and including Dada.

Not suprisingly, Tzara, Picabia, and Ribemont-Dessaignes were patently hostile to the project. Tzara in particular was immune to Breton's fervor: he had barely heard of Maurice Barrès, let alone invested such emotion in him, nor was he much interested in having Dada sit in judgment on anyone. By the date of the trial, Picabia had walked out on Dada altogether, while Tzara and Ribemont assisted only grudgingly.

The public was not so reluctant, however, and on Friday, May 13, at the Salle des Sociétés Savantes on the aptly named Rue Danton, the trial of Maurice Barrès began before a packed house. The defendant himself had been summoned to stand before his

accusers, but a speaking engagement kept him far away from Paris that evening; the Dadaists claimed he had not dared show his face. In his place sat a store dummy, dressed in formal evening wear and sporting Barrès's characteristic mustache. The Dadaists appeared in white surgical smocks and birettas—red for the prosecution, black for the defense—to simulate judicial garb.

At around nine-thirty, the Honorable André Breton, flanked by his "assessors," launched the proceedings by reading out the bill of indictment: Barrès was charged with having "usurped the reputation of a thinker," "failed to fulfill his mandate," and having been only the illusion of "a free man." In the final account, Breton said, Barrès was on trial not because he had contradicted himself, but because even his early works contained the seeds of his current reactionism—a somewhat diluted position that revealed Breton's own uncertainty toward self-revision.

Fully at home in his role of grand inquisitor, Breton then interrogated each witness in turn, amplifying the issues raised by the indictment. Still, he found the participants less than cooperative, and none less so than Tzara, who had clearly set out to subvert the proceedings. Declaring his "profound disgust and deepest antipathy" for the entire event, Tzara, to Breton's irritation, improvised a long and nonsensical testimony, then concluded by belting out an extended "Dada song":

> Eat chocolate
> Wash your brain
> Dada
> Dada
> Drink water [etc.],

before leaving the hall, slamming the door behind him.

If the spectators generally appreciated Tzara's diversion—many of them had come expecting Dadaist shenanigans, and were mystified or bored by the ponderous perform-ance—they were almost uniformly outraged by the appearance of Benjamin Péret as the "Unknown Soldier." Dressed in a German uniform and gas mask, Péret came onstage, barked a few lines in schoolboy German, and goose-stepped off again, while the hall erupted in vociferous protest and strains of "La Marseillaise." Several incensed patrons rushed the stage, on which the curtain was hastily dropped. The "Unknown Soldier" barely escaped with life and limb.

From that point on, the ruckus was so great that closing statements by "public prose-cutor" Ribemont-Dessaignes and "defense attorneys" Soupault and Aragon went almost

unheard. The trial continued nonetheless, and Barrès was ultimately sentenced to twenty years' hard labor—short of the death penalty Judge Breton had wished.

The "sentence" was the least of Breton's disappointments. The Barrès trial, although far more ambitious and costly than the café debate that had spawned it, had been no more conclusive. The participants had mainly used the event as a stage for their individual wit, or simply proven unequal to the issues raised. And the public had grasped almost nothing of Breton's intentions, perking up only when its national symbols were mocked. All in all, as far as anyone could see, this had simply been another Dada demonstration, subject to the usual criteria of scandal and entertainment by which Dada shows were rated. Newly depressed, Breton retreated to Lorient, and on June 5 told Doucet that he was thinking of writing "an article bidding farewell to Dada."

Back in Paris by June 15, Breton watched from afar as Dada sank deeper and deeper into self-parody. Rather than try anew to steer it onto a more acceptable course, however, he turned his attention to other concerns. Among these was his work for Doucet, which required almost daily presence at the rare-book library, artists' studios, or galleries. It was with Doucet that Breton attended the Kahnweiler auction on June 14 (the first of three) at the Hôtel Drouot, alongside Paulhan, Eluard, and Tzara. The German-born dealer Daniel-Henry Kahnweiler had opened his gallery in 1907, and had since become the exclusive agent for many of the leading Cubist painters, including Picasso, Braque, and Gris. But the French government had seized Kahnweiler's stock during the war, and was now disposing of it cheaply as part of the Versailles Treaty provisions allowing for the sale of sequestered "German" goods. Breton publicly denounced the auction, but it was nonetheless because of the bargain prices that he was able to acquire some of the works—not all of them on Doucet's behalf. As Robert Desnos later wrote: "For a pitiful amount one could walk away . . . with paintings that, several years later, would be worth fortunes." Breton himself walked away with a Picasso head study for 350 francs.

Another concern of Breton's was his marriage to Simone. It had been nearly a year since their engagement, but despite the salary from Doucet he was still not in a position to provide for his intended. At around this time Simone's parents nonetheless asked to meet her young man. The evening began at the ballet (which Breton found interminable) and continued over dinner at the Kahns' apartment on exclusive Avenue Niel. Conversation was limited to practical details; the parents' welcome did not rise above lukewarm. Finally, in mid-July, Doucet remedied at least the financial aspects of Breton's situation by offering him full-time curatorship of the literary library, increasing his annual salary to around 20,000 francs.

But although Breton's newly respectable income finally won him the grudging con-
sent of Simone's parents, it did not entirely lift his spirits, at least not right away. Part of
his dark mood that July was caused by the new issue of *391*, which Picabia had renamed
Le Pilhaou-Thibaou for the occasion, and in which he lashed out at his former comrades-
in-Dada. Breton responded by again closing ranks with Tzara, apparently feeling that
"the enemy of his enemy was his friend." Hoping that a change of scene would mend
their recent differences, he also planned to vacation with Tzara and a few others in the
Tyrol region of Austria later that summer: the area was well-suited to everyone's limit-
ed economies and, besides, Breton felt that the Alpine scenery would make a perfect
honeymoon site. He and Simone would join the Dadaist in September, their wedding
having now been set for mid-month.

In August, meanwhile, as Tzara, Arp, Ernst (who was getting his first glimpse of his
renowned fellow Dada), and their wives rendezvoused in the Tyrolean village of
Tarrenz-bei-Imst, where they spent their time assembling a counter-*Pilhaou-Thibaou*
called *Dada augrandair* [Dada in Fresh Air], Breton, still back in Paris, contended with
problems closer to home. Already concerned about Dada's internal ruptures, he also had
to face the matter of *Littérature*'s disastrous sales: the August number, entirely taken up
by a transcript of the Barrès trial, was in fact the magazine's last, at least in its current
form. Even the three musketeers were experiencing disunion, and Soupault, after a fight
with Breton over *Littérature*'s future, had expunged his co-editors' names from the mast-
head. To make matters worse, Breton was suffering from a severe respiratory infection
accompanied by high fever, which lasted for several weeks.

And yet, as the wedding date approached, his mood seemed to lighten considerably.
On September 14, at a prenuptial celebration at the Certa, the festive atmosphere contrast-
ed sharply with the usual hardness of the Dada sessions. "Neither ferment nor conspira-
cy," Ribemont-Dessaignes reported to Tzara. "The marriage is dissipating the shadows
for a while and Breton was all smiles." The wedding itself took place on Thursday,
September 15, 1921, at 11:30 A.M., at the town hall of Paris's 17th arrondissement.
Simone's parents, their reservations about the groom notwithstanding, agreed to give
their daughter a monthly advance against her inheritance, and would occasionally lodge
the couple over the coming months. Louis Breton made the trip from Brittany to stand
uncomfortably among his more worldly in-laws. Marguerite did not see fit to attend.

The Kahns also gave Simone a respectable dowry, which she wisely invested in art—
and which, along with the new salary and commissions on sales of artwork to Doucet,
made for one of the few periods of material ease Breton would ever know. More art came
from André Derain, who gave a painting as a wedding present, which complemented a

small Derain that Breton had earlier bought Simone for their engagement. Breton had even asked Derain to be his best man, but the painter had declined, and the dependable Valéry had provided a last-minute replacement.

· The newlyweds arrived in Tarrenz on September 20 to find *Dada augrandair*—in the event, the last issue of *Dada*—ready for the printer, and Tzara, Arp, and Ernst on the point of leaving. Even in the few days they had together, however, Breton realized how illusory his hopes had been for a grand reconciliation. Arriving (as Ernst later put it) like "a hair in the soup," he soon recognized that his and Tzara's ideas about Dada had become hopelessly incompatible; and when he tried to read aloud from Lautréamont, Tzara and Ernst did not hide their boredom. But the friction was productive as well, causing Breton to think about a new departure and a new magazine to supersede *Littérature*. By the time Eluard and Gala arrived on the cusp of the month, they found only the Bretons. With little to keep them in the Tyrol, Breton decided to cut short their stay: the four would travel to Vienna, after which the Eluards would head to Cologne to meet Ernst.

Breton's main hope in going to Vienna was to interview Sigmund Freud. A fervent admirer of Freud's investigations since his days at Saint-Dizier, he had drawn heavily upon them in writing *The Magnetic Fields*. More than this, he felt that, by generating a text without the fetters of conscious censorship, he had contributed a significant advance to psychoanalytic readings of literary works in general. He had earlier sent Freud a copy of the book with a flattering inscription; and in his journal, all the while admitting that Freud's interpretations of Shakespeare and Goethe were "brilliant," he had wondered why the analyst never sought out "better documents":

> The censorship that, despite everything, was very active in these famous writers, does not allow one to take analytical advantage of their output as a whole . . . By writing *The Magnetic Fields*, Soupault and I believed we had taken the question a major step forward. For the first time, I think, writers gave up judging their work, to the point of not giving themselves the time to recognize what they were creating . . . Many have criticized us for furnishing only the raw minerals, without realizing that our intention was precisely to return the metal (which art tends to purify indefinitely) . . . to its primitive state.

In addition, Breton, as a former practitioner of psychiatry, considered himself on common professional ground with his elder colleague. It was thus as an equal, and not a pilgrim, that he expected to be received.

The foursome arrived at Vienna's City Hotel in the first week of October, but during his first days in the capital Breton could not find the courage to make the planned visit. On the 7th he wrote to Fraenkel, "Here I prowl around Freud's house without finding the resolve to knock: I'm carrying such a reassuring photo of him." He finally contacted the analyst, who, although "having very little free time in these days," sent a note of invitation to his hotel on the 9th. At three o'clock the next afternoon, while Simone waited in a nearby café, Breton rang at the door of Berggasse 19.

The meeting was a disappointment. Breton first had to sit in the waiting room alongside a dozen patients, staring at the allegorical engravings and the photographs of Freud himself on the walls. When he was finally ushered into the famous study, the interview proved hardly worth the anticipation: despite Breton's expectations, Freud considered his visitor a poet rather than a scientist, and saw little relation between his own research and the young Frenchman's literary interests. Breton, whose knowledge of the theory and practice of psychoanalysis was, in reality, superficial, had little to interest the Austrian. In addition, the two were clearly speaking at cross-purposes: Freud considered the practical techniques and raw materials of psychoanalysis the means to a therapeutic end, whereas for Breton their primary aim should be "the expulsion of man from himself." Finally, there were insurmountable differences in generation (Freud, then sixty-five, was forty years Breton's senior), culture, and taste in literature, which for Freud meant the classics. Bored, pressed for time, and eager to move on to his next client, Freud soon drew the conversation to a close. Breton, who had looked forward to the meeting with excitement, returned to the café so sad and discouraged, said Simone, that he refused to talk about it.

Instead, he vented his chagrin in a short article, "Interview with Doctor Freud," describing the pioneer analyst as "a little old man with no style who receives clients in a shabby office worthy of the neighborhood GP" (photographs of Freud's cabinet show that this was hardly the case). "Ah! he doesn't much like France, the only country to have remained indifferent to his work," Breton reported. "I try to make him talk by throwing names such as Charcot and Babinski into the conversation, but either because the memories I'm calling on are too dim or because he maintains a posture of cautious reticence with strangers, I can get him to speak only in generalities." Years afterward, Breton dismissed his "interview" as "a regrettable sacrifice to the Dada spirit," but the sacrifice had less to do with Dada than it did with Breton's own feelings of spite and disillusionment. As the future would show, these feelings died hard.

✳

The honeymooners were back in Paris by mid-October, living "in the air," as Simone told her cousin Denise, either at her parents' apartment on Avenue Niel or at Breton's hotel on Rue Delambre. Breton himself returned to work for Doucet.

Despite frequent contact with his advisers, Doucet preferred to handle matters largely by correspondence. Breton, when he wanted Doucet to buy a given work, was obliged to write a series of long missives, mixing extravagant praise for the item in question with copious flattery of Doucet's taste, in an attempt to wear down the cautious patron's resistance. Breton's perseverence was often rewarded, however, and over the next five years he engineered the acquisitions of important works by, among others, Henri Rousseau, Seurat, Picasso, Chirico, Duchamp, Picabia, and Miró.

That December, he launched a particularly arduous campaign in favor of Picasso's 1907 masterpiece *Les Demoiselles d'Avignon*. "You know that I cannot help but deplore . . . that you have not yet acquired a major work of Picasso's (I particularly mean a thing whose historical importance is absolutely indisputable, such as *Les Demoiselles d'Avignon*, which marks the origin of Cubism, and which it would be such a shame to let go to a foreign country)," Breton wrote Doucet. "I hope you will pardon my frankness, Monsieur, but it still seems to me that you almost owe it to yourself—and not only because of your taste, which is imprescriptible—to welcome into your home the most significant works of two or three of today's greatest artists."

This was the first of many such letters that Doucet received about the painting, for despite Breton's enthusiasm, it was one of his hardest sells. Two years later, he was still trying to persuade Doucet that the *Demoiselles* must enter his collection "because here, one looks directly into Picasso's laboratory, and because it is the core of the drama, the center of all the conflicts that gave rise to Picasso . . . the theatre of everything that has been happening for the past fifty years." Doucet finally acceded at the end of 1923; even then, it took another year for the transaction to be completed. The buying price was 25,000 francs—far below market value, in Breton's estimation—in twelve monthly installments.*

What time Breton did not spend with employer or bride he continued to devote to Dada, in a last effort to respark his enthusiasm for the movement. At the Certa, which was both Dada's workshop and its parlor, the group schemed and experimented, having

* Between decision and execution, Doucet echoed Breton's warning about letting the painting "go to a foreign country" to his former adviser André Suarès: "It's too stupid to let everything go. On the contrary, there were two or three vaguely scandalous things [the *Demoiselles*, a Matisse, a Seurat] . . . I bought them, in two years I'll be proven right . . . With these I'm all set and I can sit back knowing they won't get them in America." Premature assurance: the work was acquired by New York's Museum of Modern Art in 1939.

by now become such a fixture that the bar began serving a "Dada-Cocktail." The "meeting place of the Dadaists" even figured in guided tours, attracting curious foreigners away from the Louvre to gawk at the strange birds plotting their arcane revolution.

It was at the Certa that the group was joined by the young poets Jacques Baron, Roger Vitrac, Max Morise, Georges Limbour, and René Crevel, editors of the fledgling literary periodical *Aventure*. Aside from the sixteen-year-old Baron, all were in their early twenties. Morise was tall and lanky, with a long face and blue eyes that accentuated the British demeanor he affected; he dabbled in writing and drawing, without showing a marked commitment to either. Vitrac, later known as an important playwright, had a mild manner and a profound interest in dreams, humor, and childhood—themes he would explore to great effect in his 1928 play *Victor ou Les Enfants au pouvoir* [Victor, or Power to the Children]. In the previous year he had been both married and divorced, his provincial bride having little tolerance for either her new Paris home or her husband's cronies. Poet and journalist Limbour was a childhood friend of the painter-sculptor Jean Dubuffet and the playwright Armand Salacrou. Athletic and unrefined, he was a prodigious swimmer and (like Aragon) an inveterate pub crawler. He had early on developed a lifelong passion for the works of Verlaine, as well as a taste for practical jokes that some, notably Breton, would come to find abrasive. And the handsome Crevel hid his hypersensitivity behind an affectionate, seductive charm. Highly intelligent, he had a grounding in philosophy (especially Diderot) that surpassed that of his fellows, as well as a marked gift for violent polemical prose.

Marcel Duchamp also checked in at the Certa from time to time, after his first meeting with the Dadaists in May. Duchamp was then building an enormous multi-media work on glass, *The Bride Stripped Bare by Her Bachelors, Even* (or *Large Glass*), a complex, mechanistic diagram of lovemaking, which he would abandon after eight years in order to devote his time ostensibly to chess. In the meantime, he had created a feminine alter ego for himself, "Rrose Sélavy" (*éros, c'est la vie*), a behatted and perfumed transsexualization whose only remaining traces are several photographic portraits and a series of intricate aphoristic puns. And, perhaps most notably, he had earlier caused a scandal in the art world with his "ready-mades," found objects that Duchamp "elevated" to the stature of a work of art by the sole virtue of choice. These included a bicycle wheel, a bottle rack, a snow shovel titled *In Advance of the Broken Arm*, and a urinal. Forerunners of the postmodern aesthetic, Duchamp's ready-mades posited a world in which art was no more than the artifacts of culture constantly recycled, until the only things left to recycle were the recyclings themselves.

Breton had become aware of Duchamp some time before, through Picabia, and by

now was laboring to have Doucet acquire some of his paintings and objects. Upon their first meeting, he was immediately taken with the man's "twinkling eyes . . . without sarcasm or self-indulgence," his faculty of reaching "the *critical point* of ideas faster than anyone else." Although the thirty-four-year-old Duchamp joined neither Dada nor, later, Surrealism, he would always be an amiable fellow traveler, viewing the younger Breton with a mixture of respect and sarcastic amusement. For his part, Breton felt a lifelong deference toward Duchamp, whom he called "the man from whom I would be the most disposed to expect something, if he weren't so aloof and, at bottom, so desperate . . . the mind that one finds at the origin of every modern movement, and which these various movements have not begun to understand."

Finally, it was to the Certa that a much-heralded newcomer, fresh off the boat from America, was taken to meet the Dadaists. Man Ray had arrived in Paris on July 22, 1921, just shy of his thirty-first birthday, with an admirable list of works to his credit: paintings, collages, assembled objects, and the photographic portraits that ensured his livelihood. Along with Duchamp he had been one of the most active members of New York Dada. That spring, his imagination fired by tales brought to the States by Duchamp and Picabia, by European works that were beginning to cross the Atlantic, and by Tzara's correspondence, Man Ray had decided to head for the hub of the action. He'd sailed for Le Havre in June, having pared his given name of Emmanuel Radnitsky down to the leaner pseudonym. The following month, Duchamp had met him at the station and taken him to see Dada.

Duchamp having prepared the ground, the welcoming committee of Breton, Aragon, Soupault, Eluard, Gala, Fraenkel, and Rigaut had greeted Man Ray with curiosity and favor. They were further impressed by the works the American had lugged over in his steamer trunk—and were probably amused by his thick Brooklyn accent, which mutated French words such as *quarante* into "care-aunt." The newcomer, for his part, had immediately felt "at ease with these strangers who seemed to accept me as one of themselves, due, no doubt to my reputed sympathies and the knowledge they already had of my activities in New York." He also liked the contrast between their self-serious attitudes and the infantile pranks they often pulled.

Already at this first meeting in July, the Dadaists had begun planning for a show of Man Ray's works. Six months later, on December 3, Mick Soupault's gallery-bookshop, Librairie Six, was festooned for the occasion with bright red balloons, which were popped by lighted cigarettes throughout the afternoon. The exhibit itself featured some thirty-five paintings, collages, and "gratuitous objects"—including one, *The Gift*, which Man Ray had created at a hardware store earlier that day. (Seeing the object, a flatiron

adorned with a row of carpet tacks down the front, the confused salesman had protested: "But you'll ruin the shirt if you put tacks on there!"). Although none of the work sold, it attracted respectable attendance and press.

Still, such events bespoke the group's wish to deny its own chronic loss of breath, rather than an actual resurgence. And more than any of the others, Breton had become convinced that his future was not in Dada. At year's end he returned to Lorient with Simone, again finding a haven from the frenzy of the Paris intellectual milieu, and a vantage point from which to contemplate the movement's inner collapse. Dada as an extreme point of the modern spirit had roused his passionate enthusiasm. But by integrating itself into Parisian life, Dada had succumbed to a confused, superficial theatricality, until only the shell of revolt remained, hollow and meaningless. No longer a Dadaist but not yet a Surrealist, Breton would spend the next two and a half years seeking a way to channel the energies Dada had released into a more productive course—one, moreover, that *he* intended to set this time.

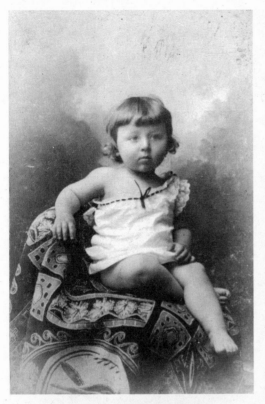

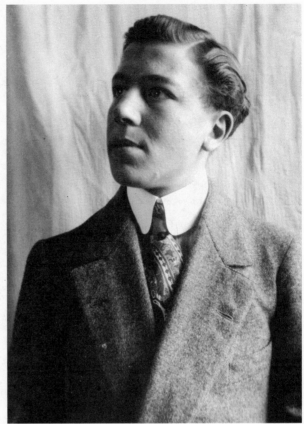

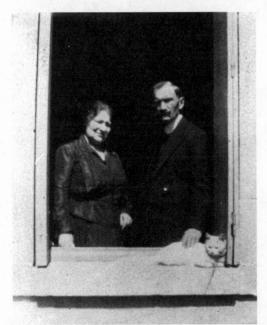

top left:
Breton in 1897, aged eighteen months.
Already the expression foretold the group
leader to come

top right:
As a *lycée* student, 1909

left:
Marguerite and Louis Breton later in life

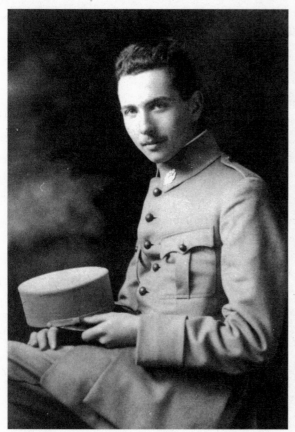

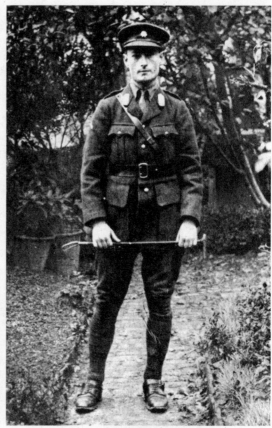

SOLDIERS OF THE GREAT WAR:

top left:
Louis Aragon at the time of his first meeting with Breton

top right:
Jacques Vache, ca. 1915

bottom left:
The military intern, ca. 1916

bottom right:
Théodore Fraenkel, the "Polish people"

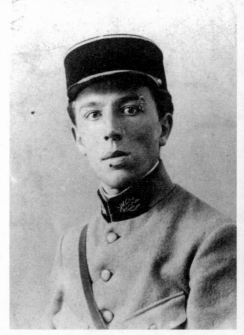

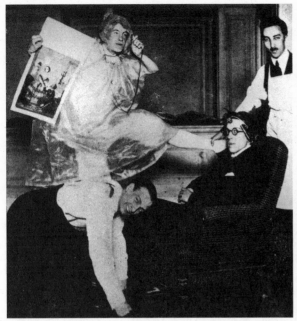

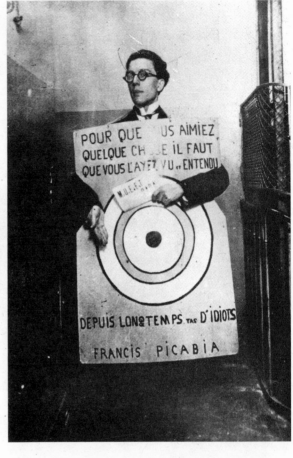

DADA IN PARIS: *Vous m'oublierez* performed by its authors on May 26, 1920. Surrounding Breton are Eluard in drag, Fraenkel (entering stage right), and Soupault, who can't keep a straight face

right:
A walking advertisement for Dada, spring 1920

bottom:
The visit to St.-Julien-le-Pauvre, April 14, 1921. Although the excursion was Breton's idea, its failure convinced him all the more that Dada was finished. Visible in the crowd are Péret and Rigaut (second and third from left), Tzara, Fraenkel, Breton, Raymond Duncan in his toga, and Simone Kahn

FACING PAGE:

top: With Tzara and Simone, at around the time of Breton's split from the former and marriage to the latter

bottom left: Picabia (left) and Breton, in goggles and overalls, motoring to Barcelona, November 1922

bottom right: Simone and Max Morise in the Rue Fontaine studio, ca. 1923

THIS PAGE:

top: At the amusement park, early 1920s. Morise is at the wheel, followed by Eluard, Simone, Joseph Delteil, Gala Eluard, Robert Desnos, and Breton, with Max Ernst riding alongside

bottom: René Crevel, initiator of the sleeping fits

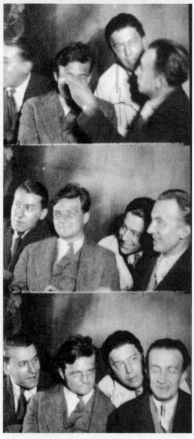

top:

SURREALISM AT WORK . . . : Taking automatic dictation from Desnos at the Central, 1924 (Morise at far left, Breton and Eluard at center, Chirico straining to see the camera)

bottom right:

. . . AND AT PLAY: Photo-booth shots, ca. 1930 (René Char, Georges Sadoul, Breton, Eluard)

bottom left: Robert Desnos in a trance

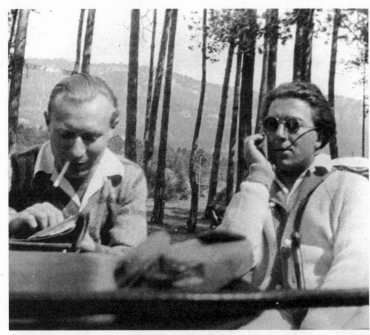

top left:
The summer of our discontent:
Breton discovers Communist politics
with André Masson, August 1925

bottom left:
Antonin Artaud, poet, actor, and
firebrand, as Jacques Dupuis in
Luitz-Morat's *Le Juif errant* (1926)

bottom right:
Lise Meyer, the "Queen of Sheba,"
at around the time of her meeting
with Breton

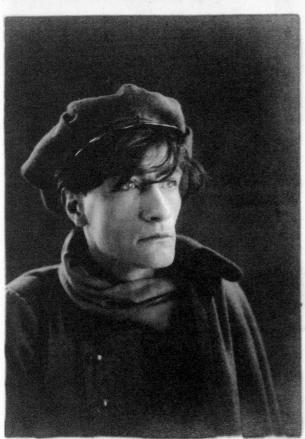

above left:
Breton in 1927, at around
the time he wrote *Nadja*

top right:
Breton as viewed by Nadja
(Léona Delcourt)

middle right:
Nadja as viewed by herself

left:
Two of Boiffard's lonely
Paris scapes for *Nadja*

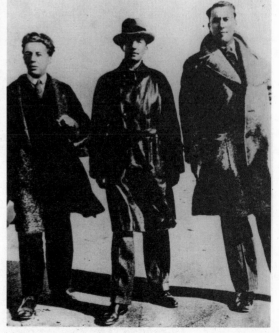

above and top right:
Suzanne Muzard, with and without Breton

bottom right:
Breton, Eluard, and René Char in Avignon, at the
time of *Ralentir travaux*

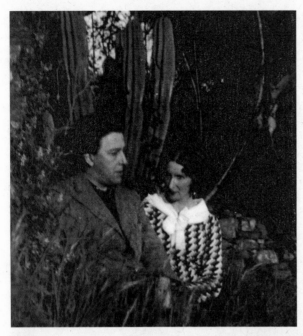

top:
Breton and Valentine Hugo on holiday, ca.
1931. André Thirion later wrote that while
Valentine was desperately in love with the
Surrealist leader, he "felt merely the emo-
tional and slightly irritated tenderness of a
man who is still thinking of someone else"

bottom:
Jacqueline Lamba in 1934, the year she met
and married Breton

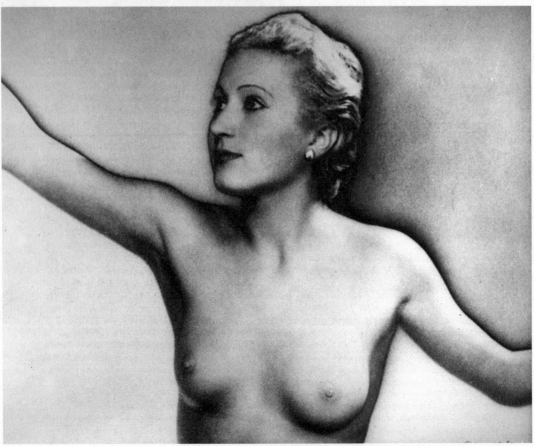

A ROOM ABOVE HEAVEN AND HELL

(January 1922 – May 1924)

ON THE FIRST DAY OF 1922, Breton and Simone moved into their first home, a two-room studio in a nondescript building at 42 Rue Fontaine. Located at the northern tip of the 9th arrondissement, Rue Fontaine provided the short link between the nightclubs and brothels of Places Blanche and Pigalle and the residential, working-class modesty of Rue Notre-Dame-de-Lorette. The Bretons' apartment, standing between these two extremes, contained, as Simone told Denise, one room "of silence and shadow"—their bedroom overlooking the claustral courtyard—and one "of noise and light" that faced Place Blanche. And as if to sanction these contrasts, a venerable cabaret downstairs was named Le Ciel et L'Enfer: Heaven and Hell.

For the first time in seven years, Breton occupied neither a barracks nor a hotel. The studio on Rue Fontaine, perhaps in reaction to the transience of his recent life (and although it would always be rented, never owned), acquired a permanence that soon garnered the aura of legend: more than a dwelling, it became a symbol, as much a part of the history of Surrealism as Breton himself. It was "his crystal, his universe," his daughter later said; the site of many of the group's evening gatherings and the showcase for his various collections. In the wake of Dada's dissolution, it was also a space in which to rebuild the group. Breton, having left Tzara's Dadaism to seek a "room of his own," found at least its physical realization in the new studio. Although in the late 1940s he would move into a slightly larger apartment one floor below, 42 Rue Fontaine would be his address for the rest of his life.

Visitors reached the apartment by climbing four flights of a "sordid staircase," and in coming years were greeted by a small sign on the door bearing the date 1713. This was Breton's self-referential joke: he had earlier noticed that the figures 17 and 13, when written in Continental characters (in which the 7 is barred), closely resembled his own initials; he had even modified his signature to accentuate the similarity. At times his notes were signed simply with the enigmatic number, and Aragon recounted that Breton's friends sometimes referred to him as "seventeen-thirteen."

Along with a stable domicile came equally stable habits. In contrast to the group's

more noctambulistic elements (Aragon, for example, who spent his evenings cruising the streets and clubs of Montmartre), Breton led an existence that was a model of regularity. During the day he would file manuscripts at Doucet's library, after which he would attend the group's café meeting. The meetings normally ran from six-thirty to seven-thirty, followed by dinner, either in an inexpensive restaurant or at home in the company of a few close friends, each contributing his own portion of the improvised meal. Finally, after several hours of games or experiments at Rue Fontaine, Breton and Simone retired to bed, while Aragon and the others went barhopping only yards away.

Immediately after moving in, Breton set to the task of furnishing the studio. By summer, the walls were covered with the paintings that had excited his imagination, many of them created by those who joined in his preoccupations and discoveries: Ernst, Picabia, Man Ray, Derain, and Duchamp; Picasso, Chirico, Braque, and Seurat—as well as an astounding number of African and Oceanic masks, fetish dolls, and unusual objects found at random. For the rest of his life, Breton would be an avid art collector, buying outright when his budget allowed, or selling one work to finance the purchase of another. His acquisitions bespoke both exceptional foresight (given the stature of most of these works today) and a finely tuned sensitivity to the works' emotional power, so much so that many visitors were overwhelmed. André Thirion, entering the studio several years later, was reminded of "one big museum . . . Every painting, every object sent out an exceptionally powerful emanation, a hallucination, which adhered to it like a shadow wherever it was put."

One of the most powerful works in Breton's collection was Giorgio de Chirico's 1914 painting *The Child's Brain*, which Breton had first spied during the war while passing Paul Guillaume's gallery on a bus, and whose "exceptional ability to shock" had so moved him that he had immediately gotten off to contemplate it, ultimately acquiring the work around 1919. The painting itself—which shows a balding, overweight man standing with eyes shut, truncated at the waist by a table and a closed book—is a striking example of Chirico's wartime "metaphysical" period, during which the artist sought to "come close to the dream state, and also to the mentality of children" by juxtaposing obsessively repetitive objects onto disturbingly quiescent landscapes. But for Breton, *The Child's Brain* also responded to a deeper and more personal iconography, for the man sectioned by a table was none other than the one "cut in two by the window" in the automatic phrase that had first occurred to him around that time—either in echo of, or foreshadowing, his discovery of Chirico's painting.

Breton's talents as a collector of art and literature served him well at Doucet's. Under his curatorship, the library began to include manuscripts and first editions directly relat-

ed to his and his friends' interests. In late January, when Aragon followed Breton's lead by abandoning his own medical studies, Breton persuaded Doucet to hire him as co-curator. The pair immediately drafted a long prospectus for a collection of texts tracing "the formation of the poetic mentality of our generation," basing their choice on works cited in Ducasse's *Poésies*, along with the Romantics and principal modernists.

Meanwhile, Breton was busily organizing an equally encyclopedic, but much more spectacular, event. On January 3, 1922, a notice in *Comœdia* announced an "International Congress for the Determination and Defense of the Modern Spirit," or "Congress of Paris," scheduled for late March. Signed by the seven members of the organizing committee—Breton (actually sole author); the composer Georges Auric; the painters Robert Delaunay, Fernand Léger, and Amédée Ozenfant; Jean Paulhan of the *NRF*; and Roger Vitrac—the communiqué rather broadly defined the Congress as an attempt to examine recent "artistic groups or schools, such as Impressionism, Symbolism, Unanimism, Fauvism, Simultanism, Cubism, Orphism, Futurism, Expressionism, Purism, Dada, etc.," in order to help "stem the current confusion." Two of the questions used to frame the debate were: "Has the so-called modern spirit always existed?" and "Among objects considered modern, is a top hat more or less modern than a locomotive?" Although the seven committee members were ostensibly equals, it was understood from the outset that Breton would direct the proceedings: he had initiated the project, showed the most enthusiasm for it, and, as one Surrealist later wrote, enjoyed "the largest credit in literary and artistic circles."

In part, the Congress of Paris sought to counter a recent return to traditional notions of beauty. Since the war's end, many writers, artists, and critics had seemed bent on rediscovering craft at the expense of innovation. Paul Valéry had questioned the very possibility of modern creation in his 1919 article "La Crise de l'esprit." And even as Breton was launching the Congress of Paris, Chirico was renouncing metaphysical painting for the "more solid base" of neo-Classicism. Faced with this retrospective trend, Breton hoped that by highlighting modernism's common denomiators he could restore the sense of surprise that Apollinaire had once labeled art's "greatest new resource." More importantly, however, the Congress marked a conscious break from Breton's Dada activities: not only did it soberly (one might even say ponderously) undertake to explore a serious question, but, unlike the trial of Barrès, it did not even make a pretense of flying the Dada banner. Breton's leadership tendencies, repressed for two years in Tzara's favor, were now asserting themselves with renewed vigor. By grouping Dada with all the other "isms" under study, he hoped both to explore new territory and to consign Dada—and Tzara—to the intellectual junkyard once and for all.

Breton's communiqués were reported widely in the press, and in the ensuing weeks the committee received membership requests from a large cross-section of European intelligentsia, known and unknown. In a pattern that would repeat itself many times in the future, Breton also approached those who had only recently been against him—most notably Picabia, with whom relations had been suspended since the painter's public defection from Dada. In part the move was calculated, a bald attempt to use Picabia against possible interference from an unenthusiastic Tzara—just as Breton had sided with Tzara against a hostile Picabia only months before. At the same time, in his desire to gather the tribes around his new project, Breton felt genuinely drawn to anyone who was seemingly of like mind. Picabia, who was currently warring with Tzara, accepted Breton's proposed alliance. Breton had even solicited Tzara's involvement in the Congress, going so far as to envision an independent Dadaist subcommittee. But Tzara, although at first tempted, politely declined: if anything, he preferred to enhance confusion, not stem it.

Instead of planning the Congress itself, therefore, Breton spent much of his energy fearing for its safety. In an attempt to forestall Dadaist sabotage, he had the steering committee adopt a number of security measures, including the "strict regulation of the right to speak [and] police intervention in the case of willful disturbance." He also drafted a now-notorious public statement, signed by the board as a whole and published by *Comœdia* on the 7th, that denounced the intrigues of "a publicity-mongering imposter . . . a person known as the promoter of a 'movement' that comes from Zurich, whom it is pointless to name more specifically, *and who no longer corresponds to any current reality*."

The next day, a rebuttal by Tzara in *Comœdia* showed a humorous dignity that sharply contrasted with Breton's overheated paranoia: "Several days ago, I wasn't yet a publicity-mongering imposter, since I was worthy of sitting among this noble conclave . . . Before the honor that the Congress committee does me by caring so intensely about my person, I can only remove my top hat and set it on a locomotive, which will speed away toward criticism's uncharted terrains." In a more serious tone, he added that "an 'international' Congress that reprimands someone for being a foreigner has no right to exist."

Many agreed: the fact was, Breton had seriously misjudged his audience. Instead of perceiving Tzara as a disruptive threat, the Congress's predominantly left-leaning and cosmopolitan constituency noticed only that Breton had echoed the kind of xenophobic discourse that right-wing elements were propounding throughout postwar France. Ribemont-Dessaignes, Erik Satie, and Eluard, among others, withdrew their support from the Congress, and called for a general hearing to be held on February 17 at the Closerie des Lilas. It was at this point that the Congress of Paris began irrevocably to fall apart.

Breton later dismissed his phrase "the promoter of a 'movement' that comes from Zurich" as an "unfortunate circumlocution," but at the time he didn't fully understand how much damage had been done. Shortly before the Closerie meeting, he smirked to Picabia that he would show his detractors "just who they were dealing with." But on the evening of the 17th, before a tumultuous gathering of some one hundred artists and intellectuals, Breton found that it was not so easy to defend his position. As if in a distorted replay of the Barrès trial, Aragon acted as defense counsel, while Tzara, "leaping to the attack, fairly screamed in his high voice." The meeting ended with a vote of no confidence in Breton: although many sympathized with his accusations, they could not stomach his phrasing. The following day, some fifty artists and writers, including many of the Congress's most prestigious adherents, publicly disavowed Breton's actions and retracted their support.

Breton still retained the loyalty of Aragon, Desnos, Morise, Vitrac, Rigaut, Baron, and Picabia, who from his retreat in the South of France penned satiric jabs at the enemy camp: "Ribemont-Dessaignes is a fool . . . whose only personality is his remarkable baldness. Tzara shares his hair with him and Ribemont hypnotizes him with grateful and approbatory winks." But despite these fidelities, the Congress of Paris was dead. Dada had managed to neutralize the event weeks before its projected starting date, and without staging a single intrusion.

In barely two years, Breton and Tzara had moved from close intellectual complicity to open hostility. This was partly the result of competition between two men with strong leadership tendencies and partly of a divergence in outlook. And in part, as Breton later acknowledged, Tzara had simply disappointed Breton by not being "as I had imagined him." Still, relations between the two brother-enemies did not end here: an odd assortment of cordial solicitations and burlesque hostilities would continue for another year before contact finally ended. And even then . . .

In the wake of the Congress, various pundits took it upon themselves to interpret the wrong turns. Some called its failure regrettable, others inevitable, and some, like Tzara, made no secret of their delight. Breton himself never explicitly revealed his feelings about the Congress's demise, but some trace of them perhaps shows through in an unpublished automatic text written at around this time: "It's cold tonight on Rue Fontaine and if people continue not to take greater care with me, I'm going to die. The game of tag starts up again: now the engagement is over."

✳

On the afternoon of January 16, 1922, during the height of preparations for the Congress, Breton was on his way to meet Aragon and André Derain at the Deux-Magots when he spied a young woman wearing a tailored suit and matching cap, "who kept glancing over her shoulder, even though she seemed not to be waiting for anyone." Struck by the contrast between the woman's proper attire and her "*extraordinarily lost*" air, Breton watched as she chatted with "an utterly vile passerby," then with another, with whom she suddenly ran for a passing bus. Meeting Aragon, he was amazed to learn that his friend had his own anecdote to tell about the same woman. Shortly afterward, Derain exclaimed in turn, "But I just saw her near the fence at Saint-Germain-des-Prés!" Moments later, "unable to give up the idea of finding the key to the riddle," Breton and Aragon scoured the neighborhood for her: in vain.

Objectively speaking, the event itself hardly rose above the level of coincidence, but nonetheless it deeply affected Breton. For one thing, the chance encounter was made undeniably erotic by the presence of a beautiful woman—the one who might just as easily have wandered into Breton's room one night at the Hôtel des Grands Hommes. (He later reflected that such chance encounters "explicitly or not always tend to assume female traits," by which he meant that the ones that truly counted were those heralding a love relationship.) For another, the fact that she had appeared to three friends heading to meet each other seemed to give it a predestined quality. In fact, the power of the event lay in the contrast between its fundamental ordinariness and the impact it had independently had on their imaginations. The thrill resulting from an otherwise banal occurrence suggested to Breton that such events were worth exploring further—which in the immediate he did by setting it down on paper.

Although this was not the first such incident for Breton (among others, he had had a similar experience with Annie Padiou in 1916), it was the first time he was moved to examine it in writing. The clinical tone he adopted harked back to the internal monologue of the shell-shock patient in "Subject," and foreshadowed the more extended, and more famous, relation of a similar encounter in *Nadja*. He sensed that these encounters might provide a glimpse into the underside of daily reality, just as automatic writing looked into the underside of language. As if to stress the event's importance for him, he borrowed for his short account Apollinaire's emblematic title "The New Spirit."

The problem was where to publish such explorations, now that *Littérature* had stopped appearing. In February, even before the demise of the Congress, Breton decided to revive the magazine with a fresh look and format. The first issue, published in March, no longer had the yellow jacket and traditional appearance of its forebear. Instead, a bright pink cover featured the words "*Littérature*: New Series" and a Man Ray

drawing of a shiny top hat (no doubt the one that might or might not be more modern than a speeding locomotive).

As on several previous occasions, *Littérature* evinced the desire, if not always the means, to disserve its name. Alongside the usual poems and reviews, the new series strove to include material that was not "literature" in the usual sense: articles such as "The New Spirit"; dream narratives and automatic texts; and various surveys and questionnaires along the lines of the earlier "Liquidation." Reflecting the magazine's more exclusive orientation, the table of contents was restricted almost entirely to group members. The better-known writers who had helped launch the first series were now ignored or, better still, sacrificed to the caustic, insolent tone that the magazine sought to maintain.

So it was that in the first issue, Breton decided to bury two figures from his recent past: he published his snide account of the disappointing "interview with Freud," along with another interview called "André Gide Speaks to Us of His Selected Works." Breton had chatted with Gide after Gallimard published an anthology of his writings, then reproduced the man's words verbatim from memory. While he apparently didn't change Gide's remarks, he arranged them so as to portray a vainglorious has-been, grotesquely parading before his younger, smarter protégé:

> GIDE: Really, what do you want from me? Didn't my anthology, which just came out with [Gallimard], give you complete satisfaction?
>
> I: I'm sorry, Monsieur, I haven't read it.
>
> GIDE: Here's a copy. But don't ask me to sign it . . . I won't owe any explanations until after my death. And what difference does it make, since I'm quite certain I'll be the one wielding the greatest influence fifty years from now!

A shocked Gide later complained in his diary, "Everything that André Breton makes me say in his false interview is much more like him than like me. The form of ambition he ascribes to me is absolutely foreign to me; but it is the form of ambition that he is most disposed to understand . . . I cannot believe that Breton, so very careful about the influence he intends to exert over young minds, did not aim to discredit me, to destroy me." But Breton's agenda was more complex: not only did he mean to sweep Gide away as part of an outmoded past; he was also writing his farewell to yet another man who had disappointed him: as had been the case with Valéry and Tzara, Breton could not forgive Gide, the father of Lafcadio and the *acte gratuit*, for his failure to incarnate his supreme creation.

Breton also continued to sever ties to the most visible piece of his recent past: Dada. On March 2, just as the new *Littérature* was hitting the stands, *Comœdia* published his

anti-Dada manifesto, "After Dada," in which he minimized the movement's past influence and sounded its present death-knell. In place of labels, Breton said he now put his trust in the "quest" (the one that had led him toward Dada in the first place), and in the ideas to which he would continue to "devote his life." When Tzara then defended his maligned movement in an article entitled "Les Dessous de Dada" [Dada's Undergarments], Breton rebutted in the April *Littérature* with "Leave Everything." "It has been said that I change men the way most people change socks," he wrote. "Kindly allow me this luxury, as I can't keep wearing the same pair forever: when one stops fitting, I hand it down to my servants." For the end of the article, Breton had drafted a long diatribe against Tzara, but at the last minute he replaced it with what soon became a celebrated call to arms:

> I can only assure you that I don't give a damn about any of this and repeat:
> Leave everything.
> Leave Dada.
> Leave your wife, leave your mistress.
> Leave your hopes and fears.
> Drop your kids in the middle of nowhere.
> Leave the substance for the shadow.
> Leave behind, if need be, your comfortable life and promising future.
> Take to the highways.

As an exhortation it was stirring, and as a polemic it was a masterstroke: by taking an essentially personal quarrel to a higher, philosophical ground, it neutralized Tzara's moral advantage from the previous months and made any further commentary seem superfluous (which did not keep Breton from pursuing his attacks throughout the fall).

Along with battles waged on outer fronts, Breton was facing conflicts with his friends. Eluard, Péret, and Fraenkel, formerly close collaborators, were no longer welcome at Rue Fontaine after having sided with Tzara in February. In addition, tensions with Soupault had been mounting over the latter's resentment of Picabia and new job on the board of *La Revue européenne*, which left him little time for *Littérature*.

A further worry centered on Simone, who had fallen seriously ill in March and had undergone an operation at the Lannelongue sanatorium. By month's end she was back at Rue Fontaine, but required constant care. In early May, sufficiently recovered, Simone went to spend a few weeks with her cousin Denise in Strasbourg, leaving Breton alone to pass his evenings with his friends.

Already in 1922, the Bretons' marriage was developing a character that would last throughout: a mutual respect and affection offset by physical absence. Simone continued to be dazzled by Breton's energy and creativity, the richness of his thought and his ability to express it, and the "very special personality of a poet" that had first attracted her. For his part, Breton relied on Simone for her discernment and intuitive warmth. "She knew how to put newcomers to Rue Fontaine at ease, and made many friends among them," wrote Marcel Duhamel, soon to be one of these newcomers. Breton also valued Simone's wide-ranging knowledge, the active part she took in the group's activities, and her excellent eye for art (after the Second World War, she would manage two successful Paris galleries).

At the same time, and despite their intellectual and emotional complicity, the Bretons' union was marked by frequent separations. Some of them, in these first years, were caused by Breton, for literary or editorial reasons (such as heading off to write in solitude, or traveling to a faraway printer's to oversee production of a magazine). More often they resulted from Simone's visits to Denise. Eventually, husband and wife took to spending their vacations apart altogether. Initially, however, these separations did not signify emotional distance. Almost daily during her absences, Breton kept Simone informed of the group's activities; related his visits to artists' studios with Doucet; and, often, consulted her on his own acquisitions.

That spring, with the Dada demonstrations and the failed Congress of Paris behind him, Breton began casting about for a new collective activity. The café gatherings became the setting for automatic writing sessions, dream recitals, and various games—including the game of Truth or Consequences, in which players were required to answer all questions, no matter how private or embarrassing, with absolute honesty. Breton also thought for a while of founding a "Vague Movement" (*mouvement flou*), impossible to define by its very nature; but this came to naught. If anything, the expression merely served to describe the hazy period between the end of *Littérature*'s association with Dada and the official birth of Surrealism in 1924.

Not every café meeting was so ambitious, however: Jacques Baron recalled the desultory nature of most discussions, "to Breton's great annoyance." The fact was, Breton was often dissatisfied with the daily gatherings, their aimlessness, the careerism that seemed to plague his friends despite his best efforts. At the end of 1920, describing for Doucet how Jacques Vaché had steered him away from a standard literary career, Breton had

said: "I pride myself in turn with not being completely foreign to the fact that, today, several young persons who write no longer have the slightest literary ambition." But was the claim still valid? Had it ever been? "It's a pity that all these young people think about are novels and other things of the same ilk," he complained to Simone on July 25.

Meanwhile, Paul and Gala Eluard were returning from an extended visit to the Austrian Alps, where they had again joined Max Ernst, his wife, Lou, and their infant son, Jimmy (later a well-known painter in his own right). For the Eluards, the visit rekindled a veritable love affair begun during their first stay the previous November: Eluard had been seduced by the artist's iconoclastic inventiveness, and adopted Ernst as a kind of revered older brother; Gala had been seduced even more by Ernst's hawklike beauty and athletic demeanor; and Ernst was dazzled by his two honored guests from the mythic French capital. In June 1922, the two couples had rented a villa together in the Tyrol, where it took little time for Ernst and Gala to openly begin an affair. Lou Ernst raged against "that Russian female . . . that slithering, glittering creature," but Eluard claimed not to mind, saying that he "loved Max Ernst much more than he did Gala." At summer's end, with Eluard's borrowed passport in his pocket, Ernst left Lou in Cologne and followed Paul, Gala, and their young daughter, Cécile, to their house in the Paris suburb of Saint-Brice. Partly out of respect for Ernst, Breton welcomed Eluard back into the *Littérature* circle.

Littérature itself had gone unpublished during Eluard's absence, owing to financial difficulties, disputes with co-editor Soupault, and problems with its distributor, Au Sans Pareil (taking advantage of his relations with the *NRF*, Breton switched distributorship to Gallimard, thereby ending any lingering friendship with Hilsum). Breton had spent part of the summer trying to remedy these problems: notably, he had convinced Doucet to help defray production costs and persuaded Soupault to remove his name from the masthead, leaving the way open to Picabia's "*full* collaboration." This most immediately took the form of aggressive visual puns, which henceforth replaced Man Ray's genial top hat on *Littérature's* covers.

For yet another time, Breton was determined to make a new start. In "Clearly," an editorial that opened the September issue, he dismissed many figures from his past, including Valéry and Tzara, and celebrated the group currently around him: Picabia and Duchamp; his "dear lifelong friends" Aragon, Eluard, and Soupault (despite their recent dispute); and relative newcomers Baron, Morise, Vitrac, and Pierre de Massot, a young ex-Dadaist who worked as Picabia's secretary. "Never let it be said," he concluded, "that Dadaism served any purpose other than to keep us in a state of perfect readiness, from which we now head clear-mindedly toward that which beckons us."

Like the redesigned magazine, Breton's editorial promised a fresh start, one based on liberation from past attachments and the strengthening of new ones. But for the moment, such a fresh start was merely theoretical. It would still be several weeks before "that which beckoned them" took particular shape, at which point the call would become irresistible and very nearly fatal.

✳

In August, René Crevel, twenty-two years old and handsome as a god, had been vacationing with his family on a Norman beach when a young woman fell at his feet and begged him to press geraniums between her breasts. That evening, Crevel, the girl, her mother, and an old woman named Madame Dante had sat around a table and held a séance. Within minutes Crevel had fallen into a deep sleep, during which (as the women told him afterward) he had come out with extraordinary statements. But the experiments progressed no further, as Crevel, still in uniform, had had to return to barracks the next morning.

Because he had sided with Tzara, Crevel had not seen Breton since the Congress of Paris, but his friends Baron and Morise had kept him apprised of the group's experiments with dream narratives and collective games. When he ran into Breton shortly afterward, therefore, Crevel mentioned his experiences in Normandy. Keenly interested, Breton proposed a reprise of the séance at Rue Fontaine, as soon as possible.

Breton's interest in séances coincided with a general rise in the popularity of spiritualism. Psychic phenomena had become the rage in France since the war, and particularly since Nobel Prize-winning physiologist Charles Richet had founded the Institut de Métapsychique in 1920. Richet's faithfully reported experiments with the medium Eva Carrière and the publication of his best-selling *Traité de métapsychique* in 1922 kept the supernatural firmly in the public eye—and made fakirs and mediums indispensable ingredients of any worthwhile salon.

But while Breton took an interest in such experiments, and while he agreed to adopt the trappings of spiritualism for his own research, from the outset he drew a distinction between his goals and the spiritualists'. Breton was interested neither in communicating with the dead nor with interpreting the flow of words. Rather, it was the manifest content of the discourse itself, dredged up from the living unconscious, that attracted him.

Shortly before nine o'clock on Monday evening, September 25, Crevel and Max Morise climbed the four flights to the Rue Fontaine studio, where Breton, Simone, and the young poet Robert Desnos, another newcomer to Breton's circle, were waiting.

Crevel then demonstrated the recommended procedure: lights out, silence, chain of hands around the table. In darkness punctuated only by the flashing lights of the cabarets below, he soon fell into a deep slumber. As Simone described the session to her cousin:

> It's dark. We are all around the table, silent, hands stretched out. Barely three minutes go by and already Crevel heaves hoarse sighs and vague exclamations. Then he begins telling a gruesome story in a forced, declamatory tone. A woman has drowned her husband, but he had asked her to. "Ah! the frogs! — Poor madwoman. Maaaaadd . . ." Painful, cruel accents. Savagery in the slightest images. Some obscenity as well . . . Nothing can match the horror of it. Only the most terrifying passages of *Maldoror* could give you some idea.

Three days later, Desnos fell into a similar slumber, during which he answered questions in writing. Breton reported Desnos's exchanges while under hypnosis:

> *I place my hand on his. Someone tells him it's me.*
> A. - The convolvulus and I know the hypotenuse.
> *Fraenkel's hand.*
> Q. - Who is Fraenkel?
> A. - A gaping belly with an egg INSIDE . . .
> Q. - What will Breton do five years from now?
> A. - (*Drawing of a circle with its diameter*): Picabia Gulf Stream Picabia.
> Q. - Do you like Breton?
> A. - Yes (*the pencil lead breaks, then, legibly*): yes.

Still asleep, Desnos then improvised a perfect sonnet.

Almost nightly over the coming month, the Bretons' living room above Place Blanche became a laboratory for the unearthing of buried voices. For Breton, the results obtained by Crevel and Desnos alone seemed to validate his interest in the "sleeping fits," as they came to be known, and from the beginning he focused his attention primarily on them. The two men soon found themselves competing for Breton's approval, engaging in a parapsychological one-upmanship that quickly erupted into outright hostility: Desnos openly accused Crevel of cheating, while Crevel was not above jostling Desnos "by accident," once so violently that Desnos's head struck the mantelpiece.

René Crevel had what Matthew Josephson described as "the face of a laughing cupid," with a square jaw, sensual lips, doe-like eyes, and hair that crowned his forehead

in light brown ringlets. These, along with his engaging manner (except where Desnos was concerned), attracted numerous friends and sexual partners, female and male. At the same time, Crevel was tortured and deeply neurotic, quick to fall in love and almost fated to be hurt; he once confessed that "no human contact made him feel less alone." Like Eluard, he suffered from tuberculosis, and passed much of his life in sanatoriums, sometimes in Eluard's company. It would be an oversimplification to say that Crevel saw Breton as an ideal father. But the suicide of Crevel's own father when the boy was four-teen—combined with a bitter hatred of the mother who had forced him to stare at the dangling corpse "for his own edification" while she insulted her husband's remains—as well as a susceptibility to Breton's own physical attractiveness, inspired in Crevel an intense and passionate admiration. Introducing the slumbers was one way of making that admiration mutual.

Robert Desnos's admiration for Breton was no less intense than Crevel's, and his desire for approval no less fierce. From the start he had idolized Breton, and within weeks of his entry into the group—at around the time of the Congress of Paris—he was writing a prose narrative, *Pénalties de l'Enfer ou Nouvelles Hébrides* [Penalties of Hell, or New Hebrides], in which Breton frequently appeared, usually as a demigod or a corpse. "He's my best friend, and the more you know him the more you love him," Desnos wrote to a confidant the following February. "The constant anxiety that drives him and the quality of his mind are the best reasons for our little group's existence." Where Desnos unmistakably differed from Crevel was in appearance and demeanor: Desnos had child-ishly puffy cheeks, stiff black hair, and dark-ringed, protuberant eyes that often gave his face a look of clownish half-slumber. And where Crevel was "so soft and feminine" (to use Simone's words), Desnos confronted the world with quick-witted brashness. That both men tended to be high-strung did little to soothe their mutual antagonism.

Desnos was born in Paris on July 4, 1900. A large part of his childhood was spent in conflict with his ambitious but narrow-minded working-class parents, particularly over his mediocre school performance. By age seventeen, he was frequenting a band of anar-chists that included former members of the Bonnot gang. While this fact endowed him with some prestige in the *Littérature* group, Desnos secretly felt ashamed of his lack of education vis-à-vis his better-schooled colleagues. As did Crevel, he saw the slumbers as a way of winning their esteem.

Still, Desnos and Crevel were not the only ones to perform under hypnosis. On one occasion, Péret's girlfriend fell into an agitated state and screamed, "It's soaking me. The clear sweat of my father is soaking me!" Only with great difficulty, hand on her forehead and soothing words in her ear, was Breton able to calm her down. Péret himself explod-

ed into prolonged bursts of laughter and invented humorous, often obscene stories. "Yesterday he was sitting firmly in his chair when he cried out: 'Well, goddam! Well, goddam! Hey, I'm a flower!'" Simone related to Denise on October 9. "We tried to convince him that he could wither and drop. He became very angry, and with an enormous bang on the table stated, 'I will not drop.' Then he began struggling, knocked everything over, and fell flat on the ground."

Although such rambunctiousness made Simone worry about the neighbors, particularly after the concierge arrived one day bearing their complaints (Simone managed to pacify the old woman with a small bribe, and assurances that they wouldn't summon any dead spirits), she and Breton were enthralled by the sleeping fits. "We're living simultaneously in the present, the past, and the future," she told her cousin. "After each séance, we're so dazed and broken that we swear never to start up again, and the next day all we can think about is being back in that catastrophic atmosphere where we all take each other's hands with the same anxiety."

Not everyone felt the same enthusiasm, however, and some refused to participate at all. When Tzara returned from a vacation abroad, Breton, despite their feud, invited him to Rue Fontaine and tried to interest him in the séances; he also took the liberty of listing Tzara as a "virtual associate" in "The Mediums Enter," his account of these early sessions.* But Tzara preferred to snicker on the sidelines with Ribemont-Dessaignes. Soupault, another virtual associate, came and saw but did not believe. "Witnessing these phenomena, [Soupault's] attitude was disgraceful," Breton noted in his essay. And Aragon, who was in Berlin, missed the sessions altogether. As with *The Magnetic Fields*, he returned to find that his friends had progressed without him; and as with *The Magnetic Fields*, he then became one of the experiment's most ardent proponents.

Even among those who did participate, many remained skeptical. Jacques Baron dismissed the sleeping fits as "not exactly a joke, but not serious either." And Georges Limbour, after having barked like a dog and eaten from the animal's dish while under hypnosis, later admitted to the painter André Masson that the whole thing had been a setup, just to see Breton's reaction (he was mesmerized). Masson claimed, in fact, that most of the sleepers simulated their fits for Breton's benefit—a charge to which many of these sleepers have since confessed.

It is impossible to gauge to what extent Breton himself believed in the reality of the trances, just as it is impossible to determine their actual measure of authenticity and sim-

* "The Mediums Enter" was also notable in that it contained Breton's first definition of "Surrealism" as "a certain psychic automatism that corresponds rather well to the dream state"—terms similar to the ones he would use two years later in the *Manifesto of Surrealism*.

ulation. Breton was never able to verify the experience for himself: as he confided in "The Mediums Enter," he was one of several who could not fall asleep "despite all our goodwill." His accounts of the sleep period generally sidestep the issue of veracity. Still, the evidence suggests that Breton took the sleepers, and particularly Desnos, at their unconscious word.

But far more important to Breton were the slumbers' greater implications. By provoking these "trance-like states" where the mind escapes "the constraints that weigh on supervised thought," he hoped to see what verbal marvels would come of it—to see, as Duchamp put it, how "words make love." As with automatic writing three years earlier, Breton felt he had tapped into a fabulously rich poetic vein, a new beginning that left even "the most blasé" among them "trembling with gratitude and fear." To Doucet he announced: "A dazzling new day is dawning."

Still, the issue of simulation cannot be dismissed, for one can only doubt—as did many in the group—that even the most committed sleepers could consistently plumb these depths and dredge up verbal gold. Desnos, for example, even though he claimed to have no memory of his actions, possessed an exceptional gift for such wordplay even while awake, and later admitted that not all his trances were genuine. The truth is most likely a combination of the real and the spurious: that both Desnos and Crevel, susceptible to hypnosis and eager to please Breton, began by entering veritable trances, but later found themselves forced to simulate in order to keep the "mouth of shadows" speaking.

Meanwhile, competition between the two men was intensifying. Hoping to outshine his rival once and for all, Desnos began improvising long and intricate spoonerisms, which he claimed were the result of telepathic communication with Marcel Duchamp (who was back in New York, and whom Desnos had never met). He adopted "Rrose Sélavy" as general title and patron saint of his utterances: a way both of marking his indebtedness to Duchamp and of justifying his plagiarism. Breton, although skeptical about the claims to telepathy, was thunderstruck by the inventiveness and volume of the puns themselves; he immediately jotted down a long list of them for Picabia, and reproduced nine pages'-worth in December's *Littérature*. (Duchamp, at the other end of the psychic hotline, was less enchanted: "Got a note from [painter Jean] Crotti this morning, accompanied by 50 of Desnos's rantings," he wrote Breton in November. "What a telepath! / or rather 'psychic'——— / In any case he'll come in useful for *Littérature* . . . Why doesn't he ask for Rrose's hand? She'd be thrilled—")

Not to be outdone, Crevel began improvising long, breathless stories and terrorizing his audience with horrific predictions: "You will all become ill one after the other. You will go insane . . . I've put a curse on this house. You will all die. Mad. Tubercular . . ."

Within days, Crevel's curse had seemingly become a reality: Ernst, who had never been sick, began spitting blood, Eluard's tubercular cough returned, and Simone Breton was struck on the head by a falling transom. "I saw that I could become crazy with terror," she told Denise. "André and I could think only one thing: Crevel's curse." (During a subsequent evening, Jacques Baron caused an awkward silence by predicting in turn that Crevel would be the first among those present to commit suicide. Thirteen years later, Crevel bore him out.)

By this time, the sessions were becoming less and less controlled, their character turning so acrid that Breton began to fear for the group's safety. Under the influence of the nightly trance, alarming personality traits started coming to the fore. Breton recalled one incident when about ten people simultaneously fell under hypnosis:

> They came and went, trying to outdo each other in prophecies and gesticulations . . .
> At around two in the morning, concerned about the disappearance of several of them,
> I finally found them in the dimly-lit anteroom, where, as if by common accord and
> provided with the necessary rope, they were trying to hang themselves from the coat
> rack. Crevel, who was with them, seemed to have been the instigator. I was forced to
> wake them with scant ceremony.

Then Crevel abandoned the sessions altogether, embittered at Desnos's success in an activity he had initiated. He later accused Breton of trying to push the others beyond sanity with his relentless pursuit of marvels. Breton himself seriously considered ending the experiments. In early October he had accepted Picabia's invitation to go to Spain; by the date of departure at month's end, he was no doubt relieved to get away from the sleeping fits for a while.

The occasion was provided by an exhibit of Picabia's paintings at the José Dalmau gallery in Barcelona, which had earlier been the site of *391*'s birth. The painter suggested that his friend Breton join him for the November 18 opening—and that he take the opportunity to give a talk on modern poetry and art (which, given the current state of Breton's sentiments, would not have been unfavorable to Picabia).

On October 30, Breton and Simone, Picabia and Germaine Everling left Paris in Picabia's open-air Mercer, Breton protected from the cold by thick goggles, a leather pilot's helmet, and a heavy fur coat lent by Doucet. Stopping off in Marseille, they visited the colonial exhibition, where Breton bought a stuffed armadillo for twenty francs. "As if it were a dog, he carried it in his arms, petted it, warmed it in his sumptuous fur coat," Picabia recounted; "and thus occurred the only miracle since the world began: the

armadillo came back to life and leaped to the ground." It was certainly the only "miracle" to be had that afternoon: the reconstituted African huts, Moroccan souks, and black jazz bands reminded the two friends of a "loathsome cemetery in which we are the corpses." Afterward Picabia took Breton to the red-light district, where the stuffed armadillo delighted the prostitutes. Deeply embarrassed, Breton answered their advances with mute stares, and when one woman teasingly stole his hat he had Picabia intervene on his behalf. That evening Simone asked Picabia not to bring André to such places, as they "depressed him terribly."

The party arrived in Barcelona on November 7, the Bretons lodging in the Pension Nowé on Ronda San Pedro. For the most part Breton found Spain disappointing, unattractive and too expensive, although he did admire Antoni Gaudí's Sagrada Familia. "Do you know this marvel?" he asked Picasso on a postcard—apparently unaware that Picasso had not only grown up in Barcelona but considered the cathedral "something of a joke."

Disappointment turned to worry shortly after their arrival, when Simone came down with salmonella poisoning. Although she and Breton wanted to return to Paris and end the unpleasant journey, Breton's promise to give his talk, and Picabia's unwillingness to leave before the vernissage, kept Simone bedridden and shut away in her hotel room. Breton dedicated to her an eight-part automatic poem, titled "Le Volubilis et je sais l'hypoténeuse" [The Convolvulus and I Know the Hypotenuse] after Desnos's first sleep sentence, in which traces of their plight resurfaced.

On the 17th, the eve of the Picabia opening, Breton delivered his address at the Ateneo, an overview of the "characteristics of the modern evolution and what it consists of." In it, he proclaimed the death of Dada (which the Barcelona Dada group, come to hear one of their brethren, staunchly refused to believe) and denounced Tzara's actions during the Congress of Paris. "It would not be a bad idea to reinstitute the laws of the Terror for things of the mind," he told his audience. Before a crowd that was educated but removed from Parisian infighting, Breton was free to promote his own version of the truth as if it were generally accepted fact.

One aspect of the "modern evolution" to which Breton alluded only indirectly was the sleeping fits, which had been continuing in his absence. "Here we're still holding our little séances, our good little séances, which are no longer so good now that you're not here," Eluard reported on the 14th. "On Sunday Limbour fell asleep. Tears, foot stamping, desire to leave, punches, he scratches, bites, tries to swallow the coins in his pocket . . . Desnos pulls his hair out in despair, swears he's full of good intentions, tries to entertain us and make us laugh, pulls funny faces, demands his coat and hat as if to leave, claims he'll never wake up, that it's no use."

Breton, however, was not so eager to rejoin the atmosphere he'd left several weeks before. When he returned to Paris on November 20, he instead turned his attention to founding a new salon with Picabia, a response to the stodginess of the established artistic salons called "Salon X," which never got off the ground. Max Ernst, meanwhile, was forming his own, more prescient salon—at least on canvas. That same month, in the Eluards' home in Saint-Brice, he completed his celebrated group portrait *The Rendezvous of Friends*, which portrayed Crevel, Soupault, Morise, Fraenkel, Paulhan, Péret, Aragon, Chirico, Desnos, his old collaborators Arp and Baargeld, patron saints Dostoevsky and Raphael, and his hosts, Paul and Gala Eluard (tellingly placed on opposite sides of the canvas)—in other words, and with few exceptions, those who would soon constitute the early Surrealist group. Dominating them all is Breton, running in from stage right, cape over his shoulder, arm raised like a Renaissance Christ. "Max Ernst is working on a painting," André Masson told a friend at the time: "the Dada kids around a photographic Dostoevsky. Limbour finds the figures in it more lifelike than they are in reality . . ."

After several months, the group's interest in the sleeping fits was beginning to wane, and Breton, who nonetheless continued to instigate the sessions, and who remained fascinated by some of the results, increasingly began replacing the slumbers with other activities. Before long, the only one still eager to continue the sleeping fits was Desnos. For him, they were no parlor trick: they were his narcotic, as well as his major claim to status, and his involvement in them had come to look like severe neurotic dependence. "Robert was extremely responsive [to hypnosis], loved the treatment, and came through with some extraordinary verbal effusions. But [he] also began to be violent," recalled Matthew Josephson, for whom Desnos was "plainly psychotic."

At times this "psychosis" did not extend beyond high-strung violence. But in other instances, Desnos's behavior veered toward the patently murderous. Early in the year, he had attended a dinner in honor of Ezra Pound, with the express intention of killing fellow guest Jean Cocteau. Learning that Cocteau would not attend, he had drawn a long knife from his coat and moved to stab Pound in the back; he was grabbed before reaching the guest of honor and tossed unceremoniously into the street. At around the same time, during a sleep session at Eluard's, Desnos again had to be restrained after chasing Eluard across the lawn, once more brandishing a knife. Clearly, the slumbers were liberating not only "words making love" but some deep-seated antipathies as well.

Finally, in late February 1923, after a sleeping Desnos had locked the others in a room

for several hours, Breton decided to put an end to the séances once and for all. But Desnos, unwilling to give them up, began arriving at Breton's apartment late at night, begging to be hypnotized. "Hardly an evening went by when he didn't show up at my door, even if more often than not it meant finding me home alone," Breton recounted.

> On top of which, it was becoming more and more difficult to awaken him with the usual passes. One night when I was absolutely unable to bring him out of it, and when his frenzy had reached its peak—it must have been around three in the morning—I had to slip out to get a doctor. Desnos greeted the man with insults, but nonetheless awoke before he was forced to intercede. That incident, and my worsening fears about damage to Desnos's mental equilibrium, convinced me to take all necessary steps to ensure that the same thing would never happen again.

Although he continued to see Breton, Desnos felt deeply betrayed by the cessation of the sleeping fits, and in his spite he deemed that the group had severely declined. "For a while your company was enough to reassure me," he wrote to Breton on April 7. "Unfortunately the spell has been broken, and if my affection for you is as strong as ever, I'm perfectly aware of being no more than a curiosity for you, who I could barely admit to myself were one of my reasons for living." Although written for Breton, the letter was actually mailed to Desnos's own apartment; the ostensible addressee did not learn of its existence for another forty years.

Breton, too, was depressed by the failure of the sleep sessions and the tensions with Desnos. In addition, and despite his income from Doucet, he was beset by money worries, which in March forced him to sell three large Braques, a Derain, and a Picasso still life from his collection (although this did not keep him from attending the third Kahnweiler auction two months later). Meanwhile, the daily meetings seemed empty and directionless, and to Simone, absent once more, he vented his annoyance toward those who invaded their home to practice automatic writing, transforming the studio into a "copy desk": "I always feel like grabbing a broom from the kitchen and chucking them all the hell out."

Breton was feeling especially critical of Aragon, who in late March was hired by Jacques Hébertot to save the moribund literary newspaper *Paris-Journal*. Aragon needed the income, and no doubt enjoyed having editorial control over a periodical; he was also pleased to help his friends financially by assigning them articles. But Breton felt that such mercenary use of talent ended up "spoiling" these talents, and condemned Aragon's "journalistic activities."

One of Breton's few satisfactions at this time came from a newly finished essay. Grown largely out of his early autobiographical letters to Doucet (and often reproducing portions of them verbatim), "The Disdainful Confession" laid out the main tenets of Breton's attitudes toward art, literature, and life itself. It retraced his intellectual development and literary enthusiasms, before arriving at a detailed portrait of Jacques Vaché, who as such became the culmination of Breton's philosophical quest. Through Picabia's intercession, the article was published later that winter in the political weekly *La Vie moderne*.

Breton had by now accumulated a number of such essays, beginning with his article on Apollinaire from 1918 and continuing through his various prefaces, Dada manifestoes, art criticism, and recent descriptions of the sleeping fits. Together, they constituted a vessel, of which "The Disdainful Confession" became the figurehead, conveying "the tendencies and figures of our age: Dadaism, Surrealism, 'new spirit,' seen especially from a moral viewpoint." The title Breton gave his collection, *The Lost Steps* (*Les Pas perdus*), had in fact been in his mind since 1920, and had been announced in 1921 as belonging to a forthcoming volume of automatic texts. But the automatic volume had never been completed, and it was for a book of essays called *The Lost Steps* that Gaston Gallimard sent a contract on March 28.

Still, Breton's mood that spring was such that, by the time *The Lost Steps* was under contract, he had again decided to renounce writing altogether. On April 7, in an interview with Roger Vitrac for the *Le Journal du peuple*, he made his resolution public, citing as his motive the predominance of "literature" over such "spontaneous forces" as Lautréamont, Rimbaud, or Vaché. "Literature allows one never to change anything . . . this is why I've never sought to do anything, I repeat, but destroy literature . . . [Poetry] is not where one thinks it is. It exists outside of words, style, etc. . . . Therefore, I cannot recognize any value in any means of expression." The only recourse, he said, was silence. Vitrac headlined his interview with the words "André Breton Gives Up Writing."

While Breton was adopting silence as his watchword, the prolific Aragon was cutting against the grain. That April, he found himself being accused by the group of literary vanity, prostitution of talent, and a pathological need to shine in public. Aragon decided to leave *Paris-Journal* and Paris itself for Matthew Josephson's house in Giverny. He immediately used his new freedom to embark on a mammoth novel, *La Défense de l'infini* [Defense of the Infinite], which, although ultimately unfinished, would devour the next four years of his life and reach a length of several thousand pages. It would also help cause a permanent rift between him and Breton.

By abandoning journalism for fiction, Aragon had changed only the surface, not the substance, of the debate. Breton condemned novels just as much as he did journalism, as

the repository of "literature" in its basest form. "Despite its pretensions, no novel has ever proven anything," he had written in 1920. Aragon, however, defended *La Défense*, maintaining that the novel could be just as subversive as any other genre, and cited the group's admiration for Sade and such Gothic classics as Matthew G. Lewis's *The Monk*. He also likened the novel-writing process to Breton's experiments with automatism. But, he later commented, "it was as if A. B. had simply not heard a word of what I was saying."

The fact was, Breton was arguing less from a coherent position than from his emotional reality of the moment. While the vast majority of novels would bear out his charges of literary vanity, his own predilection for Sade, Lewis, Huysmans, Restif de la Bretonne (as well as the Thomas Hardy of *Tess of the D'Urbervilles* and *Jude the Obscure*, and, more recently, Joseph Delteil's *Sur le fleuve Amour*) belied any sweeping condemnation on the basis of genre alone. If it was the author's attitude Breton prized above all—insolent, offhanded, disdainful of the very literature he created—such examples showed that this attitude might just as readily be found in a novel as elsewhere. But Breton had fully absorbed the theoretical condemnation of fiction by Isidore Ducasse, to whom he gave greater credit than to Aragon. "The novel is a false genre," Ducasse had said in the *Poésies*, "since it describes the passions for their own sakes: the moral conclusion is missing."

On top of which, Breton distrusted novels, particularly since the same Aragon had depicted him as the fictional "Baptiste Ajamais" in his 1920 roman à clef *Anicet*. Although the book reflected all of Aragon's adulation for his friend, and although the model (said the author) "found the portrait a good likeness," Breton was less than pleased. "I'm in [*Anicet*] too, from a certain unflattering angle," he had told Simone in September 1920: "a taste for passageways, some cheap idealism." And Breton would have still more cause for distrust over the ensuing decades, as he lent his traits to, among others, the poet-pimp André ("Dédé") Vésuve in Ribemont-Dessaignes's 1926 *Céleste Ugolin*, "who despised poetry because it produced poets"; Anglarès, a coercive intellectual tyrant, in Raymond Queneau's 1937 satire *Odile*; and the self-important Caël, head of the group "Révolte," in Pierre Drieu la Rochelle's 1939 book *Gilles*. Aragon himself later brushed a far less laudatory portrait of Breton in his 1944 novel *Aurélien*, in which the pompous "Ménestrel" sharpens his claws on his disciples.

Finally, Breton's recriminations betrayed his own struggles with the muse: despite his repeated denigrations of literature, time and again he had demonstrated his irresistible need to write and his relief when the writing went smoothly. In this period of scant composition and personal demoralization, Aragon's ease in human relations, his greater prestige at the *NRF*, and above all his seemingly effortless productivity must have irritated Breton no end.

As so often happens, however, distance from the overheated intimacy of daily group life went a long way toward softening animosities, and Aragon's relations with his comrades improved soon after his departure. Over the following weeks, he received visits from a number of friends, including the Bretons—all of them glad to renew contact and, no doubt, to spend a few days in the country.*

Aragon was back in Paris in July, for Dada's final, and perhaps most notorious, demonstration. Hoping to revive his comatose brainchild, Tzara had assembled a multimedia show, featuring his remaining colleagues, the ever-present Jean Cocteau, a smattering of other avant-garde faithfuls, and his 1921 play *The Gas Heart*. The "Evening of the Bearded Heart," as the event was billed, took place on the evening of July 6, 1923, at the Théâtre Michel, before a hall "packed with gawkers and snobs, for whom this kind of show still held out the attraction of novelty . . . along with artists and regulars drawn by the prospect of seeing the wolves devour each other." Among these "wolves" were Breton, Aragon, Eluard, Desnos, and Péret, who had come looking for trouble. Tzara had recently enraged Breton by publishing an interview—also with Roger Vitrac for *Le Journal du peuple*—in which he rebutted Breton's recent positions on Dada and proclaimed his own taste for money, renown, and success.

A brawl was almost inevitable in such circumstances, but when it finally happened it was triggered not by Tzara but by "charming, pint-sized" Pierre de Massot. It was while Massot read a monotonous proclamation: "André Gide, dead on the field of honor. Pablo Picasso, dead on the field of honor. Francis Picabia, dead . . ." that Breton jumped onstage, heavy cane in hand, ostensibly to defend Picasso's name. Desnos and Péret held the young man from behind, while Breton ordered him to leave the theater; when Massot refused, Breton struck him with his cane so violently that he fractured Massot's left arm. Tzara rushed onstage and signaled to the police, and after a small scuffle the three aggressors were thrown out, to the tune of the audience's boos. Massot, despite his injury, returned to finish his recitation in the restored calm.

But this was not the last of it. The subsequent skits were performed in a tense atmosphere, vocally annotated from the balcony by Eluard and Aragon. The antagonists took a brief intermission to watch some short films, including Man Ray's aptly titled *The Return to Reason*, only to start up again when six actors—Jacques Baron, René Crevel,

* Breton did, however, take a certain measure of revenge a few months later, by making Aragon recite portions of his unfinished book *Paris Peasant* during a well-attended evening at Rue Fontaine. As Breton announced the reading, Aragon recalled, "I felt as if he had just turned his thumb earthward before the Roman populace." Afterward "there was silence, some coughing, the sound of scraping chairs . . . then, finally, with great kindness, someone—a woman—said: 'But, darling, why do you waste your time writing such things?'"

and the valiant Massot among them—began performing *The Gas Heart*, in stiff cardboard cylinders designed by Sonia Delaunay. This time the disruption came from Eluard, who fulminated against Tzara for having called the cops. When Tzara emerged from the wings to restore order, Eluard leapt onstage and slapped both him and Crevel in the face (while the latter, hampered by Delaunay's costume, tried with tiny steps to shuffle offstage) before he was grabbed in turn by a band of stagehands and severely beaten. He fell into the orchestra pit, shattering some of the footlights and inflicting further damage on a by now devastated theater, while the horrified owner wrung his hands.

For her part, Simone was less than pleased with the evening's events. She blamed much of the violence on Desnos, whom she saw as a bad influence on her husband. "What annoys me is that Desnos overstimulates the side of André's nature I most fear: his propensity to endow every disappointment with a general and definitive import," she told Denise. Breton himself long remembered the incident. In 1924, he sent Tzara a copy of *The Lost Steps* with the inscription: "To Tristan Tzara, to the novelist of 1924, to the swindler-of-all-trades, to the old parrot, to the *police informant*." And four years after that, he was still smarting about when Tzara "handed us—Paul Eluard and myself—over to the police," an action "so revealing that in its light . . . Tzara's *25 Poems* (the title of one of his books) becomes *25 Policeman's Lucubrations*."

Still, it was certainly Eluard who suffered most that night, not only because of his treatment by the stagehands but also because several weeks after the incident Tzara dunned his former friend for 8,000 francs in damages to the theater. Eluard countersued for his beating by personnel "in the service of Monsieur Tzara." The affair lasted nearly a year, replete with lawyers and court dates, before ultimately fading away—a sadder and more incontrovertible testimony to Dada's decease than its harshest critics could have devised.

In August 1923, Breton and Simone went to spend their vacation in Lorient. After the tumults of the previous months, Breton found it relaxing to fish, spend time with his wife, and enjoy the air away from Paris. Perhaps the largest factor in his improved spirits, however, was the recent spate of poems—some automatic, most a combination of automatic and conscious—that he had been writing as of the previous month. It was almost as if his public declaration of silence had liberated a flood in him: in the space of six weeks he wrote eighteen poems, including some of the most important of his entire œuvre. By late August he had decided to gather these poems into an eighty-four-page

volume, to be called *Earthlight* (*Clair de terre*). "Some of the poems in this collection are perhaps a little more important to me than anything I've written up until now," Breton told Doucet on the 22nd. "I'm even happy with them, which is rare." Breton had no formal publisher for *Earthlight*, and when the book came out on November 15 it was in a limited edition of 240 copies, with the entire production cost of 2,300 francs borne by himself. In place of a publisher's colophon, the cover simply bore the words "*Littérature* Collection."

There are nonetheless advantages to self-publication, among them complete control of design and content. Breton chose a nonstandard format for the book and was so set on the look of the title page (the words were formed by white spaces in a black background) that he spent an entire afternoon drawing it. He had originally hoped to illustrate the book with four sketches by Chirico; he had also been offered a drawing of himself by Max Ernst, portraying him shirtless with his arm in a sling. But Breton disliked the Ernst (which was finally used on advertisements), and the Chiricos never materialized. Instead, *Earthlight* eventually featured a portrait by Picasso.

This portrait was etched during a visit the Bretons made to the painter and his wife, the ballerina Olga Koklova, at Cap d'Antibes that summer. Breton avidly admired Picasso's work, just as he was cognizant of the painter's rising status in the art world. It was no doubt a combination of these reasons that pushed him to try to involve Picasso in various projects (such as the ill-fated Salon X) and to bring him closer into contact with *Littérature*, to which Picasso had finally contributed an illustration in May. Picasso, for his part, was not unaware of Breton's efforts on his behalf with Doucet, particularly for the acquisition of *Les Demoiselles d'Avignon* (which at the time was still in negotiations). And while his celebrated friendships included a number of figures on Breton's blacklist, such as Cocteau and Max Jacob, he was openly sympathetic to the Dadaists, whom he saw as heirs to the Cubist circle of his youth.

Breton had first met Picasso several years before, and periodically saw him in Paris while making his rounds with Doucet. He also paid occasional visits to the painter on his own account. But the stay at Cap d'Antibes in the summer of 1923 added a new element of friendship to what had previously been a mutually respectful, professional relationship. Breton's discourses on automatism intrigued Picasso, who later tried his hand at it in poetical writings and some visual works, though it was never a major part of his aesthetic. The painter was also impressed by Breton's prophetic aura, and the portrait he drew is unmistakably that of a leader: formally dressed, torso rigid, "eye somewhat fearsome," as a pleased Breton described his likeness. Breton himself began stepping up his contact with Picasso as of that fall, and made a point on several occasions of publicly and

privately stressing their friendship. "My admiration for you is so great that I can't always find the words to express it," he wrote in October.

Coming soon after Breton's vow of silence—and being almost the paradoxical off-shoot of this vow—*Earthlight* embodied his conflicting desires both to turn his back on poetic activity and to delve more deeply into it. "Even with all the disappointments it has already caused me, I still see poetry as the terrain on which the terrible difficulties that consciousness has with confidence, in a given individual, have the best chance of being resolved," he had written in "The Disdainful Confession." "That is why I occasionally act so harshly toward it, why I can forgive it no abdication."

Earthlight manifested this ambivalence in several ways. Breton had included dream narratives, calligrams, and automatic prose alongside the more visually traditional poems from July and August, suggesting at once a renunciation of the poetic form and a reinvigoration of its possibilities. Still more ambivalently, he ended the book with a text called "To Rrose Sélavy," which implicitly paid homage (via Duchamp's aphorisms) to the poetic fertility of the unconscious, even as the text itself, a single alexandrine ("I've left behind my tricks, my pretty tricks of snow"), sounded a farewell. But what was Breton saying farewell to? His past writings? Poetry in general? Would other volumes follow *Earthlight*, or was this, literally, the final text? And by addressing his farewell "to Rrose Sélavy," was he in fact celebrating or dismissing the products of induced slumber? "To Rrose Sélavy," on one side, and Breton's opening dedication to the "forgotten" poet Saint-Pol-Roux, on the other, acted as thematic bookends, enclosing some of his most vital compositions even as they sought to negate the works' very existence.

In the fall of 1923, Breton found himself in a situation similar to that of spring 1919: he experienced an utter discouragement that left the future wide open; a desire to, as Apollinaire had said, "Lose / But lose genuinely / To make room for discovery." His letters and actions of the previous eighteen months bespoke his hesitation between jettisoning the past (friends and activities) and salvaging what might still serve. So it was that a decision to stop writing altogether soon yielded to a revival of automatic poetry, which would reach its height the next spring. So it was, too, that discouragement with Dada led at times to a desire for solitude, at others to collaborative projects such as the Congress of Paris or the "Vague Movement."

One aspect of the past seemed clearly destined for abandonment, however, and that was *Littérature*. Despite its various format changes and Gallimard's distribution, the

magazine's audience was shrinking steadily. In April, Breton had told Vitrac that *Littérature* would soon be down to twenty-five readers, and that they would stop publishing it. (This was no hyperbole: internal memoranda in the Gallimard files show that, even though they needed to sell only forty copies per issue to break even, the magazine was still in the red.) By late summer, his spirits lifted, he had instead decided to limit *Littérature* to special issues. But it was a stopgap measure at best, and the magazine would appear only twice more before ceasing publication altogether in June 1924.

The status of certain friends, too, turned quite brittle that fall. In November, Breton came away from a visit to Eluard's new home in the suburb of Eaubonne with barbed words for both the host and his permanent houseguest, Max Ernst. Ernst had decorated the house with large murals, including a giant nude of Gala that advertised the trio's unorthodox sexual arrangement like a billboard. "[The mural] surpasses in horror anything one could imagine," Breton opined to Simone on the 11th. "To think that the suburbs, the countryside hide such machinations: I know that if I were lightning, I wouldn't wait for summer." As for Eluard, his huge art collection inspired only Breton's contempt: "The paintings and other precious objects are lined up like kitchen utensils from cellar to attic . . . Not the slightest temperament, nothing to indicate any sort of choice."

Given the passionate nature of Breton's own collecting, it is not hard to see how he would be troubled by the seemingly haphazard quality of Eluard's, its lack of "temperament." It was true that Eluard, unlike Breton, collected voraciously—one could almost say in bulk. At the same time, at least on one level, Breton might have been trying to justify philosophically a basic jealousy: Eluard's family situation and salary allowed him to acquire a number of works that Breton would have liked to own himself. Various statements of Breton's throughout the two men's friendship betrayed his envy at the other's better fortune. It is significant that only three days before Breton's visit to Eaubonne, Eluard had snapped up a Chirico that Breton hoped to buy for Rue Fontaine.

If Breton was able to acquire artwork at all, it was due mainly to his job for Doucet, which provided him with a steady and comfortable, if hardly extravagant, income. The position also exercised his knowledge of literary and artistic matters and allowed him to help his friends, many of whose paintings and manuscripts joined the collection through Breton's efforts. Moreover, the patron had frequently proven generous: he treated his protégé to meals and small gifts, had hired Aragon at Breton's insistence, and helped finance *Littérature* even though he personally found the magazine distasteful.

Despite this, Breton derived little pleasure from his relations with Doucet. He resented being treated like the man's factotum, while everyone else considered him a leader. The wary Doucet made Breton account for any absences during business hours, and

would even appear unannounced at the library to verify that his employee was indeed earning his wages. On top of which, the self-made collector was no intellectual, and his interest in artistic investments could not match Breton's passion for the works themselves. He tended to greet Breton's recommendations with cautious reserve, constantly throwing the reins of wait-and-see over his young colleague's rampant enthusiasm. Doucet's biographer spoke of the "essential incompatibility" between the collector's innate skepticism, belief in social hierarchy, and fear of being exploited, on the one hand, and, on the other, Breton's "hostility to pragmatism," "predilection for ambiguity," and other traits fundamentally inimical to Doucet's world.

Perhaps most frustrating for Breton was the issue of money: Doucet never forgot who was writing the checks, for either salaries or artworks, to his adviser's frequent mortification. Breton felt that Doucet, a millionaire several times over, should unstintingly support those artists and writers that he, Breton, deemed worthy. But Doucet was ever on the lookout for a bargain, and he often proved boorish in his dealings with artists. Breton bitterly recalled one visit to Max Ernst's studio:

> Ernst was then living in extreme poverty . . . and accepted a ridiculous price, 500 francs, for a painting entitled *The Interior of Sight*, which depicted five transparent vases with flowers growing upside-down. I don't know what crossed Doucet's mind, but he suddenly got it into his head that the painting would be much better with three vases instead of five. He told Ernst—who had the weakness to agree—to treat the same subject with only three vases, and, of course, the price was adjusted accordingly: 300 francs instead of 500!*

Anecdotes such as this helped foster Breton's subsequent characterization of Doucet as "Ubu, patron of the arts." "I judged him as being rather thick-witted, and he knew it," Breton recalled, "for he often said, 'Breton would like to cut my head off,' which wasn't entirely false." But Doucet's somewhat idealized vision of youth kept him from giving too much credence to Breton's animus. With a mixture of fondness and sarcasm, he referred to Breton and Aragon as his "young lions," and confided to André Suares, "Between you and me, I think they're really goslings . . . today's youth [is] somewhat

* There were, however, times when Doucet met his match. He once asked André Derain the price of a still-life, only to have the painter take out a measuring tape. "Well, it's very simple, Monsieur Doucet," he was told: "this makes so many square centimeters, so that comes to 40,000 francs." A humbled Doucet bought the painting without his customary haggling, remarking to Breton as they left: "These modern artists are astounding! They've become real businessmen. In my day, they were much less methodical."

heartless, but they're young, what a wonderful thing!" It would take Doucet several more years to realize just how savagely these young lions could bite.

✳

By early 1924, Breton was emerging as a significant presence in the Paris intellectual scene, endowed with an authority beyond his twenty-eight years. Much of this authority derived from his two publications of the time, *Earthlight* and *The Lost Steps*.

Despite its lack of publisher, *Earthlight* had garnered a number of favorable notices. One of these, by the influential critic Edmond Jaloux in *Les Nouvelles littéraires*, spoke of the book's "extraordinary poetic richness" and "dreamlike impression that few writers have evoked." Perhaps the only frankly hostile response was by the minor Symbolist poet André Fontainas for *Le Mercure de France*: he dismissed the book as a "rather laborious fantasy" and, even worse, neglectfully banalized its title into *Moonlight*. Livid, Breton rebutted in the same publication: "It's been quite some time since your name, the sorriest in all of Symbolism, faded from everyone's memory. André Fantômas, what's that? All the same, it was the worst thing going for about twenty years."

The Lost Steps, which Gallimard brought out in February in an edition of 2,000 copies, received even wider coverage. Franz Hellens, in a long article for *Le Disque vert*, called Breton's writing style "the purest discovery that any writer has made since Rimbaud and Lautréamont." Edmond Jaloux focused primarily on "The Disdainful Confession" and the figure of Vaché ("the prototype of a certain form of humanity, born around 1916"), of whom he evidently wanted to see more. Many others praised Breton's literary breadth, richness of ideas, and personal insights into Dada (which for the mainstream public was still very much alive).

Still, the volume received far from unanimous acclaim, and almost as many articles criticized its "excessive subjectivism." The *NRF*'s Marcel Arland, whose pronouncements aimed as much at the author as at his work, chided Breton for distorting his subjects to suit his own ends—a charge Arland was neither the first nor the last to make:

> Mr. Breton examines only the side [of his subjects] that resembles himself . . . Biased, André Breton rejects everything that might liken him to other men; what he cherishes, what he cultivates, what he exacerbates are those things specific to him . . . He is a mystic without object, a conqueror without a goal, a prophet without faith.

Paradoxically, just as some were taxing Breton for his resolute individuality, he was

consolidating the group around him. He welcomed newcomers to Rue Fontaine, notably the poets Maxime Alexandre and Marcel Noll. He also renewed his ties with Robert Desnos. During the month of March, Desnos appeared almost nightly at 42 Rue Fontaine, particularly as Simone was again away. "Desnos has discovered a new and marvelous faculty in himself, which consists in being able to tell stories in the dark without being asleep," Breton told his wife on the 18th: "splendid stories, very long and complicated, which are spoiled by neither contradiction nor hesitation. It's more disquieting than ever, on top of which his mental state is worrisome: he's predicted his own death in three months' time." Desnos had again become Breton's star—one of the "three fanatics of the first order" that Breton knew of, as he said in July; the other two were Picasso and Freud.

More than at any time since *The Magnetic Fields*, Breton plunged back into automatic writing that March, exhorting the others to do the same, and filling seven notebooks with long, fabulous narratives. In the space of two months, he composed over a hundred of these texts, employing a variety of methods—freehand notation, oral dictation, assemblage of poems from newspaper clippings (although the debt to Tzara's famous "recipe" was never acknowledged)—all in an effort to coax "that capricious voice I try to force from time to time." Eventually, thirty-two examples of this "Surrealism," as Breton had by now dubbed the written traces of uncensored thought, were selected for a volume. It seemed to him that the secrets of automatic activity were far from exhausted, and that *The Magnetic Fields* had been only the beginning.

It was in the same month of March that Paul Eluard suddenly disappeared. He had been suffering anxiety attacks all the previous year, brought on by his sensitivity to tensions within the group, by Breton's disapproval of his job in the family real estate business, and particularly by the strain of his ménage à trois with Gala and Ernst. Like many an unhappy lover before him, he had tried to drown his sorrows in late-night barhopping with Aragon and Marcel Noll, "throwing his money away, drunk, afraid to go to bed alone," as Simone told Denise. Early in the month, Eluard's new book of poems, *Dying from Not Dying*, had carried the ambiguous message: "To simplify matters, I dedicate my last book to André Breton." Finally, on the 24th, he embezzled 17,000 francs from his father's company, sent the old man a *pneumatique* threatening death to anyone who came after him, and vanished.

In one stroke, Eluard erased any misgivings Breton might have had about him. Breton became deeply concerned about his friend's well-being and was afraid that he would never see him again. Inevitably reminded of the earlier, equally sudden disappearance of Jacques Vaché, he suffered a period of extreme mood swings: Simone told

Denise that she found "André depressed, worried, more removed than is good for him," even as Marcel Noll reported that he had seen Breton laugh "as I'd never seen him laugh before; he had tears in his eyes." Over the ensuing months, as the rest of the group gradually forgot, Breton continued to wonder obsessively about Eluard's whereabouts. An automatic text from late March began: "Which is he? Where is he going? What has become of him? What has become of the silence around him?"

But personal anxiety was not the only force driving Breton, and his concern for Eluard as an individual was amplified by more abstract resonances. To Breton, Eluard was not merely a friend in trouble, but an Olympian figure who had wrested himself from his predictable course and set off heroically to navigate the seas of pure chance. He considered the disappearance as significant as Rimbaud's mythic flight to Harrar, and he made the group reread Eluard's poems in this new light. Like Rimbaud, like Vaché, Eluard had elevated himself to symbolic stature.

Attempting to convey the magnitude of the event, Breton told Jacques Doucet that Eluard's action "so strangely reinforces at this moment the mystique of life to which I'm violently attached, that it hurls me to the furthest point of myself." But the blasé collector saw Eluard's escapade mainly as good party chat, and he mentioned it so often that some newspapers picked it up for their gossip columns. Exasperated, Breton sent Doucet a pointed reprimand, after which the chastened employer abstained from further comment about Eluard.

"Leave everything": two years after Breton's exhortation, Eluard had taken the command literally. Now, inspired by his friend's example, Breton put his own words into practice. "Adventurers from Paris. They're going to leave . . . They're leaving," went a newspaper collage text from this period. In the first days of May, Breton left his Rue Fontaine studio and, along with Aragon, Morise, and Vitrac, took to the proverbial highway. The four men caught a train to Blois, a town they had picked at random on the map, then set off haphazardly on foot; their only planned detours would be for eating and sleeping. Their goal was an absence of goals, an attempt to transpose the chance findings of psychic automatism onto the open road. Just as Eluard had apparently done, they wanted to leave themselves open to whatever might occur.

On the 5th they arrived in Romorantin, some one hundred miles south of Paris; on the 7th they were in Argent, where Morise vandalized a crucifix in the train station; on the 9th they passed through Moret, the site of one of Breton's wartime summers. During rest stops they composed automatic texts, many of which contained reflections of their momentary surroundings. But for the most part, they wandered aimlessly throughout the French countryside, conversing all the while, resolutely following their lack of itinerary.

Almost from the start, the stroll's very randomness began to have troubling effects. Breton later related that the trip "took an initiatory turn. The absence of any goal soon removed us from reality, gave rise beneath our feet to increasingly numerous and disturbing phantoms." Some of these phantoms appeared in rather unexpected settings, such as the bathroom of a small inn, where Breton suddenly noticed an enormous white cockroach crawling toward him. "Now, *everyone knows that there's no such thing as a white cockroach!*" he recounted to a friend. "Fascinated to the point of wondering whether some spirit didn't inhabit that 'thing,' who perhaps had a message for me, I watched it come closer"—before fleeing the bathroom in a panic. Not long afterward, a fistfight broke out between Aragon and Vitrac, the former disgusted by the other's insistence on seeing every minor coincidence as a major revelation. The hostility and growing fatigue contributed to the sense of disorientation, and on the 14th, some ten days after setting out, Breton put an end to the trip. This exploration of "the boundaries between waking life and dream life" was hardly exhaustive; but as with his earlier experiments, Breton feared letting it get out of hand. A train carried the adventurers safely back to Paris the next day.

Breton had now brought together a group passionately motivated by a common set of ideals: that society as it existed was to be rejected; that literature was, in his words, "one of the sorriest roads that lead to everything"; but also—and in this they differed from the Dadaists—that poetry could provide a "specific solution to the problem of our lives." Through such activities as the Congress of Paris, the sleeping fits, and the resurgence of automatic writing, he had sought to create a domain of his own, one that would replace Dada. In Rue Fontaine, he also had a place for the group to conduct its experiments.

Still, whatever the shortcomings of the May excursion, it left Breton convinced that his laboratory was not solely in his apartment or in the depths of his unconscious; part of it would always be on the streets. Tapping hidden stores of creative power was insufficient unless it could be brought into the open, made available not only to a small circle of like-minded individuals but to society at large. As Tzara had before him, Breton recognized that the group needed a means of capturing widespread attention. It needed a public image.

THE "POPE" OF SURREALISM

(May 1924 – July 1925)

ANDRÉ BRETON WAS A MAN OF VIOLENT ENTHUSIASMS, which were almost inevitably followed by a long, slow decline into indifference, even outright hostility. Forever caught between a native ardor and a bedrock of pessimism, he could no more help giving in to his initial attraction than he could growing disillusioned with its object—whether artwork, activity, or person. While many possess this trait, in Breton's case both the enthusiasm and the ensuing hostility often assumed outsized proportions. They were also unusually volatile: after spitting venomously on the former object of passion, Breton might embrace it just as fiercely all over again.

One area particularly affected by this ambivalence was Breton's tendency toward leadership, which was pushed to the forefront now that he had assembled a group fully his own. On the one hand, and with rare moments of exception, this collective revolved around the figure of Breton. "There were other poets and artists at [the café], who were perhaps more interesting, more likable, and even more amusing," recalled the Serbian poet Dušan Matić. "But it was Breton who grabbed your attention . . . The others gave the impression of only passing through. Breton appeared to be 'in his element.'" This presence, the almost fanatical commitment to his activities, made Breton the inevitable center of attraction. But on the other hand, Breton's will to leadership was counterbalanced by an impulse toward abdication, and his central status was sometimes conferred against his own wishes. Those who saw the legendary intransigence and authoritarianism were often unaware of how much doubt and indecision lay beneath them.

The same kind of ambivalence applied to his friendships. Like the charismatic figures he had himself admired, Breton had developed a remarkable ability to spark admiration in others, to inspire a friendship that Desnos considered "one of the moral honors of our time." The group "loved Breton like a woman," Jacques Prévert later said; and the historian Maurice Nadeau observed that "those who enjoyed the moments of his unforgettable friendship . . . were ready to sacrifice everything to him: wives, mistresses, friends." Many former Surrealists still recall the extraordinary attention Breton paid them, his talent for *listening* as no one else could, for making them feel as if their

thoughts were the most important in the world. It was Breton's personal magnetism above all that held together the disparate figures in his circle.

At the same time, the desire to gather people around him cohabited with a need to reject. Breton's underlying pessimism led him constantly to question his friendships, to probe and examine them, often until the emotional bond—one he had forged with complete sincerity—cracked under the strain. The list of Breton's lifelong fidelities is revealingly short: a few colleagues (rarely the closest), one or two paintings, the works of Lautréamont, the memory of Vaché. Years later, when asked by Eluard whether he had any friends, Breton replied: "No, dear friend."

Just as Breton could keep people by his side, so he could expel them with little warning. Some, finding themselves the target of his sudden furies (when only shortly before they had enjoyed the privilege of his affection), actually contemplated suicide. Desnos later reflected on this fickleness, in words that bore all the sting of banishment: Breton, he said, "needs marvelous encounters. Each time he will devour a soul and, if the encounter is too long in coming, he will infuse the first person he meets with enough flame and simulated genius to make a puppet into a poet for a few instants—only to be the first to toss that carcass aside when a worthy visitor comes along."

For Breton, these rejections were necessitated by a deep-seated—many would say neurotic—need for purity: by his own distinction, "ideological friendship," based on intellectual accord, predominated over "affective friendship." In his view, one's actions, thoughts, and productions established an expectation, which one was then bound to honor. His "propensity to endow every disappointment with a general and definitive import," as Simone had said the previous year, "madly dramatized" intimate friendships and private moods, drawing them into a global worldview that left little room for weakness or deviation. A spectacular act or moment of genius could magnify its author to larger-than-life stature. But as many cases had shown, from Barrès to Tzara, the disappointment caused by failure to live up to this promise became grounds for an equally spectacular rejection.

In the spring of 1924, the main target of that rejection was Picabia, toward whom feelings of cordial complicity had again yielded to rivalry, disappointment, and resentment. For the second time, Breton was finding much to condemn in the painter's recent activities, such as his collaboration with Erik Satie on the ballet *Relâche* (too frivolous and commercial) and, even worse, a novel the painter was writing, *Caravansérail*, a thinly camouflaged satire of the Dada years whose protagonist, "Claude Lariençay," was an unflattering caricature of Breton. For his part, Picabia disliked being supplanted; he felt that his forty-five years and status as precursor desig-

nated him, and not the young upstart from *Littérature*, as head of the post-Dadaists.

The novelist Joseph Delteil, who had recently joined the group around Breton, recalled the painter's untimely arrival at Rue Fontaine one evening. Picabia and Breton stood "facing each other like two stags during mating season," Delteil said, "both aware that it was the duel to the death for disciples and posterity. One dressed in shimmering velvets and gaily-colored scarves, the other in somber cloth and sharp contours; one all fire and flame . . . the other immobile, massive, monolithic . . . his torso cutting slantwise across the checkerboard floor, cigarette dangling from his lips." As Picabia compulsively talked, Breton became "still more immobile, his mask still more impassive," dropping only an occasional, stinging word—until the painter finally stormed out.

Even as he sparred with Picabia, Breton was forging a new identity for a revitalized collectivity. By midsummer, the terms "*Littérature* group" and "Vague Movement" had been replaced by "Surrealism," a word that Breton had used since 1920 to designate automatic writing and that had increasingly served as an informal label for the group's activity. Accordingly, plans were made to replace *Littérature* with a magazine that better reflected the Surrealist image and objectives. The new periodical was to be called *La Révolution surréaliste*: the Surrealist revolution.

At the same time, Breton finished preparing the manuscript of his recent automatic texts, which by now had been accepted by a young publisher and literary critic named Léon Pierre-Quint, editorial director of Simon Kra's Editions du Sagittaire. Soupault, who assumed responsibilities with Pierre-Quint at the time, and who had in the interim renewed his friendship with Breton, seems to have been instrumental in acquiring the project.

Breton's title for the assembled texts, "Soluble Fish," itself came from an automatic notation in his journal that spring: "A bowlful of goldfish swim in my head and in this bowl there are only soluble fish, alas. SOLUBLE FISH, I've thought about it and that's me to some extent, my native severity that asks only to laugh, to lash out." Shortly afterward, Breton returned to the image to note: "SOLUBLE FISH, am I not the soluble fish, I was born under the sign of Pisces, and man is soluble in his thought!"

"Soluble Fish" gathered thirty-one of the automatic "short anecdotes" that Breton had composed between March 16 and May 9, along with one from early 1922. As the title suggests, these texts are populated by fantastic flora and fauna—a turkey on a dike named Threestars, a "wasp with the waist of a pretty woman," fluid electric fish and birds that lose their shape and color—juxtaposed on impossible landscapes: the earth becomes an enormous unfolded newspaper, a large watering trough stands before the Panthéon, gravestones turn into boats. But above all, "Soluble Fish" is haunted by figures

of elusive women: women "with breasts of ermine" and transparent hands, who wear "garments of the pure air," who dematerialize into shadows and veils during lovemaking, then disappear forever. For although many of these brief tales are stamped with humor and a fierce, *Maldoror*-like inventiveness, "Soluble Fish" is first and foremost a record of loss: loss that most often takes an erotic form, but that surely reflects the renunciations and abandonments of Breton's life in the period before the summer of 1924.

Hoping to avoid the neglect and incomprehension that had greeted *The Magnetic Fields*, Breton thought to preface the volume with a short theoretical introduction, which he had begun writing on his return from the random walk in May. But he soon hesitated about the nature of the text, and in June considered replacing his preface with a collective statement. "Soupault, Aragon, and I are perhaps going to collaborate on a kind of manifesto of our mutual ideas at this moment," he told Simone on the 17th. "About a fifteen-page text, which . . . will be called 'Letter to Dawn' ('Madam, . . .' etc.)." But the collective "Letter" was then abandoned in turn, and the "fifteen-page" collaborative text split into, for Aragon, a twenty-page article entitled "Une Vague de rêves" [A Wave of Dreams] and, for Breton, a declaration of some seventy pages, eventually titled *Manifesto of Surrealism*.

Unlike the automatic texts they prefaced, the *Manifesto* was written painstakingly. Simone observed that it "demanded great effort and confronted [Breton] with a series of obstacles and frustrations," whereas he had composed "Soluble Fish" rapidly, feverishly, "as if possessed." Throughout the month of July, most of it spent in Lorient, Breton worked to set the tone of what he still considered an introduction. Discussions late in the month with a visiting Max Morise convinced him to expand his preface into a full-scale manifesto. The text was for the most part finished, and given its definitive title, in late August. By then, the automatic texts that were originally the book's main body and inspiration had mutated into an illustrative appendix, important but not essential. Subsequent editions are indicative in this respect: whereas the *Manifesto* was reissued five times during Breton's life, only the 1929 and 1962 republications contain "Soluble Fish."

The *Manifesto of Surrealism*, one of Breton's best-known and most influential works, distills his intellectual trek since the days immediately preceding Dada, and clarifies the link between the group's recent experiments (sleeping fits, dream narratives) and those he had conducted during the writing of *The Magnetic Fields*. As Breton later said: "It sanctioned a way of seeing and feeling that had slowly been delineated and pondered, had gradually taken shape and formulated its demands over the preceding years. When the *Manifesto* was published in 1924, it already had behind it five years of uninterrupted experimental activity, involving a considerable number and variety of participants."

Indeed, one of the book's main objectives was to define a distinct group of individuals, as indicated by the enormous number of proper names it contains. Foremost are those of Breton's close collaborators, the "permanent guests" at a mythical castle "not far from Paris": Aragon, Péret, Fraenkel; Desnos, whom Breton singled out as "he who, more than any of us, has perhaps got closest to the Surrealist truth"; Soupault, back in favor since Breton's break with Picabia; "our great Eluard," who "has not yet come home"; Limbour, Baron, Vitrac, Morise, Noll; Georges Auric and Jean Paulhan, neither of whom would be part of the Surrealist movement; plus several newcomers: writers Pierre Naville and Joseph Delteil, lawyer Francis Gérard, photographer Jacques-André Boiffard, and artist Georges Malkine. Duchamp, Picasso, and even Picabia were named as visitors to the castle, a manor whose "outbuildings [were] too numerous to mention," and in which Breton was clearly lord and master.

Breton was also careful to provide Surrealism with a pedigree, by listing past figures who had been "Surrealists" in at least one respect. Among these were Sade, who was appropriately labeled "Surrealist in sadism"; Poe, "Surrealist in adventure"; Swift ("in malice"); Baudelaire ("in morality"); Rimbaud ("in the way he lived, and elsewhere"); Reverdy ("at home"); and, in a revealing personal reference more than five years after his death, Vaché: "Surrealist in me." Even Dante and, "in his finer moments," Shakespeare "could pass for Surrealist."

Breton's concern with lineage in the *Manifesto* might seem surprising, unless one recalls that almost all of his explorations had been conducted with a watchful eye on his precursors. As he'd told Doucet in 1922: "An emerging mind or movement is obliged to retain everything that bygone minds and movements could not embrace. Without that safeguard, I don't believe evolution is possible." On top of which, he was eager to show that Surrealism was not simply the ravings of a band of young radicals. Earlier, Tzara had maintained that "Dada was not modern," that (as one tract stated) it had "always existed." Now Breton took equal care to portray Surrealism as a timeless manifestation of the human spirit "in its finer moments." (It is significant to note, given painting's subsequent role in the movement and in its public profile, that Breton at this point conceived of Surrealism as primarily a literary and philosophical manifestation. Every one of the twenty-four precursors he names in the *Manifesto* is a writer, and only in a footnote does he credit some visual artists—Seurat, Moreau, Derain, Picasso, and a few of his contemporaries—with having occasionally demonstrated the same spirit.)

More than anything, however, the *Manifesto of Surrealism* is a call to liberation, an attempt to win man, "that inveterate dreamer," away from the "lusterless fate" imposed on him by centuries of stifling Greco-Roman logic. "Latin civilization has had its day,

and for my part, I ask that we unanimously forgo trying to save it," he declared that winter. "It now seems no more than the last rampart of bad faith, old age, and cowardice." And in the *Manifesto*, he rails against "the absolute rationalism that is still in vogue."

To counter the damage wrought by logic and all its works, Breton offers Freud's discoveries, the marvels found in dreams, certain forms of mental distraction (particularly madness), and especially the new vistas afforded by Surrealism in the realm of language —which "has been given to man so that he may make Surrealist use of it." Automatic writing, induced slumbers, and other aspects of "poetic Surrealism" are promoted not as methods or techniques ("future Surrealist techniques do not interest me," Breton claims), but as doorways to a state that "acts on the mind very much as drugs do; like drugs, it creates a certain state of need and can push man to frightful revolts." To the bland conformity of modern life, Breton responds with his own peremptory credo: "Let us not mince words: the marvelous is always beautiful, anything marvelous is beautiful, in fact only the marvelous is beautiful."

One of the *Manifesto*'s most memorable sections is Breton's famous definition of Surrealism itself:

> SURREALISM, *n.* Psychic automatism in its pure state, by which one proposes to express—verbally, by means of the written word, or in any other manner—the actual functioning of thought. Dictation of thought, in the absence of any control exercised by reason, exempt from any aesthetic or moral concern.

> ENCYCL. *Philos.* Surrealism is based on the belief in the superior reality of certain forms of previously neglected associations, in the omnipotence of dreams, in the disinterested play of thought. It tends to ruin once and for all all other psychic mechanisms and to substitute itself for them in solving all the principal problems of life.

By clearly defining Surrealism as "psychic automatism" and "the actual functioning of thought . . . in the absence of any control," Breton immediately placed his main activities of the past five years—with the notable omission of Dada, which he accorded one passing reference—under the same large and mysterious umbrella. He also explicitly portrayed Surrealism as a philosophical, not aesthetic, undertaking. As the historian Maurice Nadeau explained: "The movement was envisaged by its founders not as a new artistic school, but as a means of knowledge, a discovery of continents which had not yet been systematically explored: the unconscious, the marvelous, the dream, madness, hallucinatory states—in short . . . the other side of the logical décor. The final goal remained

the reconciliation of two hitherto warring realms: man and the world." Like the Columbus whose "madness" discovered America, Breton set out to conquer, as he stated in a contemporaneous press release, "the huge, indeterminate area over which the protectorate of reason does not extend." And if art and literature were the primary means of his exploration, they were still only means; one could, like Vaché, be a Surrealist without ever having "produced anything."

Like any manifesto, Breton's filled not only a broader philosophical function but also a specific, polemical one. On the one hand, his definitions, craftily modeled on standard dictionary format, gave journalists an easily quotable passage for their reviews—for in part the *Manifesto* was a model publicity release, demonstrating that Tzara's lessons had not been wasted. On the other, the text's scope and importance served as a barrier against rival claims to define Surrealism. "Breton was already very suspicious at that time of competitors, since Surrealism, if he let it be used any which way, could easily have disappeared," said the future Surrealist Marcel Jean.

One such claim came from Aragon, whose own manifesto, "Une Vague de rêves," had been completed two months before Breton's and delivered to the magazine *Commerce* in late June. In the elusive, elliptical style at which he excelled, Aragon described his own brand of Surrealism, a state of endless hallucination that was mainly equated with the sleeping fits: "Surreality, a relation in which the mind encompasses all notions, is the common horizon of religions, magic, poetry, dreams, madness, intoxications, and puny life." He, too, introduced Surrealism's precursors, "the Presidents of the Republic of Dreams," and then the dreamers themselves: with few exceptions, the same list as Breton's. "Who is there?" the text concluded. "Ah, very good: please show infinity in." Having missed several of the key elements leading to Surrealism, Aragon now made himself the most fervent champion imaginable of the automatic message.

Concurrently, another, more explicit and more heated rivalry soon turned into a battle over the moral copyright to the word "Surrealism" itself. It had begun on May 22 when Paul Dermée, one of Dada's hangers-on, opined in *Paris-Soir* that the term "literary Cubism" should be replaced by "Surrealism," to designate the works of Reverdy, Max Jacob, Apollinaire, and himself. In response, the *Littérature* group had protested that "Surrealism," although Apollinaire's by name, had in fact begun with Lautréamont and Rimbaud, and continued with *The Magnetic Fields*; Reverdy and Jacob sacrificed "too much to the critical spirit" to properly be called Surrealists.

Breton had previously associated himself publicly with the term "Surrealism": first in "For Dada," where he began pulling Apollinaire's definition into the domain of unconscious activity; then more recently in "The Mediums Enter." In his view, everything he

had done since 1919 defined what he meant by "Surrealism." But the rival faction saw things differently, and on August 16 the poet Yvan Goll leapt into the fray with a "rehabilitation of Surrealism" for *Le Journal littéraire*. Goll, a close associate of Dermée and devotee of Apollinaire, had previously published several Expressionist works in Berlin, all the while agitating on the fringes of Paris Dada. In his article, he dutifully reminded readers of Apollinaire's coinage, then went on to deplore that the younger generation, "which has lived only for overnight success," had now co-opted Surrealism, whereas the "most faithful" to its spirit were Dermée, Pierre Albert-Birot, and himself.

On the 23rd, the Rue Fontaine gang responded in a letter to the same *Journal littéraire*, flatly rejecting the strictly Apollinairian definition that the "unqualified" Goll sought to impose. Not wishing to be caught short, Goll and Dermée rebutted on the 30th, and this time the note was more personal. Incensed by the charge that he had merely played Dada's "grotesque bit parts," Dermée shot back that Breton, "stifled by the corpse of Dada, which he killed with his social-climbing excesses and his scheming little mind . . . seeks in vain a breath of fresh air." Goll, meanwhile, censured Breton for his claims to exclusivity: "It is ridiculous to try to wage a Surrealist 'Revolution,' in order to set oneself up as the dictator of Surrealism. Mr. Breton, get used to it: you will never be the Pope of Surrealism."

Not willing to let the matter rest, and despite *Le Journal littéraire*'s hope that the Goll and Dermée letters would spell "the end of the controversy," Breton responded on September 6 with a long excerpt from the as yet unpublished *Manifesto* (the passage detailing his discovery of automatic writing, his differences with Apollinaire, and his dictionary definition). By late summer, the confusion of claims and counterclaims had become such that many readers, and some reporters, were unable to tell just who could legitimately lay claim to "Surrealism"; a few articles, in fact, haphazardly mixed the Goll and Breton brands, crediting one with the other's viewpoint, or describing two competing manifestations as complementary.

In an attempt to win the title once and for all, Goll rushed to press with a magazine, provocatively called *Surréalisme*. Out on October 24—mere days before Breton's *Manifesto*—it featured Apollinaire's famous letter to Dermée of March 1917, which included his original definition of Surrealism. In addition, Goll, Dermée, and Albert-Birot each contributed a statement reiterating Apollinaire's paternity of the word. "Reality is the basis of all great art," Goll wrote. "Our Surrealism . . . moves, with completely new artistic materials, toward construction, toward will." This was quite different from Breton's "psychic automatism," which the three made sure to attack, and which Goll promised would "soon be put out of circulation."

But in the end it was the *Manifesto*, published by Sagittaire in late October, that became the definitive statement on Surrealism. Quite simply, Breton had outmaneuvered his predecessors: though his language and tone fully befitted his esoteric message, he nonetheless retained a patina of discursive, almost scientific objectivity that made the *Manifesto* accessible to a broader audience; whereas Aragon, by adopting a self-consciously literary and, in a word, *vague* style for his text, had in essence written a tract "for members only." As for Goll, his reheated Apollinairian leftovers simply could not compete with Breton's celebration of "the seductions of the marvelous, the landscapes of dreams, the space of thought set free." And even if one rejected Breton's promotions of Freud and trance states, or his substitution of automatic writing for traditional composition, it was impossible to dismiss the trenchant intelligence and authority of his prose. Moreover, Breton's constant touches of ironic humor—such as his recipes, in a passage called "Secrets of the Magical Surrealist Art," for using Surrealism to "write false novels" or "catch the eye of a woman you pass in the street" (five lines of dots)—and the numerous references to himself, his friends, and the raging controversy, gave the *Manifesto* a living, seductive quality that was hardly matched by Goll's and Dermée's repetitive obeisance to Apollinaire.

The critics seemed to agree. On October 11, four days before the *Manifesto* had even come off press, the influential journalist Maurice Martin du Gard in a major review called Breton "one of the most attractive figures of the generation now turning thirty, of an intellectual class obviously superior to that of Goll and Dermée," who wielded over his followers "the magnetic authority of an Oscar Wilde." Not all reactions were so enthusiastic, of course. Jean Cassou in the *NRF* dismissed Surrealism as an "extended adolescent crisis," while *Paris-Midi* branded it "an interesting method for psychologists, physicians, and psychiatrists: but poets and writers have no use for it." And some, such as Tzara, were simply hostile. "Shit means Surrealism," he snarled in a Belgian Dada periodical (one of the few remaining in any country); "Surrealism is the odor of shit." But nearly all the reviews, positive and negative, attested to the importance of Breton's statement: by December, when the first issue of *La Révolution surréaliste* hit the stands, his version of Surrealism had imposed itself as a public fact, and Yvan Goll's claims to the word had been all but forgotten. It was with only small exaggeration that Sagittaire ran an advertisement claiming: "The whole younger literary generation is talking about the *Manifesto of Surrealism* by André Breton." In fact, the only one to view the situation with mixed feelings was the author himself. "Yesterday I received eleven press clippings," he wrote Simone. "The *Manifesto* is no doubt a rousing success—which I don't find especially encouraging."

✳

The publication of the *Manifesto* consolidated Breton's stature, not only in the eyes of his circle but with the public as well. Even as he continued to rely on Jacques Doucet for his income and to fill his days with tedious chores for the library, to his friends he was the undisputed authority, and to the outside world the brilliant head of an exciting new movement. "In 1924, the entire Surrealist group recognized him as their leader, without there ever having been a question of investiture," noted Victor Crastre, a leftist writer who made contact with the Surrealists the following year: "authority—a spiritual one, of course—emanated from his entire person." Pierre Drieu la Rochelle observed that although each member of the group "personally believes he is going beyond Surrealism," the only one who truly surpassed it—even as he embodied it like no other—was Breton himself.

With typical ambivalence, Breton had both fought for the position and done his best to reject it. The *Manifesto* had been careful to point out Soupault's role in the development of Surrealism's cornerstone, automatic writing; and the long enumerations of other members tended to dilute his own leadership role in the group. Several months earlier, in an article for *Le Journal littéraire*, Breton had also singled out Desnos as Surrealism's "prophet." Everything in his writings seemed to bespeak a will to divide control with as many others as possible.

At the same time, it was Breton, not the others, who had done most to shape the movement, and who, with the *Manifesto*, was now receiving the lion's share of the credit. Not yet twenty-nine, he had become almost a celebrity in intellectual circles: his stiffly solid frame, his "huge head, like one of the old Jacobin leaders," and his "gait, at once weighty and light," were by now identifiable features of the Montmartre landscape. André Thirion said Breton's carriage "had the nobility of his entire person. A lightly gliding step reminded one of Versailles at the time of Louis XIV." Equally distinctive were Breton's ornate cane and even the bottle-green suits and shirts he habitually wore, made from material chosen by Simone. Describing Breton's appearance in those years, Thirion recalled the "discreetly eccentric" ties, often red, that sometimes livened the dark outfits; as well as the abundant hair, "almost russet, slightly wavy, long, and combed back, even when short hair was in fashion."

Even Breton's personal tics added to his aura. One of these was his love of the color green, not only in his dress but in art, in the dark sunglasses he wore at that time, and even in the turquoise ink that flowed from his pen—"that prairie-colored ink that took the place of a magic potion," as one Surrealist said. Another was his handwriting, notable

as much for its extreme regularity as for the unusual sameness it maintained throughout his life. This handwriting rolled in unwavering lines across the page like ripples over a calm lake. It was in this handwriting that Breton composed letters and manuscripts for over fifty years, tracing his sentences in a green almost as invariable as the characters themselves.

But what most impressed both intimates and outsiders was Breton's irresistible air of conviction, the cutting intelligence that—one easily sensed—could be used to charm, to sway, or to destroy. "Like the men of 1793, [Breton] had in him a combination of fanatical idealism and ruthlessness," said Matthew Josephson:

> A person unknown to him might be received at first with the most exquisite courtesy; Breton would listen to him attentively, using terms of such elaborate politeness that to some observers his good manners seemed to serve mainly as an armor of defense . . . Then in an instant his blue eye might blaze with anger at some idea he disliked, his heavy brows turn scowling, and he would proceed with measured words to tear the man before him apart, as if he enjoyed eating him up bit by bit.

Georges Neveux, who began his brief passage through Surrealism not long afterward, remembered his initial surprise at seeing "such fiercely independent men living in a state of fear" because of Breton. "Not one of them could have conceived of a greater misfortune than falling from grace in the eyes of the man who incarnated the conscience of the entire group."

As Neveux suggested, this fear was not the simple terror of the autocrat, but an unwillingness to lose Breton's fellowship and guidance. For many, Breton was a kind of teacher or guru, an unparalleled initiator, a mesmerizing speaker whose eloquent insights were delivered in a voice that kept his listeners enthralled. "When he began to talk, you really listened. The modeling of his phrases was dazzling," said the American writer Lionel Abel.

Indicative of Breton's stature was his famous nickname, "the Pope of Surrealism." Employed by both friends and detractors—the former with humorous respect for Breton's place as their spiritual conscience, the latter to decry his more authoritarian tendencies—the phrase was first used at around this time, possibly by Yvon Goll (although Maurice Martin du Gard had referred to Breton as the "Pope of Dada" in 1921). Breton himself is said to have been profoundly irritated by the sobriquet, at least in later years, and made no reference to it in his writings. Others, particularly the Surrealists of the post-1945 generation, have vehemently opposed the nickname. The issue, however, is

not whether Breton was or was not a "pope," but simply to recognize what gives the image its tenacity: for although the term was hardly invented for Breton—others before and since have worn it, from Victor Hugo to Gaston Gallimard (once he became the grand old man of French publishing)—in his case it struck a particularly resonant chord, and many still consider the words "pope" and "Breton" synonymous. The solemnity of Breton's manner, the frequently mystical turn of his thought, and the occult aura of the café meetings—not to mention the group's later practice of "excommunicating" members deemed unworthy—gave Surrealism an intensely religious coloration in many observers' eyes, and Breton the distinct air of a pontiff. This air, regardless of Breton's feelings about the label, helped turn "the Pope of Surrealism" from a rival's quip into an indelible stamp.

As Surrealism was heightening its public profile, the group was increasing its numbers, and the year 1924 saw the arrival of several new members. One of these was Pierre Naville, who in 1928 would become the second husband of Simone's cousin Denise. The editor of another avant-garde magazine from the Dada epoch, *L'Œuf dur*, Naville had first met Breton at the beginning of the year, and by summer considered Place Blanche his "center of gravity."

There was also the painter André Masson, whose work Breton had discovered in February at Kahnweiler's Galerie Simon. Breton had bought Masson's *The Four Seasons* for Rue Fontaine, and had recommended the painter to Doucet, earning Kahnweiler's gratitude. Masson, for his part, had admired Breton from afar for some time, and as early as 1923 had told Joan Miró to see Breton rather than Picabia: "Picabia is already passé. Breton is the future." (In fact, Breton's meeting with Miró would not take place until 1925.) In mid-1924, a first meeting between Breton and Masson sparked a mutual esteem: the painter had Breton's love of Lautréamont and Raymond Roussel, and Breton was particularly interested in Masson's past history of nervous breakdowns.

But the most notable newcomer at the time was the young actor and poet Antonin Artaud. Breton first took notice of Artaud in September, when the *NRF* published the actor's correspondence with Jacques Rivière about his manuscript of poems *The Umbilicus of Limbo*. Rivière, while turning the collection down, had been sufficiently affected by it to engage its author in a yearlong exchange of letters, which he had then offered to publish in lieu of the poems (although the *NRF* did eventually publish *The Umbilicus* in 1925).

Breton, too, had been roused by this exchange, for Artaud's letters sketched a dark and visceral poetics that fed directly on the same currents as Surrealism—even as it set itself apart from the new movement. Comparing the "weakness" that marred his own poems with that of Tzara and Breton, for example, Artaud observed: "But in their case the soul is not physiologically damaged, it is not damaged substantially . . . They do not suffer and . . . I do suffer, not only in the mind but in the flesh and in my everyday soul." Artaud also touched fingers with Breton's own remarks on psychic automatism when he related the "sudden stops and starts" in his poems "to the very essence of inspiration." Shortly after reading these declarations, Breton contacted their author and invited him to join the movement.

Initially, Artaud was less than impressed by the offer of membership, and after his meeting with Breton he wrote to a friend: "I met all the Dadas, who tried to entice me onto their latest Surrealist boat, but nothing doing. I'm far too Surrealist for that." But Artaud was also a tortured, frenzied man, and Surrealism's deep excavations into the darkness of the self beckoned to him at a time when little else seemed worthwhile. As he wrote several years later: "Surrealism came to me at a time when life had managed to weary me utterly, make me despair, and when I had no other outlets except madness or death. Surrealism was that virtual and ungraspable hope, which was probably as deceitful as any other, but which pushed you in spite of yourself to make one last try." In early 1925, as his health and personal life fell apart, Artaud would enlist body and soul on the "latest Surrealist boat."

Antoine-Marie-Joseph Artaud was born in Marseille on September 4, 1896, the first of eight children, of which only two others survived; Artaud himself nearly died of meningitis at age five. Even in childhood, despite particularly close ties to his mother, he showed signs of an extremely nervous temperament, often expressed by facial tics. At the age of thirteen, he became addicted to the laudanum administered to combat the intense headaches he suffered throughout his life. By age twenty, he had passed through a fervent religious phase, spending entire days in his room praying and studying for the priesthood, and had been in a sanatorium for treatment of "acute neurasthenia." During the 1920s and 1930s he was also prone to hysterical fits, culminating in 1937 with his internment in the first of several psychiatric hospitals as a paranoid schizophrenic.

From childhood, Artaud had demonstrated a penchant for art, and particularly for the theater. In 1920 he went to Paris and found a place with Lugné-Poe's company at the Maison de l'Œuvre, then joined Charles Dullin's troupe the year afterward. Artaud's engaging personality and brooding good looks, as well as his arresting mix of authoritarian rigidity and childlike vulnerability, seduced Dullin and his wife, who housed the

impoverished young actor for several months in 1922. Still, as Artaud's biographer notes, their hospitality "was eventually frayed by his habit of rehearsing his roles at 3 A.M. or awaking Dullin to read him a play he had just written, and definitively obliterated when Mme. Dullin . . . found him urinating on her living room carpet: something he seemed to find permissible since her six dogs were never let out of the apartment and had already turned the carpet into the best fertilized and most highly perfumed plot in the neighborhood."

Two years later, Artaud's charms were not lost on the Surrealists. "Handsome as a wave, likable as a catastrophe" was how Simone described him to Denise. Breton, looking back on Artaud's early days with the group, particularly remembered the "gothic landscape" he seemed to drag behind him, "pierced throughout by lightning. He was possessed by a kind of fury that spared no human institution, but that occasionally dissolved into laughter containing all the defiance of youth." He also noted that "no one had put all his abilities, which were considerable, so spontaneously in the service of the Surrealist cause as [Artaud] had."

It was during this time of consolidation and emergence that Paul Eluard suddenly returned to Paris. Breton had not forgotten the "great Eluard's" departure, and in early July had sadly attended an auction of his friend's acquisitions—the same ones he'd criticized the previous year—at the Hôtel Drouot. "The paintings and primitive objects he had so lovingly collected were sold off for practically nothing," he later lamented. The money, it turned out, was used by Gala to book passage to Saigon, where she and Eluard had arranged to meet weeks before. For Eluard had gone not to some mythic Harrar, but on a trip around the world, stopping in Holland, Martinique, Tahiti, Java, New Guinea, New Zealand, Singapore, and finally Saigon, where he had been joined in August by Gala and Ernst. Gala had actually known of Eluard's whereabouts since receiving his first letter in May, but had mentioned none of this to Breton and friends— whom she nonetheless continued to frequent throughout the summer, and who had been helping her financially. Finally, on Wednesday morning, October 1, a brief note in Eluard's hand appeared at Rue Fontaine, laconically inviting Breton to meet in a café. From then on, Eluard refused to talk about what he termed his "idiotic voyage."

The next day, Simone wrote a description of the event for Denise that expressed all of the group's ambivalence toward the anticlimactic end of the great adventure:

> First thing: Eluard is back. No comments. It would take too many. Too bad for those
> who feel that thought requires some justification. I don't ask anyone to incarnate a
> concept, and I'm always more grateful when a man naturally accomplishes a small

action than when he expresses a grand attitude that goes against his nature . . . I will always maintain that André abandoned more when he conceived "Leave Everything" than Eluard did when he took off for six months . . . Gala had known for months where he was . . . She inspires limitless revulsion in me. I cannot forgive anyone for stealing my emotions. Still less André's . . . What is a creature compared with a symbol? "Not dying from dying."—Then a living man appeared . . . Now it's as if he never left.

Relieved as Breton was to see his friend home safe, he, too, couldn't entirely forgive him for having squandered the promise of his disappearance. A note to Marcel Noll betrayed his underlying disappointment. "Would you believe: Eluard, well well, he was quite simply in Tahiti, Java . . . So then he left me a note, he was waiting for me yesterday at Cyrano, no + no −. He hasn't changed, no doubt about it. Just took a vacation."

Eluard's return coincided with Surrealism's definitive emergence on the public stage, an emergence heralded not only by the controversy with Yvan Goll and the publication of Breton's and Aragon's manifestoes, but also by the inauguration of the Bureau of Surrealist Research and, only days afterward, by the group's first major scandal.

The Bureau of Surrealist Research opened its doors on the afternoon of Friday, October 10, 1924, at 15 Rue de Grenelle, on the ground floor of a large private villa with concave façade called the Hôtel de Bérulle. The space, which was rented by Pierre Naville's father and offered to his son's friends the way future dads would donate garages to fledgling rock bands, stood in the heart of a district generally known for its staid ministries and sumptuous *haut-bourgeois* apartments. Several doors down, at No. 3, was the editorial seat of *La Nouvelle Revue Française*, one of whose own authors quipped the following spring: "Before, when one said 'Rue de Grenelle,' it meant either the Ministry of Public Education or the *NRF*, two rest homes. Today it means the Soviet Embassy or the Bureau of Surrealist studies [sic] (I'll speak another time about their points in common)."

Breton intended the Bureau, which was also called the Surrealist Central, to be a center of contact and information for interested individuals. As one press release specified: "The Bureau . . . is devoted to collecting by every appropriate means communications relating to the various forms that the mind's unconscious activity is liable to take." All interested members of the public were invited to come and display their unconscious wares between the hours of 4:30 and 6:00 P.M., Monday through Saturday (on the seventh day, Surrealism rested).

But the Bureau had other functions as well: it provided a workspace for the group, a

site for its public functions, and editorial offices for *La Révolution surréaliste*; it gave Surrealism a mailing address, one at which to receive communications from outside, and from which to send tracts and inquiries; it acted as a storehouse for objects, photographs, and documents relative to the movement; and, by establishing a physical territory, it helped push Yvan Goll and his fellow claimants further into the background (at a time when the debate was still raging—as evidenced by the fact that some newspapers gave Rue de Grenelle as Goll's address, only to receive written rectification from the Surrealists).

At least in conception, the Bureau was far more organized than many of Breton's previous projects. A recent addition to the group, Francis Gérard (who under his real name of Gérard Rosenthal would later become Trotsky's counsel), was appointed general director. Each day two members were expected to be on hand to greet visitors: Breton and Aragon served Mondays; Simone, with Jacques-André Boiffard, took Wednesdays and Saturdays. Those on call were also responsible for various daily tasks, such as keeping up with correspondence, saving press clippings, and noting the day's events in a large black-covered logbook, the record of all activity at the Central. Breton helped organize the library (which included a volume entitled *Model Speeches and Compliments for Every Occasion*!) and oversaw the decoration of the locale: visitors were greeted by the sight of Chiricos and a volume of *Fantômas* fixed to the wall (the latter with forks), and plaster casts of nude women suspended from the ceiling. (The décor was immortalized by Man Ray several weeks later, as the backdrop to several group portraits.)

One week after the Bureau opened, the Surrealists jabbed further at the public eye with the publication of a four-page broadside called *A Corpse*, a violent diatribe against the dying novelist Anatole France. Despite similarities with the earlier trial of Maurice Barrès, *A Corpse* was not an expression of disappointed hopes in a former mentor; rather, France had always stood for Breton and Aragon as the symbol of everything they hated in literature. The author of numerous best-sellers and recipient of the 1921 Nobel Prize for Literature, France was almost universally revered. His celebrated Gallic skepticism and penchant for political satire had won him passionate admirers among Western conservatives and Russian Communists alike—a popularity that the novelist, to the Surrealists' disgust, made no secret of enjoying. "France represented the prototype of everything we despised," Breton said. "We considered his attitude the shadiest and most despicable of all: he had done everything possible to win the approval of both right and left. He was bloated with honors and self-satisfaction." In 1921 the Dadaists had given France a grade of −18, making him second only to popular poet Henri de Régnier in their disdain.

The idea for the pamphlet had originated with Aragon and Pierre Drieu la Rochelle in early October, as the eighty-year-old France lay dying in his villa. Drieu put up the money for the printer, and he and Aragon, joined by Breton, Soupault, Eluard, and Joseph Delteil, quickly composed six excoriations of France's life and work. Knowing that the press would outdo itself to report the decease—the papers were already filled with daily bulletins on the patient's worsening condition—they hoped to distribute the broadside on the very day of France's death, both to counter the inevitable paeans and to gain maximum attention. But because of the printer's qualms, it finally trailed the novelist's decease by nearly a week.

Eluard dismissed France as "an old man like the rest," while Breton's entry, "Refusal to Inter," raised the tone a notch: "With France, a bit of human servility leaves the world . . . To bury his corpse, let someone on the quays empty out a box of those old books 'he loved so much' and put him in it and throw the whole thing into the Seine. Now that he's dead, the man no longer needs to make any more dust." But the most violent attack came from Aragon (in a text called "Have You Ever Slapped a Dead Man?"), who dismissed France as "the *littérateur* hailed simultaneously by the imbecile [Charles] Maurras and doddering Moscow . . . Execrable mountebank of the mind, did he really have to incarnate French ignominy for this obscure nation to be so happy to have lent him its name?"

When *A Corpse* was finally distributed on October 18, it provoked an immediate scandal. The pamphlet was attacked as a "foul assassination," and garnered angry rebuttals in the literary press, notably *Le Mercure de France*. Breton gleefully quoted the right-wing critic Camille Mauclair, who had called him and Aragon "raving lunatics" with the manners not merely of "hoodlums but of jackals." But some of the harshest critiques of *A Corpse* came from the left. The pro-Communist newspaper *Clarté*, for example, all the while praising the Surrealists' initiative, took issue with the "thoughtlessness" that Aragon had shown in his jab at "doddering Moscow." A week later, *Clarté* editor Jean Bernier received a stinging reply from Aragon:

> The Russian Revolution? Forgive me for shrugging my shoulders. On the scale of ideas, it is, at best, a vague ministerial crisis . . . The problems raised by human existence do not derive from the miserable little revolutionary activity that has occurred in the East during the course of the last few years. I shall add that it is only by a real abuse of language that this latter activity can be characterized as revolutionary.

But the harshest reaction of all—at least according to Breton—came not from the

newspapers, but from the normally tolerant Jacques Doucet. Breton later recounted how Doucet, immediately after the publication of *A Corpse*, summoned him and Aragon to his shop on Rue de la Paix: "He first indulged in a long preamble about everything and nothing, then ended up by asking if we didn't think brevity was indeed the soul of wit. As we had no particular opinion on the subject, he launched into a tirade over what was so odious and ill-mannered about what we'd just done, and, after having given free rein to his indignation, informed us that his relations with us were terminated."

The reality appears to have been somewhat less romantic. Although shocked by the rude *Corpse*, Doucet had seen others before it, and within several weeks was "perfectly amiable once more," as Breton told Simone. If Doucet indeed terminated his advisers' employment, it was less for reasons of propriety than of pride: ill-intentioned third parties, envying Breton's position at the library, had made Doucet aware that his "young lions" were laughing at him behind his back. The wounded patron informed Breton that his contract would not be renewed at the end of the year, but not for the reasons Breton later cited. Twice Breton wrote back, trying to justify his actions of the previous months. "To live, to overcome the obstacles this presupposes—which is so easy for most men— still plunges me into a state of immense perplexity. I believe I've put all the audacity, power, and hope of which I'm capable into things of the mind. These things possess all of me, jealously; on my behalf, they scoff at the goods of this world," he told the collector on December 28. But Doucet, motivated by more emotional forces, was unable or unwilling to hear. Although he continued to see Breton over the next two years, to solicit his opinions and treat him to lunch, the "series of acceptable misunderstandings," as Breton had once described their mismatched collaboration, had essentially come to an end.

One further task remained, however. That same December, Doucet, having paid off his last installment to Picasso, finally took possession of *Les Demoiselles d'Avignon*. Not satisfied with the acquisition itself, he again asked Breton to justify the purchase in writing—the least Breton could do, the collector reasoned, as it was he who had been nagging Doucet to buy it for the past three years! Breton was no doubt annoyed to cover the same ground yet again—it "very quickly turned into pure verbiage," he later admitted—but, as he was still technically Doucet's employee, he complied with a long missive on December 2. "How delighted I am to see these 'Demoiselles' again," he exclaimed. "One never realizes fully enough that Picasso is the only authentic genius of our age, the kind of artist who has never before existed, except perhaps in Antiquity." With a fine irony he added: "And what a sign of the times that a man such as yourself should receive this work!"

✳

Between *A Corpse* and the *Manifesto*, published almost simultaneously, Surrealism was very much in the news that fall. From almost the moment it opened its doors, the Bureau of Surrealist Research began receiving visitors. Among these were a number of old acquaintances: "Monsigneur T. Fraenkel and his umbrella (it isn't raining)"; Valéry, come to buy *A Corpse*; Léon Pierre-Quint, offering to distribute *La Révolution surréaliste* at Sagittaire; Doucet; and *Clarté's* Jean Bernier. Others came out of friendship, curiosity, or simple boredom. But in the beginning, almost no one was brining any new grist to the Surrealist mill. "Each day worried men arrive, bearing weighty secrets," Aragon had written in "Une Vague de rêves." The inconsequence of the actual visits, however, was proving this to be wishful thinking.

In fact, the vast majority of those who came to Rue de Grenelle were friends, girl-friends, business acquaintances, society women looking for a safe thrill, or simple rub-berneckers, including a certain "Mr. Caby, chatty and unbearable," who monopolized Breton and Aragon for most of an afternoon. There were also distractions caused by other Surrealists, as an annoyed Breton noted in the Bureau's register: "The Central's activity leaves much to be desired, and this is due to the daily presence of seven or eight of us who have no reason to be here. It is absolutely essential that the two Surrealists on duty be left to work in peace." (But even Breton was not exempt from occasional horse-play: one entry mentioned him, Aragon, and Eluard locking the hapless Boiffard "in the closet for ten minutes.")

Despite its intended status as a record of the Bureau's activities, the logbook in fact became the diary of a failure: in the final account, it preserved far more aborted projects, personal animosities, and discouragements than it did heroic innovations. "The logbook. Too much useless wit," Breton noted on October 30, having glanced through its pages. "I'd prefer a much more general offensive, and if this has not occurred in the next two weeks . . . we will have to move on to another sort of exercise." As Breton understood, the true problem lay not so much with outside intruders as within the group itself. Few were willing to devote as much seriousness and effort to Surrealism as he; few had the discipline or the drive to give fully of themselves, to take risks, at least not without pub-lication in view. Instead, they were content to note visitors' addresses, complaints about the nonpayment of dues, an occasional flight of mediocre fancy, and even conflicts between officiants. But so far, nothing seemed to legitimize, "apart from some vague statements, the existence of a bureau of research."

Between disappointing results at the Bureau and his final chores for Doucet, there

was little to brighten the end of 1924 for Breton. One pleasure, at least for a while, was the visit from Rome of Giorgio de Chirico in November. "I'm seeing him and getting to know him better with each day," Breton told Simone on the 11th. In particular, he found Chirico's sense of humor "of a very specific, very rare quality . . . All this is infinitely more likable than I'd been told." Among the painter's more curious traits was his supposed familiarity with ghosts (among whom he numbered his otherwise healthy dealer, Paul Guillaume); one evening he amused Breton and Aragon by identifying the "spirits" among the patrons of a Place Pigalle café. Chirico also inspected the Bureau of Surrealist Research and witnessed some of Desnos's automatic storytelling sessions there: a group photograph shows him craning to be seen over Naville's head, while the others gather intently around Desnos and Simone dutifully takes down the somnambulist's narrative.

But even here storms were brewing. Despite Breton's presumptions of mutual enthusiasm, Chirico felt that many of the Surrealists' activities "reached the heights of comedy." One incident in particular shows the gap separating the two men: when Breton recited long passages of Lautréamont one evening, it left him so exalted that he thought it "inexcusable" that he should keep writing; Chirico, on the other hand, remembered suffering through interminable readings "in [Breton's] sepulchral voice" of "extracts from Lautréamont [and] foolish remarks by Isidore Ducasse." Chirico nonetheless hoped to increase his renown in Paris, and on the 18th went with Breton to meet Doucet—only to treat the collector with embarrassing haughtiness. Finally, having fallen ill, he abruptly returned to Rome at the end of the month.

Meanwhile, Breton was busily preparing the first issue of *La Révolution surréaliste* for the printer. After much discussion, the group had offered the editorship to Péret and Naville, who, Breton said, "seemed the most completely driven by the new spirit and the most resistant to compromise." This time, there was no question of approaching Valéry or Gide for contributions.

Hoping to avoid the pitfalls that had plagued *Littérature*, the editors again resolved to exclude "literature" from the magazine. By December, the final contents were assembled, and on the 3rd, Breton, Aragon, Eluard, Morise, and Naville drove to Alençon to oversee the printing. The first copies arrived in Paris on the 16th. "It's not bad," co-editor Naville reported to Denise, "*maybe a little too calm*." Down the street at the *NRF*, which again handled distribution, Jean Paulhan was having the same thought, and wondered if "Aragon-Breton" weren't after "Cocteau-style success."

And in fact, the look of the magazine was surprisingly sober for the organ of so notoriously rambunctious a group. Its format had been modeled on that of a popular science periodical, *La Nature*. "Irony," wrote one historian, "but also a desire, as in hard-science

periodicals, to offer proofs: Surrealism exists." The cover, printed on bright orange stock that Aragon had discovered at the printer's, sagely listed the magazine's title and contents; the only hint of subversion lay in the slogan, taken from "Une Vague de rêves" and placed at the center: "We must formulate a new declaration of the rights of man."

The interior was slightly more adventurous, although hardly new to readers of *Littérature*—and in any case, a far cry from making *La Révolution surréaliste* (as a later advertisement claimed) "the most scandalous magazine in the world." The issue opened with a joint statement by Eluard, Boiffard, and Vitrac ("only dreams leave man with his right to freedom intact . . . Realism is the pruning of trees, Surrealism is the pruning of life"), followed by dream narratives, automatic texts, newspaper accounts of suicides, columns on topics ranging from mechanical inventions to love, and a list of press clips on Surrealism, mostly unfavorable. A statement on the inside cover invited readers to "take part" at the Bureau of Surrealist Research. Like the scientific periodical it emulated, the magazine had very few illustrations: some Man Ray photographs, some drawings and reproductions, presented as if to attract the least possible attention—or to distract as little as possible from the writing.

One piece that did raise some eyebrows was a new inquiry. "We live, we die. How much will is involved in all this? . . . It is not a moral question we're asking: IS SUICIDE A SOLUTION?" the editors wondered, taking their cue from the large upsurge in suicides in Paris during the 1920s. The responses, published in the second issue, ranged from the furious to the unintelligible. The poet Francis Jammes topped the list by warning: "The question you are asking is wretched, and if ever a poor child kills himself because of it, *you* will be the killers!" Reverdy, who had converted to Catholicism three years earlier, responded with a long homily, and Breton's publisher, Léon Pierre-Quint, wrote: "I can't think of a more absurd question." Many others expressed similar disapproval, or tried to wittily beg the question. Breton himself answered inconclusively, with a quote from the nineteenth-century philosopher Théodore Jouffroy: "Suicide is a poor word; the one who kills is not identical to the one being killed." The only unequivocally positive response came from René Crevel, for whom the matter was anything but academic: "A solution? Yes." He later credited the inquiry with being a major component in his reconciliation with the Surrealists at around that time. In the main, however, the responses contributed little, in the way either of serious debate or of simple, gratifying outrage.

But whatever its initial shortcomings, *La Révolution surréaliste* helped define a group identity, and stood as concrete proof that the Surrealist movement had now been launched. As 1924 ended, the group gave further proof by multiplying its physical traces. Among other things, they printed up *Révolution surréaliste* stationery and—borrowing a

technique from Dada—placed brightly colored stickers throughout Paris: "PARENTS! Tell your dreams to your children." "If you like LOVE, you'll love SURREALISM." "Is SURREALISM the Communism of genius?" Looking back many years later, Breton was forced to admit that the stickers "seemed to hesitate as to the best route to take (poetry, dreams, humor) and, all things considered, were highly inoffensive."

＊

In late January came a change of café, when the Passage de l'Opéra was bulldozed by an extended Boulevard Haussmann and the Certa was forced to move. From this point on, the Surrealists spent their afternoons at the Radio on nearby Rue Caulaincourt, or the Globe near the Porte Saint-Denis, and sometimes at the Deux-Magots on Boulevard Saint-Germain. Mainly, however, they favored the Cyrano on Place Blanche (next door to the Moulin Rouge), which now became their standard meeting place. Maurice Nadeau later described the Cyrano as standing in the heart of a "Montmartre of suspect boulevards swarming with the odd fauna of whores and their pimps . . . Encounters here were astounding: circus people (the Cirque Médrano was two steps away) accompanied by trapeze girls with their eyes 'elsewhere,' Americans with their gold-filled mouths, who were to be avoided like the plague, tiny humans, so tiny and so filled with mysteries."

The Surrealists' inquiries were not confined to café tables, however, and often they could be found covering the lost byways of Paris—flea markets, proletarian cinemas, out-of-the-way parks such as the Buttes-Chaumont with its Suicides' Bridge—probing the city like topographical psychoanalysts. "The important thing was to rediscover life under the thick carapace of centuries of culture—life pure, naked, raw, lacerated. The important thing was to bring the unconscious of a city into unison with the unconscious of men," said Nadeau.

Still, more often than not daily life fell prey to depressing banality. Simone later recalled "many evenings of idleness and boredom" during that period, while Victor Crastre noted that "the atmosphere of the 'aperitifs' at the Cyrano and the evenings at Breton's was nothing short of morose." At times, the activities consisted of little more than a few hands of poker (at which Breton, a skillful player, sometimes won valuable paintings from his less able colleagues). At others, the group indulged in more adventurous pursuits, such as a session at Eluard's during which Breton, Eluard, Péret, and Naville tried automatic pornography. But even this proved disappointing: Breton became entangled in descriptions of setting, and in any case the participants' nervous giggling turned the experiment into a farce.

A further disappointment in those months centered on Chirico. In February, the painter sent photographs of his recent, neo-Classical work for *La Révolution surréaliste*, which Breton deemed "very poor." He also deplored Chirico's current habit of forging his own early canvases "with his present heavy hand," in order to sell the same picture twice. Unaware of the change in his fortunes, Chirico returned to Paris in April 1925, expecting the Surrealists to support his show at Léonce Rosenberg's gallery. Instead, as he later wrote, he "found strong opposition from that group of degenerates, hooligans, childish layabouts, onanists, and spineless people who had pompously styled themselves Surrealists." Bitter to the end of his life, the painter later vilified Breton as "the classic type of pretentious ass and constipated impotent."

And yet another dissatisfaction arose from Surrealist activity itself, and notably from the Central. As with Dada four years earlier, Breton was caught in a conflict between his own will to discipline and the others' refusal of it. For her part, Simone, tired of being treated as the Bureau's den mother, angrily protested "the procedures employed with certain female members who come to handle certain chores and [are] treated like machines." Even outside the group, the idea of a permanent Surrealist open house seemed to inspire more sarcasm than wonder. "I occasionally walk by the mansion on Rue de Grenelle," Jean Paulhan smirked in a letter, "in which Aragon, or Breton, stands waiting every afternoon for 'subjects.'"

In an attempt to "remedy the workings of the Central," the group held a meeting on January 23 at the Certa (one of the last before the old bar's demolition). Hoping to "restore efficiency," the committee chose Antonin Artaud to replace Francis Gérard (who in any case was frequently absent because of military service) as head of the Bureau. In the weeks since his initial contact with the group the previous fall, Artaud had become a fervent participant in Surrealist activity and, along with Breton, one of the Central's most pitiless critics. Breton now hoped that Artaud's passion and resistance to compromise could help save it from the rut of triviality. "He will provide a new basis for the workings of the Central, and he seems more resolved than anyone to bring our revolutionary action to the forefront," he told Simone on January 22.

The recipient of these lines was herself a component in Breton's discontent that January: Simone had left in mid-month for Megève near the Swiss borer, along with her sister Janine and Max Morise. Her departure was prompted not merely by disgust at the menial tasks she was often given; she was also aware that Breton had recently developed a passionate attraction for a twenty-six-year-old brunette named Lise Meyer.

The former Anne-Marie Hirtz was the daughter of a renowned physician, and was related on her mother's side to the Dreyfus banking dynasty. She had increased her for-

tune early on by marrying Pierre Meyer, heir of a prominent French family, who had committed suicide not long afterward—"which perfectly suited the style of the times," as one of her friends quipped. Wealthy and well connected, Lise frequently hosted the intellectual beau monde of arts patrons and their pet causes at her salon on fashionable Avenue du Bois, where guests could admire the famous divan of Apollonie Sabatier, the nineteenth-century demimondaine who had inspired Baudelaire's most ardent sonnets. She nourished her own literary ambitions as well, and in later years, under the name Lise Deharme, published poems, stories, and novels marked by dreamlike eroticism.

Lise Meyer was small and pretty, with "a very handsome figure and a narrow face." One Surrealist called her "a very attractive sorceress, with the voluptuous and seductive eyes of the Queen of Sheba . . . She surrounded herself with oddly behaving animals and wore jewels that most women would have regarded as baleful." She was also extremely flirtatious, and knew how to excite men with her physical and personal charm. Among the main aspects of this charm was her gift for enchanting expression, and particularly her voice: "the voice of a heliotrope," as her friend Jean Cocteau put it. The composer Ned Rorem, who met Lise after World War II, noted that it was still "her voice which makes [her] a great lady. The sound of a whore in a room where she doesn't belong . . . She talks and wins hearts." One of these hearts belonged to Breton, who succumbed to the same attributes that he himself used so advantageously.

"Visit from Mme. Lise Meyer," the Bureau register had laconically noted on December 15. Breton, tending shop that day with Aragon, had been struck by the beautiful intruder; flustered and gauche, he had nearly panicked when the more urbane Aragon suggested Lise leave one of her long sky-blue gloves as a calling card. "I don't know what there can have been, at that moment, so terribly, so marvelously decisive for me in the thought of that glove leaving that hand forever," he later wrote. It was as if, by removing her glove, Lise were offering herself to Breton then and there, an offer he simultaneously desired and dreaded. Amused, she proposed instead to leave the Bureau another glove she owned, but this one made of bronze. From that moment on, Lise became for him "the lady of the glove"; the object itself eventually found a home in his study, where it remained until long after his death.

Sensing an easy conquest, Lise teased the Surrealist leader into hopeless infatuation. It was for her that Breton composed one of his few poems of the time, shortly after their meeting: "You are solemn in the absolute grace of being lighter / Than my tempest," he told her. "I shall pick up the glove / The glove heaven has tossed me and shut myself forever / In the prison of my lips . . . / Go my lovely foreigner my loss of paradise . . ." And in late December, he began sending Lise somber letters, filled with sadness and futility,

and almost inexhaustible in their frequency (much as he had done with Simone early in their courtship). "The event of our meeting," he told her in one of the first, "was like the end of the world for me, while for you it was an insignificant happenstance."

Indeed, true love seems to have interested Lise less than conquest, and Breton found himself powerless against her changing humors, and against the "absurd world" in which she circulated so easily. Lise, while flattered by the interest of someone she admired intellectually, was no doubt wary of the poet's gravitas, and unwilling to change her lifestyle to suit his moral imperatives. Despite Aragon's agile mediations on his friend's behalf, she was never to become Breton's mistress.

From the outset, Breton had confessed all to Simone, even made her something of an accomplice. Throughout January and February, his letters to his absent wife detailed the frustrations of his unreciprocated ardor. Breton's openness and Simone's equanimity, which might seem surprising, stemmed at least in part from their shared emotional and intellectual standards: he refused to indulge in sordid back-door affairs, and she wouldn't harbor petty bourgeois expectations of absolute fidelity. For Breton, his passion for Lise was an incontrovertible fact—unexpected, perhaps, and certainly painful, but part of the idealized sphere of love that he valued above all else. As he saw it, both his respect for Simone and his desire for Lise demanded that he open his heart to his wife and confidante—a position that simultaneously suggests touching honesty, maddening naïveté, buried narcissism, and leftover remnants of childhood misogyny. As for Simone, who was swayed both by her intellectual convictions and by her love for her husband, and who no doubt expected the infatuation to wither on its own, she offered no recriminations. And indeed, it was not this affair that would cause irreparable damage.

With Simone in Megève that January and February, Breton suffered his torments of unrequited love in the empty studio on Rue Fontaine. Alone, he put the finishing touches on a thirty-page text, "Introduction to the Discourse on the Paucity of Reality," which appeared in February in *Commerce*. (The "Discourse" itself, which he had mentioned in the *Manifesto* and was still planning to write, was never composed.) A long meditation on love and imagination, the "Introduction" mirrored the melancholy tone of his letters to Lise. In the meantime, he paid frequent visits to Lise's salon, each time feeling an irresistible need to play with the bronze glove that for the moment remained hers, and each time leaving with his desires thwarted.

Trying to forestall his depression, Breton indulged with his friends in less high-minded pursuits, such as composing insulting letters to famous writers or watching Péret call Jean Cocteau's beloved mother late at night to announce her son's fictitious death in an auto accident. Many evenings were spent at the Luna-Park at Porte Maillot, or at one of

the other working-class carnivals that dotted the Paris outskirts, and for which Breton had a particular fondness. Photographs of the period show him there, staring severely or with face pulled into an unaccustomed smile. He posed against painted backdrops, screamed through roller-coaster rides, giggled "like a schoolboy" when the wind lifted women's skirts, and crowded with the others into the newly invented photo booths: surviving photo strips show that Breton, even into his thirties, had not lost his capacity for juvenile enjoyment.

✳

Initially, it seemed that Antonin Artaud was just the man to help the Bureau of Surrealist Research find its lost way. With the enthusiasm of new responsibility, Artaud set out to impose a working discipline. "From today onward, the logbook is once more to be kept *strictly* up to date. Everyone is to serve his time in the Bureau on the days originally set," he announced on February 27. More ambitiously, he strove to make the Bureau a center for "rehabilitating life" and to reinfuse Surrealism with some of its lost vehemence and sense of purpose. "Under Artaud's influence, [we published] collective texts of great violence . . . filled with an insurrectional ardor," Breton said. "Their language had been stripped of all ornaments; it eschewed the 'wave of dreams' that Aragon had spoken of; it meant to be sharp and gleaming, but gleaming like a weapon."

Among the first of these "sharp and gleaming" texts was the "Declaration of January 27, 1925," which Artaud wrote on the group's behalf, and which expressed a collective desire to make the movement more of an eternal force—to realize an "indispensable objectification of ideas," in Breton's words. "SURREALISM is not a poetic form," Artaud proclaimed. "It is a cry of the mind turning back on itself, and is determined to break apart its fetters, even if it must be by material hammers!"

The "Declaration" was unveiled at a general meeting that same evening, at which the new Bureau chief put forth various projects and positions, all of them unanimously adopted. Among these were support of the spiritual East over the decadent West;* a

* Far from being an idiosyncrasy of Artaud's, this stance actually responded to a widespread debate of the period, which found French intellectuals taking sides on the issue of cultural Eurocentrism. During the same period, Breton, too, professed his faith in the Orient, stating in a newspaper survey that "today, our light comes from the East" and calling for "the extermination of Mediterranean influences." Unlike the fervent Artaud, however, Breton's embrace of Orientalism reflected a hatred of "Latin reason" rather than a deep understanding of Eastern thought. He would soon admit that he was attracted to the East more as an "image" than as a reality, and would abandon it altogether by the fall. Nonetheless, it was this attraction—along with a common equation of "Orientalism" with "Bolshevism"—that helped lead the Surrealists to their more resolutely political stances of the following year.

series of vitriolic "open letters" to such establishment figures as the Pope and the rectors of universities, written or co-written by Artaud and intended for the third issue of *La Révolution surréaliste*—of which Artaud was concurrently appointed guest editor; and, most immediately, the closing of the Surrealist Central to the public, in deference to the fact that few of the expected "Surrealists at large" had actually materialized in the past three months. So active was Artaud during this period that for many, within and without the group, he became the true leader of Surrealism. "Artaud has shown extraordinary leadership qualities," Pierre Naville wrote to Denise shortly after the meeting. "He has already formed a number of projects, and is really taking care of everything."

Before long, however, Artaud started to encounter the same disillusionment about the Bureau as Breton had the previous fall, and for the same reasons: no one else's commitment to the project seemed to match his own. Even Breton, formerly so conscientious, began excusing himself more and more often from his weekly duty, prompting Pierre Naville on March 21 to post an acerbic note about his "wraithlike presence" at the Central. Breton, his nerves set on edge as it was by his trials with Lise, furiously snapped back on the 25th: "I understand that Pierre *Naville*, in a poster hung yesterday on the walls of this room, allowed himself to judge, in terms I consider *insulting*, my current nonparticipation in Bureau activities. I regret that my friends Louis Aragon and Antonin Artaud did not take it upon themselves to rip this notice to shreds. Under these conditions, I declare that I have no further interest *whatsoever* in the Surrealist Revolution."

Tense and depressed, on March 27 Breton tried to confide the reasons for his discouragement to Artaud. He protested the attitude that singled him out as "Surrealism's mainstay and reason for being"—once more denying the leadership he did everything to maintain—and complained about the rapid deterioration of the Bureau's goals:

> I wonder at times if we really need to go through this: one reads you a poem that you
> have no desire to hear, and that melts into a haze of similar poems; another tells you
> what he did last night, when he might just as well have been sleeping. And even that
> is better than when they bend your ear about publishing projects, planned trips, and
> other idiocies I can't even name. Is that what so many grudges against the world lead
> to, and must one take sides on these issues? . . . The genuine distress that drives the
> two of us is, alas, too easy to simulate for us not to fall prey to the worst forgeries.

Breton concluded by asking Artaud to "*stay vigilant*, and—even if the Surrealist movement should suffer for it—in no case subordinate the immediate interests of the mind to political or other necessities."

In the weeks following, from heated committee meetings to high-strung articles for the third *Révolution surréaliste*, it seemed that Artaud was faithfully complying. And yet it was precisely this compliance that finally alarmed Breton, who soon found the overall tone of the new issue worrisome, and who "distrusted [the] fever pitch that Artaud was definitely trying to reach . . . I felt it entailed an expenditure of energy that we would not subsequently be able to offset." Despite his recent solidarity with Artaud and his denials of being Surrealism's "mainstay," Breton decided to take matters in hand. On April 20, less than a month after his recommendations to Artaud, he closed the Bureau of Surrealist Research altogether, putting an end to the five-month experiment. He also condemned both Artaud's mysticism and Naville's acrimony as "little acts of sabotage," and finally seized full editorial control of *La Révolution surréaliste*.

Not surprisingly, Breton's actions drove a wedge between himself and the two others. He had not forgiven Naville's posted criticism from March, and was further annoyed by his statement in the third issue that, "as everyone now knows, there is no such thing as *Surrealist painting*": for if this were true, then Breton's hopes for Masson, Miró, Ernst, and fellow traveler Picasso were in vain. Naville, for his part, was loath to relinquish his editorship, and more generally resented Breton's dictatorship over an office that Naville, Sr., was financing. Soon afterward, however, the twenty-two-year-old Naville was called up for military service, sparing him further run-ins with Breton.

Still more serious was the rift between Breton and Artaud. Even as he continued to respect Breton's intelligence, Artaud felt that Breton was missing his last chance to save Surrealism from futility, and to his lover, the actress Génica Athanasiou, he spoke of "a series of misadventures and disappointments owing to my dear Surrealists, who on the whole have shown themselves, Breton and Aragon excepted, to be the biggest bunch of assholes the earth ever spawned." In a state of "fantastic indignation," Artaud notified Breton that he was leaving the group.

In firing Artaud, Breton might on one level have been reacting to a rivalry born of too great a similarity. Both he and Artaud were extremely serious men with a fierce moralizing streak, a passion for revolt, a belief in the marvelous, and intolerance for others' "transgressions." At the same time, profound differences separated them. Although both believed in revolt, for instance, their concept of it greatly differed. For Breton, any revolution to be waged must pass from his intellect to the outer world. From the beginning, he had felt the call—diversely expressed, and unevenly answered—to externalize the wellsprings of his inner being. But Artaud, "a foreign body wherever he went," as Masson called him, could only drag the world into the black hole of his own tortured consciousness.

✳

In the wake of Artaud's reign, the Surrealists resurfaced in force. On May 29, they stormed the Vieux-Colombier to protest a lecture by the young professor Robert Aron on "literature and the average Frenchman." As if Dada had briefly risen from the dead, Soupault jumped onstage, Desnos and Vitrac harangued the staid audience, and Eluard, who had evidently learned little from the "Bearded Heart" brawl, was again beaten up.

But the disruption of the Aron conference was minor compared with an incident that occurred a little over a month later and became the most renowned scandal in the history of Surrealism. It began with a visit Breton had paid in 1923 to the Symbolist poet Saint-Pol-Roux at his home in Brittany. That same year, it was to Saint-Pol-Roux that Breton had dedicated *Earthlight*. And two years later, on May 9, 1925, he and a few others drafted a joint "homage to Saint-Pol-Roux" for *Les Nouvelles littéraires*, protesting "the neglect and indifference" that the public had shown the venerable, if obscure, Symbolist bard.

The May 9 homage was published to coincide with one of the sexagenarian's rare visits to Paris, for which the Surrealists showed up en masse to greet him at the train station. They also participated in a celebration of the poet on June 11. Less to their taste, however, was a literary banquet hosted by *Le Mercure de France*, to be held on the evening of July 2 at the Closerie des Lilas, and to which the benign Saint-Pol-Roux had naturally invited his young admirers. "Even as we honored Saint-Pol-Roux as one of the great creative minds of Symbolism . . . we unanimously deplored that his visit to Paris had occasioned these outmoded and ridiculous feasts," Breton explained. "If he had all too readily agreed to them, it was because, in the solitude of Brittany, he had lost any true contact with the companions of his youth, most of whom were now woefully decrepit. He didn't doubt for a moment that, if only for one evening, he could bridge the gap between them and the Surrealists."

Still, even given the potentially explosive mix, the Saint-Pol-Roux banquet might never have caused the uproar it did were it not for two additional factors. The first was the so-called Rif War. Begun four years earlier between Spain and Morocco, the conflict in the Rif had implicated France that spring when a successful rebellion led by Abd-el-Krim ("Abd-el-Kriminal" to the conservative press) caused France to send in its own army under Marshal Philippe Pétain. In protest, the Communist newspaper *L'Humanité* ran an "Appeal to Intellectual Workers," signed by more than a hundred leftist intellectuals, including nineteen Surrealists. The petition, which decried France's participation in the war and supported Abd-el-Krim's revolt—sentiments as popular at

the time as a plea for al-Quaeda would be eight decades later—was published on July 2, the very morning of the banquet.

Breton had shown little previous interest in organized politics, particularly since his disappointing overtures to the Communist Party in 1920. In general, he considered political activism to be "prosaic, despicable, and rather sordid." But his sympathy for Abd-el-Krim's uprising had been roused by a report in *Clarté*, while his gut antimilitarism left him horrified at the French government's readiness to return to war. "The war in Morocco surpasses in implausibility, stupidity, and horror anything that we might have expected from those people," he wrote Simone. "After this, who can still talk about writing poems and the rest? No written protest is sufficient against such a thing. What is to be done?" Whatever his reservations about the Communist Party, at the time it was the only entity that openly expressed a similar hatred of the Rif War.

The second factor that turned the Saint-Pol-Roux banquet into a tumult was a violent "Open Letter to Mr. Paul Claudel, French Ambassador to Japan," handed out at the banquet itself. Although Breton admired Claudel's poetic skill, there was no love lost between the Surrealist and the renowned poet-playwright. Claudel's self-satisfied conservatism and widely read interpretations of Rimbaud as a Catholic visionary enraged Breton, as did his readiness to combine his status of poet with that of diplomat—and even to boast, in an interview that *Comœdia* printed on June 24, of having purchased "great quantities of lard" for France during the war. But what had truly set off the explosion was Claudel's statement in the same interview that "not one [of the present movements] can lead to a genuine renewal or creation. Neither Dadaism nor Surrealism which can have only one meaning: pederasty."

Breton was outraged by Claudel's "very unexpected and very unjust attack," as he told Jacques Doucet the next day. "It is shameful, after all, that a man should take advantage of his social standing and French ambassador's title to lie and slander, and in the name of the Catholic religion to boot!" On the 29th he wrote to *Comœdia*'s editor, demanding right of rebuttal. But *Comœdia* refused, and Breton was forced to seek other means of redress.

Dated July 1 and signed by twenty-eight Surrealists, the "Open Letter" answered Claudel's interview on all points, and echoed the revolutionary sentiments of the *Humanité* petition. "The only pederastic thing about our activity is the confusion it introduces into the minds of those who do not take part in it," the letter began:

> Creation matters little to us. We profoundly hope that revolutions, wars, and colonial insurrections will annihilate this Western civilization whose vermin you defend

even in the Orient . . . We take this opportunity to dissociate ourselves publicly from all that is French, in words and in actions. We assert that we find treason and all that can harm the security of the State one way or another much more reconcilable with Poetry than the sale of "great quantities of lard" in behalf of a nation of pigs and dogs . . . Write, pray, and slobber on; we demand the dishonor of having treated you once and for all as a prig and a swine.

The letter came off press, printed on garish purple-red paper (which actually made it fairly hard to read), on the afternoon of the banquet. Taking advantage of the timing, a party that included Breton, Aragon, Soupault, Desnos, Morise, Boiffard, and Ernst arrived early at the Closerie des Lilas and slipped a copy of it under each place setting.

Between the letter to Claudel and their petition against France's war effort, the Surrealists were in bad odor that evening. From the outset, the predominantly conservative and elderly guests—some one hundred of them, featuring the likes of Jean Royère, Remy de Gourmont, J. H. Rosny the elder, Lugné-Poe, and Rachilde—looked with hostility upon the band of outsiders, whose age and public stance dramatically isolated them. As for the Surrealists, they particularly resented the presence of the chauvinistic, socially well-connected Rachilde, who seemed to them the living counterpart of the very Claudel they were reviling on paper. Having once aroused their antipathy with her anti-Dada sentiments, she had recently rekindled it by declaring in *Paris-Soir* that a Frenchwoman could never marry a German.

The banquet began with Breton and art critic Florent Fels trading insulting quips at Rachilde's expense. When others around the table (including Saint-Pol-Roux) reproached them for their lack of gallantry, the Surrealists answered with cries of "Down with France!," which in turn sparked shouts in defense of the homeland. One of the women in the room, feeling faint, asked Breton to open the window behind him. "I must have complied rather violently," Breton later recounted, "or else the façade of that second floor facing Boulevard de Montparnasse was pretty dilapidated, since the two doors of the casement came off their hinges in my hands. Those sitting next to me quickly grabbed them and helped me set them on the floor, thus keeping the glass from breaking."

By the time the main course was served, the tension had reached its peak. Ironically, it was Rachilde who set the match to the fuse, when she audibly reprised her anti-German wedding advice to a tablemate. Breton, elegantly dressed and in his most dignified tone, rose to his feet and accused Rachilde of insulting his friend Max Ernst with her opinions; according to some, he then flung his napkin in her face and called her a "camp follower." Several guests leapt up to defend Rachilde, and the painter Jean

d'Esparbès—or so the Surrealists later claimed—tried to push Breton through the open second-story casement (at all events, he landed a few punches). Three of the diners ran out to fetch the police. By the time they returned the banquet was in total chaos.

Soupault, swinging from the chandelier, sent plates and glasses cascading to the floor. Aragon screamed obscenities at Lugné-Poe, while Desnos grappled with d'Esparbès and pulled his hair. Cries of "Long live Germany!" and "Long live the Riffs!" flew across the room, crossing paths with fruit projectiles. The recent Surrealist recruit Michel Leiris, having previously bolstered his courage with shots of Pernod, leaned out the window and screamed, "Down with France!" to a crowd of nearly five hundred gathered outside, drawn by the ruckus. Dared to come repeat his words by the irate passersby, Leiris rushed down to the boulevard—and was severely beaten before the police dragged him off to the station (where they beat him in turn before releasing him). Upstairs at the Closerie, the anarchist critic Louis de Gonzague Frick, hearing the tumult from the next room, rushed in to defend his "friends the Surrealists" and shattered the restaurant's large mirror with his cane. Still, it was not the Surrealists the incoming police arrested, but Rachilde: she had become so hysterical by this point that they mistook her for the instigator of the brawl (which was not entirely false). Meanwhile, an uncomprehending Saint-Pol-Roux vainly called into the din that he was "captain of this ship."

More than any previous demonstration, the Surrealists' actions at the Saint-Pol-Roux banquet unleashed a concerted fury in the press and the Parisian literary milieu, and marked (in Breton's words) "Surrealism's final break with all the conformist elements of the time." Many vowed to boycott the group and all its works. "Each of us . . . will in the future say nothing of their articles and books until they have adopted less unworthy methods of publicity," *L'Action Française* promised. The once favorable *Journal littéraire*, angered before this by the letter to Claudel, vehemently condemned the Surrealists' latest activities in the name of France and Western culture, while *Le Temps* disapprovingly noted that "the Eye of Moscow will be pleased." And in fact, the only votes of support for the Surrealists came from the far left.

In the aftermath of the affair, Rachilde gave a series of interviews in which she vividly described her alleged mistreatment by the Surrealists, such as being kicked in the stomach by "a large German." But with each interview, the account of her injuries seemed to diminish, and by July 18—as the Surrealists put it in their own statement to the press—her "dress had scarcely been creased." As for Saint-Pol-Roux, the July 2 banquet marked the end of his relations with the Surrealists, who had unaccountably ruined his night of glory. At his request a second banquet was thrown ten days later. The Surrealists did not attend.

REVOLUTION BY ANY MEANS

(July 1925 – December 1926)

"IF THE WORDS 'SURREALIST REVOLUTION' [still] leave most people cold, at least they cannot deny us a certain amount of ardor and an instinct for potential devastation. It is up to us not to abuse such power," Breton stated in his July 1925 editorial, baldly titled "Why I'm Taking Charge of *La Révolution surréaliste*." In contrast to the overheated frenzy of Artaud's issue, this fourth number was cooler, more self-possessed, but in its own way just as trenchant. Breton protested both the favor that certain critics showed Surrealism and the compromises that some members seemed willing to make for their own advancement. "Even were the scale of the Surrealist movement to suffer for it, it seems essential that I open the pages of this magazine only to those who are in search of more than just a literary alibi," he warned. The editorial left no doubt that Breton had again taken the magazine—and Surrealism itself—firmly in hand.

Also in the fourth issue, Breton took steps to counter earlier statements by Naville and Morise about the nonexistence of Surrealist art. Prior to this, in the *Manifesto,* he had insisted on the visual aspect of automatic imagery. Now, in his seminal essay *Surrealism and Painting* (published in installments over the next two years), he set about establishing the Surrealist nature of certain artworks via a detailed discussion of Ernst, Derain, Man Ray, Masson, the early Chirico, and Picasso, whose *Demoiselles d'Avignon* was reproduced here for the first time in Europe—all manifestations of the eye as it "exists in its savage state."

For Breton, painting, like poetry, was not a matter of visual technique, but the externalization of a *"purely internal model."* It was the artist's inner vision that engaged his interest, the ability to make him see that "which is not visible," rather than the skill with which line or color was applied to canvas. "It is impossible for me to envisage a picture as being other than a window," he wrote, "and . . . my first concern is then to know what it *looks out* on." Breton was seeking not only to define an aesthetic philosophy, however: by devoting particular attention to select individuals, he was also (as he had done in the *Manifesto*) defining a group of artists as properly Surrealist. When Gallimard published *Surrealism and Painting* in book form in 1928, Breton added lengthy examinations

of Miró, Tanguy, and Arp, bringing them, too, into the ever expanding fold.*

Finally, in the same month that the Surrealists helped protest the Rif War, Breton steered Surrealist activity onto an overtly political plane. "In the current state of European society, we remain devoted to the principle of any revolutionary action whatsoever, *even if* it takes class struggle as a starting point, just so long as it goes far enough," he declared in his editorial, announcing the group's more active hard line (even if the "*even if*" betrayed a certain lingering hesitation). He also worked to expand Surrealism's field of action by making or renewing external contacts with left-leaning intellectuals. Among these were Paul Nougé and Camille Goemans of the Belgian proto-Surrealist magazine *Correspondance*, whom Breton traveled to Brussels to meet later that month, Pierre Morhange and Henri Lefebvre of *Philosophies*, the young actor Pierre Brasseur, and a few others. Most of all, in the wake of their common stance against the Rif War, he drew closer to the editors of the periodical *Clarté*.

The first concrete result of this multiple embrace was a joint tract in August, roughed out by Aragon and *Clarté*'s Victor Crastre, called "Revolution Now and Forever!" Like *L'Humanité*'s "Appeal to Intellectual Workers," the tract was mainly a protest against French military intervention. It urged soldiers in the Rif to desert, and hailed Lenin's "magnificent example of immediate disarmament" in the 1917 Treaty of Brest-Litovsk: "We don't believe *your* France will ever be capable of following such an example." Not content merely to echo the "Appeal's" liberal pacifism, however, the authors took a more aggressive stand, and called for the downfall of Western civilization itself. "Wherever Western civilization is dominant, all human contact has disappeared, except contact from which money can be made," they stated. "It is the turn of the Mongols to bivouac in our squares. We should never for a moment worry that this violence could take us by surprise or get out of hand. As far as we are concerned, it could never be enough."

The tract combined the polemical talents of some of the left's most intelligent young sympathizers, and expressed a very real rage against the political and philosophical iniquities of French life. So violent were the statements, in fact, that many of the petitioners expected government reprisals, and some retracted their signatures before publication. Eluard worried about being arrested, and Breton warned foreign Surrealists to safeguard their manuscripts in the event of police searches. Nonetheless, when "Revolution Now

* In some cases, however, he overstepped his jurisdiction, such as when he tried to persuade Henri Matisse that he, too, was a Surrealist. In August, a wickedly delighted Man Ray described the scene for Gertrude Stein: "I thought it delicious to hear Matisse speak of drawing hands that look like hands and not like cigar butts. Breton, expecting to find a sympathetic iconoclast, found himself facing an instructor in painting! And as they talked, it seemed that the two men were speaking entirely different languages."

and Forever!" was published as a broadside later that summer, the reaction was relative-ly mild. While right-wing columnists showed the customary hostility, their protests paled next to the aftermath of the Saint-Pol-Roux banquet. And although some government agencies did in fact call for sanctions, the public prosecutor demurred on the grounds that he could not identify the parties responsible: he believed the tract was the work of anar-chists hiding behind the names of little-known poets.

One of the more complex responses to the Surrealists' recent positions came from Aragon's close friend Pierre Drieu la Rochelle. A novelist, political journalist, and future fascist, Drieu had met Aragon in 1916 and immediately been drawn into an intense emo-tional, and occasionally sexual, intimacy. He maintained an almost fanatical admiration for Aragon and his writing, and was therefore all the more distraught to see his friend joining the Surrealists in demeaning nonliterary activities. In the August *Nouvelle Revue Française*, he published an open letter, titled "La Véritable erreur des surréalistes" [The Surrealists' True Error], in which he upbraided Aragon for endorsing the Riffs and the Communists—partly because Drieu himself disagreed, and even more so because he saw it as mere posturing, something to talk about "after having exhausted all other topics of conversation at the Café Cyrano."

Although Drieu's letter was motivated largely by a recent breakdown in his friendship with Aragon, he nonetheless touched upon a twofold problem facing the Surrealists in their attempts to "objectify their ideas" politically. On the one hand, the Surrealists' social initiatives were themselves pretty vague. And if "Revolution Now and Forever!" marked an important step in their development from self-reflective dreamers to militants, its expression was still, as Breton recognized years later, "rather confused ideologically." At the same time, even a more rigorous political agenda would have had trouble winning cre-dence because of the signatories' predominantly literary affiliations. At this point, neither the Surrealists nor their associates had firm ties with any militant organization. Violent as their program might have been, they did not enjoy sufficient clout to make good on their threats, or even to be taken seriously outside of the most restricted intellectual circles.

One obvious solution was to join forces with a substantial political entity, and more specifically the French Communist Party. But despite the Surrealists' inflammatory statements, they were not ready to relinquish their autonomy for the good of the Revolution. Eluard expressed the feelings of more than one group member when he told Breton: "It is absolutely necessary that we remain Surrealists and that they not count us among the Communists." By the time his letter was received, however, events were con-spiring to push Surrealism closer to the Communist Party, and into an upheaval that would last for more than a decade.

✳

In early August, Breton and Simone had gone to stay with Georges Malkine in Nice. Breton passed much of his time sitting at outdoor café tables, protected from the Côte d'Azur sun by dark green shades, a windbreaker, and a pith helmet. But the vacation was not a pleasant one: he despised the heat and the noisy tourists, while "the ocean constantly made [him] want to vomit." On top of which, his mind was filled with thoughts of the elusive Lise. As Simone told Denise, Lise had become a source of "incessant, exhausting torment" for Breton, who had been engaging in "a courtship that her extreme flirtatiousness made by turns hopeful and desperate." Neither Simone's proximity after her long absences that spring nor the couple's visits to André Masson, also vacationing in the area, provided relief. Unable to change his emotional situation, Breton could at least improve his physical one: on August 24 he and Simone left Nice, heading inland toward the Alps and the town of Thorenc-sur-Loup.

Thorenc's cooler climate and surrounding landscape immediately raised Breton's spirits; the mountains were "what I find most restful and satisfying in Nature," he told Doucet. It was there, in the local cafés or in his room at the Grand Hôtel du Château, that Breton wrote two of his more important texts from that period—texts that, taken together, illustrate the dual track he felt Surrealism should now follow.

The first, "A Letter to Seers," reflected Breton's longstanding interest in automatism and the marvels of the unconscious, his fascination with mediums and clairvoyants as the privileged transmitters of extra-rational messages. At around this time, he and several others had begun consulting a clairvoyant named Angelina Sacco. On July 9, he had written Simone of Madame Sacco's predictions for his future: that his life would change drastically around 1931; that he and Simone would not divorce; that he would be the head of a political party; and that he would spend twenty years in China, returning rich and famous. Although Madame Sacco's predictions contained the standard allotment of hits and misses, her analysis of Breton's personality was more accurate. She immediately sensed the intellectualism, enormous complexity, and almost paralyzing contradictions that formed so much of his character—although it is possible, as one Surrealist later speculated, that her understanding of Breton stemmed less from "clairvoyance" than from the steady flow of his friends through her parlor.*

* Breton made an astonishing forecast of his own when he wrote in his 1925 "Letter": "There are people who claim that the war taught them something; even so they aren't as far along as I am, since I know what the year 1939 has in store for me." Fourteen years later, when France again found itself at war, Breton highlighted his prediction as evidence of the natural clairvoyance that Surrealism helped foster.

Written almost simultaneously with the "Letter to Seers," Breton's second article that September, a review of Leon Trotsky's book on Lenin, promoted Surrealism's concurrent interest in external political action. It was during his stay in Thorenc that Breton first read Trotsky's memoir. He immediately told Eluard about the "marvelous book," and on September 3 sent him his review for *La Révolution surréaliste*, saying, "I was determined to commit myself, to stick my neck out as much as possible in my remarks."

Until this point, Breton and the others had had only a sketchy notion of the Russian Revolution, and when the more political Francis Gérard, for one, had tried to interest them in it further, he had been met by "Homeric laughter." Instead, the Surrealists' model for insurrection was primarily the French revolutionary Convention of 1792. But Trotsky's descriptions brought to life, as if for the first time, a newer, more exciting model for revolt, one that seemed to reinforce and justify Surrealism's hesitant steps toward social action over the past several months. "If there are some among us whom such a fear [of political action] leaves still hesitant," Breton now stated, "it goes without saying that I oppose to their concern, minor as it may be, the general spirit we maintain, which can rest only on *revolutionary reality*, carrying us forward *by any means and at any price*."

Breton's enthusiasm for Trotsky's book was the result of various components. For one, it perfectly matched the frame of mind that had dictated "Revolution Now and Forever!" For another, he could not help responding to the heroic stature Trotsky had conferred on the Russian revolutionaries. As he later said, "Something very engaging emerged from a certain relation between the *human* (the personality of Lenin himself as the author had known him) and the *superhuman* (the task he'd accomplished), which, by the same token, made his ideas enormously attractive." To Breton's mind, the social revolution of the Communists perfectly mirrored the moral and aesthetic revolution that Surrealism had set as its own goal.

But perhaps more than anything, what swayed Breton was Trotsky's mastery of style, and the terms in which he praised the book were telling. It was Trotsky's "brilliant reason," "perfect tone," and "fine and desperate" critiques that most enchanted Breton, as well as "the brilliant, the *just*, the definitive, the magnificent pages" in which he refuted rival accounts of Lenin by Maxim Gorky and H. G. Wells. In the final analysis, it was less Trotsky the bureaucrat, about whom Breton knew little, than Trotsky the consummate biographer who won his admiration.

The limitations of Breton's perspective are all the more significant in that, even as he was reading Trotsky, the situation in the Soviet Union was rapidly changing. For several years, and particularly since Lenin's death in January 1924, a power struggle had been dividing former allies in the Party. In a very short time, this struggle would be resolved

in favor of Joseph Stalin, while Trotsky would be expelled from the Central Committee, sent into exile, and eventually murdered by the very state he had helped found. But Breton knew little of this. His vision of the USSR tinged by Trotsky's heroic colorations, he—along with many other European intellectuals drawn to Communism at the time— imagined only a virile brotherhood striving selflessly toward the common good.

Full of his new enthusiasm, Breton began examining the others' political attitudes, and most notably Aragon's. Several days earlier, responding to Drieu la Rochelle's gibe that he "howled 'Long live Lenin!'" out of sheer obstinacy, Aragon had said, "I won't say that I've never shouted, '*Long live Lenin!*' I will *howl* it tomorrow, if this shout becomes banned." For Breton, such reasoning was flippant and counterproductive. He had grudgingly kept silent over Aragon's earlier rebuttal to *Clarté* about the Russian Revolution being "a vague ministerial crisis." This time, however, he attacked his friend's retort as "a concession to our worst detractors, who are also Lenin's, letting them suppose that we would only take up a challenge. To the contrary: 'Long live Lenin!' only *because he was Lenin!*" The Marxist revolution was the only one with which Surrealism could align itself, Breton maintained, because "Communism alone among organized systems permits the accomplishment of the greatest social transformation . . . Good or mediocre in itself, defensible or not from the moral point of view, how can we forget its role as the instrument by which ancient buildings are destroyed?"

Concurrently, Breton recommended that all Surrealists read Trotsky's book, and, with his communicable ardor, soon had them proclaiming it (in Eluard's words) "one of the greatest works I've ever read." Eluard himself zealously adopted Breton's positions; and even Aragon, who had earlier jeered at Communism in the name of individual anarchism, now began writing "distinctly Marxist" articles for *Clarté*, denouncing anarchy as the "origin and foundation of every kind of fascism." Trotsky had managed to inspire not only Breton's personal enthusiasm for the Soviet revolution, but, through him, a dramatic change in attitude for Surrealism as a whole.

Breton's turn toward the Soviets was further encouraged that summer by a series of discussions with André Masson. On September 2, Masson had sent Breton his own profession of faith in the Dictatorship of the Proletariat. The next day, he and his wife, Odette, joined the Bretons in Thorenc. Although much of the daytime was spent hunting for insects and crayfish, the evenings were filled with intense political debate. When the Massons returned home several days later, Breton—who prolonged his stay in Thorenc thanks to the sale of some paintings to Doucet—was left behind to ponder how Surrealism might best negotiate the Communist path.

✳

Breton's return to Paris in mid-September 1925 inaugurated a period of fervent political activity: signatures on petitions (against the Romanian government's arrest of 386 Bessarabian peasants, protesting Hungary's suppression of the workers' movement), further statements against the Rif War, and, most of all, numerous meetings with the Clarté group with a view to an eventual fusion.

The Clarté [Clarity] movement, and its eponymous magazine, had originally been founded in 1919 by the pacifist intellectuals Raymond Lefebvre, Paul Vaillant-Couturier, and Henri Barbusse (who enjoyed widespread renown from his anti-war novel *Under Fire*). Its steering committee initially featured such prominent lights as Thomas Hardy, Georges Duhamel, Vicente Blasco Ibañez, Magdeleine Paz, Upton Sinclair, Jules Romains, H. G. Wells, Stefan Zweig, and Anatole France. Within several years, however, it had gone from being "an international rallying-ground for intellectuals" to a center for revolutionary indoctrination, under the group's younger, more hard-line constituents —notably Vaillant-Couturier, Jean Bernier, Marcel Fourrier, and Victor Crastre—while Barbusse himself resigned in 1923. By 1924, Clarté had evolved to the point of being the only other group, along with the Surrealists, to attack its former patron Anatole France— even as both the Communist newspaper *L'Humanité* and the far right warmly memorialized him.

Like most Western Communists in the early 1920s, the Clarté group had lived in the expectation of a coming revolution. Their rhetoric, which might seem inflated or naive today, appeared justified at the time by the certainty that they were helping prepare the ground for an inevitable overthrow of the bourgeoisie. The Bolshevik takeover in Russia provided a successful model, while various uprisings, such as the Spartacist revolt in Germany in 1919, although it had failed, seemed to promise a repetition of the October Revolution throughout Europe. (Few at the time had recognized the importance of another failed putsch in Germany four years later, which had landed the fledgling agitator Adolf Hitler in jail and inspired him to pursue "his struggles" on paper.) But by 1925, the European left was coming to realize that the revolution would not arrive as soon as they had thought. France in particular had been governed since the war by the conservative Bloc National, which in 1923 had occupied Germany's industrial Ruhr region against failure to pay war reparations. And although the Bloc National had been supplanted in 1924 by the Cartel des Gauches, an alliance of Radicals and Socialists, for the Communists it hardly seemed an improvement: whereas one had gone to occupy the Ruhr, the other readily sent troops to quell both the Rif uprising and a revolt in Syria.

France's poor economic situation only made the national mood more conservative, encouraging a steep increase in conversions to Catholicism (to the point where even the Radical Party didn't dare break off relations with the Vatican). Meanwhile, the Nazi Party was forming in Germany, Mussolini had come to power in Italy, and Spain had a military dictatorship. Even the Soviet Union, which was now preoccupied with its own industrialization programs, seemed to have little time for its comrades in the West. Having reluctantly admitted the stalemate of European Communism, at least for the time being, Clarté's Jean Bernier again changed his group's program: from pedagogy to undermining the dominant bourgeois culture.

It was against such a background that Breton sought to realize a union with Clarté. This union was encouraged notably by Clarté's stand on the Rif War; its lone support of *A Corpse* and its sympathetic attention to Surrealism in general; and its attempts, similar to those of Surrealism, to wage a revolution against the decadence of Western culture. The main determinant, however, was mutual need: Clarté had lost several members, and its magazine many readers, through repeated changes in policy and editorship, and now hoped that the Surrealists would help revitalize it. Putting aside his earlier tiff with Aragon over "doddering Moscow," Bernier soon proclaimed that the two groups had a "dual purpose: to demonstrate to our proletarian readers the ignominious ruin of what is pompously called French thought." As for Breton, he was all too aware that Surrealism, despite its revolutionary sympathies, was fast being overrun by snobs and collectors, who attended its demonstrations, bought its paintings, and—in Doucet's case, for example—even subsidized its writings (while the extreme right, whose attacks Breton awaited as a proof of revolutionary pedigree, often seemed to ignore it). Fearing that the movement would degenerate into the same sterility as had afflicted Dada, Breton looked toward Clarté as an ideological guarantor.

On October 5, a first meeting was held at *Clarté's* editorial offices on Rue Jacques-Callot. The newly formed joint committee, comprising Surrealists, Clarté members, and editors of the magazine *Philosophies*, undertook to define its ideological positions vis-à-vis the Communist International, pledging allegiance to both Communism and the French Communist Party. "No doubt we will run up against criticism from the PCF. We deserve it, because of our inexperience or stupidity." (Clearly, the Soviet tactic of "self-criticism" had found a home among the new revolutionaries.)

Still, despite the proclaimed sympathies with the Communists—and even the adoption, as Crastre noted, of the Party's tone and formulas in the joint meetings—the general consensus was not to join the Party as a block. Some, such as Clarté's Fourrier, were already members, and others were left free to join as individuals. But many of those

present were deemed unready for membership, liable only to hurt the group's chances of acting effectively within the Party. Moreover, the joint committee was aware of its strength as an independent entity, and saw no reason to relinquish that independence.

In a sense, the three constituent factions were founding a party of their own, a "dictatorial body" that would encourage and enforce the discipline they had agreed to adopt. Members were bound to keep all proceedings secret from nonmembers, and to restrict all debate to the joint meetings. All individual activity was to be subordinated to the interests of the group. *Clarté* and *La Révolution surréaliste* traded contributions, and a secret code was proposed to camouflage "subversive" words ("Russian" would be replaced by "American," "proletarian" by "artist," "Communism" by "poetry," etc.). Crastre remembered that the shadows of dusk added a conspiratorial atmosphere to the enterprise, which the Surrealists welcomed "with visible joy."

Surrealism's hesitant steps toward militancy affected its members in different ways. For some, such as Masson, revolutionary politics provided a ground for closer contact with Breton. And Pierre Naville, who had converted to Leninism while in the army, was tentatively allowed back into the group in November. Others, however, found their relations with Breton strained over the recent developments. René Crevel, deemed to have "made unacceptable statements" about the revolution, was kept at a distance, and the other members sworn to secrecy in his presence. Soupault, who had little tolerance for either poet-politicians or the endless round of meetings, was also put under suspicion, although his case was deferred at Breton's request.

But it was Roger Vitrac who became the first in a long line of Surrealists to suffer official exclusion. In poor standing with the group for actions deemed "cowardly" at the Saint-Pol-Roux banquet, his open commitment to theater, and his revolutionary limpness—"And anyway, the hell with the Revolution!" Breton later quoted Vitrac as saying—the even-tempered young playwright was harangued by his friends until he finally stormed out. Although Vitrac claimed to have quit Surrealism without regrets, Jacques Baron later saw him sitting sad and alone at a café, complaining of the intellectual quarantine in which his exclusion had placed him.

Knowing that Vitrac was close to Artaud, who still haunted the fringes of Surrealism, Breton tried to force the latter's support. Artaud told Génica Athanasiou that he had "received a threatening letter from Breton about Vitrac, in which he calls him a swine and more or less orders me to stop seeing Vitrac." But Artaud refused, and this refusal, combined with his absorption in a painful breakup with Athanasiou the following month, effectively ended his participation in the group. "Forgive me *but things are bloody*," he wrote Breton in late October. "That is why you must ask nothing of me, not

try to see me right now . . . I beg you, don't try to make me think about anything but my own distress."

Even within the new federation, matters were proving difficult. By the end of October, Breton, Aragon, Bernier, and Fourrier were debating what to do about *Philosophies*, of which two members in particular, Lefebvre and Morhange, were fast proving incompatible with the others. They were often absent from meetings, refused to give up their autonomous activity, and—perhaps worst of all—confessed to having strong religious convictions. Their case was discussed over the next several days, Breton insisting on, and eventually obtaining, the formal exclusions of both men.

Curiously, after his initial revolutionary fervor, Breton would also fight to maintain Surrealism's autonomy, just as he had denounced Lefebvre for doing with *Philosophies*. But in these first months of new activity, the headiness of daily meetings, seemingly earth-shattering concerns, and condemnatory power intoxicated him much as it had the architects of the French Revolution's Reign of Terror. One Surrealist who first met Breton at that time described him as "the Fouquier-Tinville of modern poetry," referring to the Terror's ruthless public prosecutor. The model of the Convention lived on.

The Communist orthodoxy, meanwhile, had varied reactions to the Surrealists' recent activities: some were sympathetic, while others continued to view the movement with a jaundiced eye. Indicative of this were the hesitations within the Party organ *L'Humanité*. The newspaper hired Péret and Noll as columnists, and in September had reprinted "Revolution Now and Forever!" But in its presentation of the tract, it had also felt obliged to add: "Let's accept for the moment the support this handful of young intellectuals wants to lend to our struggle against the Rif War and to the proletarian denunciation of bourgeois culture . . . We know all too well that, whatever they do, these young men cannot be more revolutionary than the conscious part of the working class that suffers daily in the capitalist inferno." Support or no, when it came to a choice between conscious laborers and poets of the unconscious, there was little question as to the Party's preferences.

Anxious to reassure the Party, the Surrealists issued a vehement (and patently revisionist) disclaimer: "Only a simple confusion of words allowed some people to think that there existed *a Surrealist revolutionary doctrine. Nothing is farther from the truth* . . . There has never been a Surrealist theory of revolution. We have never believed in a 'Surrealist revolution.'" But the PCF had every reason to be skeptical. For one thing, the very name of the group's magazine contradicted any denials of a "Surrealist revolution." For another, the Surrealists, although genuinely roused by the example of the Soviet uprising, retained, almost in spite of themselves, a tenacious faith in their own perspective. Masson

expressed all the precariousness of the Surrealist position when he stated that the group's task was "to formulate a dialectic all our own, which will set us apart . . . [and] situate us morally *and above* the bolshevism of Lenin and Trotsky." It goes without saying that a revolution "morally above" bolshevism, "set apart" from the French Communists, was not entirely what the leaders of the PCF had in mind.

Despite their reassurances, moreover, the Surrealists continued to act independently. In October they had published the fifth issue of *La Révolution surréaliste*, which included Breton's note on Trotsky's *Lenin* and "Revolution Now and Forever!" but also featured the inner-directed "Letter to Seers," as well as numerous poems, automatic texts, and dream narratives. And on Friday, November 13, at midnight, they inaugurated the first exhibit of Surrealist painting. The show, which ran for ten days at the Galerie Pierre on Rue Bonaparte, was Breton's further way of resolving the debate begun that summer with *Surrealism and Painting*. Like the essay, the exhibit centered on the works of Man Ray, Arp, Klee, Masson, Ernst, Miró, the "metaphysical" Chirico, and Picasso. (Breton was especially proud to have won Picasso's participation, and considered it a large step taken by the painter toward Surrealism—all the more so in that Picasso customarily avoided exhibiting in group shows.)

In its own way, this first Surrealist exhibit was indicative of the general ambiguity surrounding the group's participation in social struggle. On the one hand, Breton meant for it to promote the visual aspect of Surrealism, and therefore to widen Surrealism's public presence; but on the other, he tried to present the exhibit as constituting a bona fide revolutionary act. The joint committee as a whole showed the same ambivalence: at a meeting on October 19, it was resolved that "Surrealist art is the only revolutionary art in France"; but at the same time, it was also resolved that "given [the exhibit's] fashionable side, the Communists will not be part of it." Was Surrealism following the revolutionary path, or wasn't it? No one seemed able to decide.

Least of all Breton, who felt besieged by doubts. The effectiveness of the committee's work, the speed with which they were embracing the Party line, their ability to surmount individualistic tendencies, and even the harshness of their critiques now inspired his caution rather than his praise. On November 9, in a letter to the other members, he excused himself from committee duties for two weeks, hoping to get the necessary distance "to judge authoritatively what we are doing." He also took the opportunity to express his feelings of discouragement and futility:

> I am extremely tired, morally fatigued . . . Either because the tendencies I've recently had to adopt for myself run too counter to my previous tendencies, or because in

trying to break down others' resistances I've momentarily killed my own, or for any other reason, I have come to doubt the current value of my collaboration with you . . . Our deliberations have demonstrated an evident will to get things done quickly, which I cannot condemn, but which makes me fear that in our impatience we have denied in ourselves and around us personal feelings that cannot be shed so lightly . . . Our individual possibilities are not yet strong enough to prevent the recurrence of minor weaknesses. With our heads bent over our little decrees, we risk seeming not very understanding, and indeed quite harsh . . . It has already been said that four or five of us were simply playing at Revolution: it shows you how badly we've expressed ourselves.

The document was remarkable, given Breton's attitudes of only days before, and at the same time typical of a pattern. As with Dada, the launching of Surrealism, and even the Bureau of Surrealist Research, Breton was caught between a drive toward community and an unwillingness to deny his individual determinations. The exuberance of collective action had once more given way to a deep and isolated pessimism; the "solitary man who could not live alone," to use Soupault's phrase, was again suffering the contradictions of his own complex nature.

Adding to the discouragement was a growing sense of imbalance within the committee's remaining constituency. While the Surrealists struggled in good faith with the unfamiliar rudiments of dialectical materialism, the Clarté faction remained divided in its attitude toward Surrealism. And Breton began to have less and less tolerance for some of Clarté's penchants, such as the long diatribes that Jean Bernier would occasionally deliver at meetings. A friend recalled him leaning over during one of them to hiss: "'Idiosyncrasy, idiosyn . . . , is that the only word he can say! Do *you* know what he's talking about?' And without giving me time to answer: 'He must have found it in the dictionary this morning!'" Breton also noted with dissatisfaction that, despite an earlier resolution to write for each other's periodicals, the Surrealists were contributing far more material than they were receiving in return. Victor Crastre was the member of Clarté most favorable to the Surrealists, but even he had to admit that *La Révolution surréaliste* struck his group as an esoteric, "technical" publication, whose dream narratives and reproductions of modern art put them ill at ease.

Breton's unwillingness to relinquish Surrealism's autonomy should not have surprised anyone familiar with an article he contributed to the December *Clarté*. Titled "La Force d'attendre" [The Strength to Wait], it reaffirmed Surrealism's devotion, "body and soul, to the revolution," and criticized "the isolation of the poet, the thinker, the artist . . . from

the masses." At the same time, however, Breton took issue with those who advocated the abandonment of Surrealist activity in favor of a more orthodox form of Marxism. "It would be like throwing out weapons because they're no longer shiny enough, before procuring any replacements," he argued, maintaining that it was just as revolutionary "to draw inspiration from Lautréamont and Rimbaud" on the spiritual level as it was to embrace Marx and Lenin on the social one.

The position contained the seeds of both Surrealism's specific value as a philosophy and its irreconcilable differences with Communism as a doctrine. Breton, a man of deeply ingrained poetic and—for lack of a better word—spiritual concerns, responded to the subversive *tone* of Communism more than to its actual objectives. The Surrealists despised all those virtues that mainstream French society held dear: family, religion, patriotism, and conformity; most of all, they despised the boorishness and arrogance of the ruling class. But they were interested in neither work, nor economics, nor laborers per se. Eluard, future bard of the Stalinist masses, once confessed: "I don't love the wretched, not in the least. I don't feel any love for the man I come across begging at the entrance to the metro." And Breton admitted that it was "not the burden of [a proletarian's] labor" that predisposed him in the workers' favor, but "the vigor of his protest against it"—a protest that seemed to mirror the Surrealists' own "insatiable and boundless" refusal of the human condition.

By concentrating on the poor status accorded "the poet, the thinker, the artist" in capitalist society, Breton seemed content to ignore Communism's other face, the one that hailed labor as a virtue and promised singing economic tomorrows for the working classes. Instead, he looked toward the PCF, as earlier he had toward Dada and the Orient, as a means of toppling Western cultural attitudes. And indeed, so long as Communism acted as "the instrument by which ancient buildings are destroyed," Breton could continue to believe that they were pursuing essentially the same goals. It was only later, when it came to erecting new buildings, that he would find himself working from a set of blueprints very different from the ones the Communists had in hand.

✳

In the early months of 1926, Breton's response to the setbacks inflicted by the PCF was to turn his attention to more specifically Surrealist concerns and to expand the movement's creative activities, as he had so far been unable to broaden its political ones. None of these activities helped bring Breton closer to the Communists, of course—if anything, they only seemed to confirm the Party's suspicions about Surrealist rebelliousness. But it

was as if Breton, on the verge of turning thirty, and after the events of the previous six months, needed to remind himself that Surrealism was still alive.

Among the most encouraging signs of life was the spate of memberships during this period, which by the end of 1925 had brought the Surrealist roster to nearly forty. The earliest recent adherents, who shared studio space at 45 Rue Blomet in the 15th arrondissement, loosely included current and future Surrealists Masson, Joan Miró, Georges Malkine, Masson's friend Roland Tual, and Michel Leiris; as well as frequent visitors Artaud, Limbour, Desnos, Vitrac, and the painter and sculptor Jean Dubuffet.

Although Breton would never establish very strong ties with the Rue Blomet group collectively, it did contribute some notable individuals to Surrealism. One of these was Michel Leiris, who would later become known for his ethnographic work at the Musée de l'Homme as well as for such autobiographical tomes as *Manhood* and *The Rules of the Game* (and who had distinguished himself at the Saint-Pol-Roux banquet the previous July). Acerbic, self-deprecatory, and painfully honest, Leiris once said that he loathed "unexpectedly catching sight of myself in a mirror, for . . . I seem humiliatingly ugly to myself each time." Though only five years younger than Breton, he confessed to feeling "like a little boy" in comparison. Another was Miró, whose paintings Breton had first seen in Barcelona in 1922. Excited by the recent work he now discovered at Rue Blomet, Breton bought one of them, *Catalan Landscape*, and deemed Miró "the most 'Surrealist' of us all." (He later tempered this statement with a more acerbic appreciation of Miró's childishness, his "partially arrested development at the infantile stage which has left him ill protected against unevenness, overproduction, and playfulness.")

But Rue Blomet wasn't the only Surrealist cell to form independently of Place Blanche. Several blocks east, in a semi-dilapidated house at 54 Rue du Château, just south of Montparnasse station, lived a trio consisting of the poet Jacques Prévert (who didn't yet write), the painter Yves Tanguy (who had barely begun to paint), and Marcel Duhamel (who did neither). Visitors to the house found a hodgepodge of spare mattresses, stolen shop signs, assorted junk, and a toilet decorated with a crucifix flush handle and a military kepi. A key on the outside window ledge offered easy access to one and all.

Desnos and Georges Malkine had discovered the small bohemian community shortly before, and Aragon and Péret had paid an exploratory visit soon afterward. Aragon was seduced by Tanguy's first artistic essays, while Péret, who had ripped up Duhamel's prized accordion just to test the other's reaction, was so favorably impressed that he moved in with the trio. A meeting at Rue Fontaine was then arranged. Intimidated by Breton's reputation, Tanguy and Duhamel had fortified their spirits with cocaine— which caused them to chatter uncontrollably and kept Breton from placing a word all

evening. "If you know the man, that's a minor miracle," Duhamel later observed.

While Breton had reservations about Rue Blomet, he was charmed by the "absolute nonconformism [and] total irreverence" of the Rue du Château group. "Never had Surrealism shown such an organic unity, or known greater effervescence," he recalled. "That was the veritable alembic of humor, in the Surrealist sense of the word." Before long Rue du Château became a kind of Surrealist branch office, a slightly disheveled counterpart to the more polished ministry at Rue Fontaine. André Thirion, remembering the house as it was a few years later, when its revolving occupancy might go as high as eighteen people at a time, wrote: "One knocked on the door, stepped inside, had a drink, and departed with grave and mysterious feelings. It was like a secret assignation with strangely disturbing persons . . . There was a bit of all this at the Cyrano, but away from Breton, everyone . . . was warmer, more genuine, less strained."

Of Rue du Château's principal tenants, all three as old as the century, two would number among Surrealism's most famous members. One, Jacques Prévert, offset his air of a working-class tough with an "infectious liveliness" and an extraordinary verbal inventiveness. It was only in later years, after his break from Surrealism, that Prévert would gain enormous popularity as the poet of *Paroles* and the scenarist of such films as *Les Enfants du paradis* and *Le Jour se lève*. But while he produced no lasting work during his association with the movement, Prévert's linguistic verve was in itself a refreshing gust, and often Breton went to Rue du Château just to hear him talk.

In contrast, Yves Tanguy was taciturn, given to drink and, when in his cups, violence. But his half-infantile, half-deranged demeanor (not to mention the jolt of hair that sprang up from his skull) hid a keen and original mind. "To a superficial observer, Yves seemed to be moving in a simplified universe," said Thirion. "But his simplifications reflected merely his modesty and preference for clarity." Although desperately poor, Tanguy was scrupulous about his personal hygiene—which didn't keep him, when in the country, from eating live grasshoppers, spiders, ants, and whatever else crawled by. He had been inspired to paint several years earlier by the sight of Chirico's *The Child's Brain*, the same painting that had so captivated Breton several years earlier, and that Tanguy, on his first visit to Rue Fontaine in late 1925, was amazed to discover hanging on Breton's wall.

The third member of the trio, Marcel Duhamel, although at best a marginal contributor to Surrealism, nonetheless made the Rue du Château gathering possible by providing the capital, which he earned as manager of the posh Grosvenor Hôtel. Passionate, like his two roommates, about jazz and the movies, Duhamel would for a while be Surrealism's most gracious host: thanks to him, Prévert, Tanguy, Péret, and later such

figures as Raymond Queneau (the future author of *Zazie in the Metro*, who also met the Surrealists during this period) would enjoy rent-free lodgings for long periods.

It was also at Rue du Château that one of Surrealism's richest new activities was invented: the game of Exquisite Corpse. A variation on the traditional French game of Petits Papiers, it involved composing a sentence in collaboration with several others, no one having seen what was already written. The name was based on the first sentence obtained: "The exquisite / corpse / shall drink / the new / wine." "André shouted for joy, and immediately saw in [the Exquisite Corpse] one of those natural sources or cascades of inspiration that he so loved discovering," recalled Simone. "The suggestive power of those arbitrary juxtapositions of words was so stupefying and dazzling, so brilliantly verified the Surrealist thesis and mentality, that the game became a system, a research method . . . perhaps even a drug." Among the examples Breton later cited as most "*jolting*" were: "The anemic little girl makes the wax-polished mannequins blush," and "Caraco is a beautiful slut: lazy as a dormouse and wearing glass gloves to save her from having to lift a finger, she threads pearls with the scapegoat." Several years later, a question-and-answer variation on the Exquisite Corpse produced a curiously resonant definition: "What is André Breton? An amalgam of humor and a sense of disaster; something like a top hat."

The technique was soon extended to include drawing. By now, the visual domain had become very much part of Surrealist territory, and painters such as Masson, Miró, Man Ray, Tanguy, and Ernst were beginning to produce important works as members of the group. At the same time, these artistic endeavors were mainly limited to *artists*. With the Exquisite Corpse, however, artists and writers alike (including Breton, who demonstrated respectable drawing talent) could join indistinguishably in producing these creations, as a kind of plastic counterpart to the "poetry made by all" that Breton had earlier adopted as his watchword.

Breton had by now begun to define a specifically Surrealist art in *Surrealism and Painting*. In early 1926, this new form of Exquisite Corpse added another arrow to his quiver. And on March 26, he took a further step toward codifying visual Surrealism by opening a Galerie Surréaliste at 16 Rue Jacques-Callot (near the Ecole des Beaux-Arts)—until recently the site of *Clarté*'s editorial offices. Its aim was to showcase Surrealist art, or art that embodied the Surrealist spirit, just as *La Révolution surréaliste* showcased Surrealist writing.

Still, neither the Exquisite Corpse nor the Galerie Surréaliste could compensate for the rejections from the PCF and Lise, whom he continued to court in vain with letters and poems. Breton soon entrusted the gallery to Marcel Noll and headed alone to the

South of France, but the distance only increased his depression: "And yet, I was so full of good intentions," he told Simone on April 5, from Marseille. Within days he was back in Paris, his mood no lighter. A letter to Lise in May spoke of his love for her "which is aggravated only by its insecurity."

Breton's state of mind led to various outbursts that spring of 1926. In some cases the connection with Lise was explicit, such as when Aragon published an extract from *La Défense de l'infini* called "Le Cahier noir." Apparently goaded by Péret, Breton exploded in rage over one of Aragon's phrases, "Visits, a pair of gloves . . . love," which he took as flippancy toward his "lady of the gloves." Aragon protested his innocence, and rewrote the line for a later version of the work.

Even Breton's more philosophically justifiable outbursts seemed at least partially fueled by the spite of unrequited love. On May 18, he and Aragon drafted a "Protest" against Diaghilev's production of the ballet *Romeo and Juliet*, and especially against the participation of Miró and Ernst as set designers, which Breton felt betrayed Surrealist principles to strictly commercial interests. In purest Dada tradition, the tract was sent raining over amazed theatergoers that evening at the ballet's gala premiere. Meanwhile, Surrealists throughout the hall shouted, "Long live the Soviets!" and "Long live the Russian Revolution!" until they were beaten up by the audience and carted away by the police—to the consternation of their wives and girlfriends in the café next door. The gesture was appreciated by *L'Humanité*, less so by Miró and Ernst, who long afterward held grudges against Breton and his "pretty revolutionary stances, carefully studied in front of the mirror."

Unable to find happiness with Lise, Breton refused to accept any substitutes for the love she denied him. When the affluent Valentine Hugo began making tentative advances to him in May, he rebuffed her by saying that "there was no place [in her world] for anything that I might hold dear." Simone, too, was kept at a distance, despite Breton's continued affection for her. Their vacation in the Pyrenees that summer was marred by his somber spirits, which he vented on the landscape, the tourists in Biarritz, and the religious pilgrims from nearby Lourdes—so numerous "that even from a long way off the glaciers appear soiled by their steps," as he told Doucet in one of his last letters to the patron. It did not help that Lise, all the while resisting Breton's entreaties, was not so virtuous with her other suitors.

Lise was not the only cause of Breton's moodiness that summer. As the Surrealists' political profile faded, the PCF seemed to revoke any previous confidence it might have expressed in the young bourgeois radicals. So did some of Breton's own associates, among them Pierre Naville, who in June had published a brochure criticizing the Surrealists'

revolutionary ineffectiveness. *La Révolution et les intellectuels* reviewed the group's posi-
tions over the past year and chided it for vacillating "between an absolutely anarchistic
attitude and Marxist revolutionary conduct." While the movement had recently taken
large strides toward the latter, Naville argued, its vague calls for collaboration between
intellectuals and the proletariat still left many practical questions unanswered. "For [the
revolution], today, the support of intellectuals can only mean the help of technicians and
men used to journalistic tasks . . . But from poets, thinkers, and artists"—a reference to
Breton's "La Force d'attendre"—"the proletariat can expect nothing." As Naville saw it,
Surrealism had two choices: either to persist in its anarchistic attitude, "a false attitude a
priori because it does not justify the idea of revolution it claims to uphold," or to accept
Marxism as "the only revolutionary path." While awaiting the decision, he—like the
Party—questioned the ultimate legitimacy of the Surrealists' recent declarations.

Breton later acknowledged that Naville's critiques "gave rise among us to consider-
able anxiety." This anxiety would eventually lead to penetrating self-examinations with-
in the group, its first major spate of excommunications, and even the decision of several
members to join the Communist Party. More immediately, it provoked a response from
Breton, written during his vacation in the Pyrenees and published in pamphlet form on
September 30.

Titled *In Self-Defense* (*Légitime défense*), Breton's text actually responded less to
Naville, whose points he used as springboards, than to the PCF's recent hostility toward
Surrealism. Breton rejected as "wholly artificial" the opposition that both Naville and
the Party maintained between inner reality and the factual world: "There is not one of
us who does not hope for the passage of power from the hands of the bourgeoisie to those
of the proletariat. In the meantime, we deem it absolutely necessary that inner life should
pursue its experiments, and this, of course, without external control, not even Marxist.
Doesn't Surrealism, moreover, tend to posit these two states as essentially one and the
same . . . ?" He also reserved harsh critiques for *L'Humanité* ("puerile, bombastic, need-
lessly *cretinizing*") and particularly for its literary editor, Henri Barbusse—attacking
him, not inaccurately, as a narrow-minded buffoon, whose taste did not rise above
Claudel and Cocteau, and who so misunderstood Surrealism that he had asked Breton
to contribute "short stories" to *L'Humanité*'s literary pages.

Behind the apparent cavils, Breton was in fact aiming at the fundamental conflict
between Surrealism and orthodox Communism: the question of whether it was worth
staging a material revolution without first seeing to man's spiritual betterment. The
Communists held that economic changes must come first, because a change in the social
superstructure would necessarily entail a change in outlook. Besides, as Naville had

pointed out, in the current state of affairs only a financially independent bourgeois could *afford* the Surrealist lifestyle. But to Breton's mind, the matter of outlook must come first: simply raising the proletariat's wages would not automatically heighten its spiritual awareness (on the contrary). As such, he argued, so-called avant-garde writing and art were more vital to the revolution than all the propagandistic short stories Barbusse could stuff into *L'Humanité*.

Moreover, the success of such a revolution demanded the highest personal integrity on the part of its leaders: the question in revolution, as in any collective action, was one of moral temperament. Breton therefore reasoned that Surrealism could do more for the revolution if allowed to carve out its own territory, rather than be forced to choose between strict adherence and rejection. By remaining outside the Party but sympathetic to its goals, Surrealism meant to fill an indispensable role as Communism's moral arbiter. "We thought we were fulfilling our roles by denouncing the most characteristic impostures and deviations around us," Breton stated. From "the Communism of genius," as Surrealism had styled itself in 1924, it now intended to be the genius of Communism.

In the final account, however, *In Self-Defense* was a miscalculation. Instead of providing a compelling new argument for mutual respect, it essentially restated positions unchanged since the previous fall, as if Breton failed to see (as one historian put it) "why repeated declarations of faith in the proletarian revolution should not be sufficient both for the Party and for Naville." Nor were these positions convincing in themselves: the proletarians, mainly individuals for whom material issues were simply more pressing than spiritual ones, and who prized such Surrealist targets as "family life, the artwork on French banknotes . . . and modesty," refused to adopt Breton's priorities. The Party administration, meanwhile, found Breton's statements offensive and considered his pamphlet a leave-taking rather than an attempt at rapprochement. It did not occur to Breton that the PCF, whose psychology was patterned on a Soviet model that answered external critiques with purges, was not overly disposed to accepting the guidance of an independent conscience—or to having its house organ reviled in public.

Even as Breton returned to the political arena, Aragon and Eluard were contributing some of the movement's most important lyrical works. On July 20, Gallimard brought out Aragon's *Paris Peasant*, a fabulous excursion through the recently razed Passage de l'Opéra (including the old Certa) and the Buttes-Chaumont. The book, which its author labeled a "modern mythology," gave Aragon a chance to exercise his customary narrative flair while straying only as close to fiction as Breton would allow. And on September 8, Eluard's most important collection of poems, a book he had originally thought to call "The Art of Being Wretched," was published by Gallimard as *Capital of Pain*.

Though at first these two poles of Surrealism's activity might appear to be in conflict, in fact the dichotomy was not so large. Breton's reasoned polemics on the one hand, Aragon's lyrical flights on the other, were two different—but, to them, in no way contradictory—means of demanding the right to build a more stimulating world, one richer in possibilities and marvels than contemporary French society permitted. All the while promoting Surrealism as a revolutionary movement, Breton maintained its "appeal to the marvelous," its faith in "the experiments of the inner life." And even if the social revolution occasionally paved over the unruly fields of marvel and chance, it was never long before the irrational pushed through to the surface.

❈

"You can be sure of meeting me in Paris," Breton wrote the following year, "of not spending more than three days without seeing me pass, toward the end of the afternoon, along Boulevard Bonne-Nouvelle between the *Matin* printing office and Boulevard de Strasbourg. I don't know why it should be precisely here that my feet take me, here that I almost invariably go without specific purpose, without anything to induce me but this obscure clue: namely that it (?) will happen here." The "it," still unrealized, was nothing less than the concrete occurrence of the "marvelous." The theatre of this marvelous might be the poet's own internal resources, when they allowed themselves to be coaxed from the "mouth of shadows"; or it might be the open city streets, scene of potential wonders untold. Having severed his ties with Doucet save for sporadic meetings (which would themselves cease within a few months), Breton was now for all intents and purposes master of his time. For most of the day he wrote, maintaining a strict discipline. But as of late afternoon his occupation was to wander the streets, seeking out the most likely entrances into the unconscious of Paris and of life itself—and then, at around seven, to meet with the others around a favored café table.

The price of Breton's liberal schedule was the severe frugality that he and Simone were soon forced to observe. Their erratic income was derived from the occasional sale of paintings from Rue Fontaine and of manuscripts and first editions to one or two interested collectors. Breton also received royalties from his publications, but for the moment these were scant indeed. (With Gallimard, moreover, Breton was actually in the red: he had agreed—though he often neglected—to reimburse the publisher 500 francs per month against old expenses from *Littérature*, and by the end of 1926 had accumulated a debt of over 3,000 francs.) And he borrowed: from Eluard and, generally with less success, from his parents.

Despite his often dire financial state, however, Breton refused to accept the idea of employment—an attitude previously expressed by such intellectual guides as Rimbaud and Duchamp, but for which (as Breton knew only too well) the Communists had little use. "Let no one speak to me of work," he declared. "I admit that life's grim obligations make it a necessity, but never that I should believe in its value . . . The event from which each of us is entitled to expect the revelation of his own life's meaning—that event which I may not yet have found, but on whose path I seek myself—*is not earned by work*."

At the same time, Breton also rejected the equally traditional life of poetic contemplation. For him, the "revelation of life's meaning" was to be found in neither the office nor the study, but rather in areas generally ignored by sightseers and bohemians alike. As such, his own quest often brought him to the then little-known Clignancourt fleamarket, in search of "objects that can be found nowhere else: old-fashioned, broken, useless, almost incomprehensible, even perverse"; or to the clutch of streets between Boulevard Bonne-Nouvelle and the Gare du Nord, populated by secretaries, laborers, strollers, and prostitutes; or to such tawdry venues as the Théâtre Moderne in Passage de l'Opéra or the Théâtre des Deux-Masques on Rue Fontaine, where Breton (though he generally disliked theater) reveled in the amateurish performances, the "grillwork loges entirely without air or light," and "the hall itself where during the performance rats crept about, running over your feet."

On Monday, October 4, 1926, at the end of an "idle, gloomy" afternoon, Breton was walking on Rue La Fayette, not far from the "extremely handsome, extremely useless Porte Saint-Denis" that provided the backdrop of his daily wanderings. He stopped at *L'Humanité* bookstore to buy Trotsky's latest, then headed away from the Gare du Nord toward the Opéra, watching the office workers pour from buildings and disappear into the Poissonnière metro stop. At that point, his musings were cut short by the sight of a "young, poorly dressed woman," wearing curious make-up and a faint smile, who "carried her head high, unlike everyone else on the sidewalk. And she looked so delicate she scarcely seemed to touch the ground as she walked." It was especially the young woman's eyes that grabbed and held Breton's attention. "What was so extraordinary about what was happening in those eyes?" he wondered. "What was it they reflected—some obscure distress and at the same time some luminous pride?" Irresistibly drawn, but fearing that she might turn out to be a prostitute, he engaged the woman in conversation, and soon led her to the sidewalk of a nearby café. As if nothing were more natural for her than these chance encounters, she told Breton of her parents, her home in northern France, a student she'd loved and left behind. She called herself Nadja, she said, "because in Russian it's the beginning of the word hope, and because it's only the beginning."

It was Nadja's astonishing casualness, an unearthly lightness about people, her name, even herself, that most fascinated Breton. Everything about her—her unpredictable wanderings, her seeming obliviousness to money and accepted custom, the nonchalance with which she chose clothes, restaurants, friends—responded to an ideal that Breton had hitherto only partially glimpsed. Her presence seemed to be floating in an ethereal haze, and her words were a disquieting combination of the frivolous and the extraordinary: after a long and mundane story about her attempts to find work, Nadja suddenly touched Breton by comparing his ideals to "a star you were heading toward . . . like the heart of a flower with no heart."

Since becoming the eponymous heroine of Breton's most famous book, Nadja has been the center of enormous speculation and debate touching on her identity, her authenticity, even her actual existence. Some have staunchly maintained that she and the actress Blanche Derval, whom Breton mentioned in connection with his first meeting with Nadja, were one and the same; others have questioned whether Breton indeed presented her story as factually as he claimed, or whether he didn't instead (as one prominent scholar suggests) "put in her mouth words that coming from him would have appeared too egocentric"; still others, finally, have denied that there ever was such a woman, making *Nadja* into the kind of novel that its author openly despised. Recent research, however, has established both the existence and the identity of the woman who defined herself as "the soul in limbo."

Léona-Camille-Ghislaine Delcourt was born near Lille on May 23, 1902, of a working-class family.* Her father was a typesetter turned traveling salesman who had fallen

* After decades of strict secrecy, Nadja's family name was made public in the wake of the Breton auction in April 2003. Before this, scholars resorted to using simply the initial "D.," as did I in previous editions of this biography, where I marked her introduction with the following footnote: "Despite repeated attempts, as of this writing I have been unable to verify Nadja's last name. There are, in fact, few alive today who know this name: generally either Breton family intimates or members of the psychiatric profession. In both cases, the strictures weighing upon its disclosure rival those used for military maneuvers in wartime. The Surrealists' justification for the secrecy has generally run along the lines of sparing Nadja's relatives painful reminders and the 'inopportune curiosity' of the world at large. But one can't help also seeing a direct ascendance back to such blackouts as the ones surrounding Breton and Aragon's 'conspiracy' in the spring of 1919, the discovery of automatic writing, and the fusion with *Clarté*, among others. The fact is, a certain taste for 'occultation' (to use Breton's word) was part and parcel of the Surrealist experience—creating a legacy that Surrealism's spiritual heirs have faithfully maintained to this day."

Over the past several years, more information about Nadja has emerged, including the publication of her letters to Breton in the auction catalogue *André Breton, 42 rue Fontaine* (DVD version), published by the auction house of CalmelsCohen in 2003; an informed discussion of the relations between Breton and Nadja by Georges Sebbag in his book *André Breton, L'Amour-folie*; and a forthcoming book on Nadja herself, based on numerous unpublished documents—with, no doubt, more works to follow. The point about the Surrealist will to occultation, however, remains unchanged [*note from 2007*].

on hard times; her Belgian mother worked in a factory. As with Breton's own parents, Léona's mother appears to have been far more religious than her husband, without entirely embracing Marguerite Breton's dour piety; and as with Breton, Léona felt greater warmth toward her father. Léona herself had a small daughter, born when she was eighteen, whom she had left behind three years later to come to Paris. Now twenty-four, she subsisted on a meager income that only rarely came from menial jobs, more rarely still from the theatrical milieus in which she was a hopeful, if generally unemployed, presence. (Her pseudonym, which she pronounced "Nad-*ja*," was most likely inspired not by a nonexistent knowledge of Russian, but by a popular American dancer who used Nadja as a stage name.) She supplemented her income by doing occasional "favors" for friends—including at least one episode of drug trafficking—and accepting gifts from various admirers; but although these latter sources were more lucrative, money, as Nadja said, tended to "get away from her."

Breton ended their first meeting by announcing that his wife expected him for dinner, to which Nadja responded with a mixture of disappointment ("Married! Oh, well then . . .") and playful flirtatiousness—the same winning combination that had attracted Breton to Lise. "She keeps me a few minutes more to tell me what it is about me that touches her," he reported. "It is—in the way I think, speak, in my whole manner, apparently: and this is one of the compliments which has moved me most in my whole life— my *simplicity*." They agreed to meet the next afternoon; Nadja asked Breton to bring some of his books.

The following day, Nadja seemed quite different: instead of appearing the lost, impoverished waif, she had donned an elegant red dress and silk stockings, and "an extremely pretty hat which she takes off, revealing her straw-colored hair which has lost its incredible disorder." Like Nadja's appearance, the conversation had become more constrained as well. At a loss, she told Breton of her two gentlemen friends, one a wealthy septuagenarian, the other an American who took her for his dead daughter— stories that Breton greeted with obvious impatience. It was only at the end, as he was preparing to return home, that Nadja reengaged his interest by "visualizing" Simone and their apartment. "Your wife. She is dark, of course. Short. Pretty. Now I see a dog beside her"—all of which was correct. Accompanying him home in a taxi, she closed her eyes and invented an elaborate scene. "That's how I talk to myself when I'm alone . . . actually, I live this way altogether," she told Breton.

The next several days of Breton's life revolved around Nadja, to the exclusion of everything else. To Simone and his close friends, he confessed the passionate curiosity he felt toward her—even spoke "too much" of her, according to Michel Leiris—and tried

to arouse a collective emotion in his listeners to match his own disturbance. He saw in the enigmatic and free-spirited young woman "the extreme limit of the Surrealist aspiration." During this period Nadja called Breton's home in his absence; when Denise Naville asked where she could be "reached," she answered in a calm and distant voice, "No one can 'reach' me."

One of the things that kept Breton enthralled was the seemingly fated nature of his encounters with Nadja. On October 6, the day of their third meeting, he was walking in an unfamiliar neighborhood when he met Nadja by chance; she later confessed that she had intended to miss their rendezvous that afternoon. On the 7th, a day when he hadn't expected to see Nadja at all, he suddenly glimpsed her from a taxi while discussing her with Simone, and rushed out to join her on the sidewalk.

If Simone also caught a glimpse, she would have noticed a woman with dark blond hair framing an oval face, full lips, and slightly hooded eyes. A portrait of Nadja taken at around this time, in fact, suggests some of the qualities that would have attracted Breton about her demeanor. The eyes in particular hold the viewer's attention, carrying a slight sadness but also a sense of wonder and openness; they gaze directly at the camera as if in defiance. Her lips, slightly parted on prominent upper teeth, carry a trace of a smile, but no more than a trace. The conservative look of the dark-colored dress she is wearing, buttoned to the chin, is belied by the unruliness of her thick, wavy hair— although one gets the sense that she is trying to look her best for the camera, a certain measure of chaos still seeps in. One surprising aspect of the photograph is the resemblance Nadja bears (also remarked upon by Pierre Naville) to Gala Eluard, minus the wolfishness, and even more so to Breton himself at around this time: similarities in the shape of the face, chin, nose, and upper lip could almost let her pass for his sister or cousin. More striking still is the air of self-possession that emanates from Nadja, a certain confidence in the frank gaze and slight tilt of the head that challenges Breton's description of her and of their relationship—and, needless to say, of the image that readers have had of her ever since.

"A kiss is so soon forgotten," Breton had said in "Soluble Fish", speaking of an amorous encounter in Place Dauphine—a square that always caused him an indefinable malaise. On the evening of October 6, it was to the same Place Dauphine that Nadja led Breton in a taxi. On the way she had offered her lips to him for the first time; she told him that his kiss impressed her both as "something sacred, where her teeth 'substituted for the host,'" and as "a threat." (She later drew a portrait of Breton, his face encircled by a snake and crowned by the caption: "The kiss that kills.") That evening, after a dinner that was persistently interrupted by a roving derelict, Nadja drew Breton's attention

to a window overlooking their outdoor table: "'It's black, like all the rest. Look hard. In a minute it will light up. It will be red.' The minute passes," Breton related. "The window lights up. There are, as a matter of fact, red curtains."

But increasingly, such moments of almost implausible coincidence were counterbalanced by rambling monologues of (as Breton soon admitted) variable interest. And as Breton's relations with Nadja slowly became more physical—the kiss in the taxi led to others—he also began encountering the sordid realities of her daily life. It was at their fourth meeting, on October 7, that Nadja detailed her financial woes, confessed to Breton an earlier run-in with the police over a drug-smuggling incident, and "made no secret of the means she would employ to obtain money" were it not for him. It had taken only days for Léona Delcourt to begin interfering with the ethereal spirit that was Nadja.

Breton's disappointments, however, did not yet overcome his interest in the woman. He helped her financially (she asked for 500 francs to stave off eviction from her hotel; he gave her 1,500), and feared he might never see her again when she failed to show for an appointment. Seeking to communicate his interest to the others, he also brought Nadja unannounced to the Galerie Surréaliste, where Simone and Naville were present. "She truly is a strange woman," Naville told Denise, who was now his wife. "Fantastic eyes that change shape, and talking exactly as [Breton] said." At the same time, Naville could not help noticing that Breton had begun to "lose patience with her." Nadja herself appeared very ill at ease in front of Simone, "not knowing what tone (what words) to use when talking about André" with her undeclared rival. As for Simone, she displayed her customary equanimity.

On October 12, Breton's relations with Nadja reached a turning point. In the afternoon, the young woman showed him a drawing, the first of numerous strange, allegorical "self-portraits" that Breton would receive from her. As evening wore into night, Breton began finding Nadja's rambling, self-absorbed conversation increasingly hard to follow, until, to counter his unease, he suggested they catch a late train to the suburb of Saint-Germain-en-Laye. While awaiting the 11:30 departure, Nadja pointed out that everyone in the station was gaping at them: "They can't believe it, you see," she told Breton, "they can't get over seeing us together. That's how rare that fire is in your eyes, and in mine."

Later, as Breton began kissing her in the solitude of their first-class compartment, Nadja screamed: she claimed to have seen a head floating upside-down in the window. At first dubious, Breton finally spotted a railroad employee spying on them from the roof of the train. People getting off at the next station blew Nadja kisses, which she accepted "with both satisfaction and gratitude," evidently used to such tributes. Arriving at Saint-

Germain at around one in the morning, Breton and Nadja checked into the Hôtel du Prince de Galles, and there they became lovers.

This act of intimacy, instead of bringing Breton and Nadja closer, seemed to concretize everything that separated them. Breton remained fascinated by Nadja's startling turns of mind, but such encounters with her physical reality only called forth the unavoidable and all too prosaic aspects of her daily existence: "Astonished as I continued to be by her behavior," he wrote, "I was also increasingly alarmed to feel that, whenever I left her, she was sucked back into the whirlwind of ordinary life continuing around her and eager to force her, among other concessions, to eat, to sleep."

Breton seemed to want to remove Nadja as much as possible from these concessions, imposed by the world and her physical being—a being to which, as their night in Saint-Germain had shown, he was perhaps more attracted than he wished to be. For him, Nadja had become the embodiment of all that was marvelous in life, "a free genius, something like one of those spirits of the air which certain magical practices momentarily permit us to entertain but which we can never overcome." (It is indicative that Breton, even in private, always referred to the young woman as "Nadja," never as "Léona.") In his later account of their relations, all the while recognizing the existence of her earthbound self, he constantly highlighted the otherworldly glimmers that occasionally shone through. As with Jacques Vaché, the other Surrealist "genius" to live on in Breton's writings, the portrait left of Nadja is not so much of a living creature as of a philosophical concept.*

Breton's reflections about Nadja betrayed a painful indecision, an almost paternalistic concern for her well-being: "It would be hateful to refuse whatever she asks of me, one way or another, for she is so pure, so free of any earthly tie, and cares so little, but so marvelously, for life. She was trembling yesterday, perhaps from cold: so lightly dressed." At the same time, the real Nadja was rapidly losing her charm. Increasingly Breton found her conversation frankly boring, and was annoyed by her lack of attention to him. "For some time, I had stopped understanding Nadja," he said. "She had decided once and for all . . . to make no differentiation between the trifling remarks which she happened to make and those others which meant so much to me, to ignore my momentary moods and my considerable difficulty in forgiving her her worst fits of abstraction."

To Breton's horror, Nadja seemed to enjoy taunting him with ugly episodes from her

* Breton's later revisions to the book make this all the clearer: although the 1928 version of *Nadja* hinted at their sexual encounter, a "definitive" text from 1963, which otherwise contained only small stylistic amendments, erased both the mention of the hotel and the specificity of the couple's first-class train compartment, which they had taken in a vain bid for privacy. Nadja, already etherealized by the young Breton, was obnubilated by the older one thirty-five years after the fact.

past life, which wounded him to tears and "almost managed to alienate me from her forever." In addition, and despite Breton's insistence on a "pure, free" Nadja, he could not have been entirely blind to the arrangement of financial support that had crept between them—an arrangement that, on one level, made him only another of the many admirers who succumbed to Nadja's unsettling appeal, and who paid for the pleasure of her company. Finally, there were moments when Nadja's behavior actually turned dangerous: once, while she and Breton were driving toward Paris, she pressed his foot onto the gas pedal and tried to cover his eyes with her hands "in the oblivion of an interminable kiss, desiring to extinguish us, doubtless forever, save to each other, so that we should collide at full speed with the splendid trees along the road."

But Nadja had misead her man: Breton, although he admired transgression and those who transgressed, rarely followed suit. It was as if he were forever standing at the edge of a precipice: applauding those who had jumped or had had the *good fortune* to fall; scorning the ones who held back; himself unable to take the fatal step. Instead of yielding to Nadja's impulses, he curtailed their relations. Although he continued to see Nadja until early the following year, from mid-October onward their meetings were much more sporadic. "Can it be that this desperate pursuit comes to an end here?" he wondered after their trip to Saint-Germain. Barely a week after their first encounter, the answer was yes.

The more Breton pulled away, the more Nadja's attachment seemed to grow. She began sending him letters, often decorated with strange drawings. One featured a "symbolic portrait" of Breton, as a lion whose tail ensnared that of a mermaid Nadja. Another represented "the Lovers' Flower," made of two hearts and two pairs of eyes, and bore the message: "You must be very busy at the moment? Find time to send a few words to your Nadja." She told Breton he was her "master": "If you desired it, for you I would be nothing, or merely a footprint." As neutrally as possible, Breton noted that "in every sense of the word, she takes me for a god, she thinks of me as the sun."

On November 8, Breton sadly told Simone that Nadja had fallen in love with him "in that grave and desperate way that perhaps I impose on her." Nadja's vulnerability was touching, and her devotion no doubt flattering, but, as Breton guiltily acknowledged, she would never inspire the passion he still felt for the unattainable Lise. "She is only capable," he added to Simone, "and you know how, of implicating everything I do love, and my way of loving. No less dangerous for all that." At the same time, the guilt did not pre-

clude some simple human annoyance, for Nadja's dreamy exaltation—initially so prized—became tiring, and her "grave and desperate" love both worried Breton and grated on his nerves. After the night in Saint-Germain, he had confided to Naville that sex with Nadja "was like making love to Joan of Arc."

Which is not to say that Breton's relations with Nadja had entirely ended, despite the impression he later gave. Throughout the winter, as Nadja's letters teetered between coquettishness and despair, Breton's own reactions vacillated between silence (or, at times, stern reproof) and renewed interest. "I'm enjoying myself like a little girl surrounded by her toys," Nadja wrote to her fickle lover in December. "I also sing . . . what difference does it make. I'll see you soon, won't I? — and then I'll be good, like a well-behaved toy." Judging from their correspondence, Breton seems to have found it easier to respond to these invitations than to her cries of distress.

Breton also remained concerned about the insoluble problem of Nadja's finances. Nadja's hotel, shabby though it was, was rapidly surpassing her slender means, and she envisioned leaving Paris to find work as a domestic. Horrified at the prospect, Breton wrote Simone that he was trying to sell one of his Derains in order "to prevent this disaster, which is mine as much as hers, and that of everyone I love. The vacant space this painting leaves on the wall will be a thousand times more precious than the painting itself. You know how afraid I am of anything having to do with money, but this time it seems to me I have no cause for fear." And he lamented: "Is life truly like that, even more horrible than we think, where everything pure and beautiful must be sullied and punished?"

The sudden illumination that was Breton's meeting with Nadja had rapidly darkened, and Breton now found himself plunged back into the emotional distress that had marked the previous spring and summer. Simone was again away in Strasbourg, and thoughts of Lise, which had been softened by Nadja's arresting presence, returned in all their ferocity. Eluard, although he tried to offer counsel, was mainly preoccupied with rising tensions over Gala and Max Ernst. And Aragon, normally Breton's *fidus Achates*, had been away with his new lover, the British heiress Nancy Cunard, and so had once again missed a crucial turn in his friend's life.

As had happened the previous spring, Breton engaged in various actions whose violence and pettiness reflected the turmoil within. He bitterly criticized Eluard because his latest book of poems, *Les Dessous d'une vie ou la pyramide humaine* [The Underside of Life, or The Human Pyramid], mixed prose poems, dreams, and automatic texts without distinction (although he himself had done the same in *Earthlight*); at Breton's insistence, Eluard inserted a short explanatory text. And on November 7, Breton and several others went to the Comédie des Champs-Elysées to impede a performance of "Surrealist dances"

by the German dancer Valeska Gert—a spectacle that roused Breton's fury not only for its unauthorized use of the qualifier but also because it had been organized by the ever-hopeful Yvan Goll.

Of more lasting consequence were the sacrifices made to Breton's ideological fire, which rekindled as his relations with Nadja died down, and which was further stoked that November by a viewing of Sergei Eisenstein's *Potemkin* that moved the Surrealists to tears. On November 23, a meeting held at the café Le Prophète, attended by Surrealists and some remaining colleagues from Clarté, reopened the question both of Surrealism's relations with the Communist Party and of individual Surrealists' ideological commitment. As with the sessions the previous fall, this one closely hewed to the Party example in tenor and agenda—purges included.

The first to be called on the carpet was Antonin Artaud. That fall, he, the excommunicated Vitrac, and Robert Aron had launched the Alfred Jarry Theater, the crucible of Artaud's "Theater of Cruelty." Although the nature of the project conformed to many of Surrealism's original tenets—"The spectator who comes to our theater knows that he is to undergo a real operation in which not only his mind but his senses and his flesh are at stake," Artaud had said in the *NRF*—Breton now found little place for such pursuits in the newly politicized group. He also objected to Artaud's work as a film actor, which at the time found him playing Marat in Abel Gance's *Napoleon* (and which soon after would land him the role of a monk in Carl Dreyer's *The Passion of Joan of Arc*). But Artaud was not cowed by his accusers. Asked whether or not he "gave a damn" about the Revolution, he retorted, "I don't give a damn about the kind of revolution you mean." He snapped that he had attended the November 23 meeting strictly out of courtesy and, after a mutual blitz of invectives, spared Breton the trouble of drumming him out by leaving voluntarily. Two months later he attacked the Surrealists as "toilet-paper revolutionaries."

On November 27, it was Soupault's turn to stand before the jury. Soupault had become at best a sporadic participant in Surrealism, kept away by both his travels and his temperament. He was dismayed by the group's new orientation and strictures, and for some time had ignored the unspoken obligation that found fifteen or twenty members seated daily in the Cyrano—a routine that Nadja had only temporarily disrupted. "You were expected to show up every day at five o'clock at such and such a café," he recalled, "and if you were absent even once, the next day they suspiciously asked you why."

Disgusted by Artaud's treatment on the 23rd, Soupault had bitterly critiqued the group's exclusionary tactics and its faith in political action. Four days later, he was summoned to a meeting on Rue du Château, where he found himself in an ill-lit room, facing a tribunal chaired by Breton, Aragon, and Morise. A bill of indictment charged him

with wasting his literary talents on novels and journalism, treating the revolution too lightly, contributing to "fascist" periodicals (the Italian literary magazine *900*, one of whose editors did in fact have ties with the Fascist Party, but to which Soupault had con-tributed solely at James Joyce's urging), and even smoking English cigarettes. Soupault tried to answer the accusations, but he was unanimously voted out of Surrealism and he left Rue du Château under the jeers of his former friends.

These exclusions were prosecuted by Breton with a mixture of relish and regret. On the one hand he demonstrated a marked purgatory skill, accumulating his grievances for one final, explosive, and all-encompassing moment of dismissive fury. At the same time, it pained him to see that even strong emotional bonds could not "withstand significant ideological divergences." If, particularly over the next several years, the Surrealist group would see a number of such exclusions, it was because Breton felt that extreme circum-stances demanded extreme measures: just as the PCF was at odds with a hostile political climate that would use any weapon against it, so Surrealism, in aligning itself with the Party's goals, was bound to maintain unimpeachable credentials. As Breton saw it, who-ever claimed the title "Surrealist" must either abide by the movement's redefinition along revolutionary lines or renounce that title altogether. Those who openly resisted, like Artaud and Soupault, were banished; the others either endorsed Breton's convic-tions or, fearing his inquisitorial flair, kept silent.

Late that fall, Breton's renewed political fervor led him to reconsider a step that had previously been vetoed: joining the Communist Party. The issue was debated in group meetings throughout the last weeks of 1926. Finally, on December 24, Breton, Aragon, Eluard, and newcomer Pierre Unik decided in favor of Party membership. Together with Péret, a member since the fall, they became known collectively as "the Five."

The decision was not made easily, and Breton continued to worry about Surrealism's deference to an entity that in many ways seemed its antithesis—as indicated by the tor-tuous nature of his resolution: "I'm in favor of joining the PCF without conditions, while nonetheless pursuing my current activity despite everything," he told the others, "even if it meant being excluded from the Party, which I'll do everything in my power to avoid." On December 23, talking with visiting Romanian poet Marco Ristich, he compared Surrealism to a stream that "at a certain moment met the river of Communism . . . It's possible that Surrealism will flow into this river and follow the same course; or it's pos-sible that it will only cross this river to come out on the other bank, which would be rather curious; or it's possible that it will pull the river along with it." For now, the only certainty about these options was their uncertainty.

Moreover, it was hardly proven that the Party would even welcome the Surrealists

into its ranks. Breton in particular had run afoul of its officials by publishing *In Self-Defense* in the fall. (He later claimed to have "pulled [the pamphlet] out of circulation and destroyed [it] out of loyalty" to the Communists, but there is no record of such a retraction; if anything, Breton compounded the offense by reprinting the text in *La Révolution surréaliste* that same December.) All things considered, the advice of one Party official to Masson—that Surrealism "remain in the heart of the bourgeoisie, the better to poison it"—was perhaps less a recipe for political effectiveness than a way of keeping these dogged intellectuals at bay.

All the more so in that Surrealism had clearly not renounced its quest for the marvelous. Even as he resolved to join forces with the PCF, Breton continued to be haunted by the world of magic coincidence that Nadja had briefly opened to him. To Ristich, moments after speculating about Surrealism's dissolution in the Communist "river," he admitted that if he were to learn of a house in the Paris suburbs "where things happen that no one in the world has ever seen," he would rush there "without caring about anything else. We once believed that Surrealism was this house. But it is a house like any other."

For Breton, a revolution could have only one ultimate aim: to lift the oppressive constraints visited on humanity by centuries of Latin logic and morals. And if his desire to approach the Party sometimes led him to conceive of this revolution "only in a social form," the poet he nonetheless remained could not deny that marvels, and the emotional liberation they afforded, were just as useful as "material hammers." Revolutionary reality was not only in the streets but also in the mind and in the heart.

So it was that Breton, who for two and a half years had devoted his talents almost exclusively to criticism and polemics, now envisioned a book about the mysterious apertures that chance could open in everyday life, to be based on his meeting with Nadja. He had taken copious notes on their encounters, and his prodigious memory retained large portions of her conversation verbatim. By the end of the year, he was almost ready to begin writing.

"André? André? . . . You will write a novel about me. I'm sure you will," Nadja had said. "Be careful: everything fades, everything vanishes. Something must remain of us . . . You'll find a Latin or Arabic pseudonym. Promise. You have to." Breton, however, wanted none of pseudonyms or novels. As he stated in his preamble to *Nadja*: "I insist on knowing the names, on being interested only in books left ajar, like doors; I will not go looking for keys . . . I myself shall continue living in my glass house where you can always see who comes to call . . . where I sleep nights in a glass bed, under glass sheets, where *who I am* will sooner or later appear etched by a diamond."

Nadja, caught with Breton under those glass sheets, was somewhat ambivalent about the picture her ex-lover meant to draw. While she claimed to be "enchanted" at the prospect of starring in a book—"You'll use me and I'll do my best to help you make something good," she told him on November 30—she was nonetheless hurt when he showed her his notes. "How could you write such mean-spirited deductions of *what we were* without the breath leaving your body? . . . And how could I read this report, glimpse this distorted portrait of myself without rebelling, or even crying," she complained. Expecting a mere novelistic disguise, Nadja was shocked to find that she had in fact undergone a far more drastic transformation: from woman to symbol.

She also rebelled against her reduced role in Breton's life: after the daily contact of early October, by December she was seeing him only two or three times a month. Instead of "the sun" or "a god," Breton had now become a "wildcat," and she his prey; in January 1927 she wrote: "I feel lost if you abandon me . . . I'm like a dove wounded by the lead she carries in herself . . . Alas, you've only come by 2 times, and my poor pillow has seen much bitterness, many dried tears or tears held in, calls, moans — no — Maybe you're really cured of me. Someone told me that love was a sickness? . . . Life is stupid, you said when we first met. Ah, my André, know that everything is finished for me. But I had you, and it was so beautiful." Breton guiltily fended off Nadja's declarations of love and dependence.

This part of the Nadja story was never reported in Breton's book. Instead, and despite many passages justly celebrated for their openness, Breton concentrated on the enchanting, mystical aspect of his encounters with the young woman. Scrupulously, willfully, he turned Nadja's erratic physical and emotional behavior into the teachings of an oracle—and in so doing, infused Surrealism with a new energy. The attentiveness to any external sign of wonder increasingly became a hallmark of the movement from this point onward. However tragic Léona Delcourt's actual situation might have been, and however blind Breton was to it, the *message* implicit in Nadja's rejection of conventional reality and lifestyle became a touchstone that would far outlast Breton's belief in organized politics. Like a chemical reaction, the contact between the unstable waif and the acidic theoretician produced one of the Surrealist revolution's most durable, and potent, weapons.

ADMIRABLE LOVE AND SORDID LIFE

(January 1927 – December 1928)

ON JANUARY 14, 1927, AFTER MUCH HESITATION, Breton applied for membership in the Communist Party. His adherence, like his previous political actions, mixed genuine ideological fervor with a desire for legitimization and a naïve belief in Surrealism's value to the Communist apparatus. Breton was convinced that by joining he would both prove his commitment to the revolution once and for all and put an end to the criticisms that PCF officials continued to level against Surrealism. But instead of accepting his action as proof of good faith, the Party questioned his motives. The PCF counted relatively few intellectuals among its numbers at the time, and those it did (such as Henri Barbusse) generally distrusted the literary avant-garde. On top of which, Breton's overtly political statements, such as the controversial *In Self-Defense*, argued against his submission to the Communist mainstream: not only were his views unorthodox but, in lambasting Barbusse, he had attacked one of the Party's own in public. Finally, and perhaps most of all, the Party resented the independent existence of Surrealism as a group. "If you're a Marxist, you have no need to be a Surrealist," Breton quoted one PCF official "bawling" at a Surrealist applicant.

Before his membership became official, therefore, Breton was summoned to appear before three separate committees. The meetings began early in the morning, in an empty schoolroom or union hall, and often ran into the afternoon. Their object: to reassure nervous Party leaders that Surrealism was not "a political movement with a strong anti-Communist and counterrevolutionary orientation," as many of them seemed to believe. "Nothing seemed more like a police interrogation," Breton later said of them. "My explanations were deemed satisfactory soon enough, but there was always a moment when one of the inquisitors would brandish a copy of *La Révolution surréaliste* and put everything back in question . . . In the end, each committee was in favor of ratifying my membership. But for some unknown reason, a new committee always decided to meet shortly afterward to hear my comments and, to everyone's consternation, the orange-covered magazine was once again thrown on the table."

Despite the inconclusiveness of these sessions and the Party's tenacious suspicion,

Breton was assigned in February to a cell composed of utilities employees from the gasworks. Still, his reaction was not relief at this apparent token of acceptance, but disappointment: he had expected to collaborate with the Party's leading theoreticians, not listen to complaints about the gasman's lot. His disgruntlement was heightened at his first meeting in early March, when he was asked to submit a written report on the coal-mining industry in fascist Italy—a task he considered demeaning to his intelligence and that in his mind came to represent every rudeness Surrealism had had to suffer at the hands of the PCF. "A report on something I can understand, fine," he later complained to Luis Buñuel. "But . . . coal?"

In fact, this assignment was probably less a gesture of defiance than a simple delegation of labor to the one who seemed best qualified. Maxime Alexandre, who joined the Party shortly afterward, suggested that the gas workers, "for once having an 'intellectual' in their midst, no doubt thought they were doing the right thing by assigning him an intellectual task." And Pierre Naville, a Communist militant for nearly a year by now, pointed out that the Party wanted writers to serve the proletariat, not lead it: "They were expected to melt into the working class itself and lend its efforts a practical hand." But Breton, who felt that "literary work was dirty work," was outraged by the assignment, as well as by the criticisms from his new comrades on his "idle" way of life. After three or four such meetings that March, his attendance at the "gas cell" came to an end.

His disappointments notwithstanding, Breton continued to hope for membership in the PCF, and with it the Party's recognition of the special contribution that Surrealism could make. In early May, he and the rest of "the Five" published a joint statement that simultaneously proclaimed and defended their overtures to the Communist Party. Entitled *Au grand jour* [In Broad Daylight], the tract consisted mainly of five open letters to Surrealists, some of their associates (such as Clarté), and the Party itself. While four of the letters criticized their addressees for various perceived shortcomings—the "anarchistic" tendencies of the non-Communist Surrealists, for example—the one to the Communist Party was more delicate. Reiterating that "never . . . have we thought to stand before you as Surrealists," Breton (the sole author of the text) deplored the poor use to which the Party was putting their services. Economic debates, important as they might be, were simply not the Surrealists' forte, he argued, his recent experience of the gas cell fresh in his mind. "On the other hand, we believe that we are uniquely qualified to judge, without gaps or weaknesses, everything that, whatever its provenance, touches the moral truth that our Party is alone in defending."

As with *In Self-Defense*, as with practically every one of his public addresses to the PCF, Breton was seeking to establish a moral territory within the Party's purely prag-

matic domain. Phrases such as "the moral truth [of] our Party" show that Breton—despite the obvious lip service paid to such PCF hobbyhorses as the "defense of salaries" and the "eight-hour workday"—had never entirely bent his thought to the demands of dialectical materialism, and away from the revolution of the mind. Unfortunately for him, the Party had no more need of moralists in 1927 than it had had the year before. But Breton continued to see the Party's continued distrust as merely a temporary setback.

Two who were not directly addressed, but were nonetheless very present, in *Au grand jour* were the disbarred Artaud and Soupault. Artaud, who had recently attacked the Surrealists' politics in print, was singled out as a "swine" and a "mental retard." If the mentions of Soupault in *Au grand jour* were comparatively less bitter, it is only because Breton had fired a harsher salvo the previous month. Soupault had published in March an edition of Lautréamont's works, complete with biographical preface, for Au Sans Pareil. Breton, who prized "the enigma of Isidore Ducasse" (as the title of a Man Ray photograph had put it), was enraged by Soupault's attempts at elucidation. In protest, he, Aragon, and Eluard distributed a broadside called *Lautréamont envers et contre tout* [Lautréamont Against Anything and Everything], an evisceration of Soupault and his biographical endeavors. Unfortunately for Soupault, his critics' task was made all the easier by a glaring blunder: trusting in an offhand (and perhaps intentionally misleading) remark by Desnos, he had confused Isidore Ducasse with a nineteenth-century political agitator named Félix Ducasse, and had even included in his edition transcripts of the political meetings at which "Lautréamont" had supposedly orated. The delight Breton took in ridiculing Soupault and his historical "find" permeates the tract like an oil stain.

Predictably, tensions were rising within the group as well. Desnos in particular had come under fire, for although he did not reject Communism as openly as had Soupault and Artaud, he was unwilling to relinquish his individuality for the benefit of political commitment. On top of which, he was displeased that Breton was once again renouncing automatism—Desnos's trump card—for the more ineffable charms of "petrifying coincidence" (what Breton would later term "objective chance"). Resentful at having again lost the spotlight, Desnos voiced his complaints throughout the spring, claiming that he was being shunned by his friends. Breton protested that Desnos had lost none of his standing in the group—"My dear friend, let me assure you once more that you're mistaken and that, to my knowledge, no one is plotting against you . . . Please don't cause me the pain of doubting me, I have never changed my opinion or my feelings about you," he wrote on August 31—but some impatience was beginning to show through the warmth.

Meanwhile, Breton's relations with Simone were deteriorating under the strain of his continued desire for Lise. It had now been two and a half years since his meeting with

the "Queen of Sheba," during which he had overcome neither her resistance nor his unrelieved passion. Late the previous year, poetry had again borne witness to his despair: "You see the women you have loved / Without them seeing you you see them without them seeing you / How you've loved them without them seeing you," he'd written. Throughout the spring he continued his hopeless courtship, seeing Lise socially and reading her manuscript of poems—which, with Freudian transparency, he then left behind in a taxi. As Simone was painfully realizing, this was no mere infatuation.

In July, no longer willing to be party to Breton's *états d'âme*, Simone left Rue Fontaine for the Manche region of Normandy, along with Yves Tanguy and wife, Max Morise, and Marcel Noll. The departure was sparked by a fight over Breton's "sublime love" for Lise, no doubt exacerbated by the pressure of professional and amorous failures—what in a subsequent letter he called his "bouts of pessimism." Contrite, Breton wrote Simone a rambling apology on July 29, excusing himself for his hurtful remarks: "I was extremely unhappy, that's all . . . I'm absolutely not cured. If any 'cure' is to be had . . . I'm still haunted. 'Insane passion,' you say; it's not certain." At the same time, Breton defended his conduct over the past several years, reminding Simone that he had "never hidden anything" from her, and protesting that "out of loyalty"—which much have rung very strange to Simone's ear—"I don't think I should run away from [Lise]." Instead, he blamed Simone for running out on *him*, just when he needed her most.

Still, obtuse as the charge might seem, there was more justification to it than at first appears. For a good year and more before the meeting with Lise—since early 1923—Simone and Morise had been conducting a kind of amorous friendship that at times clearly grated on Breton's nerves. "I think there was a moment when André was worried about [my] relationship [with Morise], and he was distant and cold with me," Simone had told Denise in May 1923. At the same time, her letters from this period are filled with protests of love for her husband, and with concern about his love for her. "Perhaps before that day [when I grow old] André will stop loving me," she confessed to her cousin in the fall. "In that case, it will no doubt give me great satisfaction to kill myself." In love with the idea that "someone could be in love with" her and often driven to despair by Breton's moodiness and retreats within himself, Simone had palliated her anxiety during these years with the attentions of several Rue Fontaine regulars. Morise, as the most constant and comforting of those who responded to her charms, offered a companionship that helped compensate for Breton's emotional reserve, while the "dolorous" love he declared for her inspired an almost maternal tenderness. "I'm happy to have a friend, and [Morise] fills precisely the void left by André, who has become less and less interested in outer life," she had written in April 1923.

But Simone was playing with fire, and before long was grappling with conflicting responsibilities: "I love André. Is that any reason to make Max's life miserable? There are degrees of love," she told Denise. By the time of Breton's infatuation with Lise, therefore, Simone knew the symptoms from the inside out, and her mentions of the situation show a mix of respect for her husband's feelings, distrust of Lise's motives, and a certain amount of pain at having her own attitudes turned against her.

Cut off from Simone and wishing to sort out his feelings about Lise, Breton headed alone to Varengeville-sur-Mer, a luxurious seaside resort on the Normandy coastline, several miles from Dieppe. Arriving in the first days of August 1927, he took residence just outside of town in the splendid Manoir d'Ango, a sixteenth-century manor with magnificent tiled dovecote that now served as an inn. If it was quiet Breton wanted, he was not disappointed: that summer, he was the inn's only guest.

The only guest, but not strictly alone for all that. During his stay, Breton received several visits (notably from Prévert and Duhamel), and almost daily he had the company of Aragon, who was vacationing with Nancy Cunard only fifteen minutes away. Lise herself had rented a villa in the nearby town of Pourville; hoping to turn the situation in his favor, Breton often saw her during that month of August, but succeeded only in deepening Lise's feelings of friendship.

The main result of Breton's stay at the Manoir d'Ango, however, was not emotional but literary, for it was here that he composed most of the book that had been haunting him for the past eight months: the story of his meeting with Nadja. The writing did not come easily. Despite the calm setting and the groundskeeper's solicitude, Breton's agitated state of mind prevented him from settling down to work. "I'm still at the mercy of a moment of panic that might send me flying back to Rue Fontaine or, rather, rushing to join you," he told Simone on August 5. Several days later Simone reassured him, in one of her occasional telephone calls that month, that the "shadows" between them had dissipated.

Even after the reconciliation, Breton wrote almost nothing in the first two weeks of his stay in Varengeville, and by mid-month was still grappling with the preamble. He was finding it difficult to "set the tone" of his book, for he particularly desired to give *Nadja* an atmosphere as dispassionate and clinically objective as one of Freud's case studies. He later explained that "the tone adopted for this narrative is copied from the one used in medical observations . . . which tend to preserve a trace of everything that examination and interrogation might reveal, without seeking to give its expression the least stylistic polish." Still, as even a casual reading of the book shows, Breton was far from able to bleach out all the drama of his relations with Nadja.

Breton was made even more aware of his slow progress through the proximity of Aragon, who was concurrently writing the dazzling, violent *Treatise on Style*, a sulfuric diatribe against everything from French society and the military ("I shit on the French army in its entirety") to critics, fellow writers, and the "*Nouelle Reüe Fronçaise.*" With his habitual ease, Aragon was tossing off ten to fifteen pages each morning, while Breton (as he later recounted) barely scratched out one or two; in the late afternoon, over cocktails by the sea, the two friends would read their labors to each other and Nancy Cunard. "What Aragon is writing, which he reads to me nearly every day, is keeping me from writing too much. It's so, so brilliant: you have no idea," a discouraged Breton told Simone. At the same time, he took comfort in noting that, talented as Aragon was, his text remained "barely human, as always."

There were other distractions as well: walks with Aragon in nearby Pourville, or with the visiting Duhamel in the forest around the Manoir d'Ango (during which Breton lost his way and, in a panic, had to be guided back to the manor house); trips to Lise's villa, with its magnificent trompe l'oeil fresco; work on the next *Révolution surréaliste*, the first since December, for which Breton solicited material long-distance; and finally, riots in Dieppe to protest the executions of Sacco and Vanzetti on August 23.

It is perhaps because of these very difficulties, the distractions and discouragements, the grinding reflection they brought about, that Breton's preamble—which forms one-third of the finished book—provides one of the most compellingly elusive and *vital* portrayals ever written of coincidence and the "marvelous," as the Surrealists conceived of them. Weaving together a series of "decisive episodes" in his life—his meetings with Eluard and Péret, Desnos during the sleeping fits, Jacques Vaché in Nantes, curiosities observed, films or plays seen: moments or occurrences "which on each occasion present all the appearances of a signal, without our being able to say precisely which signal, and of what"—Breton fashioned a tapestry of intense but ungraspable power, a shifting mosaic whose underlying strangeness both illustrated the book's thesis on the determining value of chance and prepared the ground for Nadja herself. "I think that these generalities around Nadja will be fairly interesting," Breton told Simone once he'd begun to set them down. "I speak rather coherently of things that are, I believe, fairly specific to me."

But even with the ground prepared, Breton found it no easier to write the book's second part, a day-by-day account of his ten days with Nadja and the subsequent breakdown in their relations. "My little story is still coming along very slowly," he reported to Simone on August 30. "I'm nothing but a two-bit journalist." Nonetheless, and for all Breton's complaints, *Nadja* was written in a notably short time: in a mere two weeks he essentially completed the first two parts, roughly nine-tenths of the overall text.

Breton intended the second part of his book, like the first, to convey more an atmosphere than strictly factual information. "Do not expect me to provide an exact account of what I have been permitted to experience in this domain [of chance]," he cautioned in the preamble. Can one, then, as so many have done, consider *Nadja* a novel? It's true that Breton's romancelike approach (not to mention the unusual personality of his heroine) led several reviewers simply to assume that the book was a work of fiction. It's also true that various details were rearranged for narrative purposes, and certain facts avoided altogether. But the larger reality of Nadja's precarious existence, the frailty and wonder of her grasp on life, and above all the *revelation* she embodied in Breton's eyes, were rendered with rigorous authenticity. Whatever liberties Breton might have taken with the details, this is no novel in the traditional sense, but what we might call a lyrical manifesto, or (as several reviewers put it) a "confession."

To further substantiate this authenticity, as well as to eliminate the "inanity" of narrative description, Breton decided to include photographs as an integral part of the text. These photographs—forty-four in the original edition—illustrate key moments in the story, taking people, places, and objects "at the special angle from which I myself had looked at them." Paraded before us, like exhibits of evidence, are the Parisian sites so scrupulously named throughout; relevant letters and documents; reproductions of paintings and Nadja's drawings; and portraits of the parties named: a heavy-lidded Desnos in slumber, Eluard stiff and pensive, Péret grinning from ear to batwing ear, and even Breton himself, rigidly posed and with distant authorial gaze.

And yet, a closer look at these very signs of authenticity shows just how unreliable a document *Nadja* can be, and just how much (for all its purported objectivity) it is guided by Breton's own subjective viewpoint. Breton, who takes pains to show practically everyone mentioned in his account, neglects to include any photographs of Nadja herself (although he partly filled this gap in the 1963 revised edition with an extreme close-up of her eyes, multiplied in four horizontal strips); nor, despite his insistence on "knowing the names," does he ever mention her true identity. With all such biographical particulars carefully erased, the figure of Nadja appears wraithlike, almost spectral.

But it is with the outcome of Nadja's story that Breton's "glass house" becomes particularly cloudy. Breton's interactions with Nadja had all but ended the previous December: between his bad conscience over her instability and his difficult dealings with the Communist Party, he had little time or inclination to pursue their relations. Financially and emotionally desperate, the woman had moved from her cheap hotel across from the Collège Chaptal into a wretched one near Rue Fontaine. Throughout January and February 1927 she continued to send Breton sad and touching notes, trying to regain the

position she had held in his life scant months before. "André, I want to win your respect—I'll change my life if necessary," she wrote on January 20; and over the telephone, she told Simone, "At times, it is terrible to be so alone. I have no friends but you." By this point, however, practically her only contact with Breton revolved around a borrowed notebook of her jottings. And even this came to an end in mid-February when, at Nadja's request, Breton sent the notes back, receiving in return one final letter slipped quietly under his door: "Thank you, André, I've received everything. I have confidence in the image that will shut my eyes. I feel connected to you by something very powerful; perhaps this trial was the necessary beginning of a higher event. I have faith in you . . . — I don't want to waste any of the time you'll need for loftier things — Whatever you do will be done well — Let nothing stop you — There are enough people whose mission it is to put out the Flame — — Every day thought is renewed — — It's wise not to dwell on the impossible." With these words, Nadja the woman stepped out of Breton's life.

Almost immediately, Nadja's "eccentricities" (to use Breton's word) darkened into serious aberration. In late January, foreseeing things to come, she had written: "It's raining still / My room is dark / Heart in the abyss / My sanity is dying . . ." Following her last contact with Breton in February, she became increasingly erratic, until finally, on March 21, the manager of her hotel found her in the hallway, screaming in terror at visual and olfactory hallucinations. Nadja was brought by the police to a city infirmary, then committed later that day to the Sainte-Anne psychiatric hospital. On the 24th, she was admitted to the Perray-Vaucluse Hospital in the southern Paris suburb of Epinay-sur-Orge, with symptoms that included hallucinations and feelings of persecution. She was not quite twenty-five years old.

Breton made no secret of Nadja's breakdown: "I was told, several months ago, that Nadja was mad," he wrote in his book. But as with the woman herself—and so many aspects of Breton's personal dealings—Nadja's purported insanity was magnified into a higher enlightenment, an escape from the "hateful prison" of logic. In Breton's account, Nadja became the victim of poverty, of an uncomprehending society, and even of Breton's own "terribly decisive" role in her life—although, as he told it, his fault was to have inspired in her too great a taste for "emancipation." Her internment provided the excuse for a long castigation of the very psychiatric profession that Breton had once thought to join:

> The method which consists in surprising you by night, forcing you into a straight jacket or capturing you in any other way, is no better than that of the policeman who slips a revolver in your pocket. I know that if I were mad, after several days of

confinement I should take advantage of any lapses in my madness to murder any-
one, preferably a doctor, who came near me. At least this would permit me, like the
violent, to be confined in solitary. Perhaps they'd leave me alone.

And yet, Breton never visited Nadja during her confinement in the Paris area
(although it seems that Aragon and Eluard did), and quickly eliminated her from his
conversation. Was it only out of his "general contempt for psychiatry"? Or because, as
he'd once confessed to Simone, he was at bottom "horrified by pathology, especially men-
tal pathology"? Or perhaps because, as Breton recognized only too well, he had helped
precipitate Nadja's delirium by coaxing her emotional frailty beyond the limit? Could he
have been so blinded by his search for marvels that Nadja's behavior, as he later claimed,
truly "did not seem exorbitant" to him? It is far more likely that Breton simply chose to
ignore Nadja's symptoms in all but their most "poetic" manifestations, and that his sub-
sequent protests of surprise at the news of her collapse, anger at the psychiatric profes-
sion, and refusal to visit her in the hospital all masked a deep guilt over her fate.[*]

And we have to wonder as well, despite Breton's characterizations and the doctors'
diagnoses, whether Nadja was truly insane. There is no question that her writings, draw-
ings, and reported statements set her apart from the mainstream, but the same could be
said of Desnos, whose own drawings were successfully passed off as psychotic artifacts;
or Vaché, whose life seems to have been one long fable; or any number of the other figures
around Breton. Now that many of Nadja's letters have come to light, what is striking is
how much they seem to convey not so much a delusional system as the all-too-normal
desperation of a woman in love with someone who simply doesn't love her back.

Myths about Nadja proliferated in the decades following the book's publication: let-
ters to Breton from women claiming to be Nadja; insistent reports of her murder; and
even poet André Pieyre de Mandiargues's affirmation in the 1970s that Nadja, long since
cured, was living as a typist in a quiet French village. The reality is more prosaic and
more tragic: after a fourteen-month stay at Perray-Vaucluse, Léona Delcourt was trans-
ferred in May 1928 to a hospital near her native Lille, where she died of typhoid fever on
January 15, 1941. It is not known whether she ever saw the book that drew both her and
its author into lasting fame.

[*] It is also possible, as Théodore Fraenkel claimed many years later (but this claim has never been verified),
that Breton was not only aware of Nadja's madness, but actually tried to have her committed. According to
Fraenkel, Breton approached him in early 1927 and asked him to sign internment papers for her in his
capacity as a doctor. Fraenkel refused, and his relations with Breton, which had continued sporadically over
the past years, for all intents and purposes ended that day.

✳

Breton carried his unfinished manuscript back to Paris on the evening of August 31, and immediately read it to his friends. "I was rather worried about this prose and somewhat in need of compliments," he told his still-absent wife on September 2: "I was paid many." Encouraged by his friends' reaction, he published the book's first section in *Commerce*, plus a second excerpt in *La Révolution surréaliste* the next March, and began planning the third and final section. He also set to work gathering photographs to complement the text: he had Man Ray (the group's official portraitist) take photographs of individual Surrealists; and for views of Paris he turned to Jacques Boiffard, who matched Breton's unadorned prose with some eerily depopulated cityscapes. Finally, he wrote to Lise, asking to photograph her bronze glove (which eventually figured in the book) and the trompe l'oeil fresco in her vacation home (which didn't). "I think it would make the book far more disturbing," he explained.

More disturbing still were his relations with Lise herself, which reached a crisis point during the fall. In September, while frustrated by the impasse in their relations, he still nurtured the hope that some "inevitable resolution" would tip in his favor. "No, how could it be limited to those walks we took together! It can't be, Lise. We'll see each other in the other world, which is included in this one!" But instead, Lise married her current lover, radio pioneer Paul Deharme. Breton, his infatuation finally killed by her "spite and incomprehension," wrote one last letter of reproach, and courted Lise no more.

Instead, he turned against his former friend and mentor Jean Paulhan, in an incident whose burlesque nature masks his genuine emotional turmoil. Under the pseudonym "Jean Guérin," Paulhan had briefly commented in the October *NRF* on the Surrealists' recent tiff with Artaud. Although his remarks were fairly innocuous, Breton was not in the mood, and on October 5 he answered with a violently insulting note, whose vocabulary, distended handwriting, and occasional lapses into gibberish suggest that he might have been drunk at the time: "You're going to come off looking like an ass," he warned. "Putrefaction, swine, French cocksucker, copper's nark, asshole, especially asshole, dried out piece of shit wearing a bidet and besnotted with a fat dickwad." Determined not to let the Surrealists "blackmail" the *NRF*, Paulhan sent two friends to challenge Breton to a duel—which earned him further insults from Péret, Eluard, and Aragon, as well as Breton's refusal. Although Paulhan would eventually become Breton's editor at Gallimard, it was nearly ten years before their next exchange.

Breton also vented his spleen on the group, setting his sights in particular on Aragon's novel-in-progress, *La Défense de l'infini*. Fearing Breton's hostility, Aragon had labored on

the project in secret for four years (although excerpts, such as "Le Cahier noir" with its equivocal sentence about Lise, had appeared by this point), eventually amassing some 1,500 pages. In early 1927, however, he finally made the novel public and read excerpts to the group, only to find that his fears had not been unfounded: the others, with Breton at the head, made no secret of their disapproval. Fearful of losing his friends, and despite a contract already signed with Gallimard, Aragon went to Madrid with Nancy Cunard in November and, in the fireplace of a hotel room overlooking the Puerta del Sol, consigned his 1,500 pages to the flames. "Those jerks," he had written in another independent fragment called *Le Con d'Irène* [Irene's Cunt]. "Everywhere they look they see novels, romances." Numerous passages written throughout the rest of Aragon's life suggest that he never got over the self-imposed auto-da-fé, nor entirely forgave Breton for pushing him to it.

<p style="text-align:center">✳</p>

Toward the middle of November, Breton met with the thirty-five-year-old novelist and essayist Emmanuel Berl to discuss a joint publishing venture. Although Berl (like his friend and colleague Drieu la Rochelle) was critical of the Surrealists' Communist leanings, he greatly admired the movement's more lyrical offerings. He now proposed co-publishing with Breton a series of deluxe editions of his and the Surrealists' works—including *Nadja* and *Treatise on Style*, which, given the recent contretemps with Paulhan, were in jeopardy at Gallimard. Interested, Breton invited Berl to talk it over at the Cyrano. But the project ended in "tumultuous failure" when Berl brought his mistress to one of the early meetings—unwittingly introducing Breton to the woman who would alter the course of his life.

Blonde, sensually beautiful, with an endearing mole on her left cheek and a slightly haunted shadow behind blue eyes, Suzanne Fernande Muzard was born in the Paris suburb of Aubervilliers (adjacent to the Pantin of Breton's own childhood) on September 26, 1900. Having lost her father at the age of five, she was even more devastated by the accidental death of her beloved grandfather seven years later. André Thirion described Suzanne as "tall, slender, gracefully shaped, with regular, slightly Nordic features . . . Very flirtatious and attractive, [she] loved love and luxury." Somewhat less flatteringly, another acquaintance saw Suzanne as "secretive, distant, quick-tempered, authoritarian, capricious, and irresolute."

Determined to leave behind the "waste lands and old battlements" of her youth, Suzanne had arrived in Paris three years earlier with her childhood friend, Hélène Zéma

(who soon became involved with Roger Vitrac and later fell in with Surrealist and future film historian Georges Sadoul). Penniless, she had gravitated to a brothel on Rue de l'Arcade, where Berl had found her on one of his many visits with Drieu and, most likely, Aragon. With casual disregard for his marriage, Berl had taken her away on a long trip, finally settling her in an apartment he owned near Place de l'Etoile. He had also, as part of her "education," given her books to read that fall, among them the unpublished typescript of *Nadja*. Suzanne, enchanted by the book, had asked Berl to introduce her to its author at the next café meeting.

Suzanne's relations with Berl seem to have been mainly an exchange of sex for security—or at least so said Berl, who was convinced that his earnings enticed Suzanne more than his pen. As he later recalled, "She was not in the least interested in my writing, and I only mildly interested in the story of her past: a hodgepodge of confessions and lies." Breton, however, his feelings encouraged by both natural inclination and the void Lise had opened, saw Suzanne with more passionate eyes. It took only one meeting at the Cyrano and a group dinner at his home for him to fall desperately in love with the beautiful blonde. The next day, having invited Suzanne and Berl to accompany him to Eluard's, he took the woman aside and asked her to telephone him as soon as possible. "But what about your wife?" Suzanne asked. "Please, that's of no importance," he apparently replied. "Call me." For her part, and despite her misgivings, Suzanne felt the same attraction as Breton, and later recalled thinking to herself at their first meeting that "if he wants you, the answer will be yes." The next day, the two met for a clandestine taxi ride through the Bois de Boulogne, and Breton proposed taking Suzanne away to the South of France.

Seduced by the woman's physical beauty, the unrepentant sensuality that so contrasted with Simone's quasi-platonic affection and Lise's inconclusive flirtations, Breton cast Suzanne as the first of several "preordained loves" that would mark his life. This preordained quality both seemed to bear out Breton's notion of privileged encounters and acted as a justification for the upheaval Suzanne would soon cause in his marriage. He seized on such heralds as the common suburbs of their childhood, to which Suzanne added her own reinforcement: "Didn't I tell him that, as a very young girl, surely I had stood alongside him at a crossroads of that suburb where, when a student in Paris, he returned every evening to join his family?" she later wrote. "We gave that chance event the quality of a strange coincidence that was to lead us, inevitably, to meet later." Taken as Breton was by Suzanne herself, his attraction was surely enhanced by the aura of predestination that surrounded her.

On November 18, mere days after their first meeting, Breton and his paramour escaped to the Midi, Suzanne having left Berl a simple note of farewell. They stopped

first in Lyon, then in Avignon on the 20th; from there on to Aix, Marseille, and finally Toulon on the night of the 24th. Wind and freezing rain pursued them, and Breton arrived at Toulon's Hôtel des Négociants nursing the flu. But, as he reported to Simone the following day, they were very comfortable, and he raved to his wife that "not for a moment" had Suzanne "been anything but what I imagined her to be and that you imagined too, maybe a thousand times better. This is the first time in a week I've left her side for ten minutes, so I could write you." He asked for reassurances that their departure had spawned "no serious incidents," that the others had "behaved well" toward Simone, Suzanne, and himself; and—for a writer's work is never done—he reminded Simone to inquire at Gallimard about proofs for the book edition of *Surrealism and Painting*, which was due out in the spring. Finally, he wondered why there had been no word from her to greet them on arrival.

The request and the overall tone of Breton's letter were at once naïvely obtuse (did he really expect Simone to rejoice in his good fortune?) and wholly in keeping with the understanding that, at least to his mind, existed between the two spouses. As in the case of Lise, Breton felt that his passion for Suzanne must be shared with Simone, that the "glass house" in which he was determined to live never be fogged over by hypocrisy or deceit. This was, of course, more an ideal than a reality, both in Breton's personal dealings and in his works; but under the influence of his new love, it seemed only natural that his wife and soul mate should approve. It was a kind of unspoken pact, based on the principle that no lies should soil their relations; so long as one was motivated by true passion, the taboo was not infidelity but dissimulation. And indeed, Simone again showed every sign of acceptance: having weathered the nearly three-year storm of Lise, and with Morise for moral comfort, she evidently felt she could outlast Suzanne as well. Loyal to the end, she also fended off an angry visit from the aggrieved Berl, who vainly tried to find out where the runaway couple was staying. Within days, Breton received a letter from Simone, duly reporting Berl's visit and enclosing the requested galleys of *Surrealism and Painting*. "I'm thinking of you," he wrote back. "And to think this way of someone means not to be unworthy of that person." (Suzanne herself cheerfully added that she had borrowed Simone's sweater for the trip.)

But in fact the situation was not nearly so rosy as Breton seemed to think. Back in Paris, catching wind of the hasty leave-taking (possibly thanks to a disgruntled ex-Surrealist), the scandal sheet *Aux écoutes* noted on November 26 that "the man they called the Pope of Surrealism" had abandoned his "troops" for parts unknown: "All those who counted on him are starting to understand that he's far from being a leader, only a 'tyrant.'" At home, meanwhile, Simone was coping with serious money worries:

Breton had become so blissfully absorbed in his new passion that he neglected even to answer Gaston Gallimard's offer on December 1 of a 2,000-franc advance for *Surrealism and Painting*, thereby delaying payment by several months and forcing Simone to sell a Miró from their collection. And clouds came to trouble even Breton's idyll with Suzanne. By mid-December, the couple's own finances had forced them to head back to Paris. The honeymoon turned definitively bitter during a stop at the restaurant Sous les Aubes in Avignon, when Suzanne enjoined Breton to divorce Simone and marry her instead. Tearfully, she warned her lover that it was "all or nothing."

This demand was one that Breton had not anticipated. Blinded by the passion of the moment, he found himself unprepared to contemplate leaving Simone for good. When the couple arrived in Paris shortly afterward, the matter far from resolved, Breton returned to Rue Fontaine and Suzanne took a room on Rue Tholozé, only minutes away. Seizing his chance, Berl proposed a voyage to Tunisia on the day after Christmas—but Breton, having been alerted to the departure by Suzanne, rushed with several friends to the Gare de Lyon in an effort to stop them. Suzanne hesitated, swayed by this show of force on her behalf; but, pressed by Berl, she finally let the train carry her away.

In the wake of Suzanne's disappearance, during the last days of the year, Breton composed the third and final section of *Nadja*, to which he had added no new pages since the end of August. He had originally intended to conclude the book with a meditation on beauty, a certain kind of beauty consisting "of jolts and shocks," represented by Nadja herself and the disturbing message she had tried to deliver. Now, "bent beneath a burden of infinitely greater emotion," he dedicated his final twenty pages to she who, "as if by chance, knowing of the beginning of this book, [had] intervened so opportunely, so violently, and so effectively" in its conclusion.

Referred to only as "You," Suzanne came to embody for Breton the summation and justification of Nadja's clouded signal, the marvelous creature that Nadja had unwittingly prophesied. And just as he had magnified Nadja, so now he magnified Suzanne, turning the book's last chapter into a manifesto on the intrusion of marvelous chance and "jolting" beauty in human life. He ended with the now famous credo: "Beauty will be CONVULSIVE or will not be at all."

More privately, Breton used his pages to rewrite and amend events of the preceding days, symbolically keeping Suzanne from leaving on a train with Berl. "I see beauty as I have seen you," he told his absent love. "Beauty is like a train that ceaselessly roars out of the Gare de Lyon and which I know will never leave, which has not left." In Breton's idealized version, the loved one made no impossible demands, did not run away with his rival, but stayed to consummate a passion without end.

And in fact, as Breton would soon learn, his relations with Suzanne were far from over: in 1930 he confessed to a collector that the "somber pages" of *Nadja*'s final section were only the preface to several years of torment. Ultimately, however, he laid the blame for his emotional upset on life's injustices rather than on his lover, and his assessment of this period showed a curious fatalism, even a kind of faith. Suzanne, he wrote, "did not entirely kill in me the man to whom a vanishing Nadja, by a miracle of grace and selflessness, had perhaps entrusted her. That man, in April 1930, *would do it all over again*, terribly, if it had to be done . . . He can imagine no disappointment in love, but he imagines and has never stopped imagining life—in its continuity—as the locus of every disappointment. It's already rather curious, rather interesting that it should be so . . ."

In early 1928, living with Simone but awaiting Suzanne's return, Breton reacted to the chaos of his emotional life in ways that were typical and, occasionally, not so typical. He tightened his control over the group, forbidding members to publish in magazines other than *La Révolution surréaliste*. And he was on guard lest others assume too much influence in the group—notably Aragon, his able lieutenant, who faithfully carried out Breton's directives by day, but who at night, from bar to bar, became the Surrealist leader that Breton refused to acknowledge during business hours.

It was also during this period, and perhaps equally due to his emotional turmoil, that Breton arrived at the café one day high on drugs. Breton had always condemned the use of mind-altering substances, perhaps as a remnant of his medical experience, possibly out of resentment against the opium that had carried off Jacques Vaché, and quite likely out of distrust for anything that would lessen his mental self-control. If many of his writings praised the dizzying powers of "vertigo" and the expansion of consciousness, it was understood that he meant the linguistic and intellectual vertigo of Surrealism—which, as he had stated in the *Manifesto*, "acts on the mind very much as drugs do." Nonetheless, the group was mystified one winter afternoon to see Breton and Jacques Prévert arrive bandy-legged and teary-eyed, practically falling over each other in their hilarity. When an unsuspecting Aragon arrived shortly afterward with Nancy Cunard, the pair greeted him with such guffaws that he turned on his heels and left. As it soon became clear, it was not Surrealism acting on Breton's mind, but hashish: dubious about Baudelaire's praise of the drug in *Artificial Paradises*, he had nonetheless yielded to Prévert's urging and taken some by way of experiment. Once was apparently enough, and he seems never again to have indulged in narcotics.

Equally atypical in such a period of tension was Breton's brief reconciliation with Artaud. Despite the violence of their parting, by late 1927 Artaud had come to regret his loss of contact with Breton, and sent word through mutual acquaintances. Oddly, the grounds of the reconciliation were the same on which the two men had enacted their breakup: the Alfred Jarry Theatre. On January 14, 1928, Artaud staged one act of a play by "a 'well-known' writer," whose identity was withheld (even from the actors) until after the performance. Heeding rumors that the mystery playwright was Aragon, Breton and the others were in the front row, ready to heckle. But they were disarmed when Breton recognized the play as Paul Claudel's disavowed *Partage du Midi*—"Shut up, you assholes, it's by Claudel!" he shouted at the sniggering audience—and won over when Artaud came onstage to announce: "The play we have just performed for you was written by Mr. Paul Claudel, French Ambassador to the United States"—a pause—"and an infamous traitor!" While the statement raised a public outcry, it was all Breton needed to forgive past differences—all the more so since the play had been performed against Claudel's express wishes. The Surrealists immediately welcomed Artaud back into the fold.

They also turned out to support Artaud's protest of the film *The Seashell and the Clergyman*. Although the film had been made from Artaud's own screenplay, he had been angered by director Germaine Dulac's poor realization of the project. For the February 2 premiere at the Studio des Ursulines, Breton came armed with a copy of Artaud's original scenario, which he read aloud to the packed house during the film's projection, pointing out differences between Artaud's intent and Dulac's results. (Artaud, meanwhile, sat in another part of the theater with his mother, but took no active part in the demonstration.) The audience tried its best to ignore Breton and watch the film, but then another voice—probably Desnos's—shouted in the darkness: "Who made this film?," to which a third voice replied: "Madame Germaine Dulac." "And who is Madame Germaine Dulac?" Whereupon Breton rose and, in his most courteous tone, announced: "Madame Germaine Dulac is a cunt." Madame Germaine Dulac herself fainted away in the front row, while the cinema's owner had the Surrealists duly eject-ed—shouting obscenities and smashing the house mirrors as they went.

But no doubt the most direct and fruitful reflection of Breton's longing for Suzanne were the various "inquiries on sexuality" that began that January. Up until now, Breton's celebration of love in various writings had had much the same tone as his union with Simone: spiritual, subtly erotic, rarely sensual. But his relation with Suzanne Muzard was the most unabashedly erotic he had ever known. Unlike the sisterly Simone or the elusive Lise, Suzanne took unbridled pleasure in sex; as one Surrealist would put it, she "was incapable of making anything, except love." And Breton responded to the woman's

appeal, both bodily and in a newly awakened interest in physical love as a concept. Just as his partnership with Simone had stood behind the more cerebral verse of 1923 and the muted sexuality of "Soluble Fish," so now this new intrusion of eroticism in his life coincided with Surrealism's first group investigations into the very nature of sex, as if Breton were trying mentally to come to grips with his attraction to Suzanne at a time when the woman herself was still far away.

Six group discussions were held in as many weeks, followed by six more at irregular intervals until 1932. According to Pierre Naville, the conversations first began informally in late January 1928, during an evening at Rue du Château, among Breton, Morise, Naville, Péret, Prévert, Queneau, Tanguy, and Unik. Breton soon asked Morise to take down the exchanges, and, as several prominent Surrealists (notably Aragon) were absent that evening, he decided to hold a second discussion four days later. By then, the nature of the sessions had become more formal, the answers better thought out.

The first two sessions covered topics ranging from masturbation ("a legitimate compensation for certain of life's misfortunes," Breton decreed) to impotence to depravity. Among the sexual dislikes Breton aired were brothels ("places where everything has a price"), multiple partners, "artificial" means of reaching orgasm ("for me it's a moral issue"), voyeurism, exhibitionism, black women (too prone to bearing children, he felt), women who didn't speak French, women who farted in his presence, and promiscuity. More stridently, he attacked as "vulgar" Péret's and Unik's practice of asking women partners their preference in lovemaking: "I think that's colossal, phenomenal. Talk about complications!" (In a later session, he stated: "If I desire a woman, it doesn't matter to me whether she comes or not"—perhaps a reason for his intermittent troubles with Suzanne.) And most of all, he violently condemned male homosexuality, threatening to end the discussions altogether when Queneau, Aragon, and Boiffard expressed their acceptance of it: "I accuse pederasts of testing human tolerance with a mental and moral deficit," he declared.

Oddly, what mainly emerges from these and subsequent discussions, despite the frankness of language, is Breton's distance from eroticism, his distrust of women and pessimism about intimacy in general. Even after his experience with Suzanne (but then, hadn't her leaving only confirmed his dark view?), Breton claimed that he "did not know what sexual 'pleasure' was"; and more than the others, he evinced deep disquiet in sexual matters—while Aragon, for example, freely joked about his occasional bouts of impotence. He worried about a woman judging him on his sexual prowess, and shuddered at the thought of her touching his limp penis. He strongly defended an idealized concept of monogamy, denouncing anything else as "the most absolute" denial of love.

And he expressed his horror at the idea that a woman might fake orgasm: Marcel Duhamel later recalled Breton, after some of these sessions, polling his friends' wives about whether they really had orgasms, "bent on proving that 90 percent of women only pretend to enjoy sex."

It is also notable that these sessions, except for three brief ones in November 1930, were exclusively between men and represent a firmly male point of view. Indeed, despite Breton's hatred of vulgarity and "barracks humor," some of the observations sound more like barroom banter. Breton's opinions about a woman's beauty, or his estimates of the number of times he could make love in a single night, border on sexual swagger. And even his earnest pronouncements on menstruation, or on the differences between "vaginal" and "purely clitoral" orgasms (with percentages), suggest only a sketchy familiarity with the physical reality of women. Challenged by Pierre Naville about the single-gender aspect of these sessions, he replied that he was afraid the presence of women would discourage the others from being completely candid. (Naville wasn't alone in his assessment. When Youki Fujita, the painter's wife, visited during that same period, her reaction was: "You'd do better to get laid. There aren't enough women here. You boys need to learn a few things.")

But despite their obvious shortcomings and limitations, the discussions on sexuality show a sincere desire to probe an issue most often repressed, at a time when even serious researchers were dismissing it (Freud, Krafft-Ebing, and Wilhelm Reich being the notable exceptions), and when a book such as D. H. Lawrence's *Lady Chatterly's Lover* was subject to prosecution. Inspired most directly by his sexual desire for Suzanne, but also by his longstanding interest in psychoanalysis and his hostility toward societal taboos, Breton approached these discussions with utmost seriousness, prodding the others for the most graphic details of their sexual tastes and experiences, occasionally erupting in frustration at their reluctance or their humorous sallies (and, as seen above, sometimes playing the outraged censor in spite of himself). Although in retrospect the final results of these sessions might seem confused and abstract, Breton considered them a groundbreaking approach to a central question, and in the first months of 1928 he gave them his full commitment.

Breton was so convinced of the importance of these sessions that he ran transcripts of the first two in the eleventh *Révolution surréaliste*, under the title "Research on Sexuality: Share of Objectivity, Individual Determinations, Degree of Awareness." Published at the end of March, the magazine featured a number of provocative texts, including an extract from Aragon's *Treatise on Style* and "The Fiftieth Anniversary of Hysteria," in which Breton and Aragon celebrated hysteria as "the greatest poetic discovery of the later nine-

teenth century." But it was the "research on sexuality" that attracted the most attention—although much .of it, even within the ranks, was unfavorable. The Belgian Surrealist painter René Magritte regretted how "facile" and "predictable" the answers were. The openly gay René Crevel deplored the homophobic overtones of the discussions (to which he had not been invited). And several newspapers, ignoring Breton's scientific intentions, simply clucked that the Surrealists were indulging in smut.

✳

When *La Révolution surréaliste* appeared that spring, the magazine was trying to cope with increasing financial hardship and diminishing levels of interest. As with *Littérature* before it, publication was becoming less and less frequent: it had appeared four times in 1925, three in 1926, and only once in 1927. This latest issue, the only one dated 1928, was the first in nearly six months, and it was giving indications of the magazine's demise.

Nor were the other aspects of Breton's life going any more smoothly. In particular, he was again embroiled in his difficult affair with Suzanne. Learning that she and Berl had proceeded from Tunisia to Corsica, and unable to stand her absence any longer, Breton decided to crash their vacation. Although suffering from the flu, he told Simone—who had herself left for the Bouches-du-Rhône—that he was suddenly "obsessed" by the idea of going to Corsica's capital: "I don't believe it's out of desire to see Suzanne, but to get to know, *in all its detours*, a city such as Ajaccio," he disingenuously wrote on March 7. One week later, taking a vague financial dispute with Berl as his excuse, he joined the runaway couple on the island. But although the two-day excursion left him feeling "very happy" about his future with Suzanne, he returned alone and still feverish—consoling himself with a visit to Simone in Avignon on the way back. A seventh "inquiry on sex," held several weeks afterward, found Breton dejectedly telling his friends, "I'm never lucky in love."

By mid-March, Suzanne was back in Paris, and—at least for now—again with Breton. That month she participated in a Surrealist game called "Dialogue in 1928," a series of blind questions and answers, modeled on the Exquisite Corpse, that were published some ten days later in *La Révolution surréaliste*. But even in this moment of reconciliation, Breton, so sensitive to the jolts of petrifying coincidence, cannot have failed to register the evil omen of the couple's fortuitous exchange during the game: "B[reton]: What is hovering over S. and me? S[uzanne]: Large, dark, threatening clouds."

Meanwhile, group activity was again on the wane, and to Eluard, Breton complained of the "rather queer period" he was living through, "full of silent, tragic restlessness."

The evening gatherings, he said, were rapidly becoming pointless. "Fewer and fewer exchanges of ideas, or worthwhile conversations. Countless games. The phonograph. The sheerest indifference."

That "the phonograph" was tolerated at all might surprise those who know of Breton's legendary imperviousness to music. It's true that Breton had little use for music in general, equating it (particularly the classics) with the snobbish gala-nighters he despised. In addition, he was certainly influenced by such predecessors in melophobia as Ducasse, whose laconic dismissal, "Music, begone," he was fond of repeating. And perhaps most to the point, Breton simply had no musical sense: despite the rhythm that infused his writing and recitations, he couldn't tell Satie from Satchmo. Unable to "hear the difference between two sounds," as he once confessed, Breton turned this incapacity into a higher principle, rejecting music as "the indeterminate," the most "deeply confusing" form of expression. "Breton," said composer Virgil Thomson, "posing as a universal intelligence, had no ear for music, so he had to invent reasons why music was an inferior art." Here as elsewhere, Breton censored those of his fellows who did not feel the same distaste: he ridiculed Aragon for once bringing some Bach sheet music to the café, chided Desnos for his articles on jazz, and so terrorized Masson and Ernst that they attended concerts only in secret.

But despite this general proscription, Breton did in fact enjoy a few select works, including Gregorian chants; Offenbach's *Orphée aux enfers* and *La Belle Hélène*, which so made him howl with laughter that he went to see it several evenings in a row; and the perversely comic ditties of Fortugé and Dranem (Armand Ménard). Over and over, Breton played Dranem's 78s for his friends, seeking to communicate his delight. Eluard, faithful as ever, then spread the word to his own friends.

In this latest period of turmoil, however, even Eluard suffered Breton's barbs. As was made evident during the discussions on sex, Breton had never appreciated promiscuity (which Eluard had elevated to a fine art), and was especially rankled when Eluard would hurriedly leave café gatherings to join some "ravishing beauty" he had just met: "Another fat-assed laundress," Breton would grumble to the others. In March, Breton was further angered when Eluard was the only Surrealist to figure in an anthology of contemporary poets published by the magazine *Les Marges*: it was a further attempt by outside interests to "confiscate" Surrealism, not to mention a slap in the face for the poet Breton.

But these dissensions were relatively minor compared with Breton's rifts—in a curious replay of three years before—with Artaud and Naville. In June, Artaud demolished his fragile truce with the Surrealists by staging August Strindberg's *Dream Play* at the

Alfred Jarry Theater. At issue was not so much the production itself as Breton's belief that Artaud had accepted subsidy monies to mount it. In fact, the only "subsidy" was the purchase of a row of seats (and the promise of future support) by members of the Swedish consulate. But Breton saw this as an unacceptable concession, and accused Artaud of selling out to official interests. Still, he privately assured Artaud that the Surrealists would not interrupt the premiere.

And in fact, everything seemed in order on the afternoon of June 2, as Artaud prepared to unveil his production to an audience that included assorted royalty, the Swedish ambassador, and a large percentage of Paris's sizable Swedish colony. It was only as guests were taking their seats that Artaud noticed something amiss: reservations had somehow been changed, so that the Surrealists now occupied several prominent rows. As the curtain lifted, the latter began to shout disruptive slogans, while in the wings Breton pressured the hypertense Artaud to denounce his patrons. In a clumsy bid for reconciliation, Artaud went onstage to inform the audience that Strindberg hated all nations, "and especially his Swedish homeland." But not only did this fail to mollify the Surrealists, it also caused the offended Swedes to leave the theater, taking their moral and financial support with them.

The rift was consummated one week later, at a second performance of *Dream Play*. Breton had warned Artaud of further interventions should he persist in staging the work; but Artaud and co-director Robert Aron had responded that they would "use every means, even those it found most repugnant" (i.e., the police), to safeguard their freedom. Despite this, some thirty Surrealists were again on hand on June 9 to disrupt the proceedings. This time the antagonists came to blows: faces were scratched, punches landed, and four or five Surrealists arrested, as Artaud pointed out the troublemakers from the stage: "There! There!" Several days later the battle was again joined when Breton and Pierre Unik—who by coincidence lived in the same hotel as Artaud—met the latter on the stairway. According to Breton, Artaud and Unik tumbled to the floor in a brawl, while Artaud's mother rushed downstairs screaming, "It's the Surrealists! They're jealous of my son!" and tried to beat his assailants over the head. Breton escaped with a scratch that further swelled his prominent lower lip.

Shortly after breaking with Artaud, Breton also severed ties with Naville. A visit to the USSR the previous December had given Naville a closer view of Stalinism in action than any of his colleagues had yet had. Naville was already leaning toward the Trotskyist "opposition" (i.e., opposition to Stalin) in his writings for *Clarté*, and Trotsky's expulsion that year from the Soviet Communist Party earned Naville his own exclusion from the PCF for "deviationism." Nor was he shown much more understanding by Breton, who

still nurtured hopes of acting within the Party structure. In July, the two men quarreled over Naville's support of the Trotskyist writer Victor Serge (the nom de guerre of Victor Lvovich Kibalchich). Although Serge's credentials were of a nature to interest Breton—among other things, he had been a member of Jules Bonnot's original band in 1912—Breton greeted the name so sourly that Naville finally walked out, not returning for another ten years.

Breton's intolerant mood, roused that spring by Suzanne's caprices, was further exacerbated by the circumstances surrounding his two most recent books. *Surrealism and Painting* had come out on February 11—two months later than hoped—in an edition of 1,000 trade copies, plus fifteen deluxe. The work received little attention and sold poorly: it was four years before the first edition ran out. In all, at least initially, the book seems to have earned Breton only a 2,000-franc advance from Gallimard and a falling-out with Masson, who was jealous of the preferential treatment given Max Ernst.

On the surface, it seemed to be a different matter with *Nadja*, Breton's other book to appear that spring. Published on May 25, *Nadja* sold nearly half of its 3,300-copy printing in the first week. It would also garner widespread praise from reviewers and fellow writers alike, and—no doubt because of its "accessible" style, romantic subject matter, and reassuring sobriety—won Breton a far wider audience than had any previous book. Still today, *Nadja* remains Breton's most popular work.

But like *Surrealism and Painting*, *Nadja* also suffered various production delays. Breton, anxious as it was about a work that engaged so much of his recent life, had seen the promised date of April 1 (whose irony seems to have escaped him) come and go without a trace of the finished product. To make matters worse, Gallimard had unwittingly stoked his buried rivalry with Aragon by publishing *Treatise on Style* on time, despite promises to bring out both books simultaneously. On May 18, giving in to authorial pique, Breton complained to Gaston Gallimard about his various dissatisfactions during the publication process—over the delays, the slow reimbursement of expenses, the proposed advertising copy, his treatment by several house employees, and his royalty scale—showing that, whatever his attitude toward literature and *littérateurs*, he was still an author. "Forgive me, Monsieur," he concluded, "but I find it tiresome that despite your efforts we go from vexation to vexation, each time we undertake something with your help."

Once *Nadja* was finally off press, critical recognition was as slow in coming as the book itself had been; more than two months after its appearance Breton was bemoaning to Eluard the newspapers' "almost total silence." Starting in September, however, reviewers began paying serious attention. On the 8th, *L'Europe nouvelle* proclaimed *Nadja* "a book

that marks a date in the history of literature, a turning-point in the evolution of sensibility." Other critics added their own praise throughout the fall and into the spring. Edmond Jaloux extolled *Nadja*'s "mysterious and somber beauty," and praised Breton for having imbued ostensibly banal events with such a marvelous atmosphere. "No alcohol can give you dreams like the ones inspired by André Breton's moving prose," he said in *Les Nouvelles littéraires*. *La Voix* devoted several columns to "Surrealism's masterpiece," and even some traditionally hostile voices came out in Breton's favor—such as *L'Humanité*, which highlighted his critique of "bourgeois 'life'"; or Jean Cocteau, who told an interviewer that *Nadja* had given him a "much purer pleasure than the kind derived from enjoying a friend's work."

It was precisely this overwhelming acceptance that worried the young poet René Daumal, who published one of the most insightful critiques of *Nadja* in the November *Cahiers du Sud*. "How predictable men are!" Daumal began:

> *Nadja* gave the critics every opportunity to indulge in their depreciative efforts: they didn't pass it up . . . "Finally," I can hear them thinking, "a book by Breton that lets us show off our knowledge of psychology, and the tastes of our time, and the tendencies of the new generation, and show that we're impartial into the bargain! A remarkable literary event; Surrealism has made something of itself after all, and . . ."
> —oh, enough! It would be easier to pardon the evil said of *Nadja* than these degrading praises.

The following year, alarmed by increasing signs that Surrealism was gaining literary acceptance, Breton would come to share Daumal's view. But for the time being, he seems to have welcomed the public's "degrading praises," and by late September the man who shortly before had bemoaned the lack of attention was telling Simone that *Nadja* had suddenly gotten "magnificent" press.

And still there was discontent, for not even the comparative success could help Breton's sagging finances. In the fall, Gallimard drew up a check for the less than princely sum of 1,740 francs, representing the author's combined revenues to date on *Nadja* and *Introduction to the Discourse on the Paucity of Reality*, which the house had published as a chapbook the previous year. Breton wrote to complain about his sluggish earnings—"I don't believe there is any reason for 'Nadja' not to sell better than it has so far," he informed Gaston Gallimard in January—as well as about the mere 800 francs he had received for *The Lost Steps*. Nor was Breton entirely pleased with *Nadja* itself, finding the illustrations in particular "dreary and disappointing," the places they depicted stripped

of the magic they had had for him, earlier, when briefly he had seen them through Nadja's "fern-colored eyes."

✳

In June, Suzanne's romantic pendulum swung back to Breton, who told Simone that he now believed she was through with Berl. He also reported that he was over his love for Lise, especially after the new Mme. Deharme tried to cast aspersions on Suzanne. "What a base, ugly woman," he now said of Lise: "I'm more and more convinced of that."

For her part, Simone was finally beginning to lose hope in her marriage, and told Breton, to his dismay, that she felt she had wasted her life. She had earlier left the Bouches-du-Rhône for the northern coastal town of Beg-Meil, and over the course of the fall would receive Breton's long, detailed letters in Brittany, the Pyrenees, the Rhône once more, and the French Riviera—anywhere, it seemed, but Rue Fontaine. Along with a fluctuating band of companions that usually included her sister Janine, Raymond Queneau, Pierre and Denise Naville, and, always, Max Morise, Simone spent the second half of 1928 crisscrossing the French map, pursued by the almost daily reports that she both requested and seemed determined to flee. And Breton appears to have omitted little of his doings in his accounts to his wife, from the purchase of a Skye terrier (whom they named Melmoth, after Charles Maturin's Gothic hero), to his discovery of James Joyce's "quite remarkable" *Ulysses*, to his financial ups and downs. By far the majority of the news, however, concerned his ever unstable relations with Suzanne, her nonstop shuttling between Place Blanche and Place de l'Etoile.

While it is easy to attribute Suzanne's chronic indecisiveness—as Breton sometimes did—to acute insecurity or emotional instability, it was no doubt equally rooted in a primordial conflict between material and spiritual needs. The fact is, Suzanne appears to have been in love with Breton far more than with Berl, and no doubt she suffered from the very separations that she generally incurred. But Berl offered advantages that his rival simply could not. For one, his relative wealth allowed him to treat his mistress to a lavish lifestyle, whereas Breton often shocked Suzanne's bourgeois sensibilities by exhausting the couple's meager finances on some whimsical object, leaving the bills unpaid. In later years, Suzanne lightheartedly summarized the situation by saying that she would spend "one month living on potatoes with Breton, then the following month recovering at Berl's," but at the time there was little humor to be found in it. In addition, Breton was clearly more attached to Simone than Berl was to his own wife: not only did he resist the idea of divorce (opting instead for some kind of idealized threesome), but he

continued to rely on Simone for counsel and emotional support throughout this period. From every rational standpoint, Berl was the better match. But, for the moment, Suzanne's heart kept tugging her toward Breton.

In late summer began a period of extraordinary tension for Breton, even by the previous months' standards. Berl, tired of Suzanne's escapades, was keeping her a virtual prisoner in his apartment; nearly every day, Breton received the woman's hysterical phone calls. Occasionally Suzanne slipped away for a clandestine meeting with Breton, using shopping as a pretext—until the suspicious Berl chided her for her newfound materialism, adding his own flares of temper to an already melodramatic atmosphere and tightening his control over her outings. Suzanne took to her bed and slid toward a complete breakdown, while Breton, his "nerves utterly shot," fumed to Simone about "the scum watching over her."

At the end of August, Suzanne finally told Berl that she could no longer stand the situation. Berl left Paris to give her time to make up her mind, but when he returned several days later it was to find that Suzanne had again moved to Rue Fontaine. To spare them Berl's fury, Breton immediately took Suzanne to Moret. While there, he composed several automatic texts that reflected his rekindled passion for his young lover. "Make it so daylight doesn't enter yet," he prayed, extolling "What I adore what nothing could ever make me burn / Thou Suzanne the very shape of fire."

But the idyll could not last. Fragile and emotionally drained, Suzanne wanted guarantees of stability, demanding more insistently that Breton divorce Simone. And Breton, though reluctant to leave his wife, nonetheless expected an emotional exclusivity from Suzanne, a passion to match the ideal forged over their weeks of separation. Another automatic text from Moret, written on September 3, reflected the tensions between the reunited couple in a tale about "love" and "the idea of love":

> Love undid the bed that the idea of love always tried to make anew. It had lasted too short a time . . . Love, who demanded absence in presence, stared long and hard at the idea of love, who demanded utter presence in absence, and cried out, "Death to you, absinthe-robed sprite, paler than the lampshades of leaves on glowworms . . . you who want the most because you can do the least . . ." And yet the quarrel had lasted since the dawn of time.

Back in Paris soon afterward, Suzanne broke off relations with Berl and moved into Rue Fontaine, but even this did not bring peace to her relations with Breton. "My life for the past two months could not have been more horrendous," the latter told Simone on

September 25, adding that Suzanne was "sometimes *delirious* (that's the right word); she fears me terribly, believes that I could stop loving her from one minute to the next and all because of you . . . She feels she has too many flaws for me not to judge her extremely harshly someday."

Desperate to reassure Suzanne, he begged Simone to help him convince his lover that she was the passion of a lifetime, and to treat Suzanne with patience and understanding "even if she says things you deem unacceptable." But Simone would have none of it, and by early October her patience and understanding had finally run out. Coldly, she informed Breton that she believed Suzanne to be no more than one affair among others, past and future, but that *their* life together was finished. Nor did Suzanne herself provide any assurances, for during her first weeks at Rue Fontaine she ran back to Berl, returned for a tearful reunion with Breton several days later, then went back to Berl once more, chased away by Breton's jealousy and his reluctance to divorce Simone. To his wife, Breton justified Suzanne's behavior as a product of her desperate origins, but admitted that she was "perhaps completely insane. I think so about her much more than I ever did about Nadja."

One year later, in October 1929, Breton would sum up these ongoing conflicts in another group inquiry, centering on love in its "strict and threatening sense of total involvement with a human being." The questionnaire, drafted entirely by Breton, provided a schematic but painfully exact view of the frictions governing this period in his life:

> I. What sort of hope do you place in love?
>
> II. How do you envision the passage from the *idea of love* to the *fact of loving*? Would you (voluntarily or not) sacrifice your freedom for love? Have you already? . . . How would you judge someone who would even betray his convictions in order to please the woman he loved? Can such a token be asked for, can it be obtained?
>
> III. Do you feel you have the right to deprive yourself temporarily of your loved one's presence, knowing how exhilarating absence is for love, but realizing the mediocrity of such an ulterior motive?
>
> IV. Do you believe in the victory of admirable love over sordid life, or of sordid life over admirable love?

As with matters as diverse as his interest in sexuality and his dislike of music, Breton here objectified his problems with Suzanne into a topic of public debate—once again seeking relief from his private torments in some form of reassuring consensus. But the questionnaire, which was distributed to group members, newspapers, and various out-

side intellectuals, mainly elicited the same kind of response that might have greeted any other Surrealist tract. Some answered with high praise, others with scornful dismissal, and René Magritte contributed the celebrated image of sixteen Surrealists, photographed with their eyes closed, around a painted nude with the caption: "I do not see the [woman] hidden in the forest." Only a few seem to have given the questions more than intellectual consideration.

Even Breton sidestepped his own inquiry, reproducing instead answers that Suzanne—his "love genius," as he'd told a skeptical Berl—offered during a rare moment of harmony: "I. The hope of never recognizing any reasons for being outside of it. II. . . . Nothing can compare to the fact of loving; the idea of love is weak and its representations lead to mistakes. To love is to be sure of oneself. I cannot accept that love wouldn't be reciprocal, and therefore that two people who love each other could have different views on a subject as serious as love. I don't wish to be free, which involves no sacrifice on my part. Love as I understand it has no barriers to cross or causes to betray. III. If I managed to have an ulterior motive, I would be too worried to dare claim I was in love. IV. I'm alive. I believe in the victory of admirable love." To this, Breton simply appended the words: "No answer other than this may be considered my own."

Most of the other Surrealists echoed Breton's countersigned optimism, with the notable exceptions of Aragon and Eluard—the latter stating simply, "Admirable love kills." Eluard was speaking from knowledge: at the time of the inquiry, his marriage to Gala was crumbling.* For his part, Aragon would proclaim the victory of "everything sordid over everything admirable," a statement that (although written one year later) perfectly expressed his state of mind in 1928.

In the summer of 1928, Aragon had followed Nancy Cunard to Venice, counting on the sale of a Braque nude through the Galerie Surréaliste to pay for the trip, and hoping to resolve some of the conflicts that made their relationship as tumultuous as Breton's was with Suzanne. But in Venice, Nancy fell in love with the black American jazz pianist Henry Crowder and abandoned Aragon to his own devices. In Paris, mean-

* By now, Ernst had ended his affair with Gala and taken up with a twenty-year-old Frenchwoman named Marie-Berthe Aurenche, a "fragile, birdlike creature" whom he had met in early 1927 and seduced away from her rigidly Catholic and chauvinistic family. Despite opposition from the girl's parents (who tried to have the German painter arrested and their daughter, a minor, returned to them by force), Ernst had married Marie-Berthe later that year. Ironically, this development actually worsened relations between Ernst and Eluard, and following Marie-Berthe's jealous remarks about Gala at Rue Fontaine one evening in May 1927 the two old friends had come to blows. "Last night at Breton's I had a fight with that pig Max Ernst, or rather he punched me unexpectedly and pretty hard in the eye . . . I feel quite calm about it all. I shall not see Max again. EVER," Eluard had reported to Gala. Needless to say, he and Ernst were soon reunited.

while, Marcel Noll, who was handling the sale of the Braque, absconded with the funds for a desperate relationship of his own. Emotionally and financially stranded, Aragon took a hotel room and swallowed a near-fatal dose of barbiturates, only to be found at the last minute.

Back in Paris by October, a depressed Aragon joined forces with an exasperated Breton on a theatrical sketch called *Le Trésor des jésuites* [The Jesuit Treasure]. Taking its theme from the actual, unsolved murder of a Catholic Mission treasurer the previous winter, *Le Trésor des jésuites* was mainly a homage to Musidora, the erotic goddess of the authors' youth: the anagrammatic lead role of "Mad Souri" was written specifically for her, and the play's serial-film structure and wartime setting recalled the actress's heyday.

But although Breton and Aragon adroitly managed to infuse the play's 1915 atmosphere with clever jabs at numerous current events, the overall effect seemed trivial and dated. As André Thirion later wrote, "In 1928, Musidora was fifty years old [*sic:* she was not quite forty] and several pounds overweight but dying to get back on stage in the famous black tights she had worn at twenty-five. Aragon and Breton were probably also seeking their mid-twenties." He added that the sketch, if performed by Desnos or Soupault, "would certainly have prompted Breton to mobilize the group and create a scandal." And indeed, *Le Trésor des jésuites* often seems to be a poor pastiche of Surrealism, with its stereotyped insistence on seedy hotels and café tables and "mysteries" as flabby and middle-aged as Musidora herself had become. On the whole, this opera buffa version of Surrealism stands mainly as a testament to Breton's and Aragon's nostalgia for a romantically simpler time, as well as to their emotional distraction that fall.

Aragon, meanwhile, resolved his emotional troubles in November, when he met the Russian-born novelist Elsa Triolet at a Montparnasse café. A legend skillfully orchestrated by Elsa herself—and energetically perpetuated by Aragon in numerous lengthy poems—has the two lovers coming together in starry-eyed wonder on the night of their first meeting, and being carried away on the wings of mutual respect, passion, and fictional prose. The truth of the matter is that Elsa waged an arduous and hard-won campaign to become the companion and muse of Aragon's post-Surrealist years.

Born Elsa Kagan in Moscow in 1896, the younger sister of Vladimir Mayakovsky's longtime lover Lili Brik, Elsa by the early 1920s had moved to Paris, married and divorced a French officer named André Triolet, and become part of the group around the influential Soviet novelist and critic Ilya Ehrenburg. She had soon become attracted to the handsome figure Aragon cut in after-hours Montparnasse. But Aragon, in the wake of his near-fatal separation from Nancy Cunard, paid the young Russian scant attention when she left Ehrenburg's table at the Coupole to join his. For one thing, he

was still suffering over his "Nane." For another, Elsa had a decidedly pushy way about her and a shrill, even grating voice. She was also short, slightly plump, and not especially beautiful. Aragon told his friends that he found Elsa unlikable and frightening, and (with typical Surrealist paranoia) suspected her of being a police spy.

But Elsa was determined and in love, and that November, thanks to a visit from her unofficial brother-in-law Mayakovsky, she seized her chance. She enticed Aragon with an introduction to the man the Surrealists considered Russia's greatest living poet; then, during a dinner party for Mayakovsky at Rue du Château, she maneuvered him into a darkened back room and seduced him. Shortly afterward she matter-of-factly informed Aragon that she was moving in. The couple settled into a large studio of their own, whereupon Elsa began taking charge of her man: she organized his belongings, removed all traces of former mistresses, and set about eliminating Aragon's friends—most notably the Surrealists, whom she considered cumbersome and boring. Little by little, she began drawing him to her political and aesthetic views. And, over the next several decades, she instilled in her lover a worship that would inspire almost all of his later work. In later years, wrote André Thirion, Elsa "replaced her vanishing beauty with the myth of eternal love and wanted the whole world to know that she was admired and loved. Thus was born the cult of Elsa's Eyes [the title of one of Aragon's books], which concealed the ravages of old age more effectively than any beauty parlor." Aragon, who had found a lover, promoter, dominatrix, and mother all in one, stayed with Elsa for the rest of her life, enshrining them both for posterity as the John Lennon and Yoko Ono of Surrealism.

Elsa's campaign had benefited from her singular tenacity and from Aragon's deep-seated need to submit to a higher authority—a role that had so far been filled by Breton. The growing conflict of allegiances, added to myriad subterranean tensions and jealousies that Elsa's presence would help bring to the fore, eventually caused a violent parting between the two old friends. Elsa found Breton's attitudes toward women stiflingly conventional; according to Thirion, she understood only one thing about Surrealism: that Aragon did not occupy its primary seat. That fall of 1928, however, Breton seems not yet to have recognized Elsa as a threat to his relations with Aragon, although from the outset he greeted her with distrust.

In fact, if Breton took any notice of Elsa at all, it was mainly because of her special relations with Mayakovsky. Breton, like Aragon, admired the celebrated Russian Futurist as living proof of the freedom the Soviets extended the poetic avant-garde (a freedom that Mayakovsky energetically promoted during his mission abroad). Wishing to discuss views with his fellow poet, and perhaps hoping to bypass the PCF by establishing direct ties with Moscow, Breton had several conversations with Mayakovsky during

his November visit to Paris. But Mayakovsky spoke no French, and even with an interpreter it was impossible for the two artisans of language to move beyond basic civilities. Apart from an acknowledgment of mutual sympathy, little came of the Surrealists' contact with the Soviet bard.

✳

As Aragon's emotional life seemed to stabilize, Breton's only became more tortuous, as Suzanne continued to vacillate between him and Berl. Increasingly frantic, Breton had finally acceded to her demands early in October, when he asked Simone to "give him back his freedom." But this was not yet enough for Suzanne, who complained about the continued presence of Simone in Breton's life. "The day will surely come when I won't love her anymore. *For certain*," an exasperated Breton told his wife, even while promoting a divorce as "the only thing that can cut through this horrible nest of vipers."

Suzanne, meanwhile, became seriously ill, even suicidal, and so erratic in her behavior that her doctor feared encephalitis. In what was now a typical pattern, she again fled to Berl's in mid-October, only to call Breton several days later and—at the price of a harsh confrontation between the two rivals—have him carry her back to Rue Fontaine. Breton, naïvely content, told Simone that Suzanne would never again return to Berl. But after a week, he, too, doubted that he could live with Suzanne; unfortunately, neither could he live without her.

By month's end, Simone had agreed to the divorce, and Breton's reports to her began including practical advice on finalizing the separation. He counseled Simone to file against him, as it would count in her favor during the hearing, and he hired Marcel Fourrier, his former colleague from Clarté and a practicing attorney, to help with the legal details. Even now, however, Breton was unwilling entirely to relinquish his relationship with Simone, telling her in the same breath that he hoped nothing fundamental would change between them. "He's really something, André!" an exasperated Simone reported to her cousin. "How can he hope to reconcile Suzanne's demands and his need of her with my presence in his life? He swears to me that he believes he can, that he hopes to, that he wants to. I'm just waiting and seeing."

Now that the situation was more or less resolved, at least in Breton's mind, he and Suzanne planned to escape Paris and their recent crises for several months. In reality, the couple's life remained just as unstable as ever, and the tension showed through in Breton's letters to Simone, in which he defensively justified himself as having acted "as I believe I have a right to and as I have always done. I'm free to see things as I like."

With misplaced anger, he also swore not to repay his father ("that vile boor") a loan of 10,000 francs.

But it wasn't until mid-November that the frustrations and tensions of the past year finally exploded, when Breton suddenly learned, over lunch with Simone, that for some time his wife had been sexually involved with Max Morise. All at once, her absences in recent years, Morise's accompaniment on her travels, and his frequent presence at Rue Fontaine took on sinister overtones. Shocked and furious, Breton sent Simone a letter filled with recrimination: "I pride myself on having lived my life *in broad daylight*. I've never hidden a thing from you, and I've always infinitely respected what I thought I knew about you (stupidly)," he spat. Throwing Simone's own words back in her face, he concluded: "If you 'perhaps no longer have the right to say you love me,' I have the *duty* to say that in fact I no longer love you." The letter was signed "André Breton."

Breton accused Simone of not having lived up to their pact of total openness, of having deliberately lied to him. Simone claimed to believe that Breton had always known about Morise. There was some measure of bad faith on both sides: Simone had sworn her travel companions to secrecy (although Marcel Duhamel, for one, insisted that the affair was known to all but Breton); and Suzanne, for her part, later maintained that Breton had known about his wife's affair all along, and had even used it to reassure Suzanne when he first declared his love. Breton, meanwhile, while outraged by Simone's disregard of their pact—her "abuse of confidence," as he put it—was no doubt equally so for reasons that were purely emotional: at a time when Suzanne was back with Berl, the salient fact in his mind was that someone he trusted had once again betrayed him.

At the same time, Breton's position contains a fundamental sincerity. It is clear that, on some level, he did know about the affair, which appears to have been consummated around the end of 1923 (a full year before his meeting with Lise, and therefore not, as is often supposed, a retaliatory response on Simone's part). But to all evidence he also practiced a fair amount of denial, not fully recognizing the extent of his wife's involvement with his friend, and even frequently asking Max to act as Simone's escort or travel companion. Only when the plain truth was put before him does he seem to have fully absorbed the emotional implications.

From this point on, the amicable separation turned irrevocably ugly. While Simone took a hotel room in the eighteenth arrondissement, Breton ordered the others to denounce her and Morise, gathering—as during previous internal crises—as many allies as possible to his side. During bitter evenings at Rue Fontaine, he harangued the remaining faithful about Simone's perfidy, fuming that people were out to make him into a character from a bedroom farce.

Then, on December 1, Breton received a second shock when Suzanne unexpectedly married Emmanuel Berl. Breton hadn't realized that Suzanne was making the same demands on both her lovers, and that her need for security ultimately took precedence over any emotional leanings. Berl, whose own divorce had recently been granted, and who therefore was legally available before Breton, won out simply by virtue of speed.

Demoralized and irritable, Breton spent the end of 1928 in a series of conflicts: disputes with Jacques Prévert, Jacques Baron, and Roland Tual, who chafed against his constant exigencies; a shouting match with Soupault in the editorial offices of Editions Kra; the money shortages that kept the twelfth (and last) issue of *La Révolution surréaliste* unpublished for a year and that finally obliged him to close the Galerie Surréaliste. As he sighed to Eluard on December 30, "Too many people are interested in seeing things go badly for me. They've put a lot of effort into it this year . . . What a state I'm in at this year's end!" For the moment, victory was squarely on the side of sordid life.

THE CRASH OF '29

(January 1929 – March 1930)

IN 1929, AS SUZANNE BECAME MORE ELUSIVE and the divorce from Simone entered an especially bitter phase, Breton's attempts at maintaining control would turn increasingly strident. His outrage over Simone's affair with Morise had given way to harsh negotiations about the division of property. Simone, although now living with Morise, still considered Rue Fontaine and its extensive art collection her domain, and over Breton's repeated objections she used the apartment as she saw fit. Matters were further complicated when Suzanne, whose marriage to Berl had settled nothing, returned to live with Breton that January. In an attempt to forestall Simone and establish her own dominion, Suzanne rearranged the entire studio, moving furniture, hiding paintings and books, and sending manuscripts out for safekeeping.

Overwhelmed at home, Breton responded by further tightening his hold on his own protectorate. The daily café sessions, long a gauge of fidelity to the group, became an incontrovertible measure of personal loyalty. At the Cyrano, the Radio, or the Globe, Breton arrived twice daily with (as André Thirion later noted) the regularity of an office worker, expecting the others to follow suit. "The aperitif sessions became an almost permanent gathering for Surrealism. Assiduously attended, they were a ceremony of allegiance to Breton . . . The meetings were also a kind of test for newcomers; they sustained the leader's authority and allowed some participants to shine, others to elude oblivion and make up for their mediocre services by genuine faithfulness." Roland Tual later confessed that merely arriving late put him in a state of dread, making him grope to justify his tardiness more fearfully than when he'd been a schoolboy (meeting a "dazzling woman" was apparently one of the few acceptable excuses).

Not only did Breton demand faithful attendance; he also oversaw the choice of beverages—for this "communion" required wine, and the stronger the better. Thirion remembered a virtual "hierarchy of aperitifs": at the top figured anise liqueurs (Pernod, Ricard, and other substitutes for prohibited absinthe); then bitters, particularly mandarin curaçao, "a black potion that effectively cleaned out your innards," and the ever-popular Picon *citron*; and finally beers and Aragon's grudgingly tolerated vermouth. But the

hierarchy was sometimes altered, and red wine, especially Beaujolais, also found favor at certain times: preference in drinks, like so many other aspects of café life, changed with Breton's mood.

And like any celebration, the café meetings involved a fair amount of ritual, notably in the discussion topics: these nearly always revolved around the day's events, current readings, real or imagined slights, digs at former friends, and the latest political scandals. Breton would also read aloud samplings from his mailbox: letters from provincial admirers seeking admission to the Surrealist Camelot, or from fledgling poets hungry for endorsement, or from simple eccentrics drawn to Surrealism by what they perceived as kindred strangeness. As the leading figure in Europe's most visible artistic movement, he had by now become (in one historian's words) "the leading avant-garde intellectual power broker in France," and the hopeful were not shy about coming forward. Nor did they limit their approaches to correspondence; Thirion recalled that "strangers, some curiosity seekers, some invited by Breton, Eluard, or Aragon, would sit down at a table and be subjected to an entrance exam" during café sessions.

Thirion himself, along with his friend Georges Sadoul, was among those who had passed this entrance exam in recent months. The twenty-one-year-old Thirion was one of Surrealism's most active political militants, having been a member of the PCF since 1926. A fervent partisan of hard-core action, he favored the Surrealism of "Revolution Now and Forever!" over that of *The Magnetic Fields*, and his written contributions to the movement were mainly essays on social and economic issues, which hewed fairly closely to the Party line.

Georges Sadoul was interested in politics, too, although by this time he was leaning more toward Trotskyism than toward orthodox Stalinism. He was an ex-law student in his mid-twenties, "massive and stocky" in build and, according to Thirion, "willful, tough, obdurate," and "extremely caustic" by nature (which didn't keep him, during his first meetings with the Surrealists, from being so intimidated "that it took many months for [him] to open [his] mouth"). Later a renowned film critic and historian, Sadoul would ultimately have only a brief tenure in the Surrealist movement; nonetheless, within the next two years, his name would be linked to two of its most notorious upheavals.

The combination of recent arrivals and exclusions in the course of five years had caused some significant changes in the Surrealist roster. If many early members—such as Aragon, Arp, Crevel, Duhamel, Eluard, Ernst, Leiris, Péret, Man Ray, Tanguy, and Unik—still partook of the daily life of the group, numerous others had become persona non grata or simply disappeared along the way, while still others participated in a desultory fashion that often bespoke tensions with Breton.

One who was finding his situation in the group increasingly difficult was Raymond Queneau. A sometime tenant at Rue du Château, Queneau had been introduced to the Surrealists by Pierre Naville, and since 1927 had participated in various tracts and activities. The twenty-five-year-old Queneau, a mathematician by training, combined intellectual precision with stinging humor, foreshadowing both the verbal gamesman who would produce *Exercises in Style* and the cutting satirist behind the Surrealist spoof *Odile*. But Queneau's relation to the group was also peculiar in that, having married Simone's sister Janine the previous year, he was now Breton's brother-in-law. And in early 1929, with his divorce underway, Breton was pressuring Queneau to disavow Simone as proof of his loyalty—a demand Queneau greeted with understandable reluctance.

But nowhere was Breton's desire for control exerted more strongly that winter—and at no other time would it ultimately bring about such an exodus—than in his attempt to explore "the possibilities for joint action between a certain number of individuals" of independent leftist tendencies. Although previous attempts at such a fusion (the 1922 Congress of Paris and the short-lived conjunction with Clarté being two examples) had ended in failure, Breton seemed unable to forgo trying to revitalize his activities by gathering around him as many people as possible.

On February 12, a vaguely worded form letter by Breton and Aragon was sent to seventy-six persons, ranging from Surrealists past and present (including even Artaud and Vitrac, but not Soupault) and former Dadaists Picabia, Tzara, and Fraenkel; to the members of other groups such as Clarté, *Philosophies* (now renamed *L'Esprit*), and a band of young poets called the Grand Jeu; to independents such as Georges Bataille. Seeking to make a preliminary cut, Breton asked respondents their thoughts about individual versus joint action, then set about eliminating elements deemed unworthy: among those disinvited were Artaud, Leiris, Bataille, Boiffard, the *Philosophies* group, Tual, Vitrac, Baron, and Prévert. A summons was addressed to the remaining fifty-seven, calling them to gather on Monday evening, March 11, at the Bar du Château, located across the street from Duhamel's house. The stated purpose of the meeting was to discuss Leon Trotsky's recent banishment from Soviet territory.

In organizing the summit, Breton was responding to the philosophical upsets caused by his recent disputes with the Communists: he still believed that Surrealism had much to give to the cause of social revolution, and hoped that by creating an independent action committee he could make a political contribution while avoiding Party constraints. But there was also a very real internal tension and frenzy underlying the project, evident not only in the vehement tone of the convocations but even in the private letters Breton sent at this time. To Eluard, he complained, "How exhausted I am, and for

the hundred thousandth time where are we going! Things are literally no better than before . . . To tell the truth, I'm rather frightened. I'm pursuing, as always with the complicity of marvelous lightning flashes, my small and rigorously exterminating existence." (It was perhaps no coincidence that, shortly afterward, the two men decided to have plaster "death" masks made of themselves—masks that hung face to face in the window of Rue Fontaine for several decades.) Finally, it is likely that there was another, hidden factor in Breton's organization of the Bar du Château meeting: a desire to discredit those who eluded Surrealism's dominion, and most especially the Grand Jeu.

The Grand Jeu [the Big Game] comprised the poets René Daumal and Roger Gilbert-Lecomte, the critic (and future magistrate) André Rolland de Renéville, the novelist and journalist Roger Vailland, the cartoonist Maurice Henry, and the painter Josef Sima. Barely in their twenties, they were already gaining attention in intellectual circles as the most interesting new group to form in Surrealism's wake. Indeed, many of the group's attitudes and procedures had clearly been inspired by Surrealism, even as they jealously maintained their independence from Breton's circle. "We are Surrealists, nuances aside," Daumal had told Maurice Henry several years before.

These "nuances" were in fact quite significant, for even apart from their more iconoclastic bent, the Grand Jeu differed from Surrealism in several fundamental respects— notably their belief in supernatural phenomena, their precocious use of drugs (which would eventually kill Gilbert-Lecomte), and their habit of playing Russian roulette. As a group, they "projected" their specters out of their bodies, meeting up for ghostly "walks" around town; could enter such trances that, in one instance, Daumal did not react as a lit cigarette slowly singed his fingers; and provoked visual and auditory illusions. And they took their sustenance not only from the daily bread of Jarry and Lautréamont but also from such sources as Theosophy, the ancient esoterics, and Hindu philosophy: in later years, Daumal would become a leading Sanskrit scholar.

Breton had first become aware of the group the previous March, and, despite the differences, had been impressed enough with Grand Jeu principals Daumal, Gilbert-Lecomte, and Rolland de Renéville to offer them a place in his group (while disdaining other members whom he found less noteworthy). But the Grand Jeu had resisted appropriation, and had instead attracted some dissatisfied ex-Surrealists to their own ranks, much to Breton's annoyance. The Grand Jeu had further angered Breton by answering his February summons collectively (whereas he had addressed it only to certain individual members), and insisting that they would attend the Bar du Château meeting as a unit or not at all. Soured by their refusal to come under Surrealism's wing, Breton changed his stance from enticement to one of hostility.

The timing of the March 11 meeting further indicates the Grand Jeu's role in Breton's motivations, for it took full advantage of two recent incidents that could only have undermined the younger group's credibility. The first concerned a violently anti-military petition signed by students of the prestigious Ecole Normale Supérieure, at a time when such statements were grounds for prosecution. Gilbert-Lecomte, who possessed the document, had at first promised it to an enthusiastic Aragon, but had then destroyed it when the student radicals got cold feet. To Aragon and Breton, Gilbert-Lecomte's obliging of some pampered students cast serious doubt on the Grand Jeu's motives. This episode, however, paled next to a second matter that came to Breton's attention that winter, concerning Grand Jeu member Roger Vailland. Vailland, later a successful novelist and political pamphleteer, at the time earned a living as a stringer for the mainstream Paris dailies. Not only did this mercenary use of literary talent make him suspect in Breton's eyes, but the previous September he had gone so far as to write a puff piece for the conservative *Paris-Midi*, glorifying Paris police commissioner Jean Chiappe (an extreme right-winger whom one historian called "the French equivalent of J. Edgar Hoover") as "the purifier of our capital." It took little more than this to give Breton the ammunition he needed against the young resisters.

The meeting began at 8:30 P.M. Thirty-two of the fifty-seven invitees crowded into the back room of the grimy Bar du Château to witness the proceedings. His personal quarrel with Breton notwithstanding, Morise had been designated to chair the meeting—a situation whose potential for discomfort was exacerbated when Simone herself arrived in a "dazzling outfit," evidently intending to cause a stir (no doubt in retaliation against Suzanne's commandeering of Rue Fontaine). Livid, Breton soon after reproached Simone for her "sensational or, at very least, very *noticed*, entrance."

Still, despite the shock of Simone's arrival, and regardless of Morise's nominal presidency, Breton was clearly master of the situation that evening. He immediately had acting secretary Queneau read out the collected responses to the February 12 letter, while he passed each of their authors in review. Those who had reservations about the project were treated with sarcasm, while those more favorable to community action were praised.

But Breton's true talents emerged in the next phase of the meeting, when he argued that, given the vast divergence of views represented, it was premature to launch into a discussion of Trotsky's exile without first determining "the qualifications, moral or otherwise—but certainly moral—of each man present." Here Breton was firmly on home ground. It was like the Barrès trial all over again—only this time, instead of a department-store dummy, the tribunal could set its sights on some flesh-and-blood defendants.

Having imposed such an inquest, Breton turned to the matter of the Grand Jeu. It

was worrisome, he pointed out, to see Gilbert-Lecomte relinquish the subversive Ecole Normale letter merely so as not to inconvenience some bourgeois students. "Are we wrong to fear that, in more serious circumstances, his personal scruples might also lead him to compromise a situation in which he has been handed a crucial role? Does he understand this?" Gilbert-Lecomte nodded, and the Grand Jeu was roundly booed by its main detractors. Like a skillful prosecutor, Breton then began chipping away at the unity that the Grand Jeu had striven to maintain, causing Gilbert-Lecomte to posit more and more vehemently the perfect understanding among the group's members. But at that moment Breton brandished Vailland's incriminating article on police commissioner Chiappe, underscoring and repeating the phrase "the purifier of our capital." Did the Grand Jeu's perfect understanding embrace *that*?

As Gilbert-Lecomte fumbled for an answer, Ribemont-Dessaignes leapt to his feet and angrily accused Breton and Aragon of acting like "court justices." A round of accusations and counteraccusations, which quickly escalated into a shouting match between the principals, ended when Ribemont stormed out of the café, the jeers of Breton's supporters pursuing him as he went. The next day, Ribemont sent Breton a long letter deploring the evening's events:

> So this is where all your collective efforts lead: judgment, judgment, judgment, and of what kind! Your revolutionary action: sweeping people away. In short, have you ever done anything else? Has any collective enterprise been anything more than constant personal quarrels, generally fought with schoolboy pettiness? When will you stop testing those closest to you? . . . I don't understand how playing a poor man's Stalin, a two-bit Stalin (when the real Stalin is already no joke), can appeal to you . . . I'm on your side for everything I like about you, Breton . . . but I can't stand the little games you repeat all too often, a caricature of all the historical memoirs of the Revolution, replete with Great Men and their famous words.

After Ribemont's departure, the debate over Vailland's article resumed in an increasingly heated and antagonistic climate. By this point, the young members of the Grand Jeu were out of their depth: they had never faced such a gathering before, and were ill equipped to handle the maneuvering and sectarianism that now challenged them. Put on the spot, they falteringly disavowed the paean to Chiappe but hesitated to break solidarity with Vailland, further damaging their standing in the eyes of the assembly. Vailland himself apologized for the article, and under pressure from Breton agreed to write an open retraction for the Surrealists to use as they saw fit. But even on this condition, only

some of those present agreed to have further contact with the Grand Jeu, and the meeting finally ended, well past midnight, on a note of failure and recrimination. Gilbert-Lecomte, who had previously worked out some projects for future meetings, ripped his notes to shreds as he left the bar.

Following the meeting, Breton and Aragon drafted a detailed account of the proceedings, justifying their actions under the portentous title "A suivre: petite contribution au dossier de certains intellectuels à tendances révolutionnaires (Paris 1929)" [To Be Continued: A Small Contribution to the Files of Certain Intellectuals with Revolutionary Tendencies]. "Comic though our *major excommunications* might appear in retrospect," the authors wrote, "the mere sight of our former *comrades*—those we deemed it cleaner to jettison—defending themselves, lashing out, tying themselves up in knots, was enough to convince us that, all things considered, such sanctions are neither unwarranted nor ineffectual." More than three decades later, Breton would still be defending the events of March 11, 1929, as a necessary safeguard against armchair revolutionaries.

As with earlier purges, Breton's urgency and vehemence reflected a horror of betrayal—in this case, the intellectual treason of writers (at least partly as a substitute for the amorous treason he could not remedy). Breton feared that, like the intellectuals of 1914 who had embraced wartime chauvinism, the most gifted writers of the current generation would sooner or later betray the causes they had once defended; for this reason, they must constantly be reevaluated and, if found wanting, eliminated before they could wield a pernicious influence. Breton's sense of mission clearly showed through the concluding lines of the tract: "The intellectual trade is plied with such impunity that there's no sense in waiting to bring [seemingly harmless individuals] to public attention, no sense in waiting for these innocuous little boys to become respected gentlemen, who will then bring to the service of everything we despise their long-standing knack for confusion and their ability to stand on their hind legs for the amusement of dogs."

The pugnacious antagonism of the tract reflected the prevailing mood left by the Bar du Château meeting: far from the collaborative unity ostensibly desired in Breton's initial summons, the meeting had only stoked buried animosities and resentments, alienating even some of those who had initially favored a project of joint action—which, needless to say, went no further. Leiris and Desnos, sickened by the turn of events, pulled away from the group.* Simone's splashy entrance at the Bar du Château heightened the feuding

* In Leris's case, not without trauma. He went through a period of alcoholic and sexual excess, and at one point tried to castrate himself. He then underwent psychoanalysis and, in 1931, left on the Dakar-Djibouti ethnographic expedition. While there, he had a wet dream about patching things up with Breton. "To hell with psychoanalysis," he noted in his diary the next morning.

between the estranged spouses. And along with Ribemont-Dessaignes's reproachful letter, Breton received a harsh note from Vailland.

Still, this was not the end of Breton's relations with the Grand Jeu. In the ensuing months, he turned his seductive attentions to Rolland de Renéville, having admired the latter's recent book on Rimbaud; Renéville, flattered, ignored his colleagues' advice and began frequenting the Surrealists. As for Vailland, his "fucking stupidity" (*dixit* Gilbert-Lecomte) soon led to a break with the Grand Jeu. Rejected by the Surrealists and his own friends, humiliated in front of the intellectuals he most admired, Vailland developed an abiding hatred for Breton that sometimes translated into actual death threats. The Grand Jeu itself, seriously damaged by the Bar du Château incident, finally succumbed to slow corrosion in 1932.

One final discordant aftermath of the meeting came in April, when Georges Bataille, whose attitude toward the project had been sharply criticized, began publishing a luxurious arts and ethnology periodical called *Documents*. Featuring the work of Leiris, Desnos, Boiffard, Masson, Vitrac, and Limbour, *Documents* immediately incurred Breton's displeasure for two main reasons. The first was Bataille himself, who because of his vehement writing style was frequently compared with Breton—all the more so in that he'd managed to gather so many disgruntled ex-Surrealists around him. The second was the nature of Bataille's statements, which evinced a joyously scatological view of life, love, and eroticism that contrasted sharply with the man's retiring demeanor and that profoundly shocked Breton's romanticizing sensibilities. Breton was repelled by Bataille's fascination with excrement, corruption, horror, and suicide; his insistent conjunction of beauty and sordidness; and the "old antidialectical materialism" that seemed to govern his thinking. Bataille, for his part, considered Breton a harmless idealist in radical's clothing, and all his efforts at social action mere wind. To the Marx who proclaimed "Transform the world" (a phrase that Breton would often cite in admiration), Bataille preferred the one who had noted: "In history as in nature, decay is the laboratory of life."

Georges Bataille worked as a librarian in the rare manuscripts department of the Bibliothèque Nationale. The author of several erudite articles inspired by his curatorial duties, he had also written two slim volumes tellingly entitled *W.C.* and *L'Anus solaire* [The Solar Anus], as well as a novel called *Story of the Eye*, whose eroticism and Sadean overtones were so violent that he had published it under a pseudonym. Bataille had attended one session at the Cyrano in late 1925, introduced by his friend Leiris. But he had not shared Leiris's awestruck appreciation of Breton and his writings, and his first audience with "the Pope" was marked by malaise and boredom. "It seemed to me that if Breton required silence from those listening to him, he was never silent himself," he later

wrote. "Thus I was forced not only to remain quiet but to hear only the measured, pretentious, artfully swelling voice of Breton."

While some of Bataille's writings elicited Breton's admiration (notably *Story of the Eye,* "the most beautiful erotic work I know"), Bataille in person struck him as an "obsessive," and the two men's relations had at best remained sporadic and uncomfortable. By the time of the Bar du Château project, the mild-mannered librarian was fast becoming one of Breton's most vituperative critics.

In the wake of the March debacle, Breton took several trips outside Paris, including, in mid-April, a brief excursion to Brussels with Eluard and Aragon to visit the newly formed Belgian Surrealist group. Of all the Surrealist-inspired movements that were beginning to spring up around Europe at the time, none was more active than the Belgian group around painter René Magritte, poets E. L. T. Mesens and Marcel Lecomte, biochemist and essayist Paul Nougé (whom some have called the "Belgian Breton"), and art dealer Camille Goemans. Begun in 1928 by members of the former Correspondance group, Belgian Surrealism would contribute some major literary and pictorial works to the movement. Because of its linguistic and geographical proximity, it also maintained the strongest ties (and at times the most heated debate) with its Parisian counterpart. On their side, the French stayed in close touch with the Belgians, keeping them apprised of events through visits and letters, and occasionally using them as outlets for publication. So it was that, early in the year, Breton had accepted an offer from Paul-Gustave van Hecke, editor of the magazine *Variétés*, to prepare a special issue on Surrealism—Breton's condition being that he and Aragon have strict editorial control.

By April, the two guest editors had assembled some 130 pages of text, including a map of the world "in the time of the Surrealists": Russia and China swelled to monstrous proportions, the United States disappeared between Alaska and Mexico, and, in an unwitting premonition of things to come, Europe was consumed by Germany, with Paris as its capital. But the centerpiece of the issue turned out to be "A suivre," distinctively printed on pink stock and paginated independently of the rest. The tract had actually been intended for *La Révolution surréaliste* but, as poor finances had kept the magazine unpublished since winter, Breton opted at the last moment to include it in *Variétés*— a move that both played havoc on *Variétés*'s own unstable economics and delayed publication by a month. In the final account, however, the decision served the tract well, for the visual demarcation, along with its length (one-third of the overall magazine), left lit-

tle doubt in readers' minds as to the current primacy in Surrealism of polemics over poetics. It was no accident that an advertisement for *Variétés* had promised, among other things, "exhibitionism" and "the smashing of faces."

Faces were in fact being smashed right and left that spring. In June, as *Variétés* was hitting the stands, a new edition of the *Manifesto* featured a preface officially marking Breton's rift with certain of his former colleagues. That same month, the group targeted Emmanuel Berl, via some acerbic remarks of Thirion's cited in "A suivre." Although these remarks ostensibly aimed at Berl's philosophic positions, the impetus was, of course, Breton's continuing rivalry with him over Suzanne.

This rivalry flared anew that spring when Suzanne, after having spent the first months of her marriage at Rue Fontaine, again left. She and Breton had been on vacation in Biarritz when Berl arrived on the scene and once more wooed his wife away; as Breton told Eluard in May, he feared it was for the last time. Nonetheless, Breton soon persuaded Suzanne to return, and in early June the reunited lovers headed north to the town of Le Pouldu on the Brittany coast. But the inns were expensive and the beaches full of family vacationers, whose rattle and squawk obscured the landscape's austere beauty.

In July, sick of the crowds, Breton and Suzanne joined Sadoul, Unik, and the Tanguys and headed for the Ile de Sein, a small island off Brittany's westernmost extremity. The island provided the perfect contrast to the noisy coastal town: tiny, free of tourists, perpetually shrouded in fog, and frequently crossed by distant sirens from the boats offshore. (No doubt the inquirer on love and sexuality was also taken with the name: "Breast Island.") "The streets are only a yard wide and some of the furniture in the houses is made of flotsam. There's not a tree or horse to be found," Breton wrote to Desnos. Enchanted with the island's remote desolation, Breton, who felt a lifelong pull toward his native region, would often return there in the years to come.

Breton devoted much of his time while on vacation to familiarizing himself with the works of Marx, Engels, and Hegel, in preparation for a second manifesto of Surrealism that would codify all the changes the movement had undergone in its first five years—most notably the shift, if at times hesitant and tortuous, away from psychic automatism and toward political militancy, along with the various upheavals that this had wreaked on the group itself. The time had come for a new declaration of principles.

Breton was counting on the tranquil remoteness of the Ile de Sein to organize his notes for this new statement and to begin drafting the text. But despite his solitude, the vacation was less than peaceful. Relations with Suzanne fell back into their tempestuous pattern shortly after their arrival; unable to handle her emotional fluctuations, Breton

(forgetting the despair her absences caused him) agreed with the others present that she made life "impossible." It was also at this time that the last threads of friendship between Breton and Desnos snapped, the break preceded by an exchange of correspondence in which attempts at reconciliation ran up against years of pent-up grievances, and ending with a postcard from the Ile de Sein: "So, it's over?" Breton wrote the poet of the sleeping fits on July 29. "You once said that nothing in the world could come between us. I thought so, too."

Breton responded to the emotional blows dealt by Suzanne and Desnos, the "demoralization" they had caused him in recent months, by verbally lashing out at friend and foe alike—most directly in the new manifesto that he began composing that summer. The *Second Manifesto of Surrealism* bore the traces of Breton's unsettled circumstances, its tone making it clear that he was no longer negotiating marvelous oneiric landscapes, but the harsh minefields of daily life—that the "inveterate dreamer" of 1924 had now been replaced by an exacting censor. "In spite of the various efforts peculiar to each of those who used to claim kinship with Surrealism, or who still do, one must ultimately admit that, more than anything else, Surrealism attempted to provoke, from the intellectual and moral point of view, *an attack of conscience* . . . and that the extent to which this was or was not accomplished alone can determine its historical success or failure," he declared. To maintain this kinship, the criterion no longer involved "performing acts of absolute Surrealism," but rather not succumbing to the (seemingly ubiquitous) temptations of vanity and worldly success. "What could those people who are still concerned about the position they occupy *in the world* expect from the Surrealist experiment?"

Indeed, if the first *Manifesto* had dismissed the distinction between "living and ceasing to live," the current text unambiguously described Surrealism as "plung[ing] its roots into life and, no doubt not by chance, into *the life of this period*."* Surrealism was no longer a state of mind unto itself, but a moral imperative. It was indicative of Breton's mood and circumstances that this manifesto, unlike its predecessor, was addressed not to the "very few" who had met this imperative, but to the many who had betrayed it along the way. By his aggressive tone, his preoccupation with others' failings, and his insistence on "standards" (what he would later call the "Surrealist pact"), Breton made it clear that he was no longer calling for adventurers to join in a spiritual quest but was fighting for his movement's very life.

* Just how deeply Breton was plunging his roots into daily life was suggested by some of his recommendations for Communism, which went so far as to offer the revolutionaries nutritional advice: "A future revolution would have a better chance of success if the people were better nourished, in this specific case"—a direct reflection of Breton's own culinary and coloristic preferences—"with peas instead of potatoes."

Among those called into question were the same predecessors that Breton had so carefully invoked in the first *Manifesto*, and whom he now renounced one after the other—with the sole exception of Lautréamont—as having left "questionable traces" in their biographical wake. So it was that Rimbaud was damned for "not having made completely impossible" Christian interpretations of his work by Claudel; as was Baudelaire, for his occasional references to God; and Poe, for having created an "intellectually attractive" policeman in August Dupin. In this sense, the *Second Manifesto* stood as the culmination of a grand sweep that had begun with the exclusions of 1926 and intensified that spring with the Bar du Château incident: a purge of every discordant element in Surrealism; of every figure, idea, or inspiration that had not managed to keep up with the sinuous developments of Breton's own evolution.

The manifesto of 1929 is, of course, more than just a long list of condemnations, and intertwined with the scathing critiques are important philosophical points, notably concerning Surrealism's ongoing debate with Communism over the issue of artistic freedom. "The problem of social action . . . is only one of the forms of a more general problem which Surrealism set out to deal with, and that is *the problem of human expression in all its forms*," Breton stressed. In addition, it contains numerous declarations of dogged, even idealistic faith. Taking his cue from Hegel's *Phenomenology of Mind*, Breton wrote what has come to be one of his most famous pronouncements, as well as one of the most concise statements of Surrealism's position at that time: "Everything tends to make us believe that there exists a certain point of the mind at which life and death, the real and the imagined, past and future, the communicable and the incommunicable, high and low, cease to be perceived as contradictions. Now, search as one may one will never find any other motivating force in the activities of the Surrealists than the hope of finding and fixing this point."

But in keeping with Breton's bleak outlook, such idealistic moments are constantly undermined in the *Second Manifesto* by diatribes, accusations, embattled self-justifications, and admissions of failure. Despite his faith in an ultimate reconciliation of the political and expressive spheres, Breton was forced to recognize the stalemate he had so far reached in his attempts to practice his political convictions within the sectarian Party structure. Although the text's general thrust is toward philosophical optimism, there is no question that the *Second Manifesto* is also the angriest and most bitter of Breton's major works.

Meanwhile, even as Breton waged verbal warfare against Surrealism's public antagonists, conflicts with Suzanne that summer rapidly turned the otherwise peaceful Ile de Sein into a private hell. Beautiful but neurotic, the young woman was as unable to sur-

mount the conflicts of her love affairs—conflicts that stemmed from the possessiveness of her lovers, Suzanne's own desperate need for material comfort, and her cripplingly low self-esteem—as Breton was to put the affair behind him. In September, these conflicts led to another separation from the woman whose love was both nectar and poison. Nor were matters any more comforting at home: Breton arrived back in Paris toward mid-month to find that the authorities, at Simone's request, had changed the locks on the Rue Fontaine apartment in his absence.

In a blind fury, Breton took a room at the nearby Terrass' Hôtel, joining a similarly dispossessed Eluard (who, having finally had enough of the suburbs, was waiting for workmen to finish a new apartment he had bought for himself and Gala in Montmartre's Rue Becquerel). There, he exploded in a savage burst of verbal rage against anyone who had ever "failed" Surrealism. It was during his stay at the Terrass' Hôtel that Breton composed the volley of public excoriations which, for better or worse, form the bulk of the *Second Manifesto*, and which still remain the most famous aspect of the text.

Taking up and furthering the criticisms leveled in "A suivre," Breton replaced the earlier text's cool sarcasm with steaming black bile. He now wrote some thirty-five pages of invective against his blacklisted former colleagues, and against the "journalistic jerks" who mocked his penchant for excommunications. "Why should we go on acting fed up and disgusted?" he sarcastically demanded. "A policeman, a few gay dogs, two or three pen pimps, several mentally unbalanced persons, a cretin: is this not the making of an amusing, innocuous team, a faithful replica of life? SHIT."

Among the "pimps and cretins" Breton lambasted were Artaud and Vitrac; Georges Bataille, "a staid librarian . . . more closely [allied] with the dead than with the living"; and Soupault, whom Breton accused of leaking "slanderous insinuations" about his trysts with Suzanne to the gossip columns. (Although Soupault was most likely innocent of the charges, Breton long held against him the alleged breach of confidence.) Still others were taken to task for various "disappointments," and none more so than Desnos, who alone warranted several pages. "I believe we are now forced to say to Robert Desnos that, as we no longer expect anything whatsoever from him, we have no choice but to free him from any commitments he may have made in the past with us," Breton stated, adding that this unfortunate step was dictated by Desnos's "abuse of his critical faculties" over the past several years (i.e., his work as a journalist and the formally traditional verse that filled his latest book). Mere weeks after his last attempts to patch things up with Desnos, Breton was writing off their friendship once and for all.[*]

[*] Breton also attacked his old comrade Pierre Naville, calling him a rich dilettante whose "insatiable penchant

Finally, Breton focused on the "fairly disastrous impression" left in March by the Grand Jeu. Still trying to divide and conquer, he singled out René Daumal as worthy of special interest, even as he dismissed the rest of his colleagues. "It is unfortunate," he noted, "that Daumal has hitherto avoided stating in no uncertain terms his personal position, and that of the Grand Jeu . . . with respect to Surrealism." Ironically, this wish was granted in the fall of 1930 when the group's periodical, also called *Le Grand Jeu,* published Daumal's caustic "Open Letter to André Breton." Daumal's critiques of some of Surrealism's positions, his dissatisfactions with the movement's "little parlor games" and "piddling experiments," and his indictment of Breton's divisive tactics were pointedly apt. With irreverent sarcasm, Daumal concluded by extending his own invitation for Breton to join the Grand Jeu, and cautioned him against "eventually figuring in literature textbooks"—a warning whose pertinence needs no further comment.

Embittered by his recent failures, Breton pulled Surrealism back out of the light and, in contrast to the publicity barrage that had accompanied the manifesto of 1924, promoted instead a closed, hermetic gathering. "I ASK FOR THE PROFOUND, THE VERITABLE OCCULTATION OF SURREALISM," he proclaimed, adding that "the approval of the public is to be avoided like the plague. It is absolutely essential to keep the public from *entering* if one wishes to avoid confusion." It was a curious echo of Breton's confession to Picabia in 1920: "My 'closest' friends . . . know that on the days when I'm saddest I prefer to keep to myself."

But perhaps the bleakest passage of all is Breton's definition of "the simplest Surrealist act" as consisting "of dashing down into the street, pistol in hand, and firing blindly, as fast as you can pull the trigger, into the crowd. Anyone who, at least once in his life, has not dreamed of thus putting an end to the petty system of debasement and cretinization in effect has a well-defined place in that crowd, with his belly at barrel level." Of all the pronouncements made in the *Second Manifesto,* this was to become the most famous—and the one that, frequently taken out of context (particularly after the Nazi occupation), would be held against Breton the longest. Albert Camus, one of many such critics, would later liken it to Hermann Göring's famous quip: "When I hear the word 'culture,' I always feel like taking out my revolver." Some commentators have recognized that Breton, in choosing his imagery, was harking back to his admiration for anarchist terrorists such as Emile Henry or Germaine Berton; while others have noted

for notoriety" led him to try to "dictate revolutionary opinion" by financing several Trotskyist periodicals with family money. In a singular piece of bad faith, he also chided Naville's "very rich" father for lending his "private mansion" on Rue de Grenelle to one of these periodicals. As Naville later pointed out, the same Rue de Grenelle mansion had also, and with Breton's gratitude, housed the Bureau of Surrealist Research.

the echo of Jacques Vaché's threat to "fire on the crowd" at the premiere of *Les Mamelles de Tirésias*. But few, in 1929 or afterward, seem to have realized how much sheer personal bitterness lay behind the sentiments Breton expressed.

Breton himself later allowed that such "extremes of expression" might have been dictated by "a certain upheaval in [his] personal life." But as with his actions at the Bar du Château, he maintained that his overriding concern had been to preserve a necessary integrity within the Surrealist group. As he later explained to interviewer André Parinaud:

> It was certainly not with a light heart that I attacked, in the *Second Manifesto*, a number of those on whom I had counted, with whom I'd shared a common stretch of road for a fairly long time. One of the worst drawbacks of committed intellectual activity in the collective sense is the need to subordinate personal sympathies to that activity, come what may . . . If only for the benefit of ideas, perhaps it was necessary to cut certain ties in order to move forward.

✳

By October, the circumstances stoking Breton's ire had begun to die down. Renewed access to Rue Fontaine ended his relatively brief exile at the Terrass' Hôtel, and even his separation from Suzanne—which turned out to be no more final than any other—was temporarily suspended. It was during these weeks that Breton, enjoying their latest reconciliation, launched the "Inquiry on Love"—and, as noted earlier, even went so far as to countersign Suzanne's responses.

It was also during these weeks that, following a typical pattern of repulsion and attraction, he began to think of additional recruitments to bolster Surrealism's ranks; for not only had he officially pronounced the loss of fourteen former collaborators, but others not mentioned in the *Second Manifesto*—notably Queneau and Morise—had left the group for personal reasons. Moreover, Prévert, Tual, and Leiris were taking their own leave, in reaction to what they considered Breton's suffocating authority. All told, Surrealism had recently lost some twenty members, most of them in the course of a single year.

One of the few who actually drew closer to Surrealism at this time was Picasso. Although never part of the movement itself, Picasso began producing work that showed a greater awareness than ever of Surrealism's aesthetic tenets, and that seemed to justify Breton's insistent solicitation of him. Picasso's biographer John Richardson noted that

one such painting, *The Crucifixion* of February 1930, takes one deeper into Picasso's psyche than almost any previous work, having been created while "in the trancelike state that Breton had urged on his followers" at the time of the sleeping fits. In December, for an upcoming group show of collages and *papiers collés*, Breton asked Picasso for some recent works, "without which we won't be able to do much of anything worthwhile." Picasso's atypical acquiescence, as with the Galerie Pierre show of 1925, only seemed further proof of his favorable disposition toward Surrealism (although this favor did not keep the egalitarian Picasso from allowing *Documents* to publish a special issue on him in April).

More direct support came from the twenty-two-year-old poet René Char. Char's ancestral home was in the village of L'Isle-sur-la-Sorgue, near Avignon, and it was there that he first came into personal contact with Surrealism: Eluard, to whom he had sent his book of poems, *Arsenal*, had been moved to visit him. Physically massive, with a long, juglike face and short black hair, Char looked the part of the rugby player he had been in his native Vaucluse. This prowess would be put to good use in the course of various scuffles in the coming years. "He was a great big fellow, and boy, could he punch," recalled Man Ray, who witnessed a fair number of these scuffles. "He was terribly strong and always good to have on your side." Most often, however, Char's violence surfaced in his exquisite but hard-edged poetry.

It was also at this time that Breton reconciled with one of his earliest companions, Tristan Tzara. During the summer, Tzara had sent Breton a copy of his just-published book of poems, *De nos oiseaux* [About Our Birds]; Breton had praised the book by return mail, inaugurating a warm correspondence and ending the "stupid misunderstanding" that had separated the two men for seven years. He took to reciting Tzara's poetry at evening gatherings, priming the others for the Romanian's return within the Surrealist fold that autumn.

But by far the most important new arrival in Surrealism during this period was the twenty-five-year-old Spanish painter Salvador Dalí. One of the strangest and most flamboyant figures ever to pass through Surrealism, Salvador Felipe Jacinto Dalí i Domènech was born on May 11, 1904, in Figueras, Catalonia. Dalí would later portray his father, a conservative and respected town notary, with a certain amount of scorn, but in fact Salvador Dalí, Sr., had enough intelligence and wit to appreciate his son's talents and eccentricities—even if he also tried to keep them from getting out of hand. Still, this appreciation had its limits, and shortly after Dalí joined Surrealism he was thrown out of the paternal house for exhibiting a drawing of the Sacred Heart with the caption: "Sometimes I spit with pleasure on my mother's portrait."

Dalí, in fact, seemed to enjoy courting ire. At the age of seventeen, he had infuriated his instructor at Madrid's Academy of Fine Arts by brazenly painting, in place of the Gothic Virgin he had been assigned, a clearly delineated pair of scales. Later, while living at the Residencia de Estudiantes, he was equally insolent toward his dormitory mates, who included Federico García Lorca, Rafael Alberti, and future fellow Surrealist Luis Buñuel. Although reclusive and distrustful by nature, however, Dalí eventually formed close friendships with Buñuel and Lorca. With the former he would collaborate on two of Surrealism's most famous films, while with the latter he would nurture a relationship that—at least in Lorca's case—soon blossomed into full-blown passion. (Dalí himself, who always claimed an aversion to homosexuality, later allowed that he had been "flattered" by the "prestige" of having Lorca in love with him: "I felt that he was a great poet and that I did owe him a tiny bit of the Divine Dalí's asshole.")

By twenty-five, Dalí had become a dapper, well-groomed dandy, whose eyes had not yet grown to the full manic width of his later years and whose narrow face and pencil moustache (a precursor of the famous elongated handlebar) seemed better suited to the Latin Lover of B pictures than to the mad genius of his public persona. Those familiar with the master clown and consummate huckster of Dalí's heyday would also have found him extraordinarily shy at the time, and painfully unable to handle even the smallest daily tasks. On his first encounter with the Paris metro during a visit in March, Dalí became so panic-stricken that he howled with nervous laughter—his standard reaction to the terrors with which life frequently challenged him. (Emerging safely at the next stop, he later recounted feeling as if he "had been spewed out of some monstrous anus . . . I understood I had just been through a great initiation.") Even after his relocation to the capital, Dalí would remain unnerved by the mechanics of life: still terrified of the subway, he took taxis to go even two blocks; and after café meetings he would pay for his modest glass of milk by leaving a fifty-franc note on the table, weighted down with an additional coin, then rush away before having to confront his change. But the young Spaniard was also intensely ambitious, and if he spent much of his March visit staring awestruck at the famous artists parading through Montparnasse, it was partly with the thought that someday he would top them all.

Like Char, Dalí had first met the Surrealist inner circle in the person of Eluard, when his future dealer Camille Goemans introduced them at a Paris ball that same March. Goemans "pointed out a man who was just coming in with a lady dressed in black spangles," Dalí later recounted. "'That's Paul Eluard, the Surrealist poet,' he said. 'He is very important, and what's more he buys paintings.' . . . Eluard struck me as a legendary being. He drank calmly, and appeared completely absorbed in looking at the beautiful

women. Before we took leave of each other, he promised to come to see me the next summer at Cadaqués." And indeed, Eluard—along with Gala, daughter Cécile, Goemans, the Magrittes, and Luis Buñuel—had acted on Dalí's invitation in August, paying a visit that has enlivened the annals of art history ever since.

"To the little provincial that I was, [the Eluards] were the very salt of Paris," Dalí later told an interviewer; "their self-assurance, their blasé attitude, their luxuriousness were a shocking provocation that fascinated me." Upon the couple's arrival in Cadaqués, the young painter had managed to greet them only with another fit of nervous laughter; but the next day he had set out to dazzle them with all the weapons in his slightly unbalanced mental arsenal. In preparation for a meeting on the beach that morning, Dalí took his best shirt and scrupulously cut it to ribbons, then donned it over a bathing suit turned inside-out to show the intimate stains. He shaved his armpits, deliberately cutting them so that the blood would run down his ribs; stuck a jasmine flower behind his ear and a pearl necklace around his throat; and smeared laundry bluing onto his sweating torso. Finally, to complete the effect, he lathered himself in a lovingly confected paste made of fish glue and goat dung. "Then, I opened my window wide, and stood there, hideous and superb." But in fact, Dalí's French visitors were never given the opportunity to appreciate his handiwork, for at that moment the young Catalan got his first real glimpse of Gala—or, more precisely, of her back—and decided that she was the "Unknown Woman" he had been seeking all his life: "I could see nothing beyond that screen of desire that ended with the narrowing of the waist and the roundness of the buttocks," he later said. Until that time, Dalí had been living on a diet of frenzied painting and frequent masturbation (often simultaneously), but had never known a woman sexually. Now, the vision of Gala's back plunged him into a mad ecstasy, even as it sobered him to his own appearance. Humbled, he removed his getup the best he could.

Over the following days, the painter and his new muse quickly developed a bond that would last the rest of their lives. This bond was forged by elements both passionate and practical. Dalí immediately mythologized Gala as his "divine mother" and "sister soul," but was not blind to the fact that the Parisian wife of a famous Surrealist wielded precious influence in Europe's art capital. And Gala, who sought out (in Thirion's words) "the companionship of genius," recognized that she would never again find so marketable a genius as Dalí. The naively romantic Eluard nonetheless assumed that his marriage would last, and that, no matter who else came into their lives, Gala would always be his "darling little girl." Gala, more lucid, knew that the honeymoon was over.

Eluard had returned to Paris in September, leaving Dalí, Gala, and an ailing Cécile behind in Cadaqués. He moved back into the Terrass' Hôtel (where Breton was still liv-

ing), whiling away his solitude by overseeing final construction on the Rue Becquerel apartment, whose completion would be the signal for Gala's return. But when Gala did return, in October, it was with Dalí in tow. Eluard—although he would continue to enjoy Gala's affections and sexual favors for many years to come—had definitively taken second place. He seemed to accept the arrangement readily enough, becoming one of Dalí's biggest boosters and later defending him against the others' accusations and resentments. But his answer that fall of 1929 to the "Inquiry on Love"—that "admirable love kills"—bespoke his underlying sense of betrayal.

From the outset, Breton also greeted Dalí with enthusiasm, although this enthusiasm was tempered with reservations. He immediately recognized in the young painter the dash of innovative genius that could extricate Surrealism from its current impasse and compensate for the year's vast talent drain. Thunderstruck by Dalí's paintings, he and Eluard bought many of the works the Spaniard had brought with him to Paris. Still, Breton was disquieted by Dalí's manic deliria, both on canvas and in life. As earlier with Bataille, he also distrusted the scatological obsessiveness of his work, which took no back seat to the author of *Story of the Eye*. That fall Breton's doubts centered on *The Lugubrious Game*, which Dalí had painted over the summer, and which prominently featured a man whose shorts, seen from behind, were very clearly stained with shit. Although he tried to express interest when Dalí proudly showed him the painting, he was hesitant about the suspect pants, and (at least according to Dalí) felt reassured only after the artist justified the stain as a "simulation" of excrement.

Dalí himself responded to Breton with his typical mix of awe and arrogance. On the one hand he could only admire the man who had organized such an exciting and far-ranging aesthetic current, word of which had reached him even in provincial Cadaqués. At the same time, he was disappointed to find the Surrealist group subject to so many moral strictures (Breton's response to *The Lugubrious Game* being a case in point), which reminded him of the paternal constraints he had expected to leave back home. Ferociously ambitious, Dalí also resented Breton's sway over the others, and his reaction to the café meetings (at least in retrospect) is reminiscent of Bataille's four years earlier. Breton, said Dalí, "already seemed like a pontiff . . . with the aperitif as Eucharist":

> No way of getting away from listening to Breton orating to his court of followers like a big turkeycock. The main reason for these gatherings was to let him keep control over his troops; to maintain his authority by killing in the egg the slightest tendency to dissent and making sarcastic remarks about those who were not present, and therefore automatically at fault . . . The bittersweet aperitifs were supposed to

keep up the morale of the Surrealists while Breton read the newspaper aloud to them or pilloried some poor nameless nonentities who had had the misfortune of displeasing him . . . It was sort of like a Tribunal of the Inquisition set up in the village's main café. I was bored to death.

Dalí long remembered "Breton's blue eye looking fixedly at me and forming a question mark above my head. He mistrusted me." As the painter's biographer has pointed out, Breton had good reason: Dalí knew where the action was and, whatever reservations he had about them in person, the Surrealists were the only group "offering me an adequate outlet for my activity." Quite simply, the shy young painter was plotting to take control of the best game in town.

One of Dalí's main talents was his astounding inventiveness, which in the 1930s would be responsible for some of Surrealism's preeminent attractions, such as the "Surrealist objects" and the "paranoia-critical method," Dalí's answer to automatism and objective chance. Another was his disarming humor, which, combined with his comically accented French, reduced even his harshest detractors to hilarity. Dalí even exercised this humor on his "dear friend Breton," to whom he began sending ludicrous missives, which Breton would duly read at café meetings "in gravely measured tones until the audience dissolved in laughter."

In addition, there were the paintings themselves, which by this point exhibited the startling personal iconography that—with Gala's help—would soon bring Dalí fame and fortune. On November 20, Goemans exhibited some dozen of these at his Rue de Seine gallery, sanctioned by a preface from Breton. "Perhaps, with Dalí, this is the first time that the mental windows can open wide," Breton wrote. "Dalí's art, the most hallucinatory we know so far, constitutes a real threat. Totally new beings with obvious bad intentions have just started out. It's a dark joy to see how they pass by on their path unhindered." Breton's enthusiasm was mirrored by both rich art collectors and by a sizable portion of the viewing public. In every way, it seemed that Dalí was taking Paris, and Surrealism, by storm.

And Dalí's gifts to Surrealism did not stop there, for he was also co-creator (with Luis Buñuel) of the movement's most celebrated cinematic work, *Un Chien andalou*. Dalí and the twenty-nine-year-old Buñuel had pieced together a script earlier that year from the mutual narration of their dreams, eliminating any "idea or image that might lend itself to a rational explanation of any kind." With financial backing from his mother, Buñuel went to Paris and shot the twenty-four-minute film, which, with its unforgettable opening close-up of a razor slicing an eyeball—actually the eye of a dead cow, cutting into

which made Buñuel sick—and relentless visual puns, remains arguably the most power-ful burst of Surrealism ever put on film. (In 1989, MTV ran a colorized abridgment of *Un Chien andalou*, with many of its most famous sequences cut. At sixty years of age, the Andalusian dog still had too much bite for the mainstream media.)

By fall, Man Ray and Aragon had seen the film, been duly impressed, and taken Buñuel to meet the Surrealists at large. A premiere was arranged for October 1 at the Cinéma des Ursulines, attended by a number of established artists, patrons, and the com-plete roster of Surrealists. But despite Aragon's enthusiasm, Buñuel was nervous: he remembered the scandal surrounding Artaud's *The Seashell and the Clergyman* at the same theater, and, expecting the worst, had filled his pockets with stones to throw at the audience in case self-defense became necessary. His fears were groundless, for at the end of its projection the film was greeted by prolonged applause from aristocrats and Surrealists alike; Buñuel quietly disposed of his pebbles.

So taken was Breton with *Un Chien andalou* that he both welcomed Buñuel into the group and inserted the complete screenplay into the twelfth *Révolution surréaliste*, which after a year of sitting on the shelf was finally published on December 15—hav-ing swelled to an outsized eighty pages. This issue, which also turned out to be the last, featured a noteworthy array of material, including paintings by Dalí and the "Inquiry on Love." But by far the most sensational inclusion was Breton's *Second Manifesto of Surrealism*, with its unsparing roster of shame. The text began on page one, illustrated by the lip prints, in red ink and actual size, of the Surrealists' wives and lovers. None of those specifically addressed in the manifesto needed further confirmation that they had just been "kissed off."

The *Second Manifesto* was in many ways a fitting centerpiece to this final issue, for both marked the closing of (as Aragon put it) "a kind of mental year that lasted half a decade." By this time the group and its aims had evolved to such an extent that the "Surrealist revolution" had become less a general rallying cry than a source of confusion and irritation, especially for the PCF. In addition, hardening economic times (culminat-ing in the Wall Street crash that autumn) brought increased difficulties: dependent on donations from its collaborators and distributor Gallimard's sparse goodwill, *La Révolution surréaliste* had lain dormant throughout 1929 for lack of funds. But perhaps more than anything, the inaugural Surrealist periodical succumbed to simple boredom on Breton's part, an urge toward new beginnings that affected virtually all of his actions. One later Surrealist, discussing this trait, observed: "Periodically Breton would get tired of a magazine, even when it was going well, morally speaking. That's why they stopped publishing *La Révolution surréaliste*—what better title could you ask for? But Breton

liked change." This consideration, just as much as financial hardship and the Communists' disapproval, finally closed the book on *La Révolution surréaliste*, and on the first cycle of Surrealism's history.

✳

By year's end, the crisis of the preceding months seemed to be ebbing. The recent purges had been at least partly counterbalanced by new memberships (Char, Magritte, Dalí and Buñuel, Sadoul and Thirion) and a few reunions (Tzara and Crevel, the latter after the exit of his old rival Desnos). But these infusions could not mask the fact that the Surrealist group had grown smaller, and Crevel, for one, was struck by the noticeable diminishment when he began once more attending café meetings. Nor did this relative settling ensure Breton a calmer frame of mind. On December 14, even as the twelfth *Révolution surréaliste* was introducing its readers to the work of René Magritte (who had recently allied himself with the Paris group), Breton nearly caused the Belgian painter to leave the ranks when he exploded in anger against Magritte's wife for wearing a crucifix.

Meanwhile, Breton had not heard the last of those targeted in the *Second Manifesto*. On January 15, 1930, ten ex-Surrealists, plus Georges Bataille and the Cuban writer Alejo Carpentier, responded with an anti-Breton broadside that gave voice to all the fury Breton's text had caused in the dissident camp. In memory of 1924's anti-Anatole France invective, they entitled their sheet *A Corpse*.

The first thing one noticed about *A Corpse* was the large blow-up of Breton in the center, the same photograph (by Boiffard) that had been used for Magritte's "I do not see the [woman] hidden in the forest" collage, now embellished with a bloody crown of thorns: at thirty-three, Breton was being repudiated by his twelve "apostles." The mock-religious imagery was repeated in the texts themselves, as a further slap at Breton's proclaimed anticlericalism, while others made good use of details from Breton's private life. He was "very sensitive," said Prévert:

> over a line in the newspaper, he kept to his room for eight days, and spat, spat everywhere—on the ground, on his friends, on his friends' wives. And his friends often permitted this, being too much in love to protest . . . He was not very sure of himself, he spat on the dinner that was not ready on time, he flew into dreadful rages at the sight of a sardine can, he was lugubriously droll, painful to see but always very dignified.

Morise, whose *entente cordiale* with Breton had since ended, not inaccurately described Breton "magnifying his petty personal affairs and his most banal appetites"; and Desnos, perhaps the most emotionally vulnerable of all, attacked with the ferocity of a jilted lover. Under the title "Thomas the Imposter" (consciously borrowed from Cocteau), Desnos transcribed the "confessions" of Breton's "stinking ghost": "I simulated everything: love, poetry, a taste for revolution. I had a true friend: Robert Desnos. I betrayed him. I lied to him, falsely gave him my word of honor . . . But so much impudence ruined me, and this true but proud friend abandoned me and revealed my slug-like soul."

Printed in 500 copies, *A Corpse* was sold up and down the boulevards of the Latin Quarter, to a public largely befuddled by its violence and ignorant of the underlying quarrels. Many, however, particularly those in the know, were repelled by such a concentrated show of hatred and by the emotional, even juvenile way in which these young men spat their bile. Tanguy, shocked at Prevert's participation, broke with his longtime friend and housemate. Young people who had never met Breton began sending him letters of support. And even *Paris-Midi*, normally no booster of Surrealism, noted in a review: "Without our having a clear idea of what he might have done, the poor André Breton is woefully mistreated."

Although these attacks had clearly been prompted by his own statements, Breton was stung by them. Returning from a brief trip with Eluard to find himself pilloried in *A Corpse,* he sank into a profound depression. He felt abandoned by his friends and, according to Maxime Alexandre, spoke for months of a *"collective suicide* as the most dignified outcome of the Surrealist experiment." It was as if Breton, sustained by the cleansing ire of the *Second Manifesto*, had not stopped to consider that his targets might resent such categorical dismissal or that they, too, might have charges to level against their former leader. Given the same treatment that he had recently meted out, Breton withdrew into a hollow of doubt and anxiety.

Those who remained faithful, notably Eluard, tried their best to provide encouragement. But for the moment, the antagonists had the upper hand. In the early months of 1930, the authors of *A Corpse* supplemented their written invectives with practical jokes: crank calls in the middle of the night, funeral wreaths delivered to Rue Fontaine at dawn, poison-pen letters, threats against the new Surrealists. By March, Breton was at his wits' end, and Suzanne, who was living with him, had become "ill and nervous" over the siege. She again moved out of Rue Fontaine, leaving Breton more demoralized than ever.

Despite their personal tone, however, these vehement attacks were not solely motivated by friendship gone sour. One of the things that Desnos and the others held most against Breton, and that had largely determined the current break, was his insensitivity

to their need for survival. It was one thing to be in one's early twenties, courting public disapprobation and casually enduring the hardships. But most of the Surrealists were now in their thirties; many of them had marriages to support, or at least were tiring of the privations that went with ostracism. For them, to supplement Surrealist intransigence with a small journalistic or cinematic income, or to express their talents in ways not sanctioned by Surrealism, was becoming a necessity. To these dissident Surrealists, it was intolerable that Breton (who, unlike many of them, was still published by the powerful Gallimard organization) should begrudge them the simple desire to live and be heard.

Throughout his life, Breton would complain about various conspiracies of silence around Surrealism. Yet on the one hand he reserved his most scathing comments for those who had sought—or found—a larger audience than the one habitually accorded the movement; and on the other, insofar as his own influence could be exerted, he often practiced the same kind of ostracism of which he accused the press. Not only did a shunned ex-Surrealist lose all contact with his former friends; he was often abandoned by large parts of his audience simply on Breton's say-so. André Masson later spoke of Breton warning, "When you leave Surrealism, you're no longer a painter," and of losing his buyers after Breton deemed him a "reactionary."

Breton's main antagonist during this episode was clearly Desnos, who added to his insults in *A Corpse* still another slap in the form of a newly opened Montparnasse nightclub called the Bar Maldoror. Breton learned of the bar's existence (as always, from the well-informed Aragon) during the afternoon meeting on February 14, and resolved to attack it that very night. It was bad enough that Lautréamont's hero had been travestied into something as "stupid, base, and loathsome" as a dinner-and-dance hall. But knowing that Desnos himself had suggested the name was deemed an intolerable provocation.

At around midnight, a commando group led by the formidable René Char ("not very famous but well built," said one newspaper), along with Breton, Aragon, Elsa, Eluard, Sadoul, Thirion, and the Tanguys, stormed the glass entrance to the Bar Maldoror, even as a private supper was being hosted inside by the Romanian princess Agathe Paléologue. Char lifted the bouncer and literally tossed him aside, smashing several windows and the front door in the process. Breton then strode into the dining room, stamped the floor with his heavy cane, and announced to the astonished diners, "We are the guests of Count Lautréamont!" For a moment the Surrealists seemed to have obtained their desired effect: the formally clad guests fled toward the orchestra or jumped onto barstools, while Breton and Thirion yanked away tablecloths, scattering dishes, champagne bottles, and furniture. But within moments the hardier souls among the revelers rushed forward, and the Surrealists found themselves besieged in turn by fists, bottles, swinging ice buckets, and

flying stools. Char, grappling with the bartender, the waiters, and several of the princess's friends, received a serious knife wound to the leg; and Sadoul, realizing that the entire group would soon be thrown back out the front door, rapidly pulled glass shards from its frame to avoid their being lacerated. "The whole affair ended," *Paris-Midi* reported the next day, "like all Montparnasse brawls, at the police station on Rue de la Gaîté."

If the Bar Maldoror incident ended as something of a military defeat, Breton soon turned it into a moral victory in the *Second Manifesto*, which he amended that month for its forthcoming book publication. Notably, he fired further salvos at Desnos (whom he portrayed as a pitiful drunk), particularly stressing his role in naming the bar. "There is, in a negation as vulgar as the association of the word 'Maldoror' with the existence of a cheap bar, enough to restrain me from this time forth from voicing the least judgment as to what Desnos may write," said Breton. The two men would have no further contact.

Breton, however, had one last riposte for Desnos and his fellows, a promotional leaflet for the upcoming *Second Manifesto* composed entirely of their own statements. A parody of the "Before and After" format used in advertising, the flyer juxtaposed early quotes by five ex-Surrealists (Desnos, Ribemont-Dessaignes, Limbour, Baron, and Vitrac) with their accusations in *A Corpse* to provide a wittily damning view of the prosecution. Desnos's, for example, went:

BEFORE:

Preoccupied with morality, that is with the meaning of life, and not with the observation of human laws, André Breton, by his love of exact life and adventure, once again gives its true meaning to the word "religion."
—ROBERT DESNOS, *Intentions*

AFTER:

And the final vanity of this ghost will be to stink eternally among the foul smells of paradise promised at the certain and not-far-distant conversion of the pheasant André Breton.
—ROBERT DESNOS, *A Corpse*, 1930

Still, while this sufficed for the personal quarrels, it hardly resolved the larger problems facing Surrealism, which extended far beyond the disgruntlement of its former members. If anything, Breton's "Before and After" gave a compressed view of the challenges facing Surrealism as it entered its second decade. The preceding year had been one long death-rattle of the "before." Now, if Surrealism was to rise from its ashes, it was time for Breton to take a more generative road, to forget past disappointments and fulfill the promise of renewal that the *Second Manifesto*, beneath all its polemics and quarrels, had nonetheless managed to make.

IN THE SERVICE OF THE REVOLUTION

(March 1930 – March 1932)

WHEN THE NEW DECADE FLEW IN, it carried like a parasite the turmoil of a widening economic crisis. "Black Thursday" had hit Wall Street on October 24, 1929, beginning its ten-year havoc on the Western world's finances. Even the Surrealists would find themselves affected by what the French soon baptized "*le krach*": Eluard's stock portfolio diminished, leaving him with fewer funds to devote to group projects; collectors acquired and patrons subsidized less lavishly; and the group's already modest book sales became even more so.

Making matters worse was the fact that Breton's relations with Editions Gallimard, his main publisher, had been increasingly tense for the past two years. Various letters from this period show Breton complaining to Gaston Gallimard about his (as he saw it) puzzlingly low royalty statements and about the fact that so many of his books seemed to be out of print—only to be reminded that both royalty statements and print status were commensurate with sales. Apart from two notable exceptions, Breton would not publish another book with Gallimard until well after the next war. Instead, as the economics of publishing worsened and the Surrealists' works moved even further away from the mainstream, he would rely on various small and midsized publishers. Among these were Simon Kra's two imprints, Editions Kra and Editions du Sagittaire, which had published the *Manifesto of Surrealism* and were now preparing to issue the *Second Manifesto*; as well as the short-lived Editions des Cahiers Libres, run by René Laporte; the Belgian house of René Henriquez; and Guy Levis-Mano's Editions GLM.

Breton also began to rely more heavily on the aid of patrons and collectors, who periodically visited his stock of paintings, manuscripts, and rare editions and who in lean times provided desperately needed funds. In the early 1930s, his main collector was a wealthy Belgian perfume merchant and bibliophile named René Gaffé. Gaffé paid elevated prices for the first numbered copy of each of the Surrealists' books and, like Jacques Doucet before him, commissioned the author to annotate the works in question: it is to Gaffé that we owe some of Breton's most revealing marginalia on works ranging from *The Magnetic Fields* to the political pamphlets. Two other notable patrons were the

Viscount Charles de Noailles and his wife, the former Marie-Laure Bischoffsheim, a descendant (several times removed) of the Marquis de Sade. An assiduous patron of the avant-garde, Marie-Laure had persuaded her stodgier husband to back various projects by individual Surrealists throughout the 1920s (as well as by such Surrealist anathemas as Cocteau and Poulenc). In the 1930s, although the effects of the crash would force the couple to support artistic innovation more selectively, many works would still be beholden to the Noailles.

But perhaps the most important new relation for the Surrealists in this regard was with a young bookseller and publisher named José Corti. It was Corti who had agreed to distribute the last issue of *La Révolution surréaliste* after Gallimard backed out, and who helped the Surrealists out of minor financial jams (such as lending Breton sixty francs to keep the gas from being shut off at Rue Fontaine). And it was Corti who provided the Surrealists with a precious resource throughout the economic crisis, by distributing and supporting an ad hoc publishing collective called Editions Surréalistes, a last resort for works no commercial publisher would touch (as was becoming increasingly common). Surrealism's angel investor was hardly risking bankruptcy, however: Editions Surréalistes published its books at the authors' expense or with money raised by subscription. In some cases Corti advanced a little cash, but most often he simply agreed to produce the volume and handle orders through his store.

Despite the twin depletion of the world's finances and the movement's own ranks, Surrealism gave every outward sign of carrying on as before. Twice a day the group met at the Cyrano to discuss current events and projects. Most evenings were spent at Breton's, exploring objective chance or simply playing a game of cards—including one from the Vendée region in which cheating was the rule—to the strains of Offenbach or Dranem. The Luna-Park remained a dependable and inexpensive source of entertainment, as did the movies, especially American serials and the slapstick comedies of Charlie Chaplin ("Charlot" to his French fans) and Buster Keaton (or "Malek").

But the group had suffered serious damage the previous year, and despite its recent memberships and Breton's efforts, it had not recaptured its lost coherency. With so many new elements mixed in with the old, there was no longer the solidarity that came with shared experience and evolution. Moreover, the veterans of Surrealism's early days were no longer obscure young rebels, bound together by the same hunger, but in many cases artists who were developing their own renown. In particular, Aragon's 1928 *Treatise on Style* had become a *succès de scandale*, winning its author overnight fame; while Eluard, on the strength of *Capital of Pain* in 1926 and *Love, Poetry* in 1929, was widely considered one of the premier poets of his generation, quite independently of—even despite—

his activities as a Surrealist. (With some bitterness, Breton later remarked that "Eluard was the only one of us for whom the critics, for some time, had had only praise.") Among the painters, Ernst, Tanguy, and Dalí were beginning to command noteworthy audiences, encouraging a turn toward individual creation and away from group cohesion.

Finally, the Surrealists themselves, now well into their thirties (midlife for their generation), showed many of the responsibilities, strictures, and trappings of adulthood. Gone were the dandified monocles, cigarette holders, and narrow-cut suits of their youth, replaced by more solid flannels and tweeds—and in Breton's case, a "proletarian" leather coat that became his standard attire until the next war. Many in the group were married or involved in stable relationships. Max Ernst was living with Marie-Berthe, and Aragon with Elsa. Péret, after a peripatetic sexual life, had married the singer Elsie Houston in 1927 and temporarily moved to Brazil, where he would father a son named Geyser (a compromise choice, as he had been denied permission to name the boy Deserter). And Tzara had married Greta Knutson, a Swedish painter whose dowry had financed the couple's elegantly furnished townhouse in Montmartre, designed by the Viennese architect Adolf Loos. Others had professional obligations that limited their availability. And Dalí was absorbed by Gala and his own obsessions—although he would still manage to become one of Surrealism's main contributors during this period.

Breton, demoralized by the group's disarray and the recent attacks in *A Corpse*, became still more despondent as his personal situation worsened. His relations with Simone had hit a new low over the past year, to the point where he had to disguise his handwriting on letters to her so that she wouldn't destroy them unopened. What she found inside the envelope, in any case, tended to be cold and bitter that spring.

Suzanne, meanwhile, even though she had again left Breton in March, stayed just close enough to be a constant torment. Disheartened by her latest flight, Breton developed a crush on a young dancer from the Moulin Rouge named Claire, and within two weeks of Suzanne's departure had installed her at Rue Fontaine. At twenty years of age—fourteen years younger than Breton—Claire had enough youthful blush, and at least the illusion of innocence, to satisfy Breton's need for a simple and undemanding relationship. For her part, Claire seems—at least for a time—to have been dazzled by her older lover's accomplishments and friends. Marcel Duhamel remembered her, "thin, blond, with large eyes and not very pretty," clumsily executing a dance of the seven veils for the Surrealist group one evening at Rue Fontaine.

No sooner had Breton taken up with Claire than he left Paris for a visit to Avignon, registering at the Hôtel Régina on March 20. He was joined soon after by Char, Eluard, and finally Claire herself. The group toured the Vaucluse and visited Char's ancestral

grounds in nearby L'Isle-sur-la-Sorgue. Meanwhile, the three men wrote poems: at the café, while walking along the road or driving in the car (the handwriting on the manuscript is often quite wobbly), touching pen down on paper with the lightness of migratory birds. What makes these poems so wholly representative of the Surrealist ethos is not only the casualness of their composition but also their inextricably collaborative nature: like extended Exquisite Corpses, many of them were composed by all three authors, each taking up where the other had left off. Thirty short texts, ranging from three to twenty-five lines each, were written between March 25 and March 30. In keeping with the off-hand method of composition, the collection's general title was suggested by chance during a car ride along the Durance River, when they saw a sign warning of road repairs ahead: *Ralentir travaux* [Slow Under Construction].

And yet, despite their multiple authorship, these poems show a striking concordance of tone and theme. Almost without exception they are pervaded by distress, and many of them make hidden or explicit reference to love's impossibility: it was no coincidence that both Breton and Eluard were suffering withdrawal from intense love affairs when they wrote *Ralentir travaux*. One of the collection's most haunting poems shows just how close the dialogue was between the two: "I hold in my arms women who want only to be with another / Women who in love hear wind crossing the poplars / Women who in hate are taller and slimmer than praying mantises," wrote Breton, to which Eluard added: "And I held in my arms apparitions under the mark / Of ashes and loves newer than the first / That ever closed my eyes my hope my jealousy." At the same time, and despite the overall sadness, the odd collisions of one poet's thought against another's —sometimes in mid-line—give these poems a deceptive buoyancy, pulling the reader through them with such speed that their violent impact isn't felt until much further down the road. The completed manuscript of *Ralentir travaux* was then given to Char's local printer, and the book came off press on April 20 in an edition of 300 copies, bearing the colophon of Editions Surréalistes. Critical reception was slightly more extensive than usual for such a limited printing, and, on the whole, favorable.

By the time the reviews appeared, one witness to the book's creation had vanished from Breton's life. Claire returned to Rue Fontaine with Breton in mid-April, only to pack her bags again several days later, offended that he hadn't let her participate in *Ralentir travaux* and exasperated by his insistence on treating her as a child-woman: she had left her own childhood too recently to play her lover's nymphet.

With Claire gone, and still under attack from the *Corpse* faction, Breton tried leading the fast life with Sadoul at the Bois de Boulogne, the mecca of prostitution; or at cheap vaudevilles featuring nude dancers. "Everything's gloomy," Eluard wrote Gala in April.

"Breton's at the end of his rope. Since Suzanne left, he's been going with a dancer from the Moulin Rouge, who left him yesterday. They're all pricks and bastards, all of them." Eluard himself soon found a release from his own amorous despair when on May 21 he picked up a beautiful, impoverished Alsatian waif named Maria Benz, who was wandering the street in a state of near-starvation. Almost immediately the couple began living together, and before long "Nusch," as she was nicknamed, became the second great love of Eluard's life. But Breton was not so favored.

In an attempt to cheer Breton, Eluard and Aragon, along with Nusch and Elsa, took him to spend a weekend in the country, in a quaint wooden inn near a lake. But if anything, Breton must have felt even more disheartened in that romantic setting, surrounded by the happy couples. A photograph taken that weekend shows Nusch happily clinging to Eluard, who hugs a dog; a contented Aragon sagely resting his hand on the contented Elsa's shoulder; and standing behind them all, doleful eye staring past the camera, a solitary Breton.

At Breton's request, Eluard also helped draft a collective statement of support for the *Second Manifesto of Surrealism*. "The SECOND MANIFESTO," it proclaimed, "is the surest way to appreciate what is dead and what is more living than ever in Surrealism . . . In this book, André Breton . . . sums up the rights and duties of the mind." The text was inserted into the book version of the *Second Manifesto*, which Editions Simon Kra published on June 25, 1930, in a deluxe edition of 110 copies. (A larger trade run was put on sale in November.)

In both financial and psychological terms, the book came none too soon. Breton at this time was facing ever-worsening hardship, which only added to his overall discouragement that spring. During these months, he had staved off ruin with sales to collectors: 10,000 francs for the first deluxe copy of *The Magnetic Fields* to René Gaffé, with special binding and manuscript documents; 13,000 for one of his favorite Chiricos, *I'll Be There . . . The Glass Dog*. Now royalties from the *Second Manifesto*, however modest, would help keep the wolf at bay a little while longer.

The *Second Manifesto* garnered extensive coverage, although many reviewers tended to answer the spleen Breton had vented in the text with some irascibility of their own. *La Nouvelle Revue Française*, while it admired the philosophy, deplored all the infighting as "too obvious an attempt to demolish rival periodicals." *Le Crapouillot* seized the opportunity to needle both Breton and his detractors: "The time it has taken [the ex-Surrealists] to notice that their chief was a bastard . . . doesn't seem to speak particularly highly for their perspicacity." And *Le Mercure de France* limited itself to the insightful gloss that the *Second Manifesto* was "written in the style of a manifesto."

More substantial, and harsher, criticisms were raised by the Communists. "Claiming to view the problems of love, dreams, madness, art, and religion from the same angle as revolutionaries do, [Breton] has the gall to write that 'prior to Surrealism, nothing systematic has been done in this direction,'" wrote Henri Barbusse's newspaper, *Monde*. "It would be an easy thing to confound the author of these lines and to prove his ignorance of Marxist literature in Europe. But this would mean ascribing far too much importance to a joke that barely means anything anymore." And the Surrealists' former ally Jean Bernier, at one time the editor of *Clarté*, dismissed Breton's "flirt with the Third International" as a poor attempt to save Surrealism from neglect, and objected to his efforts to define Surrealism's philosophical positions "as if he were Einstein or Freud."

Some critics had more positive things to say, notably Léon Pierre-Quint (who by a noteworthy concordance of interests was also Simon Kra's business partner). But whether the critics praised or blamed, whether they set their sights on Breton's polemics or on his politics, everyone seemed to recognize that Surrealism had definitely taken on an ideological cast; while its lyrical side, the Surrealism of *Nadja* and *The Magnetic Fields*, seemed to be receding further into the background.

This ideological turn was reinforced that same month by the appearance of a new magazine, which replaced the "Surrealist revolution" with a movement now willing to put itself "in the service of the revolution." *Le Surréalisme au service de la Révolution* (or *SASDLR*, as the mouthful of a title was abbreviated) debuted in July, and at first glance was far more austere than its predecessor: in place of the glossy orange cover, *SASDLR* used plain white stock, with a sober, pea-green label bearing the title and a mysterious coat of arms whose blazon symbolized the very rare "conjunction of Uranus with Saturn, which took place from 1896 to 1898"—the conjunction that presided over the births of Breton, Aragon, and Eluard. The new publication was not quite so sober as it appeared, however: for one thing, the cover had been printed with the "radiana process," which when exposed to light caused title and blazon to glow in the dark with an unearthly green pallor.

The first issue included writings by Surrealism's current roster, who now devoted their combined talents largely to political or polemical issues: no dream narratives, no automatic texts, no poems, and little in the way of personal prose. From the very first page the tone was set by a telegram from the International Bureau of Revolutionary Literature to Breton: "PLEASE REPLY FOLLOWING QUESTION WHAT YOUR POSITION IF IMPERIALISM DECLARES WAR ON SOVIETS STOP," and the Surrealists' response:

COMRADES IF IMPERIALISM DECLARES WAR ON SOVIETS OUR POSITION WILL CON-
FORM TO DIRECTIVES THIRD INTERNATIONAL POSITION OF MEMBERS FRENCH
COMMUNIST PARTY

 IF YOU JUDGE BETTER USE OF OUR FACULTIES IN SUCH CASE WE ARE AT YOUR
DISPOSAL FOR SPECIFIC MISSION REQUIRING ANY OTHER USE OF US AS INTELLEC-
TUALS STOP . . .

 IN CURRENT SITUATION OF UNARMED CONFLICT WE BELIEVE POINTLESS TO
DELAY PUTTING OUR PARTICULAR ABILITIES IN SERVICE OF THE REVOLUTION

The statement of support was meant to be rousing, and to show the Communists yet again that the Surrealists were revolutionaries in good faith. And to the extent that they knew about it, Breton's telegram was indeed "welcomed by the Russian Communists, who staunchly believed that the powers were preparing a war against the USSR."

But in fact, this commitment, and all the magazine's revolutionary ardor, were more the product of heated enthusiasm than of mature reflection. Whatever his promises to the Soviets, Breton did not intend to abandon Surrealist activity. "Despite our desire . . . to affirm our absolute and unconditional solidarity with the proletarian cause, the Surrealist experience nonetheless continued with total independence," he later acknowledged. For one thing, allegiance to the revolution did not prevent him from accepting financial support for *SASDLR* from Viscount Charles de Noailles, who in return kept the original manuscripts. Nor had Breton renounced his criticisms of the Soviets' French branch office. The economic crisis, and the rising influence of fascism in Germany and Italy (as well as of reactionary policies at home), had led to a drastic hardening in the Communist Party line, away from ideology and in favor of industrial and economic concerns (the so-called Third Period). Moreover, as the Stalinists were waging open battle against the Trotskyist opposition, which was mainly fueled by intellectuals, a marked anti-intellectualism and stiffening of internal discipline now characterized the PCF. Given the political realities, there was little here to suggest that Surrealism could put itself in the service of this particular revolution for very long.*

One indication of this came in Breton's main contribution to the first issue, an homage to Vladimir Mayakovsky entitled *"Lyubovnaya lodka razbilas o bit"* [Love's Boat Has

* As a magazine, Breton long considered *SASDLR* the "richest" of all the movement's periodicals, the one in which "Surrealism burned with the most intense flame." But the richness came from the combination of talents and material, rather than from any efforts to hew to a political line. The new title, in fact, which was apparently suggested by Aragon, was never entirely to Breton's liking: he had trouble accepting its implications of servitude and considered it "an appreciable political concession."

Smashed against the Daily Grind]. The Soviet poet had committed suicide on April 14 at the age of thirty-six, after having been denied a visa to join his émigrée lover in Paris. Deeply moved, and angered by attacks against Mayakovsky in both the leftist and the conservative press, Breton pleaded for an understanding of the poet's tragedy. For him, Mayakovsky's torment had stemmed from the frequent incompatibility of ideological commitment and romantic passion. It was a torment to which Breton himself was particularly sensitive, and his assertions in the essay seem to derive more from his own feelings about Suzanne than from his knowledge of Mayakovsky's circumstances:

> It goes without saying that the situation of women in contemporary society leads the most physically favored among them to, at the very least, undervalue revolutionary action . . . In addition—and will Socialism have any power to change this?—they have an inborn horror of anything that is not done strictly out of love for them. Will these unfortunate attitudes result in bona fide revolutionaries avoiding such women at all costs, and taking refuge, when they need love, far away from them, in a world of triviality and disgrace?

What Breton did not mention in his article—what he perhaps didn't know at the time—were the other reasons behind Mayakovsky's suicide: the backlash against his work by hard-liners in the Cultural Ministry, the poet's depression over Soviet bureaucratization. Instead, he concentrated, as he had in his review of Trotsky's *Lenin*, on his subject's moral character, the *tone* of his suicide: "Now that Mayakovsky is dead, we refuse more than ever to sanction this undermining of the spiritual and moral stance he had taken," Breton concluded. "On this score, let no one expect us to make any concessions." Despite its title, *Le Surréalisme au service de la Révolution* was showing a very definite independence of mind.

In the summer, after another brief appearance, Suzanne again left Rue Fontaine, this time to take shelter at Lise Deharme's house in Saint-Brice. Furious, Breton accused Lise of having incited this latest break and charged that the two women were plotting against him. But Lise—although she in fact believed that Suzanne had never really loved Breton and was only using him as emotional blackmail against Berl—had merely offered hospitality.

To make matters worse, a number of Breton's friends (like most of Europe) were on

vacation, leaving him stranded in Paris. At the end of July, Aragon told an absent Eluard, "I'm fighting against André's pessimism as best I can . . . The women are not very encouraging, I won't even tell you what he's been through in that area. You can imagine and you can't imagine. And it's complicated by the fact that he feels very alone [and] thinks everyone has forgotten him . . . He's started talking about suicide again."

Whether the result of intuition or planning, it was at this moment that Breton began receiving warmly inviting letters from a woman who had been waiting in the wings for several years. Valentine Hugo (née Gross) was born in Boulogne-sur-Mer on March 16, 1887, into a cultivated and comfortable milieu. A whimsical, impressionable child with a taste for magic and adventure stories, she had by this time matured into a successful painter, designer, and illustrator, transmuting her literary tastes into a romantically imaginative, soft-focus visual style. Valentine had also hosted several artistic salons, and at one time or another had befriended many promising representatives of modernism: Picasso, Proust, Ravel, Diaghilev, Stravinsky, Poulenc, her onetime lover Edgard Varèse, Gaston Gallimard, Max Jacob, Valéry, and her intimates Erik Satie and Jean Cocteau. She had married fellow artist Jean Hugo, Victor's great-grandson, in 1919; but the couple had by now drifted into separation, pending their divorce in 1932.

Valentine had first met Breton during the war, when the young army medic had attended some of the poetry readings she hosted. But her fascination with him—which rapidly became an obsession—seems to date from March 1926, when she saw Breton at the Galerie Surréaliste opening and where Breton first introduced her to Eluard. She later described Breton that evening as "very tall, thin, nervous and slow at the same time, with a large face that was both soft and harsh, blue eyes that were both tender and hard." He and Eluard struck her as "young . . . handsome and proud of their exhibit, which moreover was magnificent." At a time when Valentine was beginning to rebel against the restrictive, passionless trappings of the Hugo lineage, the nascent Surrealist explosion left her dazzled and hungry for something new.

Following the gallery opening, Valentine had dreamed she saw Breton's face coming down the stairway, "white as ivory" and staring fixedly at her, which so terrified her that she awoke with a start. He had appeared to her several times after that, always with the same supernatural aura: "his eyes shone in a night sky," her husband recalled, "or else a beam of light projected from his face, a crescent moon with its horns turned earthward." But the flesh-and-blood Breton had offered no encouragement to the woman's tentative advances, and Valentine had settled for occasional meetings with him in the intervening years, as well as for a close friendship—and likely a brief sexual liaison—with Eluard. In 1930, however, as her marriage reached its end, a solid resolve took hold of her, and

Breton began receiving long missives in a flowery hand, their fine blue stationery and fashionable return address bespeaking the writer's patrician status.

Initially, Breton's reaction to these letters was primarily bemused annoyance. He rejected Valentine's admiration as misguided, seeing it as the whimsy of a bored socialite. "You must be aware, Madam—you who see me—that I live almost in darkness," he answered one of her early entreaties. "For the past ten years, it's true, almost all the daylight that remained in me has faded . . . Please believe me, today I am able to get along only with three or four other hoodlums like myself (and even then, only on the grounds of 'evil'!), and with a few denizens—once again—of the streets. With you, I could not be myself." Later that summer, in response to another letter, he questioned whether "it is really to me that you are writing, or to one of those roving personifications who assume this or that name in a dream."

In his own archly courteous way, Breton was sending out a *noli me tangere* to a woman whose life and attitudes seemed diametrically opposed to his own. And in fact, the terms Valentine used in her letters—as well as her many drawings and paintings of Breton, which highlighted soft features and a gentle gaze utterly absent from photographs of him—suggest that she viewed the man with somewhat rose-tinted spectacles. One longtime friend called her "a ribbon around the bomb of Surrealism," a description that was all too apt. Valentine saw in Breton the author of *Nadja* and the prospector of marvels, but seems to have ignored the dark-hearted iconoclast that cohabited with him; and while she admired his polemical writings and stances, and even adopted some of them out of empathy, she was clearly seduced by her vision of a tender and exalted love-prophet hiding beneath the "bad boy" exterior.

Not surprisingly, Breton rebelled against Valentine's feminizing view of him, as well as against her entire social background. He feared that accepting her friendship could only lead to his becoming an exotic showpiece for the upper crust, a tamed lion. No doubt he was also dissuaded by the woman herself: at forty-three years of age, Valentine Hugo was nine years Breton's senior (a sore point: she carefully hid her driver's license to keep friends from seeing her birth date), and was elegant rather than beautiful. The long, graceful neck that in her youth had earned her Cocteau's nickname "the Swan of Boulogne" had become less so with age; the smiling lips and "piercing, darting" eyes had become a bit pinched. Photographs of her at this time also reveal a sartorial and facial primness—cloche hat, sober neckline, disciplined curls—that, while belied by the ardor of her passion for Breton, could scarcely have appealed to a man more at home with chorus girls, working-class demimondaines, and child-women.

In addition to which, Valentine's letters began taking on a worrisome intensity, and

by late summer were being written, if not necessarily mailed, at the rate of several per week. The elegant handwriting became more agitated, lines of prose scattered in all directions, and the tone often bordered on hysteria. "I'd like to know why I've been so haunted for so long," she wrote on August 25. "I hate everything I appeared to love. I'd happily skin the whole world alive to know just a little of the truth about all this." A number of letters from this period are heartrending in their distress; many of them have been slashed into pieces as if with a razor, then carefully taped back together—all in all, not likely to attract a man made frankly uncomfortable by naked instability. For all this, however, Breton did not entirely shut the door on Valentine. Even in his early replies, he palliated his rebuffs with "the idea, which I haven't yet expressed, that someday I might dare turn to you for moral support."

In hopes of hastening that day, Valentine began courting Breton's favor in every way possible. She annulled her longstanding friendship with Cocteau, bought a Chirico that Breton admired, and attended several Communist Party cell meetings. She befriended, and financially aided, a number of Surrealists, including the Dalís, the Ernsts, Char, Crevel, and Tzara. She gave money to Surrealist projects and, following Breton's example, jotted down and illustrated her dreams with what one critic called "entomological precision." She sent Breton little gifts, including a succession of exotic ferns, and abundantly praised his latest writings.

The result was enormous ambivalence on Breton's part. Even as he warned Valentine: "Do you begin to see the night to which I belong, and how, whether I like it or not, it is kept apart from your *daylight*?" and refrained from giving in to her advances, he began occasionally accepting invitations for intimate dinners at her Rue Vignon apartment—and then breaking them at the last minute, leaving the woman more distraught than ever. Consciously or not, Breton was replaying with Valentine the same teasing hesitations that Suzanne had shown toward him, engendering in her the same confusion and desperation that *he* had felt earlier—even as he finally began to recognize that his relations with Suzanne were nearing an end.

Suzanne herself appears to have resurfaced in the fall, but only briefly, and seemingly for the last time. In October, after her visit, Breton confided to Valentine, "I can . . . expect from a woman only her love. I can offer her only my own. And, sadly or not, I have fallen in love—and, I believe, been loved . . . And yet it's certainly over and done with, in all honesty I don't want it to start up again—what would be the point? Where would it go? There's no doubt that everything would only get worse."

Still, despite this certainty, Breton continued to elude Valentine, although he tactfully blamed their incompatibility not on the woman herself, but rather on "a certain social

distance that apparently separates us, and that I take into account, whereas you clearly don't wish to . . . Which puts me on guard, for your sake and mine, against certain demands, external to you, and to me, made by life as it is lived in 1930 in France, and which are absolutely not the same for you as for me." Ever courtly toward the "fair sex," Breton tried to spare the lovesick woman's feelings—even as he made sure not to close a door that he might someday wish to open.

Shortly before this, in August, Breton had made his annual visit to Lorient, alone. He returned at the end of the month to find Eluard living in a studio at 42 Rue Fontaine, two flights up from him. While on his own vacation, Eluard had received word from Gala that she wanted a divorce, a request that not even Nusch's adoring presence had made more palatable. Depressed in turn, he had returned to Paris and removed his effects from the apartment on Rue Becquerel (which Gala had previously allowed him to use in Dalí's absence). The late August heat found the two friends sharing the same address and the same love sorrows. (Eluard, moreover, as Valentine's confidant, heard not only Breton's laments about Suzanne but also Valentine's about the elusive Breton.)

At a loss, the two men passed the time and outwitted their pain by collaborating on a written text. One of Surrealism's best-known works, *The Immaculate Conception* lies midway between poetry and manifesto. On one level, the book is a series of prose texts describing mankind's various creative impulses. But as the title suggests, its aims are not only literary but ideological and philosophical as well: at once an implied attack on Catholic dogma and the moral strictures it entails, and a practical attempt at rectification, at defining a creative process (in one critic's words) "devoid of literary original sin"—sins that include social conformity and concessions to literary success.

Like a treatise, *The Immaculate Conception* is divided into sections. The first of these, "Man," sets out to explore the stages of human existence, from conception to death. The section's overall atmosphere, which melds cool irony with accents of passion, and which allows startling imagery to surge forth at any moment, often yields examples of automatic writing at its finest. The third section explores other concepts dear to the Surrealists, most notably in the chapter called "Love," a rewriting of the *Kama Sutra* that replaces the standard variations with thirty-two other positions. (Breton's contributions include: "When the man lies on top of his mistress, who entwines him with her legs, it is the *Virginia Creeper*"; and, "When the virgin leans back with her body powerfully arched with her hands and her feet resting on the ground, or even better, her head and her feet, and the man kneels, it is *aurora borealis*.") The fourth and final section, "The Original Judgment," melds the previous three into a kind of Surrealist credo on life and creation. Taking (as did Ducasse's *Poesies*) the form of brief moral maxims, these last few pages

promote an anti-morality that rejects predictability and common consent in favor of sur-
prise, spontaneity, and revolt. Against the then dominant Catholic moral code, and the
society that fostered it, Breton and Eluard set forth their own gospel, one written accord-
ing to Hegel, Marx, Lautréamont, and Freud.

But it is the second section, "The Possessions," that has become the most celebrated:
its five "attempted simulations" of psychotic states (mental debility, acute mania, gener-
al paralysis, interpretative delirium, and dementia praecox) tried to reconstruct the dis-
course of insanity from within—or, as Breton stated in his preface, "to show that, given
a state of *poetic* tension, the normal mind [can] harbor the main ideas of delirium with-
out being permanently affected thereby or in any way jeopardized in its *faculty* of equi-
librium." Prolonging the experiments of *The Magnetic Fields* and the 1916 narrative
"Subject" (which themselves had been inspired by Breton's psychiatric readings), Breton
and Eluard now set out to demonstrate that the boundary between the language of
insanity and that of poetry was at best fluid, if not totally illusory.

Breton's longstanding interest in the relations between poetry and madness, as well
as his distrust of psychiatric categorizations, provided perhaps the main impetus for *The
Immaculate Conception*, but the work also reflected Dalí's latest contribution to the
Surrealist hope chest, a process he would soon dub the "paranoia-critical method." Dalí
later defined "paranoia-criticism" as "a spontaneous method of *irrational knowledge*
based on the critical and systematic objectification of delirious associations and interpre-
tations." He had hit upon the theory when, leafing through some papers, he came across
what appeared to be a face by Picasso. "Suddenly, the face disappeared, and I realized it
was merely an illusion," he said: the "face" was actually a photograph, turned sideways,
of an African hut with men sitting in front of it. Dalí, who tended to view madness as a
kind of ideal state, and who once declared that "the sole difference between myself and
a madman is the fact that I am not mad," immediately recognized in his delusion a
means of bending external phenomena to his own subjectivity.

Just as Dalí was trying to adapt paranoia to suit his own purposes, the authors of *The
Immaculate Conception* sought to re-create the psychotic experience from within, as a fur-
ther means of plumbing the sources of poetic language. On the one hand, these texts read
like poetry of the most striking kind: at times zanily comic (the self-aggrandizing delu-
sions of "acute mania" are especially rich in disquieting humor), at others intensely
ardent ("Thou my great one whom I adore beautiful as the whole earth and in the most
beautiful stars of the earth that I adore thou my great woman adored by all the powers
of the stars . . ."—a passage by Eluard that recalls many of his letters to Gala). On the
other, they form a valuable psychological document, infused as they are with the authors'

most deep-seated concerns. It does not take much imagination, for example, to see traces of Suzanne (or Simone) in Breton's line: "The great thing would be if when one being has deceived another, that person became incapable of picking up a glass without it breaking immediately." It is precisely this strange intertwining of real and simulated experience, of consciousness operating on several levels at a time, that makes this both one of the richest and one of the most disorienting works in Breton's opus.

So disorienting, in fact, that no publisher would go near it, and the book appeared with the colophon of Editions Surréalistes. Even then, José Corti agreed to print it only on condition that the authors raise the necessary 25,000 francs; thanks to Charles de Noailles and the willing purse of Valentine Hugo, who paid Corti 15,000 francs for the original manuscripts, the book was finally printed. On November 24, within two months of its completion, *The Immaculate Conception* was published in an edition of 2,116 copies. That evening, the two authors, along with several others, feted their publication day by holding another "inquiry on sexuality"—during which Breton, perhaps with his recent benefactress in mind, declared that he could not "sleep with a woman I don't love or don't think I love." Valentine, sadly for her, was not present to heed the warning.

Instead, she doggedly pursued further ties with the Surrealists, and in particular vehemently joined them in defending Luis Buñuel's new film, *L'Age d'or*, against conservative public opinion. Like *Un Chien andalou*, this had begun as a collaboration between Buñuel and Dalí, although fundamental differences (notably Dalí's love of the "splendor of Catholic myths" versus Buñuel's complete disdain of them) had soon alienated Dalí from the project. The end result, finished by early fall, was one of the most scandalous films ever made: virulently anticlerical and antimilitary, scathing in its portrait of bourgeois society (in a way that put most other social critiques, past and future, to shame), and flagrant in its disrespect for every commonly accepted virtue, *L'Age d'or* spared nothing except, as an admiring Breton put it, "love in its most carnal aspects [and] freedom pushed to the point of delirium." In the course of its sixty-minute running time, invalids are kicked, governments and clergy ridiculed, and a child casually shot to death by his father. The heroine performs fellatio on a statue's big toe, then exchanges French kisses with an avatar of her own father. And in the famous closing sequence, characters from Sade's *The 120 Days of Sodom* emerge from a castle after having tortured a young girl to death—their leader being none other than Jesus Christ.

L'Age d'or started its public run on November 28 at the Studio 28 cinema in Montmartre, on a bill with two comic shorts and a cartoon. Wishing to ensure that the film's subversive intent would not go unnoticed, the Surrealists had turned the screenings into a kind of demonstration, complete with polemical program notes and, in the

cinema lobby, provocative canvases by Arp, Dalí, Ernst, Miró, Man Ray, and Tanguy. The message was loud and clear, and this time the response was not only verbal: on December 3, less than a week after the premiere, two ultra-right groups calling themselves the "Patriots' League" and the "Anti-Jewish Youth League" invaded the Studio 28 during a showing, spattered the screen with purple ink, destroyed projection equipment, smashed the seats, threw stink bombs and tear gas, attacked patrons with blackjacks, and lacerated the paintings, books, and magazines on display. "In that theater," said Breton, "one could visually measure the depth of the abyss that separated us from the 'right thinkers,' or those who claimed to be such."

Within days, *L'Age d'or* had become a cause célèbre on both sides of the political fence. While *L'Humanité* tried vainly to defend it, the right-wing press and certain politicians, incensed by the film's anarchistic and sacrilegious bent, demanded its withdrawal; and the anti-Semitic papers (evidently oblivious to the fact that it had been made by two Spanish Catholics) fulminated against "those gentlemen of the synagogue." Even the normally restrained *Le Figaro* was beside itself with rage: condemning the film as "a Bolshevist attempt of a peculiar kind, yes, truly peculiar, that aims to eat away at us," it called upon Police Commissioner Chiappe to make "a clean sweep! You can do it. You must do it."

On December 11 city officials banned the film and confiscated the two available prints; although *L'Age d'or* soon became a staple of French cinémathèques, the ban on commercial showings remained in effect for the next fifty years. Moreover, the uproar it had caused was so great that Charles de Noailles, who had financed the production, was threatened with excommunication from the Catholic Church and, perhaps even more damningly, was made to resign from the prestigious Jockey Club. He was also denied a permit for another film he had financed, Jean Cocteau's otherwise innocuous *The Blood of a Poet*, which had to wait more than a year before it could be released. For the Surrealists, it was a small measure of unexpected consolation.

One of those who could not be present either for the publication of *The Immaculate Conception* or for the *L'Age d'or* affair was Aragon, who had left with Elsa for the Soviet Union at the end of the summer. The reasons for the trip were complex: in part it had to do with the couple's financial difficulties (they were living mainly on income from homemade necklaces that Elsa fabricated and that Aragon shopped door to door to the large fashion houses); in part with Elsa's desire to comfort her sister, Lili, Mayakovsky's ex-

lover, after the calamity of the poet's suicide that spring; and in part with her wish to show Louis off to friends and family back home. By mid-August the couple had saved enough money to book passage to Moscow.

Aragon was growing increasingly aloof from the Surrealist group, as he and Elsa further cemented their union and as Breton continued to veto his novelistic impulses. Most recently, he had undertaken a project subtly titled *Les Aventures de Jean-Foutre La Bite* [The Adventures of Fuckoff Dickhead], but abandoned it after a discouraging word from Breton. He had also tried—ultimately without result—to involve Breton in a joint opera libretto called *Le Troisième Faust* for the film director René Clair, then watched as his friend instead collaborated with Eluard on *Ralentir travaux*. By summer, Aragon was no doubt happy to leave both money woes and group tensions behind.

Aragon was not the only Surrealist traveling to Moscow that year: in early October he and Elsa were joined by Georges Sadoul, who was fleeing a jail term. The previous autumn, Sadoul and his fellow Surrealist Jean Caupenne had found themselves in a café in a provincial town, where they'd noticed a newspaper article listing the entering class at the prestigious Saint-Cyr military academy. Their ingrained antimilitarism bolstered by whiskey, the two had drafted an insulting note to the top-listed student, a certain Keller ("your face is covered with oozing pustules, slavishness, patriotism, shit, and abjectness," etc.), whom they threatened with a "public spanking." Keller had handed the note to the head of the academy, and the two epistlers had been summoned by the police. Caupenne had publicly apologized to Keller in 1930, entailing his immediate dismissal from the Surrealist ranks. But Sadoul refused to retract his statements, or even to appear before the magistrate; in June, despite petitions by the Surrealists and the legal efforts of Marcel Fourrier, he had been sentenced to three months in prison and had spent the next several months dodging arrest. In October, his nerves at an end, he seized upon Aragon's Russian journey (and 4,000 francs from the Viscount de Noailles) to flee the country altogether.

Aragon's trip to the Soviet Union that fall would have a lasting and irreparable impact on the Surrealist group and its orientations. Its constituent elements were Sadoul's "drunken practical joke" (as Breton later termed it) and the desperate frame of mind in which his situation put him; Aragon's increasing resentment of Breton's literary strictures, along with his deepening involvement with Elsa Triolet; and Elsa herself, who encouraged Aragon's independence from the group and who flattered precisely those aspects of his personality that Breton muffled. But none of these would have had such lasting effect had they not been catalyzed by a fourth element: a Congress of Revolutionary Writers to be held in Kharkov, in the Ukraine, from November 5 to 12.

According to Breton, he and Aragon had learned of the Kharkov Congress shortly before the latter's departure. In the event that Aragon was allowed to attend, they had even drafted a "resolution" condemning the newspaper *Monde* and its editor, Henri Barbusse, who had been elected in absentia to the Congress's Presidium, and whom the Surrealists despised for his mealy-mouthed pacifism, limited artistic vision, and vast international renown. (Even his best-selling life of Jesus didn't seem to hurt his standing among the Communists.) But as it turned out, Aragon was not only allowed to attend: owing to a shortage of French participants and to Elsa's connections within the powerful RAPP (Russian Association of Proletarian Writers—the same group that had hounded Mayakovsky to death), he and Sadoul were named official French delegates. He excitedly cabled the news back to Breton, who joined him in seeing it as a sterling opportunity to advance Surrealism's cause in the very birthplace of the October Revolution.

And indeed, in the first days of the Congress, Aragon seemed to rack up point after point, as his telegrams home sounded ever more optimistic notes. With Elsa as interpreter, he exercised his infallible eloquence on the assembly. He elicited favorable responses to *Le Surréalisme au service de la Révolution* (copies of which he'd had rushed to him), and even of its jabs at the PCF. When the Congress created an International Union of Revolutionary Writers, he was named to its board, and he was all but assured the editorship of the Union's periodical, *Literature of the World Revolution*. Against all hope, he even managed to have the Presidium condemn *Monde* and Barbusse as "instruments of the bourgeoisie." Most of all, he seemed to have convinced the Soviets that their true representatives in France were not the Communists but the Surrealists.

But Aragon, carried away by his apparent successes, had neglected to report some other, less palatable details in his wires to Breton—such as his assurance to the Congress that he and Sadoul were there "not as Surrealists but as Communists" (a sentiment that Breton could hardly have endorsed), or his claim that Surrealism's evolution would inevitably lead to dialectical materialism. He also seems to have defended the Surrealists with scant conviction against attacks by some of the delegates, particularly with regard to "the flagrant errors contained in [the] 'Second Manifesto of Super-Realism' [*sic*]."

In fact, as the Congress progressed, Aragon veered more and more sharply toward the positions of the RAPP, which ultimately was the true policymaker at Kharkov. These positions, with their insistence on workers' literature to the exclusion of all others, reflected Barbusse's general viewpoint far more than they did Breton's, and one would have expected Aragon to condemn them with all due verve. But by mid-November, the author of the anarchistic *Treatise on Style* had undergone a singular evolution: from consummate literary dandy to model proletarian. Caught in the wonderment of this strange

world, so different from everything he had left behind—and encouraged by Elsa, who saw her lover's future much more with the Communist mainstream than with the politically isolated Surrealists—Aragon succumbed to a temptation familiar to many first-time travelers, of wanting to become more native than the natives. Although the effects would not be visible for another year and more, it was during this trip to the Soviet Union that Aragon definitively shed his Surrealist skin.

Moreover, Aragon actually understood little of what was happening at Kharkov. It took little backstage maneuvering by hard-liners to sway the Congress against the Surrealists, and to effectively void Aragon's gains. Forced into a choice between the internationally respected Barbusse and these little-known dissidents, the Congress finally gave its confidence to the former, who was made editor of *Literature of the World Revolution* in Aragon's stead while the resolution against him was annulled.

But the biggest reversal of all was yet to come. In December, shortly before their departure from the USSR, Aragon and Sadoul were handed a letter to sign. If they didn't, they were told, the Surrealists' hard-won access to the Party's cultural organisms would be shut off. Almost point for point, the letter erased any understanding Aragon had reached with the Soviets: it repudiated the two men's criticisms of Barbusse and the PCF, as well as Surrealist activities in general (notably its Freudianism) and Breton's *Second Manifesto* in particular, "insofar as it contradicts dialectical materialism." It also bound them to submit all future work for Party approval. Pressed to choose, Sadoul signed the letter, hoping both to salvage Surrealism's ties with Communism and to win PCF protection should the French pursue the Keller affair on his return. Aragon, his head reeling from "the hallucinatory effect of the intellectual, moral, and political conditions of Russia in 1930," and pushed by both Sadoul and Elsa, followed suit. In the final account, the PCF, far more adept at the game of politics, had scored an easy victory against their troublesome Surrealist critics.

While Aragon stopped off in Brussels on the way back to Paris, Sadoul went to Rue Fontaine to be debriefed. "I can still see the more than anxious expression Sadoul wore on his return, and the painful embarrassment my questions caused him," Breton related. "Yes, everything had gone smoothly; yes, our goals had been met; but . . ." Sheepishly, Sadoul mentioned the letter of repudiation. "So?" Breton asked sharply. "I assume you refused?" Sadoul admitted that they had deemed it better to sign. Recounting the incident twenty years later, Breton observed: "This was the first time that I saw open at my feet the abyss that since then has taken vertiginous proportions."

Then, as soon as Aragon returned, Breton furiously demanded that his errant amanuensis publicly refute the Moscow letter in a counterdisclaimer. Breton hoped that

this new statement, which Aragon stammeringly agreed to write, would both strength-en the Surrealists' internal solidarity and demonstrate their continued goodwill toward Communism. But Aragon had so blandly worded his text that it did neither.

In reality, the "abyss" Breton saw was far wider than he imagined. Despite a brief moment of solidarity over the *L'Age d'or* scandal, by year's end *L'Humanité* was again damning the Surrealists as injurious to the working class. The Surrealists, for their part, and despite lip service to the Communist orthodoxy, continued to arouse the Party's sus-picions with their decidedly unorthodox writings: the second issue of *SASDLR*, for example, had featured a celebration of the sexually deviant Marquis de Sade, an excerpt from the incomprehensible *Immaculate Conception*, and (all too comprehensible) attacks on *L'Humanité* staff members. As Breton saw it, the troubling evidence of manipulation at Kharkov—which had now reached into the heart of the Surrealist group itself—both heightened his own distrust of the Party machinery and made him painfully aware just how fragile the "Surrealist pact" truly was. Still, he stopped short of expelling Aragon and Sadoul (the normal recourse for such a transgression), showing both his sentimental attachment to the two men and his underlying hope that, despite everything, Surrealism could yet make common cause with the PCF.

From the Communist viewpoint, no doubt one of the most objectionable portions of Surrealism's current activity was its promotion of an organization to be called the Association of Revolutionary Artists and Writers (Association des Artistes et Ecrivains Révolutionnaires, or AAER). Breton and Thirion had drafted the Association's charter in the fall, during Aragon's absence. Its goal was to group all artists with revolutionary politics, from strict realists to the most avant-garde, into a Communist trade union that would "safeguard the artist's independence" against the dictates of the bourgeois mar-ketplace. At first, Breton was highly enthusiastic about the AAER, and had postponed the project only on Aragon's promise from Kharkov of eventual PCF help. But the PCF directorate had little interest in sending its intellectuals to gather under a Surrealist-colored banner, and it withheld its support (which Aragon, once back in Paris, did little to raise). In the face of this opposition, Breton's own enthusiasm soon died down: as he was beginning to learn, the bourgeois marketplace was not nearly so formidable an enemy as the very Communist apparatus the AAER meant to serve.

This would become all the more evident a year later, when *L'Humanité* announced the PCF-sponsored Association of Revolutionary Writers and Artists (AEAR), point for point almost an exact replica of Breton's project, even down to the name—except that the Surrealists were neither consulted during its creation nor invited to join. But already in these last days of 1930, the prospects had turned somber enough. "And there you have

it," an exasperated Breton told Eluard in January. "This is where it's all led us—the absurd politics of these past months, the interruption of the magazine, the trip to Russia, the Association . . . the constant underestimation of the Surrealist viewpoint, the humility, the somber idiocy."

Aragon, meanwhile, continued to vacillate between the Party and Breton. He swore that his bonds with the group were "a matter of life and death," and even threatened suicide if the Surrealists didn't take him back. At the same time, there was something forced about Aragon's proclamations of fidelity. His disclaimer of the Moscow letter had practically been extorted from him, and it showed.

Moreover, Aragon, with his newfound political faith, reacted violently to some of the group's more anarchistic tendencies, and in particular to the antics of Salvador Dalí. When that winter Dalí unveiled his latest invention, a dinner jacket studded with shot glasses full of milk, Aragon stridently objected that the wasted milk could have been used to feed destitute children. The "nervous little Robespierre," as Dalí later dubbed him, had changed in the last five years, and he was now finding many of the Surrealists' jokes in poor taste. On top of which, there was no doubt an element of jealousy: Breton, while he continued to value Aragon's friendship, more and more frequently took issue with his statements; whereas Dalí exercised his iconoclastic sense of humor to increasing advantage (even as Aragon seemed to be losing his own sense of humor entirely).

That December, Breton further sanctioned Dalí's advantage by prefacing his book *La Femme visible* [Visible Woman]; in a clear bow to Dalí's paranoia-critical world view, he denigrated "reality" (including Socialist reality) as a "miserable mental expedient." But perhaps the most apt comment on the group at the time came from Max Ernst: a new version of *The Rendezvous of Friends* shows photographic cutouts of the Surrealists splayed in a disjointed collage, facing in different directions and clearly having no contact with each other. At the bottom, a portrait of Breton stoically sinks into black water.

*

"The year 1931 began for me with an extremely somber outlook. My heart was prey to constant bad weather," Breton wrote the next summer. "[Suzanne] was never there any more, nor was it likely that she would ever be there again . . . I have never suffered so much (this is an understatement) from someone's absence." In addition to which, he was dispirited by "the extraordinary difficulty" of making headway with the Communist apparatus. "Nothing had ever been more hotly contested than the sincerity of our declarations in this domain . . . Purely *Surrealist* action, limited as it was for me by these two

sorts of considerations"—loss of love, loss of social efficacy—"had in my eyes, I must say, lost all its most convincing reasons for being."

The discouragement was no mere conceit: brought low by the Communists' distrust, and even more so by what Eluard called "Aragon's flagrant ill will," Breton decided to quit Surrealism once and for all. On January 15, he handed his friends a written resignation. The gesture was inspired by a burst of despair, and Breton soon retracted it at the others' urging. But the crisis had brought to light some underlying conflicts in the group, and—at least temporarily—it left some changes in its wake.

For one thing, the Surrealists began gathering less exclusively in Place Blanche. Against resentment that meetings were always held in Breton's neighborhood, these shifted for a while to Tzara's "relatively neutral" townhouse on Avenue Junot (actually only several blocks away); or to the Café Batifol near the Porte Saint-Denis, a boisterous hang-out of streetwalkers, unemployed actors, and performers from the nearby vaude-villes that Breton described as "a real Court of Miracles."

More importantly, Breton decided to subject all of Surrealism's activity to general critical scrutiny, carefully weighing others' opinions and trying to steer a common course between those—such as Aragon, Sadoul, and Unik—who wanted the Surrealists to start behaving like responsible Communists, and those who pushed for a return to the more lyrical principles of the first *Manifesto*. After much discussion, a compromise was reached in Surrealism's longstanding anticlericalism, which was now adopted as the group's primary focus.

Adding further tension to Breton's life that spring was his chronic poverty. Many times he was unable to buy a book or postage, or even to pay for basic utilities, and more than once he found himself working by candlelight because the electricity had been cut. Some relief came via Eluard, who arranged the auction of his and Breton's African and Oceanic statuettes at the Salle Drouot—a sale that ultimately netted each man nearly 150,000 francs, and that briefly left Breton "high-spirited and changed." But much of this revenue was spent bailing out *SASDLR*, which had sold only 350 copies of its first two issues (about one-third the sales of *La Révolution surréaliste*), and which, like its prede-cessor, was now awaiting funds to pay for the third. Eluard, moreover, sometimes proved too hardheaded for his own (or Breton's) good. When René Gaffé, as was his custom, asked to purchase the first copy of *The Immaculate Conception* from José Corti, Eluard set the price inordinately high, and remained intractable despite Corti's negotiations on the collector's behalf. Gaffé finally bought the book at the requested price, but soon after stopped acquiring Surrealist writings altogether.

It was during this period, too—on March 30—that Breton's divorce from Simone

was granted "with all legal consequences in the wife's favor." Simone retained half the couple's art collection, while Breton kept the Rue Fontaine studio, along with their Skye terrier, Melmoth, and the services of Claire, their housemaid. Although Breton and Simone would eventually settle into a lasting, if distant, friendship, the emotional and intellectual complicity that had once sustained their marriage was gone.

More than anything, however, Breton's depression that spring came from the knowledge that after three years his love affair with Suzanne Muzard had finally reached its end. As always, there had been sporadic reunions during the fall, inevitably followed by fights, tears, and absences—just enough contact to keep Breton from losing hope in an eventual reconciliation. More often, however, Suzanne flaunted her marriage at well-frequented nightspots, and taunted Breton with reports that Berl and Barbusse were successfully conspiring against the Surrealists in the Communist Party, even as she sent him violently jealous letters about the "old bitch" Valentine Hugo. But the situation was untenable, and in January Breton confided to Eluard that this time the break was final.

Thirion later remarked that Suzanne "had been flattered but outdone by [Breton's] position. Versatile, flirtatious, and frivolous, she was always open to flings, but Breton's exclusiveness permitted her only temptation. Breton was too lucid, too intellectual, and too passionate for a woman like her." And Suzanne later offered her own assessment of the problems she and Breton had faced:

> Breton over-flattered his loves; he molded the woman he loved so that she should correspond to his own aspirations and thus become, in his eyes, an affirmed value. But I was only an object of disappointment since I was inadaptable to what he wanted me to be. Too restive, I used to be seized by uncontrollable, fleeting impulses, I was unable to submit to suggested feelings . . . I did not love the man with an eye to a posterity that would place him on a pedestal. That was too high for me, my objective was to seek only emotions within the heart's reach. Love is a trap for lovers in search of the absolute. I was often much flattered, much moved by homages paid to me by Breton in public, but never won over in private by habits that broke the spell . . . I had perhaps the faculty of provoking love, and he had that of inspiring it, without possessing the magical gift of being able to make it last. Our liaison . . . lasted long enough to kill love by inches.

Describing the breakup, Breton told his father that Suzanne had done him "immense, incommensurable harm." But it is not certain that he ever truly recognized the emotional barriers posed by his and Suzanne's incompatible natures. He would for-

ever maintain that they had been kept apart by the capitalist "hypocrisy," that Suzanne's infidelities were the only recourse left her by the iniquitous society in which they lived, that the desperation of her origins and her desire for comfort had forced her back into Berl's more affluent arms, and to some extent this was true. But in the final account, what Suzanne was seeking was perhaps no more complicated than what she expressed many years later: "to love and to prove it, and to be loved and have it proven to me"—something that neither Breton nor Berl, for differing reasons, was ultimately able to offer her. And this part of their dynamic Breton seems never to have understood.

Suzanne continued to drift for several more years, becoming briefly involved with onetime Surrealist Frédéric Mégret. After her divorce from Berl in 1936 she went to live in Tahiti, and during that period met Jacques Cordonnier, who became her second husband in 1940 and with whom she appears to have lived in harmony and fidelity until his death twenty-one years later. After the war she would renew relations with both Breton and Berl via correspondence, forming, at least with Breton, a relatively serene long-distance friendship. In the 1950s, upon her return to Paris, she would even revisit the past by attending some of the Surrealists' meetings, the emotional torture of previous years seemingly long forgotten.

In the spring of 1931, however, Suzanne continued to oppress Breton's mind; and, as during his most discouraging moments with Lise, he translated that oppression into heightened poetic output. Many of these poems reflected the depression of love's end: in one, he spoke of "the crackling / Nameless woman / Who smashes the jewel of this day into a thousand shards." Throughout the spring, Breton wrestled with the failure of his love in line after line of verse, ranging from automatic texts to carefully crafted sonnets. In one marathon performance, from 10 P.M. on May 7 to 3:15 the next morning, he wrote a series of six "genre poems," with titles like "Prophetic Poem," "Scatological Poem," "Poem with Vocabulary," and "End-of-the-World Poem." Perhaps because these texts contain some of the most naked expressions of bitterness and sorrow, they remained unpublished until well after Breton's death. One, aptly titled "Exhibitionistic Poem," spoke of "Women scrupulously torn apart / Women set with men who shine while loving them . . . / Since everything grows cold anyway even lava / Even memories . . ."; and of "the porcupine quills of my name / When it is spoken in the round / In a murmur as if I were still loved / As if I had ever been loved."

But by far the most famous poem to be inspired by Suzanne—and arguably the most famous poem of Breton's entire opus—was "Free Union," which he composed while on vacation in Lyons-la-Forêt on May 20 and 21. A long litany of his lover's physical features in the manner of the Renaissance *blason*, "Free Union" seemed both to conjure up

Suzanne's erotic reality for one final time and forever to etch her body, inch by inch, in Breton's memory:

> My wife whose hair is a brush fire
> Whose thoughts are summer lightning
> Whose waist is an hourglass . . .
> My wife whose buttocks are sandstone and asbestos
> Whose buttocks are the back of a swan and the spring
> My wife with the sex of an iris
> A mine and a platypus
> With the sex of an alga and old-fashioned candies
> My wife with the sex of a mirror
> My wife with eyes full of tears . . .
> My wife with eyes that are forests forever under the ax
> With eyes of sea level air level earth and fire level

Did Breton fear revealing too much? When "Free Union" was published as a pamphlet on June 10, in a limited edition of seventy-five copies, it identified neither author nor publisher. (And in fact, only one reviewer guessed the poem's authorship.) Even among his closest friends, Breton tried to conceal the truth. Aragon later described an outing during which Breton handed him and Eluard a copy of the pamphlet, claiming to have received it anonymously in the mail. "It's rather curious, I'd like to know what you think . . ." Eluard, "bowled over," immediately suggested running a classified ad to find the author; but Aragon pulled Breton aside and asked if he took them for fools. "You recognized me?" Breton admitted. "No," answered Aragon, "but I recognized the woman." (In any case, Breton publicly acknowledged his paternity of "Free Union" by reprinting it in his next collection of poems the following spring.)

Breton's despondency over Suzanne was expressed in various ways that range from an "inquiry on sexuality" of extremely bitter tenor to a juvenile group letter to the Belgian periodical *Le Journal des poètes*: "The Belgian contributors to the Belgian *Journal des poètes* get it suckt [*sic*] every day by the Belgian princess Marichaussée," Breton wrote, evidently not having ransacked his imagination. In dreams, he relived the frustrations and barriers of the past several years. One of these featured a fleeting Suzanne and "an old woman, who seems crazy to me" (Breton interpreted her as representing Nadja, but one might also recognize the mature profile of Valentine Hugo). Viciously hateful, the old madwoman seemed to be hunting Suzanne, whom Breton feared was involved in

"some shady business." He awoke feeling beset by powerlessness and frustration.

Desperate for love, Breton engaged in a series of pathetic exploits, such as betting his friends that he could get "respectable" women to talk to him on the street (five out of the eight agreed to meet him afterward); or offering unknown women a rose, no strings attached—which met with far less success. He also passed through a series of brief infatuations: with a dancer from the Folies-Bergères named Parisette, who demonstrated a cynicism and "freedom of language" worthy of Sade's heroines, and who disappeared from Breton's life as suddenly as she had come; with a sixteen-year-old girl whose glance reminded him of Gustave Moreau's *Delilah*, and who failed to show for their second date; with a young German tourist in a café, who so moved him that he tried to send her a written marriage proposal: "I madly desire to know you," his note read. "If you are unmarried, I ask for your hand in marriage. I beg you." But the woman's watchful husband made sure it was not delivered.

As Breton later recounted, he lived through the month of April 1931 in a state of mental and physical instability, compulsively wandering the Paris streets, prey to the most extravagant interpretations of everything that came before him, as if the openness to "objective chance" had tipped him into ambulatory delirium. A newspaper cartoon about cuckoldry, a woman's name heard in passing, an object in a shop window, a coincidence of dates: everything seemed laden with infinite meaning in his eyes, connected to an endless network of significant autobiographical facts. Once while following a young woman in the street, and although he knew better, Breton mistook Lariboisière Hospital—a massive and lugubrious edifice known in the nineteenth century as a place for dying—for the Maternity Hospital across town: a lapse all the more ironic in that Lariboisière would later be the site of Breton's own death from heart failure.

Despite his sentimental tortures that spring, Breton continued to keep Valentine Hugo at arms' length, leaving the woman dangling between hope and misery, between promises that she would never bother him again and vows that "one would have to kill me for this to finally end . . . I will love you so long as the last particle of myself still knows what love is." In letter after letter, Valentine commiserated, counseled, cajoled, and chided; she reiterated her offers of love and support, approved the Surrealists' stances, accepted (if a bit shrilly) the dying embers of Breton's passion for Suzanne, and tried to understand (often hysterically) why Breton denied her his intimacy. "I'm flaying myself all over trying to understand what I did wrong," she cried out to him in April. Earlier, she had writ-

ten in her diary: "What I have is so great, so beautiful—so miraculous for me—that I'm afraid of losing it—that I'm afraid someone will take it away from me—will destroy it—will put me to sleep . . ."

Restless, finding no consolation in her fading marriage or her courtship of Breton, Valentine left on a series of trips that spring and summer: to the Midi with Max and Marie-Berthe Ernst; to visit Char in Avignon with Eluard and Nusch. Finally, in July, Breton agreed to join her—apparently for the first time—on a long automobile excursion to Brittany with the Eluards. The foursome traveled throughout the Finistère in Valentine's Ford, stopping in Nantes and Quimper, in Lorient to see Breton's parents; then (after waiting out a storm) they moved on to the Ile de Sein, where they were met by Georges Sadoul. There, Breton and Eluard, dressed in sailor's uniforms ("And no one had spoken of making me a naval officer"), posed as corpses for Valentine's camera in the hold of a rusted shipwreck; Eluard shut his eyes in good faith, but Breton's remained slightly open. On the beach, Breton saw a pig playing in the surf. "There's God," he smirked to Eluard. Valentine, not entirely liberated from her Catholic upbringing, piped in: "Indeed, since He's everywhere."

It was toward the end of the month that Breton submitted to Valentine's attentions and the two became lovers. An entry from her diary rhapsodized about "the intense voyage during which your face did not leave me for an instant." Breton himself showed uncharacteristic affection in the ensuing days, and on the morning of July 31 told Valentine, "You are absolutely wonderful (moreover I suspected as much, without seeming to). I'm thinking only of you. I love you." During their travels he took to slipping love notes under the door connecting their rooms. But despite Breton's surge of grateful affection, Valentine was never to be more than a rebound relationship, and his time with her would be crisscrossed with the lightning of resentment and bad faith. As André Thirion observed, Valentine "entered Breton's life by the back door. This adorable, intelligent, inexhaustibly sweet woman was passionately in love with him. He, however, felt merely the emotional and slightly irritated tenderness of a man who is still thinking of someone else and knows that this new woman has lost in advance."

Valentine was nonetheless prepared to make any sacrifice. Later that summer she moved out of her spacious apartment because Jean Cocteau had taken one two floors below. And at Breton's request, she would sell off her beloved piano (Valentine was an accomplished musician) and priceless collection of scores to a waiting Marie-Laure de Noailles. Perhaps most of all, she gamely tried to follow Breton's mood swings and sallies of ill temper; for as she later told an interviewer, her lover "could be both an extremely enthusiastic, seductive, charming youth, and a harsh old judge. It seems to me that in

the years when we traveled together . . . André Breton, from one hour to the next, from one day to the next, could change mood and expression depending on what was in the air. These moods could go from the most beautiful to the most insufferable and back again."

Throughout July the travelers were pursued by rain, which finally chased Eluard and Nusch home and made the Ile de Sein bleak and grey. In early August, Breton, Valentine, and Sadoul traveled back across the mainland to Tinchebray, in one of Breton's rare visits to his birthplace. Then, after a brief stopover in Paris, the same trio, along with Melmoth the dog, set off again toward Provence, where they caught crayfish in puddles and butterflies in green nets, and praying mantises that Valentine carefully pinned to bits of cork. They enjoyed the exotic local delicacy of fried squash flowers, but not the fried flies inside them. During the six-week-long excursion—and always before Valentine's insatiable camera—they also visited the town of Saumane, where the Marquis de Sade had misspent his youth; and Hauterives, site of Ferdinand Cheval's "Ideal Palace," a conglomeration of odd stones, shells, tile bits, broken glass, cement, and iron wire, which a local postman, known as the Facteur Cheval, had fashioned into one of the world's most whimsical architectural monuments. Part Gaudí cathedral, part Temple of Angkor, part grotto, the Facteur Cheval's palace—which Breton was seeing for the first time on the recommendation of the Surrealist poet and filmmaker Jacques-Bernard Brunius—was to become one of Surrealism's privileged sites.

Most of this second trip, however, was spent in the town of Castellane in the Basses-Alpes, which they reached shortly after mid-August, settling into the Hôtel du Levant on the town's main square. While Valentine drove back to Paris to oversee her change of address, Breton and Sadoul staved off boredom by playing the slot machines in the local casino (they lost), analyzing each other's dreams, drinking, going to popular movies, and watching the hotel guests. One guest in particular, a pretty young woman writing poetry at a table, so absorbed Breton's attention that he missed his own table while setting down his water carafe, sending the glass pitcher crashing to the floor. (In any case, such attentions were soon curtailed by Valentine's reappearance.) Sadoul also spent his time avidly reading the Communist classics, which he then passed on to Breton. And the two men discussed recent developments in the group—giving rise to some brief arguments over Sadoul's misadventures in Kharkov.

But mainly, as Breton told Tzara on August 26, he spent his time in Castellane writing "something fairly long in the well-known style of the manifestoes." The book was titled *The Communicating Vessels* (*Les Vases communicants*), after a scientific experiment in which liquids or gases pass back and forth between two joined recipients until they

reach equilibrium. It was Breton's central assertion that dream life and waking life behaved in much the same way as these liquids, that under the proper conditions the human mind could grasp and exploit the "constant exchange . . . that must exist between the exterior and interior worlds, an exchange that requires the continuous interpenetration of the activity of waking and that of sleeping." Although he later repudiated some of the book's materialist terminology, Breton long considered *The Communicating Vessels* "the best of [his] works."

Fully absorbed in his book, Breton spent most of his day writing "at a little rectangular table situated under the exterior arcades of the hotel," working from nine o'clock until noon and from two to seven, while Valentine admiringly looked on. Sadoul later described Breton's writing method that summer: "He spent a lot of time on a single page. He often crossed out the lines of his clear, meticulous, tidy handwriting. Occasionally he would then read us his finished text, which he did not revise again." He finally interrupted his labors toward the end of September, having exhausted both his energy and his stationery supplies. Curiously, given his initial momentum, the book would remain unfinished for nearly a year.

Like *Nadja*, its stylistic predecessor, *The Communicating Vessels* is broken into three parts. The first is composed of painstaking analyses of two recent dreams (including the dream of the old madwoman, mentioned above), in which Breton details the interconnections between oneiric imagery and the preoccupations of his recent life, particularly his depression over Suzanne, who in the book is referred to simply as "X." In the second part, Breton reverses the focus to plumb the twilight state of his diurnal life, exploring—with the same blend of earnest candor and subtle concealment that marked *Nadja*—his abortive amorous encounters of April and the extra-rational interpretations they inspired in him, in a kind of "psychoanalysis of reality."

These parallel accounts, rendered with an emotional force and precision that convey all the author's despair and dogged hope, combine to produce an aura of irremediable sadness. This sadness came not only from the failure and ultimate futility of the exploits he detailed but even more so—as one critic has pointed out, and as Breton himself recognized—from the overarching impossibility of his very endeavor: for he was asking love of women who had none to offer, even as he tried to woo a proletarian readership in language that was patently abstruse. Written under the sign of these twin failures, the first two sections of *The Communicating Vessels* offer what is certainly the most wistful writing of Breton's career.

In the more theoretical third part, however, Breton adopts a fervently critical tone, and even rallies a sense of promise. Blending the book's first two movements in a dialec-

tical synthesis, he calls for a simultaneous revolution in the conscious *and* the uncon-
scious. "The poet to come," he concludes with mustered optimism,

> will surmount the depressing idea of the irreparable divorce between action and
> dream. He will hold out the magnificent fruit of the tree with those entwined roots
> and will know how to persuade those who taste of it that it has nothing bitter about
> it . . . He will hold together, whatever the cost, these two terms of human relation-
> ship . . . the objective consciousness of realities and their interior development.

Although parts of Breton's final argument sound similar to those of the first *Manifesto*,
the difference is that the promotion of dream life is now made *alongside*, not in place of,
waking life. The marvels of the pure dream state, in themselves, are now seen to be just
as incomplete as a purely prosaic view of the quotidian world. It is only by favoring the
constant interplay of the two, Breton says, that a true revolution of the heart, mind, and
world can be achieved.

The difference partly stemmed from the fact that Breton was now defending the
unconscious not only against scoffing bourgeois rationality (as had been the case in 1924)
but also against bullheaded Communist sectarianism. Wishing to convince PCF ideo-
logues rather than rebut them, he argued for a revaluation of irrational thought within
the context of social revolution, and criticized the "totally pragmatic," narrowly materi-
alistic programs of the Third Period as detrimental to any true revolution in human
behavior. "At no price," he wrote, "must we let the loveliest roads of knowledge be
absurdly blocked off or rendered impassable, under the pretext that it is only temporar-
ily a question of hastening the Revolution on its way."

At the same time, Breton took care to distance himself from the "idealistic" aspects of
dream study, and in particular (the Kharkov letter no doubt in mind) the limitations of
Freud's own research—notably its "lack of dialectical conception" and its all too bour-
geois reserve in dream analyses. And he made sure to celebrate the Soviet Union as the
only country to have "triumphed over . . . the exploitation of one class by the other."
Existence, in other words, was no longer "elsewhere," as the first *Manifesto* had put it,
but here in the erupting streets—so long as these streets were made to accommodate the
flux of untamed desire. Breton's confidence in the revolutionary worth of his thesis was
bolstered by the militant Sadoul, who continued to feed his friend reflections from Marx
and Engels, and who enthusiastically greeted Breton's turn of mind. But the
Communists, blind to Breton's nuances, saw his current arguments as being no different
from ones they had been rejecting since the mid-1920s.

Ever hopeful, Breton turned his attention that fall to the ability of *The Communicating Vessels*, and Surrealism in general, to reach a proletarian audience. Back in Paris on October 6, he unhesitatingly assured Eluard that he felt he could adapt his writing style to suit proletarian tastes, "since I don't want to provide any food for thought to the aristocracy and bourgeoisie. I aim to write for the masses." Still, it seemed that every time Surrealists and Communists stepped closer to each other, an impenetrable tangle of rivalries, educational differences, and conflicting priorities sent them jumping back again. This time, however, the conflict would not only make future cooperation virtually impossible, but would result in the shattering of some of Breton's most valued friendships.

The first part of the dispute centered on *SASDLR*, the third and fourth issues of which appeared simultaneously in December. In the main, the seventy-two pages of material featured textbook Marxism: reflections on Hegel, attacks on French foreign and domestic policy, articles on unemployment and racism, and some inoffensive poetry—all except for the final text of the fourth issue, a six-page "daydream" by Salvador Dalí that related in excruciating detail the author's masturbatory fantasy about an eleven-year-old nymphet named Dulita, complete with footnotes describing how Dalí stuffed his foreskin with bread dough to reach orgasm. The appalled Communists immediately protested this affront to morality, the upshot being that the magazine Breton had hoped would demonstrate his commitment to the proletarian cause now drove a further wedge between the two sides.

The second, and more directly consequential, part of the dispute stemmed not from Surrealist immorality, but from Aragon's best Communist rhetoric, in a long and inflammatory poem called "Red Front" that he had written in Moscow the previous fall. In both style and sentiment, "Red Front" was one more concession to Soviet literary policy, a kind of poor man's Mayakovsky; and if it artfully translated Aragon's overheated enthusiasm during his Soviet pilgrimage, on the level of poetry—or even pure propaganda—it showed little of his usual verbal panache. What it did show was Aragon's customary sense of provocation:

> . . . Bring down the cops
> Comrades
> Bring down the cops . . .
> Fire on Léon Blum
> Fire on [Socialist deputies] Boncour Frossard Déat
> Fire on the trained bears of social-democracy . . .
> I sing the violent domination of the bourgeoisie by the Proletariat

for the annihilation of that bourgeoisie
for the total annihilation of that bourgeoisie . . .
Hail to materialist dialectic
and hail to its incarnation
the Red
army
Hail to
the Red
army . . .

"Red Front" had been published the previous April, in the first *Literature of the World Revolution*, but it had gone practically unnoticed. This had not been the case in October, however, when the poem was reprinted in Aragon's new collection, *Persécuté persécuteur* [Persecutor Persecuted]: because of "Red Front," distribution of the collection had been suspended, and all copies of *Literature of the World Revolution* belatedly seized by the police. An official investigation had been opened, and on January 16, 1932, Aragon was indicted for "inciting soldiers to disobey orders and incitement to murder for purposes of anarchist propaganda." If convicted, he faced five years in prison.

By the time of his indictment, Aragon's relations with his fellow Surrealists were again becoming strained. His growing stature in the PCF during 1931 helped revive Breton's lingering resentments over the Kharkov trip and over *L'Humanité*'s renewed hostilities toward the other Surrealists. For his part, Aragon did not appreciate Breton's sniffing dismissal of "Red Front" as "occasional verse." On January 5, eleven days before the indictment, tension was further heightened by *L'Humanité*'s unveiling of the AEAR, the Communist-sponsored artists' union that so closely mirrored Breton's earlier, aborted AAER, but that made no room for Breton himself. Furious at being kept on the sidelines, Breton reminded Aragon of the group's "courage and patience in the face of underhanded maneuvers by certain members of the CP." He also wrote an urgent letter to Jean Fréville, literary editor of *L'Humanité*:

> I feel that I have an obvious place in [the AEAR]. For ten years I have done everything in my power to help bring about such an organization in France and, within the scope of my capabilities, I believe I've succeeded rather well. I have done all I could to expose the counterrevolutionaries, crooks, and even police spies who tried to make such a project impossible. More than ever I am ready to pursue these efforts. I respectfully request that you invite me to your next meeting.

But for the moment, the AEAR, which took its cues from the RAPP in Moscow, declined Breton's services. At Breton's "indignant, pressing, but friendly and cordial" insistence, Aragon wrote *L'Humanité* to protest, but only with great reluctance. With over a year's delay, Aragon's Soviet conversion was taking full effect, and Breton was finding his friendship for his old sidekick wearing thin.

Still, when Aragon was officially indicted on January 16, Breton immediately leapt to his defense. "Whatever my reservations about both the spirit and the form of ['Red Front'], it goes without saying that one issue took precedence in my view," he later clarified. "At all costs we had to save Aragon from legal proceedings and, to do that, to sway public opinion in his favor." The first response was a group tract called *L'Affaire Aragon*, which argued for the defendant's innocence on the grounds that Aragon, as a Surrealist poet, could not be held responsible for the seditious dictates of his unconscious—notwithstanding the fact that he had clearly premeditated "Red Front" from start to finish.

The petition garnered more than 300 signatures by prominent intellectuals, including Matisse, Léger, Brecht, Thomas Mann, García Lorca, Picasso, and Le Corbusier, but many others refused to support it. None, however, rejected the tract more vehemently than the Communists: even as they supported Aragon's "proletarian" poem, they vigorously denounced "the use of this incident by the Surrealist group as a publicity stunt . . . We don't think much of these pretentious intellectuals who won't lift a finger when repression strikes the working classes, but who move heaven and earth when it touches their precious person," *L'Humanité* wrote on February 9.

Indeed, despite the Surrealists' desire for solidarity, relations with the Communists were rapidly deteriorating. In late January, Aragon, Sadoul, Unik, and Alexandre—the four Surrealists who were also PCF members—had been called on the carpet to explain Dalí's notorious "daydream" to a PCF supervisory council, treated to a harangue for belonging to a group of "bourgeois degenerates," and told to sign a document—yet another one—repudiating this gross example of Freudian pornographic perversion. "All you want is to complicate the simple, healthy relations between men and women," one official had screamed at them. Furious at the heavy-handed tactics, Aragon had threatened to take his grievance all the way to Stalin if need be, causing the high-strung official finally to recant. But although he refused to sign this particular repudiation, deep down Aragon himself saw little merit in Dalí's erotic lucubrations, or in Breton's promotion of them. As he confided to a friend, he was now agreeing with the Surrealists "only one day in four."

Meanwhile, hoping to answer his critics on all sides, at the end of February Breton drafted a longer pamphlet called *The Poverty of Poetry: The "Aragon Affair" and Public*

Opinion. He again stressed the dangers inherent in subjecting *any* expression of opinion to legal sanctions; and, while he recognized that "Red Front" was not an automatic poem per se, he argued that all of Aragon's previous work forbade a literal interpretation of its calls to murder. "Who would dare claim that Aragon, in a prose article, would have allowed himself to write: 'Comrades, kill the cops,' when such an order (which moreover has no real bearing) runs counter to the Communist Party's own watchwords?" he maintained. In other words, "Red Front" and its inflammatory imperatives should simply be dismissed as mere rhetoric.

Ultimately, however, *The Poverty of Poetry* was a rather confused statement, showing Breton's discomfort at having both to affirm the revolutionary significance of poetry as a whole and to deny "Red Front" any political effectiveness by virtue of its being a poem. For Breton to downplay the subversive intent of "Red Front" meant coming dangerously close to the "art for art's sake" position that Surrealism had always refused. And in fact, his explanation of this all too apparent contradiction—that "we never have stopped attacking such a conception and demanding that the writer and the artist play an active role in the social struggle"—seemed ready-made, a matter of faith rather than proof. Not surprisingly, the tract left most readers as dissatisfied as they had been with *L'Affaire Aragon*.

Aragon in particular seems to have disliked *The Poverty of Poetry*, feeling that Breton's defense undercut his will to become the voice of the Revolution. For him, this was simply another instance of a literary rivalry that had dogged the two friends from the beginning, and that had manifested itself in ways as various as Breton's interdiction of novels (a form at which Aragon felt he excelled) and his sarcasms over Aragon's facility with writing. And in fact, while Breton was clearly motivated by friendship to save Aragon from prosecution, he clearly took a certain pleasure in exonerating "Red Front" on the grounds of its being "poetically regressive," worthless as literature and ineffective as propaganda. Breton liked neither "Red Front" nor Aragon's growing allegiance to Communism, and no one recognized this fact—or bitterly resented it—more than Aragon himself.

Although *The Poverty of Poetry* finally had little effect on Aragon's legal situation,* it did provide the catalyst for the latter's break with Surrealism—not for Breton's depreciation of "Red Front," but for a seemingly insignificant aside. In early March, before send-

* Ironically, it was a presidential assassination that finally saved Aragon: several months later, on May 6, the conservative Paul Doumer was shot by a Russian extremist named Pavel Gorgulov; Doumer's successor immediately put an end to the Aragon Affair by issuing an official pardon. There were those in the Russian émigré community who maintained that Gorgulov, who harbored literary pretensions, had been inspired to commit the act by none other than "Red Front."

ing the text to press, Breton showed it to Aragon. The latter consented to the publication, with one exception: a footnote in which Breton quoted the PCF official's remark (which Aragon had earlier reported to him) about "complicating the simple, healthy relations between men and women"—a clear illustration, Breton felt, of "just how much bad faith or mental indigence we were up against." Aragon considered internal Party statements to be confidential, and asked that the footnote be removed; according to him, Breton "spontaneously crossed out the note on the galleys with a delete mark that I can still recall . . . saying that he wanted to give the Party no excuse for expelling me." But when *The Poverty of Poetry* came off press the next day, the incriminating footnote was still there.

Whether Breton retained the note as a test of Aragon's loyalty, or whether he deemed this example of PCF stupidity too good to waste, or whether the printer simply neglected to make the correction, no one has ever established. But the result was that this single act came to represent for Aragon every philosophical difference, stricture, and humiliation that had ever darkened his long friendship with Breton. On March 10, he responded to the tract via an anonymous note in *L'Humanité*: "Our comrade Aragon informs us that he has absolutely nothing to do with the publication of a pamphlet entitled *The Poverty of Poetry* . . . He wishes to make it clear that he entirely disavows both the contents of this pamphlet and the attention it has drawn to his name, every Communist being duty-bound to condemn the attacks contained in this pamphlet as incompatible with the class struggle." This short paragraph was the only notice he ever saw fit to give of his resignation from Surrealism.

Aragon himself later dismissed "Red Front" as "that poem which I hate," and said of his rift with Breton: "Nothing I have ever done in my life cost me so dearly. To break up like that with the friend of my entire youth was horrible . . . It was a wound I inflicted on myself, which never healed." At the same time, he had found a surrogate family in the Communist Party, one that ironically promised him more leniency than the authoritarian Breton and that did not offend his newfound sense of proletarian modesty. In addition to which, he had pleased Elsa, who had never liked Surrealism or Breton and who saw Aragon's Soviet allegiance as a chance for him to gain much greater renown (she was not wrong). With the cheering of the masses to encourage him, Aragon plighted his troth to "*his* party," until death did them part.*

* Aragon soon became the official bard of the PCF, and he and Elsa something of a mythic couple in Communist circles. He had liberated himself from Surrealist servitude to become the factotum of Stalin and, more directly, of Elsa herself, whom he tirelessly celebrated in verse and prose. Finally, toward the end of his life—after Elsa's death in 1970 and a falling-out with "his party"—Aragon dropped his role of proletarian troubadour for that of homosexual libertine-about-town; like the *xiphophorus helleri*, he seemed to change sex with advancing age.

Aragon was not the only one to leave Surrealism that March. On the 7th, Sadoul sent Breton a letter expressing his own complete disagreement with *The Poverty of Poetry*. Buñuel, for his part, proclaimed that he could no longer stay in a group whose aims had become incompatible with those of the Party. And Maxime Alexandre, arriving at the Cyrano on the afternoon of Aragon's resignation, was handed a tract denouncing his friend; when he refused to sign, Breton informed him: "In that case, your place is no longer with us."

The rest of the group rallied behind Breton and reacted to Aragon's defection with undiluted rage. Mere days after the notice in *L'Humanité*, nine Surrealists responded with *Paillasse! (Fin de "l'Affaire Aragon")* [Clown! (The End of the' "Aragon Affair")], a damning recapitulation of Aragon's "cowardice," from Kharkov through the notice in *L'Humanité*. Deeming even this indictment "too moderate," Eluard, whose animosity toward "the bastard . . . that whimpering filth . . . that coattailed flunky" had been brewing for some time, drafted his own *Certificat*. Aragon, said Eluard, "seized upon the first pretext to denounce [Surrealist activity] . . . precisely when Breton was [protesting] the indictment of one of his poems . . . Inconsistency becomes self-interest, skill becomes scheme. Aragon becomes *someone else* and his memory no longer touches me."

Although he gave at least tacit consent to both tracts, Breton signed neither. Instead, he spent the rest of his life digesting this unexpected outcome of his attempted defense, alternating between sadness and spite. He was still telling friends in the 1960s that he would not speak to Aragon even if they were alone on a desert island; and he disparaged the "tender souls" who were "still weeping" over the breakup decades after the fact.

Still, there is no question that Breton felt deeply betrayed by Aragon's defection. The covenant of March 1919, the oath sworn by two young poets "one particular evening," had been irrevocably shattered, and twenty years later Breton admitted that he still felt the loss: "There are those whose memory long haunted me, whose memory still assails me at certain times of the day, and I won't deny that it's like a wound being reopened every time." This was neither the first nor the last of Breton's friendships to succumb to ideological divergences. But to the end of his life, he would see the break with Aragon as perhaps the most memorable and painful of all the sacrifices made to his jealous and exacting ideal of revolution.

THE GREAT UNDESIRABLE

(April 1932 – September 1934)

"Dying heraclitus, pedro de luna, sade, the millet-headed cyclone, the anteater: his fondest wish is to have belonged to the family of great undesirables." This "judgment by the author about himself" neatly summed up the drama of Breton's life in the wake of the Aragon Affair. Like the terminally ill Heraclitus, who against medical advice tried to cure his dropsy by standing in sunlight; like the "Antipope" Pedro de Luna of Avignon, who defied Roman canonical authority; like Sade, who offended both the monarchy and the Convention, Breton saw himself as a heretic, a rebel against the system, the undesired and undermining voice of doubt. As he later told André Parinaud, "By temperament as much as or more than by reasoning, I fell in with the opposition; I was ready, come what may, to join an indefinitely renewable minority." Following Aragon's flight to the Communist Party, Breton and the Surrealists would increasingly find themselves in such a minority, as their stances—despite some final attempts at reconciliation with the PCF in the coming years—clashed more and more openly with the Stalinist orthodoxy.

In a by now familiar pattern, Breton sought to compensate the Party's antipathy, and its absorption of his first lieutenant, by strengthening his friendships with several of the remaining troops. And he renewed relations with Benjamin Péret, recently back from his stay in Brazil (where he had become a fervent Trotskyist). It was at this point that Péret began assuming a more prominent position in the group, and in Breton's affections. The shy bumpkin of 1921 had hardened into a confirmed radical, in both his convictions and his means of expression, emerging as the most intransigent broker of the Surrealists' ideological grumbles, particularly those that targeted middle-class French virtues. (It was he, for example, who had been captured insulting a priest on the street, in a snapshot made famous by *La Révolution surréaliste*.)

In addition, Breton accepted several new members to the group over the subsequent months. One of these was the poet and historian Georges Hugnet, the twenty-six-year-old son of a successful furniture maker, whose friends included Gertrude Stein and the American composer Virgil Thomson, and who had come to Breton's attention via some writings about Dada. "Hugnet was small, truculent, and sentimental, a type at once

tough and tender," Thomson later recalled. "His conversation [was] outrageous and, if you like outrage, hilarious. Rarely have I heard matched the guttersnipe wit with which he can lay out an enemy." Another was a twenty-year-old philosophy student named Henri Pastoureau, who was invited to join the Surrealists after helping them protest a lecture on Rimbaud by a parish priest. And the following year, the group added the artist and critic Marcel Jean, who would later publish two important histories of the movement; and another twenty-year-old philosophy student, Roger Caillois, future co-founder (with Georges Bataille and Pierre Klossowski) of the College of Sociology.

While Breton clearly welcomed these adhesions, a change was beginning to occur in the group, as veterans from the early days were increasingly supplanted by individuals young enough to be considered part of the next generation—the first generation to come of age when Surrealism was an established fact. Although the shift was not yet so drastic as it would become after the next war, already Breton's position in the group was slowly mutating, from respected equal to spiritual mentor or father figure—one to be revered and, often by the same token, despised. This account by Pastoureau, for example, conveying his first impression of Breton and Rue Fontaine, displays a typical mix of admiration and irony:

> In Paris, [Breton] was never neglectful of his attire; his long hair was carefully waved. He liked to dress in green, which contrasted sharply with his garnet-colored velour shirts. He always wore a tie—except in the country—whose color differed only slightly from that of his shirt, but in a lighter hue . . . Everywhere [in his study] were carefully shelved books, almost all of them rare, oddly bound, in old or deluxe editions. Everywhere, too, were African or Oceanic statuettes . . . and paintings or drawings by Surrealists, pre-Surrealists, naifs, or the mentally deranged . . . There was always a single photo, prominently placed, of his current wife or girlfriend . . . When he received [a visitor] there was nothing on his desk (an old Breton table), but I know through his friends' indiscretions that when he wrote, he always kept a liter of very ordinary red wine at hand, which he occasionally refilled.

For his part, Breton was beginning to deplore the difference in his relations with the group. In the summer of 1932 he complained to Tzara (in terms only a fellow veteran could truly appreciate): "These young apprentices in Dadaism or Surrealism are rather tiresome. Do we now have to start correcting their homework?"

One relative newcomer who escaped this generational syndrome—perhaps because the age difference between himself and Breton was a mere five years—was Alberto

Giacometti. The thirty-one-year-old Italian-Swiss sculptor and painter had first joined the Surrealists two years earlier. Thirion remembered him at the time as "a skinny fellow of medium height, with hair like a Sicilian shepherd . . . Shy and fidgety, he was careful not to support any opinions condemned by the chieftains. He even went so far as to utter nothing out of line with their judgments, so he might contradict himself three times in the same evening according to the way the discussion was evolving."

By mid 1932, after nearly leaving Surrealism in the wake of the Aragon crisis, Giacometti had entered his most active period as a Surrealist. Although Breton occasionally complained about Giacometti's "unreliability," by which he meant that the artist did not always supply drawings or petition signatures on demand; and although Giacometti, no longer so shy, occasionally protested the strictures placed on the Surrealists (from required attendance at the café to Breton's pronouncement one day that the group should eat and drink only green foods and liqueurs), the two men, said Giacometti's biographer James Lord, "obviously took such pleasure in their friendship that they were prepared to make exceptional allowances." In large part, the friendship derived from mutual esteem: Giacometti was an extraordinary conversationalist, one of the few who could truly hold his own with Breton; and in the early 1930s, he was also one of the artists Breton most admired. For many years Breton kept Giacometti's sculpture *Suspended Ball* displayed prominently in the Rue Fontaine studio.

But without question, Breton's most intimate friend at this time of his life was Paul Eluard. The "fourth musketeer" had become the longest-standing member of the group; particularly since Aragon's departure, he had taken an unparalleled role by Breton's side, as adjutant, confidant, and emotional support. Despite occasional moments of friction, Eluard remained the most ardent defender of Breton's theories and interests, and practically the only one to whom Breton unburdened himself of his innermost doubts. "In those days," wrote Thirion, "their intellectual rapport was absolute."

One who was rapidly falling out of Breton's favor, on the other hand, was Valentine Hugo. The day after Aragon's public resignation, a beautiful but cold Friday, March 11, Valentine took her troubled lover (and the ubiquitous Melmoth) away from the scene of his trials, driving southward toward Cadaqués to visit Dalí and Gala. On Saturday the weather turned to freezing rain and a tire burst, almost causing them to skid into a ditch. Breton, perhaps grateful to be alive, had passionate sex with Valentine at their hotel that night—the "head of Vercingetorix," she specified in her diary, referring to one of his "positions" from *The Immaculate Conception*: "When the man stands up and the woman rests the upper part of her body on the bed, with her thighs holding the man round the waist, it is the *head of Vercingetorix*."

But such moments of harmony were few. After a brief stay with Dalí and Gala in Cadaqués—practically the only trace of which is a four-way Exquisite Corpse drawn on the back of a postcard—the couple returned to France in late March, swinging east to the Côte d'Azur to visit Eluard and Nusch. Like the weather, Breton's mood turned increasingly cold on the return journey, and Valentine's diary makes no further mention of fervent lovemaking. Instead, while crossing the rocky Ardèche region the two quarreled, clouding over the rest of their trip until their return to Paris on April 5. "That was hell," Valentine later told a friend.

It was after their return that the relationship irrevocably started down the final slope. On May 7, the couple had a violent argument, apparently owing to some inappropriate statements Valentine had made at the café in front of an American magazine editor. Chastised by Breton, Valentine went home and swallowed a vial of sleeping pills, then drank a bottle of perfume; but, fearing that her suicide would only cause Breton further embarrassment, she then called Eluard to come save her. Several days later she lamented to her lover: "André, the last days have been so sad and so anxious for so many reasons . . . My darling, don't say that you find yourself back exactly where you were before we took our first trip together. Please don't say that."

But Breton, who at bottom had never considered this more than a relationship of convenience, was only put off by Valentine's hysterics. He began making impromptu changes in the group's meeting place in an attempt to avoid her altogether. Earlier in the year, the Surrealists had left the Cyrano for the Café de la Place Blanche across the square. But in May, these café variations became much more syncopated, leaving Valentine to sit and wait in vain for a reunion that was secretly happening elsewhere.

Valentine was not so easily deterred, however, for it was also at around this time that she herself took a studio at 42 Rue Fontaine, putting her in the same building with both Breton and, until the following spring, Eluard. Still, it was one thing to share Breton's address, entirely another his life: Breton briefly fell in love with another young woman (most likely Consuelo de Saint-Exupéry, wife of the famous aviator and novelist, a "shimmering little tropical bird" whom he met at around this time), and although his courtship of her proved fruitless, he avoided Valentine all the more. "Breton has *definitively* broken with Valentine, who's trying to bide her time in the hopes of one day being on a friendly basis with him," wrote Eluard, a daily witness to Valentine's plight. Valentine, meanwhile, became obsessed by the image of Ganymede, the beautiful Trojan prince who was spirited away to Olympus. Over the coming months, to one's mounting dismay and the other's frequent annoyance, Valentine would go from being the "ribbon around the Surrealist bomb" to the millstone around Breton's neck. The woman had

played many roles in her life: painter, set designer, musician, hostess, dutiful wife and daughter; but Breton was no doubt the first to cast her as the pariah.

✳

On June 25, Breton's next collection of poems, *The White-Haired Revolver* (*Le Revolver à cheveux blancs*, its title taken from a line in an unpublished automatic text of 1924), was published by the recently founded Editions des Cahiers Libres. Shortly before, Breton had contacted the house's owner, a young poet named René Laporte, and offered him the volume; aided by a 1,000-franc contribution from the author, Laporte brought out *Revolver* in an edition of 1,000 copies, priced at 15 francs, plus 10 deluxe at 500 francs. Simultaneously, Cahiers Libres published two other volumes of Surrealist poetry: *La Vie immédiate* [Immediate Life] by Eluard (to whom *Revolver* was dedicated) and Tzara's *Où boivent les loups* [Where Wolves Drink].

The White-Haired Revolver was Breton's most ambitious collection to date, 173 pages of material that included not only most of his verse since *Earthlight* (with the exception of the 1931 "genre poems" and a few others inspired by Suzanne) but also a generous choice of poems from his earlier collections. Breton prefaced the book with a short theoretical text, "Once Upon a Time to Come," in which he defined "the imaginary" as "what tends to become real." As an example of this imaginary, he described a fabulous castle he dreamed of renting near Paris ("All I need is the money"): although the guests would permanently number several beautiful young women, it would be "strictly forbidden, on pain of immediate and permanent expulsion . . . to perform, within the walls encircling the grounds, the act of love." Like many of the poems that came after it, the introduction, which dated from June 1930, reflected the alternating hope and bitterness that had marked Breton's final days with Suzanne.

Breton's preface clearly struck a nerve, for many of the reviews the book received, while ranging from the laudatory to the hostile, singled it out for special attention. Georges Bataille, in a delayed rebuttal to his own public flogging in the *Second Manifesto*, termed the introduction "without a doubt the most degenerate product of all Surrealist literature." Along with the Tzara and Eluard volumes, he gloated, *Revolver* was "just about the only example this year of Surrealism's diminished activity."

Bataille's dismissal of "Surrealism's diminished activity" was correct in one sense: in the past two years (and due, at least in part, to the world economic crisis), the Surrealists had published comparatively little. Breton's entire output for 1931 had consisted of a handful of tracts, some short texts for *SASDLR*, and the anonymous "Free Union"; and

1932 had so far been consumed by his broadsides concerning the Aragon Affair. At the same time, *The White-Haired Revolver* and its two companions were only one aspect of the lyrical activity that, like rhizomes, constantly underlay Surrealism's more public demonstrations.

Most notable among these was the wave of "Surrealist objects" that had begun sweeping through the group in 1931. These objects—which might be fabricated, embellished, recombined, or simply found—were meant to provoke an unaccustomed response in the viewer. Maurice Nadeau later described the Surrealist object as "any *alienated* object, one out of its habitual context, used for purposes different from those for which it was intended, or whose purpose is unknown."

In the early 1930s, the manufacture of such objects became a veritable craze in the Surrealist group. "No more coverings on objects, nor condoms on ideas," René Crevel jubilated. "Today, if objects get hard-ons, that's no metaphorical fancy. And they're not getting hard in solitude: they're feeling each other up, sucking each other off, coming into each other—these Surrealist objects are making love!" Before long, their creation had become so promiscuous that Man Ray suggested stamping them so as to tell the real objects from the many counterfeits that soon began to appear.

Breton himself, at various periods during his life, would be one of the most assiduous makers of Surrealist objects. Among his works of this period were an agglomeration featuring (among other things) a bicycle seat, a polished wooden ball, a clay pot filled with tobacco, a tipped hourglass, a taut slingshot, numerous lichens, and a miniature photograph of the Tower of Pisa; and various "poem-objects," a combination of text and sculpture that Breton developed in the 1930s. One of his best-known, from 1936, was a pack of cigarettes next to a mirror, its collage label reading: "THE GLACIAL OCEAN / a young blue-eyed girl / whose hair / was already white."

Breton later ascribed the group's interest in Surrealist objects to several influences, including Duchamp's ready-mades, Giacometti's early sculptures, and several objects that Breton had seen in his own dreams. But no doubt the greatest inspiration behind these objects, and one of their most prolific inventors, was Salvador Dalí. For Dalí, they were a concrete realization of paranoia-criticism, an externalization of the perverse transformations his eye practiced on painted images. His "objects with symbolic functions" (as he called his own special variety) were small assemblages meant to inspire, in Nadeau's words, "a violent and indefinable emotion, doubtless having some relations with unconscious sexual desires"—although the aim was not to satisfy such desires, but rather to elicit some form of "irritation, the kind provoked by the disturbing perception of a *lack*." In this regard, these small sculptures dovetailed with Breton's dream-objects,

reinforcing his thesis of the interpenetration of dreams and waking life, and giving the Surrealist group a fresh start. (Among the most intriguing realizations were Giacometti's *Suspended Ball*, a cloven sphere hanging "in impossible equilibrium over an inclined crescent," and an arrangement by Dalí: a red woman's shoe containing a glass of warm milk, into which a sugar cube with a shoe painted on it could be dipped so that it would slowly dissolve. The most famous such object, however, and one of few to have survived the ravages of time, was Meret Oppenheim's *Déjeuner en fourrure*, somewhat prosaically, though accurately, known in English as *Fur-Covered Cup, Saucer, and Spoon*.)

But in fact, and paradoxically, Dalí's objects both greatly contributed to Surrealism's renewal in the 1930s and constituted the greatest threat to its survival: for the Spaniard had introduced them less to shore up Breton's movement than to raise his own star. Dalí had never relinquished his ambition of becoming Surrealism's head, and in the "objects with symbolic functions" he now saw a means both to topple the long reign of automatism and ultimately to dethrone the Surrealist "Pope" himself. As he later confided: "I was going to make a bid for power, and for this my influence had to remain occult, opportunistic, and paradoxical . . . One maxim became axiomatic for my spirit: If you decide to wage a war for the total triumph of your individuality, you must begin by inexorably destroying those who have the greatest affinity with you."

Breton, whether out of blindness or willful ignorance, left Dalí's conquistadorial designs unchecked for the moment, just as he tolerated the painter's more avowed heresies: his fascination with Catholicism, attraction to the aristocracy, and patent lack of interest in politics. For one thing, Breton sincerely admired Dalí, considering him the "incarnation of the Surrealist spirit"; and he recognized that the other man's inventive wit provided Surrealism with a sorely needed impetus, at a time when old activities had grown tired and inspiration was at a premium. Moreover, Dalí's paranoia-critical theory had won Surrealism credit in advanced psychoanalytical circles: a recently published thesis by the noted young psychiatrist Jacques Lacan, *De la psychose paranoïaque dans ses rapports avec la personnalité*, even confirmed some of Dalí's intuitions, enhancing Surrealism's aura as a pioneer force in the study of the mind. Finally, there were personal issues behind Breton's unusual complaisance, including the support of Dalí by Eluard (who was himself driven by Gala) and Dalí's own gift, claimed by few others, for making Breton laugh "until tears came to his eyes." To Breton's mind, these combined assets were evidently worth the extension of a little extra credit.

✳

By mid July, Valentine had again patched up her relations with Breton. The two planned a vacation together in Castellane, the site of their blissful journey the year before; and on the afternoon of August 4, they, Eluard, Nusch, and the indispensable Melmoth bundled into the Ford and took to the highway.

Still, despite the seeming reconciliation, from the outset this vacation promised not to live up to its predecessor. Breton, suffering from eye pain and an earache, was in a bad mood for most of the trip south, and much of Valentine's time was spent in fear of a new breakup. On the night of their arrival in Castellane, she dreamed that a blonde woman (Suzanne?) was leaning out of Breton's window at Rue Fontaine and cursing her—a dream she didn't dare tell Breton. Several days later she organized a picnic near the river, but Breton, who "hate[d] sitting on the ground," quickly became bored. More to his taste was the game he played with his fellow travelers that same evening, a round of Surrealist questions and answers. One of Breton's responses, intended for Valentine, was: "An admirable woman will appear nude on a zebra." Valentine, ever eager to please, soon painted an admirable nude on a zebra, arms raised in loving abandon to one specific viewer. The face and body were rejuvenated versions of her own.

But these idealized self-portraits could not remedy the fact that Valentine had become less Breton's mistress than his guardian and supervisor, like a vaguely eroticized maiden aunt. She stitched his torn pants and footed the hotel bills, played the chauffeur (Breton did not drive), and made all the travel arrangements. She took photographs of Breton and the others until her camera jammed, and dutifully recorded every stage of their trip. For all this, and despite Breton's occasional moments of gaiety during the vacation, it was clear that he was biding his time rather than enjoying it.

At the end of the month Breton and Valentine joined René Crevel in Montpellier, while the Eluards went to visit René Laporte at his property near Toulouse. Then, after another visit with Dalí and Gala in Cadaqués, they headed to Saint-Etienne-de-Boulogne in the Ardèche, near where Max and Marie-Berthe Ernst were staying with Marie-Berthe's friend, a pretty young redhead named Colette Pros. The group toured the area in Valentine's car and, despite the intermittent storms, vainly tried to fish in the river. Prolonged cloudbursts later that week kept Breton and Valentine in their hotel for several days, where they, the Ernsts, and Colette played dispirited games of poker and Exquisite Corpse. Breton's mood was turning increasingly somber, due as much to the weather and the shoddy hotel ("Flies the size of cigarette packs, spiders with three-inch feet and legs the size of women's. No bathrooms. Very, very pleasant," he complained to Eluard) as to Valentine's presence. Breton chafed under what he saw as his mistress's constant watchfulness, and cringed at her primly disapproving remarks about

everything and everyone. The couple now argued daily, and with increasing venom.

The situation was rapidly coming to a head, and on the night of September 9 tensions exploded into a violent scene. Convinced that Breton had been flirting with Marie-Berthe, Valentine sobbed and screamed—"a bloodcurdling performance with a more skillful encore later that night," Breton described it—and beat Breton with her fists. The next morning she awoke to find him gone: Breton had left their hotel and moved to the next town, nearer the Ernsts.

Valentine had been mistaken only about the object of Breton's flirtations, for although he had indeed conceived a sudden passion, it was not for Marie-Berthe but for her friend Colette. Now away from Valentine's prying eyes, he immediately took the young redhead to a local café for a tête-à-tête. "Physically, she's a young girl of twenty-five, tall, slim, very red-headed, hair in a bun, and eyes like certain English dolls must have," he described his current crush to Eluard, in a long missive that combined flights of lyricism for the child-woman with vituperations against "the odious Madame Hugo": "Enormous eyelashes. Countless freckles. Her face is mainly amusing, only occasionally very pretty. A ravishingly beautiful body, without any particular eccentricities in the breasts or buttocks." Several days later he added: "She really is a young girl, a virgin, with everything she needs to become a real young woman in no time at all, but who still has a number of very 'childlike' sides about her." Despite numerous incompatibilities—Colette's convent upbringing, her love of music and dance, the "girlish" pastimes she enjoyed—Breton proposed marriage after only three days.

Colette, although taken aback by the impetuous offer, did not refuse outright. Instead, while Marie-Berthe urged her to accept, she spent the week weighing her suitor's drawbacks: his lack of money, irregular lifestyle, frequent ill temper, and the obvious difference in their tastes and ages. Breton awaited her decision, pacing the several miles between his hotel and the local café like an expectant father, writing detailed accounts for Eluard, and dreading his forthcoming return to Paris.

For her part, Valentine spent the days after their fight in a state of desperation. Unable to locate her renegade lover, she returned to Rue Fontaine, where she composed many impassioned pleas for forgiveness. She also canvassed Breton's friends for information on his whereabouts; but some simply didn't know, and those who did pretended not to. Finally, Eluard sent a telegram from René Laporte's, where Breton had just joined him: "No use writing, André here."

Still, Breton made it clear, both by letter and on his return to Paris later in the month, that the relationship was over. Although Colette ultimately turned down his proposal, and although Valentine would keep her studio at Rue Fontaine for four more years,

from now on her feelings for Breton would slowly devolve from anxious passion to hopeful friendship, and finally to defeated resignation. In December, in one of her last letters to him, she professed her faith in their spiritual bond: "I'm not sad anymore. I'll wait for the day when you wish to see me again, I'll wait until you've understood that someday we can share a calm affection, without returning to the past . . . If we should meet again don't be afraid of me. Look upon me only as the creature who loves you most in all the world."

Once Valentine seemed finally to have accepted the situation, Breton began showing her the tenderness that had so often been lacking during the time of their intimacy. He praised her artwork (albeit without much conviction), and in December he gave her the manuscript of *The Communicating Vessels* with the dedication: "To Valentine Hugo, this copy of 'The Communicating Vessels,' made for her and before her eyes." But while she continued to frequent the Surrealists until 1936, contributing numerous drawings, Exquisite Corpses, objects, and paintings (including a large and flattering group portrait circa 1935), never again would she enjoy the favored attention of the man she continued to love until the day she died.

Breton's "awkward attempt at living," as he once thought to describe *The Communicating Vessels*, was published on November 26, 1932, by Cahiers Libres, in a printing of 2,000 copies plus 25 deluxe. This first edition featured a frontispiece by Max Ernst, but none of the seven photographs (some of them by Valentine) that would illustrate postwar editions.

Despite Breton's most sincere attempt yet to align his thinking with Marxism, the political theorizing in *The Communicating Vessels*, with its implied criticisms of PCF policy, only angered the leftists and elicited condescending kudos from the right. The pacifist-leftist monthly *Les Humbles* summed it up by writing: "It is obvious that the proletariat will give not a thought to Mr. Breton or care about Surrealism's latest evolutions, and in any case will retain nothing of all this for the revolutionary cause . . . Forgive me for asking, Mr. André Breton, but why is a well-bred poet such as yourself taking an interest in revolution?"

Another aspect of the book that elicited condemnation was Breton's attempt to define his personal science of dreams. Some critics praised while others busily damned. But the overall tally of responses suggests that Breton's foray into the politics of the unconscious inspired not so much admiration as dismissal—not to say outright hostility.

One such reaction came from Sigmund Freud, to whom Breton—no doubt expect-

ing that this time the renowned analyst could not fail to see the links between the Surrealist quest and his own—had sent a copy of the book. But Freud cautiously limited his response to noting some inaccuracies of detail, such as Breton's insinuation that *The Interpretation of Dreams* had plagiarized some previous research. In a subsequent letter, Freud added: "And now a confession, which you will have to accept with tolerance! Although I have received many testimonies of the interest that you and your friends show for my research, I am not able to clarify for myself what Surrealism is and what it wants. Perhaps I am not destined to understand it, I who am so distant from art." In response, Breton published Freud's letters to him in *SASDLR*, along with a somewhat condescending rebuttal. Still, the hurt was evident, and Breton's "last word" could not compensate for the fact that Freud, like the leftist press, would never see Surrealism as anything more than what Breton least wanted it to be: an artistic movement.

That fall of 1932, meanwhile, Breton renewed his demand for ideological purity within the ranks, prompted, at least in part, by the Surrealists' recent acceptance (after ten months of lobbying) into the Association of Revolutionary Writers and Artists. In the final account, the decision had less to do with Surrealism than with a brief, and relative, wave of liberalization in Moscow. Earlier that year, Stalin had dissolved the sectarian RAPP, on which the AEAR had been modeled, paving the way for slightly greater tolerance in the French branch office. AEAR president Paul Vaillant-Couturier accordingly reversed his previous objections, and in October welcomed Breton, Eluard, Crevel, Char, and several others into the Association, going so far as to name Breton to the board of directors. Even Aragon applauded the idea, telling Vaillant-Couturier that "despite everything, he would be glad to work alongside Breton in this new context."

In the first months of 1933, Breton attacked his duties in the AEAR with enthusiasm, even when they entailed a considerable realignment of Surrealism's positions. In February he drafted the journalistic "'M. Renault est très affecté'" ["Mr. Renault Is Very Concerned"], protesting an accident at the Renault automobile factory that killed nine workers; and on the 23rd, he delivered a lecture on proletarian literature, advocating a "Marxist study guide to general literature" to offset the biased primary school curriculum. The group in general also signed protests against Nazi oppression in Germany and participated in a conference on "fascism versus culture."

But almost from the outset, there were discrepancies. Although spectators applauded the Surrealists' speeches at the "fascism versus culture" conference, other delegates used their own speeches to attack them; leaving the hall, Eluard and Crevel swore that "it would be a cold day in Hell before they set foot in the AEAR again." And Breton, although he tried to adopt a more accessible, "proletarian" style in his tracts, was still a

long way from having mass appeal. On top of which, his voting record often put him out of step with his co-directors, and by March he was again telling Eluard: "I'm coming to believe more and more that we must make a loud break from these Commies and resume Surrealist activity with more intransigence than ever. This is where three months of hard work have gotten us."

Once again, it was *SASDLR*, the fifth and sixth issues of which appeared on May 15, 1933, that brought the latent conflicts between Breton and the Communists to a head. This time the dispute concerned a letter to Breton from university professor Ferdinand Alquié, which denounced "the wind of systematic cretinism blowing from the USSR" in "proletarian" literature and art. Breton felt that "the intensity of life and revolt that ran through that letter" dictated its publication. Not so the Communists, who saw it as indicative of the widening gap "between Surrealism and the revolutionary masses," and who questioned what Breton was doing in the AEAR to begin with. The situation was rapidly becoming untenable, and in June the Party gave Breton an ultimatum to publicly retract the Alquié letter. When he refused, he was drummed out of the Association, never again to work within the Party structure. The other Surrealists followed him out the door. But although the group had emerged from this last skirmish intact, and although, as Thirion noted, Breton had remained true to his convictions, he "considered this exclusion a personal failure. It left him rather distraught."

As it happened, the latest issue of *SASDLR*, which had played such a role in Breton's expulsion, was to be the last. The magazine had never sold well enough to support itself, and by now was suffering the same financial headaches that had spelled the end of *La Révolution surréaliste*. José Corti had resigned his distributorship after the December 1931 issues, leaving the magazine without a publisher for eighteen months. René Laporte had then agreed to handle it, but only on condition that the Surrealists contribute 6,000 francs toward publication. Although Eluard's sale of some paintings had provided the wherewithal that spring, the increasingly stringent conditions of the economic crisis left the Surrealists unable to raise further funds. No sooner had the last two issues appeared than Breton decided to end the venture altogether, bringing to a close fourteen years of virtually uninterrupted magazine editorship. The Surrealist group would not have another magazine of its own for nearly a decade.

Instead, Breton pondered an offer by Swiss art books publisher Albert Skira to launch an upscale art periodical called *Minotaure*. Skira had first approached Breton and Eluard in February, but at the time they had remained noncommittal: *SASDLR* hadn't yet folded, and Breton had qualms about Skira's insistence that he co-edit the project with his old rival Georges Bataille. Furthermore, Skira made it clear that this would be

an arts and anthropology magazine—to be modeled, in fact, on Bataille's now-defunct *Documents*—and that the Surrealists would have to leave their politics at the door. Still, a sufficient compromise had been reached by late April, and on June 1 the first two issues appeared, their contents reflecting the ongoing split: one (in echo of *Documents*'s former preoccupations) was entirely devoted to the Dakar-Djibouti ethnographic expedition; the other featured works by Eluard, Dalí, Crevel, and Marcel Jean, considerations on "the paranoiac forms of experience" by Jacques Lacan, and, by Breton, a major celebration of Picasso's "extra-pictorial" output called "Picasso in His Element." Picasso himself contributed the cover, a lighthearted collage showing an engraved Minotaur surrounded by bits of ribbon, lace, and faded flowers, and (Cubism redivivus) prominently featuring the thumbtacks that held the whole thing together.

Unlike the austere *Révolution surréaliste* or the Marxist-oriented *SASDLR*, *Minotaure* was frankly opulent. It featured full-color covers (each one depicting a Minotaur as conceived by a different artist), glossy stock, abundant illustrations, and a sumptuous layout. It also promoted the side of Surrealism concerned with art and the mind, and patently shied away from any controversial politics: at thirty francs per copy (as opposed to five or ten francs for the Surrealists' previous magazines), *Minotaure* needed to attract a well-heeled patronage, and the salons were not really interested in political leftism.

Although the first few issues of *Minotaure* were beset by conflicts between the Surrealists and the former *Documents* group, they contained some of Breton's most important writings for this period—most notably "The Automatic Message," his first major statement on automatism since the 1924 *Manifesto*. In the intervening ten years, Breton's hopes for "the mouth of shadows" had considerably dampened. And if he reaffirmed his faith in the ability of automatism "to cleanse the literary stables definitively" and "throw open the floodgates," he nonetheless had to admit that for many who practiced it automatic writing seemed an easy path to literary success. Given this, he stated, "The history of automatic writing in Surrealism . . . is one of continual misfortune."

The disillusionment with automatism reflected Breton's generally dispirited life in the summer of 1933. Alone in the sweltering heat of his apartment, he spent sleepless nights and saw practically no one. His annual trip to Lorient in August was made with Eluard. Breton had often used these visits as the occasion to enjoy the company of (or settle problems with) the women sharing his life, but he now had neither wife nor lover to bring along.

Back in Paris by month's end, he spent most of his time at the Bibliothèque Nationale doing research for "The Automatic Message" and awaiting the others' return from vacation—his solitude further deepened in September when his phone service was cut for

nonpayment of bills. Even the café meetings held little consolation. The discouragement reached such proportions that Breton and Eluard decided on a radical, if comic, strategy. "André and I have decided not to complain for a whole week. The first one who complains must give the other 1 franc. It might yield some good results," Eluard reported to Valentine, adding in violation of his own wager: "(In any case, I'm noticing yet again that I don't know how to write.)"

Perhaps to outwit his low spirits, Breton buried himself in various projects that summer and fall. In June, he helped organize a new exhibit of Surrealist art—the first since 1928—and worked hard on *Minotaure*, both preparing the December issue for press and plotting with Eluard to eliminate the *Documents* faction from the magazine altogether. His withdrawal into these activities, and away from direct political involvement after the AEAR, was such that he seemed strangely removed from developments in the world.

Unquestionably, the most significant of these developments was the rise of Nazism. In March 1933, Hitler had been handed de facto leadership of Germany (which would become unconcealed dictatorship the following year, after President Hindenburg's death and Hitler's blood purge of his own party). But Breton, apart from having signed an AEAR protest against Hitler's election, had little to say about Nazism at this time. Neither did the Communists, for that matter: they were so embroiled in a bitter territorial rivalry with the Socialists (or "Social-Traitors") that they openly applauded fascist political gains in Germany as a victory for their side. Given this, and the delays it would cause in Communist opposition to fascism, it is especially tragic that Breton—one of the few to see through the factional mire during these years—was all but silent about the growing Nazi threat. With no affiliations to satisfy, and enjoying (despite everything) a marked prestige in French intellectual circles, he might have helped foster a more timely awareness of the German situation. But it was as if he had momentarily shut his eyes to the world around him.

Which is not to say that Breton was unaware of the Nazi menace, for while he said little about it in public, he was not nearly so silent within the confines of the Surrealist group. The issue of Surrealism's attitude toward Nazism become especially pressing in late 1933, owing to the antics of Salvador Dalí. Throughout the year, Dalí had been testing the limits of Breton's political tolerance. Knowing his privileged standing in the group, he virtually taunted the others with his passions for religion, wealth—and, as of the summer, the person of Adolf Hitler.

In reality, Dalí's obsession reflected not so much an admiration for Hitler's politics— he despised politics of any kind, and flesh-and-blood Nazis terrified him—as a delirious

fascination with Hitler's "paranoiac" possibilities (not to mention the painter's unerring instinct for shock value). Hitler's "fat back" and the uniform that "tightly held in his flesh" aroused "a delicious gustatory thrill" in Dalí, who felt that the dictator belonged with Lautréamont and Sade on the Surrealist lunatic fringe. But although Dalí's outrageous whims were grudgingly ignored at first, by late 1933, as Hitler consolidated his control over a fanaticized Germany, the painter's comestible embroideries were becoming increasingly difficult to accept.

At around the time the Dalí situation was turning into a crisis, Breton met a vibrant, seductive young woman with abundant red hair, "as bedizened and painted as a carnival," named Marcelle Ferry. Marcelle had left her garage owner husband and her native Caen for Paris and moved in with Georges Hugnet, who had nicknamed her "Miami." Still, no sooner had Hugnet brought Marcelle to a Surrealist meeting in late summer 1933 than she decided to change lovers; as Marcel Jean told it, she visited Breton later the same evening and "fell into his arms." The next day, Breton, who was "not hostile to the woman's vulgarity," had summoned Hugnet to the café and announced that he and Marcelle were passionately in love. "Georges was awfully fond of that girl," recalled Virgil Thomson, "but he was terribly devoted to the literary movement and to Breton. He didn't like it, but he had to take it." Marcelle had moved into Rue Fontaine as of September, filling the studio with barracks ditties that she belted out at the top of her lungs. Hugnet got used to seeing his beloved Miami at Breton's side in the coming months, and even to hearing her called "Lila," the new nickname Breton had given her.

In reality, the boisterous Marcelle and the moody, cerebral Breton were an exceedingly poor match. But Breton, after a year of abstinence (and despite his claim that he could "remain celibate for two years" if need be), had clearly been won over by Marcelle's flagrant sex appeal. Moreover, the circumstances of Breton's meeting with the woman must have reminded him of his earlier conquest of Suzanne, who six years before had suddenly entered his life during a café session, on someone else's arm. As he had done with women as diverse as the youthful dancer Claire and the precious Valentine Hugo, Breton convinced himself that Marcelle was his predestined lover. Soon after, he dedicated for her a copy of "Free Union"—a poem inspired by Suzanne—with the words: "To Marcelle, my wife here foretold." ("Free Union" actually became Breton's personal Valentine for new loves: at least two other women would receive copies of the poem with dedications stating that he had written it in anticipation of their meeting. Unlike the common Lothario, however, Breton seems to have believed it each time.)

Meanwhile, the unease provoked by Dalí's attitudes was increasing. In December 1933, the painter adorned his grudging contribution to a pamphlet supporting accused

patricide Violette Nozières with plays on the word "Nazi." Then he added the proverbial last straw with a new work, *The Enigma of William Tell*, which featured a genuflecting Lenin wearing a worker's cap with grotesquely distended bill, whose naked right buttock was as long and flaccid as a soggy baguette. Dalí later described *William Tell* as depicting "the psychological tragedy of the Surrealist revolt of the son against his father; at the time it was painted it was almost possible that William Tell, in other words my father, would end up eating me voraciously like a cannibal." Although Dalí did indeed have an intensely conflictual relationship with Salvador Dalí, Sr., the "father" here was clearly Breton himself, both for his ideological identification with Lenin and for the position of authority, both hated and revered, that he had occupied in Dalí's life up until then. Later, Dalí would openly refer to Breton as his "second father."

Neither the manifest nor the latent significance of Dalí's painting was lost on Breton, and on January 23 he drafted a written indictment of the Spaniard for the group's benefit, citing Dalí's contempt for the proletariat, his taste for academic painters, his *Enigma of William Tell*, and most of all his continuing fascination with Hitler. Dalí responded with a long self-defense, arguing that his "paranoia-critical" interpretation of Hitler would hardly find favor in Nazi Germany. "All the novelty resides in the truculent disorientation of these myths, given the concrete circumstances of the times, the intellectual situation, etc., which constitute the entire phenomenological meaning of the problem," he stated. Although Breton seemed willing to accept even this convoluted explanation, less than a week later Dalí undermined his own defense by making *The Enigma of William Tell* his main entry at the Salon des Indépendants, which opened on February 2 at the Grand Palais. A long debate at the café that afternoon ended with a motion for Dalí's expulsion for "counterrevolutionary acts tending to glorify Nazi fascism." The next day Breton sent Dalí an official summons for Monday, February 5, at Rue Fontaine. He, Péret, and a few others also visited the Grand Palais in an attempt to slash the offending painting; but the work had been hung too high on the museum wall, and although Breton batted at it with his cane, he was unable to knock it down. William Tell's enigma remained intact.

By 9 P.M. on February 5, the combined Surrealists were gathered at Rue Fontaine for the trial of Salvador Dalí. They squeezed onto the sofa, perched on haphazardly placed chairs, or sat on the floor, while over them all watched the plaster death masks of Breton and Eluard, hanging in the window near one of Dalí's own paintings. Hugnet later described the scene:

> Paintings by Duchamp, Chirico, Miró, and others cover the walls and hang above a gradated bookcase, of very artistic effect and apparently designed by the master of

the household, on which Gothic novels, Surrealist objects, primitive objects, and found objects stand side by side. In this atmosphere, already opalized by cigarette smoke, the Surrealists are grouped by personal affinity. Dalí makes a spectacular entrance, dressed in a large camelhair coat that floats around his body, stumbling and tripping over his untied shoelaces. He is preceded by Gala, who has the glare of a cornered rat, and who does not understand (as a wife) how they could torment her genius of a husband, or (as a manager) how they could hinder her protégé's brilliant career. A regular visitor to the place, self-important like a cabinet minister, she heads straight to the already crowded sofa and squeezes in without further ado. A stir. Dalí's embattled and wild-eyed face emerges from the upturned collar of his coat.

Pleading a high fever, Dalí kept a thermometer in his mouth during the entire session. Breton, dressed in bottle green from head to foot and clenching a pipe between his own teeth, recapped the group's grievances against Dalí and demanded an explanation, while the painter countered Breton's accusations with embroiled countercharges of his own. As the tone of the discussion grew more heated, so did Dalí, whose body temperature was kept elevated both by his fever and by a plethora of sweaters. Dripping perspiration, he began peeling these sweaters off layer by layer; but then, fearing a chill, he put his jacket back on, only to remove it again several minutes later. Finally, he pulled a wad of papers from his pocket, a kind of jumbled manifesto-cum-defense, and began to read—constantly interrupting himself to pull up his socks, remove another article of clothing, and check his temperature. It soon became clear that the Spaniard had renounced none of his controversial positions, for Dalí's manifesto wove another fabric of irrational divagations around Hitler and his "plump edibility." At one point, as he was explaining that Hitler had "four balls and six foreskins," Breton broke in with a blunt "Are you going to bore us much longer with this crap about Hitler?" Then, as soon as Dalí had finished reading, Breton and the others immediately launched into a violent critique of his statement.

But although Dalí found himself attacked by virtually the entire room, he soon emerged as the master of the situation. His comical accent, the thermometer that decanted saliva into Breton's face as he spoke, the sweaters and jackets that he ceaselessly removed and redonned to the others' increasing mirth, undercut the atmosphere that Breton sought to impose on the proceedings. On top of which, few of those present were any match for his wit. The poet Gui Rosey, who venerated Breton, unconsciously parroted him as he began indicting the painter: "That said, it is nonetheless the case that your indefensible attitude authorizes me, at the risk of being taken for an ass—" at which point Dalí stabbed his thermometer at Rosey and retorted, "But that's exactly what I do

take you for," before returning to spar with Breton as if the nonplussed Rosey had never existed. Citing Breton's own precepts from the first *Manifesto*, Dalí maintained that he was merely setting down his dreams in the most faithful way possible—regardless of whether these dreams were of Gala, Dulita, Sade, or Hitler. "And so, my dear Breton," he concluded magisterially, "if tonight I dream I am buggering you, tomorrow morning I will paint all of our best fucking positions with the greatest wealth of detail." Breton, for once caught short, could only splutter in cold rage: "I wouldn't advise it, my friend."

By now Dalí was down to his last sweater, but by no means his last argument. Frenetically, he began a long, dizzying filibuster about dreams, paranoia, and the "unique, grandiose" spectacle of the Nazi concentration camps. The more Breton pressed him to renounce his obsession with Hitler, the more Dalí countered that Surrealism's very tenets protected such obsessions. Finally, at well past midnight, Breton demanded one last time that Dalí forsake his counterrevolutionary sentiments. The exhausted painter readily swore that he was no enemy of the proletariat—"about which in fact I didn't give a fig," he later added—and, kneeling on the thick pile of his discarded sweaters, nude torso gleaming with sweat, he tried to kiss Breton's hand, which the latter jerked away in annoyance. As Breton well knew, the very fact that the evening had ended in a stalemate was a victory for Dalí. Quite simply, no one had been able to hold on to the elusive Spaniard long enough to throw him out.

In the final account, however, Dalí's largest reprieve came not so much from his own artfulness as from the very politics he despised. On February 6, 1934, the day after his farcical trial, Paris exploded in a series of bloody riots that wrenched the group's attention back to the social realm. The world economic collapse had by now fully hit France, and, by the beginning of 1934, the country had reached a crisis point. Predicting the fall of capitalism, some turned to Communism, but many more at the time looked approvingly on the order and discipline preached by the fascists. The situation came to a head in February when Alexandre Stavisky, a Russian-Jewish con artist with highly placed government connections, died in a shoot-out with the police. Stavisky had been charged with stock fraud at the end of 1933, after years of prosecutorial laxity, and had tried to flee Paris. The police who had tracked him to his hideout in January claimed Stavisky had shot himself to avoid arrest, but many felt he had been murdered to protect his prominent co-conspirators. The scandal was such that Prime Minister Camille Chautemps was forced to resign. A new prime minister, Radical Socialist Edouard Daladier, was being sworn in on February 6; but several right-wing extremist groups, charging that the government was composed of radicals and crooks, staged a demonstration that same afternoon in Place de la Concorde.

Chanting "Down with the thieves!," some 60,000 pro-fascist demonstrators soon headed out of Place de la Concorde and toward the Chamber of Deputies, threatening to lynch the politicians inside (many of whom crept out the back way). Oddly, they were seconded by some 5,000 Communist militants, whom PCF general secretary Maurice Thorez had sent in to "give the protests a 'proletarian' character"; several witnesses remember hearing, as the mob stormed toward the Chamber, "La Marseillaise" blending with strains of "L'Internationale." Fearing a coup d'état, mounted police rushed in to contain the crowd, and as darkness fell, the demonstration escalated into a full-fledged riot. Rocks were thrown and overturned buses set on fire. Protestors surrounded the police and slashed their horses' legs with razor blades, while the overwhelmed police fired into the mass of demonstrators and slapped at them with their sabers. At Breton's urging, Marcel Jean and Georges Hugnet "covered" the event for *L'Humanité*, dodging the mayhem and the gunfire. Former Surrealist Pierre Unik, on assignment for another Communist newspaper, picked up a worker's cap filled with the brains from the man's crushed skull and brandished it before the crowd; pursued by the police, Unik escaped by running through a subway tunnel. By midnight, seventeen people lay dead and over two thousand more had been wounded. The Daladier cabinet handed in its own resignation several days later.

The next day, Breton was visited by a group of young radicals and asked for his support in protesting the fascist riots. A meeting was held that evening, over which Breton presided; by the end of the all-night session, the ad hoc committee had drafted a tract entitled *Appel à la lutte* [Call to Battle]. Its tone, in keeping with the general atmosphere, was strident and apocalyptic: "With unheard-of violence and speed, the events of the past days have brutally faced us with an immediate fascist threat," it proclaimed. "THERE'S NOT AN INSTANT TO LOSE. We have not yet achieved unity of action in the working class. This must happen *without delay* . . . LONG LIVE THE GENERAL STRIKE!"

Appel à la lutte garnered some ninety signatures over the next several days. Breton was also mandated to obtain the support of Socialist leader Léon Blum, who enjoyed great respect and enormous prestige in the nonaligned left, and whose signature on *Appel à la lutte* would clearly have attracted many others. But just as Freud had denied Breton any scientific validity, so Blum now refused him credibility as a statesman. He readily agreed to an interview, but kept his petitioner away from the intended terrain. "All morning long, in his office on Ile Saint-Louis, I labored in vain to turn the conversation away from the literary track onto which he had steered it," Breton later recounted. "Unfortunately, that wasn't what I had come for. Blum showered me with kindness, but every time I tried to bring him back to the object of my visit, he confined himself to dila-

tory statements." When *Appel à la lutte* was published on February 10, it was without Blum's support.

Even before the tract's appearance, the general strike it promoted seemed on the point of occurring. On February 9, the Communists held a demonstration of their own at Place de la République, despite formal interdiction from a government that had seen enough with the fascists. When the Communists took to the streets anyway, the demonstration quickly turned into a violent brawl. The mounted police, who only days before had fired on the radical right, now charged on the leftists flooding Paris's northeastern districts, their flashes of gunfire sending bursts of eerie light over the blacked-out avenues. The Surrealists, who had mounted the barricades alongside the Communists, soon found themselves in the thick of the fray; that evening, Tanguy's front teeth were shattered by a police nightstick. Georges Hugnet later remembered the northern boulevards being awash in blood.

For one other witness, the aftermath of the riot was just as emotionally charged as the event itself:

> Someone walking up from the boulevard had stopped near where I stood . . . [He] was staring at the curb, and poking at the pool of blood with his cane, a cane I knew well: a stick with Tahitian figures . . . Yes, it was André Breton who owned it. Who didn't see me. I said: *André*, and we spoke about what had happened here, what I'd seen. It was all as if nothing had happened . . . between us. And then, Breton began to talk politics. You understand. There were certain things I didn't want to say to him. We parted.

The speaker was Aragon. He and Breton would never meet again.

In fact, Breton's "calls to battle" had once more set him against the mainstream left, for the Stalinists were still too busy squabbling with the Socialists to pay serious attention to the fascists—as evidenced by their presence at the February 6 demonstration. The situation would change somewhat in July, when Maurice Thorez, acting under orders from the Komintern in Moscow (which had finally recognized the danger Hitler posed), made common cause with the Socialists: for a very brief moment, the "politics of the outstretched hand" and the founding of the cooperative Popular Front would appear to leave political maneuvering behind in favor of more concerted goals. But that spring, stances such as the Surrealists' fell under the category of what was soon termed "premature anti-fascism." In any case, outstretched hands or not, Breton had by now lost all residual faith in the Communist Party machine.

In April, Breton further removed himself from the Communists by signing another tract, *La Planète sans visa* [The Planet without a Visa], which protested the government's recent decision to expel Leon Trotsky from French soil. Trotsky had been granted political asylum in France less than a year earlier; but the recently formed "truce cabinet," set up under the elderly Gaston Doumergue after Edouard Daladier's resignation (and which would itself dissolve in November), bowed to pressure from both left and right and annulled its predecessor's hospitality. Although the Surrealists stated that they were "far from sharing all of [Trotsky's] current positions," they nonetheless saluted "Lenin's former companion . . . [author] of the motto that for us has been a permanent reason to live and act: 'Socialism will mean a leap from the realm of necessity into the realm of freedom; in the sense that contemporary man, full of contradictions and lacking in harmony, will pave the way for a new and happier race.'"

Breton had admired Trotsky since his discovery of *Lenin* in 1925, but in the intervening years had more or less downplayed his admiration in deference to the Communist Party. Following his own expulsion from the AEAR, however, he turned once again toward "Lenin's former companion." For one thing, he felt a personal sympathy for Trotsky's lone stance, having himself been ostracized by the PCF. In addition, Trotsky seemed to have maintained the revolution's ideals as Breton saw them—resolution of man's paralyzing contradictions, forging a new and liberated race—while Stalin promoted colorless materialism and five-year plans. Finally, Trotsky was a consummately talented writer and thinker, whereas Stalin was at best a shrewd functionary. In nearly every respect, the educated, cosmopolitan Lev Bronstein appealed more directly to Breton's intellectual sensibilities than did the Georgian peasant Iosif Dzhugashvili.

Meanwhile, lasting tensions from Dalí's February "trial" were affecting Breton's relations with Eluard. Caught between his admiration for "little Darys" (as he called Dalí) and his ideological condemnation of the Spaniard's crypto-fascism, Eluard spent the spring in a state of dyspeptic retreat. "I have had no news from Paris from our 'good' friends in a fairly long time," he complained to Gala from Nice. "I'm starting to think that our inaction is shameful and I intend to tell them so. It is also my delightful intention (and one could not be firmer) not to allow myself to attend those café meetings any longer, so sterile, so childish. I'm completely fed up with them." Even *Minotaure*, in which Eluard had formerly been so involved, now inspired only his disgust. As preparations for the fifth issue got underway—the first to be fully co-opted by the Surrealists—he vowed not to work on it "unless they pay me. I'm sick of wearing myself out for things that I can better do without than eating." Though Eluard would

be persuaded to remain both in Surrealism and with *Minotaure*, these strains of discord marked the beginning of a difficult phase in his friendship with Breton.

✳

Although 1928's *Nadja* had been, commercially and critically speaking, Breton's most successful book to date—it had sold just under 3,000 copies by early 1934, nearly twice the number of his other titles—he had not published with Editions Gallimard since then. In the intervening years, his contact with the house had mainly concerned various disappointments and disgruntlements. Still, Gaston Gallimard, although by now the head of one of Europe's largest and most prestigious publishing firms, maintained direct personal contact with his sometime author, dutifully considered each request for additional royalties or advances, and occasionally even granted them. Moreover, he had kept several of Breton's titles in print despite sales that generally stalled at 1,500 copies, and was now planning to reissue the 1927 chapbook *Introduction to the Discourse on the Paucity of Reality*, bolstered by a rasher of newer critical texts. This latter project had officially come under contract on February 26, bearing the title *Break of Day* (*Point du jour*).

A sequel to *The Lost Steps, Break of Day* included (alongside the *Introduction*) fifteen of Breton's major critical and polemical essays since 1923, from his contribution to the Anatole France *Corpse* and *In Self-Defense*, through his statements on Mayakovsky's suicide and proletarian literature, to his recent essays on Picasso and the "automatic message." And like *The Lost Steps* before it, the volume summed up nearly a decade of activity, presenting Surrealism's trials and mutations, and Breton's own continuing explorations. But *Break of Day* also bore traces of the previous ten years' struggles, the weight of disappointment and responsibility. Although these essays show greater maturity in both style and concerns, they generally lack the sense of enthusiasm and almost boundless possibility that shone through such earlier pieces as "The Disdainful Confession" and "The New Spirit."

In May, as *Break of Day* was heading for press, Breton turned his attention to Brussels. The periodical *Documents 34*, edited by the Belgian Surrealists E. L. T. Mesens and Paul Nougé, was preparing an upcoming special issue on their French colleagues, and on May 12 the Musée Royal des Beaux-Arts inaugurated a major exhibit of Surrealist art. Although Breton did not accompany Eluard, Dalí, and Valentine Hugo to Brussels for the opening, Nougé and Mesens had arranged for him to give a keynote lecture at the museum on June 1.

The lecture, which the Belgian publisher René Henriquez would bring out on July

15 under the title *What Is Surrealism?*, is generally considered to be one of Breton's most important expository statements. Breton began by drawing a distinction between Surrealism's "purely intuitive" or "heroic" epoch—i.e., the period stretching from 1919 to 1924, which promoted "the omnipotence of thought," and which Breton now denounced as "extremely mistaken"—and the "*reasoning* epoch" that started with its turn toward revolutionary politics. Evoking "the magnificent and overwhelming *spiritual legacy* that has been handed down to us," he declared: "We have accepted this legacy from the past, and Surrealism can well say that the use to which it has been put has been to turn it to the overthrow of capitalist society." The Surrealists used literary means, he said, not as writers and artists, but rather as "chemists and technicians." And if some individuals were injured by the movement's "perilous exercises," they were simply left "by the wayside."

What Is Surrealism? was a synthesis and summary of fifteen years of Surrealist activity, evolution, positions, and principal works. On its publication, one critic praised the text as a "lively, alert clarification . . . perhaps the most likely text to provide a wide, rapid introduction to Surrealism." But according to Marcelle Ferry, who watched her lover grumpily struggling with its composition mere days before he was scheduled to deliver it, Breton himself dismissed the effort as "pure vulgarization and extremely boring." His writings of the past two years had been almost exclusively tracts and expositions, and by now he seemed eager to pursue a more lyrical vein. But lyricism required personal inspiration, and this was in short supply.

A day or two before he was to leave for Brussels, at seven-thirty on May 29, Breton was holding the afternoon meeting at the Place Blanche when a woman with brilliant blond hair entered and immediately seized his attention. He later described her entrance:

> She was very young, but her distinctive youth did not strike me at first sight, because of this illusion she gave of moving about, in broad daylight, within the gleam of a lamp. I had already seen her here two or three times, her coming announced before I saw her each time by an indefinable quiver moving from one pair of shoulders to the next, from the door of this café toward me. For me this motion itself . . . has always, whether in art or in life, signaled the presence of the *beautiful*. And I can certainly say that here, on the twenty-ninth of May 1934, this woman was *scandalously* beautiful . . . From the first moments, a quite vague intuition had encouraged me to

imagine that the fate of that young woman could some day, no matter how tentatively, be entwined with mine.

Breton was all the more struck by his "intuition" in that, in the previous weeks, he had reexamined the question of "preordained" or "fortuitous" encounters in a new essay, focusing on a particular incident that he had witnessed while lunching at the Maison Bergey bistro near his apartment: he had been musing about the pretty waitress when her boss sharply summoned, "Here, Ondine!" [*Ici, l'Ondine!*]. "The exquisite and childish answer came in a whisper, perfect," Breton wrote: "'Ah, yes, one dines here!' [*Ah! oui, on le fait ici, l'On dine!*] Could there be a more touching scene?" Ever watchful for marvelous coincidences, he now became convinced that the charming "Ondine" had foreshadowed the arrival of the "scandalously beautiful" blonde in the Café de la Place Blanche.

Adding to the blonde's mystique was the fact that she was writing, an act that always piqued Breton's curiosity. "I had already agreeably supposed very quickly that she might have been writing to *me*, and found myself awaiting her letter," he later said. "*Naturally*, nothing." But against all odds, the woman's letter *was* meant for Breton, as he discovered later that evening when he met her again in the street. She introduced herself as Jacqueline Lamba, expressed surprise that the waiter at the Place Blanche hadn't given Breton her note, and then, before disappearing into the homebound crowds, made a date to meet him again at midnight.

Fourteen years Breton's junior, Jacqueline Mathilde Lamba was born in the Paris suburb of Saint-Mandé on November 17, 1910, the daughter of an agricultural engineer who had died in a car accident when she was three. She was an energetic, spirited, and at times temperamental woman, as spontaneous as Breton could be calculated. Short and well formed, with intense eyes, slightly pointed features, and a golden mane every bit as leonine as Breton's (though her hair was in fact naturally auburn, to which she returned it in the 1940s), she soon earned the nickname "Bastille Day," both for her brilliant looks as for her "fiery, vigorous" personality. Jacqueline was intelligent and well read; a member of the PCF since the age of fifteen, she held strong ideological convictions similar to Breton's own. Her initial attraction to Surrealism, in fact (which she had discovered several years earlier on the advice of her cousin, ex-Grand Jeu member André Delons), had more to do with its political positions than with its narrative works. She later specified that what interested her was not Surrealism itself but rather "what Breton was saying, because he was saying things that affected me, exactly what I was thinking, and I had no doubt that we were going to meet one way or another."

In 1934, the twenty-four-year-old Jacqueline was developing her talents as a painter,

honed at the prestigious Ecole des Arts Décoratifs, and making her living as a nude underwater dancer at a large Montmartre music hall on Rue Rochechouart called the Coliséum: it was after her evening's performance that she was to meet Breton. While Jacqueline seems to have enjoyed the job, it was clearly meant as a stopgap while she built an artistic career for herself. But Breton (who had previously demonstrated a penchant for dancehall girls) immediately fell in love with the image of his naked mermaid, and forever after saw Jacqueline as the *ondine*, or water sprite, who had been predicted in the young waitress's sigh at the Maison Bergey. Many years later, Jacqueline would say that Breton introduced her to his friends as a naiad because he found it more aesthetic than if she were simply a struggling painter: "He saw in me what he wanted to see, but he didn't really see me."

Breton and Jacqueline spent their first night together wandering, mostly in silence, throughout Paris: across the city's central meat and vegetable markets at Les Halles, across the Seine to the Latin Quarter, and by the Tour Saint-Jacques—"swaying like a sunflower," as Breton had earlier described it in a poem. Momentarily seized by panic, he stopped and stared at the woman before him; but Jacqueline slipped her arm into his, "recalling me to real life while enlightening me with its pressure about the shape of a breast." The giddiness of the meeting, and of this walk through a Paris bustling with nocturnal life, seemed to Breton to be laden with magical significance, a synthesis of the "real" and the "imaginary," a consummate instance of "*lyric behavior* such as it is indispensable to everyone, even if for only an hour of love, such as Surrealism has tried to systematize it, with all possible predictive force." At dawn, he saw Jacqueline to her room at the Médical Hôtel on Rue du Faubourg-Saint-Jacques, and several hours later sent her a message: "I walked down the white stairway, trembling as if I were watching you lie down and go to sleep."

But the greatest moment of revelation came several mornings later, when Breton found himself unconsciously reciting lines from an old poem from *Earthlight*, one that he claimed never to have liked very much. The poem, "Sunflower," had been written in August 1923, in the wave of automatic verse that Breton had produced that summer. Though he had given it little thought since its first publication, "Sunflower" now insistently drummed on his distracted mind, like one of the automatic phrases that, as he said, "knocked at the window." It was only when he consciously turned his attention to the poem that he realized what presages it contained:

> The traveler who crossed Les Halles at summer's end
> Walked on tiptoe . . .

At the Chien qui Fume
Where pro and con had just entered
They could hardly see the young woman and then only at an angle . . .
A farm prospered in the heart of Paris
And its windows looked out on the Milky Way
But no one lived there yet . . .
Some like that woman appear to be swimming
And a bit of their substance becomes part of love . . .

Amazed by what he considered on closer reading to be "a brilliant and uninterrupt-ed suite of discoveries," Breton analyzed each line in relation to his nocturnal stroll with Jacqueline (which in honor of the poem he dubbed "the night of the sunflower"). Each phrase seemed to foreshadow the events of May 29, from the "traveler who crossed Les Halles" (the silent Jacqueline during their walk through that same marketplace), to the "young woman" ill seen in a café, to the "farm prospering in the heart of Paris," to the woman who "appeared to be swimming" (Jacqueline's underwater dance at the Coliséum). While Breton, in the flush of new passion, had briefly believed several of his mistresses to be preordained (the latest of these, Marcelle Ferry, was still living with him at Rue Fontaine), Jacqueline's appearance seemed to be heralded by the most extensive series of concordances yet.

That Breton should need such justifications at all is, no doubt, the oddest part. He clearly wanted Jacqueline, and she him. But he had always placed his trust in the inter-vention of outside forces, whether in leaving his door ajar nights at the Hôtel des Grands Hommes, in following Nadja and the anonymous protagonist of "The New Spirit," or in reading the signs—like some vague private horoscope—of his meetings with Suzanne, Marcelle, and others. On the one hand, such signs provided outside confirmation of his guiding belief in objective chance: it is significant in this regard that Breton almost never wrote of a love affair without relating it to the philosophy of Surrealism. On the other, they bespoke a general passivity in his relations with women, evident as far back as in his seduction by his cousin Manon in 1915, and most recently in his moment of panic while strolling at night with Jacqueline. These coincidences, symptoms of an incontrovertible necessity, were invoked by Breton almost as talismans against poor choices—and against the specters of rejection and betrayal that haunted him like no other. (Somewhat more prosaically, they might also have provided a convenient excuse when it came time to con-front Marcelle.)

The circumstances of Breton's meeting with Jacqueline are largely known thanks to

his own detailed relation of them in the book *Mad Love*, which has elevated this encounter to one of the most celebrated moments in the Surrealist mythology. In reality, however, the union wasn't quite so fortuitous as Breton seemed eager to believe, or to make others believe. Jacqueline had in fact been trying to meet the poet for some time. Six months earlier, she had written to the Surrealist leader, on the pretext of wanting to borrow his rare edition of Sade's *120 Days of Sodom*, and had asked to see him—though Breton, who apparently didn't accept the rendezvous, would have had no reason to connect that correspondent with the woman he later noticed in the café. She had also appeared at the Café de la Place Blanche for several days in a row before the fabled encounter, sitting at a table neighboring the Surrealists' and (as Marcel Jean recalled) "looking insistently toward our little gathering," which she would no doubt have continued to do until the contact was made. But Breton appears, naively or willfully, to have glossed over this fact, just as he glossed over Jacqueline's painterly aspirations in favor of her incarnation as water nymph. In *Mad Love*, he described his meeting and initiatory walk with the young "traveler who crossed Les Halles" in tones of dreamlike predestination.

Soon after meeting Jacqueline, Breton left with Marcelle for several days in Belgium. At the Antwerp zoo, he was struck by the sight of two lions copulating in their cage, as if the spirits of himself and the tawny-maned Jacqueline had traveled with him. And on June 1, he delivered his lecture *What Is Surrealism?* to a receptive crowd. Shortly before this, René Henriquez had published a history of Surrealism by a certain Guy Mangeot, a dry, party-line rehearsal that at least had the merit of being the first. Word of the movement was spreading outside France as never before.

It was spreading so quickly, in fact, that some of its own members became alarmed, and perhaps none more so than René Crevel. Later that year, Crevel told Tzara that Surrealism's recent manifestations reminded him of a swan song: "What Surrealism has brought us remains established. But anything established can be surpassed or (let's be optimistic) must surpass itself." And in Brussels, he tried to express his concerns to Breton; but the man who had demanded "the profound, the veritable occultation of Surrealism" five years earlier now seemed so impervious to such qualms that Crevel let the matter drop.

The fact was, Breton was simply in too good a mood. He was elated by his reception in Brussels, and even more so by his relationship with Jacqueline. Shortly after his return to Paris, he evicted Marcelle Ferry from Rue Fontaine—an action not without its

conflicts: witnesses recall a violent public spat between the two at around that time, perhaps over "Lila's" direct appeal to Jacqueline to leave André alone. He also became engaged to Jacqueline and welcomed her in turn to his studio, which she immediately filled with nude photographs of herself. (Still, those of Breton's friends who wished to admire Jacqueline's unadorned charms did not need to visit Rue Fontaine: in the following weeks, Breton took many of them to see his fiancée dance underwater at the Coliséum.) In August, he told her: "I have a thousand better reasons to love everything in nature since I've begun loving you. I'd like to multiply the memories I already have of you by infinitely varying the places you might appear before me."

On August 14, less than three months after their meeting, Breton and "the all-powerful commander of the night of the sunflower" were married at the town hall of the 9th arrondissement. Eluard and Giacometti acted as Breton's witnesses (one week later, Breton returned the favor when Eluard married Nusch), but the family of neither party was in attendance, in Jacqueline's case because she was an orphan. The wedding announcements, designed by the bride, featured spiky white letters on a green background. Afterward the celebrants and a few friends enjoyed an outdoor picnic. Jacqueline posed nude for Man Ray's camera in a reenactment of Manet's *Le Déjeuner sur l'herbe*.

In September, Breton composed for Jacqueline a series of fourteen love poems, published later that year by Editions Cahiers d'Art under the title *The Air of Water* (*L'Air de l'eau*). The collection was written quickly, in about one week, as Breton sat alone by the river in Moret-sur-Loing. Breton "knew [Moret] well and loved it, and knew that it was propitious to him," Jacqueline later recalled. "The poem is entirely about me, or better about us." Jacqueline stayed behind in Paris because of her job; in any case, she felt that Breton "preferred being alone to write it . . . [Afterward] he came back and read it to me, making a commentary of it, explaining each sentence."

Placed under the sign of Jacqueline as "Undine," *The Air of Water* sings the rebirth of conjugal bliss after nearly ten years of uncertainty and despair. "The sexual eagle exults it's going to gild the earth again," one poem begins. Each text is filled with references to Breton's new bride, her aquatic profession, and their first days together. Most of all, these poems celebrate love given and received without reservation. "I've discovered the secret / Of always loving you / For the first time," Breton told his wife.

For the first season in many years, despite the "*extremely* painful material condition" in which Breton still found himself (exacerbated that winter when Jacqueline, after a blowup with her boss, left the Coliséum), hope seemed to rule the day. This hope brightened even Breton's perception of the external world, and of the impact Surrealism might

have on it. "I believe in a favorable and upcoming change in the conditions under which we'll have to act," he optimistically wrote Marco Ristich in August. Renewed desire and mutual passion had visited Breton in his thirty-eighth year, providing "the great undesirable" with at least a momentary respite from his defiant and dolorous self-image.

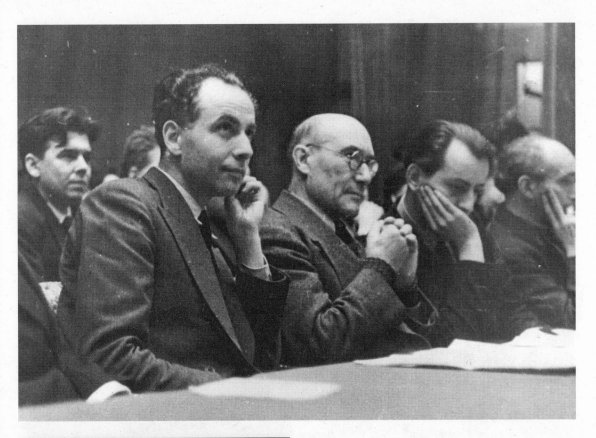

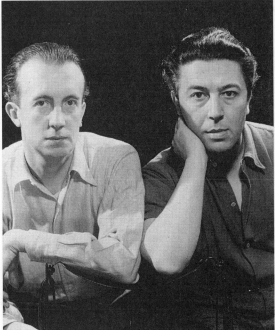

top:
The Party line: Aragon, Gide, and
Malraux at the 1935 Writers' Congress

bottom:
After Aragon's defection, Eluard became
Breton's closest confidant—at least for a
few more years

SURREALISM INTERNATIONAL:

top:
With Jacqueline at the Surrealist exhibit in London, 1936

bottom:
Diego Rivera, Leon Trotsky, and Breton in Mexico, 1938, as photographed by Manuel Alvarez Bravo

top left:
In the uniform of a medical officer at the flight training school in Poitiers, 1940

top right:
With Victor Brauner and Aube at Villa Air-Bel. Their faces betray the anxiety of uncertain departure

bottom:
Breton, Masson, Jacqueline, and Ernst review emigration possibilities with Varian Fry, winter 1940

top:
Breton created *Tragic, in the Manner of the "Comics"* in New York City in 1943. The form bears witness to his discovery of American comic-book art, while the departing woman reflects the breakup of his marriage to Jacqueline

bottom left:
Breton in New York, 1943

bottom right:
Jacqueline with one of her paintings in the Bleecker Street apartment, 1943

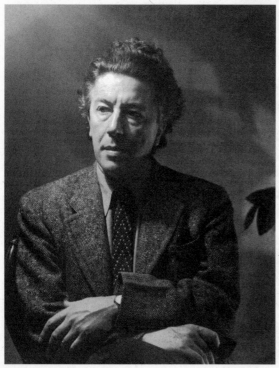

top:
Elisa Claro at the time of her meeting
with Breton

bottom:
Breton photographed by Elisa in the Gaspé
Peninsula, Canada, during the writing of
Arcanum 17

left:
At the Zuni reservation, 1945

right:
With Wifredo Lam in Haiti, early 1946

OLD LOVES:

top:
Suzanne Cordonnier (formerly Muzard) with Breton, Elisa, and Péret in the Bretons' studio, 1948

bottom:
Breton and Simone at the house in St.-Cirq-Lapopie, 1959

top:
In the garden of Breton's house in St.-Cirq, August 1960. *Standing, left to right:* Gérard Legrand, Simone Jaguer, Breton; *seated, left to right:* Elisa, Adrien Dax, Edouard Jaguer

bottom:
Breton and Edouard Jaguer in the second Rue Fontaine studio, 1961. On the wall is Chirico's *The Child's Brain*, one of Breton's few lifelong treasures

top:
Chasing butterflies with Péret in
St.-Cirq, ca. 1959

bottom:
"I seek the gold of time": Breton's
tombstone in Batignolles cemetery

ON THE INTERNATIONAL STAGE

(September 1934 – December 1936)

BY THE TIME OF ITS FIRST DECENNIAL, Surrealism had become virtually a revolving door. The period around early 1935 witnessed an almost dizzying number of entrances, exits, and renewals of affection or conflict. While some members (Arp, Ernst, Sade specialist Maurice Heine, Hugnet, Marcel Jean, Péret, Man Ray, Tanguy, and Eluard) constituted a relatively stable core, others seemed to come and go at an accelerated rhythm. Personal and ideological alliances shifted with disconcerting frequency, prompting one writer during this period to liken the movement to a "mad tea party."

One of the things that distinguished the newest arrivals was the comparatively high percentage of foreigners. While Surrealism had counted non-Frenchmen in its ranks since the beginning, the mid-1930s saw a notable rise in members from abroad. Among these were Oscar Dominguez, a massive, dark-complexioned painter from the Canary Islands who wore "an enormous shag overcoat that made him look like a bear." Dominguez, who began frequenting the group in December 1934, soon developed several new visual techniques for Surrealism, including "lithochronisms" (paintings created by the artist's distracted hand as he conversed with friends) and "decalcomanias without preconceived object," obtained by pressing diluted gouache between two sheets of paper until it yielded Rorschach-like results. Another artist, the German Hans Bellmer, met the group during a trip to Paris in early 1935 and immediately took to Surrealism's ideas. "The most captivating impressions of my stay in Paris are related to the spiritual atmosphere at the Café de la Place Blanche," he later told a friend. Bellmer, who permanently joined the Paris group in 1938, would soon become known for his savagely erotic drawings, as well as for his series of disturbingly twisted and dismembered dolls. A year before this, the group also welcomed the Romanian painter Victor Brauner, who had been introduced by Tanguy. A prominent member of the Romanian avant-garde, Brauner quickly became one of French Surrealism's most active visual artists—at least until his return to Bucharest truncated his contacts with Paris.

It was also during this time that Breton entered into closer contact with the Czech Surrealists, and notably with the group's co-founder, poet Vítězslav Nezval. The trans-

lator of several of Breton's works, Nezval, a corpulent man in his mid-thirties with a fanatical devotion to Surrealism, was arranging a Czech lecture tour for Breton for early 1935—to which Breton, his success in Brussels fresh in his mind, readily agreed.

Finally, this period saw the return of French-born foreigner Marcel Duchamp, who moved back to Paris after many years' residence in the United States. Although Breton had always felt profound respect, even reverence, toward this spiritual older brother, the two men's relations had fallen off during the clean sweep of 1929, when Breton had chided Duchamp for abandoning his art in favor of an "interminable game of *chess*." While Duchamp had in no way renounced his interminable game (the next year, in fact, he was named captain of the French Olympic chess team), his reconciliation with Breton was now favored both by his return to Paris and by his reentry into the artistic sphere via the publication of *The Green Box*, a collection of notes and sketches for *The Bride Stripped Bare by Her Bachelors, Even*. That December, for the sixth issue of *Minotaure*, Breton celebrated their reunion by publishing "Lighthouse of *The Bride*," a major study of Duchamp's work.

This series of arrivals, typically, was counterbalanced by an equally long list of departures. Among those exiting was Giacometti, who had recently abandoned his nonfigurative work for the more representational drawings and sculptures that would become his trademark. In December, an evening with Breton, Péret,s Tanguy, Jacqueline, and a few others turned into a bitter referendum on the "aesthetically frivolous and historically redundant" direction Giacometti was taking; Breton dismissed his latest effort, a bust, with a contemptuous "Everybody knows what a *head* is!" Pressed to defend his recent art, Giacometti instead repudiated his Surrealist works as "masturbation" and stormed out. Breton then formalized the break with a public notice of exclusion.

Another leave-taker, who had barely had time to contribute more than a few articles to Surrealism's literary corpus, was Roger Caillois. On December 26, Caillois arrived at the daily café meeting to find Breton and some friends marveling at a handful of Mexican beans, jerking in little spasms on the tabletop. Caillois (who, like the others, had never seen jumping beans before) proposed cutting them open to see what might be inside; but Breton, taken with the pure marvel of the thing, exploded in anger at Caillois's suggestion. Thirteen years later, Breton explained that he had simply wanted to exhaust "the discussion on the *probable* cause of the movements we had witnessed" before subjecting these movements to cold investigation; to "enjoy . . . before we understand." Caillois, however, read the incident as indicative of Breton's contentment with "inaccessible and 'adorable'" marvels; on top of which, the susceptible young man had clearly been wounded by Breton's outburst. The next day he sent a long letter detailing

his philosophical disagreements with his former mentor, and then disappeared from Surrealism's horizon.

One more break, although this one remained characteristically vague, was with Dalí. Following his near-exclusion in February, the Catalan painter had gone first to Barcelona, then in the fall to New York to promote an exhibit of his work. He and Gala quickly applied their flair for publicity to the conquest of the New World, and within weeks Dalí was a media and social success, occupying "entire pages in the world's best-distributed newspapers," as he wrote Eluard. But the Dalís had saved their most outrageous sally for last: on the eve of their departure, at a society costume ball, Gala arrived wearing a black headdress designed by her husband and containing the simulated corpse of an infant. Coming only several months after Bruno Hauptmann's widely reported conviction for the murder of the Lindbergh baby, the costume created a scandal, and Dalí—despite denials of any conscious provocation—left New York under a hail of protests. More protests greeted him on his return to Paris, this time from Breton, and this time for having *repudiated* the connection with the Lindbergh baby (a charge that Dalí equally denied).

In a less spectacular repetition of the 1929 purges, Breton was again tightening his hold over the group's public positions, output, and even private convictions. Unlike the earlier exclusions, however, the current series lacked the particularly acrid dimension that Breton's divorce from Simone and troubles with Suzanne had added five years earlier. Although his new marriage to Jacqueline did not allay the need to control, it at least seems to have muffled much of its violence.

This muffling was evident in Breton's comparatively mild response to three more Surrealists who left the group at this time, even though these departures constituted an open dissent against Breton's leadership. The most disheartened of the trio was René Crevel. Throughout the many fluctuations in their relationship, Crevel had remained one of Breton's fierce admirers; to his close friend, the Catholic novelist Marcel Jouhandeau, he had confided: "When I no longer believe in anything, neither in myself nor in anyone else, I'll still believe in Breton." At the same time, Crevel's absorption in "the immediate present" of Communist politics left him dissatisfied with the backward-looking aestheticism he saw in Surrealism's latest efforts—notably Breton's recent poetry and art essays, which had temporarily eclipsed political action. Moreover, when he tried to air his concerns, Breton kept turning the discussion to amiable inquiries about Crevel's personal life (a delicate subject at best, given the one's homosexuality and the other's attitude toward it), leaving a furious Crevel to conclude that Breton simply couldn't face the more serious issues at hand. Instead, Crevel outlined his own hopes and fears for Surrealism in an arti-

cle published that winter and in a series of letters to Tristan Tzara. "The whole retrospective side of Sur [*sic*] activity saddens me," he wrote in January 1935. "There will always be the famous issue of Breton's magnetism. I don't deny it, I was under its sway for too long, but no more, it's over."

Crevel's interlocutor was of the same mind. Troubled by the rise of European fascism, Tzara had himself become more involved with the Communists, and he felt (as did the Party) that Breton's current efforts were of little value. A recent article by Breton, "La Grande Actualité poétique" [The Great Poetic Present], only angered him further with its critiques of Soviet policy and its calls for a common front of poets. In a strange echo of 1922, Tzara invited Crevel, René Char (the third dissenter), and Eluard to join him in an independent coalition. In March, he took matters further with an article for *Cahiers du Sud* in which he ridiculed Breton's *The Air of Water* and "La Grande Actualité poétique." But even then, Breton, although he was moved to break off all relations with the ex-Dadaist for the second and final time ("I no longer want to hear about Mr. Tzara for any reason at all," he told Eluard), did so with surprisingly little fracas. Crevel, for his part, quietly gave Surrealism up for lost, though he retained his admiration for Breton. And Char, disgusted by the infighting and called home by a family matter, returned permanently to L'Isle-sur-la-Sorgue and severed his ties with the group.

Eluard, meanwhile, caught between his loyalties to Breton on the one hand and his affection for the three dissidents on the other, watched developments unfold with increasing anxiety. "I was utterly sure that no major rifts would occur between our friends," he had earlier written Valentine Hugo, trying to minimize the fractional tendencies he saw forming. "I know that André loves me. We're too devoted to each other for either of us ever to doubt the other. Ever." Finally, when Tzara chose his camp in *Cahiers du Sud*, Eluard was forced to choose his: he, too, broke with Tzara that March. Still, even Eluard was harboring doubts about Surrealism. Swayed by the others' opinions, he again decided to stop working on *Minotaure* and to cease attending café meetings. Although, as always, he swallowed his disgruntlements out of deference to Breton, they indicated an ongoing dissatisfaction on the part of Surrealism's first lieutenant.

On March 5, before matters with Tzara had come to a head, Breton left Paris to spend several weeks' vacation with Jacqueline and the Ernsts in the town of Jégun (Gers), at the foot of the Pyrenees. In the centuries-old Château du Pouy, with snow on the ground and hardly a person visible for miles, he began drafting his lectures for his upcoming visit to Prague, while Jacqueline went horseback riding. Vítězslav Nezval, Breton's Czech correspondent, had originally planned the trip for January; but Breton, wanting time to prepare something other than "some sort of improvisation," had delayed

his arrival, which was now set for the end of March. Back in Paris shortly after the appearance of Tzara's *Cahiers du Sud* article, he invited Eluard to accompany him and Jacqueline; Eluard, who was eager to affirm his solidarity with Breton in the face of Tzara's attack, borrowed train fare and set off with his friends, regretfully leaving Nusch at home.

One reason for Breton's interest in Czechoslovakia was that the Czech Surrealist group was among the most active of Surrealism's foreign offspring: Nezval, along with the painters Jindřich Styrský and Toyen (Marie Cermínová), the theoretician Karel Teige, and others, had earlier mounted a well-received exhibit of Surrealist art and translated several of the Paris group's main works—most recently including *Nadja* and *The Communicating Vessels*—into their native tongue. Even more intriguing from Breton's viewpoint was that the movement enjoyed excellent relations with the Czech Communist Party, and one Communist intellectual in particular, Záviš Kalandra, had expressed a very favorable opinion of Surrealist political ideals. No doubt Breton was curious to see whether some of this close rapport could be imported back to the French Communists as well.

The travelers arrived in Prague on March 27. On the 29th, Breton inaugurated his series of lectures with "Surrealist Situation of the Object," in which he analyzed Surrealist art and poetry from a Hegelian perspective. "At the present time there is no fundamental difference between the ambitions of a poem by Paul Eluard or Benjamin Péret and the ambitions of a canvas by Max Ernst, Miró, or Tanguy," he stated, in that each of these aimed at confronting "inner representation with that of the concrete forms of the real world" so as to produce the spark of the marvelous. "We have succeeded in *dialectically* reconciling these two terms—perception and representation—that are so violently contradictory for the adult man." Breton was warmly applauded by an audience that numbered seven hundred. Flushed with excitement, he wrote to Valentine Hugo: "Everything promises to go marvelously well—better than promises: we've been given a triumphant welcome."

On April 1 he won equal acclaim for his second lecture, "The Political Position of Today's Art," sponsored by the group Leftist Front. Speaking to an audience of three hundred and fifty, Breton warned against the twin dangers of making art entirely apolitical on the one hand (and therefore devoid of "historical meaning") and on the other of rendering it subservient to politics: "The very condition of objectivity in art is that it appear to be detached from every specific circle of ideas and forms. In that way alone will it conform to the primordial necessity that belongs to it alone, which is the necessity of being totally *human*." The newspapers reported the enthusiastic reception given Breton

and Eluard, and Záviš Kalandra, in the Communist *Halo-Noviny*, congratulated the Surrealists for "not having tried to degrade their poetic activity by bringing it down to the level of doggerel, whose value to the good of the revolution would surely be quite illusory."

As the days went on, Breton continued to enjoy phenomenal success in Czechoslovakia. He delivered more lectures across the country, signed copies of his books in translation, spoke on Czech radio, and gave an important interview to *Halo-Noviny*. With the Czech group, he founded the bilingual *International Bulletin of Surrealism* (the first of four), featuring long extracts from his and Eluard's speeches. "I think Prague is our gateway to Moscow," Eluard raved to Gala. "We live marvelously here. They don't let us spend anything. Delirious admiration and affection." Taken by the reception, and by the "very welcoming" Czech women, Eluard delayed his return to Nusch by an extra week. Nezval, practically hyperventilating with admiration for his guests, strained his fractured French in expressing "an adoration so vehement that, although sincere, rang false." And Breton long remembered his stay as "one of the most beautiful memories of his life"—for this favorable treatment by the Czech proletariat seemed to vindicate his earlier aim (apropos *The Communicating Vessels*) to "write for the masses." After the resistance and often willful incomprehension of the French intellectuals, the Czech welcome had made him feel truly accepted for perhaps the first time in his life.

But Breton had little time to savor his triumph, for shortly after his return to Paris on April 12 it was again time to act as Surrealism's ambassador, this time in the Canary Islands. Breton had hoped that Eluard would again accompany him and Jacqueline; but Eluard stayed behind, unable to raise the cash, and it was Péret who left with the Bretons on April 27, on the Norwegian banana boat *San Carlos*.

They arrived exactly one week later in Santa Cruz de Tenerife, for another series of lectures, interviews, and exhibits sponsored by the periodical *Gaceta de arte* and arranged by Oscar Dominguez. Shortly afterward, Breton told the newspaper *La Tarde*, "Arriving in Tenerife, I washed my hands with an ordinary soap that looked like lapis lazuli. I washed my hands of all of Europe." And in the course of his three-week stay, he discovered the island's exotic flora (some of which he smuggled back with him), the stunning black-sand beaches, and the magnificent Peak of the Tiede. He recorded his impressions of the Canaries' savage beauty in a long essay, part travelogue, part meditation on politics and on his new relationship, published the following year under the title "Le Château étoilé" [The Starry Castle].

But although the group's welcome in Tenerife was comparable to that of Prague, Breton did not come away with the same overall enthusiasm. For one thing, he was

obliged by his well-meaning hosts to endure several unavoidable tourist sites, including, to his dismay, the local bullfights. In addition, there was a distinct lack of rigor about the events themselves: one commentator recalled that during Breton's opening speech at the exhibit, "Breton said one thing in French, and Augustín [Espinosa, his translator] said the opposite in Spanish!" And the gentle island pace set his urban nerves on edge. "Getting them to make the slightest effort is a whole production; they'll take any excuse not to move," he grumbled to Marcel Jean after his return.

Breton's sojourn in the Canaries did, however, leave behind two important traces. One was a second *International Bulletin of Surrealism*, in French and Spanish, which furthered the movement's international reach—although, perhaps because of the local indolence, this second issue did not appear until October, two months after a "third" number had been published in Brussels. The other trace was an interview with the Socialist magazine *Indice*, in which Breton publicly acknowledged for the first time his rift with Aragon. "For those who have known Aragon, it is easy to see there the juxtaposing of two tendencies: 'not making one's actions consistent with one's words' (*Treatise on Style*) and 'Let's spit on all that we have loved together' (*The Great Gaiety*). One never contradicts oneself as much as one thinks." Whatever Surrealism's successes on the international stage, they could not cloud Breton's bitter memories of betrayal at home.

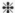

On Breton's return to Paris in June, *Minotaure* published his essay "La Nuit du Tournesol" [The Night of the Sunflower], the account of his meeting and initiatory walk with Jacqueline, and of the mysterious presages contained in the poem "Sunflower." But the gauzy atmosphere of the narrative had been undercut in Breton's own life several months earlier by the news that the real Jacqueline was pregnant. The pregnancy appears to have been accidental, and Breton, as an acquaintance recalled, was "rather terrified. It was a major responsibility." Breton's lifestyle and attitudes were hardly conducive to having children, and his various lecture tours had left him no more financially solvent than before: often during this period the couple found itself without basic utilities for months at a time. (Jacqueline, recalling those days half a century later, was still bitter about the "years spent with no money, surrounded by a priceless collection. When collecting reaches that degree, it's a pathological phenomenon.") Still, his love for Jacqueline made him somewhat more receptive to the idea, and on April 22 he had told her: "I feel that I should not, on my own initiative, refuse this offer [that life has made us], nor ask you to refuse it, loving you as I do. For a long time I was able to believe that

I would persist in this refusal, but that was when I didn't love, and today I find myself disarmed . . . I believe in natural necessity and in nothing else."

Shortly before this—and now even more urgently so with the prospect of another mouth to feed—Breton had appealed to Edmond Bomsel, co-director of Editions du Sagittaire, to find him a project that could be completed with a minimum of time and effort and that would warrant a substantial advance. When Bomsel put the question to the editorial board, Edouard Roditi, a Franco-American poet and translator who had recently joined Sagittaire, suggested that Breton edit an international "anthology of black humor." The book would ultimately group excerpts from forty writers of various European nationalities, beginning with Jonathan Swift and ending with the Surrealists (Péret, Prévert, Dalí), via Sade, Poe, Baudelaire, Lewis Carroll, Nietzsche, Jarry, Picabia, Apollinaire, Kafka, Duchamp, Vaché, and of course Lautréamont and Rimbaud. Each author would be briefly presented by Breton.

The concept of "black humor," a descendant of Vaché's umor, was the expression par excellence of an aggressively absurd, often macabre worldview, an appreciation for which had been present in Breton's writings since the earliest days of Surrealism. Breton later described this humor as a "superior revolt of the mind" and "the mortal enemy of sentimentality," and in illustration cited one of Freud's examples from *Jokes and Their Relation to the Unconscious*: "The condemned man being led to the gallows on a Monday who observes, 'What a way to start the week!'" The reference to Freud was not accidental, for Breton's codification of black humor rested largely on explicitly psychoanalytic concepts. In 1937, he defined this humor as "the revenge of the *pleasure principle* attached to the *superego* over the *reality principle* attached to the *ego* . . . The aggressiveness of the hyper-moral *superego* toward the *ego* thus passes to the utterly amoral *id* and gives free rein to its destructive tendencies. Humor, as the process that allows us to remove the overly distressing aspects of reality, can only be exercised here at the expense of others."

But although the project seemed perfectly suited to Breton's sensibilities (and although he readily agreed to it), Roditi was soon amazed at the limitations of Breton's literary culture. "He had never heard, for instance, of Ambrose Bierce, had only the vaguest notion of Mark Twain, and only recently begun to hear of Kafka; nor had it ever occurred to him that he might find examples of 'black humor' in such French classics as the writings of Cyrano de Bergerac or Rabelais [neither of whom would figure in the anthology]. In the course of our first meeting, Breton was able to suggest, as writers to be included in our proposed anthology, only Swift, Sade, Baudelaire, Lautréamont, Charles Cros, Alphonse Allais, Alfred Jarry, Raymond Roussel, and a couple of others whose names were already quoted in some of his own previous writings." It was a particular

talent of Breton's that he could appear fully knowledgeable about a subject, as he had to the publishers at Sagittaire about black humor, on the basis of a few well-chosen and often repeated references. What Roditi had failed to realize was that Breton's "erudition" was really poetic intuition—the ability to use the selected ideas of others as springboards for his own—rather than the encyclopedic grasp of the scholar. (In the event, the anthology would in no way be the quick moneymaker Breton had hoped: its compilation would take him five years, and when it was finally published the Vichy government would ban it as "subversive.")

While Breton began casting about for texts to include in the anthology, he also lobbied for inclusion in the First International Congress of Writers for the Defense of Culture, a Communist-sponsored gathering of anti-fascist intellectuals that was scheduled to open on June 21. Alongside René Crevel, who supported Breton's candidacy, the organizing committee included Aragon, Tzara, André Malraux, critics Jean Cassou, Jean-Richard Bloch, and René Lalou, and Ilya Ehrenburg, as Paris correspondent for the Soviet newspaper *Izvestia*.

Although few on the mainly Stalinist committee were actually favorable to Surrealism, none was so flagrantly hostile to it as Ehrenburg. In 1934, Ehrenburg, who enjoyed far more prestige in Paris than he did in Moscow, had published a widely read study of contemporary French letters called *Vus par un écrivain d'U.R.S.S.* [As Seen by a Writer from the USSR], in which he berated contemporary French novelists for selling out to capitalist interests, and for writing books "without substance or thought." His harshest allegations had been reserved for the Surrealists. "I am not sure as to whether they are mentally sick or merely very clever, these young fellows who make a trade of insanity," Ehrenburg had written:

> These young "revolutionists" will have nothing to do with work. They go in for Hegel and Marx and the revolution, but work is something to which they are not adapted. They are too busy studying pederasty and dreams . . . Their time is taken up with spending their inheritances or their wives' dowries; and they have, moreover, a devoted following of rich American idlers and hangers-on . . . In the face of all this, they have the nerve to call the rag they publish *Surrealism in the Service of the Revolution*.

Still, despite the presence of such hostile elements on the committee, Breton had requested a place in the Congress and, thanks to the efforts of the popular Crevel, had obtained the board's consent: the Surrealists would not figure on the program, but they

would be allowed one speech with no restrictions on content. (Ehrenburg, meanwhile, had sat silent and watchful through these discussions.) The group had designated Breton as its spokesman, giving him the responsibility of preparing a statement in its name.

But on the evening of Friday, June 14, with only a week to go before the opening of the Congress, an incident occurred that derailed all of the Surrealists', and Crevel's, efforts. It was later described by Vítězslav Nezval, who had arrived in Paris earlier that day along with Styrský and Toyen and who had just finished dining in Montparnasse with Breton, Jacqueline, and Péret:

> After dinner, walking along Boulevard Montparnasse toward the Closerie des Lilas, Toyen pointed out Ilya Ehrenburg, who had just left that very café and was about to cross the street. "Where?" asked Breton. "I've never seen him." Then: "I have a score to settle with you, sir," he said, accosting Ehrenburg in the middle of the road.
>
> "And who are you, sir?" inquired Ehrenburg.
>
> "I am André Breton."
>
> "Who?"
>
> André Breton repeated his name several times, each time adding one of the epithets that Ehrenburg had used in his lying pamphlet against Surrealism. Each of these introductions was followed by a slap. Then it was Peret's turn to settle accounts with the journalist. Ehrenburg did not even defend himself. He stood there, protecting his face with his hands. "You're going to be sorry for that!" he blurted out when my friends had finished.

Livid, Breton was still "beside himself" long after the incident, as Jacqueline recalled: "It was the first time I had ever seen such an act of personal violence *provoked by indignation and disgust*. It took André several hours to calm down."

Ehrenburg's threats had not been idle, however, for as a member of the Congress committee (something Breton claimed not to have known at the time, although this is hardly likely) he immediately demanded that the Surrealists be stripped of their right to speak—failing which, the entire Soviet delegation would walk out. An international Communist event without the participation of the Soviets was unthinkable; despite protests by Crevel and a few others, the committee voted to censure the Surrealists.

Crevel, however, was not content to let matters lie. He spent the weekend before the Congress desperately working to reverse the committee's decision, and on Monday the 17th he phoned Eluard several times during the Surrealists' café meeting, trying to get Breton to make a conciliatory gesture toward the Soviets (Breton coldly refused). That

same evening, during a committee meeting at the Closerie des Lilas, he pressed his fellow organizers one last time to drop the ban. But Ehrenburg's only comment was that "Breton acted like a cop," and none of the others wanted to risk alienating the Russians. Finally, after an exhausting and fruitless debate, Crevel went home, swallowed a handful of sedatives, and turned on the gas. "A cup of tea on the stove, the window shut tight, I open the gas tap and forget to light a match," he had written in his first novel, eleven years earlier. Found along with Crevel's body the next morning was a terse note pinned to the lapel of his coat: "Please cremate me," it read. "Disgust."

Crevel's suicide was not simply the result of his inability to reconcile his twin loyalties to Breton and Communism. Temperament and circumstance had made his life a tangle of contradictions over the past years. As one historian put it, Crevel "was homosexual, but belonged to a Surrealist group that condemned homosexuality. He believed in Marxism and wanted to pave the way for proletarian revolution, but assiduously frequented the high society that worshipped him . . . He adored André Breton, but through his sexual choices and political convictions let himself be drawn into groups that hated Breton and fired on him mercilessly." On top of which, tuberculosis had by now ravaged Crevel's once angelic features, and that same Monday morning he had received a medical report leaving no hope of recovery. At the same time, there is little question that Breton contributed to Crevel's final despair—not only by refusing to reconcile with the Communists but also by rejecting his last appeals.

The next day, the Surrealists were shocked by the news of Crevel's death. Added to their agitation over the upcoming Congress, the suicide lent further trauma to the daily gathering. Eluard, who had always been close to Crevel, and who had taken his many phone calls to the Surrealists only the day before, was particularly distraught. The manic Dalí was also "visibly shaken," and the steely Gala had tears in her eyes. As for Breton, Jacqueline remembered the "pain and confusion" her husband privately felt over the suicide: "He kept coming back to the share of responsibility that, in spite of himself, he might have had in the tragedy." "Breton was rattled," recalled Nezval. "He knew that his enemies would hold him responsible for Crevel's death."

The prediction was correct: a number of those close to Crevel did hold Breton responsible, and the next month's *Nouvelle Revue Française* even carried a letter from Crevel's friend Marcel Jouhandeau that practically charged him with murder. A livid Breton protested the "vulgarity" of Jouhandeau's maneuver in the next *NRF*; but on some level, he would always be held accountable for the death of his tortured collaborator, and his rebuttal struck many people—even those favorable to him—as unmoved and unmoving. Crevel was quietly interred in the family plot in Montrouge Cemetery on

Saturday, June 22. By a curious twist of black humor, his tombstone had been signed by its maker: a man named Breton.

✳

With Crevel dead, Breton made a final attempt of his own to be reinstated in the Congress of Writers. "I cannot believe," he wrote committee member René Lalou on June 19, "that they're blaming me for having responded as I did to the unspeakable accusations brought against my friends and me in 'Vus de l'U.R.S.S.'" Finally, the committee relented to the point of allowing Breton's speech to be read by someone other than its author—and only, it specified, out of deference to Crevel's sacrifice. Paul Eluard was chosen to replace Breton at the podium.

At around nine o'clock on the evening of Friday, June 21, during one of the worst heat waves in memory, some 3,000 delegates and spectators crushed into the auditorium of the Palais de la Mutualité for the inauguration of the Congress. The art deco building, located in the Latin Quarter, served as the headquarters of an insurance association; its large basement-level auditorium was designed to seat only 2,000. But neither the insufficient space nor the stifling temperatures deterred those eager to hear opening remarks by André Gide, who had recently proclaimed his (ultimately short-lived) sympathy for the Communists. In tones initially shy, soon stirring, the sixty-six-year-old Gide read his speech, his "startlingly bald and ascetic head" hidden "behind the spider's web of microphones." "In my opinion," he said, "we must begin with the idea that this culture which we seek to defend is the sum of the particular cultures of each country, that this culture is our joint possession, that it belongs to us all, that it is international."

Seated in the rear of the hall, Breton called Gide an "old ham," to the amusement of Nezval seated next to him. And indeed, Nezval later wrote, Gide spoke like a practiced stage actor, "slowly, amply, with variations in his tone, leaving spaces for applause." Still, when Gide asserted that "until today, all literature of quality has been oppositional," Breton himself applauded so forcefully that many in the audience turned around, thinking it to be a provocation.

In the unrelieved mugginess of the crowded hall, Gide's speech was followed by addresses from Malraux, E. M. Forster, Julien Benda, Robert Musil, and Jean Cassou, many of them in shirtsleeves. (Later nights would have speeches by Aldous Huxley, Heinrich Mann, Isaac Babel, Bertolt Brecht, Alexei Tolstoy, Anna Seghers, Max Brod, Lion Feuchtwanger, Paul Nizan, Tzara, and others.) Ehrenburg also took the floor, vaunting in the first person plural the successes of a Soviet Union that actually had little

use for him. The next day—the day that should have seen Crevel's address but instead witnessed his burial—Jean Cassou paid formal homage to his departed comrade. Aragon frequently left his seat on the stage during the proceedings to horse-trade among the delegates. Catching sight of Breton, he turned away without a sign of recognition. Later, back on the podium, Aragon seemed unable to keep his eyes off his former friend; no sooner did he detach his gaze than it drifted back, as if drawn to a hypnotist's watch. Breton leaned toward Nezval and whispered, "Sleepwalker."

By Sunday, the swelter and the monotony of the speeches were turning the proceedings into a sweaty blur. Infighting among the organizers, over who should or shouldn't be allowed to speak, became more frequent—and was gamely amplified by correspondents from the right-wing press. Brecht was cut off after three minutes (instead of the promised fifteen), but another speech, by Barbusse, was so long and boring that it "gradually drove much of the audience from the hall," despite the organizers' admonishments for people to retake their seats. Some of them did in fact return, but many preferred to stand in the lobby and guzzle cool beer.

Things picked up on the evening of Monday the 24th, when Boris Pasternak, ailing and forced under guard to attend the Congress, arrived at the Palais de la Mutualité. "Poetry will always exist down in the grass," Pasternak told his listeners. "It will always be too simple a thing to discuss in meetings. It will remain the organic function of a happy creature, overflowing with the felicity of language, tensed in the birthright of his heart, forever aware of his mission." Breton later singled out Pasternak's speech as one of the few truly "moving declarations" of the entire Congress.

A second such moment came shortly afterward, when the Italian historian Gaetano Salvemini, one of the few present to have personally suffered under fascism, raised the question of Victor Serge, the Trotskyist intellectual who had spent the past two years in a Soviet prison. The Serge case was a particularly sore point for the French Stalinists, and the Congress organizers—who were anxious about showing a united front—had so far managed to keep it out of the proceedings. But Salvemini's mention was picked up by others in the audience, sparking some angry confrontations between the various factions in the hall. Finally, André Malraux shouted that anyone else who mentioned Serge would be expelled from the room.

It was also on Monday that the Surrealists were finally given the floor. As it happened, the committee had had reason to block the group's participation, for Breton's speech directly challenged the two main banners under which the Congress had been staged and which most of the preceding speeches had gone out of their way to uphold: the Franco-Soviet Mutual Aid Pact and the recently decreed doctrine of "Socialist Realism."

Signed in May, the Franco-Soviet Pact had raised eyebrows even among loyal Communists, for it entailed Stalin's unexpected endorsement (itself dictated by concern over the German military buildup) of French rearmament. Only an energetic campaign by *L'Humanité* had swayed the Party's disgruntled rank and file. Breton, however, solidly opposed the pact from the outset, maintaining that the alliance of a revolutionary state such as Russia with "ultra-imperialist France," for whatever reason, could only lead to fatal compromise. Moreover, he rejected the pact's nationalistic spirit, which promoted specifically French and Russian aims at the expense of Germany—a Germany that, to his mind, was still mainly the birthplace of the nineteenth-century Romantics

The second prong of Breton's attack had to do with the doctrine of Socialist Realism, which had been introduced by the essayist and critic Andrei Zhdanov in 1934 and endorsed (sometimes under duress) by the Party's leading writers. Zhdanov had cut through the age-old question of the artist's political involvement by decreeing that art's *only* function was to serve revolutionary propaganda. In response, and as he had for the past decade, Breton stressed that truly revolutionary literature could honor no dictate other than absolute freedom of expression: "One of our first duties on the literary plane is to shelter such works *full of sap* against all falsification from the right or from the left." Citing Surrealism's twin poles of attraction, he ended his address with what has become one of the movement's most lapidary pronouncements: "'Transform the world,' Marx said; 'change life,' Rimbaud said. These two watchwords are one for us."

Breton's "Speech to the Congress of Writers" was one of his most passionate and controlled statements, and Eluard rendered it that night in appropriately emotional tones. But few were to hear either the content or its delivery, for the Congress organizers did not hand Eluard the microphone until twenty past midnight, when much of the audience (and nearly all the presiding delegates) had gone home and the house lights were being dimmed. "His speech echoed in a nearly empty hall," recalled Nezval.

Still, one person took it upon himself to explicitly rebut Breton's statements: on Tuesday, the final day of the Congress, Aragon stepped onstage and launched into his former Surrealist colleagues with all the fervor of the true convert. "Who has shouted the loudest for freedom of expression? Marinetti. And look where it has led him: to fascism. We have nothing to hide, and that is why we welcome as a joyful expression the new slogan of Soviet literature: Soviet realism. Culture is no longer something for just a handful of people." Breton (at least according to one witness) sat through his old friend's diatribe with a "frankly amused" smile on his face; but Jean Paulhan, describing the evening's events, shuddered over how "sarcastic, hard, and aristocratic" Aragon appeared.

Nor was this Aragon's final word. All through the proceedings, Nezval, who had

come to Paris specifically as a Czech delegate to the Congress, had been awaiting his turn at the podium. As the evening progressed, however, it became clear that the organizers had little intention of hearing another Surrealist sympathizer. When panel member André Chamson then announced the closing of the Congress, Nezval jumped onstage and protested the committee's "cowardly" treatment of him. But Aragon, walking past the agitated Czech, dryly announced: "The Congress is over."

Whether or not the 1935 Congress of Writers made a significant contribution to anti-fascism, or even to the advancement of a few specific points of doctrine, is still open to debate. What is certain is that, more than any other piece of Stalinist maneuvering, the Congress served as the final break between Surrealism and organized Communism. For Breton, the manifest ill will coming from the presidium made any further attempts at joint action pointless—not only with the French Communist Party, as had been the case after his expulsion from the AEAR, but with the Communist International itself. Even as he was warning the left against compromises with the tainted bourgeoisie, Breton was finally realizing that the Soviets could be just as conniving as any Western power. The ultimate failure to find common ground with Communism would by no means spell the end of Breton's involvement in the political sphere. But from this point onward, his actions would take place further and further outside the political mainstream.

In November, Breton compensated for his inability to be heard at the Congress by publishing his address and some other recent political statements in a volume titled *Political Position of Surrealism*. Reprinted along with these was a pamphlet called *On the Time When the Surrealists Were Right*, the result of a postmortem that Breton had held in the wake of the Congress. As he pointed out in the pamphlet, the Surrealists had hoped for two things in addressing the Congress: to draw attention "to how unconditional and dangerous the words 'defense of culture,' taken by themselves, can be"; and to ensure "that there was debate on a certain number of questions that are still disputable." Instead, they and others of like mind had been pushed into the background. While the Surrealists continued to think of themselves as revolutionaries, Breton said, "we intend not to be forced to give up anything that appears valuable to us and proper to us" simply on Stalin's say-so. No amount of revolutionary fervor, he concluded, would keep Surrealism from condemning "the *present* regime of Soviet Russia and the all-powerful head under whom this regime is turning into the very negation of what it should be and what it has been. We can do no more than to formally notify this regime, this chief, of our mistrust."

That winter, following the book's publication by Editions du Sagittaire, Breton granted an interview to the conservative *Le Figaro* in which he retraced nearly a decade of disputes with the Party and described their final parting of the ways. "I have no

regrets about the breakup," he informed his interviewer: "Soviet Russia has lost all of its revolutionary effervescence." Both the unapologetic nature of Breton's charges and the forum in which he made them indicated how little he now cared about courting Communist favor.

In August, discouraged by the coda that the Congress of Writers had provided to his triumphant spring lecture tour, Breton left on vacation with Jacqueline, Eluard, Nusch, and Man Ray. The group stayed with Lise Deharme (with whom Breton had by now reconciled) at her property near the Basque country: a baroque house filled with mysterious crannies and ornate furniture. It was there that Breton and Eluard put together a script for a Surrealist film, which Man Ray began shooting on the spot, using Lise's guests as actors. The local farmer's daughter (dressed in white tights so as to appear nude) was enlisted play the part of Lady Godiva; Lise herself—one of several "phantom women" who floated through the scenario—went before the camera with a twig and bird's nest in her hair; and Breton was filmed reading by the window, a dragonfly resting on his forehead. But the Surrealist leader quickly proved to be "a very bad actor," in Man Ray's estimation; "he lost patience, abandoned the role." In fact, said the erstwhile director, "the best part of the shot" came at the end, when Breton stormed off-camera in a fit of temper. In the final account, however, it was faulty equipment, not faulty acting, that doomed the project, whose only surviving trace is seven stills published that fall in *Cahiers d'art*. Other than this, Breton "was hardly able to work," as Eluard related to Valentine Hugo, and the two friends instead amused themselves by dousing ants with gasoline and setting them on fire.

Back in Paris that fall, Breton tried to subvert his political frustrations by delving into various activities, including an alliance with Georges Bataille called Contre-Attaque. This "combat union of revolutionary intellectuals" represented an attempt to organize a coherent political action committee outside the parameters of the Communist Party. While certain elements of Contre-Attaque's program hardly differed from that of any other leftist organization (espousal of "the workers' and peasants' cause," socialization of labor), others marked a noticeable break from the orthodoxy. For instance, the group's rejection of nationalism set it apart as much from Stalin's "Socialism in a single country" as from Hitler's National Socialism. And even while taking fascism as its target, Contre-Attaque openly embraced Hitler's tactics: "We intend to make our own use of the weapons created by fascism," its initial statement of purpose proclaimed, "which has

been able to employ man's fundamental aspiration toward emotional exaltation and fanaticism." Mainly, however, and as was often the case, Contre-Attaque differed from the Communist militancy in that its tone, approach, and concerns marked it firmly as an intellectuals' clique. Breton nonetheless entered Contre-Attaque with great commitment, believing he had again found his political voice after so many Communist attempts to muffle it—which might explain his willingness, at least for the moment, to put aside his earlier squabbles with Bataille.

Meanwhile, even as Breton was reentering the political arena, he turned his attention back to more "artistic" activities, such as an exhibit of Surrealist drawings that opened in Paris on December 13, 1935. And he renewed his longstanding friendship with Picasso. When that fall Picasso underwent one of several aesthetic crises, which coincided with the breakup of his marriage, Breton wrote consolingly: "I'm afraid . . . that you'll find yourself alone, and should that happen I'd like to be on your path to greet you, and to put into this greeting all the emotion that I've never stopped feeling when I think of you: you know how much I admire you and how I dreamed, when I was young, of occupying a small place in your life." Several months later he addressed Picasso as "the great expert in human mystery . . . one of the two or three beings who make life worth living."

Breton had celebrated Picasso's extra-pictorial work in 1933 for the first *Minotaure*. Now he encouraged the painter, who was temporarily unable to paint, to apply his vision to writing. Picasso responded with a series of automatic poems, which Breton had published that winter in *Cahiers d'art*. In an introductory essay called "Picasso poète," he stressed that poetry was no mere "hobby" for the artist, but an important "extension" of his visual output: "This poetry cannot fail to be painterly just as much as this painting is poetic." (Even more taken with the poetry was Eluard, who became an enthusiastic supporter and intimate friend of Picasso's at this time—leaving Breton, by the following spring, "jealous of the evenings" that Eluard spent in the painter's company.)

Picasso's poems did not always find such favor, however, and perhaps least of all with the Spaniard's otherwise staunch champion Gertrude Stein. When Picasso excitedly brought his new productions to his American patron, extolling both his own writing and the Surrealism that had inspired it, Stein remained unmoved. In her autobiography, she lampooned French automatism with Yankee stream of consciousness: "my poetry is good [Picasso] said Breton says so, Breton I said Breton admires anything to which he can sign his name and you know as well as I do that a hundred years hence nobody will remember his name you know that perfectly well, oh well he muttered they say he can write, yes said I you do not take their word for whether somebody can paint, don't be an ass I said . . ."

Stein's reaction was in fact typical of the Anglo-American attitude toward Surrealism up until this time. Although the English-speaking world would eventually play an important part in Surrealism's history, the movement had so far not caught on among American and British intellectuals. There had been some successes in the United States, such as a major Surrealist exhibit (the first in North America) at Hartford's Wadsworth Atheneum in 1931; a retrospective at Julien Levy's New York gallery in 1932; and a long and flattering article on Breton in the July 1933 *Sewanee Review*; not to mention Dalí's New York media success in 1934. But Stein had captured a prevailing distrust among the American avant-garde with respect to Surrealism, a distrust that kulchur arbiter Ezra Pound had somewhat more crustily expressed the year before: "Nothing much against the Surrealists," he told some young magazine editors, "save that a lot of 'em are French, and therefore bone ignorant, like the English. I believe they write, but none of 'em has ever been known to read, and it is highly doubtful the alphabet is personally known to most of them."

Meanwhile, across the Channel, the English had mainly greeted Surrealism with bemused and condescending indifference, perhaps because of their own parallel tradition of experimental literature, and perhaps because of their almost genetic rivalry with France. In 1933, the *New Statesman*'s Peter Quennell had summed up a pervasive attitude: "The horrid question—'What is it all about? Perhaps there is something in it after all; something that I am too dense to capture?' haunts our imagination when we think of Surrealism." And Quennell cited Nerval, Coleridge, and Blake among the movement's precursors—not, as Breton had in the *Manifesto*, to establish Surrealism's pedigree, but to reassure his readers that this was in fact nothing new. A more visceral reaction had come several years earlier from the English writer Norman Douglas, on a visit with his friends Nancy Cunard and Harold Acton to Breton's studio, where they had been greeted by the sight of Dalí's *William Tell*, "an intricately demoniac picture [featuring] a bright phallus protruding, and such details as the carcass of a donkey on a piano." After one horrified glance, wrote Acton, "Norman said sharply: 'I can't stay here. That picture will spoil my dinner. See you later. I must get some fresh air at once.'"

Not until 1936 would Surrealism gain serious recognition in "perfidious Albion" or the Wild West, with the publication of David Gascoyne's *A Short Survey of Surrealism*, groundbreaking anthologies by Herbert Read in London and Julien Levy in New York, the founding of an English Surrealist group, and significant art exhibits on either side of the Atlantic. Even then, particularly in America, audiences and critics would view Surrealism almost entirely as a school in the visual arts. Deterred by the awkwardness and impenetrability of its poetry in English translation, struck instead by the much more

immediate thrill of its painted imagery, and no doubt dazzled by the self-promoting antics of the frequently visiting Dalí, the public that attended these exhibits saw Surrealism's visual productions, but little of the philosophical or literary bases that underlay them.

This hesitancy and partial incomprehension, however, were not typical of Surrealism's welcome outside of France. A decade after its founding, Surrealism seemed to have permeated a notable portion of the non-Francophone world: Surrealist groups were active to a greater or lesser extent in Denmark, Sweden, Yugoslavia (thanks to the efforts of Marco Ristich), Greece, Peru, Japan (which, typically, absorbed the movement with particular energy), Romania, Czechoslovakia, and the Canaries, with Egypt soon to follow. Meanwhile, exhibits of the Paris group's artworks were being held in various countries, its writings were translated into a variety of languages, and Surrealist group members (particularly Breton) were often invited to speak about the movement abroad. Breton was clearly pleased by this trend, and in a later issue of *Minotaure* he ran a three-page feature showing Surrealist periodicals and translations from seventeen countries. The irony of all this, of course, is that even as Surrealism increased its audiences throughout the globe, its influence in France, especially after the June Congress of Writers, was visibly shrinking.

*

On December 20, 1935, Jacqueline gave birth to Breton's only child, a daughter, in a clinic in the 13th arrondissement. She was delivered by Breton's friend Pierre Mabille, an eminent surgeon, psychologist, anthropologist, art lover and critic, writer, and fervent student of occultism: barely had he brought the infant into the world than he began establishing her horoscope. Soon after the birth, Picasso brought Jacqueline—whom Breton, relating the event in "Picasso poète" several days later, identified simply as "a lady who had just given birth"—a miniature guitar, promising to decorate it with a poem of his own composition. And Eluard gave her an inscribed copy of *Nadja*, on which Breton added a rather equivocal dedication to "The whale and her calf / In the milky night." The Bretons named the girl Aube Solange (Aube meaning "dawn"), although it took some convincing by Eluard before the registrar would accept the legality of such an unusual forename. Marguerite Breton welcomed her infant granddaughter with, for perhaps the first time in her life, genuine love—more love, in any case, than she felt for Jacqueline, whose habits and appearance were hardly to her liking. Besides, this was probably the fifth woman she had seen with André in as many years.

Breton's aversion to children, and to families in general, was as longstanding as it was violent. Georges Hugnet remembered him yelling several years earlier at a young mother whose stroller had accidentally brushed his leg: "Just because you've shit out a kid doesn't mean you have to rub everyone else's nose in it!" And during a "discussion on sexuality" at around the same time, Breton had declared that he would refuse ever to see a child born to him, adding, "The sad joke that began with my birth must end with my death." A friend of his even claimed that he had once forced a former partner (possibly Simone) to have an abortion. Now, on the verge of his fortieth birthday, the reality of the infant Aube seemed to strip away many of these attitudes, revealing a devoted and indulgent—if at times maladroit—father.

Still, while Aube's birth changed Breton's private feelings about fatherhood, it seems to have had little impact on his public stance regarding the family, particularly the family as a bourgeois institution. On the evening of January 5, 1936, he, Bataille, Maurice Heine, and Péret spoke against the family—"the basis for all social constraints"—in the first of several Contre-Attaque rallies, promoting instead a vision of universal fraternity. On January 21 ("the anniversary of Louis XVI's execution"), they again spoke out against the family—this time the "200 families" of French financial power in the Third Republic.

But cracks were already forming in Contre-Attaque, and that spring they finally split it apart. For one thing, despite the union's exhortations to the proletariat, it is doubtful that workers ever read, or even heard of, a single Contre-Attaque broadside. More importantly, the will to leadership that drove both Breton and Bataille had become a source of conflict. In his interview with *Le Figaro* in December, Breton had claimed paternity for Contre-Attaque, whereas the idea had actually been Bataille's. In March, Bataille exercised some autocracy of his own by drafting a tract in Breton's absence, a denunciation of Stalinist calls for a united front against Hitler, called *Sous le feu des canons français . . . et alliés* [Under Fire From French . . . and Allied Cannons]. The last sentence of the tract particularly angered Breton, as it expressed a preference for "Hitler's anti-diplomatic brutality" over "the drooling agitation of diplomats and politicians." Breton signed, but against his will. When Bataille then published another tract, using Breton's signature without his consent, the break became complete.

While the Contre-Attaque interlude at worst represented an discouraging failure for Breton, far more damaging at the time was the deterioration of his relations with his oldest remaining friend, Eluard. In Spain for a lecture tour, Eluard had not participated in the attempted fusion with Bataille; nor, on his return to Paris in late February, did he develop any interest in its ultra-radical stances. Moreover, he felt that Breton was acting less and less tolerant of others' opinions, including Eluard's own, and was instead sur-

rounding himself with people he considered yes-men—chief among them Péret, whom Eluard particularly disliked, and whom Breton seemed more and more willing to defend.

The two friends' rapport took a more drastic downturn in April, when Breton sharply criticized Eluard in front of art dealer Charles Ratton. Hurt, Eluard sent Breton a note saying that he refused to let himself "be humiliated" anymore in front of strangers. Breton professed not to understand Eluard's attitude: "It's only natural, when I'm bored, to provoke an argument, even a nasty one, to avoid losing stamina," he told the others. But Eluard had clearly had enough. In his view, seventeen years of friendship entitled him to some consideration—failing which, as he fumed to Gala, he preferred to leave altogether:

> I have *definitively* broken with Breton . . . It's over, I will never participate in any
> activity with him again. I've had enough. Because of Breton, the whole thing all too
> often lacked a certain seriousness . . . I want to be able to criticize without Breton
> relying for his answer on people who don't give a damn about anything, on a herd
> of sheep.

In reality, the friendship would limp on for another two years, and even at this point the two men were collaborating on a Surrealist exhibit to be held that summer in London. Still, the intellectual complicity of the past years had ended, and Breton, saddened by the breakdown of his closest friendship, envisioned letting Surrealism take the same route. "If Surrealism is dead, then let's proclaim it (you know that this has always been my desire, as it must die)," he had told Eluard the previous month. "But I would have liked to proclaim it with you." Eluard, however, was not moved: Breton had offered to sacrifice Surrealism before, but his actions, now as in the past, bespoke only his will to keep it in full vigor.

Meanwhile, tension was also affecting Breton's marriage, stemming (at least in part) from the strains of child rearing, the instability of the couple's finances, and Jacqueline's frustrated ambitions as a painter. If Jacqueline attended many of the café meetings and considered herself a Surrealist in full standing, she was nonetheless expected by her society and her husband to bear the brunt of Aube's infantile requirements, while Breton seems to have made very few changes in his life. Nor had Breton, to all appearances, ever accredited Jacqueline's work, her desire to establish an independent artistic identity. As one witness later put it, Jacqueline "was expected to behave as the great man's muse, not to have an active creative existence of her own." By April, the fiery-tempered Jacqueline was chafing under the joys of motherhood, and, following an especially bitter argument,

she left Rue Fontaine for the country. Worried, Breton soon wrote her several conciliatory letters, and even encouraged her to pursue her painting. But though he could tell the Tanguys by month's end that "peace ha[d] more or less settled back into [his] household," it seems the improvements were merely cosmetic.

It was in such an atmosphere that Breton and Jacqueline left Paris in early June, to attend the opening of the International Surrealist Exhibition at the staid New Burlington Galleries in London. The show had mainly been organized by Breton and Eluard in Paris, and by a newly formed English Surrealist movement loosely grouped around the art critics Herbert Read and Roland Penrose (who hosted the Bretons during their stay).

Between its opening on June 11 and its closing on July 4, some 25,000 visitors came to see over four hundred paintings and objects. Reviews in the British press were almost uniformly execrable ("Relics of outworn romanticism," went a typical notice) and many of the spectators walked away disconcerted, but the show had clearly made an impact. Moreover, according to Herbert Read, the British artists themselves were thunderstruck by Surrealism, which "electrif[ied] the dry intellectual atmosphere" and "stirr[ed] our sluggish minds to wonder, enchantment, and derision." Still, Breton was not entirely pleased with the London exhibit: among other things, the eclecticism of the British entries—which made up fully one-quarter of the offerings, and whose selection he had not overseen—made this less a Surrealist show proper than a display of various modernist tendencies. On the evening of the 11th, Breton nonetheless inaugurated the exhibition with his lecture on the Surrealist object, before a capacity crowd of 2,000 (among them T. S. Eliot, who lingered awhile before Meret Oppenheim's *Fur-Covered Cup*). The painter Eileen Agar remembered how Breton stood "with his Roman head always slightly tipped back" during the lecture. As Breton spoke, a leggy blonde named, appropriately, Sheila Legge wandered throughout the room, head swathed in roses, carrying a prosthetic limb and a pork chop.

Several days later, another talk was given by Dalí, who almost died in the process: having come onstage on a particularly hot day wearing a deep-sea diving suit, Dalí soon realized that his sealed helmet would not come off. The more frantically he gesticulated, the more the audience believed it to be part of a hilarious performance, and only after Penrose had recognized the trouble and rushed out to find a wrench was a nearly prostrate Dalí released from his suffocating headgear. Finally, on June 24, Eluard arrived to give a lecture on Surrealist poetry, having intentionally waited until Breton and Jacqueline left London (on the 20th) before venturing across the Channel.

Breton returned home to a critical financial situation. His trip to London had been

made possible only by a 2,000-franc grant from the Ministry of Education. Now back from England, he asked Penrose to find him buyers for some of his paintings. Penrose offered to buy a Picasso in Breton's collection, a small collage called *Head*, but Breton began having second thoughts. "I am terribly anxious to keep this little picture, which I pursued for years before being able to ponder it at leisure," he wrote Penrose the following month. "It's also the last remaining Picasso I own, and I fear, should I no longer have it, that I'll only feel poorer still." Badly in need of the money, however, Breton regretfully yielded the collage to Penrose, along with Miró's *Catalan Landscape*.

Also in June came the promise (if not the actuality) of a little more income when Gaston Gallimard sent a contract for Breton's new book. Although Gallimard referred to it as "your next novel," the work was actually a series of previously published essays, to be grouped under the title *Mad Love* (*L'Amour fou*). Revolving around Breton's meeting with and marriage to Jacqueline, *Mad Love* included Breton's 1934 articles on "convulsive beauty" and fortuitous meetings, his relation of the "night of the sunflower," and his appreciations—heightened by Jacqueline's presence—of the Canary Islands from spring 1935. Just as Breton had attacked the distinction between sanity and insanity in *Nadja*, and in *The Communicating Vessels* between dreams and waking life, so in *Mad Love* he sought to abolish the barriers between subjective and objective reality. He again invoked the notion of objective chance—which he had earlier defined (quoting Engels) as "a form of the manifestation of necessity"—using it as the unifying element that gave the events of the past two years their meaning. Like the encounter with the unnamed Suzanne at the end of *Nadja*, Breton's meeting with Jacqueline here took on culminant significance, resolving all the antinomies and coincidences posed by the narrative. But the book still lacked a conclusion; and even as Jean Paulhan (Breton's old friend and nemesis, and now his editor at Gallimard) sent the manuscript of *Mad Love* to the printer, Breton pondered how he might end it.

With the remnants of his Ministry of Education stipend, Breton and Jacqueline spent part of July in Lorient. Following on two years of poverty and six months of child care, the vacation was anything but harmonious, and on the afternoon of July 20, during a walk along a windy beach, the latent discord between the spouses billowed like the rain clouds overhead. Breton later recounted the growing sense of malaise that seized him during the outing:

> As we gradually moved forward, the dismal nature of the site . . . took on a poignant twist we could sense in our conversation, however increasingly vague . . . We walked along increasingly more separate without anything conscious having been decided

on, except that I had preferred to walk on the ground along the shore to going bare-footed. But this feeling of separation was not just an effect of physical distance: it did not in fact dissipate even when a barrier of rocks I could not cross brought us back side by side for a few steps. I have no trouble admitting that as far as I was concerned, I was in a progressively worse mood.

The sense of distance became still more acute as the couple approached an old villa, reached a peak as they passed by it, then gradually subsided as they continued on their way. Breton, who had noted this phenomenon, was amazed to hear from his parents that evening that a young woman had been murdered by her husband in that same villa two years earlier. To his mind, this immediately explained the sense of estrangement that had come over him and Jacqueline as they approached the house: its evil aura had evidently "clouded over the mirror of [their] love." Shortly afterward, he appended this curious episode to *Mad Love*, closing the book with a somewhat wistful affirmation of love's triumph over supernatural adversity.

Even as Breton finished his account, however, the reality of love's triumph was becoming less certain: on September 6, Jacqueline, whose resentments had little to do with haunted houses, departed suddenly and alone for Corsica, leaving Breton to care for their eight-month-old daughter. "Jacqueline has left Breton, for good I think," Eluard told Gala several weeks later. "She found work in Algeria [actually Ajaccio]. Breton is alone with the child. Breton's parents have lost interest in him." Although Jacqueline made no mention of return (indeed, she seems to have sent no word at all during her absence), Breton refused to abandon hope—because, as he told his wife on October 5, "I am the man of miracles. But this hope is the little oil lamp just before the oil runs out (or doesn't run out, will probably run out; it goes clack, clack, cl . . . ack, like the heart)."

This estrangement, which was to last over a month, resulted from several factors. Jacqueline, now that the romance and glamour of her marriage were beginning to pale, was growing increasingly resentful of the roles in which Breton continued to cast her: muse, companion, water sprite, and most recently nanny. Meanwhile, on Breton's side, an added tension no doubt came from precisely this latter role. The fact was, Jacqueline was now a mother. "Breton always liked women who were hyper-feminine, almost like female impersonators," Edouard Roditi later mused. "It was difficult to imagine that they could ever produce children." While he appears to have been devoted to Aube, it seems unlikely that his deep resentments toward his own mother—which were no doubt exacerbated by his recent visit to the parental household—could have left his relations with Jacqueline unaffected.

"When you're almost grown, I will try to explain to you what I've learned of love, life, revolution, and the rest," Breton had written to his infant daughter on August 12, two days shy of his second wedding anniversary, as she and Jacqueline were away in the country. "You will think that it wasn't all very practical, but that it was honorable all the same." Two weeks later, on September 1, he had told Jacqueline that he was going to expand these fatherly reflections into a final text for *Mad Love*, a text he intended to write "in an uninterrupted smile" so as tell the world "about my little girl and my love for you *through her*." In keeping with the tone, the book version of the letter carries the fanciful address "Dear Chipnut of Munkhazel." But Jacqueline's departure for Ajaccio less than a week afterward pulled Breton's uninterrupted smile sharply downward.

"In the springtime of 1952 you will just be sixteen, and perhaps you will be tempted to open this book," Breton wrote to his daughter:

> Whatever happens from now until you read this letter . . . let me believe you will be ready then to incarnate this eternal power of woman, the only power I have ever submitted to. Whether you have just closed a school desk on a world crow-blue in high fantasy, or whether your sunny silhouette, except for the bouquet of flowers on your blouse, is cast against the wall of a factory—I am far from sure about your future—let me believe that these words, "mad love," will one day correspond uniquely to your own delirium . . . I want you to be madly loved.

Though the "commander of the night of the sunflower" had vanished, leaving uncertain the future of the marriage, Breton's affirmation of love and belief in the offspring of this marriage provided *Mad Love* with an appropriately uplifting coda.

Partly because of the sudden responsibility for Aube and partly because of the lukewarm response to his inquiries, Breton did not leave that fall for Spain, where several of his friends had gone to fight in the Spanish Civil War. The conflict had broken out on July 18 and immediately become the great cause of intellectuals throughout Europe and America. "Never," Breton later said, "had a battle been more circumscribed—from the start—between the forces of obscurantism and oppression on the one hand, and on the other every will toward man's liberation." Indeed, after years of frustration and anxiety over fascism in Europe, not only Breton but many other intellectuals saw this as the long-awaited start of the war against oppression.

But while Francisco Franco's forces, aided by Germany and Italy, began scoring victories against Spain's Popular Front government (the "Republicans"), the other Western powers stood idly by. France in particular, which had itself elected the Popular Front's

Léon Blum in May, would have appeared to be the Republicans' natural ally; but Blum, under pressure from French conservatives and reticent Britain, refused to send support (and thus helped precipitate his own downfall in June 1937). Unable to change their governments' policies, many prominent writers and artists flocked to Spain to fight for, or at least report on, the Republican cause.

Among them that summer was Benjamin Péret, who arrived in Barcelona in August and joined up with the Trotskyist-oriented Unified Marxist Workers' Party (Partido Obrero de Unificación Marxista, or POUM). While there, he made speeches over the radio and, according to most accounts, later fought on the Aragón front with an anarchist division under Buenaventura Durruti; years later, Breton fondly recalled a photograph of his friend "sitting in a Barcelona doorway, holding a rifle with one hand and petting a cat on his knees with the other." Apparently, it didn't bother Breton that Péret, by his own admission, had left mainly because he couldn't find work in Paris; as he explained to his friends: "If anyone else had told me that, I would have thrown him out the door. But Péret is so pure . . ." Besides, Peret's reasoning could only have struck a sympathetic chord with the desperately poor Breton—who, if not for the little girl in his care, might have used it himself.

While Breton did not fight for the Republican cause, he was nonetheless politically active during the fall of 1936. In August, he issued a Surrealist tract criticizing France's refusal to aid Spain. Soon afterward, he turned his attention farther east as news reached Paris of the Moscow "Show Trial," in which Stalin, seconded by his zealous prosecutor Andrei Vyshinsky, had purged a number of "old Bolsheviks" in a series of now infamous denunciations and executions. On September 3 Breton addressed a large rally to demand "the truth about the Moscow Trial": "We consider the staging of the Moscow Trial to be an abject police undertaking," he declared. Stalin had become "the great negator and principal enemy of the proletarian revolution . . . the most inexcusable of murderers."

Breton made a special plea on behalf of Trotsky, the largest of all Stalin's targets, who had been condemned to death in absentia during the trial: "an intellectual and moral guide of the first rank, whose life, as soon as it is threatened, becomes as precious to us as our own." And in a subsequent meeting on December 17, he again took up the cause of Trostky, who was now living in heavily guarded exile in Mexico. "Comrade Trotsky . . . your place is not in Mexico [but in] Barcelona," he stated to a cheering audience of 2,000. In January 1937, after a second Show Trial, he composed (but for lack of time did not read) another speech, in which he explicitly compared Stalin to Hitler and Mussolini, and denounced Vyshinsky's charge that Trotsky had entered into a secret alliance with Hitler against the USSR.

Having already lost all faith in Stalinism after the 1935 Congress of Writers, Breton greeted the developments in Moscow with, as Jacqueline later said, "a particular horror and dejection that he found it extremely difficult to escape." From the outset, he recognized the trials as a cynical attempt on Stalin's part to do away with political challengers under the guise of state security. "I cannot understand," he commented in 1951, "how, today, every last scrap of conscience does not rebel against the affront . . . that the staging of these trials, and the reasons adduced for the sentences, constituted. I persist in thinking that they opened, and inevitably let fester, the most horrific scourge of modern times."

Once more, however, Breton found himself in the political minority. For the Stalinists, who now constituted one of the most prominent political parties in France, these trials were simply a welcome purge of traitors to the revolution. "What a frightful display of ignominies this trial is, and over it all hovers the figure of their master: Trotsky, the Gestapo's ally, the international saboteur of the workers' movement," Aragon declared the next month. "Finally the voice of public prosecutor Vyshinsky rings out. This voice is the voice of the entire Soviet Union." Although the Stalinist purges of the 1930s have now taken their place in the history of infamy, at the time Breton was one of only a handful of nonaligned European intellectuals to raise any protest over them at all. As for the other French leftists, with few exceptions they either "vied with one another in finding formulas to justify Moscow" (as the American activist Lionel Abel put it) or simply kept quiet so as not to disturb Communist efforts against Franco.

Of all the conflicts raised by Breton's protest of the Moscow Trial, no doubt the most painful was the rift it caused with Paul Eluard. As Breton's political position moved ever closer to Trotsky's, Eluard found himself increasingly drawn to the Stalinist viewpoint. In February 1937, Eluard would laconically tell Gala that Breton was "very involved in this Moscow Trials business. Not me."

That December, Eluard indulged in outright defiance of Breton by publishing his poem "November 1936" in *L'Humanité*. The defiance was in fact double: not only had Eluard contributed to the Stalinist house organ (which obligingly hailed him as "one of the greatest poets of his generation"), but his poem—which had been inspired by the events in Spain—was clearly in the "occasional" vein that Breton had always abjured. "It's the first time that one of my poems has had a 450,000 run," Eluard crowed to Gala on the 17th. "I can guess what Breton will think of it. But . . . I don't see why I shouldn't rather contribute to *L'Humanité*, read by workers, than to the *NRF* or elsewhere, read exclusively by the middle classes." To all appearances, Eluard was rapidly ceasing to care what Breton, or Surrealism, would have to say about anything.

✳

Because of Breton's personal problems, financial hardship, and political involvements, there was one international Surrealist event in which he was scarcely involved: a major retrospective called "Fantastic Art, Dada, Surrealism" at the Museum of Modern Art in New York. Curated by Alfred H. Barr, Jr., the show was to include the work of many artists over several centuries, from such "precursors" as Dürer, Bosch, Arcimboldo, Blake, Goya, and Rousseau, through the Dadaists and other "Twentieth Century Pioneers," and finally to the Surrealists. To Barr's mind, the exhibit should trace the genesis of fantastic tendencies in art, with Surrealism as their culminating manifestation. But Breton, though favorable to the exhibit in principle, wanted an exclusively Surrealist show, and threatened to withhold the group's support if Barr kept to his original design. According to Barr, he was also "exasperated" because MoMA had not invited him to lecture. "I have had an interesting but rather harrowing fight with the Surrealist poets who have tried to control the show. It may be necessary to ignore them completely," a weary Barr had told an associate in August. After months of negotiations, however, Breton seems to have relented, at least to the point of not standing in Barr's way. Barr long remembered the exhibit as the most "appalling task" he had ever undertaken.

More than any previous exhibit, the MoMA show of 1936 truly brought Surrealism to America. While the response of the critics (echoing their equally sober British counterparts) was generally poor, the public seems to have been fascinated. "If you saw it here and the repercussions it's had, you would be very pleased," Dalí wrote Breton from New York, his enthusiasm clearly greater than his acumen. "The influence of Surrealism is enormous; they're decorating the windows of the most luxurious stores with Surrealism. The creators of animated cartoons are proud to call themselves Surrealists. I'm doing my best for our activity."

Far from reassuring Breton, however, that "best" seemed to be taking Surrealism in precisely the wrong direction: Surrealism as fashion, to be flattered for a moment, then thrown out with yesterday's news. Nor would Breton have appreciated seeing Dalí on the cover of *Time* magazine that month, in a moody portrait by Man Ray that gave him the aura of a movie star—and still less if he read *Time*'s appreciation that "Surrealism would never have attracted its present attention in the U.S. were it not for [the] handsome 32-year-old Catalan." As Marcel Jean later described it: "Dalí had launched one of those crazes which regularly grip everyone in America, from top to bottom of the social scale, like an epidemic: the Dalinian version of Surrealism was apparently the latest brilliant successor to the Coué method, mah-jongg, the Charleston, the song 'Valencia,' and so

many other dazzling and ephemeral fashions . . . His eccentric proposals were the delight of New York's snobbish coteries, while at the same time he was drawing for the 'tabloids' whole pages of concrete irrationalities, plant-armchairs and lobster-telephones, whose success rivaled that of the comic strips." Indeed, for decades to come, Dalí's lobster-telephones and melted watches would define America's vision of Surrealism, even though Dalí's own connection with the group was long severed.

Back in Paris, Breton dreamed of his own escape to distant shores. Jacqueline had returned from Ajaccio in mid-October, reconciling with her husband and freeing him from the care of his child; but Breton's financial situation remained desperate, and at the moment no foreign Surrealist groups were clamoring for his presence. Several months earlier, he had applied to Jean Giraudoux of the Ministry of Foreign Affairs for a visiting professorship abroad. With Giraudoux's encouragement, the ministry briefly considered sending Breton to Prague or Mexico, but ultimately deferred his candidacy because he "lacked the necessary university diplomas."

The rejection was all the more frustrating in that Breton had become particularly eager to visit Mexico at this time, owing to his recent reconciliation with Antonin Artaud. Artaud had just returned from nine months "in the land of the Tarahumaras" (the title of a book he was then writing), and he now thrilled Breton with tales of Indian rites and his experiences with peyote, of unprecedented spiritual intensity, of harsh landscapes like an endless set for a vast Theatre of Cruelty. This vision of Mexico was largely a creation of Artaud's own mind, but no matter: Breton was enchanted, and longed to flee the poverty and hopelessness of his present situation to discover such exotic climes. The question was, when? And how?

FOR AN INDEPENDENT REVOLUTIONARY ART

(January 1937 – September 1939)

"MAD LOVE" WAS PUBLISHED BY EDITIONS GALLIMARD on February 2, 1937, in a printing of 1,800 copies. The number was small compared with both Breton's previous works and his expectations; several months earlier, he had assured his publisher that *Mad Love*, "helped by its title," would "sell more easily" than his earlier books. But Gallimard was cautious. Because of the twenty photographs Breton had insisted on including (to underscore the book's affinity with *Nadja*), he was forced to charge a hefty twenty francs for a volume of barely 180 pages. Moreover, the alluring title notwithstanding, most readers found the work less penetrable than *Nadja*, and the sales reflected it: despite Breton's predictions, *Mad Love* sold only 544 copies in its first three years.

Among the critics, *Mad Love* received a generally favorable, if hardly copious, welcome. "To an exceptional degree, Breton here attains the art of resolving dreams and reality in a third term, the notion of which is the entire subject of Surrealist research," said the *NRF*'s André Rolland de Renéville. *Le Mercure de France*, though slightly less enthusiastic, judged Breton to be "one of the remarkable French writers of today." And Edmond Jaloux, in a belated notice for *Les Nouvelles littéraires*, likened Breton to a kind of Christopher Columbus of the mind, saying that he had revealed "a very special world, one that he is constantly discovering, and over which he exerts a kind of magical mastery." Taken together, said Jaloux, Breton's books constituted "one of the most important bodies of work to have developed in France since 1918." Touched by the review, particularly given the relative silence surrounding *Mad Love*, Breton told Jaloux that he had "single-handedly chased away the shadows that had descended over me."

One thing *Mad Love* did not garner in any appreciable way was money: with sales only in the hundreds, the book was not likely to stave off hunger in the Breton household. Then, just as the Bretons' material situation was reaching its lowest point ever, a notary public of Breton's acquaintance named Louis Bomsel hired him to manage a new gallery on Rue de Seine, in the fashionable Saint-Germain-des-Prés neighborhood.

Breton named the gallery Gradiva, in tribute to both Wilhelm Jensen's novella of that name and Freud's famous analysis of it. "You entered the shop through a glass door that

had been designed and executed by Marcel Duchamp, whose opening silhouetted, as their shadows might, a rather large man and a noticeably smaller and very slim woman, standing side by side," he later said. The gallery's aim, as he wrote in a promotional text, was to present "tomorrow's beauty, as yet hidden from the multitude, and only glimpsed here and there as one draws near some object, goes past a painting, turns the page of a book." With this in mind, Breton had gathered his favorite artworks, objects, books, and curiosities (mostly from his and other Surrealists' collections) into the gallery on Rue de Seine. The interior had been decorated under his direction, with part of the space to be used as one of the earliest bookstore-cafés. He even asked Picasso to design the gallery letterhead.

But despite Breton's stated efforts to make Gradiva the meeting place of the intellectually alert, it seems that few enjoyed the fruits of his labor. "No one ever came into the shop, only Surrealists," one group member later recalled. For one thing, Breton resented having to put pieces from his own collection up for sale (and even more so having to pay the gallery a commission when these pieces were bought). For another, and despite the seeming enticements, he had little tolerance for curiosity seekers, and often scared away prospective buyers with his ill humor. Peggy Guggenheim, who visited Breton at the gallery, remembered him looking "like a lion pacing up and down in a cage." Finally, Breton simply did not possess the skills required to manage a successful gallery. Needing the income, he dutifully spent many of his days on Rue de Seine, and even transferred the Surrealist meetings to the nearby Café des Deux-Magots. Before long, however, Gradiva looked to be going the way of the earlier Galerie Surréaliste, and by May, Eluard could tell that the enterprise wasn't destined for success. "Breton's not cut out for this kind of business," he related to Gala. "Neither is Jacqueline."

Eluard himself was seeing Breton less and less by now. That spring and summer, a variety of personal activities—which included watching Picasso paint *Guernica* (a painting that Breton himself didn't appreciate); traveling to England, where he and painter Eileen Agar swapped spouses for the trip; and serving on the jury of the stylish and retrograde Helena Rubinstein art prize—kept Eluard away from the Surrealists' meetings. More generally, he felt stifled by the strictures Breton imposed on his group. In a transparently emblematic dream from that June, he saw himself crawling down a dark corridor, suffocating, unable to speak.

Even as Eluard moved away, Breton was rekindling his old friendship with Antonin Artaud. Artaud had had little contact with Breton in the eight years since their break; but shortly after his return from Mexico the previous winter he had spotted his former colleague in a café and, as if irresistibly drawn, had gone to speak to him. He now began sending the Bretons a steady stream of flattering and portentous letters, often endowing

Breton with superhuman attributes. "This afternoon your daughter struck me as an Apparition. I saw her walking toward me like a true sun, not an imaginary one, an incarnation of the sun on the sea," he wrote in July. "I know that you are *of* the Sun and that your wife is *of* the Sea, but I thought of it only afterward." And in September he told Jacqueline: "You shall be *Avenged*, my dear Jacqueline, as will the Superior Being whose Predestined Spouse *you are* . . . To your Spouse I will reveal Mysteries, and what a sublime Rank he holds in the order of the creative Spirits of the World. He is the active intelligence of Brahma, the Father, represented Symbolically in the Middle Ages by the *Angel Gabriel*."

With others, Artaud behaved in equally worrisome fashion. His letters and declarations became filled with megalomaniacal strains and exalted prophecies, among them that he would soon bring about Earth's destruction by fire. Horribly poor, he demanded handouts from passersby on the grounds that "you and your ilk have given me enough shit over the years for you to pay me five francs in damages now." He carried a switchblade knife of disquieting proportions. And he maintained a fanatical attachment to an ornate cane, originally found in a flea market, that he believed to be the magic cane of St. Patrick. To Jacqueline, Artaud confided that "this cane contains exceptional physical properties, proof of which I've seen and continue to see every day." He covered its tip with metal so that it sent off sparks as he walked, and showed it sparingly to select friends—flying into a rage if anyone tried to touch it. "It's as if you touched my penis," he told them.

It was ostensibly to research the cane's origins, or perhaps to return it to its rightful place, that Artaud left in mid-August for Ireland. Over the five weeks of his stay, he sent Breton and Jacqueline numerous cards and letters, some tersely indicating his whereabouts at the moment, others containing lengthy predictions, spells, and messianic delusions: "Ludicrous as this idea may seem to you, the antichrist frequents the Deux-Magots," he cautioned Breton on September 14. "And another figure of the apocalypse has also been seen at the Deux-Magots."

Then, at the end of the month, Artaud's letters suddenly stopped, giving way to several months of silence. Only later, after Artaud's mother had urged his friends to make inquiries, did certain facts of his Irish sojourn come to light: In late September, after an altercation with the police, Artaud had been imprisoned for a week, then hastily deported—so hastily that he didn't even have time to recover his beloved cane—on a steamship bound for France. While on board, an incident between Artaud and some crewmen, whom Artaud believed were sent to kill him, had resulted in his being straitjacketed and committed to a psychiatric ward on arrival in Le Havre. He was diagnosed as schizo-

phrenic and transferred several weeks later to an asylum near Rouen; when his mother finally managed to locate him, he didn't recognize her. In April he was moved to Sainte-Anne, where Jacques Lacan declared him "blocked" and predicted that he would never write again, then finally to the mental hospital in Rodez, where he would spend nearly the rest of his life.

Breton did not learn of Artaud's situation for several months—not until May 1938, by which time he and Jacqueline were out of the country—and, as earlier with Nadja, he then refused to visit. "When we learned where [Artaud] was," said Jacqueline, "I said to Breton that we should go . . . He told me it was pointless, that from now on Artaud was in another universe and that nothing more could be done for him." Jacqueline went alone to visit Artaud, who asked her to obtain his release. "I am a fanatic, not a madman," he assured her in early 1939. He also asked Jacqueline to bring him narcotics, but Breton again refused, claiming that they were beyond the couple's means and that the asylum guards would only confiscate them. When on a subsequent visit Jacqueline admitted to having brought no drugs, Artaud turned away, and shunned her from then on.

For Breton, on the other hand, Artaud continued to feel only reverence. He was certain that Breton had been in Le Havre for his arrival in September 1937, and even that the Surrealist leader had died in a gun battle with the police while trying to free him from the psychiatric ward. Even years later, when Artaud again met Breton face to face, he remained convinced that the man before him was merely a phantom. "Don't tell me it wasn't you who came and got *killed* (I do say *killed*) in Le Havre in October [*sic*] 1937, shot by police machine guns," he insisted. Breton recalled that when he tried to persuade Artaud of the contrary, the other "looked at me in despair and his eyes filled with tears." Finally, in the face of Breton's repeated denials, Artaud sadly acquiesced: "I believe, since you tell me so, that in fact in October 1937 you were not in Le Havre but at the Gradiva gallery in Paris . . . For three days in Le Havre I heard police machine guns in front of the General Hospital of Le Havre. I also heard the death knell sounding from every church for a whole morning . . . It's true, we could argue for a long time over how to interpret these facts. They had told me that André Breton was trying to free me by force. You tell me you didn't do it: I believe you." Artaud never again raised the issue after this, said Breton, but "no doubt I had fallen some distance in his eyes."

✳

By a coincidence worthy of its subject, as Artaud was entering his macabre and irredeemable world, Breton was turning his attention fully to the problem of black humor.

Over the past two years, Breton had amassed representative samples by forty writers and composed introductory texts for each. In December, he signed a contract for the now completed *Anthology of Black Humor* (*Anthologie de l'humour noir*)—not with Sagittaire, the publisher that had originally commissioned it, but (Sagittaire being on the verge of bankruptcy) with Editions Denoël. Given his continuing financial difficulties, Denoël's comparatively large advance of 3,000 francs was a welcome development.

Equally welcome was a 1,000-franc stipend from the management of the Galerie Beaux-Arts on the chic Rue du Faubourg-Saint-Honoré, in view of an upcoming International Exhibit of Surrealism to take place there in January. Owner Georges Wildenstein and his associate, the art critic Raymond Cogniat, had offered the gallery's huge and well-publicized space as the setting for the most ambitious Surrealist exhibition to date. Although Cogniat had originally approached Eluard, it was clear that no authentic show could be mounted without Breton's participation; Eluard put aside his differences with his former friend to join him—along with Marcel Duchamp, who wound up supervising the entire project—in preparing the event.

Once back in contact with Breton, Eluard found himself again taking part in Surrealist activities. For a while, it even seemed that their friendship would emerge intact from the recent estrangement: Breton wrote a flattering blurb for Eluard's latest poetry collection; and somewhat hopefully he told Vítězslav Nezval: "Although on the worst and thorniest of questions—what attitude one should adopt toward the USSR today—Eluard and I . . . have not always been in agreement, it was enough, in order to maintain our indispensable cohesion . . . to bring to the fore the vital reasons [that] we have always found for uniting in public, even if it sometimes meant contradicting ourselves and not letting our points of friction show outwardly." But in fact, the "thorniest of questions" was rapidly eroding any remaining foundation to the friendship, and Eluard, for his part, was not feeling so conciliatory. When Breton drew up his friend's horoscope, showing Eluard to have a mix of high intelligence and low moral character, Eluard simply passed the document on to Valentine Hugo with the remark: "All this work was practically for nothing, since I was born at 11 at night, not 1 in the morning." This temporary rapprochement in the fall of 1937 was to be the two men's last true collaboration.

It was during the same period that the French Ministry of Foreign Affairs, a full year after Breton's initial request, finally offered to send him to Mexico for a series of historical lectures on French literature and art. The three-month stay (which ultimately lasted four) had been granted through the efforts of Henri Laugier, head of Scientific Research, and of the poet-diplomat Alexis Léger, then the ministry's general secretary, who wrote under the name Saint-John Perse.

Breton did not normally welcome foreign travel, despite his recent international tours, and he instinctively pictured life abroad as "artificial," "like a stage set." Still, as a boy, he had loved reading about Mexico in a favorite novel, *Costal l'Indien* by Louis de Bellemare, and he later noted that the country, "which the engravings in [*Costal*] had revealed to me, would remain associated in my mind with the idea of the struggle for liberation." More recently, Mexico had become newly seductive as the home-in-exile of Leon Trotsky. This, along with Artaud's accounts of the Tarahumaras, now led Breton gladly to accept the ministry's offer. "And so one of the great aspirations of my life was realized," he later said. "No matter how little I tend by nature to like travel, Mexico . . . was the one country that attracted me."

In the months preceding Breton's departure, the Surrealist group continued to explore new contacts, including a brief flirtation with French-American writer Anaïs Nin. Both Nin and her compatriot Henry Miller had discovered Surrealism through scattered English translations and nourished a vision of it as a marvelous upheaval of everyday life. By now, Nin had met members of the Surrealist group proper and invited Breton to her home, anticipating (much like Valentine Hugo before her) the visit of a love-prophet, but instead finding herself in the presence of a surprisingly cerebral and calculating man. A passage from her diary suggests the fairly typical reaction of those who expected to draw a strict parallel between the narrator of *Nadja* and its author:

> André Breton came to visit me. I expected he would be poetically and sensitively alert to the atmosphere of my life, to my inarticulate intuitions. He was not. He was intellectual . . .
>
> He had been talking about the Surrealist game of getting together and then engaging in unplanned action. They will take a train and get off anywhere, a place they do not know, and wait for surprises, things to happen . . . He tells this with solemnity, more like a King speaking at an audience than a fellow artist talking to other artists. He did not expect comments, only listeners.
>
> Then he said: "The other day I received a letter from a woman . . . She commented on my emphasis on 'surprise,' on coincidences, and said she would like to meet me alone under the Pont Royal one evening at midnight. She would not identify herself in any way."
>
> I waited for the rest of the story. Breton added: "I did not go, of course."

Asked why not, Breton explained that he had suspected a trap, but added that after a second letter he granted the mysterious woman a rendezvous—posting two friends nearby

in case of danger. "This story," wrote the dismayed Nin, "betrayed what I suspected in Surrealism, the part of it that is conscious, premeditated and an intellectual technique."*

More felicitous was Breton's meeting that fall of 1937 with the Chilean architect and painter Roberto Matta Echaurren, who signed his work simply as Matta. The art dealer Julien Levy later described Matta as "chock-full of premature optimism and impatient disappointment; believing ardently in almost everything and in absolutely nothing . . . He was an *enfant perpetuel*, always in a tantrum or a triumph of self-admiration." The twenty-six-year-old Matta had worked for Mies van der Rohe, then applied his precise draftsmanship to explosively colorful drawings. He arrived at Breton's doorstep in October, bearing a letter of introduction from Dalí. Seduced as much by the affable Chilean as by his early artworks, Breton immediately bought two of Matta's drawings and invited him to contribute to a deluxe edition of Lautréamont's writings, alongside other prominent Surrealist artists (the book was published the following year by Editions G.L.M.). Matta in turn introduced Breton to the English painter Gordon Onslow-Ford, who also joined the Surrealist group at that time. Meanwhile, Breton brought several former colleagues back into the fold: he enticed Victor Brauner back to Paris from his native Bucharest and paved over his rocky relations with Magritte and Masson, both of whom would be represented at the upcoming Beaux-Arts show.

So would another newcomer to the group, the twenty-year-old English painter Leonora Carrington, who had recently become the lover of Max Ernst. The couple had gone to live in Ernst's country house in Saint-Martin-d'Ardèche, among the Côtes-du-Rhône vineyards. Lively and uninhibited, equally talented as a writer and a painter, the darkly beautiful Carrington brought to Surrealism a keen sense of black humor all her own. She also maintained a flagrant disrespect for convention that led her, for example, to blithely slather her feet with mustard while conversing with tablemates at an expensive restaurant. Breton, for his part, was very taken with the stunning Englishwoman, whom he later described as "superb in her refusals, with a boundless human authenticity." (Presumably this "superb refusal" helped Carrington weather the moments when, as she sat beside Max during café sessions, the distraught Marie-Berthe would come rushing from across the street to pelt her new rival with coffee cups. Max soon separated definitively from Marie-Berthe, who returned to the bosom of her strict Catholic family.)

At the end of December, Breton invited Matta and his bride, Ann, to spend New

* At around the same time, Henry Miller published an equally dismayed "Open Letter to Surrealists Everywhere," in which he chided the group for not "loading their words with dynamite." Instead, he wrote, "André Breton, the great fish out of water, solemnly pontificates" while the group as a whole spouted "a lot of piffle about the revolution."

Year's Eve with him at Rue Fontaine. Either because of Breton's promises or because of the Chilean's assumptions, Matta was shocked when he and Ann arrived at the studio to find, not the wild celebration he had imagined, but the Bretons sitting in an "almost unlit" room, staring quietly and alone into a wood fire. Matta later recounted how Breton's conversation eventually turned the evening into "a leap into a space and time different from that of the street"; and how afterward, when he and Ann left to dance the night away in Montparnasse, everything around them suddenly seemed transformed. "That evening, Breton, with his enormous love of everything, revealed to me the underlying reality of my 'pedestrian' life," Matta wrote. "André Breton's genius lay in his ability to reveal the tragic man and his humor in each of us, to provoke the release of one's own freedom." But no matter how exalted the prose, it somehow can't blot out the forlorn and wistful image of Breton, revered by some but virtually friendless, watching as the final moments of a difficult year evaporated like the smoke in his chimney.

The International Exhibit of Surrealism opened at the Galerie Beaux-Arts on January 17, 1938. For the show, which many consider Surrealism's crowning moment, the group had remade the gallery in its image. As technical coordinator Georges Hugnet later described it:

> A long corridor, where one was welcomed by some fifteen mannequins metamorphosed by the painters, led to the main room, whose ceiling Marcel Duchamp had festooned with 1,200 sacks of coal [actually emptied and filled with newspapers, which didn't keep Breton from worrying about toxic fumes]. The floor, littered with damp dead leaves, rose in the center to support a glowing brazier. Four satin-lined beds spilled their quilted coverlets and the drapes of their sheets into reeds and puddles of water. Coffee roasted in a corner, sending its street aromas into this disorienting setting . . . The paintings were hung on revolving doors that didn't revolve.

Even before entering the gallery, patrons were greeted in the courtyard by Dalí's "Rainy Taxi," a real cab containing a female mannequin, wearing an evening gown and rapturous expression, surrounded by copious vegetation and drenched by rain that—via several conduits installed in the roof at great expense—fell within taxi itself. (Over the next weeks the mannequin was covered over by some two hundred live snails, turning her, as Matta said, into the "picture of Dorian Gray.") Once inside, these patrons found

themselves in a dark, leaf-strewn grotto. All around was the sound of hysterical laughter, recorded at an insane asylum and played on a hidden phonograph—which cut short, as Man Ray said, "any desire on the part of visitors to laugh and joke." Everything seemed calculated above all to confound the public's notions of what constituted art. One historian has pertinently written that the Beaux-Arts contained less an exhibit than "an environment and an experience."

The effect of this environment depended in part on subverting traditional perceptions of "indoor" and "outdoor" space: not only had the Surrealists brought such external elements as wet leaves and puddles into the gallery (and, in Dalí's case, into an old taxi), but they had also refashioned the gallery's interior as "the most beautiful streets of Paris." Signs posted on the walls led visitors through thoroughfares with such overdetermined histories as Rue Vivienne (Lautréamont's former address) and Passage des Panoramas, or through such imaginary avenues as the "Street of Lips," "Blood Transfusion Street," and "All-Devils Street." The "streets" themselves were populated by fifteen wax mannequins that had each been transformed into a given artist's object of desire. They ranged from Man Ray's simple nude adorned with glass tears and soap bubbles to Masson's, wearing a green velvet gag on which a live pansy flowered, and whose head was enclosed in a birdcage through which celluloid goldfish swam (Breton considered this mannequin the "pearl" of the exhibit).

Although many of the actual exhibits seem to denote a childlike (and sometimes infantile) spirit on the part of their authors, Breton was in fact quite serious about the effect he hoped to achieve, and he carefully weighed each element before accepting it. Dalí, for example, had unsuccessfully proposed covering the floor with an enormous wheat field, over which only the tallest visitors could see. And when the first mannequins arrived, they were returned to the manufacturer in favor of others that more satisfactorily incarnated the ideal of the "Eternal Feminine." Nonetheless, as Hugnet later confided, it was also Breton who several times endangered the exhibit by his "intolerance" and "cyclical allergy to any kind of arrangement" (particularly since Wildenstein, seeing the nature of some of the preparations, was beginning to worry about reactions from his well-heeled clientele). Fortunately, "Eluard's astute diplomacy" saved the day.

Indicative of Breton's ambitions for the show was the exhibit catalogue, an "abridged dictionary of Surrealism" assembled by him and Eluard, which with its 368 definitions and copious illustrations constitutes an important Surrealist document in its own right. Numerous themes, people, and everyday objects were emblematically and elliptically "defined," generally with short literary quotations that ranged from the profound to the inane. The entry on Breton cited Soupault's 1921 encapsulation of him as "the glass of

water in the tempest." Aragon was matter-of-factly presented as a "Surrealist writer, from the Movement's origins until 1932, at which time he violently denounced all his past activities," while Dalí provided his own introduction as the "Prince of Catalan intelligentsia, colossally rich." Other entries included Eroticism, Woman, Poetry (an entire page of definitions), Dream (ditto), Jacques Vache's delineation of Humor, assorted girlfriends and wives, Lautréamont, Rimbaud, Sade, Breast (Novalis: "The breast is the chest elevated to the state of mystery"), and Surrealism itself ("Ancient pewter table utensil, before the invention of the fork").

At ten o'clock on the night of January 17, an elegantly dressed crowd entered the Galerie Beaux-Arts to find itself plunged into darkness, clutching flashlights that had been handed them at the entrance so that they might view the works on exhibit. (This idea, the brainchild of Man Ray, was discontinued after too many patrons pocketed the flashlights on their way out, forcing the gallery to install fixed lighting for the rest of the show.) Dressed in tails, Eluard opened the exhibit by reading Breton's welcoming address: Breton, in a bad mood, had refused at the last minute to deliver the speech. Then, just as the assembled critics and specially invited arts patrons were getting used to looking at the displays (and each other) by flashlight, a vaudeville dancer named Hélène Vanel, wearing only a shirt and some masking tape, rushed through the crowd and leapt onto one of the unmade beds. She gyrated, shrieked, wrestled with a live and visibly terrified rooster, lacerated the bed linens in a frenzy, and ended by splashing in the puddles of filthy water, a spurt of which landed in the gaping mouth of a front-row spectator.

Still, although the Surrealists had devoted considerable effort to making the atmosphere as much a part of the show as the art, the 1938 exhibit was also the most complete demonstration of Surrealism's visual output to date. On display were some 230 works, representing sixty artists from fourteen countries, and including some of the movement's most intriguing creations. Apart from the transformed mannequins, the exhibit featured Meret Oppenheim's *Fur-Covered Cup*, Duchamp's *Rotary Glass Sphere*, and, by Breton, a tabernacle mounted on four running women's legs. There were also sculptures, objects, collages, and reliefs by Giacometti, Ernst, Arp, Dalí, Hugo, Jacqueline, Gala, Man Ray, Miró, the Swiss-born painter Kurt Seligmann, the American artist Joseph Cornell, and others. And of course, there were numerous Surrealist and pre-Surrealist paintings (many of them from Breton's own collection), forming a noteworthy testament to more than two decades of the Surrealist spirit in the visual arts. The combination of artworks, multisensorial environment, and the philosophical nuggets contained in the "abridged dictionary" fashioned an overall experience that brought outsiders as close as they would ever come to seeing the world through Surrealist eyes—excesses and all.

Unfortunately, these excesses were all that much of the public did see. Already on the night of the opening, some of the Beaux-Arts' regular patrons vociferously protested to Georges Wildenstein, while others simply stamped out. The press mainly went along with them, as attested by the titles of some of the reviews: "When Dada Goes Gaga," "The School for Pranksters," "Surrealism's Death Agony," "Surrealism Dead, Exhibit to Follow," etc. Some newspapers took a dismissive tone: *Le Journal* described the show as "mysterious but inoffensive," and *Le Gringoire* brushed it off as "old stories, old refrains." Others complained that this was less an art show than a nightclub act. Still others rejected the entire affair as "foreign": "The joke is not funny; its poor taste is not very French," said *Le Petit Parisien*. Finally, a few periodicals (such as the *NRF*) complained—as many had about Surrealism since its inception—that the exhibit mainly attracted "professional snobs . . . critics on the rebound, nature cultists, true reactionaries, and false revolutionaries." Still, despite the almost unanimous critical drubbing, the show became the event of the season, drawing a record number of visitors to the Galerie Beaux-Arts by the time it closed in late February; as one witness wrote: "Society people had not trampled each other so much since the fire at the Charity Bazaar."

Just as the exhibit was closing its doors, Breton's attention was once again turned to Sigmund Freud, as rumors reached Paris that the Nazis had arrested the analyst in the wake of the *Anschluss*. On March 30, Breton expressed the Surrealists' alarm: "Freud, fallen at the age of eighty-two into the grip of hoodlums, finds himself singled out for their mindless, bestial fury! . . . A symbolic cordon sanitaire must be organized around him, to secure his immediate and complete liberation, and to assure that his inspired life, which we hold as dear as our own, will be pursued to a peaceful and glorious close wherever he may choose." Appropriately, the declaration headed an anthology called *Trajectoire du rêve* [Trajectory of the Dream], a collection of writings on the unconscious that Breton had edited for Editions G.L.M. Freud had, in fact, been approached for a contribution to the volume, but had declined. "The superficial aspect of dreams, what I call the manifest dream, holds no interest for me," he had written Breton on December 8, 1937. "I have been concerned with the 'latent content' which can be derived from the manifest dream by psychoanalytical interpretation. A collection of dreams without associations and knowledge of the context in which it was dreamed does not tell me anything, and it is hard for me to imagine what it can mean to anyone else." For the final time, Freud underscored the incompatibility between therapeutic and "poetic" psychoanalysis, and rejected Surrealism's implicit claims to scientific validity. Still, any disappointment Breton might have felt was overshadowed by Freud's situation, and his plea on the Austrian's behalf was genuine. Thanks to public pressure and the efforts of sev-

eral disciples, Freud finally left Vienna on June 4 to finish his life, freely if not peaceful-
ly, in war-besieged London.

✳

On April 2, 1938, Breton and Jacqueline embarked from Cherbourg on the MS *Orinoco*,
bound for Veracruz, Mexico. In the headiness of travel preparations, Breton had readily
abandoned the Gradiva gallery that ostensibly he still ran, entrusting Tanguy with the
task of liquidating its assets and transferring its holdings to another gallery. Nor did he
have many qualms about leaving preparations for the next *Minotaure* to his fellow edi-
tors. For the latter, he nonetheless sent a hasty note from Cherbourg to be inserted in the
upcoming issue: "The Mexico toward which I'm heading, *Minotaure* that for once will
appear without me—you know that in my mind these two names hold 'the place and the
formula,' that they reveal two sides of the same truth."

With, presumably, more concern, Breton and Jacqueline also left behind the two-
year-old Aube, who would spend the next four months in the care of André Masson, his
wife, Rose, and their two young sons, in the Norman village of Lyons-la-Forêt. From the
outset, and despite the good intentions of the little girl's hosts, Aube's stay presented
problems. She first suffered what appears to have been a serious intestinal ailment, which
started with the Bretons' departure and lingered throughout April, then came down
with a bad case of bronchitis in June. What troubled Aube more than her physical ill-
nesses, of course, was the prolonged absence of "Ada and Zacline," as she called her par-
ents. As Masson reported, at first she would not believe that they had gone away at all:
"She keeps insisting you're nearby: behind the door . . . or at the edge of the forest, near
the garden," he wrote on April 14. Then, once Aube had understood the situation, she
refused to hear any more about them. With scarcely concealed disapproval, Rose Masson
watched as the toddler's sadness slowly turned into deep resentment. "To be honest, I've
stopped talking to her about you," she told Breton and Jacqueline in May. "I'd noticed
that she was troubled, worried, and depressed . . . I'm a little tormented by all this." And
she warned them not to be surprised if Aube spurned them on their return: "If her child-
ish whims tell her otherwise, no matter what we do, she won't open her arms to you."

Whatever regret the Bretons might have felt over their daughter, however, seems to
have been outshone by their experience of Mexico—both the splendors that awaited
them and the mishaps that accompanied them. On April 18, the couple arrived in what
Breton dubbed "the Surrealist place par excellence," to be welcomed by a lone, befuddled
functionary from the French Embassy. It soon became clear that, the official invitation-

notwithstanding, the embassy had made no provisions for lodgings. Furious, with only a few francs and return passage in his pocket, Breton was ready to take the *Orinoco* back to France then and there; but at that moment, the Mexican painter and muralist Diego Rivera, who had also come to Veracruz to meet the Bretons, stepped up and offered them the use of his own home for the duration of their stay. He also carried a message from his friend and mentor Leon Trotsky, inviting Breton to visit in several days' time.

At the age of fifty-one, Rivera was the most famous Mexican artist of his generation, a national legend whose paintings and murals earned him a comfortable living at home and numerous commissions abroad (not all of them successful: five years earlier in New York, a celebrated controversy had erupted when Nelson Rockefeller, who had hired Rivera to decorate the RCA Building, destroyed the work because Rivera had included a likeness of Lenin). It was Rivera who had persuaded Mexican president Lázaro Cárdenas to welcome Trotsky after his expulsion from France. And it was he who now, lodged the exiled revolutionary—along with his wife, Natalia, their grandson, and numerous bodyguards and secretaries—in the so-called Blue House in the Mexico City suburb of Coyoacán, which was owned by Rivera's wife, Frida Kahlo.

Grateful for the rescue, Breton and Jacqueline, after spending several days with another temporary host, moved into the upper floor of the Riveras' home in the fashionable suburb of San Angel. Jacqueline later described it as "one of the most modern houses of the time: two white cubes half made of glass, linked by an outside stairway without a banister and a passageway at the top . . . An Indian woman, the caretaker, prepared the family meals in the garden over a wood fire; quite visible beneath the trees, and in complete freedom, ran a giant anteater"—Breton's totem animal. Breton, delighted with the accommodations, excitedly wrote Péret: "Everything is marvelous, life with Diego and Frieda Rivera [*sic*] is as fascinating as can be."

Breton took an immediate liking to the stout, jovial muralist, and even more of one to Frida Kahlo. He was struck by the discovery of Kahlo's violent, allegorical paintings, which combined a Mexican iconography with Bosch-like overtones—seeing them, Breton immediately declared her a Surrealist—and was entranced by the woman herself. Swarthy and appealing, her mestizo features highlighted by the peasant dresses she wore, the thirty-year-old Kahlo (as one Surrealist later said) "fit completely the Surrealist ideal of woman. She had a theatrical quality, a high eccentricity. She was always very consciously playing a role and her exoticism immediately attracted attention." Kahlo, however, found Breton pompous, arrogant, and boringly intellectual. "The trouble with *El Señor* Breton is that he takes himself so seriously," she told friends, and privately referred to him as the "old cockroach." Nor did she entirely appreciate his labeling her a Surrealist. "I

never knew I was a Surrealist until André Breton came to Mexico and told me I was one," she archly wrote. "I myself still don't know what I am." She appears to have felt more solidarity with Jacqueline, another woman artist in a distinctly male world.

If Breton's presence in Mexico went all but unnoticed by French Embassy functionaries, this was not the case with the local journalists. From the moment of his arrival, he was asked to grant interviews to the newspapers, giving him the chance once again to define Surrealism's objectives for a new audience, while other periodicals ran capsule histories of the movement and translations of Breton's writings. "Breton has been here for a few days, full of admiration for the country, for Diego's paintings, for all the beautiful things in this country. On the other hand, he goes from banquets to official receptions, he is beset by a multitude of people," Trotsky's private secretary, Jean van Heijenoort, wrote to Pierre Naville in Paris. Even more attentive were the Stalinists, who regarded Breton's visit with evident suspicion. As Breton later recounted, several French Communists (Aragon among them) wrote to the major Mexican writers and artists, urging them to ensure "the systematic sabotage any sort of work that [Breton] might wish to undertake in Mexico."

Trotsky himself, meanwhile, greeted the news of Breton's visit with high interest. Increasingly isolated, he knew that Breton had strategic value as one of the few French intellectuals openly to endorse him at the time; he later told a friend, who was surprised by the Russian's welcome of the Surrealist poet, that he "could not afford to be sectarian in ideological matters when allies were so hard to come by." But Trotsky also seems to have been genuinely touched by the admiration Breton had shown over the past years, and impressed in turn by the man's intellectual reputation. According to Jean van Heijenoort, he immediately began planning for the Surrealist to spearhead an independent writers' federation in France, as a counter to similar Communist organizations in Europe and America. Before Breton's arrival, he had also requested some of his books in order to acquaint himself with Surrealism. The American art critic Meyer Schapiro sent the first *Manifesto*, *Nadja*, *The Communicating Vessels*, and probably *Mad Love* from New York—although when they arrived, Trotsky left them unread on his desk for several weeks, and leafed through them only at the last minute. Finally, through Heijenoort, Trotsky made inquiries about Breton to Naville in Paris, who sent back a generally favorable report.

By the time of the two men's meeting, therefore, Trotsky was fairly well versed in Breton's thinking (well enough, in any case, to make Breton feel he had read his books attentively) and favorably disposed toward the Surrealist leader. Early in May, he warmly welcomed Breton to the Blue House on Avenida Londres, with its "plant-filled patio,

cool rooms, collections of pre-Columbian art, and countless paintings": the house in which Trotsky had lived and worked for the past year and a half. "We were all very moved," Jacqueline recalled, "even L.D. [insiders' code for Leon Davidovich Trotsky]. We immediately felt welcomed with open arms."

As for Breton, his admiration for the fifty-eight-year-old revolutionary bordered on hero worship. "With beating heart, I saw the gate of the Blue House being opened," he told a Trotskyist group once back in Paris:

> I was led through the garden and barely had time to recognize, as I went by, the bougainvillea whose pink and violet flowers littered the ground, the omnipresent cacti, the stone idols lovingly assembled along the paths by Diego Rivera . . . I found myself in a well-lit room filled with books. Well, comrades, the moment I saw comrade Trotsky get up and come forward—the moment the real person replaced the image I had of him—I could not repress the impulse to tell him how astonished I was to find him so young-looking . . . The deep blue eyes, the wonderful forehead, the abundant hair with barely a hint of silver, the healthy complexion combine to create a mask mirroring inner peace—an inner peace that has overcome and will continue to overcome the cruelest hardships . . . As soon as his face lights up and he starts using his hands to qualify this or that statement with rare subtlety, something electrifying radiates from him.

It was, said Breton, like having "a whole wall of the revolution" stand before his eyes.

The first meeting, which lasted several hours, touched mainly on informational topics. In fluent if accented French, Trotsky inquired about French reactions to the Moscow Trials and about the activities of Malraux and Gide, whom Trotsky had vainly tried to entice to Mexico several months earlier. Heijenoort and several others sat in on the conversation, and one of Trotsky's American aides took photographs. "On some of them," said Jacqueline, "one can see André's face in a state of tension, emotion, and wondrous, almost pained surprise." Later, Natalia Trotsky served tea. Breton, who despised the beverage, nonetheless deemed that "under these conditions, it was drinkable."

Nearly fifteen years later, Breton still marveled at Trotsky's "prodigious mental organization, which allowed him, for example, to dictate three texts simultaneously," as well as his ability "to relate every small observation to a larger fact, to bend it—without this ever seeming forced or artificial—toward the hope of redefining worldly values." In this, there might have been some part of exaggeration: Heijenoort, for his part, has said that the "diligent and concentrated" Trotsky hated doing more than one thing at a time.

But rather than objective fact, Breton's recollection expresses the veneration that he would carry with him for the rest of his life. Trotsky, meanwhile, was sufficiently reassured to tell *Partisan Review*, the leftist New York quarterly, that Breton was "artistically and politically not only independent from the Stalinists but absolutely hostile to them."

Still, and despite the mutual admiration, it was inevitable that the vast formative and cultural differences between the two men should lead to occasional disputes. "No matter how great our deference," Breton later said of himself and Rivera, "and despite the care we took to contradict [Trotsky] as little as possible, we couldn't entirely avoid banding together out of an 'artistic' temperament that was fundamentally alien to him."

Some of these differences surfaced during a second meeting, on May 20, when Trotsky broached the issue of literature. Unlike Breton, Trotsky had never devoted much thought to the subject; his one work on it, *Literature and Revolution*, now seemed to him to belong "to an almost prehistoric time." Moreover, his literary tastes did not extend past the nineteenth century, particularly the novels of the great realists. "When I read Emile Zola," he said to Breton's dismay. "I enter into a broader reality." Breton stiffened in his chair, finally admitting in a pinched voice that Zola might have some merit after all. Nor did Trotsky understand Breton's love of Sade and Lautréamont; and while he admired Freud, he distrusted Surrealism's particular approach to psychoanalysis (much like Freud himself). "Are you trying to smother the conscious under the unconscious?" he asked. Finally, he questioned Breton's interest in objective chance, even though the notion had originated with Engels. Breton explained his view of the unconscious as a tool for social liberation, but Trotsky, though partly swayed, accused him of trying to keep open "a little window on the beyond."

Nonetheless, as Breton later noted, these "fleeting disagreements" could not "damage the basic harmony" of the two men's relations. Jacqueline, who was present for her husband's interviews with Trotsky, also remembered the predominantly cordial tone of their discussions:

> L.D.'s readings were very classical . . . and this gap separated them. In André, it
> provoked moments of despair. It must have been the same for L.D. when it came
> to André's political lacunae. And yet, the points of convergence were innumerable.
> They shared the same love of and respect for nature, the same joy, the same inten-
> sity of life, the same will to change the world—each in his own way, of course, but
> in the end it was the same. Both had the same violence of thought and opinions.
> What André most admired in L.D. were his rigor, his commitment, his passion,
> and his purity.

Jacqueline also saw in both men a "great power of fascination and seduction," as well as a "respectful, polite, generally deferent"—and more than a little old-fashioned—attitude toward women: Breton maintained a lifelong custom (long out of date, even in his childhood) of kissing women's hands; and Trotsky could not tolerate a woman smoking or wearing makeup. Needless to say, Jacqueline and Frida were generally excluded from the men's conversations, and instead played Surrealist and children's games together in a corner of the room.

Over the course of Breton's four-month stay, he and Trotsky held eight or ten such discussions, most of them during various trips taken together (both to provide a more pleasant context and to satisfy Breton's touristic desires). If this seems few, it should be remembered that more frequent contact was made difficult not only by the Russian's schedule—apart from seeing Breton in these months, he composed several major articles, worked on a huge book about Stalin, and kept his hand in various political arrangements—but also by the security measures he had to observe. Trotsky knew that the Soviet secret police had standing orders to kill him and his family. A mere two months before Breton's arrival, they had murdered his son, Leon Sedov, in a Paris clinic; and attempts on his own life were so likely that Rivera had installed a guard booth in front of the Blue House. All visitors (with Rivera the sole exception) were required to make appointments in advance, while road trips involved an entourage of twelve or more in several cars. Given these precautions, the tragedy that had recently visited Trotsky, and his ongoing preoccupations, the ten or so meetings granted Breton bear witness to the sincere interest "L.D." took in his foreign guest.

When not seeing Trotsky, Breton spent his time with Rivera, traveling throughout the countryside and meeting numerous Mexican intellectuals. He continued to grant interviews to the newspapers, one of which quoted him declaring that "war seems inevitable; the most we can hope for is that it will inspire more opponents than the last one, and that they will take advantage of the situation to lead the masses in overthrowing the capitalism from which it has resulted." And he attempted to fulfill his official duties as a lecturer: he briefly spoke at the opening of an art exhibit, prefaced the Mexican premiere of *Un Chien andalou*, and on May 13 delivered the first of several scheduled lectures at the Universidad Nacional in Mexico City, on "modern transformations in art and Surrealism." Trotsky, fearing disruptions by the local Stalinists, instructed his supporters to post themselves around the amphitheater.

As it happened, Breton's first lecture proved to be his last: soon afterward, the rector who was sponsoring his speeches resigned, and the embassy, preoccupied with an attempted coup against President Cárdenas, had little time to redesign Breton's sched-

ule. Moreover, after his talk at the university, Breton found himself the subject of several hostile articles in the press, which dismissed Surrealism as an "ivory tower." Despite rebuttals by Rivera, Breton was stripped of his official mission in June. He gave one last public address, a poetry reading on June 26, and then no more for the rest of his stay.

In the end, it was a small loss: the cancellation of further lectures now left him freer to tour Mexico and see Trotsky. During the months of June and July, he and the exiled Bolshevik explored Toluca, Cuernavaca, Tenayuca, Calixtlahuaco, and other magnificent villages full of Mexican and Indian lore. They visited the volcano Popocatepetl and scaled the pyramids of Xochicalco. One evening, in a small town, Trotsky took advantage of his guests to permit himself a rare treat: going to the movies. Despite Rivera's pleas to keep his face covered, Trotsky—accompanied by Natalia, Breton, Jacqueline, and a dozen bodyguards and assistants—watched the dubbed, third-rate Western with consummate enjoyment, "laughing, commenting in whispers to everyone about the film's plot and form."

He and Breton also indulged a mutual passion for the outdoors: strolling in the country, fishing for *axolotls*, hunting for butterflies. "It was all very merry," recalled Jacqueline. "They both fished with their hands. They took off their shoes, rolled up their trousers, and stepped into water that was often ice-cold . . . During their long walks they marveled at nature. I remember their conversations on the beauty of butterflies . . . It was a complete surprise for André, who certainly hadn't expected L.D. to be interested in butterflies."

But as with their initial discussions, not all the contacts were quite so harmonious. Breton later recounted how Trotsky watched disdainfully as he and Rivera combed small villages for pre-Columbian figurines—one interest the Russian did not share— representing voluptuous, ornately sculpted nudes. And Heijenoort recalled Trotsky's anger when, one afternoon in a village church, Breton discovered the marvelously decorated votive plates left by several generations of townspeople. Full of admiration for these examples of popular art, Breton "started to slip some of the votive offerings, perhaps half a dozen, under his jacket. He felt even fewer scruples by virtue of the fact that it was a church, and he perhaps even considered his act to be a legitimate expression of anticlericalism." Trotsky, however, who did not appreciate this form of sacrilege, and who moreover feared that the incident could be used to discredit him, was furious— although for once he held his tongue.

For his part, Breton was outraged when Trotsky (keeping open his own "little window on the beyond") referred to a favorite dog as his "friend" and asked Breton whether he didn't think the animal had a "human look." Shocked by Trotsky's animism, Breton

retorted that calling a dog "friendly" was just as senseless as saying a mosquito was "cruel" or a crayfish "reactionary." But Trotsky clung to his position, finally concluding with a laugh that only a third creature, "half-dog, half-man," could settle the debate. Breton remained annoyed by the incident, and on his return to Paris he fumed to Luis Buñuel: "Can you imagine how someone like Trotsky could possibly say such a stupid thing? A dog doesn't have a human look! A dog has a dog's look!"

But the most pronounced dispute between the two men concerns not a point of ideological divergence but a project on which they agreed: Trotsky's plan for a federation of revolutionary artists. It was during their second talk, on May 20, that Trotsky had spoken of such a group, which he hoped would "gather representatives of the various non-Stalinist revolutionary movements" into a unified front. Trotsky thought the project should be inaugurated with a manifesto, and he had asked Breton to draft one. In the several weeks following, however, Breton had found himself too intimidated to write anything at all, and the delay soon began to anger the exacting elder comrade. "Breton, with Trotsky breathing down his neck, felt completely paralyzed," wrote Heijenoort. "'Have you something to show me?' Trotsky would ask whenever they met. As the situation developed, Trotsky assumed the role of the schoolmaster before a Breton playing the recalcitrant pupil who had not done his homework." Breton was so mortified that he even asked Heijenoort to draft the manifesto in his stead, but Heijenoort declined.

Trotsky's wrath had finally exploded in early June, during a car trip to Guadalajara. The details of the argument have never been made clear, but it evidently had to do with Breton's delays and Trotsky's impatience. Breton obliquely evoked "the misunderstanding on the road to Guadalajara" in a subsequent letter to Trotsky: "At the time . . . I was no less offended than you, because I could not accept that *Trotsky* should ascribe to me, even with all appearances to the contrary, motivations so opposed to the ones that I've always felt toward him." In the middle of the argument itself, Trotsky's car suddenly pulled to a halt and Breton, with a look of "baffled astonishment," walked back toward a second vehicle following behind. He passed the rest of the 500-mile journey exiled in this second car with Jacqueline and Frida, while Heijenoort replaced him next to a "stiff and silent" Trotsky in the front vehicle. During the several days they stayed in Guadalajara, Breton did not once see Trotsky.

Instead, he and Rivera spent their time indulging their "artistic temperaments," like schoolboys playing hooky. They went in search of paintings and antiquities to a run-down private museum, where they were guided by a "friendly, shabby-looking" old man who asked to be paid only in lottery tickets (he had, he proudly informed his guests, spent 26,000 piasters on such tickets without ever winning). Swarms of impoverished families

went about their business in the courtyard, and on the upper balcony an elegantly dressed young man sang at the top of his lungs. "The whole of Mexico was there," Breton later wrote. During the trip, Breton also discovered the earthy, powerful photographs of Manuel Alvarez Bravo, some of which he published in *Minotaure* the next year. And while visiting a dilapidated mansion—which he dubbed the "Tumbledown Palace"—he was wonderstruck by "a magnificent creature, sixteen or seventeen years old, her hair disarranged in an ideal way [who] had answered the door," and whom he soon noticed was naked under a shredded evening gown. "The spell she cast over me at that moment was such that I failed to inquire after her position: who could she be . . . ?" he wrote. "No matter: as long as she was there, I did not care at all about her origin, I was quite content to simply render thanks for her existence. *Such is beauty*."

Once back in Mexico City, Breton and Trotsky patched up their differences, and Breton tried once again to face his manifesto. He labored over the ensuing weeks to shape his and Trotsky's ideas on art and politics into a statement worthy of the great revolutionary and of his projected federation—although it appears that no real progress was made until mid-July.

In the meantime, at the beginning of that month, Breton, Trotsky, Rivera, and entourage spent several days on the isle of Pátzcuaro, in the state of Michoacán. For the evenings, the three men had planned a series of talks about art and politics, which they intended to publish jointly under the title "Conversations in Pátzcuaro." Conflicts again arose when discussion turned to the society of the future. Breton maintained that not even a classless society would eliminate conflict (a thesis Trotsky refused to hear); and Trotsky, who dominated the conversation, asserted that in the society of the future art would simply disappear: instead of paintings or dance, houses would be beautifully decorated and people would move harmoniously. "Don't you think that there will always be people who will want to paint a small square of canvas?" a worried Breton asked Heijenoort after Trotsky had gone to bed. In any case, the "Conversations in Pátzcuaro" went no further: after the first evening, Breton came down with fever and an attack of laryngitis, leaving him voiceless for several days—by which time an annoyed Trotsky had returned to Mexico City.

The fact was, this was no mere illness, but a manifestation of the almost paralyzing awe Breton felt in Trotsky's presence. Breton himself recognized as much, and in a moving letter to Trotsky written just after his departure from Mexico, he spoke of the "inhibition to which I've fallen victim, each time it was a matter of trying to do something along your lines and before your eyes":

This inhibition is mainly a product, as I'd like at all costs for you to understand, of the boundless admiration I have for you . . . Very often I've wondered what would happen if, by some impossible chance, I found myself facing one of the men on whom I've modeled my thinking and sensibility: Rimbaud, say, or Lautréamont. All of a sudden I felt oddly stripped of my abilities, prey to a kind of perverse need to hide. It's what I call for my own personal use, in memory of King Lear, my "Cordelia complex." Please don't laugh at me; it's utterly innate, organic. I have every reason to believe it's ineradicable.

It was this "Cordelia complex" that kept Breton from pursuing formalized discussions with Trotsky in Pátzcuaro, and from drafting a text that, under normal circumstances, would have cost him little effort.

Finally, after his return from Pátzcuaro, Breton was able to make progress on the manifesto. Although the first paragraphs were somewhat halting (as the original manuscript shows, they were substantially rewritten before publication), he soon found the correct tone, and the majority of his first draft does not significantly differ from the final version. Heijenoort described the composition of the text at that point: "[Breton] gave Trotsky a few sheets of paper, covered with his tiny handwriting. Trotsky dictated a few pages in Russian, to be combined with Breton's text. I translated Trotsky's pages into French and then showed them to Breton. After more talk, Trotsky took all of the texts, cut them, added a few passages, and pasted everything into a long roll. I typed the resulting text in French, translating Trotsky's Russian and keeping Breton's prose. This was the text on which they reached final agreement."

The manifesto, finally dated July 25, 1938, and titled "For an Independent Revolutionary Art," addressed all leftist intellectuals who refused to follow the call of Stalinism. "The aim of this appeal is to find a common ground on which may be reunited all revolutionary writers and artists, the better to serve the revolution by their art and to defend the liberty of that art itself against the usurpers of the revolution," wrote Trotsky, his years of polemical directness coming to the fore. Condemning the repression of progressive art by both the fascists and the Stalinists, he announced the formation of an "International Federation of Independent Revolutionary Art" (Fédération International de l'Art Révolutionnaire Indépendant, or FIARI), which he opened to "every friend and defender of art."

Breton, meanwhile, took a more theoretical approach: "Any philosophical, sociological, scientific or artistic discovery seems to be the fruit of a precious *chance*, that is to say, the manifestation, more or less spontaneous, of *necessity* . . . It follows that art cannot,

without degenerating, bend itself to any foreign directive and obediently fill the parameters that some believe they can assign it, for the benefit of extremely shortsighted pragmatic goals . . . To those who would urge us, whether for today or for tomorrow, to consent that art should submit to a discipline which we hold to be radically incompatible with its nature, we give a flat refusal." In what might be considered an excess of zeal, Breton had also thought to include Trotsky's own former prescription: "Complete freedom for art, *except against the proletarian revolution*." But Trotsky, who too often had seen this latter caveat misused by the proponents of Socialist Realism, himself deleted the final clause—bringing the statement into line not only with his current thinking but with Breton's own writings as well. The manifesto concluded with Breton's twin injunction: "Our aims: The independence of art—for the revolution; The revolution—for the complete liberation of art!"

"For an Independent Revolutionary Art" condensed and focused many of the discussions on art and politics that had taken place between the two authors during their recent contacts. In many ways it demonstrates a notable concordance of ideas, and stands, as one critic has pointed out, as one of the few examples in history of a joint statement by a political theorist and a poet. At the same time, the manifesto shows the basic differences between Trotsky the pragmatist and Breton the quasi-utopian. For although both men agreed that art had suffered under the bourgeoisie, Trotsky's reflections on art as "expressing the inner needs of man and of mankind in its time" inevitably call to mind his earlier prediction that art would ultimately disappear when life itself better responded to those needs. Whereas Breton, here as elsewhere, conceived of a future society in which the unconscious energies of desire would be allowed to blossom into ever more daring, ever more unworldly forms of art.

Moreover, it is indicative that this manifesto, the crowning achievement and most durable trace of Breton's visit to Mexico, should be a statement about the role of the *artist* rather than a political tract—even though Breton had written many purely political statements during his thirteen years of social involvement. By meeting Trotsky on the literary terrain, Breton reinforced the vision he'd had of him since 1925: as a masterful writer and thinker, rather than as the ruthless bureaucrat to which much of his career attests. For his part—and notwithstanding the respect he felt for Breton, which had been visibly enhanced by their contacts—Trotsky underscored the attitude that had always pursued the Surrealist leader in his dealings with scientists and politicians, from Freud to Léon Blum: that in the final account, André Breton remained a poet, and his domain that of aesthetics.

Trotsky further highlighted this attitude when he insisted that the manifesto should

be co-signed not by himself but by Diego Rivera, who had actually had little or no hand in its composition. In part, as Breton later stressed, this was because his status as a refugee prohibited him from engaging in overt political action (although it clearly did not prevent him from writing numerous polemical articles during his stay in Mexico). But it was also because Trotsky believed that a manifesto *on art* should be signed by two artists.

With the manifesto completed, it was time for Breton finally to leave Mexico. He and Trotsky bade each other a warm farewell at the end of July, "on the sun-drenched patio of the Blue House in Coyoacán, amidst cactus, orange trees, bougainvillea, and idols." Trotsky disappeared into the house and returned with the original manuscript of "For an Independent Revolutionary Art," which he presented to his co-author as a gift—the only time, said Heijenoort, that Trotsky had ever given away one of his manuscripts. Breton, profoundly moved, gave Trotsky in return a portrait of himself by Man Ray, with the inscription: "To Leon Trotsky, in commemoration of the days spent in his light, with my absolute admiration and devotion."

On August 1, Breton and Jacqueline embarked from Veracruz on the Hamburg-Amerika Line's *Iberia*, dazzled by their experiences of the past four months. Breton's suitcases were filled with the masks, pottery, ornate frames, dolls, whistles, ex-votos, skulls made of sugar, wooden boxes, and other examples of popular art he had found during his travels.

It was on the return voyage that Breton composed a long letter to Trotsky (the one in which he described his "Cordelia complex"), filled with all the admiration that he had felt unable to express in the man's presence. "You are precisely one of those men [who have shaped my life and thought], perhaps even—I'm not sure because of Freud—the only one alive," he wrote on August 9. "For me you are placed very high, and it will take me much time and effort to convince myself that you are not beyond my reach." Flattered and alarmed, Trotsky responded on the 31st that the "friendly and very warm" tone of Breton's letter had left him both touched and "a little embarrassed. In all sincerity, your praises seem so exaggerated that I worry a little about the future of our relations."

More telling still was the assessment Trotsky addressed several weeks later to his French lawyer, Gérard Rosenthal (who, as "Francis Gérard," had been one of the original Surrealists):

> I don't believe that we, as a party, can expect [Breton] to turn his literary magazine into a factional publication. He represents the Surrealist school . . . We haven't the slightest responsibility for him. In the artistic domain, which has always been his main preoccupation, he naturally has the most absolute right to do as he sees fit. It is

not up to us to mix artistic tendencies, but rather to group them as they are into a common struggle against totalitarian attacks on art. Any attempt on our part to subordinate artistic tendencies as such to a given political interest could only compromise us in the eyes of true artists.

On the one hand, this was simply a defense of the artistic autonomy put forth by both Breton and Trotsky in their manifesto. But by renouncing any responsibility for Breton's "school" and defining Breton's main preoccupation as "the artistic domain," on some level Trotsky was also telling Rosenthal that politics should be left to politicians, not Surrealists.

The Bretons landed in Boulogne on August 18, where they were greeted by Aube and Divonne Ratton, the art dealer's wife. Certainly confused by her parents' long absence, and (like every child at thirty-two months) having entered the "terrible twos," Aube in all likelihood pouted for the next several days.

Before returning to Paris, the Bretons headed to Lorient for their annual vacation, during which time Breton also visited the nearby resort town of La Baule to see André Masson and Pierre Mabille. Talk between the three men alternated between Breton's plans for the FIARI and concern over the war that he already considered "inevitable."

But Breton gave few details about his visit to Trotsky. The Egyptian Surrealist Georges Henein recalled finding Breton visibly "more statuesque" from having met the revolutionary, but relatively silent about their actual contacts. "As if he were returning from the most secret place in the world, Breton spoke little of their meeting. It seemed that Leon Davidovich intimidated him, perhaps by his intransigence, which regulated even the smallest aspects of daily life."

Despite the vivid impression left by Trotsky, what Breton found on his return to France rapidly made it impossible to prolong the aura of his stay in Mexico. The Spanish Civil War was leaning more and more heavily toward victory for Franco, which would come in March; and Hitler, after having annexed Austria that spring, was now eyeing Poland and the Czech Sudetenland as well. The Western democracies, having let the Spanish Republic sink alone, made ineffectual attempts to coexist peacefully with the architect of *Lebensraum*—which not only did nothing to alleviate the tensions throughout Europe but also (and just as disastrously, from Breton's viewpoint) fostered a wave of superpatriotism and militarism at home, even among the French Communists.

Nor were events in the Surrealist group itself any more encouraging. On July 19, while Breton had been climbing pyramids with Trotsky, Salvador Dalí had fulfilled a life-long dream and visited Freud in London. As he later described it: "Freud knew nothing about me except my painting, which he admired, but suddenly I had the whim of trying to appear in his eyes as a kind of dandy of 'universal intellectualism.'" Dalí therefore tried to spark Freud's interest with his theories on paranoia, but Freud merely stared at the painter without reacting. "Before his imperturbable indifference," said Dalí, "my voice became involuntarily sharper and more insistent. Then, continuing to stare at me with a fixity in which his whole being seemed to converge, Freud exclaimed, addressing Stefan Zweig, 'I have never seen a more complete example of a Spaniard. What a fanatic!'"

While the incident in itself was, if anything, amusing, what roused Breton's jealousy was the interest that Freud had clearly taken in Dalí—however arch it might be. The day after the visit, Freud had written to Zweig that, before the encounter, "I was inclined to look upon Surrealists, who have apparently chosen me for their patron saint, as absolute (let us say 95 percent, like alcohol) cranks. The young Spaniard, however, with his candid fanatical eyes and his undeniable technical mastery, has made me reconsider my opinion." And as Dalí himself reported to Breton, Freud had made several insight-ful pronouncements about Surrealism based on his visitor's canvases. After nearly two decades of laboring in vain to interest Freud in Surrealism, it annoyed Breton that the analyst's attention should finally be captured by the "fanatical" Spaniard—whose own recent works and actions, moreover, had by now disbarred him from the movement.

Then, just as Breton was setting foot back in Paris, another troubling episode befell the group. During a dinner party on August 27, a fight broke out between the Surrealist painters Oscar Dominguez and Esteban Francès. In a drunken fury, Dominguez flung a bottle at Francès, but the projectile missed its target and instead struck fellow guest Victor Brauner full in the face, putting out his left eye. For the Surrealists, the incident was disturbing less as tragedy than as prophecy: seven years earlier, in an otherwise nat-uralistic self-portrait, Brauner had painted himself with a bloody, gaping hole in place of one eye. So strong was the group's belief in the power of such icons that Brauner himself declared, as his friends were rushing him to the hospital: "This is all my fault, I never should have painted myself with a punctured eye!"

Most disturbing of all, however, were Breton's final encounters during those same days with Eluard. In Breton's absence, Eluard had published a propagandistic poem, "Les Vainqueurs d'hier périront" [Yesterday's Victors Will Perish], in the Stalinist peri-odical *Commune*, edited by the same Aragon who was then trying to "sabotage" Breton's Mexican tour. Eluard's main concern had been to reach a large, leftist audience, and he

had acted in full knowledge of the implications. Breton, however, was at first inclined to give his friend the benefit of the doubt. "It seems impossible, even if you and I don't entirely agree politically, *that you should give your support to so flagrant an attempt to falsify the truth,*" he had written from Mexico on June 14. "*There is something poisonous about letting such a doubt come between us.*" But Eluard had not answered, and on August 31, the day before their reunion, Breton wrote: "I believe we disagree on quite a number of points. Your silence has considerably worsened this impression. Can we do anything more than simply state our disagreement? I doubt it."

Breton's doubts were well founded, for it soon became clear that he and Eluard had by now drifted too far apart for reconciliation. The next two weeks were marked by an exchange of letters attesting to what can only be described as a divorce—complete with division of property (mutually lent books and paintings), erasure of ongoing collaborations, and emotional turbulence. "I would ask you . . . to believe, despite everything, that I'll never forget what you were and what you still are to me," Eluard wrote on September 12. Somewhat more trenchantly, Breton replied the next day:

> At least recognize that for months and months I've done everything in my power to dispel the ill omen threatening our relations, and to minimize the deepest divergences that were coming between us. I resigned myself to our separation only when I was sure that we could no longer go against this current and when I found myself confronted with this dilemma: either leave you or be forced to renounce expressing my thoughts on what constitutes, alongside fascism, the principle scourge of our times [i.e., Stalinism] . . . For me, it had to do with the very meaning of Surrealism, and of my life.

Recounting the breakup many years later, Breton told André Parinaud, "Suddenly, just like that, a friendship ended that had been growing for years, to the point of making us like brothers."

There is no doubt that the break affected Breton strongly, and over the coming weeks his actions showed evidence of a deep and buried rancor. Soon afterward, he called a meeting of Surrealists and sympathizers to denounce Eluard's attitude toward Stalin as "unspeakable." Georges Hugnet, Eluard's close friend, objected that political opinions had nothing to do with great poetry. "They have plenty to do with Surrealism," Breton replied, demanding that "Eluard stop being considered a Surrealist, that he be officially, publicly branded an enemy." But Breton did not stop at Eluard's political views: in his fury, he resorted to unusually base means of discrediting his former friend, spreading

rumors that Eluard was an "orgy-goer" and ordering all the remaining faithful, on pain of exclusion, to "commit themselves to sabotaging Eluard's poetry by every means at their disposal." So vengeful was Breton, in fact, that several other Surrealists (notably Max Ernst and Man Ray), shocked at his tactics, preferred to accompany Eluard out of the movement that fall.

It was against this background that Breton began executing plans for a French section of the FIARI. Using the "Independent Revolutionary Art" manifesto as a rallying cry, he quickly formed a national committee whose members reached nearly sixty by late September. The young journalist Maurice Nadeau was named editor of the federation's monthly bulletin, *Clé*, and Georges Hugnet was appointed treasurer. Meanwhile, Diego Rivera organized a similar federation in Mexico; in London, the English Surrealists formed their own branch of the FIARI (which they abbreviated IFIRA); and in New York the *Partisan Review* encouraged the foundation of an American branch. But of the lot, the Paris group was by far the largest and best organized.

On September 27, the first FIARI tract, *Ni de votre Guerre ni de votre Paix!* [Neither Your War Nor Your Peace!], warned against the threat of war, rejecting both the anti-German policies of the Soviet Union and "the outmoded Europe of the Versailles Treaty." Instead, it urged transforming the coming war into a continent-wide proletarian revolution, one that would have the German working classes fighting alongside, rather than against, their foreign brethren. But within days of its publication, two events threw the spirit of *Ni de votre Guerre* to the winds. The first was the Munich Pact, which on a desperate prayer of maintaining "peace in our time" granted Hitler the Czech Sudetenland and opened the door to Nazi occupation of the entire country. The second, which came just one day before the signing of the Munich accord, was Breton's mobilization.

On September 29, Breton found himself the army reserves, joining his regiment in Paris that same day. In place of the sky-blue infantryman's uniform of 1915, he now wore the outfit of a military doctor, with its belted jacket, flapping jodhpurs, and garnet-colored felt kepi perched atop a mass of graying hair. "Breton is mobilized and walks around in the uniform of an assistant medical officer . . . He's the only one of us to have been called up," Péret wrote to Heijenoort. Almost immediately, the signing of the Munich Pact removed the imminent threat of war, and Breton was discharged again on October 8, with instructions to stand by. In the meantime, he spent his ten days as a medical officer seeing to "uninteresting tasks that take up three-quarters of his day," as Jacqueline told Trotsky, and devoting the rest of his time to meetings at the Deux-Magots and FIARI business—all the while dressed in his army uniform. Peggy Guggenheim later offered this portrait of Breton in the service: "In the last war he had

served in the Army as a psychiatrist and this time they made him a doctor, though he had forgotten everything he ever knew about medicine. He went around with medical books in his pockets . . . Both Jacqueline and Aube followed Breton everywhere and the child was a pest in cafes."

Aube, in fact, was now a pretty but fairly undisciplined little girl, bright and charming, her head covered with blond ringlets, and completely disruptive in café meetings. "In the name of freedom," as one Surrealist put it, she was allowed to "terrorize those at the café table" by doing everything from making noise to pelting them over the head with baguettes. Even freedom had its limits, however: Henri Pastoureau remembers an exasperated Breton pointing from the Deux-Magots to Saint-Germain-des-Prés Cathedral across the square and threatening: "If you don't behave, we're going to take you to church!"

On one occasion when Jacqueline and Aube clearly didn't follow him, Breton met Thérèse Cano de Castro, a former good-time girl with a wide, sensual face and exuberant laughter, who was known throughout Montmartre as "Thérèse Treize." Thérèse had been an intimate friend of Kiki of Montparnasse in the heady 1920s and, briefly, a lover of Robert Desnos, who had given her her nickname. Now thirty-eight, she encountered Breton in a Paris restaurant during his military service, appealing to him in much the same earthy way as had Marcelle Ferry several years before. Despite her open mockery of his "ridiculous kepi sitting on a lion's mane" (Breton was not a man who looked good in uniform), Breton tried to woo Thérèse, telling her that her laugh was "a glade, a new stream" and giving her a copy of Lautréamont's *Maldoror*—"a weird and silly book," to Thérèse's way of thinking. At Breton's insistence, Thérèse gave him her address, only to begin receiving love letters "worthy of a schoolboy," letters that she blithely showed to Breton's friend Georges Henein after a chance meeting with the Egyptian. "What struck me," Henein wrote, discomfited to be eavesdropping on Breton's private life, "is that these morsels of courtly love were poetic projections arbitrarily applied to a creature who skimmed right over them."

It is uncertain whether Thérèse ever ceded more than her address to Breton. And it is probably untrue, despite Heinein's assertions, that she and Breton met as strangers in 1938, for she would have known of him through both Desnos and Kiki's onetime lover, Man Ray. But Henein is no doubt right in describing Breton's "poetic projections" as being "arbitrarily applied" to Thérèse. For Breton's brief pursuit of the woman (which appears to have ended with his return to civilian life) seems like nothing so much as a desperate attempt—either because of the threat of war or of renewed strains in his marriage—to inject a dose of mad love into a bleak and bewildering situation.

By the end of Breton's time in uniform, the FIARI alliance was coming asunder. In part this was due to internal dissentions: seeing that Georges Hugnet continued to frequent Eluard, Breton summoned Hugnet to a FIARI meeting, at which he—with Jacqueline, wearing a flamboyant Mexican outfit, at his side—accused his treasurer of being the "friend of an orgy-goer" and a "Stalinist spy." Hugnet resigned from both the FIARI and Surrealism soon afterward. For non-Surrealist members of the FIARI, meanwhile, Breton's tactics seemed shockingly out of place. The American militant Sherry Mangan, for one, was so angered by the Hugnet meeting that he threatened to "write the Old Man [Trotsky] to let him know the FIARI is only being used to settle Breton's personal vendettas." And even before this, Pierre Naville had reported to Heijenoort that Breton was "floundering a little, for as we might have predicted, he wants to maintain his faction rather than truly bring people together." It doesn't take much insight to see the FIARI as Contre-Attaque (or the Congress of Paris) all over again—nor to predict its similar fate.

This, in any case, is how it appeared to Dalí, whom Breton had tried to enlist in the federation. In a manner perfectly consistent with his previous responses, Dalí wrote back in January 1939 to express his skepticism about the whole enterprise. This latest refusal was to be the last, however, for in its wake Dalí was officially expelled from the Surrealist movement. Ten years later, Breton wrote that the Dalí he had once admired "disappeared around 1935 to make way for . . . [a] fashionable portraitist recently converted to the Catholic faith and to 'the artistic ideals of the Renaissance,' who today boasts of receiving congratulations and encouragements from the Pope." His annoyance at Dalí's flagrant hunger for publicity also inspired the anagrammatic nickname "Avida Dollars," henceforth the only name he used for the painter. The half-amused Dalí sniffed: "That's the only truly brilliant intuition Breton ever had in his life."

But by far the greatest obstacle facing the FIARI was the fact that, with Europe tumbling uncontrollably into war, no one was very interested in what a handful of avant-garde poets had to say about world events. *Clé* dutifully published two issues filled with intelligent commentary on the political situation, but by February 1939 both the magazine's funds and its editors' enthusiasm had run dry. At around the same time, a violent rift occurred between Trotsky and Rivera, involving some deep-seated jealousies and forever alienating Rivera from the cause of Trotskyism. Given the tensions already eating away at the FIARI, the break between two of the federation's original sponsors was a mortal blow. By summer, the FIARI had gone the way of its ill-fated magazine, taking with it one of Breton's highest hopes from his Mexican sojourn.

Indeed, everything in that spring of 1939 seemed to chip one more hole in the spiri-

tual edifice that Breton had built with Trotsky and Rivera. In January, Frida Kahlo came to Paris for an exhibit of her work, which Breton had promised to organize, but became enraged over Breton's lack of initiative. "Until I came the paintings were still in the custom house, because the s. of a b. Breton didn't take the trouble to get them out," she angrily wrote a friend. To Kahlo's further dismay, Breton then surrounded her paintings with ex-votos and objects found in peasant flea markets—*"all this junk,"* as she described it. Moreover, Kahlo, who initially stayed with the Bretons, was annoyed at having to share a small bedroom with three-year-old Aube, and even more annoyed when she had to be taken to the hospital with a kidney inflammation—for which she blamed the living conditions at Rue Fontaine. "You don't have any idea of the dirt those people live in, and the kind of food they eat," she told a friend. "Its something incredible. I never seen anything like it before in my damn life." By the time Kahlo left Paris in late March, she was thoroughly disgusted with Breton and (with few exceptions) the "big cacas" of Surrealism. Breton, although he apparently left no untoward statements about Kahlo's visit—his preface to the Mexico exhibit was actually quite flattering to her—can only have felt that it had destroyed one more precious souvenir.

On June 2, with the FIARI all but extinct, Breton wrote Trotsky a letter that expressed his frustration over the problems he had encountered since his hopeful return the previous summer:

> I hardly need tell you that the break between you and Rivera has inflicted serious misfortunes on the FIARI's activity . . . Moreover, we have to recognize that a certain number of the memberships we were initially able to secure have remained, some rather platonic, others somewhat aloof . . . You know that nothing in the world could make me want to prove unequal to the task I took upon myself, with your consent, when I left Mexico. Perhaps I am not very talented as an organizer, but at the same time it seems to me that I have run up against enormous obstacles. I absolutely need your help in trying once more to overcome them.

Trotsky, however, had little help to offer at this point, and Breton's letter of June 2— the last known exchange between the two men—provides a dispirited postscript both to a brilliant philosophical conjunction and to the most gratifying experience Breton was to have for some time.

THE EXILE WITHIN

(June 1939 – May 1941)

BY THE SUMMER OF 1939, the Surrealist group bore little resemblance to any previous incarnation in its fifteen-year history. The movement now counted scarcely more than a dozen poets and artists, few of whom had known the "heroic period" of the mid-1920s. Gone were the days when the tables of the Cyrano or the Place Blanche hosted groups of forty or more. Gone, too, and for all time, were many of the figures who had helped determine the Surrealist state of mind: men such as Aragon, Artaud, Crevel, Desnos, Giacometti, Leiris, Prévert, Queneau, Soupault, Tzara, and now Dalí and Eluard—driven away in almost every instance by the conflict between their need to develop freely and Breton's will to maintain a Surrealist cohesion in his own fluctuating image. In their stead were Heine, Mabille, Matta, Pastoureau, Brauner, Georges Henein, the painters Esteban Francès and Gordon Onslow-Ford, and a few generally unexceptional newcomers. The only remaining veterans were Tanguy, the inconstant Masson, and the ever-faithful Péret, who after Eluard's departure assumed the role of Breton's closest confidant.

Hoping to escape the tensions created by the recent exits of Eluard and friends, Breton accepted an invitation from Onslow-Ford, Matta, and Francès to come to Chémillieu Castle, a sprawling manor near the Swiss border that Onslow-Ford had rented for the summer. The foursome was soon joined by Jacqueline and Aube; the self-effacing Ann Matta, whom her husband had nicknamed "Pajarito" (little bird); Tanguy, whose once wild hair had now receded far up his skull; and the wealthy American painter Kay Sage, at the time married to an Italian nobleman, who was now getting her first taste of Surrealist company.

During the day, while the painters painted, Breton strolled in the woods and read up on local history, enjoying the peaceful surroundings, hunting for insects, and looking at rocks. The group took day trips to local sites, including a return to the Facteur Cheval's "Ideal Palace"; and they visited, and were visited by, Gertrude Stein and Alice B. Toklas, who lived in nearby Bilignin. "There were birthdays with extravagant decorations of colored papers, huge drawings and flowers," said Onslow-Ford. "There were games of poker at which poems, pictures, and objects were gambled away as so much small change."

There was also a certain amount of tension in the air, owing both to the imminence of war and to personal friction between some of the vacationers. Jacqueline, struggling as ever to maintain a creative identity of her own, was clearly more impressed by Gertrude Stein than were the men (and no doubt vice versa). And Kay Sage spent her time feeling cowed by Breton, whom she regarded as a "terrorist," although she liked Tanguy enough to become his second wife the following year. Sage's satirical rendition of a dinner at Chémillieu gives some idea of the hidden discords among the castle residents that summer:

MATTA: "I saw a workman,"

BRETON: "Death is the only thing that matters in life"

MATTA: "Who was counting money,"

BRETON: "I don't understand what you saw"

MATTA: "A workman who was counting the money he'd earned"

FRANCÈS (*heavy Spanish accent*): "Hab you heard de one about,"

MATTA: "With the sweat of his own hands,"

BRETON: "I don't understand what you're saying"

TANGUY: "Fucking God"

AUBE (*mouth full of potatoes, waving her fork*): "FUCKING GOD!!"

MATTA: "I was very moved, in spite of myself"

FRANCÈS (*heavy Spanish accent*): "De one about de two men an' de cheesse"

BRETON: "That's anti-Surrealist"

PAJARITO: (*says something but no one listens*)

JACQUELINE: "Anyway, Gertrude Stein says what she thinks"

KAY: "And thinks what she says"

BRETON: "What you're saying is anti-Marxist"

FRANCÈS (*heavy Spanish accent*): "I'm telling you de two men an' de cheesse"

JACQUELINE: "What's she written, anyway? Have you read anything of hers?"

KAY: "Yes. She's written some very important things"

GORDON: "Personally, I feel entirely reborn when I hear a whistle"

KAY: "Gender. It's a bitch. It would be a bitch if it weren't a non-bitch"

AUBE (*waving her fork*): "BITCH!!"

TANGUY: "Fuck 'em all"

AUBE (*waving her knife*): "FUCK 'EM!!"

MATTA: "All the same, that workman" . . .

These discords were in no way Sage's fancy: by the end of July, Jacqueline had again run off by herself, this time heading to Antibes to see Picasso and his lover Dora Maar, who was a childhood friend of hers. She spent her time on the beach with Dora, away from the transplanted café chatter, and figured in at least one of Picasso's canvases from that time, *Night Fishing at Antibes*. Breton, meanwhile, took Aube to his parents' house in Lorient. On the 11th, he complained to Maurice Heine that he was "weighted down" by his daughter, "Jacqueline having proven unable to deny herself a trip to the Midi." The tone says much about the state of affairs between the two spouses.

In fact, although little information is available on this episode, it seems clear that Jacqueline was again feeling smothered by Breton's expectations of her. Witnesses have also hinted at the possibility of sexual problems between the two: one later pointed out that, although Breton was always interested in sexual matters from a theoretical standpoint, the man himself seemed "tired"; while Jacqueline had a sexually charged (and, perhaps, dissatisfied) air about her. Another recalls Breton and Jacqueline quarrelling in public, he "like a fishwife," she "odious" and making disparaging remarks about his masculinity.

While there is no evidence that Jacqueline was unfaithful to Breton with Picasso— though given her intense, lifelong veneration of him, and of the painter's taste for sleeping with his friends' wives, this is not out of the question—it appears that she was then conducting at least one affair, with Esteban Francès, begun shortly before the stay at Chémillieu and sporadically resumed in later years. Given Breton's physical distance during much of this period and his absorption in other matters, chances are he was as blind to this relationship as he had been to Simone's with Morise a decade earlier. What he no doubt found less easy to ignore, and what appears evident in hindsight, is that irreparable fissures were beginning to show in his marriage.

During that final month of uneasy European peace, Breton remained in Brittany, either with Aube or (after the girl had joined Jacqueline in the Midi) alone. As he had the year before, he visited Masson and Mabille. And he traveled to Nantes to meet a twenty-nine-year-old *lycée* teacher named Louis Poirier, who had just published his first novel, *The Castle of Argol*, under the pseudonym Julien Gracq. Despite his attitude toward novels, Breton had been impressed with *The Castle of Argol* and had written to Gracq soon after the book's publication. In August, the two men met for the first time, inaugurating a friendship and an intellectual complicity that would last the rest of Breton's life.

And then the war came, again finding Breton, as had the previous one twenty-five years earlier, at his parents' house in Lorient. Hitler and Stalin had signed the Nazi-Soviet nonagression pact on August 23, freeing Germany from concern over the Eastern

Front, and once more plunging the French Communist Party into tortured self-justifications (which, when war was declared, were used by the French government as a pretext for outlawing the Party altogether). Breton later told an interviewer that the signing of the pact and the various responses to it "made the situation [seem] even more inextricable, coloring reality—for the first time—in an atmosphere from Kafka's fictions." With nothing to block him, Hitler invaded Poland on September 1, putting an end to any illusions about peaceful coexistence that might have remained after Munich. French mobilization began the next day, followed on the 3rd by official declarations of war from France and England.

Called back into the service on the 2nd, Breton left to join the 22nd Section of the French army's Medical Corps in Nogent-sur-Marne, near Vincennes. It was there that he witnessed the other soldiers' reactions as the radio counted down the hours to the start of hostilities. "Impossible to recognize in those troops the emotion one would imagine such news would evoke," he later wrote. "At first it was only a vague cheerfulness, which increased as time passed. Only an hour left, five minutes. As the uproar mounted, the abundance of contortions suggested a school recess."

Within days of the declaration, Breton was sent from Nogent to the town of Sucy-en-Brie, as part of the 401st antiaircraft division, and finally, at month's end, to the Noisy fortress in Romainville, in Paris's northeastern suburbs. As Jacqueline and Aube were caught in the Midi, he arranged for them to stay temporarily with art dealer Marie Cuttoli at her villa in Antibes; thanking her, Breton wrote that she had allowed his wife and child to "enjoy, for a little while longer, beautiful horizons and perfectly sane, friendly words." As he could well predict, such pleasures would become increasingly scarce in the coming years.

The war between France and Germany nonetheless got off to a rather sluggish start. Throughout that fall and into the spring, soldiers on both sides squatted in their fortifications, staring at each other across the lines, sometimes even trading songs or jokes, and engaging in hardly more than a few skirmishes—so much so that this period has come to be known as the "phony war." Virgil Thomson later wrote that while the war was a tragedy for thousands of refugees, "to England and France, imperial powers both, it looked as if the Germans were just being naughty . . . [There was] a mood of general impatience with them, as of solid citizens toward delinquent youth."

Breton himself was finding life in the service to be strangely similar to his civilian existence. For one thing, his age, rank, veteran status, and the favor of the head doctor afforded him better food and privileges than he had enjoyed in 1915. For another, Romainville's proximity to Paris allowed for frequent leaves to the capital: during the

first weeks of the war, Second Lieutenant Breton might just as easily be found with his friends in the cafés of Saint-Germain-des-Prés as among the soldiers at the fortress. Several witnesses recall seeing him through the windows of the Deux-Magots or proudly stalking across the Saint-Germain square, incongruously girded once again in his medic's uniform. And every night, he returned to sleep at Rue Fontaine.

Breton's attitude at the outset of the war was an odd mix of scorn, discouragement, worry, and excitement. While some, such as Masson, wrote dispiritedly of "this ignoble agitation," Breton in those first weeks estimated that events were unfolding "in an exceptionally interesting way." It is not, of course, that he had developed a patriotic or militaristic streak: like Trotsky, he believed that under no circumstances should the capitalist regime be defended, not even against Hitler. Rather, he saw the current war fever as a pathological release from "the platitudes and constraints of civilian life" over the past two decades. And to Jacqueline, he admitted that he was keeping himself "as open as possible" to whatever might occur, "without worrying too much about preserving or safeguarding—at least in detail—my former attitudes." So it was that he had redonned his ill-fitting uniform in a riot of contradictory expectations and fears, tempering dismissal with curiosity, anticipation with withdrawal.

Uncertain how to confront the global situation, Breton instead focused his anxieties on the matter of his own publications. His personal experience of the "phony war" largely revolved around an exchange of letters with Gaston Gallimard, Jean Paulhan, and Sagittaire's Léon Pierre-Quint, in which he bemoaned the unavailability of his existing works and pushed two new projects that were especially close to his heart. These letters, particularly as discussions with his publishers dragged toward an indefinite conclusion, show an unusual desperation on Breton's part, finding him at times bargaining over his own writings with the persistence and accommodation of a rug merchant.

One project, which Breton had first proposed to Gallimard in the spring and which ultimately came to naught, was an omnibus edition of *Nadja*, *The Communicating Vessels*, and *Mad Love*. (Gallimard ultimately compromised by agreeing to reissue *Nadja* alone, although circumstances prevented him from doing even this until 1945.) The second proposal was for the ill-fated *Anthology of Black Humor*, which Robert Denoël had previously bought from Sagittaire, and which Breton now sought to move to Gallimard in response to Denoël's own delays. "It seems to me that this book would have a considerable *tonic* value," he told Jean Paulhan. The fact was, Denoël had completely stalled on the project—owing as much to Breton's production requirements as to his own financial setbacks—and was now more than willing to cede publication rights to his rival. Although Gallimard was at first interested, a series of complicated negotiations kept the

decision pending for months. Even Paulhan, who had initially championed the book in-house, eventually lost his enthusiasm.

Soon afterward, Breton's anger against the recalcitrant Gaston Gallimard burst out in a long letter, in which frustrations over the publisher's perpetual indecisiveness combined with various long-harbored complaints. "I feel quite strongly," he wrote, "that the fate of [*Anthology of Black Humor*] is severely compromised. Forgive me for thinking this, but it could have been otherwise if you were *more willing* to publish it and, in general, if you attached more importance to keeping me as one of your authors." Finally, in May, Gallimard announced that the anthology did not make financial sense, and turned it down once and for all. But by this time, Breton had placed it back with its original publisher, Editions du Sagittaire.

It is true that Breton, despite his lifelong disdain for the writer's "trade," had frequently shown a fair amount of anxiety over the sales, promotion, and availability of his books. But in late 1939 and early 1940, his concern over his trilogy and the as-yet-unpublished *Anthology* drew particular vehemence from several external factors. For one, Breton simply had more time on his hands than usual: retained as he was for much of the week in Romainville, his relatively light duties left him free to worry about the status of his written works. For another, and as always, Breton had severe financial worries, which he was hoping to alleviate with a new publisher's advance. In addition, he seems to have been caught between a desire to be heard at this critical time and a lack of any new works.

Finally, Breton's concern about his books no doubt sublimated much of his worry over the enforced separation from family and friends. Jacqueline and Aube were still far away in the Midi, and contact between the two spouses was infrequent—at least in part because of Jacqueline herself, and to such an extent that Breton begged his four-year-old daughter to make her mother write. Meanwhile, many of Breton's friends had been dispersed by the war. Matta had left for New York, as had Tanguy and Kay Sage. Others, such as the German nationals Max Ernst and Hans Bellmer, had been arrested as enemy aliens, and would spend the fall of 1939 imprisoned in a former brick factory near Aix-en-Provence. Péret had been drafted, and was now guarding storage depots on Ile de la Grande-Jatte. And Artaud would sit out the entire war in the asylum, convinced that Hitler (to whom he wrote regularly) had started it all to save him from the psychiatrists. For Breton, it was no doubt easier to worry about the manageable anxieties of his publications than to ponder the tragedies befalling his loved ones.[*]

[*] Not every Surrealist seems to have been hard done by the war: Aragon, who in *Treatise on Style* had declared, "Never again will I wear the French uniform," and who during the last war had made a point of

At the beginning of January 1940, Breton was transferred to the city of Poitiers, where he was named head physician at the army flight-training school. There he performed his morning rounds "as best he could, but a little as if in a dream," disconsolately exploring the provincial French city or the flat terrain of the airfield when not on call. He also struck up a friendship with a nineteen-year-old literature student named Maud Bonneaud, whom he met in a Poitiers hotel during a blackout. Charmed by the young woman, Breton spent much of his free time with her in "daily and passionate conversations." (Maud herself was awed by Breton, though she did find the medic's uniform a trifle ridiculous on him.) And he watched the progress of the *Anthology of Black Humor*, which Léon Pierre-Quint sent to the printer—at long last—in May.

The location of Poitiers also permitted occasional visits to Jacqueline and Aube, who were now staying some one hundred miles away in the Atlantic coastal town of Royan, either with Picasso and Dora Maar or at an inexpensive hotel. Breton spent his few leaves with his family by the sea and renewed contact with Picasso, who was proving to be his savior at the time: not only did the painter temporarily shelter Breton's wife and daughter, but, seeing that Breton desperately needed money, he donated one of his works for sale. "I have to tell you how happy I was to spend time with you, how all things considered it gave me back my taste for life," Breton wrote shortly afterward. "And thank you, THANK YOU again, for having offered your help so spontaneously, in the most seductive way possible."

Throughout the spring of 1940, as Germany invaded country after country and the war began in earnest, a sense of darkening began to pervade France. The Germans clearly had the advantage over the outnumbered, ill equipped, poorly trained French, and the fall of Denmark, Norway, Holland, and Belgium in the space of one month left little hope for a rapid Allied victory. Adding to the desolation were the widely heard German propaganda broadcasts of fabulous statements about Hitler—which the French public seemed only too willing to believe. Breton later recalled that a particular psychosis in those months led his countrymen to ascribe supernatural powers to the Führer, or to comb through the *Centuries* of Nostradamus for predictions about the current war.

Breton himself, meanwhile, was subject to black depression. "It's useless to try to outlast one's time," he wrote the Belgian Surrealist Raoul Ubac, reflecting on the demise of various Surrealist groups throughout Europe. He worried over the fate of Péret, who

not saluting officers, now strutted through Paris in the outfit of a military doctor. "When someone appeared not to see him, he stopped the man and reminded him to salute properly," Lise Deharme wrote in her diary in December. "The other obeyed every time."

had been sent to Rennes prison for making defeatist statements and organizing a Trotskyist cell. And he mourned the loss of a friend, Sade scholar and Surrealist mainstay Maurice Heine, who had died in Paris. A rare moment of relief came in early May, when he was briefly able to join Jacqueline and Aube at Rue Fontaine, to which they had recently returned.

And even the promise of these rare visits ended in June, when the French government collapsed and the Germans entered the capital. Almost immediately, a heavily guarded demarcation line cut over half of France off from the unoccupied south-central provinces. Germany had control of Paris and the industrial North, of every frontier except part of the Spanish border, and of every major seaport except Marseille. Passage between zones was regulated as carefully as through any international checkpoint, and communications had to be sent on special "interzone cards," preprinted multiple-choice postcards that allowed senders to transmit only standardized messages about food, health ("in good health / tired / slightly ill, seriously ill, wounded / dead"), and hopes of emigration.

As soon as the Occupation began, the disbanded Third Republic was replaced by the new "French State," whose seat was established in Vichy, just outside the Occupied Zone—for, ostensibly, France was still self-governed. Eighty-four-year-old army marshal Henri Philippe Pétain, a former war hero whose support had hitherto come mainly from veterans and the far right, was named France's prime minister, giving a grandfatherly countenance to the national defeat (rebaptized the "National Revolution"). And indeed, the stance taken by the Vichy government seemed tailor-made to comfort a bewildered and infantilized public: it proclaimed the goodness of the French soil and of the traditional values, while indicting intellectualism and large, cosmopolitan cities ("repositories of vice") as the root of the nation's downfall. That same month, even as the little-known general Charles de Gaulle broadcast his resistance appeals from London (which few in France heard), Pétain went on radio to announce an armistice with Germany. The treaty was concluded on June 22, and on the 25th the French laid down their arms. In October, Pétain would meet Hitler in the Occupied Zone and officially "enter the path of collaboration."

On June 21, the day before the armistice was signed, the flight-training school in Poitiers was evacuated and Breton sent to another flight school in Loupiac, near Bordeaux. There, while the army tried to handle the chaotic final days of war, he took a room above a bakery and waited out his last moments in uniform. To Maud Bonneaud he complained of the mass confusion, which had kept him without news of Jacqueline and Aube for two weeks. Nevertheless, his comments about France's defeat mirror his

attitudes during the early days of the war, rather than the more widespread despair. While the nation wept around him, Breton described the downfall of the Third Republic with cautious optimism: "I believe that a rather interesting time could be starting, on condition, of course, that one can live through it. It might be the monstrous infancy of something, or only another vulgar disguise."*

At the same time, Breton was fully aware how perilous the Nazi presence could be, even in the comparatively safe "Free France" of the Unoccupied Zone. Reflecting on this period years later, he balanced his sense of opportunity with a recognition of the dangers that threatened him and his friends. "It seemed to me that what was most incumbent upon intellectuals at that time was not to let this purely military defeat—which was in no way the intellectuals' doing— turn into a debacle of the mind," he said, adding that the situation at this time "was extremely somber . . . Certain courtesans of the new regime, moreover, even went so far as to accuse Surrealism in the press of having had a hand in the military defeat. The immediate prospects were quite alarming."

And indeed, many Surrealists had fled the German advance—Mabille, Brauner, Dominguez, and the painter Jacques Hérold had abandoned Paris, while Masson and Miró had left their homes in Normandy—heading for the Unoccupied Zone or, when possible, out of France altogether. Ever contrary, Péret, whom the Germans had released from prison after the armistice, returned to Paris at this time, and for a while went around mouthing pro-German sentiments—until, as André Thirion said, he finally "understood the situation." (Another who took a while to understand the situation was Eluard, who at the time was still finding the Germans "handsome as gods.")

During the autumn of 1940, intellectual life in France took a disturbing turn. In September, the German ambassador Otto Abetz published the "Liste Otto," proscribing the publication or sale of works by or about Jews, Communists, anti-fascists, or anyone else who had "poisoned French public opinion" against the German occupier. *La Nouvelle Revue Française*, as the country's leading literary tastemaker, was forced to adopt new guidelines, and Paulhan, its *éminence grise* for nearly a decade, saw his editorship handed over to Pierre Drieu la Rochelle, Aragon's former friend and now and outspoken Nazi sympathizer. *L'Humanité*, which had begun appearing clandestinely as of

* Breton's attitude can be likened to that of Rimbaud after France capitulated to Germany at the end of the Franco-Prussian War. Various factions, refusing to abide by the terms of the surrender brokered by President of the Republic Adolphe Thiers, instead formed an oppositional body, the Paris Commune, that briefly provided an alternative, labor-oriented form of government in the spring of 1871. Although the Commune was brutally suppressed by Thiers's army after only two months, its largely Socialist policies— which won the admiration of both Marx and the anarchist Mikhail Bakunin, in addition to Rimbaud—were no doubt the sort of development whose "monstrous infancy" Breton was now positing.

July, upheld the Nazi-Soviet pact by encouraging fraternization between Parisian workers and German soldiers. And Drieu's ex-partner Emmanuel Berl, a Jew, began writing speeches for Marshal Pétain.

From Breton's viewpoint, perhaps the most telling statement of all was the nonpublication of *Anthology of Black Humor*. After years of delays, the book had finally come off press on June 10, the day the government fled Paris and occupation became inevitable: a date, as many have pointed out, that did honor to its subject. Léon Pierre-Quint duly submitted the anthology to the censorship board for the obligatory publication visa (another German contribution to French culture), and over the ensuing months Breton waited with naïve optimism for its release. But in February 1941, the work would be denied a visa on the grounds that Breton represented "the negation of the spirit of the National Revolution" (the book appeared only after the war). It was further proof, if proof was needed, that the France Breton had freely scandalized for two decades was no more.

Breton was discharged at the beginning of July, finding himself without resources, mere miles from the Occupied Zone. Worried that "the climate in Paris" was "extremely unhealthy" for him, he instead sought shelter in Salon-de-Provence, near Marseille, at the home of his friend and doctor, Pierre Mabille. Jacqueline and Aube managed to join him there, and the Bretons and the Mabilles began planning ways of getting out of the country. To Kurt Seligmann, who had moved to New York the previous year, he wrote: "We have come to the conclusion that our place is currently where you yourself are, and where circumstances have willed that the greatest effervescence of ideas should be taking place." But the emigration process was long and complicated, and Breton could only wait. Meanwhile, he worked on a new poem called "Full Margin," or sat at the café with Mabille, poring (despite his later mockery) through the *Centuries* of Nostradamus, whose grave was, moreover, located in that same town.

At the end of the month, the two families moved from Salon-de-Provence to nearby Martigues, on the mouth of the Rhône, where they took an abandoned fisherman's cabin on the beach. There, "in a beekeeper's mask," as he told Victor Brauner, Breton organized "superb praying mantis fights." There, too, he finished writing "Full Margin," which he sent first to Jean Paulhan, then (the *NRF* being unable to publish it) to *Cahiers du Sud*, assuring editor Jean Ballard that readers would be glad to hear from him after a full year of silence. The poem, which Ballard placed in the magazine's November issue, celebrated Breton's intellectual guides (Hegel, Pelagius, Meister Eckhart, Novalis,

Marat) as antidotes to the current situation; his spiritual withdrawal from these bleak times; and his feelings for Jacqueline, "that Queen of Byzantium whose eyes so surpassed ultramarine / That I can never go to Les Halles where she appeared to me / Without her being endlessly multiplied in the mirrored barrows of the violet merchants."

It was also in Martigues that Breton learned of Trotsky's assassination. Following his rift with Diego Rivera, Trotsky had left the Blue House in Coyoacán, and in the ensuing months had seen his Mexican cadre dwindle to several bodyguards and some loyal aides. Eventually, Rivera and Kahlo would even join the Soviet camp, and Trotsky's former bedroom in Kahlo's house now contains a small bust of Stalin—left there "as a turd," said Heijenoort. Seeing Trotsky's defenses lowered, an assassination squad led by the Mexican painter David Alfaro Siqueiros had made one attempt on his life in May, managing only to kill one of his bodyguards. Several days later, a young Belgian who called himself "Jacson Mornard" (actually an OGPU agent named Ramon Mercader) had infiltrated Trotsky's household by seducing one of his American aides. By August, Mornard had gained the Old Man's confidence, and on the afternoon of the 20th, while alone with the Russian in his study, he had fractured his skull with a pickaxe. Trotsky had lived until the following evening.

"It was early in the morning," Jacqueline later recalled. "The newspaper had just arrived. On the first page, of course, was TROTSKY ASSASSINATED. We couldn't believe it. It was unthinkable. And yet, there was the newspaper. It was absurd of us not to accept the obvious, but we simply couldn't. André was sobbing. He kept repeating: 'The bastards, they finally got him!'" Breton himself made little reference to the murder in his subsequent writings, simply confiding long afterward that the news had struck him "as a horrible blow of fate." For his crime, Mornard received twenty years in a Mexican prison and, upon his release, the Lenin Prize from Nikita Khrushchev.

That fall, Breton intensified his efforts to leave France. "As far as Mabille and I are concerned, we think about nothing else," he told Victor Brauner. He stepped up his correspondence with Kurt Seligmann and Tanguy, who were working energetically on his behalf in New York. And he encouraged those of his friends still in France, such as Brauner and Masson, to do the same.

In September, Tanguy sent Breton and Mabille an official invitation to lecture in Mexico for a year, while Kay Sage offered to help pay their way; but in the wake of Trotsky's murder, Breton was no longer so sanguine about "the Surrealist place par excellence." Seligmann, meanwhile, arranged with Alfred Barr of the Museum of Modern Art to have Breton do a round of lectures in New York. Mabille went to the emigration office in Vichy to renew his and the Bretons' passports and to obtain exit

visas. But he was unsuccessful in getting a visa for Breton, and at the end of the month he left France for a surgeon's post in Guadeloupe. In New York, Tanguy also spent October trying to get Breton a transit visa, encountering similar difficulties on the American side. "We hope to go to New York," Breton wrote Péret on an interzone card, "but not certain."

And yet Breton was not very enthusiastic about going to America, either. As he told Maud Bonneaud: "America has become necessary . . . only in the most negative sense: I don't like exile and I have my doubts about exiles." The reality of the situation was that Breton simply saw no other way out. Attacks in the collaborationist press made France seem increasingly dangerous, leaving him and Jacqueline "rather unpleasantly suspended between New York and Paris . . . and to tell the truth, without much hope." Realizing that the situation could only get worse, Breton left Martigues and headed with his family to Marseille.

For centuries the crossroads of the Mediterranean, Marseille had always been a swarming hive of transients, black marketeers, and marginals of every stripe. But with its new status as France's one remaining free port, the city became especially chaotic in the fall of 1940, as waves of fugitives poured into it in hopes of getting out. The resident population of 650,000 swelled with the influx of refugees, who crowded the hotels (when a room could be had) with what one historian called "a motley and frequently desperate mass of flotsam and jetsam." Among this mass were the Bretons, who spent their first days in the city "precariously lodged," and who might well have been lost in the crush had they not come under the wing of the relief agency known as the Emergency Rescue Committee.

The Committee had been founded the previous winter in New York, spearheaded by Eleanor Roosevelt and a group of American liberals concerned about the fate of Europe's intellectuals. A young Columbia University professor named Varian Fry had been dispatched to France on its behalf. Idealistic and untutored, Fry had anticipated a warm welcome from both the French government and the American consulate in Marseille, but he was soon disabused: not only did the Vichy government actively obstruct the Committee's efforts to obtain papers for refugees, particularly those wanted by the Gestapo, but the American consul supported Vichy. Finding himself plunged into a human drama far beyond anyone's expectations, Fry extended his three-week reconnaissance trip into a harrowing thirteen-month adventure.

Even without Vichy resistance, leaving France was a complicated affair. In order to get an exit visa, one first needed affidavits of support and sponsorship from respondents in the host country, along with an entry visa from that country's government (no small

feat if the destination was America). In addition, transit visas had to be obtained for every stop en route; and the boats out were so few and seldom that even if one managed to obtain all the appropriate visas, by the time transportation could be booked one of them had expired, or one's money had run out, or both. But despite the red tape, not to mention French police harassment and American embassy pressure, Fry—aided by a small but dedicated cadre of Frenchmen, Germans, and Americans, as well as the sympathetic support of vice-consul Hiram Bingham in France and Department of Labor Secretary Frances Perkins in Washington—managed to help over a thousand refugees to safety. Among these were Marc Chagall, Victor Serge, the novelists Arthur Koestler, Leonard Frank, and Alfred Polgar, the reporter Egon-Erwin Kisch, the economist Heinrich Ehrmann, and the Nobel physicist Otto Meyerhoff, as well as Masson, Ernst, Péret, and Breton.

At first, Fry worked out of his small hotel room, interviewing applicants while dozens of others lined the hallways. Then, in the fall, Miriam Davenport and Mary Jayne Gold, two American Committee members, rented a large nineteenth-century villa on the outskirts of Marseille. Located at 63 Avenue Jean-Lombard, the Villa Air-Bel boasted eighteen furnished rooms and a huge terrace that led to a large wooded park, with a formal garden, a greenhouse, and a fishpond. Realizing that the house was much too large for the two of them, they invited several other Committee workers, including Fry and his French aide, Daniel Bénédite, to share the lodgings. With several rooms still unoccupied, they decided to house select refugees waiting for their visas. Their earliest guests were Victor Serge and, soon afterward, André Breton and family.

The Villa Air-Bel was owned by an elderly, fastidious, and phenomenally stingy doctor named Thumin, who lived next door with his sister. He "would keep watch outside even when it was very cold for fear that someone might help himself to a dead branch," Breton later said. Inside, the house was filled with gloomy Second Empire furniture and crowded with mediocre, heavily varnished landscapes. The walls still held the original wallpaper, which depicted faded mythological scenes, and the library contained first editions by Buffon and Saint-Simon. The parlor had inlaid-wood floors, a piano, and a huge marble mantelpiece. Although Dr. Thumin, who "judged everything by the standards of 1870," felt he had taken advantage of his tenants, the actual rent was only 1,300 francs per month (about one-third the going rate for a hotel room), which allowed the residents of Air-Bel to hire a cook named Madame Nouguet, an alcoholic cleaning woman called Rose, and a Spanish nanny to look after Bénédite's young son. Breton and Jacqueline moved into the master bedroom on the second floor, while Serge and his companion, Laurette Séjourné, took the other.

Victor Serge, now fifty years old, was the political star of Air-Bel. His fine features, wiry hair, steel-rimmed spectacles, and soft-spoken but dour demeanor were reminiscent "of a well-bred English clergyman," said Bénédite, who called Serge the group's "conscience." One of Trotsky's earliest allies, Serge knew that Breton had campaigned for his release from a Soviet prison camp in the mid-1930s and that he had spoken out against the Moscow Trials—in theory, all grounds for a good mutual understanding. But Serge had fought and suffered for the revolution, and he could not help feeling some contempt for men such as Breton, whom he considered café activists. Moreover, his novels and political essays were written in, as Mary Jayne Gold said, "a sensitive, realistic style that to André was meaningless, and he was intolerant of what he considered to be André's flirtation with the Beyond." Although both men sought to avoid conflict, their contact at Air-Bel occasionally produced some friction.

These moments of tension aside, Breton immediately took to life at the villa. He was delighted by the superannuated decor, particularly the wallpaper, and spent many hours exploring the library. He maintained good relations with most of his housemates, Fry in particular, and seems to have done his portion of the household chores with good grace, chopping firewood or raking the porch when it was his turn. He even suffered with patience the obligatory visits to Dr. Thumin next door, who savored Breton's Old World manners and who loved to show off the vast collection of stuffed fauna he kept in his study. Bénédite long remembered enduring shelf upon shelf of "pitiful birds with their dusty, moth-eaten feathers," while the doctor endlessly detailed his taxidermal skills to Breton's wilting exclamations of "Stupefying! Extraordinary!"

At times, Breton was even the villa's hero. On one evening, the housekeeper, Rose, fell down a flight of stairs in a drunken stupor and lay howling with pain in a puddle of vomit. Without hesitation, Breton gathered the woman in his arms and carried her upstairs, returning half an hour later to reassure the others that she would suffer no worse than a hangover and some bruises. Asked how he'd managed to touch such a revolting creature, Breton responded that he was, after all, a doctor. The others looked at him admiringly, and perhaps none more so than the maternal Madame Nouguet, whom Breton had "positively captivated."

Very quickly, the Bretons became the magnetic core of the Marseille band. Gold described Breton as "always the most important person in the room . . . He wasn't a show-off. He was a fascinating man, not the least bit snobbish or superior." One of Gold's favorite memories of Breton was seeing him with Fry's poodle pup, Clovis. "André was bowing and nodding at the little creature, addressing him with his special brand of dog-talk," as the dog yipped shrilly back at him. Of Jacqueline, Gold recalled a "vivacious

and provocative" woman who "wore flowers and bits of colored mirror in her hair, a necklace of tiger claws about her neck. Her clothes moved with a special swish. They were chic, eccentric for the time, and nipped in around a tiny waist." And Bénédite recalled Aube as, "in smaller size and female form, the spit and image of her father; bright and very proud." When not going to the local school, the little girl spent much of her time drawing—Fry recalled that she "was already hailed by the Surrealists as a promising artist" (which she in fact became)—and picking up a Marseille accent.

If Victor Serge was the villa's "conscience," Breton was its "group leader." From almost his first moments at Air-Bel, he began organizing evening activities, cobbling together a kind of surrogate roundtable in exile. He directed sessions of Exquisite Corpse and led discussions on sexuality, sometimes to the mortification of the uninitiated. There was also a game called Who Would You Most Like to See Dead? (the winner was invariably Stalin). Under the circumstances, these constant rounds of Exquisite Corpse and Truth or Consequences might seem unconscionably frivolous, but for Breton they were a way of not succumbing to the horror around him. One later Surrealist described such activities as "an effective measure against the temptation to sink into despair. It was not a matter of trying to deny the gravity of the situation. It was a matter of preserving, at any cost, sufficient freedom of mind with respect to it."

When not leading games, Breton would read aloud from his own works, or from the letters he received from Péret, Masson, and Duchamp, who were hoping to join him at the villa. Or he would pass around the contents of his suitcase, containing what Bénédite called "his treasures": rare issues of *Minotaure* and *SASDLR*; copies of *Nadja*, the *Manifestoes*, and *The Communicating Vessels*. On other evenings, Serge would recite from his novel-in-progress, *The Case of Comrade Tulayev*, or the residents would discuss the world situation, analyzing the little available information while Breton "with a slow shake of his great head would qualify the whole Vichy tragicomedy as 'cretinizing.'" Often, too, Breton would talk about Surrealism's past, with equanimity for all except the one he called "*Mister* Aragon." Mary Jayne Gold recalled in these mentions "a great bitterness, a great disappointment, like someone betrayed in love."

On Sundays, Breton staged more orthodox Surrealist gatherings, receiving visits that winter from his friends Victor Brauner and Jacques Hérold; Oscar Dominguez, "with his sad hound's face and thick Spanish accent," who was living in a nearby villa with a rich and elderly French mistress; René Char, who would soon become an officer in the Resistance; and even Tristan Tzara, who was himself trying to leave the country. There was also the painter Wifredo Lam, one of Picasso's rare students, who joined Surrealism at this time. And there was André Masson, who drew several portraits of Breton, his fea-

tures sculpted as if from a block of crystal. Adopting a local café called Le Brûleur des Loups as their headquarters, the group, an excited Breton at the helm, re-created the old atmosphere of discussion and creation, organizing exhibits and auctions of the artists' works and debating world events.

Otherwise, Breton corresponded with friends and awaited the results of Tanguy's and Seligmann's visa applications in New York. On November 9, Kay Sage wrote that the art dealer Pierre Matisse had signed an affidavit of support for the Bretons and that the American artist David Hare was willing to sponsor them. Meanwhile, Breton tried to help some of his friends get out. One of these was Tzara, who petitioned Breton to plead his case with the Emergency Rescue Committee; but although Breton urged Fry to help, the Committee was unable to arrange a visa for the ex-Dadaist. (After the war, Tzara would harshly criticize Breton for having left France, as opposed to those like himself who "had known a very particular aspect of the struggle.")

Breton also spent time collecting insects, and one evening brought a bottle full of live praying mantises to the dinner table as a centerpiece. Gold also remembers him staring one afternoon while a praying mantis slowly devoured another's neck. "'You see, they are making love, and she is eating her mate,' he explained with an odd satisfaction."

And he passed a good portion of that winter in Dr. Thumin's greenhouse, which was warmer than the ill-heated villa and which afforded enough peace and quiet for him to write. Bénédite remembered Breton in the greenhouse that December, "pacing back and forth, from time to time interrupting his comings and goings to jot down several lines" in a small notebook. These lines belonged to what would be Breton's longest and most ambitious poem from the period, an epic work called *Fata Morgana*. Discussing it several months later, he told the American poet Charles Henri Ford that the poem "states my resistance, which is more intransigent than ever, to the masochistic enterprises in France that tended to restrict poetic freedom or to immolate it on the same altar as other freedoms."

While this resistance might hold true for Breton's state of mind, one would be hard pressed to call *Fata Morgana* a "protest" work in the usual sense. Rather, the poem—much like the Surrealist games Breton was practicing at the same time—resists the surrounding realities of war and defeat by reaching beyond them, toward a universe governed by love and marvels, in a poetic refashioning of Vaché's "desertion within oneself." The many passing references to Breton's actual circumstances wash up like flotsam on a shore, fragments of external reality carried on a sea of oneiric fancy. These fragments include Breton's recollections of his Mexican sojourn, memories of absent friends and earlier readings, the daily concerns of life at Air-Bel, and his fears as a refugee. Mostly, however, *Fata*

Morgana is a reaffirmation of life—wistful though it may be—in the face of this "play without intermissions," and of Breton's love for his wife, to whom the work is dedicated. It is the alternation between this exalted stream of desire and the shards of daily reality that gives *Fata Morgana* its seductive power, as if the reader were constantly drifting in and out of consciousness.

But as one might expect, all the poems, games, and activities could keep reality at bay only imperfectly, and life at Air-Bel, alongside its diversions, entailed a fair number of hardships and frustrations. Along with tension of waiting for a visa and fearing for the future, by January 1941 the weather had turned unusually cold, bringing razor-sharp winds and heavy snowfalls, something that hadn't been seen in Marseille in many years. Fuel allotments were grossly insufficient. Much of the firewood had been squandered during the fall—often for the simple "pleasure of watching the flames dance"—and many times the villa went unheated through the subfreezing nights. Nor was food any more plentiful. As Bénédite described it: "Saccharin took over for sugar and real coffee was replaced by 'national coffee,' made from acorns. We ate the tops of carrots and turnips in place of spinach. Spelt substituted for rice and vetch supplanted lentils." In *Fata Morgana*, Breton speaks of the pages of a book "changing into black bread."

In addition, Breton was continually reminded of the precariousness of his situation. That November, he was sought out by an interviewer from *Le Figaro*, who was writing about Parisian writers in the Unoccupied Zone. Breton told the journalist about *Fata Morgana*, which, "to show just how sympathetic I am to the Marshal's racist concepts," he was going to have illustrated by Wifredo Lam—an exotic racial mix of Chinese and Cuban black. But to Breton's fury, the newspaper deleted these comments from its profile, and his angry letters to it in the following weeks went unanswered. "I refuse to stay in such a country!" he fumed to Fry, pressing the American to get him a visa for "anywhere at all." Several months later, the Vichy government responded by denying *Fata Morgana* a publication visa "until the definitive conclusion of the peace." Léon Pierre-Quint, who wanted to publish the poem, was able to print only five proof copies for the author's personal use, which came off press—Lam illustrations and all—on March 10.

Perhaps no single incident better highlighted Breton's circumstances than Marshal Pétain's state visit to Marseille on December 4, 1940. By the beginning of the month, the city was covered with posters blaring the new regime's slogan of "Labor-Family-Homeland" (replacing the Republic's famous triad, "Liberty-Equality-Fraternity"). The majority of Marseillais went around in a frenzy of anticipation, while a benign and magnified Marshal gazed down from countless banners and portraits. Given the pres-

ence of so many "undesirable aliens" in the city, security measures were taken to unprece-
dented lengths.

On Tuesday, December 3, the day before Pétain's visit, several plainclothesmen
arrived at Air-Bel and unceremoniously herded its occupants into the dining room.
While the boarders were held under guard, inspectors ran throughout the house, rifling
through chests of drawers and emptying closets. Fry stood stiffly in a corner, barely able
to contain his rage; Serge, more accustomed to police searches, nonchalantly leafed
through a magazine; and Breton paced back and forth muttering, "This is unbelievable!
grotesque! insane!"

The inspectors seemed particularly interested in a suitcase Jacqueline had received
from her sister the day before: as Air-Bel was located next to a train overpass on Pétain's
route into the city, a suitcase seemed the perfect container for a bomb. Jacqueline protest-
ed that the valise in fact contained her sister's clothes, but she was forced to go upstairs
with a young policemen to make a thorough search of her room; Breton trailed behind
them, still muttering, "Unbelievable." The suitcase indeed held only clothing, but the
policeman had had more luck when he opened Breton's bureau drawer to find an
unloaded pistol. "That's my service revolver; I was a medical officer in the French Army,"
Breton coldly informed him. The pistol was duly confiscated.

After interrogations, the entire household, except for the servants and Jacqueline (as
a mother), were put in a paddy wagon and taken to the station house, where they under-
went further questioning. Breton, as Gold recalled, was "singled out and given a more
thorough interrogation" than the others. "I could see him seated in one corner, answer-
ing, explaining something with what appeared to be great patience to a pesky little man.
When the interrogation was over, another detective came over and asked his colleague,
'What's so special about that big guy? Is he really a Communist?' 'No,' answered the
other disdainfully, 'a parlor anarchist.' When Breton asked me a few moments later what
the man had said, I repeated the insulting epithet. He just shrugged his shoulders."

As the police had arrested some 20,000 in anticipation of Pétain's visit, the city jails
and army barracks were overflowing with detainees. Out of room, the authorities had
commandeered several passenger ships docked in Marseille harbor, and it was into one
of them, the SS *Sinaïa*, that the Air-Bel residents were thrown—the same ship, to Fry's
consternation and Breton's amusement, in which Fry had earlier crossed the Atlantic.
Breton and Fry were put with nearly six hundred other men into the hold, where the
American encountered (to the refugees' worried bemusement) many of those he was try-
ing to help. Breton slept that first night on one of the filthy straw mats provided for the
prisoners, and the next day was designated the Air-Bel group's representative, his main

duty being to bring his unit's meager rations from the ship's galley at mealtimes. That same afternoon, the day of Pétain's visit, all the prisoners were locked below, while the Marshal's cortege passed proudly by the docks to the cheers of a carefully screened public. Finally, after four days under guard, the detainees were released and sent home.

Following the arrest, Breton's anxiety about remaining in France increased. By February he had obtained nearly all the documents necessary to leave the country: visas for both Mexico (where he might still go, depending on what ship they were able to take) and the United States, and an exit visa for Jacqueline; but he still needed an exit visa for himself. "Only one or two more months of patience," he told Pierre-Quint. "I'll hold out." Finally, in early March, the Committee managed to obtain exit visas for both Breton and Victor Serge.

Breton spent his remaining weeks in France rediscovering the greenhouse and watching as the winter slowly softened into spring. He also welcomed friends back to the villa. Shortly before, Péret had come to live in Marseille with his lover, the Catalan painter Remedios Varo, making him an almost constant presence at Air-Bel. In February and March, the previous year's visitors were joined by Duchamp, who had come to Marseille to await his own American visa; Max Ernst and Hans Bellmer, who had finally been released from prison; the playwright Arthur Adamov; and Breton's one-time crush Consuelo de Saint-Exupéry, "lively, playful, bouncy and warbling like a tropical bird." The villa also welcomed Marc Chagall and the sculptor Jacques Lipchitz, both en route to America (Chagall only after he'd been reassured that they did indeed have cows across the sea). The group organized an art exhibit on the villa's lawn, with paintings and sculptures hanging from the trees, and Péret led them all in singing songs from Jarry's *Ubu Roi*.

Perhaps the best-known result of Breton's last months at Air-Bel was the "Marseille deck," a set of thirty-two tarot cards entirely reimagined by the Surrealists to reflect their own mythology and preoccupations. Breton had previously researched the origins and history of the traditional Marseille deck in the public library, and was particularly interested to note that, according to historians, "the modifications [playing cards have] undergone over the centuries have always been linked with great military setbacks." Retaining the traditional game structure, the Surrealists replaced the four existing suits with Love (represented by a flame), Dream (a dark star), Revolution (a bloody wheel), and Knowledge (a keyhole). The face cards featured the Genius, the Siren, and the Magus in place of the King, Queen, and Jack; and were represented by various privileged figures in Surrealism: the Portuguese Nun (from a seventeenth-century libertine novel) as the Siren of Love, Freud as the Magus of Dream, Sade as the Genius of Revolution, etc. The result

is a strikingly colorful and fanciful response to five months spent in exile. Breton later said that for him the deck's main interest lay in "the *unity* of aspiration" that it demonstrated in Surrealism.

On March 25, Breton and his family boarded a creaking freighter named the SS *Capitaine Paul Lemerle*, which Serge described as "a can of sardines with a cigarette butt stuck on it." Helmeted armed guards stood along Quai de la Joliette, keeping the travelers from their loved ones, cutting short the farewells with curses and shoves.

The Bretons were headed for Martinique, and ultimately New York, holding tickets bought by Peggy Guggenheim. Among the three hundred passengers also on board were Victor Serge with Laurette and his son, Vlady, Wifredo Lam, and the novelist Anna Seghers. André Masson would embark one week later, also bound for Martinique. Max Ernst and Péret remained in Marseille a little longer: Ernst would join Breton in New York within the month, while Péret would leave for Mexico in December. In the meantime, the two veteran Surrealists tried to lead the Sunday gatherings in Breton's stead, but, as Fry said later, everyone "seemed lost without their leader, and, after a few awkward hours, they went away again."[*]

Breton's departure from France in 1941 has become one of the most controversial acts of his life. While many of his former friends stayed behind to suffer under the Occupation or to fight (and sometimes die) for its end, he was seen by many as having fled to the safe harbor of a distant—and, for the moment, neutral—land. Georges Hugnet expressed a typical sentiment when he later wrote that Breton had "dishonored Surrealism." But from Breton's viewpoint, there was little choice. He had never been a warrior by temperament and, at the age of forty-five, with a wife and young daughter in his care, he saw little advantage in staying in an increasingly hostile France, waiting for almost certain arrest and deportation, without even the opportunity to protest the tide of events in any public way. It is also true that the idea of detention filled him with dread: as he had confessed to Simone nearly fifteen years before, "I'm afraid of prison. In prison I would die." Instead, Breton opted for a place that, whatever inconveniences it might

[*] In any case, the adventure of the Emergency Rescue Committee was coming to a close. In August, Fry was expelled from France as an "undesirable alien" and returned to the United States. The Committee continued its efforts under Bénédite until June 1942, when the government finally shut it down. Back in America, Fry was sharply criticized for the work he had done abroad, and suffered personal and professional collapse: his ten-year marriage ended in divorce, and his attempts to help refugees and alert Americans to the reality of the German concentration camps went largely unheeded. In 1945 he published an account of his experiences called *Surrender on Demand*, which in the 1950s earned him attacks from Joseph McCarthy. His efforts on behalf of Europe's resisters were finally honored in 1967 by the French Consulate in New York, a mere several months before his death.

present, nonetheless allowed him to do the one thing he treasured most: speak his mind, with at least relative freedom. The decision was not made easily, and even as he had campaigned for it, Breton had been debating the wisdom of leaving France in this time of uncertainty. Several months earlier, in the most baldly declarative passage of *Fata Morgana*, he had expressed his doubts and fears over which direction to take:

> What *happens*
> Is of the utmost importance to us perhaps we should return
> Have the courage to ring
> Who says we would not be welcomed with open arms
> But nothing is verified all are afraid of ourselves
> Are almost also afraid . . .

After putting in at Oran and Casablanca, the *Capitaine Paul Lemerle* slowly made its way along the African coast to Dakar, finally heading out toward Martinique. A few passengers were offered the two available cabins, leaving the vast majority of the German, Austrian, Czech, Spanish, and French refugees to squeeze into makeshift dormitories in the ship's small hold, which had no ventilation and whose beds consisted of rough planks and straw pallets. There were two toilets on the bridge—reeking, airless cubicles—and the one shower worked on mornings only, if at all. Food was extremely scarce, but after a few days, when the starving passengers learned that the several heads of cattle roaming the bridge had been bought specifically to feed them, they forced the captain to slaughter his intended profits. Even then, as Breton said, the food never rose above "an extremely unappetizing pittance," although one morning the butchered animals did offer him "the successive apparition" of "three objects combining their flame: a skinned ox, left hanging from the day before; the flags at ship's aft; the rising sun. Their somewhat hermetic assembly, in April 1941, seemed rich with meaning."

One more passenger aboard the *Capitaine Paul Lemerle*, who soon earned Breton's special interest, was the thirty-three-year-old anthropologist Claude Lévi-Strauss. Lévi-Strauss had never met Breton, and did not at first realize that the Surrealist was on board. Only when the boat stopped over in Casablanca, while the French passengers were waiting to disembark, did he happen to hear a man near him give the famous name as he handed over his passport. The little-known anthropologist introduced himself, and he and Breton spent the rest of the voyage conversing on deck or sending each other

notes on the nature of aesthetics. "André Breton, who was very much out of place *dans cette galère*, strode up and down the few empty spaces left on deck; wrapped in his thick nap overcoat, he looked like a blue bear," Lévi-Strauss later recalled, adding that Breton, even in these wretched circumstances, "always maintained a very dignified air."

In late April, the ship finally reached Fort-de-France, capital of Martinique. Breton stood on deck with the other refugees, excitedly watching the flying fish that chased the boat to shore, elated at the sight of "a village shaded by palm trees, a waterfall on black sand." Lévi-Strauss, for his part, remembered that the passengers' excitement had mainly to do with the anticipated end of the filthy conditions on board: "Instead of the call 'Land! Land!' as in traditional sea stories, 'A bath, at last a bath, a bath tomorrow!' could be heard on every side." But the elation died with the boarding of ten khaki-clad, armed immigration officers, who treated the passengers like convicts and darkly hinted at worse to come once they set foot in Fort-de-France itself. Breton later said that when he protested the passengers' treatment, the ranking officer "tried vainly to intimidate me by marching up and looking me straight in the eye." Martinique was a French overseas colony, and it mixed all the nationalist zeal of the home government with colonial thick-headedness. For the immigrations inspectors, these incoming refugees were merely a load of riffraff, of no use whatsoever to far-off Vichy.

Before being allowed to disembark, the passengers were subjected to insulting interrogations by the authorities. Owing to connections with the captain, Lévi-Strauss was allowed to move about freely, but Victor Serge and his family were held for several days in a prison camp, as were Anna Seghers, Wifredo Lam—and, in fact, nearly all the passengers of the *Capitaine Paul Lemerle*. Breton himself was subjected to gibes about his profession and his lecture invitations in New York ("A fat lot of good *that'll* do the Americans!" sneered one official), then illegally forced to pay a 9,000-franc "deposit" in order to enter Martinique. Before he could even disembark, however, his clearance was revoked, and he, Jacqueline, and Aube were taken in turn to the camp at Pointe-Rouge—at a further cost of 1,500 francs in "internment fees."

A former leper colony, Pointe-Rouge offered sleeping accommodations "that could make you miss those on the boat," and no food except canned sardines sold to the inmates at exorbitant prices. Its location on the beach offered a view of tropical splendors, but Breton's attempts to explore them invariably brought out an armed guard to push him roughly back. Roll calls kept track of the camp "residents" morning and night; and although most of the French prisoners were routinely allowed to go across the bay to Fort-de-France to handle their visa arrangements, Breton was denied even this privilege by order of the local authorities. Finally, after nearly a week, he learned that his

arrival had been accompanied by a police report from Marseille painting him as a "dangerous agitator" and (perhaps worse) a journalist. Breton insisted that he wrote only "books of strictly poetic and psychological interest" (a curious admission, even under the circumstances, but one that expressed all his fears for his and his family's safety), and that very evening the camp commander informed him that he was free to go—with the added warning that "we don't need any Surrealist or hyperrealist poets in Martinique."

The Bretons' freedom, in any case, was only nominal. No sooner had they found lodgings in Fort-de-France, while waiting for the ship that would carry them to New York, than they were taken under the wing of two young mulattoes named Blanchard and Lamartinière. The two men were friendly and engaging—Breton typed them as students, "no doubt of the hardly studious variety"—and at first the disoriented family welcomed their company. But it soon proved impossible to avoid seeing them, and they began regulating every aspect of the Bretons' lives on Martinique; Breton later told how, after having convinced Jacqueline to go with them to a dance, they monopolized her for the entire evening, rebuffing all other suitors. It soon turned out that Blanchard and Lamartinière worked for the secret police, and had orders to keep Breton away from the islanders (particularly the "colored elements," as the camp commander had put it). And in fact, up until the moment of Breton's departure (when the two young policemen tearfully saw him and his family off at the dock), they remained his constant shadow.

Nonetheless, the police precautions were not entirely able to prevent Breton from making contacts during his stay. One of his most frequent interlocutors was André Masson, who had arrived shortly after Breton himself and who was also en route to America. The two old friends explored their philosophical and aesthetic impressions of the Martinican landscape in a "Creole Dialogue," which Masson illustrated with sketches of the rich island vegetation and the native women.

No doubt less to the authorities' liking, Breton also met the black Martinican writer Aimé Césaire. Two years earlier, the poet of Négritude had published *Return to My Native Land*, a mellifluent howl of protest against white cultural and political domination, which Breton later dubbed "the greatest lyrical monument of our times." Césaire, now twenty-eight and a teacher in the local *lycée*, had recently co-founded the literary periodical *Tropiques*, and it was this magazine that caught Breton's attention one morning as he stood in a Fort-de-France shop. Initially dubious, Breton was immediately impressed by the tone and tenor of the magazine's contributions. "I could not believe my eyes," he later wrote: "What was said there was what it was necessary to say, expressed not only in the best but also in the most powerful way it could be said!" The shopkeeper, who knew Césaire, agreed to carry a message, and the next day Breton had the first

of many meetings with the young poet. He spent his remaining days on Martinique discussing West Indian literature and folklore with Césaire and discovering the tropical exuberance of the island's flora. Césaire, Breton's tour guide, later recalled this time as "utterly crucial and decisive . . . If I am who I am today, I believe that much of it is due to my meeting with André Breton. [It was like] a great shortcut toward finding myself."

On May 16, the Bretons and Masson left Martinique on board the SS *Presidente Trujillo*. The ship stopped over in Guadeloupe, where Breton briefly saw Pierre Mabille, and at the end of the month docked in Santo Domingo (then called Ciudad Trujillo) in the Dominican Republic. While there, he dreamed he was the Mexican revolutionary Emiliano Zapata, "making ready with my army to receive [the Haitian freedom fighter] Toussaint L'Ouverture the next day and to render him the honors to which he was entitled." In this "unusually ambitious" dream (as he called it), was Breton trying to allay his anxiety in the final days before setting out to bring his own philosophical revolution to a strange new world?

THE EXILE WITHOUT

(June 1941 – May 1946)

FOR A EUROPEAN, NEW YORK IN THE SUMMER OF 1941 was no paradise. Arrivals were greeted with long and involved immigration procedures—Breton answered questions for more than two hours—to which the sheer number of refugees and national disputes over the European war added their bit of unpleasantness. Moreover, the cityscape itself quickly went from dazzling to overwhelming, and the weather was oppressively hot— a fact underscored by the installation of cactuses in Rockefeller Center. But despite the endless interrogation, the language he didn't speak, the culture he wouldn't absorb, and the heat he couldn't abide, Breton reached this hospitable ground with considerable relief. Jacqueline, for her part, wrote to Varian Fry: "I still don't know if I like New York, everything is much too new to pretend to like it at such cost. What is for sure is that America is the Christmas tree of the world."

At the beginning of June, having disembarked from the *Presidente Trujillo*, Breton emerged with his wife and daughter to find Tanguy, Kay Sage, and the English painter Stanley William Hayter waiting on the docks. Tanguy brought the immigrants to their temporary lodgings, a studio at 60 West Ninth Street that Sage had rented for them; and for a small taste of home, Hayter took them for *pastis* at the Brevoort Hotel on Fifth Avenue, the only bar in New York to feature Paris-style sidewalk tables. (After several months, the Bretons would move into a fifth-floor walk-up at 265 West Eleventh Street in Greenwich Village, between West Fourth and Bleecker. This apartment, reminiscent of their Paris studio, was decorated with paintings by the Surrealists in exile. One visitor later recalled that "as you walked up and down the living room conversing with Breton, those paintings looked at you from two sides of the room"—a reaction not unlike André Thirion's first impression of Rue Fontaine fifteen years earlier.)

Even in this new setting, Breton's experience of New York in those early days was heavily French. He sought out cafés and neighborhoods that boasted a Parisian flavor. And he kept the company of exiles like himself, many of them Surrealists, who had been similarly chased to American shores by the German Occupation: alongside Tanguy, Sage, and Hayter, there was Lévi-Strauss, who would see Breton frequently during their

stay, as well as Matta, Gordon Onslow-Ford, and the Greek poet Nicolaos Calamaris, who had joined the Surrealist group several years earlier under the name Nicolas Calas. There was Kurt Seligmann, now a permanent American resident, who would continue to use his contacts on Breton's behalf. And there was André Masson, who had settled in western Connecticut with his wife and sons.

Western Connecticut, in fact, became something of a Surrealist outpost: in addition to Masson, the area was home to Tanguy and Sage, who had bought a remodeled colonial mansion in Woodbury; Alexander Calder in nearby Roxbury; and Matthew Josephson, the American former Dadaist, who invited Breton to spend a summer weekend at his house in Sherman. As Josephson recalled, everything went smoothly until he happened to mention that Aragon had sat on the same lawn two years earlier. "At the mention of Aragon's name Breton exploded in one of his characteristic outbursts: 'If I had the power I would have Aragon shot tomorrow at dawn!'" Josephson quickly changed the subject.

Finally, Breton was on hand to greet Max Ernst when he arrived with Peggy Guggenheim. Ernst and Guggenheim had met in Marseille that April, as the painter was trying to leave France. They had soon become lovers, owing as much to Ernst's desperate straits as to the forty-two-year-old Guggenheim's charms, and after a long wait in Lisbon they had managed to leave for New York on the Pan American Clipper. Flying with them were Guggenheim's several children and her estranged husband, Laurence Vail. Not accompanying them was Leonora Carrington, who had suffered a complete mental breakdown after Ernst's arrest in 1940 and had been committed, at her family's request, to a Spanish asylum. In Portugal, while en route to another asylum, she had eluded her guardians and taken refuge with a Mexican diplomat named Renato LeDuc, whom she had married as a way of getting to America. Ernst had met her again by chance in Lisbon that May and had spent the following weeks by her side, even as he continued his affair with Guggenheim. Still in love with the beautiful, eccentric Englishwoman, Ernst was hurt by her marriage to LeDuc, and whatever gratitude he felt toward Guggenheim for getting him out of Europe was chilled by great drafts of bitterness.

Another exile, this one pointedly avoided by Breton, was Dalí. The painter's frequent trips to New York and his unerring sense of publicity had earned him considerable American notoriety—such as in March 1939, when he had caused a well-publicized scandal by smashing Bonwit Teller's Fifth Avenue display window because of the store's poor execution of his design. This and similar escapades, coupled with the Spaniard's ideological views, hardly favored his reconciliation with Breton. Nonetheless, by Dalí's own account, he had called to welcome Breton on the day of his arrival, and had even

made an appointment to see him the next day. "But the same evening," he later wrote, "friends told me that Breton had just been calumniating me again, calling me an admirer of Hitler. This was too false and dangerous a thing to do, at that period, for me still to agree to see him." Breton himself never mentioned the incident, not even to deny it, but all of his subsequent references to "Avida Dollars" suggest that his animosity toward Dalí had not diminished. The next day, Dalí pushed his defiance to the point of telling a newspaper that *he*, not Breton, "was Surrealism"—something the American press seemed all too willing to believe.*

From the start, Breton gathered his transplanted tribes and began looking for possible American converts, seeking ways to adapt Surrealism to its new context. He had earlier expressed to Seligmann his hope that America would prove to be "Surrealism's future," the source of many new members. Nonetheless, the reconstituted group, at least initially, was mainly composed of exiled Europeans; and the activities it pursued were scarcely different from those practiced in Paris before the war: games, discussions about sex, exploratory walks through the city. Moreover, as membership was now determined by availability rather than affinity, the group took on a rather splintered and haphazard quality. And to make matters worse, the expanse of the American landscape made it difficult to meet regularly: it was one thing to hop the metro from Montparnasse to Montmartre every afternoon, quite another to commute to Greenwich Village from Connecticut.

Finally, American informality itself seemed to work against Breton. The art dealer Julien Levy described an early meeting in the back room of Greenwich Village bar, to which Breton had brought the Surrealists and other exiles in an attempt to define common grounds for action. "We were all enjoying ourselves," Levy wrote, "alive with great expectations and a feeling of enormous camaraderie, when Breton raised his fist and pounded on the table. 'This will be a serious meeting,' he said. 'We will conduct it in perfect parliamentary fashion. When you wish to speak you will raise your hand and I will acknowledge your signal with the words *La parole est à tel-et-tel, la parole est à vous*!' Leonora Carrington [who had recently arrived in New York] burst into laughter which she tried in vain to smother," and several others hooted as Breton rapped for order. All in all, it was an inauspicious beginning for the relocated Surrealist movement.

Perhaps nowhere was this cultural difference more evident than in the Surrealist games. Despite their emphasis on imagination and fancy, these games were often quite

* Max Ernst, too, shunned Dali because of his political leanings. Meeting his former colleague on a New York street, Ernst refused to take the other's outstretched hand, saying, "I don't shake the hand of a fascist." "I am not a fascist," protested Dali. "I'm only an opportunist."

mirthless: their goal was revelation, not relaxation. Lévi-Strauss even likened some of them to an "initiation rite." Not surprisingly, the importance Breton attached to these games, and the level of participation he demanded from his fellow players, contrasted sharply with the expectations of an American audience seeking a slightly more risqué form of Charades.

Despite such setbacks, Breton persisted in organizing group activities: meetings, games, and, most of all, a new Surrealist magazine, which for him took "precedence over any other consideration." Numerous obstacles stalled the project, however, and for the moment Breton instead "borrowed" the existing periodical *View*, launched the previous year by the poet Charles Henri Ford and the novelist Parker Tyler. While *View* normally showcased the entire avant-garde spectrum, under Breton's supervision its October issue became Surrealism's exclusive province—beginning with a long interview of Breton on page one.

Over the next five years, *View* would welcome several more contributions from Breton, and in general demonstrate a spirit close to that of the Surrealist journals proper. Nonetheless, the reality was that Breton hated *View*: in part because he could do no more than temporarily inhabit it, like a hermit crab, and in part because both Ford and Tyler belonged to the detested race of homosexuals. Indeed, the fact that he dealt with *View* at all mainly attests to his need for a publishing outlet in this time of exile. It was one of the compromises he was learning to make in this strange new land.

Nearly all accounts (including his own) paint Breton's American period as unhappy, a moment in his life best forgotten. For one thing, he and Jacqueline had very little money; Ethel Baziotes, wife of the painter William Baziotes, recalled that he "dropped fifty pounds" during his time in the city. For another, he was shackled by a stubborn refusal to learn English. Breton justified this as an unwillingness to "tarnish" his celebrated command of French, but many felt that he mainly abstained out of arrogance or (and this is no doubt closer to the truth) an intense fear of ridicule. The painter Dorothea Tanning noted that he "was such a proud man, such a royal man in a way, that he wouldn't have wanted to look ridiculous for one moment by mispronouncing something or saying something that made people laugh. So he just preferred not to say it at all."

While Breton's monolingualism did not mean complete isolation, its practical and psychological consequences were naturally high. "I can see how much André is handicapped by the language issue," Kurt Seligmann told Pierre Mabille on August 27, relat-

ing that Breton's lack of English had already cost him a teaching position at the recently founded New School for Social Research. Moreover, while Surrealist visuals had an important impact on the American scene, the movement's ideas would have a much harder time making headway in America. Few of Breton's theoretical writings existed in English, and even then often in garbled translations. As for Surrealist poetry, it would not truly begin infiltrating American verse (notably via the New York School poets) for another decade.

Even without the language barrier, Breton's new life was filled with vexations. Café life was all but nonexistent, not only because American artists and poets tended to work in isolation but also because coffee shops were ill suited to long gatherings, forcing the group to adopt the American custom of meeting in private homes by appointment. As for the American artists, some rejected the Surrealist painters as poor craftsmen, not recognizing that for Breton the ability to wield a brush was second to the power of the artist's inner resources. Others resented the European "invasion."* Still others found the Surrealists threateningly esoteric, or simply irrelevant to a world at war. Finally, those who extended a welcome generally enjoyed Surrealism's more frivolous externals, and even claimed allegiance to the movement, without having any idea what it was actually about.

Still, despite the evident drawbacks, the stay was not without its measures of happiness. For one thing, there was the safety that Breton and his family were enjoying. And if Breton didn't receive the kind of notoriety that Dalí, for one, was so skilled at generating, he was far from being an anonymous presence in New York. Several important gallery owners, such as Julien Levy and Pierre Matisse, were actively promoting Surrealism, and many feel to this day that Breton had a decisive influence on the course of American art.

Nor was Breton entirely wanting for friendships in New York. Not only had he gathered many of the European exiles around him, but within the first months of his stay he made several interesting new contacts. Among the most important was the art historian and critic Meyer Schapiro, who by chance lived around the corner from the Eleventh Street apartment, and who met Breton via Kurt Seligmann. Erudite and culturally adventurous (one New York intellectual said that after a conversation with him, "you could get a Ph.D."), Schapiro had been one of the first on the continent to give serious

* This latter attitude was lampooned by the American painter Mark Tansey in his 1984 canvas *Triumph of the New York School*: on a rocky battlefield, Jackson Pollock, Robert Motherwell, Clement Greenberg (looking like Eisenhower), and other American art figures in military garb watch as Breton countersigns the European defeat, while around him mill Picasso, a trench-coated Duchamp, and Dali in high parade helmet.

attention to Surrealist writing and thought, both in his courses at Columbia University in the 1930s and in well-informed articles for *The Nation*. Breton, for his part, was grateful to have a neighbor who was intelligent and sympathetic, who could help him with numerous practical errands, and who spoke fluent French into the bargain. Jacqueline called him "a very precious discovery."

There were also various diversions to be enjoyed in the city. With his fellow exiles, Breton explored New York's wealth of ethnic restaurants, making it a contest among his friends to unearth the most interesting ones. He also took pleasure in riding the open double-decker buses down Fifth Avenue as it skirted Central Park, or on Riverside Drive along the Hudson River. And, somewhat atypically, he liked the zany musical review *Hellzapoppin*, just ending its three-year run on Broadway.

With Lévi-Strauss and Ernst, Breton also frequented the antiques shop of Julius Carlebach on Third Avenue, which specialized in primitive art objects, Native American kachina dolls, Eskimo masks, and sculptures from the Pacific Northwest. Carlebach, delighted to find an audience for his wares—which to Breton's amazement no one else wanted at the time—soon began unloading dusty treasures from his back room whenever the Surrealists entered the shop. (On at least one occasion, Breton no doubt wished Carlebach had left the treasure where it was: an object he handled at the shop caused a severe allergic reaction, leaving him covered with rashes and tormented by horrible itching for several days.)

Lévi-Strauss later noted a fundamental difference between Breton's approach to such artworks and his own:

> Breton had an instinct about objects he loved, and he sometimes made me appreciate things I wouldn't otherwise have seen or appreciated. We once came upon an object that had obviously been made to be sold to whites; to my mind, it had no.cultural function, and therefore was not interesting. But Breton stopped short in amazement, and after a while I, too, understood that it was nonetheless very beautiful. He wasn't a purist, or trained; but because of this he saw things that I didn't.

It was in New York, at Carlebach's and other shops, that Breton first discovered Native American art and culture, a love of which would stay with him for the rest of his life. As with the Oceanic artifacts and works of "outsider art" that had earlier entered his collection, he saw these objects as crystallizations of poetic energy, unadulterated by the bowdlerizing mediations of Indo-European civilization. "Today, it's above all the visual art of the red man that lets us accede to a new system of knowledge," he later declared.

These objects seemed to incarnate the convulsive beauty that he most prized, and that he had no doubt despaired of finding during his exile in the Americas.

✳

By January 1942, Breton had more or less settled into New York life, managing, as best he could, to adopt a workable routine. Perhaps more importantly, he found a confidant for his innermost cares—not in a fellow New Yorker, but in his old friend Benjamin Péret. Having arrived in Mexico the previous month, Péret was now within reach of the international mails. It was to him that Breton would unburden himself over the coming years in a series of long and candid letters.

The first of these, on January 4, provided a detailed portrait of Breton's life and concerns at the time. He outlined his continuing plans for a new magazine, to be named *VVV*. He complained of the cool reception he had received from American periodicals: "No curiosity about anything that isn't immediately commercial; no respect for the written word, which the publisher or editor assumes the right of cutting as he sees fit, dropping whatever he pleases." (In fact, Breton had recently experienced just such difficulties when he had sent a lengthy, and not especially flattering, report on his stay in Martinique to *Life* magazine, only to retract it when *Life* tried to edit the piece.) Somewhat hyperbolically, he boasted that "pictorial Surrealism is practically the official art here," but lamented that Surrealist poetry was "absolutely unknown." And he admitted that Surrealism had to take new and more daring forms, or be "killed" by younger movements the way Surrealism had once supplanted its own predecessors—something he clearly feared, as his letters of this period make the point several times.

Meanwhile, Breton carried out his duties as a prominent member of the New York expatriate community. In March, he sat for a now famous group portrait used to illustrate the show "Artists in Exile," to be held at the Pierre Matisse Gallery. Breton posed in the studio of George Platt Lynes, alongside his friends Matta, Tanguy, Ernst, and Masson, as well as Chagall, Léger, Mondrian, Tchelitchew, and others. As Lynes set up his equipment, the artists slighted each other in grumbling tones and avoided coming face-to-face. "Half the artists present couldn't stand the other half," Pierre Matisse gleefully recalled, adding that "they all wound up in the picture next to the one they liked the least."

For the Matisse exhibit, Breton contributed a "poem-object," a frame containing a branch of leaves, dried plants, the photo of a scantily-clad woman, stones, spools of thread, seed pods, and, scattered throughout, a fragmented text. Breton would create a relatively

large number of such objects during his American sojourn, some of them among his most enigmatic works. One, a collage called *Tragic in the Manner of the "Comics"*—perhaps the earliest use of the comic-strip motif in art, some two decades before Roy Lichtenstein's Pop variations—shows a photograph of the Facteur Cheval's "Ideal Palace" crying out: "No. Is it true? You're LEAVING?" (appropriately, the text is in a word balloon) to a woman resolutely descending its stairs. Another, one of his richest, is the multimedia work *Portrait of the Actor A. B. in His Memorable Role in the Year of Our Lord 1713*. A complex assemblage, featuring a miniature transparent valise that "allows one to travel *through time*," a locked peephole, and numerous inscriptions, this object gathers the major events of Breton's totem year, 1713, in a dispirited ensemble. At a time when both the difficulties of translation and the lack of publishing outlets made the written word a poor vehicle, it was as if these objects provided Breton with a stopgap means of disseminating his ideas.

This is not to say, however, that Breton produced no writing while in America. That spring, he composed a new addition to the series of manifestoes, the "Prolegomena to a Third Surrealist Manifesto or Not." The text briefly analyzed the bleak intellectual situation in wartime, and once again castigated those former Surrealists who in Breton's view had sacrificed their calling to the lures of fame or facility. In a curious passage called "The Return of 'Père Duchesne'"—a reference to the radical newspaper from the French Revolution—Breton even stepped out of character, though not altogether convincingly, to pastiche a freewheeling, streetwise social critic ("The time has come to refuse to swallow this whole mess of books by good for nothing bastards who urge you to stay at home and not pay any attention to how hungry you are. But what the hell," etc.). And he called for the constitution of a new "myth" on which society could be based, to replace what he considered the outmoded economic myths of Marxism and capitalism. This search for a new myth, even a new social "utopia," would increasingly preoccupy him in the coming years. In the "Prolegomena" it took the form of the "The Great Invisibles," a concept Breton had derived from the writings of William James and the German Romantic poet Novalis. The Great Invisibles were beings that surrounded humanity but went undetected by the five senses, insubstantial nodal points of our desires and aspirations toward the marvelous. This overture to a race of invisible creatures inaugurated Breton's turn toward the premises of occult thought, which would become a major facet of the Surrealist worldview in the postwar decades. Excited about the possibilities he saw in the "Prolegomena," he promised Péret that the text would "shake up the sorry bottle of these times."

Breton planned to publish the "Prolegomena" in the first issue of *VVV*, which after

months of planning was finally coming together. There nonetheless remained one impor-
tant, unresolved issue: the choice of an American editor for the magazine, someone who
could handle the English-language chores while Breton and Max Ernst acted as advisers.
Breton had initially asked Charles Henri Ford to abandon *View* and work on *VVV*—
which would have meant both acquiring an experienced editor and eliminating the com-
petition—but Ford declined, "preferring not to work with Breton looking over [his]
shoulder." From this point on, and all the while continuing to publish in it, Breton bare-
ly hid his rancor against *View*, which he later described to Péret as "pederasty internation-
al." Breton also offered the editorship to Lionel Abel, a young American writer and
Trotskyist militant whom he had recently met through the painter Robert Motherwell,
but Abel, too, declined (though he did translate several of Breton's texts for the magazine).
Finally, Breton settled on the sculptor and photographer David Hare. Originally put in
touch with Breton by his cousin Kay Sage, Hare quickly discovered many affinities with
the Surrealists. In conversations with Breton, at which the bilingual Jacqueline served as
interpreter, the two men explored their common views and, once Hare had agreed to edit
the magazine, discussed the practical arrangements.

Twenty-five years old, blond, handsome, and wiry, Hare was at the time a rising
figure in the New York art world. His sharp-cut features complemented an incisive per-
sonality, perhaps heightened by his studies under G. I. Gurdjieff. "He belonged to one of
those rich, broken families in which every child has a different father or mother, and in
which they quickly learn, from growing up among affairs and divorces, to rely only on
themselves," a friend later wrote. Hare had been expelled from several colleges and had
lived in the Arizona desert—an environment better suited to his temperament than New
York City, for he was "more comfortable nude than clothed, and in the bright sunshine
than under a roof." Not long after their meeting, Breton described Hare as "extremely
likeable, devoted and *sure*," whose one flaw was that "he speaks only English."

Finding an editor, of course, was only part of the problem, and *VVV* provides a good
illustration of just how dependent on others Breton was during his time in New York.
Not only did he face the obstacle of language, but to an even greater degree than before
he was plagued by the issue of funding. If Breton was finally able to produce a magazine,
in fact, it was due almost exclusively to the contributions of a few wealthy art lovers, such
as Bernard Reis and Peggy Guggenheim—whose marriage to Ernst, moreover, was near
an end, auguring ill for future grants.

And not even the generosity of patrons could cover all the magazine's expenses, let
alone the cost of living, ultimately leaving Breton with no choice but to take a job. After
several attempts, he found work in March 1942 as an announcer for the Voice of

America radio broadcasts. The broadcasts, produced by the Office of War Information (OWI), were a multilingual series of programs aimed at spurring resistance to Nazism throughout the occupied world. Edouard Roditi, Breton's former editor at Editions du Sagittaire and one of OWI's earliest employees, remembered it as "an enormous operation. Programs in French went on twenty-four hours a day. We were broadcasting at different hours and on different wavelengths to different countries."

The head of the French broadcasts was Pierre Lazareff, a Parisian newspaper magnate who had earlier run the tabloid *Paris-Soir*. At the suggestion of another recent friend of Breton's, the American art historian Patrick Waldberg, Lazareff now invited Breton to join the staff. His colleagues included Lévi-Strauss, Nicolas Calas, and Roditi, as well as former acquaintances Amédée Ozenfant and Yvan Goll (whom Breton first snubbed as a "*boche*," although the two men eventually settled into cordial if distant relations).

For a moderate salary of about $250 a month, Breton sat from five-thirty until eight o'clock in the evening in Studio 16 at the OWI offices on West Fifty-seventh Street, alternating with Lévi-Strauss and several others in reading propaganda over which he had no editorial jurisdiction. This dissociation from the text was voluntary: while many others worked at the OWI out of conviction, for Breton this was simply a livelihood, the price of his Surrealist activities. As Roditi put it, Breton "believed he refrained from committing himself by only 'renting' his voice." It became famous in expatriate circles that Breton had imposed only one condition on his radio announcing: that he never have to pronounce the words "God" or "Pope"—this latter a source of gibes for years to come.

And yet, for those who heard him on the other side—when static or German interference didn't prevent the signal from piercing through—Breton's voice was an inspiration. "Despite the jammings, André Breton's voice, which was easily recognizable in the broadcasts from America, resounded like an encouraging call," said André Thirion. Breton might have refused to put any of himself in these broadcasts, but his famous tone, so much a part of his charisma when face-to-face, reached out through this unlikely medium to remind Paris that someday he, too, would return.

The Paris to which Breton was speaking was entering the darkest period of the Occupation. The recently formed Resistance movement was poorly organized, and did not yet enjoy support from a population that considered these "outlaws" more dangerous than the occupier. Later that year, the Germans would enter the Unoccupied Zone, ending the fiction of a "Free France" once and for all; and Pétain's prime minister, Pierre Laval, would institute a "voluntary work program" that sent thousands of young Frenchmen to labor in Germany (by 1943, the program would no longer be even nominally voluntary).

As for the French intellectuals, they either espoused the Nazi philosophy—Louis-Ferdinand Céline pursued his campaign of hatred, Paul Léautaud publicly deplored that there "weren't more concentration camps"—or remained cautiously neutral. And Picasso, future star of the French Communist Party, hedged his bets by amiably welcoming art-loving German officers to his studio. Few and far between were groups such as the Main à Plume, a fraternity of young writers who defied the reigning atmosphere and who identified closely with Breton's Surrealism ("to the point of caricature," said Thirion). Faithful to its model, the Main à Plume abjured such "counterfeiters" as Eluard and Aragon and published a clandestine magazine, whenever it could sneak an issue past German censorship.

Meanwhile, Breton's own periodical, *VVV*, finally appeared in June. (Marcel Duchamp, who arrived in New York that same month, was immediately drafted onto the advisory board). It featured a bright green cover by Ernst, Breton's "Prolegomena" with facing English translation, and his unsigned "declaration" about the magazine's title: "VVV, that is, V + V + V . . . V as a vow—and energy—to return to a habitable and conceivable world, Victory [a reference to Churchill's famous hand gesture] over the forces of regression and of death unloosed at present on the earth . . . V again over all that is opposed to the emancipation of the spirit, of which the first indispensable condition is the liberation of man." In the course of its four issues, *VVV* would feature works by virtually all the Surrealists in exile, as well as by William Carlos Williams, Césaire, Lévi-Strauss, Picasso, Calder, and many others.

But while Breton was proclaiming "the liberation of man" in his editorial pages, he apparently failed to notice that bonds were fast coming undone at home. Increasingly since their arrival in New York, he and Jacqueline had been fighting over issues large and mundane. Jacqueline's personal flamboyance, which Breton had earlier celebrated, now became a source of tension. She later recalled Breton yelling when she tried dyeing her hair green (possibly in an attempt to please him, green being his favorite color): "You get rid of that right now or I'm leaving you!" Moreover, given comparative autonomy by her knowledge of English, and encouraged by Peggy Guggenheim and others, Jacqueline devoted time as never before to her own art—"all day long," as she joyfully told Péret. It was with little regret that she let many of the household details go by the wayside.

Phenomenally impractical, Breton was incapable of performing the most basic daily tasks. Suzanne Muzard, looking back on her own experience of sharing Breton's life, once remarked that he "always felt he was assailed by difficulties of a practical order, exaggerating their importance while affecting to despise them." Instead, Breton expect-

ed others—café waiters, taxi drivers, his wife—to handle such details for him, and his annoyance when these chores weren't performed was intense. He later told André Thirion that a major cause of fights with Jacqueline was her obliviousness to running water: "Can you imagine how irritated a man can get in a hotel room or a tiny apartment if the other person never turns off the faucets?"

While these expectations might have been fairly typical of the times, Jacqueline was no longer inclined to indulge them, no longer satisfied with being Breton's "Undine" and his housekeeper, or with subordinating her wants to his. As for Breton, said Leonora Carrington, he "wanted a muse. When a woman could no longer be this, he got tired of her. He was in love with the image, and couldn't deal with the day-to-day reality." Indeed, it was to this same Jacqueline that Breton had once written: "My new steps will have no other goal than to reinvent you. I shall reinvent you for me, since I desire to see poetry and life re-created perpetually."

Once Breton did finally recognize that his marriage was failing, he seemed, as at the end of his affair with Suzanne, to have little understanding of the causes. "Awful, terrible depression," he confided to Péret on August 27. "*Everything* in life is very dark: as for Jacqueline, incomprehensible (moving further away, becoming lost) . . ." He spent the late summer and fall in a state of dazed anger and sorrow.

There was, however, one more factor in the breakup of Breton's marriage: sometime during the summer, Jacqueline had become sexually involved with David Hare. Although Hare was not the cause of the Bretons' separation—one witness described him as simply being "conveniently there"—his presence no doubt provided the catalyst. The affair was at first kept secret, Jacqueline taking advantage of Breton's hours at the Voice of America (and the compliance of babysitting artist friends) to see Hare on the sly. In September, however, she revealed the situation by presenting him with a drawing, titled *For André Breton, Design for Living*, and announcing that she wanted a divorce. Breton at first responded with threats—"If you leave me, I will destroy you," he reportedly warned—but this was one situation over which he had no control, and Jacqueline knew it. Soon afterward she moved out of the Eleventh Street apartment, taking Aube with her.

"Oh la la!" Breton wrote Péret and Remedios Varo on October 22, in a letter full of black sarcasm. "So that's why we haven't been writing, oh la la! We're 'working,' we're 'making a living,' we're speaking English as brilliantly as ever and we're even living all alone. And I don't have to add that this solution involved a fair amount of tension, at least on my side." Jacqueline went to live with Hare on Bleecker Street, or at his house in Roxbury, Connecticut, near the homes of Tanguy and Masson. Breton moved to a studio

at 45 West Fifty-sixth Street, near his job. He maintained relations with both Jacqueline and Hare, working with the latter on *VVV*, visiting the two of them in Connecticut as a way of seeing his daughter.

But animosity between the estranged spouses was intense, further heightened in Breton's case by his separation from Aube. A passage written about the situation two years later still showed undiminished bitterness: "All that I had taken for indestructible in the realm of feeling had been swept away without my even knowing what gust did it: the only sign left was a child . . . All the world's injustice and severity separated me from this child, deprived me of her beautiful awakenings which were my joy, made me lose with her contact with everyday marvels . . . I wouldn't help in shaping her young mind which came to me so sparkling, so open." By the end of the same paragraph, as if unwittingly, Breton had segued into a diatribe against military dictatorships.

Breton furnished his spare new life with a series of projects that fall of 1942. In October, he and Duchamp organized an exhibit, titled "First Papers of Surrealism" after an immigration procedure, on behalf of the Coordinating Council of French Relief Societies. For the catalogue, given the difficulty of obtaining photographs, the participants were represented by "compensation portraits": Chirico as an antique Roman bust, Leonora Carrington as a haggard woman (by Walker Evans, lifted from *Let Us Now Praise Famous Men*), and Breton as an elderly man, peering anxiously from beneath a crumpled fedora.

At the same time, he helped Peggy Guggenheim prepare her groundbreaking show, "Art of This Century." The inaugural of Guggenheim's Fifty-seventh Street gallery, the exhibit provided a sweeping retrospective of three decades of artistic experimentation, giving many in America their first comprehensive view of the modern aesthetic evolution. Breton, one of the few people in the world to enjoy Guggenheim's trust in artistic matters, acted as her chief adviser—not only in selecting the works but also in persuading his patron to hire the architect Frederick Kiesler, a "little man about five feet tall with a Napoleon complex" who had captured Breton's confidence, to design the exhibit space. Owing in part to Kiesler's innovative design, "Art of This Century" helped ensure Guggenheim's place in posterity. It also marked the end of her relations with Max Ernst: that December, Ernst met the young American painter Dorothea Tanning, lively, beautiful, and "very, very female," and soon moved with her to the desert tranquility of Sedona, Arizona, leaving his third marriage behind.

On December 10, Breton traveled to New Haven, Connecticut, to deliver a lecture at

Yale University. The lecture, "The Situation of Surrealism Between the Two Wars," again presented Surrealism to a new audience, highlighting those aspects of it that seemed to be most pertinent to the current situation, and stressing its continuing vitality against claims that it had died in 1939: "With all due respect to some impatient gravediggers, I think I understand a little better than they do what the demise of Surrealism would mean. It would mean the birth of a new movement with an even greater power of liberation." And he specifically appealed to his young student audience by declaring that Surrealism "was born of a limitless affirmation of faith in the *genius* of youth," citing Lautréamont, Rimbaud, and others who had made their mark at a tender age.

Wallace Fowlie, then a professor on the Yale faculty, recalled the afternoon: "A large gathering of students, faculty, and townsfolk turned out to hear the lecture. M. Breton spoke in French, which was a strain for many of those present, and some passages in the lecture he read were difficult to follow even for those who knew French well. His style is highly polished and intricate. His ideas, which might in a more simple form be easily recognizable, are in his own form intensely abstracted and intellectualized." Fowlie also noted that many in the hall, while impressed at seeing Breton in person, were mainly thinking about their impending draft notices.

But no matter how busy Breton kept in those last months of 1942, his activities could not overcome the depression caused by his separation from Jacqueline: for whatever their differences, he had never expected to lose his "commander of the night of the sunflower." An unusually terse poem written during that period speaks of a long and sumptuously laid table that "Keeps me apart from the love of my life / Whom I can barely see," while the woman herself is "tilted backward / Neckline bared in a flash."

As during his first divorce in 1929, Breton's friendships suffered the effects, and perhaps none more so than his friendship with Max Ernst. Dorothea Tanning, although new in Ernst's life, could immediately see that the two men's relations had become "a tangle of thrusts and jabs and polite smiles, of Max's grinning defiance and Breton's trembling retaliation." She particularly remembered a New Year's Eve party at the end of 1942, during which Breton and Ernst found themselves shouting face to face. "I'll never write another word about you!" threatened Breton, to which Ernst replied, "*Je m'en fous*" [I don't give a shit]. "Breton raised one hand in a gesture to the room, his voice rising and full of disbelief. '*Il s'en fout! Il s'en fout!*'" As one witness put it: "The acids of exile were corroding an intimacy in which . . . feelings played less of a role than did the mind. Jostled together by force of circumstance since Marseille, the two men were rubbed raw."

During this time as well, Breton severed relations with both Kurt Seligmann and André Masson. Furious at being corrected by the erudite Seligmann on a detail of occult

lore, Breton threw every painting he owned by the man into the garbage—simultane-ously disposing of their friendship. Masson, for his part, was upset at being "kept to one side" of Surrealist activities and at Breton's refusal to publish some of his works in *VVV*. When the painter then published his rejected texts in *View*, Breton broke with him alto-gether, and for the final time.

In the spring of 1943, Breton even had a temporary falling-out with his most faithful friend, Benjamin Péret. Péret had not liked the March issue of *VVV* ("as bland as a book of floral patterns"), and had let Breton know it in a strongly worded letter. Offended by Péret's critiques, Breton was even more so by his friend's decision to submit a new prose work, an essay on Latin American myths, to *View* rather than to him. A repentant Péret then sent the text to Breton, who tried to "scoop" *View* by printing the text as a pamphlet entitled *La Parole est à Péret* [Péret Has the Floor]. At the last minute, however, Breton's financial backer withdrew, leaving him to pay all printing costs out of pocket. "This is typical of what goes on here," he complained to Péret in July. "I don't have to tell you how I feel about New York, its sites and its customs. I sometimes wonder if you were worse off in Rennes [prison] than I am pacing five or six times a day down Fifty-seventh Street."

Certainly, Breton's separation from Jacqueline wasn't the only factor in his mood during those months. His fights with other Surrealists had real motivations behind them, while the war and the lingering realities of exile were taking their toll. But however real the external factors, there is no doubt that they were exacerbated by the absence of Jacqueline and Aube, and the newly solitary lifestyle that was now his. Moreover, although Breton visited Jacqueline fairly often in her new home, these visits mainly inspired his sorrow. One friend described Breton standing in Jacqueline's studio, "slow, dark, taking up too much space, sad the way a child can be sad, standing awkwardly among the canvases, the plants, the easel." When introducing Jacqueline to others, "he still said 'my wife,' but with visible embarrassment."

Hoping to remedy his malaise, Breton's friends tried to find him female companion-ship—with, for the most part, dismal results. "One evening," Dorothea Tanning recalled, "someone brought a pretty redhead. In vain. 'I am a businesswoman,' she said dryly. 'I don't drink; I don't smoke; and I don't make love.' Unequivocal. Translated for André, who smiled."

Breton, meanwhile, briefly became infatuated with a French announcer at the Office of War Information named Dolores Vanetti Ehrenreich, who would later become the lover of Jean-Paul Sartre. "Her spontaneity, generosity, directness, and informality were extraordinarily popular in the offices of the Voice of America," Sartre's biographer wrote

of her, noting that Breton was particularly taken with "her beautiful oval face, the purity of her smile, her refreshing nonchalance, her permanent good mood, [and] the way she passed from frivolity to gravity." Edouard Roditi remembered Dolores, who at the time was married to a wealthy American doctor, as "oddly attractive, sort of a doll-like creature. She wrote a few vaguely Surrealist poems in French under the pseudonym Benedicta," which Breton published in *VVV*. But despite his courtship, it appears that Breton was never more than a friend to Dolores.

Emotionally isolated, Breton drew closer to those in New York who could still provide some measure of comfort or companionship. He spent more time with Matta, whom he appreciated for his joyful humor and whom he often treated as a kind of favorite nephew. He briefly reunited with his old friend Philippe Soupault, in New York on assignment for a French press agency: "When I saw him, he greeted me as one might greet a ghost," the latter said. And as often as possible, he met Marcel Duchamp, who since returning to New York had become a kind of spiritual mentor for him.

Toward Duchamp, Breton showed a kind of deference that few others—Picasso, Trotsky, to some extent Freud—had ever enjoyed. One witness recalled that Breton "shrank" when with his older friend. "He was naturally the central figure, as Duchamp was naturally peripheral. But when Duchamp was present, Breton refused to occupy his place. Everyone looked to him, listened to him; *he* looked and listened to Duchamp." Duchamp's offhand creations were still among the most provocative of the century (his latest, done for a contest sponsored by *Vogue* magazine, was a bust of George Washington that looked as if it was made from a blood-streaked sanitary napkin). Aside from which, as Soupault noted, Duchamp's sarcasm and nonchalance reminded Breton of Jacques Vaché. The two men often met for lunch at the French restaurant Larré on West Fifty-sixth Street, whose down-at-the-heels charm and reasonably priced cuisine made it a favorite rendezvous. Breton later described these lunches with Duchamp as one of the "brief but intense joys" he experienced in New York.

It was also in 1943 that Breton developed a close friendship with a seventeen-year-old Harvard student named Charles Duits. An American who had grown up in France, the shy, alienated Duits had discovered *VVV* the previous fall and taken to it like a drowning man to a life preserver. In November 1942, he had written Breton a letter that seemed almost calculated to win his favor: it praised Surrealism as a "new vice," castigated the "imbeciles" who pronounced it dead, and assured Breton that the young people he knew were "powerfully interested" in it. Moreover, Duits himself wrote poetry that showed distinct Surrealist leanings, some of which he enclosed.

Breton had been thrilled by the letter, as he was by any sign of young people's accept-

ance: as he had said at Yale, the "genius of youth" was one of Surrealism's most cherished credos. It was a promise of continuity, of a future generation. He had immediately written back to Duits, inviting the young man to visit him in New York.

Many years later, in one of the strangest and most evocative memoirs ever written about Surrealism, Duits recalled his first meeting with the movement's legendary leader:

> The first thing I felt, when I saw the man leaning in the doorway, was surprise: I knew André Breton. He was exactly as I had imagined him. Not as tall as I'd thought, perhaps, and maybe a bit stockier, but these details were unimportant. I knew André Breton; I had always known him . . . He was forty-five years old at the time [*sic*: Breton was almost forty-seven], but he seemed much older, humanly speaking, for he was also ageless, like a tree or a rock. He seemed weary, bitter, alone, terribly alone, enduring his solitude with the patience of a beast, silent, caught in his silence as if it were hardened lava.

Like others before him, Duits was surprised to find Breton's room so orderly, his conversation so polite, his gestures so "old world." He had expected a revolutionary firebrand, not the middle-aged gentleman who greeted him. Still, and however disconcerted he might have been by his first impressions, Duits quickly joined the Surrealist group, frequenting it as often as his studies would allow. Breton, for his part, adopted Duits as a spiritual son, encouraging him in his poetic endeavors, introducing him to expatriate society, sometimes acting as his moral or social tutor.

Breton also introduced Duits to Jacqueline and David Hare, and by summer the young poet was being invited to stay, along with Breton, at a house the couple had rented in Hampton Bays, Long Island. There Jacqueline happily painted during the week, enjoying the recognition that she was now beginning to gain (she would have her first one-woman show in New York the next spring). Breton, who was still working at the OWI, came only on weekends. On the train from Manhattan, he and his new protégé jointly composed an automatic text; Breton, remembering writing *The Immaculate Conception* with Eluard, told Duits: "With you I hold back because I know that you'll jump right in, whereas with Eluard *I* was the one who had to jump in, because I couldn't expect very much from him." It was a strange assertion, one perhaps more reflective of Breton's feelings of wounded friendship and his hopes for the new convert than of historical reality.

Introverted and maladroit, Duits shied away from social situations and balked at the chores that Jacqueline asked of her guests—something with which Breton could readily

sympathize. On one occasion, when Jacqueline complained that Duits could not even wash the dishes properly, Breton explained to her "with perfidious gentleness" that "poets simply didn't know how to do dishes. 'But,' said Jacqueline, furious, 'I can't do *everything* in this house! I barely have time to paint!' Breton kept silent, his smile less compassionate than sarcastic. The vindictive gleam in his eye expressed better than any words the feelings that Jacqueline's artistic ambitions inspired in him."

But these moments of petty revenge could not compensate for Breton's own discomfort in his wife's presence. Jacqueline and Hare, who shared a taste for nudism, often took advantage of the warm sun and relative privacy to walk naked along the sandy beach. Blond, tanned, and slim, they seemed like two lions roaming the savannas, or, said Duits, like the statues of Egyptian gods. Breton refused all invitations to accompany them to the shore, protesting that "he was just fine" on the house's shady porch, his feet well shod, his shirt buttoned. Kept company by Duits, he smoked the large black pipe that had more or less replaced his cigarettes, and listened while his young friend recited poetry. Sometimes the two went alone for walks, avoiding "places where they might run into 'the others.'" But no matter how peaceful the setting, part of Breton's mind was anxiously following the two nude figures strolling carelessly by the waves.

At other times, Breton paced over the lawn of the Long Island house, working on a new epic poem. The poem—called "Les Etats généraux" [The States-General], after the eighteenth-century governing body that had helped spark the French Revolution—was based on a phrase that had occurred to him in half-sleep: "There will always be a windborne shovel in the sand of dreams." Using fragments of this sentence to divide the poem's various parts, much as Mallarmé had done in *Un Coup de dés*, Breton created a vast, often obscure picture window that obliquely reflected elements of his life in New York: glimpses of the Long Island countryside; of his regrets about Jacqueline ("She does not accept the yoke he cannot read his loss"); of the frequent electrical "brownouts" imposed by wartime economy. "Les Etats généraux" is a poem of emotional and spiritual darkness, in which, dotted throughout like stars "lost in the fur of night," figure the names of past rebels who had defied human oppression, indicators that the war, and Breton's emotional trials, would one day be over.

This was not Breton's only poem during these years, but in tone and length (nearly that of *Fata Morgana*) it represented a significant departure from the quasi-silence that had been his since arriving in New York, and particularly since losing Jacqueline. The fact was, Breton was still in love with his estranged wife and, despite a momentary elation over "Les Etats généraux," still subject to depression. At times, his feelings about the separation took peculiar forms, such as the title he found for a small anthology of his verse

that Charles Henri Ford intended to publish in a bilingual edition under the *View* imprint. Charles Duits remembered Breton appearing one day at the Surrealist meeting, flushed with excitement over his chance discovery in a horticultural catalogue of an odd phrase that was, in fact, retained as the book's title. The phrase, which immediately struck the others as both comic and painful, but whose full implications seem to have eluded Breton, was *Young Cherry Trees Secured Against Hares*.

Young Cherry Trees was Breton's only English-language volume to result directly from his time in New York. The translations were entrusted to Edouard Roditi, who did most of the work at the OWI offices. "Breton would bring me a poem he'd chosen for the collection, which I'd begin translating between broadcasts," he recalled. "Then I'd bring the translation to Breton and we'd look it over together." Although he admired the poems themselves, Roditi found Breton "impossible to work with. Since he didn't know English, he'd show the translations to friends who didn't know much English either, and who would make suggestions that I didn't agree with, but that Breton trusted." In the end, of course, no one was satisfied.

Nor, when this first offering of View Editions was published in 1946, were the few reviews cause for much elation. Displaying a mix of admiration and sarcasm, William Carlos Williams posited that the great achievement of Breton's "simple and crystal clear verse" was its lack of surprise: "Everybody knows beforehand everything that will be said. It is completely without invention in the American sense . . ." John Berryman was less ambiguous: "Breton is an exclusive and dogmatic Surrealist, that is, an *idiot*," he wrote in *Partisan Review*. *Young Cherry Trees* was nonetheless a handsome production. The dust jacket, by Marcel Duchamp, showed a heavily screened photograph of the Statue of Liberty, its face cut out to reveal Breton's beneath. And inside were several drawings by the Armenian-born painter Arshile Gorky.

From Breton's viewpoint, Gorky was perhaps the best thing about *Young Cherry Trees*. He first met the painter in the last days of 1943 through a mutual friend, the ceramicist Jeanne Reynal, at a dinner held for Breton in the Lafayette Hotel. Over dinner, Gorky impressed Breton with his keen mind for poetic analogy, with his tales of Armenia (Breton particularly liked hearing of a rock on which Armenian woman rubbed their naked breasts), and especially with the paintings that he took out to show the Surrealist. Seeking an inner viewpoint rather than external vision, Gorky's approach was to slowly transform the scene before his eyes until his canvas bore no resemblance to its initial inspiration. Breton later called Gorky "the first painter to whom this secret has been fully revealed," and singled out one landscape, *The Liver Is the Coxcomb*, as a "great gateway open on to the analogical world." Before leaving the Lafayette that night, he

promised to find Gorky a dealer, then stepped backward out of the room, "bowing every two or three paces [like] an eighteenth-century courtier."

For his part, Gorky found in Surrealism the artistic path he had been seeking for years. "Gorky was a fabulous imitator," noted Edouard Roditi. "He imitated Juan Gris, Picasso, Matisse, went through every conceivable phase. Then he started imitating Miró, and that's when he attracted Breton's attention." Julien Levy, who at Breton's urging gave Gorky his first major show, added that the painter "found his fantasy legitimized" through contact with Breton. "He discovered that his hidden emotional confusions were not only not shameful but were the mainsprings for his personal statement."

This first meeting led to others, during which Breton (through an interpreter) honed Gorky's skills in naming his paintings and followed the progress of unfinished works. Gorky himself appears to have been less interested in Breton—he never read his books, possibly not even the poems he would soon illustrate—and before long came to reject Surrealism altogether. But he welcomed Breton's conversation and, even more, the interest that so distinguished a figure was taking in his art. It was enough for the moment: Gorky's renown grew considerably from his contact with Breton, while the latter had the satisfaction of feeling he had discovered a significant new talent. In any case, by the time of their meeting Breton's life had taken a sharp upward turn.

Breton's emotional exile came to an end on "December 9 or 10, 1943" (as he later wrote), during lunch with Duchamp at Larré, when his attention was caught by the stares of a young woman seated at a nearby table—a woman who gazed with such insistence that Breton finally went over to introduce himself. By January he was telling Péret that this woman was "the person I love the only person I adore."

Elisa Claro (née Bindhoff) had emigrated to the United States several years earlier, in the wake of a divorce. Born in Chile in 1906 of an affluent French family, she had received a top-flight education, was an excellent pianist, and spoke several languages fluently. She was now in her mid thirties, brown-haired, with the smooth features of a Hollywood femme fatale (several people have compared her to Garbo) and pale, intelligent eyes. Pierre Matisse remembered her as "very, very kind, sweeter than anyone I'd ever seen," while another friend said she was "terribly vulnerable-looking," like "a child playing at living."

Part of this vulnerability, as Breton soon learned, was due to a tragedy that had befallen Elisa several months earlier, when her teenaged daughter had drowned off the coast

of New England. Elisa herself had attempted suicide, and was only now starting to regain a taste for life. "When I saw you," Breton wrote the next summer, "all that fog, that unspeakable fog, was still in your eyes. How can one be born again, and above all *who* can one be born again after the loss of a being, a child who is everything one cherishes, with even more reason when her death is accidental? . . . I didn't know anything about this drama: I only saw you dressed in a blue shadow." He later confided to an interviewer that, "more than anything," his immediate desire had been to bring Elisa "back to life."

At nearly forty-eight years of age, Breton must have wondered whether he would ever again find love. He was still striking in appearance—his features still chiseled (if wrinkling around the eyes), the wavy mane still abundant (if graying at the temples)—and he still exerted an enormous seductive power on many of the women he met: Jeanne Reynal, for one, said that knowing Breton was like "a bath in molten steel." But Jacqueline's apparent sexual dissatisfaction during Breton's last years with her had reawakened some ugly insecurities that were visible as far back as his earliest experiences with Manon; and her liaison with David Hare—after Simone's with Morise and Suzanne's with Berl—had been yet another instance of the betrayal he found so devastating.

Given his own emotional upheaval, Breton now saw his meeting with the bereaved Chilean as nothing less than mutual salvation. "When fate brought you to me, an enormous shadow was in me," he wrote soon afterward, laying the accent on their common suffering. Moreover, like the most important of his past loves, her coming seemed to have been foretold in one of his own texts—in this case the 1942 "Prolegomena to a Third Surrealist Manifesto," with its intriguing mention of a "marvelous young woman who at this very minute, beneath the shadow of her lashes, is walking round the great ruined chalk boxes of South America." In January 1944, Elisa traveled to Mexico, where at Breton's urging she visited Péret, Remedios, and Leonora Carrington (who had settled there the previous year); but from the moment she returned to New York, she and Breton were virtually inseparable. "There is nothing in the world I've wanted so much as her return," he confessed to Péret.

Which is not to say that the spring passed in harmony, for events that season conspired to plunge Breton into frequent despair. Among the most hurtful of these was his break with Charles Duits, who—perhaps jealous of the attention Breton was now lavishing on Elisa—visited his mentor one final time and behaved like "a perfect little swine." Several months later, the influential art critic Clement Greenberg, who considered Surrealism passé, argued in *The Nation* that the movement's painters rarely violated "the canons of academic technique." (Greenberg then waited for "lightning to

descend," as he told William Baziotes, but no such lightning was forthcoming.) Even *VVV* was nearing an end: the magazine published a fourth issue in April, but Duchamp's waning commitment and the retreat of David Hare ensured that this would be the last. Breton, watching as his efforts to bring Surrealism to America dissolved before his eyes, complained to Péret that three years of struggle had "been a resounding failure; the wind of dispersal is by far the stronger."

And yet, to a large measure, these disappointments were offset by his new relationship with Elisa, whom he celebrated that summer in his next book, a "coda" to the trilogy of *Nadja*, *The Communicating Vessels*, and *Mad Love* called *Arcanum 17* (*Arcane 17*). As he later explained it, the title referred to "the tarot card called 'the Star,' symbol of hope and resurrection," and had been determined by two factors: the resurgence of his love life and the news that summer of the liberation of Paris. In Breton's mind, the end of the Nazi Occupation, and the rebirth it promised, became one with the emotional renewal Elisa had inspired.

The book was begun in August 1944, during a vacation the couple took on the coast of the Gaspé Peninsula in eastern Canada, near the Rocher Percé. It had taken them three days to reach their destination—a "long and painful journey," Elisa recalled—going from New York to Montreal, then some six hundred miles northward along the St. Lawrence River through Indian reservations and ancient French-Canadian fishing villages, and finally to the remote town of Sainte-Agathe. For the next three months, this would be their refuge from the stresses of New York and life in exile. Breton later recalled waking in his cabin early each morning to the sight of the Gulf of St. Lawrence, with its violet-colored island, "so invitingly named Bonaventure," three miles in the distance. With Elisa, he spent the afternoons walking along the rocky coastline, visiting the bird sanctuary, watching the fishermen with their nets, and collecting agates. And in the morning from five until noon, from August 20 to October 20, he worked on *Arcanum 17*.

Of all Breton's works of lyrical prose, *Arcanum 17* is at once the most discursive and the most abstract. Its treatises on social philosophy suddenly veer off into flights of poetic fancy, its observations mix the personal and the historical almost without distinction: from meandering descriptions of Gaspé and loving addresses to Elisa to musings on the problems facing humankind in the coming postwar period and invocations of the early Socialist thinkers (in this case, utopian philosopher Charles Fourier, women's rights activist Flora Tristan, and Saint-Simonian theorist Barthélémy Enfantin). By intermingling these various strata, Breton was trying to lay the ground for humanity's salvation after the now-ending tragedy.

As he saw it, this salvation could only be had via a twofold path. The first path was a

return to natural laws and mythologies, which had been buried by centuries of civilization and its constraints. The second was the female principle, as antithetical to the "male" psychology that fostered war. "May we be ruled by the idea of *the salvation of the earth by woman*, of the transcendent vocation of woman ... [which] will be triumphantly affirmed one day," he stated.

For Breton, women possessed certain elemental powers that brought them closer to the earth and to nature and that men had for the most part disastrously suppressed. This was not the first time he had raised the "problem of woman" in his theoretical writings: in the *Second Manifesto* of 1929, he had defined it as the "most wonderful and disturbing problem there is in the world"; in 1930, with Suzanne in mind, he had attacked "the situation of women in contemporary society"; and in *Mad Love* he had extolled the "eternal power of woman" as "the only power [he had] ever submitted to." But *Arcanum 17*—written under the influence of feminist writings by Fourier, Tristan, and Enfantin; the excitement of impending Nazi defeat; the idyllic Gaspé setting; and, most important, the giddiness of new love—contained Breton's most extended meditation yet on the place of women in society.

In discussing this female principle, Breton invoked the mythological figure of Melusina, a water sprite who had married a human prince, helped him become a powerful lord, and finally, when he disregarded her one request, left the realm of humans to return to that of nature. As she disappeared, she emitted a long, sorrowful wail, a cry of warning against man's denial of natural laws. The bearer of water and rebirth, fertile visionary, Melusina was the perfect symbol for Breton's image of woman as the key to humanity's reemergence after fascism. As the critic Anna Balakian has pointed out, she was a personal symbol as well, a representation of the woman who had brought about his own emotional rebirth after a painful separation, magnified into mythical proportions: "What Elisa has meant to him, Breton thinks that woman in her total sense can mean to a world distraught."

And she was more, for in *Arcanum 17* Breton specifically identified both Melusina and Elisa with the "child-woman," who "has always conquered poets *because time on her has no hold*." Part Lolita, part Salome, part Nadja, the child-woman is the distillation of the female principle, a creature of eternal youth and unsettling clairvoyance, an antidote to the rational order that Surrealism had always opposed. Although the figure of the child-woman had appeared in some of Breton's previous writings—as well as in Breton's sexual attraction to women younger than he, from Nadja to Jacqueline, Clair to Colette Pros—nowhere else had he given her so central a role as in *Arcanum 17*: "It seems to me that in her and in her alone exists in a state of absolute transparency the *other* prism of

vision which [men] obstinately refuse to take into account, because it obeys very different laws whose disclosure male despotism must try to prevent at all costs."

But Melusina, the child-woman, also embodied many of Breton's own sexual conflicts. Given prevailing attitudes, Breton's image of woman as spiritually enlightened and sexually adventurous had a distinctly subversive cast. Much of the Surrealist revolution specifically targeted, and was shaped by, the dominant Catholic morality, which put female sexuality (if it had to be at all) in the service of procreation. By placing the accent on transgression and pure desire ("the only rigor man must be acquainted with"), Breton was in fact positing a substantially liberated world, an Eden without the restrictive taint of "original sin."

At the same time, Breton was in certain respects bound by deep-seated moral and sexual prejudices of his own. His marriages had both ended when he discovered his wife's infidelities; and his relations with a number of women—notably Suzanne and Jacqueline—had foundered when these women tried to play out their own destinies, rather than maintain the romanticized image he had created for them. The child-woman, on the other hand, having no concern but to inspire, provides her lover with support, sex, and undivided attention. Visionary or naive, nurturing as Melusina or imperious as Moreau's Delilah, she is endowed with every power, allowed every freedom, but that of ignoring (or competing with) the poet who celebrates her.*

In this regard, Elisa was the ideal muse for *Arcanum 17*: her devotion and gratitude were unflagging; she had the haunted, fragile beauty Breton found particularly attractive; and she was said to possess the requisite mediumistic gifts (which Breton highlighted on several occasions). She was his Melusina made flesh, the woman "before whom I constantly rediscover the eyes I had at age fifteen for 'Beata Beatrix,'" as he wrote for her on the original manuscript. Vulnerable and passionate, apparently lacking the private ambitions that Breton had had such difficulty accepting in his other wives, Elisa remained his beloved companion for the rest of his life. Although her presence is less

* The wider debate over the place of women in the Surrealist movement, while relevant, is too large to be encompassed here. Suffice it to say that women had participated in the group since the beginning, whether as the men's companions (Simone, Gala, Jacqueline) or as creators in their own right: Leonora Carrington, Valentine Hugo, Meret Oppenheim, Dora Maar, Léonore Fini, and others exhibited in the group's shows; Carrington and thirteen-year-old prodigy Gisèle Prassinos published in its magazines. At the same time (and for a variety of reasons), their status rarely seems to have matched that of the men: seldom does one find a woman's signature at the bottom of a Surrealist tract; or her participation in such collective pursuits as the political debates and the discussions on sexuality; or her face among those who "can't see the nude for the forest." As with most aspects of the movement, responses to this state of affairs—from women and men alike, Surrealist or otherwise—have run the gamut from angry rejection (Carrington, for example, later dismissed Surrealism as "another bullshit role for women") to impassioned defense.

explicit than Nadja's or Jacqueline's had been in previous books, she is the single most important factor behind Breton's spiritual optimism during the writing of *Arcanum 17*.

This optimism, however, did not preclude a somewhat doubtful assessment of post-Occupation France: though the news was generally promising—France's cities were being liberated one by one; the Vichy government had been abolished; intellectual life in Paris was newly flourishing—Breton's memories of the previous postwar era did not leave much room for confidence. While still in Canada, with only sketchy reports of the Liberation, he had warned that once the initial euphoria wore off, people would find themselves just as much at a loss as before. And as more detailed information reached him after his return to New York in the fall, Breton found less and less to inspire elation.

Most notably, the Communist Party had gained enormous influence through its association with the underground Resistance movement, leaving Breton to fear that life under the Stalinists might prove just as oppressive as under the Nazis. And in fact, the Communist writers, Aragon, Eluard, and Elsa Triolet among them, were "purging" French letters of anyone deemed to have collaborated with the occupier, and in many cases were using this newfound mandate to settle old scores. Before it was over, a number of writers and journalists would be dead, including novelist Robert Brasillach (by firing squad) and Aragon's old friend Drieu la Rochelle (by suicide). Aragon, now risen in the Communist ranks, was one of the most intransigent figures in this literary purge. Given the acrimonious nature of their rift, as well as his longstanding opposition to Stalinism, Breton knew that the situation in France did not bode well for him. This, along with his chronic lack of money, made any immediate plans for a return to Paris seem (as he told Péret) "highly premature."

Breton's fears were compounded in January 1945 during a visit from Jean-Paul Sartre. In New York as a journalist, Sartre stopped to meet his famous compatriot and to trade impressions of the latest events. The two men seem not to have agreed on much, nor even to have liked each other, but the Existentialist did provide some first-hand details about post-Liberation Paris. "Sartre particularly stressed the 'terror' that the Stalinists waged over the literary world," Breton later remarked. "As he told it, it was extremely unwise to openly dispute the poetic merits of the Aragon who had written *Le Crève-cœur* [his latest collection]: you ran the risk of not waking up the next morning."

Another worrisome development from Breton's viewpoint was the rise in France of "Resistance poetry" or "occasional verse." Such poetry, grounded in external circumstance and often used as a vehicle for propaganda, had long been one of Surrealism's main targets. Later that year, Breton told an interviewer, "Occasional poetry written in

wartime is an eruptive phenomenon with no future. I admit that it conveyed utterly praiseworthy sentiments, at a time when they were not allowed to take any other form of expression . . . [But] today, occasional poetry has lost all right to live on." Still, despite the bravado, he was concerned about the fate of Surrealist writing at a time when its antithesis was riding so high.

Given these considerations, one can imagine his joy at receiving a slim pamphlet from Péret, published in Mexico that February (the same month as the Yalta Conference) and called *The Dishonor of the Poets*. A rebuttal to a widely read anthology called *L'Honneur des poètes*, which had circulated clandestinely in France during the Occupation—and which notably contained Resistance verse by ex-Surrealists Aragon, Eluard, and Hugnet—Péret's pamphlet excoriated those who had renounced poetry, "the source of all knowledge," in favor of paeans to God, Country, and Stalin. "All told," he wrote, "the honor of these 'poets' consists of ceasing to be poets in order to become advertising agents."

Breton wholeheartedly approved Péret's arguments in *The Dishonor of the Poets*, but many in France were outraged, and few ever forgave Péret for having mocked the poetry of the Resistance from the comparative safety of Mexico. André Thirion felt that *The Dishonor of the Poets* had been written specifically to please Breton, and he deduced that Péret "had not understood [the recent war] in the slightest." The interest of these allegations lies in the fact that, more and more, the same criticisms would be leveled against the pamphlet's spiritual godfather, André Breton.

Arcanum 17 was published on April 15, 1945, by Editions Brentano's, a French-language publishing arm of the famous New York bookstore, which simultaneously published an expanded version of *Surrealism and Painting*, incorporating most of Breton's art criticism since the original 1928 edition. To celebrate the dual publication, a display was designed for Brentano's Fifth Avenue window by Marcel Duchamp, featuring copies of Breton's works, a headless mannequin, and a poster by Matta of a couple making love. Whether it was the mannequin or the poster that offended pedestrian sensibilities is unknown, but before Duchamp had even finished installing the display Brentano's received so many complaints that the management cancelled the entire project. Charles Henri Ford then convinced Frances Steloff, owner of the Gotham Book Mart on West Forty-seventh Street, to take the display. The Gotham, too, received protests—this time from the Vice Squad, which objected to a naked female breast depicted in Matta's poster. Steloff took

the policeman's calling card, wrote "Censored" on it, and pasted it over the offending breast, after which the display remained in place unchallenged.

On May 8, Germany conceded unconditional defeat and the war in Europe came to a close (Japan would follow suit in September, after the bombings of Hiroshima and Nagasaki). That evening, as America celebrated, Breton dined with Duchamp and Man Ray at Lüchow's German restaurant on Fourteenth Street—the only restaurant in town not jammed with revelers. Man Ray recalled that the place was filled with "subdued and weeping" Germans, who all stood when the pianist played songs of the homeland. The three Surrealists remained firmly seated, and Breton contented himself with railing against the cuisine.

The following month, he and Elisa again left New York, this time bound for Reno, Nevada: Breton wanted to benefit from one particular American institution, the quick divorce, and marry his Chilean-born lover. (The process was actually not all that fast; petitioners were required to spend a minimum of six weeks in Reno before a divorce could be granted.) While Breton and Elisa briefly stopped in Chicago, Breton's friend Jeanne Reynal and her husband, Urban Neininger, went to Reno to find them lodgings. But when Breton and Elisa arrived in mid-June, a miscommunication made them miss the Reynals, and they spent their first night in Reno not in a hotel, but dazed and stranded in a gambling casino.

The four travelers spent the ensuing weeks touring the area around Reno and Virginia City, visiting Lake Tahoe, discovering the desert, exploring ghost towns "with their abandoned houses and banging doors, their theaters still showing posters from the last century." Despite the inconveniences of travel—Breton suffered from the heat and the altitude, feared scorpions, and refused to eat fish (which was practically Elisa's only food)—they enjoyed their stay out West. Breton in particular was fascinated by the landscape, which seemed to encompass all the grandeur that New York had lacked. He also enjoyed the company: Reynal was a lively companion, and Neininger, although he knew no French, patiently sat through Breton's long perorations on everything from mineral deposits to philosophy.

On July 30, 1945, Breton officially divorced Jacqueline in Reno; the same day, in another room of the same courthouse, he and Elisa became husband and wife. (Jacqueline herself married David Hare, with whom she later had a son.) In lieu of a honeymoon, the couple traveled back to New York via Arizona and New Mexico, giving Breton the chance to visit the Native American populations that had produced the dolls and masks he so admired. Traveling through the Hopi and Zuni villages—Shungopavi, Wolpi, Zuni, Acoma, Mishongnovi—Breton became "utterly convinced of [the Indians']

inalienable dignity and genius, which contrasted so sharply and movingly with their miserable living conditions." He and Elisa witnessed ritual dances (no doubt fewer than they had hoped, in view of the Hopis' distrust of whites) and were dazzled by a man in ecstasy who dangled a writhing serpent from his mouth—although on at least one occasion Breton had his notebook confiscated by the Indian police, on pain of being expelled from the village. "It's impossible to know whether the objection is on religious or *commercial* grounds," he later wrote. Breton looked for traces of the soul that imbued the artworks he loved, ignoring the fact that, to the Indians, he was just another tourist.

In the meantime, he composed his third epic poem since the outbreak of war, *Ode to Charles Fourier*. A nineteenth-century social reformer, Fourier was the theorist of the "phalanstery," a communelike society whose antecedents went back to Thomas More's Utopia and Rabelais's Abbey of Thélème. In Fourier's view, the ideal society was an association based on harmonious labor rather than commerce, and on a minutely regulated code of desire rather than civic or marital convention. In such a society, he believed, lay humankind's chances of reestablishing contact with the natural world, and with its own happiness.

There were numerous points of contact between Fourier's thought and Breton's. Fourier's concept of elective association mirrored the principle behind the Surrealist circle, while his distrust of commerce found echoes in many of Breton's writings. And his notion of strictly regulated sexual harmony—a more positivistic version of the Sadean orgy, which had been conceived during roughly the same period—could only appeal to Breton, whose own fantasies ran toward such ordered and eroticized gatherings.* Perhaps most of all, Breton prized in Fourier this shared belief in the "lost paradise" of an "erotic civilization," a place where (as he had written in 1934) one could love "The way the first man loved the first woman / In total freedom."

Although Breton had known of Fourier for years, he had not truly become interested in the socialist's theories until his time in New York, when he chanced upon an old edition of Fourier's complete writings; this edition became practically his sole reading matter during the trip West. He began writing the *Ode* in Reno, then continued it while traveling through the Hopi villages. His thoughts on Fourier's social prescriptions merged

* During the time of his separation from Jacqueline, Breton had planned with Swiss writer Denis de Rougemont to hold a three-day orgy in an abandoned mansion, to which each participant would bring one unknown woman, and where each of the masked guests would follow a set of rules as rigorously determined as anything in Sade's *120 Days of Sodom*. Like Breton's musing in the 1930 text "Once Upon a Time to Come" about a castle filled with beautiful but untouchable women—itself inspired by his break-up with Suzanne— this fantasy suggested a desperate desire for control over an unpredictable reality. And, like its predecessor, it was never realized.

with his observations of Nevada life, his awe at the sprawling landscape, and his appreciation of the Indian ethos to produce a vast poetic treatise, freer in form than anything he had yet written and more thematically transparent as well. In the course of the poem, Breton presents an abstract of Fourier's theses, along with bits of his own travel itinerary ("Fourier I salute you from the Grand Canyon of Colorado"; "this 22nd August 1945 at Mishongnovi") thrown in like so many scrapbook captions. And along the way, he interjects bits of social commentary, as if pursuing a dialogue with Fourier himself: "*Poverty swindling oppression slaughter* are still the same ills for which you branded civilization / Fourier they've scoffed but one day they'll have to try your remedy whether they like it or not." More and more in the coming years, Breton's admiration of Fourier would make the nineteenth-century socialist his last great intellectual guide, supplanting even the late Trotsky—and causing him, at least in this instance, practically to lapse into the occasional verse he despised.

Back in New York that fall, Breton renewed his contact with France, paving the way for his return and arranging various publications. To Léon Pierre-Quint he promised a new edition of the *Manifestoes* and French rights to *Arcanum 17*. To the fledgling Editions Charlot, he granted reprint rights to *The Magnetic Fields*, which had been unavailable since the early 1920s (this edition was never published). He asked Victor Brauner to oversee an anthology of "Surrealist texts and documents" (this, too, never happened). And to Gaston Gallimard, he urged republication of *Nadja* and *Mad Love*. Seeking to rebuild his publishing empire, Gallimard was actively courting many of his former authors, and his letters to Breton over the coming months would contain a mix of flattery, hopeful projection, and dismay when a title was sold elsewhere. Breton must have savored this new attitude, so different from the aloofness Gallimard had often shown before the war.

Breton envisioned returning to France in the spring of 1946. It would be none too soon: the postwar situation seemed to be taking little note of Surrealism, which many had pronounced dead with the bygone decade. Articles about the movement were appearing more and more frequently in the literary quarterlies, a change from the almost total silence of the war years, but their largely retrospective cast treated Surrealism as just one more literary movement of the twenties and thirties.

Most disturbing in this regard was a *History of Surrealism* published that year by Maurice Nadeau, the young critic who had earlier served with Breton on the FIARI. Although generally sympathetic, and chock-full of anecdotes provided by former Surrealists, Nadeau's book was anathema to Breton, who disliked what he saw as a vulgarized encapsulation of his movement. And more than this, he resented Nadeau for hav-

ing declared it a "failure" in its wider aims and for having decreed that it was time "to draw up [its] death certificate"—as if Surrealism simply had no business in postwar France.

Before returning to defend his movement, however, Breton went on a lecture tour of Haiti and the French West Indies. He had requested the mission via the Cultural Services in Paris, only to find his candidacy blocked once again, this time owing to the outcome of his trip to Mexico. But thanks to Saint-John Perse (at the time Librarian of Congress), Pierre Mabille (now French cultural attaché in Haiti), and Claude Lévi-Strauss (who was working for the French Cultural Services in New York), he was finally given the go-ahead, and on December 4, 1945, he and Elisa touched down at Bowen Field in Port-au-Prince.

The welcoming committee at the airfield included Mabille, the visiting Wifredo Lam, the requisite French functionaries, and several Haitian intellectuals. Breton posed for the journalists in wide-lapelled jacket and aviator shades; Elisa stood beside him in the tropical sun, wearing a white tailored suit and sensible shoes. "André Breton was impatiently awaited by Haiti's youth," the magazine *Conjonction* reported the following month. "In the past few weeks, the announcement of his arrival had inspired numerous articles in the press. We were finally going to see the Father of Surrealism and hear a powerful voice from modern France." It was a welcome change, the magazine added, from the "dreary characters" that France usually sent to the colonies.

The next evening, Breton was feted by Haiti's leading young poets, and on the 12th *Haiti-Journal* published a long interview between Breton and one of these young poets, René Bélance. "Surrealism is allied with people of color," Breton stated, "on the one hand because it has always been on their side against every form of white imperialism and banditry . . . on the other hand, because there are very deep affinities between so-called 'primitive' thought and Surrealist thought: both want to overthrow the hegemony of consciousness and daily life." Breton was struck by the Haitian landscape, but far more so by the impoverished living conditions he witnessed. These, alongside the muffled discontent with American-backed Haitian president Elie Lescot and the emboldened tone that student newspapers struck when reporting his visit, suggested that very little would be needed to spark a revolt.

Sensing a spiritual ally in Breton, the island's increasingly rebellious youth followed his visit with keen attention. Breton's first lecture, "Surrealism and Haiti," was delivered on Thursday, December 20, at the Rex Cinema, before President Lescot and a mostly white audience of six hundred; but demand among the black students was such that he decided to hold informal literary discussions at a local café every Friday afternoon. Roger

Gaillard, who attended the first session, remembered Breton speaking to them of Surrealism "with such conviction in his tone, such a quiver in his voice, so bright a spark in his eye, that we forgot about his graying hair." Breton's young listeners were also encouraged when they learned that he had refused to greet President Lescot after his lecture at the Rex, which so angered Lescot that he vowed to a journalist, "Mister Breton will not speak again."

It seems, however, that the Haitian youth might have been reading more into Breton's words than he himself intended. Breton's speech of the 20th was largely a retelling of Surrealism, scarcely different from his earlier conferences in Brussels and Prague (from which it borrowed long passages). But the press mainly highlighted his passing observations about the Haitians' poverty, depicting Breton as a political agitator in spite of himself. Moreover, Breton was forced to cancel the Friday roundtables after the first session; as he told Mabille, the students kept trying to pull the discussion toward politics—something that his status as official visitor made problematic.

It was nonetheless Breton who indirectly provided the catalyst for the revolution that erupted soon afterward. On January 1, 1946, the newspaper *La Ruche*, edited by a group of leftist students, devoted a special issue to Breton's speeches in Haiti, laying particular stress on statements such as: "It is absolutely necessary that youth liberate itself from the highly paradoxical inferiority complex which has been unrelentingly, through the centuries, inculcated in it." After praising Surrealism as an "enterprise of liberation," the editorialist warned: "Listen up, Old Men, there are moments in history when people, sick of being controlled with nightsticks by thick-lipped bourgeois and reactionary governments . . . respond with certain measures: you know which ones."

The next day, the police arrested several of *La Ruche*'s editors and suspended its publication. On January 7, students protested the suspension with a strike, which on the 8th spread to Haiti's workers. Breton's next lecture, scheduled for that day, was cancelled; to forestall a diplomatic incident, he avoided going into town for nearly a week. Instead, he spent his days on the beach, visited his friend Wifredo Lam, and in the evenings went with the well-connected Mabille to witness secret voodoo rituals. He was particularly impressed by the phenomenon of "possession," so like the "sleeping fits" with which he had experimented two decades earlier, and yet so dauntingly alien: "The pathetic quality of the voodoo ceremonies assailed me too durably for me to claim the ability to distinguish a generating spirit behind the persistent vapors of blood and rum, or to measure their true impact," he later recalled. "All I could do was absorb their atmosphere, make myself permeable to the unfurling of primitive forces they set in motion." Meanwhile, the streets of Port-au-Prince were filled with rioters calling for

Lescot's downfall, and on January 11 the president, realizing that nothing could stop the insurrection, fled to Miami. By mid-month, France had officially recognized the new revolutionary government.

Breton, of course, was not the cause of Haiti's popular uprising. Speaking to an interviewer later that year, he was quick to point out that "at the end of 1945, the poverty, and consequently the patience, of the Haitian people had reached a breaking point." Nonetheless, as Roger Gaillard noted, "he helped create, beyond any doubt, a climate among young people of my generation, a confidence in ourselves and in the future." And René Bélance added that while Breton "had no intention of disturbing the political order of a country which was not his own," the "banal fact was that to speak of liberty—at that moment—was certainly a subversive act."

Breton stayed in Haiti into the following month, giving further lectures and enjoying Mabille's hospitality, while Elisa visited her family in Chile. Still, he was concerned about his reentry into the United States, for although he had not incited the Haitian revolution, his inadvertent role in it could hardly have pleased the American authorities. Seeking to justify himself, he explained to Saint-John Perse, in a curious piece of backpedaling, that he had simply been "caught up in the various upheavals that shook the island in January." His statements, he claimed, "were twisted by the different factions that tried to use them against each other. For my part, I know that I in no way overstepped the bounds set for me by the terms of the mission I was sent to accomplish, as well as by the hospitality I was shown. To those who sought to use me without my consent, moreover, I constantly quoted Toussaint L'Ouverture's beautiful phrase: 'I cannot be the instrument or plaything of any man.' But some of them were hard to dissuade." Thanks to Perse, who was on good terms with President Harry Truman, Breton in fact suffered no repercussions from the American government and peacefully left Haiti on February 18, one day shy of his fiftieth birthday. Pierre Mabille was not so fortunate: apparently under American pressure, the French consulate relieved him of his post later that month.

In any case, Breton's sojourn in the United States was drawing to a close. He had asked Duchamp to book passage for himself, Elisa, and Aube for April, and he encouraged Péret to join him. (Péret, although desperate by now to leave Mexico, could not afford boat fare; it would be several more years before he saw France again.) Breton was particularly eager to have Aube return with him. With Jacqueline dividing time between the United States and Mexico, he feared a long separation from his only child; on top of which, he did not want the ten-year-old's French to be "tarnished" by the Vermont boarding school she now attended.

Back in New York by mid-March, after stopovers in the Dominican Republic and Martinique, Breton spent his final weeks preparing for his return to France. A foretaste of homecoming came at the end of the month, when he was visited by Albert Camus, in New York as a reporter for the newspaper *Combat*. Breton later recalled "how right the articles that Albert Camus was then publishing in *Combat* sounded from afar, and how they went to the heart of the matter." The two men agreed that the greatest danger facing intellectuals in France was the credence given Stalinist principles, notably the "impudent idea . . . that the end justifies the means." But despite their intellectual affinity, Breton's talk with Camus seems to have had no more lasting impact than had his meeting with Sartre the year before.

Finally, in late April, Breton, his new wife, and his daughter sailed from New York, bound for Le Havre. In the 1950s, he would summarize his five American years in just a few brief mentions, mainly concentrating on the creation of *VVV*. "Where my freedom is limited, I *am* not, and my temptation is to move on very quickly," he explained. These years now behind him, Breton looked with excitement and trepidation toward home.

THE SITUATION OF SURREALISM AFTER THE TWO WARS

(May 1946 – December 1949)

FROM THE MOMENT OF HIS RETURN, Breton nurtured hopes of reestablishing Surrealism at the forefront of French intellectual life. He harbored a faith that humanity would now rise up against the social structures (capitalist and Communist alike) that had once more led it astray, and that Surrealism, as a longstanding critic of these structures, would be called upon to play a major role in rebuilding French society. But if anything, the postwar period would find Breton more at odds than ever with his times, and he would soon see his hopes trammeled by the grim realities of human forgetfulness. As he later admitted, he had left New York without "a very clear idea of the intellectual situation in Paris."

Breton, Elisa, and Aube reached the port of Le Havre on May 25, 1946, and the following day, after an absence of almost six years, Breton again set foot inside 42 Rue Fontaine. "Mr. André Breton is moving back into his Montmartre studio," *Le Figaro* reported on June 1. "A new lock on the front door shows that some indelicate visitors had come by in his absence . . . Under his abundant mass of gray hair, the writer seemed to be altogether moved by the familiar universe he was rediscovering."

Friends had more or less watched over the apartment during the war, and Louis Breton had kept up the rent payments. Apart from items removed for safekeeping, Breton's beloved paintings still covered the walls, and the shelves still held his masks and fetishes (to which he now added his American acquisitions). Still, some items were missing, most notably several priceless manuscripts by Sade—by far the greatest loss, from Breton's viewpoint. In addition, the heat was off, telephone service had been cut, windows had been broken, and water leakage had damaged the walls, requiring lengthy physical restorations. Several months later, Breton complained to Jean Paulhan that he still hadn't managed to "repair this wall or heat this apartment that the war dilapidated." The telephone, fortunately, proved less problematic: although the normal wait for service was over a year, André Thirion, former Communist militant and now a Gaullist city councilman, was able to speed up the reinstallation.

There was also the matter of housing ten-year-old Aube, who would be sharing the

small studio with her father and stepmother. While Breton and Elisa took the single bedroom, the young girl, missing New England and Jacqueline, lay sleepless in a living room filled with sound and light from the cabarets below. She later likened the studio to "an aquarium, closed but transparent. You saw the outside world, but you were cut off from it." In any event, the arrangement was to be short-lived: Aube would return to her mother early in the new year, not seeing Paris or Breton again until 1949.

Breton had predicted in *Arcanum 17* that he would find quite another France from the one he had left behind, and in certain ways this was true. The country was groping out of one of the darkest episodes in its history, and its euphoria at liberation contained a strong dose of vengefulness against those who now embodied France's ignominy. Pierre Laval, architect of the Franco-Soviet Pact and of the Vichy collaboration, had been tried and put to death, and Pétain given life imprisonment. In October, several months after Charles de Gaulle's resignation from the provisional postwar government, the three major parties began fighting over the fledgling Fourth Republic as if over sheets at a white sale. (Socialist Vincent Auriol would finally emerge as president in January 1947.) The economy, even worse now than it had been during the Occupation, left many Frenchmen coping with rampant shortages and black marketeers. Meanwhile, Paris itself was overrun with American soldiers, whom the population greeted not with the joyous complicity of fellow victors, but with the muted resentment of the liberated.

At the same time, it was hard to credit the idea that much was truly different, or that any "rebirth" showed signs of occurring. The old political rivalries and intolerance wore on. The Communists purged their political enemies with blacklists and firing squads, and the interim cabinet, having only just finished one war, began another in Vietnam that autumn. (In protest, the Surrealists issued a tract in April 1947—their first since Breton's return—called *Freedom Is a Vietnamese Word*.) Nor had the fresh nightmares of Dachau and Buchenwald awakened the public to the insidious durability of racism. "Those weren't cremation ovens," a vaudeville comic cracked in an exemplary flourish of French enlightenment, "they were incubators!"

As for Breton himself, his long absence now made him seem to many an outsider, even a coward. In addition, his warnings about Stalinism only served to fuel accusations that he had become "reactionary." This view was particularly promoted by the Communists, who billed themselves as "the party of the executed ones" (a phrase coined by Elsa Triolet) and "the first party of France," and who energetically set about discrediting intellectuals hostile to their interests. "When Breton came back, he became a target," one later Surrealist recalled. "They stopped just short of branding him a traitor:

he'd been a friend of Trotsky's, had spoken out against the Moscow Trials, and hadn't been in the Resistance."

Breton's Stalinist accusers now included some of his oldest friends. René Char, who had emerged from the war a major Resistance poet, declined an offer to rejoin Surrealism, and instead half jokingly remarked to a young colleague: "You know, I think Breton will have to be shot." Eluard, who lacked even Char's dose of humor, snipped to Gala, "Mr. Breton, whom I have not met (or glimpsed) since his return, has become petrified in a historic pose, very much the exile . . . It's not even painful to me anymore to see Breton supported by all the worst kind of reactionaries. As for me, I am entirely at the disposal of my party [and] fully approve its politics." (Which didn't stop him from ordering a first edition of *Arcanum 17* from New York, "well wrapped so it won't be damaged—I'm still a bibliophile.") Only Aragon—ironically, the one Breton most feared—showed a certain nostalgic indulgence toward his old friend. He made up for it with his intolerance toward others. "Aragon rode around like John Wayne wearing a badge that said 'PCF,'" said one witness to the period. "He was inordinately ambitious, a politician *raté*." Perhaps not too *raté*: his industry would win him a place on the Party's central committee in 1954.

The Stalinists were not Breton's only nemeses at this time. More serious, in fact, was the general neglect that faced Surrealism, the widespread attitude that portrayed it as an anachronism, out of step with the new postwar reality. The period was witnessing a proliferation (a "total confusion," Breton said) of literary currents, movements, periodicals, tracts, and manifestoes by a generation that had emerged with the war's end. Some of these new figures spoke to the immediate political dilemmas of the atomic world, while others dipped unabashedly into the attractions of (largely American) popular culture: the most prominent of the latter group, the young novelist Boris Vian, pastiched detective novels by day and blew hot jazz in the boisterous clubs of Saint-Germain-des-Prés at night.

Of all these currents, none was drawing more attention than Existentialism, a movement that—although formulated before the war, and primarily by a German—seemed to crystallize the hopes and anxieties of many who had lived through France's occupation. Sartre, Existentialism's spokesman, was in fact enjoying great notoriety in this period, and the enthusiastic youth now swarming around him at the Deux-Magots were reminiscent of the spirited twenty-year-olds who had once surrounded Breton at the Cyrano. Breton later dismissed Existentialism as "night school" and its concerns as "academic quarrels" (while Sartre, in the words of one critic, wrote Surrealism off as "a phenomenon from after the other war, like the Charleston and the yo-yo"). Nonetheless, the

questions raised by the Sartre, Camus, and Beauvoir appeared far more relevant to a society grappling with memories of defeat and collaboration than did Breton's raptures over Hopi artifacts or his exhuming of nineteenth-century utopians. For many, as one historian put it, "Breton seemed to be preaching from another planet."

Paradoxically, Surrealism was also more acknowledged at this time than ever before. Fledgling periodicals indebted to the movement had sprung up after the war, and several literary groups claimed to be its heirs. The new generation showed an unprecedented familiarity with Breton's writings, as *Nadja*'s luxurious quotient of marvels and the bygone polemics of the *Manifestoes* attracted scores of new readers seeking romance and intellectual excitement. At first, this situation seemed to please Breton, who jubilated to Péret: "The letters from young people and strangers are piling up on my desk by the *hundreds*; this sizes up the current situation better than anything else . . . Everything is happening as if the Surrealist 'revolution' had taken place, as if there were concrete proof of it from every side."

But as would grow increasingly clear, it was a different Surrealism that now captured people's imaginations, one mythologized by its legendary scandals, circumscribed by two wars, encapsulated by Nadeau's *History*, and digested in scores of magazine articles that debated the "position of Surrealism" and the "permanence of Surrealism," that "took stock of Surrealism" or wondered whether it had been "a failure." The attention, while sweet, carried an aftertaste of formaldehyde, a sense that Surrealism was slowly hardening into its own relic, of which the newly returned Breton constituted the prize specimen. Marcel Jean later described how groups of young people would spontaneously form at cafes "to ponder André Breton in the flesh, sitting before his aperitif," then wander off again after a drink or two, leaving Breton to pick up the tab.

The fact was, Surrealism now had an established history, one that reflected on all the movement's future members (no matter how youthful), and on all of Breton's stances (no matter how current). Breton, however, refused to see Surrealism as anything but an ongoing movement—one that, as the locus of certain eternal phenomena, would never age. To the end of his life he would fight, write, and argue for its continued relevance, stressing those aspects that both concerned and transcended the political and social realities of the moment. But like a typecast actor, he would always be identified with an intellectual situation that, for many, had been relegated to prewar history. Already one could foresee the gloating dismissals to come, such as this one by Georges Hugnet several years later: "Surrealism, or rather its embalmed corpse, is now in the hands of the professors."

Still, there was at least one figure from Surrealism's history whose violence and verve had remained intact, against all odds. Antonin Artaud had finally been released from the

Rodez asylum in May, and had returned to Paris on the same day as Breton. In the space of nine years, the handsome actor had become a wizened crone, face creased and bony, eyes ringed, mouth permanently set in a downward rictus. Though barely in his fifties, he appeared to be seventy-five, as if youth had given way to old age without transition.

Artaud and Breton met again on June 1, for the first time in nearly ten years, at a small restaurant in the Latin Quarter. (It was during this first reunion that Artaud evoked Breton's supposed death in Le Havre in 1937, which Breton, in his embarrassment, tried vainly to deny.) Given the two men's shared history, Breton was also asked to preside over a benefit for Artaud, organized by several of his friends, to be held at the Théâtre Sarah Bernhardt on June 7. He was hesitant at first: having returned to Paris only two weeks before, he did not yet feel ready to make a public appearance. Still, on the evening of the 7th he stood before a capacity crowd to deliver a homage to Antonin Artaud.

Some in the audience were disappointed, particularly those who felt (not altogether unjustly) that Breton's intervention showed more concern with Surrealism's place in the current literary scene than with Artaud himself. For many others, however, Breton's words—and his very presence—were inspiring. Twenty-two-year-old Philippe Audoin, who later joined Surrealism, remembered Breton as "'larger than life.' His face had grown both harder and heavier; the creases that underlined its expressions, whether distant or familiar, formed the countenance of a male 'Medusa' who could breathe life into stone."

But could he breathe life into Surrealism, after so long a hiatus? The answer was far from certain. The same newspapers that had once vituperated against the movement's scandalous behavior now jeered at its sedentariness. "Quite a spectacle to see the old master André Breton, flanked by fifteen aging disciples and smoking his evening pipe with slow dignity on the terrace of the Deux-Magots," quipped *Le Figaro*'s Claude Mauriac. "Of the excommunications of yesteryear, of the fracas of past battles, nothing remains but the tender complicity of old veterans." The homecoming Breton had dreamed about for so long was proving anything but triumphant.

<div align="center">✳</div>

In July, Breton resumed his tradition of summer vacations in Lorient, introducing Elisa to his parents. The war had devastated the once prosperous coastal town, reducing the population to a scant 300 and most of the buildings—the Bretons' house was one of the few exceptions—to rubble. "Lorient, which I hated more than any city in France, is fair-

ly attractive in its ruin," Breton wrote to Léon Pierre-Quint on July 25. "All the walls have gaping holes, and from the window I can see three or four layers of houses with the marks of their former chimneys and staircases. It's fascinating the way Braque's first paintings were." Fascinating or not, however, the surroundings were hardly restful, and Breton soon took Elisa and Aube to the inland town of Huelgoat, located—as a tourist guide put it—"in one of the loveliest parts of Brittany and surrounded by wooded mountains, ravines, and boulders."

The family spent the month of August at the Grand Hôtel d'Angleterre, set between a magnificent lake and a large forest. It was there that Breton met eighteen-year-old poet Alain Jouffroy, the first of many young admirers who would come to populate the Surrealist group in the postwar decades. On vacation with his own family, Jouffroy was having lunch in the hotel dining room when he overheard a man at the next table discoursing on Romantic poetry, "which did not keep him from making his daughter recite the multiplication tables at dessert." Although he had "read and reread *Nadja*," Jouffroy didn't at first recognize Breton; still, he was intrigued enough to overcome his shyness and enter into conversation with the neighboring diners. After lunch, he asked the hotel manager for the name of his arresting fellow guest. The manager "looked it up on the register, mumbling: 'Mmmmmmmm . . . he's a writer from Paris . . . not very famous . . . here it is . . . Breton.' 'André?' I said. I couldn't believe it. 'Yes, that's right, André. Why, do you know him?'"

That evening, Jouffroy approached Breton again, and over the next several days he spent many hours conversing with the Surrealist in his hotel room—a room that, with the rock crystals Breton had gathered and Elisa casually smoking on the bed, struck him as "the eye of a tornado." As Jouffroy recalled, Breton was particularly eager to know how young people had experienced the war: "Breton was always interested in what the new generations were doing. In some way, he wanted to recapture lost time; he must have done it systematically with every member of my generation when he returned to France. What fascinated them, intrigued them? What did they think of Camus, of this one, of that one?" These conversations, said Jouffroy, made him feel as if he had become, "simply because Breton was questioning me, the pivot of a mental revolution to be won." Before leaving Huelgoat, Breton urged the young man to look him up in Paris.

Breton himself returned to the capital in September, but by early the following month he was back in Lorient: Louis Breton had sent a telegram to say that Marguerite was dying. Breton left on the morning of October 8, going back to the city that, despite his professed hatred of it and of his parents, had seen him return nearly every summer of his adult life. He arrived this time to find his mother—the woman who for so many

years had embodied everything he despised, and who had instilled in him an ambivalence toward women that swung from feverish exaltation to icy contempt—helpless and delirious in her last moments of life. Barely aware of her surroundings, Marguerite called persistently for Aube, perhaps the only creature on earth whom she had unashamedly loved; but Aube was not there, only André. His presence was not enough to transcend the conflicts of a lifetime: Marguerite Breton passed away on October 13, 1946, aged seventy-five, apparently having made no peace with her only son. Breton stayed in Lorient for the burial, then returned to Paris immediately afterward. A few days later, he offhandedly related to Paulhan that "my mother just died"—one of several factors, he said, that had lately conspired to "whittle [his] time down to practically nothing."

By the time of his mother's death, Breton's own health was becoming problematic. Several months after his return to France, he suffered headaches and related symptoms serious enough to keep him housebound for two weeks; laboratory tests indicated severe anemia. In early 1947, another illness left him, as he complained to a friend, "truly in poor physical shape, forced to think about doctors. I don't go out anymore, don't smoke anymore, don't drink anymore. The most bothersome part of it all is that I can't even hold a long conversation: so what's the point of anything?"

Between bouts of illness, Breton began the arduous process of settling into the life that the war had interrupted, and most immediately to securing an income. He arranged a position as editor-at-large for Pierre-Quint's Editions du Sagittaire, overseeing a line of verse and prose works—a job that, following French publishing custom, would earn him a portion of the advance and a 2 percent royalty on every title he acquired. He also signed a contract with Sagittaire for a volume of his own about the Hopi Indians, although neither this nor the editorship ultimately panned out. Of more consequence was Pierre-Quint's plan to publish a French edition of *Arcanum 17* the following year—although this arrangement immediately drew a dismayed letter from Gaston Gallimard, who had repeatedly asked Breton for work and who now expressed his regret at having lost "Arcanum 19."

Gallimard was not merely being polite: as a shrewd businessman, he had quickly recognized that, even as Surrealism was widely being dismissed as passé, Breton's own stature as a writer with long-term sales potential was growing considerably. An informal poll held by *Combat* named Breton one of the top twenty French writers of the day, trailing superstars Gide, Camus, Sartre, Malraux, Colette, and Claudel, but ahead of such hot properties as Cocteau, Prévert, Aragon, Queneau, Céline, and Georges Simenon. All the more so in that Breton had not stopped drawing attention since his

return to Paris. The next several years saw a rising number of articles and books about him, as well as numerous interviews in which he was able to detail his latest preoccupations and deliver dyspeptic assessments of the modern age.

As satisfactory as these manifestations might be, of course, they were not sufficient unto themselves, and Breton also devoted much of his energy that fall laboring to reassemble an active Surrealist group. He resumed the practice of café meetings, establishing quarters at the Deux-Magots or, when Saint-Germain-des-Prés became overrun with trendy Existentialists, at the deliciously old-fashioned Café de la Place Blanche. One witness later remembered Breton at the Deux-Magots, "camping defiantly on the very terrain of the Existentialist enemy . . . When he leaves the café after the weekly palaver, he swells his large chest, turns his muzzle toward the sidewalk tables, sweeps the street with a cold stare . . . and finally heads off to the metro."

But even more than in refugee-filled America, talented members were hard to come by. Many of Breton's former collaborators, such as Tanguy, Duchamp, Matta, and Péret, were still across the ocean, some of them permanently. Others, notably Maurice Heine and Robert Desnos, were dead: the latter, arrested by the Gestapo for harboring a fugitive, had succumbed to typhus in 1945 after internment in a Czech concentration camp. Still others, such as Georges Bataille and Jacques Prévert, with whom Breton had renewed friendly relations, remained at the fringes of any new activity. And most were either patently hostile to Surrealism—such as Aragon, Eluard, Sadoul, and Tzara—or had pledged their allegiances elsewhere: Thirion to de Gaulle; Leiris, Soupault, Queneau, Giacometti, and Dominguez to their own pursuits; Masson, Naville, and Hugnet to memories of earlier breakups that they were unwilling to forgive.

There were still, of course, some prewar Surrealists in the group, including, with varying degrees of presence, Victor Brauner, Marcel Jean, Henri Pastoureau, Hans Bellmer, Maurice Henry, Pierre Mabille, Georges Henein, Jehan Mayoux, and Jacques Hérold. There were the Czech painter Toyen and her compatriot, the poet and collage artist Jindrich Heisler, as well as the critic and filmmaker Jean Ferry (born Lévy), associated with the group since the 1930s, who had since married Breton's ex-lover Marcelle Ferry. There was also Patrick Waldberg, who had known the Surrealists in New York; and Charles Duits, now living in Paris, who renewed sporadic contact with Breton. And there was Elisa, who seems to have attended the café sessions more faithfully (if not necessarily more actively) than any of Breton's previous companions.

In January 1947, many of them joined Breton in planning the next international Surrealist exhibit. For Breton, the exhibit would serve not only to demonstrate the movement's evolution since the last major Paris show nearly a decade before, but also to deter-

mine "whether Surrealism, as a mental discipline chosen by a small number of individuals scattered all over the world, has withstood that disaster [the war] and whether it was greatly disrupted by it." The site chosen for the exhibit was the Galerie Maeght on Rue de Téhéran. A prospectus was drawn up and mailed to potential contributors.

One of those who received the prospectus was Antonin Artaud, whose wartime drawings Breton wanted to include among Surrealism's latest works. But Artaud refused, and in several long letters he castigated the Surrealists' decision to hold an exhibit "in a painting gallery, in one of those places . . . where they sell the sweat of men, the perspiration of suicides"—for all intents and purposes terminating his contact with Breton. One year later, on the morning of March 4, 1948, he would be found sitting lifeless against his bed by a caretaker at the sanatorium where he spent his final months: an overdose of chloral hydrate, though whether voluntary or accidental remains unknown.

Meanwhile, Breton had a much more public run-in with another old colleague, Tristan Tzara, over Tzara's March 17 lecture at the Sorbonne (the site alone speaks volumes) on "Surrealism and the Postwar Period." Trouble was promised from the moment Breton entered the hall: "In an auditorium bursting with onlookers," wrote one witness, "Breton entered like a huge lion"—an epithet people never tired of—"escorted by several faithful followers; hearing his name whispered on all sides, he raised his head, rounded his thumb and index over one eye, and through this improvised monocle contemplated the audience with superb arrogance."

Then the speaker took the stage. His own famous monocle having been replaced by sage horn-rimmed glasses, his Dadaist iconoclasm having yielded to Stalinist orthodoxy, Tzara chided Breton for his "absence" during the war and declared, "History has passed Surrealism by." Furious, Breton rose and, standing on a bench in the ancient Richelieu amphitheatre, finger pointed accusingly at the stage, shouted out that Tzara "should be ashamed to be speaking in such a place!" When Tzara continued with an insinuation about those who judged the Occupation "from high atop the Statue of Liberty," a livid Breton jumped onstage and (for lack of a better challenge) defiantly downed the speaker's glass of water. He then stormed out of the amphitheatre, taking a large portion of the audience with him.

One of those who followed Breton out of the Sorbonne was a young Iranian student named Sarane Alexandrian. "The spectacle galvanized me," recalled the future critic and art historian; "I ran down the steps several at a time to throw myself into the fray at Breton's side." After Breton's noisy exit, Alexandrian joined the Surrealists at a nearby café. The group he met there was younger than one might have thought: more and more, Surrealist demographics were beginning to show a generational shift, as newcom-

ers, nearly all of them under thirty, came increasingly to replace their venerable predecessors. In 1946 and 1947, these younger members would notably include Alain Jouffroy; the philosopher and sociologist Nora Mitrani; Stanislas Rodanski, a scholar of Hegel and Tibetan yoga; the poets Yves Bonnefoy and Claude Tarnaud; and Henri and No Seigle, painters who worked in collaboration. There was also the Mexican poet and critic Octavio Paz, who had met Péret in his homeland during the war and who began frequenting the Paris group on his arrival in France in 1946. Although few of these new members would participate in the movement for very long, it was they, and others of their generation, who represented Surrealism's hope for a future.

And yet, despite such memberships, Breton soon found himself dissatisfied with its current tenor. Shortly after the Tzara lecture, he complained of the reticence that so many promising young talents showed toward the movement. "More and more, it seems to me that the most original minds of the current generation—I believe I've met some of them—are preferring to wait for other occasions to come forward," he told Georges Henein. He longed to be reunited with Péret, seeing his old friend's return as the way out of Surrealism's current impasse—much as, after the last war, he had anxiously awaited a Vaché who would never arrive. "Everything will be different when Péret gets here," he now promised his young recruits.

Breton, like the public, was coming up against a line that the war had drawn between Surrealism's first two decades and the current period, an implicit comparison between the movement's earlier members and its new roster. It is not that these new members were necessarily less "talented" than their predecessors (in any case, as Breton had once bragged, "We do not have any talent"), but rather that they were on some level bound by a preexisting corpus of writings and history; whereas Péret—not to mention Soupault, Desnos, Eluard, Aragon, and others since departed—had invented Surrealism day by day, with no maps to consult or guidelines to honor. This unavoidable presence of a history, of something to "live up to" (consciously or not), was one of Surrealism's main pitfalls after the war. For many outside observers, Surrealism simply never recovered its verve, and persisted solely on the strength of Breton's obstinacy. Breton himself spent many afternoons over the coming years pacing around his studio on Rue Fontaine, grumbling to Elisa about the course of events, his doubts as to Surrealism's future, the incapacities of the people who now surrounded him. As Marcel Jean put it, "He didn't expect anything brilliant from the newcomers who crowded in at the café."

✳

In June 1947, Editions du Sagittaire published the French edition of *Arcanum 17*. This was by no means Breton's only book during this period: even before his return, Gallimard had reissued *Nadja* and *Mad Love*, Sagittaire had finally released *Anthology of Black Humor*, and the magazine *Fontaine* had published a pamphlet version of "The Situation of Surrealism Between the Two Wars," Breton's 1942 speech at Yale. More recently, Sagittaire had put out an expanded edition of the *Manifestoes*, and *Ode to Charles Fourier* had appeared as a book designed by Frederick Kiesler. But for most critics, *Arcanum 17* was Breton's first significant statement in ten years, and, based on the many lengthy and respectful reviews it received, it appears they were glad to have him back.

Arcanum 17 coincided with the opening on July 7 of "Surrealism in 1947" at the Galerie Maeght. Like the 1938 Beaux-Arts exhibit, "Surrealism in 1947" offered a wide-ranging view of the movement's visual and philosophical production over the previous decade. It featured the works of eighty-six artists from twenty-four countries, not all of them Surrealists. Explaining the seemingly heterogeneous choice, Breton wrote: "What makes a work of art a Surrealist one is, first and foremost, the spirit in which it was conceived. In the case of a visual work, the value we place on it may depend either on the visionary powers it demonstrates, or on the sense of organic life that emanates from it." The lengthy catalogue contained articles by Breton, Georges Bataille, Henry Miller, and a host of others; its cover, designed by Duchamp, featured a three-dimensional woman's breast made of soft rubber and the words "Please Touch."

As would several of Breton's endeavors during this period, the 1947 exhibit stressed the need for a spiritual component in the rebuilding of postwar society. "In the 1947 exhibit, Surrealist aspirations, whether poetic or visual, must be able to be expressed simultaneously, their common denominator residing in a NEW MYTH to be brought out," Breton had written in the prospectus. The experience of the exhibit, he said, was primarily meant to recreate "the successive stages of an INITIATION." Accordingly, Frederick Kiesler, the exhibit's designer, conceived a series of passages that would act cumulatively on the viewer. A "superstitions room" offered a "synthesis of the major existing superstitions," which visitors were forced to "overcome" before moving on. The next room (by Marcel Duchamp), in which one had to skirt both "curtains of multicolored rain" and billiard players, led to a darkened space furnished by Breton with twelve lighted octagons, each containing a pagan altar devoted to "a creature, a category of creatures, or an object LIABLE TO BE ENDOWED WITH MYTHIC LIFE."

One who figured in the exhibit only as a Surrealist marginal, rather than in his usual place of honor, was Picasso. Breton had solicited the painter's involvement in virtually every Surrealist group show to date, often with surprisingly favorable results. But short-

ly after his return to France (probably in August 1946), he and Picasso had met by chance near the latter's residence in Golfe-Juan on the Côte d'Azur, and had a fight that put an end to their twenty-five-year friendship.

Accounts vary widely as to the substance of the argument. According to one version, Breton and Elisa met Picasso while bicycling and, after the initial hugs, quarreled over when Breton could see the painter's studio: Picasso, en route to the dentist because of a toothache, insisted on postponing the visit, while Breton adamantly maintained that it was "now or never." When it became clear that neither would give in, Picasso drove away, leaving Breton and their friendship behind. For her part, Françoise Gilot, Picasso's companion at the time, gave the argument a more ideological cast: she remembered the Spaniard rushing down from his balcony after glimpsing Breton in the street and stretching out his hand "in a spontaneous, friendly way"—only to have Breton rebuff him. "I'm not at all in agreement with your politics since the Occupation," Breton reportedly told his old friend. "I don't approve of your joining the Communist Party nor with the stand you have taken concerning the purges of intellectuals after the Liberation." Picasso then objected that, while *he* didn't approve of Breton's flight to America, he placed his friendship for the Surrealist above their philosophical differences. But Breton retorted that Picasso's political affiliations (for which Breton blamed Eluard) left "no room for compromise," and he informed the painter that they would "never see each other again." Breton himself later contested this version (while not accrediting the other), telling *Paris-Match* in 1965: "The dialogue [Gilot] attributed to us is made from whole cloth: we never broached the subject of politics and I never refused to shake his hand."

The fact nonetheless remains that Breton *did* reproach Picasso for his membership in the Communist Party, the opportunism that kept the painter in good standing on both sides of the political fence—and, no doubt, his perennial refusal to join Surrealism, despite Breton's wooing. In 1947, after having granted the painter an unusually small place in the Maeght exhibit, Breton wrote: "The press keeps on feeding the dumbest sort of idle curiosity about the persona of Picasso and never tires of the idea that 'the most expensive painter in the world' is a member of the Communist Party, while it carefully avoids tackling this contradiction." Breton's rebuke—and his relative exclusion of Picasso from the exhibit—might have been mild, but the distance it marked from his earlier flattery was considerable.

By and large, reviews of the show demonstrated the same balance of admiration and scorn that had greeted the 1938 exhibit (comparisons to which were obvious, and frequently made). The ex-Surrealist Georges Limbour lamented the preponderance of "swingy little teenagers" in the audience, "who have only recently learned of Surrealism's

existence," while *La Nef* praised the "still youthful and gushing inspiration" in the displayed works. The Communist *Lettres françaises*, which Aragon edited, pooh-poohed the exhibit as "a rehash of old tricks, worn out from overuse"; *Les Nouvelles Littéraires*, in one of many snipes, rated the show suitable "for all those good folk who come from the provinces this summer to visit the capital"; and, somewhat more notably, a group of youngsters calling themselves "Revolutionary Surrealists" took Breton to task for his renunciation of social upheaval in favor of an "odious" penchant for the occult. But as with the 1938 exhibit, all the poor reviews in the world didn't seem to discourage the curious public. On the contrary, controversy played its classic trick of drawing in the crowds for the next three months.

Breton, who left on vacation shortly after the exhibit opening, continued to monitor its reception from the Auvergnat town of La Chaise-Dieu. "As I see it, it won't go very far," he wrote Henri Pastoureau about the Revolutionary Surrealist tract. "If it weren't so hot (101 in the shade at 4,000 feet) we might plan a giant offensive when everyone gets back . . . I think the exhibit was good (as Duchamp wrote me, it's wonderful to be so despised at our age)."

The time was in fact ripe for a "giant offensive," for in 1947 and 1948 Surrealism underwent some of the most damaging attacks in its history. Unlike the bourgeois fury of the 1920s, these attacks were more substantial, coming as they often did from the Surrealists' peers, and generally making the same discomfiting argument: that Surrealism had become sedentary and bourgeois, if not flatly reactionary. Particularly given Breton's vocal rejection of Stalin—at a time when "the Father of the People" had become Communism's answer to the Church's "Son of Man"—it was easy to promote the idea among leftists that Breton had sold out to his worst enemies.

Among the main levelers of this argument were the same young Revolutionary Surrealists whom Breton was trying to ignore that summer, but whose demonstrations, at least for a while, seem to have caused him a certain amount of worry. Originally launched in Brussels at war's end, the Revolutionary Surrealist movement soon counted some forty active members in Belgium and Paris. The Revolutionary Surrealists neither opposed nor renounced Surrealist principles, but rather deemed that Breton and his circle were no longer worthy of their rebellious past. They published several tracts and held well-attended meetings in mid-1947, seeking to bring Surrealism back into line (or so they saw it) with the revolutionary aims of the PCF. But Breton wanted none of their reconciliations, and the Communists, having contended with one "Surrealist revolution" before the war, asked that it be left "out of these dismal buffooneries" altogether. Revolutionary Surrealism soon faded away—although not before one of its number,

eighteen-year-old Jean-Louis Bédouin, defected to Breton's camp in the fall of 1947. Indeed, Bédouin, future author of several important histories and anthologies of Surrealism (as well as of a flattering monograph on Breton in 1950), would become the first member of long standing to join the postwar group.

Still, for every Bédouin, there seemed to be several others who kept their distance, or whose tentative approaches to Surrealism ended in failure. Such was the case with the poet Isidore Isou, prime mover of the avant-garde Lettrists, whose experiments with linguistic matter were winning them a certain notoriety as the "new Dadaists." Seeking to enhance his group's visibility, Isou invited Breton late in 1947 to attend a Lettrist demonstration, but at first Breton declined—not wanting, as he told Isou, "to serve promotional ends." The two men did arrange to meet at the café, but before long Isou's youthful iconoclasm ran up against Breton's need for fidelity, and relations ended almost as soon as they began. In 1948, Isou published his "reflections on André Breton," whom he depicted as alternately obsequious and arrogant. Breton's attitudes toward both people and things, he wrote, were "based on apoplectic rages or infatuations . . . To understand his changes of direction you have to think in terms of his 'periods,' his menstruations."

This episode indicates just how much things had changed during the war. On the one hand, regardless of Isou's petulance, it is clear that Breton had become the great reference for a certain category of young writer. But at the same time, his standing was much more precarious than it had been: no longer the object of unreserved devotion or scorn, Breton was being held up to close scrutiny by an entire generation of poets whose admiration did not preclude a sharp critical exam. Surrealism's children were coming of age, looking back at their father, and finding him wanting.

The Communists, meanwhile, pursued their own attacks on Breton. In 1948, former Grand Jeu member Roger Vailland, now a Stalinist proselyte, published a broadside called *Le Surréalisme contre la Révolution* [Surrealism versus the Revolution]. Vailland, who still smarted from his drubbing at the 1929 Bar du Château meeting, condemned Breton for such bourgeois concessions as the 1947 exhibit and his 1946 interview in *Le Figaro*. Unfortunately for Vailland, he lived in the proverbial glass house: in rebuttal, Breton merely unearthed the encomium of police commissioner Jean Chiappe that had earned his censure twenty years before.

· During the same period, Jean-Paul Sartre published a widely read article in his magazine, *Les Temps modernes* (later expanded in his book *What Is Literature?*), which—although couched in more impressive terms—scarcely differed in its essence from the arguments made by the Communists, or even by most lumpen journalists: that "the pretty lollipop" of the 1947 exhibit was a sweet for which only snobs had a taste; that the

bourgeoisie had always tolerated Surrealism's "monkey shines"; that all of Breton's verbal scandals were mere literature, and irresponsible literature to boot. For Sartre, who placed reality squarely in the realm of the conscious, Breton's attempts to unify conscious and unconscious action into "a certain point of the mind" at which dualities "cease to be perceived as contradictions" were frivolous at best. "The deep source of the misunderstanding," he explained, "lies in the fact that the Surrealist is very little concerned with the dictatorship of the proletariat and sees in the revolution, as pure violence, the absolute end, whereas the end that Communism proposes to itself is the taking of power, and by means of that end it justifies the blood it will shed."

Sartre was a shrewd critic, and from a strictly pragmatic angle his analysis was disturbingly apt—so apt that it raised considerable hackles among the Surrealists. The fact was, Breton was no politician, and his approach to the social question was largely theoretical; he offered no plans for government, only indicated possible starting-points (such as his recommendations during that period of Fourier, Helvétius, and other "alternative" social thinkers of the past). But Sartre, like the Communists before him, failed to appreciate what might have been a broader lucidity. Breton's political vision had less to do with entitlement than with human integrity, with leading people to envision "a less unreasonable *management* of human interests" than had previously existed. By emphasizing "the human condition" rather than "living conditions," as he put it to an interviewer, he meant to keep himself free of the restrictive aims of partisan politics. Breton rejected the temporal goals promoted by Sartre and the Communists, for as he saw it, such goals entailed compromise—and, inevitably, the shedding of blood that Sartre was already trying to justify. Instead, he maintained his persistent faith in humanity's inner resources and in the ultimate triumph of its most liberating instincts, and in so doing defined a social and philosophical ideal. While this ideal in itself might not change economic infrastructures, in its own way it stands as one of the least corruptible modern expressions of human aspiration—an expression that sought social harmony not in heightened comforts and Five-Year Plans but in the endless revolution of our most indomitable resource: the mind.

For those mainly concerned with defined programs, however, it was easy to dismiss Breton as merely a dreamer, or as a quasi-religious mystic. Increasingly during this period, such references were being applied to Surrealism by both well-meaning supporters and savvy detractors. Among the latter were a Benedictine monk, who posited "the ultimately religious value of our most officially atheistic poetic school," and the critic Claude Mauriac, who to Breton's fury contended that if a devout Christian had written *Fata Morgana*, he would "have expressed himself no differently." Breton was further incensed

to learn that the same Mauriac was writing a monograph provisionally entitled *Saint André Breton* (it was eventually published in 1949 simply as *André Breton*).

Breton, hostile since childhood to the Christian morality that Marguerite had so rigidly embraced, was particularly sensitive to these attempts at portraying Surrealism as a religion in spite of itself. "Nothing will reconcile me with Christian civilization," he stated to an interviewer in March 1948. "In Christianity, I reject the entire masochistic dogma based on the insane concept of 'original sin,' no less than the idea of salvation in an 'other world,' with the sordid scheming it entails in this one." Anxious to erase the image of a "Surrealist religion," Breton had Henri Pastoureau draft the tract *A la niche les glapisseurs de dieu!* [Back to Your Kennels, You Curs of god], reaffirming the Surrealists' "implacable aversion" not only to "the idea of god" but also to "any genuflecting creature." Still, altars and initiatory rites (such as the ones featured in "Surrealism in 1947") spoke louder than tracts, and all the sharp rebuttals would not keep charges of mysticism and religiosity from being made against Breton's group.

Breton's anticlerical efforts—his efforts in general—were given a boost at the end of 1947, when Benjamin Péret finally returned to Paris. Péret had no address, no wife (Remedios Varo having chosen to stay in Mexico), and no resources, but his fury and intransigence were, if anything, greater than ever. "When he came back from Mexico," Sarane Alexandrian recalled, speaking for the younger Surrealists, "we saw not the sublunar poet we had imagined, but a tanned buccaneer who at the drop of a hat exploded in curses against the gringos, as in the adventure novels of our childhoods" (although by this time Péret equally loathed Mexico, which he called "the worst country in the world"). From the moment of his return, Péret threw himself back into the Surrealist adventure with almost fanatical conviction. "Fiercely militant," said Alexandrian, "he envisioned a revolutionary government made up of Surrealists, and said: 'Just let us take power for forty-eight hours, and then you'll really see something.' He had fashioned a grandiose idea of Surrealism, and he wouldn't suffer others not living up to it." It was precisely this faithful intolerance that Breton had missed for the past eight years; in those ahead, it would often provide his sole comfort.

The period that saw Peret's return also saw several ill-fated attempts to recreate an active framework for Surrealism. One such attempt was Surrealist Solution, a rekindled Bureau of Surrealist Research. Surrealist Solution was intended as a meeting place and "coordination center," whose purpose was to "handle the flood of scattered, diverse communications, of very variable interest," that were sent to the Surrealists. Manuscripts, drawings, and other documents were accepted on Wednesdays, from three to six in the afternoon, and duly registered in the accounts ledger. At first, Breton seems to have

approached this new activity rather conscientiously: Alain Jouffroy recalled that during this period he "scrupulously answered everyone who wrote to him. When I asked him why, he told me that he could not and would not disappoint the expectations of all those who—regardless of the 'value' of their writings or paintings—had chosen Surrealism as their privileged interlocutor, and who ran the risk, if he didn't reply, of 'swinging' to the other side—that is, to the side of Surrealism's enemies."

The strategy paid off in at least one case: several months later, Breton received a manuscript from a nineteen-year-old poet named Jean-Pierre Duprey. The manuscript, *Derrière son double* [Behind One's Double], so intrigued him that he wrote to its young author: "I [am] fairly jaded as to the messages that a sign such as [Surrealist Solution] might attract, but luckily a great curiosity still keeps watch, and pages such as yours are too rare for the mechanism not to be tripped . . . You are certainly a great poet, doubled by someone else who interests me." Soon afterward, Duprey answered Breton's invitation to make contact, and for the next several years he and his wife became assiduous participants in the group's meetings. Still, such discoveries were by far the exception, and it wasn't long before Surrealist Solution went the way of its predecessor.

Given the climate of failure in those early months of 1948, as well as the reticence—if not the active hostility—of intellectuals and the benign indifference of a Paris that could no longer raise much passion for Surrealism, it is not surprising that Breton's next work showed signs of depression. In *The Lamp in the Clock*, written that February at the Shady Rock villa in Antibes, he cast a gloomy eye on the world he saw around him. "At the far end of this foul corridor through which contemporary man is making his way, it has become morally almost impossible to catch one's breath," the text began. "The shrinkage, the collapse of these perspectives forces those who want to continue to honor the name of man to withdraw into themselves, to examine unflinchingly the new conditions to which thought is being subjected."

Most depressing of all, no doubt, was the realization that the postwar world, a world thrown by the shock of Nazism and the atomic threat into apathy and spiritual impoverishment, had inadvertently been promoted by the Surrealists themselves. Who more than the nineteenth-century poets, Breton asked—the Nervals, Rimbauds, and Lautréamonts whom Surrealism praised and emulated—had instilled "the temptation of the *end of the world*"? Faced with a world whose doom was no longer merely theoretical, Breton was forced into a reversal of position: "I have no qualms about saying that this is an end of the

world that *we no longer want*. We ceased to want it when we began to see the shape it would take, which, contrary to all expectations, we find to be totally absurd. We feel nothing but loathing for that universal syncope, insofar as man's alienation alone will have been the *cause* of it." Breton had now seen the logical outcome of "dashing down into the street and firing blindly into the crowd" (as he had once defined the "simplest Surrealist act"), and could only turn away in revulsion.

And there was one more factor in Breton's discouragement: the recurrent problem of money. The previous year, Charles Duits had visited the Rue Fontaine studio to find the Bretons living without even the most basic comforts: no electricity, no coal for the old-fashioned furnace that sometimes provided heat. "I discovered Breton's *poverty*, which he endured without thinking about it, the way one endures one's shadow," Duits wrote.

In the spring of 1948, the situation reached the point where Breton and Elisa, who had borrowed the villa in Antibes from Breton's old benefactress Marie Cuttoli, were too poor even to return to Paris. On March 26, Breton wrote to Gaston Gallimard, asking him to double-check his royalty statements (the last of which he'd seen in 1935!) and to send any outstanding earnings. "I don't need to tell you that, in this regard, I am as undemanding as can be," he told his sometime publisher, "but my living conditions have become such that I can no longer entirely ignore them." Two weeks later, Gallimard replied that, indeed, the house appeared to owe Breton some 53,000 francs in back royalties, which would be sent immediately. The Bretons left Antibes in mid April.

Back in Paris, Breton spoke at the inaugural meeting of Front Humain, a group founded by political activist Robert Sarrazac to support the recently created Citizens of the World movement. The Citizens of the World were a group of intellectuals horrified by the recent war and by the concept of nationalism in general, whether French, American, or Soviet. Their aim was to abolish the frontiers between countries, replacing them with such institutions as a world court, specialized commissions to handle universal problems, and nonnational assemblies of delegates.

At the Front Humain meeting, Breton declared that the root of the "current evil" lay in "*the antagonism between governors and governed*. It is not true—indeed, it's scandalously false—that entire populations can be held responsible for their governments' mistakes and demands . . . While governments look each other up and down, test each others' biceps as if in an old burlesque film . . . the governed continue to go about their business, which has nothing warlike about it: they work, they love, they watch their beautiful children grow." Breton did not hold with the alternate, darker view that people get the government they deserve. Instead, he would continue to believe in the fundamental good-

ness of the masses and in the inherent corruption of organized leadership, whether total-itarian or democratic.

Even as Breton became involved with Front Humain, he pursued plans with the painter and sculptor Jean Dubuffet for a project that had been in the works since the previous year: the founding of a "Company of Outsider Art" (*art brut*), aimed at collect-ing, housing, and exhibiting the works of the clinically insane. Breton had long been interested in outsider art—as far back as his study of patients' drawings at Saint-Dizier—but this was his first involvement in a concerted attempt to promote such works. Over the course of the spring, he helped Dubuffet locate artworks and raise funds for the company, providing letters of introduction to Lise Deharme and others, and contributing 50,000 francs of his own money as a shareholder. Breton also com-posed a major study of outsider art, "The Art of the Insane: Freedom to Roam Abroad," which drew links between outsider and primitive objects, and castigated the critics for their inattention to both.

On August 25, Editions du Sagittaire, which was now emerging as Breton's main pub-lisher, brought out *Martinique charmeuse de serpents* [Martinique Snake-Charmer], the book Breton had written with Masson while en route to New York. (When Masson asked why he hadn't been given co-authorship credit, Breton replied that "painters make enough money as it is.") And at the end of the year, Gallimard published an anthology entitled simply *Poèmes*. The selection represented virtually all of Breton's verse that he still considered worthy of print: from the early works of *Pawnshop* and passages of *The Magnetic Fields* to many pieces from *Earthlight* and *The White-Haired Revolver*, as well as his previously uncollected wartime poems and his few postwar works. Among the last group, the most significant was "On the Road to San Romano," written in early 1948. "Poetry is made in bed like love / Its unmade sheets are the dawn of things / Poetry is made in a forest," Breton wrote. "The embrace of poetry like the embrace of the naked body / Protects while it lasts / Against all access by the misery of the world." As it turned out, "On the Road to San Romano" was virtually his last piece of published verse, a reaffirmation of his lifetime belief in poetry's omnipotence, stated one final time before Breton—whether intentionally or not—left that poetry behind forever.

But any satisfaction Breton might have derived from these publications was shattered that fall when he received news of Arshile Gorky's suicide. Although Breton seems to have had no direct contact with Gorky since leaving New York, his memories of the Armenian painter were among the warmest of his American sojourn. He had worked to promote Gorky's work in France since his return, and had featured him in the 1947 exhibit. The news of Gorky's death, and the particularly grisly details surrounding it,

now struck him a hard blow—all the more so in that, as Breton saw it, one of Surrealism's own was responsible.

In the past few years, even as his reputation grew, Gorky's life had taken several disastrous turns. His studio had burned down, destroying a number of important works. An automobile accident that summer had left him with his neck broken and his painting arm paralyzed. He had developed inoperable cancer of the anus. And perhaps worst of all, his beautiful wife, Agnes Magruder (known to her friends as "Magouch"), had decided to leave him—a fact Gorky had discovered on the very morning of his car accident. Alone and in despair, on July 21 Gorky had gone out to the barn of his Connecticut house, scrawled the words "Goodbye, my 'loveds'" across a rafter, and hanged himself.

Magouch had had several reasons for leaving her husband (purportedly including physical abuse), but one stood out foremost in Breton's mind: her affair with Gorky's close friend, the Surrealist painter Matta. Yielding to what he considered a very orthodox "erotic giddiness," Matta had abandoned his own wife for a passionate liaison with Magouch, which he had not bothered to hide from Gorky. It was this aspect of the affair, the unrestrained pursuit of desire, that justified Matta's conduct in his own mind; and it was this argument that he put forth to the Surrealists when he telephoned them from New York.

But Breton's opinion had already been formed by a strongly worded letter from Frederick Kiesler, painting Matta's role in the incident in the blackest terms. On top of which, the group had been displeased by reports of Matta's activities in New York, notably his overtures to Sartre. Moreover, Breton, for all his theoretical admiration of Sade as the "freest mind that ever was" (Apollinaire *dixit*), was clearly offended by the broad streak of sadism that Matta had shown in his treatment of Gorky: it was no coincidence that, once Gorky's living torment ended, Matta's passion for Magouch dissipated as well. When Matta phoned to explain his actions, Breton called him a "murderer" and hung up.

On October 25, the Surrealists issued a terse statement excluding Matta "for intellectual disqualification and moral turpitude." The notice was signed by twenty-five people, practically the entire active roster of Surrealism. Of these signatures, the most recalcitrant belonged to Alain Jouffroy:

> Breton practically extorted my signature, saying he would explain the reasons for the exclusion later on. I had come late to the Café de la Place Blanche; I saw that a sheet of paper was being passed around the tables and I asked what it was. Breton made me sit next to him and said, "Sign it, dear friend, trust me." I said, "But it's a bit much." And he said, "Listen, what's happened is awful, he's responsible for the sui-

cide of Arshile Gorky, I'll explain later, trust me." So I signed, but I was furious at myself for having given in.

One who flatly refused to sign was Victor Brauner, who told Breton that the accusations against Matta "were the product of bourgeois morality." Outraged, Breton called a meeting on November 8, at the end of which Brauner was in turn excluded "for factious activities"—alongside the young dissidents (Jouffroy, Alexandrian, Tarnaud, Rodanski) who had pled his case. Once again, Breton (who normally valued Brauner's company) had bowed to the principle, brought to bear so many times in the past, that "ideological friendships" must take precedence over "affective friendships." And once again, his discouragement in the wake of these exclusions was such that he envisioned disbanding the Surrealist group altogether.

Instead, he deepened his involvement with another group, the Citizens of the World, and with an American fighter pilot named Garry Davis. Horrified by what he had seen during the war, and even more by the bellicose climate he'd found on his return to the United States, Davis had gone to France earlier that year and publicly destroyed his American passport in protest. He had also disrupted several meetings of the recently founded United Nations with requests for "world citizenship." His sit-ins were at first treated as minor *faits divers*, but by autumn a number of intellectuals had begun to take notice.

On November 20, Breton and Albert Camus proclaimed their support of Davis in concurrent newspaper articles. Breton's, for *Combat*, criticized the postwar situation in general and the United Nations in particular, "the prototype of those humdrum, evil-producing organizations that Kafka's prophetic works already set before us." Several weeks later, he added that evil "resides in the compartmentalization of the world into nations and more or less disguised empires. It's the rival imperialism of Coca-Cola and disfigured Marxism that we must, by the quickest means possible, render incapable of consuming and sacrificing our lives." He also gave several public addresses in Davis's defense in December.

That same month, Breton and Camus joined Sartre, Beauvoir, Richard Wright, Maurice Merleau-Ponty, and others in the Revolutionary Democratic Rally (Rassemblement Démocratique Révolutionnaire, or RDR). Leftist in orientation, but seeking to avoid the heavy bureaucracy of Communist organizations, the RDR had been founded earlier that year as an alternative to both "the rot of capitalist democracy" and "the limitation of Communism in its Stalinist form." But like many such fusions (including several of Breton's own devising), the RDR was long on idealism and short on pragmatics,

not to mention riddled with internal rivalries, and within months the experiment proved a failure.

For Breton, the importance of these rallies and articles lay not only in the goals sought, but also in the simple fact of their occurrence. Since 1925, he had been involved in various groups constituted outside the Party, seeking to have an impact on the social realities of his time. The hopes expressed on behalf of Davis and the RDR, however ineffectual they might appear in retrospect, show more than anything a refusal to bow to the isolation with which Surrealism was increasingly threatened in the late 1940s. Despite every pressure, André Breton would not willingly retreat into silence. But as the decade turned and the Cold War intensified between the Eastern and Western superpowers, he would find even his own fierce determination no match for a world in which the European intellectual had shrunk to little more than a figurine.

The first months of 1949 saw the by now familiar litany of circuitous pleas to Gaston Gallimard about monies due or promised. This time, however, Gallimard proposed a more durable solution by offering Breton an editorship-at-large for his publishing house (essentially the same job that Breton had discussed with Pierre-Quint in 1946). Breton accepted, and that spring he returned to the same *NRF* for which he had briefly worked as a mail clerk nearly three decades before. For his efforts, he would receive a monthly stipend of 15,000 francs as an "advance" against editor's royalties on each title published, the rhythm for which was initially fixed at two per year.

Despite Breton's hatred of employment, he seems to have approached this new job with a fair amount of enthusiasm. By April, he had drawn up a list of fifteen possible titles for his imprint, which was to be called "Révélations." But as these titles show, Breton was far more faithful to the Surrealist viewpoint than to his new responsibilities as a businessman, for virtually every author or work on the list had been celebrated in his own writings and every one of them was a hard sell. They included Jean Ferry's study of Raymond Roussel, an "almanac of outsider art," the works of Arthur Cravan, long out-of-print books by Charles Fourier, the hermetic scholar Fulcanelli, and the pioneer dream researcher Hervey-Saint-Denys, Péret's anthology of myths and legends, and others in a similar vein—all projects of which a serious editor could be proud, and all of them virtually guaranteed to lose his employer money. Indeed, Gallimard's notes to Breton over the coming months would show a visible tension between intellectual respect for his famous editor and basic fiscal concern.

As his inaugural title, Breton chose Maurice Fourré's novel *La Nuit du Rose-Hôtel*. The seventy-two-year-old Fourré had published several stories at the turn of the century, then nothing more for forty years. In late 1948 he had invited Breton and several others to visit him at his Montparnasse hotel, where he read pages from "an unusual work, unctuous as Turkish delight." Breton, always ready to promote works that captured his imagination, prepared to launch the book with a long preface of his own. "The message conveyed by M. Maurice Fourré," he wrote with more enthusiasm than commercial acumen, "remains entirely to be deciphered. The keys needed to penetrate it are probably not on every ring."

Meanwhile, in May, Breton became involved in a raging literary debate over a poem attributed to Rimbaud, "La Chasse spirituelle." Rimbaud scholars had for years known of a work by this name, thought to be forever lost; but in the spring of 1949, the literary critic Pascal Pia attracted considerable attention when he unearthed the poem. On May 19, Maurice Nadeau celebrated the discovery in *Combat* (giving the world its first taste of the lost work), while the venerable *Mercure de France* rushed "La Chasse spirituelle" into print. But Breton, who had had experience of his own in discovering works by Rimbaud (such as with *Littérature's* publication in 1919 of "The Hands of Jeanne-Marie"), immediately detected a fake and lost no time in informing *Combat*. "I once again find it deplorable," he wrote the paper's editor, "that the editor of [*Combat's* literary page] can fall into such crude traps. Indeed, one must never have understood the first thing about Rimbaud to dare maintain that the 'few lines' quoted were written by him."

Still, what became known as the "*Chasse spirituelle* Affair" would no doubt have been less heated, at least for Breton, had it not been for the involvement of the poem's two main defenders: Maurice Nadeau and Maurice Saillet. Saillet, a well-known literary critic, had previously annoyed Breton by his habit of writing under both his own name and the pen name Justin Saget: he had gone so far as to review *Ode to Charles Fourier* twice in *Le Mercure de France*, favorably as Saget and unfavorably, at least in Breton's eyes, as himself. As for Nadeau, his relations with Breton had long followed a sinuous path, from the political complicity of the FIARI to the much-reviled *History of Surrealism*. Like Saillet, Nadeau had recently angered Breton by publishing an unflattering review of his poems, and one can sense Breton's rancor in his slight of Nadeau as "someone who had never understood" poetry.

This was far from a private battle, however, and the "*Chasse spirituelle* Affair" monopolized the Parisian literary pages for the next several weeks. Even after two young actors, Akakia-Viala and Nicolas Bataille, confessed to having pastiched the entire work, there were those (particularly Nadeau and Saillet) who refused to believe them. Finally,

by early July, even the poem's staunchest supporters had to admit defeat. On July 6, Breton published a seventy-page pamphlet called *Caught in the Act*, in which he devoted ample space to the humiliation Nadeau and his colleagues had suffered. "In earlier times," he later gloated to an interviewer, "such a rebuke would have kept a critic from ever taking up his pen again."

And one further concern kept Breton occupied that spring of 1949: he was changing apartments for the first time in twenty-seven years. In fact, it was hardly much of a change, as he was only moving into a more spacious studio one flight down. His famous address would remain the same, as would his view onto the nightclubs of Place Blanche. Nonetheless, the transportation of his considerable art collection and library, not to mention its reinstallation downstairs, caused him "quite a few physical woes."

The primary reason for Breton's change of hearth was the arrival of Aube, who would permanently move to Paris later that year, and who would need the extra bedroom that the new apartment afforded. Breton, who hadn't seen his daughter in over two years, had become alarmed at the grammatical mistakes he found in her letters, and petitioned Jacqueline to send the girl to France. In October, he went to Le Havre to welcome the thirteen-year-old back to her native land. Jacqueline stayed behind in America, although before long she, too, would return to Paris, without David Hare.

Aube, although glad to see her father again, was not altogether happy to be back in France: she had gotten used to living in the United States and to her mother's free-spirited ways. She now found herself "disoriented" in her own country, sharing a home with a stepmother she barely knew and a father who was loving but imperious, who seemed to her less a father than "the prow of an advancing ship," and whose universe seemed to revolve almost entirely around café meetings and political causes. As she later admitted, it was simply impossible for Breton—a man whose life, ironically, had been devoted to the rediscovery of childhood's marvels—to reenter the youthful world of his own daughter.

In anticipation of Aube's return, Breton had lovingly arranged her new room, picking every painting, every object with greatest care. But the choice was dictated by his own tastes, and the space that Aube eventually found seemed more like a small museum than an adolescent girl's bedroom. "There were nothing but staring eyes in that apartment," Aube recalled: "masks, heads, paintings." It was a place to inspire the Surrealist thrills of fascination and disquiet, but it was hardly restful. Nor did Breton's painstaking arrangement leave Aube any room for the more commonplace treasures she had brought from America, and when she asked her father to remove some of the objects, he expressed bewilderment. Finally, one day, she simply put a painting outside her door;

returning from school at noontime, she saw that it had vanished. She and Breton never mentioned the removal, and from that moment on Aube simply left anything she didn't want in the hallway.

This silent exchange was perhaps the most direct communication Breton and his daughter had engaged in since her arrival. "It was difficult to talk to him about such things," said Aube, noting that their relations were affectionate but "discreet." It was only later that she understood how much Breton took to heart her small rejections, how eager he was to make her see the objects and paintings as he saw them. "Breton wanted to make others appreciate his universe," she said. "He gave others things that fascinated him, and was frustrated when they couldn't appreciate them the way he did. He gave without stopping."

Even as Breton was welcoming his daughter to Rue Fontaine, there was one thing he did stop giving: his support of Garry Davis. By the fall of 1949, Davis had become a French celebrity, his face appearing in the newspapers so often that Breton considered the situation absurd. Worse, he felt that Davis—who urged the French government to legalize conscientious objector status for practicing Catholics—had been co-opted by the Church. Nonetheless, he remained a partisan of the Citizens of the World movement itself, and over the next several years would continue to advocate its goals and aspirations. Garry Davis, meanwhile, left France and the Citizens of the World behind and headed for India—at whose border, presumably, he was not asked for his obliterated passport.

As 1949 drew to a close, Breton once again found himself sad and dissatisfied. Despite his hopes for a better world, and despite the efforts of an isolated few, society gave every sign of progressing along the same track as before. And the Surrealist group that he had been trying ceaselessly to rebuild for four years seemed increasingly prone to attrition and inertia. "I suffered a period of depression (which I know only too well) and . . . in such cases, my only desire is to hide," he told Maurice Fourré in November. "I believe it has to do with the uninterrupted efforts I've been making to preserve some form of collective action, when all around people want only to scatter in all directions."

Nor, despite his stipend from Gallimard, were Breton's financial circumstances any better, particularly now that Aube was once again in his care. "The *extremely critical* material situation in which I'm living and making my loved ones live has forced me to contact you today," Breton wrote his publisher and boss on December 10. "You will agree

that up until now I haven't abused this sort of request and I am convinced that you will kindly take this into consideration." He urged Gallimard to reexamine his royalty statements, arguing that he had never yet received a clear account of his earnings.

The urging was well founded, for Breton's sales at Gallimard, though hardly phenomenal, had improved in recent years. By mid-1949, *Nadja* had nearly exhausted the 7,000 copies of its first three printings, prompting Gallimard to go back to press for another 4,000. He also reprinted 4,000 of *The Lost Steps*, which had long been out of stock, and 2,000 more of *Mad Love* (whose sales were at around 4,000 copies). Meanwhile, *Break of Day* had almost sold out, and *Poèmes* was doing respectably, for poems. The problem was, many of the older titles had been contracted for at an extremely low royalty rate (*Nadja*, for example, earned its author only one franc per copy), and it was only at Breton's insistence that Gallimard now increased royalties on all his titles to an advantageous 10 percent—sending an overdue royalty check for 100,000 francs at the same time.

Welcome as the royalties were, Breton was not entirely satisfied with Gallimard, particularly when it came to the "Révélations" series. In the year since its inception, not one title had yet been published, nor, as Breton saw it, did the *NRF* seem to have much interest in it. "I'm concerned," he told Gallimard that same December, "[that 'Révélations'] has not even gone into production and that you have not given me a clear idea how often the books in the series will be published. As far as I know, this project has never been mentioned, either in the *NRF* bulletin or in a publicity release." Breton's letters over the next several months were filled with concerns over press schedules, choice of titles, jacket design, and other details of book publication. The initial excitement past, he was now experiencing a distress familiar to any minor executive: that of being flattered into a given job, then left to negotiate its pitfalls alone. Indeed, Gallimard would finally bring out Maurice Fourré's *La Nuit du Rose-Hôtel* in October 1950 but, dissuaded by its poor sales and the esoteric nature of Breton's next proposals, retracted his support for the series after this one title.

There was one relatively cheering event that winter: in December, the Swiss publisher La Baconnière issued a Festschrift in Breton's honor, featuring "essays and testimonials" from Péret, Paulhan, Pastoureau, Crastre, Gracq, André Rolland de Renéville, and others. Yet, touched though Breton was by the book, there was something almost sepulchral about these tributes and scholarly studies—and, no doubt, something vaguely stifling about being their subject.

Indeed, for all Breton's attempts to stay at the forefront of events, it was precisely this retrospective view that people seemed to be imposing on him. That same December, Georges Ribemont-Dessaignes, who now worked for Radiodiffusion Française, the

French national radio, was preparing a series of interviews with well-known figures in the arts and sciences. Hoping to include Breton, he wrote to his former colleague, but did not mention the true purpose of his letter. Breton, who assumed that Ribemont was interested in rejoining the group after so long, began drafting a cordial reply; but before he could even mail it, the impatient Ribemont unexpectedly showed up at the daily café meeting. After much urging, the ex-Dadaist secured Breton's participation in the interviews, as well as permission to reprint some of Breton's early poems in a Dada anthology he was editing.

But Breton clearly remained hesitant, and shortly after returning home his buried disappointment over Ribemont's motives spilled over. "First of all, I can tell you that I've never agreed to speak on the radio, or at least to express myself personally," he angrily appended to his letter. "It's not the bait of 25 thousand fr. (which I can assure you I'm in no position to sniff at) that will make me more conciliatory, despite what was said in a certain 'Corpse.' No and *NO* under those conditions . . . Admire my candor once again: reading your letter I was convinced that you wanted to join me in a wholly different sphere, where I still had the illusion of having known you: but interviews and reprint rights, no, it was never about that."

And on that bitter note the 1940s, arguably the hardest decade of Breton's life, ended.

"I AM SURREALISM!"

(January 1950 – July 1957)

AS THE CENTURY ENTERED ITS SECOND HALF, an observer would have noted significant outer differences between the vehement, politicized Breton of the 1920s and 1930s, and the seemingly removed, almost sedentary sage of 1950. In place of Marx and Trotsky, the fifty-four-year-old Breton now professed admiration for the utopian Fourier and for the ancient doctrines of the esoteric thinkers. "Considering the scope that esotericism lends our need for investigation," he told an interviewer that year, "we have to admit that it makes historical materialism, as a system of knowledge, seem laughable." Breton also developed a fascination with alchemy, seeing affinities between its experiments with metal ores and Surrealism's research into automatic writing, "the 'prime matter' of language." But if the forms of Breton's interest had changed, the underlying concerns—to "transform the world, change life, refashion human understanding from top to bottom," as he had said in 1946—remained essentially the same. It is simply that, given his long history of political disappointments, he now looked toward other means of fomenting revolution.

One longstanding aspect of Breton's political distrust was his aversion to official honors (an issue that by this time had provided grounds for more than one exclusion from Surrealism). In January 1950, he got wind of a plan by André Thirion to give him the Grand Prize of the City of Paris, an achievement award that carried a grant of 300,000 francs. Although in dire need of money, Breton refused the prize, declaring to the newspaper *Carrefour*: "In the times we're living in, I believe that a writer or artist's most precious possession, the loss of which *nothing* can offset, is independence." To his mind, accepting any such handout from the state was the first link in a chain of fatal compromises.

At the same time, as Breton well knew, the independence he jealously guarded had a price: the 300,000 francs he refused might have gone toward a new magazine, which the Surrealists could not currently afford. Instead, as of March, the group once again borrowed an existing periodical—this time the monthly *La Nef*—to produce a special issue called "Almanach Surréaliste du Demi-Siècle" [The Mid-Century Surrealist Almanac].

Over two hundred pages long, the eclectic almanac featured, among other things, a "panorama" of the first half-century, including all the political, scientific, artistic, and social events of fifty years that the group deemed significant.

One event that might well have appeared in the panorama, had it not come several months too late, was the sentencing of Czech historian Záviš Kalandra after a Prague "show trial" in June. Kalandra, Surrealism's most fervent Communist champion during Breton's and Eluard's 1935 tour of Prague, had since left the Party to protest the Moscow Trials of 1936–38. Now, at his own trial, so similar to the ones he'd once decried, his extorted confessions earned him and several co-defendants the promise of a firing squad. On June 17, Breton was one of forty-eight intellectuals to sign a telegram to the Czech government, asking that Kalandra and the others be spared. He also addressed an open letter to his former friend and traveling companion Paul Eluard. "You must not have forgotten the welcome we were given in Prague," he wrote:

> In the slightly frantic bustle of those first few days, there is, if you recall, one man who comes by, who joins us as often as possible, who does his best to try and under-stand us, a man who is *open* . . . I think you remember the name of that man: he is— or was—Záviš Kalandra . . . How can you tolerate, deep down, such degradation to be inflicted on a man who was a friend to you?

But Eluard, who had recently visited the USSR, and whose Communist zeal went so far as to inspire a treacly ode for Stalin's seventieth birthday, tersely replied with the now infamous riposte: "I have too much to do for the innocent people who proclaim their innocence to care for the guilty who proclaim their guilt." Kalandra was executed soon afterward.

Breton spent the months before and after the Kalandra affair traveling in southern France: to the Dordogne in May, where he visited the prehistoric cave paintings of the recently opened Lascaux grottoes ("very suspect" in his estimation); then in July to the Lot Valley to inaugurate the "globalization" of the city of Cahors. Cahors had become one of several world cities to embrace the Citizens of the World movement, and that summer it declared itself a stop on the "road without borders." At the official ceremony a signpost was erected, bristling with mileage indicators for all the major world capitals.

It was in the countryside around Cahors that Breton discovered Saint-Cirq-Lapopie, a medieval village built on the side of the rocky cliffs, whose rustic population barely reached 150. Breton's attraction to Saint-Cirq was immediate and irrevocable. "You can't imagine the friendliness of the area," he told Paulhan on August 9. "One feels empow-

ered to see beyond the times we're forced to live in." But it was not only the town itself that enticed him, for he had been finding it increasingly difficult to spend his summers in the city, which the heat and the absence of his vacationing friends turned into a long obstacle. "Breton needed to get out of Paris in the summer," Aube later said. "It was psychological as much as physical." Exploring the village (no simple feat, given the steep incline), he came across a twelfth-century stone farmhouse overlooking the Lot River, with a small garden, handsome arched windows, and a square tower. Although the house was badly in disrepair, Breton wanted to buy it, both as a summer home and, more viscerally, as the castle—"not necessarily in ruins" but "in a rustic setting"—to which he had dreamed of inviting his friends in the 1924 *Manifesto*. His wish came true that fall, thanks to money given him by the thrifty Louis Breton.

Over the following summers friends would visit Saint-Cirq, helping Breton restore his second home and transplanting the group meetings from Place Blanche to the town's single café, a quaint tourist trap. One visitor later recalled his impressions of the house: "the cool silence of the living room, its walls decorated with naive paintings or with coasters containing beetles or blue butterflies from Chile"; a staircase that led nowhere; the records of folksinger Léo Ferré, whom Breton briefly admired until he became popular. As for Breton, if Saint-Cirq could not replace Paris in his affections, it nonetheless became the ideal home away from home. "Over and above many other places—in America, in Europe—only Saint-Cirq has worked this enchantment on me: the kind that *settles* one forever," he wrote for a local guidebook in 1951. "I have stopped wishing to be elsewhere."

By late 1950, Breton was noticing an increasing shift in the makeup of the Surrealist group, as the younger generation became more and more prominent. Alongside such individuals as Duprey, Bédouin, Mitrani, and Paz, the roster now included the poet and filmmaker Michel Zimbacca, born the year of the first *Manifesto*; the writer and artist Adrien Dax, come to Surrealism in the wake of the 1947 exhibit; and Monique Fong, a young Eurasian who had been attracted to Surrealism by Breton's writings on the marvelous. There was also Anne Seghers, lover of Bédouin and wife of publisher Pierre Seghers; and the Egyptian playwright Georges Schehadé, whose *Monsieur Bob'le* Breton lauded that year as "a work of exceptional beauty."

While many of these figures would play only a slight or temporary role in Surrealism, some other recent arrivals, such as the poet and novelist André Pieyre de Mandiargues

and the art critic Gérard Legrand, would become indissociably linked with the move-ment's development over the next two decades. The urbane Mandiargues, while closer in age to the Surrealist elders (he was born in 1909), had not joined the group until 1947, by which time he had published several important works. Although he rarely attended such functions as the café meetings, Mandiargues's life and writings showed clear affinities with many of the group's attitudes about love, women, and the marvelous. By contrast, Gérard Legrand was barely twenty-one when he first contacted Breton in late 1948, and he quickly became an assiduous participant in the group's activities. His main contribu-tions to Surrealism would be less his own lyrical writings than his editorship of various periodicals, critical works about the movement, and collaborations with Breton on two later volumes. Unlike the suave, independent Mandiargues, Legrand was physically unprepossessing, and he showed an involvement in the group—and an admiration for Breton—that practically reached the point of symbiosis. "Legrand tried to write like Breton, and was always dropping lapidary phrases like Breton," Monique Fong remem-bered. "He seemed to have an invisible pipe stuck in the corner of his mouth."

Finally, there was Jean Schuster, who would eventually emerge as Breton's closest second. The eighteen-year-old Schuster had at first been a member of the PCF, and had booed Breton at the tumultuous Tzara lecture of 1947. But he had been sufficiently impressed by the Surrealist exhibit several months later to ask for Breton's address, and that fall he had knocked at Rue Fontaine, undeterred by a handwritten sign reading: "André Breton, no autographs, no signings, no interviews." He later described his first encounter with Elisa and her exotic Latin American accent:

> The door opened slightly onto a cloud of smoke, from which emerged, first a long, garnished cigarette holder, then a romantic, swaying, hazy creature—femininity in its pure state . . . "You desirrre?" this person asked. "To see André Breton." "Do you have an appointment with Andrrré?" "Er, no." "Well then, telephone, *n'est-ce pas.*" She gave me the number.

Soon afterward, Breton welcomed Schuster "with his customary courtesy," gently cri-tiquing the young man's poems and suggesting some reading. He also invited him to attend the café meetings, and from that moment on Schuster would become one of the most ardently devoted of all the young Surrealists—although by his own admission, his presence during the first several years was "silent."

By 1951, all these recent memberships were causing a noticeable division in the group, between those who had entered the movement before the 1940s and those who knew only

its postwar face. While these older members—notably Pastoureau, Marcel Jean, Maurice Henry, and Jacques Hérold—had for the most part joined Surrealism in the thick of (and because of) its militant leftism of the 1930s, the later arrivals, even those who held strong political convictions, tended initially to pledge their loyalty to Breton himself rather than to a social agenda.

The split between the old guard and the new became all the more evident in late 1950, as Breton's own politics began inspiring the former's concern—not, as had been the case in 1925, because they were too extreme, but because they were judged too "soft." One of those concerned was Henri Pastoureau, who the previous spring had been angered by an article of Breton's that seemed all too tolerant of Charles de Gaulle's RPF, a recently founded centrist party that was quickly gaining influence in France, and that in principle was everything the Surrealists rejected. Several months later, it had been Marcel Jean's turn for dismay: reading the news of the Korean War, Breton had become "panic-stricken" (the word is Jean's) over the possibility of an American defeat, then manifestly relieved over the successful "MacArthur offensive." Jean, shocked to see Breton's apparent bow to "the temporary gains of American capitalism," also criticized the change of heart.

The fact was, Breton supported neither de Gaulle, whom he vocally denounced in later years, nor American capitalism, whose cultural encroachments in Europe he particularly resented. At the same time, his horror at the Moscow Trials, Trotsky's assassination, and Russia's territorial hegemony "permanently barred" him from making peace with Stalinism. He was in fact seeking, and had already expressed the need for, a third, alternative solution to the political question. But in the current atmosphere, which had turned sharply anti-American since the war, any criticism of the Soviet Union was seen simply as a concession to Western imperialism. Moreover, the old militants did not understand Breton's current preoccupation with alchemy and utopias. Nor could they approve the increasing favor shown Surrealism by such former antagonists as the bourgeois *Le Figaro*. The situation was opening a dangerous rift within the Surrealist group, and in February 1951 the crisis finally came to a head.

The catalyst was a lecture hosted by a Catholic intellectuals' circle on the topic "Is Surrealism Dead?" It was Pastoureau who first learned of the planned event, and who quickly informed Breton—expecting the latter's indignation and immediate action. But instead, Breton wistfully remarked that the question was a good one, and let it go at that. Several weeks later, Pastoureau discovered that the lecture was to be given in the sacristy of Saint-Séverin church by the Catholic philosopher Michel Carrouges, an old friend of Breton's (an "affective" friendship rather than an "ideological" one), whose study *André*

Breton and the Basic Concepts of Surrealism had won its subject's esteem the year before. As Pastoureau saw it, both Carrouges's religious affiliations and the auspices under which he was slated to speak were at odds with the Surrealist outlook, and Breton's tolerance of them unthinkable. Breton, however, again failed to react.

At their afternoon meeting on Sunday, February 11, the day before the scheduled lecture, Pastoureau and Marcel Jean proposed that the group turn out in force to "sabotage" the speech; but Breton neither sanctioned the initiative nor forbade it. Assuming they had at least his tacit consent, Pastoureau, Jean, Patrick Waldberg, and a few others arrived for what was ultimately a sparsely attended lecture. Pastoureau read aloud the anticlerical pamphlet *A la niche les glapisseurs de dieu!* while Michel Carrouges from the pulpit bewailed the Surrealists' treatment of him. The group then stormed out of the hall crying, "Shit on God and shit on Carrouges!" But when they gleefully recounted their actions at the café two days later, Breton cut the merriment short by disapproving of the entire affair. Angry, Pastoureau complained both of Breton's lukewarm support and of the tolerance shown Carrouges.

By this juncture, the incident now known as the Carrouges Affair was overspilling the simple facts to become a virtual referendum on Breton's continued authority. For while questions about Breton's politics had been raised many times since his return to France, this was the first time they came from within his own circle. Marcel Jean later suggested as much when he conjectured that Breton "would sooner or later have sent Carrouges packing anyway. What he *didn't* appreciate was others doing it for him."

In the days after Carrouge's lecture, the lines became more sharply drawn between Breton's partisans on the one hand (mainly Péret, Heisler, Toyen, and the younger members) and on the other those who were finding his conduct unworthy. A meeting called by Breton and Péret to find a "satisfactory solution" to the Carrouges question met with angry protests from Pastoureau and Jean, who rejected the entire notion of "satisfying" Carrouges, and who implied in response that Breton was a traitor to his own Surrealist precepts. That same evening, an agitated Breton called Pastoureau to cancel the meeting and, according to the latter, to put an end to group meetings in general: "From now on, [Breton] refused to go to the Café de la Place Blanche," Pastoureau reported. "He had never accepted ultimatums and *would* never accept any. He would not allow himself to stand accused." Lionel Abel later claimed that Breton, when confronted with the charges of infidelity to Surrealism, angrily responded, *"I am Surrealism!"* The Carrouges Affair had now turned into the much more bitter Pastoureau Affair.

The ensuing days saw an escalation of moves and countermoves. In mid-March, Pastoureau sent around invitations to a meeting on Monday the 19th, accompanied by a

five-point agenda regarding Surrealism's past "mistakes" and its future continuation. But Breton rejected Pastoureau's agenda, and instead called a meeting of his own—so that when the group finally gathered on the 19th, as originally planned, neither Pastoureau nor his sympathizers were present.

The atmosphere at the Café de la Place Blanche on Monday evening was like that of a corporate boardroom during a hostile takeover. According to Georges Schehadé, Breton and Péret both arrived carrying briefcases stuffed with papers. "It's the 9th of Thermidor!" Breton reportedly muttered, evoking the schism and downfall of Robespierre's revolutionary government in 1794. As he well recognized, the underlying question was that of his own exclusion, if not de jure then at least de facto, since a vote of no confidence would effectively mean the end of Surrealism in its current form. The incident, as Maurice Henry put it several days later, had now become the "Breton Affair," and Breton did not mean to be caught short: he had solicited the written proxy of as many absent members as possible and urged the presence of as many friends as he could find. Mandiargues, whose abstinence from the café was a matter of principle, remembered making an exception for that one session: "Breton, who for the first time found himself attacked from within his own group, required the support of all those who . . . had shown proof of friendship and fidelity." From nine o'clock until two in the morning (so late that Octavio Paz's wife was at one point seen prowling impatiently around the café, until the poet finally left with her), the group debated the various facts and accusations of the past two months. In the end, they voted to exclude Pastoureau, Jean, Waldberg, and the others "without appeal." The resolution was signed by the eighteen remaining Surrealists, nearly all of them recent members.*

Still, Pastoureau and Jean did score one victory, Pyrrhic though it might have been: when that same evening Breton was handed some documents proving that Carrouges wrote religious instruction manuals (something Carrouges had always denied in the past), he rushed to the phone and furiously broke off all relations with the nonplussed Carrouges, treating those present to a copious vocabulary of epithets. Breton and Péret, writing up the meeting, even deplored the fact that they hadn't been shown these items earlier, in which case "the Carrouges case would have been decided on the spot."

But Carrouges himself, as everyone recognized, was in fact only incidental to the affair, while at bottom lay much more fundamental dissensions, jealousies, and generational differences. Marcel Jean later admitted that he had no regrets about leaving

* In fact, and despite Breton's visible tension, the outcome could scarcely have been otherwise, as none of his principal accusers was present for the debate.

Surrealism, "especially since the people surrounding Breton at the time bored me stiff. I had nothing to say to all those kids. They were there only as militants, to repeat the doctrine." As for Pastoureau, he declared in a letter: "If Surrealism can't rise from its ashes, it only means that it's no longer the phoenix that we, in our blindness, still believed it to be." Both were saying what others had been feeling for some time: that Surrealism had suffered an irreparable decline since the war and that Breton was now surrounded by talentless yes-men whose sole function was to reinforce his ego.

This was not yet the official close of the affair. Following the March 19 meeting, Pastoureau and his friends circulated various critiques of Breton's actions, while the newspapers (for which the whole matter was "a sea of intellectual pretension and old-biddy pettiness," but good copy nonetheless) contributed their quota of articles and editorials. Finally, on May 24, Breton's remaining supporters published the tract *Haute fréquence* [High Frequency], in which they reasserted Surrealism as "neither a school nor a coterie" but "an adventure."

But whatever the group's public bravado, Breton emerged from the Pastoureau Affair weary and dispirited. He well knew that, despite some inflated pronouncements, the recent dispute was derisory when compared with the intellectual stakes of the Bar du Château or Aragon affairs; and in any case, he was no longer quite so eager to jump into the fray. In place of the exhilaration of victory, he now felt only lassitude. "Nothing was spared to darken our lives over these past months, and I have to admit that those dogs were slowly beginning to 'get' me," he confessed to Péret. Rather than take back the reins, however, for the moment he retreated to the haven of Saint-Cirq, where he fished for agates in the river and oversaw the masons and woodworkers who were rebuilding his ruined castle.

There was one final postscript to the Pastoureau Affair: on May 17, Maurice Saillet (as "Justin Saget") avenged himself of the verbal drubbing he'd received in *Caught in the Act* by publishing his own account of recent incidents. The article, titled "Sunset Boulevard" after the newly-released Gloria Swanson movie, drew explicit parallels between Swanson's role as an aging starlet and Breton's part in the "one-actor film" that was Surrealism. Breton might have been in Saint-Cirq at the time, but the provocation was too much to let pass—although this time, in place of a triumphantly sarcastic rebuttal, a Surrealist commando made up of Zimbacca, Bédouin, and Schuster met Saillet in front of his office and beat the stuffing out of him "on behalf of Gloria Swanson."

✳

Ever since Breton's return to France, the public had been expecting a major new statement on Surrealism, as Breton himself had promised on several occasions. But half a decade had now elapsed, and for the moment no new manifesto—indeed, no major new work at all since *Arcanum 17*—seemed to be forthcoming.

Instead, Breton's writings in 1951 and early 1952 (apart from the polemics generated by the Pastoureau controversy) were mainly limited to articles for the anarchist periodical *Le Libertaire* and for the mainstream journal *Arts*. While Breton's collaboration with *Le Libertaire* ultimately produced little more than ephemera (although one article, "Tower of Light," gave a moving account of Surrealism's perennial attraction to anarchism), for the sixteen months that it lasted it afforded the sense that he was back in the political arena.

Simultaneously, Breton gave his aesthetic concerns a hearing in the newspaper *Arts*. Particularly when compared with his writings for *Le Libertaire*, some of his contributions to *Arts* seem purely for enjoyment's sake, such as the comic strip in seven installments that he and Péret co-authored on the life of Picasso: replete with the inept illustrations and hyperbolic language typical of the genre (not to mention pointed jabs at certain aspects of Picasso's career), it provided a caricaturish footnote to Breton's once unconditional defense of the painter.

Of more consequence was a dispute with Aragon waged in the pages of *Arts*. Responding to an article in *Les Lettres françaises* that praised Soviet art but showed no examples, Breton asked: "Why is contemporary Russian painting kept hidden from us?" The answer, he said, was that art had sunk to such depths under Stalin that its champions, such as Picasso and Matisse, could no longer "close their eyes to the fact that the *travesty of art* (just as one says a travesty of justice) that alone has the approval of Moscow is the peremptory and inflexible negation not only of their own art but of any art as they are able to understand it." Aragon picked up the gauntlet in the pages of his maligned newspaper, publishing a series of pieces in defense of Socialist Realism (the same defense that had put him at odds with Breton in the 1930s), which Breton answered with an essay on "'Socialist Realism' as a means of mental extermination." The critic Claude Roy claims that the controversy was motivated more by personal spite than by politics; and in fact Breton's rebuttal, instead of targeting Aragon's aesthetic views, aimed at his past ideological waffling. He seems to have hit his mark, for Aragon stopped his own series of articles then and there.

It was also during the spring of 1952 that Surrealism was given two early signs of mainstream recognition: the first when the new edition of the *Petit Larousse* dictionary, the primary reference work for practically every schoolchild in the Francophone world,

included a definition of Surrealism (which, although disputed by those concerned, signified a giant leap into public awareness); and the second when Radiodiffusion Française broadcast a series of sixteen hour-long interviews between Breton and journalist André Parinaud. The main thrust of these interviews was Breton's personal history of Surrealism. "I had asked André Breton for an account that might allow us to reinvent the heady years of Surrealism, and to draw the pertinent lessons from that veritable epic," Parinaud later explained. Radio authorities had also asked Breton to confine his account to the years between the two wars. But Breton, unwilling to credit Nadeau's thesis that Surrealism had died in 1939, found ways to insert glosses about Surrealism's current activities throughout his narrative.

As with nearly all of Breton's interviews, these sessions were anything but spontaneous: the entire text had been composed the previous year—much of it in the thick of the Carrouges Affair, which would explain its sometimes embattled tone—and recorded soon afterward. It had long been Breton's practice to field interviewers' questions in writing rather than in person, and the manuscripts of some of these exchanges show that he would simply eliminate or rewrite questions that he didn't wish to answer. "I'm one of the world's worst improvisers," he later told *Le Monde*, musing that it was perhaps a curious admission "from someone who advocated automatic writing." Breton in fact had a horror of spontaneity and, despite his celebrated verbal command, was suspicious of journalists using his own unguarded statements against him (something that he himself had done to both Sigmund Freud and André Gide in 1922). Particularly given the large audience these radio interviews would command, Breton had no intention of saying anything that might be misconstrued.

And yet, of all Breton's interviewers, André Parinaud would seem the least likely to rouse his distrust; indeed, gauging from their conversations, his admiration for his subject bordered on devotion—albeit, as one might well imagine, a devotion behind which one can glimpse the adroitness of an experienced journalist faced with a particularly difficult subject. Parinaud had first thought of interviewing Breton several years earlier, as part of a program featuring well-known French writers; Breton seems to have agreed to the project by the end of 1950. Over the succeeding months, Breton had shaped his text—several hundred printed pages in the final version—correcting, reformulating, and deleting Parinaud's questions as he went. Several have claimed that he simply wrote his text in one block, then had Parinaud insert his own remarks as transitions or prompts (in fact, it was Parinaud who started by sending him written questions). What is certain is that, Breton's periodic exclamations of surprise or dismay notwithstanding, both sides of the conversation were fixed well before the broadcast date, then read like a script.

Just why Breton should participate in these interviews, after having so vehemently rejected Ribemont-Dessaignes's similar request at around the same time, can be ascribed to a complex tangle of strategic and personal factors. For one thing, he was simply no longer in a position to turn down the fee he would receive for the broadcasts—as well as the additional 200,000 francs that Gallimard would pay him for the publication rights. (Breton, moreover, who had not published with Gallimard since the 1948 *Poèmes*, had owed the house a new book for some time. This one, titled *Conversations* [*Entretiens*], would be the last new work of his that they published in his lifetime.) More to the point, Surrealism, though more "established" than ever before, simply did not have its former visibility; nor could Breton's writings compete with the renowned novels and plays of Sartre, Beauvoir, and Camus. The Parinaud interviews, then, served a multiple purpose; for by excavating his past, Breton was both opening Surrealism's earlier accomplishments to a broad new audience and reestablishing his own place in the here and now.

Most Frenchmen got their first taste of Breton's celebrated voice in late February 1952: a voice slightly thickened by age, somewhat higher in register than one might have expected, but used with a resonance and skill worthy of a master actor or statesman. And as with actors from a certain period, it was a voice situated less in space than in time; for while it bore no particular traces of regional accent, it carried the unmistakable tonalities and inflections of the era it was now reliving.

The conversations began on a roundabout and evasive note when Breton, answering Parinaud's query about the origins of his particular "sensibility," replied: "You know, it's not easy to retrace the development of one's own sensibility. One can readily see what one has *become*, which events have shaped the course of one's life. But what always stays out of reach, what remains more or less concealed, is precisely what might have catalyzed these events." It was an answer that "unmasked and masked at the same time," as Breton said of Vaché during these same interviews.

Over the next sixteen weeks, until mid-June, the public tuned in as Breton retraced the major stages of his life and Surrealism's development: from his early relations with the Symbolists and his war experiences; through an unabashedly tendentious analysis of the Dada years; to the beginnings of Surrealism proper, its experiments with the unconscious, and its long and difficult relations with the Communists throughout the 1930s; and finally to Breton's exile in New York and (despite the radio authorities' prohibition) some of his current preoccupations. Along the way, he treated his audience to numerous personal anecdotes about the many figures who had at one time or another shared with him the Surrealist adventure. Asked to evaluate his past activities from the vantage point of his fifty-six years, he told Parinaud: "I don't wish to sound conceited, but it's fairly

commonly admitted today that Surrealism has contributed much toward shaping our modern sensibility. Furthermore, it has managed, if not entirely to impose its scale of values, at least to make these values be taken very seriously . . . With all due respect to those who, as you know, have dug Surrealism's grave two or three times yearly for the past quarter-century, I maintain that the principle of its energy remains intact."

Still, if these interviews successfully presented Breton's public life and works, they were (as his very first answer suggested) far less revealing of the inner man. Like many Frenchmen of his generation, Breton was averse to intimate confidences with any but the closest friends. Apart from one or two veiled references, nowhere in his talks with Parinaud did he mention his childhood (instead, he began his life in 1913, at age seventeen—encoding èven here the totemic figure "1713"), the women in his life, or the then-raging Pastoureau Affair. In part, one can ascribe this to a sense of discretion no longer fashionable today. But part of it also has to do with Breton's particular reserve, and by the last session Parinaud was wondering aloud whether Breton's statements had "really let us gain some specific knowledge of [him] as a human being," or whether the interviews had simply "missed their target." Ironically, even Breton was ultimately dissatisfied with the interviews' "totally impersonal" tone: a curious objection, given the few openings Parinaud had been offered.

Breton left for Saint-Cirq before the final interview was broadcast. It was here that he now came to spend his summers, hardly setting foot in the capital for the entire season. Still, although he loved his second home, these months away were less than ideal: the birds were too noisy and the climate gave him insomnia; there was little food in the house and little money with which to buy any; and perhaps worst of all, as he told Péret, there was practically no one to talk to. This last issue in particular was a profound source of annoyance and ambivalence, as one Surrealist later said: "When Breton didn't see anyone in Saint-Cirq, he was in a horrible mood; back in Paris he'd say, 'I was bored to death, there was nobody there,' etc. But when he saw too many people he was also in a horrible mood; he'd say, 'It's not a vacation anymore, everyone's always bothering me, my house is always full.'" The fact was, Breton—who missed his beloved city environment, but hated Paris's damp winters, hot summers, and endless activity—was truly satisfied in neither place.

More and more, Saint-Cirq was becoming Surrealism's country retreat, a pastoral setting for the group's less arduous activities. As usual, evenings would be spent reading and playing Surrealist games—including, it seems, sending local postcards spiced with "licentious drawings to make the young ladies of the post office blush." During the day Breton, dressed in brightly colored shirts and shorts, would hunt with the others for butterflies,

or for agates in the riverbed—seeking in the latter, as the Surrealist Robert Benayoun put it, "signs, colors, transparencies, and sometimes *figures*, which everyone could interpret to their liking, according to their personal paranoia and the specific magic governing the time of discovery." Breton later celebrated the "language of stones," noting that "to persevere in seeking [these agates] acts on the mind like a *narcotic*" (much like Surrealism itself, according to the *Manifesto*).

But despite the seriousness with which Breton, for one, pursued these searches, many outside the movement saw Saint-Cirq as a kind of absurd summer camp. "People here in Paris used to laugh at the Surrealists chasing butterflies out in the country," recalled the writer James Lord. "Breton was a very magisterial presence, but people used to snicker behind his back. All those little games, people thought they were a joke."

One person who was not laughing that summer was a certain Bessac, a deputy in Cahors who also served as guide for the prehistoric grottoes in nearby Cabrerets. Breton, whose interest in prehistoric cave paintings had led him before this to visit several sites in the area, went with Elisa, Adrien Dax, and Dax's wife to see the Cabrerets offerings on July 24. As he told the police several days later, hardly had he and some thirty other visitors entered the cave when, seeing a painted line on the stone wall, he reached over to rub it "with the intent of judging the thickness of the chalk layer covering it." At that moment, Bessac swatted Breton's hand with his cane and sharply reminded him not to touch the cave paintings. Breton protested this "return to Nazi mores," and immediately the two men were shouting angrily at each other. At that point, Breton reached over and rubbed the painting with his thumb, causing a significant smudge—"which utterly astonished me," he said, "since the line had supposedly been drawn some 30,000 years ago." With Breton crying forgery and the other charging vandalism, the two men were on the verge of blows when Dax stepped in to separate them. Breton and his party then started to leave, but when Bessac shouted out that his antagonist was a "coward," the Surrealist ran back in and punched him in the nose.

Breton soon found himself in the local police station on charges of "defacing a historic monument." Trial was set for the following autumn, and in the meantime a team of archeologists was brought in to determine the paintings' authenticity (which appears never to have been settled). The bulletin of the French Prehistorical Society carried an editorial by a seventy-five-year-old curate scolding Breton for being a "naughty boy." And someone adorned the universal signpost in Cahors—where two years earlier Breton had come to celebrate its inauguration as a "global city"—with one more indicator: "Charenton Prison: 700 kilometers."

✳

In mid-September, after the brief, obligatory stopover in Lorient, Breton returned to Paris. The fall was a busy one: he founded the newsletter *Médium: Informations surréalistes* (edited by Jean Schuster) and planned to launch a journal called *La Mante surréaliste* [The Surrealist Mantis]. The latter would include "surveys, contests, games, even an 'advice column'"; its aim, as he told Victor Crastre, was, "without any other concessions on our part, [to target] the readership of train stations, for example. I don't think it's impossible." It was a far cry from the resolute independence of *La Révolution surréaliste*, but, as Breton recognized all too well, it was "fairly risky today to pattern a magazine on the old model." (Or even on the new model: *La Mante Surréaliste* never saw the light of day.)

And in December, Breton made another attempt (his first since the short-lived Gradiva) at running an art gallery. Located at 11 Rue du Pré-aux-Clercs in the 7th arrondissement, the new space opened on December 1, 1952, under the name L'Etoile Scellée. The Surrealist Robert Lebel later recalled Breton gathering various artists into his new gallery "with the perfect courtesy of a host who is skilled at forgetting past differences, even insults."

Under Breton's stewardship, L'Etoile Scellée featured the works of Surrealist artists present and past, as well as of various non-Surrealists deemed sufficiently interesting (most notably the Abstract Expressionists or *tachistes*, spearheaded in France by the critic Charles Estienne). In the best tradition of Surrealist meeting places, L'Etoile Scellée also became a magnet for new discoveries, such as young Hungarian refugee Simon Hantaï. Hantaï anonymously left one of his paintings by the door one evening that winter, prompting an enthusiastic Breton to give him the gallery's first one-man show soon afterward. And the gallery brought to light one of the strangest figures to pass through Surrealism in these years, the fifty-five-year-old painter Pierre Molinier, whose violently erotic women—reminiscent of Bellmer's mangled dolls and, more distantly, of Gustave Moreau's femmes fatales—immediately won Breton's admiration. "Fetishist, transvestite, bisexual, painting with his sperm, incestuous, and necrophiliac," was how a critic described him. At least one of Molinier's paintings (probably *The Flower of Paradise*) soon found its way to Rue Fontaine.

Finally, it was in late 1952—on November 18, just short of his fifty-seventh birthday—that Paul Eluard died of a heart attack. Aragon published a long retrospective of his old comrade in *Les Lettres françaises* and printed tributes from writers and artists worldwide. The burial at Père Lachaise cemetery, Communist section, reunited Picasso,

Triolet, Tzara, Cocteau, Fernand Léger, numerous Party officials, and the obligatory Aragon, who delivered the graveside oration. (Literary archivist Carlton Lake, present at the burial, remembered that as the latter spoke, his "face contorted into a snarl, his jaw shot forward, and his voice rose to the pitch of frenzy. Somewhere behind me, someone whispered, 'Hitler.'") Breton neither attended the funeral nor made any public statement about Eluard. Privately, however, he spoke of him to Julien Gracq in such "violent terms" that Gracq found them "painful to hear." Nearly fifteen years after the fact, Breton's bitterness at his old friend's betrayal went undiminished. (So did his hatred of the man who had ostensibly come between them: in March 1953 he commented on Stalin's own death, which came a few months after Eluard's, by saying that history would remember the Communist ruler only as a real-life version of Dostoevsky's Grand Inquisitor.)

More immediately painful to Breton was the death of Pierre Mabille on October 13, 1952. The man who had been his doctor and his friend for nearly twenty years, who had sheltered him at war's outbreak and brought him to Haiti at its end, had been attending a patient when he suddenly turned red and collapsed. He was forty-eight years old. Breton eulogized Mabille in a tribute published by *Arts* on October 24: "You, Pierre, in the shadows?" he wrote. "I no longer wish to see my door, where so often your passage made the light shine through." Then, on January 4, 1953, sudden death also claimed the thirty-eight-year-old Jindrich Heisler, who for the past six years had been one of the group's most active members.

In fact, as Breton sighed to Georges Schehadé several months later, the winter had been "extremely somber in every respect." Eager to escape the demoralizing atmosphere of Paris, he and Elisa left for Saint-Cirq at the end of May 1953, Breton especially looking forward to hunting orchids. That summer, he also retraced the steps of some key Surrealist precursors, revisiting the Facteur Cheval's Ideal Palace in Hauterives and, shortly afterward, the birthplaces of Alfred Jarry and Henri Rousseau in the city of Laval—as if the recent visitations of death had opened a need for the reassurance of permanency.

That same summer, Breton and his friends developed a new Surrealist game based on the principle of poetic analogy. The game, called One Inside Another, had originated in a café debate the previous March: discussing his concept of analogy as he lit a pipe, Breton had argued that one might just as easily describe the flame from his match in terms of a lion as in terms of fire. "It immediately occurred to me," he later wrote, "that under such circumstances the flame lying dormant in the match would 'reveal' the lion's mane, and that at that point, one needed only a few words specifically relative to the

match in order to bring the lion to life. The lion is *inside* the match, just as the match is *inside* the lion." In late July at Saint-Cirq, Breton and Péret put One Inside Another into verbal form: short paragraphs that described one object or action in terms of a second— an exercise as potentially rich for engendering poetry as the underground stream of automatic writing had been.

The rules of the game were simple and, since many of Breton's friends happened to be visiting, they were tried out that same evening: one player would silently think of an object (or person, or event), while the rest of the group would decide on another object, which they would reveal to the player. The player would then improvise a description of the group's object, but in such a way that the group could guess the identity of the object he had secretly chosen. During one of Breton's turns, for example, he described himself as "an HOURGLASS, one part of which, still contained in a larger hourglass, will progressively disengage itself from the latter and sever all connection. I am opaque, reddish in color, and of elastic consistency. The vermilion sand I contain flows at least every second. On the average, I am expected to work for several decades." Answer: a child being born. Other examples included a chocolate bar described as a wild boar, a coffee bean as a public bench, the Paris Opera as a field of tulips, a glowworm as the assassination of the Duc de Guise, and Galileo as "a ROASTING SPIT that pretends not to turn so as not to be roasted itself." In a written presentation of the game for *Médium* the following year, Breton pointed out that, in the three hundred times the game was played that summer, not once did the group fail to guess the answer.

In August, Sagittaire published *Free Rein* (*La Clé des champs*), Breton's first collection of essays since *Break of Day* twenty years earlier. It contained the quasi-totality of his short prose writings since the mid-1930s, including his impressions of Mexico and the collaborative manifesto with Trotsky; "The Situation of Surrealism Between the Two Wars" and *Caught in the Act*; and finally such recent pieces as an essay on outsider art and his "open letter" to Eluard over Kalandra's execution. The book had originally been scheduled for the previous winter, but a delay had been caused by the typesetter's refusal to be associated with such an "antimilitaristic and antireligious" piece of work.

Several months later, in November, Breton's case came up for trial in the matter of the Cabrerets cave paintings. In preparation for the hearing, Breton set about rallying as much support as possible. He mobilized Jean Paulhan, who put up his own laurels (Legion of Honor, Croix de Guerre, Resistance Medal, etc.) as collateral to obtain petition signatures on Breton's behalf from prominent writers—including, ironically, several members of the Académie Française, as well as the Société des Gens de Lettres, which in earlier times had called for the Surrealists' deportation. Breton also obtained the reluc-

tant signature of the now prominent André Malraux, alongside those of Lévi-Strauss, Gracq, Gaston Bachelard, Jules Romains, François Mauriac, ex-Surrealist Raymond Queneau, and the influential Camus (with whom he had recently engaged in a public dispute, and who no doubt relished the irony of now coming to Breton's defense).

But in the final account, whatever support Breton marshaled was for naught. On November 20, in a decision that was covered by all the major newspapers (*Le Figaro* even ran a large photo spread), the criminal court in Cahors found him guilty of defacing a historic site; on the 27th he was fined 5,000 francs, plus one franc in damages to the state, one franc to the town of Cabrerets, and a considerable 100,000 francs in damages to Bessac as "licensee" of the grotto. Paulhan immediately tried to get Breton advance money against future writings for *La Nouvelle Nouvelle Revue Française* (*sic*), which had begun appearing again the previous January. Before the fines could be enforced, however, newly elected French president René Coty—no doubt finding the entire affair absurd—pardoned Breton as one of his first official acts.

Breton's interest in ancient cave paintings (whatever misfortunes it might have caused him) was no isolated phenomenon, but rather one aspect of his longstanding pursuit of alternatives to the hated Greco-Roman cultural legacy. Over the past decades, this pursuit had brought numerous African, Native American, pre-Columbian, Oceanic, and Eskimo artifacts to Rue Fontaine, and to the forefront of Surrealist thinking on art. But it was only in 1954 that Breton truly turned his attention to the culture of his own birthright, that of Celtic Brittany.

The spur came from the publication of scholar Lancelot Lengyel's monograph on ancient Gaulish coins, which sparked not only nationwide interest in the art of the Gauls but also a quasi-nationalistic defense of Celtic culture on Breton's part. Celebrating Lengyel's book, he underscored the irrational basis of Celtic art (a philosophy "*of true enlightenment*") and castigated "the foreign [i.e., Latin] invaders of the year 50," whose "malignant influence" was still trying to suppress such anti-rational art movements as Surrealism and abstractionism. As Breton saw it, the Celtic tradition provided not only a strong historical precedent for his own rejection of Greco-Roman rationalism, but even an anticipation of such notions as "convulsive beauty."

From this point onward, Breton would draw explicit parallels between Celtic aesthetics and the Surrealist perspective. So deeply did he identify with the Gauls, in fact, that he refused even to visit the land of the "invader." At around that time, plans had been made for Breton and Elisa to travel to the Mediterranean with several friends; but Breton stopped at the border, declaring: "Italy and Greece will not function!" Elisa continued on without him, and several days later, as Breton was lunching with Claude Roy

and his wife back in Paris, the latter wondered why Breton had refused to join the others. In response, he asked whether *she* would have "gone sightseeing in Germany during the Occupation. For more than two thousand years we have been *occupied* by the Greco-Latins," he exclaimed, his face reddening. "Never, in my entire life, have I set foot in Greece or Italy! And never, *never* will I go to those places!"

Among the many factors involved in Breton's vehement embrace of Celtic tradition—cloaked, as were each of his philosophical stands, in peremptory reasoning—one might also see a fear of death, as more and more it claimed pieces of his past. The winter of 1952–53 had already witnessed the passing of two close friends, Mabille and Heisler, and of the once cherished Eluard. Now, on November 30, 1953, came the death of Francis Picabia. For all intents and purposes, Breton and his former brother-in-Dadaism had not collaborated since their quarrel of 1924; but in recent years, the two had enjoyed the peaceful complicity of veterans from a long-finished war. On December 4, Breton stood at Picabia's graveside and addressed his "dear Francis" for the last time: "You were one of the two or three great pioneers of what has been called, for lack of a better word, *the modern spirit* . . . Nothing, not even after this distraught salute I'm giving you, can keep you from standing at the magnetic forefront of this spirit. We would be ashamed—what am I saying, we would be *afraid*—to leave you."

It was not only the mortality of others that troubled Breton at this time, but his own as well. To Paulhan, who asked to publish the funeral oration to Picabia in the *NRF*, he confessed that he had barely begun reading his text when "a pounding in my 'occipital lobe' made me afraid that I wouldn't be able to finish." His health during those winter months, he said, was in fact "quite mediocre," leaving him "indecisive, lacking the energy to face even the projects that were dearest to me." For the rest of his life, Breton would be prey to disruptive physical ills: persistent anemia that made him tired and depressed, and recurrent respiratory ailments—worsened by his long history of smoking, by the damp chill of his poorly heated studio, by the strain of scaling Saint-Cirq's steep pathways, and by a severe allergy to the dust rampant in both his object-filled apartment and his ancient country house—that increasingly kept him from participating in the events he had set afoot. Given this, it is hardly surprising that so much of Breton's life was now centered on things of the past.

This backward glance, moreover, did not encompass only cave paintings and Gaulish coins, but also included a number of individuals—especially women—from Breton's emotional history. Beginning at the end of the 1940s, several old loves, now become friends and confidantes, reemerged in his personal firmament after a long eclipse. Simone, once the target of his outrage, now calmly visited Saint-Cirq or received Breton's

visits at the art gallery she began managing at that time in Place du Furstenberg. Suzanne, who had been the catalyst of their divorce, dined at Rue Fontaine with the Bretons or came in turn to Saint-Cirq with her own spouse, Jacques Cordonnier. (Her renewed friendship with Breton would continue until the late 1950s, finally ending for good over Suzanne's defense of the reviled Marcel Jean.) Even Jacqueline, who had left David Hare and returned to Paris, made a kind of peace with her former husband.

Perhaps closest of all in those years was Lise Deharme, who since the war had become Breton's favored companion (along with Claude Lévi-Strauss) during his long and frequent wanderings through the Clignancourt flea market. "We walk in every part of this no-man's-land, which constantly seems like the far end of the world," Lise recounted in her diary. "When one is with [Breton] life is lived to the fullest." But these were no longer the days of *Nadja*, and neither Lise nor Clignancourt were what they had been in 1926. "When you think what the flea market used to be!" one friend remembers Breton complaining. "But now that it's gotten several stars in the guidebooks and become an obligatory stop for busloads of foreigners, its charm has dissipated." As for Lise, Breton's desperate passion for "the lady of the glove" had matured into a much more tranquil friendship. Lise often invited the Bretons to her home, making her former suitor the star attraction of the cocktail parties she hosted. One witness remembered Breton "presiding at the table across from Lise, very pleasant, very courteous."

It was also with Lise that Breton, Julien Gracq, and the poet Jean Tardieu collaborated on a text, *Farouche à quatre feuilles* [Four-Leaf Clover], at the end of 1953. Originally planned as a radio broadcast, the four individual segments revolved around the notion of reverie, which each author treated in terms ranging from the gushingly lyrical to the dryly didactic. Breton's contribution, "Alouette du parloir" [Skylark in the Parlor], mixed discursive rumination with poetic dialogue in a way reminiscent of his 1925 *Introduction to the Discourse on the Paucity of Reality*—even to the point of casting reverie as "a marvelous, unpredictable, tender, enigmatic, provocative young woman, whom I never ask about her disappearances," much like the feminine incarnation of his own consciousness in the "Discourse."

Although far from Breton's best, the text is interesting for its underlying portrait of a man vainly seeking to recapture the muse, beset by outside distractions and his own diminished creativity. "What's happened to the days when we had all our time to spend together—what did you call it: automatic writing, I believe? But I've already told you everything, haven't I?" reverie—alias "Titania"—asks the narrator. Throughout, their colloquy is interrupted by the prosaic "Garo" (inspired, perhaps, by some of Surrealism's younger firebrands), who persistently engages the narrator in discussions of current

affairs even as the latter is desperately trying "to catch hold of that fleeting person [Titania], who means to take advantage of nothing so much as of our moments of distraction." It was the barely concealed confession of a man whose once notable written output had waned almost to nil.

Not that opportunities or outlets for Breton's writing were lacking. Recently, the Club Français du Livre had commissioned him to write an extensive study of "magic art," one of five projected volumes on art history that the club meant to offer its clients as premiums. The advance had been paid, the subject interested Breton, but despite his efforts the writing would not come. Several years earlier, he had also promised Gallimard two books "conceived in the spirit that is most characteristic of me, in other words the spirit that runs from *Nadja* to *Arcanum 17*." But the delivery dates had passed without either work being written.

In fact, since the *Conversations* with Parinaud—indeed, practically since *Arcanum 17* in 1944—Breton had produced little more than incidental texts: art catalogue notes, brief political editorials, presentations of Surrealist games, necrologies. Gone were the days when he could yield such works as the *Second Manifesto*, *The Immaculate Conception*, and *Ralentir travaux*, all in the space of twelve months. On the one hand, Breton in his late fifties simply no longer had the stamina of his early thirties. But José Corti, former publisher of Editions Surréalistes, also made an intriguing observation when he noted that "a meeting with a woman is at the origin of each [of Breton's major lyrical works], from *Nadja* to 'Free Union,' from Valentine to the Jacqueline of *The Air of Water* and *Mad Love* . . . Since he remarried, no more emotional shock." And Jacqueline seconded this view by observing that Breton needed "the intrusion of another Woman" in his life: "A new passion would bring us a new book."

It was as if in search of that "new passion" that Breton, in the mid-1950s, formed friendships with several young and attractive women. One of these was the filmmaker Nelly Kaplan (also known as Belen), who met Breton in March 1956 at an exhibit of pre-Columbian art. Alone in the museum, Kaplan suddenly became aware of a man staring at her, who kept reappearing as she moved from room to room. Breton finally introduced himself, and Kaplan promised to send him an invitation to a film she was completing with the renowned director Abel Gance, *Magirama* (for which she and Gance had developed a new cinematic process called "polyvision"). But *Magirama* was delayed, and it was only in December that Breton saw the film and renewed acquaintance with its lovely co-author.

Breton had never taken much interest in cinema as an art form, noting in 1951 that it "had everything it needed to catch up with [poetry]," but that, with few exceptions,

"the least that can be said is that it did not set out in that direction." Still, he claimed to be especially taken with *Magirama*, and on December 31, after the preview, he told Kaplan that the show had "bowled him over." In *Cahiers du cinéma*, he also celebrated polyvision as a decisive step toward "a new structure of time."

In fact, it was Kaplan herself who had bowled Breton over. As of January, the two began a six-month spate of "almost daily walks," recalled Kaplan, who "experienced Paris with [Breton], through him, as I never had before. Incandescent conversations in implausible cafés . . . ; in the glacial arcades of the Palais-Royal; in the still-deserted rooms of the Gustave Moreau museum; at the flea market, among signpost paintings . . ." More than companionship bound them, for Breton seems, at least for a while, to have developed a passionate attachment to the young filmmaker. "I become marvelously lost in your eyes," he told her on January 6, in one of many love letters written during those months. "In a state of pure giddiness, I steal glances at the splendid curves of your body when you walk beside me, I see the passionate spirit that inhabits it . . . I remain *saturated* with you."

In the end, however, neither polyvision nor Breton's friendship with Kaplan was to have much future. The couple continued to see each other until late July, up to the day when a disagreement over Philippe Soupault, a close friend of Kaplan's, put an end to their relations. The argument erupted as they were sitting at the upscale Café de la Paix. Breton, said Kaplan, "was furious, impolite, as I'd never seen him before. He was seething with rage, refusing to accept any opinion other than his own, before the astonished looks of the peaceful tourists surrounding us." Returning home, Kaplan received a call from Breton, who icily demanded the return of his letters. The next say, she knocked on his door and threw them in his face, after having ripped each one into small pieces; Breton stood in the rain of confetti and asked if "that was it" for their friendship. He nonetheless tried to salvage his relations with the woman in one last, impassioned letter: "I've loved you, Nelly, with all the violence of which I'm capable. You had heard about this violence, it shouldn't have caught you off guard; perhaps it's even a little of what attracted you to me." But although the two did later reconcile, there were no more "almost daily walks."

Far more durable was Breton's meeting in 1954 with the twenty-six-year-old poet Joyce Mansour. Born Joyce Patricia Adès in Bowden, England, the daughter of a wealthy Jewish-Egyptian family, Mansour had married at the age of seventeen, and then, a year and a half later, after her first husband's death, had gotten remarried to a rich businessman named Samir Mansour. The couple divided its time between Cairo and France, and it was in the latter country that Joyce (who wrote in French, a language she spoke with a pronounced British accent) published her first book of poems, *Cris*, in 1953. It was a

book filled with the cruel, violent, passionate imagery of sex and death, and it enthralled Breton from the first pages. Having come across the volume by chance, he wrote to its author soon after its publication, inviting her to visit during her next season in Paris.

Joyce Mansour was short, dark, athletic, and attractive, with intense eyes and straight black hair often worn pageboy style. Like Lise, she had the insouciance of wealth taken for granted. "She had no financial sense," her husband recalled. "Sixty francs or sixty million francs were all the same to her." In many ways, Joyce's life was that of a typical *haute bourgeoise*, who lavished attention on her children, cared for her husband (and skillfully deterred his mistresses), and hosted the fabulous dinner parties that were expected of her social class.

But it was the other aspects of her personality—the dark, frenzied eroticism that emerged in her poetry; her unconventional public behavior—that had most drawn Breton. Soon after she joined the Surrealist group, a legend sprang up that Joyce lived exclusively on oysters, hot water, and cigars—a legend that, while plainly exaggerated, indicates the kind of aura the young woman could create around herself. For Breton, this combination of poetic talent, exotic looks, and eccentricity was a proven mix. As for Joyce, although she remained devoted to Sam, she was clearly dazzled by the Surrealist leader thirty-two years her senior. For the next decade and more, at café meetings, in Saint-Cirq, and over endless walks throughout Paris (including, of course, the flea market), Breton would be nearly inseparable from the woman whom several have called his last great love.

Despite the constancy of their relations, it was also, in all likelihood, a relatively platonic love. Breton was very taken with Joyce, attracted to her both emotionally and physically. But the sexual hunger that had emerged during his courtships of Suzanne and Lise, the bodily celebration of his early years with Jacqueline, even the erotic cruelty of his affair with Valentine Hugo gave little sign of reemerging here—at least not explicitly. Breton was apparently unwilling to risk his third (and, at fifteen years, longest-lasting) marriage for the sake of sexual magnetism. Nor is it certain that Joyce's own attraction to the sexagenarian Breton was nearly as physical as his to her.

What, then, was Breton hoping to find in these friendships with Joyce Mansour or Nelly Kaplan? Kaplan believes that, by this time, he was seeking to recapture the passion now lacking in his marriage, and she remembers him complaining (in terms not unlike those of a philandering business executive) that his wife "didn't understand" him or care about his research. Suzanne Muzard, with subtler nuance, added that while Breton was "appreciative" of Elisa, "he could not help resorting to independent 'impulses,' perhaps to feel reassured and to preserve the delusion that he was evading old age." In neither

case, however, does he seem to have pursued his "impulse" (nor, perhaps, was he offered the chance). Instead, over the years Breton and Joyce would spend in each other's company, their friendship came to resemble the type between impressionable student and lovestruck mentor, with all its underlying layers of flirtation and complicity, of momentary happiness and long, wistful regret.

✳

When Joyce Mansour entered it, the Surrealist group was anything but harmonious. Various internal tensions were causing friction among certain members, their causes and feebleness reminiscent, after even the Pastoureau crisis, of Marx's famous dictum that great historical events occur twice: the first time as tragedy, the second as farce. In 1954, Jehan Mayoux, a provincial schoolteacher and sometime Surrealist since the 1930s, became agitated over a publisher's advertisement that Jean Schuster had run in the latest *Médium* for a book by Michel Carrouges (again)—occasioning a series of long protests to both Schuster and Breton. Two years later, the same Mayoux created a stir because a monograph on Péret, which Pierre Seghers was publishing and which he had hoped to write himself, had instead been commissioned of Jean-Louis Bédouin: more long missives to Breton, who was no doubt relieved that Mayoux lived too far from Paris to regularly attend the café meetings.

Such rifts, minor though they may have been in the grand scheme of things, were indicative of the unraveling weft of the Surrealist group and of Breton's slackening authority in matters of policy. No incident showed this more clearly than the exclusion in late 1954 of Max Ernst. Although not truly a participating member for some time, Ernst had periodically frequented the group meetings since his return to France in 1950. But in June 1954, the painter won the grand prize at the Venice Biennale, a situation that for him meant relief from many years of poverty, but that a number of the younger Surrealists found unacceptable. In December, after several months of discussion, a meeting was held at Rue Fontaine to decide the fate of Max Ernst. Jean Schuster and others of his generation pushed for Ernst's ouster, which Breton opposed. The doctrinarian rigidity of the younger members ultimately won out, and Breton was forced to bow to majority rule. Several commentators have taken this incident as (in Schuster's words) "exemplary of the democracy that existed in Surrealism." But compared with the dynamic, if at times autocratic, leadership that Breton had once been able to exert, it was mainly exemplary of his own tired resignation.

By early 1955, in fact—and despite Breton's increasingly frequent harangues against

"gravediggers"—it was becoming more and more difficult not to credit the notion that Surrealism was no longer a vital force. *Médium*, which Aragon had winkingly dubbed "the most inoffensive magazine in the world," folded in January after its fourth issue (hastened along by the money shortages of its publisher, Eric Losfeld). And Breton's most notable publications that year—practically the only notable publications of the entire group—were reissues of two old works: *The Communicating Vessels* with Gallimard and still another edition of the *Manifestoes of Surrealism* with Sagittaire (the latter featuring a loupe with which one could read the "Surrealist ephemera" printed in small type on the endpapers). It was little wonder that a spin-off of Lettrism called the Lettrist International soon after distributed a card announcing the death of Surrealism in France.

This death was not entirely metaphorical. That same January 1955, Breton received word from America that fifty-four-year-old Yves Tanguy had succumbed overnight to a cerebral hemorrhage. "It pushes us all the harder to take care of ourselves," he told Péret, and with good reason: at the time, Péret was in the hospital for a serious illness, and Breton himself was suffering from a persistent and debilitating cough that, coupled with his recurrent anemia, left him feeling "tired and gloomy" for months on end. Tests later in the month revealed a small but deep ulceration in the left side of his throat, identified as the cause of his coughing fits.

Despite his illnesses, Breton lost no time trying to launch a new magazine to replace *Médium*; ideas for it were debated at café sessions throughout the spring, though for the moment no viable concept had emerged. Meanwhile, in one of those periodic migrations that had now become habit, the group left the Café de la Place Blanche, and Montmartre, for the Café Musset near the Palais-Royal, not far from the Louvre. But neither the hope of a new magazine nor the change of venue seems to have revived Breton's spirits, and in July he complained to Péret that he "could no longer stand" the meetings, which he now attended only once a week. "The lack of both any kind of energy and of human warmth . . . ended up giving me a real aversion to that place."

Added to his worries was the nineteen-year-old Aube's poor scholastic performance, which left Breton unsure of his daughter's future. "I'd like at least to spare her the routine of failure," he told Péret. Perhaps hoping to spark the girl's intellectual curiosity, Breton and Elisa brought her that spring to the Black Forest, which had once inspired Breton's fascination with the German Romantics. In the summer, they also took her to Saint-Cirq, where she was surrounded by her father's lively young cohorts. Ultimately Breton needn't have worried, for if Aube left school the following year to become a social worker, in the mid-1970s she would begin applying her artistic talents to the striking collages for which she is now known.

Meanwhile, the Bretons made the yearly visit to Louis Breton in Lorient. This was in fact to be Breton's last visit to his father, for Louis died on November 10 at the age of eighty-eight. Discreet and unassertive, the old man had quietly monitored his famous son's career with a mixture of pride and well-meaning concern, secretly taking his side against Marguerite's vociferous resentment. "Even if he didn't always understand what his son was doing, he made an effort," Aube recalled of her grandfather. "He liked the fact that the newspapers talked about Breton, that he was 'somebody.'" At Louis's death, his modest house contained a complete set of his son's works, many of them inscribed, and a thick file of newspaper clippings—for the time, one of the most impressive Surrealist archives in France.

As on the death of his mother nine years earlier, Breton returned to Lorient for the burial, staying only long enough to hire a notary to handle Louis's estate. This estate was not so small as one might think: the same piecemeal economy that had allowed the retired gendarme turned crystal merchant to buy his son the house in Saint-Cirq had also left him with a fairly tidy nest egg, the equivalent (property included) of some 500,000 francs in today's currency. For the first time since the days of his employment with Jacques Doucet, Breton found himself freed from financial worries, at least for a while.

Following the relative lethargy of the previous year, 1956 seemed to begin on a more active note. On April 12, Nikita Khrushchev's revelations about Stalin at the Twentieth Party Congress generated a Surrealist tract to their "Communist comrades." Declaring that Stalin had betrayed the revolution and dulled its energy, they called on the Communists to institute "free and immediate discussion within the cells . . . about revising the History of the Party"—beginning with the rehabilitation of Trotsky. Several days later, addressing a political rally, Breton cautiously noted that recent events authorized, "as had not been the case for a long time, EVERY HOPE." (Of course, Khrushchev's revelations were motivated by politics rather than principle, and that November the Surrealists discovered how little things had changed when the Soviets crushed a Hungarian workers' uprising. "*The fascists are those who fire on the masses*," they cried in protest. "The defeat of the Hungarian people is the *defeat of the world proletariat*." Like Stalin before him, however, Khrushchev did not overly worry about the dismay of some French intellectuals. Meanwhile, the head of the French Communist Party, Maurice Thorez, answered the Soviet move toward de-Stalinization by digging in his heels and becoming, in one historian's words, "more Stalinist than the Russians.")

Also in April 1956, Breton announced the launching of a new periodical, *Le Surréalisme, même*. "A new Surrealist periodical! Why?" asked a promotional flyer. "To respond to the confidence and the often pressing questions of that portion of youth that

refuses to slip the noose over its neck; to distress and confound, once again, those who—for thirty years now—have been stubbornly proclaiming the death of Surrealism." The new magazine, promised for May (although it would not actually appear until October), would be costlier and more luxurious than the late *Médium*, printed on coated paper and copiously illustrated. Its publisher was Jean-Jacques Pauvert, whose enviable list of arcane literature was supported by his hugely successful reference books. *Le Surréalisme, même* would be overseen by Breton and edited by Jean Schuster, whose role in the group had grown considerably since the eclipse of Pastoureau and company five years earlier.

But despite this flurry of new activity, Breton spent a large part of 1956 sick and depressed. That February, his sixtieth birthday again found him in poor health, and in the spring a bout of bronchitis left him melancholy and apathetic. That summer, he acquired one more trapping of old age—becoming father of the bride—when twenty-year-old Aube married the poet and painter Yves Elléouët, who had begun frequenting the Surrealists the previous year. Meanwhile, the gallery L'Etoile Scellée, although it had brought the Surrealist group several interesting new painters, was closed that year by its owner without Breton even being notified. As for the group, although Breton had formed close ties with some of its younger members, such as Schuster, much of the current roster seemed less than inspiring. "Who *are* these young people who come to see me?" he sighed to his old friend Alain Bosquet.

Most discouraging of all was Breton's inability to write, and particularly his inability to write *L'Art magique*, which was now dragging into its third year of noncompletion. He had managed to draft an extended preface, but the body of the text was far from finished. It was not that Breton had ignored the project: it occupied him almost constantly, to the point where he spent many days—something he'd done on only a handful of previous occasions—carefully documenting his research at the Arsenal library. Rather, the problem was with the writing itself, an inner blockage that caused him deep anxiety. As he had told Jean Paulhan the previous August: "The words 'magic art,' which of course I wouldn't have chosen, and the meaning that it was, if not licit, then at least fruitful to ascribe to them, have toyed with me as a cat does with a mouse. And this for two years running, without being able to deal with anything else, while I stagnate more and more beneath its claws."

In fact, *L'Art magique* was only the most palpable example of a general creative paralysis. Breton, however, did not see it that way, and instead ascribed the work's incompletion to external, occult forces—specifically to the paralyzing influence of a voodoo doll that stared down at him from a shelf in his study, and that he dared not dispose of because, as he told Roger Caillois, this required "certain conditions that are hard to realize." (With

wry humor, Breton admitted that Caillois, the former skeptic of the Mexican jumping beans incident, must have found all this rather superstitious.) Jacqueline later confirmed that Breton believed some of his fetish objects to have "power over his daily life," and that he often moved them around on his shelves in an effort to alter their influence. Just as, twenty years earlier, Breton had attributed his troubles with Jacqueline to the influence of a "haunted house" on the Lorient seashore, so now he externalized his diminished creativity onto supernatural malevolence. It was a form of projection that Breton had practiced all his life—that lay, one could argue, at the heart of the Surrealist vision—but that this time, instead of providing philosophical impetus, merely served as self-justification.

At the same time, the issue was not solely one of writer's block, for as Breton readily admitted, his very subject had proven overwhelming. What exactly *was* the relation between art and magic, and how could one begin to define these terms for the purposes of an exposition? Breton later explained for Parinaud the "near impossibility, when one looks carefully at the matter, of defining the concept 'magic art,' which is constantly on the point of overspilling its boundaries (it is understood that all authentic art is magical), or of becoming inordinately restricted (what work of art can boast, not of having changed the face of the world, but even of having transfigured the life of its author?)."

At an impasse, Breton finally engaged the young Surrealist Gérard Legrand to collaborate with him on the book. The two men spent long hours conversing on the topic, which Legrand noted down; he then added his own material, merging it with what Breton had written over the previous months. The result was a lengthy history of art as "the vehicle of magic," from cave paintings through the modern age—ending, naturally, with Surrealism. Breton's choice of Legrand was shrewd; for not only was the twenty-nine-year-old art historian knowledgeable, but his mimesis of Breton extended even to his writing style. In fact, although Breton actually wrote (in Legrand's estimation) only the introduction and "one-quarter to one-third" of the main text, it is practically impossible to tell that the entirety of *L'Art magique* was not written by Breton himself.

Despite Breton's hardships with it, *L'Art magique* does provide an interesting personal overview of the concept of magic in art, even as the unusually large number of undigested scholarly citations and comparatively flattened tone betray the underlying difficulties. The text weaves together references to, and reflections by, ancient esoteric thinkers such as Eliphas Lévi; German Romantics such as Novalis; sociologists and anthropologists, notably Frazer, Durkheim, and Lévi-Strauss; numerous artists (including Bosch, Da Vinci, Rousseau, Munch, and Gauguin); and such indispensable Surrealist references as Freud, Baudelaire, Swedenborg, Achim von Arnim, Lautréamont, Rimbaud, Chirico, Apollinaire, and Duchamp. This is Breton at his most erudite, but by the same token at

his most dependent. And if in the course of his essay he does arrive at a passably comprehensive definition of "magic art"—art "that somehow reengenders the magic that engendered *it*"—the text as a whole mainly gives an impression of cautious uncertainty.

In Breton's view, the "centerpiece of the volume" was a long survey on "the relations between magic and art," which he had sent to eighty writers, artists, ethnologists, sociologists, historians, and psychologists. Those whose answers appeared in the book included Martin Heidegger, Malraux, Herbert Read, Octavio Paz, Lévi-Strauss, Magritte, Mansour, Péret, Carrington, Bataille, Paulhan, Caillois, Carrouges, novelists Michel Butor and Pierre Klossowski, Gracq, Mandiargues, Lancelot Lengyel, and some forty others. The totality of responses, reproduced as a separate section of *L'Art magique*, constitutes a fascinating dossier on the question—even if, as Breton pointed out, those whom he most expected "to provide highly pertinent responses" to the question (the sociologists and ethnologists) mainly answered with "ill humor."

This ill humor was particularly evident in the case of Lévi-Strauss, whose professional training balked at Breton's use of the word "magic" and who out of friendship had preferred simply to ignore the survey. But pressed by Breton, the anthropologist finally had his teenage son, Laurent, answer part of the questionnaire in his stead. Breton printed the response exactly as received, but when the finished book came out he dedicated the complimentary contributor's copy to Laurent, and broke off all relations with Claude.

After a difficult four-year gestation, *L'Art magique* was finally published by the Club Français du Livre on May 25, 1957, in an edition of 3,500 copies. Though relieved at its completion, Breton took little pride in the finished work: to keep costs down, all but sixteen of the 230 illustrations had been reproduced in black and white, rather than the color he had requested; the text (particularly of the survey) was badly designed and crammed onto the page; and the publisher had left numerous errors uncorrected. Moreover, critical response was at best slight. *Cahiers du Sud* devoted several laudatory pages to the book, and the *NRF* targeted the "confusion at the heart of the work" as "the very image of today's intellectual and spiritual anarchy." Other than this, there was little to mark the appearance of *L'Art magique*. It was sadly indicative of Breton's stature by 1957 that, when he published his first significant new work in five years, scarcely anyone took notice.

THE ANTI-FATHER

(August 1957 – September 1966)

CLAUDE ROY, LOOKING BACK FROM the vantage point of the 1970s, left this testament to the impact Breton had on people's lives: "I noticed that all around me, for years, Breton had been someone to whom others referred, whom others questioned, if only from afar . . . At every stage of my path, there was someone forever wounded or strengthened, thrown into doubt or filled with nostalgia, because Breton had dominated his life at a given moment . . . Breton had shown his contemporaries how to read, how to live, and how to love." It was a flattering but not inaccurate portrait: for even as the attention of the mainstream ebbed further away, Breton was being permanently inscribed in the intellectual register of the twentieth century.

One indication of Breton's stature at the time was the various parodies and imitations that took him as their model, making of him not so much a man as an institution. One incident involving the novelist Jean Dutourd showed just how used people had become to faux-Breton: Breton, who admired Dutourd's work, publicly praised his article on an unknown nineteenth-century German revolutionary named Ludwig Schnorr—only to learn that Dutourd had actually invented Schnorr from whole cloth. In November, he denounced Dutourd's prank in an open letter, which the amused novelist reprinted verbatim in his next book, appropriately titled *Les Dupes*. He was no doubt more amused when a reviewer of *Les Dupes* earnestly wrote that Mr. Dutourd, although a gifted comic writer, had failed to convincingly pastiche a letter by André Breton.

One of the things that made Breton such an easy target for satirists, apart from his recognizably emphatic style, was his resolute indifference—if not open hostility—to the sacred cows of public opinion. At this time, one of his main targets was the encroachments of the scientific age: for if "Dada was not modern" (as Tzara had once claimed), Surrealism could in certain ways be staunchly retrograde. Already in the 1920s, Breton had decried the invention of the sound film as diminishing the cinema's emotional impact; and in 1952 he had shocked André Parinaud by declaring that technology was of no use to humanity—on the contrary, that such "achievements" as the atom bomb had spiritually devastated it. "If religion has long been the opiate of the masses," a

Surrealist tract added several years later, "science is rapidly taking its place."

What Breton particularly held against science, at a time when Sputnik was heralding the space race and the two antagonistic blocs had the atom bomb, was both the unprecedented danger of annihilation it had brought about and the unthinking faith that people nonetheless seemed to place in it. Answering a newspaper survey on the "conquest of space" in 1961, he opined that the speculations inspired by recent space flights were vastly inferior to those found in Jules Verne, or even Rimbaud. As Breton saw it, the popularization of science was simply the latest in "a succession of religious or political obscurantisms"; mankind would do far better to seek its bearings in the luminous past rather than in the obscure future. He did, however, make an exception for one piece of modern technology, the tape recorder, which became a favorite toy at around this time.

Just as he disdained scientific advances, so Breton had little connection with the artistic and cultural "innovations" of the 1950s and early 1960s. With few exceptions, the productions of the New Novelists, New Critics, or Absurdist playwrights left him indifferent, as did any art based on pure form and intellectual dispassion. Breton, whether in art or in life—and despite charges perennially made against Surrealism's "difficulty" or "inaccessibility"—had little tolerance for the purely mental. As Charles Duits pointed out, he "loathed the cerebral and attached no value to works in whose conception the intellect played a dominant role." Instead, the man who had unmasked a Rimbaud forgery by its lack of internal passion never ceased judging works and individuals by the emotional "shivers" they could generate. "Criticism will be love or will not be at all," he had written to Simone in 1920. For more than forty years, his writings and actions had upheld that maxim.

Of the movements launched during that period, in fact, only two sparked real interest on Breton's part: the Situationist International and Tel Quel. The Situationist International was founded in 1957 by members of the Lettrist International (led by Guy Debord, who would later become famous for his 1967 book *Society of the Spectacle*) and a few others. The group had clearly taken much from Surrealism, from its anti-capitalist, anti-Stalinist politics to its use of art as an extra-artistic medium. But the Situationists, with their iconoclasm and sense of public spectacle, were finally more indebted to Dada than to Surrealism per se; and their direct filial link to Breton and company often put them in the uncomfortable position of sons needing to overcome the father.

This would be even more the case with Philippe Sollers's group Tel Quel in the early 1960s. Sollers had been considered a wunderkind of French letters since his 1958 novel, *Une Curieuse solitude* (published when the author was twenty-two), received enthusiastic boosts from François Mauriac and Aragon, much as *The Magnetic Fields* had once

been endorsed by Proust and Gide. He had founded Tel Quel in 1960, along with its eponymous magazine, and from the outset the affinities with Surrealism were clear—to the point where Breton, who had promised but failed to answer a Tel Quel question- naire, would be listed as one of the magazine's "forthcoming contributors" until a year after his death. In reality, Breton, finding Tel Quel's writings "difficult," paid the group benevolent but distant attention.

Like several young men before him, Sollers patterned his public existence after Breton's, down to the circle of cohorts (which loosely included, among others, Roland Barthes, Julia Kristeva, Jacques Derrida, Gérard Genette, Jean-Pierre Faye, and Denis Roche); the internal splits (Faye would soon leave to found his own group, Change); the territorial interest in Lautréamont, Mallarmé, and Sade, to which Sollers appended Artaud and Bataille; the house periodical; and the sanction of important political and psychoanalytical godfathers (Louis Althusser in place of Marx, Lacan in place of Freud). And just as the Surrealists had left the PCF in favor of Trotsky, Tel Quel would eventu- ally abandon the Party for Maoism.

Still, Tel Quel was too closely locked into its own "anxiety of influence" with Breton not to turn against him sooner or later. For although early issues of the magazine praised Breton's "genius" and "relevance," by the late 1960s it was attacking Surrealism for its "untheoretical and unscientific" idealism, and for having "misunderstood" the writers and philosophies it promoted. Artaud, Bataille, even Lautréamont were now turned into angels of vengeance, representatives of a harder, more rigorous Surrealism than the kind Breton had managed to impose. Locked into its own adolescent revolt, Tel Quel went from being Surrealism's champion to one of its most assiduous "gravediggers," to use a favored Breton epithet.

While young writers such as Sollers and Debord sought to build an experimental future out of Surrealism's ruins, Breton continued to seek out the lessons of the human and geological past. He was conversant with the fashionable writings of Alain Robbe- Grillet, Nathalie Sarraute, and Roland Barthes, but he preferred rereading Villiers de l'Isle Adam or Charles Fourier (whose portrait he bought from an art dealer at that time). At Saint-Cirq he hunted with his guests for agates, or drove through the area seeking out-of-the-way antiques shops. Sam Mansour, Joyce's husband, recalled that at around this time Breton began collecting vintage waffle irons and that he would spend many hours in the Mansours' Porsche scouting out local junk dealers. "Whenever he found an object that was too expensive for him," Mansour said, "he would get Joyce interested in it, and then she would get me to buy it."

As for Surrealism's new initiatives, they were increasingly coming from the younger

members, particularly Schuster. On Bastille Day, 1958, two months after French turmoil over the question of Algerian independence brought Charles de Gaulle back into the government (initially prime minister, de Gaulle would succeed René Coty as president on December 21), Schuster and leftist writer Dionys Mascolo founded the stridently anti-Gaullist periodical *Le 14 Juillet*. In September, the same two published a tract denouncing a referendum that heightened de Gaulle's constitutional powers, calling "the de Gaulle government illegal and Charles de Gaulle a usurper." And the next April, they, along with Breton and Maurice Blanchot, initiated a questionnaire on the Gaullist "coup d'état" that was sent to a hundred prominent French intellectuals. Meanwhile, Gérard Legrand, Breton's co-author on *L'Art magique*, began editing a new Surrealist newsletter called *Bief: Jonction surréaliste*, specifically designed to give the group a voice in current affairs—although, ultimately, neither *Bief* nor Schuster's tracts had much influence outside Surrealist circles.

Of more note was a manifesto dated September 1, 1960: *Declaration Concerning the Right of Insubordination in the Algerian War*, more familiarly called the "Manifesto of the 121." This, too, was largely initiated by Schuster and Mascolo, and was prompted by a six-year-old Algerian war that had become for France what Vietnam would soon be for America. Clearly reminiscent of the Surrealists' 1925 protest against the Rif War, the manifesto called for active resistance to French government policy in Algeria and aid to the separatist cause. It was drafted by Mascolo and Schuster in the spring of 1960, then revised by Breton and Legrand. By the end of August, 121 signatures had been gathered, including those of Breton and every Surrealist of French nationality, as well as Sartre and Beauvoir, Blanchot, Leiris, the film directors Alain Resnais and Claude Lanzmann, Simone Signoret, Marguerite Duras, Nathalie Sarraute, Alain Robbe-Grillet, Claude Simon, Pierre Boulez, and many others. Because of the volatile nature of the statement, and the threat of legal reprisals, no newspaper or journal in France would reprint it, and Mascolo had to distribute over 2,000 copies of the tract by mail.

Given the heated climate, mainstream reaction to the tract was predictably furious. *Le Monde* published a counterstatement in early October, the "Intellectuals' Manifesto," which defended France's actions as "safeguarding Algerian freedom." The official response was even more definite: within a month, twenty-nine of the signers had been arrested, those in the entertainment industry had been blacklisted, and the Surrealist Jehan Mayoux was temporarily suspended from his teaching post. As for Breton, on September 22 he wrote to the presiding judge to protest the arrests and claim his part of responsibility. "I declare myself one of [the tract's] co-authors and specify that by signing it I implicitly undertook to do everything in my power to disseminate it" (a

valiant gesture—even if, deep down, he must have known that the government was not likely to arrest him).

Breton's hand in the "Manifesto of the 121" is emblematic of his diminishing role in the Surrealist collective. While he enjoyed unequaled prestige in the group and was the final arbiter on most of its decisions, and while he continued to inspire, influence, and actively support certain initiatives, more and more in these years he relied on his younger colleagues to handle the details. Now in his mid-sixties, he no longer had the energy to manage the group's affairs with his former vigor.

In addition, his health was seriously declining: shortly before this he had been diagnosed as suffering from chronic asthma, which had been responsible for his respiratory troubles over the past decade and which by the late 1950s had escalated into acute crises—"suffocations," he called them—that made it nearly impossible for him to fill his lungs. Many friends remembered Breton's periodic complaints that he "couldn't get enough air," the bouts of fatigue that kept him away from café meetings for long periods, the difficulties in breathing and sleeping that had him swallowing large quantities of the antihistamine and sedative Phenergan (promethazine hycrochloride)—in itself not a wise medical choice, as Phenergan is contraindicated in asthma cases.

Finally, Breton considered his progressive retreat a kind of apprenticeship for Surrealism's next generation. Knowing how serious his asthma was—to his friends, he confided that he didn't expect to live past the age of seventy—he encouraged the others to handle matters for themselves. Claude Courtot, a Surrealist of the final years, recalled that while Breton "assessed everything, looked at everything," he nonetheless "insisted that the younger people take responsibility. It wasn't laziness on his part: he was anxious for the group to survive him. He often said, 'What will you do when I'm gone?'"

As Breton's public interventions continued to diminish, so, too, did his writings. In 1959, some eighteen months after *L'Art magique*, he published a volume of twenty-two prose poems called *Constellations*, written to accompany a series of gouaches by Joan Miró. The book was commissioned and produced in a deluxe edition of 350 copies by the Pierre Matisse gallery in New York, and sold for 60,000 francs per copy—beautiful, but at that price hardly of a nature to heighten Surrealism's visibility. All the more so since, apart from some short articles in small magazines, this was practically Breton's only publication at the time.

Charles Duits later chided Breton for not having written more, to which the Surrealist wanly replied: "I know. I had certain possibilities, but it seemed to me I should do something else. And besides, I'm lazy." Behind these words, one could still hear the adolescent who had nodded in agreement with Rimbaud's statement, "A writer's hand

is no better than a ploughman's." Ever dismissive of the writer's trade, Breton had always refused to publish simply for the sake of seeing himself in print. As he later told Pierre de Massot, while turning down an offer to contribute to *Les Nouvelles littéraires*: "I've never wanted to write except when moved by inner necessity and . . . this necessity has never mutated into a habit."

And yet, even as his "inner necessity" waned, Breton found his talents being put more and more in the service of others: the price of fame being the constant request for patronage. He wrote a considerable number of book and catalogue prefaces in these years for a number of Surrealist writers and artists—as well as for René Magritte, who in 1960 resurfaced after a long silence to ask Breton's endorsement of an upcoming exhibit. After several pressing letters from the painter, Breton finally sent a brief, laudatory statement.

Not every petitioner was so favored, of course: Octavio Paz, promised a preface for the French edition of his book *Sun Stone* in 1958, finally heard Breton decline three years later, on the grounds (worthy of the glib Aragon) that to preface the well-known Paz would be as presumptuous as introducing Mallarmé's "Afternoon of a Faun." And an unnamed Surrealist poet so besieged Breton with requests for patronage that she at long last received a few lines from his hand—praise so exquisitely damning that the group never heard from the woman again. But for every request refused, there seemed to be an equal number that Breton could not deny.*

Brief and limited in scope, Breton's latest writings no longer seemed to engage the world as they once had, no longer acted as a public reminder of Surrealism's vitality. Breton refused any such inference, of course; and in November 1958, when asked to contribute to a debate on whether "Surrealism was living or dead," he answered with a by now characteristic "warning to those still-unemployed gravediggers" that the movement was alive and well. But he had little to show in evidence, and his protests, repeated more and more frequently and always in similar terms, were sounding increasingly hollow.

In these years of illness and obligation, one of Breton's few genuine pleasures was his friendship with Benjamin Péret. Péret was the only friend of long standing who had never betrayed Breton's confidence, and in return Breton showed him extraordinary devotion and seemingly limitless tolerance. Robert Benayoun relates an anecdote that

* These prefaces weren't wholly altruistic, for in the case of art catalogues, accepted custom was for a painter to reward the writer with a piece of work. Breton's collection of such rewards was by now so extensive that it overspilled the confines of his apartment, forcing him to store many works in the upstairs attic. It also seems that, while many of the artworks in his collection were selected for strictly aesthetic reasons, others were chosen with their resale value in mind. José Pierre, who would himself become an active art critic, later recalled Breton's advice that when a painter offered work in exchange for a preface, "one should always pick the largest and most beautiful piece."

illustrates as well as any the relations between the two old Surrealists. It seems that one day at Saint-Cirq, as a dozen group members were sitting down to roast chicken at the local restaurant, the poor and ever-famished Péret began helping himself without further ado:

> "No," Breton stopped him, "ladies first." Péret, deaf to the suggestion, immediately jabbed his fork back into the chicken. "Did you hear me?" Breton insisted. Then Péret, as if standing up to his father (they were only three years apart in age), made this extraordinarily juvenile and *natural* gesture, as one would say of an aborigine: grabbing up the entire serving dish, he fled across the fields, chased for a moment by a furious André; and, like a stubborn cacique, he devoured the forbidden chicken in solitary delight.

Only Péret, after such an incident, would have dared return to Breton's side—or be welcomed back.

Over the past years, Breton had also helped Péret more actively. It was he who had raised money for the latter's return from Mexico in 1947, by organizing a sale of paintings and manuscripts to pay for boat fare. In the intervening years Breton and Elisa had often fed and lodged the poet, as Péret went through a succession of borrowed addresses, writing works that few wished to read, living on a proofreader's meager wages and the kindness of well-wishers. Finally, it was again Breton who helped organize a sale of works on Peret's behalf in the late 1950s, raising enough money for the poet finally to buy an apartment of his own.

But like Breton, Péret was in increasingly poor health in these years, owing both to the numerous hardships in his life and to the alcohol and cigarettes that he consumed with abandon. Monique Fong remembered him in the late 1940s, aged fifty but "looking like a doddering old man of seventy." Now, at the age of sixty, while Breton had at least retained his peasant robustness, Péret had the waxy, hunched appearance of a nonagenarian. He was hospitalized in the spring of 1959, so ill that he had to remain bedridden for several months. Surgery left him sufficiently well by summer to return home— "we're thrilled to know you're outside again, if not yet free to go where you please," Breton wrote him on July 29—but it was only a temporary improvement: on September 18, Benjamin Péret died in a Paris hospital of heart failure, so quietly that the girlfriend watching over him at first thought he'd merely drifted to sleep.

Like Jindrich Heisler before him, Péret was buried at Batignolles Cemetery in Montmartre's northern limits. His passing was acknowledged by homages in *Arts* and

elsewhere, while the Surrealists placed numerous memorial statements in their own publications. Breton himself said little about this death that pained him as few others had, simply reprinting in *Arts* an excerpt from his introduction to Péret from *Anthology of Black Humor*: "I speak of him from too close up, as if describing a light that, day after day for thirty years, has made my life more beautiful."

Breton was given little time to mourn his friend. On September 23, the day before Peret's burial, he obliged several young editors from the magazine *La Tour du feu* by turning his reminiscence to another vanished companion, Antonin Artaud. And on October 2, Jean-Pierre Duprey, a sporadic but important presence in Surrealism throughout the 1950s, committed suicide at the age of twenty-nine. Depressed and errat-ic for some time, Duprey had been briefly interned at Sainte-Anne not long before. That October day, he bundled together a new manuscript of poems, addressed it to Breton, and asked his wife to bring it to the post office; Jacqueline Duprey returned to find her husband hanging from a rafter in their studio. Breton received the news of the poet's death and his last manuscript at virtually the same time.

In such a context, it seems fitting that the Surrealists should end the year, and the decade, with a manifestation celebrating both the triumph of death and its complement, the power of eros. Mounted by the Canadian conceptual artist Jean Benoît, whom Breton had met through Aube, the *Execution of the Testament of the Marquis de Sade* was held on the evening of December 2 in the commodious Paris apartment of Joyce and Sam Mansour. The guests, present by special invitation, included Matta and Victor Brauner (whom Breton had begun seeing again shortly before, unbeknownst to the other Surrealists), plus some two hundred "writers, poets, painters, filmmakers, critics . . . women in evening gowns . . . their nails painted blue or green . . . As well as a woman in black velvet whose nipple fit through a small hole in her dress."

At a prearranged signal, all stood in a semicircle solemnly facing a stage area, from which emanated the prerecorded sounds of an erupting volcano and of Breton reading from Sade's *Justine*. Benoît then appeared, dressed in a specially designed costume fea-turing a huge, diabolical mask, a decorated panel with a bulging protuberance over his chest and legs, and a cape from which blood seemed to be raining. Behind him he dragged a black coffin through whose lid jutted an outsized erect penis. At that point, a woman dressed in a sober black suit undressed Benoît, who was revealed to be painted all in black, his heart covered by a red star and two-headed eagle: Sade's crest of arms. With a horrifying cry, Benoît then grabbed a red-hot iron placed nearby and branded the word "Sade" into his flesh, squarely over his heart. He then held out the still-smoking iron to his audience and demanded, "Who's next?" Matta—impetuous, drunk, and

intoxicated at being in Breton's company again after more then ten years—rushed up, tore open his shirt, and seared his own left breast.

Matta's headstrong gesture was not in vain, for two days later a communiqué signed by Breton fully reinstated both him and Brauner to the Surrealist ranks. "We would be failing the spirit that Jean Benoît fired in us on December 2, and unworthy of life with its pitfalls and its fortunes, if we did not recognize that Matta on that date showed himself in a light that utterly requalifies him in our eyes," wrote Breton, who added that this announcement was intended "to bear witness to the idea we have of *truth* . . . and of *justice*, which cannot accommodate rigor without appeal." He did not note the irony of the fact that the "rigor without appeal" of Surrealist exclusions was often his own doing; nor of the fact that Matta, who earlier had been exiled from Surrealism for his sadistic treatment of Arshile Gorky, should now be rehabilitated via a testament to Sade.

The Sade evening acted as a prelude to the "exposition intERnatiOnale du Surréalisme," held from mid-December 1959 through February 1960 at the Daniel Cordier gallery on Rue de Miromesnil. As the quasi-Dadaistic typography suggested, the show was devoted to the theme of eros—"mankind's greatest mystery," as Breton called it in his introductory note. The assembled artworks, ranging from the frank, representational nudes of Clovis Trouille to the sensuous abstractions of E. F. Granell and Adrien Dax, sought to confront the public not with the vulgarity of base pornography, but with a sexual ethos liberated from constraint and "rescued from shame." One room featured a trembling pink-satin ceiling, a "vaginal" door leading to a corridor filled with moans, and at the end a red chamber containing a cannibalistic feast.

As with the group's previous retrospectives, Breton saw the EROS show as a means both of examining a current preoccupation (as the 1947 exhibit had explored myths) and of reasserting Surrealism's impact on the arts. And as with previous shows, the critical response fell into several often used categories: hostile incomprehension, complaints about the "bourgeois" audience, insinuations of Surrealism's decline, and nationalistic laments. So familiar were these responses, in fact, that the Surrealists issued a tract in which they juxtaposed various press reactions from 1938 to the present—showing that the reviewers of two decades had favored not only the identical criticisms of their exhibits but in many cases the identical phrasings as well.

Eroticism had always been a constant of Breton's aesthetic—in his preface to the 1959 exhibit he designated it as the "highest common factor" in "the elective fascination which the entirely dissimilar works of Duchamp and Chirico [for example] have been able to exercise with unabated power upon Surrealism since its origin"—but in recent years he had focused on it with unusual insistence. In the late 1950s, alongside the Sade evening

and the EROS exhibit, Breton had celebrated sexuality in the works of Molinier, Trouille, Max Walter Svanberg, and Joyce Mansour, to name a few. And in 1960, prefacing Oskar Panizza's play *The Council of Love*, he wrote: "Desire and pleasure are integral parts of love; nothing can prevent flesh from being *one*." Just as his fascination with Suzanne Muzard had helped inspire the "inquiries on sexuality" in 1928, so now his June-December romance with Joyce Mansour seems to have turned his attention back to the persistent irritation of desire.

✳

One of the great constants of Surrealism was the role of café life, even if the actual locale had changed numerous times in the movement's history. In late 1960 the Surrealist group again moved, this time to the Promenade de Vénus on the corner of Rue du Louvre and Rue Coquillère, near the covered markets of Les Halles. Claude Courtot remembered that the café had been chosen largely for its name—the "walk of Venus"—and that the Surrealists always sat at the far end of the room, where the tables had been pushed together to accommodate up to forty persons (although most meetings were attended by only a dozen or so). Breton generally arrived first, alone or with Joyce Mansour, and installed himself at the center of the table, facing away from the entrance and toward a huge wall mirror, "which allowed him to see who was coming without his own face being seen."

As was traditional, members were expected to be at the Promenade de Vénus between five-thirty and seven o'clock—cocktail hour—every day except Sunday, when the café was closed. As before, libations were the rule. Breton, no longer able to down several mandarin curaçaos, contented himself with one glass of Beaujolais—"but good and full"—and smoked his pipe. The others did the same or ordered beer, and Mansour (one of the few women present, alongside Toyen and the faithful Elisa) habitually asked for rum and a cigar.

Although seating was more or less on a first come, first served basis, a subtle hierarchy nonetheless obtained. "The shrewd ones," said Charles Duits, "were those who managed to occupy the best seats, at Breton's side. The others strained to hear or chatted among themselves, with complicated smiles and a feeling of having been relegated to 'the outer shadows.'" By unspoken privilege, the chair to Breton's left was always reserved for Jean Schuster, who had emerged as his second-in-command. Philippe Audoin, another Surrealist of the last generation, later described Schuster's arrivals at the café, which by now caused almost as much stir as Breton's own: "Schuster sits down with the

ambiguous expression and slightly strained smile of a man who would have plenty to say—and it would be rude and blunt—but who keeps himself in check for strategic reasons. Sometimes, on second thought, he explodes, takes the offensive, and his fury blazes like his red hair." Passionate, intransigent, and articulate, Schuster was slowly filling the role left vacant by Péret, by militancy if not by poetic gift.

Topics of conversation ranged from the general—current events, books to read or paintings to see—to the particular: an exhibit to organize, a tract to be drafted, a magazine to be launched (such as Surrealism's latest periodical, *La Brèche*, at the end of 1961). Few subjects were considered unfit for discussion (music being a notable exception), and few viewpoints disallowed a priori. According to Courtot, in fact, the only thing considered truly unforgivable was the failure to *have* a viewpoint—or any other form of chronic absenteeism. "After a while, we began to wonder what someone who was always absent was doing in the group."

Despite the expectation of presence, more and more often it was Breton himself who was forced to stay away from the café, sometimes for weeks at a stretch. Particularly when he suffered an asthma attack, he disappeared for a long while, unable to stand the smoky café atmosphere or to expend the energy awaited from him. In March 1963, he complained to poet Alain Bosquet of a persistent cough that kept him "up half the night" and that forced him to "widely space out [his] presence at the Surrealist meetings."

Nonetheless, Breton continued to keep watch on his and his movement's public image. In 1958, prompted by the republication of Maurice Nadeau's *History of Surrealism*, the group had decided to write its own history, emphasizing that Surrealism had not perished in the war. The volume as planned would include a brief historical introduction (assigned to Jean-Louis Bédouin), followed by a series of chapters treating specific aspects of the past fifteen years. But to the group's dismay, Bédouin delivered not a short preface but the equivalent of 300 printed pages. Worse, the wealth of behind-the-scenes detail on such incidents as the Pastoureau Affair revealed more of Surrealism's inner workings than Breton liked; while the narrative's combative tone gave, in Schuster's words, "the impression of a considerable effort to mask the void." It was too late to change the Italian edition, then being printed by the Arturo Schwarz gallery in Milan, but Bédouin was made to accept extensive revisions for the French version—after which, annoyed, he avoided the group for three years.

Very conscious of the public eye, Breton also controlled his own statements, and perhaps nowhere more so than in interviews. In July 1962, he was visited by Madeleine Chapsal, a young journalist for the wide-circulation news weekly *L'Express*. Like many young women before her, Chapsal imagined Breton as "the man of mad love," and she

approached the interview wondering "what this passionate fellow looked like. What would happen between us? Because I was going to see André Breton, I had become a starry-eyed shop girl, the kind who devours romance novels!" But Chapsal was immediately disconcerted both by the suffocating atmosphere of Rue Fontaine and by Breton's "vapid" sartorial dandyism—in this case, a navy-blue silk shirt with white polka dots and matching tie. "Everything here had style. Too much style," she later wrote. "I felt surrounded, almost stifled by the tight web of these artworks . . . When [Breton] started speaking, surprise!, I thought I was at the theater. And even a second-rate local theater where, with standardized gestures, an old and slightly weary actor, alone on stage, projects his hackneyed tirades at the peanut gallery."

Echoing similar utterances to Parinaud ten years earlier, Breton told Chapsal, "The essential thing is that I never compromised with the three causes I've embraced from the outset, to wit: poetry, love, and freedom." The belief in freedom went only so far, however, and Breton—perhaps because this interview had been oral instead of written—held Chapsal back at the door and, "with a threatening air," made her promise to send him the transcript of their conversation before it went to press. "What could he have feared from me? Or from himself?" the disillusioned journalist wondered years later. "For a miserable interview, here he was controlling his words, his movements . . . And mine!"

The fact was, Breton *did* oversee others' gestures, and his own, and anything else that had to do with the movement he had launched nearly forty years earlier. In June 1962, one month before the interview with Madeleine Chapsal, he entered into an epistolary quarrel with Simone over an unauthorized exhibit of Surrealism that she was planning at the Furstenberg gallery. Trying to placate her ex-husband, Simone argued that Surrealism was now in the public domain, but Breton refused to accept this reasoning. Simone stood her ground, and the exhibit opened that month to the Surrealists' protests.

Breton's watchfulness extended even to his own past writings. That winter, for an upcoming republication of *Nadja*, he made a number of revisions to the 1928 text. Claude Courtot recalled him saying, "Oh, you understand, I noticed on rereading the book that there were some little stylistic flaws, some lapses of taste"—something that Breton also explained to his readers in his new preface to the work. But as Pieyre de Mandiargues and others have since pointed out, Breton's corrections were not strictly linguistic, for along with the "stylistic flaws" disappeared all trace of his physical relations with Nadja herself. It was an oddly bashful change to make in a text that had stood naked for thirty-five years; but it indicates the attention that Breton gave every trace of his existence in these, the last years of his life, as if he were making final arrangements with the posterity he had always renounced.

This posterity was no vainglorious illusion, for Breton's own stature, particularly among youth, was larger than ever before—even if it was sometimes reflected in perverse ways. One of the most curious homages paid him during this period came in January 1963, when some young poets (on drugs, Breton claimed) snuck into 42 Rue Fontaine in the middle of the night and tried to set the door to his apartment on fire—a show of affection that would have been comic were it not for the fact that the apartment's gas lines were located just behind the wall and that only luck kept the entire place from blowing up. After this incident, Breton removed his name from the door and installed a heavier lock.

The irony was that Breton's larger-than-life stature had become increasingly disproportionate to the market status of his writings. Certain texts, such as *Nadja* and the *Manifestoes*, had entered the literary canon, but many others were unavailable. René Bertelé, Breton's new editor at Gallimard, urged that the house republish *Anthology of Black Humor*, *Arcanum 17*, *Free Rein*, and *Martinique* (all of which had gone out of print with the liquidation of Editions du Sagittaire in 1959), arguing that they were "'classics' of contemporary French literature." But Gallimard's interest in acquiring these texts was minor, and ultimately it would be the independent publisher Jean-Jacques Pauvert who reissued them.*

As for new work, Breton published only a minuscule volume called *Le La* (an expression suggesting "setting the tone" in music), composed entirely of four semiautomatic sentences that he had collected during the 1950s with "all the respect shown to precious stones." One sentence from October 1951, occurring like the others in a state of half-slumber and jotted down in the middle of the night, went: "O^3 whose skin-snapping lives in C-major like an average." Issued in the spring of 1961 by specialist publisher Pierre-André Benoît, *Le La* was the last new book Breton would see in print. It was a fitting end to his literary output, for with it he returned not only to the same kind of small, independent publisher that had taken on *Pawnshop* and *The Magnetic Fields*, but also to the fleeting, enigmatic utterance that had been at the origin of Surrealism itself—the kind, he had once said, that "knocked at the window."

* It was even more difficult to find Breton's works outside of France, and particularly in the English-speaking world; for although England had an important Surrealist group of its own, and although America had hosted Breton and his friends for five years, neither had yet extended great welcome to his books. In 1960, the New York house Grove Press published the first English translation of *Nadja*—Breton's first book to appear in that language since the 1946 *Young Cherry Trees*—but no others were forthcoming. The *Manifestoes* would not be translated into English until 1969, and such major texts as *Mad Love, The Communicating Vessels,* and *The Magnetic Fields* not until the 1980s. Gallimard, meanwhile, which after considerable delay published an expanded edition of *Surrealism and Painting* in 1965, tried to interest a number of British and Americans publishers in the book, but was turned down.

Still, there was something undeniably wistful about this symmetry, for by the time *Le La* was published many of those who had helped launch the Surrealist adventure were dead, and others living in silent retirement. Two years later, on December 24, 1963, Tristan Tzara would succumb to a long illness at the age of sixty-seven. He and Breton had not seen each other since Tzara's Sorbonne lecture of 1947, but Tzara's son, Christophe, later heard that as the old Dadaist lay dying, Breton was seen pacing around his apartment building, not quite bringing himself to knock at the door. Several months after Tzara, Breton's boyhood friend Theodore Fraenkel also died, having himself flirted with the temptation to reconcile.

But it was over the memory of another departed comrade that Surrealism caused its last public scandal. The incident was set off by an article published in *Arts* on November 15, 1962, by Georges Hugnet, commemorating the death of his friend Eluard. Recalling Eluard's record as a Resistance poet during the war, Hugnet took the opportunity to lash out at "that malingerer, that exasperator, that incredible parasite of a do-nothing, Benjamin Péret," who had ridiculed Resistance poetry from (as Hugnet saw it) his safe perch in Mexico. Within days of the article's appearance, Jean-Louis Bédouin, who had been particularly close to Péret in his final years, wrote to *Arts* editor André Parinaud to protest Hugnet's "slander."

For several others in the group, however, written rebuttals were not enough, and on November 28, at around ten-thirty in the evening, Jean Schuster, Jehan Mayoux, and another Surrealist named Vincent Bounoure knocked on Hugnet's door and announced that they had come "on behalf of Benjamin Péret." In Hugnet's version, the three "aggressors" then forced their way into the apartment, Schuster and Mayoux restraining Hugnet's wife while Bounoure mercilessly beat the fifty-six-year-old, despite his protests of having a heart condition. The three Surrealists finally left after their victim had fainted and several objects had been smashed. Bounoure and Schuster, for their part, claimed that they had visited Hugnet merely in order to "demand an explanation," but that they had become enraged when from outside they saw him "fleeing toward a door at the back of the room." They also denied having laid a hand on Myrtille Hugnet or having broken anything. Still, the uncontested fact was that Hugnet had been beaten for having sullied Peret's memory—and that he had pressed charges against his assailants.

Even before the initial court hearing on December 16, the case of Schuster, Mayoux, and Bounoure was played out in the press: first in *Arts*, which received a volley of letters from both sides of the dispute, then in the large-circulation dailies. "Three Surrealists pummel the (cardiac) author of an article," blared the popular *France-Soir*—which found it necessary not only to recall that "Benjamin Pérret" had died recently, but also to

remind its readers what Surrealism was in the first place. (Several years later, satirists Michel-Antoine Burnier and Patrick Rambaud published their own dossier of the affair, complete with exchanges of letters and a newspaper headline proclaiming: "Nine Surrealists mash a cheese into the face of a (cardiac) civil servant.") The trial itself was held in June 1963. Breton, although he sent written testimony on his friends' behalf, was not present in court, nor did he make any public statement when they were each fined several hundred francs.

At around the same time, but more privately, Breton opposed the publication of a hefty study of "Dada in Paris" by a young academic named Michel Sanouillet. Despite Breton's general disdain of academic treatises ("Not a week goes by when I don't receive at least one thesis on Surrealism," he snickered to Raymond Queneau during that time. "That's what they call culture"), he was always on the lookout for intelligent commentary about his movement. In Sanouillet's case, both the interest of the subject and a letter of introduction from Duchamp had helped sway Breton, who allowed the aspiring professor to consult his unpublished correspondence with Tzara and Picabia from the 1920s, and even to reproduce these letters (nearly 100 pages' worth) in the book's appendix.

It was perhaps this very assistance that fueled Breton's wrath when he finally saw the published work in 1965. "He's made me out to be some kind of . . . He's twisted me into a . . . It's *scandalous*!" he sputtered to Claude Courtot. The fact is, Sanouillet's portrait was closely based on firsthand documents—many of them provided by Breton himself—and, although clearly biased in Tzara's favor, did not grossly distort the truth. But the man who had carefully orchestrated his public image for so many decades could not help but be incensed by seeing his younger, less assured, frequently Machiavellian, and sometimes baldly ambitious self through Dada-colored lenses.

Breton was further angered by the use reviewers made of his correspondence, which Sanouillet had indeed reproduced in his appendix and whose earnest and flattering tone was a source of mirth for a generation of journalists—and readers—familiar only with "the Pope." No doubt inspired by the Sanouillet incident, Breton donated his unpublished papers and letters to the Jacques Doucet collection (now housed at the Bibliothèque Sainte-Geneviève in Paris), placing nearly insurmountable restrictions on access to them. In this way, he both added his own manuscripts to the many documents he and Aragon had amassed for the collector, and ensured that future scholars would not have so easy a time as Sanouillet in unearthing his private sentiments. It was also around this time that Breton added a provision to his will barring publication—and in most cases consultation—of all his unpublished papers for a period of fifty years after his death. (This restriction was overturned with the auction of Breton's collection in 2003.)

Finally, in April 1964, in response to an unauthorized show curated by ex-Surrealist Patrick Waldberg, Breton decided to hold a new Surrealist exhibit "worthy of the name," which he announced would open in several months at the gallery L'Œil—though in fact it did not open until December 1965. Titled "L'Ecart absolu" [The Absolute Remove], the Surrealists' exhibit took as its theme the evils of consumer society, in an attempt to "debunk . . . the brain-deadening world of household appliances, computers, and astronautics in which we're supposed to find 'happiness.'" The acquisitive instincts of modern man were lampooned in a number of installations, one of the most notable being "The Consumer," a twelve-foot-high effigy that featured a siren head, a taxi-radio voice, a washing-machine stomach (endlessly churning mashed newspapers), and a refrigerator back from which dangled a bridal veil. There was also the "Does-Not-Computer" (*le désordinateur*), an engineering marvel whose various compartments satirized sports, leisure activities, space travel, the work ethic, child rearing, and (ironically, but significantly) the "women's liberation movement." At Breton's urging, Editions Gallimard rushed out a new, expanded edition of *Surrealism and Painting* in time for the opening, in a printing of 10,000 copies. Meanwhile, the group forestalled critics' commonplaces by providing three model reviews of its own: condescendingly benevolent, haltingly uncertain, or blatantly hostile, as one wished. Apparently the critics deemed these models sufficient unto themselves, as "L'Ecart absolu" received an unusually small number of write-ups. It was a final chance wasted: this international Surrealist exhibit, the movement's eleventh, would also be the last in Breton's lifetime.

By the mid 1960s, André Breton had become the father (or "anti-father," if one prefers; the term is Sarane Alexandrian's) of several generations of Surrealist militants—more welcoming than most elders to youthful ideas, perhaps, less vainglorious than the Anatole France he had once reviled, more constant than the Maurice Barrès he had tried for "conspiracy against the security of the Mind," but in his own way no less a grand old man of letters. So grand and old, in fact (he was now approaching seventy, and had been a significant presence in French intellectual life for over forty years), that some had begun announcing his demise: in 1964, the magazine *Strophes* published a black-bordered announcement of Breton's death "after a long agony" (further on, they specified that Breton "now lives only on his pride in the past"); while in 1966, in an "open letter" to himself, Salvador Dalí joked about "the reflexes of the facial nerves of André Breton immobilized in death for over a century."

This immobility was not merely facial, nor was it strictly Dalinian fancy: Breton, whose health was now steadily declining—already weakened by asthma, he had his mobility further curtailed when his leg was injured by a passing car—in fact spent more and more time shut up in his studio. This studio, moreover, was itself the symbol of a larger, more paradoxical immobility, one that had found the author of "leave everything" living in the same place since the day he'd first written those words—a paradox of which Breton was only too aware. "People have always reproached me for being a revolutionary who has never even managed to change his address," he quipped to Alain Bosquet at around that time.

Over the years, this address had become more and more Breton's "crystal, his universe," as Aube put it, a compendium and atmosphere that distilled the research and fascinations of decades. "His work table emerges from beneath an unbelievable chaos of haphazardly piled books, magazines, manuscripts, paintings, and African statuettes," wrote one journalist. The walls of the apartment brimmed with paintings, masks, kachina dolls, varied objects, and exotic stuffed birds. Miró jostled Dalí; Picasso's 1923 etching of Breton competed with a portrait of Baudelaire. As for Breton's study, said James Lord (who recorded his impressions after a visit in 1970), it "was more than worth the visit. I have seldom found myself in such an extraordinary interior. The room is quite large with a high window across one end. It is filled, literally as full as can be, with an astonishing profusion of heteroclite objects, paintings, sculptures, constructions, and whatnot. I have never seen so many crowded into such a limited space. And yet it does uncannily make a whole, which is the strangest thing of all."

One item of long standing that was missing by the time of Lord's visit was Chirico's *The Child's Brain*, which Breton had owned for nearly half a century, and which he finally sold—regretfully, hesitantly—to the Moderna Museet in Stockholm in 1964. In part, the decision was motivated by Breton's chronic need for money; and indeed, the sale price (which appears to have been around a quarter of a million francs) assured him financial comfort for the brief rest of his life. But there was also an element of anger, inspired by Chirico's recent attacks on Surrealism in the press: for the embittered painter had never forgiven the group's turn against him in 1926.

It was also in the mid-1960s that Breton's writings finally began to reemerge, as virtually every one of his books was put back into print. The most active reprinters were Pauvert and Gallimard, which, following reissues of *Nadja*, *Surrealism and Painting*, and other titles on its backlist, published the quasi-totality of Breton's poetry in two paperback anthologies. The person responsible for these latter volumes was ex-Surrealist Alain Jouffroy, now an editor for the venerable publishing house, who since his 1948

exclusion had renewed relations with Breton, broken a second time in the early 1960s, and finally reconciled again at the end of 1964.

In addition to reissuing the poetry, Jouffroy engineered the most important of Breton's republications at Gallimard during this time: the first edition of *The Magnetic Fields* since Sans Pareil's original 796-copy printing in 1920. Breton had tried to have the book reprinted in the 1940s, without success; but the situation had now changed, and by early 1966 Gallimard was eager to keep as much of Breton's opus under its roof as possible. (The house has since acquired copyright to virtually all of Breton's published and unpublished writings.) Sending Jouffroy as his emissary, Breton approached his ex-collaborator Soupault for permission to reprint. "Breton was quite insistent about it," Soupault recalled, "and that surprised me because so much time had passed. But he attached a lot of importance to the project" (although the book, published in 1967, would finally come out too late for Breton to see it). At Breton's suggestion, Jouffroy added the plays *Vous m'oublierez* and *If You Please*, the latter now including the fourth act missing from its original publication in *Littérature*.

Finally, it was with Jouffroy that Breton took a long automobile trip through Brittany in April 1966, not long after his seventieth birthday. Breton had scant fondness for his regional compatriots ("He thought Bretons were cretins," said Jouffroy; "to his way of thinking, it was pitiful that a race which was mythically that of the Celts and King Arthur should have fallen into such decadence, alcoholism, and stupidity"), but he had always loved the Breton landscape: the Ile de Sein where he had spent several tumultuous summers, the harsh seacoast around Lorient, the Finistère, Pont-Croix, Huelgoat, Le Pouldu—names and sites that had provided the backdrop for so much of his life. That spring, knowing he would not survive much longer, he decided to see these privileged landscapes one final time. With Jouffroy and Joyce Mansour, he visited the Quiberon Peninsula and the fishing port of Douarnenez on the western coast. There Jouffroy rented a car, and the two men drove to Huelgoat, rediscovering the marvelous forest where they had first met twenty years before.

This was to be Breton's last excursion, for his health was now visibly worsening. In July, he left Paris to spend the summer in Saint-Cirq. In the warm sun, he received visits from his friends: Soupault, who remembered that "he gave the impression of pulling away from life"; Jouffroy, for whom he recited from memory a poem by Victor Hugo. Breton had always been known for his manner of reading poetry: a lilting, old-fashioned, but extremely moving style that he had taken from Apollinaire and others. Now, said Jouffroy, he read Hugo's verse "in a hoarse voice, hammering out the words and violently emphasizing the final stanza," which evoked the death of a poet.

As in Paris of late, Breton seldom left the house, no longer able to join the others for an aperitif at the village café, nor to scale the steep inclines leading from one part of Saint-Cirq to the next. Instead, those who came to visit often found him in his bathrobe—he who, for so many years, had received even casual guests in carefully matched suit and tie. But although Breton's health was seriously compromised, he refused to see a doctor, a decision that indicates not so much stubborn pride as an unwillingness to confront the inevitable; for as Courtot later noted, the former medical student had no illusions about his condition. The reality of death was something Breton had never been able to accept, either for others or for himself. "I have great trouble admitting that my heart will stop beating someday," he had written in 1920. Perhaps hoping to forestall that day, he prolonged his summer in Saint-Cirq, talking with those who came by to visit and taking short walks in the countryside when his energy allowed.

It was in Saint-Cirq, on the evening of Tuesday, September 27, that Breton was suddenly shaken by a critical asthma attack. He was taken to the hospital in Cahors, but the local facilities proved unequal to the task, and it was decided that he should be sent to Paris. (Aube, for her part, believes that the hospital preferred to turn Breton away rather than risk losing so famous a patient.) It took an ambulance ten hours to reach the capital—the "moving van" in which Breton had once jokingly asked to be brought to the cemetery would no doubt have done better—during which time Breton, choking and on the verge of arrest, was denied an oxygen mask because of his asthma. Nonetheless, after several hours he felt well enough to halt and step out onto the roadside for a breath of air, pure relief after the stifling rear of the ambulance. He told the driver it was now useless to hurry, and asked to be taken back to Rue Fontaine instead of the hospital.

When they finally reached Paris; Breton was bundled up four flights of stairs to his apartment, where Aube was waiting. And later that night, it was she who urgently summoned the doctor when his breathing again became labored. Breton was carried by stretcher back down the stairs and rushed to Lariboisière Hospital less than a mile away—the same hospital that, while following a young girl in 1931, he had once mistaken for the Maternity. In a final surge of black humor, as he was being carried from the address that had been his home and his world, he rasped out: "I'm making a damned poor exit."

In the night Breton suffered another violent attack. An emergency tracheotomy was performed, but to no purpose: gasping for breath, barely aware of his surroundings, André Breton succumbed to massive heart failure shortly after six o'clock on the morning of Wednesday, September 28, 1966. Elisa and Aube were at his bedside. As he had predicted to friends years before, he had not lived past the age of seventy.

THE GOLD OF TIME

AT 10:45 ON SATURDAY, OCTOBER 1, 1966, a beautiful autumn morning that later turned to rain, Breton's coffin was brought to the Batignolles Cemetery. The site had been chosen by the group hastily, almost haphazardly, partly for its proximity to Rue Fontaine, partly because it was already the burial ground of Péret and Jindrich Heisler. Smaller and less ostentatious than such celebrated yards as Père Lachaise, Batignolles is one of Paris's remotest and least visited cemeteries, boasting among its entombed (apart from the three Surrealists) only the "writer and magus" Joseph Péladan, several opera singers, a famous admiral, and Paul Verlaine, whom the Surrealists had long execrated as Rimbaud's insignificant other.

The funeral was simple: there was no procession à la Victor Hugo, no official presence, no graveside oration. No flowers were deposited on the grave, save for a wreath of red roses in the name of an anarchist youth group and, here and there, a furtive bouquet left by a timid hand. A simple death announcement was distributed, bearing Breton's name and the phrase (from the *Introduction to the Discourse on the Paucity of Reality*) that would soon adorn the simple granite block and sculpted North Star covering his remains: "I seek the gold of time."* The coffin was buried in the cemetery's northernmost reach, at the corner of Avenue Centrale and Avenue des Jardins in the thirty-first division.

Of the thousand or more who came to the cemetery that Saturday, many were young: "adolescents, young couples whom [Breton] had never met, whom he didn't know, who didn't know him," recalled Jacques-Bernard Brunius. "They were there because they'd heard Breton was dead." There were also Breton's contemporaries, the friends and colleagues of a lifetime: Buñuel, Soupault, Duchamp, Leiris, Simone, Joyce, Prévert, Queneau, Gracq, Mandiargues, Lise, Nadeau, and many others. But as the Yugoslavian Surrealist Dušan Matić noted, there were few from the generation in between. Nor, conspicuously, did one see certain important figures from Breton's past, such as Aragon, Picasso, or Dalí.

* The French phrase, "*je cherche l'or du temps*," contains an untranslatable but significant play on words: *l'or du temps* (the gold of time) is a homonym for *l'hors du temps*: what stands outside of time.

By the day of the funeral, many had made their parting remarks in print, as newspapers around the world ran articles and tributes to Breton's memory. A host of figures, many of whom had become prominent through their association with Breton, joined the chorus. "Breton was a lover of love in a world that believes in prostitution," Duchamp was quoted as saying. "For me, he incarnated the most beautiful youthful dream of a moment in the world." Even Dalí, the consummate joker, was moved to state without irony that "Breton showed many artists the way. In France, and throughout Europe, he was the torch that guided their steps." Testimonials also came in from those who had watched Breton only from afar, or whose contact with him had been slight. "I put him on the same level as Einstein, Freud, Jung, or Kafka," said the playwright Eugène Ionesco. "In other words, I consider him one of the four or five great reformers of modern thought." Finally, the newspapers abounded in posthumous kudos, lauding the achievements they had so often reviled during Breton's life—among them *L'Humanité*, Breton's former nemesis, which now proffered "only words of sorrow and respect." These were Breton's final reviews, the most positive he had ever received, significantly applied not to a single book or body of writing, but to the example he had set with the actions of a lifetime.

Ultimately, however, it was Aragon, Surrealism's much-decried Judas, who provided perhaps the most heartfelt reminiscence of all:

> It will soon be forty-eight years ago, on November 9, 1918, that André Breton sent me one of the collage-letters he was then in the habit of writing . . . When I received that letter . . . a small square of paper, no doubt added on the morning of the 10th just before mailing it, blinded me to everything else. In the center one could read:
>
> > *But Guillaume*
> > *APOLLINAIRE*
> > *has just*
> > *died*
>
> Last Wednesday I came across that square of paper in André's letters, which I had sadly begun rereading. And since then, I've been unable to take my mind off it. It is impossible to say here what I would have liked to say about the friend of my youth, about that great poet whom I never stopped loving; impossible to say anything other than one sentence, like an echo . . . a sentence that blinds me to so many things:
>
> > *But André*
> > *BRETON*
> > *has just*
> > *died*

✳

In the months after Breton's death, the Surrealist group carried on as best it could, with Jean Schuster, Breton's designated successor and literary executor, taking over the leadership role. A new periodical, *L'Archibras*, was launched in May 1967, and the café meetings continued as before at the Promenade de Vénus. Meanwhile, the media continued to assess the Breton years, offering up numerous retrospectives. And in April 1967, the *NRF* published a thick homage to its former contributor, gathering still more testaments and reminiscences. Ironically, all the attention paid Breton himself ended up obscuring the reappearance of one of his most important works, *The Magnetic Fields*, which garnered hardly a mention until Aragon ran an extended essay on it in the May 1968 *Lettres françaises*—thereby finally inserting himself into the history of this seminal work that, to his undying spite, had been produced without him.

Perhaps the most notable tribute of all came eighteen months after Breton's death, during the riots of May 1968, when many of the slogans covering the walls of Paris turned out to be Surrealist or pro-Surrealist statements: "Choose life instead," "Long live the Surrealist Revolution," "Beauty will be convulsive or will not be at all," while the "Letter to the Rectors of European Universities" from 1925 was posted on the walls of the Sorbonne. Many of the Surrealists themselves joined the protesters on the barricades, and a tract put the movement "at the students' disposal for any practical action aimed at creating a revolutionary situation."

But as several members later recognized, May 1968, in many ways the greatest public explosion of Surrealism, also signaled the movement's decline as an organized entity. "The events of May 1968," said Claude Courtot, "which one could see as Surrealism in the streets, by the same token meant that it no longer remained within the confines of the group. We were almost ejected from it. We felt we had been overtaken."

Moreover, once the general euphoria had died down, the Surrealists noticed that May 1968 had acted within the movement as a catalyst for tensions that had been rising since Breton's death. It soon became clear that only he had had the personal prestige and intellectual breadth to keep the various, at times antagonistic, factions within Surrealism from splitting apart. "Once there was no more Breton," said Courtot, "things were open to discussion. Everyone stuck to his position, and it all came apart. No one had the necessary authority to chart a course for the ship." After several more months of schisms and internal dissent, Jean Schuster officially disbanded the Surrealist movement on February 8, 1969.

✳

Today, a highway overpass runs directly over Batignolles cemetery, throwing a shadow on many of the graves and filling this remote pocket of the city with the rumble of trucks shuttling between the capital and France's industrial North. Several blocks away, the neighborhood around Place Blanche—somewhat gaudier but no less tawdry than when Breton first moved into it—still abounds in cafes, traffic, and the lights of storefront cabarets. Until 2003, Breton's studio at 42 Rue Fontaine remained virtually untouched: the books gathered dust on their shelves, the massive writing desk supported the same manuscripts and curios in perpetuity, the paintings covered the wall exactly as when their owner had last seen them. Ultimately, however, Breton's heirs, unable to maintain the increasingly valuable collection privately, agreed to put it up for sale in a controversial auction that ran from the 1st to the 18th of April 2003. While the auction dispersed the works and documents gathered over the course of a lifetime, forever shattering the "crystal" that the studio had long been, it also led to many of these objects being made available for the first time to individuals eager to learn from them without restriction or critical mediation.

Up until her own death in 2000, Elisa Breton firmly resisted moving or selling the studio's famous contents, even as she forbade or protested such unwanted manifestations as a proposed statue of Breton and the opening of an "André Breton Library" in the northern suburb of Aubervilliers, next to Pantin. In 1986, however, the City of Paris officially inaugurated the Allée André Breton in the newly built Forum des Halles, one of several pedestrian walkways burying the site of Breton's nocturnal stroll with Jacqueline fifty years earlier. Nearby, in a dim and ironic echo of the long-departed Bar Maldoror and of the passions it once stirred, another new walkway bears the name Terrasse Lautréamont.

SELECT BIBLIOGRAPHY

I. Works by André Breton

Mont de Piété. Paris: Au Sans Pareil, 1919.

Les Champs magnétiques [with Philippe Soupault]. Paris: Au Sans Pareil, 1920; new ed., Paris: Gallimard, 1967.

 English: *The Magnetic Fields*, trans. David Gascoyne. London: Atlas Press, 1985. Facsimile ed.: *Les Champs magnétiques: le manuscrit original, fac-similé et transcription*. Paris: Lachenal & Ritter, 1988.

Clair de terre. Paris: Collection Littérature, 1923.

 English (containing selections from *Clair de terre, Mont de Piété*, and *Le Revolver à cheveux blancs*): *Earthlight*, trans. Bill Zavatsky and Zack Rogow. Los Angeles: Sun & Moon Press, 1993; revised ed., 2004.

Les Pas perdus. Paris: Gallimard, 1924.

 English: *The Lost Steps*, trans. Mark Polizzotti. Lincoln: University of Nebraska Press, 1996.

Manifeste du surréalisme. Paris: Sagittaire, 1924; revised eds., 1929, 1946, 1962.

 English (including *Soluble Fish, Second Manifesto of Surrealism,* and related texts): *Manifestoes of Surrealism*, trans. Richard Seaver and Helen R. Lane. Ann Arbor: University of Michigan Press, 1969.

Légitime défense. Paris: Editions Surréalistes, 1926.

Le Surréalisme et la peinture. Paris: Gallimard, 1928; revised eds.: 1946, 1965.

 English: *Surrealism and Painting*, trans. Simon Watson Taylor. New York: Harper & Row, 1972; new ed., Boston: MFA Publications ("artWorks"), 2002.

Nadja. Paris: Gallimard, 1928; revised ed., 1963.

 English: *Nadja*, trans. Richard Howard. New York: Grove Press, 1960; [with a new introduction by Mark Polizzotti] London: Penguin Books, 1999.

Ralentir travaux [with René Char and Paul Eluard]. Paris: Editions Surréalistes, 1930.

 English: *Ralentir Travaux*, trans. Keith Waldrop. Cambridge, Mass.: Exact Change, 1990.

Second manifeste du surréalisme. Paris: Editions Kra, 1930; subsequently included with the 1924 manifesto.

L'Immaculée conception [with Paul Eluard]. Paris: Editions Surréalistes, 1930.
English: *The Immaculate Conception*, trans. Jon Graham. London: Atlas Press, 1990.

Misère de la poésie. Paris: Editions Surréalistes, 1932.

Le Revolver à cheveux blancs. Paris: Les Cahiers Libres, 1932.

Les Vases communicants. Paris: Les Cahiers Libres, 1932.
English: *Communicating Vessels*, trans. Mary Ann Caws and Geoffrey T. Harris. Lincoln: University of Nebraska Press, 1990.

Qu'est-ce que le surréalisme? Brussels: René Henriquez, 1934.

Point du jour. Paris: Gallimard, 1934.
English: *Break of Day*, trans. Mark Polizzotti and Mary Ann Caws. Lincoln: University of Nebraska Press, 1999.

Position politique du surréalisme. Paris: Sagittaire, 1935.
English: *Political Position of Surrealism*, in *Manifestoes of Surrealism*.

L'Amour fou. Paris: Gallimard, 1937.
English: *Mad Love*, trans. Mary Ann Caws. Lincoln: University of Nebraska Press, 1987.

Anthologie de l'humour noir. Paris: Sagittaire, 1940 [released 1945]; revised eds., 1950, 1966.
English: *Anthology of Black Humor*, ed. and trans. Mark Polizzotti. San Francisco: City Lights Books, 1997.

Arcane 17. New York: Brentano's, 1944; revised eds., 1945, 1947.
English: *Arcanum 17*, trans. Zack Rogow. Los Angeles: Sun & Moon Press, 1994.

Ode à Charles Fourier. Paris: Fontaine, 1947.
English: *Ode to Charles Fourier*, trans. Kenneth White. New York: Grossman, 1970.

Martinique charmeuse de serpents [with André Masson]. Paris: Sagittaire, 1948.

La Lampe dans l'horloge. Paris: Robert Marin, 1948.

Poèmes. Paris: Gallimard, 1948.

Entretiens (1913–1952) [with André Parinaud]. Paris: Gallimard, 1952.
English: *Conversations: The Autobiography of Surrealism*, trans. Mark Polizzotti. New York: Paragon House, 1993.

La Clé des champs. Paris: Sagittaire, 1953.
English: *Free Rein*, trans. Michel Parmentier and Jacqueline d'Amboise. Lincoln: University of Nebraska Press, 1995.

Farouche à quatre feuilles [with Lise Deharme, Julien Gracq, and Jean Tardieu]. Paris: Grasset, 1954; new ed., 1985.

L'Art magique [with Gérard Legrand]. Paris: Club Français du Livre, 1957; revised ed., Paris: Phébus/Adam Biro, 1991.

Constellations [with Joan Miró]. New York: Pierre Matisse, 1959.
English in Paul Hammond, *Constellations of Miró, Breton*. San Francisco: City Lights Books, 2000.

Le La. Alès: P.A.B., 1961.

Perspective cavalière, ed. Marguerite Bonnet. Paris: Gallimard, 1970.

→ See also Breton's *Œuvres complètes* (Paris: Gallimard ["Bibliotheque de la Pléïade"], 1988 [vol. I: 1911–1930], 1992 [vol. II: 1931–1941], and 1999 [vol. III: 1941–1953]; as of this writing, one more volume is projected).

→ For a more complete listing of Breton's writings, the reader is referred to Michael Sheringham, *André Breton: A Bibliography* (London: Grant & Cutler, 1972), and to Rudolf E. Kuenzli, "André Breton: A Selective Bibliography, 1971–1988," in Anna Balakian and Rudolf E. Kuenzli, eds., *André Breton Today* (New York: Willis Locker & Owens, 1989).

II. Principal anthologies of Breton's work in English

Young Cherry Trees Secured Against Hares, trans. Edouard Roditi. New York: View Editions, 1946; new ed., Ann Arbor: University of Michigan Press, 1969.

Selected Poems, trans. Kenneth White. London: Jonathan Cape, 1969.

What is Surrealism? Selected Writings, ed. Franklin Rosemont. New York: Monad Press, 1978.

Poems of André Breton, ed. and trans. Jean-Pierre Cauvin and Mary Ann Caws. Austin: University of Texas Press, 1982; new ed., Boston: Black Widow Press, 2005.

My Heart Through Which Her Heart Has Passed: Poems of Love and Desperation, ed. and trans. Mark Polizzotti. Paris & London: Alyscamps Press, 1998: uncollected love poems written between 1926 and 1931.

André Breton: Selections, ed. Mark Polizzotti. Berkeley: University of California Press ("Poets for the Millennium"), 2003.

III. Principal secondary sources

4 Dada Suicides: Selected Texts of Arthur Cravan, Jacques Rigaut, Julien Torma & Jacques Vaché. London: Atlas Press, 1995.

Abel, Lionel. *The Intellectual Follies: A Memoir of the Literary Venture in New York and Paris*. New York: W. W. Norton, 1984.

Agar, Eileen, with Andrew Lambirth. *A Look at My Life*. London: Methuen, 1988.

Alexandre, Maxime. *Mémoires d'un surréaliste*. Paris: La Jeune Parque, 1968.

Alexandrian, Sarane. *Breton par lui-même*. Paris: Editions du Seuil ("Ecrivains de Toujours"), 1971.

———. *Le Surréalisme et le rêve*. Paris: Gallimard ("Connaissance de l'Inconscient"), 1974.

Alquié, Ferdinand. *The Philosophy of Surrealism*, trans. Bernard Waldrop. Ann Arbor: University of Michigan Press, 1965.

André Breton 42, rue Fontaine, DVD-Rom. Paris, CalmelsCohen/Oséa, in collaboration with CosmoBay, 2003.

André Breton 42, rue Fontaine: manuscrits, auction cat. Paris, CalmelsCohen, 11–12 April 2003.

André Breton 42, rue Fontaine: photographies, auction cat. Paris, CalmelsCohen, 15–17 April 2003.

André Breton: la beauté convulsive, exh. cat. Paris: Centre Georges Pompidou, 25 April–26 August 1991.

Andrews, Wayne. *The Surrealist Parade*. New York: New Directions, 1990.

Apollinaire, Guillaume. "Lettres d'Apollinaire à André Breton," ed. Marguerite Bonnet, *Revue des Lettres Modernes* 104–107 (1964).

Aragon. *Anicet ou le Panorama, roman*. Paris: Gallimard ("Folio"), 1972.

———. *Aragon parle avec Dominique Arban*. Paris: Seghers, 1968.

———. *La Défense de l'infini*, ed. Edouard Ruiz. Paris: Gallimard, 1986.

———. *Entretiens avec Francis Crémieux*. Paris: Gallimard, 1964.

———. "L'Homme coupé en deux," *Lettres Françaises* (8 May 1968).

———. *Je n'ai jamais appris à écrire ou les incipit*. Geneva: Albert Skira ("Les Sentiers de la Création"), 1969.

———. "Lautréamont et nous," *Lettres françaises* (1 and 8 June 1967).

———. "Premier vendredi de *Littérature*," *Digraphe* 51 (March 1990).

———. *L'Œuvre poétique*. Douai: Livre Club Diderot, 1974–75, esp. vols. I, II, and VI.

———. *Paris Peasant*, trans. Simon Watson Taylor. Cambridge, Mass.: Exact Change, 1994.

———. *Treatise on Style*, trans. Alyson Waters. Lincoln: University of Nebraska Press, 1991.

Archives du surréalisme, I. Bureau de recherches surréalistes: Cahier de la permanence (octobre 1924–avril 1925), ed. Paule Thévenin. Paris: Gallimard, 1988.

Archives du surréalisme, II. Vers l'action politique (juillet 1925–avril 1926), ed. Marguerite Bonnet. Paris: Gallimard, 1988.

Archives du surréalisme, III. Adhérer au Parti communiste? (septembre–décembre 1926), ed. Marguerite Bonnet. Paris: Gallimard, 1992.

Archives du surréalisme, IV. Recherches sur la sexualité (janvier 1928–août 1932), ed. José Pierre. Paris: Gallimard, 1990.

Artaud, Antonin. *Lettres à Génica Athanasiou*. Paris: Gallimard, 1969.

———. *Œuvres complètes*. Paris: Gallimard, 1961 *et seq.*, esp. vols. I, II, III, VII, IX, and XIV.

———. *Selected Writings*, ed. Susan Sontag, trans. Helen Weaver. New York: Farrar, Straus & Giroux, 1976.

Audoin, Philippe. *Breton*. Paris: Gallimard ("Pour une Bibliothèque Idéale"), 1970.

———. *Les Surréalistes*. Paris: Editions du Seuil ("Ecrivains de Toujours"), 1973.

Balakian, Anna. *André Breton: Magus of Surrealism*. New York: Oxford University Press, 1971.

———, and Rudolf E. Kuenzli, eds. *André Breton Today*. New York: Willis Locker & Owens, 1989.

Baldwin, Neil. *Man Ray: American Artist*. New York: Clarkson N. Potter, 1988.

Baron, Jacques. *L'An I du surréalisme, suivi de L'An dernier*. Paris: Denoël, 1969.

Bataille, Georges. *Œuvres complètes*. Paris: Gallimard, 1970 *et seq.*, esp. vols. I and VIII.

———. *Visions of Excess: Selected Writings, 1927–1939*, ed. Allan Stoekl. Minneapolis: University of Minnesota Press, 1985.

Bédouin, Jean-Louis. *André Breton*. Paris. Seghers ("Poètes d'aujourd'hui"), 1950.

———. *Vingt ans du surréalisme, 1939–1959*. Paris: Denoël, 1961.

Béhar, Henri. *André Breton, le grand indésirable*. Paris: Calmann-Lévi, 1990.

———. *Le Théâtre dada et surréaliste*. Paris: Gallimard ("Idées"), 1979.

Benayoun, Robert. *Le Rire des surréalistes*. Paris: La Bougie du Sapeur, 1988.

Bénédite, Daniel. *La Filière marseillaise: Un chemin vers la liberté sous l'Occupation*. Paris: Clancier Guénaud, 1984.

Berl, Emmanuel. *Interrogatoire par Patrick Modiano*. Paris: Gallimard ("Témoins"), 1976.

Bernheim, Cathy. *Valentine Hugo*. Paris: Presses de la Renaissance, 1990.

Bibliothèque de M. René Gaffé: Très précieux livres des auteurs du Mouvement Dada et du Groupe Surréaliste, auction cat. Paris: Hôtel des Commissaires-Priseurs, 26–27 April 1956.

Biro, Adam, René Passeron, et al., *Dictionnaire général du surréalisme et de ses environs*. Paris: Presses Universitaires de France, 1982.

Blachère, Jean-Claude. *Les Totems d'André Breton: Surréalisme et primitivisme littéraire*. Paris: L'Harmattan, 1996.

Bonneaud, Maud. "Notes sur une rencontre," *Profil littéraire de la France* (1ère série), 15 (1945).

Bonnet, Marguerite, ed. *L'Affaire Barrès*. Paris: José Corti/Actual, 1987.

———. *André Breton, Naissance de l'aventure surréaliste*. Paris: José Corti, 1975.

Brandon, Ruth. *Surreal Lives: The Surrealists 1917–1945*. New York: Grove Press, 1999.

Breton, Simone. *Lettres à Denise Lévy, 1919–1929*, ed. Georgiana Colvile. Paris: Editions Joëlle Losfeld, 2005.

Brown, Frederick. *An Impersonation of Angels: A Biography of Jean Cocteau*. New York: Viking Press, 1968.

Buñuel, Luis. *My Last Sigh*, trans. Abigail Israel. New York: Alfred A. Knopf, 1983.

Le Cadavre exquis, son exaltation, exh. cat. Milan: Galleria Schwarz, 1975.

Carassou, Michel. *Jacques Vaché et le Groupe de Nantes*. Paris: Jean-Michel Place, 1986.

———. *René Crevel*. Paris: Fayard, 1989.

Carrouges, Michel. *André Breton et les données fondamentales du surréalisme*. Paris: Gallimard, 1950.

Caute, David. *Communism and the French Intellectuals, 1914–1960*. New York: Macmillan, 1964.

Caws, Mary Ann. *André Breton*. New York: Twayne, 1973; revised ed., 1996.

———, Rudolf Kuenzli, and Gwen Raaberg, eds., *Surrealism and Women*. Cambridge, Mass.: MIT Press, 1991.

Chadwick, Whitney. *Women Artists and the Surrealist Movement*. Boston: Little, Brown/ New York Graphic Society, 1985.

Change 7 (Dec. 1970): "Le Groupe, la rupture."

Chapon, François. *Mystère et splendeurs de Jacques Doucet*. Paris: Jean-Claude Lattès, 1984.

Chapsal, Madeleine. *Envoyez la petite musique*. Paris: Grasset, 1984.

Chirico, Giorgio de. *The Memoirs of Georgio de Chirico*, trans. Margaret Crosland. Coral Gables, Fla.: University of Miami Press, 1971.

Clébert, Jean-Paul. *Dictionnaire du surréalisme*. Paris: Editions du Seuil, 1996.

Cohen-Solal, Annie. *Sartre: A Life*, trans. Anna Cancogni. New York: Pantheon Books, 1987.

Corti, José. *Souvenirs désordonnés (. . . –1965)*. Paris: José Corti, 1983.

Crastre, Victor. *André Breton*. Paris: Arcanes, 1952.

———. *Le Drame du surréalisme*. Paris: Editions du Temps, 1963.

Crevel, René. *Les Pieds dans le plat*. Paris: Jean-Jacques Pauvert, 1979.

Dachy, Marc. *Journal du mouvement Dada 1915–1923*. Geneva: Albert Skira, 1989.

Dada Zurich Paris 1916–1922 (facsimile ed.). Paris: Jean-Michel Place, 1981.

Daix, Pierre. *Aragon: une vie à changer*. Paris: Editions du Seuil, 1975.

———. *Picasso créateur*. Paris: Editions du Seuil, 1987.

Dalí, Salvador. *The Secret Life of Salvador Dalí*, trans. Haakon M. Chevalier. New York: Dial Press, 1942.

———, and André Parinaud. *The Unspeakable Confessions of Salvador Dalí*, trans. Harold J. Salemson. New York: Quill, 1981.

Daumal, René. *Lettres à ses amis*, I. Paris: Gallimard, 1958.

———. *The Powers of the Word: Selected Essays and Notes, 1927–1943*, ed. and trans. Mark Polizzotti. San Francisco: City Lights Books, 1991.

Deharme, Lise. *Les Années perdues: Journal (1939–1949)*. Paris: Plon, 1961.

Desnos, Robert. *Nouvelles Hébrides et autres textes, 1922–1930*, ed. Marie-Claire Dumas. Paris: Gallimard, 1978.

Documents 34, nouvelle série, 1 (June 1934): "Intervention surréaliste."

Dugrand, Alain. *Trotsky in Mexico, 1937–1940*, trans. Stephen Romer. Manchester: Carcanet Press, 1992.

Duhamel, Marcel. *Raconte pas ta vie*. Paris: Mercure de France, 1972.

Duits, Charles. *André Breton a-t-il dit passe*, revised ed. Paris: Maurice Nadeau, 1991.

Dumas, Marie-Claire. *Robert Desnos ou l'exploration des limites*. Paris: Klincksieck, 1980.

Durozoi, Gérard. *History of the Surrealist Movement*, trans. Alison Anderson. Chicago: University of Chicago Press, 2002.

Eigeldinger, Marc. ed. *André Breton*. Neuchâtel: La Baconnière, 1970.

Eluard, Paul. *Letters to Gala*, trans. Jesse Browner. New York: Paragon House, 1989.

———. *Lettres à Gala, 1924–1948*, ed. Pierre Dreyfus. Paris: Gallimard, 1984.

———. *Lettres à Joë Bousquet*. Paris: Editeurs Français Réunis, 1973.

———. *Œuvres complètes* [2 vols.]. Paris: Gallimard ("Bibliothèque de la Pléïade"), 1968.

Ernst, Jimmy. *A Not-So-Still Life*. New York: St. Martin's Press, 1984.

Ernst, Max. *Ecritures*. Paris: Gallimard ("Le Point du Jour"), 1970.

Europe 475–476 (Nov.–Dec. 1968): "Surréalisme."

Europe 743 (March 1991): "André Breton."

Everling, Germaine. *L'Anneau de Saturne*. Paris: Fayard, 1970.

Fauré, Michel. *Histoire du surréalisme sous l'Occupation*. Paris: La Table Ronde, 1982.

Fouché, Pascal. *Au Sans Pareil*. Paris: Bibliothèque de Littérature Française Contemporaine de l'Université de Paris VII, 1983.

Fry, Varian. *Surrender on Demand*. New York: Random House, 1945.

Garaudy, Roger. *L'Itinéraire d'Aragon: du surréalisme au monde réel*. Paris: Gallimard, 1961.

Gateau, Jean-Charles. *Paul Eluard, ou le Frère voyant*. Paris: Robert Laffont, 1988.

Gershman, Herbert. *The Surrealist Revolution in France*. Ann Arbor: University of Michigan Press, 1968.

Gold, Mary Jayne. *Crossroads Marseille, 1940*. Garden City, N.Y.: Doubleday, 1980.

Goldberg, RoseLee. *Performance Art: From Futurism to the Present*. New York: Harry N. Abrams, 1988.

Gracq, Julien. *André Breton, quelques aspects de l'écrivain*. Paris: José Corti, 1948.

Grimberg, Salomon. *Jacqueline Lamba: In Spite of Everything, Spring*, exh. cat. East Hampton, N.Y.: Pollock-Krasner House and Study Center, 2001.

Guggenheim, Peggy. *Out of This Century: Confessions of an Art Addict*. New York: Universe Books, 1987.

Guiol-Benassaya, Elyette. *La Presse face au surréalisme de 1925 à 1938*. Paris: Editions du CNRS, 1982.

Haslam, Malcolm. *The Real World of the Surrealists*. New York: Galley Press, 1978.

Heijenoort, Jean van. *With Trotsky in Exile: From Prinkipo to Coyoacán*. Cambridge, Mass.: Harvard University Press, 1978.

Herrera, Hayden. *Frida: A Biography of Frida Kahlo*. New York: Harper & Row, 1983.

Huffington, Arianna Stassinopoulos. *Picasso: Creator and Destroyer*. London: Weidenfeld & Nicolson, 1988.

Hughes, Robert. *The Shock of the New*. New York: Alfred A. Knopf, 1982.

Hugnet, Georges. *L'Aventure dada, 1916–1922*. Paris: Seghers, 1971.

———. *Pleins et déliés: Souvenirs et témoignages, 1926–1972*. La Chapelle-sur-Loire: Guy Authier, 1972.

Hugo, Jean. *Le Regard de la mémoire*. Arles: Actes Sud, 1983.

Jean, Marcel. *Au Galop dans le vent*. Paris: Jean-Pierre de Monza, 1991.

———, ed. *The Autobiography of Surrealism*. New York: Viking Press, 1980.

———. *The History of Surrealist Painting*, trans. Simon Watson Taylor. New York: Grove Press, 1960.

Josephson, Matthew. *Life Among the Surrealists: A Memoir*. New York: Holt, Rinehart & Winston, 1962.

Jouffroy, Alain. "La Collection André Breton," *L'Œil* 10 (Oct. 1955).

———. *La Fin des alternances*. Paris: Gallimard, 1970.

Lautréamont. *Maldoror and the Complete Works*, trans. Alexis Lykiard. Cambridge, Mass.: Exact Change, 1994.

Legrand, Gérard. *André Breton en son temps*. Paris: Le Soleil Noir, 1976.

———. *Breton*. Paris: Pierre Belfond ("Les Dossiers Belfond"), 1977.

Lévi-Strauss, Claude, and Didier Eribon, *De près et de loin*. Paris: Odile Jacob, 1988.

Levy, Julien. *Memoir of an Art Gallery*. Boston: MFA Publications ("artWorks"), 2003.

————, ed. *Surrealism* (facsimile of 1936 edition). New York: Da Capo Press, 1995.

Lewis, Helena. *The Politics of Surrealism*. New York: Paragon House, 1988.

Littérature (facsimile ed.). Paris: Jean-Michel Place, 1978.

Livres et Autographes appartenant à l'association philanthropique The Camargo Foundation et à divers amateurs, auction cat. Paris, 8 December 1986.

Lord, James. *Giacometti: A Biography*. New York: Farrar, Straus & Giroux, 1985.

Lottman, Herbert. *The Left Bank: Writers, Artists and Politics From the Popular Front to the Cold War*. Boston: Houghton Mifflin, 1982.

MacGregor, John. *The Discovery of the Art of the Insane*. Princeton: Princeton University Press, 1989.

Maeder, Thomas. *Antonin Artaud*, trans. Janine Delpech. Paris: Plon, 1978.

Magazine littéraire 254 (May 1988): "Le Surréalisme."

Margerie, Anne de. *Valentine Hugo, 1887–1968*. Paris: Jacques Damase, 1983.

Mariën, Marcel, ed. *Lettres surréalistes (1924–1940)*. Brussels: Les Lèvres Nues [*Le Fait accompli* 81–95], 1973.

Masson, André. "Breton, croquemitaine des peintres surréalistes," *Le Figaro littéraire* (23 Nov. 1970).

————. *Les Années surréalistes: Correspondance, 1916–1942*. Paris: La Manufacture, 1990.

McDougall, Richard, ed. and trans. *The Very Rich Hours of Adrienne Monnier*. New York: Charles Scribner's Sons, 1976.

Monnerot, Jules. *La Poésie moderne et le sacré*. Paris: Gallimard, 1945.

Mundy, Jennifer, ed. *Surrealism: Desire Unbound*. Princeton: Princeton University Press, 2001.

Nadeau, Maurice. *The History of Surrealism*, trans. Richard Howard. New York: Macmillan, 1965.

Naville, Pierre. *La Révolution et les intellectuels*. Paris: Gallimard ("Idées"), 1975.

————. *Le Temps du surréel*. Paris: Editions Galilée, 1977.

Nezval, Vítězslav. *Rue Gît-le-Coeur*. La Tour d'Aigues: Editions de l'Aube, 1988.

Noël, Bernard. *Marseille–New York, 1940–1945: Une liaison surréaliste*. Marseille: André Dimanche, 1985.

Nouvelle Revue Française 172 (1 April 1967): "André Breton et le mouvement surréaliste."

Opus International 19–20 (Oct. 1970): "Surréalisme international."

Opus International 123–124 (April–May 1991): "André Breton et le surréalisme international."

Parinaud, André. "Comment et pourquoi ont été réalisés les entretiens avec André Breton," *Arts* (5 Nov. 1952).

Paris–Paris, 1937–1957, exh. cat. Paris: Centre Pompidou, 28 May–2 Nov. 1981.

Pastoureau, Henri. "André Breton, l'homme que j'ai connu," *L'Orne littéraire* 3 (1983).

———. "André Breton, les femmes et l'amour," *Europe* 743 (March 1991).

———. *Ma vie surréaliste*. Paris: Maurice Nadeau, 1992.

———. "Le Surréalisme de l'après-guerre, 1946–1950," *L'Orne littéraire* 5 (1983).

Péret, Benjamin. *Death to the Pigs: Selected Writings*, ed. Rachel Stella. London: Atlas Press, 1988.

Philippe Soupault et le surréalisme, a documentary by Bertrand Tavernier and Jean Aurenche, *Témoins*, FR3, 1982.

Picabia, Francis. *Ecrits*, ed. Olivier Revault d'Allonnes. Paris: Pierre Belfond, 1975 (vol. I: 1913–1920) and 1978 (vol. II: 1921–1953).

———, *I Am a Beautiful Monster: Poetry, Prose, and Provocation*, ed. and trans. Marc Lowenthal. Cambridge, Mass.: MIT Press, 2007.

Pierre, José, ed. *Tracts surréalistes et déclarations collectives*. Paris: Eric Losfeld/Le Terrain Vague, 1980 (vol. I: 1922–1939) and 1982 (vol. II: 1940–1969).

Pieyre de Mandiargues, André. *Le Désordre de la mémoire: Entretiens avec Francine Mallet*. Paris: Gallimard, 1975.

La Planète affolée: Surréalisme, dispersion et influences, 1938–1947, exh. cat. Paris: Flammarion, 1986.

Random, Michel. *Le Grand Jeu*. Paris: Denoël, 1970.

Ray, Man. *Self Portrait*. Boston: Little, Brown and Company/New York Graphic Society, 1988.

Read, Herbert, ed. *Surrealism*. London: Faber & Faber, 1971.

Reverdy, Pierre. "Trente-deux lettres inédites à André Breton, 1917–1924," *Etudes littéraires* (April 1970).

La Révolution surréaliste (facsimile ed.). Paris: Jean-Michel Place, 1975.

Ribemont-Dessaignes, Georges. *Déjà jadis, ou Du mouvement dada à l'espace abstrait*. Paris: Union Générale d'Editions ("10/18"), 1973.

Richter, Hans. *Dada: Art and Anti-Art*, trans. David Britt. New York: Harry N. Abrams, [1966].

Rimbaud, Arthur. *Complete Works, Selected Letters*, trans. Wallace Fowlie. Chicago: University of Chicago Press, 1966.

Rosenthal, Gérard. *Avocat de Trotsky*. Paris: Laffont, 1975.

Roy, Claude. *Somme toute*. Paris: Gallimard, 1976.

Salvador Dalí, exh. cat. Paris: Centre Pompidou, 18 Dec. 1979–14 April 1980.

Sanouillet, Michel, ed. *391* (facsimile). Paris: Pierre Belfond/Eric Losfeld, 1960.

———, *Dada à Paris*. Paris: Jean-Jacques Pauvert, 1965.

———, and Y. Poupard-Lieussou, eds. *Documents Dada*. Geneva: Weber, 1974.

———, and Elmer Peterson, eds. *Salt Seller: The Writings of Marcel Duchamp*. New York: Oxford University Press, 1973.

Sawin, Martica. *Surrealism in Exile and the Beginning of the New York School*. Cambridge, Mass.: MIT Press, 1995.

Schuster, Jean. *Les Fruits de la passion*. Paris: L'Instant, 1988.

Schwarz, Arturo. *André Breton, Trotsky et l'anarchie*. Paris: Union Générale d'Editions ("10/18"), 1977.

Sebbag, Georges. *André Breton, L'Amour-folie*. Paris: Jean-Michel Place, 2004.

———. *Les Editions surréalistes 1926–1968*. Paris: IMEC Editions, 1993.

———. *L'Imprononçable jour de ma naissance 17ndré 13reton*. Paris: Jean-Michel Place, 1988.

———. *L'Imprononçable jour de sa mort Jacques Vaché janvier 1919*. Paris: Jean-Michel Place, 1989.

Secrest, Meryle. *Salvador Dalí*. New York: E. P. Dutton, 1986.

Shattuck, Roger. *The Banquet Years: The Origins of the Avant-Garde in France, 1885 to World War I*. New York: Vintage Books, 1968.

———. *The Innocent Eye: On Modern Literature and the Arts*. Boston: MFA Publications ("artWorks"), 2003.

Short, Robert S. "The Politics of Surrealism, 1920–36," in Walter Laqueur and George L. Mosse, eds., *The Left Wing Intellectuals Between the Wars, 1919–1939*. New York: Harper Torchbooks, 1966.

Sorrell, Martin. "Jacques Vaché's *Letters from the Front* (1916–1918): A Translation of *Lettres de guerre* with Introduction and Notes," *Journal of European Studies* ix (1979).

Soupault, Philippe. *Mémoires de l'oubli*. Paris: Lachenal & Ritter, 1981 (vol. I: 1914–1923) and 1986 (vol. II: 1923–1926).

———. *Profils perdus*. Paris: Mercure de France, 1963.

———. *Vingt mille et un jours: Entretiens avec Serge Fauchereau*. Paris: Pierre Belfond, 1980.

Speis, Werner, ed. *La Révolution surréaliste*, exh. cat. Paris: Centre Pompidou, 2002.

Steegmuller, Francis. *Apollinaire: Poet Among the Painters*. New York: Penguin Books, 1986.

————. *Cocteau: A Biography*. Boston: Atlantic-Little, Brown, 1970.

Le Surréalisme au service de la Révolution (facsimile ed.). Paris: Jean-Michel Place, 1976.

Surya, Michel. *Georges Bataille: La Mort à l'œuvre*. Paris: Séguier, 1987.

Tanguy, Yves. *Lettres de loin à Marcel Jean*. Paris: Le Dilettante, 1993.

Tanning, Dorothea. *Birthday*. San Francisco: Lapis Press, 1986.

Tashijian, Dickran. *A Boatload of Madmen: Surrealism and the American Avant-Garde, 1920–1950*. New York: Thames and Hudson, 1995.

Thirion, André. *Révisions déchirantes*. Paris: Le Pré aux Clercs, 1987.

————. *Revolutionaries Without Revolution*, trans. Joachim Neugroschel. New York: Macmillan, 1975.

This Quarter: Surrealist Number (Sept. 1932) (facsimile ed.). New York: Arno Press, 1969.

Trois suicidés de la société [Arthur Cravan, Jacques Rigaut, Jacques Vaché]. Paris: Union Générale d'Editions ("10/18"), 1974.

Tzara, Tristan. *Le Surréalisme et l'après-guerre*. Paris: Nagel, 1966.

————. *Œuvres complètes*. Paris: Flammarion, 1975 *et seq.*, esp. vols. I and V.

————. *Seven Dada Manifestos and Lampisteries*, trans. Barbara Wright. London: John Calder, 1977.

Vaché, Jacques. *Soixante-dix-neuf lettres de guerre*, ed. Georges Sebbag. Paris: Jean-Michel Place, 1989.

Villa Air-Bel: Varian Fry in Marseilles, 1940–41, a film by Jorg Bundschuh, produced by Kick Film GmbH, Munich, 1987.

Virmaux, Alain and Odette. *André Breton qui êtes-vous?* Paris: La Manufacture, 1987.

————. *Antonin Artaud qui êtes-vous?*. Paris: La Manufacture, 1986.

Weld, Jacqueline Bograd. *Peggy: The Wayward Guggenheim*. New York: E. P. Dutton, 1986.

IV. Key to abbreviations used in the notes

Full publication information for these works is given in the bibliography

AB cat. = *André Breton: la beauté convulsive*, exh. cat.

Adhérer = *Archives du surréalisme, III. Adhérer au Parti communiste?*

BN = Bibliothèque Nationale, Paris

Bonnet = Marguerite Bonnet, *André Breton, Naissance de l'aventure surréaliste*

Cahier = *Archives du surréalisme, I. Bureau de recherches surréalistes: Cahier de la permanence*

Camargo = *Livres et Autographes appartenant a l'association philanthropique The Camargo Foundation et à divers amateurs*, auction cat.

DAP = Michel Sanouillet, *Dada à Paris*

Doucet = Bibliothèque Littéraire Jacques Doucet, Paris

Gaffé = *Bibliothèque de M. René Gaffé: Très précieux livres des auteurs du Mouvement Dada et du Groupe Surréaliste*, auction cat.

Houghton = Houghton Library, Harvard University

HRC = Harry Ransom Humanities Research Center, University of Texas, Austin

JP = Jacqueline Paulhan archives, Paris

Lettres à Denise = Simone Breton, *Lettres à Denise Lévy, 1919–1929*

LTG = Paul Eluard, *Letters to Gala*

Naville = Pierre Naville, *Le Temps du surréel*

NRF 172 = *Nouvelle Revue Française* 172 (1 April 1967): "André Breton et le mouvement surréaliste"

NRF archives = Editorial archives of Editions Gallimard, Paris

OC 1, 2, 3 = André Breton, *Œuvres complètes* ("Bibliothèque de la Pléïade"), vols. I–III

Recherches = *Archives du surréalisme, IV. Recherches sur la sexualité*

Reynal = Jeanne Reynal Papers, Archives of American Art, New York

RLM = Apollinaire, "Lettres à Breton," *Revue des Lettres Modernes* 104–107 (1964)

RS = *La Révolution surréaliste*

SASDLR = *Le Surréalisme au service de la Révolution*

Sator = Sylvie Sator archives, Paris

Thirion = André Thirion, *Revolutionaries Without Revolution*

Tracts, I, II = José Pierre, ed., *Tracts surréalistes et déclarations collectives*, vols. I and II

Villa Air-Bel = *Villa Air-Bel: Varian Fry in Marseilles*, dir. Jorg Bundschuh

NOTES

NB: Breton's book-length works and uncollected writings are identified by author ("AB") on first mention. Works included in the bibliography, regardless of author, are named in full on first mention and subsequently in abbreviated form. Works not included in the bibliography are named in full with each new chapter.

1. "The Passably Haggard and Very Hounded Child"

3 FEBRUARY 18 OF THE SAME YEAR: To my knowledge, the first to point out this shift was Georges Sebbag, in his book *L'Imprononçable jour de ma naissance 17ndré 13reton* (Paris: Jean-Michel Place, 1988). See also AB, *Œuvres complètes*, II, ed. Marguerite Bonnet with Philippe Bernier, Etienne-Alain Hubert, and José Pierre (Paris: Gallimard ["Bibliothèque de la Pléiade"], 1992; hereinafter referred to as "*OC 2*"), 1448. This volume includes virtually all of Breton's published and unpublished writings from 1931 to early 1941. Like its predecessor (which covers the years 1911–30), it also contains a wealth of critical notes, commentary, and background information, all of which I have found extremely useful in preparing this biography. As of this writing, a third volume has been published, covering the years 1941–53, and a fourth (1954–66) is scheduled. I wish to acknowledge here the exemplary efforts of the late Mme. Bonnet (who provided some of these details by letter) and of her colleagues.

3 "DEPRESSION OR WEAKNESS": *Manifesto of Surrealism* (1924), in AB, *Manifestoes of Surrealism*, trans. Richard Seaver and Helen R. Lane (Ann Arbor: University of Michigan Press, 1969), 8.

3 "SEDUCTION AND FEAR": AB, *Mad Love*, trans. Mary Ann Caws (Lincoln: University of Nebraska Press, 1987), 76.

3 MEDICAL SCHOOL REGISTRATION: Henri Béhar, *André Breton, le grand indésirable* (Paris: Calmann-Lévi, 1990), 35; cf. AB, *Œuvres complètes*, I, ed. Marguerite Bonnet with Philippe Bernier, Etienne-Alain Hubert, and José Pierre (Paris:

Gallimard ["Bibliothèque de la Pléiade"], 1988; hereinafter "*OC 1*"), xxviii–xxix.

4 SEEK THROUGHOUT HIS LIFE: Jean Richer, who analyzed Breton's horoscope after his death, noted that by a certain numerical process the date February 18, 1896, yields the number 17, one of Breton's totemic figures. He also showed how the same number 17 can be derived from both 1808, the year of Nerval's birth and of Fourier's *Theory of the Four Movements*. In 1944, Breton stressed Nerval's and Fourier's importance for him in a book significantly titled *Arcanum 17*. In changing his birth date, Breton also jumped the astrological cusp from Pisces to Aquarius—and, to friends, even went so far as to complain about being an Aquarian: see Jean Richer, "Dans la forêt des signes," *Nouvelle Revue Française* 172 (1 April 1967): "André Breton et le mouvement surréaliste" (hereinafter "*NRF 172*"), 827–28; Philippe Soupault, "Souvenirs," ibid., 671.

4 VANISHED ON HIS WEDDING DAY: Information about Breton's family background is mainly derived from a family tree prepared by Breton himself, now preserved at the Bibliothèque Littéraire Jacques Doucet in Paris (hereinafter "Doucet"); from *OC 1*, xxviii; and from Breton's birth certificate, reproduced in facsimile in Sebbag, *Imprononçable jour,* [n.p.]. The certificate gives the birth hour as 10:30; Breton, in his own horoscope, gave it as 10:00.

4 MATTERS OF DISCIPLINE: Marguerite Bonnet, *André Breton, Naissance de l'aventure surréaliste* (Paris: José Corti, 1975; hereinafter "Bonnet"), 17, 23; *Mad Love*, 119; MP interviews with Aube Elléouët (6 March 1988) and Jean Schuster (26 April 1991). Cf. Breton's half-joking dialogue with himself in "Bocaux Dada" (*Littérature* 13 [May 1920], 4): "'What about your parents?' 'My father is an innocent, a man without intelligence . . . My mother is, too. I'm the one who did everything.'"

5 "INTEGRATION AND SUCCESS": Bonnet, 22.

5 "HAD GIVEN IT TO ME": *Mad Love*, 112.

5 MARKED BY DEEP RESENTMENT: AB, marginal annotations to *The Magnetic Fields*, 1930, in *Change* 7 (Dec. 1970), 15. Reprinted, with slight corrections, in *OC 1*, 1127ff. Just how much resentment can be seen in an incident from the late 1940s, when Breton discovered Hervé Bazin's novel *Vipère au poing*. In Bazin's story, the narrator's childhood is made hellish by his authoritarian, snobbish, falsely devout, excessively parsimonious mother, who dominates her bland husband and whose dislike of her son leads to frequent corporal and emotional abuse. According to one friend, Breton, reading Bazin's descriptions of the woman's "strident voice," her inventiveness with punishments and strictures, her social pretensions, her emotional distance and actual cruelty, cried out in surprise, "But that's *her*! That's *my mother*!": MP interview with Jean Schuster, 26 April 1991.

6 "DREAMS ARE SO ABOMINABLE": Charles Duits, *André Breton a-t-il dit passe*, revised ed. (Paris: Maurice Nadeau, 1991), 153.

6 "PERMEATED SURREALISM": Interview with Yves Pérès, in AB, *Œuvres complètes*, III, ed. Marguerite Bonnet and Etienne-Alain Hubert, with Philippe Bernier, Marie-Claire Dumas, and José Pierre (Paris: Gallimard ["Bibliothèque de la Pléiade"], 1999; hereinafter "*OC 3*"), 646; originally published in *La Liberté du Morbihan* (10 Oct. 1952). For the genealogical details, see Bonnet, 12; Breton family tree, Doucet.

7 "ITS OPPOSITE": AB to Simone Kahn, 24 Oct. 1920, Sylvie Sator archives (hereinafter "Sator"); Breton family tree, Doucet; Bonnet, 12; Gérard Legrand, *Breton* (Paris: Pierre Belfond ["Les Dossiers Belfond"], 1977), 26.

7 FROM THE GENDARMERIE: Alain and Odette Virmaux, *André Breton qui êtes-vous?* (Paris: La Manufacture, 1987), 127; Béhar, *André Breton*, 18–19; *OC 1*, xxviii.

7 "PARENTS AND TEACHERS": AB to J. Fontbonne, 26 Sept. 1965, in response to an inquiry from a teacher at the Lycée Chaptal about his school days: quoted in *André Breton 42, rue Fontaine: manuscrits,* auction cat. (Paris: CalmelsCohen, 11–12 April 2003), item 2532. See also Bonnet, 24.

7 "KEPT A LOVING MEMORY": On relations with grandfather: AB with Gérard Legrand, *Poésie et autre* (Paris: Club du Meilleur Livre, 1960), 10; Bonnet, 16; MP interview with Aube Elléouët, 6 March 1988. On family situation: Wayne Andrews, *The Surrealist Parade* (New York: New Directions, 1990), 1; Béhar, *André Breton*, 19–21; *OC 1*, xxix.

8 "AS SOMEHOW CHARMING": *Manifesto*, 3 (trans. slightly revised).

8 "FIRST PICTURE-BOOK": AB, *Surrealism and Painting*, trans. Simon Watson Taylor (Boston: MFA Publications ["artWorks"], 2002), 168.

8 "ANY KNOWN RESTRICTIONS": *Manifesto*, 3.

8 "HUNGER FOR THE MARVELOUS": AB, *Conversations: The Autobiography of Surrealism*, trans. Mark Polizzotti (New York: Paragon House, 1993), 63.

8 "KNOCKS A SECOND TIME": *Manifesto*, 39–40.

8 "INFLUENCE ON MY LIFE": AB and Philippe Soupault, *The Magnetic Fields*, trans. David Gascoyne (London: Atlas Press, 1985), 33. See also Andrews, *Surrealist Parade*, 1; Béhar, *André Breton*, 21.

8 "WELL BROUGHT UP": *Magnetic Fields*, 34.

8 "RANCOR AND HATRED": AB marginal notes to *Magnetic Fields*, 15.

9 POPULATION OF STREETWALKERS: Virmaux, *Breton qui êtes-vous?*, 18.

9 BE SO HARMONIOUS: *OC 1*, xxx; Legrand, *Breton*, 28.

9 "AUVERGNAT SCHOOLMASTER": AB, *Communicating Vessels*, trans. Mary Ann Caws and Geoffrey T. Harris (Lincoln: University of Nebraska Press, 1990), 99; *OC 1*, xxx.

9 "THAT IMPRISON US": "Portrait étrange" (unpublished poem, dated June 1913), in *OC 1*, 32; cf. Bonnet, 36.

10 "WINDS OF POSSIBILITY": "The Disdainful Confession," in AB, *The Lost Steps*, trans. Mark Polizzotti (Lincoln: University of Nebraska Press, 1996), 4; Bonnet, 23.

10 "COULD NOT LIVE ALONE": Philippe Soupault, *Mémoires de l'oubli*, II (1923–1926) (Paris: Lachenal & Ritter, 1986), 169n.

10 "TALK TOO MUCH": *OC 1*, xxx–xxxi; Bonnet, 26n, see also 23.

10 "OF THE TEACHERS": Bonnet, 25.

11 MARKED IMPROVEMENT: Béhar, *André Breton*, 24.

11 THE FORMER IN JEOPARDY: *OC 1*, xxx–xxxi; Legrand, *Breton*, 30.

11 "VULGAR JOKES": *OC 1*, xxxi.

11 "A WELL-PLACED JAB": MP interview with Michel Fraenkel, 18 March 1988.

11 "MY FIRST FRIEND": *Magnetic Fields*, 34 (trans. slightly revised); *OC 1*, xxxi.

12 "CAN BE DONE WITH WORDS": Bonnet, 26; *Poésie et autre*, 10; Philippe Audoin, *Breton* (Paris: Gallimard ["Pour une Bibliothèque Idéale"], 1970), 10; "Fronton-virage," in AB, *Free Rein*, trans. Michel Parmentier and Jacqueline d'Amboise (Lincoln: University of Nebraska Press, 1995), 178; *Conversations*, 5.

12 PSEUDONYM "RENÉ DOBRANT": Pascal Fouché, *Au Sans Pareil* (Paris: Bibliothèque de Littérature Française Contemporaine de l'Université de Paris VII, 1983), 95. Hilsum again became Breton's publisher in 1919, when he made the latter's first book of poems one of his inaugural projects for a new publishing venture. *Vers l'Idéal*, furthermore, counted on its staff another of Breton's future publishers, José Corti: see José Corti, *Souvenirs désordonnés (. . . –1965)* (Paris: José Corti, 1983), 14.

12 IMPRESSED BRETON AS A CHILD: On Breton's literary tastes: Gilles Gourdon, "Portrait de l'artiste en apprenti-sorcier," *Magazine littéraire* 254 (May 1988), 27; Serge Fauchereau, et al., "Conversation avec René Hilsum," *Digraphe* 30 (June 1983), 119. On interest in German philosophy: Legrand, *Breton*, 32.

13 "MORE MENTAL MATURITY": *OC 1*, xxxi.

13 "ACTIVITIES ON THE SIDE": Madeleine Chapsal, *Envoyez la petite musique* (Paris: Grasset, 1984), 222.

2. Meetings with Remarkable Men

14 "SEEDS OF SURREALISM": Bonnet, 55, see also 49, 62–63. Cf. AB, *Arcanum 17*, trans. Zack Rogow (Los Angeles: Sun & Moon Press, 1994), 31: "I was not yet very aware politically and I really have to admit that I'm still perplexed when I try to judge how it changed me. But more than ever, currents of sympathy and antipathy seem to me strong enough to bend ideas and I know that my heart did beat, will continue to beat with the very rhythm of that day."

15 "IN THE WIDEST SENSE": Bonnet, 52.

16 STRIDENT AMBIENT NIHILISM: On the late nineteenth century in Europe: Sigmund Freud and Joseph Breuer, *Studies on Hysteria*, trans. James and Alix Strachey (Harmondsworth: Penguin Books, 1974), 14–15, 34–35; Doré Ashton, "Cocteau and His Times: An Intellectual Backdrop," in Doré Ashton, ed., *Jean Cocteau and the French Scene* (New York: Abbeville Press, 1984), 48–50; Bonnet, 62; Jerrold Seigel, *Bohemian Paris: Culture, Politics, and the Boundaries of Bourgeois Life, 1830–1930* (New York: Viking Press, 1986), pass.

16 SURREALISM, AND BEYOND: *Le Figaro* (22 March 1930); Léon Somville, *Les Devanciers du surréalisme: les groupes d'avant-garde et le mouvement poétique, 1912–1925* (Geneva: Droz, 1971), pass.

16 "WIND MIGHT DESTROY IT": Quoted in David Thomson, *World History from 1914–1968* (New York: Oxford University Press, 1969), 19.

17 "LIKES AND DISLIKES": *Conversations*, 3; cf. Frederick R. Karl, *Modern and Modernism: The Sovereignty of the Artist, 1885–1925* (New York: Atheneum, 1985), 346.

17 MOST OF THE CROWD: Milton W. Brown, "The Legendary Armory Show of 1913," *The Key Reporter* liii:3 (spring 1988), 2–4. The show attracted some 75,000 visitors in its one-month New York run alone.

18 EXTENSIVE COLLECTION: MP conversation with Elisa Breton, 24 March 1987; *André Breton: la beauté convulsive*, exh. cat. (Paris: Centre Pompidou, 25 April–26 August 1991; hereinafter "AB cat."), 86; R. C. Giraud, "André Breton, collectionneur," *Jardin des arts* 67 (May 1960), 33–34.

18 GALLERIES OF PARIS: *OC 1*, xxxii; Legrand, *Breton*, 33; Gérard Legrand, "L'Amour de la peinture," *Magazine littéraire* 254, 52.

18 "NEW VISUAL EXPERIENCE": *Surrealism and Painting*, 116.

18 "A TEMPLE SHOULD BE": Ibid., 363:

19 "MY IDEA OF LOVE": Ibid.; see also Andrews, *Surrealist Parade*, 63–64.

19 "MODESTY AND REVULSION": José Pierre, ed., *Archives du surréalisme, IV: Recherches sur la sexualité* (Paris: Gallimard, 1990; hereinafter "Recherches"), 80.

19 WORRY OVER HIS EJACULATIONS: Ibid., 176.

19 "TAKING [HIM] TO SCHOOL": *Communicating Vessels*, 101–2.

19 "I EVER TRULY DESIRED": *OC 2*, 1405.

19 VAGUE FLIRTATION: *Communicating Vessels*, 30; *OC 1*, 1112.

19 "MY PARENTS, OR TOWARD ME": MP interview with Michel Fraenkel, 18 March 1988; cf. *OC 1*, xxxii.

20 "ON THE SHOULDER": Man Ray, *Self Portrait* (Boston: Little, Brown and Company/New York Graphic Society, 1988), 92.

20 "YOU AND YOUR VERSES": "Je disais quelquefois à Stéphane Mallarmé . . . ," in Paul Valéry, *Œuvres*, I (Paris: Gallimard ["Bibliothèque de la Pléiade"], 1957), 644.

20 "PLEASES MOST PEOPLE": Ibid., 647.

20 "LANGUAGE OF THE TRIBE": "Le Tombeau d'Edgar Poe," in Stéphane Mallarmé, *Œuvres complètes* (Paris: Gallimard ["Bibliothèque de la Pléiade"], 1945), 70.

20 "GOD MADE MANIFEST": AB to Fraenkel, 22 June 1914, Bonnet, 32.

20 "VERY MUCH OLD FRANCE": Adrienne Monnier, "André Breton," in Richard McDougall, ed. and trans., *The Very Rich Hours of Adrienne Monnier* (New York: Charles Scribner's Sons, 1976), 88. Breton even adopted Mallarmé's pastime of writing occasional verse, such as an *éventail* (a poem illustrating a lady's fan) dedi-

cated to Manon in September, or a "postal leisure" (a rhymed ditty bearing the addressee's name and street) on the envelopes of letters to Fraenkel.

21 "SAME PRESENCE OF MIND": *Conversations*, 4.

21 "DRAWN TO OTHER THINGS": Ibid.

21 "ONLY KIND THAT INTERESTS ME": Chapsal, *Envoyez*, 223.

21 MEDICAL TEXTBOOKS ALOUD: Bonnet, 23; *OC 1*, xxxii; Serge Fauchereau, et al., "Conversation avec René Hilsum," *Digraphe* 30 (June 1983), 119.

21 "OBSCURE AS A LILY": *Conversations*, 5.

22 "INTENTIONALLY INJECTED ": "Marvelous versus Mystery," in *Free Rein*, 6.

22 "WILD ABOUT" APOLLINAIRE: AB to Fraenkel, 30 Aug. 1914, Bonnet, 43.

22 "CARRYING ON . . . TRADITION": *Conversations*, 4–5.

22 "HIGHEST ESTEEM": Chapsal, *Envoyez*, 222.

22 "THE GREAT ENIGMA": *Conversations*, 8.

22 "SUPREME POINT OF EXPRESSION": Ibid.

22 "BURNED MY PAPERS ALSO": Paul Valéry, *An Evening with Monsieur Teste*, trans. Jackson Mathews (Princeton: Princeton University Press ["Bollingen Series XLV"], 1973), 11.

23 "VERTIGINOUS CHARACTER": *Conversations*, 9.

23 "MEMORIES OF STÉPHANE MALLARMÉ": AB to Valéry, 7 March 1914, Bonnet, 31n.

23 "SYSTEM OF YOUR VERSES": Valéry to AB, 11 March 1914, quoted in Henri Pastoureau, "Des influences dans la poésie présurréaliste d'André Breton," in Marc Eigeldinger, ed., *André Breton* (Neuchâtel: La Baconnière, 1970), 51; cf. Chapsal, *Envoyez*, 222.

23 "SHARP-EDGED LIDS": *Conversations*, 10.

23 "DIFFERENCE OF DEGREE": *Mad Love*, 8.

23 "THE SKIRTS OF TARTS": *Conversations*, 10.

23 "TIME ON SOME POEM": AB to Fraenkel, 22 June 1914, Bonnet, 27.

24 "WAR WILL BE ABLE TO": AB to Fraenkel, 3 Aug. 1914, Bonnet, 65. On early days of war, see A. J. P. Taylor, *The First World War: An Illustrated History* (New York: Perigee Books, 1980), pass.; *Life* (13 March 1963), 64ff.

24 "GUY WHO KILLED JAURÈS": Bonnet, 65–66n.

24 "TO ENTER THE BARRACKS": AB to Fraenkel, 3 Aug. 1914, Bonnet, 45.

25 "NO BETTER THAN A PLOUGHMAN'S": Arthur Rimbaud, *A Season in Hell*, in *Complete Works, Selected Letters*, trans. Wallace Fowlie (Chicago: University of Chicago Press, 1966), 175.

25 "DERANGEMENT OF ALL THE SENSES": Rimbaud to Paul Demeny, 15 May 1871, in ibid., 307 (trans. revised). See also Bonnet, 68.

25 "THAT'S MY MOTTO": Rimbaud to Georges Izambard, 25 Aug. 1870, *Complete Works*, 299 (trans. revised).

25 "ONLY EXACERBATES IT": AB to Fraenkel, 16 Aug. 1914, *OC 1*, 1538.

25 "OR INTELLECTUAL LIFE": Fraenkel to AB, 12 Aug. 1914, Bonnet, 45.

25 "TIDE OF PUBLIC OPINION": AB to Fraenkel, 30 Aug. 1914, Bonnet, 43.

26 "DRUMSKIN OF HUMAN TORSOS": All quotes from Philippe Soupault, *Mémoires de l'oubli*, I (1914–1923) (Paris: Lachenal & Ritter, 1981), 23–24. See also Michel Sanouillet, *Dada à Paris* (Paris: Jean-Jacques Pauvert, 1965; hereinafter "*DAP*"), 60; Philippe Soupault, *Profils perdus* (Paris: Mercure de France, 1963), 143–45; Jean-Charles Gateau, *Paul Eluard, ou le Frère voyant* (Paris: Robert Laffont, 1988), 44.

26 ROUTE D'AUBERVILLIERS: *OC 1*, xxxii; Béhar, *André Breton*, 32.

26 "BLOOD, MUD, AND IDIOCY": *Conversations*, 13.

27 "THE PHENOMENAL WORLD": AB to Fraenkel, 22 April 1915, Bonnet, 70.

27 "HOW VAIN ITS EFFORTS ARE": Ibid.

27 "ATROCIOUSLY SLOW LIFE": AB to Fraenkel, [spring 1915], Bonnet, 71.

27 "HEAP OF POTATO PEELINGS": Valéry to AB, 16 June 1915, *OC 1*, xxxiii; see also Béhar, *André Breton*, 34.

27 "DELIGHTFUL EVENINGS": AB to Valéry, 9 Jan. 1916, Bonnet, 73; Jean Prasteau, "Jacques Vaché: l'inspirateur foudroyé du surréalisme," *Figaro* (14 April 1986).

27 "SPIRIT OF SUPREME ADVENTURE": AB, *Nadja*, trans. Richard Howard (New York: Grove Press, 1960), 28; Gilles Gourdon, "Portrait de l'artiste en apprenti-sorcier," *Magazine littéraire* 254 (May 1988), 27; Martin Sorrell, "Jacques Vaché's *Letters from the Front* (1916–1918): A Translation of *Lettres de guerre* with Introduction and Notes," in *Journal of European Studies* ix (1979), 99.

28 "TERRIBLE SENTIMENTAL ADVENTURE": AB to Fraenkel, 3 Sept. 1915, *OC 1*, xxxiii; Béhar, *André Breton*, 35.

28 "BRIGHT LIGHT OF DAY": AB to André Paris, 13 Oct. 1915, quoted in auction cat. *Livres et Autographes appartenant à l'association philanthropique The Camargo Foundation et à divers amateurs* (Paris, 8 December 1986; hereinafter "Camargo"), item 61.

28 "MIRACULOUSLY SAFE!": AB to André Paris, 27 Oct. 1915, Camargo, item 62.

28 "A WOMAN I DESIRED": *Recherches*, 163. Although one of the earliest, this was apparently not Breton's first sexual experience. He later recounted having sex for the first time toward

the beginning of that year, shortly before his mobilization, with "a young typist from Underwood": "All night long I was very tormented about my physical capabilities, even though I made love with her four times. Marvelous feeling all the same, but the next morning at 8 violent appendicitis requiring my being taken to the hospital": ibid., 116–17.

29 "WRITTEN THAT TO ANYONE": AB to André Paris, 17 Sept. 1915, Camargo, item 59.

29 "AND BEAUTIFUL": AB to André Paris, 27 Oct. 1915, Camargo, item 62.

29 "AVENUE DE L'OBSERVATOIRE!": AB to André Paris, 13 Dec. 1915, Camargo, item 63.

29 DESCRIBED TO VALÉRY: Seigel, *Bohemian Paris*, 370–71.

29 NEXT SEVERAL DECADES: On Apollinaire: Sarane Alexandrian, *Breton par lui-même* (Paris: Editions du Seuil ["Ecrivains de Toujours"], 1971), 11; Francis Steegmuller, *Apollinaire: Poet Among the Painters* (New York: Penguin Books, 1986), 15–25 234–35. See also Roger Shattuck's illuminating chapter on Apollinaire in *The Banquet Years: The Origins of the Avant-Garde in France, 1885 to World War I*, revised ed. (New York: Vintage Books, 1968).

30 "YOUR SMILES, ABOVE ALL": AB to Apollinaire, [Dec. 1915], Doucet.

30 "WORLD OF NATURAL NECESSITY": AB, unpublished contribution to 1954 radio broadcast on Apollinaire, Doucet.

30 "TIMES AND MY SITUATION": AB to Apollinaire, [Dec. 1915], Doucet. The poem was originally titled "Vingt-cinq décembre" [December Twenty-fifth].

30 "A STRIKING TALENT": Apollinaire to AB, 21 Dec. 1915, in Guillaume Apollinaire, "Lettres d'Apollinaire à André Breton," ed. Marguerite Bonnet, *Revue des Lettres Modernes* 104–107 (1964; hereinafter "*RLM*"), 20.

30 "ALL TOO IRREGULAR SONNET": AB to Valéry, 9 Jan. 1916, *OC 1*, 1114.

31 "LITERARY MAGNIFICATION": AB to unknown correspondent, 3 Jan. 1916, *Digraphe* 30, 28–29. Given Breton's tone and his rare use of the familiar *tu*, the addressee is almost certainly Fraenkel.

31 "VERY PRETTY, VERY DELICATE": Apollinaire to AB, 18 Jan. 1916, *RLM*, 21.

31 "EACH OTHER IN A POET": Valéry to AB, [Jan. 1916], *OC 1*, 1114.

32 "NEARLY SUNK FRANCE": Pierre Albert-Birot, manifesto from *SIC* 2 (Feb. 1916), quoted in Pierre Daix, *Aragon: une vie à changer* (Paris: Editions du Seuil, 1975), 72. On spirit of times: Serge Fauchereau, "Des questions pour aujour-

d'hui," *Digraphe* 30, 19, as well as the French press of the period.

32 "UNPRECEDENTEDLY DIRECT": *Conversations*, 41. On Cravan: Georges Hugnet, *L'Aventure dada, 1916–1922* (Paris: Seghers, 1971), 38, 77–78, 152; Alain and Odette Virmaux, *Cravan Rigaut Vaché, suivi de Le Vaché d'avant Breton* (Mézières-sur-Issoire: Rougerie, 1982), 55–56, 123ff.

32 "MISTAKEN FOR A SHOW-OFF": Arthur Cravan, "André Gide," quoted in AB, *Anthology of Black Humor*, ed. and trans. Mark Polizzotti (San Francisco: City Lights Books, 1997), 259.

32 "A FLAMING PIG": Arthur Cravan, "L'Exposition des indépendants" (March 1914), in Arthur Cravan, Jacques Rigaut, and Jacques Vaché, *Trois suicidés de la société* (Paris: Union Générale d'Editions ["10/18"], 1974), 115.

32 "AND RELIEVING ONESELF": Ibid., 118.

32 "VERITABLE PRECURSOR": AB to René Gaffé, 3 Nov. 1932, quoted in Robert Matagne, "Les Archives du surréalisme," *Les Pages de la S.E.L.F.* iv (1956), 62. In the same letter, Breton claimed to attach "great historical importance" to Cravan's "*extra-litterary* and even *anti-literary* concerns."

33 "EVERYTHING TO US": "Lecture on Dada" (Sept. 1922), in Tristan Tzara, *Seven Dada Manifestos and Lampisteries*, trans. Barbara Wright (London: John Calder, 1977), 112.

33 "GOOD SAUSAGE PYTHON": Hans Arp, quoted in Karl, *Modern and Modernism*, 349.

33 "TWENTY YEARS OLD": AB, unpublished note from 1930, in *OC 1*, 1077–78.

33 "BRAVING THE ROADS": "Age," in AB, *Earthlight*, trans. Bill Zavatsky and Zack Rogow (Los Angeles: Sun & Moon Press, 1993), 24 (trans. slightly revised).

3. Joyful Terrorists

34 FASHIONABLE PARISIAN BAR: Michel Carassou, *Jacques Vaché et le Groupe de Nantes* (Paris: Jean-Michel Place, 1986), pass.; Alain and Odette Virmaux, *Cravan Rigaut Vaché, suivi de Le Vaché d'avant Breton* (Mézières-sur-Issoire: Rougerie, 1982), 64–65; *OC 1*, 198–99; Sorrell, "Vaché's Letters," 99–100.

35 "TOWARD ART AND MODERNISM": "Disdainful Confession," in *Lost Steps*, 7.

35 "SUCH AS MURDER": Vaché to AB, 18 Aug. 1917. There have been numerous publications of Vaché's *Lettres de guerre* in French. Of those currently available, the most reliable is in the appendix of Carassou, *Jacques Vaché*, 237–53; and the most complete is Jacques Vaché, *Soixante-dix-neuf lettres de guerre*, ed. Georges

Sebbag (Paris: Jean-Michel Place, 1989), which reproduces errors from past editions but includes the known totality of Vaché's wartime correspondence. There is also Martin Sorrell's English version (v. supra), on which I have sometimes leaned when translating the excerpts included in the present text.

35 "'CHARGED' FOR A FEW DAYS": "As in a Wood," in *Free Rein*, 236.

35 "THAN WAS FASHIONABLE": "Jacques Vaché," in *Lost Steps*, 42.

36 CONTINUING ON HIS WAY: Bonnet, 88–89; "Disdainful Confession," 7–8; *Nadja*, 37; Vaché, *Soixante-dix-neuf lettres*, xvi.

36 "AT AGE THIRTEEN": Excerpt from Jean Sarment, *Cavalcadour*, in Carassou, *Jacques Vaché*, 34. Sarment was perhaps Vaché's closest friend from the Nantes group, and *Cavalcadour* a thinly-disguised roman à clef about him and his friends' youthful experiences. See also Vaché, *Soixante-dix-neuf lettres*, xvii.

36 "IN OTHER WORDS ABOMINABLE": "Mon cœur mis à nu," in Charles Baudelaire, *Œuvres complètes* (Paris: Gallimard ["Bibliothèque de la Pléïade"], 1954), 1207.

36 VACHÉ'S ACQUAINTANCE IN NANTES: Fraenkel explicitly mentions seeing Vaché in Paris in June 1917: Théodore Fraenkel, *Carnets 1916–1918* (Paris: Editions des Cendres, 1990), 83. See also Carassou, *Jacques Vaché*, 236.

37 "HAVE PRODUCED ANYTHING": "For Dada," in *Lost Steps*, 52.

37 "DEAR OLD, ROTTEN BAUDELAIRE!!!": Vaché to AB, 18 Aug. 1917.

37 "DESERTION WITHIN ONESELF": *Anthology of Black Humor*, 293.

37 "ARE HATEFUL": Vaché to AB, 29 April 1917.

37 "AIR DRY, A LITTLE": Vaché to AB, 18 Aug. 1917. In some editions of Vaché's letters, the phrase is given as "art dry," an ambiguity that even consultation of the original manuscript letters has been unable to clarify (my thanks to Georges Sebbag for this information).

38 "POINTLESSNESS OF EVERYTHING": Vaché to AB, 29 April 1917. The line "It is in the essence of symbols . . ." was taken from Alfred Jarry.

38 "ITS TAINTED CHARMS": Jacques Baron, *L'An I du surréalisme, suivi de L'An dernier* (Paris: Denoël, 1969), 24.

38 "EVERYTHING IN ITS PATH": *Conversations*, 18.

39 ALMOST DAILY: Cf. Vaché, *Soixante-dix-neuf lettres*. Vaché also wrote frequently to his father.

39 "EVERY TWO OR THREE MONTHS": "Disdainful Confession," 9.

39 OTHER MEMBERS' WRITINGS: See Carassou, *Jacques Vaché*, 24, 121–23, 231.

39 "THEY USED TO": Vaché to his mother, 26 April 1917, *Soixante-dix-neuf lettres*, letter no. 44.

39 "PAGES OF THE NEWSPAPERS": AB to Valéry, 6 March 1916, *OC 1*, 1237.

39 "NOT TO BE A POET": Valéry to AB, [mid-March 1916], ibid.

40 "TRUMP CARDS IN HER HAND": *Conversations*, 27; McDougall, ed., *Very Rich Hours*, 67ff. On wartime Paris: Amédée Ozenfant, *Mémoires, 1886–1962* (Paris: Seghers, 1968), 86–87; Malcolm Haslam, *The Real World of the Surrealists* (New York: Galley Press, 1978), 15–16; Frederick Brown, *An Impersonation of Angels: A Biography of Jean Cocteau* (New York: Viking Press, 1968), 155.

41 "A SINGULAR FASHION": Monnier, "André Breton," in McDougall, ed., *Very Rich Hours*, 88–89.

41 "A REVOLUTIONARY FIGURE": Ibid., 87.

41 SENT WORD TO BRETON: Apollinaire to AB, [8 May 1916], *RLM*, 26. See also Shattuck, *Banquet Years*, 291–92.

41 "STILL CAN'T WRITE": AB to André Paris, 18 June 1916, Camargo, item 64.

42 "ADORN THE ZOO OF ART": Tzara, *Seven Dada Manifestos*, 1; cf. *RLM*, 7.

42 "BELLY OF AN ORIENTAL DANCER": Andrews, *Surrealist Parade*, 25.

42 "TO THINK OF ANOTHER": Hans Richter, *Dada: Art and Anti-Art*, trans. David Britt (New York: Harry N. Abrams, [1966]), 66.

42 "QUIET, STUDIOUS RUSSIANS": Ibid., 16.

43 "LOVELY THE WAR IS": Apollinaire, "L'Adieu du cavalier," in *Calligrammes* (1918).

43 "ALONE IN A DOWNPOUR": *Nadja*, 52.

43 "AWFULLY FAR AWAY": Georges Gabory, "Soirées perdues," *NRF* (1 Oct. 1921), 416–17; cf. Fraenkel, *Carnets*, 32–35.

44 "SEVERAL DAYS MORE": AB to André Paris, 18 June 1916, Camargo, item 64.

44 "MEAN LITTLE PENDULUM CLOCKS": Ibid.

44 "THAT NO LONGER START": *Magnetic Fields*, 35 (trans. revised). The French verb is *tourner*, which can mean either "turn" or "shoot" (as in film). Breton explicitly identifies "Alice" (surrounded by a heart) and "Nantes 1916" in his marginal notes from 1930: *Change* 7, 16.

44 "WHAT A DELICATE MARVEL!": AB to Fraenkel, 23 June 1916, Bonnet, 73.

44 "PERVERSE AND STUPID": Fraenkel, *Carnets*, 36.

44 "JOLTS OF PASSION": AB to Fraenkel, [Nov. 1916], *OC 1*, 1073.

44 "CASTIGATE THIS POEM": AB to Valéry, 9 June 1916, *OC 1*, 1071.

45 "LET US CASTIGATE, THEN": Valéry to AB, [ca. end June 1916], *OC 1*, 1072.

45 VERY HIGHLY OF IT: Aragon, "Lautréamont et nous, 1," *Lettres françaises* (1 June 1967), 7.

45 "YOUR DUBIOUS PROBABILITIES": Vaché to AB, 5 July [1916].

45 "AWAY FROM ITS COURSE": AB to Apollinaire, 15 Aug. 1916, Bonnet, 98. Several years later, in his private diary, Breton recorded a revealing conversation with André Derain: "[Derain] began by reproaching [me] for not being . . . preoccupied with 'making people suffer.' I told him he was wrong and that, personally, I think about nothing else." As a parenthetical aside, Breton added: "Alice": AB diary entry, 7 July 1921, *OC 1*, 622.

46 AUSTRIAN NATIONALITY: Emmanuel Régis and Angélo Hesnard, *La Psychoanalyse*, second edition (1914; Paris: Félix Alcan, 1922), cf. esp. ix–x.

46 "FREUD AND KRAEPELIN!": AB to Fraenkel, 25 Sept. 1916, Bonnet, 99, see also 112–13. By November, however, Breton was already writing to Fraenkel that his duties seemed merely routine: Bonnet, 111.

46 "OF MENTAL DISTRESS": *Conversations*, 20.

46 "DREAM ABOUT AT NIGHT?": AB to Valéry, 7 Aug. 1916, Bonnet, 108.

46 "WOULD OCCUR TO US": AB to Fraenkel, [Aug. 1916], ibid., 109.

46 "POETS THAN HE IS": Fraenkel, *Carnets*, 56.

47 "A SIMILAR TEST": AB to Apollinaire, 15 Aug. 1916, Bonnet, 109–10.

47 "RAREST VERBAL ALLIANCES": Ibid.

47 "YOUR SUBJECTS CAREFULLY": Valéry to AB, [late Aug. 1916], Eigeldinger, *André Breton*, 54; further portions quoted in *OC 1*, 1105.

47 "SOME 'CATATONIC' OR OTHER": Vaché to AB, 11 Oct. 1916.

47 "DIDN'T REALLY BELIEVE IT": *Conversations*, 21.

48 "BEEN MADE OF WAX": "Subject," in *André Breton: Selections*, ed. Mark Polizzotti (Berkeley: University of California Press ["Poets for the Millennium"], 2003), 130.

48 HAD BEEN PUBLISHED: *OC 1*, 1105.

48 "TESTE WAS JUST A PUPPET!": AB to Fraenkel, 18 Nov. 1916, *OC 1*, 1434; Bonnet, 35.

48 "BEEN DUPED, BETRAYED": *Conversations*, 29.

48 "AN ENDLESS ENCHANTMENT": AB to Valéry, [April 1917], Béhar, *André Breton*, 49.

48 TO SEE THEM OFF: MP interview with Michel Fraenkel, 18 March 1988.

49 "TREACHEROUS POTHOLES": AB to Valéry, 30 Dec. 1916, *OC 1*, 1116; Béhar, *André Breton*, 44–45.

49 "CIRCUMSTANCES HAVE HANDED YOU": Valéry to AB, 26 Nov. 1916, Bonnet, 53.

49 "FOR A CERTAIN TIME": AB to Valéry, 30 Dec. 1916, Bonnet, 48.

49 ONE OF "DERISION": AB to André Paris, 19 Dec. 1916, Camargo, item 68.

49 "SWIMMING, OR GALOPING": AB to Valéry, 30 Dec. 1916, *OC 1*, 1116.

50 RETURN TO A FORMER LIFE: MP interview with Georges Seligmann, 11 Aug. 1988; Georges Seligmann, untitled memoirs, manuscript provided courtesy of the author; Béhar, *André Breton*, 47.

50 "SACRED FEVER": *Manifesto*, 47.

50 "GREAT MEDICAL FUTURE": AB, *Nadja*, revised ed. (Paris: Livre de Poche, 1964), 53n. This edition, which incorporates Breton's later revisions to the text, appeared several years after Richard Howard's translation and contains material not presently available in English. See also Legrand, *Breton*, 38.

51 "GOT MY FEVER BACK": AB to André Paris, 5 April 1917, Camargo, item 70. See also Apollinaire to AB, [19 March 1917?], *RLM*, 30; Béhar, *André Breton*, 48.

51 "AS WELL AS YOU CAN": Apollinaire to AB, 24 March [1917], *RLM*, 32.

51 "ACCEPT YOUR OFFER": AB to Apollinaire, 28 March 1917, *OC 1*, 1232. See also *RLM*, 33n, 36n.

51 "HAPPY AND PROUD": AB to Apollinaire, 24 March 1917, *OC 1*, 1082.

52 THE THIRD NUMBER: *OC 1*, 1075n; Shattuck, *Banquet Years*, 294.

52 "BASEST PRACTICAL JOKE": Reported in *L'Heure* (6 June 1917), scrapbook of press clippings in the Harry Ransom Humanities Research Center (hereinafter "HRC"). Other information: Francis Steegmuller, *Cocteau: A Biography* (Boston: Atlantic-Little, Brown, 1970), 224; MP interview with Michel Fraenkel, 18 March 1988.

52 "IN A GLASS HOUSE": *Nadja*, 18.

52 "WAS BEHIND-THE-SCENES": Brown, *Impersonation*, 404.

53 "ANTI-POET" PERSONIFIED: Soupault, *Mémoires*, II, 81.

53 "BATTLE OF THE WAR": Francis Steegmuller, "Jean Cocteau: 1889–1963, A Brief Biography," in *Cocteau and French Scene*, 22; Steegmuller, *Cocteau*, 226–27; Georges Ribemont-Dessaignes, *Déjà jadis, ou Du mouvement dada à l'espace abstrait* (1958; Paris: Union Générale d'Editions ["10/18"], 1973), 155; *Philippe Soupault et le surréalisme*, a documentary by Bertrand Tavernier and Jean Aurenche, broadcast on the series *Témoins*, FR3, 1982; MP interview with Virgil Thomson, 5 May 1987. Cf. Brown, *Impersonation*, 182.

53 LIFE OF ITS OWN: Shattuck, *Banquet Years*, 294; Steegmuller, *Cocteau*, 513.

53 "USED BY THE PHILOSOPHERS": Apollinaire to Paul Dermée, March 1917, in *Surréalisme* I (Oct. 1924), [7]. A complete facsimile of this first and only issue was printed in *Europe* 475–476 (Nov.–Dec. 1968), 111–26.

53 "WITHOUT REALIZING IT": Preface to *Les Mamelles de Tirésias*, in Apollinaire, *Œuvres poétiques* (Paris: Gallimard ["Bibliothèque de la Pléiade"], 1965), 865–66.

53 "IN ITS PURE STATE": *Manifesto*, 26.

54 "AND ITS FINE-TUNING": AB to unidentified friend, [n.d.], Béhar, *André Breton*, 52.

54 "SUR-REALIST PERFORMANCE": Vaché to Fraenkel, 16 June 1917; Henri Pastoureau, "Surréalisme: le mot, ce qu'il signifie, ce qu'il désigne," *L'Orne littéraire* 10 [1987], 7.

54 THEATER THAT AFTERNOON: "Disdainful Confession," 9.

54 "A DOSE OF SYPHILIS": Ibid., 10.

54 "LITERARY TOUT-MONTMARTRE": *L'Œuvre* (25 June 1917), press clippings scrapbook, HRC. Two who "shone by their absence," according to the newspaper *La Rampe*, were Picasso and Erik Satie.

54 CURTAIN TO RISE: *Le Pays* (27 June 1917); *L'Œuvre* (25 June 1917); *Carnet de la semaine* (25 June 1917); "Francis Poulenc parle des Mamelles de Tirésias" (unidentified newspaper clipping; all excerpts from press clippings scrapbook, HRC); Youki Desnos, *Les Confidences de Youki* (Paris: Fayard, 1957), 96.

55 "GOOD-NATURED": "Guillaume Apollinaire," in *Lost Steps*, 25.

55 SHOOTING THE AUDIENCE: "Disdainful Confession," 9; *Conversations*, 18–19; Alexandrian, *Breton par lui-même*, 17.

55 "WOULD BE COMPLETE": *Conversations*, 19.

55 FRIEND OF BRETON'S: See *SIC* 27 (March 1918).

56 NOW IN ENEMY HANDS: Haslam, *Real World*, 11; Bernadotte E. Schmitt and Harold C. Vedeler, *The World in the Crucible, 1914–1919* (New York: Harper & Row, 1984), 173.

56 AND DISAPPOINTMENT: Bonnet, 83.

57 "UNACCEPTABLE TO US": *Conversations*, 32.

57 "ARE STILL DISCONNECTED!": Vaché to AB, 18 Aug. 1917.

4. The Three Musketeers

58 "MUST BECOME FRIENDS": Soupault, *Mémoires*, I, 41.

58 "SEE EACH OTHER AGAIN": Ibid., 41–42.

58 MILITARY AND ITS WORKS: Ibid., 32; Jean-Jacques Brochier, *L'Aventure des surréalistes, 1914–1940* (Paris: Stock, 1977), 77.

58 A CERTAIN ANDRÉ BRETON: Soupault, *Mémoires*, I, 38

59 "AND OF FRESHNESS": *Conversations*, 25–26.

59 "KNOCKED ON HIS DOOR": *Manifesto*, 45n; Matthew Josephson, *Life Among the Surrealists: A Memoir* (New York: Holt, Rinehart & Winston, 1962), 134–35; Sarane Alexandrian, *Le Surréalisme et le rêve* (Paris: Gallimard ["Connaissance de l'Inconscient"], 1974), 388.

59 "NOR HIS BACKGROUND": Soupault, *Mémoires*, I, 48; Soupault, "Souvenirs," *NRF* 172, 660; MP interview with Philippe Soupault, 16 June 1986.

60 "BLOOD-SOAKED FOG": Soupault, *Mémoires*, I, 45.

60 SPARED THE RITUAL: Aragon, "Lautréamont et nous, I," 5; *Aragon parle avec Dominique Arban* (Paris: Seghers, 1968), 28.

60 "ISSUE OF LES SOIRÉES DE PARIS": Aragon, "Lautréamont et nous, I," 5.

60 "NO ONE": *Aragon parle*, 29.

60 SOCIALIST PERIODICALS: Ibid., 42; Aragon, "Lautréamont et nous, I," 5; Daix, *Aragon*, 57.

61 "I WAS ASHAMED": Aragon, "Lautréamont et nous, I," 5.

61 "PROOF OF HIS VIRILITY": Aragon, *Henri Matisse, roman* (Paris: Gallimard, 1971), 214–15; Daix, *Aragon*, 57–58; Andrews, *Surrealist Parade*, 20–21; Alexandrian, *Surréalisme et rêve*, 370. Many years later, after their breakup, Breton would confide at a political meeting that Aragon was indeed "the son of former police prefect Andrieux, who boasted in his memoirs of having introduced provocation into police procedure"—the source, he would claim, of his ex-comrade's "professional false witness and hereditary tendency to inform": "Visite à Léon Trotsky" (passage not retained in *Free Rein*), in *OC 3*, 957.

62 "IN BRETON'S CHEST": *Le Cœur à Barbe* (April 1922), [2] (signed by Théodore Fraenkel); McDougall, ed., *Very Rich Hours*, 102; Maxime Alexandre, *Mémoires d'un surréaliste* (Paris: La Jeune Parque, 1968), 41–42, 96, 169–70; Daix, *Aragon*, 66–67.

62 "SUCCEEDS IN THIS AIM ALSO": Haslam, *Real World*, 113.

62 "WINDOW AND MIRROR": Soupault, *Mémoires*, I, 94, 49. The future art dealer Georges Seligmann, who was in the same class, recalled Aragon as "a tall, extremely thin young man whose body seemed as flexible as a reed. He went about with a small library of at least ten books stacked up on his bent left forearm. To balance them, he was forced into the pose of a 13th-century Virgin, upper torso thrust back, left hip protruding to support the elbow, as if to uphold the weight of the Christ child upon it . . . I recall at least one volume of poems by Apollinaire, but hardly ever room for a medical

textbook": MP interview with Georges Seligmann, 11 Aug. 1988.

63 "OPPOSITE OF CONSCIENCE": AB to Fraenkel, 23 July 1917, Bonnet, 127. See also *Aragon parle*, 29–30; Roger Garaudy, *L'Itinéraire d'Aragon: du surréalisme au monde réel* (Paris: Gallimard, 1961), 25–26. In July, after seeing Musidora in a stage show, Breton had written the actress a fan letter: "How can I tell you what you have come to incarnate for some: what a modern fairy, adorably gifted in evil, and so puerile—oh, your childish voice!": AB to Musidora, [22 July 1917], *OC 1*, 1745.

63 "EVERYTHING WE LOVE TODAY": Guillaume Apollinaire, *The Poet Assassinated and Other Stories*, trans. Ron Padgett (Berkeley: North Point Press, 1984), 29.

63 "HE WAS ALWAYS RIGHT": "Philippe Soupault: 'Le chef d'école cachait un solitaire,'" *Figaro littéraire* (27 June 1988), v; *Conversations*, 25.

64 "TO BE INEXHAUSTIBLE": *Conversations*, 33.

64 THROWN OVER HIS SHOULDERS: *OC 1*, xxxv; AB to Fraenkel, 21 Oct. 1917, ibid., 1231; "Disdainful Confession," in *Lost Steps*, 10.

64 "AWARENESS OF THAT STRENGTH": AB to Fraenkel, 21 Oct. 1917, *OC 1*, 1231.

64 "ATTEMPT WAS A FLOP": Vaché to AB, 9 May 1918.

64 TERRITORY THE FOLLOWING SPRING: James L. Stokesbury, *A Short History of World War I* (New York: William Morrow and Company, 1981), 228–42.

65 TEN MORE YEARS: Cf. *Conversations*, 29. Speaking of this period, Aragon later remarked that for him and his friends, "simply to name the war, even if in opposition, was to promote it": Aragon, *Entretiens avec Francis Crémieux* (Paris: Gallimard, 1964), 27–32.

65 "SAME DIRECTION AS YOURS": Reverdy to AB, 10 Jan. 1918, in "Trente-deux lettres inédites à André Breton, 1917–1924," *Etudes littéraires* (April 1970), 98; *Conversations*, 30–31; Soupault, *Mémoires*, I, 62.

65 "ACROSS THE FACE": Soupault, *Mémoires*, I, 63.

66 "OF POETRY THAN HE": *Conversations*, 30.

66 CANTOS OF MALDOROR: Aragon, "Lautréamont et nous, 1," 5.

66 TO "CRETINIZE" HIM: This and following quotes from Lautréamont, *Maldoror and the Complete Works*, trans. Alexis Lykiard (Cambridge, Mass.: Exact Change, 1994).

67 "MUST LEAD SOMEWHERE": "The Cantos of Maldoror," in *Lost Steps*, 47.

67 "EXCEED HUMAN POSSIBILITY": *Anthology of Black Humor*, 132.

67 "I SHALL ENLIGHTEN YOU": Aragon, "Lautréa-

mont et nous, 1," 7; Béhar, *André Breton*, 57–58; Soupault, *Mémoires*, I, 52–53; Georges Auric, *Quand j'étais là* (Paris: Grasset, 1979), 108.

68 "HORRIFYING PASSAGES": Aragon, "Lautréamont et nous, 1," 7; quotes from Isidore Ducasse [Lautréamont], *Poésies*, trans. Alexis Lykiard (London: Allison & Busby, 1978).

69 "NOTHING BUT MALDOROR": AB to Fraenkel, 29 July 1918, *OC 1*, xxxvii.

69 OF HIS FINAL YEARS: Eigeldinger, *André Breton*, 60–65.

69 "MAKES THE COLLAGE": Max Ernst, *Ecritures* (Paris: Gallimard ["Le Point du Jour"], 1970), 256.

70 "ENTITLED MISTER PAUL VALÉRY": AB to Valéry, 4 April 1918, *OC 1*, 1066.

70 ABREAST OF THE NEW TRENDS: *DAP*, 61–62.

70 "WAITING TO RETIRE": "For Lafcadio," in *André Breton: Selections*, 54.

70 FOUND THE TITLE "DELIGHTFUL": Valéry to AB, 21 June 1918, *OC 1*, 1066.

70 "I'M LEAVING IT": Valéry to AB, 25 July 1918, and AB to Fraenkel, 29 July 1918, ibid., 1095.

71 ARRIVED ON THE 20TH: Ibid., xxxvii; Béhar, *André Breton*, 60.

71 "THAT I LOVE (BUT EVEN SO)": AB to Fraenkel, 22 May 1918, *OC 1*, 1231; Aragon, "Lautréamont et nous, 1," 8.

71 "JUST GOING AWAY?": Vaché to AB, 9 May 1918.

71 "BEING KILLED IN WARTIME": Ibid.

72 FRIENDS AND ACQUAINTANCES: Béhar, *André Breton*, 61. See AB to Paulhan, 11 July 1918, Jacqueline Paulhan archives (hereinafter "JP").

72 "LOST ALL MY COMPLACENCY": AB to Paulhan, 18 June 1918, JP; Paulhan to AB, [ca. June 1918], *OC 1*, 1104. Cf. Reverdy to AB, [1 May 1918], "Trente-deux lettres," 99.

72 "THE WORK OF PAUL VALERY": AB to Paulhan, 27 June 1918, JP.

72 "DELIGHTFUL TURMOIL": AB to Paulhan, 11 July 1918, JP.

72 "POINT IN MY LIFE": AB to Paulhan, 26 July 1918, JP. This letter, along with another from the same period, was published in a limited edition of nineteen copies as AB, *Deux lettres à Jean Paulhan* (Montpellier: Fata Morgana, 1974).

73 "SELF-INDULGENCE THESE DAYS": AB to Fraenkel, 29 July 1918, Bonnet, 118n; *OC 1*, xxxvii.

73 "HARD TO RETURN": AB to Paulhan, 6 Oct. [1918], JP.

73 WORK AS AN ACCOUNTANT: *OC 1*, xxxviii. The previous spring, Paris had undergone severe bombardments by the Germans' large-bore, long-range cannon, familiarly known as "Big Bertha."

73 "A PREMONITION": *Soupault et le surréalisme.*

73 "STAR HAS FALLEN!": Reverdy to AB, 4 July 1918, "Trente-deux lettres," 102 et pass.

73 "DISTANT REALITIES": Reverdy, "L'Image," *Nord-Sud* 13 (March 1918); Breton cites this definition in *Manifesto*, 20–21. See also Reverdy to AB, 23 Aug. 1918, "Trente-deux lettres," 103, and *OC 1*, 1331, 1353.

74 "IN NO PARTICULAR ORDER": AB to Aragon, 12 Sept. 1918, "Lautréamont et nous, 1," 9.

5. A Man Cut in Two

75 "PUT HIM IN THE TOMB": "Guillaume Apollinaire," in *Lost Steps*, 26.

75 "SO MANY THINGS TO SAY!": Janet Flanner, *Paris Journal*, II (1956–1965), ed. William Shawn (New York: Harcourt, Brace, Jovanovich, 1988), 345.

75 HIS OWN DOWNFALL: Shattuck, *Banquet Years*, 296–97. Most of Apollinaire's biographers consider this story apocryphal.

75 "HAS JUST / DIED": AB to Aragon, 9 Nov. 1918, quoted in Aragon, "André Breton," *Lettres françaises* (6 Oct. 1966), 1. See also "Ombre non pas serpent mais d'arbre, en fleurs," in AB, *Perspective cavalière*, ed. Marguerite Bonnet (Paris: Gallimard, 1970), 35.

76 OF PAUL ELUARD: Aragon, "Lautréamont et nous, 2," *Lettres françaises* (8 June 1967), 7; *Nadja*, 24–27. Aragon says that the friend Breton was chatting with was Jean Paulhan; Breton, who was feuding with Paulhan at the time he wrote his own account, claims it was Picasso.

76 "AND I HOPE SO": Vaché to AB, 14 Nov. 1918.

76 "MADE MY FORTUNE—WELL": Ibid.; "Disdainful Confession," in *Lost Steps*, 11.

76 "IT'S NO SMALL MATTER": Vaché to AB, 19 Dec. 1918.

77 "BEGIN THESE ACTIONS": *Conversations*, 34.

77 "CUT IN TWO BY THE WINDOW": *Manifesto*, 21; Béhar, *André Breton*, 79. In a letter of 15 Jan. 1921 to Jacques Doucet, Breton quotes the phrase as "a man at a window passing midway through his body": *OC 1*, 1354.

77 "I'M WAITING FOR YOU": AB to Vaché, 13 Jan. 1919, reproduced in Georges Sebbag, *L'Imprononçable jour de sa mort Jacques Vaché janvier 1919* (Paris: Jean-Michel Place, 1989). Sebbag's book includes not only a full-color facsimile of Breton's letter to Vaché—the only one known to have survived—but also a detailed exegesis of each of its constituent parts.

77 A TRAIN SCHEDULE: Vaché to AB, 19 Dec. 1918.

77 "ASSUMED IT CONTAINED PRESERVES": Carassou, *Jacques Vaché*, 214–16: includes quotes from

L'Express de l'Ouest (9 Jan. 1919) and *Le Télégramme des Provinces de l'Ouest* (7 Jan. 1919), which first reported the deaths. Further information from Dominique Rabourdin, "Jacques Vaché avant Breton: Rencontre avec Robert W. Guibal," in *Docsur* 14 (Jan. 1991), 3; Vaché, *Soixante-dix-neuf letters*; MP conversation with Michel Carassou, 24 Feb. 1988.

78 FIND THE HOTEL DOCTOR: Sebbag, *Jour de sa mort*, chs. 17 and 40; Raphaël Sorin, "Un dernier témoin raconte l'histoire de Jacques Vaché et du surréalisme," *Le Monde* (4 Dec. 1979), 23; Patrick Simon and Dominique Paquet, "A propos de Jacques Vaché," *Actual* newsletter 5 (July 1985), 1, 4.

78 "JANUARY ?, 1919": Bonnet, 148; *OC 1*, 1294; Sebbag, *Jour de sa mort*, ch. 34.

78 "JACQUES VACHÉ'S DEATH": *Mad Love*, 66 (trans. revised).

78 STATE OF MIND: MOURNING: Béhar, *André Breton*, 71.

78 "EVENT OF [HIS] LIFE": AB to Paulhan, 3 March 1919, JP.

79 "MAN WAS MY FRIEND": "Jacques Vaché," in *Lost Steps*, 43. Cf. Breton's poem "Last Mail Pickup" from the early 1930s (in *Earthlight*, 126): "The letter I'm waiting for travels incognito in an envelope / . . . I only hope it isn't lost among grains of poison."

79 "IN THE WORLD TO ME": AB to Jacques Doucet, 4 Jan. 1921, Doucet.

79 "HILARIOUS TRICK ON THEM": "Disdainful Confession," 11. The phrase "hilarious trick" was taken from Vaché's letter to Fraenkel of 12 Aug. 1918: "I'm dreaming of some splendid, really heartfelt Eccentricities, or of some hilarious tricks which would leave a trail of dead . . ."

79 "DROOLING TEA WITH MILK": Vaché to AB, 5 July 1916.

79 "MY VERY BEST FRIENDS": *Anthology of Black Humor*, 294.

79 "CONFIDENT ABOUT LIFE": Carassou, *Jacques Vaché*, 217; Sebbag, *Jour de sa mort*, ch. 40; *Aragon parle*, 48.

79 EXPERIMENTED WITH DRUGS BEFORE: Sorin, "Un dernier témoin," 23.

80 "COMPLETELY DISGUSTED" HIM: *Recherches*, 173.

80 BORDERED ON PASSION: Carassou, *Jacques Vaché*, 217–18 and ff.; MP conversation with Michel Carassou, 24 Feb. 1988.

80 "NEW SPIRIT IS UNLEASHED!": Vaché to AB, 19 Dec. 1918.

81 "ABSURD AS A VOCATION": "Disdainful Confession," 11, 2.

81 ON THE "NEW SPIRIT": Cf. Carassou, *Jacques Vaché*, 14.

81 OF PREWAR EXPERIMENTS: *RLM*, 68; *Conversations*, 40.

81 "TO SWEEP, TO CLEAN": Tzara, *Seven Dada Manifestoes*, 4–12 (trans. slightly revised).

82 "PRODIGIOUS MANIFESTO DADA 3": AB to Aragon, 21 Jan. 1919, in Aragon, "Lautréamont et nous, 2," 4, 8.

82 "POETIC, TOO": *Conversations*, 40

82 AN ENTHUSIASTIC EMBRACE: Aragon, "Lautréamont et nous, 2," 5; Helena Lewis, *The Politics of Surrealism* (New York: Paragon House, 1988), 7–8.

82 "A BETTER JUSTIFICATION": *Conversations*, 42.

82 "TURNED TOWARD YOU": AB to Tzara, 22 Jan. 1919, *DAP*, 440; Sebbag, *Jour de sa mort*, ch. 1.

82 "DIED SEVERAL MONTHS AGO": AB to Tzara, 20 April 1919, *DAP*, 444.

82 "STOCK IN THE RESEMBLANCE": Ibid.

83 NOTORIOUS INAUGURAL MANIFESTO: Claude Sernet, introduction to Tristan Tzara, *Les Premiers poèmes* (Paris: Seghers, 1965), esp. 15–20. In a conversation of 29 April 1991, Tzara's son, Christophe, corrected some small errors in Sernet's introduction, and explained how his father's pseudonym had derived from the Romanian "*trist în tară.*"

83 REVIEWED BY ARAGON: Aragon to Pierre Albert-Birot, 22 Nov. [1918], HRC.

84 "CREATURE AROUND TODAY": AB to Tzara, 26 Dec. 1919, *DAP*, 454.

84 COMPLAINED OF FEELING FAINT: Brown, *Impersonation*, 188; Jean Hugo, *Le Regard de la mémoire* (Arles: Actes Sud, 1983), 125; Steegmuller, *Cocteau*, 234.

84 "BY THE HANDFUL": Cocteau to AB, 23 Feb. 1919 (draft), HRC.

84 "WITHOUT A PASSPORT": Aragon, unpublished ms., ca. 1922, quoted in Garaudy, *Itinéraire*, 60.

85 "AND RENAME IT": AB to Aragon, 30 Jan. 1919, in "Lautréamont et nous, 2," 4.

85 "BE QUICK": Ibid.

85 "VERLAINE PLAYED NO PART": *Conversations*, 34.

85 "SPIRIT WE'RE FIGHTING FOR": AB to Tzara, 18 Feb. 1919, *DAP*, 441.

85 "VERY WELL-BRED": *Conversations*, 34.

86 "THE LITERARY WORLD'S RESPECT": *Littérature* 1 (March 1919), 24; Soupault, *Mémoires*, I, 86–87; Béhar, *André Breton*, 73.

86 THE RIGHT GATHERINGS: Soupault, *Profils perdus*, 151; *Aragon parle*, 37; McDougal, ed., *Very Rich Hours*, 90.

86 "DIDN'T ASSOCIATE WITH": Aragon, "Lautréamont et nous, 2," 6–7; *Conversations*, 39.

87 "WRITTEN A SINGLE POEM": Quoted in Garaudy, *Itinéraire*, 58.

87 "IMAGINE THEY COULD WRITE": "Clearly," in *Lost Steps*, 81. First published in *Littérature* (new series) 4 (Sept. 1922).

87 "PROBLEM OF OUR LIVES": "Reply to a Survey," in ibid., 83.

87 "HUMAN CONDITION": "Clearly," 81.

87 "STOP TO READ IT?": *Aragon parle*, 134.

87 "ALSO POETIC ELEMENTS": Tzara, *Seven Dada Manifestos*, 8 (trans. slightly revised).

88 "ADVERTISEMENT FOR HEAVEN": AB to Aragon, 13 April 1919, in "Lautréamont et nous, 2," 7. Later that year, Breton echoed this line in *Magnetic Fields*: "The word has gone out; I am inventing an advertisement for heaven!" (p. 35).

88 "CONVINCING ENOUGH": Marginal notes to *Magnetic Fields*, *Change* 7, 17; Bonnet, 153.

88 "WORD OF IT TO ANYONE": Aragon, "Lautréamont et nous, 2," 7.

88 "WHO WILL LEAVE WHOM?": Ibid.

88 "ONE PARTICULAR EVENING": AB to Aragon, [ca. March 1919], ibid., 5.

88 "MIGHT BE FOUND OUT": Ibid., 8.

88 POLITICS, AND RELIGION: AB to Fraenkel, 19 April 1919, Bonnet, 153.

89 "OVERTURN SEVERAL WORLDS": AB to Tzara, 20 April 1919, *DAP*, 444.

89 "SPOKE WELL OF HIM": "A Not-Very-Solid House," in *Earthlight*, 30.

89 "DAREDEVIL THE WHOLE THING WAS": Aragon, "Lautréamont et nous, 2," 7.

89 "ALTERNATING WITH STOCK PHRASES": AB notes for René Gaffé (1930), in *OC 1*, 1098.

89 "CONTRADICTED . . . MALDOROR": Soupault, *Mémoires*, I, 97.

89 SAY TO EACH OTHER: *DAP*, 566; Aragon, "Lautréamont et nous, 2," 8; *OC 1*, 1086.

89 "ARE WE FRIENDS?": AB to Tzara, 2 March [1919], *DAP*, 443.

90 "AFRAID OF FEELING ISOLATED": Soupault, *Mémoires*, I, 99; Gateau, *Paul Eluard*, 74. Sanouillet (*DAP*, 109–10n) conjectures that the incident at *La Couleur du temps* was Eluard's ploy to meet Breton.

90 OTHERS FOUND DAZZLING: Aragon, "Lautréamont et nous, 2," 8.

90 "A MYSTICAL CRETIN": Giorgio de Chirico, *The Memoirs of Georgio de Chirico*, trans. Margaret Crosland (Coral Gables, Fla.: University of Miami Press, 1971), 117. On Eluard: Gateau, *Paul Eluard*, 30–31, 68; *DAP*, 109–10n; Andrews, *Surrealist Parade*, 147.

91 "LOOKED LIKE SOMEONE": André Thirion, *Revolutionaries Without Revolution*, trans. Joachim Neugroschel (New York: Macmillan, 1975; hereinafter "Thirion"), 180; Gateau, *Paul Eluard*, 15.

91 "PROUD TO HAVE IN HIS BED": Thirion, 180.

91 "ELIMINATING THE MEDIOCRE": Ibid.; Gateau, *Paul Eluard*, 30.

91 "FATE, ENIGMAS, AND DISSIMULATION": Henri Pastoureau, "Une soirée chez Gala," *Pleine Marge* 6 (Dec. 1987), 40.

92 "HIS GREATEST CRIME": AB to Paulhan, 3 March 1919, JP; cf. Paul Claudel, *Œuvres en prose* (Paris: Gallimard ["Bibliothèque de la Pléiade"], 1965), 514–21, 1470.

92 FOR 500 FRANCS: Aragon, "Lautréamont et nous, 2," 4; Fouché, *Au Sans Pareil*, 13–14; Aragon, *L'Œuvre poétique*, II (1921–1925) (Douai: Livre Club Diderot, 1974), 325.

92 PUBLICATION BY A FEW WEEKS: Fouché, *Au Sans Pareil*, 13–20; Serge Fauchereau, et al., "Conversation avec René Hilsum," *Digraphe* 30 (June 1983), 120–21; *DAP*, 170n.

92 THE SPRING OF 1919: *Conversations*, 43.

93 "KIND OF DAILY FATALISM": Ibid., 39.

93 "MOUTH OF SHADOWS": Cf. ibid., 65.

94 "ONLY SLIGHTLY LESS": *Manifesto*, 21–22.

94 "AKIN TO SPOKEN THOUGHT": Ibid., 22–23.

94 "TO A WRITING PROCESS": Marginal notes to *Magnetic Fields*, 11.

94 "TRIALS AND TRIBULATIONS": *Manifesto*, 44n (trans. slightly revised).

94 "WITH GREAT INTENSITY": *Second Manifesto of Surrealism* (1930), in *Manifestoes*, 162n. On the history of automatic writing: *Manifesto*, 25; MP interview with Edouard Roditi, 21 April 1987.

95 "SINGLE TWO-HEADED AUTHOR": Aragon, "L'Homme coupé en deux," *Lettres Françaises* (8 May 1968), 5.

95 "A LITTLE LESS LITERATURE": AB to Fraenkel, 22 June 1918, Bonnet, 165.

95 THE RENOWNED PSYCHIATRIST: The question of whether the development of automatic writing owes more to the theories of Freud or of Janet has been the subject of extended academic debate, which it is not my aim to explore here. Readers wanting further information can consult Anna Balakian's thesis in favor of Janet (in her *André Breton: Magus of Surrealism* [New York: Oxford University Press, 1971], 28–34) and Marguerite Bonnet's rebuttal, which gives sole credit to Freud (Bonnet, 106–8). Breton himself mentioned Janet only rarely in his writings, and never as an inspiration for *The Magnetic Fields*. Soupault, in contrast, often stressed Janet's importance to himself and Breton in 1919 (see especially *Mémoires*, I, 71–72). While on strictly philosophical grounds Freud's automatism is in fact closer to Breton than is Janet's (without this proving exclusivity), it is also likely that Breton had polemical reasons for slanting history at Janet's expense:

by the time he gave his own account of the genesis of automatic writing—privately in 1930, publicly in 1952—he had fallen out with Janet, owing to the psychiatrist's open dislike of Freud and his work, which Breton continued to admire; his incomprehension of Surrealism; and his hostility toward Breton's *Nadja* (cf. *Second Manifesto*, 119–23). "Breton could be somewhat vindictive," Soupault later remarked (interview with MP, 16 June 1986). See also Jean Starobinski's interesting article "Freud, Breton, Myers" (in Eigeldinger, *André Breton*, 153–71), in which the critic assigns a determining role to the parapsychological theories of Frederic W. H. Myers; Bonnet's response to Starobinski (Bonnet, 104–5); Sarane Alexandrian's remarks on the subject in *Surréalisme et rêve*, 51; and Bernard-Paul Robert's articles "Pour une définition du surréalisme" (*Revue de l'Université d'Ottawa*, vol. 43 [April 1973], 297–306) and "A propos d'André Breton" (*Revue de l'Université d'Ottawa*, vol. 46 [Jan.–March 1976], 128–44).

96 "EXECUTION DID THE REST": *Manifesto*, 23; Soupault, "Souvenirs," *NRF* 172, 665.

96 MAKE IT MORE MYSTERIOUS: *Soupault et le surréalisme*; MP interview with Philippe Soupault, 16 June 1986; Serge Fauchereau, "Des questions pour aujourd'hui," *Digraphe* 30, 21. The original manuscript is reproduced in facsimile in AB and Philippe Soupault, *Les Champs magnétiques: le manuscrit original, fac-similé et transcription* (Paris: Lachenal & Ritter, 1988).

96 "GREATEST SPEED POSSIBLE": Marginal notes to *Magnetic Fields*, 10.

96 GET THEM ALL DOWN: "The Mediums Enter," in *Lost Steps*, 90.

96 "FAST-MOVING PEN": *Manifesto*, 23.

96 "DANGEROUS BOOK": Marginal notes to *Magnetic Fields*, 10.

96 "MY POOR FRIEND": *Magnetic Fields*, 29.

97 "IN THE NAME OF THE LAW": Ibid., 60 (trans. slightly revised).

97 "COVERED WITH BLOOD": Ibid., 62.

97 "WERE PERHAPS CARS": Marginal notes to *Magnetic Fields*, 17.

97 "STRONG COMICAL EFFECT": *Manifesto*, 23.

97 "BURST OUT LAUGHING": Soupault, "Souvenirs," 665.

97 "ARE BUT PERPETUAL ANIMALS": This and following quotes are from *Magnetic Fields*, passim.

97 "ABSOLUTELY WILD LAUGHTER": Marginal notes to *Magnetic Fields*, 12.

97 "THE MOTHER LODE": *Conversations*, 43–44.

97 "MARVELOUSLY LIBERATED": Soupault, *Mémoires*, I, 77.

98 "I WEEP FOR HIM": *Magnetic Fields*, 35 (trans.

slightly revised); cf. marginal notes for reference to Vaché (*Change* 7, 16). The French for "gillyflower" (*giroflée*), an untranslatable pun, can also mean a slap in the face.

98 "LITTLE SHOPS, FOR EXAMPLE": Marginal notes to *Magnetic Fields*, 23.

98 "CHANGED WHILE WRITING IT": Aragon, "Homme coupé en deux," 8; Philippe Soupault, "Origines et début du surréalisme," *Europe* 475–476 (Nov.–Dec. 1968), 4.

98 "VERY MUCH AS DRUGS DO": *Manifesto*, 36.

98 CERTIFICATION ON JULY 1: *OC 1*, xxxviii.

99 "WAS CALLED LA SOURCE": Aragon, "Homme coupé en deux," 3.

100 "YOU'D FIND ME OUT": Ibid., 5.

100 "EMOTIONAL IMPACT": Aragon, "A quoi pensez-vous?," *Ecrits nouveaux* (Aug. 1921), 152.

100 "OF WRITING PIVOTS": Aragon, "Homme coupé en deux," 5.

100 IN FEBRUARY 1920: Daix, *Aragon*, 96.

100 NOT TO "JUDGE HIM": AB to Tzara, 29 July 1919, *DAP*, 447.

100 OVERALL WORK ITS TITLE: Fauchereau, "Questions pour aujourd'hui," 20.

100 ENTIRE OPENING CHAPTER: Soupault, "Origines et début," 5.

100 THE MAGAZINE'S DISTRIBUTOR: Monnier, *Rue de l'Odéon*, 118.

101 "THE COLLECTION, OF COURSE": AB to Tzara, 29 July 1919, *DAP*, 447.

101 "TOOK OF THE WAR": AB notes for René Gaffé (1930), quoted in auction cat. *Bibliothèque de M. René Gaffé: Très précieux livres des auteurs du Mouvement Dada et du Groupe Surréaliste* (Paris: Hôtel des Commissaires-Priseurs, 26–27 April 1956; hereinafter "Gaffé"), 18.

101 "YOUNG MEN OF LITTÉRATURE?": Valéry to AB, 26 July 1919, *OC 1*, 1093.

101 "SEASONAL NOVELTIES": Anonymous review, included in Radiguet to AB, 19 Aug. 1919, in Valentine Hugo, "Raymond Radiguet avant 'Le Diable au corps,'" *La Pensée française* 1 (15 Nov. 1956), 59. Sales and publishing details: Fouché, *Au Sans Pareil*, 17; Soupault, *Mémoires*, I, 117; *OC 1*, lx, 1070.

101 COLLABORATION WITH SOUPAULT: AB to Valéry, 5 Sept. 1919, *OC 1*, 1122.

101 "DESERTED AND SILENT": AB to Eluard, 5 Sept. 1919, Bonnet, 198n.

6. Dada Comes to Paris

102 "LIFE'S NECESSITIES": Chapsal, *Envoyez*, 223.

102 "STRAIGHT FROM BERLIN": *NRF* (1 Sept. 1919), 636.

102 "UNSPEAKABLE PLOYS": *Littérature* 8 (Oct. 1919), 32.

102 "WHAT A PLATITUDE!": Tzara to AB, 21 Sept. 1919, in Tzara, *Seven Dada Manifestos* (as "Open Letter to Jacques Rivière"), 87.

103 "HYGIENIC NEED OF COMPLICATIONS": Ibid., 87–88 (trans. slightly revised).

103 "WHY DO YOU WRITE?": *Littérature* 9 (Nov. 1919), 1.

103 "IN THE NEXT LITTÉRATURE": AB to Tzara, 7 Oct. 1919, *DAP* 450–51. Although "Why Do You Write?" was clearly inspired by Tzara, it is worth noting this variant version from Philippe Soupault: "We often met in a bar in Passage de l'Opéra . . . Among the house clientele there was a middle-aged fellow who, without ever saying a word, always listened in on us and kept watching us. One day, our patience at an end, we asked him, 'What's the matter with you, always watching us like that!' He replied simply, 'I'm watching because I'd like to know why you write.' It all started there." Aragon's literary executor, Jean Ristat, for his part claims that Aragon originated the survey: Daniel Rondeau, "L'Idée de l'homme en noir," *Libération*, special issue: "Pourquoi écrivez-vous?" (March 1985), 6; Aragon: *L'Œuvre poétique*, II, 327 (note 12).

103 MAJORITY AS "PATHETIC": *Conversations*, 43.

104 "CLAIM TO ACT ON IT": "Disdainful Confession," in *Lost Steps*, 5. Answers are from *Littérature* 10 (Dec. 1919), 21–26; 11 (Jan. 1920), 20–26; and 12 (Feb. 1920), 19–26. Hamsun's original passage reads: "Shall I write more? No, no. Only a little for my own amusement's sake, and because it passes the time for me to tell of how the spring came two years back . . .": *Pan*, trans. W. W. Worster (New York: Knopf, 1921), 17.

104 "INTERESTED IN OUR MAGAZINE": Soupault, *Mémoires*, I, 116.

104 A MERE "TRAP": *Conversations*, 43.

104 "FAR MORE EXHILARATING": "Magie quotidienne," in *Perspective cavalière*, 107. See also: Béhar, *André Breton*, 84; *OC 1*, xxxix.

104 "THE ACQUAINTANCE OF MADNESS": "Magie quotidienne," 115.

105 "THE FIRECRACKER ABOUT HER": Ibid., 107.

105 HIS ROOM AND BOARD: Bonnet, 203; AB to Tzara, 8 Nov. 1919, DAP, 451–52.

105 CONTACT THE PAINTER: AB to Tzara, ibid.

105 "MYSELF YOUR FRIEND": AB to Picabia, 11 Dec. 1919, DAP, 503.

105 MUSICIAN GABRIELLE BUFFET: Soupault, *Mémoires*, I, 109; AB to Tzara, 26 Dec. 1919, *DAP*, 453. In her memoirs, Everling mistakenly gives January 4, 1920—the day of her son's birth—as the date of Picabia's first meeting with Breton: see Germaine Everling, *L'Anneau de Saturne* (Paris: Fayard, 1970), 95.

105 BY EVERLING IN JANUARY: *DAP,* 114; Jean-Jacques Brochier, *L'Aventure des surréalistes, 1914–1940* (Paris: Stock, 1977), 126; Everling, *Anneau,* 95.

106 "I WAS BORED TO HELL": Francis Picabia, "Billets de faveur," in *Littérature* (new series) 5 (1 Oct. 1922), 11. On Picabia: William A. Camfield, *Francis Picabia: His Art, Life, and Times* (Princeton: Princeton University Press, 1979), pass.; Brown, *Impersonation,* 191–95; Brochier, *Aventure des surréalistes,* 125–26; Everling, *Anneau,* 79–81 et pass.

107 FEELING WILDLY ENTHUSIASTIC: *OC 1,* xli; Alexandrian, *Breton par lui-même,* 142; Everling, *Anneau,* 95.

107 "MUCH CONFUSION AS POSSIBLE": AB to Picabia, 5 Jan. 1920, *DAP,* 505.

107 A "SNOB": Soupault, *Mémoires,* I, 112–14. Cf. Balakian, *André Breton,* 54.

107 "MADE FOR THE DOOR": Everling, *Anneau,* 95–96.

107 "SO BADLY AT THE MOMENT": AB to Tzara, 14 Jan. 1920, *DAP,* 455.

107 "TIME OF THE COMMUNE": Aragon, "Dada" [unpublished ms., Dec. 1922], in Garaudy, *Itinéraire d'Aragon,* 82.

107 "TERRIBLE WISH TO DESTROY": Soupault, *Profils perdus,* 154.

107 "CALLED OUR 'GOOD BREEDING'": Ibid., 154.

107 HIS OWN BOOKSTORE IN JANUARY: *DAP,* 170; Béhar, *André Breton,* 100.

108 "KISS ME QUICK": Aragon, *Paris Peasant,* trans. Simon Watson Taylor (Cambridge, Mass.: Exact Change, 1994), 78.

108 DROWN OUT THE READINGS: *DAP,* 142–43; Aragon, "Premier vendredi de Littérature" [unpublished ms., 1923], *Digraphe* 51 (March 1990), 34.

109 DISSIPATED THE GROUP: *DAP,* 141.

109 "INTO MY HOME": Everling, *Anneau,* 98–99.

109 "SEVERAL DAYS' INCONVENIENCE!": Ibid., 99.

109 PHOTO OF TZARA'S FACE: Cf. AB to Tzara, 12 June 1919, *DAP,* 445.

110 "STARTLED BY DAYLIGHT": Unidentified typescript, quoted in *DAP,* 141n.

110 MATINEES OF HIS YOUTH: *OC 1,* xxxix–xl; Aragon to Pierre Albert-Birot, [ca. 15 Jan. 1920], HRC.

110 "BLAGO BUNG": Richter, *Dada,* 8, 19.

110 "LOCKED OUT OF THEIR HOMES": Aragon, "Premier vendredi," 32.

110 IN RECENT MONTHS: Ibid.; Soupault, *Mémoires,* I, 120; *DAP,* 144.

111 DISGRUNTLED PATRONS: Aragon, "Premier vendredi," 34–35; *DAP,* 144–45; André Salmon, *Souvenirs sans fin, troisième époque (1920–1940)* (Paris: Gallimard, 1961), 54–57.

111 "NFOONFA MBAAH NFOONFA": "The White Leprous Giant of the Countryside," in Tristan Tzara, *Selected Poems,* trans. Lee Harwood (London: Trigram Press, 1975), [n.p.].

112 SPENT THE NEXT DAY IN BED: Aragon, "Premier vendredi," 35–38; AB to Tzara and Picabia, 24 Jan. 1920, *DAP,* 507; Soupault, *Mémoires,* I, 121.

112 "A THIEF THAN A POET": Aragon, "Premier vendredi," 40–41.

112 INTO LITTÉRATURE AS WELL: *DAP,* 136.

112 DO THE TALKING: Cf. Tzara to Picabia, [early Feb. 1920], *DAP,* 497.

112 "BOURGEOIS MORAL PLAN": Josephson, *Life,* 140.

113 INTERNECINE SQUABBLES: Information for these paragraphs from *DAP,* 207–16.

113 "T'AMO, T'AMO!": Georges Ribemont-Dessaignes, "Civilisation," *391* 3 (1 March 1917), 2.

114 "STORM THE BOX OFFICE": *Conversations,* 50; *DAP,* 153.

114 LEAVING BRETON TO COVER FOR HIM: Soupault, *Mémoires,* I, 130; *DAP,* 156; Tristan Tzara, "Memoirs of Dadaism," in Edmund Wilson, *Axel's Castle: A Study in the Imaginative Literature of 1870–1930* (1931; New York: Charles Scribner's Sons, 1945), 305.

114 "NOT ONE OF THEM DARED BUDGE": André Gide, "Dada," *NRF* (1 April 1920), 480–81.

114 "THIS NATIONAL MONUMENT?": Open letter from the newspaper *Fantasio* to the Ministry of Public Investigations (Feb. 1920), quoted in *DAP,* 398.

114 "SWINDLE OF THE CENTURY": Henri Béhar and Michel Carassou, *Dada: Histoire d'une subversion* (Paris: Fayard, 1990), 165; Tzara, "Memoirs," 304–5.

114 IN TWO DAYS' TIME: Aragon, "Manifestation de la rue de Puteaux," *Ecrits nouveaux* (Jan. 1921), 61–62.

115 REBELS COULD NOT RESIST: *Archives du surréalisme, I: Bureau de recherches surréalistes: Cahier de la permanence (octobre 1924–avril 1925),* ed. Paule Thévenin (Paris: Gallimard, 1988; hereinafter "*Cahier*"), 137; *DAP,* 156.

115 "MADE THEM QUIET DOWN": Aragon, "Rue de Puteaux," 62–63.

115 WITH THE SOCIALITES: *DAP,* 157–58; Ribemont-Dessaignes, *Déjà jadis,* 97–98; Tzara, "Memoirs," 305; Aragon, "Rue de Puteaux," 61–64.

115 SYMBOLISM TO DADAISM: *DAP,* 156n.

116 "NOT VERY ABUNDANT": *Conversations,* 45.

116 "CONVENTION OF ALL": Breton, "Patinage Dada," *Littérature* 13 (May 1920), 9–10.

116 "AND DOMINEERING": Soupault, *Mémoires,* I, 99–100; Balakian, *André Breton,* 46; Claude Mauriac, *Bergère ô Tour Eiffel (Le Temps immobile,* VIII) (Paris: Grasset, 1985), 243.

117 SAW EACH OTHER AGAIN: "Magie quotidienne," 107; this 1955 essay was spurred by a letter from Georgina, sent some thirty-five years after their breakup. See also *OC 1*, xli.

117 "I PASSED THROUGH": Chapsal, *Envoyez*, 224.

117 "WITH REGARD TO EVERYTHING": Valéry to Louis Breton, 24 March 1920, Bonnet, 203.

117 GLAD TO ACCEPT: AB to Gallimard, 26 March 1920; Gallimard to AB, 27 March 1920 (both documents: editorial archives of Editions Gallimard; hereinafter "*NRF* archives"); AB to Tzara, 8 Nov. 1919, *DAP*, 451–52; Legrand, *Breton*, 42; *OC 1*, xl; Bonnet, 203.

117 "OF A LABYRINTH": Chapsal, *Envoyez*, 224.

117 "TREASURES" IN PROUST'S WORK: Rivière to Proust, 29 June 1920, in Marcel Proust and Jacques Rivière, *Correspondance, 1914–1922* (Paris: Gallimard, 1976), 110.

118 GOING TO RUE HAMELIN: MP conversation with Georges Bernier, 11 Nov. 1988.

118 TWO HUNDRED MISSED CORRECTIONS: Proust to Soupault, [ca. 25 Oct. 1920], *DAP*, 559. Although Proust tried to be gracious about the errata in his letter to Soupault (and in another to Breton himself), his annoyance was given fuller vent in a letter of the time to Jacques Rivière, to whom he complained of the "charming Dada" who had let slip numerous "errors [that] remove all meaning from the sentence" (Marcel Proust and Gaston Gallimard, *Correspondance* [Paris: Gallimard, 1989], 267).

118 BEFORE TZARA'S ARRIVAL: Cf. AB to Tzara, 14 Jan. 1920, *DAP*, 455.

118 "CURIOUS FEROCITY": Soupault, *Mémoires*, I, 108.

118 "SMOKE DOESN'T BOTHER YOU": AB and Philippe Soupault, *S'il vous plaît* [If You Please], *Littérature* 16 (Sept.–Oct. 1920), 20. This translation is based on the play's original publication in *Littérature*. The text was later reprinted in AB and Philippe Soupault, *Les Champs magnétiques* (Paris: Gallimard, 1967), 131–71, and an alternate, but rather awkward, English translation can be found in Mel Gordon, ed., *Dada Performance* (New York: PAJ, 1987).

118 "THAT MATTER TO ME?": Ibid., 27.

118 "NOT WAITING FOR ANYONE": Ibid., 24.

119 "SOMEONE WILL SHOW UP": *Conversations*, 106.

119 "I HADN'T CHOSEN": "Disdainful Confession," 4.

119 "ANYONE WHO GETS BORED": Eluard to A. J. Gonon, 23 March 1920, in Paul Eluard, *Lettres de jeunesse* (Paris: Seghers, 1962), 209.

119 "ADMIRED AND RESPECTED": Soupault, *Profils perdus*, 157.

119 "DON'T KNOW, DON'T KNOW": *DAP*, 164–69; Soupault, *Mémoires*, I, 134–35; *Soupault et le surréalisme*; Ribemont-Dessaignes, *Déjà jadis*, 100–2; Everling, *Anneau*, 122.

119 "ALL THEY DESIRED": G[eorges] C[harensol], "Manifestation Dada," *Comœdia* (29 March 1920), in Camfield, *Francis Picabia*, 142.

119 "TO ATTRACT THE PUBLIC": *Conversations*, 50.

120 "BUT IN ITSELF": Tzara, *Seven Dada Manifestos*, 112 (trans. slightly revised).

120 "MUSIC TO HEAR": *DAP*, 193.

120 "IMPLICATE ITS AUTHORS": Aragon, "Homme coupé en deux," 8.

120 "ACT FOUR NOT BE PRINTED": *Littérature* 16, 32.

120 "THIS IS RIDICULOUS": Restored fourth act of *S'il vous plaît*, *OC 1*, 133, 1175; see also Philippe Soupault, *Vingt mille et un jours: Entretiens avec Serge Fauchereau* (Paris: Pierre Belfond, 1980), 38.

121 VIGILANTES FINALLY GAVE UP: Ribemont-Dessaignes, *Déjà jadis*, 133–34; Robert Desnos, *Nouvelles Hébrides et autres textes, 1922–1930*, ed. Marie-Claire Dumas (Paris: Gallimard, 1978), 333–34; *DAP*, 198–99.

121 AN EXCEPTION FOR HIM: *DAP*, 198–99. Cf. Desnos, *Nouvelles Hébrides*, 334: "the morale of the 'DADA band' was seriously undermined, since they had admitted that one or several of its members could be suspected."

121 "WORDS OUT OF MY MOUTH": André Gide, "Dada," *NRF* (1 April 1920), 477.

121 "A DEMOLITION ENTERPRISE": Ibid., 478.

122 "FEELING A BIT CONFINED": Ibid., 481.

122 "GIVE YOU BAD BREATH": *DAP*, 201n.

122 A LITERARY CARRIE NATION: On Rachilde, see Claude Dauphiné, *Rachilde, Femme de lettres 1900* (Périgueux: Pierre Faulac, 1985), pass.

122 "SILENT SMILE" OF NEGLECT: Rachilde, "Le Sourire silencieux," *Comœdia* (1 April 1920), quoted in *OC 1*, 1403.

122 "OUT OF THE GATE": AB, open letter to Rachilde, 1 April 1920, *OC 1*, 410–11. First published in *Comœdia* (4 April 1920).

123 "OUR INFIDELITIES": Soupault, *Mémoires*, I, 142.

123 PLAN ANOTHER DEMONSTRATION: Ibid., 142–43; Everling, *Anneau*, 115.

123 KIOSKS TO PUBLIC TOILETS: *DAP*, 221–23.

123 "SOCIALLY ACCEPTABLE": Etienne Gaveau to Picabia, 21 May 1920, *DAP*, 553.

124 "GRINDING HIS TEETH!": Everling, *Anneau*, 110, 124; *DAP*, 176–77; RoseLee Goldberg, *Performance Art: From Futurism to the Present*, revised and enlarged ed. (New York: Harry N. Abrams, 1988), 84.

124 STEAKS AND CUTLETS: *DAP*, 177–78; Everling, *Anneau*, 125; *Conversations*, 45.

124 "IGNORANCE OF DADA IS NO EXCUSE": Cf. *DAP*, 223, 394.

124 "MUST STILL SPEAK OF DADA": *DAP,* 397. Cf. *DAP,* 401, for a discussion of press echoes of Dada at the time.

124 STILL HADN'T SOLD OUT: Fouché, *Au Sans Pareil,* 142. Alain Jouffroy, in his introduction to the 1967 reprint of *Les Champs magnétiques,* op. cit., says that only 300 copies were printed, an assertion that has been repeated by numerous critics. But the publication records of Au Sans Pareil clearly suggest that 796 is the correct number.

124 "THE CURRENT MOVEMENT": *L'Eclair* (11 Sept. 1920), quoted in *OC 1,* 1147.

124 BOOK'S VERY "INCOMPREHENSIBILITY": *Mercure de France* (15 Nov. 1920), 196–97.

124 "ATTRACTION OVER HIM": Paul Neuhuys, "Quelques poètes," *Ça Ira* 14 [summer 1921], 61.

125 "HEMIA HEMIA YES BOHEMIA": "Counterfeit Coin," in *Earthlight,* 45 (trans. slightly revised). The word *pièce* in the French title ("Pièce fausse") can mean either "coin" or "play," a reference to the theater piece (*Vous m'oublierez*) for which the poem was composed. As it happened, Dada's mocking sword could cut both ways: when Aragon published a poem called "Suicide," consisting entirely of the alaphabet cut into five lines, it unleashed a torrent of ridicule in the press, including an alphabet in reverse under the title "Resurrection" (see *DAP,* 208n).

126 "DENYING ME YOURS?": AB to Picabia, 19 June 1920, *DAP,* 508.

126 "AS YOU CHANGE BOOTS": Picabia to Tzara, 3 July 1920, ibid., 498.

126 "IT COULDN'T GO ON": AB to Picabia, 28 July 1920, ibid., 508–9. In a letter of the 24th to Simone Kahn, his soon-to-be fiancée, Breton claimed that he left the *NRF* "at his family's insistence."

126 PHYSICAL AND MENTAL ILL HEALTH: AB to Paulhan [two separate letters], 28 July 1920, JP.

126 "OF WORKS OR IDEAS": "For Dada," in *Lost Steps,* 51 (emphasis mine).

126 "[DADA'S] PRINCIPLE TENETS": Ibid., 53.

126 "REVISION OF MORAL VALUES": Ibid., 51.

127 "HARDLY SATISFIED": AB to Picabia, 11 Aug. 1920, *DAP,* 512.

127 "NRF ARTICLE AND RIVIÈRE'S": AB to Picabia, 28 July 1920, ibid., 509.

127 THE NRF'S PAGES: Jacqueline Chénieux-Gendron, "Les Risques du dialogue: Jacques Rivière et les surréalistes," *Revue d'histoire littéraire de la France* 5 (1987), 891.

127 "A LITTLE IN BRITTANY": AB to Picabia, 11 Aug. 1920, *DAP,* 511.

127 "WE BOTH HELD DEAR": Simone [Breton] Collinet, "Origines et tendances de la peinture surréaliste" (lecture, 1965 and 1966), in Virmaux, *Breton qui êtes-vous?,* 105–6.

127 "EACH OTHER INEXCUSABLE": Simone [Breton] Kahn to Denise Kahn-Lévy (hereinafter "Simone to Denise"), 1 June 1920, in Simone Breton, *Lettres à Denise Lévy 1919–1929,* ed. Georgiana Colvile (Paris: Editions Joëlle Losfeld, 2005; hereinafter "*Lettres à Denise*"), 53.

128 THE NEARLY FINISHED WAR: MP interview with Edouard Roditi, 11 June 1987, and conversation with Sylvie Sator, 14 Nov. 1993.

128 "EVEN IN CONTRADICTION": Simone to Denise, 31 July 1920, *Lettres à Denise,* 57.

128 THE VERGE OF FALLING: AB to Valéry, 5 Aug. 1920, Bonnet, 230.

128 "PROMISE OF A CURE": AB to Simone Kahn (hereinafter "AB to Simone"), 28 Aug. 1920, Sator. Excerpts from some of these letters are quoted in Bonnet, passim.

128 "WILL NOT BE AT ALL": AB to Simone, 1 Sept. 1920, Sator. Cf. the famous concluding line of *Nadja:* "Beauty will be CONVULSIVE or will not be at all."

128 "INNOCENCE, NOTHING MORE": AB to Simone, 19 Aug. 1920, Sator.

129 A LITTLE MORE LOVING: Cf. AB to Simone, 22 Sept. 1920, Sator. Simone's letters to Breton, now lost, were probably destroyed by him at the time of their divorce in 1930.

129 "THERE ARE ONLY SUNS": AB to Simone, 16 Sept. 1920, Sator; Bonnet, 236; Vítězslav Nezval, *Rue Gît-le-Cœur* (La Tour d'Aigues: Editions de l'Aube, 1988), 29–30; *OC 1,* xli.

129 "TOLD YOU THAT MANY TIMES": AB to Simone, 22 Sept. 1920, Sator.

129 OF SUCH "HEROISM": AB to Simone, 9 Aug. and 24 Oct. 1920, Sator; MP interview with Edouard Roditi, 21 April 1987.

129 OFFEND THEIR AMERICAN PATRON: Proust to AB, 27 Oct. 1920, *DAP,* 559–60; Gide to Valéry, 2 Oct. 1920, in André Gide and Paul Valéry, *Correspondance (1890–1942)* (Paris: Gallimard, 1955), 481–82; *OC 1,* xli.

129 "REVISION OF HIS IDEAS": AB to Rivière, 28 Sept. 1920, Chénieux-Gendron, "Les Risques du dialogue," 890.

130 WED BIANCA MACLÈS: *OC 1,* 1467. In later years, for Bianca and her three sisters, Surrealist meetings must have seemed like family reunions: Rose married painter André Masson; Simone married Jean Piel, who edited the Surrealist-oriented periodical *Critique;* and Sylvia, a successful actress, was first the wife of Georges Bataille, then that of renegade psychoanalyst (and one-time Surrealist fellow traveler) Jacques Lacan.

130 "DADA IS NOT MODERN": Related by Breton in an unpublished journal entry of 29 Dec. 1920, *OC 1*, 616.

130 "PEACE INTO MY LIFE": AB to Tzara, 14 Oct. 1920, *DAP,* 456.

130 SAW EACH OTHER AGAIN: *DAP,* 230; AB to Tzara, 21 and 22 Oct. 1920, ibid., 462.

130 THE FUTURE OF LITTÉRATURE: AB to Tzara, 14 Oct. 1920, ibid., 456.

130 "AWAITED SINCE THE WAR": *Littérature* 17 (Dec. 1920), 24.

131 "THE CARRIAGE TRADE": Steegmuller, *Cocteau,* 260; *DAP,* 230–33. The date of the reception was Dec. 9, not the 12th as is sometimes reported.

131 "THE VULGAR HERD": Tzara, *Seven Dada Manifestos,* 39.

131 BEFORE STORMING OUT: Soupault, *Mémoires,* I, 143–44.

132 HAD HIM FIRED: *OC 1*, xlii; Thirion, 85.

132 ART AND RARE-BOOK COLLECTION: François Chapon, *Mystère et splendeurs de Jacques Doucet* (Paris: Jean-Claude Lattès, 1984), 56–57; Haslam, *Real World,* 110.

132 "AND MY GRANDSON": Chapon, *Jacques Doucet,* 16.

132 "RAISED WITH THE PIGS": Ibid., 15–16.

132 A MODEST INCOME: Ibid., 226–27.

132 "PRECURSORS OF MODERNITY": Ibid., 217. On the library: ibid., 216ff, 262; *OC 1*, 1488.

133 HIS BOOK THE LOST STEPS: For a fuller discussion of these letters, see Pierre-Olivier Walzer, "Une Bibliothèque idéale," in Eigeldinger, *André Breton,* 81–93.

133 "FUTURE SPREAD BEFORE IT": Unpublished journal entry, 29 Dec. 1920, *OC 1*, 615.

133 "MYSTERIOUS IN HIS ATTITUDE": Ribemont-Dessaignes, *Déjà jadis,* 136.

133 ELSEWHERE IN THE BUILDING: Soupault, *Mémoires,* I, 201.

134 "FIRING A SECOND BULLET": Jacques Rigaut, "Jacques Rigaut," *Littérature* 17, 7.

134 "TO HIS LIFE": *Anthology of Black Humor,* 309.

134 "FOR A TIME": Desnos, *Nouvelles Hébrides,* 301.

134 "MOST NONSENSICAL THINGS": Baron, *L'An I,* 21.

134 JARRY, AND APOLLINAIRE: On Péret: *DAP,* 190–91; Rachel Stella, introduction to Benjamin Péret, *Death to the Pigs: Selected Writings,* ed. Rachel Stella (London: Atlas Press, 1988), 7–8.

135 "BENJAMIN PÉRET WAS THERE": *Nadja,* 28.

135 "WHO WANTS TO WRITE": Desnos, *Nouvelles Hébrides,* 300–1.

135 FREQUENTING THE DADAISTS: Max Jacob to Picabia, 9 March 1920, *DAP,* 557.

135 SERVICE OF THE COMINTERN: *DAP,* 417n; Dominique Rabourdin, "Attitudes politiques,"

Magazine littéraire 254 (May 1988), 48; *Aragon parle,* 87.

135 "COMMUNISM THAN I WAS": Daix, *Aragon,* 103.

136 "TO SWEAT WITH HIM": *Aragon parle,* 87–88.

136 "HOW FAR ITS DEMANDS GO": Unpublished diary entry, 28 Dec. 1920, *OC 1*, 614–15.

136 ONLY GREW SHARPER: *DAP,* 238–40.

136 SILENT COMEDIAN HAROLD LLOYD: Desnos, *Nouvelles Hébrides,* 304.

137 "I WEAR GLASSES": "Patinage Dada," 9.

137 "A HUGE ERECTION": Aragon, *Paris Peasant,* 163.

137 "BY CEASING TO EXIST": Quoted by Breton in "For Dada," 56. Blanche had originally made the comment in his article "Réponse à un professeur de rhétorique au lycée de X," *Comœdia* (17 March 1920).

137 "PRIMARILY FRENCH": AB to Doucet, 4 Jan. 1921, Doucet. This and other excerpts of Breton's correspondence with Doucet were shown at the exhibition "André Breton: La beauté convulsive."

137 "VARIETY OF INDIVIDUALS": *Conversations,* 51–52.

137 "DEVOTION OF HEART AND MIND": Ibid., 52.

137 "BUT TO DEGRADE": "Liquidation," *Littérature* 18 (March 1921), 1.

138 "WHAT SEPARATES US": AB to Doucet, [ca. March 1921], Béhar, *André Breton,* 112.

138 "HAVE ANY REASON TO EXIST": Poster announcing the first "Excursions et visites Dada" (14 April 1921), reproduced in M. Sanouillet and Y. Poupard-Lieussou, eds., *Documents Dada* (Geneva: Weber, 1974), 55.

138 "MECCA OF SUICIDE": Aragon, *Paris Peasant,* 172.

138 "AS A GARBAGE DUMP": Soupault, *Mémoires,* I, 138; Baron, *L'An I,* 45.

138 "SHOES AND HALF BOOTS": Daix, *Aragon,* 120; Soupault, *Mémoires,* I, 145; Hugnet, *Aventure dada,* 98; Asté d'Esparbès, "Les disciples de 'Dada' a l'Eglise Saint-Julien-le-Pauvre," *Comœdia* (14 April 1921), 2. To Doucet, Breton claimed that one or two hundred people had shown up, but this number was likely inflated to impress his patron: "Les 'Enfers artificiels' " [unpublished report for Jacques Doucet, 20 May 1921], *OC 1*, 627.

138 "SUCCESS YOU'VE HANDED US?": D'Esparbès, "Disciples de 'Dada,' " 2. The speeches, never written down, were preserved only in the newspaper reports of the time.

139 "WHICH ISN'T SAYING MUCH": Ribemont-Dessaignes, *Déjà jadis,* 137; D'Esparbès, "Les disciples de 'Dada,' " 2; *DAP,* 247.

139 ANIMOSITIES TO A HEAD: Soupault, *Mémoires,* I, 146.

139 "WILL EXPLODE": [Francis Picabia], "Carnet du Docteur Serner," *391* 11 (Feb. 1920), 4.

139 "UNPARALLELED ADMIRATION": *Surrealism and Painting*, 64–65; *DAP*, 249. For Breton and Aragon, Ernst's procedure and the generation of poetic imagery were "absolutely analogous": cf. Bonnet, 238n.

139 "IT'S RAINING ON A SKULL!": *DAP*, 250–51; Maurice Martin du Gard, *Les Mémorables*, I (1918–1923) (Paris: Flammarion, 1957), 116, 119–20; *DAP*, 250–51.

140 "GREEN WITH ENVY": AB to André Derain, 3 Oct. 1921, *DAP*, 248n.

140 "OF THE NOUVELLE REVUE FRANÇAISE": "M. Picabia se sépare des dadas," in Francis Picabia, *Ecrits*, II (Paris: Pierre Belfond, 1978), 14. First published in *Comœdia* (11 May 1921).

140 "SOON POLICEMEN NO DOUBT": "Francis Picabia et Dada," *L'Esprit nouveau* 9 (June 1921), quoted in *DAP*, 267.

141 "TOWN CRIER OF MASSACRES": Jean Guéhenno, quoted in *OC 1*, 1408; On Barrès: see Marguerite Bonnet's introduction to *L'Affaire Barrès*, ed. Marguerite Bonnet (Paris: José Corti/Actual, 1987), 7–24; Frederick Busi, "Dada and the 'Trial' of Maurice Barrès," *Boston University Journal* xxiii:2 (1975), 67.

141 "PARTICULAR BITTERNESS": AB to Doucet, 11 April 1921, *OC 1*, 1408.

141 "EVEN DURING THE WAR": AB to Doucet, 11 April 1921, *OC 1*, 1408–9; AB to Tzara, 29 July 1919, *DAP*, 447; Bonnet, ed., *L'Affaire Barrès*, 15.

141 "RIGHT TO CONTRADICT ONESELF": Charles Baudelaire, introduction to his translation of Edgar Allan Poe, *Œuvres en prose* (cited in *OC 1*, 1596).

141 "SECURITY OF THE MIND": "L'Affaire Barrès," *Littérature* 20 (Aug. 1921), 1. The transcript of the Barrès trial made up the entire issue. See also *Conversations*, 53.

142 SIMULATE JUDICIAL GARB: On trial preparations and background: Bonnet, ed. *L'Affaire Barrès*, 11–13, 17–18; Ribemont-Dessaignes, *Déjà jadis*, 139–40; Soupault, *Mémoires*, I, 149–51.

142 "DRINK WATER": "L'Affaire Barrès," 15–16; Soupault, *Mémoires*, I, 150.

143 JUDGE BRETON HAD WISHED: Bonnet, ed. *L'Affaire Barrès*, 13; *DAP*, 266; Soupault, *Mémoires*, I, 150; Josephson, *Life*, 131.

143 "FAREWELL TO DADA": AB to Doucet, 5 June 1921, *OC 1*, 1399.

143 "WOULD BE WORTH FORTUNES": Desnos, *Nouvelles Hébrides*, 313; *OC 1*, 1319; AB cat., 106. On Kahnweiler: Pierre Assouline, *An Artful Life: A Biography of D. H. Kahnweiler, 1884–1979*, trans. Charles Ruas (New York: Grove Weidenfeld, 1990).

143 AROUND 20,000 FRANCS: Simone to Denise, 17 July 1921, *Lettres à Denise*, 86; Béhar, *André Breton*, 117.

144 PERFECT HONEYMOON SITE: AB to Simone, 14 Aug. 1921, Sator.

144 FOR SEVERAL WEEKS: AB to Simone, 10 and 13 Aug. 1921, Sator.

144 "BRETON WAS ALL SMILES": Ribemont-Dessaignes to Tzara, 17 Sept. 1921, *DAP*, 288; AB to Derain, 7 Sept. 1921, AB cat., 96 (also 50); Balakian, *André Breton*, 58; Béhar, *André Breton*, 118–19; Alain Jouffroy, "La Collection André Breton," *L'Œil* 10 (Oct. 1955), 33.

145 "A HAIR IN THE SOUP": John Russell, *Max Ernst: Life and Work* (New York: Abrams, 1967), 64; Patrick Waldberg, *Max Ernst* (Paris: Jean-Jacques Pauvert, 1958), 171–72.

145 TO MEET ERNST: *OC 1*, 1276; *DAP*, 288–89.

145 "TO ITS PRIMITIVE STATE": Unpublished diary entry, ca. early Jan. 1921, *OC 1*, 619–20; Béhar, *André Breton*, 120.

146 "REASSURING PHOTOGRAPH OF HIM": AB to Fraenkel, 7 Nov. 1921, private collection.

146 "TIME IN THESE DAYS": Freud to AB, 9 Nov. 1921, quoted by Breton in "Interview with Doctor Freud," *Lost Steps*, 70. First published in *Littérature* (new series) 1 (March 1922), 19.

146 "MAN FROM HIMSELF": *Nadja*, 24.

146 REFUSED TO TALK ABOUT IT: *OC 1*, 1276–77; Alexandrian, *Surréalisme et rêve*, 55–56; Bonnet, 260n.

146 "ONLY IN GENERALITIES": "Interview with Doctor Freud," 70–71.

146 "TO THE DADA SPIRIT": *Conversations*, 60. In an automatic text from 1924, Breton also depicted "Satan" as a thinly disguised version of Freud.

147 "IN THE AIR": Simone to Denise, 10 Dec. 1921, *Lettres à Denise*, 88.

147 CAUTIOUS PATRON'S RESISTANCE: Jean-François Revel, "Jacques Doucet, couturier et collectionneur," *L'Œil* 84 (Dec. 1961), 51; *Conversations*, 76–77.

147 "TODAY'S GREATEST ARTISTS": AB to Doucet, 3 Dec. [1921], Chapon, *Jacques Doucet*, 267–68.

147 "THE PAST FIFTY YEARS": AB to Doucet, 6 Nov. 1923, ibid., 294.

147 IN TWELVE MONTHLY INSTALLMENTS: Revel, "Doucet," 51; Pierre Cabanne, *Pablo Picasso: His Life and Times*, trans. Harold J. Salemson (New York: William Morrow, 1977), 243n.

147 "WON'T GET THEM IN AMERICA": Doucet to André Suarès, 9 March 1924, in *Les Demoiselles d'Avignon*, I, exh. cat. (Paris: Musée Picasso/Réunion des Musées Nationaux, 1988).

148 THEIR ARCANE REVOLUTION: *DAP*, 179, 289, 401; Daix, *Aragon*, 127.

148 COME TO FIND ABRASIVE: On the *Aventure*

group: Loredana Bianchi-Longoni, *Limbour dans le surréalisme* (Berne: Peter Lang, 1987), 149–50, 154; Jean-Pierre Barrou, "De la rue Blomet à la rue Fontaine" (interview with André Masson), *Critique* 351–352 (Aug.–Sept. 1976), 767–68; Marcel Duhamel, *Raconte pas ta vie* (Paris: Mercure de France, 1972), 176; Henri Béhar, *Roger Vitrac, un réprouvé du surréalisme* (Paris: A. G. Nizet, 1966), 38. Baron and Vitrac had originally approached the Dadas after the Saint-Julien performance (see Baron, *L'An I*, 46).

149 "THAN ANYONE ELSE": "Marcel Duchamp," in *Lost Steps*, 85–86.

149 "NOT BEGUN TO UNDERSTAND": AB to Doucet, 12 Aug. 1922, Chapon, *Jacques Doucet*, 291. On Duchamp: Hugnet, *Aventure Dada*, 41, 157–58; *DAP*, 116; Andrews, *Surrealist Parade*, 33; Calvin Tomkins, *The World of Marcel Duchamp, 1887–1968* (Alexandria, Va.: Time-Life Books, 1977), 77–93; Robert Lebel, "André Breton et la peinture," *L'Œil* (Nov. 1966), 18.

149 TAKEN HIM TO SEE DADA: Neil Baldwin, *Man Ray: American Artist* (New York: Clarkson N. Potter, 1988), 16, 78–82.

149 QUARANTE INTO "CARE-AUNT": Judith Young Mallin, "Remembering the Faces of Juliet," *Quest* (summer 1991), 50.

149 "MY ACTIVITIES IN NEW YORK": Man Ray, *Self Portrait*, 91–92.

150 "PUT TACKS ON THERE!": Baldwin, *Man Ray*, 90–92, 89; Man Ray, *Self Portrait*, 92; Soupault, *Mémoires*, I, 163.

150 AN ACTUAL RESURGENCE: See, for instance, the open letter to *L'Université de Paris* (collective tract), in José Pierre, ed., *Tracts surréalistes et déclarations collectives*, I (1922–1939) (Paris: Eric Losfeld/Le Terrain Vague, 1980; hereinafter "*Tracts*, I"), 7, and Pierre's commentary, ibid., 358; *DAP*, 296–98.

7. A Room above Heaven and Hell

151 "NOISE AND LIGHT": Simone to Denise, 5 Jan. 1922, *Lettres à Denise*, 92.

151 HEAVEN AND HELL: Gérard Rosenthal, *Avocat de Trotsky* (Paris: Laffont, 1975), 47; *OC 1*, 1365; Pierre Dhainaut, "André Breton présent," *Cahiers du Sud* 390–391 (Dec. 1966), 319; supplemented by personal visits to the studio in 1987 and 1988.

151 "HIS CRYSTAL, HIS UNIVERSE": MP interviews with Aube Elléouët, 6 March 1988, and Edouard and Simone Jaguer, 10 Nov. 1993.

151 "SORDID STAIRCASE": Rosenthal, *Avocat*, 47.

151 "SEVENTEEN-THIRTEEN": Aragon, *L'Œuvre poétique*, I (1917–1920) (Douai: Livre Club Diderot, 1974), 25n.

152 ONLY YARDS AWAY: Rosenthal, *Avocat*, 47; MP interview with André Thirion, 9 March 1988. Cf. Daix, *Aragon*, 130.

152 "WHEREVER IT WAS PUT": Thirion, 93; Josephson, *Life*, 141..

152 "ABILITY TO SHOCK": "Lettre à Robert Amadou" [1 Dec. 1953], in *Perspective cavalière*, 39. On Breton's acquisition of the painting, see Paule Thévenin, "Les énigmes du 'Cerveau de l'enfant,'" in AB cat., 101–2, 105.

152 "MENTALITY OF CHILDREN": "Manuscript from the Collection of Paul Eluard," part VIII, in Giorgio de Chirico, *Hebdomeros*, various trans. (Cambridge, Mass.: Exact Change, 1992), 182.

153 "OF OUR GENERATION": Unpublished proposal for the Doucet literary collection, *OC 1*, 631; *Aragon parle*, 41; Chapon, *Jacques Doucet*, 273.

153 "STEM THE CURRENT CONFUSION": "[Appel du 3 janvier 1922]," *OC 1*, 434–35.

153 "THAN A LOCOMOTIVE?": Untitled press release (ca. 10 Jan. 1922), ibid., 1282.

153 "LITERARY AND ARTISTIC CIRCLES": Hugnet, *Aventure dada*, 108.

153 "MORE SOLID BASE": "Une lettre de Chirico [to AB, Jan. 1922]," *Littérature* (new series) 1, 11–12; see also *OC 1*, 1280.

154 KNOWN AND UNKNOWN: Much of the information on the Congress of Paris comes from letters and press clippings preserved at the Bibliothèque Nationale in a file labeled "Congrès de Paris." See also: Soupault, *Mémoires*, I, 153; Tristan Tzara, *Œuvres complètes*, I (1912–1924) (Paris: Flammarion, 1975), 592; *DAP*, 331. The respondents included Vicente Huidobro, Ossip Zadkine, the ever-present Cocteau, Constantin Brancusi, Hans Arp, F. T. Marinetti, Paul Dermée, and André Malraux; as well as those more closely associated with Breton: Aragon, Eluard, Max Morise, Péret, Man Ray, Fraenkel, Rigaut, Jean Crotti, Matthew Josephson, and Pierre de Massot. Soupault, who found the projet too eclectic, remained uncommitted.

154 DEFECTION FROM DADA: AB to Picabia, 21 Jan. [1922], *DAP*, 513; Ribemont-Dessaignes, *Déjà jadis*, 147–48.

154 NOT STEM IT: *Comœdia* (8 Feb. 1922), quoted in Tzara, *Œuvres complètes*, I, 590; Tzara to AB, 27 Dec. 1921, Doucet; *DAP*, 328, 331–32; Picabia to AB, 23 Jan. 1922, ibid., 513.

154 "CASE OF WILLFUL DISTURBANCE": Quoted in Ribemont-Dessaignes, *Déjà jadis*, 148.

154 "TO ANY CURRENT REALITY": *Comœdia* (7 Feb. 1922), quoted in *DAP*, 329; Bonnet, 253.

154 "CRITICISM'S UNCHARTED TERRAINS": *Comœdia* (8 Feb. 1922), quoted in Tzara, *Œuvres complètes*, I, 590.

154 "NO RIGHT TO EXIST": *DAP*, 330n.

154 TO FALL APART: "Characteristics of the Modern Evolution and What It Consists Of," in *Lost Steps*, 111; *OC 1*, 1469; *DAP*, 333.

155 "UNFORTUNATE CIRCUMLOCUTION": *Conversations*, 55.

155 "THEY WERE DEALING WITH": AB to Picabia, 15 Feb. 1922, *DAP*, 515.

155 "SCREAMED IN HIS HIGH VOICE": Josephson, *Life*, 149–50. Breton's prepared account of the previous weeks' events, in look and tone remarkably like a police report, is in the Congress file at the BN, and is reproduced *in extenso* in *DAP*, 331–32.

155 "APPROBATORY WINKS": Picabia to AB, 17 Feb. 1922, *DAP*, 516.

155 "I HAD IMAGINED HIM": *Conversations*, 46.

155 OF THEIR DELIGHT: See especially Tzara's "late bulletin" in *Le Cœur à Barbe* (April 1922), [8]: "The members of the Congress on Modernism, following threats from some perfidious imposters, decided several days ago to abandon their excellent idea of sniffing like leashed dogs around the hypotheses of famous theoreticians." This and other Dada periodicals are reproduced in facsimile in *Dada Zurich Paris 1916–1922* (Paris: Jean-Michel Place, 1981).

155 "ENGAGEMENT IS OVER": *OC 1*, 502.

156 "KEY TO THE RIDDLE": "The New Spirt," in *Lost Steps*, 72–73. First published in *Littérature* (new series) 1 (March 1922).

156 "ASSUME FEMALE TRAITS": *Conversations*, 106.

157 "FIFTY YEARS FROM NOW!": "André Gide Speaks of Us of His Selected Works," in *Lost Steps*, 68–69. First published in *Littérature* (new series) 1.

157 "TO DESTROY ME": André Gide, "Journal" (Jan. 1925), trans. Justin O'Brien, in *The André Gide Reader*, ed. David Littlejohn (New York: Alfred A. Knopf, 1971), 616–17.

158 "DEVOTE HIS LIFE": "After Dada," in *Lost Steps*, 76. First published in *Comœdia* (2 March 1922).

158 "TAKE TO THE HIGHWAYS": "Leave Everything," in *Lost Steps*, 78–79. First published in *Littérature* (new series) 2 (April 1922).

158 REQUIRED CONSTANT CARE: AB to Picabia, 13 and 26 March 1922, *DAP*, 517–18.

159 "MANY FRIENDS AMONG THEM": Duhamel, *Raconte pas*, 176; MP interview with Edouard Roditi, 11 June 1987.

159 "BRETON'S GREAT ANNOYANCE": Baron, *L'An I*, 138.

160 "SLIGHTEST LITERARY AMBITION": AB to Doucet, 20 Dec. 1920, Doucet.

160 "OF THE SAME ILK": AB to Simone, 25 July 1922, Sator.

160 "SLITHERING, GLITTERING CREATURE": Jimmy Ernst, *A Not-So-Still Life* (New York: St. Martin's Press, 1984), 19; Gateau, *Paul Eluard*, 95, 99.

160 "MORE THAN HE DID GALA": Josephson, *Life*, 179. For an extensive and insightful account of the Eluard-Gala-Ernst relationship, see Robert McNab, *Ghost Ships: A Surrealist Love Triangle* (New Haven: Yale University Press, 2004).

160 "FULL COLLABORATION": AB to Picabia, [early May 1922], *DAP*, 520; Chapon, *Jacques Doucet*, 265. On NRF distributorship and the split with Hilsum: Gaston Gallimard to René Hilsum, 16 and 19 Oct. 1922, and "Granjux et Cie." to Gaston Gallimard, 18 Oct. 1922, *NRF* archives.

160 "THAT WHICH BECKONS US": "Clearly," in *Lost Steps*, 82. First published in *Littérature* (new series) 4 (Sept. 1922).

161 AS SOON AS POSSIBLE: Michel Carassou, *René Crevel* (Paris: Fayard, 1989), 40–41.

161 ANY WORTHWHILE SALON: *DAP*, 354; Bonnet, 262; Haslam, *Real World*, 99; *Conversations*, 64.

162 "GIVE YOU SOME IDEA": Simone to Denise, 5 Oct. 1922, *Lettres à Denise*, 107; Carassou, *René Crevel*, 41.

162 "(THEN, LEGIBLY): YES": "Entrée des médiums," *Littérature* (new series) 6 (Nov. 1922), 8–10 (passage not included in *Les Pas perdus*).

162 STRUCK THE MANTELPIECE: Carassou, *René Crevel*, 44–45.

162 "A LAUGHING CUPID": Josephson, *Life*, 217.

163 "HIM FEEL LESS ALONE": Marie-Rose Carré, "René Crevel: Surrealism and the Individual," *Yale French Studies* 31 (May 1964), 79.

163 "FOR HIS OWN EDIFICATION": David Gascoyne, "A propos du suicide de René Crevel," *Europe* 679–680 (Nov.–Dec. 1985), 95.

163 "LITTLE GROUP'S EXISTENCE": Desnos to Jean Carrive, 20 Feb. 1923, in Marie-Claire Dumas, *Robert Desnos ou l'exploration des limites* (Paris: Klincksieck, 1980), 63.

163 "SO SOFT AND FEMININE": Simone to Denise, 5 Oct. 1922, *Lettres à Denise*, 107.

163 WINNING THEIR ESTEEM: Dumas, *Robert Desnos*, 17–19, 31.

163 "FATHER IS SOAKING ME!": "Entrée des médiums," *Littérature*, 5; Everling, *Anneau*, 152.

164 "FLAT ON THE GROUND": Simone to Denise, 9 Oct. 1922, *Lettres à Denise*, 110.

164 SUMMON ANY DEAD SPIRITS: Everling, *Anneau*, 152; Béhar, *André Breton*, 139.

164 "WITH THE SAME ANXIETY": Simone to Denise, 9 Oct. 1922, *Lettres à Denise*, 108. Breton also had Man Ray photograph several of the sessions, asking him in particular to capture Desnos "at the moment when, asleep, he raises

his astoundingly clouded eyes toward those present" (AB to Man Ray, 2 Oct. 1922, AB cat., 110).

164 INTEREST HIM IN THE SEANCES: AB to Tzara, 16 Oct. 1922, *DAP*, 464.

164 "TO THE DREAM STATE": "The Mediums Enter," in *Lost Steps*, 90.

164 "ATTITUDE WAS DISGRACEFUL": "Entrée des médiums," *Littérature*, 1.

164 ARDENT PROPONENTS: Daix, *Aragon*, 140–42.

164 "NOT SERIOUS EITHER": Baron, *L'An I*, 69, 70–71, 75. On others' attitudes: MP interviews with Bernard Minoret, 9 March 1988, and James Lord, 2 March 1988; Georges Charbonnier, *Entretiens avec André Masson* (Marseille: Editions Ryôan-ji, 1985), 51.

165 "ALL OUR GOODWILL": "Mediums Enter," 95.

165 "ON SUPERVISED THOUGHT": *Conversations*, 62.

165 "WORDS MAKE LOVE": Quoted by Breton in "Words without Wrinkles," in *Lost Steps*, 102. First published in *Littérature* (new series) 7 (Dec. 1922).

165 "GRATITUDE AND FEAR": "Mediums Enter," 92.

165 "NEW DAY IS DAWNING": Unpublished report for Jacques Doucet, *OC 1*, 1303.

165 TRANCES WERE GENUINE: Pierre Brasseur, *Ma Vie en vrac* (Paris: Calmann-Lévy, 1972), 163; Dumas, *Robert Desnos*, 48–49.

165 DESNOS HAD NEVER MET: *Nadja*, 35; AB to Picabia, 16 Oct. 1922, *DAP*, 523–24.

165 "SHE'D BE THRILLED": Duchamp to AB, [ca. 25 Nov. 1922], *OC 1*, 1315.

165 "MAD. TUBERCULAR": Simone to Denise, 9 Oct. 1922, *Lettres à Denise*, 110.

166 "ONE THING: CREVEL'S CURSE": Ibid., 111.

166 PRESENT TO COMMIT SUICIDE: Baron, *L'An I*, 66.

166 "WITH SCANT CEREMONY": *Conversations*, 70.

166 PURSUIT OF MARVELS: Review of *Les Pas perdus* (March 1924), reprinted in René Crevel, *Mon Corps et moi* (Paris: Jean-Jacques Pauvert, 1974), 192.

166 UNFAVORABLE TO PICABIA: *DAP*, 371.

167 "LEAPED TO THE GROUND": Francis Picabia, "Souvenirs de voyages: L'Exposition coloniale de Marseille," *Littérature* (new series) 8 (1 Jan. 1923), 3.

167 "WE ARE THE CORPSES": Ibid., 3–4.

167 "DEPRESSED HIM TERRIBLY": Everling, *Anneau*, 161; *OC 1*, 1306.

167 "KNOW THIS MARVEL?": AB to Picasso, 2 Nov. 1922, AB cat., 110.

167 "SOMETHING OF A JOKE": John Richardson, *A Life of Picasso: The Early Years, 1881–1906* (New York: Random House, 1991), 62.

167 IN HER HOTEL ROOM: *OC 1*, 1202–3.

167 REFUSED TO BELIEVE: Henri Béhar and Michel

Carassou, *Dada: Histoire d'une subversion* (Paris: Fayard, 1990), 192.

167 "FOR THINGS OF THE MIND": "Characteristics of the Modern Evolution," 122.

167 "THAT IT'S NO USE": Eluard to AB, 14 Nov. 1922, *DAP*, 376n.

168 GOT OFF THE GROUND: AB to Picabia, [ca. 15 Dec. 1922], *DAP*, 528–29; Jacques-Emile Blanche to AB, 5 Dec. 1922, ibid., 539.

168 "THEY ARE IN REALITY": André Masson to Roland Tual, 21 Nov. [1922], in André Masson, *Les Années surréalistes: Correspondance, 1916–1942* (Paris: La Manufacture, 1990), 28. The painting's French title (*Au Rendez-vous des amis*) was a play on a typical café name.

168 "PLAINLY PSYCHOTIC": Josephson, *Life*, 221.

168 BRANDISHING A KNIFE: Ibid., 222; *Conversations*, 70; Bonnet, 270n.

169 "WOULD NEVER HAPPEN AGAIN": *Conversations*, 70–71; *OC 1*, xlvi; Bonnet, 267.

169 "MY REASONS FOR LIVING": Desnos to AB, 7 April 1923, Bonnet, 310–11.

169 THIRD KAHNWEILER AUCTION: AB to Eluard, 7 May 1923, *OC 1*, xlvi; AB cat., 113.

169 "ALL THE HELL OUT": AB to Simone, 12 and 14 March 1923, AB cat., 55.

169 "JOURNALISTIC ACTIVITIES": Bonnet, 272, 319; *OC 1*, xlvi; AB to Picabia, 13 March 1923, *DAP*, 527.

170 "FROM A MORAL VIEWPOINT": AB to *Nouvelles littéraires*, 25 Aug. 1923, *OC 1*, 1217.

170 CONTRACT ON MARCH 28: Contract conserved in *NRF* archives. On original use of title: *OC 1*, 1216–17.

170 "ANY MEANS OF EXPRESSION": Roger Vitrac, "André Breton n'écrira plus," *Le Journal du peuple* (7 April 1923), quoted in *OC 1*, 1214–15.

170 JOSEPHSON'S HOUSE IN GIVERNY: *OC 1*, xlvi; *DAP*, 380n.

171 "HAS EVER PROVEN ANYTHING": "For Dada," in *Lost Steps*, 51.

171 "WHAT I WAS SAYING": Aragon, *Je n'ai jamais appris à écrire ou les incipit* (Geneva: Albert Skira ["Les Sentiers de la Création"], 1969), 38–39.

171 SOLE BASIS OF GENRE: Bonnet, 271.

171 "MORAL CONCLUSION IS MISSING": Ducasse, *Poésies*, 225.

171 "A GOOD LIKENESS": Aragon, *Anicet ou le Panorama, roman* (1921; Paris: Gallimard ["Folio"], 1972), 134.

171 "SOME CHEAP IDEALISM": AB to Simone, 3 Sept. 1920, Sator.

171 "BECAUSE IT PRODUCED POETS": Georges Ribemont-Dessaignes, *Céleste Ugolin* (Paris: Sagittaire, 1926), 94.

172 DAYS IN THE COUNTRY: Edouard Ruiz, introduction to Aragon, *La Défense de l'infini* (Paris: Gallimard, 1986), 17.

172 "WRITING SUCH THINGS?": Aragon, *Je n'ai jamais*, 56–57.

172 "WOLVES DEVOUR EACH OTHER": *DAP*, 382. The evening's title was taken from an anti-Breton pamphlet published by Tzara earlier that year.

172 MONEY, RENOWN, AND SUCCESS: Tzara, *Œuvres complètes*, I, 622–24.

172 "CHARMING, PINT-SIZED": Josephson, *Life*, 152.

173 OWNER WRUNG HIS HANDS: *DAP*, 380–85; Carassou, *René Crevel*, 48–49; Baron, *L'An I*, 146–47; Richter, *Dada*, 190. Hugnet (*Aventure dada*, 119) gives a slightly different version of events, in particular citing Breton as the one who slapped Crevel; but letters from the time bear out the present text.

173 "GENERAL AND DEFINITIVE IMPORT": Simone to Denise, 29 July 1923, *Lettres à Denise*, 141.

173 "THE POLICE INFORMANT": *DAP*, 385n.

173 "25 POLICEMAN'S LUCUBRATIONS": *Nadja*, 18–19. "Lucubrations" is actually a mistranslation for "rantings."

173 "SERVICE OF MONSIEUR TZARA": Maître Boulard (Eluard's attorney) to Roger Lefébure (Tzara's attorney), 27 July 1923, *DAP*, 385–86.

174 "WHICH IS RARE": AB to Doucet, 22 Aug. 1923, *OC I*, 1181–82, 1184–85.

174 BORNE BY HIMSELF: *OC I*, 1181n. Gallimard agreed to distribute the book but, despite Breton's hints, did not offer to underwrite its production: AB to Gallimard, 4 Sept. 1923, and Gallimard to AB, 21 Sept. 1923, *NRF* archives.

174 ENTIRE AFTERNOON DRAWING IT: AB cat., 115.

174 A PORTRAIT BY PICASSO: *OC I*, 1182; Béhar, *André Breton*, 149.

174 HIS OWN ACCOUNT: AB to Picabia, [ca. Dec. 1922], *DAP*, 528; Pierre Cabanne, *Pablo Picasso: His Life and Times*, trans. Harold J. Salemson (New York: William Morrow, 1977), 240. Breton's probable first letter to Picasso was written for Doucet in late 1921: see AB cat., 108.

174 "EYE SOMEWHAT FEARSOME": AB to Simone, 6 Nov. 1923, Sator.

175 "WORDS TO EXPRESS IT": AB to Picasso, 9 Oct. 1923, AB cat., 210.

175 "FORGIVE IT NO ABDICATION": "The Disdainful Confession," in *Lost Steps*, 6.

175 "ROOM FOR DISCOVERY": "Always," in *Selected Writings of Guillaume Apollinaire*, ed. and trans. Roger Shattuck (New York: New Directions, 1971), 177.

176 TO SPECIAL ISSUES: AB to Gallimard, 4 Sept. 1923, and internal memo, 19 Sept. 1923, *NRF* archives.

176 "ANY SORT OF CHOICE": AB to Simone, 11 Nov. 1923, Sator.

176 BUY FOR RUE FONTAINE: AB to Simone, 7 Nov. 1923, Sator.

176 FOUND THE MAGAZINE DISTASTEFUL: Chapon, *Jacques Doucet*, 268.

177 INIMICAL TO DOUCET'S WORLD: Ibid., 263–64; François Chapon, "Une série de malentendus acceptables . . . ," in AB cat., 116–17.

177 "INSTEAD OF 500!": Jean-François Revel, "Jacques Doucet, couturier et collectionneur," *L'Œil* 84 (Dec. 1961), 81.

177 "MUCH LESS METHODICAL": Revel, "Doucet," 81.

177 "PATRON OF THE ARTS": *Conversations*, 77.

177 "WASN'T ENTIRELY FALSE": Revel, "Doucet," 81.

178 "WHAT A WONDERFUL THING!": Doucet to André Suarès, [19 March 1922], Chapon, *Jacques Doucet*, 264.

178 "FEW WRITERS HAVE EVOKED": *Nouvelles littéraires* (12 April 1924), 3.

178 "RATHER LABORIOUS FANTASY": *Mercure de France* (15 July 1924), 462.

178 "FOR ABOUT TWENTY YEARS": AB to *Mercure de France*, 15 July 1924 (published 1 Sept. 1924), Bonnet, 294n.

178 "SINCE RIMBAUD AND LAUTRÉAMONT": *Disque vert* (Jan. 1925), 76, 81.

178 WANTED TO SEE MORE: *Nouvelles littéraires* (12 April 1924), 3. Unfortunately, all the reviews did not guarantee a readership: the book sold only 800 copies in its first year, and a mere 500 more by the end of the decade (internal memos, 22 April 1924 and 6 Feb. 1931, *NRF* archives).

178 "EXCESSIVE SUBJECTIVISM": Cf. reviews quoted in *OC I*, 1220.

178 "PROPHET WITHOUT FAITH": *NRF* (1 May 1924), 621–22.

179 "IN THREE MONTHS' TIME": AB to Simone, 18 March 1924, Sator.

179 "FANATICS OF THE FIRST ORDER": "Robert Desnos," in *OC I*, 473. First published in *Le Journal littéraire* (5 July 1924).

179 "FORCE FROM TIME TO TIME": AB to Simone, 22 March 1924, Sator; *Manifesto*, 41.

179 "GO TO BED ALONE": Simone to Denise, 27 March 1924, *Lettres à Denise*, 169.

179 "BOOK TO ANDRÉ BRETON": Paul Eluard, *Œuvres complètes*, I (Paris: Gallimard ["Bibliothèque de la Pléiade"], 1968), 136; Robert D. Valette, "Le Fil de la tendresse humaine," *Europe* 403–404 (Nov.–Dec. 1962), 15–16.

180 "THAN IS GOOD FOR HIM": Simone to Denise, 27 March 1924, *Lettres à Denise*, 169.

180 "TEARS IN HIS EYES": Marcel Noll to unknown correspondent [Denise?], [ca. 30 March 1924], Naville, 72.

180 "THE SILENCE AROUND HIM?": "Soluble Fish," in *Manifestoes*, 88 (trans. slightly revised).

180 "FURTHEST POINT OF MYSELF": AB to Doucet, 9 April 1924, *OC 1*, 1389; Maurice Nadeau, *The History of Surrealism*, trans. Richard Howard (New York: Macmillan, 1965), 98.

180 COMMENT ABOUT ELUARD: Chapon, "Série de malentendus," 120.

180 "THEY'RE LEAVING": Unpublished collage text, early 1924, *OC 1*, 578.

180 WHATEVER MIGHT OCCUR: *Conversations*, 59–60.

181 "DISTURBING PHANTOMS": Ibid., 60

181 "WATCHED IT COME CLOSER": Duhamel, *Raconte pas*, 170.

181 "WAKING LIFE AND DREAM LIFE": *Conversations*, 60; Béhar, *André Breton*, 155.

181 "ROADS THAT LEAD TO EVERYTHING": *Manifesto*, 29 (trans. slightly revised).

8. The "Pope" of Surrealism

182 "TO BE 'IN HIS ELEMENT'": Dušan Matić, "Un chef d'orchestre," *NRF* 172, 680; Duhamel, *Raconte pas*, 203.

182 "HONORS OF OUR TIME": Desnos, *Nouvelles Hébrides*, 297.

182 "LIKE A WOMAN": Nadeau, *History*, 86.

182 "WIVES, MISTRESSES, FRIENDS": Ibid.

183 MOST IMPORTANT IN THE WORLD: Remarks by Jean-Michel Goutier, in *Nuits magnétiques* by Alain Veinstein, dir. by Bernard Treton, radio broadcast on France-Culture, 9 May 1991; MP interviews with Monique Fong, 12 Jan. 1988, and Jean-Louis Bédouin, 29 April 1991.

183 "NO, DEAR FRIEND": Ernst, *Ecritures*, 415.

183 "WORTHY VISITOR COMES ALONG": Desnos, *Nouvelles Hébrides*, 297.

183 "AFFECTIVE FRIENDSHIP": José Pierre, ed., *Tracts surréalistes et déclarations collectives*, II (1940–1969) (Paris: Eric Losfeld/Le Terrain Vague, 1982; hereinafter "*Tracts*, II"), 324.

183 "MADLY DRAMATIZED": Patrick Waldberg, *Max Ernst* (Paris: Jean-Jacques Pauvert, 1958), 195.

184 HEAD OF THE POST-DADAISTS: Maria Luisa Borràs, "Breton et Picabia: une amitié difficile," in AB cat., 112; Marie-Claire Bancquart, "1924–1929: Une année mentale," in *La Révolution surréaliste* (facsimile edition) (Paris: Jean-Michel Place, 1975), v. The name "Claude Lariençay" came from "Lorient," a fact that Picabia had underscored when he misspelled it "Loriençay" in a letter to Breton of Feb. 1924.

184 "MASK STILL MORE IMPASSIVE": Joseph Delteil, *La Deltheillerie* (Paris: Grasset, 1968), 117–19.

184 THE SURREALIST REVOLUTION: *OC 1*, xlix. Aragon had also used the term "Surrealist" in an article from 1921: cf. Bonnet, 323.

184 ACQUIRING THE PROJECT: Soupault, *Mémoires*, II, 103.

184 "TO LAUGH, TO LASH OUT": Unpublished diary entry, ca. 1 May 1924, *OC 1*, 467.

184 "SOLUBLE IN HIS THOUGHT!": *Manifesto*, 40.

184 AUTOMATIC "SHORT ANECDOTES": *Manifesto*, 40.

185 "'LETTER TO DAWN' ('MADAM, . . .' ETC.)": AB to Simone, 17 June 1924, Sator.

185 "AS IF POSSESSED": Balakian, *André Breton*, 64n.

185 IN LATE AUGUST: *OC 1*, 1332–33; Bonnet, 322.

185 "VARIETY OF PARTICIPANTS": *Conversations*, 61.

186 "NOT FAR FROM PARIS": *Manifesto*, 16.

186 "TO THE SURREALIST TRUTH": Ibid., 29.

186 "NOT YET COME HOME": Ibid., 17.

186 "TOO NUMEROUS TO MENTION": Ibid., 16–17.

186 "SURREALIST IN ME": Ibid., 27.

186 "COULD PASS FOR SURREALIST": Ibid., 26.

186 "EVOLUTION IS POSSIBLE": AB to Doucet, 23 Aug. 1922, Chapon, *Jacques Doucet*, 272–73.

186 "ALWAYS EXISTED": "Dada soulève tout," in Sanouillet and Poupard-Lieussou, eds., *Documents Dada*, 52.

186 THE SAME SPIRIT: *Manifesto*, 27n.

186 "LUSTERLESS FATE": Ibid., 3–4

187 "OLD AGE, AND COWARDICE": "Introduction to the Discourse on the Paucity of Reality," in AB, *Break of Day*, trans Mark Polizzotti and Mary Ann Caws (Lincoln: University of Nebraska Press, 1999), 18.

187 "STILL IN VOGUE": *Manifesto*, 9.

187 "SURREALIST USE OF IT": Ibid., 32.

187 "DO NOT INTEREST ME": Ibid., 44.

187 "TO FRIGHTFUL REVOLTS": Ibid., 36.

187 "THE MARVELOUS IS BEAUTIFUL": Ibid., 14.

187 "PRINCIPAL PROBLEMS OF LIFE": Ibid., 26. The concern was not new with Breton: cf. his remark from May 1922, quoted above, regarding poetry as a "specific solution to the problem of our lives" (*Lost Steps*, 83).

188 "MAN AND THE WORLD": Nadeau, *History*, 80. The remark about Columbus comes from *Manifesto*, 6.

188 "REASON DOES NOT EXTEND": Press release on the Bureau of Surrealist Research, Nov. 1924, *OC 1*, 482.

188 "COULD EASILY HAVE DISAPPEARED": MP interview with Marcel Jean, 1 March 1988.

188 COMMERCE IN LATE JUNE: *Aragon parle*, 45; Soupault, *Mémoires*, II, 97.

188 "AND PUNY LIFE": Aragon, "Une vague de rêves," in *L'Œuvre poétique*, II, 236.

188 "REPUBLIC OF DREAMS": Ibid., 243.

188 "PLEASE SHOW INFINITY IN": Ibid., 251.

188 "TO THE CRITICAL SPIRIT": *Paris-Soir* (22 May 1924 for Dermée; 27 May 1924 for *Littérature*), cited in Bonnet, 328–29.

189 "OVERNIGHT SUCCESS": Yvan Goll, "Une réhabilitation du Surréalisme," *Journal littéraire* (16 Aug. 1924), 8; Adam Biro, René Passeron, et al., *Dictionnaire général du surréalisme et de ses environs* (Paris: Presses Universitaires de France, 1982), 186–87; Claire Goll, "Goll et Breton," *Europe* 475–476, 109; Henri Béhar, *Le Théâtre dada et surréaliste* (Paris: Gallimard ["Idées"], 1979), 97.

189 SOUGHT TO IMPOSE: Open letter from Breton, et al., *Journal littéraire* (23 Aug. 1924), 8.

189 "GROTESQUE BIT PARTS": Ibid.

189 "BREATH OF FRESH AIR": Dermée, open letter, *Journal littéraire* (30 Aug. 1924), 4.

189 "POPE OF SURREALISM": Goll, open letter, ibid.

189 "END OF THE CONTROVERSY": "Autour du surréalisme," *Journal littéraire* (30 Aug. 1924), 4.

189 MANIFESTATIONS AS COMPLEMENTARY: Cf., among others, *Les Carnets de la Semaine* (12 Oct. 1924) and *L'Action Française* (9 Oct. 1924), both preserved at the HRC. The ever-attentive *Comœdia* (9 Oct. 1924) was one of the few newspapers to specify that "we are faced here with two distinct formulas." Breton's excerpt, published as "La Querelle du surréalisme," *Journal littéraire* (6 Sept. 1924), 10, preproduces the passage from *Manifesto*, 21–26.

189 HIS DEFINITION OF SURREALISM: "Une lettre de Guillaume Apollinaire," in *Surréalisme* 1 (Oct. 1924), [7]. Cf. Claire Goll, "Goll et Breton," 110.

189 "TOWARD CONSTRUCTION, TOWARD WILL": [Yvan Goll], "Manifeste du surréalisme," *Surréalisme* 1, [2–3].

189 "PUT OUT OF CIRCULATION": Ibid., [3].

190 "THOUGHT SET FREE": Georges Hugnet, *Pleins et déliés: Souvenirs et témoignages, 1926–1972* (La Chapelle-sur-Loire: Guy Authier, 1972), 238.

190 "PASS IN THE STREET": *Manifesto*, 29–32. Instead of dots, Breton had originally composed a short set of instructions for "catching a woman's eye": "Walk past her in front of a luthier's shop and make sure that she catches up with you under the lamp of a post office. After taking eleven steps beside her and to her left, offer her a red-tobacco cigarette from a holster" (*OC 1*, 1359).

190 "AUTHORITY OF AN OSCAR WILDE": Maurice Martin du Gard, *Feux tournants* (Paris: Camille Bloch, 1925), 119. First published in *Nouvelles littéraires* (11 Oct. 1924).

190 "EXTENDED ADOLESCENT CRISIS": *NRF* (1 Jan. 1925), 30–34.

190 "WRITERS HAVE NO USE FOR IT": *Paris-Midi* (22 Jan. 1925).

190 "THE ODOR OF SHIT": Henri Béhar and Michel Carassou, *Dada: Histoire d'une subversion* (Paris: Fayard, 1990), 192.

190 "BY ANDRÉ BRETON": *OC 1*, 1342.

190 "FIND ESPECIALLY ENCOURAGING": AB to Simone, 11 Nov. 1924, Sator.

191 "FROM HIS ENTIRE PERSON": Victor Crastre, *Le Drame du surréalisme* (Paris: Editions du Temps, 1963), 44.

191 "IS GOING BEYOND SURREALISM": Rosenthal, *Avocat*, 48.

191 AS SURREALISM'S "PROPHET": "Robert Desnos," in *OC 1*, 474.

191 "OLD JACOBIN LEADERS": Josephson, *Life*, 117.

191 "WEIGHTY AND LIGHT": Duhamel, *Raconte pas*, 203.

191 "OF LOUIS XIV": Thirion, 172.

191 "SHORT HAIR WAS IN FASHION": Ibid.

191 "OF A MAGIC POTION": Pierre Naville, *Le Temps du surréel* (Paris: Editions Galilée, 1977; hereinafter "Naville"), 207.

192 "HIM UP BIT BY BIT": Josephson, *Life*, 117.

192 "OF THE ENTIRE GROUP": Georges Neveux, "Un poète révolutionnaire," *Figaro littéraire* (6 Oct. 1966), 1.

192 "PHRASES WAS DAZZLING": Judith Young Mallin, unpublished interview with Lionel Abel, 20 Sept. 1988 (courtesy of Judith Young Mallin).

192 THE "POPE OF DADA": Martin du Gard, *Les Mémorables*, I (1918–1923) (Paris: Flammarion, 1957), 119.

192 IN HIS WRITINGS: Guy Le Clec'h, "L'Inimitable aventure du surréalisme," *Le Figaro littéraire* (6 Oct. 1966), 10; MP interview with Jean-Louis Bédouin, 29 April 1991. One ex-Surrealist, during an otherwise cordial interview, even threatened me with bodily harm if I used the term "pope" in the present book.

193 OF FRENCH PUBLISHING: MP interview with Marcel Jean, 1 March 1988; Jean Cau, *Croquis de mémoire* (Paris: Julliard, 1985), 37.

193 "CENTER OF GRAVITY": Naville, 73; Biro, et al., *Dictionnaire général*, 298; Pierre Naville to MP, 17 Dec. 1991.

193 KAHNWEILER'S GRATITUDE: Kahnweiler to AB, 20 March 1924, AB cat., 170.

193 "BRETON IS THE FUTURE": André Masson, "Breton, croquemitaine des peintres surréalistes," *Le Figaro littéraire* (23 Nov. 1970), 11.

194 "IN MY EVERYDAY SOUL": Artaud to Jacques Rivière, 25 May 1924, in Antonin Artaud, *Selected Writings*, ed. Susan Sontag, trans. Helen Weaver (New York: Farrar, Straus & Giroux, 1976), 44.

194 "ESSENCE OF INSPIRATION": Ibid.

194 "SURREALIST FOR THAT": Artaud to Madame Toulouse, [early Sept. 1924], in Antonin Artaud, *Œuvres complètes*, supplement to vol. I (Paris: Gallimard, 1970), 26–27.

194 "ONE LAST TRY": Antonin Artaud, "Point final [1927]," *Magazine littéraire* 61 (Feb. 1972), 27.

194 A PARANOID SCHIZOPHRENIC: Thomas Maeder, *Antonin Artaud*, trans. Janine Delpech (Paris: Plon, 1978), 23–35, 49, 217.

195 "PLOT IN THE NEIGHBORHOOD": Ibid., 51. The original English text, as yet unpublished, was graciously provided by the author.

195 "AS A CATASTROPHE": Simone to Denise, 3 Oct. 1924, *Lettres à Denise*, 204.

195 "THE DEFIANCE OF YOUTH": *Conversations*, 84.

195 "CAUSE AS [ARTAUD] HAD": Ibid.

195 "FOR PRACTICALLY NOTHING": Ibid., 76

195 MEET IN A CAFÉ: Gateau, *Paul Eluard*, 117–27.

195 HIS "IDIOTIC VOYAGE": Robert D. Valette, "Le Fil de la tendresse humaine," *Europe* 403–404 (Nov.–Dec. 1962), 9.

196 "AS IF HE NEVER LEFT": Simone to Denise, 3 Oct. 1924, *Lettres à Denise*, 203.

196 "JUST TOOK A VACATION": AB to Marcel Noll, [ca. 5 Oct. 1924], Naville, 74.

196 "POINTS IN COMMON": Albert Thibaudet, "Réflexions sur la littérature: du surréalisme," *NRF* (1 March 1925), 339; Victor Crastre, *André Breton* (Paris: Arcanes, 1952), 83; *Libération* (19 May 1988), ii. The Bureau logbook mistakenly says they opened on Friday the 11th.

196 "LIABLE TO TAKE": Press release on the Bureau of Surrealist Research, Nov. 1924, *OC 1*, 481.

197 FROM THE SURREALISTS: Paule Thévenin and Jean-Paul Morel, "La Centrale surréaliste au jour le jour," *Magazine littéraire* 254, 35; *Cahier*, 17.

197 "AND SELF-SATISFACTION": *Conversations*, 74.

198 "MAKE ANY MORE DUST": "Refusal to Inter" (from *A Corpse*), trans. Richard Howard, in Nadeau, *History*, 235. An alternate translation, titled "Burial Denied," appears in *Break of Day*.

198 "LENT HIM ITS NAME?": Aragon, "Have You Ever Slapped a Dead Man?," ibid., 236–37 (trans. slightly revised).

198 A "FOUL ASSASSINATION": *Tracts*, I, 378; Bonnet, 340n.

198 "BUT OF JACKALS": *Conversations*, 74–75.

198 "THOUGHTLESSNESS": Jean Bernier, "Un cadavre," *Clarté* (15 Nov. 1924), 500.

198 "CHARACTERIZED AS REVOLUTIONARY": Quoted in Nadeau, *History*, 101. First printed in *Clarté* (1 Dec. 1924).

199 "WITH US WERE TERMINATED": Ibid., 78

199 "AMIABLE ONCE MORE": AB to Simone, 11 Nov. 1924, Sator.

199 "GOODS OF THIS WORLD": AB to Doucet, 28 Dec. 1924, *OC 1*, xvi; Béhar, *André Breton*, 171.

199 "ACCEPTABLE MISUNDERSTANDINGS": AB to Doucet, 1 Feb. 1921, Chapon, *Jacques Doucet*,

266 (see also 305–6); Chapon, "Une série . . . ," 120; MP conversation with François Chapon, 8 Nov. 1993. It was also the case that, having recently sold his business, Doucet no longer disposed of the same extravagant income as before, and was able to pay Breton's successor at the library only one-third the former's salary.

199 "INTO PURE VERBIAGE": *Conversations*, 77.

199 "SHOULD RECEIVE THIS WORK!": AB to Doucet, 2 Dec. 1924, Chapon, *Jacques Doucet*, 298. Still not content, Doucet obliged Breton to add yet another document to the files ten days afterward. Laying it on even thicker, the lame duck adviser wrote: "This is the painting that we would carry through the streets of our capital, as they once carried Cimabue's Virgin, if skepticism did not outshine the great specific virtues by which our age manages to exist, despite everything . . . For me, it is a sacred imge": AB to Doucet, 12 Dec. 1924, AB cat., 174.

200 "UMBRELLA (IT ISN'T RAINING)": *Cahier*, 29 et pass.

200 "BEARING WEIGHTY SECRETS": Aragon, "Vague de rêves," 248.

200 "CHATTY AND UNBEARABLE": *Cahier*, 59.

200 "LEFT TO WORK IN PEACE": Ibid., 26.

200 "CLOSET FOR TEN MINUTES": Ibid., 69.

200 "ANOTHER SORT OF EXERCISE": Ibid., 36.

200 "OF A BUREAU OF RESEARCH": Ibid., 38.

201 "THAN I'D BEEN TOLD": AB to Simone, 11 Nov. 1924, AB cat., 173.

201 A PLACE PIGALLE CAFÉ: Ibid.; *Surrealism and Painting*, 17.

201 "HEIGHTS OF COMEDY": Chirico, *Memoirs*, 119.

201 HE SHOULD KEEP WRITING: AB to Simone, 11 Nov. 1924, AB cat., 173.

201 "REMARKS BY ISIDORE DUCASSE": Chirico, *Memoirs*, 119–20.

201 ABRUPTLY RETURNED TO ROME: Naville, 105; Chapon, *Jacques Doucet*, 302.

201 "RESISTANT TO COMPROMISE": *Conversations*, 83.

201 "A LITTLE TOO CALM": Naville to Denise, 16 Dec. 1924, Naville, 105–6.

201 "COCTEAU-STYLE SUCCESS": Paulhan to Franz Hellens, [Jan. 1925], Jean Paulhan, *Choix de lettres*, I (1917–1936) (Paris: Gallimard, 1986), 88.

202 "SURREALISM EXISTS": Bancquart, "Une année mentale," ii.

202 "MAGAZINE IN THE WORLD": Advertising insert for *La Révolution surréaliste*, Houghton Library collection, Harvard University (hereinafter "Houghton").

202 "PRUNING OF LIFE": *RS* 1 (1 Dec. 1924), 1–2.

202 "IS SUICIDE A SOLUTION?": Ibid., 2 .

202 "A SOLUTION? YES": All quotes: *RS* 2 (15 Jan. 1925), 8–15. See also: Haslam, *Real World*, 127.

202 AT AROUND THAT TIME: "Révolution, surréalisme, spontanéité," in René Crevel, *Révolution, surréalisme, spontanéité* (Paris: Plasma, 1978), 19n. Article written in Nov. 1924.

203 "WERE HIGHLY INOFFENSIVE": *Conversations*, 85. The stationery, showing an anvil and the carcass of an edible crab over a splash of bright red blood, was drawn by Georges Malkine after an image in *Maldoror*.

203 STANDARD MEETING PLACE: Crastre, *André Breton*, 89; Bancquart, "Une année mentale," iv.

203 "FILLED WITH MYSTERIES": Nadeau, *History*, 98.

203 "THE UNCONSCIOUS OF MEN": Ibid.

203 "IDLENESS AND BOREDOM": Simone [Breton] Collinet, "The Exquisite Corpses," in *Le Cadavre exquis, son exaltation*, exh. cat. (Milan: Galleria Schwarz, 1975), 30.

203 "NOTHING SHORT OF MOROSE": Crastre, *André Breton*, 141.

203 WON VALUABLE PAINTINGS: Crastre, *Drame du surréalisme*, 69–70.

203 EXPERIMENT INTO A FARCE: Naville, 123–24.

204 DEEMED "VERY POOR": AB to Simone, 10 Feb. 1925, AB cat., 176.

204 "HIS PRESENT HEAVY HAND": *Surrealism and Painting*, 17. First published in *RS* 7 (15 June 1926).

204 "STYLED THEMSELVES SURREALISTS": Chirico, *Memoirs*, 117.

204 "AND CONSTIPATED IMPOTENT": Ibid. (trans. slightly revised).

204 OTHERS' REFUSAL OF IT: Naville, 108.

204 "TREATED LIKE MACHINES": *Cahier*, 75.

204 "AFTERNOON FOR 'SUBJECTS'": Paulhan to Henri Pourrat, [ca. 10 Jan. 1925], Paulhan, *Choix de lettres*, I, 90.

204 "WORKINGS OF THE CENTRAL": *Cahier*, 81. See also: Naville to Denise, [ca. 25 Jan. 1925], Naville, 278; *Cahier*, 114.

204 "RESTORE EFFICIENCY": *Cahier*, 81.

204 "TO THE FOREFRONT": AB to Simone, 22 Jan. 1925, Sator.

205 "STYLE OF THE TIMES": MP interview with Myrtille Hugnet, 2 March 1988.

205 MARKED BY DREAMLIKE EROTICISM: On Lise: MP interviews with James Lord, 2 March 1988, Bernard Minoret, 9 March 1988, and Myrtille Hugnet; Paul Eluard, *Letters to Gala*, trans. Jesse Browner (New York: Paragon House, 1989; hereinafter "*LTG*"), 326; Biro, et al., *Dictionnaire général*, 122.

205 "A NARROW FACE": MP interview with Bernard Minoret.

205 "REGARDED AS BALEFUL": Thirion, 250.

205 "VOICE OF A HELIOTROPE": MP interview with Bernard Minoret.

205 "TALKS AND WINS HEARTS": Ned Rorem, *The Paris and New York Diaries of Ned Rorem* (San Francisco: North Point Press, 1983), 95.

205 "LEAVING THAT HAND FOREVER": *Nadja*, 56.

205 LONG AFTER HIS DEATH: Ibid., 55–56, 59; *OC 1*, 1540.

205 "MY LOSS OF PARADISE": "Tu es grave . . . ," in *OC 1*, 609–10. The poem remained unpublished during Breton's lifetime.

206 "INSIGNIFICANT HAPPENSTANCE": AB to Lise Meyer, 26 Feb. 1925, *OC 2*, 1442n.

206 AGAINST THE "ABSURD WORLD": AB to Simone, 6 Feb. 1925, Sator.

206 PLAY WITH THE BRONZE GLOVE: *Nadja*, 56.

206 IN AN AUTO ACCIDENT: MP interview with Bernard Minoret, 9 March 1988.

207 "LIKE A SCHOOLBOY": Alexandre, *Mémoires*, 178, 99; *OC 1*, xliv; Béhar, *André Breton*, 175.

207 "DAYS ORIGINALLY SET": *Cahier*, 83.

207 "REHABILITATING LIFE": Antonin Artaud, "L'Activité du Bureau de Recherches Surréalistes," *RS* 3 (15 April 1925), 31.

207 "GLEAMING LIKE A WEAPON": *Conversations*, 85.

207 "OBJECTIFICATION OF IDEAS": AB to Simone, 22 Jan. 1925, Sator.

207 "BY MATERIAL HAMMERS!": "Declaration of 27 January 1925," in Nadeau, *History*, 241.

207 "MEDITERRANEAN INFLUENCES": Response to a survey in *Cahiers du mois* 9–10 (Feb.–March 1925), in *OC 1*, 898.

207 AS AN "IMAGE": "La Révolution d'abord et toujours!" in *Tracts*, I, 55n. On Surrealism and the Far East, cf. Marguerite Bonnet, "L'Orient dans le surréalisme: Mythe et réel," *Revue de littérature comparée* liv:4 (Oct.–Dec. 1980), 411–24.

208 "TAKING CARE OF EVERYTHING": Naville to Denise, [late Jan. 1925], Naville, 278.

208 "WRAITHLIKE PRESENCE": *Cahier*, 97; *Libération* (19 May 1988), iii.

208 "IN THE SURREALIST REVOLUTION": *Cahier*, 97.

208 "THE WORST FORGERIES": AB to Artaud, 27 March 1925, *Cahier*, 125–27.

208 "POLITICAL OR OTHER NECESSITIES": Ibid., 127.

209 "BE ABLE TO OFFSET": *Conversations*, 85–86.

209 "LITTLE ACTS OF SABOTAGE": AB, "Pourquoi je prends la direction de la Révolution surréaliste," *RS* 4 (15 July 1925), 3. Because of a transposition in the facsimile edition by Jean-Michel Place, Naville and Péret are erroneously listed as editors on the inside cover of issue no. 4 and Breton as editor of no. 3, rather than the reverse.

209 "AS SURREALIST PAINTING": Pierre Naville, "Beaux-Arts," *RS* 3, 27.

209 RUN-INS WITH BRETON: Naville, 109.

209 "THE EARTH EVER SPAWNED": Artaud to Génica Athanasiou, 14 May 1925, in Antonin Artaud,

Lettres à Génica Athanasiou (Paris: Gallimard, 1969), 182.

209 "FANTASTIC INDIGNATION": Naville to Denise, [ca. 30 May 1925], Naville, 109–10.

209 "WHEREVER HE WENT": Maeder, *Antonin Artaud*, 52. See also Artaud to Max Morise, 16 April 1925, Artaud, *Œuvres complètes*, I (sup.), 37–38. Masson recalled an evening when he and Aragon were "caught" dancing in a seedy nightclub by a furious Artaud, who forced them to go elsewhere: Masson, "Breton, cro-quemitaine," 13.

210 WAS AGAIN BEATEN UP: Victor Crastre, "Notes," *Clarté* (June 1925), 37; R. Comminges, "Le Français moyen et les Surréalistes," *Le Journal littéraire* (13 June 1925).

210 "NEGLECT AND INDIFFERENCE": "Hommage à Saint-Pol-Roux," in *Tracts*, I, 41.

210 "THEM AND THE SURREALISTS": *Conversations*, 88.

211 MORNING OF THE BANQUET: "Appel aux Travailleurs intellectuels [2 July 1925]," in *Tracts*, I, 51–52, and Pierre's commentary, 393–94; Clément Vautel, "Mon film," *Le Journal* (11 July 1925), quoted in Elyette Guiol-Benassaya, *La Presse face au surréalisme de 1925 à 1938* (Paris: Editions du CNRS, 1982), 215.

211 "AND RATHER SORDID": Rosenthal, *Avocat*, 53–54. Breton had, however, kept Communism in the corner of his eye, and according to Simone had attended at least one Communist meeting in 1922: Simone to Denise, 1 July 1922, *Lettres à Denise*, 95.

211 "WHAT IS TO BE DONE?": AB to Simone, 7 July 1925, Sator.

211 CLAUDEL'S POETIC SKILL: MP interview with Georges Schéhadé, 14 March 1988.

211 "QUANTITIES OF LARD": "Open Letter to M. Paul Claudel, French Ambassador to Japan," trans. Richard Howard, in Nadeau, *History*, 239. The tract misdates the interview 17 June.

211 "ONE MEANING: PEDERASTY": Ibid., 238.

211 "CATHOLIC RELIGION TO BOOT!": AB to Doucet, 25 June 1925, *OC 1*, li.

211 RIGHT OF REBUTTAL: *Tracts*, II, 439.

212 "A PRIG AND A SWINE": "Open Letter," 238–39 (trans. slightly revised).

212 "THE GLASS FROM BREAKING": *Conversations*, 88.

213 "CAPTAIN OF THIS SHIP": The Saint-Pol-Roux banquet has been recounted many times and with many variations. The preceding description, which pieces together the most reliable bits of information, is based on the following: *Conversations*, 88–89; "Déclaration des surréal-istes à propos du banquet Saint-Pol-Roux [18 July 1925]," in *Tracts*, I, 53; Nadeau, *History*,

112–14; Shattuck, *Banquet Years*, 359–60; Soupault, *Mémoires*, II, 118–19; Youki Desnos, *Les Confidences de Youki* (Paris: Fayard, 1957), 86–87; Duhamel, *Raconte pas*, 219; Michel Leiris, "Breton, le patron" (interview with Catherine David and Claude Roy), *Nouvel observateur* (20 May 1988); Leiris to Jacques Baron, 3 July [1925], in auction cat. *Biblio-thèques d'un surréaliste et d'un critique d'art* (Paris: Salle Drouot Richelieu, 17 March 1994), item 129; Champs des activités surréalistes, *Bulletin de liaison* (new series) 17 (Feb. 1983), 43–44; various press remarks reproduced in Guiol-Benassaya, *Presse face au surréalisme*, 218–21, 226, 229, 244–45. Some witnesses remember Desnos (rather than Soupault) swinging from the chandelier, or from a curtain rod; and Jean d'Esparbès (Ch. des act. surr., *Bulletin* 17, 44) claims that the Surrealists tried to push Lugné-Poe out the window. But as Nadeau notes (p. 113n), "There exist as many versions of this banquet as there were witness-es"—and then some.

213 "ELEMENTS OF THE TIME": *Conversations*, 89.

213 "UNWORTHY METHODS OF PUBLICITY": *L'Action française* (6 July 1925), quoted in Nadeau, *History*, 114n.

213 FRANCE AND WESTERN CULTURE: *Le Journal lit-téraire* (1 Aug. 1925), ibid.

213 "MOSCOW WILL BE PLEASED": *Le Temps* (5 July 1925), quoted in Guiol-Benassaya, *Presse face au surréalisme*, 227.

213 "SCARCELY BEEN CREASED": "Déclaration des surréalistes à propos du banquet Saint-Pol-Roux," *Tracts*, I, 53, and Pierre's remarks, 397.

9. Revolution by Any Means

214 "ABUSE SUCH POWER": "Pourquoi je prends la direction de la Révolution surréaliste," *RS* 4, 3.

214 "A LITERARY ALIBI": Ibid.

214 "IN ITS SAVAGE STATE": *Surrealism and Painting*, 1. First published in *RS* nos. 4, 6, 7, and 9–10.

214 "PURELY INTERNAL MODEL": Ibid., 4.

214 "WHICH IS NOT VISIBLE": Ibid., 1.

214 "WHAT IT LOOKS OUT ON": Ibid., 2.

215 "ENTIRELY DIFFERENT LANGUAGES": Man Ray to Gertrude Stein, 23 Aug. 1925, Baldwin, *Man Ray*, 125.

215 "GOES FAR ENOUGH": "Pourquoi je prends," 3.

215 "FOLLOWING SUCH AN EXAMPLE": "Révolution d'abord et toujours!" in *Tracts*, I, 55. A partial translation of this text was published as "Revolution Now and Forever!" in AB, *What is Surrealism? Selected Writings*, ed. Franklin Rosemont (New York: Monad Press, 1978), 318–20. Unless otherwise noted, page numbers

refer to Part II of this volume, an anthology of Breton's work in English translation; Part I, independently numbered, consists of Rosemont's introduction.

215 "COULD NEVER BE ENOUGH": Ibid.

216 EVENT OF POLICE SEARCHES: *OC 1*, lii; *Tracts*, I, 401.

216 NAMES OF LITTLE-KNOWN POETS: Béhar, *André Breton*, 181.

216 "AT THE CAFÉ CYRANO": "La Véritable erreur des surréalistes [Aug. 1925]," in Pierre Drieu la Rochelle, *Sur les écrivains* (Paris: Gallimard, 1982), 42; Alexandre, *Mémoires*, 76.

216 "RATHER CONFUSED IDEOLOGICALLY": "What is Surrealism?," trans. unknown, in *What is Surrealism?*, 117.

216 "AMONG THE COMMUNISTS": Eluard to AB, [Aug. 1925], *Tracts*, I, 401.

217 "WANT TO VOMIT": AB to Desnos, 28 Aug. 1925, Doucet (card signed "17 13").

217 "HOPEFUL AND DESPERATE": Unpublished preface to *Nadja* for René Gaffé, quoted in *OC 1*, 1504.

217 "SATISFYING IN NATURE": AB to Doucet, 11 Sept. 1925, *OC 1*, lii.

217 FRIENDS THROUGH HER PARLOR: *OC 1*, 1693–94.

217 "IN STORE FOR ME": "A Letter to Seers," in *Manifestoes*, 202.

218 "MARVELOUS BOOK": AB to Eluard, [ca. 29 Aug. 1925], *OC 1*, 1698.

218 "IN MY REMARKS": AB to Eluard, 3 Sept. 1925, ibid.

218 "HOMERIC LAUGHTER": Rosenthal, *Avocat*, 54.

218 "AND AT ANY PRICE": "Leon Trotsky's 'Lenin,'" trans. Stephen Schwartz, in *What is Surrealism?*, 29 (trans. slightly revised).

218 "ENORMOUSLY ATTRACTIVE": *Conversations*, 93.

218 "MAGNIFICENT PAGES": "Trotsky's 'Lenin,'" 30.

219 STATE HE HAD HELPED FOUND: Arturo Schwarz, *André Breton, Trotsky et l'anarchie* (Paris: Union Générale d'Editions ["10/18"], 1977), 36–37; Marguerite Bonnet, "Trotsky et Breton," *Cahiers Léon Trotsky* 25 (March 1986), 12–16.

219 "HOWLED 'LONG LIVE LENIN!'": Drieu, "Véritable erreur," 47.

219 "SHOUT BECOMES BANNED": *NRF* (1 Sept. 1925), quoted in *OC 1*, 1699.

219 "BECAUSE HE WAS LENIN!": "Trotsky's 'Lenin,'" 29 (trans. slightly revised).

219 "BUILDINGS ARE DESTROYED?": Ibid.

219 "GREATEST WORKS I'VE EVER READ": Bonnet, "Trotsky et Breton," 9. The Yugoslav poet Monny de Boully also remembered the excesses of Breton's newfound enthusiasm: "Two days after discovering [Communism], he arrived sporting a cap, evidently trying to 'look like a worker.' It looked terrible on him, and that was the only time I saw him wearing it. Breton also went to the Communist bookstore and bought a number of pamphlets that he read at top speed, as if he wanted to become a specialist of Party literature in record time": Michel Random, "Les Entretiens de Monny de Boully," *NRF* (1 Nov. 1969), 713.

219 "DISTINCTLY MARXIST" ARTICLES: Jean Bernier, "Où nous en sommes," *Clarté* (30 Oct. 1925), 331.

219 "EVERY KIND OF FASCISM": Aragon, "Le Prolétariat de l'Esprit," ibid., 337; Daix, *Aragon*, 170; *Conversations*, 93.

219 FOLLOW THE COMMUNIST PATH: Masson, *Années surréalistes*, 87n, 93n; Masson to AB, 2 Sept. 1925, *RS* 5 (15 Oct. 1925), 30; *Conversations*, 91; Béhar, *André Breton*, 182.

220 AN EVENTUAL FUSION: *OC 1*, lii; "'Clarté,' 'Philosophies,' 'la Révolution surréaliste' solidaires du Comité Central d'Action," *Tracts*, I, 61–62; "Télégramme au Président du Conseil de Hongrie," ibid., 62–63, see also 401.

220 "RALLYING-GROUND FOR INTELLECTUALS": Nicole Racine, "The Clarté Movement in France, 1919–21," *Journal of Contemporary History* ii:2 (April 1967), 208. For information about the Clarté movement, see this and Nicole Racine, "Une revue d'intellectuels communistes dans les années vingt: 'Clarté' (1921–1928)," *Revue Française des Sciences Politiques* xvii:3 (June 1967).

221 DOMINANT BOURGEOIS CULTURE: Crastre, *Drame du surréalisme*, 49; Racine, "Clarté Movement in France," 195, 205–7; Haslam, *Real World*, 142.

221 "CALLED FRENCH THOUGHT": Bernier, "Où nous en sommes," 334.

221 AN IDEOLOGICAL GUARANTOR: Lewis, *Politics of Surrealism*, 35, 37ff; Crastre, *Drame du surréalisme*, 74.

221 "INEXPERIENCE OR STUPIDITY": *Archives du surréalisme, II: Vers l'action politique (juillet 1925–avril 1926)*, ed. Marguerite Bonnet (Paris: Gallimard, 1988), 34–36.

222 RELINQUISH THAT INDEPENDENCE: Ibid., 36; Crastre, *Drame du surréalisme*, 45.

222 "DICTATORIAL BODY": *Vers l'action politique*, 37.

222 "COMMUNISM" BY "POETRY": Ibid., 58.

222 "WITH VISIBLE JOY": Crastre, *Drame du surréalisme*, 43.

222 "UNACCEPTABLE STATEMENTS": Ibid., 50, 52; on Naville: 120–21.

222 ACTIONS DEEMED "COWARDLY": *Tracts*, I, 399.

222 "HELL WITH THE REVOLUTION!": *Second Manifesto*, 134n.

222 EXCLUSION HAD PLACED HIM: Soupault, *Mémoires*, II, 43; Baron, *L'An I*, 153; Henri Béhar, *Roger Vitrac, un réprouvé du surréalisme* (Paris: A. G. Nizet, 1966), 101.

223 "MY OWN DISTRESS": Artaud to AB, [late Oct. 1925], Artaud, *Œuvres complètes*, I (sup.), 48.

223 EXCLUSIONS OF BOTH MEN: Cf. *Vers l'action politique*, 71, 80, 89–91; *Conversations*, 96.

223 "FOUQUIER-TINVILLE OF MODERN POETRY": Georges Neveux, "Un poète révolutionnaire," *Figaro littéraire* (6 Oct. 1966).

223 "THE CAPITALIST INFERNO": *L'Humanité* (21 Sept. 1925), quoted in Naville, 486–87.

223 "IN A 'SURREALIST REVOLUTION'": "Les Intellectuels et la Révolution," *Tracts*, I, 63–64.

224 "OF LENIN AND TROTSKY": Masson to Leiris, [6 Oct. 1925], Masson, *Années surréalistes*, 102.

224 EXHIBITING IN GROUP SHOWS: See *Surrealism and Painting*, 5 (from *RS* 4); Arianna Stassinopoulos Huffington, *Picasso: Creator and Destroyer* (London: Weidenfeld & Nicolson, 1988), 184.

224 "REVOLUTIONARY ART IN FRANCE": *Vers l'action politique*, 49.

224 "NOT BE PART OF IT": Ibid., 49, 52.

225 "WE'VE EXPRESSED OURSELVES": AB to committee members, 9 Nov. 1925, ibid., 122–23.

225 "DICTIONARY THIS MORNING!'": Duhamel, *Raconte pas*, 163.

225 PUT THEM ILL AT EASE: Crastre, *Drame du surréalisme*, 44–45, 87–88; *Conversations*, 95. For more on the contradictions between Surrealism and more orthodox leftists, see Nadeau, *History*, 123–24, 255; *Conversations*, 94–95; Didier Periz, "Autour de 'Légitime Défense,'" *Docsur* 4 (Oct. 1987), 1; Robert S. Short, "The Politics of Surrealism, 1920–36," in Walter Laqueur and George L. Mosse, eds., *The Left Wing Intellectuals Between the Wars, 1919–1939* (New York: Harper Torchbooks, 1966), 10; Lewis, *Politics of Surrealism*, 52.

226 "FROM THE MASSES": "La Force d'attendre," in *OC I*, 920. First published in *Clarté* (Dec. 1925).

226 "PROCURING ANY REPLACEMENTS": Ibid., 921.

226 "LAUTRÉAMONT AND RIMBAUD": Ibid., 918.

226 "ENTRANCE TO THE METRO": Short, "Politics of Surrealism," 22.

226 "HIS PROTEST AGAINST IT": *Nadja*, 68.

226 "INSATIABLE AND BOUNDLESS": "What is Surrealism?," 113.

227 SCULPTOR JEAN DUBUFFET: Dumas, *Robert Desnos*, 72; AB to Simone, 11 Nov. 1924, Sator; Chapon, *Jacques Doucet*, 300; *Cahier*, 135; Maeder, *Antonin Artaud*, 52; Haslam, *Real World*, 130.

227 "MYSELF EACH TIME": Michel Leiris, *Manhood: A Journey From Childhood into the Fierce Order of Virility*, trans. Richard Howard (New York: Grossman Publishers, 1963), 3–4; MP interview with Michel Leiris, 1 July 1986; Michel Leiris, "Breton, le patron," *Nouvel observateur* (20 May 1988); Duhamel, *Raconte pas*, 181. Leiris also knew Raymond Roussel through his father, who was Roussel's financial advisor.

227 "'SURREALIST' OF US ALL": *Surrealism and Painting*, 36, 38; AB to Simone, 10 Feb. 1925, Sator.

227 "OVERPRODUCTION, AND PLAYFULNESS": *Surrealism and Painting*, 70.

227 ACCESS TO ONE AND ALL: Georges Sadoul, introduction to *Aragon* (Paris: Seghers ["Poètes d'aujourd'hui"], 1967), 8.

228 "THAT'S A MINOR MIRACLE": Duhamel, *Raconte pas*, 157–59.

228 "SENSE OF THE WORD": *Conversations*, 112.

228 "MORE GENUINE, LESS STRAINED": Thirion, 89.

228 "INFECTIOUS LIVELINESS": Ibid., 90; Alexandrian, *Surréalisme et rêve*, 410.

228 "PREFERENCE FOR CLARITY": Thirion, 91.

228 HANGING ON BRETON'S WALL: Paule Thévenin, "Les énigmes du 'Cerveau de l'enfant,'" in AB cat., 101–2; Patrick Waldberg, *Max Ernst* (Paris: Jean-Jacques Pauvert, 1958), 280. Tanguy dates his meeting with Breton in November 1925: cf. Yves Tanguy, *Lettres de loin à Marcel Jean* (Paris: Le Dilettante, 1993), 122.

229 LODGINGS FOR LONG PERIODS: Cf. Duhamel, *Raconte pas*, passim.

229 "DRINK / THE NEW / WINE": *Surrealism and Painting*, 289.

229 "PERHAPS EVEN A DRUG": Simone [Breton] Collinet, "The Exquisite Corpses," in *Le Cadavre exquis, son exaltation*, exh. cat. (Milan: Galleria Schwarz, 1975), 30.

229 "PEARLS WITH THE SCAPEGOAT": *Surrealism and Painting*, 289.

229 "SOMETHING LIKE A TOP HAT": "Le Dialogue en 1928," *RS* 11 (15 March 1928), 7.

230 "FULL OF GOOD INTENTIONS": AB to Simone, from Pax Hôtel, Marseille, 5 April 1926, Sator.

230 "ONLY BY ITS INSECURITY": AB to Lise, 17 May 1926, *OC I*, 1774.

230 "PAIR OF GLOVES . . . LOVE": Aragon, *Défense*, 356, see also 19, 208. A passage from Raymond Queneau's novel *Odile* suggests that Aragon might indeed have resented Lise's hold over Breton. "She's a charming lady," Saxel [Aragon] says of a woman known only as "the Countess." "Anglarès [Breton] is in love with her: she knows every medium in Paris. I don't think she's in love with him. In fact, she's leading him on, the bitch": Raymond Queneau, *Odile*, trans. Carol Sanders (Elmwood Park, Ill.: Dalkey Archive Press, 1988), 37.

230 "IN FRONT OF THE MIRROR": Ernst to Goemans, 2 June 1926, in Marcel Mariën, ed., *Lettres surréalistes (1924–1940)* (Brussels: Les Lèvres Nues [*Le Fait accompli* 81–95 (May–Aug. 1973)]), 18; AB and Aragon, "Protestation [18 May 1926]," *Tracts*, I, 64–65, see also 407–8; Ernst, *Not-So-Still Life*, 36; Duhamel, *Raconte pas*, 255–57; Marcel Jean, *The History of Surrealist Painting*, trans. Simon Watson Taylor (New York: Grove Press, 1960), 156–57.

230 "I MIGHT HOLD DEAR": AB to Valentine Hugo (hereinafter "Valentine"), 30 May 1926, HRC.

230 "SOILED BY THEIR STEPS": AB to Doucet, 4 Sept. 1926, *OC 1*, liii; Henri Pastoureau, "André Breton, les femmes et l'amour," *Europe* 743 (March 1991), 87.

231 "REVOLUTIONARY CONDUCT": Pierre Naville, *La Révolution et les intellectuels* (1926; Paris: Gallimard ["Idées"], 1975), 58; cf. Naville, 490.

231 "CAN EXPECT NOTHING": Ibid., 86–87.

231 "ONLY REVOLUTIONARY PATH": Ibid., 76–77.

231 "TO CONSIDERABLE ANXIETY": "What is Surrealism?," 128.

231 "ONE AND THE SAME": "In Self-Defense," in *Break of Day*, 34. First published as a pamphlet and in *RS* 8 (Dec. 1926).

231 "NEEDLESSLY CRETINIZING": Ibid., 23.

231 "SHORT STORIES": Ibid., 27 et pass.

232 "DEVIATIONS AROUND US": Ibid., 33.

232 "THE PARTY AND FOR NAVILLE": Lewis, *Politics of Surrealism*, 59.

232 "BANKNOTES AND MODESTY": Thirion, 113.

232 ATTEMPT AT RAPPROCHEMENT: Ibid., 115.

233 "IT (?) WILL HAPPEN HERE": *Nadja*, 32.

233 FAVORED CAFÉ TABLE: Henri Pastoureau, *Ma vie surréaliste* (Paris: Maurice Nadeau, 1992), 309.

233 DEBT OF OVER 3,000 FRANCS: R. Saucier to Gaston Gallimard, 22 Dec. 1926 (internal memo), *NRF* archives. On borrowing: *OC 2*, xii–xiv.

234 "IS NOT EARNED BY WORK": *Nadja*, 59–60.

234 "EVEN PERVERSE": Ibid., 52.

234 "RUNNING OVER YOUR FEET": Ibid., 38; Susan Suleiman, "Between the Street and the *Salon*: The Dilemma of Surrealist Politics in the 1930s," *Visual Anthropology Review* (spring 1991), 42.

234 "USELESS PORTE SAINT-DENIS": *Nadja*, 32, 63–64.

234 "THE GROUND AS SHE WALKED": Ibid., 64. For a discussion of Breton's meeting with Nadja, cf. Jean-Paul Clébert, "Traces de Nadja," *Revue des sciences humaines* 184 (1981), 79–94.

234 "SOME LUMINOUS PRIDE?": *Nadja*, 65.

234 "ONLY THE BEGINNING": Ibid., 66.

235 "A FLOWER WITH NO HEART": Ibid., 70–71 (trans. revised).

235 "APPEARED TOO EGOCENTRIC": Balakian, *André Breton*, 114, see also 112.

235 "THE SOUL IN LIMBO": *Nadja*, 71.

235 "INOPPORTUNE CURIOSITY": *OC 1*, 1509.

236 "GET AWAY FROM HER": *Nadja*, 92, 65–70; *OC 1*, 1509–10, 1542–43; Georges Sebbag, *André Breton, L'Amour-folie* (Paris: Jean-Michel Place, 2004), 50–60 et pass.

236 "OH, WELL THEN": *Nadja*, 70.

236 "MY WHOLE LIFE — MY SIMPLICITY": Ibid., 71.

236 "LOST ITS INCREDIBLE DISORDER": Ibid., 72.

236 "A DOG BESIDE HER": Ibid., 74.

236 "LIVE THIS WAY ALTOGETHER": Ibid.

236 "TOO MUCH" OF HER: MP interview with Michel Leiris, 1 July 1986; Naville, 357.

237 "THE SURREALIST ASPIRATION": *Nadja*, 74n.

237 "NO ONE CAN 'REACH' ME": Naville, 358.

237 JOIN HER ON THE SIDEWALK: *Nadja*, 77, 91.

237 HAD OF HER EVER SINCE: Description of Nadja based on an unpublished photograph generously communicated by Hester Albach. Closer examination reveals that it's from this portrait that Breton took the picture of Nadja's eyes that figures in later editions of his book.

237 "SO SOON FORGOTTEN": "Soluble Fish," in *Manifestoes*, 86. Breton later attributed his malaise about Place Dauphine to the realization that, for him, it was "unmistakably the sex of Paris" ("Pont-Neuf," in *Free Rein*, 225). The visual analogy is borne out by aerial views of the triangular, tree-lined square.

237 "SUBSTITUTED FOR THE HOST": *Nadja*, 93.

237 "A THREAT": Ibid., 85.

237 "THE KISS THAT KILLS": *OC 1*, 1545.

238 "RED CURTAINS": *Nadja*, 83.

238 OF VARIABLE INTEREST: *Nadja* (French ed., 1963), 101. This phrase does not appear in the English version.

238 "EMPLOY TO OBTAIN MONEY": *Nadja*, 92.

238 SHOW FOR AN APPOINTMENT: Ibid., 94, 97.

238 "EXACTLY AS [BRETON] SAID": Naville, 358–59.

238 "WHEN TALKING ABOUT ANDRÉ": Ibid., 359.

238 "YOUR EYES, AND IN MINE": *Nadja*, 106.

238 "SATISFACTION AND GRATITUDE": Ibid., 107.

239 THERE THEY BECAME LOVERS: Ibid., 105–8; *OC 1*, 1515–16; MP interviews with André Thirion, 9 March 1988, and Michel Leiris, 1 July 1986.

239 "TO EAT, TO SLEEP": *Nadja*, 114–15.

239 "WE CAN NEVER OVERCOME": Ibid., 111.

239 AFTER THE FACT: Cf. André Pieyre de Mandiargues, *Le Désordre de la mémoire: Entretiens avec Francine Mallet* (Paris: Gallimard, 1975), 113–15, for a discussion of this revision.

239 "SO LIGHTLY DRESSED": *Nadja*, 90. Cf. Alexandre, *Mémoires*, 167: "[Breton] was afraid for Nadja, as one can be afraid for a child."

239 "FITS OF ABSTRACTION": *Nadja*, 130, see also 115.

240 "FROM HER FOREVER": Ibid., 113–14.

240 "TREES ALONG THE ROAD": Ibid., 152–53n.

240 "COMES TO AN END HERE?": Ibid., 108.

240 "WORDS TO YOUR NADJA": Ibid., 117 (trans. mine from illustration), 118.

240 "MERELY A FOOTPRINT": *Nadja*, 116, see also 79, 91.

240 "THINKS OF ME AS THE SUN": Ibid., 111.

240 "I IMPOSE ON HER": AB to Simone, 8 Nov. 1926, Sator.

240 "FOR ALL THAT": Ibid.; cf. *Conversations*, 108.

241 "MAKING LOVE TO JOAN OF ARC": Naville, 359.

241 "A WELL-BEHAVED TOY": Nadja to AB, 1 Dec. 1926, Sebbag, *Breton, L'Amour-folie*, 52.

241 "SULLIED AND PUNISHED?": AB to Simone, 8 Nov. 1926, Sator.

241 HIS FRIEND'S LIFE: *DAP*, 542; Thirion, 124. Aragon later remarked that his frequent absences because of Nancy "led to a critical or uneasy situation between me and the Surrealists, who were used to seeing me at the Cyrano in Place Blanche—regular attendance being in their eyes a gauge of fidelity" (*Aragon parle*, 62).

241 A SHORT EXPLANATORY TEXT: Gateau, *Paul Eluard*, 141.

242 EVER-HOPEFUL YVAN GOLL: Claire Goll, "Goll et Breton," *Europe* 475–476, 110; Alexandre, *Mémoires*, 155–57; *L'Intransigeant* (29 Oct. 1926), 5, and ibid. (6 Nov. 1926), 5.

242 SURREALISTS TO TEARS: Janine Bouissounouse, *La Nuit d'autun: Le Temps des illusions* (Paris: Calmann-Lévy, 1977), 26; *Archives du surréalisme, III: Adhérer au Parti communiste? (septembre-décembre 1926)*, ed. Marguerite Bonnet (Paris: Gallimard, 1992; hereinafter "*Adhérer*"), 34n. *RS* 8 ends with the words, "The Battleship Potemkin. LONG LIVE THE SOVIETS!" (p. 36). Cf. Periz, "Autour de 'Légitime Défense," for other remarks on Breton's return to politics during this period.

242 "HIS FLESH ARE AT STAKE": "The Alfred Jarry Theater," in Artaud, *Selected Writings*, 155–57. First published in *NRF* (1 Nov. 1926).

242 "OF REVOLUTION YOU MEAN": *Adhérer*, 24–25.

242 "TOILET-PAPER REVOLUTIONARIES": "Manifesto for a Theater that Failed," in Artaud, *Selected Writings*, 161.

242 "SUSPICIOUSLY ASKED YOU WHY": Jean-Jacques Brochier, "Philippe Soupault: Exclu pour cause de littérature," *Magazine littéraire* 16 (March 1968), 21; Soupault, *Profils perdus*, 169; Thirion, 86; Duhamel, *Raconte pas*, 163.

243 OF HIS FORMER FRIENDS: Soupault, *Mémoires*, II, 164–65; Elizabeth Ayre, "The Surrealist Who Defied the 'Regiment,'" *International*

Herald Tribune (20 Feb. 1989), 18. Cf. the minutes of this meeting in *Adhérer*, 69ff.

243 "IDEOLOGICAL DIVERGENCES": *Conversations*, 175.

243 KEPT SILENT: Cf. Naville, 325.

243 COLLECTIVELY AS "THE FIVE": *Adhérer*, 110–12.

243 "IN MY POWER TO AVOID": Ibid., 32

243 "RIVER ALONG WITH IT": Marco Ristich, "La Nuit du Tournesol," *NRF* 172, 703.

244 "OUT OF LOYALTY": *Conversations*, 94; *OC* 2, 1457. In 1930, Breton specified that although 5,000 copies of the pamphlet had been printed, only "several hundred" had been sold when he pulped the remaining stock "at the request of the political bureau of the French Communist Party": see AB to René Gaffé, 16 March 1930, Gaffé, 78.

244 "BETTER TO POISON IT": Béhar, *André Breton*, 186. The official in question was Anatoly V. Lunacharsky, the Soviet commissar of education, who was comparatively sympathetic to the Surrealists.

244 "A HOUSE LIKE ANY OTHER": Ristich, "Nuit du Tournesol," 703.

244 READY TO BEGIN WRITING: Ibid.

244 "PROMISE. YOU HAVE TO": *Nadja*, 100–1.

244 "ETCHED BY A DIAMOND": Ibid., 18.

245 CLAIMED TO BE "ENCHANTED": Nadja to AB, 2 Dec. 1926, *OC 1*, 1511.

245 "HELP YOU MAKE SOMETHING GOOD": Nadja to AB, 30 Nov. 1926, ibid.

245 "REBELLING, OR EVEN CRYING": Nadja to AB, 1 Nov. 1926, Sebbag, *Breton, L'Amour-folie*, 51.

245 BECOME A "WILDCAT": Nadja to AB, 11 Dec. 1926, *OC 1*, 1512.

245 "IT WAS SO BEAUTIFUL": Nadja to AB, 30 Jan. 1927, Sebbag, *Breton, L'Amour-folie*, 56.

10. Admirable Love and Sordid Life

246 "BE A SURREALIST": *Second Manifesto*, 142; AB cat., 184; *Aragon parle*, 90; *Conversations*, 99.

246 "COUNTERREVOLUTIONARY ORIENTATION": *Second Manifesto*, 142.

246 "THROWN ON THE TABLE": *Conversations*, 100.

247 "BUT . . . COAL?": Luis Buñuel, *My Last Sigh*, trans. Abigail Israel (New York: Alfred A. Knopf, 1983), 138.

247 "INTELLECTUAL TASK": Alexandre, *Mémoires*, 154.

247 "EFFORTS A PRACTICAL HAND": Naville, 335.

247 "WAS DIRTY WORK": Short, "Politics of Surrealism," 12

247 CAME TO AN END: *OC 1*, 1541, 1717.

247 "BEFORE YOU AS SURREALISTS": *Au grand jour*, in *Tracts*, I, 75.

247 "IS ALONE IN DEFENDING": Ibid., 76.

248 "EIGHT-HOUR WORKDAY": Ibid.

248 A TEMPORARY SETBACK: *Conversations*, 102.
248 A "MENTAL RETARD": *Au grand jour*, 68. Artaud responded with a tract of his own, *In Total Darkness, or the Surrealist Bluff* (in Artaud, *Selected Writings*, 139), in which he pointed out, among other things, that the terms of the attack against him were taken practically verbatim from an unpublished diatribe Artaud himself had drafted against the Surrealists.
248 HAD SUPPOSEDLY ORATED: *Adhérer*, 33. Cf. the minutes of these political gatherings, in *Œuvres complètes du Comte de Lautréamont* (Paris: Au Sans Pareil, 1927), 421–40.
248 OF POLITICAL COMMITMENT: Desnos, *Nouvelles Hébrides*, 298.
248 "PETRIFYING COINCIDENCE": *Nadja*, 19.
248 "MY FEELINGS ABOUT YOU": AB to Desnos, 31 Aug. 1927, Doucet (cf. AB to Desnos, 17 Jan. and 14 Aug. 1927, Doucet); Naville, 336.
249 "WITHOUT THEM SEEING YOU": "Allotropy," in AB, *My Heart Through Which Her Heart Has Passed*, ed. and trans. Mark Polizzotti (Paris: Alyscamps Press, 1998), 15. Originally published (without title) in *RS 8*, 11.
249 BEHIND IN A TAXI: Report of lost object filed with the police by Breton, 12 July 1927, Doucet.
249 MANCHE REGION OF NORMANDY: AB cat., 185.
249 "BOUTS OF PESSIMISM": AB to Simone, 9 Aug. 1927, Sator; Sebbag, *Breton, L'Amour-folie*, 79.
249 "RUN AWAY FROM [LISE]": AB to Simone, 29 July 1927, Sator.
249 "DISTANT AND COLD WITH ME": Simone to Denise, 14 May 1923, *Lettres à Denise*, 133.
249 "SATISFACTION TO KILL MYSELF": Simone to Denise, 26 October 1923, ibid., 154.
249 "BE IN LOVE WITH" HER: Simone to Denise, 13 March 1923, ibid., 121.
249 "INTERESTED IN OUTER LIFE": Simone to Denise, 21 April 1923, ibid., 131; see also: letters of 16 and 29 July (pp. 137–39, 142) and others throughout the fall.
250 "DEGREES OF LOVE": Simone to Denise, 16 July 1923, ibid., 139. A number of letters from these months rehearse the same question, suggesting that Simone was perhaps not quite so secure in her conviction as she tried to appear.
250 DISTRUST OF LISE'S MOTIVES: See, for instance, Simone to Denise, July 1925, ibid., 227: "Some of [Lise's] actions make me think she's out to harm me . . . I've always shown the greatest respect for what was going on between her and André. For a while I thought she was the kind of woman who would operate on a similar plane. But now I think nothing of the kind—that she's mainly a *woman*."
250 THE INN'S ONLY GUEST: *OC 1*, 1503–4.

250 "RUSHING TO JOIN YOU": AB to Simone, 5 Aug. 1927, Sator.
250 "SHADOWS" . . . HAD DISSIPATED: AB to Simone, 9 Aug. 1927, Sator.
250 "SET THE TONE": *Conversations*, 111.
250 "LEAST STYLISTIC POLISH": "Avant-dire (dépêche retardée)," in *Nadja*, revised ed. (P:aris: Livre de Poche, 1964), 6. This preface, dated Dec. 1962, is not included in the American edition of the work.
251 "ARMY IN ITS ENTIRETY": Aragon, *Treatise on Style*, trans. Alyson Waters (Lincoln: University of Nebraska Press, 1991), 118 (trans. slightly revised).
251 "NOUELLE REÜE FRONÇAISE": Ibid., 62.
251 "YOU HAVE NO IDEA": AB to Simone, 22 Aug. 1927, Sator.
251 "BARELY HUMAN, AS ALWAYS": AB to Simone, 9 Aug. 1927, Sator; *Conversations*, 111; Bonnet, 383n; Daix, *Aragon*, 219n.
251 BACK TO THE MANOR HOUSE: Duhamel, *Raconte pas*, 172–73.
251 MAGNIFICENT TROMPE-L'ŒIL FRESCO: *OC 1*, 1505. Breton mentions the fresco in *Nadja*, 59.
251 EXECUTIONS OF SACCO AND VANZETTI: Daix, *Aragon*, 216, 219; Naville, 340. Cf. *Nadja*, 153.
251 "DECISIVE EPISODES": *Nadja*, 19.
251 "WHICH SIGNAL, AND OF WHAT": Ibid.
251 "SPECIFIC TO ME": AB to Simone, 22 Aug. 1927, Sator.
251 "A TWO-BIT JOURNALIST": AB to Simone, 30 Aug. 1927, Sator.
251 OF THE OVERALL TEXT: *OC 1*, 1505.
252 "EXPERIENCE IN THIS DOMAIN": *Nadja*, 23.
252 A WORK OF FICTION: Some examples are cited in *OC 1*, 1518.
252 A "CONFESSION": Cf. Roger Cardinal, *Breton: Nadja* (London: Grant & Cutler, 1986), 62–77 (esp. 68–69), for a discussion of genre as applied to *Nadja*.
252 "INANITY": "Avant-dire," 6.
252 "HAD LOOKED AT THEM": *Nadja*, 151–52.
252 NEAR RUE FONTAINE: *OC 1*, 1547; cf. *Nadja*, 94.
253 "CHANGE MY LIFE IF NECESSARY": Nadja to AB, 20 Jan. 1927, *OC 1*, 1512n.
253 "NO FRIENDS BUT YOU": *Nadja*, 142.
253 "DWELL ON THE IMPOSSIBLE": Nadja to AB, [25 or 26 Feb. 1927], Sebbag, *Breton, L'Amour-folie*, 59.
253 NADJA'S "ECCENTRICITIES": *Nadja*, 136.
253 "MY SANITY IS DYING": *OC 1*, 1512.
253 TWENTY-FIVE YEARS OLD: Ibid., 1513, 1555; *Nadja*, 136.
253 "THAT NADJA WAS MAD": *Nadja*, 136.
253 "HATEFUL PRISON": Ibid., 143–44.
253 "TERRIBLY DECISIVE": Ibid., 136.

253 TASTE FOR "EMANCIPATION": Ibid., 142–43.

254 "THEY'D LEAVE ME ALONE": Ibid., 141. More specifically, Breton railed against a Dr. Henri Claude, with his "dunce's forehead" and "stubborn expression" (p. 139), who since *Nadja*'s publication has stood for Breton's readers as the prototype of scientific narrow-mindedness. Breton had attended several of Claude's Sunday-morning lectures in the Sainte-Anne amphitheater, during which the psychiatrist would introduce his case studies. He came away from the sessions angered by Claude's air of "obtuse superiority," and his description in *Nadja* of the analyst's blunt interrogation tactics is no doubt accurate. But Breton also implies that Claude similarly browbeat Nadja at Sainte-Anne (in fact, he never treated her), and he fails to mention that Claude was a pioneer in introducing psychoanalysis to French medicine. Cf. *OC 1*, 1555; Janine Bouissounouse, *La Nuit d'autun: Le Temps des illusions* (Paris: Calmann-Lévy, 1977), 26–27; Gaston Ferdière, *Les Mauvaises fréquentations: mémoires d'un psychiatre*, in collaboration with Jean Quéval (Paris: Jean-Claude Simoën, 1978), 74.

254 "CONTEMPT FOR PSYCHIATRY": *Nadja*, 141.

254 "ESPECIALLY MENTAL PATHOLOGY": AB to Simone, 12 Aug. 1921, Sator. André Thirion later remarked that "Breton didn't like madmen, and madwomen still less" (interview with MP, 9 March 1981). Cf. Harold Wylie, "Breton, Schizophrenia and *Nadja*," *The French Review* xliii:1 (winter 1970), 101; John MacGregor, *The Discovery of the Art of the Insane* (Princeton: Princeton University Press, 1989), 276.

254 "DID NOT SEEM EXORBITANT": *Nadja*, 143.

254 HIS CAPACITY AS A DOCTOR: MP interview with Jacques Fraenkel, 14 March 1988.

254 QUIET FRENCH VILLAGE: Roger Shattuck, "The Nadja File," *Cahiers Dada/Surréalisme* 1 (1966), 55n; Pieyre de Mandiargues, *Désordre*, 115. Cf. *OC 1*, 1509n, 1513; Hester Albach to MP, 24 May 2004 (for rectification of certain details).

255 "I WAS PAID MANY": AB to Simone, 2 Sept. 1927, Sator.

255 DEPOPULATED CITY SCAPES: AB to Simone, 25 Nov. 1927, Sator; cf. Marie-Claire Bancquart, "Paris, capitale du désir," *Magazine littéraire* 254, 37.

255 "FAR MORE DISTURBING": AB to Lise, 16 Sept. 1927, *OC 1*, 1505.

255 "INCLUDED IN THIS ONE!": AB to Lise, 27 Sept. 1927, Béhar, *André Breton*, 204.

255 "SPITE AND INCOMPREHENSION": *OC 1*, liv.

255 "WITH A FAT DICKWAD": AB to Paulhan, 5 Oct. 1927, JP. Cf. Jean Guérin, "Notules," *NRF* (1

Oct. 1927), 557; Eluard to Paulhan, 10 Oct. [1927], JP; Aragon to Paulhan, 10 Oct. 1927, JP; Paulhan to Ponge, [ca. 15 Oct. 1927], Paulhan/Ponge, *Correspondance*, I, 27. Paulhan responded on the next *NRF*, stressing "how much cowardice hides behind that individual's violence and filth": "Correspondance," *NRF* (1 .Nov. 1927), 704.

256 "THEY SEE NOVELS, ROMANCES": Aragon, *Défense*, 93.

256 PUSHING HIM TO IT: Daix, *Aragon*, 209, 219–20; Aragon, *Défense*, 352.

256 "TUMULTUOUS FAILURE": Unpublished preface to *Nadja*, quoted in *OC 1*, 1506–7.

256 "LOVED LOVE AND LUXURY": Thirion, 125; Sebbag, *Imprononçable jour*, ch. 44; Sebbag, *Breton, L'Amour-folie*, 137.

256 "CAPRICIOUS, AND IRRESOLUTE": Pastoureau, "Breton, les femmes et l'amour," 88.

256 "AND OLD BATTLEMENTS": Jean, *Autobiography*, 191.

257 THE NEXT CAFÉ MEETING: MP interview with André Thirion, 9 March 1988; Thirion, 124–26; Pastoureau, "Breton, les femmes et l'amour," 82, 88; Emmanuel Berl, *Interrogatoire par Patrick Modiano* (Paris: Gallimard ["Témoins"], 1976), 45–46; *OC 1*, 1507.

257 "CONFESSIONS AND LIES": Berl, *Interrogatoire*, 46; *OC 1*, 1508.

257 "CALL ME": Sebbag, *Breton, L'Amour-folie*, 34.

257 "ANSWER WILL BE YES": Ibid., 33, 34–35, 228–29. This description is largely based on an unfinished memoir by Suzanne Muzard and her interview with Georges Sebbag (both published in *Breton, L'Amour-folie*), which sometimes reveal inconsistencies in her recollection of the facts.

257 "TO MEET LATER": Jean, *Autobiography*, 191.

257 SIMPLE NOTE OF FAREWELL: Sebbag, *Breton, L'Amour-folie*, 35; Berl, *Interrogatoire*, 46; Sebbag, *Imprononçable jour*, ch. 39. In his memoirs, Marcel Duhamel describes going to Berl's apartment before the couple's departure and, like a modern John Alden, demanding on Breton's behalf that Suzanne choose between the two men. Berl "was somewhat taken aback," Duhamel relates, "but the ludicrous and cheeky nature of my visit created a literary atmosphere that appealed to him; and at bottom, he must have been flattered to find himself competing with Breton." The older writer then reportedly disappeared into the bedroom, to return several minutes later. "She can't leave right away," he informed Duhamel. "But you can tell Breton that she'll be there soon" (Duhamel, *Raconte pas*, 242). Suzanne's own

recollections contradict this story, however.

258 "I COULD WRITE YOU": AB to Simone, 25 Nov. 1927, Sator.

258 "UNWORTHY OF THAT PERSON": AB to Simone, 30 Nov. 1927, Sator; Sebbag, *Breton, L'Amour-folie,* 113.

258 "ONLY A 'TYRANT'": *Aux écoutes* (26 Nov. 1927), 27.

259 MIRÓ FROM THEIR COLLECTION: AB to Simone, 30 Nov. 1927, Sator; Gallimard to AB, 1 and 30 Dec. 1927, *NRF* archives; AB to Gallimard, 23 Jan. 1928, *NRF* archives. *Surrealism and Painting,* originally scheduled for early Dec. 1927, was finally published in mid Feb. 1928.

259 "ALL OR NOTHING": *Nadja,* 155–56, 158.

259 TRAIN CARRY HER AWAY: Sebbag, *Imprononçable jour,* chs. 38, 39; *OC 1,* 1562–63; Sebbag, *Breton, L'Amour-folie,* 225.

259 SINCE THE END OF AUGUST: Cf. *Nadja,* 151: Richard Howard, evidently reading *interruption* as *irruption,* mistranslates: "I prefer thinking that from the end of August, the date of her first appearance, to the end of December . . . ," instead of: "the end of August, the date of its [i.e., the narrative's] interruption."

259 "JOLTS AND SHOCKS": Ibid., 160.

259 "AND SO EFFECTIVELY": Ibid., 156.

259 "NOT BE AT ALL": Ibid., 160; cf. *Conversations,* 108.

259 "WHICH HAS NOT LEFT": *Nadja,* 159–60.

260 "THAT IT SHOULD BE SO": Unpublished preface to *Nadja,* quoted in *OC 1,* 1561.

260 THAN LA RÉVOLUTION SURRÉALISTE: Alexandre, *Mémoires,* 111. According to Alexandre, Breton himself didn't always obey this restriction.

260 DURING BUSINESS HOURS: Georges Bataille, "La Publication d' 'Un Cadavre,'" *Le Pont de l'épée* 41 (1969), 143; cf. Thirion, 137–38. Bataille quotes Aragon crying to Masson, after a particularly harsh tongue-lashing by Breton: "And to think that I broke off with my family for *this!*"

260 "VERY MUCH AS DRUGS DO": *Manifesto,* 36.

260 INDULGED IN NARCOTICS: Duhamel, *Raconte pas,* 201; Alexandre, *Mémoires,* 151.

261 MUTUAL ACQUAINTANCES: AB to Simone, 30 Nov. 1927, Sator.

261 "A 'WELL KNOWN' WRITER": Antonin Artaud, *Œuvres complètes,* II (Paris: Gallimard, 1961), 265.

261 "IT'S BY CLAUDEL!": Maeder, *Antonin Artaud,* 112.

261 "AN INFAMOUS TRAITOR!": Artaud, *Œuvres complètes,* II, 267; Artaud, *Lettres à Génica,* 372; Paulhan/Ponge, *Correspondance,* I, 85–86n; Robert Aron, *Fragments d'une vie* (Paris: Plon, 1981), 83; cf. *RS* 11, 29; Maeder, *Antonin Artaud,*

111; Jean Prévost, "Spectacles," *NRF* (1 Feb. 1928), 243–45.

261 "DULAC IS A CUNT": Maeder, *Antonin Artaud,* 110; Virmaux, *Breton qui êtes-vous?,* 133; Pierre Ajame, "Les Yeux fertiles," *Europe* 475–476, 141; Denise Tual, *Le Temps dévoré* (Paris: Fayard, 1980), 43; Antonin Artaud, *Œuvres complètes,* III (Paris: Gallimard, 1978), 326–27 (each of these versions contains slight variants).

261 "ANYTHING, EXCEPT LOVE": Pastoureau, *Vie surréaliste,* 354.

262 BETTER THOUGHT OUT: Naville, 145–47.

262 "CERTAIN OF LIFE'S MISFORTUNES": *Recherches,* 41. The first two sessions were originally published in *RS* 11 (15 March 1928), 32–40. Cf. Harry Mathews, "Some Sexual Positions," *Times Literary Supplement* (13 Aug. 1993), 3–4.

262 "EVERYTHING HAS A PRICE": *Recherches,* 50.

262 "IT'S A MORAL ISSUE": Ibid., 60.

262 PRONE TO BEARING CHILDREN: Ibid., 99.

262 "TALK ABOUT COMPLICATIONS!": Ibid., 45.

262 "WHETHER SHE COMES OR NOT": Ibid., 159.

262 "MENTAL AND MORAL DEFICIT": Ibid., 39, see also 39–75, 138.

262 "WHAT SEXUAL 'PLEASURE' WAS": Ibid., 128.

262 BOUTS OF IMPOTENCE: Ibid., 87.

262 "ABSOLUTE" DENIAL OF LOVE: Ibid., 118.

263 "PRETEND TO ENJOY SEX": Duhamel, *Raconte pas,* 171; *Recherches,* 87–90, 138.

263 BEING COMPLETELY CANDID: Naville, 148; *Recherches,* 125, 134–35.

263 "LEARN A FEW THINGS": Duhamel, *Raconte pas,* 252.

264 "NINETEENTH CENTURY": AB and Aragon, "The Fiftieth Anniversary of Hysteria," in *What is Surrealism?,* 320–21. First published in *RS* 11.

264 INDULGING IN SMUT: Magritte to Paul Nougé, [ca. March 1928], *Lettres surréalistes,* 73; Naville, 148; Carassou, *René Crevel,* 143.

264 "CITY SUCH AS AJACCIO": AB to Simone, 7 March 1928, Sator.

264 FEELING "VERY HAPPY": AB to Simone, [15?] March 1928, Sator; *OC 1,* liv; Sebbag, *Breton, L'Amour-folie,* 42–45, 120, 123.

264 "NEVER LUCKY IN LOVE": *Recherches,* 145.

264 "DARK, THREATENING CLOUDS": "Dialogue en 1928," *RS* 11, 7.

265 "THE SHEEREST INDIFFERENCE": AB to Eluard, 8 May 1928, *OC 1,* 1584.

265 "MUSIC, BEGONE": Ducasse, *Poésies,* 44 (trans. revised). Ducasse's phrase, "*Allez, la musique,*" literally translates as "Go on, music" (or "Music, ho," as Lykiard renders it); but the unmistakably dismissive tone suggests the freer version given here.

265 "DIFFERENCE BETWEEN TWO SOUNDS": Gérard Legrand, *André Breton en son temps* (Paris: Le Soleil Noir, 1976), 64; MP interview with Michel Leiris, 1 July 1986.

265 "DEEPLY CONFUSING": *Surrealism and Painting*, 1; Masson, "Breton, croquemitaine," 12.

265 "WAS AN INFERIOR ART": MP interview with Virgil Thomson, 5 May 1987.

265 CONCERTS ONLY IN SECRET: Naville, 247; MP interview with Michel Leiris; Masson, "Breton, croquemitaine," 12–13.

265 TO HIS OWN FRIENDS: Paul Eluard, *Lettres à Joë Bousquet* (Paris: Editeurs Français Réunis, 1973), 57, 68 et pass.; AB to Simone, 14 Aug. 1928, Sator; Alexandre, *Mémoires*, 107; Marcel Jean, *Au Galop dans le vent* (Paris: Jean-Pierre de Monza, 1991), 35; Legrand, *Breton en son temps*, 64.

265 "ANOTHER FAT-ASSED LAUNDRESS": Rosenthal, *Avocat*, 47.

265 TO "CONFISCATE" SURREALISM: *OC 1*, 1583n.

266 OFFICIAL INTERESTS: Maeder, *Antonin Artaud*, 113–14; Yvonne Allendy to AB, 1 June 1928, Artaud, *Œuvres complètes*, III, 365.

266 INTERRUPT THE PREMIERE: Artaud to AB, [ca. 9 June 1928], Artaud, *Œuvres complètes*, II, 60.

266 "HIS SWEDISH HOMELAND": Maeder, *Antonin Artaud*, 114; Artaud, *Selected Writings*, 612; Aron, *Fragments*, 87–88.

266 "FOUND MOST REPUGNANT": Robert Aron, "Le Théâtre Alfred Jarry et les surréalistes," in Artaud, *Œuvres complètes*, II, 266.

266 "THERE! THERE!": Alain and Odette Virmaux, *Antonin Artaud qui êtes-vous?* (Paris: La Manufacture, 1986), 158.

266 HIS PROMINENT LOWER LIP: AB to Simone, 11 June 1928, Sator; Aron, *Fragments*, 89–90. The following year, Breton revived the incident to ridicule Artaud "being slapped in a hotel corridor by Pierre Unik, calling out for help *to his mother*!" But both Breton's private account to Simone and Artaud's own version of the story suggest that this piquant detail was a subsequent embellishment: *Second Manifesto*, 133; AB to Simone, 11 June 1928, Sator; Artaud to Monsieur Titin, [June 1928], *Œuvres complètes*, II, 74–75.

267 FOR ANOTHER TEN YEARS: Naville, 344–45.

267 GIVEN MAX ERNST: Legrand, *Breton*, 58; Gallimard to AB, 21 July 1932, *NRF* archives.

267 IN THE FIRST WEEK: AB royalty statement, 30 May 1928, *NRF* archives.

267 "SOMETHING WITH YOUR HELP": AB to Gallimard, 18 May 1928. Breton particularly complained about R. Hirsch, the house's production manager, who in turn reported,

bemused, that he'd bent over backward to accommodate Breton (R. Hirsch to Gallimard, [internal memo, ca. 20 May 1928]). Cf. AB to Gallimard, 23 Jan. 1928: *Nadja* promised for the beginning of March, along with *Treatise on Style* (all documents: *NRF* archives).

267 "ALMOST TOTAL SILENCE": AB to Eluard, 9 Aug. 1928, *OC 1*, 1517.

268 "EVOLUTION OF SENSIBILITY": *L'Europe nouvelle* (8 Sept. 1928), 1213.

268 "BRETON'S MOVING PROSE": *Les Nouvelles littéraires* (22 Sept. 1928).

268 "SURREALISM'S MASTERPIECE": *La Voix* (1 Nov. 1928), in Legrand, *Breton*, 195.

268 "BOURGEOIS 'LIFE'": *L'Humanité* (3 Dec. 1928), *OC 1*, 1520.

268 "ENJOYING A FRIEND'S WORK": *Les Nouvelles littéraires* (4 Aug. 1928).

268 "THAN THESE DEGRADING PRAISES": "Nadja," in René Daumal, *The Powers of the Word: Selected Essays and Notes, 1927–1943*, ed. and trans. Mark Polizzotti (San Francisco: City Lights Books, 1991), 23. First published in *Cahiers du Sud* 106 (Nov. 1928).

268 GOTTEN "MAGNIFICENT" PRESS: AB to Simone, 25 Sept. 1928, Sator.

268 THE PREVIOUS YEAR: AB royalty statement, 30 May 1928, *NRF* archives. Editions Gallimard had nearly shortchanged Breton 365 francs.

268 "THAN IT HAS SO FAR": AB to Gallimard, 10 Jan. 1929, *NRF* archives. In late January, Gallimard advanced Breton 1,000 francs: Gallimard to AB, 23 Jan. 1929.

268 "DREARY AND DISAPPOINTING": AB cat., 188.

269 "FERN-COLORED EYES": *Nadja*, 111.

269 "CONVINCED OF THAT": AB to Simone, 16 June 1928, Sator.

269 HAD WASTED HER LIFE: AB to Simone, 14 Aug. 1928, Sator.

269 "QUITE REMARKABLE": AB to Simone, 12 Aug. 1928, Sator, and various letters from AB to Simone throughout the fall.

269 "RECOVERING AT BERL'S": Sebbag, *Breton, L'Amour-folie*, 166.

270 "NERVES UTTERLY SHOT": AB to Simone, 4 Sept. 1928, Sator.

270 "SCUM WATCHING OVER HER": AB to Simone, 14 and 19 Aug. 1928, Sator.

270 TOOK SUZANNE TO MORET: AB to Simone, 29 Aug. 1928, Sator.

270 "VERY SHAPE OF FIRE": "Make it so daylight," in *My Heart Through Which Her Heart Has Passed*, 20 (poem unpublished in Breton's lifetime).

270 "THE DAWN OF TIME": "The idea of love," in ibid., 22–23 (poem unpublished in Breton's lifetime); see also *OC 1*, 1772.

271 "EXTREMELY HARSHLY SOMEDAY": AB to Simone, 25 Sept. 1928, Sator.

271 "YOU DEEM UNACCEPTABLE": Ibid.

271 LIFE TOGETHER WAS FINISHED: AB to Simone, 8 Oct. 1928, Sator.

271 "EVER DID ABOUT NADJA": Ibid.

271 "TO A HUMAN BEING": "Enquête [sur l'amour]," *RS* 12 (15. Dec. 1929), 65.

271 "OVER ADMIRABLE LOVE?": Ibid.

272 "HIDDEN IN THE FOREST": Ibid., 73.

272 HIS "LOVE GENIUS": AB to Berl, [late Sept. 1928], *OC 1*, 1560.

272 "BE CONSIDERED MY OWN": "Enquête," 71.

272 "ADMIRABLE LOVE KILLS": Ibid., 72.

272 "BIRDLIKE CREATURE": Ernst, *Not-So-Still Life*, 91; Whitney Chadwick, *Women Artists and the Surrealist Movement* (Boston: Little, Brown/ New York Graphic Society, 1985), 33–34.

272 "SEE MAX AGAIN. EVER": Eluard to Gala, [ca. 25 May 1927], *LTG*, 4–5, 294.

272 "OVER EVERYTHING ADMIRABLE": "Enquête," 71.

273 AT THE LAST MINUTE: Daix, *Aragon*, 226; Aragon, *Œuvre poétique*, IV, 314–20; Gateau, *Paul Eluard*, 155; AB to Simone, 9 Aug. 1928, Sator; Eluard to Bousquet, [Oct. 1928], *Lettres à Joë Bousquet*, 50.

273 "CREATE A SCANDAL": Thirion, 170. *Le Trésor des jésuites* was intended for a benefit gala that December, and in preparation the authors met at Musidora's hotel to rehearse. Pierre Lazareff of the newspaper *Le Gringoire* described Breton, "athletic, with superb, long-maned head tossed back," emphatically reading the script to his leading lady, who listened with "mouth agape": see Pierre Lazareff, "Musidora répète un sketch surréaliste," *Le Gringoire* (7 Dec. 1928). The gala was ultimately cancelled and the play did not premiere until 1935, in Prague and without Musidora. However silly the text, it does contain one remarkable piece of dialogue (reso-nantly echoing Breton's prediction in his 1925 "Letter to Seers"): "What does 1940 hold in store for us? 1939 was a disaster. It's already been twenty-one years since what they so oddly called the Great War!" (AB and Aragon, *Le Trésor des jésuites*, in *OC 1*, 1007). In 1940, after seeing what a disaster 1939 had indeed been, Breton tried unsuccessfully to have the Belgian Surrealist Marcel Mariën reprint the passage, stressing its "oddly prophetic" character: see AB to Marcel Mariën, 16 March 1940, in AB, *Cinq lettres* (En Hollande: MMXVI [sic]), 10. The spurious "publication date" of 2016 refers to Breton's testamentary interdiction against the publication of his letters for fifty years after his death in 1966.

274 "THAN ANY BEAUTY PARLOR": Thirion, 141–57; Daix, *Aragon*, 223–39; Helena Lewis, "Elsa Triolet: The Politics of a Committed Writer," *Women's Studies International Forum* ix:4 (1986), 386.

274 GREETED HER WITH DISTRUST: Thirion, 155; Lewis, "Elsa Triolet," 387.

275 WITH THE SOVIET BARD: Thirion, 150.

275 "GIVE HIM BACK HIS FREEDOM": AB to Simone, 8 Oct. 1928, Sator.

275 "HORRIBLE NEST OF VIPERS": AB to Simone, 11 Oct. 1928, Sator.

275 COULD HE LIVE WITHOUT HER: AB to Simone, 13, 18, and 27 Oct. 1928, Sator; Béhar, *André Breton*, 215.

275 HELP WITH THE LEGAL DETAILS: AB to Simone, 27 Oct. 1928, Sator.

275 "JUST WAITING AND SEEING": Simone to Denise, 26 Oct. 1928, *Lettres à Denise*, 247. Simone later confessed to her daughter that, despite every-thing, she wouldn't have left Breton had he not insisted (ibid., 249n).

275 "SEE THINGS AS I LIKE": AB to Simone, 11 Nov. and 8 Oct. 1928, Sator.

276 "NO LONGER LOVE YOU": AB to Simone, 15 Nov. 1928, Sator.

276 KNOWN TO ALL BUT BRETON: Sebbag, *Breton, L'Amour-folie*, 162–63, 166; Duhamel, *Raconte pas*, 253.

276 THE END OF 1923: See Simone to Denise, 14 Nov. 1923, *Lettres à Denise*, 155–56, in which she speaks of a "mystical ecstasy" and "mar-riage before God" with respect to Morise, the "serenity *beyond* passion" that they reached the night before, ending with questions about the meaning of fidelity.

276 ESCORT OR TRAVEL COMPANION: Ibid., 154n.

276 FROM A BEDROOM FARCE: Duhamel, *Raconte pas*, 253.

277 SIMPLE VIRTUE OF SPEED: Cf. Pastoureau, "Breton, les femmes et l'amour," 88.

277 "AT THIS YEAR'S END!": AB to Eluard, 30 Dec. 1928, *OC 1*, 1584, see also lv; MP interview with André Thirion, 9 March 1988; Thirion, 163–64.

11. The Crash of '29

278 OUT FOR SAFEKEEPING: Pastoureau, "Breton, les femmes et l'amour," 88; *OC 1*, lv; AB to Simone, 12 Jan. 1929, Sator.

278 "BY GENUINE FAITHFULNESS": Thirion, 176–77.

278 MEETING A "DAZZLING WOMAN": Emmanuel Berl, "Une vie de saint," *Arts* (30 Sept. 1959), 3.

278 "CLEANED OUT YOUR INNARDS": Thirion, 177; *Soupault et le surréalisme*.

279 "POWER BROKER IN FRANCE": Allan Stoekl, intro-duction to Georges Bataille, *Visions of Excess:*

Selected Writings, 1927–1939 (Minneapolis: University of Minnesota Press, 1985), xi.

279 "AN ENTRANCE EXAM": Thirion, 177–78.

279 "EXTREMELY CAUSTIC": Ibid., 59–60.

279 "OPEN [HIS] MOUTH": Biro, et al., *Dictionnaire général*, 373. Breton seems to have enjoyed Sadoul's company enough to spend several vacations with him during this period—the affinity perhaps encouraged by the coincidence of Sadoul's being madly in love with Suzanne's childhood friend Hélène Zéma.

279 NOTORIOUS UPHEAVALS: On Thirion: Thirion, 82–83, 85 et pass.; Biro, et al., *Dictionnaire général*, 403. On Sadoul: Thirion, 59ff, 86 et pass.; Biro, et al., *Dictionnaire général*, 373; Sebbag, *Imprononçable jour de ma naissance*, ch. 41.

279 TENSIONS WITH BRETON: Cf. Biro, et al., *Dictionnaire général*, pass.; Alain and Odette Virmaux, *La Constellation surréaliste* (Paris: La Manufacture, 1987), pass.

280 "NUMBER OF INDIVIDUALS": AB and Aragon, "À suivre: petite contribution au dossier de certains intellectuels à tendances révolutionnaires (Paris 1929)," in *Tracts*, I, 98. First published in *Variétés*, special issue: "Le Surréalisme en 1929" (June 1929).

280 FROM SOVIET TERRITORY: Ibid., 98–99, 102–3.

281 "EXTERMINATING EXISTENCE": AB to Eluard, 5 Feb. 1929, *OC 1*, 1584, see also 1770; Naville, 346; AB cat., 188.

281 "NUANCES ASIDE": Daumal to Maurice Henry, 8 June 1926, René Daumal, *Lettres à ses amis*, I (Paris: Gallimard, 1958), 139.

281 LEADING SANSKRIT SCHOLAR: On Daumal: Michel Random, *Le Grand Jeu*, I (Paris: Denoël, 1970); Mark Polizzotti, introduction to Daumal, *Powers of the Word*; Alexandrian, *Surréalisme et rêve*, 471–73.

281 TO BRETON'S ANNOYANCE: Michel Random, "Les Entretiens de Monny de Boully," *NRF* (1 Nov. 1969), 714; Alain and Odette Virmaux, *Roger Gilbert-Lecomte et le Grand Jeu* (Paris: Pierre Belfond, 1981), 48–50; Roland Dumas, *Plaidoyer pour Roger Gilbert-Lecomte* (Paris: Gallimard, 1985), 48; Daumal to Rolland de Renéville, [19 Sept. 1928], Daumal, *Lettres à ses amis*, 167.

281 ONE OF HOSTILITY: Leiris (interview with MP, 1 July 1986), Thirion (*Revolutionaries*, 166–67), and Ribemont-Dessaignes (*Déja jadis*, 205) have all stated that the meeting was specifically held to discredit the Grand Jeu.

282 GRAND JEU'S MOTIVES: Thirion, 165–66; *OC 1*, 1741; "À suivre," 120; Nadeau, *History*, 157.

282 "OF J. EDGAR HOOVER": Andrews, *Surrealist Parade*, 78.

282 "PURIFIER OF OUR CAPITAL": "L'Hymne Chiappe-Martia," in Roger Vailland, *Chronique des années folles à la Libération* (Paris: Messidor/Editions Sociales, 1984), 58–59. First published in *Paris-Midi* (15 Sept. 1928).

282 "VERY NOTICED ENTRANCE": AB to Simone, 15 March 1929, Sator; "À suivre," 104; MP interview with André Thirion, 24 April 1991.

282 "OF EACH MAN PRESENT": "À suivre," 117.

283 "DOES HE UNDERSTAND THIS?": Ibid., 121.

283 "THEIR FAMOUS WORDS": Ribemont-Dessaignes to AB, 12 March 1929, ibid., 126–28.

284 AS HE LEFT THE BAR: "Open Letter to André Breton on the Relation of Surrealism to the Grand Jeu," in Daumal, *Powers of the Word*, 52–53; "À suivre," 123–24 et pass.

284 "UNWARRANTED NOR INEFFECTUAL": "À suivre," 96. The text was written almost entirely by Aragon.

284 ARMCHAIR REVOLUTIONARIES: Cf. *Conversations*, 115.

284 "THE AMUSEMENT OF DOGS": "À suivre," 129.

284 "HELL WITH PSYCHOANALYSIS": Alexandrian, *Surréalisme et rêve*, 355–58.

285 HARSH NOTE FROM VAILLAND: "À suivre," 125; Michel Leiris, "Breton, le patron," *Nouvel observateur* (20 May 1988); AB to Simone, 15 March 1929, Sator.

285 HIS "FUCKING STUPIDITY": Virmaux, *Gilbert-Lecomte et le Grand Jeu*, 52, 55.

285 ACTUAL DEATH THREATS: Vailland to AB, 9 Aug. 1948, Random, *Grand Jeu*, I, 222n, see also 222–23.

285 "OLD ANTIDIALECTICAL MATERIALISM": *Second Manifesto*, 183.

286 "SWELLING VOICE OF BRETON": Georges Bataille, "Le Surréalisme au jour le jour," in *Œuvres complètes*, VIII (Paris: Gallimard, 1976), 173.

286 "EROTIC WORK I KNOW": AB to Simone, 19 Aug. 1928, Sator.

286 AS AN "OBSESSIVE": Bataille, "Surréalisme au jour le jour," 177.

286 STRICT EDITORIAL CONTROL: Aragon, *Œuvre poétique*, IV, 333; André de Ridder to Camille Goemans, 24 Sept. 1926, *Lettres surréalistes*, 24.

287 "THE SMASHING OF FACES": Announcement for *Variétés* (June 1929), quoted in *Tracts*, I, 93; Eluard to Gala, [15 April 1929], *LTG*, 43; AB to Goemans, 10 April 1929, and AB to Nougé, 5 May 1929, *Lettres surréalistes*, 92–93.

287 WITH HIM OVER SUZANNE: Thirion, 251; MP interview with André Thirion, 9 March 1988; Virmaux, *Breton qui êtes-vous?*, 136. Cf. "À suivre," 115; André Thirion, "Réponse à un recours en grâce," *Le Surréalisme au service de la Révolution* 2 (Oct. 1930), 32–36.

287 FOR THE LAST TIME: AB to Eluard, 24 May 1929, *OC 1*, lv.

287 "HORSE TO BE FOUND": AB to Desnos, [summer 1929], ibid., lv; Georges Sadoul, "L'Homme que j'ai connu," *Les Lettres françaises* (6 Oct. 1966), 15; Pastoureau, "Breton, les femmes et l'amour," 89; Tzara to AB, 28 Aug. 1929, Doucet.

288 MADE LIFE "IMPOSSIBLE": *OC 1*, lv.

288 "I THOUGHT SO, TOO": AB to Desnos, 29 July 1929, Doucet.

288 "DEMORALIZATION" THEY HAD CAUSED: AB to Eluard, 30 Dec. 1928, *OC 1*, 1583.

288 "SUCCESS OR FAILURE": *Second Manifesto*, 123.

288 "THE SURREALIST EXPERIMENT?": Ibid., 124

288 "LIFE OF THIS PERIOD": Ibid.

288 "PEAS INSTEAD OF POTATOES": Ibid., 142.

288 TO THE "VERY FEW": Ibid., 135.

288 THE "SURREALIST PACT": "Surrealist Comet," in *Free Rein*, 96.

289 "QUESTIONABLE TRACES": All quotes in this paragraph from *Second Manifesto*, 127.

289 "FIXING THIS POINT": Ibid., 123–24. More locally, Breton had expressed a similar hope to Simone mere weeks before the downturn in their relations and Suzanne's marriage to Berl: "I believe, once again, in the perfect resolution of these variously passionate states into a single state, which involves Suzanne's peace of mind, as well as yours and mine" (AB to Simone, 18 Oct. 1928, Sator).

290 IN HIS ABSENCE: Béhar, *André Breton*, 220; Meryle Secrest, *Salvador Dalí* (New York: E. P. Dutton, 1986), 101; Eluard to Gala, [15 April] and [Sept.] 1929, *LTG*, 43, 64; Janine Bouissounouse, *La Nuit d'autun: Le Temps des illusions* (Paris: Calmann-Lévy, 1977), 45.

290 "JOURNALISTIC JERKS": *Second Manifesto*, 131.

290 "REPLICA OF LIFE? SHIT": Ibid., 131 (trans. slightly revised).

290 "THAN WITH THE LIVING": Ibid., 184–86.

290 "SLANDEROUS INSINUATIONS": Ibid., 133–34; *OC 1*, 1600; MP interview with Bernard Morlino, 8 May 1991. Breton cites the remarks as coming from the scandal sheet *Aux écoutes*, but he appears to have been mistaken.

290 "IN THE PAST WITH US": *Second Manifesto*, 164.

291 "DICTATE REVOLUTIONARY OPINION": Ibid., 147, 149; Naville, 500. Naville also points out (p. 498) that his father was not "very rich," and rented, rather than owned, the space.

291 "FAIRLY DISASTROUS IMPRESSION": *Second Manifesto*, 172.

291 "WITH RESPECT TO SURREALISM": Ibid.

291 "PIDDLING EXPERIMENTS": Daumal, "Open Letter," 53.

291 "LITERARY TEXTBOOKS": Ibid., 56 (trans. revised); Virmaux, *Gilbert-Lecomte et le Grand Jeu*, 55–57; cf. Daumal to Rolland de Renéville, [26 April 1930], Daumal, *Lettres à ses amis*, 180–84.

291 "OCCULTATION OF SURREALISM": *Second Manifesto*, 178.

291 "TO AVOID CONFUSION": Ibid., 177.

291 "TO KEEP TO MYSELF": AB to Picabia, 19 June 1920, *DAP*, 508.

291 "AT BARREL LEVEL": *Second Manifesto*, 125.

291 "TAKING OUT MY REVOLVER": Josephson, *Life*, 226; Albert Camus, *The Rebel: An Essay on Man in Revolt*, trans. Anthony Bower (New York: Knopf, 1961), 91.

292 "IN [HIS] PERSONAL LIFE": *Conversations*, 117.

292 "IN ORDER TO MOVE FORWARD": Ibid., 116–17.

293 "URGED ON HIS FOLLOWERS": John Richardson, "Picasso and l'Amour Fou," *New York Review of Books* (19 Dec. 1985), 64.

293 "ANYTHING WORTHWHILE": AB to Picasso, 14 Dec. 1929, AB cat., 190.

293 "HAVE ON YOUR SIDE": Baldwin, *Man Ray*, 331. On Char: *OC 1*, 1566; Alexandrian, *Surréalisme et rêve*, 413.

293 "STUPID MISUNDERSTANDING": Tzara to AB, 28 Aug. 1929, Doucet; AB to Tzara, [Aug. 1929], Doucet.

293 SURREALIST FOLD THAT AUTUMN: Thirion, 183; AB to Tzara, 22 Nov. 1929, Doucet.

293 "ON MY MOTHER'S PORTRAIT": Secrest, *Salvador Dalí*, 116, 21–24.

294 "DIVINE DALÍ'S ASSHOLE": Ibid., 76, 66–67; Buñuel, *My Last Sigh*, 64–65.

294 "A GREAT INITIATION": Salvador Dalí, *The Unspeakable Confessions of Salvador Dalí, as told to André Parinaud*, trans. Harold J. Salemson (New York: Quill, 1981), 82.

294 WOULD TOP THEM ALL: Thirion, 195; Secrest, *Salvador Dalí*, 103; Jean, *Au galop*, 180.

295 "NEXT SUMMER AT CADAQUÉS": Salvador Dalí, *The Secret Life of Salvador Dalí*, trans. Haakon M. Chevalier (New York: Dial Press, 1942), 217.

295 "THAT FASCINATED ME": Dalí, *Unspeakable Confessions*, 89.

295 "HIDEOUS AND SUPERB": Ibid.

295 "ROUNDNESS OF THE BUTTOCKS": Ibid.

295 BEST HE COULD: Ibid., 88–90; Dalí, *Secret Life*, 216.

295 "SISTER SOUL": Dalí, *Unspeakable Confessions*, 90–91.

295 "COMPANIONSHIP OF GENIUS": Thirion, 180.

295 "DARLING LITTLE GIRL": *LTG*, 57 et pass.; Secrest, *Salvador Dalí*, 101.

296 ACCUSATIONS AND RESENTMENTS: Gateau, *Paul Eluard*, 168–69.

296 "SIMULACRUM" OF EXCREMENT: Dalí, *Secret Life*,

219n; Alexandre, *Mémoires*, 181; Thirion, 195.

297 "I WAS BORED TO DEATH": Dalí, *Unspeakable Confessions*, 84.

297 "HE MISTRUSTED ME": Ibid.

297 "FOR MY ACTIVITY": Dalí, *Secret Life*, 250.

297 "DISSOLVED IN LAUGHTER": Secrest, *Salvador Dalí*, 134.

297 "ON THEIR PATH UNHINDERED": "The First Dalí Exhibit," in *Break of Day*, 52–53 (trans. slightly revised); *OC 2*, 1471.

297 "EXPLANATION OF ANY KIND": Buñuel, *My Last Sigh*, 104; Haslam, *Real World*, 188. Dalí, typically, takes full credit for the film in his memoirs: see *Secret Life*, 206.

298 DISPOSED OF HIS PEBBLES: Buñuel, *My Last Sigh*, 106; Denise Tual, *Le Temps dévoré* (Paris: Fayard, 1980), 65.

298 "LASTED HALF A DECADE": Aragon, "Introduction à 1930," *RS* 12, 62.

299 "BRETON LIKED CHANGE": MP interview with Jean Schuster, 30 June 1986.

299 ATTENDING CAFÉ MEETINGS: Carassou, *René Crevel*, 182, 187.

299 FOR WEARING A CRUCIFIX: Buñuel, *My Last Sigh*, 113; Goemans to Magritte, 15 Dec. 1929, *Lettres surréalistes*, 94–95.

299 "BUT ALWAYS VERY DIGNIFIED": *Un Cadavre*, in *Tracts*, I, 135. The twelve contributors were Ribemont-Dessaignes, Prévert, Queneau, Vitrac, Leiris, Limbour, Boiffard, Desnos, Morise, Bataille, Baron, and Carpentier. (Despite Thirion's insinuation [*Revolutionaries*, 184], the members of the Grand Jeu had refused to join them.) A translation of Prévert's text appears in Nadeau, *History*, 275–76.

300 "HIS MOST BANAL APPETITES": Ibid., 145.

300 "REVEALED MY SLUG-LIKE SOUL": Ibid., 144; Jean Schuster, *Les Fruits de la passion* (Paris: L'Instant, 1988), 19. See also *Tracts*, I, 429; Virmaux, *Breton qui êtes-vous?*, 137; Masson, *Années surréalistes*, 261n. The overall project had been instigated by Bataille, possibly out of loyalty to his childhood friend Simone.

300 "IS WOEFULLY MISTREATED": *Paris-Midi* (23 Jan. 1930), quoted in Desnos, *Nouvelles Hébrides*, 471; *Tracts*, I, 426; Jean, *Au galop*, 29; Eluard to Gala, [early Feb. 1930], *LTG*, 69–70.

300 "OF THE SURREALIST EXPERIMENT": Alexandre, *Mémoires*, 56.

300 "ILL AND NERVOUS": Eluard to Gala, [early Feb. 1930], *LTG*, 70; Baron, *L'An I*, 123; *Conversations*, 117; *OC 1*, lvi.

301 "NO LONGER A PAINTER": Masson, "Breton, croquemitaine," 11.

301 DEEMED HIM A "REACTIONARY": Ibid., 121.

301 "STUPID, BASE, AND LOATHSOME": *Second Manifesto*, 167; Desnos, *Nouvelles Hébrides*, 560; Thirion, 220.

301 "BUT WELL BUILT": *Paris-Midi* (15 Feb. 1930), 1.

302 "STATION ON RUE DE LA GAÎTÉ": Ibid.; Thirion, 220–22. Georges Hugnet, with some credibility, contests numerous details of Thirion's account: see Hugnet, *Pleins et déliés*, 396–98.

302 "WHAT DESNOS MAY WRITE": *Second Manifesto*, 168.

302 "PHEASANT ANDRÉ BRETON": Ibid., 191–92.

12. In the Service of the Revolution

304 BEHOLDEN TO THE NOAILLES: Andrews, *Surrealist Parade*, 105; Corti, *Souvenirs désordonnés*, 58, 61; Steegmuller, *Cocteau*, 403. Marie-Laure de Noailles was the granddaughter of Laure de Sade.

304 ORDERS THROUGH HIS STORE: Thirion, 251.

304 BUSTER KEATON: Georges Sadoul, "L'Homme que j'ai connu," *Les Lettres françaises* (6 Oct. 1966), 15.

305 "HAD ONLY PRAISE": *Conversations*, 151; Haslam, *Real World*, 174.

305 UNTIL THE NEXT WAR: Philippe Audoin, *Les Surréalistes* (Paris: Editions du Seuil ["Ecrivains de Toujours"], 1973), 49–50; Henri Pastoureau, "André Breton, l'homme que j'ai connu," *L'Orne littéraire* 3 (Jan. 1983), 15.

305 ARCHITECT ADOLF LOOS: Thirion, 283; Billy Klüver and Julie Martin, *Kiki's Paris: Artists and Lovers 1900–1930* (New York: Harry N. Abrams, 1989), 132.

305 BITTER THAT SPRING: Cf. AB to Simone, 9 and 22 May 1930, Sator.

305 "NOT VERY PRETTY": Duhamel, *Raconte pas*, 251. A letter of Aragon's to Eluard suggests that Claire's relationship with Breton was not entirely disinterested: "He [Breton] doesn't have a dime . . . he doesn't know how he's going to pay off Claire, first of all, and everything that goes with her": Aragon to Eluard, ca. 30 July 1930, in Louis Aragon, "Lettres à Paul Eluard," *NRF* 562 (June 2002), 48. The arrangement alluded to by Aragon apparently outlasted the relationship itself, which had ended in the spring.

306 ROAD REPAIRS AHEAD: *OC 1*, 1576; Gaffé, 23.

306 "MY EYES MY HOPE MY JEALOUSY": "I Listen to Myself Still Talking," in AB, Paul Eluard, René Char, *Ralentir Travaux*, trans. Keith Waldrop (Cambridge, MA: Exact Change, 1990), 51–52.

306 FEATURING NUDE DANCERS: Gateau, *Paul Eluard*, 175; Pastoureau, *Vie surréaliste*, 360; Béhar, *André Breton*, 226–27.

307 "BASTARDS, ALL OF THEM": Eluard to Gala, [April 1930], *LTG*, 78.

307 "RIGHTS AND DUTIES OF THE MIND": *OC 1*, 1627, lxii; *Bibliographie de la France* (18 July 1930), 4468, and ibid. (7 Nov. 1930), 5963. The phrase "what is dead . . ." was a direct reference to Benedetto Croce's *What Is Living and What Is Dead of the Philosophy of Hegel*, one of Breton's main references on dialectical philosophy.

307 HIS FAVORITE CHIRICOS: Eluard to Gala, [27 April 1930], *LTG*, 80; Breton to Goemans, 18 May 1930, *Lettres surréalistes*, 100.

307 "DEMOLISH RIVAL PERIODICALS": *NRF* (1 Feb. 1930), 293.

307 "FOR THEIR PERSPICACITY": *Le Crapouillot* (1 March 1930), quoted in *OC 1*, 1591.

307 "STYLE OF A MANIFESTO": *Mercure de France* (1 April 1931), 131.

308 "MEANS ANYTHING ANYMORE": *Monde* (21 Dec. 1929), quoted in Bernard-Paul Robert, "Breton, Engels et le matérialisme dialectique," *Revue de l'Université d'Ottawa* (July–Sept. 1976), 297.

308 "WERE EINSTEIN OR FREUD": *La Critique sociale* 1 (March 1931), 35–36.

308 FURTHER INTO THE BACKGROUND: At the time, Breton noted that the *Second Manifesto* "puts an end to the first phase of Surrealist activity," and that from then on the group would operate "in ever closer relation to the action of social revolution": Unpublished autobiographical note from 1930, private collection.

308 "FROM 1896 TO 1898": *Second Manifesto*, 182n.

309 SERVICE OF THE REVOLUTION: *Le Surréalisme au service de la Révolution* (hereinafter "*SASDLR*") 1 (July 1930), 1.

309 "WAR AGAINST THE USSR": Thirion, 249–50.

309 "TOTAL INDEPENDENCE": *Conversations*, 120.

309 CHARACTERIZED THE PCF: Lewis, *Politics of Surrealism*, 97; Dominique Rabourdin, "Attitudes politiques," *Magazine littéraire* 254, 51; David Caute, *Communism and the French Intellectuals, 1914–1960* (New York: Macmillan, 1964), 110; André Thirion, *Révolutionnaires sans révolution* (Paris: Robert Laffont, 1972), 174–75 (passages omitted from the English translation); Short, "Politics of Surrealism," 11; MP interview with James Lord, 2 March 1988.

309 "MOST INTENSE FLAME": *Conversations*, 120.

309 "APPRECIABLE POLITICAL CONCESSION": Ibid., 119–20; *Tracts*, I, 433; Audoin, *Breton*, 29. Aragon claims Breton thought up the title in homage to Mayakovsky: *Œuvre poétique*, V, 97.

310 "OF TRIVIALITY AND DISGRACE?": "*Lyubovnaya lodka razbilas o bit*," in *Break of Day*, 55–56. First published in *SASDLR 1*. The essay's Russian title was taken from a line in Mayakovsky's final poem, left as a suicide note.

310 "TO MAKE ANY CONCESSIONS": Ibid., 63 (trans.

slightly revised); *SASDLR* 1, 21–22; Aragon, *Œuvre poétique*, V, 96.

310 MERELY OFFERED HOSPITALITY: Thirion, 250.

311 "TALKING ABOUT SUICIDE AGAIN": Aragon to Eluard, ca. 30 July 1930, Aragon, "Lettres à Paul Eluard," 48.

311 THEIR DIVORCE IN 1932: Hugo, *Regard de la mémoire*, 121–23, 135; Steegmuller, *Cocteau*, 133; Jean-Pierre Cauvin, "Valentine, André, Paul et les autres, or, the Surrealization of Valentine Hugo," in Mary Ann Caws, Rudolf Kuenzli, and Gwen Raaberg, eds., *Surrealism and Women* (Cambridge, MA: MIT Press, 1991), 183; Cathy Bernheim, *Valentine Hugo* (Paris: Presses de la Renaissance, 1990), 22–33, 206, 231 et pass.

311 "WAS MAGNIFICENT": Bernheim, *Valentine Hugo*, 229–30.

311 "HORNS TURNED EARTHWARD": Hugo, *Regard de la mémoire*, 318; Cauvin, "Valentine, André, Paul," 184–86; cf. Valentine to AB, 25 Aug. 1930, HRC.

311 LIAISON WITH ELUARD: Caws, et al., *Surrealism and Women*, 232.

312 "COULD NOT BE MYSELF": AB to Valentine, 29 June 1930, HRC.

312 "THAT NAME IN A DREAM": AB to Valentine, 24 July 1930, HRC.

312 "BOMB OF SURREALISM": Anne de Margerie, *Valentine Hugo, 1887–1968* (Paris: Jacques Damase, 1983), 137.

312 "PIERCING, DARTING": Hugo, *Regard de la mémoire*, 122; Margerie, *Valentine Hugo*, 54.

312 DEMIMONDAINES AND CHILD-WOMEN: Cf. *Communicating Vessels*, 75: poverty, says Breton, "had to be the case at this epoch of my life for all my potential emotion at the sight of a woman to be put in play."

313 "TRUTH ABOUT ALL THIS": Valentine to AB, 25 Aug. 1930, HRC. Many of Valentine's letters to Breton are in draft form only, and the condition of even the "finished" letters is such that it's often impossible to tell which letters were or weren't mailed: cf. Cauvin, "Valentine, André, Paul," 201.

313 "FOR MORAL SUPPORT": AB to Valentine, 24 July 1930, HRC.

313 "ENTOMOLOGICAL PRECISION": Margerie, *Valentine Hugo*, 55, 53; Hugo, *Regard de la mémoire*, 318; Cauvin, "Valentine, André, Paul," 187; AB cat., 194; Valentine to AB, 4 Oct. 1930, HRC; AB to Valentine, 7 Aug. 1930, HRC.

313 "APART FROM YOUR DAYLIGHT?": AB to Valentine, 11 Aug. 1930, HRC.

313 "WOULD ONLY GET WORSE": AB to Valentine, 8 Oct. 1930, HRC.

314 "FOR YOU AS FOR ME": Ibid.

314 ABOUT THE ELUSIVE BRETON: AB cat., 195; Gateau, *Paul Eluard*, 179.

314 "LITERARY ORIGINAL SIN": Antony Melville, introduction to AB and Paul Eluard, *The Immaculate Conception*, trans. Jon Graham (London: Atlas Press, 1990), 7. Cf. Eluard to Gala, [27 Aug. 1930]: "With Breton, I'm writing a long, five-part article on Man . . . Not bad, but what work" (*LTG,* 91).

314 "IT IS AURORA BOREALIS": *Immaculate Conception*, 103, 105.

315 SPONTANEITY, AND REVOLT: Cf. Melville, introduction to ibid., 19–20.

315 "FACULTY OF EQUILIBRIUM": "Introduction to the Possessions" (from *Immaculate Conception*), trans. Samuel Beckett, in *What is Surrealism?,* 50–51. At the risk of confusing readers with two separate translations of the same work, I can only say that Beckett's versions are so vastly superior to those of the complete text that I have used his excerpts whenever possible. They were first published in *This Quarter* (Sept. 1932): "Surrealist Number."

315 "ASSOCATIONS AND INTERPRETATIONS": "Derniers modes d'excitation intellectuelle pour l'été 1934," in Salvador Dalí, *Oui 2: L'Archangélisme scientifique* (Paris: Denoël/Gonthier ["Médiations"], 1971), 40. Other crucial influences were Hans Prinzhorn's *Artistry of the Mentally Ill*, which Breton and Eluard had discovered through Max Ernst, and Hegel's *Phenomenology of Mind*, which Breton knew in Augusto Véra's 1867 French translation.

315 "MERELY AN ILLUSION": *SASDLR* 3 (Dec. 1931), [40].

315 "I AM NOT MAD": Dalí, *Secret Life*, 349n.

315 "THE POWERS OF THE STARS": "Simulation of General Paralysis" (from *Immaculate Conception*), trans. Samuel Beckett, in *What is Surrealism?,* 52–53.

316 "BREAKING IMMEDIATELY": *Immaculate Conception*, 93. To conform with the French original, the translation has been slightly altered to erase the gender of the deceitful "person."

316 AN EDITION OF 2,116 COPIES: Corti, *Souvenirs désordonnés*, 60–61; Pastoureau, "Breton, les femmes et l'amour," 91; *OC I*, lxii.

316 "DON'T THINK I LOVE": *Recherches*, 166.

316 "SPLENDOR OF CATHOLIC MYTHS": Dalí, *Secret Life*, 252; Valentine to AB, 8 Dec. 1930, HRC; Buñuel, *My Last Sigh*, 117.

316 "THE POINT OF DELIRIUM": *Conversations*, 121. It was also technically advanced, as one of the earliest sound films to be made in France up to that time.

317 "CLAIMED TO BE SUCH": Ibid.; "L'Affaire de 'l'Age d'or,'" in *Tracts*, I, 189; *L'Avant-scène cinéma* 27–28 (15 June–15 July 1963), 23.

317 "GENTLEMEN OF THE SYNAGOGUE": Quoted in Lewis, *Politics of Surrealism*, 94.

317 "YOU MUST DO IT": *Le Figaro* (10 Dec. 1930), quoted in *Tracts*, I, 449.

317 IT COULD' BE RELEASED: Steegmuller, *Cocteau*, 410; "L'Affaire de 'l'Age d'or,'" 189; Susan Suleiman, "Between the Street and the *Salon*: The Dilemma of Surrealist Politics in the 1930s," *Visual Anthropology Review* (spring 1991), 46; René Micha, "L'Age d'or aujourd'hui," *NRF* 172, 942; Lewis, *Politics of Surrealism*, 93–94; Eluard to Gala, [27 Jan. 1931], *LTG*, 97–98.

318 BOOK PASSAGE TO MOSCOW: Thirion, 259.

318 GROUP TENSIONS BEHIND: Thirion, 255, 258–59; Daix, *Aragon*, 249; Aragon, *Œuvre poétique*, V, 141; *Communicating Vessels*, 44.

318 "SHIT AND ABJECTNESS": Georges Sadoul and Jean Caupenne, "Lettre à M. Keller, reçu premier à l'Ecole militaire de Saint-Cyr (Seine-et-Oise)," 16 Sept. 1929, in *Tracts*, I, 129.

318 FLEE THE COUNTRY ALTOGETHER: *Tracts*, I, 424–25; Georges Sadoul, "Mémoire," and related documents, *SASDLR* 1, 34–40; Buñuel, *My Last Sigh*, 120–21.

318 "DRUNKEN PRACTICAL JOKE": *Conversations*, 128.

319 OF THE OCTOBER REVOLUTION: Thirion, 266–69; Aragon, *Œuvre poétique*, V, 142; *Paillasse! (Fin de "l'Affaire Aragon"),* in *Tracts*, I, 224; Helena Lewis, "Elsa Triolet: The Politics of a Committed Writer," *Women's Studies International Forum* ix:4 (1986), 387; Lewis, *Politics of Surrealism*, 58–59, 97ff. (supplemented by conversations with Helena Lewis); *Conversations*, 129.

319 "INSTRUMENT OF THE BOURGEOISIE": Lewis, *Politics of Surrealism*, 100–2; *Conversations*, 129; cf. *Paillasse!*, 224.

319 "BUT AS COMMUNISTS": *Literature of the World Revolution* (Nov. 1931), quoted in Lewis, *Politics of Surrealism*, 104.

319 "MANIFESTO OF SUPER-REALISM": Ibid., 101, 103; Thirion, 269.

320 SHED HIS SURREALIST SKIN: Aragon, *Œuvre poétique*, V, 142–43.

320 "CONTRADICTS DIALECTICAL MATERIALISM": Aragon and Georges Sadoul, "Lettre d'autocritique," 1 Dec. 1930, in *Tracts*, I, 185–86. Recently unearthed documents suggest that Aragon and Sadoul had been made to sign the letter of repudiation at least two weeks before their departure from the USSR: cf. *OC 2*, 1292n.

320 "OF RUSSIA IN 1930": Thirion, 272, see also 271; Daix, *Aragon*, 251.

320 "HAD BEEN MET; BUT": *Conversations*, 129; Thirion, 272–73.

320 "VERTIGINOUS PROPORTIONS": *Conversations*, 129.

322 "THE SOMBER IDIOCY": AB to Eluard, 9 Jan. 1931, *OC* 2, 1294; Thirion, 263–65, 275–77, 298.

322 "OF LIFE AND DEATH": *Conversations*, 130.

322 "NERVOUS LITTLE ROBESPIERRE": Dalí, *Secret Life*, 338; *Conversations*, 130.

322 "MISERABLE MENTAL EXPEDIENT": AB and Eluard, promotional insert for Dalí's *La Femme visible*, end 1930, in *OC* 1, 1027. See also *Tracts*, I, 434; Thirion, 282.

322 "FROM SOMEONE'S ABSENCE": *Communicating Vessels*, 26, 67.

323 "REASONS FOR BEING": Ibid., 26–28.

323 "FLAGRANT ILL WILL": Gaffé, 25; cf. *Tracts*, I, 457.

323 "RELATIVELY NEUTRAL": Aragon, *Œuvre poétique*, V, 178–79; Thirion, 283.

323 "REAL COURT OF MIRACLES": *Communicating Vessels*, 95; MP interview with Marcel Jean, 1 March 1988.

323 GROUP'S PRIMARY FOCUS: Thirion, 283; Aragon, *Œuvre poétique*, V, 178–79; *Aragon parle*, 86.

323 ELECTRICITY HAD BEEN CUT: Nezval, *Rue Gît-le-Cœur*, 28; *OC* 2, xiii–xiv.

323 "HIGH-SPIRITED AND CHANGED": Manuscript notation by Valentine, 3 July 1931, HRC; AB cat., 203.

323 PAY FOR THE THIRD: Gateau, *Paul Eluard*, 183.

323 COLLECTING SURREALIST WRITINGS: Corti, *Souvenirs désordonnés*, 61–62.

324 "THE WIFE'S FAVOR": Béhar, *André Breton*, 241.

324 THE "OLD BITCH": MP conversation with Jean Schuster, 26 April 1991; Thirion, 277–78; Béhar, *André Breton*, 241.

324 THE BREAK WAS FINAL: AB to Eluard, 9 Jan. 1931, *OC* 1, 1772.

324 "A WOMAN LIKE HER": Thirion, 250.

324 "KILL LOVE BY INCHES": Jean, *Autobiography*, 190 (trans. slightly revised).

324 "INCOMMENSURABLE HARM": *Communicating Vessels*, 31.

325 CAPITALIST "HYPOCRISY": Ibid., 71.

325 "HAVE IT PROVEN TO ME": Sebbag, *Breton, L'Amour-folie*, 205–6.

325 SEEMINGLY LONG FORGOTTEN: Ibid., 186–87; Berl, *Interrogatoire*, 47. Photos taken in the spring of 1936 suggest that, even then, Suzanne was on perfectly amiable terms with Breton's second wife, Jacqueline: cf. Sebbag, *Breton, L'Amour-folie*, 186, 194.

325 "INTO A THOUSAND SHARDS": "After the Giant Anteater," in *My Heart Through Which Her Heart Has Passed*, 28. Originally published in AB, *Le Revolver à cheveux blancs* (Paris:

Editions des Cahiers Libres, 1932), 132–33.

325 "I HAD EVER BEEN LOVED": "Exhibitionistic Poem," ibid., 24. Poem dated 7 May 1931, 10:15 P.M., unpublished in Breton's lifetime.

325 ON MAY 20 AND 21: *OC* 2, 1317. The editors of Breton's complete works deny any direct connect between "Free Union" and Suzanne, calling it instead an ode to "woman in general" (ibid.). Although there is certainly an aspect of this in the poem, it nonetheless seems clear that Suzanne was its primary inspiration, as suggested both by Breton's personal circumstances at the time and by the comments of two witnesses from the period: Marcel Jean (*Autobiography*, 187) and Aragon (*Œuvre poétique*, V, cited infra).

326 "EARTH AND FIRE LEVEL": "Free Union," trans. David Antin, in *André Breton: Selections*, 89–91 (trans. slightly revised).

326 THE POEM'S AUTHORSHIP: Legrand, *Breton en son temps*, 101. The critic, Francis de Miomandre, was also the only reviewer to mention the book in the press.

326 "I RECOGNIZED THE WOMAN": Aragon, *Œuvre poétique*, V, 114–16. Aragon insists that this incident occurred in 1930, but the manuscripts of "Free Union" (in three different, complete versions) are clearly dated May 1931: see *OC* 2, 1317.

326 "BELGIAN PRINCESS MARICHAUSSÉE": "Lettre au 'Journal des Poètes,'" in *Tracts*, I, 193; *Recherches*, 182–83.

327 "SOME SHADY BUSINESS": *Communicating Vessels*, 23–24, 28–32.

327 "I BEG YOU": Ibid., 66, 74–76, 96–98.

327 DEATH FROM HEART FAILURE: Cf. ibid., 78–79. See also Jean Richer's analysis of this incident, in "Dans la forêt des signes," *NRF* 172, 830–31.

327 "KNOWS WHAT LOVE IS": Valentine to AB, 1 March 1931, HRC.

327 "WHAT I DID WRONG": Valentine to AB, 1 April 1931, HRC.

328 "WILL PUT ME TO SLEEP": Manuscript entry in Valentine's diary [ca. early 1931?], HRC.

328 "SINCE HE'S EVERYWHERE": Béhar, *André Breton*, 247–48; Roger-Jean Ségalat, *Album Eluard* (Paris: Gallimard ["Bibliothèque de la Pléïade"], 1968), 139; Margerie, *Valentine Hugo*, 54; Gateau, *Paul Eluard*, 184. Cf. Breton's remark in *Surrealism and Painting*, 10: "God, whom one does not describe, is a swine."

328 "LEAVE ME FOR AN INSTANT": Valentine's diary [ca. Aug. 1931], HRC.

328 "I LOVE YOU": AB to Valentine, 31 July [1931], HRC.

328 CONNECTING THEIR ROOMS: Cf. AB to

Valentine, loose note, 18 Sept. 1931, HRC: "Valentine. I love you. André. Good night, Valentine."

328 "HAS LOST IN ADVANCE": Thirion, 292 (trans. slightly revised).

329 "AND BACK AGAIN": Margerie, *Valentine Hugo*, 56n, 53; Steegmuller, *Cocteau*, 412; Hugo, *Regard de la mémoire*, 322.

329 SURREALISM'S PRIVILEGED SITES: Biro, et al., *Dictionnaire général*, 90; Margerie, *Valentine Hugo*, 54; Béhar, *André Breton*, 249; AB to Tzara, 27 July [1931; misfiled as 1933], Doucet. On Cheval: Robert Hughes, *The Shock of the New* (New York: Alfred A. Knopf, 1982), 229–31.

329 SADOUL'S MISADVENTURES IN KHARKOV: Sadoul, "Homme que j'ai connu," 15–16; *Communicating Vessels*, 31; Schuster, *Fruits de la passion*, 16.

329 "STYLE OF THE MANIFESTOES": AB to Tzara, [26 Aug. 1931], Doucet.

330 "AND THAT OF SLEEPING": *Communicating Vessels*, 139; see also Mary Ann Caws, introduction to ibid., ix.

330 "BEST OF [HIS] WORKS": AB, text of a lecture on "Surrealism and knowledge," Mexico City, ca. May 1938, in *OC* 2, 1279; cf. *Conversations*, 133.

330 "ARCADES OF THE HOTEL": *Communicating Vessels*, 30.

330 "DID NOT REVISE AGAIN": Sadoul, "Homme que j'ai connu," 15–16; Eluard to Valentine, [ca. 12 Sept. 1931], HRC; Bernheim, *Valentine Hugo*, 259; *OC* 2, 1349–50.

330 "PSYCHOANALYSIS OF REALITY": AB, marginal note on ms. of *Communicating Vessels*, quoted in *OC* 2, 1353.

331 "THEIR INTERIOR DEVELOPMENT": *Communicating Vessels*, 146–47

331 WORLD CAN BE ACHIEVED: Cf. Caws, introduction to *Communicating Vessels*, xiv.

331 "TOTALLY PRAGMATIC": *Communicating Vessels*, 122, 125–27.

331 "REVOLUTION ON ITS WAY": Ibid., 136.

331 "OF DIALECTICAL CONCEPTION": Ibid., 14.

331 "ONE CLASS BY THE OTHER": Ibid., 121.

332 "WRITE FOR THE MASSES": Meeting minutes, 6 Oct. 1931, quoted in Thirion, 293, see also 285, 324.

333 "HAIL TO / THE RED / ARMY": Aragon, *The Red Front*, trans. e. e. cummings (Chapel Hill, NC: Contempo Publishers, 1933), [n.p.]. See Aragon, *Œuvre poétique*, V, 145–46.

333 "OF ANARCHIST PROPAGANDA": Aragon, *Œuvre poétique*, V, 301.

333 "OCCASIONAL VERSE": AB, *Misère de la Poésie*, in *Tracts*, I, 218. First published as a pamphlet by Editions Surréalistes, March 1932. A partial English translation, by Richard Howard, was

published as *The Poverty of Poetry* in Nadeau, *History*, 296–303.

333 "MEMBERS OF THE CP": Meeting minutes, 6 Jan. 1932, file of manuscript documents relating to the Aragon Affair, BN.

333 "TO YOUR NEXT MEETING": AB to Jean Fréville, [ca. 7 Jan. 1932], Aragon Affair file, BN.

334 "BUT FRIENDLY AND CORDIAL": AB to Aragon, 15 Jan. 1932, Gaffé, 26.

334 "OPINION IN HIS FAVOR": *Conversations*, 131.

334 "THEIR PRECIOUS PERSON": *Misère de la Poésie*, 218, 210; *Tracts*, I, 465; Eluard to Gala, [2 Feb. 1932], *LTG*, 120; Haslam, *Real World*, 214; Thirion, 301–2; Maurice Martin du Gard, *Les Mémorables*, III (1930–1945) (Paris: Grasset, 1978), 84; Lewis, *Politics of Surrealism*, 110.

334 "BOURGEOIS DEGENERATES": Pierre Unik to Maurice Thorez, [ca. 1 Feb. 1932], Gaffé, 26; Alexandre, *Mémoires*, 209–10.

334 "BETWEEN MEN AND WOMEN": *Misère de la Poésie*, 219n.

334 "ONE DAY IN FOUR": Pastoureau, "Breton, l'homme que j'ai connu," 9.

335 "PARTY'S OWN WATCHWORDS?": *Misère de la Poésie*, 213, 215.

335 "IN THE SOCIAL STRUGGLE": Ibid., 218.

335 BEING "POETICALLY REGRESSIVE": Ibid.

335 NONE OTHER THAN "RED FRONT": MP interviews with Edouard Roditi, 21 April and 11 June 1987; Edouard Roditi, "Publisher of the Surrealists," unpublished manuscript, courtesy of the author; *Le Temps* (8 May 1932), 1–2, and following issues; cf. Aragon, *Œuvre poétique*, V, 327.

336 "WE WERE UP AGAINST": *Conversations*, 131; Daix, *Aragon*, 265. In his own account, Aragon suggests that someone else reported the remark to Breton: see Aragon, *Œuvre poétique*, V, 308.

336 "EXCUSE FOR EXPELLING ME": Aragon, *Œuvre poétique*, V, 304–10.

336 "WITH THE CLASS STRUGGLE": *L'Humanité* (10 March 1932), quoted in *Paillasse!*, 223; Daix, *Aragon*, 265.

336 "POEM WHICH I HATE": Aragon, *Œuvre poétique*, V, 141.

336 "WHICH NEVER HEALED": Ibid., 310.

337 "NO LONGER WITH US": Alexandre, *Mémoires*, 211; Sadoul to AB, 7 March 1932, and Buñuel to AB, 6 May 1932, Aragon Affair file, BN.

337 "TOO MODERATE": Crevel to Dalí and Gala, [ca. March 1932], cited in Paul Eluard, *Lettres à Gala, 1924–1948*, ed. Pierre Dreyfus (Paris: Gallimard, 1984), 441. The French edition contains copious notes, not included in *LTG*.

337 "THAT COATTAILED FLUNKY": Eluard to Gala, [15 March 1932], *LTG*, 127, see also 131.

337 "NO LONGER TOUCHES ME": Paul Eluard, *Certificat*, in *Tracts*, I, 229–30.

337 "TENDER SOULS": *Conversations*, 132; Alexandrian, *Surréalisme et rêve*, 368; MP conversation with Jean Schuster, 1 March 1988.

337 "REOPENED EVERY TIME": *Conversations*, 172.

13. The Great Undesirable

338 "OF GREAT UNDESIRABLES": AB, "Jugement de l'auteur sur lui-même," [unpublished manuscript, ca. 1931], Doucet.

338 "RENEWABLE MINORITY": *Conversations*, 173. Pedro de Luna was also known as Benedict XIII of Avignon.

338 THE STALINIST ORTHODOXY: Relations with the Party were further strained when the Surrealists openly protested two Communist-backed peace conferences: the Amsterdam conference of Aug. 1932 and the rally held in Paris's Salle Pleyel in June 1933. Cf. the collective tract "La Mobilisation contre la Guerre n'est pas la Paix," in *Tracts*, I, 241–44, against the Amsterdam conference (which José Pierre [ibid., 480] misdates as Aug. 1933). See also *Paris–Moscou, 1900–1930*, exh. cat. (Paris, Centre Pompidou, 31 May–5 Nov. 1979), 466; Thirion, 322–26; Herbert Lottman, *The Left Bank: Writers, Artists and Politics From the Popular Front to the Cold War* (Boston: Houghton Mifflin, 1982), 50–52; Jean-Charles Gateau and Georges Nivat, "Les Surréalistes et l'U.R.S.S.: histoire d'une déclaration," *Cahiers du 20ème siècle* 4 (1975), 149–54.

339 "LAY OUT AN ENEMY": Virgil Thomson, *Virgil Thomson: An Autobiography* (New York: Obelisk Books, 1985), 94; MP interview with Virgil Thomson, 5 May 1987; Biro, et al., *Dictionnaire général*, 210.

339 "HE OCCASIONALLY REFILLED": Pastoureau, "Breton, l'homme que j'ai connu," 14–15.

339 "CORRECTING THEIR HOMEWORK?": AB to Tzara, 19 July 1932, *DAP*, 459.

340 "DISCUSSION WAS EVOLVING": Thirion, 261.

340 "EXCEPTIONAL ALLOWANCES": James Lord, *Giacometti: A Biography* (New York: Farrar, Straus & Giroux, 1985), 119; unpublished notes for *Giacometti*, courtesy James Lord; AB cat., 206.

340 "RAPPORT WAS ABSOLUTE": Thirion, illust. p. 5.

340 "THE HEAD OF VERCINGETORIX": *Immaculate Conception*, 105; Valentine Hugo, unpublished notes, 11–13 March 1932, HRC (hereinafter "VH notes").

341 "THAT WAS HELL": Margerie, *Valentine Hugo*, 54; VH notes, 31 March, 3 and 5 April 1932. The postcard is reproduced in *NRF* 172, illust. p. 8.

341 "PLEASE DON'T SAY THAT": Valentine to AB, 10 May 1932, HRC; cf. Valentine to AB, 9 May 1932, HRC. The American editor was most likely Edward W. Titus of *This Quarter*, who published a special issue on Surrealism in September of that year.

341 SECRETLY HAPPENING ELSEWHERE: MP conversation with Georges Bernier, 13 March 1988. Victor Crastre (*André Breton*, 91) also speaks of the group changing cafés "to throw off a few bores who had become bothersome."

341 STUDIO AT 42 RUE FONTAINE: Chadwick, *Women Artists*, 195; VH notes, 8 May 1932; Eluard to Gala, [April 1933], *LTG*, 172.

341 "LITTLE TROPICAL BIRD": Pastoureau, "Breton, les femmes et l'amour," 92. Consuelo's friend Madeleine Goisot has privately suggested as much (Madeleine Goisot to MP, 17 March 1993), and Consuelo more or less confirms it in her description of a brief and ultimately unconsummated dalliance at this time with a poet named André: see Consuelo de Saint-Exupéry, *The Tale of the Rose*, trans. Esther Allen (New York: Random House, 2001), 119–21. As a footnote to Breton's infatuation, an unpublished dream narrative dated Christmas 1933 begins: "I marry Consuelo . . . (At the same time?) I make love to Consuelo in a room, the door to which remains open despite my protests . . .": quoted in *André Breton 42, rue Fontaine: manuscrits,* auction cat. (Paris: CalmelsCohen, 11–12 April 2003), item 2179.

341 "FRIENDLY BASIS WITH HIM": Eluard to Gala, [ca. 10 July 1932], *LTG*, 139.

341 THE IMAGE OF GANYMEDE: Margerie (*Valentine Hugo*, 67) reproduces a portrait of Breton by Valentine, ca. 1932, with a clear image of Ganymede in the background.

342 10 DELUXE AT 500 FRANCS: *Bibliographie de la France* (28 Oct. 1932), 3978–79; cf. *OC 1*, 530.

342 "TENDS TO BECOME REAL": "Once Upon a Time to Come," in *Earthlight*, 90.

342 "THE ACT OF LOVE": Ibid., 91.

342 "ALL SURREALIST LITERATURE": Georges Bataille, *Œuvres complètes*, I (Paris: Gallimard, 1970), 324–25. First published in *La Critique sociale* 7 (Jan. 1933).

342 "DIMINISHED ACTIVITY": Ibid., 323.

343 "PURPOSE IS UNKNOWN": Nadeau, *History*, 185.

343 "OBJECTS ARE MAKING LOVE!": René Crevel, *Dalí ou l'anti-obscurantisme* (Paris: Editions Surréalistes, 1931), 23.

343 BEGINNING TO APPEAR: Legrand, *Breton en son temps*, 119.

343 "PERCEPTION OF A LACK": Nadeau, *History*, 188; *Conversations*, 126.

344 "AN INCLINED CRESCENT": *Conversations*, 126.

344 "GREATEST AFFINITY WITH YOU": Dalí, *Secret Life*, 251, 313.

344 INTEREST IN POLITICS: *Conversations*, 143; Dalí, *Secret Life*, 252.

344 "OF THE SURREALIST SPIRIT": *Conversations*, 124.

344 "TEARS CAME TO HIS EYES": Robert Benayoun, *Le Rire des surréalistes* (Paris: La Bougie du Sapeur, 1988), 47n; Claire Goll, *La Poursuite du vent*, in collaboration with Otto Hahn (Paris: Olivier Orban, 1976), 244; Brassaï, *Picasso and Company*, trans. Francis Price (Garden City, N.Y.: Doubleday, 1966), 31–32; Nadeau, *History*, 183–84.

345 TOOK TO THE HIGHWAY: VH notes, 4 Aug. 1932, HRC; AB to Tzara, 19 July 1932, *DAP*, 460.

345 "ON THE GROUND": VH notes, 9 Aug. 1932, HRC; AB to Tzara, 31 Aug. 1932, Doucet.

345 "NUDE ON A ZEBRA": Manuscript dated 9 Aug. 1932, HRC; Margerie, *Valentine Hugo*, 71.

345 RATHER THAN ENJOYING IT: VH notes, 5, 6 and 9 Sept. 1932, HRC.

345 "VERY, VERY PLEASANT": AB to Eluard, 11 Sept. 1932, HRC; VH notes, 27 and 29 Aug., 7–10 Sept. 1932, HRC.

346 "ENCORE LATER THAT NIGHT": AB to Eluard, 11 Sept. 1932, HRC.

346 "BREASTS OR BUTTOCKS": Ibid.

346 "'CHILDLIKE' SIDES ABOUT HER": AB to Eluard, 19 Sept. 1932, HRC.

346 "ANDRÉ HERE": Eluard to Valentine, [ca. 19 Sept. 1932], Béhar, *André Breton*, 260; Valentine to AB, 11 Sept. 1932, HRC.

347 "IN ALL THE WORLD": Valentine to AB, 29 Dec. 1932, HRC.

347 "BEFORE HER EYES": VH notes, 25 Dec. 1932, HRC.

347 "AWKWARD ATTEMPT AT LIVING": AB dedication to René Gaffé, [ca. Nov. 1932], Gaffé, 27; *Bibliographie de la France* (25 Nov. 1932), 4428–29.

347 "AN INTEREST IN REVOLUTION?": Maurice Parijanine, "Mystique surréaliste," *Les Humbles* (June 1933), 3–10.

348 "SO DISTANT FROM ART": Freud to AB, 26 Dec. 1932, quoted in *Communicating Vessels*, 152, see also 11, 149–51.

348 CONDESCENDING REBUTTAL: AB to Freud, [early 1933], ibid., 154. The complete exchange was first published in *SASDLR* 5 (15 May 1933).

348 "THIS NEW CONTEXT": Thirion, 331–32 (trans. slightly revised); Aragon, *Œuvre poétique*, V, 351–52; André Thirion, *Révisions déchirantes* (Paris: Le Pré aux Clercs, 1987), 19; Short, "Politics of Surrealism," 18.

348 "GUIDE TO GENERAL LITERATURE": "On the Proletarian Literature Contest Sponsored by *L'Humanité*," in *Break of Day*, 87. First published in *SASDLR* 5.

348 "FASCISM VERSUS CULTURE": Thirion, 344; "Protestez!" in *Tracts*, I, 238–40, see also 478–80; Lewis, *Politics of Surrealism*, 119.

348 "IN THE AEAR AGAIN": Eluard to Gala, [23 March 1933], *Lettres à Gala*, 210. Browner (*LTG*, 168) mistranslates the phrase as "I don't think we're close to knocking the AEAR on its ear."

349 "HARD WORK HAS GOTTEN US": AB to Eluard, 11 March 1933, *OC* 2, 1493.

349 "BLOWING FROM THE USSR": Ferdinand Alquié to AB, 7 March 1933, *SASDLR* 5, 43.

349 "THROUGH THAT LETTER": *Conversations*, 133.

349 "THE REVOLUTIONARY MASSES": Paul Nizan, article from July 1933, quoted in Lewis, *Politics of Surrealism*, 121.

349 "LEFT HIM RATHER DISTRAUGHT": Thirion, *Révisions*, 21. In the minutes of the AEAR Executive Committee meeting of 27 June 1933, Breton is said to be drummed out for his "counter-revolutionary attitude": *OC* 2, xl. See also *Conversations*, 132; Eluard to Bousquet, [early June 1933], *Lettres à Bousquet*, 84–85.

349 NOT HAVE ANOTHER MAGAZINE: Eluard, *Lettres à Gala*, 452–53; AB cat., 206.

350 THE WHOLE THING TOGETHER: Carassou, *René Crevel*, 227; Eluard to Gala, [ca. 10 April 1933], *LTG*, 170; Pierre Daix, *Picasso créateur* (Paris: Editions du Seuil, 1987), 425; Brassaï, *Picasso and Company*, 10. "Picasso in His Element" was reprinted in both *Break of Day* and *Surrealism and Painting*. Lacan, who had begun frequenting the Surrealists shortly before, would also contribute a study of the homicidal Papin sisters to a later issue of *Minotaure*. His relations with the group ended in 1934, after he sent Breton an invitation to his church wedding. Breton ripped the card into pieces and mailed them, without comment or further contact, back to the groom-to-be: Roger Caillois, *Rencontres* (Paris: Presses Universitaires de France, 1978), 291.

350 "CONTINUAL MISFORTUNE": "The Automatic Message," in *Break of Day*, 130. First published in *Minotaure* 3–4 (12 Dec. 1933).

350 NEITHER WIFE NOR LOVER: Pastoureau, *Vie surréaliste*, 309.

351 "KNOW HOW TO WRITE": Eluard to Valentine, 30 Aug. 1933, HRC; Eluard to Gala, [ca. 20 Sept. 1933], *LTG*, 182.

351 THE DOCUMENTS FACTION: Cf. Eluard to Gala, various letters Sept. 1933, *LTG*, 177–82.

351 ABOUT NAZISM AT THIS TIME: Cf. "Protestez!" 238–40.

352 "GUSTATORY THRILL": Dalí, *Unspeakable Confessions*, 125; Secrest, *Salvador Dalí*, 135, 175.

352 "PAINTED AS A CARNIVAL": Thirion, 56.

352 "FELL INTO HIS ARMS": Jean, *Au galop*, 27.

352 "THE WOMAN'S VULGARITY": MP interview with André Thirion, 9 March 1988.

352 "HE HAD TO TAKE IT": MP interview with Virgil Thomson, 5 May 1987.

352 BRETON HAD GIVEN HER: Pastoureau, "Breton, les femmes et l'amour," 92; MP interviews with Virgil Thomson, Myrtille Hugnet, 2 March 1988, and Marcel Jean, 1 March 1988; Georges Bernier to MP, 12 April 1988.

352 "CELIBATE FOR TWO YEARS": *Recherches*, 165.

352 "MY WIFE HERE FORETOLD": Béhar, *André Breton*, 243.

352 OF THEIR MEETING: *OC* 2, 1317–18.

353 "VORACIOUSLY LIKE A CANNIBAL": *Salvador Dalí*, exh. cat. (Paris: Centre Pompidou, 18 Dec. 1979–14 April 1980), 162.

353 HIS "SECOND FATHER": Dalí, *Unspeakable Confessions*, 112; cf. Dalí, *Diary of a Genius*, 10.

353 "MEANING OF THE PROBLEM": AB to Dalí, 23 Jan. 1934, and Dalí to AB, 25 Jan. 1934, in Karin von Maur, "Breton et Dalí, à la lumière d'une correspondance inédite," AB cat., 197–99.

353 "GLORIFY NAZI FASCISM": AB to Dalí, 3 Feb. 1934, ibid., 201; Hugnet, *Pleins et déliés*, 253–54.

353 ENIGMA REMAINED INTACT: Hugnet, *Pleins et déliés*, 256.

354 "COLLAR OF HIS COAT": Ibid., 257–58.

354 "PLUMP EDIBLILITY": Ibid., 259.

354 "THIS CRAP ABOUT HITLER?": Jean, *History of Surrealist Painting*, 220 (trans. slightly revised).

355 "WOULDN'T ADVISE IT, MY FRIEND": Dalí, *Unspeakable Confessions*, 126 (trans. slightly revised); Hugnet, *Pleins et déliés*, 260–61; Jean, *History of Surrealist Painting*, 220.

355 "DIDN'T GIVE A FIG": Dalí, *Unspeakable Confessions*, 126.

355 TO THROW HIM OUT: Ibid., 111–12; Hugnet, *Pleins et déliés*, 257–62; Jean, *History of Surrealist Painting*, 220.

356 "A 'PROLETARIAN' CHARACTER": Thirion, 348.

356 RESIGNATION SEVERAL DAYS LATER: Lottman, *Left Bank*, 76–77; Buñuel, *My Last Sigh*, 111; Helen Schawlow, *Prisons and Visions: Pierre Unik's Journey from Surrealism into Marxism* (New York: Peter Lang, 1989), 73; *L'Humanité* (6, 7, 8, 10, and 13 Feb. 1934), pass; Haslam, *Real World*, 219–28; *Tracts*, I, 490; Thirion, 348–49; Hugnet, *Pleins et déliés*, 263; Lewis, *Politics of Surrealism*, 123–24; Jean, *Au galop*, 39–40; Amédée Ozenfant, *Mémoires, 1886–1962* (Paris: Seghers, 1968), 274–77. The number of casualties varies with different accounts; the figures

cited here are taken from the most reliable newspaper reports of the time.

356 "LIVE THE GENERAL STRIKE!": *Appel à la lutte*, in *Tracts*, I, 262–63. Breton (*Conversations*, 137) makes it sound as if the tract was his idea, which is contradicted by the eyewitness accounts of Marcel Jean (*Au galop*, 40) and Louis Chavance ("L'Appel à la lutte," *Le Monde libertaire* [Nov. 1966], 8).

357 "TO DILATORY STATEMENTS": *Conversations*, 137; Lottman, *Left Bank*, 81.

357 AWASH IN BLOOD: Hugnet, *Pleins et déliés*, 263; Thirion, 350 (the French edition contains a more detailed description); Aragon, *L'Œuvre poétique*, VI (Douai: Livre Club Diderot, 1975), 22–23; Eluard to Valentine, [22 Nov. 1934], HRC.

357 "WE PARTED": Aragon, *Œuvre poétique*, VI, 24.

357 COMMUNIST PARTY MACHINE: Thirion, 349, 366; Carassou, *René Crevel*, 235–36; Lottman, *Left Bank*, 77–78; cf. Dominique Rabourdin, "Attitudes politiques," *Magazine littéraire* 254, 51; *L'Humanité*, editorials from Feb. 1934.

358 "A NEW AND HAPPIER RACE": *La Planète sans visa* [24 April 1934], in *Tracts*, I, 268–69.

358 "FED UP WITH THEM": Eluard to Gala, 13 March [1934], *LTG*, 191.

358 "DO WITHOUT THAN EATING": Eluard to Gala, [ca. 27 March 1934], ibid., 193.

359 DISAPPOINTMENTS AND DISGRUNTLEMENTS: AB to Gallimard, 12 May and 28 Feb. 1934; Brice Parain to AB, 5 March 1934. *Nadja* sales figures: internal memo, 13 July 1934 (all documents: *NRF* archives).

359 UNDER CONTRACT ON FEBRUARY 26: Gallimard to AB, 26 Feb. 1934. See also AB to Gallimard, 25 Nov. 1933; Gallimard to AB, 14 Dec. 1933; internal memo, 28 Feb. 1934; Gallimard to AB, 2 July 1934; AB to Gallimard, 9 July 1934 (all documents: *NRF* archives).

360 "REASONING EPOCH": "What is Surrealism?," in *What is Surrealism?*, 116, 127.

360 "OF CAPITALIST SOCIETY": Ibid., 139.

360 "CHEMISTS AND TECHNICIANS": Ibid.

360 "BY THE WAYSIDE": Ibid., 118.

360 "INTRODUCTION TO SURREALISM": *Mercure de France* (1 Nov. 1934), 565–66; cf. *Cahiers du Sud* 168 (1er semestre 1935), 63.

360 "AND EXTREMELY BORING": Marcelle Ferry to Valentine, 26 May 1934, HRC.

361 "BE ENTWINED WITH MINE": *Mad Love*, 41–42.

361 "A MORE TOUCHING SCENE?": Ibid., 19, 42, see also 22; Nezval, *Rue Gît-le-Cœur*, 55.

361 "NATURALLY, NOTHING": *Mad Love*, 42.

361 "FIERY, VIGOROUS": MP interview with Mary Jayne Gold, 16 May 1989; *OC* 2, 1720.

361 "ONE WAY OR ANOTHER": Teri Wehn Damisch interview with Jacqueline Lamba, in Salomon Grimberg, *Jacqueline Lamba: In Spite of Everything, Spring*, exh. cat. (East Hampton, N.Y.: Pollock-Krasner House and Study Center, 2001), 9–10, et pass.; André Delons to Jacqueline, 2 Feb. 1933, in André Delons, *Au carrefour du Grand jeu et du surréalisme* (Mézière-sur-Issoire: Rougerie, [1988]), 76–77; Schwarz, *Breton, Trotsky*, 212.

362 "DIDN'T REALLY SEE ME": MP telephone conversation with Jacqueline Lamba, 24 Feb. 1988; Pastoureau, "Breton, les femmes et l'amour," 93; *OC* 2, 1720.

362 "LIKE A SUNFLOWER": *Mad Love*, 45–47.

362 "THE SHAPE OF A BREAST": Ibid., 45.

362 "POSSIBLE PREDICTIVE FORCE": Ibid., 53.

362 "LIE DOWN AND GO TO SLEEP": AB to Jacqueline, 30 May 1934, *OC* 2, 1717.

363 "BECOMES PART OF LOVE": "Sunflower," in *André Breton: Selections*, 71–72.

363 "SUITE OF DISCOVERIES": *Mad Love*, 55.

363 "NIGHT OF THE SUNFLOWER": Ibid., 64.

363 DANCE AT THE COLISÉUM: See ibid., 53–63.

364 "TOWARD OUR LITTLE GATHERING": Jean, *Au galop*, 44. Jacqueline's letter, dated 15 Dec. 1933, was among the private papers brought to light by the Breton auction in 2003; my thanks to Georges Sebbag for bringing it to my attention.

364 DREAMLIKE PREDESTINATION: Cf. *Mad Love*, 42–43.

364 HAD TRAVELED WITH HIM: "Accomplissement onirique et genèse d'un tableau animé," in AB, ed., *Trajectoire du rêve* (Paris: G.L.M., 1938), 58; *OC* 2, xli.

364 "MUST SURPASS ITSELF": Crevel to Tzara, [ca. 20 Sept. 1934], in René Crevel, *Les Pieds dans le plat* (Paris: Jean-Jacques Pauvert, 1979), 308.

364 THE MATTER DROP: Carassou, *René Crevel*, 238.

365 TO LEAVE ANDRÉ ALONE: *OC* 2, 1720; MP interview with Virgil Thomson, 5 May 1987.

365 UNDERWATER AT THE COLISÉUM: James Lord, unpublished *Giacometti* notes; Pastoureau, "Breton, l'homme que j'ai connu," 15.

365 "MIGHT APPEAR BEFORE ME": AB to Jacqueline, 4 Aug. 1934, *OC* 2, 1549.

365 MARRIED AT THE TOWN HALL: *Mad Love*, 67.

365 LE DÉJEUNER SUR L'HERBE: Pastoureau, *Vie surréaliste*, 392; AB cat., 215.

365 "OR BETTER ABOUT US": Balakian, *André Breton*, 143; *OC* 2, 1546.

365 "EXPLAINING EACH SENTENCE": Balakian, *André Breton*, 143.

365 "GILD THE EARTH AGAIN": AB, *The Air of Water*, in *Earthlight*, 144.

365 "FOR THE FIRST TIME": Ibid., 159.

365 "PAINFUL MATERIAL CONDITION": AB to René Lalou, 15 June 1934, BN.

366 "WE'LL HAVE TO ACT": AB to Marco Ristich, 17 Aug. 1934, in Marco Ristich, "La Nuit du Tournesol," *NRF* 172, 705; *OC* 2, xlii.

14. On the International Stage

367 "MAD TEA PARTY": Doré Ashton, "Cocteau and His Times: An Intellectual Backdrop," in Doré Ashton, ed., *Jean Cocteau and the French Scene* (New York: Abbeville Press, 1984), 64.

367 "LOOK LIKE A BEAR": Jean, *Au galop*, 44.

367 "WITHOUT PRECONCEIVED OBJECT": *Surrealism and Painting*, 128; Biro, et al., *Dictionnaire général*, 131.

367 "CAFÉ DE LA PLACE BLANCHE": Hans Bellmer to Roland Valençay, 5 March 1935, AB cat., 220; Biro, et al., *Dictionnaire général*, 55.

367 CONTACTS WITH PARIS: Biro, et al., *Dictionnaire général*, 62–63.

368 READILY AGREED: AB to Nezval, 20 Dec. 1934 and 18 Jan. 1935, in Philippe Bernier, "Le Voyage à Prague," AB cat., 223.

368 "GAME OF CHESS": *Second Manifesto*, 170; Robert Lebel, *Marcel Duchamp* (Paris: Pierre Belfond ["Les Dossiers Belfond"], 1985), 239.

368 "HISTORICALLY REDUNDANT": Lord, *Giacometti*, 154.

368 "WHAT A HEAD IS!": Ibid.

368 SURREALIST WORKS AS "MASTURBATION": Ibid., 154–55; AB cat., 220.

368 "BEFORE WE UNDERSTAND": "Fronton-Virage," in *Free Rein*, 179.

368 "ADORABLE" MARVELS: Caillois to AB, 27 Dec. 1934, in Roger Caillois, *Approches de l'imaginaire* (Paris: Gallimard, 1974), 35–38; Roger Caillois, "Divergences et complicités," *NRF* 172, 686–89; Roger Caillois, *Rencontres* (Paris: Presses Universitaires de France, 1978), 293; Jean, *Au galop*, 43; Maxime Alexandre, *Journal, 1951–1975* (Paris: José Corti, 1976), 213. In "Fronton-Virage" (p. 178), Breton claims that Lacan was a witness to this incident, and has been seconded on faith by Alexandrian (*Surréalisme et rêve*, 464) and Béhar (*André Breton*, 279). But given that the episode took place several months after Lacan's break with the Surrealists, Caillois's refutation of this claim is more likely.

369 "BEST DISTRIBUTED NEWSPAPERS": Dalí to Eluard, [fall 1934], Gateau, *Paul Eluard*, 207.

369 "BELIEVE IN BRETON": Henri Rode, *Marcel Jouhandeau et ses personnages* (Paris: Frédéric Chambriand, 1950), 132.

369 "THE IMMEDIATE PRESENT": Carassou, *René Crevel*, 253.

369 SERIOUS ISSUES AT HAND: Crevel to Tzara, 6 March 1935, Crevel, *Pieds dans le plat*, 315.

370 "NO MORE, IT'S OVER": Crevel to Tzara, 21 Jan. 1935, ibid., 313.

370 "ANY REASON AT ALL": AB to Eluard, 2 March 1935, *OC* 2, xliii. See also "Lettre aux *Cahiers du Sud*," in Tristan Tzara, *Œuvres complètes*, V (Paris: Flammarion, 1982), 258–59; Gateau, *Paul Eluard*, 208–9, 217; Carassou, *René Crevel*, 243, 246, 248–49; Crevel, *Pieds dans le plat*, 292; Thirion, *Révisions*, 25–26; *Tracts*, I, 290–91, 501–2; *Tracts*, II, 445; MP conversation with Florence Delay, 13 Nov. 1990. Breton scarcely reacted to the epistolary maneuvers occurring behind his back, though in late December he had told Eluard that he was thinking "very seriously of publishing a *Final Manifesto of Surrealism*, which will raise some hackles" (AB to Eluard, 30 Dec. 1934, *OC* 2, xlii). Apparently no such text was drafted.

370 "DOUBT THE OTHER. EVER": Eluard to Valentine, [ca. Jan. 1935], Robert D. Valette, *Eluard: Livre d'identité* (Paris: Henri Veyrier/Tchou, 1983), 134; Eluard to Tzara, 20 March 1935, Doucet; Eluard to Gala, 22 Feb. 1935, *LTG*, 202; Gateau, *Paul Eluard*, 210–12.

370 "SOME SORT OF IMPROVISATION": AB to Nezval, 18 Jan. 1935, Bernier, "Voyage à Prague," 223; *OC* 2, xliii.

371 LEAVING NUSCH AT HOME: AB to Man Ray, 4 March 1935, HRC; AB to Valentine, [14?] March 1935, HRC; Gateau, *Paul Eluard*, 213. The editors of *OC* 2 (p. xliii) claim that Nusch went to Prague as well, but Eluard's correspondence and other accounts would indicate the contrary.

371 COMMUNISTS AS WELL: Bernier, "Voyage à Prague," 223; Gateau, *Paul Eluard*, 213–14; Nezval, *Rue Gît-le-Cœur*, 49.

371 "FORMS OF THE REAL WORLD": *Political Position of Surrealism*, in *Manifestoes*, 260.

371 "FOR THE ADULT MAN": Ibid., 277–78.

371 "A TRIUMPHANT WELCOME": AB to Valentine, 30 March 1935, HRC.

371 "HISTORICAL MEANING": *Political Position*, 233.

371 "BEING TOTALLY HUMAN": Ibid., 220.

372 "QUITE ILLUSORY": Quoted in Gateau, *Paul Eluard*, 214; Alexandrian, *Breton par lui-même*, 110.

372 "ADMIRATION AND AFFECTION": Eluard to Gala, 7 April [1935], *LTG*, 206.

372 "ALTHOUGH SINCERE, RANG FALSE": Jean, *Au galop*, 47.

372 "MEMORIES OF HIS LIFE": AB to Nezval, 14 April 1935, Bernier, "Voyage à Prague," 225.

372 "OF ALL OF EUROPE": Emmanuel Guigon and Edouard Jaguer, "Autour du Château Etoilé," *Docsur* 7 (March 1989), 1–2; Eluard to Gala, 2 May 1935, *LTG*, 207. See also *Mad Love*, 67–97; Nezval, *Rue Gît-le-Cœur*, 26.

373 "OPPOSITE IN SPANISH!": Quoted in Michael Richardson, ed., *The Dedalus Book of Surrealism: The Identity of Things* (Sawtry, Cambs.: Dedalus, 1993), 81.

373 "ANY EXCUSE NOT TO MOVE": Jean, *Au galop*, 47; Béhar, *André Breton*, 286.

373 "AS MUCH AS ONE THINKS": "Interview with 'Indice,'" in *What is Surrealism?*, 146 (trans. slightly revised); Guigon and Jaguer, "Autour du Château Etoilé," 4.

373 "A MAJOR RESPONSIBILITY": MP interview with Edouard Roditi, 21 April 1987.

373 "PATHOLOGICAL PHENOMENON": Quoted in Jean-Claude Blachère, *Les Totems d'André Breton: Surréalisme et primitivisme littéraire* (Paris: L'Harmattan, 1996), 138. My thanks to the author for having let me consult his work in manuscript for the first edition of this biography.

374 "AND IN NOTHING ELSE": AB to Jacqueline, 22 April 1935, *OC* 2, 1735; Nezval, *Rue Gît-le-Cœur*, 27–28; cf. Eluard to Gala, [ca. end July 1935], *LTG*, 209.

374 PRESENTED BY BRETON: Edouard Roditi, "Publisher of the Surrealists," unpublished manuscript; MP interview with Edouard Roditi, 21 April 1987. Breton's first mention of the anthology appears to have been a brief proposal addressed to Edmond Bomsel, editorial director of Sagittaire, on 11 Feb. 1935: see *OC* 2, 1760–63.

374 "SUPERIOR REVOLT OF THE MIND": *Anthology of Black Humor*, xvi..

374 "ENEMY OF SENTIMENTALITY": Ibid., xix.

374 "WAY TO START THE WEEK!'": Ibid., xviii.

374 "AT THE EXPENSE OF OTHERS": AB, "Eclosion et prolifération sociale d'Ubu," in *Tracts*, I, 314.

374 "OWN PREVIOUS WRITINGS": Roditi, "Publisher of the Surrealists."

375 TO CAPITALIST INTERESTS: Ilya Ehrenburg, "La Littérature française contemporaine vue par un écrivain soviétique," *L'Humanité* (27 Feb. 1933), 5. Reprinted in Ilya Ehrenburg, *Duhamel, Gide, Malraux, Mauriac, Morand, Romains, Unamuno vus par un écrivain d'U.R.S.S.* (Paris: Gallimard, 1934).

375 "SERVICE OF THE REVOLUTION": Ilya Ehrenburg, "The Surrealists," trans. Samuel Putnam, *Partisan Review* (Oct.–Nov. 1935), 11–16. Article originally written in July 1933 and included in *Vus par un écrivain d'U.R.S.S.* Breton responded—weakly—by reprinting Lenin's remark

that Ehrenburg was the "dirty scum" on the shores of the Revolution: "Portrait d'Ilya Ehrenbourg," *Documents 34* (new series) 2 (Nov. 1934), 62.

376 STATEMENT IN ITS NAME: AB to René Lalou, 19 June 1935, BN; Carassou, *René Crevel*, 261; *Political Position*, 243; Lewis, *Politics of Surrealism*, 131.

376 "MY FRIENDS HAD FINISHED": Nezval, *Rue Gît-le-Cœur*, 21.

376 "TO CALM DOWN": Schwarz, *Breton, Trotsky*, 213.

376 CENSURE THE SURREALISTS: *Tracts*, I, 498; Roger Shattuck, *The Innocent Eye: On Modern Literature and the Arts* (Boston: MFA Publications ["artWorks"], 2003), 3–4.

377 "ACTED LIKE A COP": Lottman, *Left Bank*, 4.

377 "TO LIGHT A MATCH": René Crevel, *Détours* (1924), quoted in Carassou, *René Crevel*, 266.

377 "DISGUST": Carassou, *René Crevel*, 263–66; Gascoyne, "A propos du suicide de Crevel," 92; Lottman, *Left Bank*, 4; Nezval, *Rue Gît-le-Cœur*, 42; Thirion, 319–20, 380–81.

377 "FIRED ON HIM MERCILESSLY": Alexandrian, *Surréalisme et rêve*, 309; MP interview with Edouard Roditi, 21 April 1987; cf. Klaus Mann, *Der Wendepunkt: Ein Lebensbericht* (Munich: Nymphenburger Verlag, 1969), 338.

377 "VISIBLY SHAKEN": Gascoyne, "A propos du suicide de Crevel," 92.

377 "IN THE TRAGEDY": Schwarz, *Breton, Trotsky*, 213.

377 "RESPONSIBLE FOR CREVEL'S DEATH": Nezval, *Rue Gît-le-Cœur*, 56.

377 HIM WITH MURDER: Marcel Jouhandeau, "René Crevel," in Rode, *Jouhandeau et ses personnages*, 132. First published in *NRF* (1 July 1935). Cf. Breton's rebuttal, *NRF* (1 Aug. 1935), 291–93, and AB to "the Editor-in-Chief of the *NRF* [Paulhan]," 5 July 1935, JP.

378 A MAN NAMED BRETON: Gascoyne, "A propos du suicide de Crevel," 93; Carassou, *René Crevel*, 13, 16; Nezval, *Rue Gît-le-Cœur*, 67–68. The signature on the gravestone was first mentioned in Louis Morin, "Le Jour n'a rien repeint," *NRF* 172, 961, and verified first-hand.

378 "IN 'VUS DE L'URSS'": AB to René Lalou, 19 and 21 June 1935, BN.

378 "SPIDER'S WEB OF MICROPHONES": Shattuck, *Innocent Eye*, 4. The opening chapter, "Having Congress: The Shame of the Thirties," is perhaps the most evocative description in print of the 1935 Congress.

378 "THAT IT IS INTERNATIONAL": Lottman, *Left Bank*, 87.

378 "SPACES FOR APPLAUSE": Nezval, *Rue Gît-le-Cœur*, 84.

378 "HAS BEEN OPPOSITIONAL": Ibid., 84, 70; Shattuck, *Innocent Eye*, 3–4; Lottman, *Left Bank*, 35.

379 AND WHISPERED, "SLEEPWALKER": Nezval, *Rue Gît-le-Cœur*, 70, 84–88; Lottman, *Left Bank*, 87; Shattuck, *Innocent Eye*, 12–14; Gaston Ferdière, *Les Mauvaises fréquentations: mémoires d'un psychiatre*, in collaboration with Jean Quéval (Paris: Jean-Claude Simoën, 1978), 95; Carassou, *René Crevel*, 17.

379 "AUDIENCE FROM THE HALL": Lottman, *Left Bank*, 90–91, 97.

379 "AWARE OF HIS MISSION": Shattuck, *Innocent Eye*, 14.

379 "MOVING DECLARATIONS": AB, *Position politique du surréalisme* (Paris: Jean-Jacques Pauvert ["La Bibliothèque volante," no. 2], 1971), 19. Because of a misprint in most French editions (picked up in *Political Position*, 245–46), Breton seems to be lumping Pasternak, Malraux, and Waldo Frank in with the "bath of useless repetitions, infantile considerations, and toadying" that marked most of the Congress, whereas he is in fact setting them apart. The quote should read: "They partly suppressed the speeches of Magdeleine Paz, of Plisnier . . . and instead—in between moving declarations, such as those by Malraux, Waldo Frank, or Pasternak—[we were given] a bath of useless repetitions," etc.

379 EXPELLED FROM THE ROOM: Lottman, *Left Bank*, 92–93; Shattuck, *Innocent Eye*, 21–22.

380 "ULTRA-IMPERIALIST FRANCE": *Political Position*, 235; Lewis, *Politics of Surrealism*, 130.

380 NINETEENTH-CENTURY ROMANTICS: *Political Position*, 235–37.

380 REVOLUTIONARY PROPAGANDA: Lewis, *Politics of Surrealism*, 126; Haslam, *Real World*, 230–31.

380 "OR FROM THE LEFT": *Political Position*, 240.

380 "ARE ONE FOR US": Ibid., 241.

380 "NEARLY EMPTY HALL": Nezval, *Rue Gît-le-Cœur*, 98.

380 "A HANDFUL OF PEOPLE": Shattuck, *Innocent Eye*, 20–21.

380 "FRANKLY AMUSED" SMILE: Pierre Minet, "Sur une séance du Congrès de la Culture," *Cahiers du Sud* 174 (July 1935), 610.

380 "HARD, AND ARISTOCRATIC": Lottman, *Left Bank*, 98.

381 "THE CONGRESS IS OVER": Nezval, *Rue Gît-le-Cœur*, 100; Jean, *Au galop*, 48.

381 "THAT ARE STILL DISPUTABLE": *Political Position*, 243; AB cat., 221.

381 "AND PROPER TO US": *Political Position*, 248.

381 "OF OUR MISTRUST": Ibid., 253. The pamphlet was signed by twenty-six Surrealists and sympathizers. Among those who did not sign—

despite Breton's requests and Nezval's desire—were the Czech Surrealists, some of whom had been troubled by Breton's anti-Soviet statements. Breton downplayed the "temporary divergence," but within a few years' time Nezval himself would become a voice of Czech nationalism and the Prague Surrealist group would disband altogether: see AB to Nezval, [ca. Oct. 1935] and 18 March 1938, Bernier, "Voyage à Prague," 226, 227.

382 "REVOLUTIONARY EFFERVESCENCE": Maurice Noël, "Le Surréalisme en liberté," *Le Figaro* (21 Dec. 1935), 7.

382 THE BASQUE COUNTRY: Gateau, *Paul Eluard*, 223; AB cat., 221.

382 "OF THE SHOT": Man Ray, *Self Portrait*, 232.

382 SETTING THEM ON FIRE: Eluard to Valentine, 1 Sept. [1935], HRC; *OC* 2, 1333.

382 "AND PEASANTS' CAUSE": "Contre-Attaque," in *Tracts*, I, 281, 283.

383 "AND FANATICISM": Ibid., 281–90; Audoin, *Breton*, 33; Lewis, *Politics of Surrealism*, 136–37; Thirion, *Révisions*, 35; Jean, *Au galop*, 54; Michel Surya, *Georges Bataille: La Mort à l'œuvre* (Paris: Séguier, 1987), 223–26; Pierre Klossowski, "De 'Contre-Attaque' à 'Acéphale,'" *Change* 7, 104–5. Most likely, it was also because of Bataille that Breton began attending Alexandre Kojève's lectures on Hegel that winter.

383 "SMALL PLACE IN YOUR LIFE": AB to Picasso, [Sept. 1935], quoted in Marie-Laure Bernadac, "André Breton et Pablo Picasso: 'tout le sang du possible vers le cœur,'" in AB cat., 210.

383 "MAKE LIFE WORTH LIVING": AB to Picasso, 16 March 1936, ibid.

383 "THIS PAINTING IS POETIC": AB, "Picasso poète," *Cahiers d'art* 7–10 (1935), 186.

383 "JEALOUS OF THE EVENINGS": AB to Picasso, 16 March 1936, in Barnadac, "Breton et Picasso," 210. An English translation of Picasso's poems was published as *The Burial of Count Orgaz and Other Poems*, ed. Jerome Rothenberg and Pierre Joris (Boston: Exact Change, 2004).

383 "BE AN ASS I SAID": Gertrude Stein, *Everybody's Autobiography* (1937; New York: Vintage Books, 1973), 36.

384 MEDIA SUCCESS IN 1934: Cf. S. A. Rhodes, "Candles for Isis: The Moving Spirit of Surrealism, André Breton," *Sewanee Review* (July 1933), 296–97; Jean, *History of Surrealist Painting*, 259–60.

384 "TO MOST OF THEM": Ezra Pound to editors of *Demain*, 21 July 1934, in Andrews, *Surrealist Parade*, ix.

384 "WE THINK OF SURREALISM": Peter Quennell, "Surrealism and Revolution" (Aug. 1933),

quoted in Paul C. Ray, *The Surrealist Movement in England* (Ithaca: Cornell University Press, 1971), 83.

384 "SOME FRESH AIR AT ONCE": Harold Acton, *Memoirs of an Aesthete* (1948; London: Hamish Hamilton, 1984), 226.

385 FROM SEVENTEEN COUNTRIES: *Minotaure* 10 (Dec. 1937), 62–64; Biro, et al., *Dictionnaire général*, pass; *Le Puits de l'hermite* 29–31 (March 1978): "Le Domaine poétique international du surréalisme," passim.

385 "HAD JUST GIVEN BIRTH": "Picasso poète," 186; Alexandrian, *Surréalisme et rêve*, 444; "Pontlevis," in *Perspective cavalière*, 194; AB to Rose Adler, 26 Dec. 1935, Doucet.

385 "IN THE MILKY NIGHT": Dedication dated 21 Dec. 1935, in Sebbag, *Imprononçable jour de ma naissance*, ch. 22; Pastoureau, *Vie surréaliste*, 395.

386 "NOSE IN IT!": Hugnet, *Pleins et déliés*, 414.

386 "MUST END WITH MY DEATH": *Recherches*, 104.

386 HAVE AN ABORTION: Pastoureau, *Vie surréaliste*, 237.

386 "FOR ALL SOCIAL CONSTRAINTS": "La Patrie et la Famille," in *Tracts*, I, 294.

386 CLAIMED PATERNITY: Noël, "Surréalisme en liberté," 7.

386 "DIPLOMATS AND POLITICIANS": *Sous le feu des canons français . . . et alliés*, in *Tracts*, I, 298, see also 505–7; Marcel Jean, ed., *The Autobiography of Surrealism* (New York: Viking Press, 1980), 372.

387 WILLING TO DEFEND: Gateau, *Paul Eluard*, 228–29; *OC* 2, xlvii.

387 "AVOID LOSING STAMINA": Jean, *Au galop*, 70.

387 "A HERD OF SHEEP": Eluard to Gala, [April 1936], *LTG*, 214.

387 "IT WITH YOU": AB to Eluard, 9 March 1936, *OC* 2, xlvii; Gateau, *Paul Eluard*, 234.

387 "EXISTENCE OF HER OWN": Eileen Agar, *A Look at My Life*, in collaboration with Andrew Lambirth (London: Methuen, 1988), 120.

388 "INTO [HIS] HOUSEHOLD,": AB to Jeannette Tanguy, [29 April 1936], Doucet.

388 "OUTWORN ROMANTICISM": *Daily Telegraph* (12 June 1936), quoted in Jean, *Autobiography of Surrealism*, 368.

388 "ENCHANTMENT, AND DERISION": Herbert Read, *The Philosophy of Modern Art* (New York: Meridian Books, 1957), 110.

388 "ALWAYS SLIGHTLY TIPPED BACK": Agar, *A Look at My Life*, 120, 117; Roland Penrose, "André Breton: 1886–1966," *Studio International* 884 (Dec. 1966), 313; Biro, et al., *Dictionnaire général*, 189; Chadwick, *Women Artists*, 119.

388 ACROSS THE CHANNEL: Secrest, *Salvador Dalí*, 164; Gateau, *Paul Eluard*, 234.

389 "ONLY FEEL POORER STILL": AB to Penrose, 6 July 1936, AB cat., 230..

389 "YOUR NEXT NOVEL": Gallimard to AB, 27 May 1936, NRF archives. The contract was sent on 25 June 1936.

389 "OF NECESSITY": *Communicating Vessels*, 92.

389 HOW HE MIGHT END IT: Cf. L. Chevasson to AB, 20 June 1936; AB to [L. Chevasson?], 9 July 1936 (both documents: *NRF* archives); Nadeau, *History*, 205.

390 "PROGRESSIVELY WORSE MOOD": *Mad Love*, 102.

390 "MIRROR OF [THEIR] LOVE": Ibid., 110, see also 104.

390 "LOST INTEREST IN HIM": Eluard to Gala, 15 Sept. [1936], *LTG*, 220 (trans. slightly revised). Both Béhar (*André Breton*, 301, where he misdates Eluard's letter July 1936) and Pastoureau ("Breton, les femmes et l'amour," 93) conclude that Breton, in telling his friends that Jacqueline had run off to Ajaccio—as opposed to Algeria—had confused his wife's departure with Suzanne's eight years earlier. But Breton's correspondence with Jacqueline during this period shows that it was Eluard, not Breton, who was in error: cf. *OC* 2, 1693.

390 "LIKE THE HEART": AB to Jacqueline, 5 Oct. 1936, *OC* 2, L.

390 "EVER PRODUCE CHILDREN": MP interview with Edouard Roditi, 21 April 1987.

391 "HONORABLE ALL THE SAME": AB to Aube, 12 Aug. 1936, Béhar, *André Breton*, 301; *OC* 2, xlix.

391 "FOR YOU THROUGH HER": AB to Jacqueline, 1 Sept. 1936, *OC* 2, 1693. The phrase "Chipnut of Monkhazel" is borrowed from an earlier translation by Maria Jolas.

391 "TO BE MADLY LOVED": *Mad Love*, 111–19. This coda, however uplifting, is also slightly misleading: the specific mention of "the springtime of 1952" suggests that Aube had been born not in December 1935 but in early 1936—that is, at the same time that Breton was turning forty. Just as he had celebrated the dawning of his twenties in the poem "Age" ("Dawn, farewell! I emerge from the haunted wood"), whose date of composition he had amended to coincide with his birthday, so now he inaugurated his forties with a child named "Dawn"—once again, in the process, "rectifying" an imperfect chronology and lending a sometimes reticent "objective chance" a helping hand: Cf. Sebbag, *Imprononçable jour de ma naissance*, chs. 22 and 36, to which I am indebted for some of these insights.

391 "TOWARD MAN'S LIBERATION": *Conversations*, 140. Cf. AB to Eluard, 18 Aug. 1936: "I've been told that I couldn't leave Barcelona, where

they'd try to use me as a military doctor: if *that's* the case . . ." (*OC* 2, xlix).

392 DOWNFALL IN JUNE 1937: Lottman, *Left Bank*, 102, 104–6; Audoin, *Les Surréalistes*, 87; Thirion, *Révisions*, 83; cf. *Conversations*, 140.

392 "KNEES WITH THE OTHER": *Conversations*, 140; Henri Pastoureau, "Entretien avec G. Bertin sur le surréalisme, Juin 1986," *L'Orne littéraire* 10, 29.

392 "PÉRET IS SO PURE": Jean, *Au galop*, 61.

392 AND EXECUTIONS: Cf. "Neutralité? Non-sens, crime et trahison!" and "Appel aux Hommes," in *Tracts*, I, 302–6.

392 "INEXCUSABLE OF MURDERERS": "Déclaration lue par André Breton le 3 septembre 1936 au meeting: 'la Vérité sur le Procès de Moscou,'" ibid., 306–7.

392 "AS OUR OWN": Ibid., 307.

392 "MEXICO [BUT IN] BARCELONA": ["Déclaration lue par André Breton au meeting du P.O.I. le 17 décembre 1936"], in *Tracts*, II, 449–50.

392 HITLER AGAINST THE USSR: Alain Dugrand, *Trotsky in Mexico, 1937–1940*, trans. Stephen Romer (Manchester: Carcanet Press, 1992), 128.

393 "EXTREMELY DIFFICULT TO ESCAPE": Schwarz, *Breton, Trotsky*, 214.

393 "SCOURGE OF MODERN TIMES": *Conversations*, 141.

393 "THE ENTIRE SOVIET UNION": *Commune* (Oct. 1936), quoted in *Tracts*, I, 513.

393 "FORMULAS TO JUSTIFY MOSCOW": Lionel Abel, *The Intellectual Follies: A Memoir of the Literary Venture in New York and Paris* (New York: W. W. Norton, 1984), 49. See also Thirion, *Révisions*, 41; Dominique Desanti, *Sonia Delaunay, magique magicienne* (Paris: Ramsay, 1988), 243. In the United States, a commission of prominent American leftists headed by John Dewey conducted its own investigation into the Moscow Trials, concluding that the whole business was nothing more than a "frame-up." But this condemnation was no more effective against Stalin than the European waffling. See *Tracts*, I, 509–12, for an analysis of the Moscow Trials, and Abel, *Intellectual Follies*, 55–58, for a description of the New York hearing.

393 "MOSCOW TRIALS BUSINESS. NOT ME": Eluard to Gala, 14 Feb. 1937, *LTG*, 225; Gateau, *Paul Eluard*, 240.

393 "POETS OF HIS GENERATION": *LTG*, 329.

393 "BY THE MIDDLE CLASSES": Eluard to Gala, [17 Dec. 1936], ibid., 222. Eluard makes the identical comment in a letter to Man Ray, same date, HRC.

394 "IGNORE THEM COMPLETELY": Alfred H. Barr to Thomas Mabry, Jr., 1 Aug. 1936, Barr papers (roll 2165), Archives of American Art, New

York. See also: Alice Goldfarb Marquis, *Alfred H. Barr: Missionary for the Modern* (Chicago: Contemporary Books, 1989), 187–88.

394 MOST "APPALLING TASK": Baldwin, *Man Ray*, 205, 200; Jean, *History of Surrealist Painting*, 272–74 (gives a complete list of works exhibited); William S. Rubin, *Dada, Surrealism and Their Heritage*, exh. cat. (New York: Museum of Modern Art, 1968), 211.

394 "BEST FOR OUR ACTIVITY": Dalí to AB, 28 Dec. 1936, AB cat., 230.

394 "32-YEAR-OLD CATALAN": *Time* (14 Dec. 1936), quoted in Secrest, *Salvador Dalí*, 167.

395 "OF THE COMIC STRIPS": Jean, *History of Surrealist Painting*, 261. In 1945, the *New York Times* would confirm Breton's fears about Dalí's consumer-friendly version of Surrealism by commenting that the Spaniard had made the movement "as comfortable as a pair of scuffed old-fashioned slippers . . . He has put Surrealism in curl papers for the night and given it a glass of milk": *New York Times* (25 Nov. 1945), quoted in Secrest, *Salvador Dalí*, 191.

395 "UNIVERSITY DIPLOMAS": *Conversations*, 144; AB cat., 230; Balakian, *André Breton*, 170.

395 VAST THEATRE OF CRUELTY: Virmaux, *Breton qui êtes-vous?*, 99–100; Virmaux, *Artaud qui êtes-vous?*, 84; Maeder, *Antonin Artaud*, 178–90; Schwarz, *Breton, Trotsky*, 56–57; Béhar, *André Breton*, 22. Maeder (p. 173) puts Artaud's reconciliation with Breton in late 1935, but Roger Blin, who was instrumental in bringing the two men back together, says that it happened after Artaud's return from Mexico: see *Breton qui êtes-vous?*, 99.

15. For an Independent Revolutionary Art

396 "SELL MORE EASILY": AB to [L. Chevasson?], 30 Sept. 1936, *NRF* archives; *Bibliographie de la France* (5 March 1937), 687.

396 ITS FIRST THREE YEARS: Internal memoranda, 20 Nov. and 31 Dec. 1939; L. Chevasson to AB, 19 Nov. 1936 (all documents: *NRF* archives). The price for a book of comparative type and length was around 10–15 francs (*Bibliographie de la France* for 1937). Judging from trade publications of the time and from Breton's complaints (esp. AB to Gallimard, 30 March 1940, *NRF* archives), the house does not seem to have put much energy behind the publication.

396 "SURREALIST RESEARCH": *NRF* (1 April 1937), 613–14.

396 "WRITERS OF TODAY": *Mercure de France* (1 Sept. 1937), 343–46.

396 "IN FRANCE SINCE 1918": *Nouvelles littéraires* (3 July 1937), 4.

396 "DESCENDED OVER ME": AB to Edmond Jaloux, 19 July 1937, Doucet.

397 "STANDING SIDE BY SIDE": *Conversations*, 144; *OC* 2, lii. Freud analyzed the novella in *Delusion and Dreams in Jensen's "Gradiva"* (1907).

397 "PAGE OF A BOOK": "Gradiva," in *Free Rein*, 19.

397 THE GALLERY LETTERHEAD: AB to Picasso, 15 March 1937, AB cat., 235; Alexandrian, *Breton par lui-même*, 150; Blachère, *Les Totems d'André Breton*, 138.

397 "ONLY SURREALISTS": MP interview with Leonora Carrington, 25 April 1986.

397 "IN A CAGE": Peggy Guggenheim, *Out of This Century: Confessions of an Art Addict* (New York: Universe Books, 1987), 160; Jean, *Au galop*, 69.

397 "NEITHER IS JACQUELINE": Eluard to Gala, 1 May [1937], *LTG*, 230. Jacqueline confirmed this inaptitude in her remarks to J.-C. Blachère (*Les Totems d'André Breton*, 138).

397 RUBINSTEIN ART PRIZE: Gateau, *Paul Eluard*, 242; Agar, *A Look at My Life*, 133; Pierre Gaudibert, "Picasso et le surréalisme," *Opus international* 123–124 (April–May 1991), 64. Rubinstein, wife of magazine editor Edward W Titus, also funded *This Quarter*, for which Breton had edited an issue on Surrealism in 1932.

397 UNABLE TO SPEAK: "Je rêve que je ne dors pas" (dream dated 18 June 1937), in Paul Eluard, *Œuvres complètes*, I (Paris: Gallimard ["Bibliothèque de la Pléiade"], 1968), 933; Eluard to Gala, [Aug. 1937], *LTG*, 232; Gateau, *Paul Eluard*, 246; Eluard, *Lettres à Gala*, 479; Alexandrian, *Surréalisme et rêve*, 298.

398 "THOUGHT OF IT ONLY AFTERWARD": Artaud to AB, [July 1937], Antonin Artaud, *Œuvres complètes*, VII (Paris: Gallimard, 1967), 235. See also Virmaux, *Artaud qui êtes-vous?*, 219.

398 "THE ANGEL GABRIEL": Artaud to Jacqueline, [21 Sept. 1937], ibid., 297.

398 EARTH'S DESTRUCTION BY FIRE: Cf. Artaud to AB, 30 July 1937, ibid., 241–42.

398 "IN DAMAGES NOW": Maeder, *Antonin Artaud*, 199.

398 "TO SEE EVERY DAY": Artaud to Jacqueline, 28 July 1937, Artaud, *Œuvres complètes*, VII, 239.

398 "YOU TOUCHED MY PENIS": Maeder, *Antonin Artaud*, 197–98; Artaud to Henri Parisot, 6 Oct. 1945, Antonin Artaud, *Œuvres complètes*, IX (Paris: Gallimard, 1971), 195–96; Bettina L. Knapp, *Antonin Artaud, Man of Vision* (New York: David Lewis, 1969), 156–57; Virmaux, *Artaud qui êtes-vous?*, 186.

398 "AT THE DEUX MAGOTS": Artaud to Breton, 14 Sept. 1937, Artaud, *Selected Writings*, 408.

399 REST OF HIS LIFE: Maeder, *Antonin Artaud*, 203–14, 229–30; Knapp, *Artaud, Man of Vision*, 158–

59; Alexandrian, *Surréalisme et rêve*, 341; Virmaux, *Artaud qui êtes-vous?*, 18.

399 "BE DONE FOR HIM": Virmaux, *Artaud qui êtes-vous?*, 175–76. Jacqueline says that they learned of Artaud's fate only in 1939, but cf. Tanguy to AB, 27 May 1938 (AB cat., 238), while Breton was in Mexico: "Artaud is probably in Sainte-Anne. I'll try to get information through Mabille."

399 "NOT A MADMAN": Artaud to Jacqueline, 7 April 1939, in Ronald Hayman, *Artaud and After* (New York: Oxford University Press, 1977), 123.

399 SHUNNED HER FROM THEN ON: Virmaux, *Artaud qui êtes-vous?*, 176.

399 "POLICE MACHINE GUNS": Artaud to AB, 31 May 1946, quoted by Breton in "A Tribute to Antonin Artaud," in *Free Rein*, 281, note 1. Artaud actually arrived in Le Havre on 30 Sept.: cf. Virmaux, *Artaud qui êtes-vous?*, 224.

399 "EYES FILLED WITH TEARS": "Sur Antonin Artaud," in *Perspective cavalière*, 173.

399 "I BELIEVE YOU": Artaud to AB, 3 June 1946, Antonin Artaud, *Œuvres complètes*, XIV (part 1) (Paris: Gallimard, 1978), 278. Breton also cites this letter in "A Tribute to Antonin Artaud," misdating it 3 May.

399 "SOME DISTANCE IN HIS EYES": "Sur Antonin Artaud," 173.

400 A WELCOME DEVELOPMENT: Publishing contract between Editions Denoël and AB, dated 10 Dec. 1937, *NRF* archives.

400 PREPARING THE EVENT: Hugnet, *Pleins et déliés*, 323; Gateau, *Paul Eluard*, 246, 248; Daniel Abadie, "L'Exposition internationale du surréalisme, Paris 1938," in *Paris–Paris, 1937–1957*, exh. cat. (Paris: Centre Pompidou, 28 May–2 Nov. 1981), 72; Béhar, *André Breton*, 308.

400 "FRICTION SHOW OUTWARDLY": AB to Nezval, 18 March 1938, Gateau, *Paul Eluard*, 249–50.

400 "NOT I IN THE MORNING": Eluard to Valentine, [1941], in Alice Sedar, "Règlements de comptes surréalistes," *Le Figaro* (1 Dec. 1993).

401 "STRUGGLE FOR LIBERATION": AB, "Souvenir du Mexique," in Schwarz, *Breton, Trotsky*, 156. First published in *Minotaure* 12–13 (May 1939), and reprinted in an abridged version in *La Clé des champs* (English translation in *Free Rein* as "Memory of Mexico").

401 "COUNTRY THAT ATTRACTED ME": *Conversations*, 144; Schwarz, *Breton, Trotsky*, 58; Dugrand, *Trotsky in Mexico*, 32. In a letter of 21 June 1938 to Philip Rahv, conserved at the Houghton Library at Harvard University (hereinafter "Houghton"), Trotsky says that Breton will leave Mexico in late June; but instead he stays until the end of July.

401 "DID NOT GO, OF COURSE": Anaïs Nin, *The Diary of Anaïs Nin*, II (1934–1939), ed. Gunther Stuhlmann (New York: Harcourt, Brace & World, 1967), 247–48.

402 "INTELLECTUAL TECHNIQUE": Ibid., 248.

402 "PIFFLE ABOUT THE REVOLUTION": Henry Miller, "An Open Letter to Surrealists Everywhere" (1938), in *The Cosmological Eye* (New York: New Directions, 1939), 159–60.

402 "TRIUMPH OF SELF-ADMIRATION": Julien Levy, *Memoir of an Art Gallery* (Boston: MFA Publications ["artWorks"], 2003), 247–48.

402 UPCOMING BEAUX-ARTS SHOW: AB cat., 236; Matta, untitled obituary of AB, *Lettres françaises* (6 Oct. 1966), 17.

402 "HUMAN AUTHENTICITY": AB to Péret, 4 Jan. 1942, Doucet; Ernst, *Not-So-Still Life*, 114; Chadwick, *Women Artists*, 74–75, 240; *Anthology of Black Humor*, 335.

403 "OF THE STREET": Matta, obituary of AB, 17.

403 "OF ONE'S OWN FREEDOM": Ibid.

403 "THAT DIDN'T REVOLVE": Hugnet, *Pleins et déliés*, 247; Pierre Cabanne, *Dialogues with Marcel Duchamp*, trans. Ron Padgett (New York: Viking Press, 1971), 81; *OC 2*, liv.

403 "PICTURE OF DORIAN GRAY": Matta, "Souvenir d'une cohue, 1938," in G. Ferrari, ed., *Matta: Entretiens morphologiques, Notebook No. 1, 1936–1944* (London: Sistan Ltd., 1987), 56.

404 "TO LAUGH AND JOKE": Man Ray, *Self Portrait*, 232; Hugnet, *Pleins et déliés*, 339.

404 "AND AN EXPERIENCE": Haslam, *Real World*, 248; cf. "Before the Curtain," in *Free Rein*, 80–81.

404 "PEARL" OF THE EXHIBIT: Abadie, "L'Expsition internationale," 74; Hugnet, *Pleins et déliés*, 331–33; Jean, *History of Surrealist Painting*, 281.

404 THE "ETERNAL FEMININE": Hugnet, *Pleins et déliés*, 328–29; Thirion, 399.

404 "ASTUTE DIPLOMACY": Hugnet, *Pleins et déliés*, 334.

405 "INVENTION OF THE FORK": All quotes from AB and Paul Eluard, *Dictionnaire abrégé du surréalisme* (1938), in *OC 2*, 787–862. Breton's nickname, a reversal of the common expression "*Un tempête dans un verre d'eau*" (a tempest in a teapot), was first used in *Proverbe* 6 (July 1921).

405 A FRONT-ROW SPECTATOR: Hugnet, *Pleins et déliés*, 342; Gateau, *Paul Eluard*, 247; Jean, *History of Surrealist Painting*, 282; Man Ray, *Self Portrait*, 233.

406 "MYSTERIOUS BUT INOFFENSIVE": *Le Journal* (25 Jan. 1938), quoted in Guiol-Benassaya, *Presse face au surréalisme*, 217.

406 "OLD STORIES, OLD REFRAINS": *Le Gringoire* (28 Jan. 1938), quoted in *Tracts*, II, 190.

406 "NOT VERY FRENCH": *Liberté* (17 Jan. 1938) and *Le Petit Parisien* (9 Feb. 1938), quoted in *Tracts*, II, 188–89.

406 "FALSE REVOLUTIONARIES": *NRF* (1 March 1938), 516; *OC 2*, liv. The *NRF* ran a second review, positive this time, on 1 May 1938 (pp. 859–61).

406 "THE CHARITY BAZAAR": Quoted in "Ephémérides surréalistes," in AB, *Les Manifestes du surréalisme* (Paris: Sagittaire, 1955), endpapers.

406 "WHEREVER HE MAY CHOOSE": "Freud in Danger," trans. unknown, in *What is Surrealism?*, 172. First published in *Trajectoire du rêve*.

406 "MEAN TO ANYONE ELSE": Freud to AB, 8 Dec. 1937, in Nicolas Calas, "Surrealist Intentions," *Trans/formations* 1 (1950), 49; *Tracts*, I, 521.

407 "OF THE SAME TRUTH": AB, untitled note, *Minotaure* 11 (May 1938), 1; AB cat., 238; Eluard to Valentine, 10 April 1938, HRC.

407 BRONCHITIS IN JUNE: Masson to AB, 8 and 14 April and [ca. 14 June] 1938, Doucet.

407 "NEAR THE GARDEN": Masson to AB, 14 April 1938, Doucet.

407 "HER ARMS TO YOU": Rose Masson to AB and Jacqueline, 31 May [1938], Doucet.

407 "SURREALIST PLACE PAR EXCELLENCE": Rafael Heliodoro Valle, "Diálogo con André Breton," *Universidad: Mensual de cultura popular* 29 (June 1938), 6.

408 SEVERAL DAYS' TIME: Schwarz, *Breton, Trotsky*, 59, 203–4; notes describing the unpublished volume *André Breton au Mexique*, *Docsur* 2 (April 1987), 2.

408 OWNED BY RIVERA'S WIFE: Jean van Heijenoort, *With Trotsky in Exile: From Prinkipo to Coyoacán* (Cambridge, Mass.: Harvard University Press, 1978), 133; Hayden Herrera, *Frida: A Biography of Frida Kahlo* (New York: Harper & Row, 1983), 161–66.

408 "A GIANT ANTEATER": Schwarz, *Breton, Trotsky*, 204.

408 "FASCINATING AS CAN BE": AB to Péret, [27 April 1938], Doucet.

408 "ATTRACTED ATTENTION": Herrera, *Frida*, 234, quoting Nicolas Calas.

408 "TAKES HIMSELF SO SERIOUSLY": Ibid., 262.

408 THE "OLD COCKROACH": Kahlo to Ella and Bertram Wolfe, 17 March 1939, ibid., 252.

409 "KNOW WHAT I AM": Ibid., 230, see also 227, 254.

409 "MULTITUDE OF PEOPLE": Heijenoort to Naville, 29 April 1938, Houghton (English trans. from Heijenoort, *With Trotsky in Exile*, 121).

409 "UNDERTAKE IN MEXICO": "Visit with Leon Trotsky," in *Free Rein*, 39; Gateau, *Paul Eluard*, 253.

409 "SO HARD TO COME BY": Etiemble, "The Tibetan Dog," *Yale French Studies* 31, 130.

409 IN EUROPE AND AMERICA: Apparently, the idea of an independent alliance had simultaneously occurred to some of the Surrealists, but hadn't gotten very far: see Péret to AB, 31 March and 18 April 1938, in Claude Courtot, *Introduction à la lecture de Benjamin Péret* (Paris: Le Terrain Vague, 1965), 37–38. José Pierre (*Tracts*, I, 526) suggests that Breton, on the strength of Péret's letters, might have proposed the idea of such a federation to Trotsky; but most accounts agree that Trotsky originated it.

409 GENERALLY FAVORABLE REPORT: Naville to Heijenoort, 12 May 1938, Houghton; Heijenoort, *With Trotsky in Exile*, 121; Gérard Roche, "La Rencontre de l'aigle et du lion: Trotsky, Breton et le manifeste de México," *Cahiers Léon Trotsky* 25 (March 1986), 25–26.

409 "AND COUNTLESS PAINTINGS": Dugrand, *Trotsky in Mexico*, 18 (trans. slightly revised); "Visit with Leon Trotsky," 39–40.

410 "WITH OPEN ARMS": Schwarz, *Breton, Trotsky*, 60. "L.D." was one of the codenames used by intimates in referring to Trotsky; another was "the Old Man" (*le Vieux*).

410 "RADIATES FROM HIM": "Visit with Leon Trotsky," 39–40.

410 "ALMOST PAINED SURPRISE": Schwarz, *Breton, Trotsky*, 205, 209; Heijenoort, *With Trotsky in Exile*, 117–18.

410 "IT WAS DRINKABLE": Schwarz, *Breton, Trotsky*, 205.

410 "WORLDLY VALUES": *Conversations*, 148.

410 ONE THING AT A TIME: Heijenoort, *With Trotsky in Exile*, 160.

411 "ABSOLUTELY HOSTILE TO THEM": Trotsky to Philip Rahv, 12 May 1938, Houghton.

411 "ALIEN TO HIM": *Conversations*, 148.

411 "ALMOST PREHISTORIC TIME": Trotsky to AB, 6 Dec. 1938, Houghton; cf. Gérard Roche, "Breton, Trotsky: une collaboration," *Pleine Marge* 3 (May 1986), 92.

411 SOME MERIT AFTER ALL: Heijenoort, *With Trotsky in Exile*, 122 (several accounts conflate these two talks); Dugrand, *Trotsky in Mexico*, 34; Schwarz, *Breton, Trotsky*, 209–10.

411 "UNDER THE UNCONSCIOUS?": Heijenoort, *With Trotsky in Exile*, 122; Schwarz, *Breton, Trotsky*, 210.

411 "WINDOW ON THE BEYOND": "Visit with Leon Trotsky," 45.

411 "THE BASIC HARMONY": *Conversations*, 148.

411 "PASSION, AND HIS PURITY": Schwarz, *Breton, Trotsky*, 64.

412 "POLITE, GENERALLY DEFERENT": Ibid., 211.

412 CORNER OF THE ROOM: Georges Henein,

"L'Anti-Nadja," *Magazine littéraire* 64 (May 1972), 14; Herrera, *Frida*, 227. Jacqueline and Frida became very close during this time, perhaps to the point of sexual involvement, as suggested by a letter that Frida wrote to Jacqueline after her visit to Paris in 1939: see *The Diary of Frida Kahlo: An Intimate Self-Portrait*, ed. Sarah M. Lowe (London: Bloomsbury, 1995), 208–9.

412 TWELVE OR MORE: Heijenoort, *With Trotsky in Exile*, 119–20, 124, 129; Heijenoort to Naville, 30 June 1938, Houghton; Schwarz, *Breton, Trotsky*, 206.

412 "IT HAS RESULTED": Valle, "Diálogo con André Breton," 8.

413 REST OF HIS STAY: *Docsur* 2, 2–4; Marguerite Bonnet, "André Breton au Mexique: rencontre avec Léon Trotsky," in AB cat., 242; Dugrand, *Trotsky in Mexico*, 34; Béhar, *André Breton*, 310–11.

413 "FILM'S PLOT AND FORM": Schwarz, *Breton, Trotsky*, 206–7; *Docsur* 2, 4.

413 "INTERESTED IN BUTTERFLIES": Schwarz, *Breton, Trotsky*, 61.

413 "OF ANTICLERICALISM": Heijenoort, *With Trotsky in Exile*, 125, 127; *Conversations*, 148.

414 "HAS A DOG'S LOOK!": Buñuel, *My Last Sigh*, 113; Schwarz, *Breton, Trotsky*, 210; "Prolegomena to a Third Surrealist Manifesto or Not," in *Manifestoes*, 292.

414 "REVOLUTIONARY MOVEMENTS": *Conversations*, 152.

414 "NOT DONE HIS HOMEWORK": Heijenoort, *With Trotsky in Exile*, 125.

414 "ALWAYS FELT TOWARD HIM": AB to Trotsky, 9 Aug. 1938, Houghton.

414 DID NOT ONCE SEE TROTSKY: Heijenoort, *With Trotsky in Exile*, 126–27.

415 "WHOLE OF MEXICO WAS THERE": "Memory of Mexico," in *Free Rein*, 25–27.

415 "SUCH IS BEAUTY": Ibid., 27–28; Jean-Clarence Lambert, "Le Mexique imaginal d'André Breton," *Pleine Marge* 12 (Dec. 1990), 51

415 "SMALL SQUARE OF CANVAS?": Heijenoort, *With Trotsky in Exile*, 128; *Conversations*, 148.

415 RETURNED TO MEXICO CITY: Heijenoort, *With Trotsky in Exile*, 128.

416 "BELIEVE IT'S INERADICABLE": AB to Trotsky, 9 Aug. 1938, Houghton.

416 "REACHED FINAL AGREEMENT": Heijenoort, *With Trotsky in Exile*, 128. The text of the original manuscript is reproduced in Roche, "Breton, Trotsky: une collaboration," 76–84.

416 "USURPERS OF THE REVOLUTION": AB and Diego Rivera [sic], "Manifesto: Towards a Free Revolutionary Art," trans. Dwight Macdonald, *Partisan Review*, vi:1 (fall 1938), 52. The French

version was first published as a broadside in Mexico City on 25 July 1938.

416 "DEFENDER OF ART": Ibid., 52–53.

417 "GIVE A FLAT REFUSAL": Ibid., 49, 51. The sentence "It follows . . . pragmatic goals" is missing in the English translation.

417 BRETON'S OWN WRITINGS: Roche, "Breton, Trotsky: une collaboration," 81; "Visit with Leon Trotsky," 44–45.

417 "COMPLETE LIBERATION OF ART!": "Towards a Free Revolutionary Art," 53.

417 "MANKIND IN ITS TIME": Ibid., 51; cf. Roche, "Breton, Trotsky: une collaboration," 73–93.

418 SIGNED BY TWO ARTISTS: Lewis, *Politics of Surrealism*, 146; Bonnet, "Breton au Mexique," 243.

418 "BOUGAINVILLEA, AND IDOLS": Heijenoort, *With Trotsky in Exile*, 129.

418 "ADMIRATION AND DEVOTION": Dugrand, *Trotsky in Mexico*, 93 (my translation, from photograph). Apparently Breton had tried to book passage for 15 July, but couldn't get a reservation: see *OC* 2, lvii.

418 "NOT BEYOND MY REACH": AB to Trotsky, 9 Aug. 1938, Houghton; Bonnet, "Breton au Mexique," 244.

418 "FUTURE OF OUR RELATIONS": Trotsky to AB, 31 Aug. 1938, Houghton.

419 "EYES OF TRUE ARTISTS": Trotsky to Gérard Rosenthal, 27 Oct. 1938, Rosenthal, *Avocat*, 291–92. A similar letter to Breton, dated the same day, is reproduced in Schwarz, *Breton, Trotsky*, 129.

419 CONSIDERED "INEVITABLE": Valle, "Diálogo con André Breton," 8; AB cat., 241.

419 "ASPECTS OF DAILY LIFE": Henein, "L'Anti-Nadja," 14. Breton did, however, make oblique references to "that dispossessed chief who is somewhat our own / . . . that single man advancing down the great circuit" in a poem written that October—practically his first in five years: "Run-them-all," poem dated 29 Oct. 1938, in *Poems of André Breton: A Bilingual Anthology*, ed. and trans. Jean-Pierre Cauvin and Mary Ann Caws (Austin: University of Texas Press, 1982), 125.

420 "OF 'UNIVERSAL INTELLECTUALISM'": Dalí, *Secret Life*, 24.

420 "WHAT A FANATIC!": Ibid., 25; MacGregor, *Art of the Insane*, 271–72.

420 "RECONSIDER MY OPINION": Freud to Stefan Zweig, 20 July 1938, in Ernst L. Freud, ed., *The Letters of Sigmund Freud*, trans. Tania and James Stern (New York: Basic Books, 1960), 448–49.

420 HIS VISITOR'S CANVASES: Dalí to AB, 12 Jan. 1939, *Salvador Dalí*, exh. cat., 137.

420 "WITH A PUNCTURED EYE!": Jean, *Au galop*, 74; cf. Jean, *Autobiography of Surrealism*, 343.

421 "COME BETWEEN US": AB to Eluard, 14 June 1938, *OC 2*, lvi.

421 "I DOUBT IT": AB to Eluard, 31 Aug. 1938, ibid., lvii.

421 "STILL ARE TO ME": Eluard to AB, 12 Sept. 1938, ibid.

421 "AND OF MY LIFE": AB to Eluard, 13 Sept. 1938, ibid.

421 "MAKING US LIKE BROTHERS": *Conversations*, 151; Gateau, *Paul Eluard*, 257.

421 "BRANDED AN ENEMY": Maurice Nadeau, *Grâces leur soient rendues* (Paris: Albin Michel, 1990), 34.

422 "AT THEIR DISPOSAL": Gateau, *Paul Eluard*, 257.

422 LARGEST AND BEST ORGANIZED: Lewis, *Politics of Surrealism*, 154–55; Schwarz, *Breton, Trotsky*, 81, 84–85; AB to Trotsky, 24 Sept. 1938, Houghton; Hugnet, *Pleins et déliés*, 403.

422 "OF THE VERSAILLES TREATY": *Ni de votre Guerre ni de votre Paix!*, in *Tracts*, I, 340.

422 "HAVE BEEN CALLED UP": Péret to Heijenoort, [ca. early Oct. 1938], Houghton; Hugnet, *Pleins et déliés*, 311.

422 "THREE-QUARTERS OF HIS DAY": Jacqueline to Trotsky, 4 Nov. 1938, Houghton.

423 "A PEST IN CAFÉS": Guggenheim, *Out of This Century*, 189.

423 "TAKE YOU TO CHURCH!": Pastoureau, *Vie sur-réaliste*, 402; George Melly, *Paris and the Surrealists* (New York: Thames and Hudson, 1991), 130.

423 "RIGHT OVER THEM": Henein, "L'Anti-Nadja," 14–15; Billy Klüver and Julie Martin, *Kiki's Paris: Artists and Lovers 1900–1930* (New York: Harry N. Abrams, 1989), 112.

424 A "STALINIST SPY": Hugnet, *Pleins et déliés*, 404–5; Jean, *Au galop*, 72.

424 "BRETON'S PERSONAL VENDETTAS": Hugnet, *Pleins et déliés*, 405.

424 "BRING PEOPLE TOGETHER": Naville to Heijenoort, 8 Oct. 1938, Houghton; Haslam, *Real World*, 250; Nadeau, *Grâces*, 34.

424 "FROM THE POPE": *Anthology of Black Humor*, 323; Dalí to AB, 12 Jan. 1939, *Salvador Dalí*, exh. cat., 138.

424 "HAD IN HIS LIFE": Goll, *Pousuite du vent*, 245; Secrest, *Salvador Dalí*, 152–53.

424 THE CAUSE OF TROTSKYISM: Heijenoort to AB, 11 Jan. 1939, Houghton; Heijenoort, *With Trotsky in Exile*, 136–37. The rift was sparked by a letter Rivera had written Breton in late Dec. 1938, which contained political statements that Trotsky hadn't approved; this, added to hidden jealousies on Rivera's part (stemming from both his own political ambitions and Trotsky's earlier liaison with Frida), led to the two men's final breakup in mid-January.

425 "TO GET THEM OUT": Kahlo to Nikolas Muray, 16 Feb. 1939, Herrera, *Frida*, 241.

425 "ALL THIS JUNK": Ibid., 242.

425 "IN MY DAMN LIFE": Kahlo to Nikolas Muray, 27 Feb. 1939, ibid., 242–43.

425 "BIG CACAS": Kahlo to Ella and Bertram Wolfe, 17 March 1939, ibid., 252.

425 FLATTERING TO HER: Partially quoted in AB cat., 248.

425 "TO OVERCOME THEM": AB to Trotsky, 2 June 1939, Houghton.

16. The Exile Within

426 "SO MUCH SMALL CHANGE": Gordon Onslow-Ford, "Spring 1939," in G. Ferrari, ed., *Matta: Entretiens morphologiques, Notebook No. 1, 1936–1944* (London: Sistan Ltd., 1987), 81. On the stay at Chémillieu: AB cat., 248; AB to Péret, 12 June 1939, Doucet; AB to Maurice Heine, 19 July 1939, BN.

427 SECOND WIFE THE FOLLOWING YEAR: Kay Sage, "Château de Chémillieu," in Ferrari, *Matta*, 82.

427 "ALL THE SAME, THAT WORKMAN": Ibid., 82–83.

428 "TRIP TO THE MIDI": AB to Maurice Heine, 11 Aug. 1939, BN; Pastoureau, "Breton, les femmes et l'amour," 94; Legrand, *Breton*, 73; Daix, *Picasso créateur*, 272; William Rubin, ed., *Pablo Picasso: A Retrospective*, exh. cat. (New York: Museum of Modern Art, 1980), 350: in the painting, Jacqueline is the figure standing at right, next to Dora eating an ice cream cone.

428 AIR ABOUT HER: MP interview with Mary Jayne Gold, 16 May 1989.

428 ABOUT HIS MASCULINITY: MP conversation with Judith Young Mallin, 18 July 1989 (based on comments by Jacqueline Goddard).

428 RESUMED IN LATER YEARS: Grimberg, *Jacqueline Lamba*, 24.

428 OF BRETON'S LIFE: "Béatrix de Bretagne," in Julien Gracq, *Œuvres complètes*, I (Paris: Gallimard ["Bibliothèque de la Pléïade"], 1989), 958.

429 "FROM KAFKA'S FICTIONS": *Conversations*, 153; Haslam, *Real World*, 256.

429 "A SCHOOL RECESS": *Arcanum 17*, 109.

429 "SANE, FRIENDLY WORDS": AB to Marie Cuttoli, [early Sept. 1939], Béhar, *André Breton*, 325; AB to Simone, 29 Sept. 1939, Sator; Gateau, *Paul Eluard*, 242; AB cat., 248. Breton's addresses are derived from his correspondence of the time.

429 "TOWARD DELINQUENT YOUTH": Virgil Thomson, *Virgil Thomson: An Autobiography* (New York: Obelisk Books, 1985), 298.

430 SLEEP AT RUE FONTAINE: MP interviews with

Virgil Thomson, 5 May 1987, and André Thirion, 9 March 1988; Virmaux, *Breton qui êtes-vous?*, 141; cf. Hugnet, *Pleins et déliés*, 311–12; *OC* 2, lx–lxi.

430 "THIS IGNOBLE AGITATION": Masson to AB, 23 Sept. 1939, Doucet.

430 "EXCEPTIONALLY INTERESTING WAY": Quoted in Béhar, *André Breton*, 325. See also Thirion, *Révisions*, 185; Abel, *Intellectual Follies*, 69.

430 "OF CIVILIAN LIFE": *Arcanum 17*, 110.

430 "MY FORMER ATTITUDES": AB to Jacqueline, [mid-Sept. 1939], *OC* 2, lx.

430 EVEN THIS UNTIL 1945: AB to Gallimard, 25 April 1939; AB to Gallimard, 15 Nov. 1939 (both *NRF* archives); AB to Paulhan, 2 Dec. 1939, JP; Paulhan to AB, 12 Dec. 1939, Doucet; Gallimard to AB, 23 May 1940, *NRF* archives.

430 "CONSIDERABLE TONIC VALUE,": AB to Paulhan, 25 Nov. 1939, JP.

431 LOST HIS ENTHUSIASM: AB to Paulhan, 24 Feb. 1940, JP.

431 "ONE OF YOUR AUTHORS": AB to Gallimard, 30 March 1940, *NRF* archives. Cf. Robert Denoël to Gallimard, 9 Nov. 1939; AB to Gallimard, 15 Nov. 1939 (both *NRF* archives); AB to Paulhan, 16 Dec. 1939, JP; Paulhan to AB, [ca. late Dec. 1939], Doucet.

431 ONCE AND FOR ALL: Gallimard to AB, 3 May 1940, *NRF* archives; Pierre-Quint to AB, 24 April 1940, BN.

431 LACK OF ANY NEW WORKS: Cf. AB to Paulhan, 16 Dec. 1939 and 29 Jan. 1940, JP; Paulhan to AB, 20 Nov. and [27 Dec.] 1939, Doucet. The space of several months saw some fifteen letters from Breton to Gallimard and Sagittaire, and an equal number in return.

431 MAKE HER MOTHER WRITE: AB to Aube, 15 Sept. 1939, private collection (exhibited at "Breton, la beauté convulsive"); AB to Simone, 29 Sept. 1939, Sator.

431 BEFALLING HIS LOVED ONES: René Magritte, *La Destination: Lettres à Marcel Mariën (1937–1962)* (Brussels: Les Lèvres Nues, 1977), 39n; Masson to AB, 25 and 27 Nov. [1939], Doucet; AB cat., 248; Legrand, *Breton*, 73; Maeder, *Antonin Artaud*, 227; Virmaux, *Artaud qui êtes-vous?*, 139; Gateau, *Paul Eluard*, 262–64; Ernst, *Ecritures*, 61. For Artaud's state of mind at the time, cf. this 1939 letter to "Hitler, chancellor of the Reich": "I had shown you in 1932, at the Ider café in Berlin, on one of those evenings when we became acquainted shortly before you took power, some barriers set down on a map . . . Today, Hitler, I'm lifting the barriers I had erected. The Parisians are in dire need of gas": Robert Aron, "Du

génie à la folie," *Nouvelles littéraires* (7 Aug. 1969), 1.

432 "OTHER OBEYED EVERY TIME": Lise Deharme, *Les Années perdues: Journal (1939–1949)* (Paris: Plon, 1961), 24.

432 "AS IF IN A DREAM": *Conversations*, 153.

432 "PASSIONATE CONVERSATIONS": Maud Bonneaud, "Notes sur une rencontre," *Profil littéraire de la France* (1ère série), 15 (1945), 31. On this period, see AB to Pierre-Quint, 2 May 1940, BN; Jean-Louis Bédouin, *Vingt ans du surréalisme, 1939–1959* (Paris: Denoël, 1961), 25; and Breton's poem "Carte postale": "Were there only war / Nothing like it to revive / The hermetic life / I play at ceasing to exist . . .": *L'Invention collective* 2 (April 1940), in Marcel Mariën, *L'Activité surréaliste en Belgique (1924–1950)* (Brussels: Editions Lebeer Hossmann ["Le Fil Rouge"], 1979), 317.

432 "SEDUCTIVE WAY POSSIBLE": AB to Picasso, 26 March 1940, AB cat., 346; AB to Péret, 12 Feb. 1940, Doucet; AB to Pierre-Quint, 29 April 1940, BN.

432 ABOUT THE CURRENT WAR: *Conversations*, 182–83; Bernard Noël, *Marseille–New York, 1940–1945: Une liaison surréaliste* (Marseille: André Dimanche, 1985), 8; Edgar McInnis, *The War: First Year* (London: Oxford University Press, 1940), 176ff.

432 "OUTLAST ONE'S TIME": AB to Raoul Ubac, [ca. April 1940], *Tracts*, II, 300.

433 "PATH OF COLLABORATION": Lottman, *Left Bank*, 159; Noël, *Marseille–New York*, 8–16; McInnis, *The War*, 225–28.

433 NEWS . . . FOR TWO WEEKS: AB to Bonneaud, 1 July 1940, quoted in auction cat. *Les Autographes* (Paris: Thierry Bodin, Feb. 1990), item 62; AB cat., 346

434 "ANOTHER VULGAR DISGUISE": AB to Bonneaud, 1 July 1940.

434 "WERE QUITE ALARMING": *Conversations*, 154.

434 "UNDERSTOOD THE SITUATION": MP interview with André Thirion, 9 March 1988; Agnès Angliviel de La Beaumelle, "La Dispersion des surréalistes: Marseille," in *Paris–Paris, 1937–1957*, 82, see also 86.

434 "HANDSOME AS GODS": Naville, 86.

435 SPEECHES FOR MARSHAL PÉTAIN: Pierre Assouline, *Gaston Gallimard: A Half-Century of French Publishing*, trans. Harold J. Salemson (New York: Harcourt Brace Jovanovich, 1988), 227–28; Christopher Sawyer-Lauçanno, *The Continual Pilgrimage: Americans in Paris, 1944–1960* (New York: Grove Press, 1992), 49; Caute, *Communism and French Intellectuals*, 146; Berl, *Interrogatoire*, 88; Lottman, *Left Bank*, 155.

435 "of the national revolution": *Conversations*, 155; AB to Pierre-Quint, 4 Feb. 1941, BN. After the government fled, Paris was declared an open city on June 13 and fell under occupation the next day.

435 "extremely unhealthy": AB to Bonneaud, 1 July 1940.

435 "should be taking place": AB to Seligmann, 10 Aug. 1940, quoted in *La Planète affolée: Surréalisme, dispersion et influences, 1938–1947*, exh. cat. (Paris: Flammarion, 1986), 56, see also 105.

435 located in that same town: "Pont-levis," in *Perspective cavalière*, 195–96.

435 "praying mantis fights": AB to Brauner, 19 Sept. 1940, *Planète affolée*, 56.

435 full year of silence: AB to Jean Ballard, 7 Oct. 1940, *OC 2*, 1777.

436 "of the violet merchants": "Full Margin," in AB, *Young Cherry Trees Secured Against Hares*, trans. Edouard Roditi (1946; Ann Arbor: University of Michigan Press, 1969), [19] (trans. slightly revised).

436 left there "as a turd": Heijenoort, *With Trotsky in Exile*, 160, 141.

436 until the following evening: Dugrand, *Trotsky in Mexico*, 46–51, 53.

436 "they finally got him!": Schwarz, *Breton, Trotsky*, 86.

436 "horrible blow of fate": "Pont-levis," 197.

436 "think about nothing else": AB to Brauner, 19 Sept. 1940, *Planète affolée*, 56.

437 "but not certain": AB to Péret, 12 Oct. 1940, Doucet; Seligmann to AB, 10 Oct. 1940, *Planète affolée*, 56–57; AB cat., 347.

437 "doubts about exiles": AB to Bonneaud, 13 Oct. 1940, published as AB, *Lettre à Maud, 13 octobre 1940* (Marseille: Villa Bel-Air, 1989), 7.

437 "without much hope": Ibid., 6–7.

437 "flotsam and jetsam": Noël, *Marseille–New York*, 7–10.

437 "precariously lodged": Daniel Bénédite, *La Filière marseillaise: Un chemin vers la liberté sous l'Occupation* (Paris: Clancier Guénaud, 1984), 58.

437 thirteen-month adventure: *Villa Air-Bel: Varian Fry in Marseilles, 1940–41*, a film by Jorg Bundschuh, produced by Kick Film GmbH, Munich, 1987 (hereinafter "*Villa Air-Bel*").

438 ernst, péret, and breton: Bénédite, *Filière marseillaise*, 21, 50–51, 68, 75; *Villa Air-Bel*; Ernst, *Not-So-Still Life*, 171, 195; Noël, *Marseille–New York*, 26, 52.

438 breton and family: Bénédite, *Filière marseillaise*, 54–57; *Villa Air-Bel*; Mary Jayne Gold, *Crossroads Marseille, 1940* (Garden City, N.Y.: Doubleday, 1980), 237–43; Varian Fry, *Surrender on Demand* (New York: Random House, 1945), 113; Seligmann to Emergency Rescue Committee, 2 Oct. 1940, *Planète affolée*, 56.

438 "to a dead branch": "The Marseilles Deck," in *Free Rein*, 48.

438 "standards of 1870": Mary Jayne Gold, quoted in *Villa Air-Bel*; Gold, *Crossroads Marseille*, 243; Bénédite, *Filière marseillaise*, 59; Fry, *Surrender on Demand*, 114–15; Noël, *Marseille–New York*, 32, 42.

439 "english clergyman": Bénédite, *Filière marseillaise*, 116, 118.

439 "with the beyond": Gold, *Crossroads Marseille*, 254.

439 "stupefying! extraordinary!": Bénédite, *Filière marseillaise*, 120–21.

439 "positively captivated": Bénédite, *Filière marseillaise*, 218, 121; MP interview with Mary Jayne Gold, 16 May 1989.

439 "least bit snobbish or superior": MP interview with Mary Jayne Gold.

439 "brand of dog-talk": Gold, *Crossroads Marseille*, 249.

440 "around a tiny waist": Ibid., 248.

440 "bright and very proud": Bénédite, *Filière marseillaise*, 120.

440 "promising artist": Fry, *Surrender on Demand*, 117; MP interview with Mary Jayne Gold.

440 its "group leader": Bénédite, *Filière marseillaise*, 118; Gold, *Crossroads Marseille*, 246; MP interview with Mary Jayne Gold.

440 "with respect to it": Bédouin, *Vingt ans*, 27. See, as an example of the opposing viewpoint, Ernst, *Not-So-Still Life*, 251.

440 "tragicomedy as 'cretinizing'": Gold, *Crossroads Marseille*, 245; Bénédite, *Filière marseillaise*, 124.

440 "betrayed in love": MP interview with Mary Jayne Gold; Bénédite, *Filière marseillaise*, 118.

440 "thick spanish accent": Gold, *Crossroads Marseille*, 250; Fry, *Surrender on Demand*, 117.

441 commenting on world events: Bénédite, *Filière marseillaise*, 125–26; AB to Jean Ballard, 2 Jan. 1941, *Planète affolée*, 57.

441 willing to sponsor them: AB cat., 347.

441 "aspect of the struggle": Tristan Tzara, *Le Surréalisme et l'après-guerre* [1947] (Paris: Nagel, 1966), 37; *Conversations*, 155.

441 "odd satisfaction": Gold, *Crossroads Marseille*, 249–50.

441 "down several lines": Bénédite, *Filière marseillaise*, 122–23; Gold, *Crossroads Marseille*, 264.

441 "as other freedoms": *Conversations*, 188.

442 "the flames dance": Bénédite, *Filière marseillaise*, 209.

442 "vetch supplanted lentils": Ibid., 127.

442 "ANYWHERE AT ALL": Ibid., 124–25.

442 OFF PRESS . . . ON MARCH 10: Pierre-Quint to AB, 10 Feb. 1941, BN; AB cat., 349.

443 UNPRECEDENTED LENGTHS: Bénédite, *Filière marseillaise*, 141; Berl, *Interrogatoire*, 88; Noël, *Marseille–New York*, 12.

443 "GROTESQUE! INSANE!": Bénédite, *Filière marseillaise*, 143.

443 "IN THE FRENCH ARMY": Ibid., 144; Gold, *Crossroads Marseille*, 265–66.

443 "SHRUGGED HIS SHOULDERS": Gold, *Crossroads Marseille*, 273–74.

444 RELEASED AND SENT HOME: Bénédite, *Filière marseillaise*, 147–50; *Villa Air-Bel*; Fry, *Surrender on Demand*, 144; Gold, *Crossroads Marseille*, 271.

444 "I'LL HOLD OUT": AB to Pierre-Quint, 4 Feb. 1941, BN.

444 "LIKE A TROPICAL BIRD": Bénédite, *Filière marseillaise*, 212.

444 SONGS FROM UBU ROI: Ibid., 159, 211–13.

444 "GREAT MILITARY SETBACKS": "The Marseilles Deck," 49.

445 "THE UNITY OF ASPIRATION": AB, interview with Charles Henri Ford, in *Conversations*, 188n (first published in *View* 7–8 [Oct.–Nov. 1941]); Noël, *Marseille–New York*, 34–36; Bénédite, *Filière marseillaise*, 213; Georges Raillard, "Marseille, passage du surréalisme," in *Planète affolée*, 53. The deck was published in facsimile in 1983 by André Dimanche, Marseille.

445 "BUTT STUCK ON IT": Bénédite, *Filière marseillaise*, 191; Raillard, "Marseille, passage du surréalisme," 47.

445 "THEY WENT AWAY AGAIN": Fry, *Surrender on Demand*, 221; Noël, *Marseille–New York*, 70.

445 MONTHS BEFORE HIS DEATH: *Villa Air-Bel*; Noël, *Marseille–New York*, 50–52.

445 "DISHONORED SURREALISM": Hugnet, *Pleins et déliés*, 407.

445 "IN PRISON I WOULD DIE": AB to Simone, 5 April 1926, Sator.

446 "ALMOST ALSO AFRAID": AB, "Fata Morgana," trans. Clark Mills, *New Directions* 41 (1941), 663. This was the first publication of the poem; the French-language text did not appear in print until 1942, in Roger Caillois's expatriate magazine *Les Lettres françaises* (Buenos Aires).

446 "RICH WITH MEANING": AB, *Martinique, Charmeuse de serpents*, with texts and drawings by André Masson (1948; Paris: Jean-Jacques Pauvert, 1972), 56–57; AB cat., 349; Noël, *Marseille–New York*, 54; Claude Lévi-Strauss, *Tristes Tropiques*, trans. John and Doreen Weightman (New York: Atheneum, 1974), 24–26; Alain Dugrand, "La Traversée des mal-pen-

sants," *Le Monde* (27 July 1984), 15; MP interview with Claude Lévi-Strauss, 21 Feb. 1989.

447 "DIGNIFIED AIR": Lévi-Strauss, *Tristes Tropiques*, 25; Claude Lévi-Strauss and Didier Eribon, *De près et de loin* (Paris: Odile Jacob, 1988), 45; MP interview with Claude Lévi-Strauss.

447 "WATERFALL ON BLACK SAND": *Martinique*, 57.

447 "HEARD ON EVERY SIDE": Lévi-Strauss, *Tristes Tropiques*, 26.

447 "STRAIGHT IN THE EYE": *Martinique*, 59.

447 "INTERNMENT FEES": Ibid., 60; MP interview with Claude Lévi-Strauss.

447 "THOSE ON THE BOAT": *Martinique*, 61.

448 "POETIC AND PSYCHOLOGICAL INTEREST": Ibid., 61–65; Noël, *Marseille–New York*, 56.

448 "POETS IN MARTINIQUE": *Martinique*, 65.

448 "HARDLY STUDIOUS VARIETY": Ibid., 68.

448 THE "COLORED ELEMENTS": Ibid., 65.

448 HIS CONSTANT SHADOW: Ibid., 68–72.

448 "OF OUR TIMES": "A Great Black Poet: Aimé Césaire," trans. Dale Tomich, in *What is Surrealism?*, 232. First published in the Francophone New York magazine *Hémisphères* 2–3 (fall 1943).

448 "IT COULD BE SAID!": Ibid., 230.

449 "TOWARD FINDING MYSELF": Virmaux, *Breton qui êtes-vous?*, 103–4.

449 "HE WAS ENTITLED": *Conversations*, 183n.

17. The Exile Without

450 "CHRISTMAS TREE OF THE WORLD": Jacqueline to Fry, 24 June 1941, Varian Fry Archives, Columbia University, Box 8; Jacqueline Lamba to MP, 8 Oct. 1988; Grimberg, *Jacqueline Lamba*, 19; Noël, *Marseille–New York*, 86. Breton was the subject of at least one FBI investigation during his stay in New York, but according to the FBI's Information Management Division, his entire file has now been lost: J. Kevin O'Brien, FOIPA Section Chief, to MP, 28 Sept. 1992.

450 "SIDES OF THE ROOM": Abel, *Intellectual Follies*, 94; Jacqueline Lamba to MP, 8 Oct. 1988; Balakian, *André Breton*, 173; Guggenheim, *Out of This Century*, 249; Martica Sawin, "Aux Etats-Unis," in *Planète affolée*, 109; Denis de Rougemont, *Journal d'une époque (1926–1946)* (Paris: Gallimard, 1968), 501; MP interviews with Lionel Abel, 14 Nov. 1989, and Pierre Matisse, 5 Dec. 1988. Breton's addresses are derived from his correspondence of the period.

451 "SHOT TOMORROW AT DAWN!": Josephson, *Life*, 342; Sawin, "Aux Etats-Unis," 109.

451 DRAFTS OF BITTERNESS: *New York Times* (15 July 1941), 17 (for arrival information); Guggenheim, *Out of This Century*, 230–31, 237–38, 276;

Chadwick, *Women Artists*, 84–85; Jacqueline Bograd Weld, *Peggy: The Wayward Guggenheim* (New York: E. P. Dutton, 1986), 164, 227; Leonora Carrington, *The House of Fear: Notes from Down Below* (New York: E. P. Dutton, 1988), 163–214, esp. 164–65, 171–75, 210–14.

452 "AGREE TO SEE HIM": Dalí, *Diary of a Genius*, 32; Secrest, *Salvador Dalí*, 169–70.

452 "WAS SURREALISM": Dalí, *Diary of a Genius*, 32.

452 "I'M ONLY AN OPPORTUNIST": Weld, *Peggy*, 271.

452 "SURREALISM'S FUTURE": Sawin, "Aux Etats-Unis," 109. Lionel Abel later remarked that "Breton wanted to keep Surrealism going, not recreate it. He wanted to keep it alive": interview with MP, 14 Nov. 1989.

452 "TRIED IN VAIN TO SMOTHER": Levy, *Memoir of an Art Gallery*, 279.

453 AN "INITIATION RITE": Baron, *L'An I*, 81; Guggenheim, *Out of This Century*, 267.

453 "ANY OTHER CONSIDERATION": AB to Roger Caillois, 12 Oct. 1941, private collection.

453 RACE OF HOMOSEXUALS: Cf. Weld, *Peggy*, 269; AB to Péret, 19 April 1943, Doucet. *View* was not the only American magazine to open its pages to Surrealism (among others, *New Directions* published a compendious Surrealist anthology in its 1940 issue), but it was by far the most consistent. The interview with Breton, both in the October *View* and as reprinted in *Conversations*, is credited to Charles Henri Ford (who spoke no French), but might have been conducted by Nicolas Calas.

453 "DROPPED FIFTY POUNDS": Weld, *Peggy*, 270.

453 "SAY IT AT ALL": MP interview with Dorothea Tanning, 15 Sept. 1987.

453 "THE LANGUAGE ISSUE": Seligmann to Mabille, 27 Aug. 1941, *Planète affolée*, 85.

454 PRIVATE HOMES BY APPOINTMENT: Cf. Jean, *Autobiography of Surrealism*, 410.

454 IT WAS ACTUALLY ABOUT: MP interview with Jean Schuster, 30 June 1986.

454 COURSE OF AMERICAN ART: Weld, *Peggy*, 273–74; George Melly, *Paris and the Surrealists* (New York: Thames and Hudson, 1991), 70; Pierre Cabanne, *Dialogues with Marcel Duchamp*, trans. Ron Padgett (New York: Viking Press, 1971), 146; MP interview with Pierre Matisse, 5 Dec. 1988. Much of this influence was transmitted by the better-connected Matta, who introduced Baziotes, Pollock, Robert Motherwell, and Lee Krasner to automatic drawing, a direct precursor of Abstract Expressionism.

454 "YOU COULD GET A PH.D.": William Phillips, editor of *Partisan Review*, quoted in Deborah Solomon, "Meyer Schapiro: A Critic Turns 90," *New York Times Magazine* (14 Aug. 1994), 24;

MP interview with Meyer Schapiro, 5 Feb. 1990; Sawin, "Aux Etats-Unis," 107.

455 "VERY PRECIOUS DISCOVERY": Jacqueline Lamba to MP, 8 Oct. 1988.

455 RUN ON BROADWAY: "Prolegomena to a Third Surrealist Manifesto or Not," in *Manifestoes*, 283; Balakian, *André Breton*, 176; Legrand, *Breton*, 75; MP interview with Claude Lévi-Strauss, 21 Feb. 1989.

455 ITCHING FOR SEVERAL DAYS: AB to Péret, 15 Nov. 1943, Doucet; Lévi-Strauss and Eribon, *De près et de loin*, 51; Jouffroy, "Collection André Breton," 35; MP interviews with Edouard Roditi, 21 April 1987, and Claude Lévi-Strauss.

455 "THINGS THAT I DIDN'T": MP interview with Claude Lévi-Strauss.

455 "NEW SYSTEM OF KNOWLEDGE": "Interview with Jean Duché," in *Conversations*, 202. First published in *Figaro Littéraire* (5 Oct. 1946).

456 "DROPPING WHATEVER HE PLEASES": All quotes this paragraph from AB to Péret, 4 Jan. 1942, Doucet. See also: Legrand, *Breton*, 76; Péret to Sherry Mangan, 11 Jan. 1942, Houghton. To Breton's dismay, the magazine was originally to be titled *Pour la victoire*, "which always seems a little indecent": AB to Peggy Guggenheim, 21 Dec. 1941, ILAB–LILA database detail page, www.ilabdatabase.com.

456 "STAND THE OTHER HALF": MP interview with Pierre Matisse, 5 Dec. 1988.

456 "THEY LIKED THE LEAST": Weld, *Peggy*, 271; Ernst, *Not-So-Still Life*, 223.

457 "TRAVEL THROUGH TIME": *Surrealism and Painting*, 285.

457 "BUT WHAT THE HELL": "Prolegomena," 290.

457 "SORRY BOTTLE OF THESE TIMES": AB to Péret, 8 June 1942, Doucet; Sawin, "Aux Etats-Unis," 110; Legrand, *Breton*, 136. The *VVV* translation of the "Prolegomena" (most likely by Lionel Abel) was reprinted in *What is Surrealism?*

458 "LOOKING OVER [HIS] SHOULDER": Serge Fauchereau, "Questions à Charles Henri Ford," *Digraphe* 30 (June 1983), 101.

458 "PEDERASTY INTERNATIONAL": AB to Péret, 19 April 1943, Doucet; Abel, *Intellectual Follies*, 93–94; MP interview with Lionel Abel, 14 Nov. 1989.

458 THE PRACTICAL ARRANGEMENTS: Balakian, *André Breton*, 176; Judith Young Mallin, notes for *Stars, Stripes and Surrealists* (unpublished ms.), courtesy of the author.

458 "RELY ONLY ON THEMSELVES": Duits, *Breton a-t-il dit passe*, 95.

458 "THAN UNDER A ROOF": Ibid.

458 "SPEAKS ONLY ENGLISH": AB to Péret, 8 June 1942, Doucet.

458 FOR ANY FUTURE GRANTS: AB to Rebecca Reis, 29 March 1944, private collection; Weld, *Peggy*, 257; MP interview with Edouard Roditi, 21 April 1987.

459 "TO DIFFERENT COUNTRIES": MP interviews with Edouard Roditi, 11 June 1987, and Claude Lévi-Strauss, 21 Feb. 1989.

459 IF DISTANT RELATIONS: Amédée Ozenfant, *Mémoires, 1886–1962* (Paris: Seghers, 1968), 499, 502; Lévi-Strauss and Eribon, *De près et de loin*, 50; Edouard Roditi, "Publisher of the Surrealists," unpublished manuscript; Claire Goll, *La Poursuite du vent*, in collaboration with Otto Hahn (Paris: Olivier Orban, 1976), 231; Robert Lebel, "Surréalisme, années américaines," in *Opus international* 123–124, 77; MP interview with Edouard Roditi, 11 June 1987.

459 "'RENTING' HIS VOICE": Roditi, "Publisher"; AB cat., 351; *Conversations*, 156; AB to Péret, 7 April 1942, Doucet.

459 WORDS "GOD" OR "POPE": Alexandrian, *Breton par lui-même*, 159.

459 "AN ENCOURAGING CALL": Thirion, 469.

460 "MORE CONCENTRATION CAMPS": *Soupault et le surréalisme*. Soupault later remarked that this was "the sort of thing that made me disgusted with literature."

460 "POINT OF CARICATURE": Thirion, *Révisions*, 193. On the Main à Plume: Michel Fauré, *Histoire du surréalisme sous l'Occupation* (Paris: La Table Ronde, 1982), pass., and *Tracts*, II, 300–11.

460 "THE LIBERATION OF MAN": [AB], "Declaration VVV," (trans. unknown), in *What is Surrealism?*, 338. First published in *VVV* 1 (June 1942). See also: Noël, *Marseille–New York*, 98.

460 "OR I'M LEAVING YOU!": Duits, *Breton a-t-il dit passe*, 104.

460 "ALL DAY LONG": Jacqueline, postscript to AB to Péret, 8 June 1942, Doucet; Noël, *Marseille–New York*, 90.

460 "TO DESPISE THEM": Jean, *Autobiography of Surrealism*, 191 (trans. slightly revised); Audoin, *Breton*, 74.

461 "TURNS OFF THE FAUCETS?": Thirion, 175.

461 "THE DAY-TO-DAY REALITY": MP interview with Leonora Carrington, 25 April 1986.

461 "LIFE RE-CREATED PERPETUALLY": *Mad Love*, 84–85; Duits, *Breton a-t-il dit passe*, 103; Balakian, *André Breton*, 175–76.

461 "FURTHER AWAY, BECOMING LOST": AB to Péret, 27 Aug. 1942, Doucet.

461 "CONVENIENTLY THERE": MP interview with Dorothea Tanning, 15 Sept. 1987.

461 "DESTROY YOU": Grimberg, *Jacqueline Lamba*, 21, from an interview with Lamba; MP conversation with Judith Young Mallin, 18 July 1989.

461 "AT LEAST ON MY SIDE": AB to Péret and Varo, 22 Oct. 1942, Doucet.

462 OF SEEING HIS DAUGHTER: MP interview with Aube Elléouët, 6 March 1988, and AB correspondence of the period (for addresses).

462 "SO SPARKLING, SO OPEN": *Arcanum 17*, 69.

462 "WITH A NAPOLEON COMPLEX": Guggenheim, *Out of This Century*, 270; Weld, *Peggy*, 268; Noël, *Marseille–New York*, 112, 114.

462 "VERY, VERY FEMALE": Weld, *Peggy*, 295; MP interview with Dorothea Tanning, 15 Sept. 1987.

463 "POWER OF LIBERATION": "The Situation of Surrealism Between the Two Wars," trans. Robert Greer Cohn, in *What is Surrealism?*, 237. First published in French in *VVV* 2–3 (March 1943), and in English in *Yale French Studies* i:2 (fall 1948). Later reprinted in *Free Rein*.

463 "THE GENIUS OF YOUTH": Ibid., 238.

463 "ABSTRACTED AND INTELLECTUALIZED": Wallace Fowlie, *The Age of Surrealism* (Bloomington: Indiana University Press, 1960), 102–3.

463 "BARED IN A FLASH": "Intérieur," in AB, *Signe ascendant* (Paris: Gallimard ["Poésie"], 1975), 57. First published in *VVV* 2–3.

463 "TREMBLING RETALIATION": Dorothea Tanning, *Birthday* (San Francisco: Lapis Press, 1986), 21.

463 "IL S'EN FOUT!": Ibid., 21.

463 "TWO MEN WERE RUBBED RAW": Duits, *Breton a-t-il dit passe*, 88.

464 DISPOSING OF THEIR FRIENDSHIP: MP interview with Meyer Schapiro, 5 Feb. 1990; Sawin, "Aux Etats-Unis," 107; José Pierre, "Le Parcours esthétique d'André Breton," in AB cat., 18. Pierre claims that the disagreement was over Fourier.

464 "KEPT TO ONE SIDE": Masson to AB, 14 May 1942, Doucet; Masson, *Années surréalistes*, 11; AB cat., 356.

464 "BOOK OF FLORAL PATTERNS": Péret to Duits, 1 May 1943 [misdated 1942], in Duits, *Breton a-t-il dit passe*, 187.

464 "DOWN FIFTY-SEVENTH STREET": AB to Péret, 25 July 1943; cf. AB to Péret, 26 May and 30 June 1943 (all documents: Doucet).

464 "WITH VISIBLE EMBARRASSMENT": Duits, *Breton a-t-il dit passe*, 102.

464 "ANDRÉ, WHO SMILED": Tanning, *Birthday*, 20.

465 "FROM FRIVOLITY TO GRAVITY": Annie Cohen-Solal, *Sartre: A Life*, trans. Anna Cancogni (New York: Pantheon Books, 1987), 237.

465 "THE PSEUDONYM BENEDICTA": MP interview with Edouard Roditi, 21 April 1987; Simone de Beauvoir, *Letters to Sartre*, ed. and trans. Quintin Hoare (New York: Arcade Publishing, 1991), 412.

465 "ONE MIGHT GREET A GHOST": Soupault, "Souvenirs," *NRF* 172, 670.

465 "LISTENED TO DUCHAMP": Duits, *Breton a-t-il dit passe*, 99.

465 "BRIEF BUT INTENSE JOYS": *Conversations*, 155; Soupault, "Souvenirs," 670; Jouffroy, "Collection André Breton," 39.

465 "POWERFULLY INTERESTED": Duits to AB, 1 Nov. 1942, *VVV* 2-3, 14.

466 "WERE HARDENED LAVA": Duits, *Breton a-t-il dit passe*, 33-34.

466 GESTURES SO "OLD WORLD": Ibid., 35.

466 MORAL OR SOCIAL TUTOR: Cf. ibid., 43-47, and Breton's fatherly letter to Duits, 18 March 1943, ibid., 185-86.

466 "VERY MUCH FROM HIM": Ibid., 231 (text reproduced 188-91); Levy, *Memoir of an Art Gallery*, 280; Jeanne Reynal to Agnes Gorky, 19 April 1944, Jeanne Reynal Papers, Archives of American Art, New York (hereinafter "Reynal").

467 "AMBITIONS INSPIRED IN HIM": Duits, *Breton a-t-il dit passe*, 115.

467 "RUN INTO 'THE OTHERS'": Ibid., 113-15.

467 "CANNOT READ HIS LOSS": "Les Etats généraux," in *Signe ascendant*, 69. First published in *VVV* 4 (Feb. 1944).

467 "THE FUR OF NIGHT": Ibid., 74.

467 ONE DAY BE OVER: Legrand, *Breton*, 146; Balakian, *André Breton*, 189-93. Another poem from this period, "Premiers Transparents," contains Breton's most explicit references to New York life, including blown fuses and ticker-tape parades.

467 SUBJECT TO DEPRESSION: AB to Péret, 15 Nov. 1943, Doucet.

468 SECURED AGAINST HARES: Duits, *Breton a-t-il dit passe*, 89; MP interview with Dorothea Tanning, 15 Sept. 1987; Fauchereau, "Questions à C. H. Ford," 101; MP interview with Charles Henri Ford, 25 Jan. 1989.

468 "THAT BRETON TRUSTED": MP conversation with Edouard Roditi, 23 April 1991.

468 "IN THE AMERICAN SENSE": William Carlos Williams, "The Genius of France," *View* vii:1 (Oct. 1946), 46-47.

468 "THAT IS, AN IDIOT": *Partisan Review* xiv:1 (1947), 82. In the end, View Editions published only one other volume, Edith Sitwell's *Green Songs*.

468 "TO THE ANALOGICAL WORLD": *Surrealism and Painting*, 199-200.

469 "EIGHTEENTH-CENTURY COURTIER": Matthew Spender to MP, 1 June 1993 (based on letters of Agnes Gorky); AB cat., 356; R. C. Giraud, "André Breton, collectionneur," *Jardin des arts* 67 (May 1960), 41.

469 "ATTRACTED BRETON'S ATTENTION": MP interview with Edouard Roditi, 11 June 1987.

469 "FOR HIS PERSONAL STATEMENT": Levy, *Memoir of an Art Gallery*, 285; MP interview with Lionel Abel, 14 Nov. 1989.

469 SIGNIFICANT NEW TALENT: Matthew Spender to MP, 1 June 1993.

469 "DECEMBER 9 OR 10, 1943": Manuscript dedication to Elisa on the ms. of *Arcane 17*, reproduced in AB cat., 359.

469 "ONLY PERSON I ADORE": AB to Péret, 13 Jan. 1944, Doucet; Balakian, *André Breton*, 177; MP interviews with Monique Fong, 12 Jan. 1988, Dorothea Tanning, 15 Sept. 1987, and Alain Jouffroy, 24 June 1986.

469 "ANYONE I'D EVER SEEN": MP interview with Pierre Matisse, 5 Dec. 1988; cf. Claude Roy, *Somme toute* (Paris: Gallimard, 1976), 300.

469 "CHILD PLAYING AT LIVING": MP interview with Monique Fong, 12 Jan. 1988.

470 "IN A BLUE SHADOW": *Arcanum 17*, 36. Elisa was thirty-seven years old when she met Breton; her daughter had been sixteen at the time of her death: see Jennifer Mundy, ed., *Surrealism: Desire Unbound*, exh. cat. (Princeton: Princeton University Press, 2001), 168.

470 "BACK TO LIFE": *Conversations*, 158.

470 "IN MOLTEN STEEL": Reynal to Agnes Gorky, 17 April [1945?], Reynal.

470 "SHADOW WAS IN ME": *Arcanum 17*, 68. Elisa later confirmed that meeting Breton had the same significance for her: conversation with MP, 24 March 1987.

470 "OF SOUTH AMERICA": "Prolegomena," 284.

470 "AS HER RETURN": AB to Péret, 29 March and 13 Jan. 1944, Doucet.

470 "LITTLE SWINE": AB to Péret, 29 March 1944, Doucet; Duits, *Breton a-t-il dit passe*, 134-37.

470 "CANONS OF ACADEMIC TECHNIQUE": Clement Greenberg, "Surrealist Painting," *The Nation* (12 Aug. 1944), 193.

471 "LIGHTNING TO DESCEND": Greenberg to Baziotes, 23 Aug. 1944, Baziotes Papers, Roll N/70-21, Archives of American Art, New York.

471 "BY FAR THE STRONGER": AB to Péret, 29 March 1944, Doucet. See also AB to Péret, 31 May 1944, Doucet; Baldwin, *Man Ray*, 244. The last issue of *VVV* is dated Feb. 1944, and is actually the third number: no. 2-3 had been a double issue.

471 "HOPE AND RESURRECTION": *Conversations*, 158.

471 "LONG AND PAINFUL JOURNEY": Balakian, *André Breton*, 202.

471 "NAMED BONAVENTURE": *Conversations*, 159; Balakian, *André Breton*, 202; Armand Hoog,

"Le Rocher de Mélusine," *Nouvelles littéraires* (8 Oct. 1966), 6.

472 "AFFIRMED ONE DAY": *Arcanum 17*, 52, see also 45.

472 "IS IN THE WORLD": *Second Manifesto*, 180n.

472 "IN CONTEMPORARY SOCIETY": "*Lyubovnaya lodka razbilas o bit*," in *Break of Day*, 55.

472 "EVER SUBMITTED TO": *Mad Love*, 112.

472 DENIAL OF NATURAL LAWS: Balakian, *André Breton*, 203–4; Chadwick, *Women Artists*, 141. This is not Breton's first mention of Melusina: Nadja, for example, had also identified with the water sprite: see *Nadja*, 106.

472 "TO A WORLD DISTRAUGHT": Balakian, *André Breton*, 204.

472 "ON HER HAS NO HOLD": *Arcanum 17*, 64.

473 "PREVENT AT ALL COSTS": Ibid., 65.

473 "MUST BE ACQUAINTED WITH": *Mad Love*, 88 (trans. slightly revised). In France, for example, women's suffrage was obtained only in October 1944, the same month that Breton finished writing *Arcanum 17*.

473 "BULLSHIT ROLE FOR WOMEN": MP interview with Leonora Carrington, 25 April 1986. Interested readers might notably consult Chadwick, *Women Artists*; Xavière Gauthier, *Surréalisme et sexualité* (Paris: Gallimard ["Idées"], 1971); and a curious bit of spleen by Guy Ducornet called *Le Punching-Ball et la vache à lait: La Critique universitaire nord-américaine face au Surréalisme* (Angers: Actual/ Deleatur, 1992).

473 "FOR 'BEATA BÉATRIX'": AB dedication on *Arcane 17*, AB cat., 359. On Elisa's claims of clairvoyance, cf. for example "De qui est-ce," *Le Surréalisme, même* 5 (spring 1959), 46–47, describing a test in which Elisa divined characteristics of certain individuals based on their hand-addressed envelopes.

474 AT A LOSS AS BEFORE: *Arcanum 17*, 94.

474 JOURNALISTS WOULD BE DEAD: Lottman, *Left Bank*, 223–28; Helena Lewis, "Elsa Triolet: The Politics of a Committed Writer," *Women's Studies International Forum* ix:4 (1986), 391; Gateau, *Paul Eluard*, 288.

474 "HIGHLY PREMATURE": AB to Péret, 23 Feb. 1945, Doucet; Gateau, *Paul Eluard*, 288–89.

474 "UP THE NEXT MORNING": *Conversations*, 162. Breton makes a nearly identical remark to Péret in his letter of 23 Feb. 1945.

475 "RIGHT TO LIVE ON": "Interview with René Bélance," in *Conversations*, 192. First published in *Haïti-Journal* (12–13 Dec. 1945).

475 "SOURCE OF ALL KNOWLEDGE": *The Dishonor of the Poets*, trans. James Brook, in Péret, *Death to the Pigs*, 200.

475 "ADVERTISING AGENTS": Ibid., 204 (trans. slightly revised).

475 "IN THE SLIGHTEST": Thirion, *Révisions*, 231–32, 236.

476 REMAINED IN PLACE UNCHALLENGED: "Lazy Hardware," in VèVè A. Clark, Millicent Hodson, Caterina Neiman, eds., *The Legend of Maya Deren: A Documentary Biography and Collected Works*, I(2) (New York: Anthology Film Archives/Film Culture, 1988), 145–47.

476 RAILING AGAINST THE CUISINE: Man Ray, *Self Portrait*, 192–93.

476 A GAMBLING CASINO: Reynal to Agnes Gorky, 22 June [1945], and others from the same month, Reynal; AB to Péret, 1 July 1945, Doucet; AB to Enrico Donati, [18 June 1945], *Pleine Marge* 7 (June 1988), 13. After the first night, the Bretons stayed at the Elmhurst Guest House on Mill Street.

476 "FROM THE LAST CENTURY": *Conversations*, 160. On the trip: Reynal to Agnes Gorky, 22 June and 24 Sept. 1945, Reynal; AB to Péret, [1 Feb. 1946], Doucet.

477 "LIVING CONDITIONS": *Conversations*, 161.

477 "OR COMMERCIAL GROUNDS": Unpublished notebook of travels among the Indians, in *OC 3*, 197. Breton's plan at the time was to write a large, well-illustrated book about his travels in Mexico, Martinique, and the American Southwest (AB to Pierre-Quint, 15 Sept. 1945, BN). See also Reynal to Agnes Gorky, 9 Nov. 1945, Reynal; Jacques Meunier, "Les Poupées Hopi," *Magazine littéraire* 254, 41–42. Date of divorce based on AB to Péret, 1 July 1945: "So by this letter, I'm announcing my marriage to Elisa, which will take place on July 30, to be precise" (Doucet).

477 WITH ITS OWN HAPPINESS: This brief presentation of Fourier is primarily based on Jean Gaulmier's annotations to AB, *Ode à Charles Fourier* (Paris: Klincksieck, 1961), 78–97, and Kenneth White's introduction to AB, *Ode to Charles Fourier*, trans. Kenneth White (New York: Grossman, 1970), n.p.

477 120 DAYS OF SODOM: Rougemont, *Journal*, 515.

477 AN "EROTIC CIVILIZATION": White, introduction to *Ode to Fourier*, [20–21].

477 "IN TOTAL FREEDOM": *Air of Water*, in *Earthlight*, 146; cf. Gauthier, *Surréalisme et sexualité*, 196.

478 "AT MISHONGNOVI": *Ode to Fourier*, [53, 59].

478 "THEY LIKE IT OR NOT": Ibid., [39].

478 "TEXTS AND DOCUMENTS": AB to Brauner, 6 Oct. 1945, AB cat., 364; AB to Pierre-Quint, 15 Sept. 1945, BN; AB to Gallimard, 15 Sept. 1945, *NRF* archives; cf. Gallimard to AB, 8 and 26 July 1946, *NRF* archives.

479 "DRAW UP [ITS] DEATH CERTIFICATE": Maurice Nadeau, *Histoire du surréalisme* (Paris: Editions du Seuil, 1945), 245, 258 (statement deleted from subsequent editions); *Conversations*, 165–66; MP interview with Marcel Jean, 1 March 1988.

479 HIS TRIP TO MEXICO: AB to Péret, 1 July 1945, Doucet.

479 "VOICE FROM MODERN FRANCE": "André Breton en Haiti," *Conjonction* 1 (Jan. 1946), 67, see also: photo illustrations, facing p. 18.

479 "AND DAILY LIFE": *Conversations*, 193; "Breton en Haiti," 67. On Breton's impressions of Haiti: AB to Enrico Donati, [29 Dec. 1945], *Pleine Marge* 7, 13; *Conversations*, 201.

480 "ABOUT HIS GRAYING HAIR": Roger Gaillard, "André Breton et nous," *Conjonction* 103 (Dec. 1966), 5.

480 "WILL NOT SPEAK AGAIN": Ibid., 7.

480 HIS STATUS . . . MADE PROBLEMATIC: Bédouin, *Vingt ans*, 75; Béhar, *André Breton*, 366; cf. AB, "Le Surréalisme," *Conjonction* 1, 10–26.

480 "INCULCATED IN IT": "Speech to Young Haitian Poets" (address delivered by Breton at a dinner in his honor, 14 Dec. 1945), trans. Stephen Schwartz, in *What is Surrealism?*, 260.

480 "YOU KNOW WHICH ONES": *La Ruche* (1 Jan. 1946), quoted in Bédouin, *Vingt ans*, 76; René Depestre, "La Révolution de 1946 est pour demain . . . ," in *Trente ans de pouvoir noir en Haiti, 1946–1976*, I (Lasalle, Que.: Collectif Paroles, 1976), 22.

480 "FORCES THEY SET IN MOTION": "Pont-levis," in *Perspective cavalière*, 200.

481 REVOLUTIONARY GOVERNMENT: Ibid., 199–200; *Conversations*, 161; Bédouin, *Vingt ans*, 76–77.

481 "THE BREAKING POINT": *Conversations*, 201.

481 "AND IN THE FUTURE": Gaillard, "Breton et nous," 7.

481 "CERTAINLY A SUBVERSIVE ACT": Lewis, *Politics of Surrealism*, 164. Several other lectures by Breton, from January 1946, were later discovered among the papers of Pierre Mabille and mistakenly attributed to him: see Pierre Mabille, *Traversées de nuit* (Paris: Plasma, 1981).

481 "WERE HARD TO DISSUADE": AB to Saint-John Perse, 17 April 1946, in Béhar, *André Breton*, 370–71; Legrand, *Breton*, 79.

481 PÉRET TO JOIN HIM: Duchamp to AB, 10 Jan. 1946; AB to Péret, [1 Feb. 1946] and 14 Aug. 1946 (all Doucet); Péret to Mabille, 14 April 1946, HRC.

481 SCHOOL SHE NOW ATTENDED: MP interview with Aube Elléouët, 6 March 1988.

482 "HEART OF THE MATTER": *Conversations*, 159–60.

482 "END JUSTIFIES THE MEANS": Ibid., 129, 205.

482 THE YEAR BEFORE: Camus, for example, doesn't even mention this meeting in his *American Journal*, nor do most of his biographers.

482 "MOVE ON VERY QUICKLY": *Conversations*, 155.

18. The Situation of Surrealism after the Two Wars

483 "SITUATION IN PARIS": *Conversations*, 161.

483 "HE WAS REDISCOVERING": "M. André Breton a fait une révolution politique à Haiti . . . avant de regagner Paris," *Le Figaro* (1 June 1946).

483 "THE WAR DILAPIDATED": AB to Paulhan, 18 Oct. 1946, JP; MP interview with Aube Elléouët, 6 March 1988; Pierre Descaves, "La Rentrée d'André Breton," *Erasme* (Sept. 1946), 371.

483 THE REINSTALLATION: Thirion, 479–80.

484 "WERE CUT OFF FROM IT": MP interview with Aube Elléouët, 6 March 1988.

484 "THEY WERE INCUBATORS!": Quoted in Association des Amis de Benjamin Péret, *De la part de Péret* [no place or date of publication], 29.

485 "BEEN IN THE RESISTANCE": MP interview with Jean-Louis Bédouin, 29 April 1991; Bédouin, *Vingt ans*, 85–86.

485 "HAVE TO BE SHOT": MP interviews with Jean-Louis Bédouin, 29 April 1991, and André Thirion, 24 April 1991. Char's quip becomes slightly less excessive when we recall that a number of French intellectuals were indeed executed for political reasons during the post-war "purifications."

485 "FULLY APPROVE ITS POLITICS": Eluard to Gala, 25 Nov. 1946, *LTG*, 261.

485 "I'M STILL A BIBLIOPHILE": Eluard to Gala, 27 March 1946, ibid., 258.

485 "A POLITICIAN RATÉ": MP interview with Jean-Louis Bédouin, 29 April 1991; Pieyre de Mandiargues, *Désordre*, 121; *Paris-Paris*, 374.

485 "TOTAL CONFUSION": *Conversations*, 25.

485 SAINT-GERMAIN-DES-PRÉS AT NIGHT: Bédouin, *Vingt ans*, 92; Audoin, *Les Surréalistes*, 116–17; Lottman, *Left Bank*, 231.

485 "ACADEMIC QUARRELS": Gérard Legrand, "André Breton, les idées et les idéologies," *Magazine littéraire* 64 (May 1972), 20.

485 "CHARLESTON AND THE YO-YO": Claude Mauriac, "Sartre contre Breton," *Carrefour* (10 Sept. 1947), 7.

486 "FROM ANOTHER PLANET": Olivier Todd, introduction to Roger Vailland, *Le Surréalisme contre la Révolution* (1948; Paris: Editions Complexe, 1988), 15; MP interview with Alain Jouffroy, 24 June 1986.

486 "FROM EVERY SIDE": AB to Péret, 14 Aug. 1946, Doucet.

486 HAD BEEN "A FAILURE": See, for example, Armand Hoog, "Permanence du Surréalisme,"

La Nef 33 (Aug. 1947), 119–22; Jean Delabie, "Position du surréalisme," *Arts* (18 Jan. 1946), 6; Henri-Jacques Dupuy, "Bilan du surréalisme," *Renaissances* 16 (1945), 76–87; Bernard Voyenne, "Bilan du surréalisme," *Revue de la pensée française* (Sept. 1947), 51–56; and Léon Pierre-Quint, "Le Surréalisme fut-il un échec?," *Confluences* (June 1945), 505–13.

486 "BEFORE HIS APERITIF": Jean, *Au galop*, 166.

486 "HANDS OF THE PROFESSORS": Hugnet, *Pleins et déliés*, 248–50.

487 "BREATHE LIFE INTO STONE": Audoin, *Breton*, 39; Maeder, *Antonin Artaud*, 266–67.

487 "OF OLD VETERANS": "Grippe-Soleil" [Claude Mauriac], in *Le Figaro* (6 July 1946).

488 "BRAQUE'S FIRST PAINTINGS WERE": AB to Pierre-Quint, 25 July 1946, BN; Béhar, *André Breton*, 379.

488 "RAVINES, AND BOULDERS": Quoted in René Magritte, *Manifestes et autres écrits* (Brussels: Les Lèvres Nues, 1972), 79.

488 "TABLES AT DESSERT": Alain Jouffroy, *La Fin des alternances* (Paris: Gallimard, 1970), 32.

488 "WHY, DO YOU KNOW HIM?'": Ibid., 34.

488 "EYE OF A TORNADO": Ibid., 28; Jouffroy, "Collection André Breton," 32.

488 "OF THIS ONE, OF THAT ONE?": MP interview with Alain Jouffroy, 24 June 1986.

488 "REVOLUTION TO BE WON": Jouffroy, *Fin des alternances*, 28.

489 AUBE WAS NOT THERE: AB to Simone, 7 Oct. 1946, Sator; Béhar, *André Breton*, 380.

489 "TO PRACTICALLY NOTHING": AB to Paulhan, 18 Oct. 1946, JP.

489 SEVERE ANEMIA: AB to Péret, 3 April 1947, Doucet; AB to Pierre-Quint, 10 Feb. 1947, BN.

489 "THE POINT OF ANYTHING?": AB to Blaise Allan, 5 Feb. 1947, Doucet.

489 ULTIMATELY PANNED OUT: Pierre-Quint to AB, 2 June 1946, BN.

489 HAVING LOST "ARCANUM 19": Gallimard to AB, 17 Oct. 1946; cf. Gallimard to AB, 19 March 1948 (both *NRF* archives).

489 CÉLINE AND GEORGES SIMENON: Paul Léautaud, *Journal littéraire*, XVII (Aug. 1946–Aug. 1949) (Paris: Mercure de France, 1964), 291.

490 "HEADS OFF TO THE METRO": Jean Cau, *Croquis de mémoire* (Paris: Julliard, 1985), 172; cf. "Réponses d'André Breton à des questions d'Aimé Patri," *Paru* (March 1948), 6 (reprinted, slightly abridged, in *Conversations*).

490 UNWILLING TO FORGIVE: Thirion, 480; Michel Leiris, "Breton, le patron," *Nouvel observateur* (20 May 1988); Lord, unpublished notes for *Giacometti*; AB to Prévert, 12 Nov. 1946, private collection; MP interview with Myrtille Hugnet,

2 March 1988. Breton posthumously reconciled with Desnos in his preface to the 1946 Saggitaire edition of the *Manifestoes*.

491 "DISRUPTED BY IT": "Surrealist Comet," in *Free Rein*, 93.

491 "PERSPIRATION OF SUICIDES": Artaud to AB, 24 March 1947, *Éphémère* 8 (winter 1968), 31.

491 OR ACCIDENTAL REMAINS UNKNOWN: Maeder, *Antonin Artaud*, 289.

491 "SUPERB ARROGANCE": Alexandrian, *Breton par lui-même*, 173.

491 "PASSED SURREALISM BY": Tzara, *Surréalisme et l'après-guerre*, 28. Because of a note in the printed version (p. 95), the date of Tzara's speech is often given as 11 April; but contemporary newspaper accounts confirm that it was in fact 17 March.

491 "ATOP THE STATUE OF LIBERTY": Ibid., 30.

491 AUDIENCE WITH HIM: Jean Maury, "Tzara au Panthéon!" *Combat* (18 March 1947), 4; Jean Marcenac, "Ce qu'il nous laisse," *L'Humanité* (29 Sept. 1966); Tzara, *Œuvres complètes*, V, 638–41.

491 "FRAY AT BRETON'S SIDE": Alexandrian, *Breton par lui-même*, 173.

492 "OCCASIONS TO COME FORWARD": AB to Georges Henein, [ca. 20 March 1947], Béhar, *André Breton*, 386.

492 "PÉRET GETS HERE": Alexandrian, *Surréalisme et rêve*, 396.

492 "DO NOT HAVE ANY TALENT": *Manifesto*, 28.

492 "CROWDED IN AT THE CAFÉ": Jean, *Au galop*, 171; MP interview with Aube Elléouët, 6 March 1988.

493 "EMANATES FROM IT": "Surrealist Comet," 93; Pierre Guerre, "L'Exposition internationale du surréalisme," *Cahiers du Sud* 284 (1947), quoted in *Planète affolée*, 289.

493 "OF AN INITIATION": AB, "Projet initial," in *Le Surréalisme en 1947*, exh. cat. (Paris: Maeght Editeur, 1947), 135.

493 "ENDOWED WITH MYTHIC LIFE": Ibid., 136; Guerre, "L'Exposition internationale," 290; Alexandrian, *Breton par lui-même*, 165; *Conversations*, 164.

494 "NOW OR NEVER": Pierre, "Parcours esthétique," 18.

494 "AFTER THE LIBERATION": Françoise Gilot and Carlton Lake, *Life with Picasso* (New York: Signet Books, 1965), 132.

494 "NEVER SEE EACH OTHER AGAIN": Ibid., 132–33.

494 "TO SHAKE HIS HAND": AB, rebuttal to *Paris-Match* (Nov. 1965), quoted in AB cat., 430.

494 "TACKLING THIS CONTRADICTION": "Surrealist Comet," 90; Daix, *Picasso créateur*, 304–5.

495 "OF SURREALISM'S EXISTENCE": *Action* (25 July 1947), quoted in *Tracts*, II, 188.

495 "GUSHING INSPIRATION": Hoog, "Permanence du Surréalisme," 120–21.

495 "WORN OUT FROM OVERUSE": *Lettres françaises* (18 July 1947), quoted in *Tracts*, II, 190.

495 "TO VISIT THE CAPITAL": Bernard Dorival, "Fantômes du Surréalisme," *Nouvelles littéraires* (17 July 1947), 1. See also: Mariën, *Activité surréaliste en Belgique*, 412–16; *Conversations*, 165; Michel Enrici, "Profession: éditeur," in *A proximité des poètes et des peintres: Quarante ans d'édition Maeght* (Paris: Adrien Maeght Editeur, 1986), 37.

495 "DESPISED AT OUR AGE": Henri Pastoureau, "Le Surréalisme de l'après-guerre, 1946–1950," *L'Orne littéraire* 5 (1983), 10–11; Guerre, "L'Exposition internationale," 290. Breton's reference is to a letter from Marcel Duchamp of 18 July: "It's rather nice to be despised like kids 'AT OUR AGE'" (Doucet).

495 "THESE DISMAL BUFFOONERIES": *L'Humanité*, quoted in Georges Duthuit, "Sartre's Last Class," *Transition 48* 2 (June 1948), 145.

496 JOIN THE POSTWAR GROUP: Pastoureau, "Surréalisme de l'après-guerre," 6–7; Bédouin, *Vingt ans*, 96; Alexandrian, *Breton par lui-même*, 115; MP interview with Jean-Louis Bédouin, 29 April 1991.

496 "SERVE PROMOTIONAL ENDS": Isidore Isou, *Réflexions sur André Breton* (Paris: Editions Lettrisme, 1948), 9

496 "HIS MENSTRUATIONS": Ibid., 23n. See also: "Lettre orangée à André Breton," in Henri Pichette, *Lettres arc-en-ciel* (Paris: L'Arche, 1950).

496 TWENTY YEARS BEFORE: Vailland, *Surréalisme contre la Révolution*, 39, 45, 85, et pass.; *Conversations*, 226.

497 LITERATURE TO BOOT: Jean-Paul Sartre, *What is Literature?*, trans. Bernard Frechtman (New York: Philosophical Library, 1949), 132–35, 193, 198. Sartre's remarks on Surrealism first appeared in his periodical *Les Temps modernes* 20 (May 1947), 1410–29 (esp. 1419–29), to which he added an extensive footnote for the book-length version the following year in response to Surrealist rebuttals—much as Breton had earlier done with the *Second Manifesto*.

497 "AS CONTRADICTIONS": *Second Manifesto*, 123.

497 "BLOOD IT WILL SHED": Sartre, *What is Literature?*, 184. For a discussion of this debate, see Michel Beaujour, "Sartre and Surrealism," *Yale French Studies* 30 [1963], 86–95.

497 "OF HUMAN INTERESTS": *Conversations*, 160.

497 THAN "LIVING CONDITIONS": "Interview with Claudine Chonez," in *Conversations*, 224. First published in *Une Semaine dans le monde* (31 July

1948), and not *Gazette des lettres*, as stated in *Conversations*.

497 "ATHEISTIC POETIC SCHOOL": Dom Claude Jean-Nesmy, "André Breton et l'Ambition surréaliste," *Témoignages* 14 (1947), quoted in Bédouin, *Vingt ans*, 174. See also: Guerre, "L'Exposition internationale," 289; Georges Bataille, "La Religion surréaliste [1948]," in Bataille, *Œuvres complètes*, VII (Paris: Gallimard, 1976), 386–87.

497 "EXPRESSED HIMSELF NO DIFFERENTLY": Claude Mauriac, "André Breton, mystique et moraliste," *La Nef* 30, 23; cf. Claude Mauriac, *Aimer De Gaulle (Le Temps immobile, V)* (Paris: Grasset, 1978), 330.

498 "ENTAILS IN THIS ONE": "Interview with Aimé Patri," in *Conversations*, 219.

498 "ANY GENUFLECTING CREATURE": *A la niche les glapisseurs de dieu!*, in *Tracts*, II, 41.

498 "NOVELS OF OUR CHILDHOODS": Alexandrian, *Surréalisme et rêve*, 396.

498 "COUNTRY IN THE WORLD": Jean, *Au galop*, 172.

498 "LIVING UP TO IT": Alexandrian, *Surréalisme et rêve*, 396.

498 "VERY VARIABLE INTEREST": Note featured as part of Surrealist Solution letterhead.

499 "OF SURREALISM'S ENEMIES": Alain Jouffroy, "Société secrète de l'écriture, *Change* 7, 39.

499 "WHO INTERESTS ME": AB to Duprey, 18 Jan. 1949, in Jean-Pierre Duprey, *Derrière son double* (1950; Paris: Le Soleil Noir, 1977), 15–16.

499 "THOUGHT IS BEING SUBJECTED": "The Lamp in the Clock," in *Free Rein*, 108. Originally published as a separate pamphlet in 1948.

499 "THE END OF THE WORLD": Ibid., 111.

500 "THE CAUSE OF IT": Ibid..

500 "ENDURES ONE'S SHADOW": Duits, *Breton a-t-il dit passe*, 228; Balakian, *André Breton*, 255.

500 "ENTIRELY IGNORE THEM": AB to Gallimard, 26 March 1948, *NRF* archives; Duchamp to AB, 8 March 1948, Doucet; Gateau, *Paul Eluard*, 250; Gallimard to AB, 13 April 1948, *NRF* archives. Gallimard seems to have known about these owings since Dec. 1947, judging from Breton's royalty statement dated 31 Dec. of that year, which shows a balance due of 53,061.50 francs (*NRF* Archives)..

500 ASSEMBLIES OF DELEGATES: *Conversations*, 226; AB, "Culture et révolution [speech of 21 Oct. 1949], in Schwarz, *Breton, Trotsky*, 170; *Tracts*, II, 325; Pastoureau, "Surréalisme de l'après-guerre," 15.

500 "BEAUTIFUL CHILDREN GROW": AB, "Allocution prononcée le 30 avril 1948 à la première réunion publique de Front Humain," published as an appendix to the pamphlet edition of *La Lampe*

dans horloge (Paris: Robert Marin, 1948), 66–68, 70.

501 AS A SHAREHOLDER: Dubuffet to AB, 25 May [1948], private collection; Dubuffet to Lise, [ca. 31 July 1948], in Deharme, *Années perdues*, 223; MacGregor, *Art of the Insane*, 293, 295. The founding members included Breton, Dubuffet, Paulhan, art dealer Charles Ratton, art dealer and novelist Henri-Pierre Roché, arts patron Florence Gould, and painter Michel Tapié— but, significantly, no psychiatrists. See also: *Surrealism and Painting*, 316; AB cat., 402.

501 "ENOUGH MONEY AS IT IS": Masson, "Breton, croquemitaine," 12.

501 "MISERY OF THE WORLD": "On the Road to San Romano," trans. Charles Simic and Michael Benedikt, in *André Breton: Selections*, 121–23.

502 "GOODBYE, MY 'LOVEDS'": Abel, *Intellectual Follies*, 112–13; Levy, *Memoir of an Art Gallery*, 288–95; MP interview with Lionel Abel, 14 Nov. 1989.

502 "EROTIC GIDDINESS": *Tracts*, II, 323.

502 "MIND THAT EVER WAS": *Anthology of Black Humor*, 18.

502 CALLED HIM A "MURDERER": Abel, *Intellectual Follies*, 114–15; *Tracts*, II, 323; MP interview with Alain Jouffroy, 24 June 1986.

502 "AND MORAL TURPITUDE": "[Exclusion de Matta]," in *Tracts*, II, 41.

503 "FOR HAVING GIVEN IN": MP interview with Alain Jouffroy.

503 "OF BOURGEOIS MORALITY": *Tracts*, II, 324.

503 "FOR FACTIOUS ACTIVITIES": "[Exclusion de Brauner]," in *Tracts*, II, 42.

503 DISBANDING THE SURREALIST GROUP: Henri Pastoureau, "Aide-mémoire relatif à l'affaire Carrouges," in *Tracts*, II, 61.

503 TO TAKE NOTICE: Pastoureau, "Surréalisme de l'après-guerre," 18; Herbert R. Lottman, *Albert Camus: A Biography* (1980; New York: George Braziller, 1981), 449; Cohen-Solal, *Sartre*, 309; Maurice Henry, "Garry Davis et Robert Sarrazac interrompent la séance de l'ONU," *Combat* (20 Nov. 1948), 3; AB to Paulhan, 16 Oct. 1948, JP.

503 "SET BEFORE US": AB, "Un pour tous hormis quelques-uns," *Combat* (20 Nov. 1948), 1, 3.

503 "SACRIFICING OUR LIVES": AB, "La Paix pour nous-mêmes," in *Tracts*, II, 325–26. First published in *Franc-Tireur* (Dec. 1948).

503 "ITS STALINIST FORM": Lottman, *Left Bank*, 279; Christopher Sawyer-Lauçanno, *The Continual Pilgrimage: Americans in Paris, 1944–1960* (New York: Grove Press, 1992), 79; Cohen-Solal, *Sartre*, 305.

504 AT TWO PER YEAR: Gallimard to AB, 8 July 1949;

AB to Gallimard, 11 Dec. 1951 (both *NRF* archives); Paulhan to AB, [ca. 1950], Doucet.

504 BASIC FISCAL CONCERN: Gallimard internal memo, 25 April 1949; various letters from Gallimard to AB, 1949 and 1950 (all documents: *NRF* archives).

505 "UNCTUOUS AS TURKISH DELIGHT": Pastoureau, "Surréalisme de l'après-guerre," 17; Biro, et al., *Dictionnaire général*, 172.

505 "NOT ON EVERY RING": "The Night of the Rose-Hotel," in *Free Rein*, 201–2. First published in *Cahiers de la Pléïade* 8 (fall 1949) and as the introduction to Maurice Fourré, *La Nuit du Rose-Hôtel* (Paris: Gallimard ["Révélations"], 1950).

505 "WERE WRITTEN BY HIM": AB to *Combat*, 19 May 1949, quoted in "Caught in the Act," in *Free Rein*, 165. First published as a separate pamphlet, July 1949.

505 AND UNFAVORABLY AS HIMSELF: Cf. *Mercure de France* (1 Aug. 1947), 718–22, and (1 April 1949), 699. Cf. Maurice Nadeau, "André Breton poète," *Combat* (12 March 1948); "Caught in the Act," 168; Maurice Nadeau, *Grâces leur soient rendues* (Paris: Albin Michel, 1990), 43–47.

506 "TAKING UP HIS PEN AGAIN": *Conversations*, 166. For a complete discussion of the "*Chasse spirituelle* Affair," see Bruce Morrissette, *The Great Rimbaud Forgery: The Affair of "La Chasse spirituelle"* (St. Louis: Washington University Studies, 1956). Apparently, Bataille and Akakia wrote the poem to get back at critics who had earlier panned their dramatization of some Rimbaud texts.

506 "QUITE A FEW PHYSICAL WOES": AB to Crastre, 16 March 1949, HRC.

506 WOULD RETURN TO PARIS: MP interview with Aube Elléouët, 6 March 1988; AB cat., 405.

506 "PROW OF AN ADVANCING SHIP": MP interview with Aube Elléouët.

506 "MASKS, HEADS, PAINTINGS": Ibid.

507 "HE GAVE WITHOUT STOPPING": Ibid.

507 CO-OPTED BY THE CHURCH: AB to Paulhan, 4 Oct. 1949, JP; "Culture et révolution," 172–74; "Interview with José M. Valverde [1950]," in *Conversations*, 241.

507 "SCATTER IN ALL DIRECTIONS": Schuster, *Fruits de la passion*, 26–27.

508 "THIS INTO CONSIDERATION": AB to Gallimard, 10 Dec. 1949, *NRF* archives.

508 AT THE SAME TIME: Gallimard to AB, 16 Dec. 1949; AB to Gallimard, 10 Dec. 1949; *NRF* sales memo, 30 June 1949 (all documents: *NRF* archives).

508 "IN A PUBLICITY RELEASE": AB to Gallimard, 10 Dec. 1949. See also: AB to Gallimard, 4 Jan.

1950, 11 Dec. 1951, 23 June and 13 July 1954; Gallimard to AB, 30 June 1954; *NRF* internal memo, 26 Nov. 1951. Not insensitive to Breton's concerns, Gallimard offered to continue the series if Breton could propose some more salable titles for it (in vain). In 1951, he also resiliated all of Breton's outstanding debts to the company and changed his 50,000-franc monthly advance to a flat-out salary, on condition that Breton give the *NRF* all his old titles as they went out of print: Gallimard to AB, 18 Dec. 1951; Edmond Bomsel to René Bertelé, 27 Dec. 1951 (all documents: *NRF* archives).

509 ANTHOLOGY HE WAS EDITING: Georges Ribemont-Dessaignes, "André Breton ou l'intégrité noire," *NRF* 172, 673; AB to Ribemont-Dessaignes, 28 Dec. 1949, Doucet.

509 "IT WAS NEVER ABOUT THAT": AB to Ribemont-Dessaignes, ibid.

19. "I Am Surrealism!"

510 "SEEM LAUGHABLE": *Conversations*, 229.

510 "'PRIME MATTER' OF LANGUAGE": "On Surrealism in its Living Works," in *Manifestoes*, 299–300. First published in *Médium* (new series) 4 (Jan. 1955). See also: Audoin, *Breton*, 43.

510 "CAN OFFSET, IS INDEPENDENCE": André Billy, "De l'indépendance de l'écrivain," *Le Figaro* (28 Jan. 1950). See also Alexandrian, *Breton par lui-même*, 174; Bédouin, *Vingt ans*, 165; "Two Interviews with André Parinaud [1961 and 1962]," in *Conversations*, 245.

511 "WAS A FRIEND TO YOU?": "Open Letter to Paul Eluard," in *Free Rein*, 230–31. First published in *Combat* (14 June 1950).

511 "PROCLAIM THEIR GUILT": Ibid., 289; Bédouin, *Vingt ans*, 171. The "innocent people" in Eluard's reply were the Rosenbergs, whom he was involved in trying to free at the time.

511 "VERY SUSPECT": AB to Crastre, 24 May 1950, HRC; AB to Paulhan, 17 May 1950, JP. The caves had been opened in the early 1940s.

512 "FORCED TO LIVE IN": AB to Paulhan, 9 Aug. 1950, JP.

512 "AS MUCH AS PHYSICAL": MP interview with Aube Elléouët, 6 March 1988.

512 "IN A RUSTIC SETTING": *Manifesto*, 16; Balakian, *André Breton*, 254.

512 "BUTTERFLIES FROM CHILE": Jean Malrieux, "D'un château à l'autre," *Cahiers du Sud* 390–391 (1966), 314.

512 "WISHING TO BE ELSEWHERE": Quoted in Champs des Activités Surréalistes, *Du Surréalisme et du plaisir* (Paris: José Corti, 1987), 252; Balakian, *André Breton*, 225; AB to Péret, 11 Aug. 1950, Doucet.

512 "OF EXCEPTIONAL BEAUTY": Béhar, *Théâtre dada et surréaliste*, 369n; Biro, et al., *Dictionnaire général*, pass.; MP interview with Monique Fong, 12 Jan. 1988.

513 "THE CORNER OF HIS MOUTH": MP interview with Monique Fong.

513 "GAVE ME THE NUMBER": Jean Schuster, "Place Blanche, milieu du siècle," *Opus international* 123–124, 180–81.

514 "GAINS OF AMERICAN CAPITALISM": Henri Pastoureau, "Observations relatives à l'opuscule de Breton-Péret: *L'Affaire Pastoureau et Cie* et au compte rendu de l'assemblée du 19 mars 1951," in *Tracts*, II, 85–86; Pastoureau, "Surréalisme de l'après-guerre," 23.

514 "PERMANENTLY BARRED": *Conversations*, 149.

515 AGAIN FAILED TO REACT: Henri Pastoureau, "Aide-mémoire relatif à l'affaire Carrouges," in *Tracts*, II, 53–55. Cf. AB and Benjamin Péret, "L'Affaire Pastoureau & Cie (Tenants et aboutissants)," in *Tracts*, II, 65; Monique Fong, unpublished notes from spring 1951 regarding the Carrouges Affair, courtesy of the author.

515 "AND SHIT ON CARROUGES!": Pastoureau, "Aide-mémoire," 56–59; Jean, *Au galop*, 177.

515 "DOING IT FOR HIM": MP interview with Marcel Jean, 1 March 1988.

515 "SATISFACTORY SOLUTION": AB and Péret to Surrealist group, 18 Feb. 1951, private collection.

515 "STAND ACCUSED": Pastoureau, "Aide-mémoire," 60–61.

515 "I AM SURREALISM!": Abel, *Intellectual Follies*, 97.

516 ITS FUTURE CONTINUATION: [Marcel Jean], "A l'ombre de lion diffamé et tiaré chargé en abîme d'une valise d'argent," in *Tracts*, II, 112.

516 "THE 9TH OF THERMIDOR!": MP interview with Georges Schehadé, 14 March 1988.

516 BECOME THE "BRETON AFFAIR": Maurice Henry, "Lettre à André Breton [24 March 1951]," in *Tracts*, II, 100.

516 "AND FIDELITY": Pieyre de Mandiargues, *Désordre*, 136.

516 THE OTHERS "WITHOUT APPEAL": "[Clôture définitive des affaires Carrouges et Pastoureau]," in *Tracts*, II, 74; MP interview with Georges Schehadé, 14 March 1988.

516 "DECIDED ON THE SPOT": "[Clôture définitive]," 75.

517 "TO REPEAT THE DOCTRINE": MP interview with Marcel Jean, 1 March 1988.

517 "BELIEVED IT TO BE": Henri Pastoureau to Aimé Patri, [ca. late 1951], *Tracts*, II, 347.

517 "AND OLD-BIDDY PETTINESS": *Le Figaro* (12 May 1951).

517 "AN ADVENTURE": *Haute fréquence*, in *Tracts*, II, 107.

517 "BEGINNING TO 'GET' ME": AB to Péret, 21 May 1951, Doucet.

517 "BEHALF OF GLORIA SWANSON": *Tracts*, II, 338; Justin Saget [Maurice Saillet], "Boulevard du Crépuscule," *Combat* (17 May 1951), 4.

518 DEFENSE OF THE PAINTER: AB and Benjamin Péret, "La Vie imagée de Pablo Picasso," *Arts* (28 Dec. 1951–8 Feb. 1952), each installment on p. 6 or 7.

518 "TO UNDERSTAND IT": "Why Is Contemporary Russian Painting Kept Hidden from Us?," in *Free Rein*, 264. First published in *Arts* (11 Jan. 1952).

518 PAST IDEOLOGICAL WAFFLING: See "Of 'Socialist Realism' as a Means of Mental Extermination," in *Free Rein*, 274–77 (first published in *Arts* [1 May 1952]); Roy, *Somme toute*, 294.

519 LEAP INTO PUBLIC AWARENESS: Bédouin, *Vingt ans*, 202. The definition, still in use, is: "Artistic and literary movement whose aim is to express pure thought by excluding logic and all moral or aesthetic concerns."

519 "FROM THAT VERITABLE EPIC": André Parinaud, "Comment et pourquoi ont été réalisés les entretiens avec André Breton," *Arts* (5 Nov. 1952), 4.

519 "ADVOCATED AUTOMATIC WRITING": Michel Conil Lacoste, "'Nul n'est habilité à dresser le bilan du surréalisme,'" *Le Monde* (15 April 1964), 10; MP interview with Jean Schuster, 30 June 1986.

519 READ LIKE A SCRIPT: Parinaud, "Comment et pourquoi," 1; Etiemble, "Breton? un beau classique," *NRF* 172, 843; MP interviews with André Parinaud, 5 June 1996, Marcel Jean, 1 March 1988, and Alain Jouffroy, 24 June 1986.

520 FOR THE PUBLICATION RIGHTS: AB to René Bertelé, 17 Jan. 1952, *NRF* archives. Although the English translation was published under the title *Conversations: The Autobiography of Surrealism*, the French title was simply *Entretiens*, or "interviews."

520 "CATALYZED THESE EVENTS": *Conversations*, 3. My thanks to Jean Echenoz for his insights into the particulars of Breton's voice.

520 "MASKED AT THE SAME TIME": Ibid., 33.

521 "ITS ENERGY REMAINS INTACT": Ibid., 172, 176.

521 "MISSED THEIR TARGET": Ibid., 169–70. The encoded "1713" was also noted by Georges Sebbag in *Imprononçable jour*, ch. 52.

521 "TOTALLY IMPERSONAL": AB to René Bertelé, [ca. 25 Dec. 1951], *NRF* archives. According to Parinaud, the decision to keep silent on the Carrouges Affair was made by Breton, who systematically deleted any questions about it that the interviewer submitted (MP interview with André Parinaud). Despite this, most reviewers of the printed version found much to praise; the main criticism seems to have come from Parinaud's own radio colleagues, who regretted (their injunctions notwithstanding) that the "Pope of Surrealism" had not caused a scandal on the air: Parinaud, "Comment et pourquoi," 1, 4.

521 NO ONE TO TALK TO: AB to Péret, 9 June 1952, Doucet.

521 "MY HOUSE IS ALWAYS FULL": MP interview with Claude Courtot, 24 June 1986.

521 "THE POST OFFICE BLUSH": *Le Figaro littéraire* (13 Sept. 1952); MP interview with Aube Elléouët, 6 March 1988.

522 "THE TIME OF DISCOVERY": Benayoun, *Rire des surréalistes*, 72.

522 "LIKE A NARCOTIC": "Langue des pierres," in *Perspective cavalière*, 151. First published in *Le Surréalisme, même* 3 (fall 1957).

522 "THOUGHT THEY WERE A JOKE": MP interview with James Lord, 2 March 1988.

522 "CHALK LAYER COVERING IT": "Les dessins préhistoriques de Cabrerets sont-ils authentiques?" *Arts* (15 Aug. 1952), 1; *Le Figaro littéraire* (21 Nov. 1953).

522 "DRAWN SOME 30,000 YEARS AGO": "Les dessins préhistoriques de Cabrerets," 8.

522 BEING A "NAUGHTY BOY": Bédouin, *Vingt ans*, 222; *Le Figaro littéraire* (13 Sept. 1953), 3.

523 "THE OLD MODEL": AB to Crastre, 11 Nov. 1952, HRC; AB to Pierre-Quint, 1 Sept. 1952, BN.

523 "DIFFERENCES, EVEN INSULTS": AB cat., 410; Biro, et al., *Dictionnaire général*, 157.

523 SHOW SOON AFTERWARD: Bédouin, *Vingt ans*, 242–43.

523 "INCESTUOUS, AND NECROPHILIAC": Biro, et al., *Dictionnaire général*, 287; AB to Molinier, 3 June 1955, AB cat., 415.

524 "SOMEONE WHISPERED, 'HITLER'": Carlton Lake, *Confessions of a Literary Archaeologist* (New York: New Directions, 1990), 29–30; Andrews, *Surrealist Parade*, 154.

524 "PAINFUL TO HEAR": Corti, *Souvenirs désordonnés*, 142.

524 DOSTOEVSKY'S GRAND INQUISITOR: "Staline dans l'histoire," in *Perspective cavalière*, 25. First published in *Le Figaro littéraire* (14 March 1953).

524 "LIGHT SHINE THROUGH": *Arts* (24 Oct. 1952), 6; Bédouin, *Vingt ans*, 244.

524 "SOMBER IN EVERY RESPECT": AB to Schehadé, 1 May 1953, private collection.

524 IN THE CITY OF LAVAL: AB to Paulhan, 4 Oct. 1953, JP; AB cat., 411.

525 "IS INSIDE THE LION": "L'un dans l'autre," in *Perspective cavalière*, 53. First published in *Médium* 2 (Feb. 1954). A partial English translation was published in Mel Gooding, ed., *Surrealist Games* (Boston: Shambhala/Redstone Editions, 1993), 31.

525 "WORK FOR SEVERAL DECADES": "Nouveaux éléments du dictionnaire unitaire 'L'un dans l'autre,'" in *Perspective cavalière*, 73.

525 "NOT TO BE ROASTED ITSELF": Ibid., 79.

525 "TO GUESS THE ANSWER: "L'un dans l'autre," 55.

525 "AND ANTIRELIGIOUS": Legrand, *Breton*, 88; AB to Pierre-Quint, 1 Sept. 1952, BN.

526 COMING TO BRETON'S DEFENSE: Lottman, *Albert Camus*, 529; Claude Mauriac, *Aimer De Gaulle* (*Le Temps immobile*, V) (Paris: Grasset, 1978), 531; *Le Figaro littéraire* (12 Feb. 1954); *France-Soir* (12 Nov. 1953); Paulhan to AB, [21 Oct.] and 11 Nov. 1953, Doucet. Apparently Camus at first refused, then bowed to Paulhan's entreaties. Malraux, for his part, was returning a favor: Breton had defended him in 1924 against charges of stealing Cambodian artifacts from the temple at Angkor.

526 HIS FIRST OFFICIAL ACTS: *Le Figaro littéraire* (21 Nov. 1953); *Le Monde* (28 Nov. 1953), 16; Legrand, *Breton*, 88; Paulhan to AB, [28 Nov. 1953], Doucet.

526 NOTIONS AS "CONVULSIVE BEAUTY": Biro, et al., *Dictionnaire général*, 152; Bédouin, *Vingt ans*, 279; cf. "Le Surréalisme et la tradition," in *Perspective cavalière*, 127–29; *Surrealism and Painting*, 332.

526 "GREECE WILL NOT FUNCTION!": *Du Surréalisme et du plaisir*, 225.

527 "GO TO THOSE PLACES!": Roy, *Somme toute*, 413.

527 "BE AFRAID TO LEAVE YOU": "Adieu ne plaise," in *Perspective cavalière*, 31–32. First published as a pamphlet in Jan. 1954.

527 "ABLE TO FINISH": AB to Paulhan, 3 Feb. 1954, JP; Paulhan to AB, [ca. 1 Feb. 1954], Doucet.

527 "WERE DEAREST TO ME": AB to Paulhan, 7 Jan. 1954, JP.

527 HE HAD SET AFOOT: Balakian, *André Breton*, 255; cf. AB to Péret, 23 July 1954 and 1 Feb. 1955, Doucet.

528 WITH HER FORMER HUSBAND: Various letters AB to Simone, 1950s, Sator; Jean, *Au galop*, 185–86; Tanguy, *Lettres de loin*, 175; Reynal to Agnes Gorky, [ca. July 1956], Reynal.

528 "LIVED TO THE FULLEST": Deharme, *Années perdues*, 244.

528 "CHARM HAS DISSIPATED": Marcel Schneider, *L'Eternité fragile* (Paris: Grasset, 1989), 227.

528 "VERY PLEASANT, VERY COURTEOUS": MP interview with Bernard Minoret, 9 March 1988.

528 "HER DISAPPEARANCES": "Alouette du parloir," in AB, Lise Deharme, Julien Gracq, Jean Tardieu, *Farouche à quatre feuilles* (1954; Paris: Grasset ["Les Cahiers Rouges"], 1985), 13–14.

528 "EVERYTHING, HAVEN'T I?": Ibid., 23.

529 "OUR MOMENTS OF DISTRACTION": Ibid., 11.

529 "TO ARCANUM 17": AB to René Bertelé [ca. 25 Dec. 1951], NRF archives; A[ndré] P[arinaud], "André Breton: 'Ce qui manque à l'art moderne, c'est la magie,'" *Arts* (19 June 1957), 1; Gérard Legrand, "Libre promenade," in AB and Gérard Legrand, *L'Art magique*, revised ed. (Paris: Adam Biro/Phébus, 1991), 14; MP interview with Monique Fong, 12 Jan. 1988.

529 "BRING US A NEW BOOK": Corti, *Souvenirs désordonnés*, 126.

529 ITS LOVELY CO-AUTHOR: Belen [Nelly Kaplan], "Une rencontre," NRF 172, 743–44; MP conversation with Nelly Kaplan, 16 Nov. 1993.

530 "OUT IN THAT DIRECTION": "As in a Wood," in *Free Rein*, 240. First published in *L'Age du cinéma* (Aug.–Nov. 1951).

530 "BOWLED HIM OVER": AB to Kaplan, 31 Dec. 1956, in auction cat. *Archives d'un visionnaire: Abel Gance* (Paris: Hôtel Drouot, 3 March 1993), item 270.

530 "NEW STRUCTURE OF TIME": AB, "Magirama 1957," *Le Surréalisme, même* 2 (spring 1957), 163. Also published in *Cahiers du cinéma* (March 1957).

530 "SIGNPOST PAINTINGS": Belen, "Rencontre," 743–44.

530 "SATURATED WITH YOU": AB to Kaplan, 6 Jan. 1957, Kaplan archives.

530 "SURROUNDING US": Belen, "Rencontre," 744.

530 "ATTRACTED YOU TO ME": AB to Kaplan, 30 July 1957, Kaplan archives; Nelly Kaplan, "Au hasard objectif," *Le Figaro* (24 April 1991); MP conversation with Nelly Kaplan, 16 Nov. 1993.

531 "ALL THE SAME TO HER": MP interview with Samir Mansour, 15 Feb. 1989; notice on Joyce Mansour, *Torn Apart*, www.bitteroleander.com/books.html, accessed 6/6/2007.

531 HIS LAST GREAT LOVE: Georges Bernier to MP, 12 April 1988, and MP conversation with Bernier, 11 Nov. 1988; MP interviews with Samir Mansour, Myrtille Hugnet, 2 March 1988, Bernard Minoret, 9 March 1988, André Thirion, 9 March 1988, and James Lord, 2 March 1988.

531 "DIDN'T UNDERSTAND" HIM: MP conversation with Nelly Kaplan, 16 Nov. 1993.

531 "HE WAS EVADING OLD AGE": Jean, *Autobiography of Surrealism*, 192 (trans. slightly revised).

532 ATTEND THE CAFÉ MEETINGS: Mayoux to AB, 31 May 1954, 6 Dec. 1956, and 25 Jan. 1961;

Mayoux to Pierre Seghers, 27 Jan. 1952; Mayoux to Schuster, 31 May 1954 (all documents: Doucet).

532 "THAT EXISTED IN SURREALISM": *Tracts*, II, 365–67; "A son gré," in ibid., 135–36.

533 AGAINST "GRAVEDIGGERS": Legrand, *Breton*, 194.

533 "MAGAZINE IN THE WORLD": *Les Lèvres nues* 5 (June 1955), 27; *Tracts*, II, 369.

533 SURREALISM IN FRANCE: Patrick Tacussel, "Le Grand choc des avant-gardes," *Magazine littéraire* 213 (Dec. 1984), 44. The death announcement was dated 9 Sept. 1955.

533 "TAKE CARE OF OURSELVES": AB to Péret, 17 Jan. 1955, Doucet.

533 "TIRED AND GLOOMY": AB to Péret, 29 July 1955; AB to Péret, 1 Feb. 1955 (both Doucet).

533 "AVERSION TO THAT PLACE": AB to Péret, 29 July 1955; Legrand, *Breton*, 91.

533 "ROUTINE OF FAILURE": AB to Péret, 29 July and 20 April 1955, Doucet; Béhar, *André Breton*, 428; Claude Day, "Aube Elléouët," *Obliques* 14–15 (1st trimester 1977), 105–6.

534 "HE WAS 'SOMEBODY'": MP interview with Aube Elléouët, 6 March 1988.

534 IN TODAY'S CURRENCY: Béhar, *André Breton*, 19, 428; MP interview with André Thirion, 9 March 1988.

534 "HISTORY OF THE PARTY": "Au tour des livrées sanglantes!" in *Tracts*, II, 157.

534 "A LONG TIME, EVERY HOPE": "Discours au meeting 'Pour la défense de la liberté' [20 April 1956]," in *Perspective cavalière*, 123. First published in *Le Surréalisme, même* 1 (Oct. 1956).

534 "OF THE WORLD PROLETARIAT": "Hungary: Sunrise," [trans. unknown], in *What is Surrealism?*, 344; Bédouin, *Vingt ans*, 287.

534 "MORE STALINIST THAN THE RUSSIANS": Irwin Wall, quoted in Helena Lewis, "Elsa Triolet: The Politics of a Committed Writer," *Women's Studies International Forum* ix:4 (1986), 392.

535 "THE DEATH OF SURREALISM": "[Prière d'insérer pour 'Le Surréalisme, même']," in *Tracts*, II, 154. The magazine's title ("Surrealism Itself" or "Surrealism, Even") was, of course, a reference to Duchamp's *La Mariée mise à nue par ses célibataires, même*.

535 FIVE YEARS EARLIER: *Tracts*, II, 369; Maurice Chapelan, "André Breton annonce 'Le Surréalisme, même,'" *Le Figaro littéraire* (24 March 1956).

535 "WHO COME TO SEE ME?": Cited in Olivier Todd, introduction to Roger Vailland, *Le Surréalisme contre la Révolution* (Paris: Editions Complexe, 1988), 22; Biro, et al., *Dictionnaire général*, 141; Béhar, *André Breton*, 427, 431.

535 "BENEATH ITS CLAWS": AB to Paulhan, 12 Aug.

1955, JP; Alexandrian, *Breton par lui-même*, 152.

535 "HARD TO REALIZE": Roger Caillois, "Divergences et complicités," *NRF* 172, 695.

536 ALTER THEIR INFLUENCE: Blachère, *Les Totems d'André Breton*, 148, 208.

536 "THE LIFE OF ITS AUTHOR?": Parinaud, "Breton: 'Ce qui manque à l'art,'" 1.

536 "THE VEHICLE OF MAGIC": Cf. Legrand, "Libre promenade," 14.

536 "ONE-QUARTER TO ONE-THIRD": Cf. Blachère, *Les Totems d'André Breton*, 114. Legrand's statement, from his letter of 8 Nov. 1985 to Blachère, is quoted in Blachère's manuscript (p. 174) but not in the published version.

537 "MAGIC THAT ENGENDERED IT": AB and Gérard Legrand, *L'Art magique* (Paris: Club Français du Livre, 1957), 21.

537 "CENTERPIECE OF THE VOLUME": AB to Péret, 29 July 1955, Doucet; AB cat., 419.

537 WITH "ILL HUMOR": *Art magique*, 54–55.

537 ALL RELATIONS WITH CLAUDE: MP interview with Claude Lévi-Strauss, 21 Feb. 1989; Lévi-Strauss, *De près et de loin*, 52–53.

537 LEFT NUMEROUS ERRORS UNCORRECTED: "Note des éditeurs," *Art magique*, revised 1991 ed., 10.

537 "SPIRITUAL ANARCHY": Henry Amer [H. Bouillier], in *NRF* (1 Oct. 1957), 778–81. See also: *Cahiers du Sud* 342 (Sept. 1957), 295–97.

20. The Anti-Father

538 "HOW TO LOVE": Roy, *Somme toute*, 292, 295.

538 LETTER BY ANDRÉ BRETON: Jacques Brenner, *Journal de la vie littéraire*, II (1964–1966) (Paris: Julliard, 1966), 93; AB, "Schnorr & Cie.," *Bief* 1 (15 Nov. 1958), [n.p.]. The magazine's title means "canal reach" or "visible part of a stream."

538 SPIRITUALLY DEVASTATED IT: *Conversations*, 253–54; "Enquête: A l'aube du parlant, huit poètes s'écriaient: 'Méfions-nous du cinéma,'" *Arts* (8 Oct. 1953), 10. Breton's contribution to this survey, most likely dating from 1923, was titled "Film is rushing toward nothingness."

539 "RAPIDLY TAKING ITS PLACE": "Démasquez les physiciens! Videz les laboratoires! [18 Feb. 1958]," in *Tracts*, II, 172.

539 OR EVEN RIMBAUD: "Réponse à une enquête sur la conquête de l'espace," in *Perspective cavalière*, 188. First published in *Le Figaro littéraire* (22 April 1961). The first successful *Sputnik* mission had taken place in Sept. 1957.

539 "POLITICAL OBSCURANTISMS": "Sauve qui doit," in *Tracts*, II, 214; Benayoun, *Rire des surréalistes*, 49.

539 "PLAYED A DOMINANT ROLE": Duits, *Breton a-t-il dit passe*, 72.

539 "OR WILL NOT BE AT ALL": AB to Simone, 1 Sept. 1920, Sator.

539 TO OVERCOME THE FATHER: For a discussion of Situationism, see Peter Wollen, "The Situationist International," *New Left Review* 174 (March–April 1989), 67–95. See also: Duits, *Breton a-t-il dit passe*, 73; "Entretien avec Guy Dumur," in *Perspective cavalière*, 232.

540 TEL QUEL'S WRITINGS "DIFFICULT": "Note de Philippe Sollers," *Tel quel* 42 (summer 1970), 102.

540 "GENIUS" AND "RELEVANCE": "André Breton à la radio," *Tel quel* 13 (spring 1963), 61, 63.

540 "UNTHEORETICAL AND UNSCIENTIFIC": Susan Suleiman, "As Is," in Denis Hollier, ed., *A New History of French Literature* (Cambridge, Mass.: Harvard University Press, 1989), 1015.

540 FAVORED BRETON EPITHET: Ibid., 1011–18; Lewis, *Politics of Surrealism*, 171–72; Jean-François Fourny, "La Deuxième vague: *Tel quel* et le surréalisme," *French Forum* 2 (1987), 229–38. For Tel Quel's attacks on Surrealism, see esp. Philippe Sollers, "La Grande méthode," *Tel quel* 34 (summer 1968), 21–27, and more or less the entirety of *Tel quel* 46 (1971).

540 FROM AN ART DEALER: AB to M. Sirot, 5 Aug. 1958, private collection; AB to Péret, 21 July 1958, Doucet.

540 "GET ME TO BUY IT": MP interview with Samir Mansour, 15 Feb. 1989.

541 "DE GAULLE A USURPER": *Tracts*, II, 380.

541 OUTSIDE SURREALIST CIRCLES: Cf. Thirion, *Révisions*, 251; "Enquête auprès d'Intellectuels français," in *Tracts*, II, 179.

541 THE TRACT BY MAIL: "Déclaration sur le Droit à l'Insoumission dans la Guerre d'Algérie," in *Tracts*, II, 207–8, see also 390–91.

541 "ALGERIAN FREEDOM": "Manifeste des intellectuels [7 Oct. 1960]," in *Tracts*, II, 393.

541 "TO DISSEMINATE IT": AB to [judge presiding over the "Manifesto of the 121" case], 22 Sept. 1960, Béhar, *André Breton*, 446; *Tracts*, II, 391; Eric Losfeld, *Endetté comme une mule, ou La Passion d'éditer* (Paris: Pierre Belfond, 1979), 100–1.

542 "COULDN'T GET ENOUGH AIR": Audoin, *Breton*, 47; Audoin, *Les Surréalistes*, 151; Legrand, *Breton*, 93; Béhar, *André Breton*, 440; MP interviews with Edouard and Simone Jaguer, 10 Nov. 1993, and Claude Courtot, 24 June 1986.

542 CONTRAINDICATED IN ASTHMA CASES: *Physicians' Desk Reference*, 47th ed. (Montvale, N.J.: Medical Economics Data, 1993), 2610.

542 "DO WHEN I'M GONE?": MP interview with Claude Courtot, 24 June 1986.

542 PUBLICATION AT THE TIME: AB to Crastre, 1 Jan. 1959, HRC; MP interview with Pierre

Matisse, 5 Dec. 1988. Miró's gouaches were executed in 1940–41, Breton's poems written in the fall of 1958.

542 "AND BESIDES, I'M LAZY": Duits, *Breton a-t-il dit passe*, 104.

543 "MUTATED INTO A HABIT": AB to de Massot, 24 Aug. 1962, Doucet.

543 BRIEF, LAUDATORY STATEMENT: Magritte to AB, 4 July 1960, displayed at the exhibition "Breton: La Beauté convulsive"; Magritte to AB, 27 May, 4 July, and 5 Sept. 1961, AB cat., 423–24; *Surrealism and Painting*, 269–70.

543 "AFTERNOON OF A FAUN": Gallimard to AB, 21 March 1961; AB to Gallimard, 31 March 1961 (both *NRF* archives).

543 FROM THE WOMAN AGAIN: MP interview with Claude Courtot, 24 June 1986.

543 "MOST BEAUTIFUL PIECE": MP conversation with José Pierre, 30 April 1991.

543 "UNEMPLOYED GRAVEDIGGERS": AB to Jacques Nantet, 15 Nov. 1958, in Legrand, *Breton*, 194.

544 "CHICKEN IN SOLITARY DELIGHT": Benayoun, *Rire des surréalistes*, 36.

544 APARTMENT OF HIS OWN: Stella, introduction to Péret, *Death to the Pigs*, 27; Alexandrian, *Surréalisme et rêve*, 397; AB to Péret, 26 June 1959, Doucet.

544 "OLD MAN OF SEVENTY": MP interview with Monique Fong, 12 Jan. 1988.

544 "GO WHERE YOU PLEASE": AB to Péret, 29 July 1959, Doucet.

544 DRIFTED TO SLEEP: Jean-Louis Bédouin, *Benjamin Péret* (Paris: Seghers ["Poètes d'aujourd'hui"], 1973), 59.

545 "LIFE MORE BEAUTIFUL": *Arts* (30 Sept. 1959), 3. The quote is from *Anthology of Black Humor*, 302.

545 THE SAME TIME: Biro, et al., *Dictionnaire général*, 136; Maurice Rapin, "Jacqueline Duprey," *Obliques* 14–15 (1st trimester 1977), 103; Legrand, *Breton*, 95.

545 "HOLE IN HER DRESS": Brauner to unidentified friend, 22–26 Dec. 1959, in the auction cat. *Autographes, Dessins*, no. 2 (Paris: Florence Arnaud, April 1991), item 366; Legrand, *Breton*, 95; Guy Le Clec'h, "L'Inimitable aventure du surréalisme," *Le Figaro littéraire* (6 Oct. 1966), 10; AB cat., 422; MP interview with Samir Mansour, 15 Feb. 1989.

546 HIS OWN LEFT BREAST: Brauner to unidentified friend, ibid.; *Tracts*, II, 382. Description partly based on photos of Benoît's costume in *Surrealism and Painting*, 387–88.

546 "RIGOR WITHOUT APPEAL": "Dernière heure [4 Dec. 1959]," in *Tracts*, II, 182.

546 "GREATEST MYSTERY": "Introduction to the

International Surrealist Exhibition [1959]," in *Surrealism and Painting*, 377.

546 "RESCUED FROM SHAME": Ibid., 385; Gauthier, *Surréalisme et sexualité*, 62.

546 IDENTICAL PHRASINGS AS WELL: "Des biscuits pour la route," in *Tracts*, II, 185–91, see also: xxii; Audoin, *Breton*, 45.

546 "SURREALISM SINCE ITS ORIGIN": "Introduction to the International Surrealist Exhibition," 383.

547 "FLESH FROM BEING ONE": AB, introduction to Oskar Panizza, *The Council of Love*, trans. Oreste F. Pucciani (New York: Viking Press, 1973), xviii; *Tracts*, II, xxii; *Surrealism and Painting*, pass.

547 "OWN FACE BEING SEEN": MP interview with Claude Courtot, 24 June 1986; Legrand, *Breton*, 96; Audoin, *Les Surréalistes*, 148. Breton estimated group membership at this time as "a dozen militants, some thirty participants, and of course, sympathizers who remain on the outside": Jacqueline Piattier, "'Le Surréalisme continue à vivre [. . .],' nous déclare André Breton," *Le Monde* (13 Jan. 1962), 9.

547 "BUT GOOD AND FULL": MP interview with Claude Courtot.

547 "TO 'THE OUTER SHADOWS'": Charles Duits, *André Breton a-t-il dit passe* (Paris: Denoël, 1969), 140 (phrase deleted from the revised ed.).

548 "HIS RED HAIR": Audoin, *Les Surréalistes*, 150.

548 "DOING IN THE GROUP": MP interview with Claude Courtot.

548 "THE SURREALIST MEETINGS": AB to Bosquet, 20 March 1961, *Marginales* xxxiv:125 (April 1969), 67.

548 "EFFORT TO MASK THE VOID": *Tracts*, II, 385–86. The French edition was published by Editions Denoël in 1961 as *Vingt ans de surréalisme*.

549 "ROMANCE NOVELS!": Chapsal, *Envoyez*, 217.

549 "AT THE PEANUT GALLERY": Ibid., 217–18.

549 "POETRY, LOVE, AND FREEDOM": Ibid., 225.

549 "WITH A THREATENING AIR": Ibid., 218.

549 "HIS GESTURES. AND MINE!": Ibid., 218–19.

549 THE SURREALISTS' PROTESTS: AB to Simone, 30 May and 2, 3, and 6 June 1962 (all documents: Sator).

549 "SOME LAPSES OF TASTE": MP interview with Claude Courtot, 24 June 1986.

549 WITH NADJA HERSELF: Pieyre de Mandiargues, *Désordre*, 113–14; cf. "Avant-dire (dépêche retardée)," in *Nadja,* revised ed. (P:aris: Livre de Poche, 1964), 5–7: "It is perhaps not unwarranted to try to obtain a little more aptness in terminology, and fluidity in other respects . . . After thirty-five years . . . the slight retouchings that I have decided to make to [the text] evidence only a certain concern with saying it better."

550 INSTALLED A HEAVIER LOCK: Legrand, *Breton*, 99; Anna Balakian, "Breton and Drugs," *Yale French Studies* 50 (1974), 96n; "André Breton, le combattant de l'insolite, est mort," *Combat* (29 Sept. 1966), 7.

550 "FRENCH LITERATURE": Bertelé, internal memo to Gaston and Claude Gallimard, 1 June 1960; AB to Paulhan, 15 April 1959 (both *NRF* archives).

550 WAS TURNED DOWN: Yannick Guillou, internal memo to Norah Kastelitz, 2 July 1965; cf. AB to Gallimard, 11 May 1965 (both *NRF* archives).

550 "SHOWN TO PRECIOUS STONES": Introduction to *Le La* [Dec. 1960], in *Signe ascendant* (Paris: Gallimard ["Poésie"], 1975), 174. Also in 1960, Gérard Legrand assembled a number of Breton's past writings, along with a biographical chronology and numerous illustrations, for the compilation entitled *Poésie et autre* [Poetry and other things].

550 "C-MAJOR LIKE AN AVERAGE": *Le La*, trans. Mark Polizzotti and Bill Zavatsky, in *André Breton: Selections*, 126.

551 TEMPTATION TO RECONCILE: MP interview with Jacques Fraenkel, 18 March 1988, and conversation with Christophe Tzara, 29 April 1991.

551 "DO-NOTHING, BENJAMIN PÉRET": Georges Hugnet, "Pour le dixième anniversaire de la mort de Paul Eluard," in *Pleins et déliés*, 382. First published in *Arts* (15 Nov. 1962).

551 HUGNET'S "SLANDER": *De la part de Péret*, 6. The pamphlet contains an extensive dossier on the affair as compiled by the Surrealist group.

551 OBJECTS HAD BEEN SMASHED: Ibid., 7–8.

551 "BACK OF THE ROOM": Ibid., 9.

551 CHARGES AGAINST HIS ASSAILANTS: Ibid., 7–10. Hugnet seems to have been especially prone to such punitive sallies, having already been roughed up by the Main à Plume in 1943 for making "defamatory remarks" about Surrealism. Even fate had it in for him: years later, he lost most of his extensive art and rare book collection when his Christmas tree caught fire, taking his apartment with it: "Fait divers [6 Oct. 1943]," in *Tracts*, II, 18; Valentine Hugo, undated note, Hugo papers, HRC; MP interview with Virgil Thomson, 5 May 1987.

552 IN THE FIRST PLACE: *De la part de Péret*, 13.

552 "A (CARDIAC) CIVIL SERVANT": Michel-Antoine Burnier and Patrick Rambaud, *Parodies* (Paris: Balland, 1977), 141–49.

552 FINED SEVERAL HUNDRED FRANCS: "Des coups et des sous," in *Tracts*, II, 224–26. According to Pieyre de Mandiargues (letter to Nelly Kaplan, 10 Dec. 1962, Kaplan archives), Breton was rather annoyed by the whole affair.

552 "THEY CALL CULTURE": Raymond Queneau, "Erutarettil," *NRF* 172, 605; MP interview with Claude Courtot, 24 June 1986.

552 "IT'S SCANDALOUS!": MP interview with Claude Courtot.

552 HIS PRIVATE SENTIMENTS: Corti, *Souvenirs désordonnés*, 140; MP conversation with Michel Sanouillet, 11 March 1988.

553 "WORTHY OF THE NAME": "Surrealism Continues," radio address, 17 April 1964, trans. Franklin Rosemont, in *What is Surrealism?*, 311. See also: "Against the Liquidators," trans. Franklin Rosemont, in ibid., 351–54; Michel Conil Lacoste, "'Nul n'est habilité à dresser le bilan du surréalisme,'" *Le Monde* (15 April 1964), 10; Corti, *Souvenirs désordonnés*, 123.

553 "SUPPOSED TO FIND 'HAPPINESS'": Audoin, *Les Surréalistes*, 152. The title came from Charles Fourier's *La Fausse industrie*. Timely as the subject was, according to Audoin it was not Breton's original choice. Instead, he had settled on "the exaltation of women and of love seen as a revelation: a possible irruption of Provencal *courtliness* in a world of boors and poor-man's Don Juans," and was so set on it in the face of the others' lack of enthusiasm that at one point the entire project nearly collapsed. Only when someone drew the parallel between consumerism and some precepts of Fourier's did Breton relent.

553 "LIBERATION MOVEMENT": Ibid., 152–53; *Tracts*, II, 413. Both these works were collective.

553 OR BLATANTLY HOSTILE: "A la presse," in *Tracts*, II, 244–50, see also 413; AB to Gallimard, 11 May 1965; *NRF* internal memo, 21 Oct. 1966 (both *NRF* archives).

553 "ANTI-FATHER": Alexandrian, *Breton par lui-même*, 167.

553 "PRIDE IN THE PAST": *Strophes* 3 (2nd trimester 1964), cover and p. 18.

553 "DEATH FOR OVER A CENTURY": Salvador Dalí, *Open Letter to Salvador Dalí*, trans. Harold J. Salemson (New York: Heineman, 1968), 77.

554 "TO CHANGE HIS ADDRESS": Alain Bosquet, "La Nuit gagnée," *Combat* (29 Sept. 1966), 1; Duits, *Breton a-t-il dit passe*, 169.

554 "AND AFRICAN STATUETTES": [Anon.], "Un Parisien solitaire," *Combat*, ibid., 7.

554 "STRANGEST THING OF ALL": Lord, unpublished notes for *Giacometti*.

554 QUARTER OF A MILLION FRANCS: MP interview with Edouard and Simone Jaguer, 10 Nov. 1993.

554 AGAINST HIM IN 1926: AB cat., 426; Jean-Michel Goutier, "Au regard d'Uli," in ibid., 429n.

555 "TO THE PROJECT": MP interviews with Philippe Soupault, 16 June 1986, and Alain Jouffroy, 24 June 1986. Breton granted Gallimard permission to reprint the book in a letter to Claude Gallimard, 7 Sept. 1966, *NRF* archives.

555 "ALCOHOLISM, AND STUPIDITY": MP interview with Alain Jouffroy.

555 "PULLING AWAY FROM LIFE": *Combat* (29 Sept. 1966), 7.

555 "THE FINAL STANZA": Jouffroy, *Fin des alternances*, 47.

556 FOUND HIM IN HIS BATHROBE: A.M., "'Je fais une bien mauvaise sortie,'" *L'Aurore* (29 Sept. 1966); René Lacôte, "Témoignage des années 30," *Lettres françaises* (6 Oct. 1966), 16.

556 ILLUSIONS ABOUT HIS CONDITION: MP interview with Claude Courtot, 24 June 1986; Legrand, *Breton*, 102.

556 "WILL STOP BEATING SOMEDAY": "The Cantos of Maldoror," in *Lost Steps*, 47.

556 "A DAMNED POOR EXIT": A.M., "'Je fais une bien mauvaise sortie,'"; [Anon.], "Un Parisien solitaire," 7; Jean-Jaques Lebel, "Le Grand transparent," *Quinzaine littéraire* (15 Oct. 1966), 16; *Le Figaro* (29 Sept. 1966); *France-Soir* (29 Sept. 1966), 1; Legrand, *Breton*, 102; Balakian, *André Breton*, 255; MP conversation with Jean-Michel Goutier, 12 Nov. 1993. The "moving van" reference is from *Manifesto*, 32. In his article, Lebel claims that he saw Breton at the hospital the next day, during a short remission, in low spirits but "more Tibetan than ever. His forehead was cool and firm." According to Aube, however, this is impossible, as Breton died on the same night he was admitted (letter to MP, 16 July 1996).

Epilogue: The Gold of Time

557 GROUND OF PÉRET AND HEISLER: *Arts ménagers* (Dec. 1966); MP conversation with Elisa Breton and Jean Schuster, 1 March 1988.

557 "GOLD OF TIME": Jouffroy, *Fin des alternances*, 49; Gaëtan Picon, "André Breton," *Le Monde* (3 Nov. 1966), 13; Philippe Audoin, "Comme dans un rêve," *L'Archibras* 1 (April 1967), 15.

557 "BRETON WAS DEAD": "Memories of Breton," *The Listener* (18 April 1968), 505.

557 ARAGON, PICASSO, OR DALÍ: Pastoureau, "Breton, les femmes et l'amour," 89; Dušan Matić, *André Breton oblique* (Montpellier: Fata Morgana, 1976), 112; "Les obsèques d'André Breton," *Le Figaro* (3 Oct. 1966). Alexandrian (*Breton par lui-même*, 177) claims that five thousand people attended Breton's funeral; the newspapers report about one thousand.

558 "IN THE WORLD": *Arts* (5 Oct. 1966), 5, 7.

558 "GUIDED THEIR STEPS": *Combat* (29 Sept. 1966), 7.

558 "REFORMERS OF MODERN THOUGHT": Ibid.

558 "WORDS OF SORROW AND RESPECT": *L'Humanité* (29 Sept. 1966).

558 "BRETON / HAS JUST / DIED": Aragon, "André Breton," *Lettres françaises* (6 Oct. 1966), 1.

559 AT THE PROMENADE DE VÉNUS: Audoin, *Les Surréalistes*, 155.

559 WALLS OF THE SORBONNE: Jean, *Autobiography of Surrealism*, 441–42; Lewis, *Politics of Surrealism*, 171; Benayoun, *Rire des surréalistes*, 139.

559 "REVOLUTIONARY SITUATION": "Pas de Pasteurs pour cette Rage! [5 May 1968]," in *Tracts*, II, 276.

559 "HAD BEEN OVERTAKEN": MP interview with Claude Courtot, 24 June 1986. Schuster, too, termed the May revolt "a great contribution to the dissolution of the group": conversation with MP, 1 March 1988.

559 "A COURSE FOR THE SHIP": MP interview with Claude Courtot; Audoin, *Les Surréalistes*, 157–58; cf. Jean Schuster, "Le Quatrième chant [4 Oct. 1969]," in *Tracts*, II, 291–95.

560 NEXT TO PANTIN: MP conversation with Elisa Breton and Jean Schuster, 1 March 1988; Jean Marcenac, *Je n'ai pas perdu mon temps* (Paris: Messidor/Temps Actuels, 1982), 152. In March 1989, a commemorative plaque was placed on the facade of the Hôtel des Grands-Hommes, site of the "birth of Surrealism" and the writing of *The Magnetic Fields*: see *Recueil des actes administratifs* (19 May 1989), 185. And on January 16, 2009, the Mayor of Paris officially designated the corner of Rue Fontaine and Rue de Douai "Place André Breton," affixing a similar plaque to Breton's former building.

INDEX

Thirion, André, 91, 152, 191, 228, 256, 273, 274, 278–79, 287, 295, 299, 301, 321, 324, 328, 340, 349, 434, 450, 459, 460, 461, 475, 483, 490, 510
Thomson, Virgil, 265, 338–39, 352, 429
Thorez, Maurice, 356, 357, 534
Thumin, Dr., 438, 439, 441
Time (magazine), 394
Tinchebray (Normandy), 4, 6, 8, 329
Toklas, Alice B., 426
Tolstoy, Alexei, 378
Totem and Taboo (Freud), 17
Toucas, Marguerite, 61
Tour du feu, La (periodical), 545
Tourtoulou (schoolmaster), 9, 12
Toyen (Marie Cermínová), 371, 376, 490, 515, 547
Traité de Métapsychique (Richet), 161
Treatise on Style (Aragon), 251, 256, 263, 267, 304, 319, 373, 431n
Triolet, Elsa, 273–74, 301, 305, 307, 317–20, 336, 474, 484
Triolet, André, 273
Tristan, Flora, 471
Triumph of the New York School (Tansey), 454n
Troisième Faust (Aragon), 318
Tropiques (periodical), 448
Trotsky, Leon (Lev Davidovich Bronstein), 197, 218–19, 224, 234, 266, 280, 282, 310, 358, 392–93, 422, 424, 430, 439, 465, 478, 485, 510, 534, 540; Breton's visits to, 401, 408–19, 420, 425, 525; death of, 436, 514
Trotsky, Natalia, 410, 413
Trotskyism, 266–67, 279, 291n, 309, 338, 379, 392, 424, 433, 458
Trouille, Clovis, 546, 547
Truman, Harry S., 481
Truth or Consequences (game), 159, 440
Tual, Roland, 227, 277, 278, 280, 292
Tunisia, 28, 259, 264
Twain, Mark, 374
Tyler, Parker, 453
Tzara, Christophe, 551
Tzara, Tristan (Sami Rosenstock), 92, 104, 118, 143, 149, 161, 194, 305, 313, 329, 371, 524; background of, 83; Breton's correspondence with, 82, 89, 100, 101, 102–3, 552; Breton's relations with, 87, 109–10, 117, 121–23, 126–27, 130–31, 136–37, 138n, 139, 141–42, 144–45, 153–55, 157–58, 160, 172–73, 183, 293, 339, 370; Congress of Paris and, 153–55, 167; Dada demonstrations and, 42, 110–16, 120, 123–24, 138–39, 141–42, 172–73; Dada promoted by, 42, 83, 109, 114, 181; Dada's birth and, 32–33, 42, 82–83; death of, 551; French reaction to, 114–15, 121–22, 124; *Littérature* and, 84–85, 103, 112; manifestoes of, 81, 87, 115, 116, 124, 126, 131; Paris and, 52, 81–84, 102–3, 105, 107–9, 124; periodicals edited by, 81, 83; Picabia and, 105, 106, 107, 109, 121, 122, 126–27, 130, 136, 140–41, 154–55; politics and, 280, 370, 375, 378; Sorbonne lecture of, 491, 492, 513, 551; Surrealism and, 151, 158, 164, 179, 186, 188, 190, 299, 323, 342, 364, 370, 426, 490, 538; Vaché likened to, 82; works by, *see titles of specific works*; World War I and, 33, 42–43, 82, 102, 108; World War II and, 440–41

Ubac, Raoul, 432
Ubu Roi (Jarry), 15, 36, 56, 87, 119, 177, 444
Ulysses (Joyce), 269
Umbilicus of Limbo (Artaud), 193
Unanimism, 16
unconscious, 94–95, 97, 128, 161, 165, 175, 181, 187, 188, 196, 203, 217, 223, 233, 331, 334, 343, 347, 406, 411, 417, 497, 520; *see also* subconscious
Under Fire (Barbusse), 220

Unik, Pierre, 243, 262, 266, 279, 287, 323, 334, 356
Union of Soviet Socialist Republics (USSR), *see* Soviet Union
United Nations, 503
United States, *see* America, United States of
Universidad Nacional (Mexico City), 412

Vaché, Captain (father of Jacques), 77
Vaché, Jacques, 47, 54–56, 59, 74, 129, 133, 178, 180, 188, 239, 251, 254, 292, 465, 492, 520; attitudes toward art, 35, 70, 80–81, 87; Breton's relations with, 34–39, 45, 64, 71–72; cinema and, 35, 63; correspondence of, 37, 39, 45, 69, 76, 80, 84, 92, 100, 137; Dada and, 35, 82–83, 102–3, 126, 137; death of, 77–80, 98, 101, 179, 260; humor of, 37–38, 374, 405; importance for Breton, 36, 38–39, 43, 44, 55, 57, 63–64, 68–69, 76–77, 78–81, 82, 87, 88, 93, 97–98, 108, 118, 159–60, 170, 183, 186; sexuality of, 36, 54, 80; World War I and, 34, 37, 49, 64, 65, 71, 76, 441
Vague, La (periodical), 60
"Vague de rêves, Une" (Aragon), 188, 190, 196
Vague Movement, 159, 175, 184
Vail, Laurence, 451
Vailland, Roger, 281–83, 285, 496
Vaillant-Couturier, Paul, 135, 220, 348,
"Vainqueurs d'hier périront, Les" (Eluard), 420
Valéry, Paul, 20, 22–23, 27, 29, 30–31, 33, 38, 39, 40, 44–45, 46, 47, 48, 49, 56, 61, 63, 65, 70–72, 74, 85, 101, 103, 106, 117, 128, 129, 145, 153, 157, 160, 200, 201, 311
Valette, Alfred, 122
Vampires, Les (film), 63
Vanel, Hélène, 405
Vanetti, Dolores (Ehrenreich), 464–65
Varèse, Edgard, 311
Variétés (periodical), 286–87
Varo, Remedios, 444, 461, 470, 498
"Vaseline symphonique" (Tzara), 124
Venice Biennale, 532
"Véritable erreur des surréalistes, La" (Drieu la Rochelle), 216
Verlaine, Paul, 25, 69, 85, 148, 557
Verne, Jules, 539
Versailles Treaty, 143, 422
Vers et prose (periodical), 12
Vers l'Idéal (periodical), 12
Vian, Boris, 485
Vichy government, 375, 433, 436–37, 440, 442, 447, 474, 484
Victor ou Les Enfants au pouvoir (Vitrac), 148
Vie immédiate, La (Eluard), 342
Vielé-Griffin, Francis, 12, 22
Vie moderne, La (periodical), 170
Vietnam War, 484, 541
View (periodical), 453, 458, 464, 468
Villain, Raoul, 24
Villiers de l'Isle-Adam, Philippe, 540
Vingt-cinq poèmes (Tzara), 83, 84, 173
Vitrac, Roger, 148, 153, 155, 160, 170, 172, 176, 180–81, 186, 202, 210, 222, 227, 242, 257, 280, 285, 290, 302
Vlaminck, Maurice de, 17, 29
Vogue (magazine), 465
Voice of America, 458–59, 461, 464
Voix, La (newspaper), 268
Voltaire (François-Marie Arouet), 140
Vus par un écrivain d'U.R.S.S. (Ehrenburg), 375–76, 378
VVV (periodical), 456, 457–58, 460, 462, 464, 465, 471, 482
Vyshinsky, Andrei, 392–93

Wadsworth Atheneum, 384
Waldberg, Patrick, 459, 490, 515, 516, 553
Wall Street crash, 298, 303